6

9

THOMAS HOPE

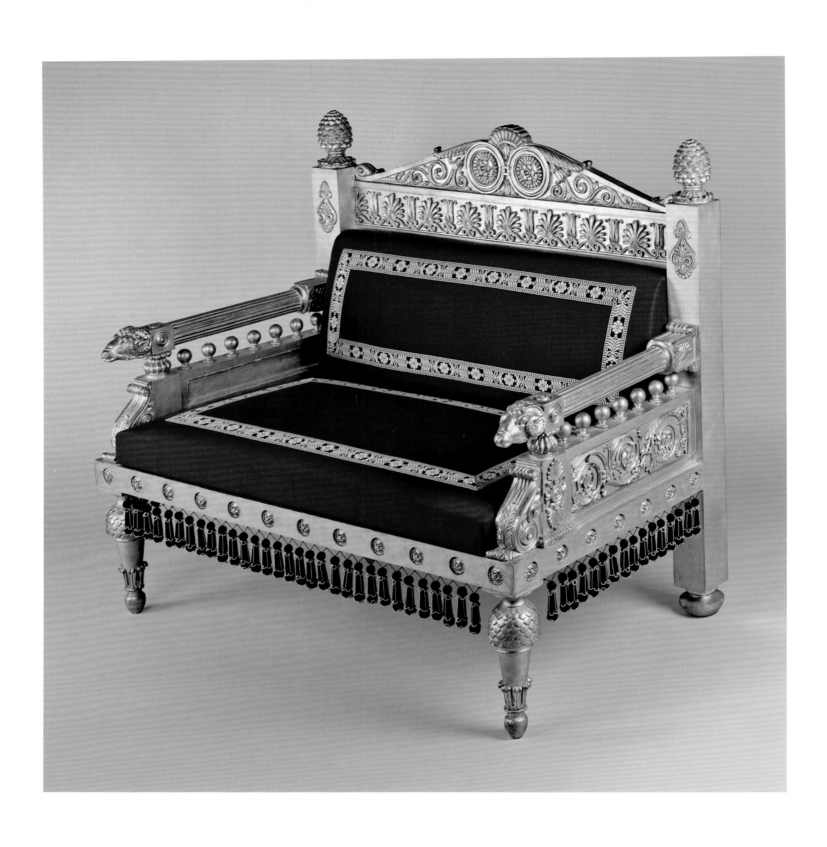

THOMAS HOPE
Regency Designer

David Watkin and Philip Hewat-Jaboor, Editors

Daniella Ben-Arie

David Bindman

Jeannie Chapel

Martin Chapman

Frances Collard

Ian Jenkins

Philip Mansel

Jerry Nolan

Aileen Ribeiro

Roger Scruton

With contributions by
Elizabeth Angelicoussis, Sally-Ann Ashton,
Martin Levy, and Fani-Maria Tsigakou

Published for The Bard Graduate Center for Studies in the Decorative Arts,
Design, and Culture, New York, by Yale University Press,
New Haven and London

This catalogue is published in conjunction with the exhibition *Thomas Hope: Regency Designer*, held at The Bard Graduate Center for Studies in the Decorative Arts, Design, and Culture from July 17, 2008, through November 16, 2008.

Exhibition tour: Victoria and Albert Museum, London, March 21 through June 22, 2008.

Exhibition curators: Philip Hewat-Jaboor, David Watkin, and Daniella Ben-Arie
Catalogue editors: David Watkin and Philip Hewat-Jaboor
Project coordinator: Olga Valle Tetkowski
Illustration coordinator: Alexis Mucha
Catalogue production: Sally Salvesen, London
Copy editor: Barbara Burn

Director of Exhibitions and Executive Editor, Exhibition Catalogues, Bard Graduate Center:
Nina Stritzler-Levine

LIBRARY OF CONGRESS CATALOGING-IN-PUBLICATION DATA

Watkin, David, 1941–
 Thomas Hope : designer and patron in Regency London / David Watkin and Philip Hewat-Jaboor.
 p. cm.
 Includes bibliographical references and index.
 ISBN 978-0-300-12416-3 (alk. paper)
 1. Hope, Thomas, 1770?–1831. 2. Art patronage--England--London--History--19th century.
3. Art--Collectors and collecting--England--London. 4. Interior decoration--England--London--History--19th century. 5. Decoration and ornament--England--London--Regency style. I. Hewat-Jaboor, Philip. II. Title.
 N5247.H67W38 2008
 709.2--dc22
 2007051416

Catalogue and jacket design: Bruce Campbell
Typesetting: Mary Gladue
Printed and bound by Conti Tipocolor SpA, Italy

Front cover: After a design published by Thomas Hope. Settee (detail). Mahogany, bronze, painted and gilded, 1802. The Trustees of the Faringdon Collection, Buscot Park, Oxfordshire. *Cat. no. 76*

Back cover: Sir William Beechey. *Thomas Hope*. English, 1798. Oil on canvas. National Portrait Gallery, London, NPG 4574. *Cat. no. 1*

Title page: After a design published by Thomas Hope. Settee. English, ca. 1802. Gilded beech and limewood. Private collection. *Cat. no. 81*

Thomas Hope: Regency Designer has been generously supported by Hyde Park Antiques, Ltd.; the Leon Levy Foundation; Lord Rothschild; Mr. and Mrs. Raphael Bernstein, Dr. H. Woody ˙amily, in honor of Wendy nds of the BADA Trust; ɹs donor.

ː *Regency Designer* at the don was supported by Hotspur Mallett & Son (Antiques) Ltd.; nald Phillips Ltd.

Errata

Page 372, second column, line 22: "66 and 85" should read "66 and 84".

Page 372, second column, line 30: "(see fig. 65-2)" should read "(see fig. 66-5)"

Page 376, first column, line 16: "fig. 66-5" should read "fig. 66-1".

Page 377, second column, line 11: "in pl. XXIX; see fig. 6-15)" should read "in plate XXIX, 5)".

Page 377, second column, line 15: "shown in fig. 6-15" should read "shown on plate XXIX, 5".

Page 378, first column, line 40: "see fig. 70-1" should read "see fig. 2-19 and fig. 70-1".

Page 390, second column, line 12: "plate XV (see fig. 69-1)" should read "plate XV, 1".

Page 394, first column, line 7: "(see also cat. no. 78)" should read "(see also cat. no. 96)".

Page 400, second column, line 29: "in cat. nos. 81 and 88)" should read "in cat. nos. 81 and 97)".

Page 402, second column, line 23: "see fig. 6-20)" should read "see fig. 6-16 and 6-20)".

Page 408, second column, line 12: "pls. XXVI" should read "pls. XXV".

Page 408, second column, line 18: "XXVI" should read "XXV".

Page 408, Fig. 85-1 caption, line 2: "pl. XXVI" should read "pl. XXV".

Page 430, first column, line 28: "(fig. 15-9)" should be omitted.

Page 482, second column, line 7: "Museu Calouste Gulbenkian, Lisbon" should read "Calouste Gulbenkian Foundation - Art Library, Lisbon".

Thomas Hope. Upright pianoforte. *Household Furniture* (1807): pl. XXIII.

Contents

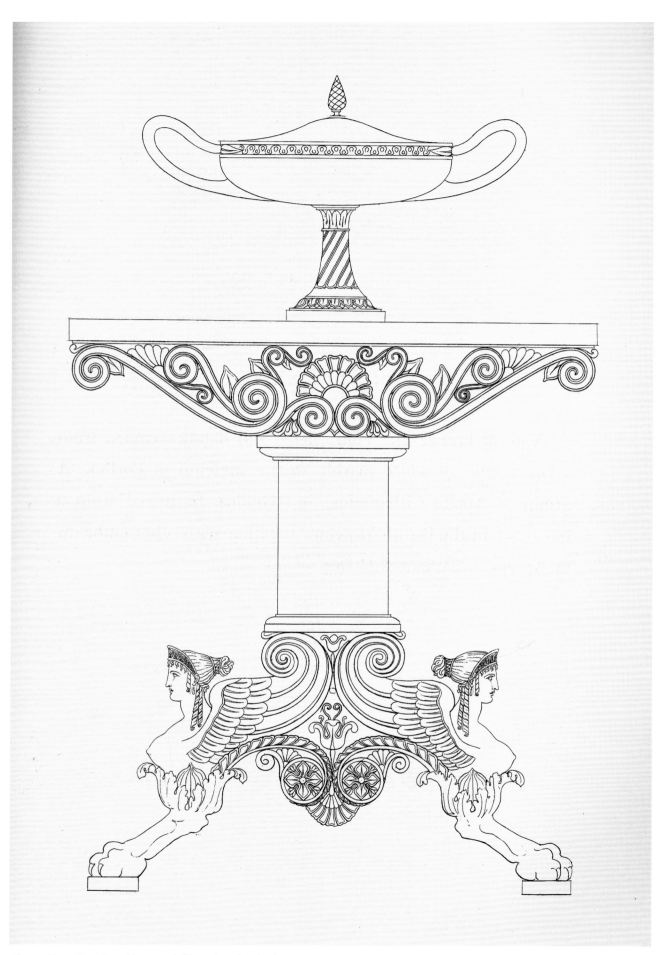

Thomas Hope. Dressing table. *Household Furniture* (1807): pl. XXXII.

Foreword

The decorative arts and design, an omnipresent dimension of the material world, are steeped in remarkable historiographies, insightful and innovative methodologies, and, of course, objects of both exceptional quality and everyday-life associations. It is certainly true that individuals who embark on studies of the decorative arts and design have fascinating and thought-provoking methods of inquiry at their disposal. *Thomas Hope: Regency Designer* epitomizes in many ways the multifaceted nature of the field, as well as the often intriguing outcomes and challenges that emerge from scholarly research and the pursuit of historical accuracy. Many enthusiasts of British art and culture know the term *Regency,* but I would imagine that its derivations and the various cultural trajectories it generated are less familiar. It will certainly come as a surprise to many readers that English Regency design, in fact, flourished in response to the creativity, passion, and thirst for collecting of a Dutch-born gentleman named Thomas Hope, who made London his home and the primary location of his remarkable art collection. Unlike his contemporary the renowned architect John Soane, Hope is an underrecognized figure. This volume, a compendium of essays and a catalogue of extraordinary works of art, gives long overdue credence to Hope as it illuminates the cultural intersections of his life in many realms, including architecture, design, literature, philosophy, painting, fashion, antiquities, metalwork, and sculpture. These are areas of art, culture, and the material world in which Hope's vision had a definite and lasting impact.

With the publication of *Thomas Hope: Regency Designer,* the Bard Graduate Center reasserts its long-standing commitment to studies of British art and culture. The focus on a polymath such as Hope resembles the project that the Bard Center initiated in 2001 on the life and work of William Beckford. It is my hope that this fascinating study will bring Thomas Hope into the forefront of public attention and foster interest among experts and students to examine little-understood areas of British architecture and design.

The exhibition *Thomas Hope: Regency Designer* is the result of the efforts of an exceptional curatorial team. Philip Hewat-Jaboor is the ultimate catalyst behind the organization of the Thomas Hope exhibition that accompanies this publication. This project would not have been possible without his inspiring commitment to Hope's legacy, his outstanding connoisseurship, and his essential hard work on numerous details pertaining to the exhibition and this catalogue. I thank him for bringing the idea of examining Hope and the English Regency to my attention. David Watkin initiated the scholarly examination of Thomas Hope with his 1968 book *Thomas Hope (1769–1831) and the Neo-Classical Idea* and has been a force in maintaining Hope's legacy within the academic and museum communities. This project has benefited substantially from his ideas and insights into Hope's position in the arts and intellectual thought of Great Britain. Early in the development of the exhibition, Daniella Ben-Arie joined Philip and David in researching Hope, especially in the search for works of art that Hope had collected. We have also benefited greatly from her knowledge and outstanding work ethic.

A project of this complexity has required support from many people. I am especially grateful to the benefactors of the Thomas Hope project: Hyde Park Antiques Ltd.; the Leon Levy Foundation; Lord Rothschild; Mr. and Mrs. Raphael Bernstein, Dr. H. Wood Brock, and members of the Levy family, in honor of Wendy Levy; Friends of the BADA Trust; and an anonymous donor.

I feel truly privileged that *Thomas Hope: Regency Designer* will open in London at the Victoria and Albert Museum, and I thank the V&A staff for their collaboration and commitment to the history of design. Mark Jones, director of the V&A, has provided essential leadership while this project was in development, and his vision has enabled the exhibition to be shown in London. I am appreciative of the effort and professional excellence demonstrated by the staff of the V&A, including Frances Arnold, Ian Blatchford, Michael Casartelli, Frances Collard, Elodie Collin, Tessa Hore, Cathy Lester, Linda Lloyd Jones, Line Lund, Sarah Sonner, Rebecca Wallace, and Damien Whitmore. The presentation of the exhibition at the Victoria and Albert Museum has received the generous support of Hotspur Ltd.; Jeremy Ltd.; John Keil Ltd.; Mallett & Son (Antiques) Ltd.; Pelham London and Paris; and Ronald Phillips Ltd.; with kind support from Christie's.

Our knowledge of Thomas Hope has been greatly enhanced by the work of the authors who have contributed essays to this publication and who have written entries on works on art shown

in the exhibition. I greatly appreciate the work of Elizabeth Angelicoussis, Sally-Ann Ashton, Daniella Ben-Arie, David Bindman, Jeannie Chapel, Martin Chapman, Frances Collard, Ian Jenkins, Martin Levy, Philip Mansel, Jerry Nolan, Aileen Ribeiro, Roger Scruton, Fani-Maria Tsigakou, and David Watkin. Barbara Burn has applied her superb editing skills to this complex and extensive publication. Bruce Campbell created the beautiful design for the book. In London Sally Salvesen, editor at Yale University Press, navigated this ambitious publication through production and printing and provided extensive assistance and support.

Hope's houses, Duchess Street and the Deepdene, were the most remarkable and comprehensive representation of the English Regency. Regrettably, both of these landmark contributions to design history have been destroyed. One of the curatorial goals of the project was to reinstate both houses in the historiography of British architecture and design. By way of the black and white illustrations and descriptions provided in Hope's book *Household Furniture*, the curators obtained considerable knowledge about Duchess Street, although the Deepdene remains more elusive and difficult to analyze. By creating a scale model of the Deepdene for the exhibition, Thomas Gordon Smith Architects have greatly enhanced our understanding of the house and helped redress many inaccuracies about its design.

The concept for this exhibition is based on the way in which Hope shaped the English Regency as a designer and as a collector. The curators determined the loans according to this idea, and they also adapted the exhibition checklist in response to the discovery of works formerly in Hope's collection, as well as to the practical and at times challenging loan-related issues. Ultimately, the exhibition is a vivid evocation of Thomas Hope. The lenders to the exhibition realized the importance of this project and kindly allowed the works in their collections to be shown in the exhibition; many were willing to let their pieces be shown in both London and New York. I would like to acknowledge all of the lenders to the exhibition and thank them for helping to make this exhibition a reality: Ackland Art Museum, Chapel Hill; the Ashmolean Museum, Oxford; Benaki Museum, Athens; the British Library, London; the British Museum, London; Stephen Calloway; Calouste Gulbenkian Museum and Art Library, Lisbon; Carlton Hobbs LLC, New York; Chen Art Gallery, Torrance; The Hon. Mrs. Everard de Lisle; Hubert de Lisle; Gennadius Library, Athens; The Huntington Library, Art Collections, and Botanical Gardens, San Marino; Lady Lever Art Gallery, National Museums Liverpool, Port Sunlight; Lambeth Archives and The Minet Library, London; Leeds Museums and Galleries (City Art Gallery and Temple Newsam), Leeds; The Metropolitan Museum of Art, New York; Musées de Poitiers; National Gallery of Modern Art, New Delhi; National Museum of Ancient Art, Lisbon; National Portrait Gallery, London; The National Trust for Scotland, Edinburgh; Phoenix Ancient Art, Geneva and New York; Alexander Stirling and Robert Stirling; Royal Pavilion and Museums, Brighton; Thomas Gordon Smith; Tate Britain, London; Thorvaldsens Museum, Copenhagen; Towner Art Gallery, Eastbourne; The Trustees of the Faringdon Collection, Buscot Park; The Victoria and Albert Museum, London; Wellcome Institute for the History of Medicine and the Shefton Museum, Newcastle University, Newcastle-upon-Tyne; as well as several lenders who wish to remain anonymous.

The Thomas Hope exhibition has been in formation at the Bard Graduate Center for a number of years, during which time it has received outstanding professional support from the staff of the exhibition department. Nina Stritzler-Levine has shepherded this project from the outset. Olga Valle Tetkowski has applied her extensive experience and superb organizational skills to the essential details involved in planning the exhibition, producing this catalogue, and making the tour to the V&A a reality. Ian Sullivan has designed a magnificent installation at the BGC. Sarah Fogel has provided outstanding support with the assembly of the exhibition both in London and New York. Alexis Mucha worked tirelessly on the numerous photography orders for this publication, and Roberta Fineman, Mary Gladue, and Joyce Hitchcock served well as its proofreaders. Han Vu created a digital media presentation for the exhibition in New York, which enables visitors to understand Hope's collecting practices and the way he presented his collection at Duchess Street. I am grateful to Susan Wall and Brian Keliher for their outstanding fund-raising efforts. Tim Mulligan and Hollis Barnhart organized the press campaign. I would also like to thank Lorraine Bacalles and her staff for attending to the daily administrative and financial needs of the Center. John Donovan and the facilities staff provide assistance with numerous details related to the maintenance of the gallery. The hard-working and skillful security staff of the Center under the direction of Chandler Small does a terrific job with this important function of the exhibition. I am grateful to all of the staff and faculty of the Bard Graduate Center for their outstanding contribution to the field and to our success over the past fifteen years.

Susan Weber Soros
Director

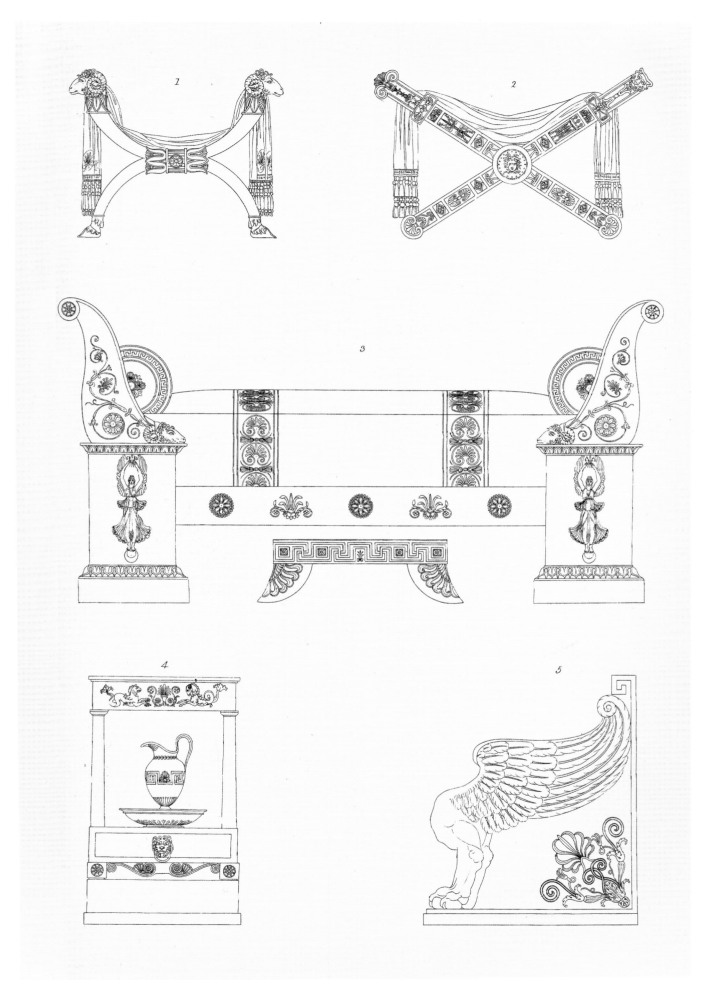

Thomas Hope. *Household Furniture* (1807): pl. XXIX.

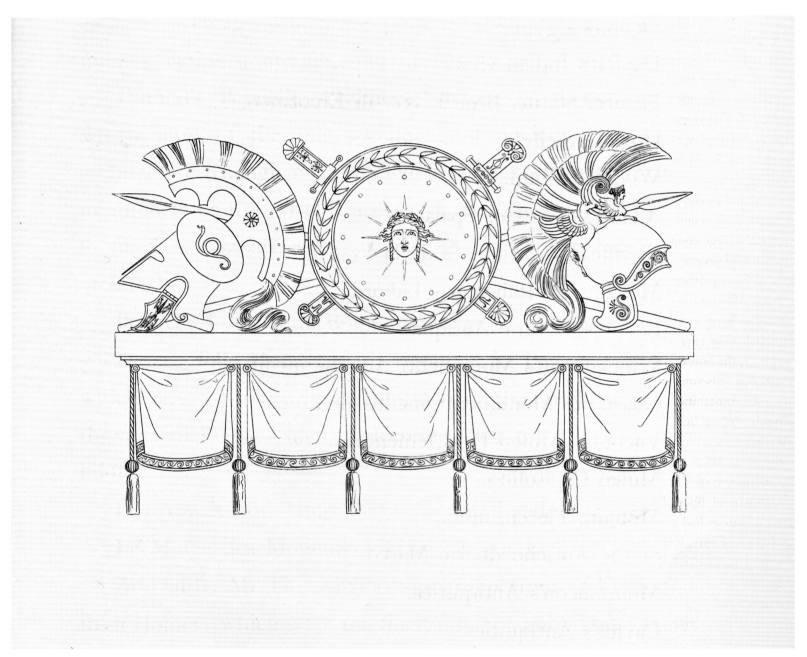

Thomas Hope. Trophy of Grecian armor. *Household Furniture* (1807): pl. LX.

INTRODUCTION

Thomas Hope: Regency Designer

This is the first exhibition and the most comprehensive publication ever to be devoted to Thomas Hope (1769–1831), a designer of furniture and interiors whose brilliance has been rarely equaled in the history of British taste. It has been an exciting challenge to present to the public the unique and innovative role that Hope played in the history of collecting, interior design, and display, beginning with his achievements in a mansion on Duchess Street in London. In 1799 he bought this imposing building designed by Robert Adam and immediately began to remodel and extend it, filling its interiors with a range of works of art, both ancient and modern, of unsurpassed quality. In 1807 he acquired a large country house, the Deepdene, Surrey, which he transformed several years later in a highly inventive Picturesque style to form another setting for his collections.

Research into the details of Thomas Hope's life and achievements has been a challenge, since the Duchess Street house was demolished in 1851 and his personal archives have been lost. However, the house was admired by Sir John Soane, whose own house and museum in Lincoln's Inn Fields of the same period suggests something of the character of Hope's, and whose strongly colored interiors, skillfully highlighted with mirrors, are crowded with antiquities and works of art, as we know Hope's house was. An even more important tool that has enabled the reconstruction of Thomas Hope's achievement is the survival of a large part of his collection until its sale in 1917, although the finest paintings had already been dispersed. Thanks to the sales catalogues of 1917, it has been possible to trace the present whereabouts of many objects in his collection.

In the process of re-creating the appearance of Hope's Duchess Street house, we have also been able to rely on the illustrations and descriptions that Hope published in his influential book *Household Furniture and Interior Decoration Executed from Designs by Thomas Hope* (1807). Since the illustrations are outline engravings in black and white, they give a rather linear and disembodied impression of the house and its furnishings, so it has been a principal aim of this exhibition and book to correct that impression by stressing Hope's sense of mass and color.

With the exception of Hope's two large Picture Galleries at Duchess Street, each of the thirteen interconnecting display rooms on the first floor of the house was not much more than about twenty feet square; some were much smaller. Packed as they were with rich and exotic objects, these rooms must have produced for visitors an overwhelming visual experience. Works of art and furniture in varying styles, many designed or commissioned by Hope himself, were mingled in a suggestive fashion in a series of interiors that reflected Egyptian, Indian, and Greek styles, as well as his personal interpretation of the contemporary work in Paris of Napoléon's architects Charles Percier and Pierre-François-Léonard Fontaine. Hope's rooms were vibrant with costly materials in contrasting colors and textures, including porphyry, granite, alabaster, basalt, serpentine, porphyry, and rare woods.

To this heady visual mix Hope added intriguing stimuli for the other senses. For example, organ music could often be heard coming from the Picture Gallery, and Hope explained that incense was regularly burned in the Indian Room, which also contained "flower baskets, and other vehicles of natural and artificial perfumes." The walls in that room were "sky blue," and the ceiling "pale yellow intermixed with azure and with sea green." Other patrons and collectors, notably William Beckford, the Prince Regent, and John Soane, created similarly personal settings for themselves in the period around 1800. It is entirely appropriate that the Bard Graduate Center has decided to follow up its 2001 exhibition on Beckford with one on Hope in 2008. As visitors to this exhibition will see, Thomas Hope brought a uniquely personal flavor to the tradition of Beckford and the Prince Regent through his skills as a "gentleman" designer of furniture, domestic utensils, and interiors.

Many objects from Hope's collection are displayed in the present exhibition and illustrated and described in the accompanying catalogue, which contains, among many other essays, a chapter on the Duchess Street house. This includes an explanation of how the house was conceived almost like a theater in which every room evoked different and appropriate sensations, with light and

illusion used to create mood. As the sculptor John Flaxman observed, Hope "affords us an excellent hint for adapting the furniture, decoration, and symbols to the Edifice and its purposes, whether it be the Church or the Fortress, the Palace, Museum, private dwelling or cottage."

This creation of appropriate character led Hope to devise idiosyncratic settings for his collection, beginning with ancient Egyptian, Greek, and Roman sculpture and including works of art that he commissioned, designed, or owned, notably sculptures by John Flaxman, Bertel Thorvaldsen, Antonio Canova; paintings by William Beechey, Joseph Michael Gandy, Benjamin West, Richard Westall, and Martin Archer Shee; objects in gilt bronze and in silver; vases; miniatures; books; drawings; and, most important of all, furniture made from his own designs. Works in silver and other objects from his collection that we know he did not design but purchased show the extraordinary care he took to choose objects that fitted exactly his own design aesthetic.

By contrast, we cannot look at Hope's most striking contribution to design, his furniture, without being aware of its distinctiveness from contemporary work in England and France, not just in the quality of its materials and execution, but especially in its power of invention and sense of structural mass. All this is well conveyed in the stimulating accounts of his furniture in this book by Frances Collard, Martin Levy, and Philip Hewat-Jaboor. Simply put, these objects have an unforgettable presence. A contributing factor is the unusual importance Hope attached to durable materials, such as stone and bronze. In her chapter on his furniture, Frances Collard stresses his admiration for colored and variegated marble slabs, as well as for pedestals and stands of stone and marble after classical models, especially evident in pieces he housed at the Deepdene. Sally-Ann Ashton, writing in fascinating detail in the catalogue about six of Hope's Egyptian sculptures explains the delight he evidently took in the varying colors and textures of stone.

Martin Chapman describes how "metalwork was an essential ingredient in the furnishing of his house," and how Hope interacted with it by providing an additional layer of designs made according to his own ideals. In his use of decorative bronzes to add sparkle to interiors lighted by candles, he followed French rather than English practice but added a measure of dark patinated bronze, "which he associated with the stoical character of Greek and Roman antiquity."

Hope's house in Duchess Street and its contents encapsulated his determination to reform public taste in design, which he further promoted by opening it to the public and by publishing *Household Furniture*, his 1807 monograph devoted to the house, a most unusual step. A single indication of his powerful impact on taste is that he was the first to use in English the phrase "interior decoration," which has since become a universal term. Interestingly, Hope borrowed this phrase from *Recueil de décorations intérieures*, a book published serially beginning in 1801 by his heroes Percier and Fontaine. Percier, a friend of Hope's, was, incidentally, born in the same year as both Napoléon and the Duke of Wellington, to whom Hope would later apply, unsuccessfully, for a peerage.

Who, then, was this extraordinary man with the wealth, artistic skills, and vision capable of creating the interiors at Duchess Street? Perhaps, not surprisingly, Thomas Hope came from a background as privileged as it was unusual. He was descended from an old Scottish family that had settled in the seventeenth century in Amsterdam, where they became the richest merchant bankers in Europe. As Philip Mansel explains in Chapter 1, the Hopes anticipated the nineteenth-century Rothschilds by becoming court bankers, in the Hopes' case to the Princes of Orange. They raised loans for foreign governments and relied for business on dynasties rather than on industry and private clients. These Hope millionaires lived in Amsterdam like princes themselves, amassing great art collections, which they made accessible to visitors. True cosmopolitans who spoke French, as well as Dutch and English, the Hope family members venerated Paris as the pinnacle of taste.

Although Thomas served briefly in the family bank, Hope and Company, his principal activity for nearly a decade, beginning in 1787 at the age of eighteen, was travel, first in Germany, Italy, Spain, and North Africa and later, in 1796–97, in Greece, Egypt, and Turkey. Those last territories were then part of the Ottoman Empire, where Hope made many drawings, which constitute a unique record of its architecture, landscape, and figures. Examples of his exquisite draftsmanship, these drawings have been studied in detail in the catalogue by Fani-Maria Tsigakou.

Hope spent as much as a year in Constantinople, where he formed a rare sympathy for Oriental taste that led him to write what Philip Mansel describes as "the first Middle Eastern novel," *Anastasius; or, Memoirs of a Greek: written at the close of the eighteenth century* (1819). Taking England by storm and at first attributed to Lord Byron, this romantic, picaresque novel and its emotional depth have been subtly analyzed by Jerry Nolan in Chapter 13 of this book.

It was on his Grand Tour of unparalleled length and extent that Thomas Hope began to create his important collection of works of art. These objects he brought with him to London, where the rest of his family had moved when they were obliged to leave Holland after its invasion by France in 1794. In her chapter on the Hope family as collectors in London, Daniella Ben-Arie explains that, unlike some who had to flee the continent before the French in the 1790s, the Hopes did not need to disperse their

collections in order to raise money. Indeed, the Hope bank in part funded the expansion of the Napoleonic Empire as it did the wars of the Russian Empress Catherine II. The extensive preparations made by Thomas Hope's second cousin Henry for the relocation of the family business and collection "allowed them to benefit from other people's turmoil."

This leads us to ask what we know of Hope's personality and of the reaction his contemporaries had to him. There is surprisingly little information here, partly because of the lack of personal papers noted above, but also because of the paucity of references to him in contemporary letters and diaries. The circumstances of his arrival in London to join his wealthy Dutch relatives and their possessions may not have endeared him to the English, and some of the references that do exist were quite unflattering. The super-rich are often unable to understand or sympathize with the situations of those less well off, and Hope probably fell into that category. He certainly exhibited the arrogance of the man who believes himself to have perfect taste in everything. He was rash enough, for example, to publish a vicious attack on designs by James Wyatt, the favorite architect of King George III and president of the Royal Academy. As a millionaire and a Dutchman who was not unwilling to express contempt for the goods he found in London and for the skills of London craftsmen, Hope remained something of an alien in London society. Even the act of designing furniture set him apart from other gentlemen.

Interesting light on Hope's personality is shed by David Bindman in his chapter on Hope's modern sculpture collection where he describes his dealings with Flaxman, Thorvaldsen, and Canova. Hope was at his easiest with Canova, whom he saw as both a sculptor of genius and a seasoned diplomat, a gentleman of high rank who kept to the letter of his contract. This contrasted dramatically with the romantic and unreliable Thorvaldsen, who "seems to have seen in Hope little beyond the hard-faced merchant who clung unyieldingly to his contract." Bindman suggests that Hope had difficulty in reconciling the two sides of his nature, as "a mercantile man" (his own words) who was accustomed to getting his own way and as a creative artist. Jeannie Chapel, writing on Hope's patronage of contemporary painters, explains how his acquisition in 1808 of *The Repose in Egypt* from the troubled painter Benjamin Robert Haydon led the artist to describe Hope as "my early Patron and first purchaser—a good but capricious man."

Hope's closest friend and associate seems to have been the younger of his two brothers, the unmarried Henry Philip; they were inseparable and their collections were to some extent interchangeable. In her chapter on the Hope family's collection and patronage in London, Daniella Ben-Arie reveals how Henry Philip was known as "the angel of the family." She reproduces his drawing of his house in Mayfair, which he remodeled with a bal-

cony featuring four Greek caryatid figures based on a drawing he had made of the Erechtheion in Athens in the 1790s, demonstrating how closely allied Henry Philip's taste was to that of his brother. Henry Philip was best known for his large collection of precious stones, notably the infamous "Blue Diamond," better known as the "Hope Diamond," a dark blue gem mounted by him as a medallion with a border of small rose-colored diamonds in arabesque pattern, now in the Smithsonian Natural History Museum in Washington, D.C.

Henry Philip's love of jewelry was shared by Thomas's wife, Louisa, who became a fashionable society hostess and had several gifted children. Thomas commissioned numerous portraits of Louisa, including one by Sir Thomas Lawrence in 1826, among others. Hope was also a member of various professional and social organizations in Georgian London; he was elected to the Society of Antiquaries in 1794, the Society of Dilettanti in 1800, and the Royal Society in 1804. He was also elected to the Travellers' Club, one of whose aims was to enable its members to receive foreign gentlemen who had entertained them abroad. Founding members in 1819 included acquaintances of Hope, including Lord Lansdowne and the architect C. R. Cockerell, as well as W. R. Hamilton, secretary to Lord Elgin.

The program that the polymath Hope initiated in 1799 with the purchase of his great house in Duchess Street turned him into a key figure in early nineteenth-century British taste and design. In this he resembled the Earl of Burlington and his role in the Palladian revival over seventy years earlier. Whereas the influence of Burlington was largely confined to architecture and garden design, Hope covered not only these fields but also sculpture, painting, costume design, theater design, and the decorative arts. In addition, he was an artist, an architectural historian, a polemicist, a novelist and essayist, and a serious collector of pictures and sculpture, as well as a designer of interiors, furniture, and household goods.

Chapter 12 is an investigation of Hope's unique contribution to the practice and theory of the Picturesque in architecture as expressed at his country house, the Deepdene, which was located in a spectacularly beautiful part of Surrey and commanded long views of wooded hills from its secluded valley. Hope remodeled and expanded this house in about 1818 and in 1823 with asymmetrical forms flowing round an Italianate loggia-topped tower. Interlocking with conservatories, terraces, and gardens, the house created an architectural incident in a landscape to which it was ultimately subordinate. Although the Deepdene has been demolished, like the Duchess Street house, its remarkable appearance was recorded in a series of watercolors painted in the 1820s to illustrate a manuscript by John Britton. Britton intended this work to accompany the book he was to publish on Sir John Soane's

Museum in 1827, the two books demonstrating, respectively, how the Picturesque could be achieved in the country and the town.

A chapter devoted to Hope's writings on architecture explains how the controversial but influential pamphlet of 1804 in which he ridiculed Wyatt's designs for Downing College, Cambridge, helped to promote the Greek Revival, which would dominate the design of countless public buildings in Britain for some years after Waterloo. By contrast, Hope's posthumously published book, *An Historical Essay on Architecture* (1835), shows his ability to change his mind dramatically, for he no longer recommended the Greek Revival in that volume. Instead, benefiting from his unique world view, one can see this book as "one of the first histories of architecture in English to include Asia Minor, Egypt, and Greece, as well as to discuss building traditions in India, Russia, and China. Topics include Early Christian, Moorish, and Byzantine architecture, the use of brick and marble, and the origins of the pointed arch." Its plates were used by architects, notably in Germany, who were moving to a round-arched style inspired by Byzantine and Romanesque models, and it was also referred to by Gottfried Semper in Germany and John Ruskin in England.

In another demonstration of the challenging diversity of outlook expressed by this surprising genius, Jeannie Chapel writes about Old Master and contemporary paintings in the collections of Hope and his family, showing that from 1798 he bought works of first-class quality by an astonishing number of major Renaissance and Baroque artists, including Ludovico Carracci, Correggio, Pietro da Cortona, Domenichino, Guercino, Poussin, Raphael, Rubens, Titian, Vasari, and Veronese. Hope's collection of antique sculpture was also as distinguished as it was extensive, although in Chapter 7 Ian Jenkins stresses that pieces then hailed as Greek masterpieces, including the much-admired *Athena* and *Hygeia*, are now seen as Roman copies of Greek originals. Elizabeth Angelicoussis describes Hope's Greek and Roman antiquities with great learning and brilliance in the catalogue.

Turning to Hope's role in the design of costume, in which one of his aims was the simplification of women's dress, Aileen Ribeiro claims in Chapter 5 that his book *Costume of the Ancients* (1809) was "the first publication in English to provide information on the clothing of classical antiquity." She sees it as "innovative and influential, not intended for antiquarians" or, as Hope put it, "to advance erudition, but only to promote taste." His task was complicated by the absence of any surviving antique garments, the scarce knowledge in Britain about the subject, and the markedly stylized representation of dress on the Greek figured vases, many in his own collection, that were his principal sources of information.

Hope can nevertheless be seen as a pioneer in the aesthetics of clothing, a theme that was developed in the minds of artists and critics as the nineteenth century progressed. In believing that beauty and harmony were best exemplified in classical civilizations, particularly Greece, he anticipated Oscar Wilde, who, as Aileen Ribeiro points out, claimed that there is not "a single line or delightful proportion in the dress of the Greeks, which is not echoed exquisitely in their architecture."

As a wealthy center of fashion and design that was both culturally and socially vibrant, the London of Thomas Hope may be said to have had much in common with London in the opening years of the twenty-first century, probably more cosmopolitan today than any city except New York. At the glamorous opening party of Hope's London house in May 1802, nearly a thousand guests, led by the Prince of Wales, trooped through the new rooms in their bewildering succession of contrasting styles, novel color schemes and decoration, and lavish contents.

As an associate of such designers and entrepreneurs as Charles Percier in Paris and Matthew Boulton in Birmingham, Hope was fascinated by the latest manufacturing techniques, as Martin Chapman shows in Chapter 6, and his aim was nothing short of the complete reform of taste in modern Britain. In this role, Hope anticipated William Morris (1834–1896), sharing his dissatisfaction with the household goods currently available in London shops, He used his own wealth and skills as a designer to create new furniture and domestic objects, both for his own use and to serve as a model for others. He was not only followed by Morris but also by Sir Henry Cole in the 1850s and the founders of what would become the Victoria and Albert Museum, whose aim was to raise the level of modern design in all the arts and crafts, both fine and applied.

In Chapter 14, Roger Scruton discussed Hope's *Essay on the Origin and Prospects of Man* and explains Hope's relationship to such thinkers as Hobbes, Locke, and Schopenhauer, even revealing him as anticipating aspects of Darwin and of modern physics. Other aspects of Hope's influence that have survived from the late nineteenth century to the present day are traced here, notably in the concluding chapter on his "Afterlife," in which Frances Collard and I focus on twentieth-century collectors, historians, and architects, such as Edward Knoblock, Mario Praz, Lord Gerald Wellesley, and many others.

Playing an unusually distinctive and carefully orchestrated role by dedicating his wealth and creativity on art in all its aspects, Thomas Hope disseminated his reforming views in many ways, including publications, large-scale entertaining, and ticketed visits to his house and collection. With this first exhibition devoted to Hope and its accompanying catalogue, his fame has reached a new high point, one that enforces a new evaluation of his role as a major catalyst in the arts of Regency London.

* * *

My greatest thanks go to my co-editor of this volume, the scholar and collector Philip Hewat-Jaboor, who with Daniella Ben-Arie is also co-curator of the exhibition and has spent several years establishing the present whereabouts of all Hope objects in public and private collections throughout Europe and the United States. The resulting data base of every object known to have been associated with Hope has made this exhibition and catalogue possible, giving this project the definitive status that we believe it has achieved.

David Watkin

The editors would like to extend their appreciation to the many individuals and institutions who made this project a reality. This publication and the exhibition it accompanies required the assistance of innumerable people listed here, each of whom deserves a great debt of gratitude. First and foremost is, of course, Susan Weber Soros, whose vision, energy, and support enabled the project to come to fruition.

Abbotsford, Melrose, Roxburghshire: Jacquie Wright; Alexander Acevedo; Ackland Art Museum, Chapel Hill: Scott Hankins, Anita Heggli, Emily Kass, Tammy Wells-Angerer, Carolyn Wood; Acorn Bank, National Trust: Sara Braithwaite; Lady Adby; Jane Anderson; The Earl of Annandale and Hartfell DL; Archaeological Museum, Newcastle: Lindsay Allason-Jones; Archive of Art and Design, Victoria and Albert Museum: Lynn Young; Art Gallery of Ontario, Toronto: Felicia Cukier; The Art Institute of Chicago: Barbara Hinde, Aimee L. Marshall; Art Resource, New York: Jennifer Belt, Ann Mark; Ashmolean Museum, Oxford: Christopher Brown, Aisha Gibbons, Geraldine Glynn, Amanda Turner, Michael Vickers, John Whiteley, Tim Wilson; Philip Astley-Jones; Avery Architectural and Fine Arts Library, Columbia University, New York: Gerald Beasley, Janet Parks, Julie Tozer; Reinier Baarsen; The Baring Archive, London: Moira Lovegrove, Claire Twinn; Julia Basiroff; Tim Bathurst; The Benaki Museum, Athens: Angelos Delivorrias, Fani-Maria Tsigakou; Jacey Bedford; Sir Geoffrey de Bellaigue; Oved and Valerie Ben-Arie; Barry Bergdoll; James Berry; Birmingham Central Library: Paul Taylor; Birmingham Museum and City Art Gallery: Rachel Cockett, Brendan Flynn; Gerald Bland; Blenheim Palace: Loraine Fergusson, John Forster; John Lord Booth II; The Bowes Museum, Barnard Castle, County Durham: Claire Jones, Rachel Metcalfe, Syd Neville; Valentina Branchini; Vanessa Brett; Bridgeman Art Library, New York: David Savage; The British Library, London: Robert Davies, Barbara O'Connor, and others on the staff; The British Museum, London: Charles Arnold, Trevor Coughlan, Virginia Ennor, Celeste Farge, Ian Jenkins, Juddith Swaddling, Michael Willis; Peter Byrne; B.T. Batsford, London: Verity Muir; Patrick Caddel; Anthony Cairns; Stephen Calloway; Carlton Hobbs, LLC, New York: Carlton Hobbs, Jami Fritz, Stefanie Rinza; Anna Ottani Cavina; Chen Art Gallery, Torrance: Sophia Chao, Holly Chase, Tei Fu Chen, Sophy Lin; Chhatrapati Shivaji Maharaj Vastu Sangrahalaya formerly Prince of Wales Museum, Mumbai: Kalpani Desai, Dilip Ranade; Graham Child; Christie's London: Rufus Bird, Marijke Booth, Stella Calvert-Smith, Charles Cator, Robert Copley, John Hardy, Conall Macfarlane, Lynda McLeod, Francis Russell, Harry William-Bulkeley; Christie's New York: Melissa Gagen, Anthony Phillips, Will Strafford; The Cleveland Museum of Art: Kathleen Kornell; Sir Timothy Clifford; Condé Nast Publications Ltd., London: Tracey Brett, Nicky Budden; Martyn Cook; Corcoran Gallery of Art, Washington, D.C.: Ila Furman, Rebecca Sobel, Nancy Swallow; Country Life Picture Library, London: Helen Carey, Margaret Donnelly, Mary Miers; Amelia Courtauld; Courtauld Gallery, London: Louisa Dare; Fiona Cowell; Alan Cowie, Richard Crowther; John Culme; Mary Davie-Thornhill; John Davis; Julie Day; Mary Day; Shawn De Clair; Diana de Lisle; Gerard de Lisle; Hubert and Marie-Dominique de Lisle; The Hon. Mrs. Everard de Lisle; Madeleine Deschamps; Curt di Camillo; Alastair Dickenson; Djanogly Gallery, Nottingham University Art Gallery: Neil Walker; Prince Jonathan Doria-Pamphilj; Dorking and District Museum, Dorking, Surrey: Fred Plant, Mary Turner; Jamie Drake; The Drapers' Company, Drapers' Hall, London: Penny Fussell; Jane Eade; James Ede; English Heritage, National Monuments Record, Swindon: Alyson Rogers, Emma Whinton-Brown; Eugene Edelmann; Giles Ellwood; The Faringdon Collection, Buscot Park: Lord Faringdon, David Freeman, Sharon Lander; Lord Alexander and Lady Clare Fermor-Hesketh; The Fitzwilliam Museum: Sally-Ann Ashton, Lucilla Burn, Diane Hudson, Julia Poole, David Scrase; The Frick Collection: Colin Bailey, Zoe Browder; Joe Friedman; Gay Gassmann; Gay Gardner; Richard Garnier; The Gennadius Library, Athens: Elias Elidas, Maria Georgopoulou, Sophie Papageorgiou, Katerina Papatheophani, Maria Volterra; Gemeente Amsterdam Stadsarchief: Clémentine van Stiphout; Georgetown University Library, Washington, D.C.: Heidi Rubenstein, Nicholas Scheetz; The Getty Research Institute, Los Angeles: Sally McKay, Julio Sims, and others on the staff; The J. Paul Getty Museum, Los Angeles: Jacklyn Burns; Phillipa Glanville; Government Art Collection, UK Department for Culture, Media, and Sport, London: Robert Jones; Chris Gravett; Lionel Green; Charles Greig; Guildhall Library, Prints and Maps Section, London: Jeremy Smith; Ann Guite; Hedrig Györy; Michael Hall; Jane Hamilton; Jill, Duchess of Hamilton; Edgar Harden; Michele Beiny Harkins; Paul Harman; Dennis Harrington;

Eileen Harris; John Harris; Lucian Harris; Christopher Hartop; William Hauptman; The Heinz Archive and Library, National Portrait Gallery, London; Tim Moreton; John Henderson; John Hill; Hillwood Estate, Museums & Gardens, Washington, D.C.: Heather Corey; Niall Hobhouse; Anthony Hobson; Alister Hoda; Robert Holden; Peter Hone; Houghton Library of the Harvard College Library, Cambridge: Caroline Durosell-Melish, Thomas Ford, Hope Mayo, Leslie Morris; Lynda S. Howard; Hugh Howard; Paula Hunt; The Huntington Library, Art Collections, and Botanical Gardens, San Marino: Shelley Bennett, Jacqueline Dugas, Melinda R. McCurdy, John Murdoch, Maura Walters; John Husband; Fred Imberman; ING Barings, London: John Orbell, Stephen Soanes, Jane Waller; Instituto Português de Museus, Lisbon: Vitória Mesquita; Robert Israel; The Israel Museum, Jerusalem: Ziva Haller Rubenstein, Shlomit Steinberg, Gioia Perugia Sztulman; Stephen Jarrett; Amin Jaffer; Tim Jeal; Simon Jervis; Daniel Katz; Bernie Karr; Rachel Karr; Keele University: Marion Gidman; Rodney Keenan; John Kenworthy-Browne; Alice King; Lady Lever Art Gallery, National Museums Liverpool, Port Sunlight Village: Johanna Booth, Godfrey Burke, Robin Emmerson, Alex Kidson, Sandra Penketh, Claire Sedgwick, Sam Sportun, Julian Treuherz; Deborah Lambert; Lambeth Archives and Minet Library, London: Jon Newman, Andrew O'Brien, Len Reilly, Anne Ward; Anne Langton; Leeds Libraries, Arts, and Heritage: Jim Bright; Leeds Museums and Galleries (City Art Gallery and Temple Newsam): Penelope Curtis, Jen Kaines, James Lomax, Sophie Raikes; Martin Levy; Stuart Lochhead; Simon Lock; Andrew Lockwood; the staff of the London Library; Todd Longstaffe-Gowan; Lotherton Hall, Leeds: Adam White; Los Angeles County Museum of Art: Mary Levkoff, Piper Wynn Severance; Lyons Demesne, Celbridge: Marion McGowan; Manchester Art Gallery: Andrew Loukes, Ruth Shrigley, Tracey Walker; Marquand Library, Princeton University: John Blazejewski, Rebecca Friedman; Henriette Manners; Peter Marino; Kate Mayne; Miranda McCarthur; Duncan McLaren; The Metropolitan Museum of Art, New York: Cynthia Chin, Deanna Cross, Philippe de Montebello, Jeffrey Munger, Matthew Noiseux, Doralynn Pines, Michelle Povilaitis, William Rieder, Mary Zuber; Ministero per I Beni e le Attività Culturali Soprintendenza per I Beni Archeologici delle province di Napoli e Caserta, Naples: Maria Luisa Nava; Minneapolis Institute of Arts: DeAnn Dankowski, Christopher Monkhouse, Jennifer Komar Olivarez; Brian Mitchell; Lennox Money; J. M. Monk; John Morton; James Mosley; Municipal Archives, Amsterdam: Corinne Staal; Alastair Murdie; John Murray, 11th Duke of Atholl; Musée Cognacq-Jay, Paris: George Brunel; Musée du Louvre, Paris; Musée National du Château de Malmaison, Paris: Bernard Chevallier; Musée Rupert de Chievres, Poitier: Philipp

Bata; Musées d'art et d'histoire, Geneva: Isabell Brun-Ilunga; Musées de Poitiers: Yves Bourel, Anne Péan; Musées royaux des Beaux-Arts de Belgique, Brussels: Michel Draguet, Rik Snauwaert; Museu Calouste Gulbenkian, Lisbon: Maria Rosa Figueiredo, José Afonso Furtado, João Castel-Branco Pereira; Museum of Fine Arts, Boston: Erin Schleigh; Museum of London: Nikki Braunton; National Archaeological Museum, Athens: Nikolaos Kaltsas; the staff of The National Archives, Kew, London; the staff of The National Art Library; National Galleries of Scotland: Dr. Stephen Lloyd; National Gallery of Ireland, Dublin: Marie McFeely, Louise Morgan; National Gallery of Modern Art, New Delhi: Rajeev Lochan, M. Shanker; National Gallery Picture Library, London: Margaret Daly; National Gallery of Victoria, Melbourne: Ted Gott, Anna Niewenhuysen, Megan Patty; National Museum of Ancient Art/Museu Nacional de Arte Antiga, Lisbon: Paula Pelúcia Aparício, Paulo Henriques, Dalila Rodrigues, Maria João Vilhena de Carvalho; National Museum of Antiquities, Leyden: R.B. Halbertsma; National Museum of Fine Arts, Stockholm: Suzanne Mohr-Rydqvist; National Portrait Gallery, London: Emma Butterfield, David McNeff, Sandy Nairne, Kathleen Soriano; The National Trust of Scotland: Ian Gow, Kate Mitchell, Diana Stevens; The National Trust: Roger Carr-Whitworth, Christopher Rowell; Charles W. Newhall III; New-York Historical Society: Jill Reichenbach, Nicole Wells; New York Public Library: Andrea Felder, Tom Lisanti; J. W. Niemeiyer; Nottingham Art Gallery: Michael P. Cooper, Clare van Loenen; Nottingham Castle: Sarah Skinner; Nottingham University Archives, Department of Manuscripts and Special Collections: Lynda Carter, Dorothy Johnston; Roxanna van Oss; Paleis Het Loo, The Netherlands: Marijke Wagtho; Parham Park, Storrington: Patricia Kennedy; Lady Kathleen Pelham-Clinton; Lady Patricia Pelham-Clinton-Hope; The Hon. Clayre Percy; Philpott; Phoenix Ancient Art, Geneva and New York: Bibiane Choi, C. Michael Hedqvist; Michael Pick; Robert Plampin; Platinum Inc., Geneva: Céline Fressart, Charlotte Soehngen; Tania Buckrell Pos; Sharon Powell; The Powerhouse Museum, Sydney: Iwona Hetherington, Anne Watson; Alexandre Pradere; the late Lord Michael Pratt; The staff of the Probate Search Room, London; Faith Raven; Antonia Reeve; Christi Richardson; Alan Robertson; David Roche; Mark Rogers; Phillis Rogers; Pierre Rosenberg; Felix Rosenstiels' Widow & Son Ltd., London: Nicholas Edgar; Lord Rosse; Baronne Alain de Rothschild; Roop Roy; The Royal Collection, London: Joanna Marschner; Royal Collections Picture Library, London: Katy Martin; Royal Institute of British Architects, London: Valeria Carullo, Catriona Cornelius, Robert Elwall, Charles Hind, Lucy Rowe, Justine Sambrook, Laura Whitton; The Royal Pavilion, Libraries & Museums, Brighton: Stella Beddoe, David Beevers, Jessica Rutherford; Royal Ontario

Museum, Toronto: Nicola Woods; Alan Rubin; Alan Salz; San Antonio Museum: Jessica Powers; Jennifer Scarce; Bruno Schroder; Tim Schroder; Jane Sconce; Jonathan Scott; Miki Slingsby; Sir John Soane's Museum, London: Stephen Astley, Julie Brock, Helen Dorey, Tim Knox, Susan Palmer, Margaret Richardson, Kate Wilkinson; Roger Smith; Thomas Gordon Smith; Philip Smithies; Graham Snell; The Society for the Protection of Ancient Buildings, London: Ms. Greenhill; Sotheby's London: Joanna Booth, Julia Clarke, Scott Nethersole, Simon Stock; Sotheby's New York: Peter Lang, Florent Heintz, Ian Irving, Kevin Tierney, George Wachter; Charles Stableforth; Michael J. Stanley; Stratfield Saye Estate: Eleanor Burt, Kate Jenkins; Suzanne Stephens; Lady Mary Stirling; Alexander and Mary Stirling; Robert Stirling; Surrey County Council, Kingston-upon-Thames: Martin Higgins; The staff of the Surrey History Centre; Anthony Sykes; Wilkinson; Stratfield Saye Estate, Stratfield Saye: Eleanor Burt, Kate Jenkins, Arthur Valerian Wellesley, 8th Duke of Wellington; Szépművészeti Múzeum, Budapest: Sára Kulcsár-Szabó; Tate Britain, London: Sarah Fahmy, Alison Fern, Nicole Simões Da Silva; Thorvaldsens Museum, Copenhagen: Margrethe Floryan, Stig Miss, Charlotte Lahn Pedersen; Towner Art Gallery, Eastbourne, East Sussex: Charlie Batchelor, Sarah Blessington, Sara Cooper, Matthew Rowe; Charlie Truman; Paul Tucker; Nigel J. Turk; University College London Art Collections: Emma Chambers; University College London, Petworth House: Josephine Barry, Helen Downes, Andrea Frederickson; University of Lyon: Philippe Bordes; University of Nottingham: Linda Shaw, Neil Walker; Cornelius C. Vermeule III; Anthony Verschoyle; Victoria and Albert Museum, London: Ercin Aktaner, Sarah Armond, Frankie Arnold, Richard Ashbridge, Ian Blatchford, Val Blyth, Kate Brier, Fergus Cannan, Michael Casartelli, Matthew Clarke, Frances Collard, Elodie Collin, Olivia Colling, Leo Crane, Mike Deane, Ann Eatwell, Richard Edgcumbe, Anne Fay, Mick Figg, Nadine Fleischer, Dave Flipping, Camilla Graham, Tessa Hore, Mark Jones, Cathy Lester, Linda Lloyd Jones, Line Lund, Sophia Marques, Vivienne McCormack, Susan Mouncey, Nicole Newman, Roxanne Peters, Peter Quirk, Geoff Rowe, Laura Saffill, Joanna Sanderson, Jane Scherbaum, Sarah Sevier, Rebecca Smith, Sarah Sonner, Michael Snodin, Greg Sullivan, Peter Timms, Lucy Trench, Rebecca Wallace, Damien Whitmore, Cassie Williams, Lucy Wood; Victoria Memorial, Calcutta: Chittaranjan Panda; Jane Wainright; The Wallace Collection, London: Andrea Gilbert, Rosalind Savill; Stephen Wallis; Geoffrey B. Waywell; Lady Wedgwood; Wedgwood Museum, The Wedgwood Centre, Barlaston, Stoke-on-Trent: Lynn Miller; Wellcome Institute for the History of Medicine and the Shefton Museum, Newcastle University, Newcastle-upon-Tyne: Lindsay Allason-Jones; Patricia Wengraf; The Westmoreland Museum of American Art, Greensburg: Douglas Evans; Timothy J. Whealon; Bruce White; Jeremy and Denise White; John Whitehead; Violet Whitehead; Sir William Whitfield; Elizabeth Wilson; Andrew Wilton; Alison Winter; Matthew Withey; the staff of The Witt Library, Courtauld Institute of Art, London; Woburn Abbey: Chris Gravett; Tim Woolley; Yale Center for British Art, New Haven: Phillip Basner, Melissa Gold Fournier, Scott Wilcox; Yale University Art Gallery, New Haven: Laurence Kanter, Allison Peil; Yale University Press: Catherine Bowe, Sally Salvesen; Jonathan Yarker; Ruth Zandberg, Rainer Zietz; Henry Zimet; Katherine Zock.

Hope Family Tree and Chronology

Daniella Ben-Arie

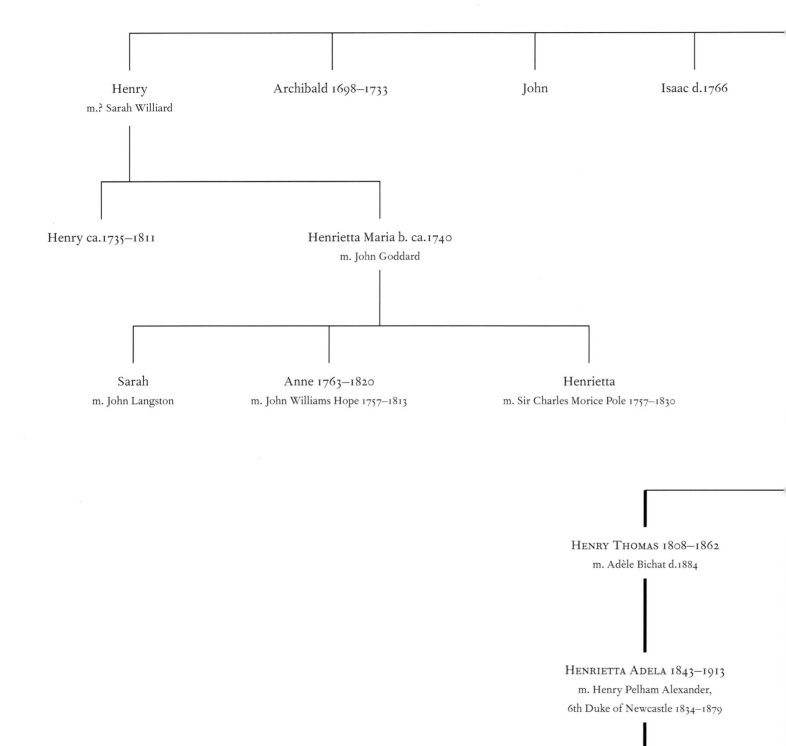

Henry
m.? Sarah Williard

Archibald 1698–1733

John

Isaac d.1766

Henry ca.1735–1811

Henrietta Maria b. ca.1740
m. John Goddard

Sarah
m. John Langston

Anne 1763–1820
m. John Williams Hope 1757–1813

Henrietta
m. Sir Charles Morice Pole 1757–1830

HENRY THOMAS 1808–1862
m. Adèle Bichat d.1884

HENRIETTA ADELA 1843–1913
m. Henry Pelham Alexander,
6th Duke of Newcastle 1834–1879

Beatrice Adeline 1862–1935

Emily Augusta Mary 1863–1919

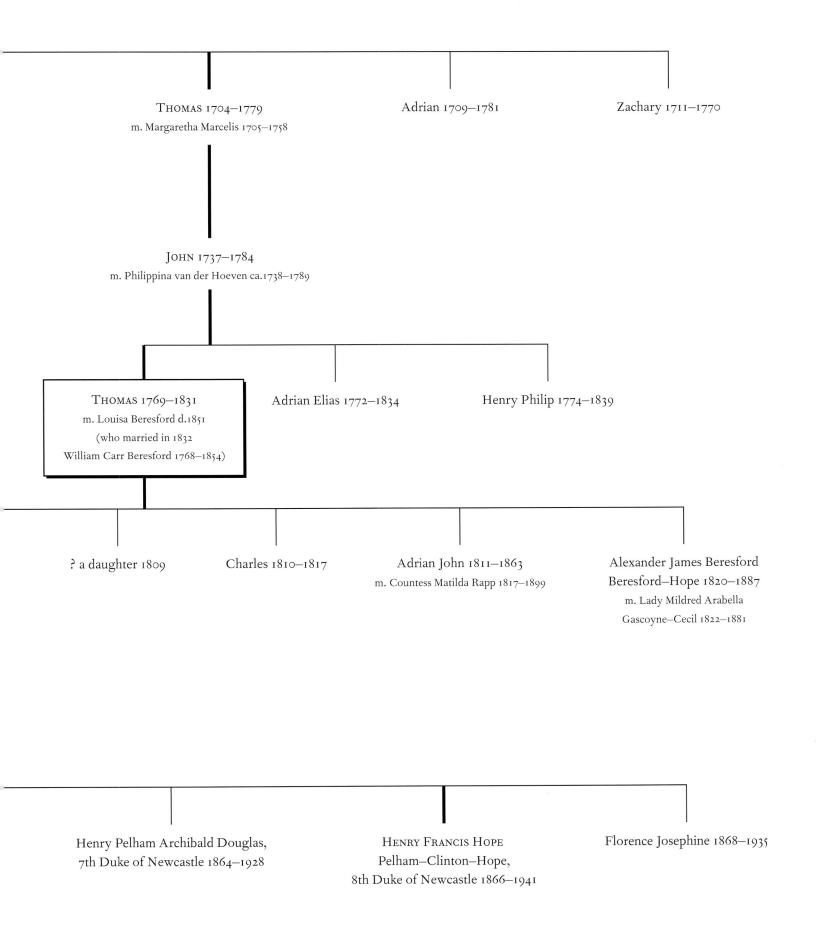

THOMAS 1704–1779
m. Margaretha Marcelis 1705–1758

Adrian 1709–1781

Zachary 1711–1770

JOHN 1737–1784
m. Philippina van der Hoeven ca.1738–1789

THOMAS 1769–1831
m. Louisa Beresford d.1851
(who married in 1832
William Carr Beresford 1768–1854)

Adrian Elias 1772–1834

Henry Philip 1774–1839

? a daughter 1809

Charles 1810–1817

Adrian John 1811–1863
m. Countess Matilda Rapp 1817–1899

Alexander James Beresford
Beresford–Hope 1820–1887
m. Lady Mildred Arabella
Gascoyne–Cecil 1822–1881

Henry Pelham Archibald Douglas,
7th Duke of Newcastle 1864–1928

HENRY FRANCIS HOPE
Pelham–Clinton–Hope,
8th Duke of Newcastle 1866–1941

Florence Josephine 1868–1935

THOMAS refers to Thomas Hope (1769–1831).

1735 Henry Hope (1735–1811), cousin of THOMAS, born in Boston.

1737 John Hope (1737–1784), father of THOMAS, born in Rotterdam.

1758 John Hope moves to Amsterdam.

1762 John Hope and Henry Hope join Thomas Hope (1704–1779) and Adrian Hope (1709–1781) in the family banking business. Name of bank changed to Hope and Company.

1763 John Hope marries Philippina Barbara van der Hoeven.

1768–71 Clerk House, 1 Mansfield Street (later Duchess Street). Built by Robert Adam for Major-General Robert Clerk.

1769 30 August: THOMAS born in Amsterdam.

1771 John Hope and his uncle Adrian buy the Jan and Pieter Bisschop collection of mainly Dutch and Flemish pictures.

1771–75 1 Mansfield Street rebuilt by Adam brothers after a fire in 1771.

1772 Adrian Elias Hope (1772–1834), brother of THOMAS, born.

1774 Henry Philip Hope (1774–1839), brother of THOMAS, born.

1779 Thomas Hope (1704–1779), founder of Hope and Company, dies.

1781 Adrian Hope (1709–1781), founder of Hope and Company, dies.

1784 John Hope, father of THOMAS and partner in Hope and Company, dies.

1785–89 Henry Hope builds Paviljoen Welgelegen near Haarlem.

1789 Philippina Barbara van der Hoeven (Philippina Hope) dies.

1787–95 THOMAS embarks on a Grand Tour that includes Italy, Sicily, Spain, Portugal, Syria, the Balkans, Hungary, France, Germany, and England.

1790 Returns to Amsterdam five times during his tour: January 1790, April 1791, March 1793, July and October 1794.

1791 In Rome.

1792 In Sicily with the painter George Augustus Wallis.

April: returns to Rome.

1792–93 Commissions John Flaxman to illustrate Dante's *Divine Comedy*.

1794 22 May: Elected a Fellow of the Society of Antiquaries.

French Republican armies approach Dutch border.

17 October 1794: THOMAS, with his two brothers, leave for Germany; their cousin, Henry Hope, and John Williams Hope travel by ship to London.

December: THOMAS in Berlin.

1795 In Rome with his two brothers; Guy Head paints portraits of THOMAS and Henry Philip (now lost).

18 January: The Prince of Orange flees to England.

20 January: The French enter Amsterdam.

27 January: The Hopes arrive in England.

Henry Hope purchases no. 1 Harley Street, Cavendish Square.

1796–98 THOMAS visits the Ottoman Empire, including Constantinople, Ephesus, the Aegean Islands, and mainland Greece, for the first time late in 1796, leaving in 1797 or early 1798; he makes detailed drawings of his travels.

1797 September/October: in Egypt, visiting Pyramids with Frederick Hornemann.

1798 Returns to London. Commissions portrait of himself from William Beechey.

1799–1802 Purchases Clerk House in Duchess Street, by Robert Adam, from Lady Warwick, sister of Sir William Hamilton, in 1799. He alters and remodels the house with the help of Charles Heathcote Tatham (1772–1842), enclosing the courtyard with a new wing containing a picture gallery on the first floor.

1799 THOMAS made a member of the Royal Institution.

Travels with the French artist Michel-François Préault.

C. H. Tatham publishes *Etchings of Ancient Ornamental Architecture* (1799–1800).

1799–1800 September: Travels in Athens and the Morea. Henry Philip Hope travels through the Ottoman Empire.

1800 THOMAS elected to the Society of Dilettanti.

1801 Acquires a large portion of the second vase collection of Sir William Hamilton.

Receives his first invitation to the annual Royal Academy dinner.

Percier and Fontaine publish *Recueil de décorations intérieures* in serial form (1801–12).

1802 25 March: Treaty of Amiens signed.

Spring: THOMAS visits Paris.

May: Gives a party for nearly 1,000 guests, including the Prince of Wales, at Duchess Street.

Autumn/Winter: Visits Naples.

Adrian Elias returns to live in Amsterdam and Bosbeek.

1803 January–March: THOMAS in Rome, sees Thorvaldsen's *Jason*.

18 May: The Treaty of Amiens is revoked and Thomas returns quickly from Paris to England.

Welgelegen is made over to John Williams Hope by Henry Hope. John Williams eventually sells Welgelegen to Louis Bonaparte, king of Holland in 1806.

1804 THOMAS elected to Royal Society and Royal Society of Arts.

1 February: Sends tickets to sixty Royal Academicians to view the Duchess Street house between 10 February and 31 March.

February: Charles Townley and Samuel Rogers visit Duchess Street.

Publishes *Observations on the Plans … by James Wyatt, Architect for Downing College.*

28 April: Excluded from annual Royal Academy dinner because of his attack on Wyatt.

Satirical poem, "Hope's Garland," published anonymously by Henry Tresham.

1805 Appointed to publication committee at Society of Dilettanti for series of books, *Select Specimens of Ancient Sculpture* (1799–1807).

Becomes member of British Institution.

Matthew Boulton sends John Phillp to draw furniture and decoration at Duchess Street.

Joseph Michael Gandy publishes *Designs for Cottages, Cottage Farms and Other Rural Buildings*, dedicated to Thomas Hope.

1806 16 April: marries Louisa Beresford.

Becomes a member of the "Committee of Taste" overseeing monuments to national heroes in St. Paul's Cathedral.

Thomas Skinner Surr publishes *A Winter in London; Or, Sketches of Fashion*, a novel containing a description of a house probably inspired by Duchess Street.

1807 Publication of *Household Furniture and Interior Decoration Executed from Designs by Thomas Hope*, with drawings engraved by the architect Edmund Aikin and the painter George Dawe.

26 May: Purchases the Deepdene from Sir Charles Burrell, Bt., at Garraway's Coffee House for £9030.

Appointed to the Committee for the Superintendence of the Royal Academy Exhibition Models.

1808 Publishes essay "On The Art of Gardening."

George Smith publishes *Collection of Designs for Household Furniture and Interior Decoration.*

Birth of eldest son, Henry Thomas Hope (1808–1862); Princess of Wales is godmother.

21 October 1808: Welgelegen is sold by John Williams Hope to King Louis Napoléon.

1809 Publishes *Costume of the Ancients.*

Possible birth of daughter, who dies young.

1810 Birth of second son, Charles Hope (1810–1817).

Antoine Dubost exhibits satirical portrait of THOMAS and Louisa, entitled "Beauty and the Beast," in a Pall Mall gallery.

1811 Prince of Wales appointed Prince Regent.

Death of cousin Henry Hope.

Birth of THOMAS's third son, Adrian John Hope (1811–1863).

Member of committee to select design for Theatre Royal, Drury Lane.

1812 Publishes *Designs of Modern Costume*, engraved by Henry Moses.

1813 Hope brothers' share in the bank bought by Alexander Baring, 1st Baron Ashburton (1773–1848); the brothers are divested of their interest.

1813–14 Enlarges the grounds at the Deepdene with acquisition of neighboring property, Chart Park.

1814 By November: Probably in Paris for the winter season.

1815 February: Holds balls in Paris throughout the month.

March: Returns to London when Napoléon escapes from Elba.

September: Returns to the Continent with his family.

1816 Travels through Switzerland.

2 September: In Florence.

December: In Pisa. His son Charles falls ill.

by 25 December: in Rome. Visits Thorvaldsen and discusses the completion of *Jason.*

1817 Rome: The family sits for marble portrait busts by Thorvaldsen.

April: Son Charles dies in Rome from a fever.

June: Returns to England via Paris.

Summer: Returns to the Deepdene where Charles is buried.

1818–19 The first recorded work at the Deepdene, a mausoleum over the burial place of Charles's ashes.

Remodels and redecorates the Deepdene, adding two side wings, one with a tower; a new entrance front and staircase hall; offices, and stables.

1819	Publishes *Anastasius* anonymously.
	Addition of Flemish Picture Gallery at Duchess Street, designed by William Atkinson.
1820	Death of George III; Prince Regent crowned George IV.
	Birth of THOMAS's fourth son, Alexander James Beresford (1820–1887).
1821	John Britton begins the first volume of his history of the Deepdene with watercolors by William Henry Bartlett (1809–1854) and Penry Williams (1798–1885).
1822	Canova's *Venus* arrives at Duchess Street.
	10 July: THOMAS and Louisa travel through France with their three sons.
1823	27 January: The family returns to England.
	Further building work at the Deepdene; William Atkinson adds a new wing with an Orangery, Conservatory, Sculpture Gallery, and Theatre of Arts.
	Publication of *A Series of Twenty-nine Designs of Modern Costume drawn and engraved by Henry Moses*, adding nine plates to the twenty of the 1812 edition.
1824–25	Part of sculpture collection transferred from Duchess Street to the new galleries at the Deepdene.
1825–26	John Britton begins a second volume of watercolors of the Deepdene by William Henry Bartlett and Penry Williams.
	November: First visit of HRH the Duke of Clarence and his Duchess to the Deepdene.
1828	Bertel Thorvaldsen's *Jason* finally delivered to the Deepdene, twenty-five years after it had been commissioned.
1830	THOMAS prepares his *Essay on the Origin and Prospects of Man* for publication.
	Accession of the Duke of Clarence as King William IV; Louisa appointed Woman of the Bedchamber to Queen Adelaide.
1831	2 February: THOMAS dies at Duchess Street.
	12 February: THOMAS buried at the Deepdene.
1832	29 November: Louisa Hope marries her cousin Field-Marshal Viscount Beresford.
1833	Many statues from the Deepdene returned to Duchess Street by Henry Thomas Hope.
1834	Adrian Elias Hope dies.
1834–38	Purchase of neighboring lands doubles the size of the Deepdene estate.
1835	Posthumous publication of *Historical Essay on Architecture*.
1836	Henry Philip Hope dies.
1836–41	Remodeling of the Deepdene by Alexander Roos for Henry Thomas.
1849–51	Henry Thomas builds new town house, designed by P. C. Dusillon, at 116 Piccadilly, to replace Duchess Street.
1849	Duchess Street contents transferred to the Deepdene, some eventually going to 116 Piccadilly.
1851	Duchess Street house is demolished.
1862	Henry Thomas Hope dies.
1873	Bosbeek sold by Hope heirs.
1884	Death of Anne Adele Hope, Henry Thomas's widow, who was living at the Deepdene.
1893– 1909	Lord Francis Hope Pelham-Clinton-Hope (1866–1941, hereafter Lord Francis Hope), 8th Duke of Newcastle from 1928, and great-grandson of THOMAS, inherits the Hope collection but is declared bankrupt in 1894. The Deepdene is let to Lillian Warren Price Hammersley, Dowager Duchess of Marlborough, and her husband from 1895, Colonel Lord William Beresford (1847–1900). The exterior of the house and the grounds are illustrated in *Country Life*, 20 May 1899.
1898	Dispersal of the Hope collection begins with sale of pictures to Asher Wertheimer.
1901	Lord Francis Hope sells the infamous "Hope Diamond."
1909–14	Lady William Beresford, former Dowager Duchess of Marlborough, dies in 1909; the Deepdene lease taken over by Almeric Paget, later Lord Queensborough
1910	Dispersal of pictures continues with sale to Charles Fairfax Murray.
1913	Henrietta Adela Hope, wife of 6th Duke of Newcastle, dies, leaving the Deepdene to her son, Lord Francis Hope.
1917	Sale by the Trustees of Lord Francis Hope of the contents of the Deepdene by Christie's in July and by Humbert and Flint in September.
1920	Sale of the Deepdene. It eventually becomes a hotel and then British Railway offices.
1957	The Deepdene Mausoleum sealed.
1966	British Railway vacates the Deepdene.
1968	David Watkin publishes *Thomas Hope (1769–1831) and the Neo-Classical Idea*.
1969	The Deepdene is demolished.

THOMAS HOPE

Editor's note: Regarding style and citations in the text and footnotes, for each chapter bibliographic citations are given in full when they first occur and in a short form thereafter; for each catalogue entry, citations are given in a short form in every instance. There are two exceptions: Thomas Hope's book *Household Furniture and Interior Decoration Executed from Designs by Thomas Hope* (London: Longman, Hurst, Rees, & Orme, 1807) is referred to throughout this book as *Household Furniture* (1807); David Watkin's seminal book on Hope, *Thomas Hope (1769–1831) and the Neo-Classical Idea* (London: John Murray, 1968), is referred to throughout as Watkin, *Thomas Hope* (1968). The full citations for all books referenced are given in the bibliography.

Figure references are keyed to each chapter or catalogue entry; the notation "see" indications that an illustration is cited out of sequence in the chapter or is found elsewhere in the book. A catalogue number at the end of an illustration caption indicates that an object is in the exhibition and is described in an entry in the catalogue section.

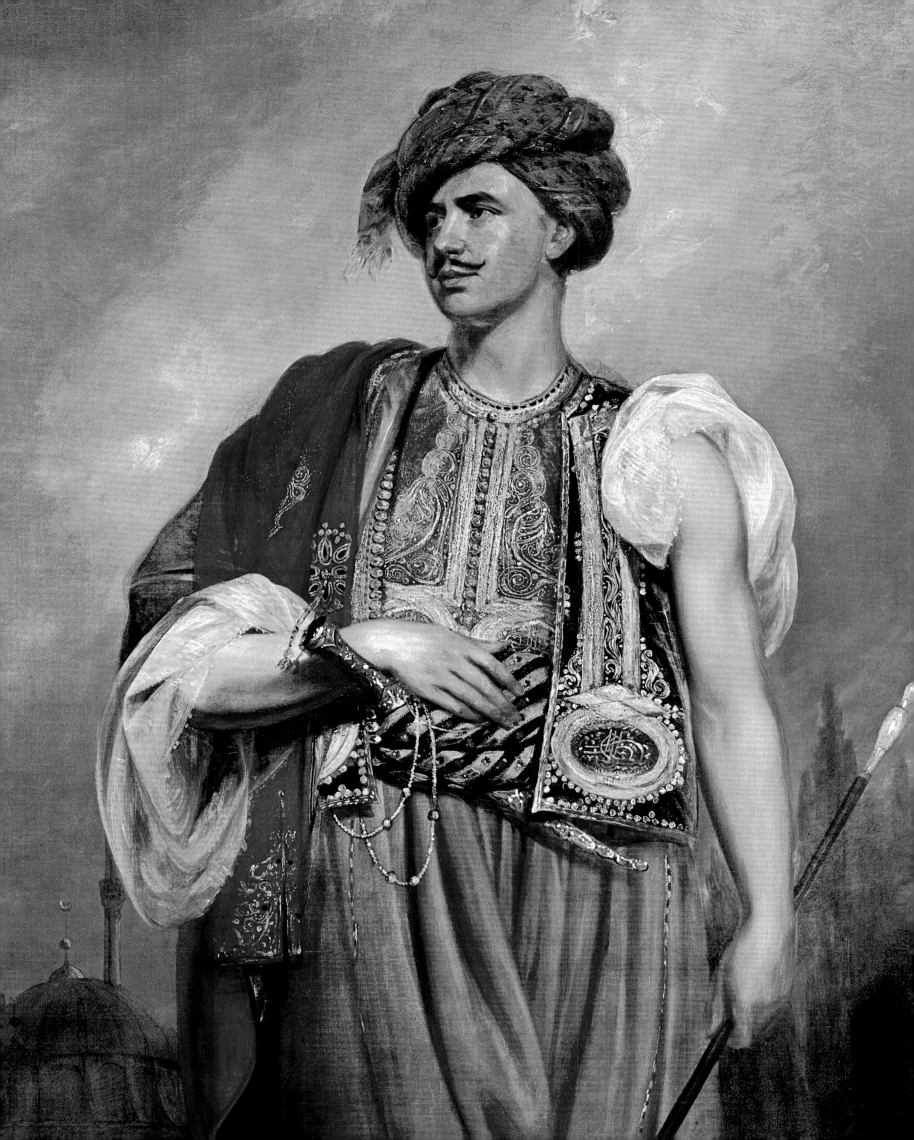

European Wealth, Ottoman Travel, and London Fame

Philip Mansel

Amsterdam and London; revolutions in the Netherlands and the Grand Tour in the Ottoman Empire; wars to free Europe from French domination; and the emergence of London as the financial capital of Europe—Thomas Hope's background and career were as international as the neoclassicism he preached.

The Hope Bank and Life in Amsterdam

The fortune that helped Thomas Hope (1769–1831) to become one of the greatest art patrons in London came from the continent of Europe. He was born in Amsterdam on August 30, 1769, into a family that included the richest merchant bankers of the age. The wars of Catherine II, the Louisiana Purchase, and the expansion of the Napoleonic Empire were funded, in part, by Hope and Company. The basis of the Hopes' lives and fortune was the connection between Great Britain and the Netherlands, described by Sir James Harris, George III's ambassador in The Hague in 1784–88, as "the ancient union and alliance between the two Nations."[1]

Power, money, and Protestantism were the foundations of this "ancient union and alliance." Without Dutch ships, soldiers, and money, William Prince of Orange, grandson of Charles I and Stadholder of six of the seven provinces of the Netherlands, could not have invaded England in November 1688 and been proclaimed King William III three months later, after the flight of his father-in-law and uncle, James II. Thereafter the Dutch alliance—and the Dutch troops who continued to garrison London until 1697 and the Dutch advisers who helped establish the bank of England in 1694—helped Britain to remain a Protestant, parliamentary monarchy and to become a world power that helped to free Europe from the threat of French hegemony, as William III had intended.

The "ancient union and alliance" weakened but did not disappear in the eighteenth century. The concern shown for the Elec-

torate of Hanover after 1714 by George I, George II, and George III,[2] along with the growth of trade, and the Grand Tour, strengthened the links of Great Britain with Europe, as the British rivalry with France increased Britain's need for European allies. In 1734 William III's cousin and principal heir, William IV Prince of Orange, married Anne, the eldest daughter of George II. In 1745, in accordance with their treaty obligations, 6,000 Dutch troops moved to England to help protect the throne of George II from the Jacobite menace. Even then the Protestant Succession in Britain apparently required the guarantee of troops from the Netherlands.

In the eighteenth century, Amsterdam remained one of the largest ports in Europe. With a population of 150,000, it was surrounded by a forest of masts, which can be seen in the background of the portrait of Thomas Hope's cousins Henry Hope (1735–1811) and John Williams Hope (1757–1813) and their families, painted by Benjamin West in 1802 (fig. 1-2).[3] During some winters as many as 3,000 ships were anchored in Amsterdam.[4]

The lure of Amsterdam, the "ancient union and alliance" between Britain and the Netherlands, and the habit of younger sons going into trade explain why, in the second half of the seventeenth century, an earlier Henry Hope had crossed the North Sea from Scotland and had become a merchant in the Netherlands. He came from the Hope family of Hopetoun and Rankeillor in Scotland (he was a second cousin of Sir Archibald Hope of Rankeillor and of the father of the first Earl of Hopetoun). Both the Scottish and Dutch branches of the Hope family continued to use a common motto—*At Spes non Fracta* (But Hope is not Broken)—and coat of arms; they also corresponded with and entertained each other until at least the end of the eighteenth century.[5]

Early in the eighteenth century, Henry Hope's eldest son, Archibald (1664–1743), owned four ships and two malt houses in East Anglia.[6] Archibald and his brothers Thomas and Adrian were bankers in the right place at the right time. When the Netherlands was neutral during the Seven Years' War, the Hope bank helped raise loans for the British government and pay subsidies to Britain's allies.[7] In 1762 the bank was named Hope and Company. Thanks to a persistent policy of reinvestment of

profits, the bank's capital grew between 1762 and 1769 from about 4.3 million florins to 6.8 million. Profits averaged 8.25 percent of mean capital.[8]

Like the Rothschilds sixty years later, the Hopes followed what one of their partners would call "the royal path." They were court bankers, relying for business on governments and dynasties rather than on industry and private clients.[9] The Netherlands contained a court society, centered on the princes of Orange, who resided in The Hague and at their country palace at Het Loo, in addition to a merchant society, which was based in Amsterdam. Although the Prince of Orange was not a sovereign in the Netherlands, merely governor of each province, his household was referred to as "the court."[10] Whereas on formal occasions Amsterdam merchants generally wore black, the princes of Orange and their supporters, like members of court society throughout Europe, wore brightly colored court dress, usually imported from Paris.[11] In the conflict for power and influence in the Netherlands between the princes of Orange and the urban elites based in Amsterdam, who were called "the Patriots," the Hopes sided with the House of Orange. Both inside and outside the Netherlands, they were appalled by what they saw of republican government.[12]

Moreover, the princes of Orange, like the Hopes, supported the Dutch alliance with Britain. The Hopes strengthened the princes' links with the merchant community. Thomas Hope's grandfather Thomas represented both William IV and William V, princes of Orange, on the boards of the West India and East India trading companies.[13]

Because of the stagnation of the Dutch economy and the Amsterdam stock market in the eighteenth century, Hope and Company became a force in Europe. Dutch investors regularly saved between 25 and 37 percent of their income, and since there were few opportunities for domestic investment, they hoped to place their money abroad.[14] Hope and Company became Europe's leading merchant bank, investing in areas as diverse as cochineal, flower bulbs, and Brazilian diamonds.[15] The firm also raised loans for foreign governments, beginning with Sweden. Between 1768 and 1787, they issued ten loans to the Kingdom of Sweden: interest was between 4 and 5 percent and commissions between 4.5 and 9.5 percent. Such loans enabled King Gustavus III to finance both his court festivals and his preparations for war with Russia without being obliged to raise taxes, which required the prior approval of the Swedish parliament.[16]

The Hopes were European in their private lives as well as in their investments. Scottish in origin, pro-British by inclination and religion,[17] they always married Dutch wives. In 1763 John, or Jan, Hope (1737–1784), Thomas Hope's father, married Philippina Barbara van de Hoeven, a daughter of the burgomaster of Rotter-

dam. Continuing the family tradition, John became an Orangist member of the town council of Amsterdam in 1768 and a director of the East India Company in 1770. He ran the bank with his first cousin Henry Hope (1735–1811), who had been born in Boston, Massachusetts, and with his father, Thomas, and his uncle Adrian. Reflecting the European character of their city and bank, they were later joined by a young clerk from Cornwall named John Williams (1757–1839), and the son of a Huguenot cloth merchant named Pierre Cesar Labouchère (1772–1839), of whom it was said that he spoke French like an Englishman and English with a French accent.[18] The bank remained a family business. In 1782 John Williams married the heiress and niece of Henry Hope, Anne Goddard (1763–1820), the daughter of John Goddard of Rotterdam and Woodford Hall Essex and of Henry Hope's sister Henrietta Maria Hope. Thereafter, John Williams became a partner in the bank and added the name Hope to his own.[19]

At home the Hopes spoke English and Dutch, but also French—as was common throughout educated Europe until the mid-twentieth century.[20] Although no doubt his patriotism led him to exaggerate, the Baron de Frénilly remembered a visit to Amsterdam in 1785 where he found Dutch millionaires who patronized a French theater and "who made a point of being French, who spoke only French." The magnificence of the Hopes' table, where they were served by footmen in red and gold livery, owed as much to the French food as to the display of glass and porcelain. "With all this show," noted another French visitor, "the dinner was very frigid and extremely boring; it had the air of ceremoniousness and constraint of the 'maisons de bonne compagnie' in Paris."[21] But if they lived à la française, the Hopes' travels were English. In January 1794, Henry Hope wrote to Francis Baring, a member of a North European banking family originally from Groningen and Bremen, which had established itself in London and was already working in partnership with the Hopes: "I am so completely in the habit of considering Holland and England as the same Country that I can very easily find myself as much at home in the one as in the other"—a freedom from nationality more common in the eighteenth century than in the twenty-first.[22]

Like other contemporary financiers, such as the *fermiers-généraux* in France, the Hopes were distinguished by their art collections as well as by their wealth. Amsterdam was then the center of the European art market, and in 1771 Thomas Hope's father, John, bought the Bisschop collection of 230 Dutch and Flemish pictures, including works by Philips Wouwermans, Gerard Terborch, and Jan Steen. John Hope owned a large house on the most elegant street in Amsterdam, the Keizersgracht (fig. 1-3), as well as a house in The Hague and country seats near Haarlem and Utrecht. On a visit to the Low Countries in 1781, Sir Joshua Reynolds called

his collection "the first in Amsterdam" and praised "the particular attention and civility of its possessors."[23] "By his British descent and international connexions, his travels and his enormous fortune," writes J. W. Niemeijer, "[John Hope] stood somewhat apart from the other Dutch patrician families, developing a taste and lifestyle to which present day Holland is indebted for the possession of several works of art of international significance."[24]

John Hope's cousin Henry constructed a magnificent neoclassical villa at Welgelegen near Haarlem between 1785 and 1789; it was designed for him by the Sardinian consul Triquetti (also a British secret agent) on the model of the Villas Borghese and Albani in Rome. He filled it with pictures by Titian and Rembrandt, among others, and decorated its façade with sculpture. Thomas Jefferson admired it on his visit in 1788. The Hopes lived like kings. In 1808 Welgelegen would be sold, shorn of its contents, for 300,000 florins to Louis Napoléon Bonaparte, recently appointed King of Holland by his brother. The King of Holland occasionally resided there until his deposition in 1810. Today Henry Hope's mansion houses the offices of the government of the Province of North Holland.[25]

In 1788 Hope and Company, switching from Sweden to Russia, issued the first of eighteen loans on behalf of Catherine the Great. She needed funds in order to fight another war against the Ottoman Empire, and Dutch investors appreciated a country like Russia that could not be swept off the map in one campaign and had a reputation for being creditworthy. Moreover, whereas the King of Sweden in 1787 paid the Hope bank a 6 percent commission, the Empress of Russia in 1788 paid 6.5 percent. The empress sent Henry Hope her portrait (see fig. 11-7); he replied by a letter to her banker Robert Sutherland, praising her "elevated genius and almost supernatural loftiness of mind."[26] Hope and Company also organized loans to the Polish government in 1793, two years before the country disappeared off the map in the last partition. Hope's partner Robert Voute, another son of a Huguenot, was appalled by the sight of the Polish parliament surrounded on one side by Prussians and on the other by Russian troops. This did not, however, stop him from traveling to Saint Petersburg in search of more business. At Tsarskoe Seloe on June 5, 1794, he was given a two-hour audience with the empress. He found her amiability itself, although she had only the vaguest notion of rates of exchange. Surrounded by tables piled high with books and papers, she seemed to lead a life of servitude, whereas her courtiers spent much of the day playing cards. Continuing to organize loans for her successor, Paul I, the Hopes called themselves for a time "Messrs Hope and Company, Bankers to His Majesty the Emperor of the Russian Empire."[27]

In Western Europe, however, the Hopes' world of courts and dynasties was soon to be threatened by revolutionaries in love with

Fig. 1-1. John Hoppner. *Portrait of William V, Prince of Orange (1758–1810)*. Oil on canvas, 1801. Paleis Het Loo, The Netherlands, on loan from Stichting Historische Verzamelingen van het Huis Oranje-Nassau. Like the Hopes, the Princes of Orange supported the British alliance and fled to London from the French invasion of the Netherlands.

liberty. On August 9, 1787, Henry Hope lamented to Laborde de Méréville, a Paris banker, patron of the arts, and friend of Marie Antoinette, that whereas the French government was, in his opinion, strong enough to survive the current fashion for liberty, "here . . . everything has been upset and it can only end in absolute tyranny whether by the prince or by the people—the inevitable outcome of the complete anarchy which reigns today."[28] The struggle for power in the Netherlands between the Prince of Orange (fig. 1-1) and the Patriot Party erupted that autumn, reflecting the rivalry between Britain and France, as well as the divisions in Dutch society. The Orangists were supported and organized by the British ambassador, Sir James Harris, but the Patriots, as in the reign of Louis XIV, were supported by France. Harris called the Patriots "the French party" and claimed they wanted "an entire subversion of the stadholderate"; in July the States-General forbade men even to whistle tunes in honor of the House of Orange.[29]

In the end, to avenge the Patriots' temporary detention on June 28, 1787, of the Princess of Orange, her brother, the King of Prussia, sent an army under his cousin the Duke of Brunswick

Fig. 1-2. Benjamin West. *The Hope Family of Sydenham, Kent*. Oil on canvas, 1802. Museum of Fine Arts, Boston, Abbott Lawrence Fund 06.2362. Seated (left to right) are: Henry Hope, head of the family bank; his sister Henrietta Maria Goddard; Anne Goddard, her daughter and the wife of John Williams Hope, who stands to her right. Behind the table stand the Williams Hopes' children: Henry Adrian, Elizabeth, and Henrietta Dorothea Maria. Mrs. Williams Hope holds her youngest son, Francis.

into the Netherlands. The Patriot militias, known as free corps, melted away (as, when they invaded France in the summer of 1792, Brunswick and the King of Prussia assumed French militias would do as well). The European counter-revolution had begun two years before the French Revolution. On September 20, 1787, the Prince of Orange re-entered The Hague in triumph, his carriage drawn by cheering burghers wearing orange ribbons. He was reinstated in all his rights and privileges; that evening he told Harris that "he considered he owed everything which had passed to His Majesty's support and protection."[30] On October 10, Amsterdam capitulated to the Duke of Brunswick.[31] Although Paris would defeat the Bourbons in 1789. In 1787 Amsterdam was defeated by the Oranges.

Even after Amsterdam surrendered, Dutch society remained violently divided, as the Hopes soon discovered. On October 12, 1787, two days after Amsterdam capitulated, Henry Hope and John Williams Hope entered the bourse, in the transactions of

which they played such a prominent part, wearing large Orange cockades. Jostled by hostile Patriot merchants, they were soon in danger of falling and losing their lives. They were, however, saved by "the whole body of the Jews"[32] (traditionally pro-Orangist), who came out of their quarter, delivered the Hopes from their assailants, and carried them away. The Hopes returned to the bourse only when they knew they would receive a speech of apology.[33]

The Hopes Move to London

In 1789, as bread prices in France soared to their highest level in the century—increasing the fear and unrest that culminated in the storming of the Bastille—the Hopes' *grootboeken* (account books) show they purchased half a million guilders' worth of wheat on behalf of Louis XVI, in order to help feed Paris. The finance minister, Joseph Necker, used his personal fortune as security for

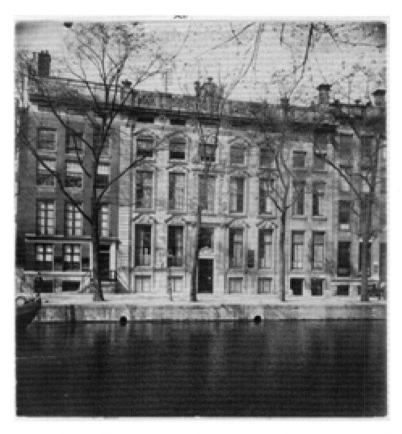

Fig. 1-3. The Hopes' house at Keizersgracht 444–446, Amsterdam. Unknown date and photographer. Amsterdam City Archives.

the purchases.[34] Thereafter, Dutch investors, who had preferred French loans because of their higher rate of interest, suffered as they were paid in revolutionary *assignats* rather than in real money.[35]

Soon Hope and Company would suffer in their persons as well as in their pockets: it was the French revolutionary wars that led Thomas Hope to launch his neoclassical revolution in London rather than Amsterdam. In 1794, having conquered the Austrian Netherlands, French Republican armies approached the Dutch frontier—partly in order to cut off their enemies in Europe from the Amsterdam capital market. On October 17, 1794, Henry Hope and John Williams Hope with their families and collections fled to England. Perhaps because they planned to travel on the Continent, their cousins Thomas, Henry Philip, and Adrian Elias—the sons of John Hope, who had died in 1784—fled to Germany. On January 18, 1795, as French troops entered Amsterdam, the other partners in the bank, Baring and Labouchère, and the Prince of Orange himself also fled to London.

On January 27, the painter and Royal Academician Joseph Farington recorded in his diary meeting "the Mr. Hopes of Amsterdam.—they spoke of the people of Holland as being divided into parties and though not eager for the French coming, yet ill inclined to associate for a general defence. . . . The Mr. Hopes have brought to England their fine collection of pictures and have

removed so much of their property as they said as to have left only chairs and tables behind them.—It is supposed Mr. Hopes have realized in this country half a million and that the Stadholder has secured as much while the storm has been brewing."[36] Signaling that London had become Europe's leading capital market, as it remains to this day, Hope and Company's payments were henceforth made in London, not Amsterdam. Henry Hope settled, with John Williams Hope and his family, and his own collection of four hundred pictures, in a house in Harley Street that he bought from his cousin Lord Hopetoun.[37] The Prince of Orange lived in the palace that his cousin William III had built at Hampton Court. Resolutely pro-British (as Britain remained pro-Orange until the restoration of the House, with British help, to power in the Netherlands in 1813), he ordered the authorities in Dutch colonies to admit British troops as those of an ally. Ceylon and the Cape Colony passed from Dutch to British rule, under which they would remain for the next 150 years.[38]

London, rather than Amsterdam, was henceforth home to the Hopes. In 1795 London was the largest and richest city in the world. Capital of an empire that ruled the oceans, it was believed to attract "all treasures that the four quarters of the globe possess." It also attracted European bankers.[39] As German wars drove the talents and capital of Europe to London in the twentieth century, so did French wars in the late eighteenth and early nineteenth centuries. In addition to Dutch Orangists like the Hopes and French royalists like the fathers of Pugin and Brunel, German bankers, including Nathan Rothschild in 1798, Schroeder in 1802, and Fruehling and Goschen in 1814, moved to London. "The war against France was in part financed by mobilising the resources of the Continent through the London capital market."[40]

Fig. 1-4. Henry Moses. Le Beau Monde. Engraving, 1823. From Thomas Hope's *Designs of Modern Costume* (1823): pl. 1.

Fig. 1-5. Jacques Henri Sablet. *Mr. Hope of Amsterdam.* Oil on canvas, 1792.
© Marylebone Cricket Club, London / The Bridgeman Art Library.

Thomas Hope's Grand Tour

By the time he settled in London in 1798, Thomas Hope had completed his education. In 1790, at the age of twenty-one, he had briefly served as a partner in the family bank but showed little appetite for it, despite the partners' determination "to exert ourselves to make the best man we can of him."[41] Instead, he embarked on his travels, whose extent reflects the breadth of his curiosity as well as the depth of his purse. He visited Italy four times, in addition to Seville, Cordoba, Granada, Portugal, and North Africa. In 1791 he called on the sculptor John Flaxman in Rome; in 1792 he was in Sicily with the painter George Wallis. Back in Rome he was portrayed by a French painter, Jacques Henri Sablet, playing the newly fashionable English game of cricket (fig. 1-5). After his flight to Berlin in December 1794, as French armies approached Amsterdam, and a passage through London, Hope was again in Rome by December 1795. In 1796 he went on to the Ottoman Empire.

Such a destination was not then as unusual as it may appear in retrospect. Since the early eighteenth century, some of the more adventurous travelers on the Grand Tour had proceeded from Rome or Venice to the Ottoman Empire, lured by the quality of the classical remains and by the power and exoticism of the empire. John Montagu and William Ponsonby had traveled from Rome to Constantinople in 1738; Robert Wood and Richard Dawkins in 1751 had visited Palmyra and Baalbek, about which they published celebrated illustrated accounts.[42] In 1794–95, only a year before Hope, John Morritt had traveled to Constantinople, Greece, and Anatolia, staying with Turks and wearing Turkish dress.[43] The major cities of the Ottoman Empire, such as Aleppo and Izmir, had bankers who cashed drafts and letters of credit for foreign merchants and travelers. Once an imperial firman ordering the authorities to allow the traveler to proceed without hindrance had been purchased in Constantinople, Ottoman officials and subjects were generally cooperative.[44] Richard Pococke traveled in the Empire in 1738–40 and on his return to London helped found an Egyptian Society open to "any gentleman who has been in Egypt."[45] He later wrote:

> *I happened to see Constantinople at a time when the Turk was in good humour, and had no reason to be displeased with the Franks. . . . I went freely all over Constantinople and was so far from being affronted in the least that I rather met with civility in every place; entered publicly into such of the mosques as I desired to see and sometimes even on Fridays just before the service began and when the women were coming into the mosques to hear the harangers [needing to pay "only a very small gratuity"]. . . . And indeed to speak justly of the Turks they are a very tractable people when they are well used and when they have no prospect of getting anything by ill treatment.[46]*

The Ottoman Grand Tour was especially popular during the French revolutionary and Napoleonic wars, since much of the rest of Europe was closed to British travelers. Indeed, Hope probably left Italy in order to avoid the advance of the French Republican armies under Bonaparte that occupied Lombardy in the spring of 1796. From early 1796 to late 1797, Thomas Hope traveled in the Ottoman Empire, at first with a French émigré, a Prince de Rohan. The exact parameters of his journey are lost, but he probably went overland to Constantinople, where he said he spent twelve months. Then, after traveling via Mount Athos (where he was in May) and the islands of the Aegean, including Paros, Naxos, Tinos, and Mykonos, he visited Athens. By October 1797 he was in Cairo with Frederick Hornemann, an African traveler, and a Major Schwarz from Göttingen.[47]

It was customary for travelers in the Ottoman Empire to be accompanied by an artist, as well as by servants, interpreters, bodyguards, and couriers. Montagu and Ponsonby had taken Liotard; Wood and Dawkins took a Piedmontese draftsman named Giuseppe Borra, who later worked at Stowe. Five leatherbound volumes labeled "Drawings by Hope" (figs. 1-6–1-14 and

Fig. 1-6. Thomas Hope. "Mosque of Djezzar Pasha at Acre." Drawing from the Benaki Album, vol. V, 27379. Benaki Museum, Athens. Djezzar Pasha was a particularly cruel provincial governor, but he helped defeat Bonaparte's siege of Acre in 1799.

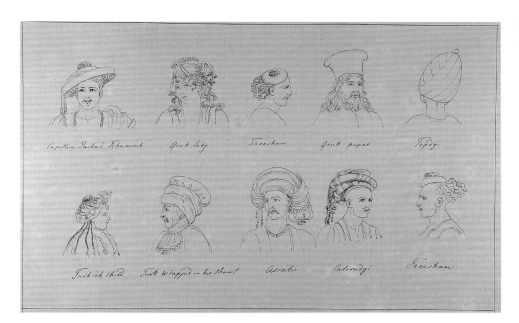

Fig. 1-7. Thomas Hope. Head Studies. Drawing from the Benaki Album, vol. II, 27113. Benaki Museum, Athens.

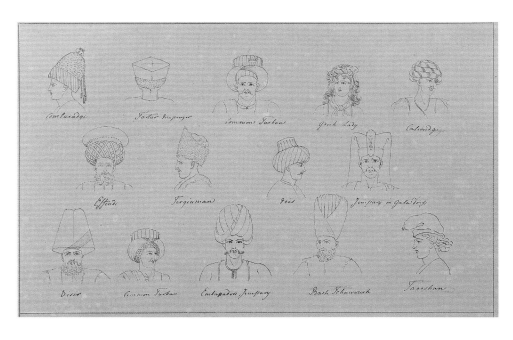

Fig. 1-8. Thomas Hope. Head Studies. Drawing from the Benaki Album, vol. II, 27110. Benaki Museum, Athens.

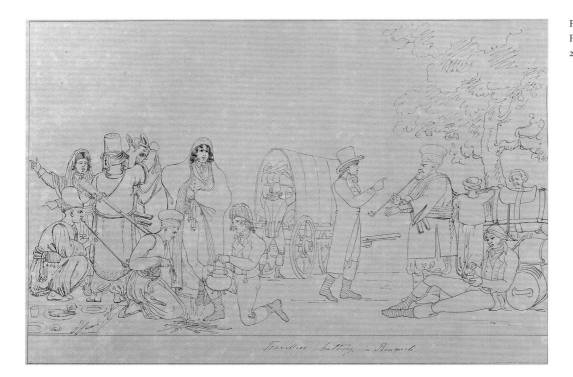

Fig. 1-9. Thomas Hope. "Travellers halting in Roumeil." Drawing from the Benaki Album, vol. I, 27056. Benaki Museum, Athens.

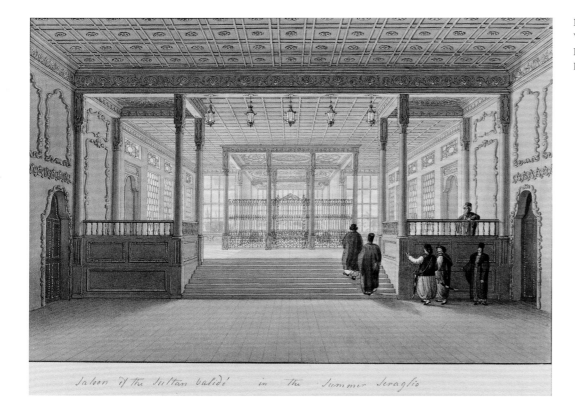

Fig. 1-10. Thomas Hope. "Quarters of the Sultan Valide in the Summer Seraglio at Constantinople." Drawing from the Benaki Album, vol. V, 27367. Benaki Museum, Athens.

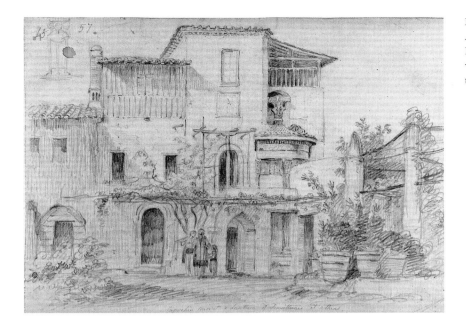

Fig. 1-11. Thomas Hope. "View of the Capuchin convent in Athens." Drawing from the Benaki Album, vol. IV, 27240. Benaki Museum, Athens. Capuchins, like other Christian orders, were allowed to follow their vocation with relative freedom in the Ottoman Empire.

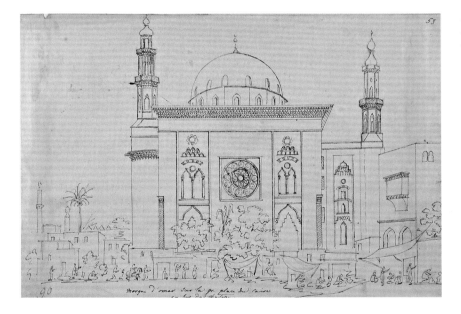

Fig. 1-12. Thomas Hope. "Mosquee d'omar sur la grande place du Caire en bas du chateau." Drawing from the Benaki Album, vol. IV, 27276. Benaki Museum, Athens.

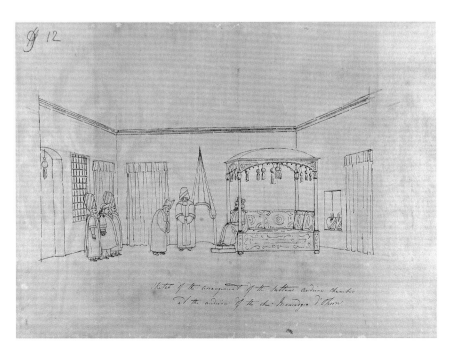

Fig. 1-13. Thomas Hope. "Sketch of the arrangement of the Sultan's audience chamber at the audience of the Chevalier Mouradgea d'ohsson." Drawing from the Benaki Album, vol. IV, 27195. Benaki Museum, Athens. Mouradgea d'Ohsson was an Armenian Catholic merchant, interpreter, and author of the *Tableau General de l'Empire Ottoman*. He served in Constantinople in the Swedish embassy from 1792, advised Sultan Selim III on his reforms, and was Minister Plenipotentiary of Sweden in 1795–99. This audience probably took place in early 1797.

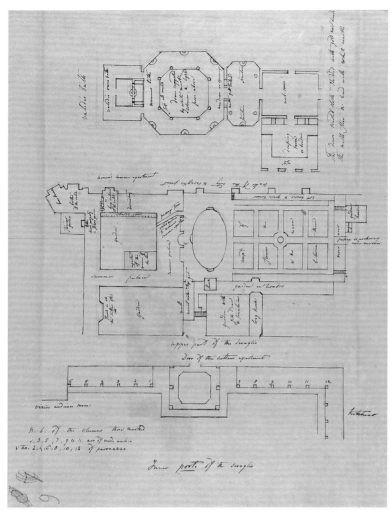

Fig. 1-14. Thomas Hope. "Great Hall or Saloon in the Summer Palace of Hadidge Sultan." Drawing from the Benaki Album, vol. IV, 27192. Benaki Museum, Athens.

cat. nos. 16–34) contain drawings of scenes and monuments in the Ottoman Empire. Most are by Thomas Hope himself; some, however, are by other hands, including Louis Sébastien Fauvel, the French consul at Athens, who later helped Lord Elgin secure his marbles. Many were finished later, rather than drawn on the spot, and may have been intended for publication. Two years before Bonaparte's expedition to Egypt, and a decade before the publication of the *Description de l'Egypte,* Hope and his artist, or artists, showed an interest, unprecedented for the time, in Ottoman mosques and palaces, the Sultan's barges, and Ottoman and Arab cities and costumes, as well as pyramids and classical temples. Hope or his artist depicted a vizier, a Tartar messenger, Greek dancing boys, Bedouin men and women, and details of Ottoman decoration. The drawing of the sultan's mother's bath, for example, is annotated: "The doors scarlet cloth studded with gold nail heads, the walls, floor etc. laid with white marble."[48]

"The first Middle Eastern novel"[49]

Hope later wrote: "In the course of long and various travels I resided nearly a twelvemonth at Constantinople; visited the arsenal and bagnio frequently; witnessed the festival of Saint George[50]; saw Rhodes; was in Egypt, in Syria, and in every other place which I have attempted to describe minutely; collected my Eastern Vocabulary . . . on the spot, and whilst writing my work had at one time an Albanian in my service . . . adopted a fictitious hero in order to embody my observations on the East in a form less trite than that of a journal; avoided all antiquarian descriptions studiously as inconsistent with the character assumed; I am the sole author of *Anastasius.*"[51]

The last remark, however, is economical with the truth. The style of the novel is more polished and the sentences are shorter than in Thomas Hope's other works. It is possible that, just as Hope suppressed the contribution of Charles Heathcote Tatham to the design of his house in London, so he suppressed the role of others in his novel. A book by Hope's descendants states that *Anastasius* was revised with the help of his sons' tutor, the Reverend J. Hitchens, later vicar of Sunninghill, near Hope's house in Surrey.[52]

In 1798, soon after his return to London, Hope celebrated his Ottoman Grand Tour, as Ponsonby and Montagu had done sixty years earlier, by commissioning his portrait with a mosque in the background. John Montagu had been painted in Ottoman Muslim dress by George Knapton. Thomas Hope was painted by Sir William Beechey in the dress of the levents, low-ranking Greek sailors in the Ottoman navy (cat. no. 1).[53]

Thomas Hope's novel was a more original commemoration of his Ottoman Grand Tour. Described as "Memoirs of a Greek; written at the close of the eighteenth century," *Anastasius* took London by storm when it was published, at first anonymously, in 1819 (see cat. no. 108). It is both the personal story of Anastasius, a Greek who lies, steals, seduces, and murders his way across the Ottoman Empire, and a picture of that empire in the late eighteenth century, when it was, as Hope writes, "an empire tottering to its base," under attack from Russians, Arabs, and rebellious governors.[54] Rather than evoking Greece or the classical world, as the Abbé Barthélemy had done in his once-celebrated novel *Les Voyages du Jeune Anacharsis* (1788), *Anastasius* is the first Middle Eastern novel. The hero converts to Islam, travels from Chios to the Peloponnese, Smyrna, Constantinople, Aleppo, Egypt, Mecca, and Arabia under the Wahhabis—all of them, except the last, places visited by Thomas Hope.

As critics pointed out, *Anastasius* showed the author's accuracy and his familiarity with the scenery and cities he describes. The novel describes among other events: the Russian-backed rising in

the Peloponnese against the Ottoman Empire in 1770; the rise and death by "the fatal bow-string" in 1790 of Nicholas Mavroyennis, dragoman of the fleet; Hospodar of Wallachia and the only Greek to command an Ottoman army[55]; the "dazzling career" of Ghazi Hassan Pasha, commander of the Ottoman fleet; the power of the Karaosmanoglu family in western Anatolia; the power struggles between Janissaries and *sherifs*, or descendants of the Prophet, in Aleppo[56]; the practices and beliefs of the Druze religion[57]; the sight of the pilgrim caravan to Mecca "winding their way through the white sands like a black and slender milliped"; and the rise of "a new and heretical" Wahhabi power in the 1790s under the warrior followers of the House of Saud, "a race of men with bodies of steel, with souls of fire whose own abode was the inaccessible heart of the desert."[58] Thomas Hope is one of the first Western writers to praise the "energy" and "freedom" of the desert, "a country where the heart resembles a volcano whose eruptions never cease."[59]

Hope also describes, at length, the complex power structure of Ottoman Egypt where Mameluke beys, Ottoman governors, and Coptic scribes governed "smoke-dried men, tattooed women and blear-eyed bloated children," in a land of "filth and ruins," where the plague was so widespread that "the living became too few to bury the dead."[60] As befitted a partner in the bank that had helped finance Catherine II's wars, Thomas Hope knew that in the 1770s the empress had planned to attack the Ottoman Empire in alliance with Mameluke beys; that there was doubt over the legitimacy of the Ottoman Sultan's claim to be Caliph of the Muslims; and that as a result of the many cruelties of Djezzar Pasha, Ottoman governor of Acre, people could be seen walking through its streets short of a nose, a hand, or lips; "the wailings of the tortured mixed themselves with the murmurs of the fountains."[61]

Manners and customs are noted in detail: Turks' habit of commissioning landscapes without figures, owing to their prejudice against human representation; the contrast between the bright dress of the Muslims—which he called "Mohammed's hateful livery"—and the compulsorily dark costume of the Christians; the prohibition in Istanbul against Christians riding on horseback; and the dismal appearance of their houses from the outside, designed to deflect the hostility of the mob, compared to the "eastern magnificence" within.[62] The prison next to the Constantinople arsenal is described with the same detail as the opium market, "where insanity was sold by the ounce."[63]

The mannered cynicism of the style appealed to Regency London and showed that Thomas Hope had acquired a sense of humor. Anastasius says: "Never did we take a fellow's booty whom we did not also rid of a life thus become worthless to him. To do otherwise would have been tempting Providence and was against my oath." Money is called "the universal language," con-

science "the relentless monitor."[64] A man who has been castrated is described as being "furnished with his passport for the harem." Referring to the honesty of Nicholas Mavroyennis's nephew Stephen, "His enemies rejoiced at it though his friends still kept hoping that he was not too old to mend."[65] Hope was praised for his "easy condensation" and "epigrammatic and most searching wit." Thus he wrote of Djezzar Pasha's torture of his wives: "The greatness of the raptures he had tasted became the measure of the pangs he inflicted."[66] "Among Jews and among gentiles, in scripture and in fable, in ancient times and in modern, it has been the invariable rule for ladies to accuse of too much warmth those in whom they have found too little."[67]

In the end, Anastasius dies in Austria, broken-hearted by the death of his son—a sign that the final composition of the novel, rather than immediately following Hope's return from his Ottoman tour, can be dated to the months after the death of his young son Charles of fever in Rome in 1817, an event that devastated Hope and his wife.[68] In the novel, Hope reveals Whig views, surprising in a member of an Orangist family that had fled from French revolutionary armies. For him the papacy represented a combination of "imbecility and impotence," French revolutionary regimes "a more promising system" than old monarchies.[69] Although Hope laments the state of regions "once adorned by the Greeks and now defaced by the Turks," he was not pro-Greek. He attacked their "credulity, versatility and thirst of distinctions" and claimed to be "equally disgusted with the brutal stupidity of the rulers as with the servile apathy of the ruled."[70] His name did not appear on lists of British Philhellenes during the Greek war of independence in the 1820s, although a Greek boy called Aide, "not only young but handsome with keen black eyes and a most gentle submissive voice and apparent timidity," of whom nothing more is known, came to visit him in London.[71] Hope loved the Levant. In comparison, he called Western Europe "heartless . . . frigid . . . dull and prosaic."[72] However, he never returned to the Levant.

The Assault on London

After returning to London, Thomas Hope began a lifelong battle to impose his taste and style on England. Neoclassicism, not Philhellenism, was the passion of his life. He believed that, in contrast to the "degraded French school of the middle of the last century," a return to "true elegance and beauty" in dress and design, modeled on the patterns of the Greeks and Romans, would contribute immensely "to the extension of our rational pleasures," give "the eye and the mind the most lively, most permanent and most unfading enjoyment," refine "the intellectual and sensible enjoyments of the individual," advance the "virtue and patriotism" of the nation—and provide practical encouragement for artists and

craftsmen.[73] In addition to the scholarly aims revealed in such works as *Household Furniture and Interior Decoration* (1807) and *Costume of the Ancients* (1809), another motive for his propagation of neoclassicism may have been a desire to regain in London, through the splendor and originality of his residence, some of the prestige that his family had once enjoyed in Amsterdam. Indeed, some of the chairs he designed and owned look like thrones. In addition, Thomas Hope had inherited a tradition of collecting and connoisseurship from his father and his father's cousin Henry Hope. Of the three great European banking houses in the century between 1760 and 1860—Hope, Baring, Rothschild—none produced an art patron as original and creative as Thomas Hope.

He had enough money to realize his aims. As one of the four heirs of the Hope bank, his capital in Hope and Company alone consisted of 3,223,802 *guldens courant* in 1798; his share of annual profits amounted to 148,750 *guldens courant*.[74] In the classic tradition of transforming new wealth into a great collection, Thomas Hope was the fourth generation from the founder of the bank, and the first not to work in it. The bank continued to be run by Henry Hope and John Williams Hope, who worked closely with Barings, another London bank owned by a family from northern Europe, especially after the marriage of Pierre César Labouchère to Dorothy Baring in 1796.

In November 1802, during the temporary interlude in the "French wars," when even Great Britain had made peace with France, the Hope bank was re-established in Amsterdam. For a time, it resumed its European role. In 1803 the Hopes helped finance the American purchase of Louisiana from the French government—the most foolish voluntary cession of territory in history.[75] Thereafter, despite the resumption of war between Britain and France in 1803, Hope and Company helped organize both the private investments and the government loans of Napoléon's brothers.[76] Between 1802 and 1808, the Hope bank also arranged the contributions exacted by the French government from Napoléon's satellites, including the kings of Spain and Portugal. It is possible that these foreign loans, earning between 3 and 5 percent, helped, like the previous government loans, to keep the Dutch wealth of the seventeenth century intact and to fund the economic revival of the nineteenth.[77] Despite the Napoleonic wars and the continental blockade, the Hopes' partner Labouchère, one of Talleyrand's most intimate friends, continued to travel between London, Paris, Frankfurt, and Amsterdam: Napoléon I himself used Labouchère as a source of information on English politics.[78]

Many members of Hope's family remained attached to the Netherlands. Henry Hope and Thomas's beloved bachelor brother, Henry Philip Hope (1774–1839), often returned there. His second cousin and occasional hostess, Mrs. Williams Hope, famous for

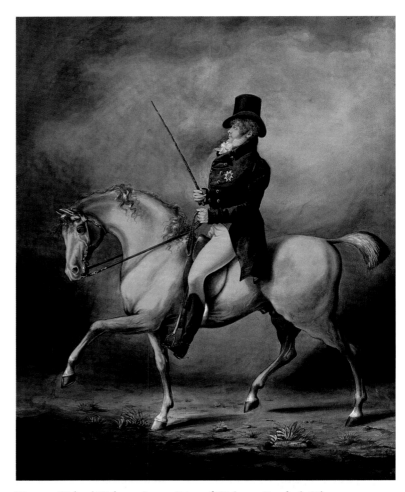

Fig. 1-15. Richard Dighton. *George, Prince of Wales, on Horseback*. Oil on canvas, 1804. The Royal Collection, © HM Queen Elizabeth II, 453262. The Prince of Wales came to the Hopes' parties but his views of Hope's taste and the interiors in Duchess Street are not recorded.

her scornful remarks about the English, left London when she could; she married her daughters to Dutch gentlemen and eloped with a Prussian officer called the Baron von Dorpff. Her decision to marry von Dorpff on her uncle's death in 1813 and to withdraw her capital precipitated the final sale of the Hope bank to Barings that year for a total of £250,521 sterling.[79] Thomas Hope also returned to the continent, visiting Paris, Rome, and Naples in 1802–3, and again in 1816–18.[80] However, by then he had become English. As far as is known, he never returned to his childhood home in Amsterdam, and after 1798 he never lived anywhere but London or his country house, the Deepdene.

The principal means he chose to impose himself and his taste on London was the creation of a fashionable house. Between 1799 and 1802, he was extending, redesigning, and redecorating his house on the corner of Mansfield Street and Duchess Street, near his cousins Henry Hope and John Williams Hope in Cavendish Square. Three pictures of Indian scenes commissioned from Thomas Daniell hung in a drawing room with a sofa after the Eastern fashion and a Turkish ceiling.[81] The splendid, brightly

colored neoclassical and neo-Egyptian interiors were filled with furniture in similar styles that Hope designed; classical sculpture that he had bought in Italy, including a porphyry head of Nero set in gilt bronze by Valadier[82] and statues of Athena and Hygieia[83] recently discovered in the ruins of Ostia (see figs. 7-16, 7-13, 7-14); eleven neoclassical busts by Bertel Thorvaldsen; many works by John Flaxman; and works by such fashionable painters as Benjamin West and John Martin.

The highlight of the collections, bought in 1801 for 4,500 guineas, were 750 Greek and Roman vases that made up two-thirds of Sir William Hamilton's legendary collection of Greek and Roman vases, which Hope arranged in three "vase rooms."[84] Hope also displayed his rank, wealth, and taste by the purchase and commission of silver-gilt candlesticks, vases, and other objects, such as a tea service from Paul Storr and the royal gold-smiths Rundell, Bridge, and Rundell, and by the purchase of pictures formerly in the collection of the ducs d'Orléans.[85] Thomas Hope now had a house to rival in splendor and originality the other "lions" of Regency taste: the Prince of Wales's London residence at Carlton House and "Chinese" pavilion at Brighton; Beckford's neo-Gothic abbey at Fonthill; and John Soane's house in Lincoln's Inn Fields.

The difference was that Hope's house was more modern and more public. Fonthill was inaccessible, except to the few guests whom Beckford allowed in; the Brighton pavilion and Carlton House were usually reserved for the prince's guests. "During the season when the nobility is in town," however, Duchess Street, like many other great London collections, could be visited by ticket. In contrast to Beckford and the prince, Hope was a didact, determined to promote a neoclassical revolution among the English.

The artistic role of the house in Duchess Street is described elsewhere in this book. Its human function was not only to house Thomas Hope but also to provide an arena for his conquest of London. From its completion in 1802 until his death in 1831, Hope entertained there constantly. Money spent on parties was then considered so admirable in England that the number and weight of the candles—a considerable expense—as well as the names of the guests were reported in full in the leading daily newspapers. On May 10, 1802, below a list of six to ten parties held every night that week in the London "beau monde," *The Times* reported:

One of the most splendid Routs that has taken place this season was given by Mr. THOMAS HOPE at his house in Mansfield Street on Friday night last [May 7] which was attended by nearly one thousand persons of the first rank and fashion in the country. Sixteen rooms were opened to receive the visitors, which were decorated with great taste, and very brilliantly lighted up so as to excite great admiration: there were two hundred and fifty wax lights in the different rooms, many of which exceeded

in weight two pounds and a half. The golden candlesticks so much admired on the Prince of WALES's visit were used on this occasion. The arrangements were under the direction of Mrs. WILLIAM[S] HOPE who did the honours of the house. His Royal Highness the Prince of WALES was among the guests[86] (fig. 1-15).

Nevertheless, Thomas Hope's first steps into the world of "rank and fashion" revealed his awkwardness. Hope was blamed for inviting members of the Royal Academy to his house not "to meet Company, the Duchess of Gordon etc but as professional men to publish His fine place."[87] He won a reputation for didacticism, vanity, and thrift. Writing in praise of his own "elegance and unity of design and classic taste which I must confess to have sought in vain in the habitations of my neighbours" was unlikely to make him friends.[88] Lord Glenbervie wrote that he was "said to be the richest but undoubtedly far from the most agreeable man in Europe. . . . He is a little ill-looking man of about thirty with a sort of effeminate face and manner, and speaking a kind of language which you are in doubt whether to think merely affected or what is called broken English."[89] The great architects James Wyatt and Robert Smirke, among others, disliked him; for a time, despite his patronage of the arts, he was not invited to Royal Academy dinners. His exclusion was referred to as "Mr. Hope's business."[90] Satirical verses were directed against him. "Hope's Garland," for example, ends:

Each grace of style to me is known
Sound sense, deep thinking are my own.
And willing worlds in pleased surprise
Proclaim me rich! And great! And WISE!!!

Or:

Lo! Tommy Hope beyond conjecture,
Sits judge supreme of architecture.
Contracts his brows and with a fiat
Blights the fair fame of classic Wyatt.
And gravely proves himself alone is able
To form a Palace very like—a Stable.[91]

Some considered a preoccupation with style a sign of frivolity, at a time when the country was fighting for its existence against the Napoleonic Empire. In *The Edinburgh Review* of April–July 1807, Sydney Smith wrote with unaccustomed pomposity: "At a time when we thought every male creature in the country was occupied with its politics and its dangers, an English gentleman of large fortune and good education has found leisure to compose a volume on household furniture." Such matters, he continued with a dig at Hope, should be left to slaves and foreigners.[92]

Many Londoners disagreed. In 1804 Benjamin West had proclaimed that Hope's house was "the finest specimen of true taste

that is to be found either in England or in France."[93] At the Royal Academy dinner in 1805, Hope sat between Viscount Lowther and the Bishop of Lincoln, opposite Earl Cowper. He joined the Royal Society and the Royal Society of Arts in 1804, the British Institution and the Society of Antiquaries in 1805, and the Committee of Taste in 1807.[94]

Marriage and Social Life

After 1806, moreover, Hope was helped by a beautiful and popular wife. Farington reported that at first—like others, including Susan Beckford and a Miss Dashwood—the Honorable Louisa Beresford had refused Hope but "was afterwards persuaded by Her friends not to refuse so splendid a prospect."[95] Their marriage, on April 16, 1806, was a union of birth and wealth. Daughter of the Anglican Archbishop of Tuam and a niece of the Marquess of Waterford, Louisa Beresford had little money of her own. Although he was extremely rich, Thomas Hope was considered by many to be painfully ugly.[96] A caricature representing them as "Beauty and the Beast" by an artist called Dubost, whom Hope had annoyed, was displayed in a shop window in Pall Mall until "cut to pieces" by Mrs. Hope's brother in 1808.[97]

Despite or perhaps because of an unromantic beginning, they soon became a happy couple. In 1810 Miss Berry called them "the image of domestic comfort and good understanding."[98] In a letter of 1811, Hope praised his wife for having "a warm heart, a good understanding, an excellent sense and a kind affectionate disposition which can hardly ever allow you to say, and never to do, anything that can give the least pain to those that love you."[99] In another letter, he wrote to her as "my dearest dearest Lou."[100] In public he acknowledged her as "the sole partner of all my joys and sorrows . . . whose fair form but enshrines a mind far fairer."[101] To mark the success of *Anastasius,* he bought her two rows of pearls, known in the family as "the *Anastasius* pearls."[102]

For her part, she wrote to "my dearest Hope" that she enjoyed being "adorned and set off to every advantage," "an object of envy for these distinctions," and "courted and recherché in society," only because she received these "many worldly advantages" in return for having conferred happiness on him: "I had rather follow him I love or belong to a convict's ship or share the meanest garret with him." For her he was "a beloved friend" and she complained if she was excluded from his travels.[103] In 1807 they bought a country house, the Deepdene in Surrey. It was soon sumptuously furnished with Egyptian-style and neoclassical furniture and sculpture and fitted with thirty-three bedrooms, although the novelist Maria Edgeworth, an old friend of Mrs. Hope's from Ireland, found it "much too fine for a country house even putting the idea of comfort out of the question."[104] Children followed: Henry

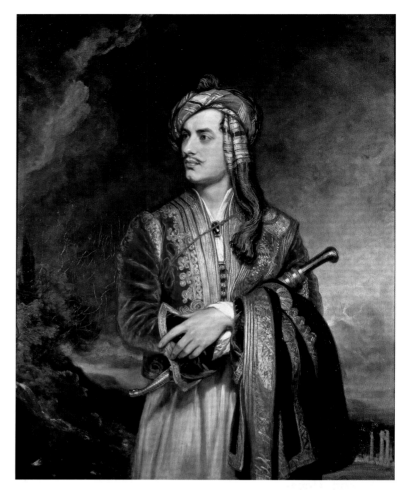

Fig. 1-16. Thomas Phillips. *George Gordon Byron, 6th Baron Byron (1788–1824) in Albanian Dress.* Oil on canvas, 1814. UK Government Art Collection, GAC1976. © Queen's Printer and Controller of HMSO, 2007. Byron traveled in the Ottoman Empire in 1809–11 and, like Hope, had himself painted in a local (in his case Albanian) costume after he returned to London. He disliked Hope but went to his parties and was envious of the success of *Anastasius.*

Thomas in 1808, Charles in 1810, Adrian John in 1811, Alexander James in 1820.

The diaries and letters of the time record the Hopes' conquest of London—particularly Whig London. Holding regular assemblies, or routs, throughout the season, the Hopes made their house one of the most hospitable in the capital. At a rout on June 6, 1806, soon after their marriage, there was such a crowd that some guests could not reach the house, let alone the host. Having already been to George III's Birthday Drawing Room at court that day, Mrs. Spencer Stanhope at half past eleven "set out for Mr. T. Hope's rout but after waiting in the street till near one we found to get in was impossible. Therefore very reluctantly we turned about and came home."[105] In 1809 Miss Berry found "all the world," including the Princess of Wales, dancing in the Statue Gallery; a year later she attended "an enormous assembly; the whole house open and the Princess of Wales there."[106] In 1813 Maria Edgeworth wrote: "We have been to a grand night at Mrs. Hopes—furniture Hope—rooms really deserve the French epithet *superbe*! All of

beauty, rank and fashion that London can assemble I believe I may say in the newspaper style, was there and we observed that the beauties past fifty bore the belle. The Prince Regent stood holding converse with Lady Elizabeth Monck one third of the night—she leaning gracefully on a bronze table in the centre of the room in the midst of the sacred but very small space of circle etiquette could keep around them."

There were nine hundred guests and the Regent stayed till half past three. Many walked to the house, as there was no space for coaches to deposit them. When Maria Edgeworth asked Hope the name of one guest he replied: "I really don't know; I don't know half the people here, nor do they know me or Mrs. Hope even by sight."[107] Many people were probably brought, uninvited, by their friends or were admitted, as at some court receptions, on the strength of their dress and manners, rather than by invitation.

Lord Byron himself did not disdain the Hopes (fig. 1-16). His letters to Lady Melbourne in 1814 contain remarks such as: "we shall meet at Mrs. Hope's I trust"; "I believe I told you the claret story at Mrs Hope's—last ball but one."[108] *Anastasius* impressed him. He said he would have given two of his most approved poems to have written it. Or, in another version, that it made him weep for two reasons, because he had not written it and "Tommy Hope" had.[109]

For both Hopes, social life became an addiction as well as a strategy. If Thomas Hope did not accompany his wife to "assemblies," she tried in letters, as a loyal wife, "to give you as much information and amusement as I could and to be the vehicle through which you were informed of one of the endless tributes of just praise to your abilities, information and genius."[110] They arranged for a similar social life to follow them wherever they were. Like many Londoners, they visited Paris after the fall of Napoléon. In 1815 the liberal writer Sismonde de Sismondi attended a "Bal fort brillant" and many other parties at the Hopes' in Paris.[111]

By the 1820s the Hopes were "big Whigs," friends of previous mockers such as Lord Glenbervie and of Lady Holland herself.[112] A "select early party" in Duchess Street consisted of a hundred guests.[113] The Hopes were equally hospitable in the country. The visitors' book, known as "The Deepdene Album," contains entries by, among others, Walter Scott, Samuel Rogers, John Wilson Croker, and Thomas Moore.[114] Nevertheless, reservations remained. In 1823 Lady Holland's son Henry Edward Fox wrote, after seeing the Hopes every day one season in Brighton:

I got better acquainted here with Mrs. Hope who is uncommonly pretty and very good natured, with some of the drollery and none of the vulgarity of her country. . . . Mr. Hope has a foolish manner and a very disagreeable voice and says silly little

nothings that make people almost disbelieve his having written Anastasius. *He has a talent for drawing and has good taste (a further acquaintance with him has made me scratch out the epithet; its place may be supplied by the word "peculiar"). But certainly nothing appears to make one think him at all equal to such a book as I believe that to be.*[115]

Hope suffered a major defeat that year. A peerage remained the supreme symbol of acceptance in London. Despite British society's reputation for elasticity, it was rarely awarded to a banker, let alone one born abroad, like Thomas Hope, who supported the Whigs under a Tory administration. The elevation of the Tory banker John Smith to the peerage as Lord Carrington had been permitted, in 1797, only after much resistance from the king. The first peerage awarded to a Baring, whose family had settled in England in the 1760s and had long been useful to the government over foreign loans, was not granted until 1835.[116] Nevertheless, Hope made a bid and in 1823 he offered to buy a peerage for £10,000. The Duke of Wellington, his intermediary with the government, was outraged.[117] Despite their generosity to charities, neither Hope nor his equally wealthy sons ever obtained a peerage. His social life, however, continued undisturbed. In 1827 Wellington's friend Mrs. Arbuthnot wrote in her diary: "London is beginning to fill and to be gay. We have just the same society as last year. Ladies Belfast and Gwydyr and Mrs. Hope are at home the Mondays, Wednesdays and Fridays; Tuesdays and Saturdays the Opera and Thursday is left for chance people."[118]

If Hope failed to storm the House of Lords, he succeeded in opening another door to social position, one perhaps more accessible to a banking fortune, namely the court. Although little is known about relations between Hope and George IV, the Hopes were seen at a Christmas party at the Royal Pavilion in Brighton in 1823: Mrs. Hope is described as "dressed in solid gold, with rare birds flying in different directions out of her head."[119] With an eye to the future, Mrs. Hope also contributed to charities patronized by the Duchess of Clarence, the pious wife of George IV's younger brother, the future William IV. From 1826 the Clarences began to visit the Hopes at the Deepdene. In 1829 the Hopes' eldest son, Henry Thomas, became a Groom of the Bedchamber, and for three years he served as a Member of Parliament for the rotten borough of East Looe, purchased for him by his father.[120] In 1830 Mrs. Hope became a Woman of the Bedchamber to the new Queen Adelaide. A less elevated position than that of Lady of the Bedchamber, it provoked a blast of contempt from Lady Holland: "The services are not dignified; and at Court she cannot be admitted into the Circle or be spoken to as her own station entitles her to. Otherwise she gains the [right to carry the Queen's] fan and gloves."[121]

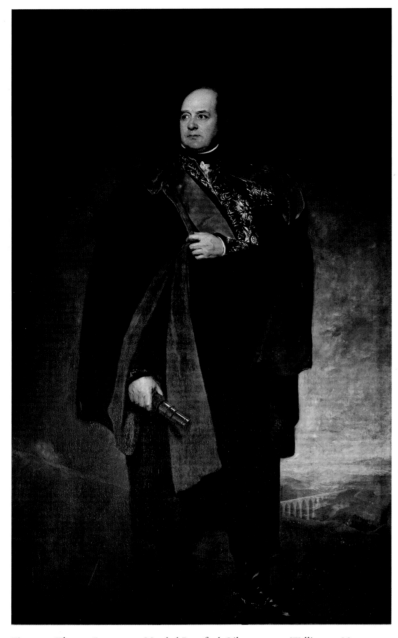

Fig. 1-17. Thomas Lawrence. *Marshal Beresford*. Oil on canvas. Wellington Museum Apsley House, London. Victoria and Albert Museum, WM.1480-1948. V&A Images. Marshal Beresford fought under Wellington in the Peninsula and subsequently ruled in Portugal until the return of King João VI from Brazil in 1822. The opposite of Thomas Hope in career and character, Beresford became Mrs. Hope's second husband after Hope's death in 1831.

By then, however, Thomas Hope was ill. He was killed by what he loved most—his collection. According to Maria Edgeworth, he was on the road to recovery from an indisposition when he caught a chill out on his roof in January, directing workmen to make a skylight for a new picture gallery.[122] As he lay dying, he was watched over night and day by his wife and his sons Adrian and Henry. He said: "I am extinguishing but not as fast as I could wish." He died on February 2, 1831, and was buried at the Deepdene in the mausoleum he had erected for his son Charles. "Some of the last words he ever uttered," Mrs. Hope wrote to her mistress the queen, "were of gratitude and attachment to Your Majesty

and the King."[123] By securing them places in the royal household—and by keeping his fortune intact—Thomas Hope had ensured that his family remained part of court society. His two older surviving sons married Frenchwomen (Adèle Bichat, an actress, and Mathilde Rapp, daughter of a Napoleonic general); his youngest son married Lady Mildred Cecil, whose brother, the Marquess of Salisbury, became one of the most successful Victorian prime ministers.

Hope's personality remains elusive. He was more popular with women than with men. Perhaps because of similarities in taste and character, two of the most sympathetic accounts of Hope are by unmarried lady writers, Miss Mitford and Miss Edgeworth.[124] The former wrote that

> Of all the persons I ever knew, I think he was the most delightful. There was a quick glancing delicate wit in his conversation such as I never heard before—it came sparkling in, chequering his grave sense like the sunbeams in a forest. He had also (what all people of any value have) great truth and exactness of observation and said the wisest things in the simplest manner. Above all there was about him a little tinge of shyness, a modesty, a real and genuine diffidence most singular and most charming in a man of his station, his fortune and his fame. He had the air and bearing of a man of the highest distinction.[125]

Maria Edgeworth had frequently stayed at the Deepdene and at Duchess Street. She praised his "information and general powers of conversation"; he was "so entertaining" during a walk that she almost forgot "the beauties of nature." Above all, he was always "as kind as possible"; "nothing can be more kind or obliging than he is to us."[126]

The houses and the family that Thomas Hope created have vanished, as have his style and his world. The simplicity and purity of neoclassicism to which Thomas Hope had devoted much of his life were beginning to be replaced, at the time of his death, by ornamental eclecticism. The Anglo-Dutch alliance, of which his family and its bank had been such a notable embodiment, had been replaced, by 1831, by British support for an independent Belgium, free of Dutch control.

Hope's widow and his sons quarreled over his will, as well as that of his bachelor brother, Henry Philip Hope.[127] Mrs. Hope may have been devoted to her first husband, but she remarried, less than two years after his death, on November 29, 1832, to her cousin and childhood sweetheart Marshal Beresford (fig. 1-17). Known by his stepsons as "the Marshal," he was as different from Thomas Hope as a man could be. Large, ill-tempered, and rough-mannered, he had won fame as the commander of the Portuguese army during the Peninsular War and subsequently as unofficial ruler of Portugal. Confirming that Thomas Hope had been the driving force behind their entertainments, Louisa Beresford

ceased to hold routs or receptions after her second marriage. Although still listed as a Woman of the Bedchamber in the *Royal Calendar* of 1833, her name does not appear in that of 1834. On inheriting his stepfather's fortune, Hope's youngest son, Alexander James, took his stepfather's name and became Alexander James Beresford Hope, as keen an advocate of neo-Gothic style as his father had been of neoclassical.[128]

Hope's collections were dispersed by his descendants in sales in 1898 and 1917. His last descendant in the male line died in 1917. Moreover, in a remarkable double loss, both Hope's houses were demolished, Duchess Street by his eldest son in 1851, the Deepdene by its owner, British Railways, in 1969.

This exhibition will, it is hoped, revive the reputation of an apostle of neoclassicism who, at the end of his life, summed up his character and ambitions in the following words: "I who though of merchant blood am not a merchant; who though dabbling in authorship rank not among the inspired; who have only been able to bestow on a few humble artists the feeble patronage of an humble individual have done all I could; and should I succeed in kindling for the arts a more intense and universal love when comes the hour of death I shall think I have not lived in vain."[129]

Acknowledgments

The author is grateful to Edward Chaney, Antony Edmonds, Didier Girard, Philip Hewat-Jaboor, Francis Russell, and David Watkin for their comments on this essay.

1. James Harris to Marquess of Carmarthen, 14 March 1788, quoted in James Harris, 1st Earl of Malmesbury, *Diaries and Correspondence*, vol. 2 (London, 1844): 419.
2. On George III and Hanover, see David Watkin, *The Architect King: George III and the Culture of the Enlightenment* (London: The Royal Collection, 2004): 18–23.
3. Henry Méchoulan, ed., *Amsterdam XVIIe siècle: marchands et philosophes, les bénéfices de la tolérance* (Paris: Autremont, 1993): 11, 21, 28. The picture is now in the Museum of Fine Arts, Boston.
4. Madeleine van Strien-Chardonneau, *Le voyage de Hollande: récits de voyageurs français dans les Provinces Unies 1748–1795* (Oxford: Voltaire Foundation, 1994): 82.
5. See, e.g., Marten G. Buist, *At spes non fracta: Hope & Co. 1770–1815, Merchant Bankers and Diplomats at Work* (The Hague: Bank Mees and Hope, 1974): 3. John Hope to Earl of Hopetoun, 12 March 1776, quoted in ibid., 5, 7. Note of Charles Hope of Hopetoun, 22 February 1701, authorizing Archibald Hope "my cousin merchant in Rotterdam" to collect a debt, quoted in ibid., 5, 233. I am grateful for information on the Hope genealogy to Patrick Cadell, archivist at Hopetoun House.
6. Buist, *At spes non fracta* (1974): 5.
7. Jan de Vries and Ad van der Woude, *The First Modern Economy: Success, Failure and Perseverance of the Dutch Economy, 1500–1815* (Cambridge: Cambridge University Press, 1997): 124.
8. James C. Riley, *International Government Finance and the Amsterdam Capital Market 1740–1815* (Cambridge: Cambridge University Press, 1980): 13.
9. Letter of Labouchère, August 1815, quoted in Buist, *At spes non fracta* (1974): 380.
10. See, e.g., Harris, *Diaries and Correspondence*, vol. 2 (1844): 419 (despatch of 14 March 1788 referring to "the gentlemen of the court"), cf. General Baron de Dedem de Gelder, *Mémoires* (1900): 8 (referring to "la cour stadhouderienne").
11. See, e.g., *Modes en miroir: la France et la Hollande au temps des lumières*, exh. cat., Musée Galliera, Paris (Paris: Editions Paris Musées, 2005): passim, 107 (Pascale Gorguet Ballasteros, "La France, modèle de mode"), 120–21 (Madelief Hohe, "La mode française à la cour de La Haye: les gardes-robes des Princesses Wilhelmine de Prusse et Louise d'Orange-Nassau").
12. Buist, *At spes non fracta* (1974): 120.
13. Ibid., 14, 16.
14. De Vries and van der Woude, *The First Modern Economy* (1997): 124.
15. Buist, *At spes non fracta* (1974): 33.
16. Ibid., 83–87, 495.
17. Thomas Hope was baptized in Amsterdam on 3 September 1769 in the English Presbyterian church: see the entry for him at www.worldroots.com.
18. Vincent Nolte, *Fifty Years in Both Hemispheres* (London: Trubner, 1854): 51.

19. For biographical details, see the relevant entries in the new *Oxford Dictionary of National Biography*.
20. For the Hopes speaking English like natives, see John Ingamells, *A Dictionary of British and Irish Travellers in Italy, 1701–1800* (New Haven and London: Yale University Press, 1997): 521. Well into the 19th century, the Prince of Orange and his family corresponded exclusively in French: cf. Johanna W. A. Naber, *Correspondentie van de Stadhouderlijke Familie, 1795–1820*, 5 vols. (The Hague, 1931–36).
21. Baron de Frénilly, *Souvenirs* (Paris, 1908): 48; van Strien-Chardonneau, *Le voyage de Hollande* (1994): 392.
22. Philip Ziegler, *The Sixth Great Power: Barings, 1762–1929* (London: Harper Collins, 1988): 13–14, 54.
23. Buist, *At spes non fracta* (1974): 18; "A Journey to Flanders and Holland in the Year 1781," in *Literary Works of Sir Joshua Reynolds*, vol. 2 (London, 1835): 208.
24. J. W. Niemeijer, "A Conversation Piece by Aert Schouman and the Founders of the Hope Collection," *Apollo* 108, no. 199 (September 1978): 185–86.
25. Buist, *At spes non fracta* (1974): 42; Alfred Cobban, *Ambassadors and Secret Agents: The Diplomacy of the 1st Earl of Malmesbury at the Hague* (London: Jonathan Cape, 1954): 113; Jhr. F.W.A. van Blokl et al., *Paviljoen Welgelegen, 1789–1989. Van buitenplaats van de bankier Hope tot zetel van de provincie Noord Holland* (Haarlem, 1989), passim. I am grateful to Reinier Baarsen for this reference.
26. Buist, *At spes non fracta* (1974): 92, 104–5, 274, 497. See Chapter 11 in this volume, nn. 117, 118.
27. Ibid., 120, 134, 151, 163, 170.
28. Ibid., 431 (Henry Hope to Laborde de Méréville, 9 August 1787).
29. Despatches to Carmarthen, 6 and 13 July 1787, quoted in Harris, *Diaries and Correspondence*, vol. 2 (1844): 331, 336–37.
30. Despatches to Carmarthen, 18 and 20 September 1787, quoted in ibid., 376, 379.
31. Ibid., 397, 10 October 1787.
32. Cobban, *Ambassadors and Secret Agents* (1954): 196, 251, n. 86 (quoting a letter of the Rev. A. Maclaine to Sir Joseph Yorke, 16 October 1787).
33. Buist, *At spes non fracta* (1974): 44.
34. Ibid., 46; cf. Edouard Chapuisat, *Necker 1732–1804* (Paris, 1938): 181, 187, 241 (Madame Necker to M. Le Sage, 4 July 1793, referring to "le même argent qu'il avait engagé il y a quatre ans chez MM Hope pour sauver Paris de la famine" [the same money that he had advanced four years ago to MM Hope to save Paris from famine]).
35. Buist, *At spes non fracta* (1974): 107. France also may have seemed more creditworthy and, for Patriot investors, more politically attractive than Britain: see R. R. Palmer, ed., *The Age of the Democratic Revolution: The Challenge* (Princeton: Princeton University Press, 1969): 328, 338.

36. *The Diary of Joseph Farington*, vol. 2 (New Haven and London: Yale University Press, 1979): 296–97 (27 January 1795).

37. Buist, *At spes non fracta* (1974): 49–50; Nolte, *Fifty Years* (1854): 156.

38. G. J. Renier, *Great Britain and the Establishment of the Kingdom of the Netherlands 1813–1815* (London and The Hague, 1930): 40, 72.

39. Celina Fox, *London World City 1800–1840* (New Haven and London: Yale University Press, 1992): 16 (quoting *Letters from Albion* [1814]), and 226.

40. Martin Daunton, "London and the World," in Fox, *London World City* (1992): 25, 28.

41. John Williams Hope to Sir France Baring, 26 January 1790, quoted in T. L. Ingram, "A Note on Thomas Hope of Deepdene," *Burlington Magazine* (June 1980): 428; Ingamells, *Dictionary* (1997): 521–22.

42. See Philip Mansel, "The Grand Tour in the Ottoman Empire 1699–1826," in Paul and Janet Starkey, eds., *Unfolding the Orient: Travellers in Egypt and the Near East* (Dryden, N.Y.: Ithaca Press, 2001): 44, 50.

43. John B. S. Morritt of Rokeby, *Life and Letters*, ed. G. E. Marindin (1914): 136, 169 (letters of 12 November 1794, 18 January 1795).

44. Cf. Buck Whaley, *Memoirs, Including His Journey to Jerusalem* (London: Alexander Morting, 1906): 191, 226, 236 (at Acre "the governor received us with all that kind of politeness and pompous ceremony peculiar to Asiatic grandees"); William Turner, *Journal of a Tour in the Levant*, vol. 2 (1820): 60 (in Beirut "the Aga was very civil and begged that if I had need of anything here which he could do for me I would not fail to apply to him").

45. Mansel, "Grand Tour" (2001): 49.

46. Richard Pococke, *A Description of the East and Some Other Countries*, vol. 2 (London, 1743–45): 126, 133. The relative ease of access of Constantinople mosques is confirmed in other accounts; see Sir Francis Sacheverell Darwin, *Travels in Spain and the East 1808–1810* (Cambridge: Cambridge University Press, 1927): 49 (July 1809: "Mr. Adair procured a firman to make the tour of all the principal mosques").

47. Zeki Celikkol, Alexander de Groot, Ben J. Slot, *It began with the Tulip. The history of Four Centuries of Relationship between Turkey and the Netherlands in Pictures* (Ankara, 2000): 2005 refers to a *yol emri*, or travel permit, between Istanbul and the Morea secured by the Dutch embassy for Hope and Rohan. H. Walter Lark, with David J. Mabberley, *The Flora Graeca Story* (Oxford: Oxford University Press, 1999): 133, 136. I am grateful to Michael J. Stanley for information on Hope's itinerary.

48. David Watkin and Fani-Maria Tsigakou, "A Case of Regency Exoticism: Thomas Hope and the Benaki Drawings," *Cornucopia* 5 (1993–94): 52–59.

49. On the significance of *Anastasius*, see also Chapter 13 in this volume.

50. An annual spring festival on Saint George's Day on the island of Buyukada, formerly known as Prinkipo, in the sea of Marmara opposite Istanbul; it is still celebrated today.

51. Thomas Hope, letter of 9 October 1821, reproduced in Hope, *Anastasius*, vol. 1 (Paris, 1831; reprinted New York: Adamant Media Corp., 2001): viii.

52. Henry William Law and Irene Law, *The Book of the Beresford Hopes* (London: Heath Cranton, 1925): 51.

53. Part of the costume brought back by Hope for the purpose of accurate representation is still preserved with his portrait in the National Portrait Gallery (see cat. no. 2). The distrust that led the Ottoman authorities to confine Greeks to the lower ranks of the Ottoman navy proved justified: Greek sailors deserted in 1821, after the outbreak of the Greek war of independence.

54. *Anastasius*, vol. 2 (2003): 195.

55. Ibid., 28, 76.

56. Ibid., 64, 100, 179.

57. Ibid., 275.

58. Ibid., 188, 193, 195, 264.

59. Ibid., 219, 239, 246.

60. *Anastasius*, vol. 1 (2003): 231, 298.

61. Ibid., 257, 392–93; vol. 2, 273, 280.

62. *Anastasius*, vol. 1 (2003): 51, 150, 151.

63. Ibid., 53.

64. Ibid., 26, 114, 149.

65. Ibid., 314, 400.

66. Ibid., x; vol. 2, 281.

67. Ibid., 200.

68. Law, *The Beresford Hopes* (1925): 51.

69. *Anastasius*, vol. 2 (2003): 366, 371.

70. *Anastasius*, vol. 1 (2003): 362–63.

71. *The Diaries of Sylvester Douglas Lord Glenbervie*, vol. 2 (London, 1928): 101 (10 November 1810).

72. *Anastasius*, vol. 2 (2003): 353.

73. *Household Furniture* (1807): 2, 7.

74. Buist, *At spes non fracta* (1974): 522.

75. Ibid., 56–57.

76. Ibid., 61–62, 359.

77. M. G. Buist, "The Sinews of War: The Role of Dutch Finance in European Politics (1750–1815)," in *Britain and the Netherlands*, vol. 6: *War and Society*, ed. A.C. Duke and C.A. Tamse (The Hague, 1977): 129, 130.

78. Buist, *At spes non fracta* (1974): 64, 257, 424; Emmanuel de Waresquiel, *Talleyrand le prince immobile* (Paris: Fayard, 2003): 280.

79. Law, *The Beresford Hopes* (1925): 69; Buist, *At spes non fracta* (1974): 68.

80. Watkin, *Thomas Hope* (1968): 9.

81. *Household Furniture* (1807): 24.

82. Now in the Royal Ontario Museum, Toronto.

83. Now in the Los Angeles County Museum of Art.

84. Watkin, *Thomas Hope* (1968): 36; and Jonathan Scott, *The Pleasures of Antiquity: British Collectors of Greece and Rome* (New Haven and London: Yale University Press, 2002): 238–45.

85. Watkin, *Thomas Hope* (1968): 57.

86. I am grateful for this reference to Daniella Ben-Arie and Philip Hewat-Jaboor.

87. Farington, *Diary*, vol. 6 (1979): 2235 (7 February 1804).

88. Scott, *The Pleasures of Antiquity* (2002): 240.

89. Watkin, *Thomas Hope* (1968): 8.

90. Farington, *Diary*, vol. 6 (1979): 2281, 2303, 2306 (8 March and 20, 24–25 April 1804), vol. 8 (1982): 3114 (29 August 1807).

91. Scott, *The Pleasures of Antiquity* (2002): 240.

92. Watkin, *Thomas Hope* (1968): 215–16.

93. Farington, *Diary*, vol. 6 (1979): 2284 (28 March 1804).

94. Ibid., vol. 7 (1982): 2545, 2573 (27 April and 11 June 1805), vol. 8 (1982): 2985 (9 March 1807).

95. Ibid., 2754 (9 May 1806).

96. Watkin, *Thomas Hope* (1968): 16.

97. Farington, *Diary*, vol. 9 (1982): 3214 (3 February 1808), vol. 10 (1982): 3670, 3674 (15 and 22 June 1810).

98. Watkin, *Thomas Hope* (1968): 18.

99. Law, *The Beresford Hopes* (1925): 36.

100. British Library Add Mss 54227, f. 23, letter of 1808.

101. *Anastasius*, vol. 1, i.

102. Law, *The Beresford Hopes* (1925): 37.

103. Ibid., 37–38.

104. Watkin, *Thomas Hope* (1968): 179; Maria Edgeworth to Mrs. Edgeworth, 17 April 1819, quoted in *Maria Edgeworth: Letters from England 1813–1844*, ed. Christina Colvin (Oxford: Clarendon Press, 1971): 197.

105. Farington, *Diary*, vol. 7 (1982): 2779 (6 June 1806); Mrs. Spencer Stanhope to John Spencer Stanhope, 6 June 1806, quoted in A. M. W. Stirling, *The Letter Bag of Lady Elizabeth Spencer-Stanhope*, vol. 1 (London, 1913): 51.

106. *Diaries and Correspondence of Miss Berry*, vol. 2 (London, 1865): 380, 413 (31 May 1809, 4 April 1810).

107. Letter to Sophy Ruxton, 16 May 1813, quoted in *Maria Edgeworth* (1971): 55–56.

108. Letters to Lady Melbourne, 29 April and 16 May 1814, quoted in Byron, *Letters and Journals*, vol. 4 (London: John Murray, 1974): 110, 116.

109. Ibid., vol. 7 (1974): 138n, 182; *Lady Blessington's Conversations with Lord Byron*, ed. Ernest J. Lovell Jr. (Princeton: Princeton University Press, 1969): 51.

110. Law, *The Beresford Hopes* (1925): 36, 38.

111. Sismondi to his mother, 26 January 1815, 12 and 25 February 1815, quoted in Sismonde de Sismondi, *Epistolario*, vol. 2 (Florence, n.d.): 75, 91, 105.

112. Lady Cowper to Frederick Lamb, 16 March 1821, quoted in Mabell, Countess of Airlie, *Lady Palmerston and Her Times*, vol. 1 (London: Hodder, 1922): 87.

113. Letter of 9 March 1822, quoted in *Maria Edgeworth* (1971): 362.

114. Law, *The Beresford Hopes* (1925): 122–23.

115. *Journal of Henry Edward Fox*, ed. Lord Ilchester (London, 1923): 187 (entry for late 1823).

116. G.E.C., *The Complete Peerage*, vol. 3 (London: Sutton, 1982): 63n. I am grateful to Francis Russell for his views on 19th-century attitudes to bankers.

117. 22 March 1823, *The Journal of Mrs Arbuthnot*, vol. 1, ed. Francis Bamford and the Duke of Wellington (London: Macmillan, 1930): 224; cf. the draft of letter of application for a peerage to the Duke of Wellington by Mrs. Hope, possibly in 1830, quoted in Law, *The Beresford Hopes* (1925): 63: "Our family connections both as Hopes and as Beresfords are, we believe, quite unobjectionable, and the fortune of our house, I need not say to you, is more than sufficient to maintain the dignity of any honour. We may fairly say that our eldest son will be one of the richest commoners of the kingdom. We have done everything, and we trust and believe not unsuccessfully, to give efficiency to his natural talents, and whatever they are we trust they may come to be useful to the support of your administration, and at a vast expense we have secured his always being in a situation to be so."
In return for a seat in the House of Lords, Hope, a Whig, is offering to support a Tory administration in the Commons.

118. 15 February 1827, *The Journal of Mrs Arbuthnot*, vol. 1 (1930): 80.

119. By Lady Granville, quoted in Watkin, *Thomas Hope* (1968): 23.

120. Law, *The Beresford Hopes* (1925): 60, 106.

121. Letter of 23 July 1830, *Elizabeth Lady Holland to Her Son 1821–1845*, ed. Earl of Ilchester (London: John Murray, 1946): 110.

122. To Mrs Edgeworth, 22 March 1831, quoted in *Maria Edgeworth* (1971): 499.

123. Law, *The Beresford Hopes* (1925): 65–66.

124. Another spinster admirer, who may have hoped to marry him, was Horace Walpole's last attachment, Mary Berry; see letter to Mrs. Edgeworth of 17 April 1819, quoted in *Maria Edgeworth* (1971): 196.

125. Letter to Miss Jephson, quoted in *The Friendships of Mary Russell Mitford*, ed. Rev A. Lestrange, vol. 2 (1882): 163–65.

126. Letters of 24 March and 17 April 1819 to Mrs. Edgeworth, quoted in *Maria Edgeworth* (1971): 185, 196.

127. Law, *The Beresford Hopes* (1925): 116–17.

128. Ibid., 106–7, 113, 119; and "Alexander James Beresford Hope," in the *Oxford Dictionary of National Biography*.

129. Watkin, *Thomas Hope* (1968): 29.

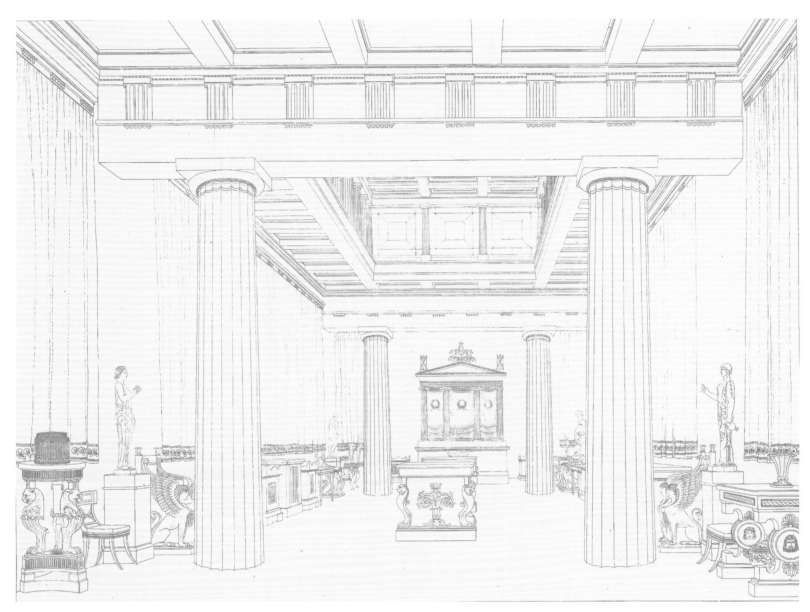

Thomas Hope. Picture Gallery. Engraving from *Household Furniture* (1807): pl. II.

The Reform of Taste in London: Hope's House in Duchess Street

David Watkin

Thomas Hope's house in Duchess Street, which he remodeled and extended from 1799 to 1802—together with its fine collections and its superb furniture and fittings, largely designed by him—was his principal contribution to the arts of design. The interiors and their dazzling contents were, with Sir John Soane's house and museum in Lincoln's Inn Fields, among the most striking of their time in London. Soane's museum survives intact, so his achievement is well known, but Hope's has been obscured because his house was demolished in the nineteenth century. Yet in the house he created in Duchess Street, all the sensations were gratified, including smell—with incense burners in the Indian Room—and sound—with the playing of the organ in the Picture Gallery. Everywhere the eye was arrested by vibrant colors, which were among the most striking and inventive features of his interiors. Hope may well have known *Le Génie de l'Architecture; ou, l'analogie de cet art avec nos sensations* (1780) by Nicolas Le Camus de Mézières,[1] a work studied closely by Soane. Le Camus provided a room-by-room description of a great town house of the ancien régime, arranged according to the principle of evoking sensations through appropriate character: "Each room must have its own particular character. The analogy, the relation of proportions, decides our sensations; each room makes us want the next; and this agitation engages our minds and holds them in suspense. It is a satisfaction in itself."[2] This could be a description of Hope's Duchess Street mansion, as could Le Camus's characterization of a house as a theater in which every room evoked different and appropriate sensations, with light and illusion used to create mood.

Although Hope's house was destroyed in 1851, we know its appearance, because many of its contents survive in private collections and museums, and also because he took the unusual step of publishing a monograph on it, *Household Furniture and Interior Decoration Executed from Designs by Thomas Hope* (1807), which included plates of interiors and of individual objects, such as furniture and silver. In addition to the account of a visit to the house made in 1812 by the antiquarian Francis Douce and Charles Molloy Westmacott's *British Galleries of Painting and Sculpture* (1824), Hope's book will be our principal guide as we make our tour of the house in this chapter. A false impression, however, can be given by the plates in *Household Furniture*, because the rooms were doubtless tidied up before being engraved. Also, each plate of a room shows at most three sides of it, omitting one quarter, and some objects may have been added after 1807, when the plates were published. Far more significant is the lack of shadow and color in these outline engravings. Hope explained that he chose not to have color plates because this would have priced the book beyond the pocket of the craftsmen and designers he wished to influence. He accepted the fact that his outline engravings allowed "no blending tints of light and shadow" nor "the harmonious blending, or the gay opposition of the various colors."[3] Nevertheless, one can only regret that he did not produce a luxury edition with hand-colored acquatints of the ravishing quality of those in William Henry Pyne's *Royal Residences* (1819).

Hope's use of color, especially as an expression of character, echoed Goethe's interest in the allegorical and symbolic associations of color in his *Zur Farbenlehre* (1810), where he "drew attention to the 'symbolic applications of color,' its 'allegorical applications,' and its capacity for 'mystical allusion.'"[4] We know something of Hope's sensitivity to color from the man of letters Richard Monckton Milnes, later Lord Houghton, who tells us that Hope avoided the color green on the grounds that it was inappropriate to imitate the color of nature. Lord Houghton redecorated his family seat, Fryston Hall, Yorkshire, in 1854, choosing colors on a theory popular in his youth, when Thomas Hope's design ideas were fashionable. Writing of the drawing-room walls, Monckton Milnes claimed, "I have no green on them," explaining that he had once sat next at dinner—it was at Lord Carleton's[5]— "to Tommy Hope, Anastasius, he who wrote a book upon furniture and decoration, & was regarded as the Corypheus[6] of Art & Taste. All our talk was on it, & it was his main injunction to avoid having green. He said it was the color of Nature's freshness & Nature disdain'd imitation. She showed it, by having her green turn brown by candlelight. It was the color of all others to have where apartments were in accompanyment with out-door scenery—as summer houses, & villas on the Thames—these intended only for enjoyment in the day—Thus, on these walls,

which are for the night there is nothing of green. They are violet & pale yellow."[7]

Writing of Duchess Street in 1861, Thomas Hope's youngest son, Alexander, was also aware of its novel use of color, claiming that the "position which my father occupied in the artistic movement of our age has never been appreciated nor even understood." He thus went on

> to leave on record the impression of early but vivid recollections of the taste, the fancy, the eye for color and for form, which characterised the whole conception [of Duchess Street]. . . . It was the experiment of a man of genius, and not to be confounded with the contemporary and parallel, but far more insipid, "Empire" epoch of French art. The great fact for which Thomas Hope deserves the gratitude of posterity . . . was that he, first of Englishmen, conceived and taught the idea of art-manufacture, of allying the beauty of form to the wants and productions of common life.[8]

The House by Robert Adam

The house in Duchess Street that Hope bought in 1799, partly to serve as a setting for his growing collection, had been built by Robert Adam in the 1770s. Hope left it largely intact but rebuilt and extended the wings in the courtyard. Since 1794, Hope's first cousin once removed Henry Hope had been living nearby in the former Hopetoun House, off Cavendish Square, which had recently become extremely fashionable. Henry Hope had built Paviljoen Welgelegen, an enormous mansion near Haarlem,

Holland, in 1785–89,[9] to house his collection of paintings and antiquities, including a chimneypiece by Piranesi that had belonged to his cousin John Hope, Thomas Hope's father.[10] Resembling a public building more than a private residence and indebted to the Villa Albani in Rome, Welgelegen has a raised pedimented center containing three huge rooms that form a gallery. The only one of its kind in Holland, this gallery was surely a powerful influence on Thomas Hope (cat. no. 15).

Thomas Hope's house at 1 Mansfield Street was initially built by Adam in 1768–71 for General Robert Clerk, as part of his Portland Place development. It was bounded on the south by Queen Anne Street, on the west by Mansfield Street, on the north by Duchess Street, and on the east by the garden and stables of Adam's Chandos House of 1770–71. Since the entrance to 1 Mansfield Street was in Duchess Street, it was usually by the latter address that it was known. Damaged by fire in 1771, Clerk House was rebuilt in 1771–75 by the Adam brothers for Clerk and his wife, the former Dowager Countess of Warwick, at her expense. It was unique in Adam's career in that it took the form of a Parisian *hôtel particulier,* built *entre cour et jardin* (fig. 2-2). General Clerk, a "confidential adviser" to Lord Shelburne, had lived in the 1760s in Paris, where, according to David Hume, he was "a rare instance of people who acquired a place in French society."[11] He thus may have asked that his house have a Gallic disposition, which would eventually appeal to Hope, for whom Paris was the center of taste. But Hope must also have been attracted to the large forecourt and flanking wings, which provided space for the creation of galleries for his collections.

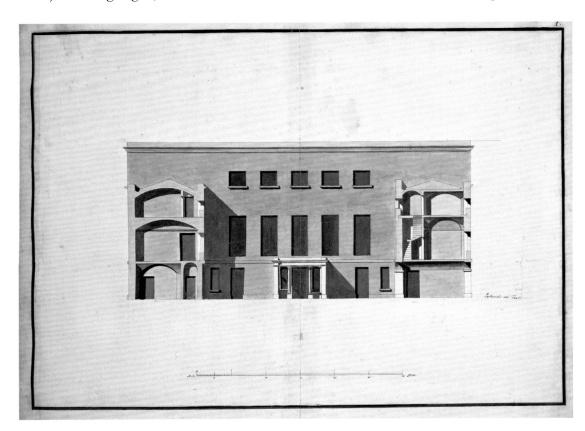

Fig. 2-1. Office of Robert Adam. Entrance front of the house in Duchess Street and section through wings. Ink and colored wash, ca. 1770. Private collection, courtesy of Hobhouse Ltd., London.

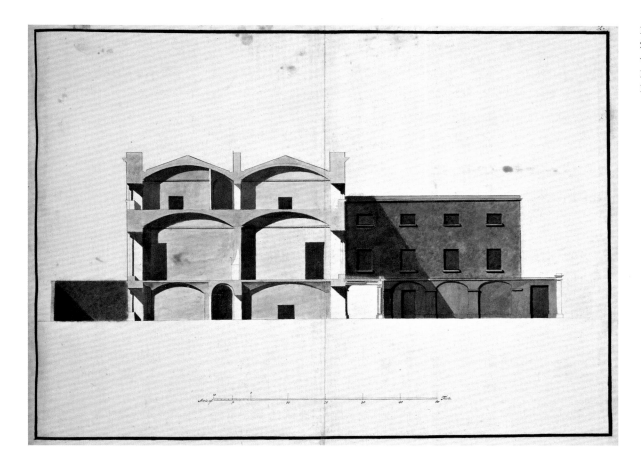

Fig. 2-2. Robert Adam. Duchess Street, section through the house and wings. Ink and colored wash, ca. 1770. Private collection, courtesy of Hobhouse Ltd., London.

The north entrance front of the house seems to have been devoid of ornament, with windows cut plainly into the brickwork (fig. 2-1). A drawing for the nine-bay south, or garden, front shows Ionic pilasters, sculptural roundels, and long decorative panels of swags between the first and second floors. It seems that these were not executed: "Externally, the house, so far from possessing any architectural beauties or imposing appearance, presents plain brick walls without dressings or ornaments of any kind."[12]

In 1831 the German Nazarene painter and pioneer art historian Johann David Passavant recorded: "Being furnished with the necessary card of admission, we turned our steps towards the mansion of the late Thos. Hope, Esq. for the purpose of inspecting his celebrated gallery. What was our astonishment on finding

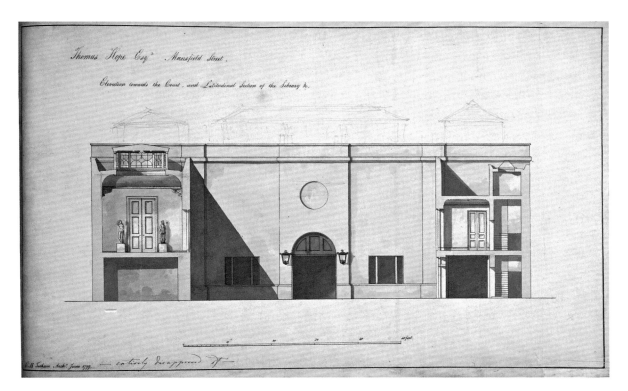

Fig. 2-3. Charles Heathcote Tatham. Duchess Street, elevation of courtyard with side wings. Ink and colored wash, 1799. Private collection, courtesy of Hobhouse Ltd., London.

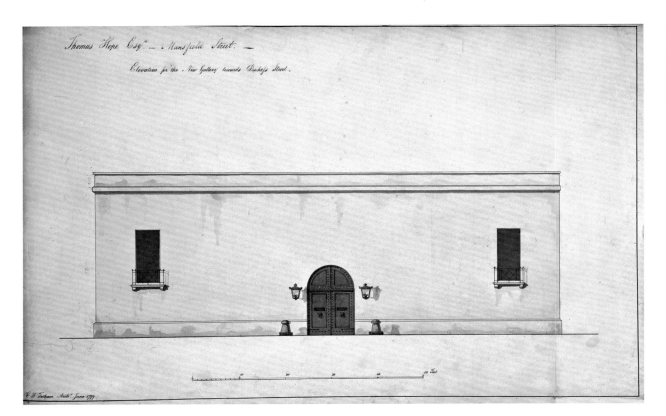

Fig. 2-4. Charles Heathcote Tatham. Duchess Street, new entrance front. Ink and colored wash, 1799. Private collection, courtesy of Hobhouse Ltd., London.

ourselves before a heavy gloomy building, almost entirely devoid of windows, blackened with accumulations of soot, and to all outward appearance conveying rather the idea of a large brewery, than of an opulent banker's town residence."[13]

Since the house had been partially built on a reservoir, it had no basement, so the ground floor, except for the entrance hall and staircase, was reserved exclusively for the servants' quarters; even the wine cellar was on the ground floor. An unusual feature of the construction of both the house and the courtyard wings was that Adam's ceilings were segmental vaults, formed from tiles or flat bricks (fig. 2-2). This technique of recent French origin, which was both economical and fire-proof, had been introduced to England by the comte d'Espie's book *Manière de rendre toutes sortes d'édifices incombustibles* (1754; translated into English in 1756), a work praised by Marc-Antoine Laugier. Adam had also adopted this technique in his library at Kenwood about 1767 and in the second drawing room at 20 St. James's Square, designed in 1772.[14] The technique had been first used in England in 1756 for the construction of Fonthill House, Wiltshire, which was personally supervised for Alderman William Beckford by the comte d'Espie, who dedicated to him the English translation of his book.[15]

The House Remodeled by Hope and Tatham

The wings of the Adam house were set back from Duchess Street so that when Hope remodeled the house in 1799–1802, he extended the wings northward to meet the street, along which he added a fourth wing with a large picture gallery. He thus created a

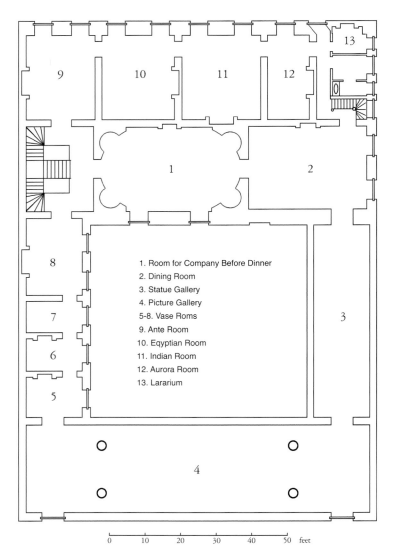

1. Room for Company Before Dinner
2. Dining Room
3. Statue Gallery
4. Picture Gallery
5-8. Vase Roms
9. Ante Room
10. Eqyptian Room
11. Indian Room
12. Aurora Room
13. Lararium

Fig. 2-5. Plan of Duchess Street in 1804, as reconstructed by David Watkin.

first-floor suite comprising sculpture gallery, picture gallery, and four vase rooms around three sides of the court. Eleven drawings for the new gallery and library, signed and dated, "C.H. Tatham. Archt. June 1799," the year Hope bought the house, were discovered in 2003[16] (see cat. no. 120). Labeled "Plan of the new Galleries," these drawings, some of which bear annotations in Hope's hand, establish for the first time that Charles Heathcote Tatham was the executant architect of these celebrated interiors. It is likely that Hope first met Tatham in Rome in the mid-1790s, when he and his two younger brothers were buying antique sculpture. A pupil of Samuel Pepys Cockerell and Henry Holland, with whose financial support Tatham visited Italy, he stayed in Rome from 1794 to 1796, meeting Antonio Canova, Angelica Kauffmann, Sir William Hamilton, the Earl Bishop of Derry, and the Earl of Carlisle.[17]

Hope chose wisely, for Tatham became the leading architect of such picture galleries as those at Castle Howard, Yorkshire (1800–1802), for the Earl of Carlisle; Cleveland House, St. James's (1803–6),[18] for the Marquess of Stafford; and Brocklesby Park, Lincolnshire (1807), for the Earl of Yarborough. Since Tatham's work for Hope preceded these three galleries, he must have been indebted to Hope for setting him on this path of success, even if he received no acknowledgment from Hope. Indeed, the tart tone of some of Hope's inscriptions on Tatham's designs suggest that he was a difficult patron, who wanted, with whatever justice, to be identified as the sole architect. His suppression of Tatham's name was so successful that Westmacott made no reference to his role at Duchess Street in his book on modern galleries of 1824,[19] even though the book included both Duchess Street and Tatham's gallery at Cleveland House.

A sectional drawing by Tatham shows the rather graceless inner façade to the courtyard of the new wing which contained an entrance archway and a porter's lodge on the ground floor and a picture gallery above (fig. 2-3). This drawing bears the inscription in Hope's hand, "entirely disapproved of." By contrast, the corresponding drawing showing the façade to Duchess Street of this new wing bears no such criticism and was presumably executed (fig. 2-4). A striking neoclassical design, it boasts a cubic starkness, which features in the contemporary work of Friedrich Gilly in Berlin, derived from Claude-Nicolas Ledoux. It is essentially blank, save for the round-arched entrance doorway and two widely separated windows in surrounds without moldings.

One drawing by Tatham of the longitudinal section of a proposed top-lit library at Duchess Street (about 50 x 17 feet 10 inches) is identified by Hope as "Mr. Tatham's own design—with respect to the lights—rejected." At its south end the library was entered from Adam's dining room in the main house, and at its north end it led into the new gallery set at right angles to it. The

walls of the library are shown painted blue and the room sports a monumental if austere chimneypiece surmounted by a large arched mirror, but no bookcases. Hope soon decided to turn this room into the sculpture gallery that we know filled the west side of the courtyard (fig. 2-5).

Open to the Public

The transformation by Napoléon of the role of the Louvre as a public museum was under way in March 1802, by the time of the Peace of Amiens, which enabled the English to visit Paris. Those of them who saw the Louvre as a model for England included Benjamin West and Charles James Fox, who were seen there in 1802,[20] the same year Hope was also in Paris. His house in Duchess Street seems by now to have been largely complete, for in May 1802 he gave a grand party at which the Prince of Wales was present. *The Times* reported that "sixteen rooms were opened to receive the visitors, which were decorated with great taste."[21] In 1804 Hope felt ready to open his house officially to the public, or at least to selected members of it. On February 1, 1804, he sent tickets to sixty members of the Royal Academy, which were to admit the bearer and three friends to the house between February 10 and March 31.[22] However, at a Council Meeting of the Royal Academy on February 7, there was criticism of what was described as the "want of respect" in Hope's idea of admission tickets, members complaining that they "were not invited to meet company, the Duchess of Gordon &c, but as professional men to publish His fine place."[23] The situation was not improved when at the end of March, Hope published a pamphlet condemning the designs for Downing College, Cambridge, by James Wyatt, president of the Royal Academy.[24] A typical response to this pamphlet was that of the painter Robert Smirke, who observed that it was "an extraordinary piece of Egotism,—and that it might easily be answered"; he thought that the architect William Porden "might do it well."[25] It can scarcely have surprised Hope when it was decided to exclude him from the annual Academy dinner to be held on April 28. To complete Hope's humiliation, about two hundred copies of a satirical poem entitled "Hope's Garland" holding him up to ridicule were delivered to the Royal Academy on the very day of the dinner. When it turned out that this had been written anonymously by Henry Tresham, a Royal Academician and minor artist, some began to feel sorry for Hope. As a result, on May 14, Benjamin West and Joseph Farington called at Duchess Street to convey the sympathy of the Academy to Hope. He was not easily placated, however, and argued that he felt he had some claim on the Academy by opening his house to its members and their friends, and through being "manifestly a person devoted to the Fine Arts." He intended never again to accept an

invitation from the Academy, observing that "others felt as He did and it had been much taken up."[26]

The significance of public access to Hope's galleries was stressed as early as 1809 by the painter Sir Martin Archer Shee, whom Hope had earlier commissioned to paint a portrait of his wife (see cat. no. 3). Urging national patronage of the arts, Shee observed that in times when continental wars prevented Englishmen from seeing the art of some foreign countries, it was Thomas Hope who "took the lead in offering to the public this desirable indulgence. The facility with which admission was obtained to view his magnificent establishment and the assembly of interesting objects which it contains, may be said to have given the first impulse to that liberality which has so materially contributed to our gratification and instruction."[27] Hope's example in opening his galleries was soon followed in London by the Marquess of Stafford in May 1806 and Lord Grosvenor by 1809.

Tickets were issued to those wishing to visit the Duchess Street house according to methods that included an "application signed by some persons of known character and taste" or by "personal introduction of any friend of the family." Westmacott noted that "Visitors are admitted on the Monday during the season of the nobility being in town."[28]

The Search for Appropriate Meaning

Before making our own tour of the house, we should consider how the preoccupation of the Enlightenment with the return to origins and primary sources suggested that ancient ornament had a religious and secular origin and should thus not be used by modern designers in a purely decorative way. The doctrine of appropriate character was developed by such writers as Jacques-François Blondel, Germain Boffrand, Le Camus de Mézières, and Quatremère de Quincy. Hope's reaction to this new development was clearly stated in *Household Furniture*, where he explained that he had drawn on the works in the bibliography "to animate the different pieces of furniture here described, and to give each a peculiar countenance and character, a pleasing outline, and an appropriate meaning."[29]

Throughout the house, he also took pains to ensure a meaningful and appropriate connection between the object displayed and its setting. Hope acknowledged in the bibliography to *Household Furniture* the *Collection of Etruscan, Greek and Roman Antiquities from the Cabinet of the Honble William Hamilton* (1766–67),[30] by Pierre-François Hugues ("Baron d'Hancarville"), and he doubtless knew d'Hancarville's three-volume *Recherches sur l'origine, l'esprit et les progrès des arts de la Grèce; sur leur connexion avec les arts et la religion des plus anciens peuples connus; sur les monuments antiques de l'Inde, de la Perse, du reste de l'Asie, de l'Europe et de*

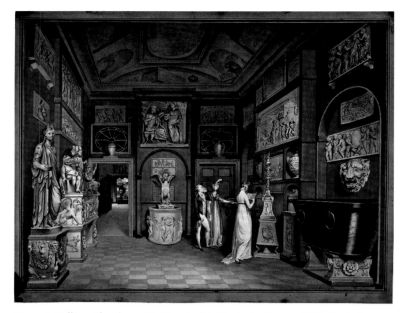

Fig. 2-6. William Chambers. *The Townley Marbles in the Entrance Hall of 7 Park Street, Westminster.* Watercolor, 1794. British Museum, London © The Trustees of The British Museum.

l'Egypte (1785). This gripping study of religious symbolism and its relation to ancient sexual and creation myths had taken by storm the world of Hope's immediate predecessors, including such connoisseurs and collectors as Charles Townley, William Hamilton, and Richard Payne Knight. It was also studied obsessively by Soane.[31]

Hope's furniture and interiors were an early attempt to re-create the kind of symbolical ornament along lines envisaged by d'Hancarville, and he may also have been influenced by d'Hancarville's friend, the antiquarian and collector Charles Townley. A key figure in the history of collecting and display, Townley had an important collection of antique sculpture, the nucleus of which he had formed in Rome in 1768.[32] He established an inventive type of display in his London house at 7 Park Street (today 14 Queen Anne's Gate), where the walls contained columbarium niches containing cinerary urns (fig. 2-6).[33] D'Hancarville stressed that the dining room at Park Street, also crowded with sculpture, expressed "the character of what it was destined for" and explained that "all the ornaments are relative to the attributes of those Gods, who were supposed by the antients to preside over the festive board."[34]

In manuscript notes for his review of *Household Furniture*, John Flaxman argued that "Mr. Hope's principle affords us an excellent hint for adapting the furniture, decoration, and symbols to the Edifice and its purposes, whether it be the Church or the Fortress, the Palace, Museum, private dwelling or cottage."[35] Flaxman will have derived from Hope himself his understanding of Hope's house as an essay appropriate to his character.

Tour of the Duchess Street Mansion

Visitors would have approached the public galleries and reception rooms on the first floor by ascending Adam's great staircase (see fig. 2-5). From 1824, the staircase was dominated by the large and strikingly romantic portrait of Hope in Turkish dress painted in 1798 by Sir William Beechey (see cat. no. 1), which had in 1810 hung in the house in Cavendish Square of Hope's cousin Henry. The first important interior visitors saw was the Drawing Room, the center room on the north front of the house, identified in Adam's plan as a "Room for Company before Dinner." A set of Adam's designs survives showing details of the shutter panels of the two windows facing south onto the garden.[36] Elaborately ornamented with painted arabesques, these panels would have added life and color to this room, from which Hope illustrated several pieces of furniture; the room as a whole is possibly evoked in nine of the plates in Hope's *Designs of Modern Costume* (1812), where the walls feature broad pilaster strips ornamented with various patterns of scrolled and anthemion ornament.

Hope did not give a full plate to either this room or the adjacent Dining Room in *Household Furniture*, probably because he did not significantly alter their appearance from the imposing form in which Adam had left them. This seems implied in the claim of Francis Douce, who recorded his visit to the house in 1812: "The painting the walls & ceiling of this room [the Drawing Room] cost only 20 pounds. The carpet which is very beautiful Mr. Hope found there."[37] The ambitious chimneypiece with classical figures in relief was obviously such an important piece that Hope may well have put it in the Drawing Room.[38] It was probably made by John Flaxman, whom Hope paid for two chimneypieces in 1800.[39] Douce also tells us that the room contained "two shelves with Etruscan and Greek vases," "an Indian Bacchus," "a Greek priestess," busts of Homer and Pindar, and Parisian chairs and sofas ornamented with lyres.[40]

In the Dining Room, Hope showed his belief in appropriate symbolic ornament in the chimneypiece[41] dominated by a white marble bust of his brother Henry Philip (cat. no. 8), for which he paid Flaxman £84 in October 1803. Hope asked Flaxman to follow Greek practice in adopting a severely frontal pose, not the angled one of Roman and later sculptors. Hope was a pioneer in this aspect of neoclassical taste, which would be adopted in busts by Thorvaldsen (see cat. nos. 9, 12, 13). Henry Philip seems to have been known by the second of his Christian names, since his bust is inscribed *philippos,* in Greek characters. Projecting far into the room from a canted term on each side of the chimneypiece was a pair of unusually large horses' heads taken directly from ancient Greek models. These were striking evidence of the fact that "Philip" in Greek means "horse lover."

Hope tells us that the Dining Room sideboard[42] was adorned with the elements of Bacchus and Ceres and the cellaret beneath it with amphorae and figures "allusive to the liquid element." It is clear from the account by Douce that this room was an ambitious neoclassical statement, for he mentioned that it contained "several mahogany tripods, cellarets, candelabra &c. All copied from the antique," an antique statue of Apollo with bow and quiver, as well as three modern paintings: a view of the Roman Campagna by Jacob More, a scene with a mosque by Thomas Daniell, and a Bacchus and Ariadne by Andries Lens who had been a key figure in Rome in the world of Winckelmann and Anton Raphael Mengs.

Statue Gallery

From the Dining Room visitors passed into Hope's new, top-lit Statue Gallery (fig. 2-7), where, he explained, he had left the walls "totally plain" so as not to compete with the sculpture (see Chapter 7). In fact, he painted the walls yellow, the same color as that

Fig. 2-7. Thomas Hope. Statue Gallery. *Household Furniture* (1807): pl. 1.

Fig. 2-8. Thomas Hope. Picture Gallery. *Household Furniture* (1807): pl. II.

Gallery, but in 1807 it contained twenty standing figures or busts, three candelabra, four cineraria, and three urns. The principal pieces were the statues of Athena and of Hygeia, the Goddess of Health, and also the fine Dionysus and Idol, or *Bacchus and Hope* as Hope knew it[44] (see figs. 7-13, 7-14, 7-9).

Picture Gallery

At right angles to the Statue Gallery was the great Picture Gallery, built about 1800 as one of the earliest and most striking Greek Revival interiors (fig. 2-8). With its Greek Doric columns, it may have echoed the art gallery that is known to have existed in the fifth century B.C. in the Propylaea on the Acropolis in Athens. About ninety-six feet long and twenty-four feet wide, Hope's imposing room was tripartite in plan, each section lighted by a raised clerestory that incorporated miniature Greek Doric columns. The large central area was separated by pairs of full-scale Doric columns from the two smaller end sections, each of which contained a single sash-window (fig. 2-9). Uniting architecture with the arts of painting and sculpture, both ancient and modern, the gallery contained tables intended for portfolios of drawings and books of prints, suggesting that this was a place for serious study. The design influenced the development of both private and public galleries.

On Tatham's drawing for the longitudinal section of the Picture Gallery, Hope added after Tatham's signature, "from my own design, afterwards altered with respect to the lights." Tatham

used in Soane's South Drawing Room in Lincoln's Inn Fields. Hope described how the room was "designed solely for the reception of ancient marbles," while "the ceiling admits the light through three lanterns." These clerestory lights were supported on rafters, which, Hope explained, "imitate a light timber covering."[43] In this room he placed his finest pieces of antique sculpture; his secondary sculpture and more decorative pieces were housed in the Picture Gallery. By 1824 he had moved several marbles from the Dining Room and Drawing Room to the Statue

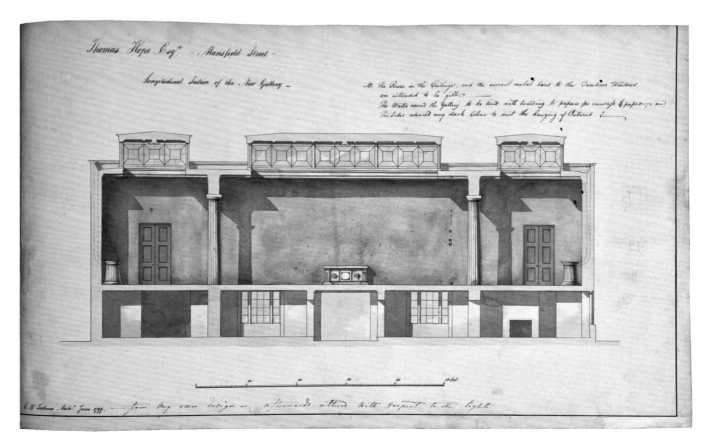

Fig. 2-9. Charles Heathcote Tatham. Section through the Picture Gallery at Duchess Street. Ink and colored wash, 1799. Private collection, courtesy of Hobhouse Ltd., London.

seems to have followed the constructional system of Adam's house, because John Britton explained that the Statue Gallery was supported on groined arches so that "every precaution has been employed to protect its valuable contents from fire," while arched ceilings supported "floors of Roman cement."[45] A drawing by Thomas Hope, labeled by him as for the "large picture gallery" and doubtless made in 1799, was the kind of sketch that he must have given to Tatham to turn into a proper architectural drawing[46] (fig. 2-10). Hope's rather scratchy sketch shows the west end of the gallery with two Greek Doric columns framing a view of the organ flanked by fitted bookcases with narrow, round-arched doors. Hope notes on this drawing that "the organ & bookcases should be higher in proportion to the room. The organ white & gold. The spaces between the columns painted as drapery, red, the ornaments gold—the bookcases mahogany & ormolu." It seems that in execution the organ was made higher; the Doric columns in the west end of the clerestory were reduced in number from six to four; and the ceiling coffering was simplified. Bookcases are not shown flanking the organ in the engraving of the room in *Household Furniture*, but they seem to appear in the view in Westmacott's *British Galleries*. The unusual presence of an organ in a picture gallery, combined with Hope's design for an upright piano at Duchess Street,[47] suggests that he had keen musical interests.

The inscription on Tatham's drawing for the gallery reads: "The Roses in the Ceiling, and the several metal bars to the Tambour Windows are intended to be gilt. The Walls round the Gallery to be lined with boarding to prepare for canvass and paper, and the Sides colored any dark Color to suit the hanging of Pictures." The walls are shown a deep pink, perhaps related to the Pompeiian red that Soane had introduced into England in 1792 in his dining room at 12 Lincoln's Inn Fields. The pairs of doors at each end are painted green, presumably to resemble patinated bronze. Tatham shows the room without pictures or furniture, save for a pair of circular stoves at each end shaped like fluted columns, and a rectangular stove in the form of a sarcophagus in the middle of the long wall. Such generous provision for heating suggests that Hope may have been a cold-blooded Dutchman.

Hope referred on one drawing to part of the interior as "the Cella," confirming that he saw the gallery as a sacred temple of the arts with its templar organ case, which "gives it the appearance of a sanctuary."[48] The Greek Doric columns were made of timber and grained a stone color, and the drawings show sculptural friezes on one side of the entablature carried by the columns (fig. 2-11). These figured friezes seem not to have been executed, for they are not shown in the view of the room in *Household Furniture*. However, fluted, baseless, Greek Doric columns of this

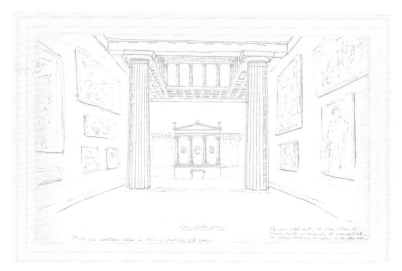

Fig. 2-10. Thomas Hope. Design for Picture Gallery, Duchess Street. Pen and ink, ca. 1799. Private collection.

accuracy had scarcely featured in any interior since the ancient world. In conformity with Hope's role as inspirer of the academic austerity of Downing College, Cambridge, the room was an anthology of classical quotations from Athenian monuments: the four principal columns from the Propylaea; the trabeated ceiling from the Hephaesteion; and the miniature columns in the glazed clerestory from the Tower of the Winds. The four winged sphinx thrones of Coade stone in the room (see fig. 4-17)[49] may have been inspired by those in the painting by Louis Gauffier in Hope's collection, *Augustus Meeting Cleopatra after the Battle of Actium* (1787–88).[50]

This temple of the muses was symbolically guarded by a statue that Hope believed to be a priestess of Isis, an archaistic maiden of the late first century B.C. or the early first century A.D.[51] The statue is visible in the left foreground of his engraving of the room. On the tripod table in front of the figure stands a strange Roman cinerary urn made of marble in the form of a basket,[52] perhaps of the early Imperial period and possibly related to the *cista mystica*, or covered basket, in Bacchic rites (see fig. 7-18). In the right foreground, balancing the *cista mystica* on the left, is a white marble vase in the form of a lotus plant, beautifully demonstrating the origins of Greek art in nature[53] (cat. no. 44).

Aware that the ancient Greeks intended art not for private but for public and religious display, Hope created a version of the Greek *mouseion*, a cult center built for the cultivation and worship of the Muses of the arts and sciences, not necessarily a temple but an open portico with an altar. A gallery at the Propylaea on the Acropolis, for example, contained a collection of precious votive pictures. By the reign of Augustus, Strabo described the shrine of Hera on Samos as having become effectively an art gallery.[54] Hope claimed, as we have seen, that his gallery had "the appearance of

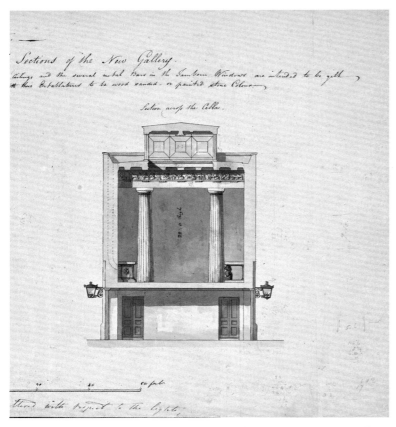

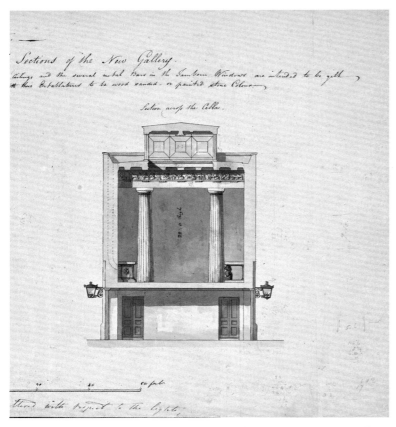

Fig. 2-11. Charles Heathcote Tatham. Cross section of the Picture Gallery at Duchess Street. Ink and colored wash, 1799. Private collection, courtesy of Hobhouse Ltd., London.

a sanctuary," so Karl Friedrich Schinkel, twenty years later, described the Pantheon-like sculpture gallery at the heart of his Altes Museum in Berlin as "the sanctuary wherein the most precious is stored."[55] Thus did both men reveal the extent to which art took the place of religion in the Enlightenment.

The organ in the Picture Gallery (fig. 2-8) was decorated with great iconographical care. Hope described how the "car of the god of music, of Apollo, glides over the centre of the pediment. The tripods, sacred to this deity, surmount the angles. Laurel wreaths and other emblems, belonging to the sons of Latona, appear embroidered on the drapery, which, in the form of an ancient peplum or veil, descends over the pipes."[56] Douce tells us that even the "stoves are in the form of cinerary urns, a subject that too much pervades this noble place & gives it rather a lugubrious appearance in some respects."[57] In 1813 Soane similarly condemned the ceiling of the gallery for its cold whiteness, showing an unusual awareness for this date of the key role that architectural polychromy played in Greek architecture. He complained in private unpublished notes: "what a difference between the monotonous cold and frightful sight of those modern plastered ceilings, and the view of the ancient majestic ceilings, so calculated to animate the artist, so varied, whose beams and joists forming compartments were decorated with the greatest care and protected from damp and insects by fine colour. O Mr. Hope, why

did you in your new gallery forget the beautiful ceiling of Minerva [Parthenon]?"[58]

Hope eventually housed his *Venus* by Antonio Canova here (cat. no. 57), together with many busts and bronze vases, but we should also remember that the room also housed the rich Old Master paintings of the seventeenth-century Italian schools that he had acquired in 1798 at the Orléans sale of the disgraced Philippe Egalité (see Chapter 10). Hope may have felt that such paintings as Guercino's powerful *Betrayal of Christ* would clash with the Grecian character of the room and the neo-antique furniture he designed for it.[59] Thus, in the engraving of the room in *Household Furniture*, its walls are, surprisingly, shown veiled from floor to ceiling, which created an atmosphere of pristine purity. By the time Westmacott published an engraving in his 1824 book, the veils had been removed.[60]

Vase Rooms

The Picture Gallery led into a series of rooms on the east side of the courtyard (figs. 2-13, 2-14) for the display of Hope's collection of Greek vases. Many of these had been in the second Hamilton collection, from which Hope had acquired about 750 vases on April 3, 1801.[61] Although Tatham's drawings of 1799 made no provision for vase rooms, they clarify the disposition of the three rooms that, as Adam's drawings show, had originally been a suite of private family or guest rooms, not servants' rooms. Hope illustrated three vase rooms in *Household Furniture*, but we know that there were four of them on the east side of the courtyard.[62] He probably displayed vases in the small anteroom that he had built at the east end of his gallery. This may be illustrated in plate III in *Household Furniture* (see fig. 7-25), for it has a flat ceiling, which suggests that it cannot have been in that part of the east wing of the courtyard built by Adam where the ceilings had a segmental profile.

Hope must have decided to create these small rooms rather than one great gallery because he felt that such intimate settings would recall those in which the vases had been found in tombs near Naples. He explained in the caption to the first "Room Containing Greek Fictile Vases" that since the vases "were all found in tombs," they were displayed "in recesses, imitating the ancient Columbaria, or receptacles of Cinerary urns." An impression of this is conveyed in the self-portrait of Adam Buck of 1813 (fig. 2-12), doubtless inspired by Duchess Street.[63] Since Hope said that his vases "relate chiefly to the Bacchanalian rites, which were partly connected with the representations of mystic death and regeneration . . . [they] have been situated in compartments, divided by terms, surmounted with heads of the Indian or bearded Bacchus"; following d'Hancarville, he elsewhere

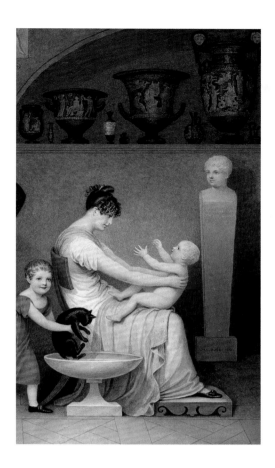

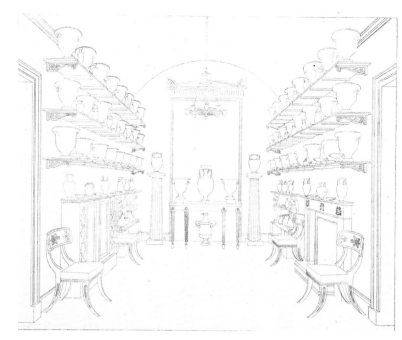

Fig. 2-12. Adam Buck. *The Artist and His Family* (detail). Watercolor and graphite, 1813. Yale Center for British Art, Paul Mellon Collection, New Haven, B1977.14.6109.

Fig. 2-13. Thomas Hope. Second Vase Room. *Household Furniture* (1807): pl. IV.

described Bacchus as "the first legislator who attempted to civilize the Greeks, on his return [from India]."[64]

Two pairs of consoles with supports in the form of panthers in the second Vase Room (fig. 2-13) and a table in the third Vase Room (fig. 2-14) supported by three bronze chimaera, as well as benches with similar terminations, were directly inspired by furniture discovered at Pompeii, perhaps after drawings by Tatham;

Hope described how this last interior also contained "a bronze lamp, bronze candelabra, and a few other utensils, of a quiet hue and of a sepulchral cast, analogous to the chief contents of this room,"[65] that is, the vases. This must have been influenced by d'Hancarville, and, as we have noted, it had also been attempted by Townley.[66]

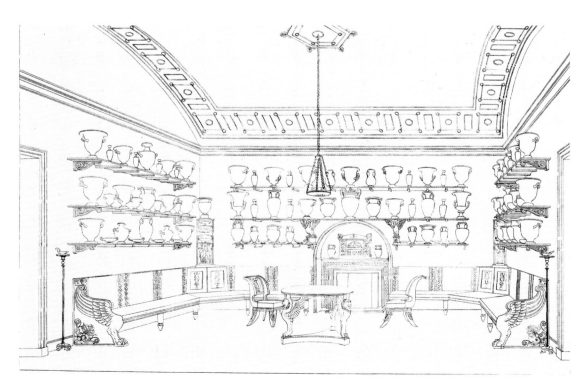

Fig. 2-14. Thomas Hope. Third Vase Room. *Household Furniture* (1807): pl. V.

Ante-Room

The second half of the tour of Duchess Street began when the visitor, having ascended the main staircase, turned to the left at the top instead of continuing straight ahead through the Drawing Room. The left turn took him into the Ante-Room, which was the introduction to the sequence of five first-floor rooms that opened into each other along the garden front. Hope did not describe the interior decoration of this room, suggesting that it remained in its Adam form, but we know from Douce and Westmacott that, despite its comparatively small size, it was crowded with antique marbles and modern paintings and sculpture. In the center was placed a striking object, a colossal porphyry foot, three times life size. Bought by Hope at considerable expense at the Bessborough sale in 1801, it was possibly a votive object (cat. no. 46). Near it Hope placed a porphyry head of Nero with gilt-bronze drapery added by Luigi Valadier in the late eighteenth century (see fig. 7-16).[67] There were also copies by John Flaxman, Pietro Pisani, and John de Vaere, of celebrated antique statues, as well as the two great Grecian canvases commissioned by Hope from Richard Westall in 1804: *Paris and Helen* and *The Expiation of Orestes* (cat. no. 63).

Egyptian Room

There was a powerful contrast as the visitor passed from the classically inspired Ante-Room to the adjacent Egyptian Room, an exotic interior that Hope said was designed to house his collection of Egyptian antiquities (fig. 2-15). It probably owes something to sources in Rome, such as the display of Egyptian antiquities at the Villa Albani and Piranesi's Egyptian Room in the Caffè Inglese, illustrated in his *Diverse Maniere* (fig. 2-16). Hope had been familiar from boyhood with the work of Piranesi, his father having bought a chimneypiece by him for their house in Amsterdam. He explained of the Egyptian Room that its furniture and ornaments were of "that pale yellow and that blueish green which hold so conspicuous a rank among the Egyptian pigments; here and there relieved by masses of black and of gold."[68] To achieve these effects he used an authentic bluish-green pigment, probably the so-called Egyptian frit,[69] which had become obsolete by 1800 but whose manufacture was described by Vitruvius and mentioned by Pliny.[70] Attaching great importance to color in interiors, Hope chose these hues because the richly polychromatic objects in the room were "wrought in variously coloured materials, such as granite, serpentine, porphyry, and basalt, of which neither the hue nor the workmanship would have well accorded with those of my Greek statues, chiefly executed in white marble alone."

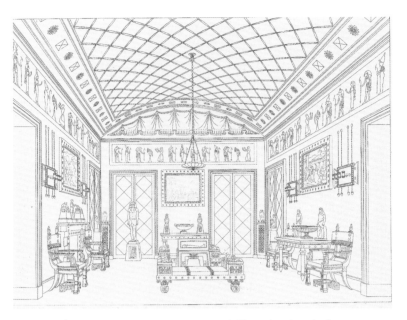

Fig. 2-15. Thomas Hope. Egyptian Room. *Household Furniture* (1807): pl. VIII.

Determined to create interiors of appropriate character, he "thought it best to segregate these former [Egyptian antiquities], and to place them in a separate room, of which the decoration should, in its character, bear some analogy to that of its contents."[71] Thus, the walls of the Egyptian Room were adorned with a large frieze of figures, disposed here like a classical frieze as at the Parthenon. Although Hope claimed that he had based this on "Egyptian scrolls of papyrus," he probably took as his model simi-

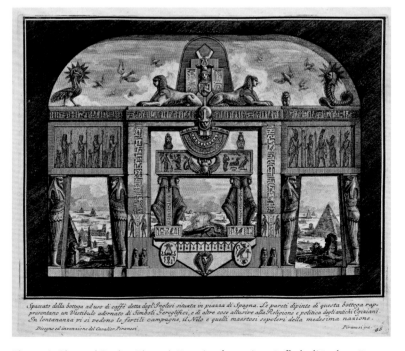

Fig. 2-16. Giovanni Battista Piranesi. Egyptian decoration, Caffè degli Inglese, Rome. From *Diverse Maniere d'Adornare i Cammini* (1769): pl. 46. Avery Architectural and Fine Arts Library, Columbia University, New York.

lar figures in the Mensa Isiaca, the ancient Roman neo-Egyptian work with bogus hieroglyphs. Discovered and published in the sixteenth century, details of it were later illustrated in Bernard de Montfaucon's *Antiquité expliquée* (1719–24).[72]

The lunettes at the two ends of the ceiling were painted with the kind of formalized, simulated drapery found in a Roman columbarium that Hope illustrated in his *Costume of the Ancients* of 1809 (fig. 2-17). Such decoration, which appeared on Greek vases and in Roman wall paintings, became popular in French Empire interiors for its supposed association with martial tents. It was also an influence on wall decoration in England following the promotion for curtain design of what George Smith called "Roman drapery" in his *Collection of Designs for Household Furniture* (1808).[73] The segmental ceiling was painted in a criss-cross pattern to resemble quilting, probably echoing sarcophagus decoration, with a rather similar treatment given to the double doors, two sets on three sides of the room, some of them false. Visitors must have felt as though they were shut inside a cushioned work basket. Another break from convention was the lack of a dado, which was probably also absent in the Indian Drawing Room. This absence anticipated the same feature in Soane's Breakfast Room of 1802 at Pitzhanger Manor and in Henry Holland's anteroom to the Blue Velvet Suite at Carlton House, probably of 1811.[74]

One of the most commanding objects in the Egyptian Room was the alabaster figure of a pharaoh (cat. no. 48) placed on a specially designed stand in front of the pair of false doors on the back or north wall of the room. We cannot know whether Hope regarded it as Ptolemaic, First Empire, or eighteenth century, but it has recently been identified as Romano-Egyptian work of the first century A.D. The table near it on the north wall was a symphony in black: on it stood a pair of modern canopic jars of black marble inspired by those at the Vatican.

In front of this table was a painted Egyptian wooden child's mummy case of the type that, according to Herodotus, was exhibited at banquets. Percier and Fontaine illustrated a number of Egyptianizing pieces they designed in their *Recueil de décorations intérieures* (1801–12), and Percier is believed to have designed mummy cases. Hope housed his mummy in a glass case standing on a large block in the shape of a pylon with sloping sides and open at the center like a gateway. Two seated priests wearing animal masks guarded the entrance to this gateway over which hovered a winged Isis, emblematic of the immortality of the soul. Within this shrine, on the floor, stood an antique cinerary urn of Egyptian alabaster.

The chimneypiece in the Egyptian Room, carved in black marble, was inspired by a sepulchral chamber hewn from the rock on the coast of ancient Lycia in southern Turkey, near the site of the city of Antiphellos, mentioned in Strabo. Described by Douce as

"representing a timber frame, decorated with appropriate subjects in bronze of modern work," it was a demonstration in marble of the origins of the Doric form in timber construction. Hope described it as "a façade or screen of rude and massy timber-work, in which may be discerned the upright posts, the transverse beams, the rafters, the wedges, and the bolts."[75] This springs from the theories about the origins of Greek architecture proposed by Enlightenment thinkers with whose work Hope must have been familiar, notably Quatremère de Quincy's *De l'architecture égyptienne considérée dans son origine, ses principes et son goût, et comparée sous les mêmes rapports à l'architecture grec* (1803).

The two couches and four armchairs in the Egyptian Room, which were painted in black and gilded with bronze mounts, survive today in all their bright archaic splendor as one of the prime monuments of Hope's imaginative genius[76] (cat. nos. 76, 77). In analyzing their design, we should note that Hope acknowledged Baron Vivant Denon's *Voyage dans la Basse et le Haute Egypte* (1802) as a source. Hope's country house, the Deepdene (see Chapter 12), also contained an Egyptian Room, which included a remarkable suit of Egyptianizing furniture designed by Denon himself. The "Egyptian" furniture by Hope and Denon was not an archaeological reproduction but the outcome of a synthetic process of design that incorporated echoes from a range of objects. Thus,

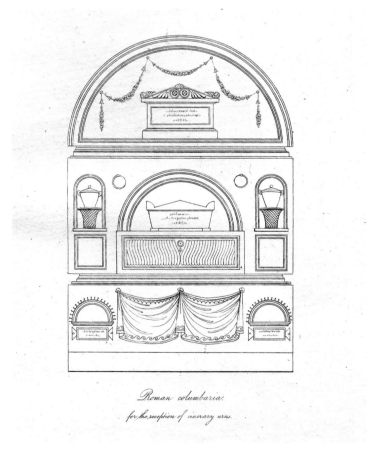

Fig. 2-17. Thomas Hope. Roman Columbaria. *Costume of the Ancients*, vol. 2 (1812): pl. 299.

Hope pointed to a wide variety of sources for the chairs: "an Egyptian idol in the Vatican . . . an Egyptian mummy-case in the Institute [today Museo Civico] at Bologna . . . [small canopic vases] imitated from the one in the Capitol; and the other ornaments are taken from various monuments at Thebes, Tentyris, &c."[77]

On the table on the right, or west, side of the room were two antique black marble or basalt statues of Antinous, the lover of Hadrian, in Egyptian dress, indicating Hope's awareness of the neo-Egyptian aspects of the Roman Empire, especially under Hadrian. Above these hung Gauffier's painting of *Achilles Recognized by Ulysses,* and over the chimney opposite hung his *Rest on the Flight into Egypt* (cat. no. 60). With its depiction of pylons adorned with hieroglyphs from Heliopolis and Luxor, possibly based on the obelisk in front of the Pantheon in Rome, the latter painting was singularly appropriate for the Egyptian Room.

For Hope, Egyptian art was admirable for its "immensity" and "indestructibility," so he echoed its use of permanent and monumental materials, granite and serpentine, porphyry and basalt, marble and bronze. By contrast, he condemned "modern imitations of those wonders of [Egyptian] antiquity, composed of lath and of plaster, or callico and of paper, [which] offer no one attribute of solidity or grandeur to compensate for their want of elegance and grace, and can only excite ridicule and contempt."[78]

Indian Room

Next to the Egyptian Room was the Drawing Room or Blue Room, generally known as the Indian Room (fig. 2-18), although Hope does not use that name for it. However, he describes it as decorated in "the Saracenic" and "the Moorish style." His account of its exotic colors and even aromas shows him as a key creator of the Regency style at its most exotic, echoing the dreams of William Beckford and anticipating John Nash's orientalizing interiors of 1815–23 for the Prince Regent in the Royal Pavilion at Brighton. Hope explains of this startling room:

Its ceiling, imitated from those prevailing in Turkish palaces, consists of a canopy of trellice-work, or reeds, tied together with ribbons. The border and the compartments of this ceiling display foliage, flowers, peacock's feathers, and other ornaments a rich hue, and of a delicate texture, which, from the lightness of their weight, seem peculiarly adapted for this lofty and suspended situation. Persian carpets cover the floor.

As the colours of this room, in compliance with the oriental taste, are everywhere very vivid, and very strongly contrasted, due attention has been paid to their gradually lightening, as the eye rose from the skirting to the cornice. The tint of the sofa is deep crimson; that of the walls sky blue; and that of the ceiling pale yellow, intermixed with azure and with sea green. Ornaments of gold, in various shades, relieve and harmonize these colours.

Round the room are placed incense urns, cassolettes, flower baskets, and other vehicles of natural and artificial perfumes.[79]

This light, south-facing room was evidently indebted to the strong coloring—blues, greens, and yellows—of Islamic tiles in private houses and mosques that Hope had studied during his stay in Turkey. Affording a similarly exotic experience, involving scent as well as color, the Indian Room was claimed by Douce as copied "from one in the summer Seraglio at Constantinople." However, it seems to have been equally inspired by an interior in the house in Constantinople of the Greek Mavroyeni, of which Hope wrote in *Anastasius* that it "contained rooms furnished in all the splendour of Eastern magnificence. Persian carpets covered the floors, Genoa velvets clothed the walls, and gilt trellice-work overcast the lofty ceilings. Clouds of rich perfumes rose on all sides from silver censers."[80] In his account of Hope's Indian Room, Westmacott mentioned that "the curtains, ottomans, &c., are all of rich damask silk."

Hope commissioned three large Indian pictures for this room from Thomas Daniell in 1799/1800, *The Taj Mahal* and *The Masjd Mosque, Durayahanj, Delhi;* and *The Manikarnika Ghat, Benares* (cat. nos. 58, 59). To suggest the links between Eastern and Western cultures, these impressive topographical views were framed identically within heavy borders of fasces so as to match a fourth painting by Giovanni Paolo Panini of the Forum in Rome.[81] Here was the union of painting, sculpture, and architecture that John Britton admired at the Soane Museum. The room was given further visual coherence by the "low sofa, after the eastern fashion," running around three walls and replacing a dado. This was a form also favored by Percier and Fontaine in furnishing contemporary Parisian rooms. Hope also designed the

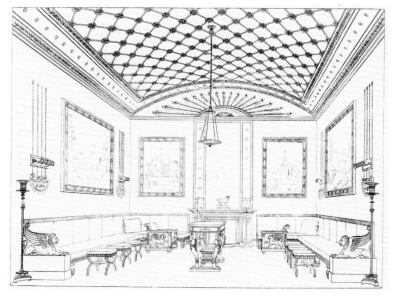

Fig. 2-18. Thomas Hope. Indian Room. *Household Furniture* (1807): pl. VI.

set of bizarre pendant wall-lights in the Indian Room, which was painted in black and gold with Greco-Egyptian ornaments and incorporated shields of the Greek *pelta* form, as well as the fire screens, in the same room, formed by shields supported on javelins. In view of these unexpectedly militaristic touches, this room may have been the home of the ambitious window cornice incorporating classical helmets flanking a circular shield, which Hope illustrated with the caption "Trophy of Grecian armour; applicable to the cornice of a window curtain"[82] (cat. no. 98). This seems related to Hope's illustration of a massive folding door, "in mahogany, studded with gilt nails," the decorative panels of which included representations of a helmet and a shield.[83]

Aurora Room

Adjacent to the Indian Room to the west was a room variously known as the Aurora, Flaxman, or Star Room (fig. 2-19; see Chapter 8). Conceived as a setting for the sculptural group of *Aurora Abducting Cephalus* (cat. no. 55), which Hope had purchased from Flaxman in Rome in the early 1790s, the elaborately iconographical decoration of this room and its furnishings was "rendered . . . analogous to these personages, and to the face of nature at the moment when . . . the goddess of the morn, is supposed to announce approaching day."[84] This recorded a scene in the *Metamorphoses* in which Ovid described "saffron-robed Aurora, dispelling the darkness with her morning light." To evoke this sensation, the walls were covered with mirrors edged with black velvet over which were draped curtains of black and orange satin, the latter echoing Aurora's saffron robes. The curtains were parted mysteriously in three places to reveal the Flaxman group and its reflection in the mirrored side walls, so that in the engraving of the room, the eye is pleasingly confounded into supposing for a moment that the room contains not one but three pieces of sculpture. In romantic purple prose, Hope shows how the combined tints of draperies, ceiling, and accessories suggest "the fiery hue which fringes the clouds just before sunrise . . . [while] in a ceiling of cooler sky blue are sown, amidst a few unextinguished luminaries of the night, the roses which the harbinger of day . . . spreads on every side around her." Flaxman's group was flanked by two exotic candelabra composed of a lotus flower issuing from a bunch of ostrich feathers, a form based on an Egyptian motif shown in Norden's *Travels in Egypt and Nubia* (1757), cited as a source in *Household Furniture*.[85]

The Aurora Room is probably the interior in which Hope came closest to Percier and Fontaine and to the use of mirrors, combined with the handling of light and color to create appropriate sensations, as recommended by Le Camus de Mézières. An expert in the use of mirrors in domestic interiors, Le Camus

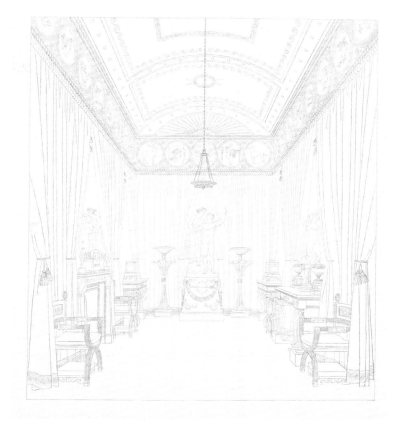

Fig. 2-19. Thomas Hope. Aurora Room. *Household Furniture* (1807): pl. VII.

explained how a marble table combined with a mirror extending to the floor created an "effect [that] is somewhat like a detached altar, adorned with candelabra; one might imagine it consecrated to the Goddess of gardens, to judge by the flowers and the opulence of the vases that contain them."[86] His advice that "When a glass appears on the one side, there must be a glass on the other, of the same dimensions and in a frame of the same shape"[87] was adopted by Hope in his Aurora Room. As well as using mirrors, Hope and Soane also gave full expression to Le Camus's recommendation that we should "reunite Architecture, Painting, and Sculpture" on the grounds that "who can resist this threefold magic, which addresses almost all the affections and sensations known to us?"[88]

Hope's familiarity with the writings of d'Hancarville on the religious systems of the ancients and the decoding of the symbolical language of antiquity is suggested in the Aurora Room. Here the pedestal that supported Flaxman's sculpture was adorned with torches, garlands, and wreaths, emblematic of Cephalus and his mistress. These were disposed around a diadem of stars bisected by the fatal dart that Aurora gave her lover. On either side appeared the sinister head of Jupiter, Serapis, or Pluto, representing death. Opposite the chimneypiece stood a large table (cat. no. 68) whose four legs were composed of pairs of the Horae, the four

goddesses of the seasons. In the frieze above their heads were four medallions representing the deities of night and sleep.

On the table stood an Egyptian clock (cat. no. 71), made in Paris, which features a black bronze figure of the horned Isis, symbolic of the moon, between two hieroglyphic marble blocks with finely worked gilt-bronze panels. The apis heads and tablets surmounting these blocks are derived from Piranesi's plate of a "Camino egizio sormontato da due grandi obelischij" in his *Diverse Maniere d'Adornare i Cammini*, where the top tablet is based on the Mensa Isiaca, the ancient Roman neo-Egyptian work that we have already noted.

The chimneypiece in the Aurora Room was of black marble ornamented with bands of nine stars of gilt bronze, and a pair of owls, appropriately nocturnal, supported the shelf. Around the top of the room was a broad frieze depicting the heads of Aurora and Cephalus and the animals, instruments, and emblems of the chase, the favorite sport of Cephalus. "Round the bottom of the room," observed Hope, "still reign the emblems of night."

Balancing each other on either side of Flaxman's sculpture were strange rarities preserved in glass showcases rather like the relics of saints in a Catholic church. One case contained a male arm, believed to be a Lapith from one of the Parthenon metopes by Phidias. Douce noted that it was about a foot long, with the hand grasping a weapon, and that Hope gave a Turk four guineas for it, "at the peril of the latter's life." Hope unexpectedly displayed the arm as a counterpart to a stalactite from the grotto on the Greek island of Antiparos in the balancing showcase, a juxtaposition showing the characteristic Enlightenment belief in the origin of Greek design in nature. This parallel between art and nature was echoed by Soane in the dining room window at the Soane Museum, about which he explained that "the lovers of Grecian art will be gratified by comparing the outline of this work ["a frieze of Grecian sculpture"] with the two natural productions on the sides of the window, found growing in the hollow of an old oak pollard."[89]

Lararium

The last of the five rooms along the south front of the house that Hope chose to illustrate was described by him as a "Closet or boudoir fitted up for the reception of a few Egyptian, Hindoo, and Chinese idols and curiosities" (fig. 2-20).[90] He showed only one end of this curious space, nine feet high by eight feet wide, which, with its combination of mirrors and drapery, had something in common with Parisian boudoirs of the 1790s. Its sides were formed from "pillars" supporting a ceiling of bamboo lathes hung with "cotton drapery, in the form of a tent," probably reflecting Quatremère de Quincy's opinion that the tent, along

with the cavern and the hut, was one of the three principal types of primitive architecture.

Hope called it a Lararium, or room of the household gods, because it was a "tabernacle" housing objects that represented the different religions of the world and doubtless owed something to the belief in the common origins of religious symbolism that informed the writings of d'Hancarville. Thus, not only the pagan religions were represented but Eastern religions and Christianity as well. The plate shows a pair of statues based on the celebrated many-breasted Diana of Ephesus, but we know from Westmacott that there was also, not shown in Hope's view, an ivory crucifix (cat. no. 99) that had belonged to his father, on which the body of Christ was nearly two feet long.

Hope explained that "one end of this tabernacle is open" to a chimneypiece "in the shape of an Egyptian portico," which was dramatically "placed against a back ground of looking-glass,"[91] so that it anticipated Soane's use of mirrors in the Soane Museum, as well as Percier and Fontaine's chimneypiece against a wall of mirrors designed for a prince in Poland.[92] The jambs of the Lararium chimneypiece were in the form of Egyptian pylons adorned with gilt-bronze reliefs of male and female figures inspired by the *Mensa Isiaca*. The winged Isis above them and the

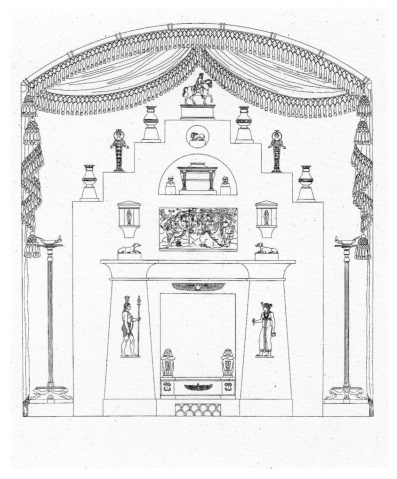

Fig. 2-20. Thomas Hope. Lararium. *Household Furniture* (1807): pl. X.

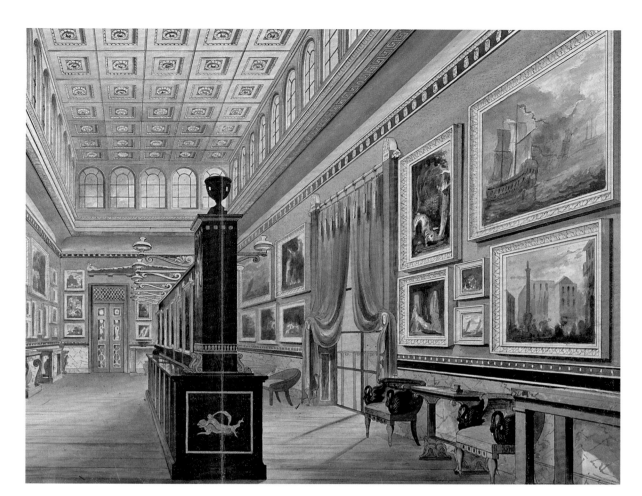

Fig. 2-21. Robert William Billings. *The Flemish Picture Gallery, the Mansion of Thomas Hope, Duchess Street, Portland Place* (detail). Watercolor, before 1851. The Metropolitan Museum of Art, New York, The Elisha Whittelsey Collection, The Elisha Whittelsey Fund, 1963, 63.617.2. *Cat. no. 108.*

canopic jars on the fireguard below them were echoed on the mummy case and on the armchairs in the Egyptian Room. The Lararium chimneypiece was set against a tall, stepped superstructure, faintly echoing the similar configurations in the Egyptian chimneypieces in Piranesi's *Diverse Maniere d'Adornare i Cammini* (1769), which was included in the bibliography to *Household Furniture*, but it had a more authentic flavor than the fanciful designs of Giovanni Battista Piranesi.

Over the chimneypiece was a relief probably of *rosso antico* marble depicting Bacchus and Ariadne beneath a grapevine. This was unexpectedly flanked by two small Egyptian *oushbetis* in blue enamel, housed in little tabernacles, while in a semicircular niche above these were small bronze busts of Dante and Napoléon as improbable neighbors. The whole composition was surmounted by an early seventeenth-century Italian bronze after the famous equestrian statue of Marcus Aurelius in Rome, which, since it had belonged to Hope's father, added a personal note to the character of a room devoted to "household gods." Indeed, the whole room could he seen as a family shrine, for not only had Hope inherited the important collection of works of art assembled by his father (see Chapters 9 and 10), but the Hopes were also a family who were close-knit at every generation.

Flemish Picture Gallery

In the autumn of 1819, Hope made the first significant addition to the Duchess Street house since he had opened it to the public fifteen years earlier. This was a large new gallery (fig. 2-21) to house the John Hope collection of about one hundred superb Dutch and Flemish paintings that had been inherited by his brother, Henry Philip, from their father in 1784[93] (see Chapter 10). Carried out from Hope's designs by William Atkinson, who was then supervising the alterations at the Deepdene, this was an imposing two-storied gallery, forty-two feet long by nineteen feet wide, with a coffered ceiling above lantern lights. We know its appearance from a watercolor by R.W. Billings (cat. no. 107), which is related to one of the two plates of the room in *Illustrations of the Public Buildings of London* (1825).[94] Its precise position is unclear, but it was top-lit through a high clerestory, twenty-five feet above floor-level, with a single window in the center of one side.[95] On a visit to the house in February 1827, Prince Pückler-Muskau observed that "on a sort of terrace on part of the house are hanging gardens; and though the shrubs have only three feet of earth, they grow very luxuriantly."[96] Perhaps this feature, recalling designs by Schinkel, may have been related to the roof of the new Flemish Picture Gallery.

There had been no public galleries in Britain in the eighteenth century, so Hope was in the vanguard of change in creating interiors such as his first Picture Gallery at Duchess Street of 1799–1802 and now his Flemish Picture Gallery of 1819. Since both were top-lit, Hope also anticipated the debates about this and related forms of lighting, which did not become common until the 1820s and 1830s.[97] In Hope's Flemish Picture Gallery, the continuous clerestory of tall round-headed windows, eleven along each side and five at each end, provided the principal source of natural light in a spectacular fashion.

However, additional artificial light came from an unusual source, a dozen colza-oil lamps on elaborate gilt-bronze brackets that extended outward from a great mahogany screen with gilt-bronze mounts. Running down the center of the room, the screen was hung with ten pictures on each side at eye level. The device of a screen was shortly taken up by Schinkel in the Altes Museum in Berlin and by Leo von Klenze at the Hermitage in Saint Petersburg. Hope's paintings could, moreover, be swung on hinges for the greater ease of the connoisseur, a device that had been introduced by 1804 by Sir Francis Bourgeois and Noel Desenfans to display the collection they had assembled.[98] John Soane, in his house and museum in Lincoln's Inn Fields, echoed this technique in 1824 in the "moveable planes" of his Picture Room, where he hung a portrait of his friend Bourgeois by Sir William Beechey.[99] The lamps on Hope's screen illuminated the paintings, as well as the folios of engravings and books on the fine arts in the compartments below. Along the top of this art historian's paradise were arranged bronze figures and classical vases.

The panels of the two mahogany entrance doors, one of them false, at the north end of the room, were inlaid with classical figures and decorations finely engraved in brass. Around the south end of the room was an ottoman upholstered in a light blue fabric; and below the pictures along the side walls were pier tables, bronze casts of classical sculptures, and chairs, some with the swan arms also featured in designs by Percier and Fontaine.

A visitor to the Flemish Picture Gallery in 1846 wrote ecstatically: "No collection in the world excels it, with the single exception, perhaps, of the Dresden Royal Gallery. That of the Hague is even inferior in perfection to this assembly of wondrous works."[100] The room certainly resembled a public rather than a private interior and thus represented an important step in the development of the public museum, in which Hope's house, like Soane's, played an important part. It continued the path on which Hope had set out in his first Picture Gallery of 1799–1802. Hope tells us that there was a Music Room containing a table with lyre supports and presumably the upright piano that he also illustrated.[101] We know from an account in 1846[102] that there was also a handsome library in the house, although we do not know on which floor it was housed.

Apartments on the Second Floor

We should not forget that Hope and his wife and children did not live in the interiors we have so far seen but in their private apartments on the floor above. A small number of these rooms may have been open on the occasion of great parties; the account of his rout of May 1802 mentions that a thousand visitors saw sixteen rooms, slightly more than there were on the first floor. No description of them survives, nor any inventory of their contents, but their flavor may perhaps be guessed from hints in the engravings in Henry Moses's *Designs of Modern Costume* (1802), which include the ambitious cradle, described by Hope as of "mahogany, ornamented in gilt bronze, with emblems of night, of sleep, of dreams, and of hope."[103] It was almost identical to one shown in a portrait of Mrs. Hope and her children (see fig. 4-6).[104]

A mahogany table (cat. no. 84), though succulently carved from Hope's designs, lacked gilt-bronze mounts and may have been characteristic of the simpler pieces in private rooms.

Visitors to Duchess Street

John Soane visited Hope at Duchess Street in May 1802, and Hope paid a return call four days later. The following month, Soane made his first designs for the columbaria in his Breakfast Room at Pitzhanger Manor, suggesting that he was influenced by those in Hope's "Room Containing Fictile Vases."[105] Soane was at Duchess Street again in March 1804, after which he wrote to Hope of "the high gratification in viewing again some days since your collections," which he described as a "last[ing] Monument of your public spirit & Classical Taste." He went on to say that, "[I would be] happy on further occasions to avail myself of your kindness and taste."[106] It is significant that Soane should have seen the house as a product of Hope's "public spirit," in other words, that in true Enlightenment fashion it was not a private indulgence but was intended to reform public taste and manufacture. An anonymous critic in 1809 linked Hope's Greek Revival interior at Duchess Street to John Soane's Bank of England, which, he complained, Soane had made "resemble a Mausoleum."[107] It is interesting, therefore, to learn from the diarist Farington that in May 1804 Hope visited the Bank of England "at the request of Soane," but that he "did not approve the Architectural taste of Soane."[108]

George Dance, Soane's master, made his first visit to Duchess Street in March 1804 in a group that included the musician Dr. Charles Burney. They stayed for about two hours, after which Farington recorded that

Dance told me He thought it better than He expected, & that by the singularity of it good might be done as it might contribute to

emancipate the public taste from that rigid adherence to a certain style of architecture & of finishing & unshackle the artists.—But He disapproved Hope's pamphlet against Wyatt thinking it conceited & unwise, & that though Hope had shewed taste in what He had done it did not follow, nor could it be supposed that He was qualified to make a design for any work of consequence.—He sd. however much there might be amusement in seeing the House we had gone through it certainly excited no feelings of comfort as a dwelling.[109]

Unshackled architecture, which he hoped might be promoted by Hope's experiments, was a preoccupation of Dance's. He probably derived the concept from Piranesi, who had urged that the architect "must not content himself with copying faithfully the ancients, but studying their works he ought to shew himself of an inventive, and I had almost said, of a creating Genius; And by prudently combining the Grecian, the Tuscan, and the Egyptian together, he ought to open himself a road to the finding out of new ornaments and new manners."[110] Dance, who followed this advice in some revolutionary designs, was recorded as confirming, in a discussion with Sir George Beaumont in March 1804, that he "derided the prejudice of limiting Designs in Architecture within certain rules, which in fact though held out as laws had never been satisfactorily explained." Dance argued that, as a result, "Architecture unshackled wd. afford to the greatest genius the greatest opportunities of producing the most powerful efforts of the human mind."[111]

Some visitors, however, were disturbed by Hope's eclectic synthesis. Farington recorded on June 29, 1808, that Dance's friend Mr. Mostyn "was at Mr. T. Hope's last Monday & did not like the stile of his House & furniture. He said much of it was in imitation of a *barbarous taste*, not of that which is deemed Classical."[112] Sir George Beaumont at a dinner party in April 1804 declared that "it was more a *Museum* than anything else."[113] In October 1812, Farington stayed with Sir George and Lady Beaumont at Coleorton Hall, Leicestershire, which George Dance had built for Beaumont in 1804–8 in a strange, stripped Gothic style as an essay in his "Architecture unshackled." Farington gives us a revealing glimpse of the extent to which "household furniture and interior decoration," in Hope's phrase, was a central topic of conversation in artistic circles during the Regency. Farington explains that "at breakfast we had conversation abt. taste in choosing furniture. Lady Beaumont sd. that the splendour of the furniture at Carlton House is so great that let the company who go there be ever so finely dressed they are not seen, the eyes of all being drawn off to the gorgeous decorations of the apartments. Sir George said it was not so at Lord Grosvenor's[114] where the furniture has a fine solemn effect, & when the apartments are filled with company the effect is like that of a Venetian picture.—Lord Lonsdale said of Mr. Thos. Hope's house [that it] resembled a museum."[115]

In view of Dance's reaction that Duchess Street "excited no feelings of comfort as a dwelling" and of Beaumont and Lonsdale's complaint that it resembled a museum, it is ironical that when the German art historian Passavant visited Dance's Stratton Park, Hampshire (1803–6) in 1832, he wrote of the hall that it "may not unaptly be compared to the entrance of a museum."[116]

Flaxman, who had been extensively patronized by Hope, was not surprisingly a great admirer of Hope's achievement at Duchess Street. He wrote a review of *Household Furniture*[117] in which he claimed that "it is but justice to Mr. Hope to acknowledge that he is the first in this country who has produced a system of furniture, collected from the beautiful examples of antiquity, whose parts are consistent with each other, and the whole suited to domestic ease and comfort."[118] This last claim must be regarded as special pleading, in view of the comments by Dance, Lonsdale, and Beaumont.

A visitor in 1846 claimed that "a perfect unity of taste is evinced in every article of furniture throughout the series of apartments," pointing out that the house could be "viewed on Monday in every week during the season" and to artists on other days as well.[119] The distinguished German archaeologist Adolf Michaelis wrote perceptively in 1882: "All the rooms and all their contents, down to the humblest utensil or piece of furniture, were made after Hope's own drawings and designs, not uninfluenced by the Pompeiian discoveries, and at the same time in full harmony with the antiquarian tendencies of art in the Napoleonic era . . . the picture galleries derived an air of life from a few marbles." He added: "In this condition Hope's collection remained during many years in London, much visited and admired by strangers."[120]

On Thomas Hope's death in 1831, his house in Duchess Street passed to his eldest son, Henry Thomas Hope (1808–1862), who was also a connoisseur, collector, and author. A founder of the Art Union of London in 1836, he remodeled in Barry's Italianate style his father's country house, the Deepdene, Surrey, in 1836–40 and had a hand in the arrangements of the Great Exhibition of 1851. However, in that year he sold the house in Duchess Street,[121] replacing it as a London residence with a sumptuous new mansion at 116 Piccadilly. Following his father's passion for up-to-date Parisian taste, this ambitious *hôtel particulier* was designed for him by the French architect P.-C. Dusillion, its elaborate carvings made by French craftsmen in Paris.[122] It was in turn demolished in 1936, and so far as we know, no record was made of the Duchess Street mansion at the time of its demolition.

1. Translated as *The Genius of Architecture; or, The analogy of that art with our sensations* (Santa Monica: Getty Center, 1992).

2. Ibid., 88.

3. *Household Furniture* (1807): 14, 15.

4. Ian Bristow, *Architectural Color in British Interiors 1615–1840* (New Haven and London: Yale University Press, 1996): 190, citing Rupprecht Matthaei, *Goethe's Color Theory* (London, 1971): 189–90.

5. Baron Carleton (1771–1842) succeeded his father as 3rd Earl of Shannon in 1807.

6. The leader of the chorus in Greek drama.

7. James Pope-Hennessy, *Monckton Milnes, The Flight of Youth: 1851–1885* (London: Constable, 1949): 111–12.

8. Alexander Beresford Hope, *The English Cathedral of the Nineteenth Century* (London: John Murray, 1861): 63–64.

9. Built from designs by Henry Triquetti (1704–1774) and J.-B. Dubois (1762–1851). See L.H.M. Quant et al., *Paviljoen Welgelegen 1789–1989* (Haarlem, 1989).

10. Giovanni Battista Piranesi, *Diverse maniere d'adornare i cammini* (Rome: Generoso Salomoni, 1769): pl. 2. The chimneypiece is today in the Rijksmuseum, Amsterdam.

11. Arthur T. Bolton, *The Architecture of Robert and James Adam*, vol. 2 (London: Country Life, 1922): 100.

12. John Britton and A.C. Pugin, *Illustrations of the Public Buildings of London*, vol. 1 (London: J. Taylor, 1825): 310.

13. Johann Passavant, *Kunstreise durch England und Belgien*, Frankfurt 1833, the first volume of which appeared in abridged and revised form as *Tour of a German Artist in England*, 2 vols. (1836), repr. with intro. by Colin Bailey (East Ardsley: EP Publishing, 1978): 223–24.

14. Eileen Harris, *The Genius of Robert Adam, His Interiors* (New Haven and London: Yale University Press, 2001): 186.

15. Philip Hewat-Jaboor, "Fonthill House: 'One of the Most Princely Edifices in the Kingdom,'" in Derek Ostergard, ed., *William Beckford, 1760–1844: An Eye for the Magnificent*, exh. cat., Bard Graduate Center, New York (New Haven and London: Yale University Press, 2001): 53, 67.

16. For an account of these drawings and of those by Adam for the house, see David Watkin, "Thomas Hope's House in Duchess Street," *Apollo* (March 2004): 30–39.

17. Susan Pearce and Frank Salmon, "Charles Heathcote Tatham in Italy, 1794–96: Letters, Drawings and Fragments, and Part of an Autobiography," *Walpole Society* 67 (2005): 1–91.

18. *Survey of London*, vol. 30: *Parish of St James Westminster*, pt. 1: *South of Piccadilly* (London: Athlone Press, 1960): 494–95, pl. 233.

19. Charles Molloy Westmacott, *British Galleries of Painting and Sculpture* (London: Sherwood, 1824).

20. Prince Hoare, *Epochs of the Arts: including Hints on the Use and Progress of Painting and Sculpture in Great Britain* (London: John Murray, 1813): 17–18.

21. *The Times*, 10 May 1802, p. 2, no. 5412. I am indebted for this reference to Daniella Ben-Arie.

22. *The Diary of Joseph Farington*, vol. 6 (New Haven and London: Yale University Press, 1979): 2230.

23. Ibid., 2235.

24. Thomas Hope, *Observations on the Plans and Elevations designed by James Wyatt, Architect, for Downing College, Cambridge, in a letter to Francis Annesley, esq., M.P. by Thomas Hope* (London: D. N. Shury, 1804).

25. Farington, *Diary*, vol. 6 (1979): 2281.

26. Ibid., 2322.

27. *Elements of Art: A Poem in 6 Cantos; with Notes and a Preface* (London, 1809): 25. Sir Martin Archer Shee, who succeeded Sir Thomas Lawrence as president of the Royal Academy in 1830, was influential in the foundation of the British Institution in 1805.

28. Westmacott, *British Galleries* (1824): 212.

29. *Household Furniture* (1807): 51.

30. Ibid., 52.

31. David Watkin, *Sir John Soane: Enlightenment Thought and the Royal Academy Lectures* (Cambridge: Cambridge University Press, 1996): 256–71.

32. Brian Cook, *The Townley Marbles* (London: The British Museum, 1985).

33. Brian Cook, "The Townley Marbles in Westminster and Bloomsbury," *Collectors and Collections, British Museum Year Book* 2 (1977): figs. 24, 30.

34. British Museum, *Townley Misc.* fol. 26.

35. John Flaxman, review of *Household Furniture*, fol. 7, Gennadius Library, American School of Classical Studies, Athens.

36. Sir John Soane's Museum, *Adam Drawings*, vol. 24, nos. 280–84.

37. Francis Douce, "Memoranda relating to Mr. Hope's house" (1812), Bodleian Library, Oxford, MS. Douce e. 60.

38. *Household Furniture* (1807): pl. 48.

39. Edward Croft-Murray, ed., "An Account Book of John Flaxman, R.A. (B.M., ADD.MSS.39,784.B.B.)," *Walpole Society* 28 (1940): 68.

40. For a table "adorned with an antique lyre," see *Household Furniture* (1807): pl. xv, no. 2.

41. Ibid., pl. 50.

42. Ibid., pl. 9.

43. Ibid., 21.

44. Geoffrey B. Waywell, *The Lever and Hope Sculptures: Ancient Sculptures in the Lady Lever Art Gallery, Port Sunlight* (Berlin: Gebr. Mann Verlag, 1986).

45. Britton and Pugin, *Illustrations* (1825): 311.

46. The drawing was in the possession of Mr. John Harris, to whom I am indebted for providing a photograph of it.

47. *Household Furniture* (1807): pl. XXIII, "Upright piano-forte. Two genii, contending for a wreath form a group round the key-hole."

48. Ibid., 22.

49. See Chapter 4, note 5.

50. National Gallery of Scotland, Edinburgh. See *Egyptomania: L'Egypte dans l'art occidentale, 1730–1930*, exh. cat., Paris, Musée du Louvre (Paris: Reunion des musées nationaux, 1994): 580–82.

51. Now in the Walters Art Gallery, Baltimore.

52. Now in the Metropolitan Museum of Art, New York. Only a few other examples are known, including one in the Vatican.

53. Now in the Lady Lever Art Gallery, Port Sunlight, Liverpool.

54. Strabo, *Geography XIV*, 1, 13.

55. Karl Friedrich Schinkel to Alois Hirt, 5 February 1823, quoted in Paul Ortwin Rave, *Karl Friedrich Schinkel, Lebenswerk, Berlin*, vol. 1, *Bauten für die Kunst, Kirchen, Denkmalplege* (Berlin: Deutscher Kunstverlag, 1981): 35.

56. *Household Furniture* (1807): 22.

57. Douce, "Memoranda" (1812). See Peter Thornton and David Watkin, "New Light on the Hope Mansion in Duchess Street," *Apollo* (September 1987): 162–77.

58. Soane Museum, Soane Case 170, fol. 238, cited in Watkin, *Soane* (1996): 529.

59. Hope's 1799 sketch for the room (fig. 2-10) did not include the veils included in *Household Furniture* (1807): pl. 2.

60. Westmacott, *British Galleries* (1824): pl. 1, in which Guercino's *Betrayal of Christ* is hanging second from the left in the upper row of paintings.

61. Aubin Louis Millin, *Monuments Antiques, Inédites ou nouvellement expliqués*, vol. 2 (Paris, 1806): 88, n. 7.

62. Britton, *Illustrations* (1825): 310–12; and "Visits to Private Galleries, no. X," *Art-Union* (April 1846): 98.

63. In the Yale Center for British Art, New Haven.

64. *Household Furniture* (1807): 22–23, 49.

65. Ibid., 23.

66. In 1802 Soane echoed Townley in the front and back parlors at Pitzhanger Manor, where he housed cinerary urns in niches echoing the shelving of Roman catacombs; Margaret Richardson and MaryAnne Stevens, eds., *John Soane: Architect of Space and Light*, exh. cat. (London: Royal Academy of Arts, 1999): cat. nos. 61, 62.

67. In the Royal Ontario Museum, Toronto.

68. *Household Furniture* (1807): 26–27.

69. Bristow, *Architectural Color* (1996): 185.

70. Vitruvius, *The Ten Books of Architecture*, VII, xi, "on making the color blue"; Pliny, *Natural History*, XXXIII, vol. 9, 118–19.

71. *Household Furniture* (1807): 26.

72. See the English translation as *Antiquity Explained, and Represented in Sculptures*, vol. 2 (London: J. Tonson and J. Watts, 1721–22): pl. 36.

73. George Smith, *Collection of Designs for Household Furniture* (1808): xii–xiii.

74. Bristow, *Architectural Color* (1996): 212.

75. *Household Furniture* (1807): 43.

76. The furniture is divided equally between the Faringdon Collection Trust, Buscot Park, and the Powerhouse Museum, Sydney.

77. *Household Furniture* (1807): 44.

78. Ibid., 27.

79. Ibid., 24–25.

80. Thomas Hope, *Anastasius*, vol. 1, 2nd ed. (New York, 1820): 111–12.

81. At Yale University, New Haven.

82. *Household Furniture* (1807): 51, pl. 50.

83. Ibid., 43, pl. 45.

84. Ibid., 25.

85. Ibid., 52. The form also appears in Quatremère de Quincy, *Architecture Egyptienne* (1803), while Hope echoed it again in the design of a hanging light in the Theatre of Arts at Deepdene.

86. Le Camus de Mézières, *The Genius of Architecture* (1992): 90.

87. Ibid., 89.

88. Ibid., 70.

89. John Soane, *Description of . . . The Residence of John Soane, Architect* (London: James Moyes, 1830).

90. *Household Furniture* (1807): 28.

91. Ibid.

92. Percier and Fontaine, *Recueil de décorations intérieures* (1812): pl. 31.

93. A. Wertheimer, *The Hope Collection of Pictures of the Dutch and Flemish Schools* (1898).

94. Britton, *Illustrations*, vol. 2 (1825): 310–12.

95. It is described as on the west side of the courtyard and approached from the Statue Gallery in *Art-Union* (April 1846): 97.

96. *Tour of Germany, Holland and England, in the years 1826, 1827, and 1828 . . . in a series of letters by a German Prince*, vol. 3 (London: E. Wilson, 1832): 380.

97. See Michael Compton, "The Architecture of Daylight," in Giles Waterfield, ed., *Palaces of Art: Art Galleries in Britain, 1790–1990* (Dulwich: Dulwich Picture Gallery, 1991): 37–47.

98. Edward Bray noted on 15 January 1804 in the drawing room at 39 Charlotte (now Hallam) Street, London, "that the pictures are moved on hinges and some even draw out into a good light by means of iron supports,—a most excellent plan!" (Anna Eliza Bray, *Traditions, Legends, Superstitions, and Sketches of Devonshire on the Borders of the Tamar and the Tavy illustrative of Its Manners, Customs,*

History, Antiquities, Scenery, and Natural History, vol. 3 [London: John Murray, 1836]: 310). I am indebted for this little-known reference to Jonathan Yarker.

99. Soane would have seen the hinged pictures of Desenfans and Bourgeois at their house in Charlotte Street, to which he added a mausoleum in 1807, later building Dulwich College Gallery (1811–14) to house their collection.

100. *Art-Union* (April 1846): 97.

101. *Household Furniture* (1807): pl. xv, no. 2; pl. xxiii.

102. *Art-Union* (April 1846): 97–98.

103. *Household Furniture* (1807): 42, pl. xliv.

104. In Nottingham City Art Gallery.

105. Bianca De Divitis, "New Drawings for the Interiors of the Breakfast Room and Library at Pitzhanger Manor," *Architectural History* 48 (2005): 164.

106. Soane Museum, private correspondence, I / I / H / 22.

107. *Monthly Review* 58 (1809): 176.

108. Farington, *Diary*, vol. 6 (1979): 2316.

109. Ibid., 2286.

110. Piranesi, *Diverse Maniere* (1769): 33.

111. Farington, *Diary*, vol. 6 (1979): 2276.

112. Ibid., vol. 9 (1982): 3305.

113. Ibid., vol. 6 (1979): 2312.

114. Grosvenor House, Mayfair, remodeled by William Porden for the 2nd Earl Grosvenor in 1806–8.

115. Farington, *Diary*, vol. 12 (1983): 4225–26.

116. Passavant, *Tour* (1836): 277.

117. *Annual Review* 7 (1809): 632. Some unpublished passages survive in a manuscript in the Gennadius Library, American School of Classical Studies, Athens.

118. Gennadius Library, Flaxman review of *Household Furniture*, fol. 4.

119. *Art-Union* (April 1846): 98.

120. Adolf Michaelis, *Ancient Marbles in Great Britain* (Cambridge: University Press, 1882): 107.

121. St. Marylebone Ratebooks, 1851. However, the Flemish Picture Gallery seems to have survived as an attachment to a house built in 1872 in Queen Anne Street, on the garden of Hope's house, for a collector, David Price (see *The Art Journal* 11 [1 November 1872]: 281–83; [November 1891]: 321–28). I am indebted to Daniella Ben-Arie for this information.

122. *The Builder* 7 (1849): 493–94, 498–99, 534. See Chapter 11 for a fuller account of this house.

Fig. 3-1. Title page of *Household Furniture* (1807).

CHAPTER 3

Critic and Historian:
Hope's Writings on Architecture, Furniture, and Interior Decoration

David Watkin

The Downing College Controversy and the Greek Revival

Early in his career as a critic, Thomas Hope played a significant role in the designs of Downing College, Cambridge (fig. 3-2). In 1804 he roundly condemned the designs by James Wyatt in a polemical pamphlet, and by his intervention, which resulted in Wyatt's rejection, Hope helped to promote a flood of Greek Revival buildings that covered Britain starting in 1810, not only churches and country houses but also town halls, law courts, hospitals, and museums. This British passion for Greece, which was promoted in various ways by such figures as Hope, William Wilkins (the ultimate architect of Downing), Lord Byron, and Lord Elgin, had its origins in the 1790s in the circle I have called the Cambridge Hellenists.[1] It was key figures in this group who were responsible for inviting Hope to comment on the designs for Downing College.

After years of litigation, a royal charter for the establishment of a new college at Cambridge was issued on September 22, 1800, followed on July 23, 1805, by detailed statutes for its regulation.[2] These extended the privilege of providing housing beyond the Master and his family to include the professors of law and medicine, who, unlike other Fellows, were free to marry. No other professor in the university was entitled to accommodation for both himself and his family within the college precincts. Downing College thus introduced the notion of resident professors, which was eventually adopted in American universities, although it was not taken up in Britain. Thomas Jefferson created no less than ten lodges for professors when he designed the University of Virginia at Charlottesville in 1817. It has been suggested that, even if Jefferson did not know of Wilkins's designs, he was probably familiar with the Downing statutes.

Early in 1804, Dr. Francis Annesley, the first Master of Downing and a hereditary trustee of the British Museum, applied to Hope for his opinion of the designs for the college submitted by James Wyatt.[3] The idea to seek Hope's advice may have come from Sir Busick Harwood, the Professor of Medicine at Downing, who had been one of Thomas Hope's three sponsors for election to the Society of Antiquaries in 1800, along with Craven Ord, its

vice president, and Thomas Kerrich, the University Librarian at Cambridge and a distinguished antiquarian and collector.

As the opening move in the controversy about the designs for Downing, which became an architectural cause célèbre, Hope published a pamphlet in February 1804 under the title *Observations on the Plans and Elevations designed by James Wyatt, Architect, for Downing College, Cambridge; in a Letter to Francis Annesley, Esq., M.P.* This document proved to be a revolutionary condemnation of modern architecture, which, as a piece of iconoclasm, anticipated Pugin's *Contrasts; or, a Parallel between the Noble Edifices of the Fourteenth and Fifteenth Centuries, and Similar Buildings of the Present Day; Shewing the Present Decay of Taste* (1836) or Le Corbusier's *Vers une architecture* (1923).

With the words "Every thing alike in them is trite, common place, nay, often vulgar,"[4] Hope contemptuously dismissed the designs by Wyatt, a key member of the establishment, a favorite architect of King George III, Surveyor of the Office of Works, and shortly to become president of the Royal Academy. Hope recommended instead a return to pristine cultural purity, which he found completely lacking in Wyatt's lumpish and old-fashioned Roman Doric designs. He wished that, "instead of the degraded architecture of the Romans, the purest style of the Greeks had been exclusively adhibited."[5] This was in conformity with the eighteenth-century rationalist doctrines of Marc-Antoine Laugier, which upheld the primitive wooden hut as the model for modern architects, an expression of the essence of ancient Greek principles of construction. In the spirit of Laugier's austere functionalism, Hope observed: "All pilasters I would proscribe without remission," except in the form of *antae*, or piers, on the grounds that they were decorative, that is, untruthful.

In anthropomorphic language, derived from Johann Joachim Winckelmann's accounts of ancient sculpture, Hope argued that Greek Doric is "a body in its youth and vigor, full of sap and substance; with limbs marked by rare, but striking divisions: the other [Roman Doric], on the contrary, is a body in deep decline, where bones, joints, tendons, cartilages, and muscles, arteries and

veins, destroy at every inch the smoothness of the surface."[6] In the writer of such prose, Wilkins found a powerful advocate. Hope had evidently been in touch with Wilkins before writing his pamphlet, for he noted that "Mr. Wilkins has lately brought home and soon intends to publish designs of a Greek temple, in the cella of which Doric columns rise on distinct bases." Making clear his belief that continental taste was ahead of England, Hope referred to "that admiration which . . . one of the good living architects of the continent any longer withhold from the most chaste of orders," i.e., the Greek Doric, though he added that he would be satisfied were he "at least able to obtain that the Ionic, of a later but still of a Grecian origin, might be preferred to a bastard order." In this Hope was prophetic, because the lack of funds at Downing meant that the Greek Doric element in Wilkins's design, the entrance *propylaea*, was never executed.

Wilkins's designs for his propylaea (fig. 3-2) were inspired by the Brandenburg Gate in Berlin (1789–93) by Carl Gotthard Langhans, the gateway to Prussian neoclassicism as well as to Berlin. However, Langhans imitated the propylaea in Athens only in general disposition, since his details were basically Roman Doric. Wilkins was probably indebted to Hope for his knowledge of the Brandenburg Gate, as Hope referred admiringly in his *Observations* to "a superb town gate I saw at Berlin, imitated from the Propylaea."

As a result of Hope's intervention, it was initially decided to invite George Byfield to submit alternative designs for Downing in 1804. The following year, more designs were submitted voluntarily by Wilkins, Francis Sandys, Lewis Wyatt, and William Porden, whose designs were in an ambitious Gothic style. It has been observed of these proposals: "Porden's design was as much representative of the aesthetic issues of his times as the neo-classical projects submitted by Byfield and Wilkins. All of them saw the past, be it classical or mediaeval, as embodying moral, civic and artistic values lost by the moderns."[7]

The Grecian designs of Wilkins were finally selected in 1806 and partially executed from 1807 to 1820. Revolutionary for Cambridge, the designs consisted of a succession of independent but interrelated blocks that "abandoned the closed mediaeval court of the traditional college with its celibate dons, in favour of a large and open campus-type plan incorporating houses for married professors."[8] As we have noted, these ideas were adopted in American universities but were associated with Cambridge, where the period after the Napoleonic Wars saw the rise of a concern with self-reform.

The role of classical Greece as part of a program for austere reform followed on from Cambridge scholars such as Richard Porson, Regius Professor of Greek, and Gilbert Wakefield. The first Cambridge Hellenists included John Marriott of St John's,

who left for Greece in 1794, and John Tweddell, Fellow of Trinity, who died in Athens. The Napoleonic Wars had by now effectively shut off most of Western Europe, so that English travelers naturally gravitated further east, particularly to Greece, then part of the Ottoman Empire, which was neutral in the wars. The remarkable number of Cambridge Hellenists who traveled to Greece between 1804 and 1812, frequently publishing architectural or topographical studies of the country, included William Wilkins, Charles Kelsall,[9] and George Hamilton Gordon, 4th Earl of Aberdeen, founder of the Athenian Society in 1805, president of the Society of Antiquaries in 1812, and Prime Minister of the United Kingdom from 1852 to 1855. Subscribers to Wilkins's major study, *The Antiquities of Magna Graecia* (1807), included Thomas Hope, Lord Aberdeen, Sir Busick Harwood, and Lord Elgin.

In the most remarkable of Kelsall's many books, *Phantasm of an University* (1814), he showed himself to be part of the world in which Hope had become involved. Kelsall illustrated proposals for a cultural phantasm, a "Nurse of Universal Science," which consisted of six colleges of Civil Polity and Languages, Fine Arts, Agriculture and Manufactures, Natural Philosophy, Moral Philosophy, and Mathematics. Undergraduates would follow their university course by an extended period of world travel. All this was prompted by Kelsall's hostility to the educational program of Cambridge in his day, which led him to advocate "measures to keep pace with the present age, in all the departments of science and art."

Calling for the liberation of Greece from the Turkish yoke in his *Letter from Athens addressed to a friend in England* (1812), Kelsall saw political freedom as bound up with architectural reform. Praising Greek Doric architecture for its permanence and longevity, he was delighted to record what he described as "the rapid progress of the present age to the attainment of true taste in architecture."[10] He was doubtless familiar with Hope's *Observations*, for he pointed as evidence of "true taste" to the Grecian work of Wilkins at Downing, Haileybury, and the Lower Assembly Rooms at Bath.

As always with Hope, reforming austerity was only one part of his message in *Observations* (cat. no. 114). For all his adulation of the strict purity of the Greek Doric, he could not resist criticizing the standard archaeological publications on Greek architecture, because in "the least unfaithful, the least inadequate even, such as Stuart's Athens, Revett's Ionia,[11] no adequate idea can be obtained of that variety of effect produced by particular site, by perspective, a change of aspect, and a change of light."[12] Sir John Soane, in the margin of his own copy of Hope's *Observations*, wrote of this phrase that it was "worthy of the most serious consideration." In order to recapture some of the rich liveliness lacking in the images of Stuart and Revett, Hope recommended that

the porticos at Downing be made as deep as possible to give "to the entire façade more motion, more picturesqueness and more dignity."[13]

These aspects of Greek architecture, which he would not have found acknowledged in the writings of Laugier, Hope emphasized in an article he published in 1808 called "On Grecian and Gothic Architecture," in which he praised Greek architecture precisely for its freedom and variety. Observing how it was more adaptable "to the peculiar exigencies of every object," he referred to the "nicety with which its richness may be proportioned to the peculiar character of every work," suggesting that he had become aware of the developing stress on appropriate character in the writings of theorists such as Quatremère de Quincy. Having established this point, however, Hope proceeded to argue that "nothing less than a total misapprehension of these principles could so often make modern architects apply the vigorous symmetry of the ancient temple . . . to the private habitations [of a modern Englishman, or . . .] give the box of a London citizen that exact correspondence of external forms, to which the villa of a Roman emperor, even of Hadrian himself, did not aspire."[14]

It is an indication of Hope's intellectual rigor that, though he supported the Doric of Greek temples for a public building such as a college, he felt he could not recommend it for a private house. He may even have had in mind Wilkins's Greek Doric designs for Grange Park, Hampshire (ca. 1809), the most complete example of the type in the country.[15]

Hope's strictures on the absurdity and inconvenience of using the Greek temple as the model for a modern English house also followed closely those of Richard Payne Knight in his *Analytical Inquiry into the Principles of Taste* (1805). Sir John Soane, who took seriously Hope's suggestions in *Observations,* also agreed with Payne Knight and Hope about the impropriety of Greek temples as models for modern architecture.[16] As we shall see, Hope was to repeat this criticism of buildings such as Grange Park in his posthumously published *Historical Essay on Architecture* (1835; cat. no. 116).

It is a measure of the force of Hope's criticisms of Wyatt in his *Observations* that as late as December 1804 Wyatt was still very disturbed by them. Farington recorded that Charles Burney "had been in company with Wyatt and had expected to find that He treated the matter of Thomas Hope lightly; but He was surprised to find it otherways & that it seemed to have made a serious impression on His mind."[17] We know that at this time Hope was considering expanding his critical account of Wyatt's work, for Benjamin West told Farington that Hope was "following Wyatt up, having examined many of his works & is preparing a critical examination of them."[18]

Nonetheless, the immediate future lay with the Greek Revival as promoted by Hope at Downing College, for good or ill: characteristic buildings were to be Grange Park, Hampshire (1809), by William Wilkins; Covent Garden Theatre (1808–9) and the British Museum (1823–46), London, by Sir Robert Smirke; Wellington Assembly Rooms, Liverpool (1815–16), by Edmund Aikin; and St. Pancras New Church, London (1819–22), by William Inwood and his son Henry William Inwood, who dedicated to Hope plates of Greek remains in Attica, Megara, and Epirus.[19] Inwood was also proud to note that Payne Knight had told him Hope "had been pleased to express much approbation" of St. Pancras New Church, "lately completed on the model of the temple of the Erechtheus."[20]

Meanwhile, Edmund Aikin, who had been employed with George Dawe to execute the engravings for Hope's *Household Furniture* (1807), published *An Essay on the Doric Order of Architecture, containing . . . a critical investigation of its principles of composition and adaptation to modern use* (1810). Echoing the program and language of his master, Hope, Aikin expressed "a confident hope, that the genuine Doric Order, the precious legacy bequeathed by the first-born and most favoured sons of Taste . . . may finally triumph over the degraded substitute [Roman Doric] compiled by the moderns." He went on to claim: "Already, by one grand example the inhabitants of the metropolis are enabled to appreciate the effect of this antique Order, and soon may we see it appropriated to all public works of a severe and dignified character."[21] It is conceivable that this praise of a recent Greek Doric work in London may have been an oblique reference to the Picture Gallery at Duchess Street, but Aikin's own Wellington Assembly Rooms at Liverpool Street was a building far more inventive and powerful than most Greek Revival buildings of their date.

Household Furniture and Interior Decoration

Hope's illustrated monograph on his Duchess Street mansion and its contents, *Household Furniture and Interior Decoration executed from Designs by Thomas Hope* (1807), was one of the most remarkable publications of its kind (fig. 3-1; cat. no. 113).[22] John Soane's *Plans, Elevations, and Perspective Views of Pitzhanger Manor-House* (1802) may have been the first monograph written by an architect on his own house, but like most of his other books, it was not published but privately printed by himself for distribution to friends. Hope's book, by contrast, was brought out by Longman, a leading commercial publisher, and was intended to influence public taste. A folio volume with sixty plates, it was accompanied by a full descriptive text and bibliography and preceded by a long introduction of about 5,000 words. Here Hope explained the novelty of his achievement in striking out what he

Fig. 3-2. William Wilkins. Greek Doric Porter's Lodge, Downing College, Cambridge. Engraving, 1806.

heralded as "a new line of industry and taste." His aim, fully in harmony with Enlightenment beliefs, was to urge a return firstly to the "productions of Nature herself . . . and in the second place, [to] those monuments of antiquity which show the mode in which the forms of nature may be most happily adapted to the various exigencies of art."[23]

The introduction is followed by ten plates depicting the principal interiors on the first floor of Hope's mansion on Duchess Street and then by fifty more plates of individual objects, usually with several grouped on a single plate. In this unique program, all the objects are numbered in order to relate easily to the lengthy captions, which often explain in which rooms they were to be found. As an act of self-advertisement, the book continued the onslaught Hope had made on the public by opening Duchess Street to members of the Royal Academy by special ticket in 1804. A rare precedent was provided by Horace Walpole, who had opened his house, Strawberry Hill, Middlesex, to the public in 1763, published an inventory in the form of a guidebook in 1760, and even printed tickets of admission in 1774.

The appearance and title of Hope's book, as well as his designs, were influenced by Napoléon's architects, Charles Percier and Pierre-François Fontaine, the latter of whom was in London in 1793–94. Referring to Percier as "an artist of my acquaintance" in the introduction to *Household Furniture*, Hope wrote a lengthy eulogy of him, based on personal knowledge. He included an account of how, having "devoted the first portion of his career to the study of the antique chef-d'oeuvres in Italy, [Percier] now devotes the latter portion of his life to the superintendence of modern objects of elegance and decoration in France . . . the most beautiful articles of furniture, of cabinet-work, and of plate."[24] In explaining that his model in producing his own book was that by Percier "which at present appears at Paris on a

similar subject,"[25] Hope referred obliquely to the *Recueil de décorations intérieures* by Percier and Fontaine (cat. no. 118), a title incorporating what was probably the first use of the phrase "interior decoration," which Hope also adopted for his own book (fig. 3-3).

Hope's self-confessed debt to Percier must be seen of considerable importance, but the extent of stylistic influence remains a matter for debate, especially in the absence of any known documentation of their personal relationship. It should be noted that Hope cited as a source twelve "vignettes by Percier; some of which offer exquisite representations of the mode in which the ancient Romans used to decorate their town and country houses."[26]

Hope explained that, to encourage imitators, all the objects illustrated in *Household Furniture* had been made and were not merely projects, and they were also depicted in outline engravings to "facilitate the imitation of objects."[27] For the same reason, he included measurements of many of the objects, as Percier and Fontaine had done in their *Recueil*, which was also illustrated with outline engravings. This neoclassical technique had been pioneered by John Flaxman in the illustrations of Dante that Hope had commissioned in Rome in 1793. Hope praised the artists responsible for the engravings in *Household Furniture*: Edmund Aikin, a Greek Revival architect, and George Dawe, later Court Painter to Alexander I of Russia.

The bold sans-serif lettering of the title page was a daring novelty in 1807, having been introduced about 1790 for its austere and "primitivist" character on architectural drawings by Georg Dance and John Soane and on sculpture by John Flaxman and Thomas Banks.[28] The sans-serif revival was at this time exclusive to England, where it became known in the early nineteenth century as "Egyptian," in spite of its ancient Roman origin. The typeface of the text of *Household Furniture* was, surprisingly, characterized by use of the old-fashioned long "s," which was beginning to be distinctly rare by 1807 but happened to be a favorite of the printer of the book, Thomas Bensley.[29]

The title page (fig. 3-1) is framed by an unusual decorative border, which Hope describes as "copied from the frame of a picture, representing a Turkish personage."[30] The outer section includes crescent moons within stars, part of late Ottoman visual culture from the mid-eighteenth century, but with classical palmette motifs in the corners. The inner border has a different origin, which did not "owe its invention to the Grecian architects of the lower empire,"[31] as Hope suggests, but was part of the three-dimensional decoration of Islamic architecture in Iran and the Arab world by the twelfth century.[32] This used to be called "stalactite molding" but is now referred to as "mugarnas." Hope's framing device, incorporating these two disparate "Turkish" motifs, is probably a European invention for the Turkish

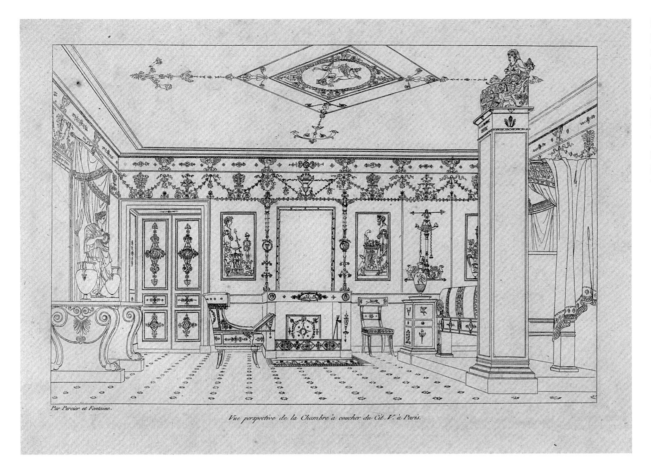

Fig. 3-3. Charles Percier and Pierre-François Leonard Fontaine. "Vue perspective de la Chambre à coucher du Cit. V. à Paris." Engraving from *Recueil de décorations intérieures* (1812): pl. 13. Art and Architecture Collection, Miriam and Ira D. Wallach Division of Art, Prints and Photographs. The New York Public Library, Astor, Lenox and Tilden Foundations.

market in Europe, perhaps for a portrait of a diplomatic representative of Turkey, Hope's "Turkish personage." Hope had drawn stalactite moldings while he was in Constantinople, and that may have inspired Edmund Aikin to recommend the merits of Islamic architecture to modern designers, in preference to the Gothic Revival, in a book he dedicated to Hope, *Designs for Villas* (1808).

Another unusual aspect of *Household Furniture* was the inclusion of a bibliography, absent from Percier and Fontaine's work. Hope's annotated list of the work of more than thirty-five English, French, and Italian authors—mainly archaeologists, architects, and artists—fills more than two pages. It is a useful scholarly tool, as well as being of practical assistance to designers. Not the least striking aspect of the book, characteristic of articles in the *Encyclopédie*, was Hope's ambition to encourage previously unappreciated craftsmen, including "the race of draughtsmen and of modellers, that of carvers in wood and stone, and of casters in metal and composition,"[33] whom he intended to promote. Like William Morris after him, he had been unable to find anything of quality in the shops and thus adopted a policy of not only "giving new food to the industry of the poor, but new decorum to the expenditure of the rich,"[34] by training a new generation of craftsmen. No longer dominated by the machine, these were to adopt "a nobler species of labour" in order to achieve "the totally new style of decoration here described."[35]

An Historical Essay on Architecture

During C. R. Cockerell's three-day stay with Thomas Hope at the Deepdene in August 1823, the two men discussed topics ranging from Pompeian villas and ghost stories to John Flaxman's illustrations of the *Iliad*. However, in one brief note of their discussion, Cockerell recorded that they also "talked of Churches, of Early Xtians founded on Tombs of Martyrs, altar, or communion table being the Tomb."[36] It is Hope's pioneering interest in Early Christian and Italian Romanesque architecture that helps explain the curious balance of subject matter in his two-volume posthumous work, *An Historical Essay on Architecture by the late Thomas Hope, illustrated by drawings made by him in Italy and Germany* (1835). Half the text of the book and most of its ninety-seven illustrations are devoted to Romanesque, which Hope calls Lombard, and a small number are devoted to Gothic, which he calls Pointed. He seems to have written the book in the 1820s, at about the same time as his *Essay on the Origins and Prospects of Man* (1831; cat. no. 115), but he never completed it. However, an important key to the development of Hope's changing attitude to architectural history is a small sketchbook that he made in Italy.[37] Though undated, it is probably from about 1812 and seems to be the record of a single journey from Rome to Florence, Siena, Parma, Modena, and Piacenza, with a few drawings made on the way home in Dijon, Auxerre, and Paris.

Fig. 3-4. Thomas Hope. Sketches of details of S. Maria in Cosmedin and S. Antonio Abate, Rome. From his sketchbook of a tour in Italy, ca. 1812. Royal Institute of British Architects, London, SKB122/2. p. 13.

As one would expect of Thomas Hope, the drawings in this sketchbook are of exceptional delicacy. More surprisingly, they concentrate on Early Christian, Italian Romanesque, and Gothic architecture, liberally interspersed with details of modern objects in the Empire style. Hope emerges as something of a pioneer in the appreciation of Italian Romanesque with its rich inlaid patterns, gilt-bronze encrusted surfaces, and bizarre use of carved animals, particularly on porches. His drawings of the throne from S. Maria in Cosmedin (fig. 3-4), flanked by lion monopodia, and of the porch of S. Antonio Abate, with columns resting on wingless sphinxes, suggest that he was struck by the affinities between such work and the Empire style. All these features were to be strikingly deployed in Hope's own furniture designs. The sketchbook also contains drawings of some of the great Renaissance gardens of Rome at the Villas Aldobrandini and Borghese and the Villa Doria Pamphili (fig. 3-5), where his sketch of a semicircular stone bench recalls the curved terrace he would soon create at the Deepdene as part of his Italianate gardens with their steps, fountains, and urns. But he also took particular interest in the recently created gardens of the eighteenth century, with their exotic garden buildings, and made drawings at the Villa Poniatowski in Rome (fig. 3-6) and at the Cascine and Orti Oricellari in Florence.

Twelve of the drawings in the Italian sketchbook were used for engravings in his *Historical Essay on Architecture,* in which most of the illustrations were of Romanesque buildings in Italy and the Rhineland (figs. 3-7, 3-8, 3-9). The curious balance of this book means that out of a total of 561 pages, less than 30 are devoted to Greek architecture, to which he had earlier been so devoted. The book was published posthumously in 1835 by Hope's eldest son, Henry Thomas Hope. Apologizing that the work had defects because it "has not had the advantage of revision or reconstruction by the Author," Henry Hope defended his decision to publish it in its present form because of his knowledge that "the drawings were intended for publication, and the following pages destined, in a shape similar to the present one, to accompany them." He further explained that "he has been actuated solely by the desire of adding nothing, and of altering as little as possible."[38] Without this confirmation from Henry Hope, it might be difficult to accept that the curious balance of subject matter could have represented anything like his father's own intention.

In one of the first histories of architecture in English covering Asia Minor, Egypt, Greece, and Europe, Hope unusually discussed building traditions in India, Russia, and China. His outlook was colored by the eighteenth-century rationalist tradition of the Enlightenment from Montesquieu to Quatremère de Quincy, which placed great stress on what were seen as the determining factors of climate, social conditions, materials, and tools. From Quatremère came the explanation of Egyptian, Chinese, and Greek architecture in terms of the cave, the tent, and the hut, respectively. Hope noted with interest that whereas Chinese and Egyptian architecture have disappeared, "the Greek style alone . . . not only has continued to live and to flourish to this day, but . . . has assumed [such] a wholly different form; that most people refuse to recognise in its last developments the uninterrupted descent from its first principles."[39] He noted also that there is more local variety in Greek architecture than is generally granted, but he regretted the Greek lack of the curve and swell introduced by the Romans and censured "the dark timidity of Greek interiors."[40]

In general, however, Hope followed the later eighteenth-century denigration of Roman architecture, dependent ultimately

Fig. 3-5. Thomas Hope. Sketch of fountain and bench at the Villa Doria Pamphili, Rome. From his sketchbook of a tour in Italy, ca. 1812. Royal Institute of British Architects, London, SKB122/2, p. 40.

Fig. 3-6. Thomas Hope. Sketch in the gardens of the Villa Poniatowski, Rome. From his sketch-book of a tour in Italy, ca. 1812. Royal Institute of British Architects, London, SKB122/2, p. 11.

on Winckelmann, for being a debased and ornamental copy of Greek architecture. He criticized the decorative architectural devices of the Romans, complaining that "their minds might be fertile in useful inventions: in those calculated for beauty they were sterile. They were obliged to borrow these from elsewhere, and were not even ashamed of thus confessing their deficiency."[41]

He proposed the strange idea that Romanesque, which he believed had been invented in Lombardy, spread from there throughout Europe through the influence of Freemasons acting as protégés of the papacy.[42] He even tried to explain Gothic as a consequence of freemasonic activity. On this subject he must have been familiar with the work of such writers as Thomas Pownall and James Norris Brewer,[43] but it is a minor irritation that he cited none of the many books and articles he must have consulted. He must have read the papers on medieval architecture in *Archaeologia*, the publication of the Society of Antiquaries in London, which he joined in 1794. He did condescend to mention at least the names of Jean-Baptiste-Louis-Georges Séroux d'Agincourt,[44] whom he found useful for the wide European base of his knowledge; Carl Friedrich von Wiebeking,[45] from whom he drew

Fig. 3-7. Thomas Hope. Tomb in S. Cesareo, and Capital in the Vatican Grottoes, Rome. From his sketchbook of a tour in Italy, ca. 1812. Royal Institute of British Architects, London, SKB 122/2, p. 14.

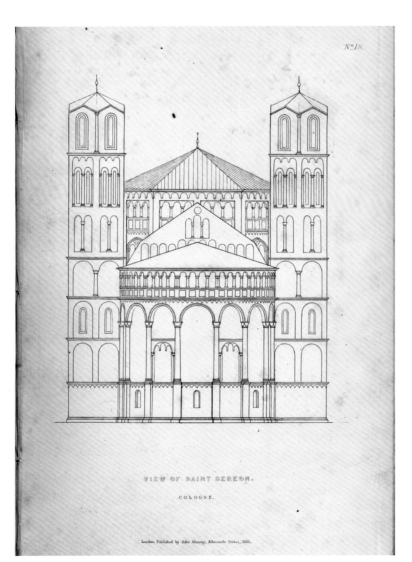

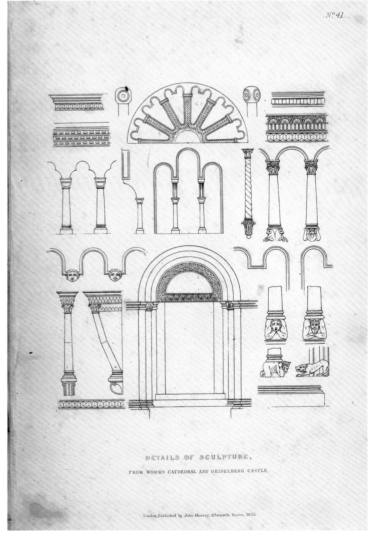

Fig. 3-8. Thomas Hope. View of Saint Gereon, Cologne. Engraving from *An Historical Essay on Architecture*, vol. 2 (1835): pl. 18.

Fig. 3-9. Thomas Hope. Details of sculpture at Worms Cathedral and Heidelberg Castle. Engraving from *An Historical Essay on Architecture*, vol. 2 (1835): pl. 41.

the idea that Gothic was invented in Germany; and the English antiquarian John Milner.[46]

Hope did not share the long-accepted view, which went back to Christopher Wren, of the Saracen origins of Gothic, or that the pointed arch "happened" when a series of Romanesque round arches were interlaced, for this would have been to make Gothic decorative, whereas he saw it as constructional. He was sensitive to the current intellectual climate, in which the problems surrounding the origins and nomenclature of Gothic were precisely those on which the study of architectural history, a subject then in its infancy, cut its teeth.[47] His dating of medieval architecture was often wildly inaccurate, and he did not consider which schools of Romanesque or Gothic influenced which.[48] However, he wrote sensitively of Gothic that it is "like carcasses of vertebral animals," and he was right to stress that the "fundamental characteristics . . . [of Gothic] are independent of, lie deeper than, that arch [the rib vault]." Paul Frankl believed that Hope was correct to see that "the pointed arch alone does not after all determine what he means by Pointed Style. He finds pointedness its essential characteristic, everywhere—in vaults and roofs, as well as in pinnacles and ornaments. Thus, Pointed Style does not mean here the pointed-arch style but a style with the quality of *pointedness*." Frankl concluded generously that, "in view of his inadequate knowledge, [Hope is] surprisingly enlightened as regards his understanding of the Gothic system."[49]

However, Hope believed that the downfall of the Freemasons led to the end of Gothic and "forced architecture immediately backwards from that highly complex and scientific system into one more simple in its principals and more easy in its execution [i.e. Renaissance architecture]."[50] He claimed that the revival in the Renaissance of interest in the work of the ancients "afforded to these new and less skilful architects means of concealing their ignorance" so that "they eagerly adopted the mask." He went on to explain that "the real antique style, when it first arose, sprung gradually, and connectedly, out of the climate and institutions for which its buildings were required. . . . This new style, imitative of the antique, was derived from none of these circumstances."[51]

Despite this general denigration of the Renaissance, in which Hope claimed that Michelangelo "wholly wanted taste,"[52] he praised Palladio for creating "the only architecture whose simplicity of style approached that of the best antique models."[53] He reserved his real anger for Baroque, his condemnation doubtless influenced by that of Francesco Milizia, whose name he cited. The most important architectural theorist of the Enlightenment in eighteenth-century Italy, Milizia had inherited a rationalist cast of mind from the theorists Algarotti and Memmo and was responsible for introducing an astringent note into art criticism,

which had previously been largely descriptive and benevolent in character.[54]

Modern English architecture was also unacceptable to Hope, who complained that some architects unwisely revived the public rather than the private style of the ancients so that, "by building houses in the shape of temples, [they] have contrived for themselves most inappropriate and uncomfortable dwellings."[55] The Gothic Revival brought him no more satisfaction, for he complained of those who "have lodged themselves in a church," doubtless thinking of Fonthill Abbey, Wiltshire, built for William Beckford by James Wyatt from 1796 to 1812. In condemning those who "affected to raise rude and embattled castles,"[56] he may have been referring to the country houses of Robert Smirke, such as Eastnor Castle, Herefordshire (1812–20). In all these opinions he followed Sir John Soane in the lectures he delivered from 1810 at the Royal Academy.[57] For example, like Soane, Hope condemned modern street architecture on the grounds that "copyhold tenures, short leases, and the custom of building whole streets by contract, still increase the slightness, the uniformity, the poverty of the general architecture."[58]

However, unlike Soane, Hope was locked in an Enlightenment tradition that led him to regard Roman architecture as debased, Renaissance as merely imitation, Baroque as an aberration, and modern as ridiculous. He also, unaccountably, failed to grasp the important implications of the recent discoveries of polychromy in Greek architecture. What was new was his belief in Byzantine and Romanesque as preferable to Gothic. In the end, he was left to recommend an eclectic approach in a final paragraph that has been widely quoted as a herald of the Victorian future:

No one seems yet to have conceived the smallest wish of only borrowing of every former style of architecture whatever it might present of useful or ornamental, of scientific or tasteful; of adding thereto whatever other new dispositions or forms might afford conveniences or elegances not yet possessed; of making new discoveries, the new conquests, of natural productions unknown to former ages . . . and thus of composing an architecture, which, born in our country, grown on our soil, and in harmony without climate. Institutions, and habits, at once elegant, appropriate, and original, should truly deserve the appellation of "Our Own."[59]

Such a call had recently been made in Germany by the architect Heinrich Hübsch, who published *In welchem Style sollen wir bauen?* (1828).[60] Hübsch's answer was the round-arched style, known as Rundbogenstil, which appealed to many as a compromise between antiquity and the Middle Ages. Such models were precisely what Hope was to illustrate seven years later in the influential plates of his book. These played a part in the revival of round-arched architecture, which was such a feature of the 1830s

and 1840s, especially in Germany in the work of Leo von Klenze and Friedrich von Gärtner. In religion, Hope was a deist rather than a Christian, and in architecture he welcomed the survival of classical elements wherever he could find them. These are some of the reasons why the Rundbogenstil, finding Gothic unacceptable through its exclusive identification with Christianity, appealed to him as a solution to architectural problems in the nineteenth century.

Hope's book, of which French and Italian translations appeared between 1839 and 1856,[61] was widely read in nineteenth-century Europe. One passionate admirer of Hope's achievement at the Deepdene, John Claudius Loudon, published extensive extracts from it in the *Architectural Magazine*,[62] where in 1837–38 he was also the first to publish Ruskin.[63] These were the years when architectural debate was truly international. Loudon also published translations of the theoretical writings of Quatremère de Quincy[64] and of Friedrich Weinbrenner,[65] as well as reviews of Schinkel's *Sammlung Architektonische Entwürfe*.[66]

Hope's *Historical Essay on Architecture* was cited by Gottfried Semper, the greatest German architectural theorist of the nineteenth century, in his seminal work, *The Four Elements of Architecture* (1851).[67] However, Semper was critical of the materialist interpretation of architecture that had developed in the eighteenth

century. He thus complained that "the store of architectural forms has often been portrayed as mainly conditioned by and arising from the material, yet by regarding construction as the essence of architecture we . . . have thus placed it in fetters." As an example of this process, Semper cited what he nonetheless called "the shrewd hypotheses on the tent roofs of the Chinese . . . in Hope's history of architecture."[68]

In his study of medieval architecture, Daniel Ramée[69] also commented on Hope's *Historical Essay*, criticizing some aspects of it but praising it overall for its "excellent ideas" and "judicious insights."[70] In England, the prolific historian Edward Freeman, in *A History of Architecture* (1849), drew heavily on Hope's book, finding its broad speculative approach helpful and recommending "English Norman as a form of Romanesque suitable for the present time, particularly in our colonies and neglected parts of our own land," at a meeting of the Cambridge Camden Society in 1845.[71] Ruskin cited Hope on several occasions,[72] praising his chapter on the "Influence upon Architecture of Habit and Religion" and his account of Santa Sophia in Constantinople. Finally, as Kruft observed, "Hope's development from Classicist to eclecticist is not merely the result of his dilettante status but is significant for the whole nineteenth-century discussion of style in England."[73]

1. Watkin, *Thomas Hope* (1968): 64–70.

2. David Watkin, *The Age of Wilkins: The Architecture of Improvement* (Cambridge: Fitzwilliam Museum, 2000).

3. These drawings, now in the RIBA Drawings Collection, were probably made at this time, though it has been suggested that they were made twenty years before when Wyatt was first named as architect of the college.

4. Thomas Hope, *Observations on the Plans . . . By James Wyatt, Architect, for Downing College* (London: D.N. Shury, 1804): 33.

5. Ibid., 16.

6. Ibid., 19.

7. Cinzia Sicca, *Committed to Classicism: The Building of Downing College, Cambridge* (Cambridge: Downing College, 1987): 40.

8. David Watkin, *The Triumph of the Classical: Cambridge Architecture, 1804–1834* (Cambridge: Fitzwilliam Museum, 1977): [1].

9. See David Watkin, "Charles Kelsall: The Quintessence of Neo-Classicism," *Architectural Review* 140 (August 1966): 109–12.

10. Charles Kelsall, *A Letter from Athens addressed to a friend in England* (1812): 41.

11. James Stuart and Nicholas Revett, *The Antiquities of Athens*, 3 vols. (London: John Haberkorn and John Nicholls, 1762–94); Society of Dilettanti, *Ionian Antiquities* (London: Spilsbury and Haskell, 1769), and *Antiquities of Ionia* (London: Bulmer & Co., 1797).

12. Hope, *Observations* (1804): 9.

13. Ibid., 25.

14. Thomas Hope, "On Grecian and Gothic Architecture," *Review of Publications of Art* 4 (1808): 297, 299.

15. Rhodri Windsor Liscombe, *William Wilkins 1778–1839* (Cambridge: Cambridge University Press, 1980): 59.

16. See David Watkin, *Sir John Soane: Enlightenment Thought and the Royal Academy Lectures* (Cambridge: Cambridge University Press, 1996): 242–43, 337.

17. *The Diary of Joseph Farington*, ed. K. Garlick et al., vol. 6 (New Haven and London: Yale University Press, 1979): 2463.

18. Ibid., 2478.

19. Henry William Inwood, *The Erechtheion at Athens: Fragments of Athenian Architecture and a Few Remains in Attica, Megara and Epirus* (London: James Carpenter, 1827): pls. XXXIV–XXXIX. Hope was a subscriber to this book, which became the standard work on its subject.

20. Ibid., 154.

21. Edmund Aikin, *An Essay on the Doric Order of Architecture* (London: London Architectural Society, 1810): 23.

22. The reprint of this book by Dover Publications, New York (1971), with an introduction by David Watkin, contained all the plates and text but was not a facsimile, for the arrangement and pagination were altered, as was the placing of some items in the engravings.

23. *Household Furniture* (1807): 17.

24. Ibid., 14.

25. The publishing history of Percier and Fontaine's influential designs is uncertain, but the 72 engraved plates seem to have been published in six suites of 12 plates from 1800 or 1801 onward, with no text and over the name of Percier only, not that of Fontaine. The full series was published with text in 1812 as *Recueil de décorations intérieures, comprenant tout ce qui a rapport à l'ameublement . . . composé par C. Percier et P.F.L. Fontaine, exécuté sur leurs dessins* (Paris: Didot, 1812). It was the 1812 edition, not that of 1801, which appeared in the sale catalogue of the library at the Deepdene in 1917 (lot 592), where lots 593 and 594 were other works by Percier and Fontaine: *Choix des plus célèbres Maisons de Plaisance de Rome et de ses environs* (Paris: Didot, 1809), bound with the Hope arms on the sides, and *Palais, Maisons et autres édifices modernes, dessinés à Rome* (Paris: Didot, 1798), the latter included in the bibliography to *Household Furniture* (p. 52) as "Percier's Edifices de Rome moderne."

26. *Household Furniture* (1807). Percier's vignettes appeared as illustrations in an edition of Horace published as *Horatius Opera* (Paris: Didot, 1799), a copy of which was lot 405 in the catalogue of the sale of the Deepdene library in 1917.

27. *Household Furniture* (1807): 12.

28. James Mosley, *The Nymph and the Grot: the Revival of the Sans Serif Letter* (London: Friends of the St Bride Printing Library, 1999): 23–36.

29. I am indebted to James Mosley for information about the long "s" and Thomas Bensley.

30. *Household Furniture* (1807): 19.

31. Ibid.

32. I am indebted for this information and for my account of Hope's frame to Mr. Tim Stanley, Senior Curator, Middle East and Asian Department, Victoria and Albert Museum.

33. *Household Furniture* (1807): 10.

34. Ibid., 6.

35. Ibid., 5, 7.

36. C. R. Cockerell, *Diary*, 16 August 1823.

37. RIBA Library. See David Watkin and Jill Lever, "A Sketch-book by Thomas Hope," *Architectural History* 23 (1980): 52–59.

38. Thomas Hope, *An Historical Essay on Architecture*, vol. 1 (London: John Murray, 1835): xi–xii.

39. Ibid., 31.

40. Ibid., 41.

41. Ibid., 65.

42. See Susanne Stephens, "In Search of the Pointed Arch: Freemasonry and Thomas Hope's *Historical Essay on Architecture*," *Journal of Architecture*, no. 2 (June 1996): 133–58.

43. Thomas Pownall, "Observations on the Origin and Progress of Gothic Architecture and on the Corporation of Free Masons supposed to be the Establishers of it as a regular Order," *Archaeologia* 9 (1789): 110–26; and James Norris Brewer, *Introduction to . . . The Beauties of England and Wales* (London: Harris, 1818): 447–51, 476.

44. Author of *Histoire de l'art par les monumens, depuis sa décadence . . . jusqu'à son renouvellement au XVIe*, 6 vols. (Paris: Treuttel et Würtz, 1823).

45. The library at the Deepdene contained Wiebeking's *Theoretisch-praktische bürgerliche-Baukunde*, 4 vols. (Munich, 1821–26).

46. For example, "On the Rise and Progress of the Pointed Arch," in *Essays on Gothic Architecture* (London: J. Taylor, 1800).

47. David Watkin, *The Rise of Architectural History* (London: The Architectural Press, 1980): 61–63.

48. See Nikolaus Pevsner, *Some Architectural Writers of the Nineteenth Century* (Oxford: Clarendon Press, 1972): 73.

49. Paul Frankl, *The Gothic: Literary Sources and Interpretations through Eight Centuries* (Princeton: Princeton University Press, 1960): 519.

50. Hope, *Historical Essay*, vol. 2 (1835): 527.

51. Ibid., 529.

52. Ibid., 538.

53. Ibid., 556.

54. Milizia's *Memorie degli architetti antichi e moderni* had first appeared anonymously in 1768.

55. Hope, *Historical Essay*, vol. 2 (1835): 560.

56. Ibid.

57. Watkin, *Soane* (1996), passim.

58. Hope, *Historical Essay*, vol. 2 (1835): 559.

59. Ibid., 561.

60. Wolfgang Herrmann, intro. and transl., *In What Style Should We Build? The German Debate on Architectural Style* (Santa Monica: Getty Center, 1992).

61. Brussels 1839 and 1852; Paris, 1839 and 1856; and Milan, 1840. See Tina Bizzarro, *Romanesque Architectural Criticism: A Prehistory* (Cambridge: Cambridge University Press, 1992): 148.

62. Vol. 2 (1835): 502–3, 538–46; vol. 3 (1836): 32–36, 86–88, 129–30, 225–26, 317–18; vol. 4 (1837): 245–49, 529–32; vol. 5 (1838): 171–73, 317–20, 422–23, 475–78, 611–18.

63. "The Poetry of Architecture," in *Architectural Magazine* 4 (1837): 505–8, 555–60; vol. 5 (1838): 7–14, 56–63, 97–105, 145–54, 193–98, 241–50, 289–300, 337–44, 385–92, 433–42, 481–94, 533–54.

64. Vol. 2 (1835): 53–56, 241–42; vol. 3 (1836): 1–3, 52–53, 145–49, 289–93, 441–50, 489–92; vol. 4 (1837): 1-3.

65. Vol. 5 (1838): 392–408.

66. Vol. 2 (1835): 81–82, 365–67.

67. He also made selections from his writings. See Wolfgang Herrmann, *Gottfried Semper: Theoretischer Nachlass an der ETH Zürich: Katalog und Kommentare* (Basel: Birkhäuser, 1981): 27, 54.

68. Gottfried Semper, *The Four Elements of Architecture and Other Writings*, trans. Harry Mallgrave and Wolfgang Herrmann (Cambridge: Cambridge University Press, 1989): 102. Hope had interpreted the sloping ridges of Chinese roofs as formal imitations of the catenary curve of nomadic tents.

69. Ramée published *Architecture de Ledoux*, 2 vols. (Paris: Lenoir, 1847), a major addition to Ledoux's important *L'architecture considérée sous le rapport de l'art . . .* (Paris: Perronneau, 1804).

70. *Le Moyen-Age monumental et archéologique*, *Introduction Générale* (Paris: Paulin, 1843, 2nd ed., 1852): 8–9.

71. *Ecclesiologist*, vol. 4 (1845): 76

72. *The Works of Ruskin*, Library Edition, 39 vols. (1903–12): vol. 8, 63; vol. 10, 22 and note; and vol. 12, 186–87.

73. Hanno-Walter Kruft, *A History of Architectural Theory from Vitruvius to the Present* (London and New York: Zwemmer, 1994): 325.

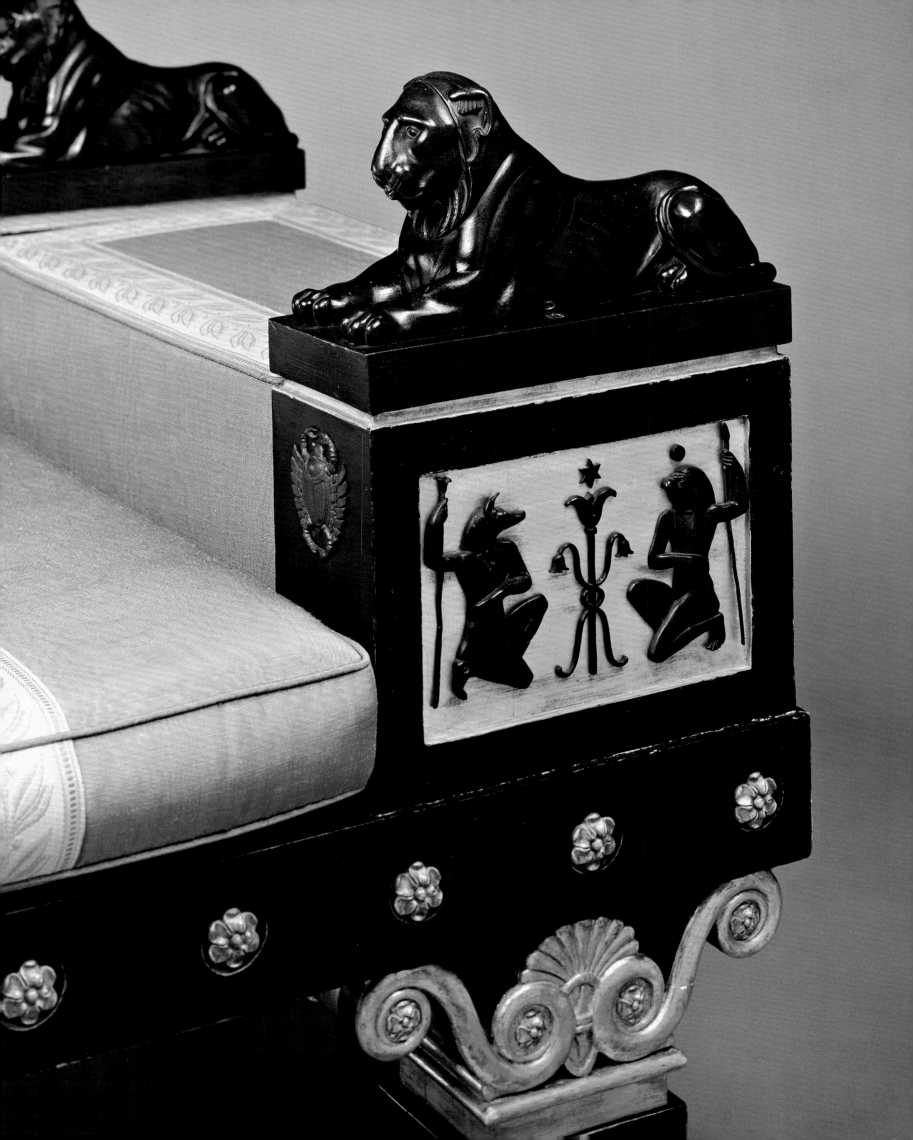

CHAPTER 4

Thomas Hope's Furniture:
"A delightful and varied significance of shape and embellishment"[1]

Frances Collard

As a patron of furniture designers and makers, and a collector of antique and contemporary furniture, Thomas Hope resembled many of his contemporaries, but his active involvement in design, coupled with his concern to improve standards in furniture design and manufacture, was far more unconventional for someone from his wealthy and cultured background. In contrast to such contemporaries as William Beckford and the Prince Regent, who collected primarily eighteenth-century French furniture, Hope bought modern, newly designed French pieces. Described by the Honorable Henry Fox, later Lord Holland, as having "a talent for drawing,"[2] Hope was also sufficiently skilled to produce his own sketches on which to base his designs for furniture. His family traditions encouraged his development as a collector and patron, but it was his extensive Grand Tour from 1787 to 1797, when he visited France, Germany, Italy, Greece, Turkey, Syria, and Egypt, that stimulated his interest in and expanded his knowledge of contemporary and classical furniture.

Thomas Hope visited public museums, such as those in Bologna, Portici, and Rome, and private collections of classical antiquities; he also inspected archaeological sites and formed his own collection while recording his impressions of architectural, interior, and design details in pen and watercolor sketches.[3] As he explained to the manufacturer Matthew Boulton in 1805, "if the forms of my furniture were more agreeable than the generality of those one meets with, it was only owing to my having, not servilely imitated, but endeavoured to make myself master of *the spirit* of the Antique."[4]

His interest in improving the status of design and industry in Britain was both patriotic and practical: for example, his innovative approach to the use of British materials and techniques, including Mona marble for fireplaces and Coade stone for furniture,[5] emphasized his commitment to his adopted country, particularly during periods of military conflict and commercial competition with France. Hope wished to encourage the lover of elegant refinement to find at home "those objects of superior design and execution, which formerly he could only obtain from abroad; by converting into lucrative articles of home manufacture, and of beneficial exportation, those very commodities which had heretofore only appeared in the repulsive and unpatriotic shape of expensive articles of foreign ingenuity and of disadvantageous importation."[6]

Hope was clearly frustrated by the lack of skilled craftsmen who possessed his requirements of familiarity with the ancient world as well as the ability to design furniture. He thus complained that, "I found no one professional man, at once possessed of sufficient intimacy with the stores of literature to suggest ideas, and of sufficient practice in the art of drawing to execute designs, that might be capable of ennobling, through means of their shape and their accessories, things so humble in their chief purpose and destination as a table and a chair, a footstool and a screen."[7] He was, therefore, obliged to depend on his own artistic ability for the "laborious task of composing and of designing every different article of furniture, which I wanted the artisan and the mechanic to execute."[8]

Although some of Hope's collecting activities during his Grand Tour are documented, these references are mainly confined to antiquities, such as those he bought in Rome in 1792 and 1795, or to modern sculpture, and there is little evidence for his purchases of actual examples of furniture. He certainly owned fragments, such as the nonfunctional throne legs from tombs (see fig. 11-3) or marble tripod tables described as antique.[9] He enthusiastically collected slabs of different marbles and various colored stones, which he admired for their deep hues, and he incorporated some of these into pieces of furniture.[10]

It may have been during this visit to Rome that he met the architect and draftsman Charles Heathcote Tatham, who arrived in Rome in July 1794, having been sent to Italy by the architect Henry Holland to collect antique fragments and casts for use in design. We do not know whether Tatham assisted Hope in his

After a design published by Thomas Hope. Settee (detail). Mahogany, bronze, painted and gilded, ca. 1802. The Trustees of the Faringdon Collection, Buscot Park, Oxfordshire. *Cat. no. 76.*

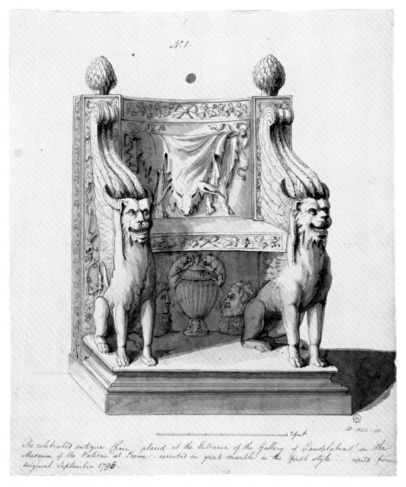
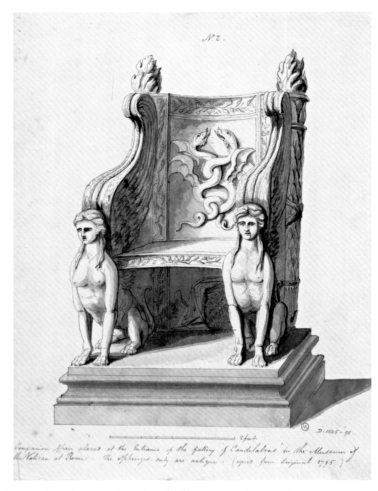

Fig. 4-1. Charles Heathcote Tatham. Antique chairs in the gallery of candelabra in the Vatican Museum. Drawing, 1795. Victoria and Albert Museum, London, D.1545-98. V& A Images.

designs for furniture, but he may have found helpful Tatham's technical ability as a draftsman, as well as his skill in visualizing the possibilities of classical antiquities as sources for modern furniture designs (fig. 4-1).[11]

Duchess Street and the Publication of *Household Furniture*

Hope's designs for Duchess Street, drawn up by C. H. Tatham in June 1799,[12] suggest that he moved swiftly to remodel, decorate, and furnish the house he had bought that year, possibly adding to his existing collections during his absence abroad in the autumn and winter of 1799–1800, and from May 1802 to May 1803. He apparently retained some furnishings already in the house, bought sculptures in 1800, and purchased Sir William Hamilton's collection of vases in 1801.[13] He also edited his collection and disposed of unwanted works, presumably in preparation for his thematic schemes of interior decoration at Duchess Street.[14]

Hope owned publications that illustrated pieces he admired, including C. H. Tatham's *Etchings of Ancient Ornamental Architecture* (1799) (cat. no. 117), to which he subscribed, and J. N. L. Durand's *Recueil et Parallèle des édifices de tout genre, anciens et modernes* (1800–1801), which he acknowledged as a source. He

also admired contemporary French furniture, inspired by antiquity and executed by prominent makers including the Jacob dynasty after designs by Charles Percier and Pierre-François Fontaine. Their book of outline designs for interior furnishings and furniture, *Receuil de décorations intérieures comprenant tout ce qui a rapport à l'ameublement*, published in parts from 1801

Fig. 4-2. Thomas Hope. Sketches of chair, stool, candelabrum, border, Quirinal Palace. From his sketchbook of a tour in Italy, ca. 1812. Royal Institute of British Architects, London SKB 122/2, p. 50.

(cat. no. 118), may have stimulated his designs for pieces in situ in Duchess Street by 1802, including the tables with anthemion decoration and scrolling legs with lion's-paw feet (cat. no. 66).[15]

He enthusiastically recorded architectural and design details that he saw on his foreign travels before and after the publication of *Household Furniture* in 1807, which suggests that he continued the process of designing and commissioning furniture after that date (fig. 4-2).[16] Public knowledge of Hope's designs and patronage existed well before the publication of *Household Furniture*, which indicates how quickly his ideas for appropriate furniture may have become accessible to visitors. Although details of the process of designing, commissioning, and purchasing furniture for Duchess Street have not yet been found, Hope's knowledge of classical antiquities, his contacts, his resources, and his social ambitions would have enabled him to design and commission certain pieces by 1802, when in May a splendid party was held at Duchess Street attended by the Prince of Wales.[17] These pieces may have included furniture based on classical models, for Hope had taken note of such original pieces during his Italian visits. His tripod tables of wood executed for various interiors at both Duchess Street and the Deepdene, one of which is illustrated in *Household Furniture*,[18] were presumably inspired by original antique models in alabaster and marble in the Vatican Museum, Rome, which he had seen in 1795, as well as by marble ones in his possession (see cat. no. 45) believed by him to be ancient.

It is also possible that in May 1802 the house was still not as fully furnished as suggested by the illustrations in *Household Furniture*, for Hope confessed to frustration about the delays in completing his furnishing schemes because of the lack of skilled craftsmen. He complained that "I need not add how slow and tedious this scarcity of workmen has rendered the completion of my little collection."[19] Also, his purchase of paintings by Thomas Daniell for the Indian Room in 1800 and 1804 suggests that this room may not have been fully completed until 1804, after his French and Italian tours of 1802–3. These visits, following the Peace of Amiens in 1802, may have been prompted by Hope's interest in the latest Parisian designs for furniture or by his desire to expand his collection in preparation for the official opening of Duchess Street to invited members of the Royal Academy in February 1804.

His desire to reinforce his social position through marriage, including his courtship of Susan Beckford, daughter of the collector William Beckford, in 1805, and his marriage in the following year to Louisa Beresford, daughter of the future Lord Decies, could also have provided a stimulus for acquiring new furniture for Duchess Street, such as the bedroom pieces decorated with swans, the symbol of Venus, and the cradle illustrated in *Household Furniture*.[20] The cradle appears again in *Designs of Modern Costume* (1812) by Henry Moses, a book of engravings commissioned by Hope some years after *Household Furniture* that illustrated a series of furnished interiors complete with sociable groups in fashionable dress (see cat. no. 111). The furniture illustrated includes strongly archaeological Greek Revival designs with elaborate classical mounts and decoration, but also more modest and conventional pieces, such as Pembroke tables and a small sideboard. This may indicate that the plates illustrate some of the private rooms on the second floor of Duchess Street that were not necessarily accessible to all of Hope's visitors.

Fig. 4-3. Thomas Hope. Sketches of gates, walls, and balustrade. From a sketchbook of decorative details in the antique style. Graphite, pen and brown ink. Yale Center for British Art, Paul Mellon Collection, New Haven, B.1977.14.4762.

Fig. 4-4. Thomas Hope. Sketches of ceiling rose. From a sketchbook of decorative details in antique style. Graphite, pen and brown ink. Yale Center for British Art, Paul Mellon Collection, New Haven, B.1977.14.4764.

Hope's drawings show his interest in certain forms, such as Egyptian temples or pylon-shaped gate piers (fig. 4-3), which could be developed into designs for cabinets with pediments, or in Empire pelmets formed of spears with drapery, tassels, and fringes, appropriate for interior decoration. Other architectural details he sketched, such as screens, colonnades, pediments, cornices, capitals, and doors, may indicate ideas for future alterations to interior schemes (fig. 4-4). Sketches of *secretaires*, settees, chairs, candelabra, and urns suggest his continuing fascination for recording appropriate furniture and furnishings as inspiration either for Duchess Street or for the Deepdene. Details of floral trails, bell flowers, anthemia, rosettes, Greek key and guilloche patterns, and butterflies and beetles could have provided ideas for decorative ornament for borders, inlays, and mounts. Hope's interest in the ancient world also included Early Christian furniture, for he sketched details of bishop's thrones.

Hope also believed that proficiency in drawing was as important as a study of Greek vases for those involved in trade and manufacture. He argued that

> *Until a certain proficiency in drawing the figure, (which, as the most difficult and the more comprehensive attainment, implies the power of easily acquiring a proportionate proficiency in drawing every other inferior object,) become general, can neither those that are engaged in manufactures obtain any certain rules, by which to give their work that elegance which must enhance their value, or those that are employed in trade possess any unfailing criteria, by which to display, in the choice of their various articles, that taste which must ensure and increase their rent.*[21]

Hope's interest in the improvement of British design and manufacture may have been the motive behind the invitation to one visitor who was offered particularly privileged access at Duchess

Fig. 4-5. John Flaxman. *The Song of Demodocus*. Illustration for the *Odyssey* (Book VIII, 583). Pen and ink on wove paper, ca. 1800. The Art Institute of Chicago, Sidney A. Kent Fund, 1919, 2142m.

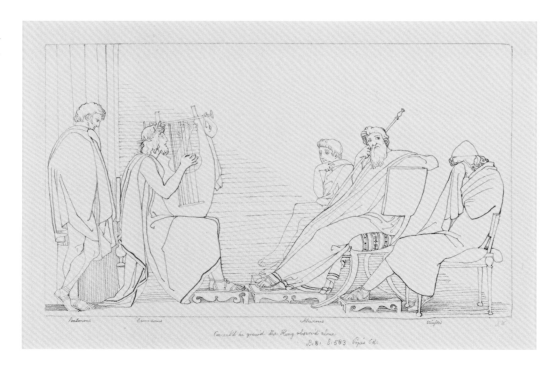

Street in August 1805. This was John Phillps, the illegitimate son of Hope's friend the manufacturer Matthew Boulton. Hope, who was away at the time, left instructions that Phillps be shown everything, presumably including the private family rooms on the upper floor, as well as the main reception rooms illustrated in *Household Furniture,* and that "every convenience might be afforded him for copying at his greatest ease and leisure whatever he might think worthy of any attention."[22] Evidence of the furniture that may have furnished the private family rooms is suggested by Phillps's sketch of a chair combining several familiar details derived from classical sources.[23] These include saber legs, a lyre-shaped back (a decorative feature sketched by Hope and used also in *Household Furniture*), and the X-frame seat supports, seen also in John Flaxman's drawing of Neptune from the *Iliad*.[24]

This and other drawings by Flaxman were acknowledged by Hope as significant inspiration for furniture for Duchess Street. Hope described Flaxman's drawings of the *Iliad* and the *Odyssey* as offering "the finest modern imitations I know of the elegance and beauty of the ancient Greek attire and furniture, armour and utensils" (fig. 4-5)[25] This fulsome tribute by Flaxman's dedicated patron suggests that Hope truly appreciated his ability to draw particular classical pieces, such as tripod tables with lion masks, X-frame stools, klismos chairs with broad curving backs and saber legs, footstools with shaped frames, or tall stands for lamps, all of which were to be represented in Hope's furnishing schemes. Flaxman's attractive presentations of classical furniture were matched by his understanding of conventional furniture design, such as the modest dining chair in his sketch of a group at a party given by the poet Samuel Rogers in 1800.[26]

Although Hope subscribed to the first edition of Tatham's book *Etchings of Ancient Ornamental Architecture* (1799) and owned copies of his other publications, he did not acknowledge Tatham's contribution to the remodeling, decoration, and furnishing of Duchess Street in *Household Furniture*.[27] Hope's sharp criticisms of some of Tatham's designs for Duchess Street and his strong claim of personal responsibility for design details on others suggest that he perceived himself as the creative genius and Tatham as a draftsman employed to provide working drawings based on Hope's own designs for the process of commissioning the furniture he required.

As an exacting and knowledgeable client, Hope provided specific instructions concerning the materials and decoration of the rooms at Duchess Street. On one of the drawings supplied by Tatham, Hope noted that "the organ & bookcases should be higher in proportion to the room. The organ white & gold. The spaces between the columns painted as drapery, red, the ornaments gold—the bookcases mahogany & ormolu."[28] The mention of materials and finishes not only for interior decoration of the

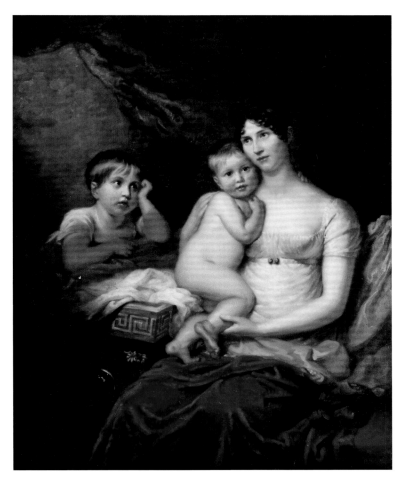

Fig. 4-6. George Dawe. *Portrait of Mrs. Hope and Her Two Children.* Oil on canvas, 1811. Manuscripts and Special Collections, The University of Nottingham.

gallery but also for the organ and bookcases suggests that one purpose of Tatham's drawings may have been to provide guidance for the firms that would provide estimates for supplying these pieces of furniture.

Hope commissioned drawings for furniture from other artists based on his own ideas and presumably worked up from his own sketches. According to the diarist Joseph Farington, one of those involved was "Daw, a young artist who obtained the gold medal of the Royal Academy for the best Historical picture, & has been employed by Thomas Hope to draw designs for furniture."[29] George Dawe and Edmund Aikin were both commissioned by Thomas Hope to prepare drawings for the plates in *Household Furniture.* Another commission for Dawe was the 1811 portrait of Mrs. Hope and her children (fig. 4-6), which included the Empire cradle decorated with appropriate ornament illustrated in *Household Furniture*.[30]

Thomas Hope and Cabinetmakers

Hope's clear vision for his interiors and furniture and his careful selection of appropriate working drawings based on his designs

Fig. 4-7. Thomas Hope. Sketch of pedestal. From a sketchbook of decorative details in antique style. Graphite, pen and brown ink. Yale Center for British Art, Paul Mellon Collection, New Haven, B.1977.14.4763.

suggest that he was equally selective in commissioning craftsmen to make his furniture. He chose to acknowledge only two individual craftsmen in *Household Furniture*, a bronzist, Alexis Decaix (see Chapter 6) and a carver named Bogaert, probably Peter Bogaert or Bogaerts, whom Hope warmly praised for his technical skill.[31] It is likely, however, that Hope commissioned and purchased furniture from other firms if only to ensure that his house was furnished in time for occupancy and entertaining. Bogaert was described by Hope as the only carver in London "to whose industry and talent I could in some measure confide the execution of the more complicated and more enriched portion of my designs."[32] The distinctive quality of the carving on several pieces of furniture, including the gilt-wood settee (cat. no. 76) and the mahogany table (cat. no. 66), illustrates Bogaert's skill and justifies Hope's praise of his ability. The carved elements on the mahogany table were made separately, possibly in a different workshop, and then joined to the uncarved sections, suggesting that Bogaert collaborated with a so-far unidentified furniture maker.

Through his employment of Tatham, Hope must surely have known of his brother, Thomas, a partner in the well-established firm of cabinetmakers Elward, Marsh and Tatham, later Marsh and Tatham. This firm was already involved in furniture commissions for the Prince of Wales at Carlton House, London; for Samuel Whitbread II at Southill, Bedfordshire; and for other clients of the architect Henry Holland, who had sent Tatham to Italy.[33] A link between Hope, Tatham, and his brother's firm may be seen in the set of library cabinets supplied in 1806 by Marsh and Tatham for Carlton House, which incorporate bronze busts very similar to those published a year later in *Household Furniture*.[34] Hope described the busts as heads of the Indian or bearded

Bacchus and "peculiarly appropriate" for the pilasters of a press, or cabinet, containing a collection of Greek vases.[35] Hope's text suggests that he had already incorporated the busts into a press, whereas he certainly used the bearded heads of Bacchus on other pieces of furniture at Duchess Street, including the open stands in the first Vase Room. The knowledge of Hope's collection that Tatham doubtless acquired when working for him probably explains the repetition of the Bacchic busts on the Carlton House cabinets in 1806.

Another cabinetmaker familiar with Hope's furniture was Nicholas Morel, who may have been French. The sofa with a frieze of Greek and Roman gods along the top in the Lararium at Duchess Street is closely paralleled in contemporary commissions involving Morel (see fig. 15-12).[36] These include one at Southill, Bedfordshire, where he was one of the craftsmen supplying furniture for Samuel Whitbread from 1798 to 1807, and another for the Earl of Bradford at Weston Park, Shropshire.[37] Morel and Robert Hughes submitted an invoice to Lord Bradford in 1806 for "a large handsome Sofa of a new design on antique feet & do. ornaments richly carved & gilt."[38] The surviving furniture at Weston Park also includes library chairs designed with curved back rails with double convex ends and ebony and ivory inlay, very similar to the klismos chairs in the second Vase Room at Duchess Street, and possibly another indication of a link between Morel and Hope.[39] There may have also been a professional connection between Morel and Bogaert, since Morel later employed Bogaert's son for a commission at Windsor Castle.[40]

Thomas Hope lived no more than a ten-minute walk from the socially ambitious George Bullock, who presided over a fashionable furniture establishment in Tenterden Street. Hope may have commissioned furniture, upholstery, and Mona marble slabs and fireplaces from Bullock, who moved from Liverpool to London in 1813.[41] Hope and Bullock both believed in the importance of symbolic decoration for furniture, admired the aesthetic impact of colored marble slabs for the tops of cabinets and tables, and promoted the use of British rather than imported materials. They had mutual personal and professional contacts, such as the Boulton family and the architects William Atkinson and Joseph Gandy. Indeed, Atkinson, who worked with Bullock on many occasions, seems the most likely candidate to have introduced Hope to the cabinetmaker who was to furnish Napoléon in exile on St. Helena. Bullock's designs, like Hope's, owe clearly identifiable debts to the French Empire style.[42] By 1809 Bullock was in partnership in Liverpool with the architect Joseph Gandy, who had already dedicated to Hope in 1805 his *Designs for Cottages, Cottage Farms and Other Rural Buildings*. Hope acquired some of Gandy's watercolors, for which he designed frames.[43] William Atkinson was employed

by Hope both for the Flemish Picture Gallery at Duchess Street and for additions at the Deepdene (see Chapters 2 and 12).

Even contemporaries acknowledged the influence of Hope's designs on Bullock. Hope's sketch of a pedestal or dwarf cabinet (fig. 4-7), decorated with crossed thyrsi and a wreath, is very similar to the pedestal supplied in 1816 by Bullock for the bust of Shakespeare in the library at Abbotsford (fig. 4-8).[44] On November 22, 1816, Scott wrote ecstatically to his friend J. B. S. Morritt, whose estate at Rokeby, Yorkshire, had provided the yew for this pedestal: "Its arrival has made a sensation in Edinburgh. There really is great taste in the form and colouring of the cabinet and it would do Bullock immortal honour were it not to be suspected that it was executed under the direction of a certain Classical Traveller."[45]

Despairing at the lack of skilled modelers in England and the compromise he was forced to adopt, Hope explained that

if I had in vain sought a species of designers, still less was I able to find a description of modellers, sufficiently familiar with

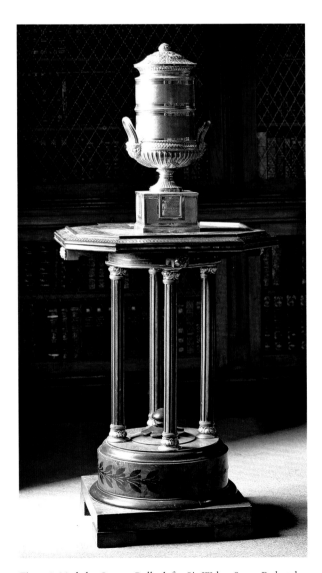

Fig. 4-8. Made by George Bullock for Sir Walter Scott. Pedestal. Yew with gilt brass mounts, 1816. Abbotsford, Melrose, Scotland.

the various productions of art and of nature, with the costume of ancient times, and with the requisites of modern life, with the records of history, and with the illusions of mythology, to execute, in an accurate and a classic style, that prodigious variety of details and of embellishments. . . . Thence I found myself under the necessity of procuring, with great trouble, and still greater delay, models and casts from Italy, for almost all the least indifferent compositions which I have had executed.[46]

This does not exclude the possible involvement of C. H. Tatham, whose knowledge of the processes of taking casts of classical objects would also have been an advantage in creating a smooth transition of Hope's designs into three-dimensional models for the furniture makers.[47]

Hope reinforced his knowledge of the classical world, gathered through his extensive Grand Tour and subsequent journeys, by the acquisition of contemporary publications "either representing actual remains of antiquity, or modern compositions in the antique style, which have been of most use to me in my attempt to animate the different pieces of furniture here described."[48] His furniture designs appear to have been stimulated by a complex mixture of personal observation during his travels, examples of antiquities in his and other collections, and illustrations in these contemporary publications, all combining with his creative genius to produce some strikingly original pieces.

Although Hope's ideas for some furniture, including his tables with sphinx legs (cat. no. 84) and klismos chairs, can be traced back to classical sources, such as the bronze tripods in the museum at Portici, or to his vase paintings, for other pieces he combined elements and decoration copied from antique fragments with his original versions of classical forms. For example, he described the arm supports on the settee illustrated in *Household Furniture*[49] as based on an antique marble chimaera he had seen in the Rome studio of Bartolommeo Cavaceppi, but Hope incorporated these into a severely classical seat, adding Grecian drapery and trimming. Other furniture of equal originality in the architectural details include his distinctive library table (fig. 4-9), which consisted of a pair of tall presses for papers with a writing surface suspended in the middle, like a bridge between towers.[50] Hope explained that the tops of the presses were based on the roofs of ancient Greek houses and that the pediments were appropriately decorated with the heads of Apollo and Minerva, patron and patroness of science, but he gives no source for the overall design, which was presumably his own idea.

Hope's Designs for His Family and Friends

Thomas Hope may have designed furniture for his brother Henry Philip, who lived at 3 Seamore (or Seymour) Place in London and

Fig. 4-9. Thomas Hope. Design for library table. *Household Furniture* (1807): pl. XI, no. 1.

who shared his brother's enthusiasm for antiquities and paintings. Several pieces with close similarities to designs in *Household Furniture* have been identified from his collection.[51] These include a rosewood and ebony writing table with carved and gilded mounts (fig. 4-10), a settee with ebonized frame and gilded swan armrests, and a bronze tripod table[52] (cat. no. 82).

The collection of Samuel Rogers had much in common with Hope's, including sculpture by John Flaxman, as well as Greek vases and other antiquities. Rogers also commissioned furniture after Hope's designs for his London house at 22 St. James's Place.[53] Since Rogers's new interiors were completed by 1803, he must have seen Hope's original designs for the Duchess Street furniture and may have commissioned carved furniture from Bogaert.[54] Rogers's furniture included "an elegant mahogany circular stand on three bronze lions legs, surmounted by sphinxes, and triangular plinth—18 in. diameter *Designed from Hope's Book of Furniture*," as well as chairs with griffin supports and a stool decorated with swans.[55] Intriguingly, interior features designed by Hope for Duchess Street were echoed by Rogers, whose first-floor anteroom was described as fitted with "a Mahogany Arched Recess, copied from Mr. Hope's design, with plate glass front raised by pullies, leading to the Drawing Room."[56]

Hope's friendship with Boulton may be the explanation for furniture made after Hope's designs by the cabinetmaker James Newton of 63 Wardour Street, London.[57] Newton supplied furnishings for Boulton's home, Soho House, Birmingham (1797–99), and may have visited Duchess Street using an introduction from Boulton; alternatively, he may have had knowledge of Hope's furniture through the visit made by Phillps in 1805. Four armchairs, one with Newton's trade label and apparently dated 1806

(figs. 4-12, 4-12a),[58] survive from a set that must have included at least eight pieces, because of the constructional details, the gilded and rosewood-grained finishes, and the numbers chiseled into the frames.[59] The original purpose of this set, whether for another commission or for stock, is unknown, but the existence of such a large set suggests a definite commission rather than models made solely for display in a showroom.[60]

In 1805 Newton may also have supplied Boulton with some klismos chairs for Soho House, which can be compared with designs in *Household Furniture* (fig. 4-11).[61] Radical in their uncompromising form, particularly with the single support for the back, these chairs illustrate the achievement of designers and makers in creating a three-dimensional form from images depicted on classical vases or on carved reliefs. That such radical designs were known to contemporaries of Boulton and Hope can be seen in contemporary views showing such chairs as J. M. Gandy's view of the Front Parlour at Pitzhanger Manor, Ealing, Sir John Soane's country house.[62]

Contemporary Furniture in the Greek Revival Style

Hope was obviously aware of this developing interest in classical forms and ornament among commercial furniture makers, as well as among designers and their clients, many of whom shared his interests. His didactic purpose in promoting his theories with the designs for his home and furniture, and publishing them in *Household Furniture* was to offer alternative designs to the "extravagant caricatures such as of late have begun to start up in every corner of this capital, [and] seem calculated for the sole purpose of bringing this new style into complete disrepute."[63] Such interest

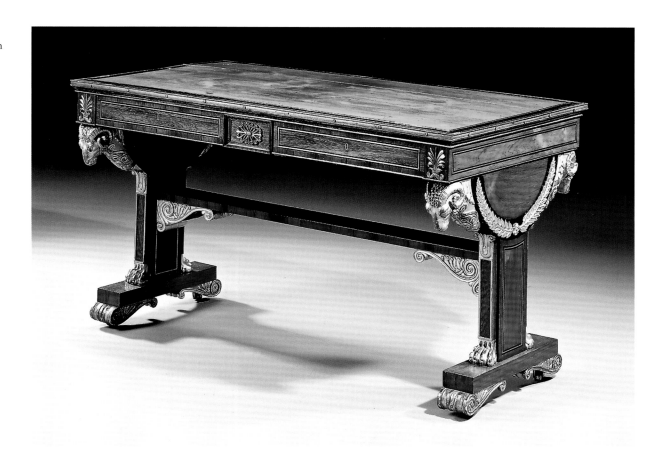

Fig. 4-10. Probably designed by Thomas Hope. Writing table from the collection of Henry Philip Hope. Rosewood and ebony. Christie's Images Limited 2007.

from those involved commercially in making furniture was clearly to Hope's advantage when he published clear outline designs for guidance. He believed these were necessary because the trade is "rarely initiated even in the simplest rudiments of designs, whence it has happened that immense expense has been employed in producing furniture without character, beauty or appropriate meaning."[64]

The classical vocabulary of lion or leopard monopodia, anthemion scrolls, tripod stands, klismos chairs, and other designs promoted by Hope was available to consumers and to commercial furniture designers and makers from other sources, as well as from the interiors at Duchess Street. Aware of fashionable trends, the furniture trade was quick to respond to consumer interest in classical styles. Thus, designs for Grecian chair legs and backs were illustrated in *The London Chair Maker's and Carver's Book of Prices* (1802), a publication intended to regularize prices among the furniture-making trades but that also acted as a guide to new designs.[65]

Other trade publications included pattern books, which were aimed at potential patrons and those who were commercially involved in providing patrons with the latest fashions in classical style. Thomas Sheraton's *Cabinet Dictionary* (1803) illustrates a range of designs in the latest fashion, including a quintessentially classical piece, the "Grecian squab," a couch with scrolling ends and lion's-paw feet. The subscribers to C. H. Tatham's *Etchings*

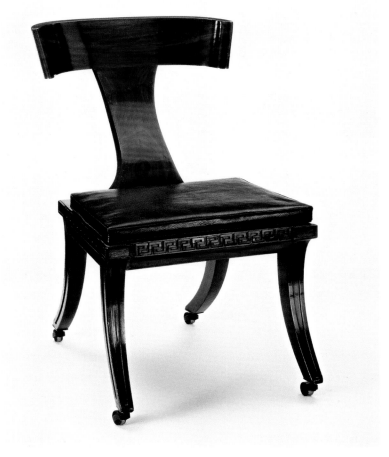

Fig. 4-11. James Newton. Klismos chair. Victoria and Albert Museum, London, W.2-1988. © V&A Images.

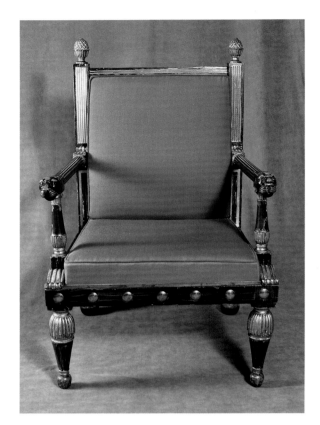

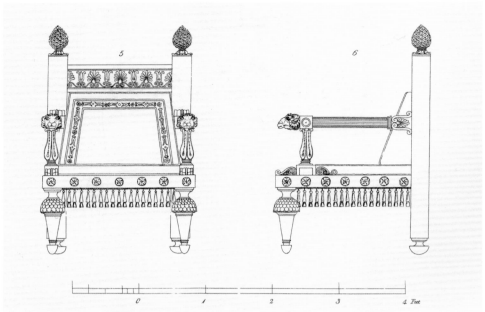

Fig. 4-12. Armchair, after a design published by Thomas Hope, *Household Furniture* (1807): pl. XXII, nos. 5 and 6, with the label of James Newton. Brighton Museum and Art Gallery, DAMAS000222.

Fig. 4-12a. Front and side of a large armchair. *Household Furniture* (1807): pl. XXII, nos. 5 and 6.

of Ancient Ornamental Architecture (1799), of which three editions were published by 1810, included potential clients, along with fellow designers and architects. Perhaps the most direct and immediate reflection of Hope's influence on commercial furniture design was George Smith's pattern book *Designs for Household Furniture and Interior Decoration* (1808), which contained a fulsome dedication to the Prince of Wales and colored illustrations of furniture dated 1804 and 1805. These illustrations included designs so similar to Hope's that Smith must have had fairly accurate drawings or personal knowledge of the Duchess Street interiors and furnishings.

Less direct influence can be detected in the illustrations of designs for classical and exotic furniture, including one in 1811 of an imperial Turkish ottoman with swan ends in the fashionable periodical *The Repository of the Arts*.[66] Perhaps more influential on contemporary patrons, designers, and makers was Hope's emphasis on the importance of symbolic ornament for furniture. This is evident from comments in *The Repository of the Arts* and in Richard Brown's *Rudiments of Drawing Cabinet and Upholstery Furniture* (1820).[67]

Hope has become associated with various furniture designs in the Greek Revival style, including the lion or leopard monopodium small table, the larger inlaid round table on a triangular base, the X-frame or curule chair, and the Empire-style chair with a lyre inlaid in the back. The klismos chairs with sharp-edged upholstered seats, promoted by Hope for British patrons, designers, and makers through *Household Furniture*, became the

quintessential example of Greek Revival furniture in Britain, as well as on the Continent.[68]

The extent of the commercial awareness of current fashionable trends also extended to such firms as Gillow & Co., furniture makers who were originally established in Lancaster with a branch in London and who were capable of making furniture in appropriate styles. Although the firm did not attract the same numerous royal commissions as Marsh and Tatham, Gillows had a substantial clientele among aristocratic and county families, and by 1805 they were supplying furniture incorporating the highly fashionable lion or leopard monopodia. Examples include a sideboard for the Earl of Lowther and a large suite of seat furniture for the Reverend Edward Hughes of Kinmel Park, Denbighshire, which included two couches with lion monopodia ends and anthemion decoration.[69]

The Influence of French Furniture on Hope

Thomas Hope combined his classical and exotic furnishings with contemporary French furniture, which he greatly admired and believed to be superior to that of any other style. His keen interest in French furniture design was doubtless extended during his stay in Paris in 1803, when, like other British visitors to the city, he probably saw the furniture made in 1798 by the firm of Jacob for the Hôtel Récamier, Paris (fig. 4-13).[70]

Among his French acquaintances was the architect Charles Percier, who was involved in the decoration of the Hôtel Récamier.

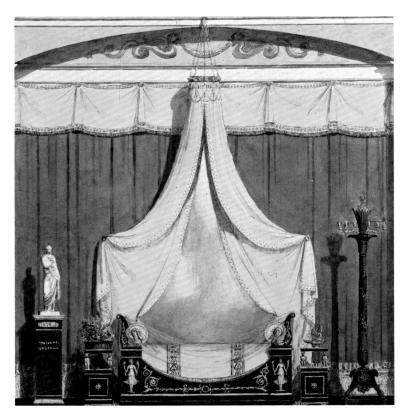

Fig. 4-13. Robert Smirke. *Mme Récamier's Bedroom*. Watercolor, 1802. Royal Institute of British Architects, London.

Hope described him as "uniting in himself all the different talents of the antiquarian, the draughtsman, the modeller, and the engraver."[71] Percier and his partner, Pierre-François Fontaine, promoted the Empire style in *Receuil de décorations intérieures*[72];

indeed, the similarity between the presentation of their book and of *Household Furniture*, and the similarity between their designs and Hope's, shows how important this influential source was for him, as Hope duly acknowledged.

As noted above, Hope also owned other contemporary French publications that served as useful sources of ideas, such as J. N. L. Durand's *Recueil et parallèle des édifices de tout genre, anciens et modernes*. Hope's sketchbooks include many details of French furniture, as well as classical and Early Christian monuments, which also inspired French designers. His sketch of the bishop's throne in Santa Maria in Cosmedin, Rome (see fig. 3-4), is strikingly similar to Durand's plate of a ceremonial seat.[73]

Hope admired the high quality of materials and techniques then fashionable in Paris, notably decorative metal inlay in wood, a technique that he typically praised both for aesthetic and practical reasons. He explained that

> *these species of inlayings in metal, on a ground of ebony or dyed wood, seem peculiarly adapted to the nature of the mahogany furniture so much in use in this country, which they enliven, without preventing it, by any raised ornaments, from being constantly rubbed, and kept free from dust and dirt. At Paris they have been carried to a great degree of elegance and perfection. The metal ornament, and the ground of stained wood in which it is inserted, being, there, stamped together, and cut out, through dint of the same single mechanical process, they are always sure of fitting each other to the greatest degree of nicety.*[74]

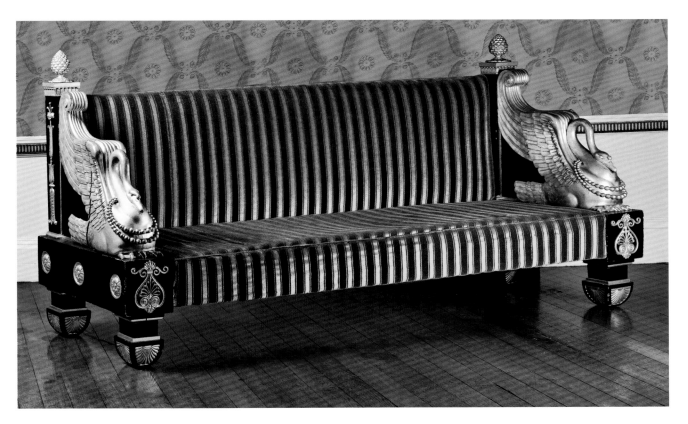

Fig. 4-14. Settee probably from the collection of Henry Philip Hope at Seamore Place. Ebonized and gilded wood, early 19th century. Private collection.

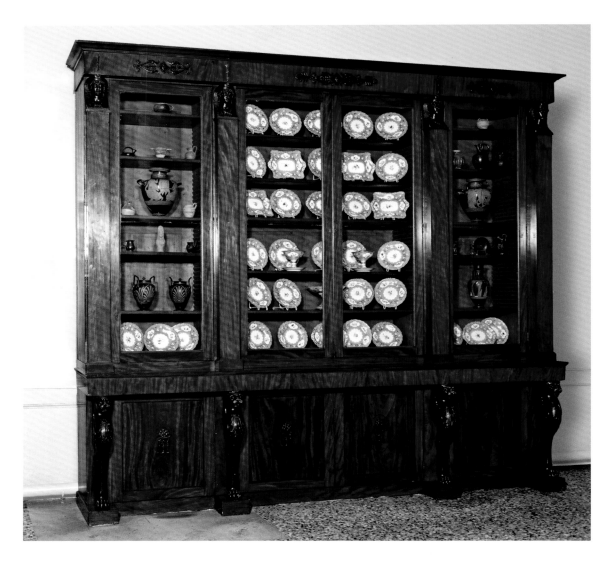

Fig. 4-15. Probably designed by Thomas Hope. Bookcase. Mahogany, bronze, ca. 1810. Bowes Museum, Barnard Castle, County Durham, FW.1972.64.

Hope appears to have favored this technique for various types of chairs at Duchess Street, including the klismos and chairs with backs featuring lyres illustrated in the third Vase Room and in one of the drawing rooms. According to Francis Douce, who visited the house before 1819, the Drawing Room on the first floor intended for company before dinner included a suite of seating furniture decorated with lyres, as well as a centrally placed table en suite, possibly of the type with lyres used as end supports (see cat. nos. 66, 74).[75] Hope's lyre-back chairs are strikingly similar to those illustrated in 1803 by a fashionable and influential French periodical, *Meubles et Objets de Goût*.[76] Other pieces of furniture at Duchess Street that may have been French are the small tables on caryatid or chimaera supports, one of which was in the center of the Indian Room, and other examples illustrated by Moses. Typical of Hope's preference for designs reflecting fashionable French furniture were the various pieces that incorporated images of swans (fig. 4-14).[77] He probably designed this furniture himself after French models, including those illustrated by Percier,[78] and he may also have seen furniture incorporating this motif made by the firm of Jacob-Desmalter in 1803 for the Empress Joséphine, who adopted the swan motif.

Hope was probably also inspired by contemporary French fashions in his designs for the deeply cushioned Directoire ottomans covered in rich silk damask that were illustrated in the third Vase Room and in the Indian Room, as well as for the elaborate drapery and distinctive patterns for curtains, seat upholstery, and beds. Wreaths, lyres, masks, anthemia, and other classical ornaments appear in the wide appliqué bands that edged plain curtains and decorated sofa covers. Some of this appliqué may have been made of printed cotton, a highly fashionable alternative to woven and patterned silks. Readily available in London, this fabric could have been adopted by Hope as part of his keen interest in promoting British materials. Distinctive trimmings include long tassels hanging from a trellis band, which was used extensively on settees and couches, including those in the Egyptian Room; on a variety of chairs and armchairs, including the klismos; and as edging on the cotton drapery around the bamboo arches in the Lararium.[79]

Household Furniture includes not only furniture and objects specifically created for Hope but also the far smaller number of pieces he acquired from commercial manufacturers and retailers. The publication thus reflects his approval of work more generally

available and must have fulfilled Hope's ambition to improve the taste of his contemporaries.

Some of his furniture sold during the great dispersal of the Deepdene collection in 1917 can be linked to particular plates in *Household Furniture*.[80] Although contemporary records, such as Hope's accounts or an inventory of his furniture, have not yet emerged, surviving pieces of distinctive design and manufacture can be identified as coming from his collection at either Duchess Street or the Deepdene.[81]

Hope's descriptions of individual pieces of furniture in *Household Furniture* did not always identify where they were placed in Duchess Street, nor did he include them in the views of the interiors. One example of this is the large-scale chandelier with candle supports in the form of griffins, which was later to hang in the Vase Room at the Deepdene (cat. no. 94). Hope's design, with a wreath of deadly nightshade below a crown of stars, symbolizing the triumph of light over dark, might suggest that he originally intended this chandelier for the Aurora Room, but the scale would make it too large for this intimate space.

However, the interiors at Duchess Street as illustrated in 1807 in *Household Furniture* subsequently changed as his collection grew, especially after his acquisition that year of the Deepdene, which offered greater opportunities for introducing new ideas for decoration and furnishing. Hope's sketch for the "large picture gallery" at Duchess Street includes bookcases not shown in the same view in his book, though they reappear in Westmacott's view of 1824.[82] Additions at Duchess Street, which must have influenced Hope's choices of appropriate furniture for new interiors, included his new Flemish Picture Gallery of 1819 (see Chapter 10). Here he combined a novel screen hung with pictures above cabinets with furniture from earlier interiors at Duchess Street, including armchairs with X-frame backs and smaller chairs with concave backs (see cat. nos. 65, 79), both types dating from about 1800 and illustrated in *Household Furniture* (cat. no. 113).[83] There were also swan armchairs similar to those designed by Percier and Fontaine and made by the firm of Jacob-Desmalter in 1803 for the boudoir of the Empress Joséphine at St. Cloud. However, Hope's chairs have front legs with a round section rather than the saber legs of the French model, suggesting another amalgamation of different influences typical of his furniture designs.[84]

The Egyptian Style

Hope was fascinated by the rich exoticism of Egyptian antiquity. The bold colors and strong outlines of Egyptian art and architecture inspired Hope to design his own Egyptian furniture, which may have shocked his contemporaries more than his designs inspired by Greek or Roman antiquities. Hope based his designs on observations from his Egyptian travels in 1797 and on the Egyptian antiquities he saw in Italian collections, such as the Capitoline and Vatican Museums in Rome, which he recorded in his sketchbooks.[85] As well as expanding his collection of antiquities, he also purchased large stones, including the slabs of green Egyptian porphyry he probably bought in Rome during his stay in 1795, which he admired for their deep color and used for the tops of tables, stands, and bookcases.

Hope's Egyptian furniture was revolutionary, because the overall form and details of decoration and ornament were based directly on Egyptian sources, an approach adopted more in France than in England.[86] Among the contemporary sources he acknowledged was the influential publication by Dominique Vivant Denon, *Voyages dans le Basse et la Haute Egypte* (1802), the illustrations of which must have influenced him. For example, he shows X-frame stools and armchairs with lion's-paw feet,[87] which were both reflected in Hope's furniture, the former in his designs for stools and the latter in his purchase for the Deepdene of armchairs designed by Denon and made by Jacob (see cat. no. 100).[88] The technique of taking casts and models from Egyptian antiquities already in public and private collections, as mentioned by Tatham, would have assisted Hope in commissioning these exotic pieces.

In order to reinforce his didactic approach and to emphasize the accuracy of his Egyptian furniture designs, Hope cited precise sources in Italy and Egypt for the details but not for the overall form, which he presumably based on his own observations or on printed sources.[89] He was also influenced by contemporary French furniture, since the profile of the bronzed and gilt chairs from the Egyptian Room at Duchess Street are similar to examples by Jacob.

Hope's wholehearted adoption of Egyptian forms and decoration for his furniture was not reflected in the pieces commissioned by his contemporaries, as his classical designs were. Egyptian details, such as sphinx heads, winged stars, and crocodile mounts, were applied to furniture of restrained classical form, as in the library furniture made for Stourhead by Thomas Chippendale the Younger in 1805. However, the Egyptian style was adopted for several contemporary schemes of interior decoration possibly influenced by those at Duchess Street. These included the dining room at Goodwood House, Sussex, decorated about 1803–6; the Egyptian Hall at Craven Cottage, London, decorated from 1805 by Walsh Porter and two interiors of 1805 at Stowe, Buckinghamshire; the Egyptian Hall and a bedroom decorated for the Duke of Clarence; and a short-lived "Egyptian Gallery" at Brighton Pavilion.[90]

Materials and Techniques

Hope used color and materials to define particular elements of his interiors and to distinguish between the different styles of furnishing in the more important rooms on the first floor of Duchess Street. His preference was for strong and vivid colors combined with contrasting textures and finishes, bolder and stronger than those used in France and reflecting his interest in Egyptian antiquities. Eastern aspects of the furnishing included Persian carpets and low, fitted ottomans with wall cushions, covered in crimson silk damask. This type of luxurious and unconventional seating, featured elsewhere at Duchess Street, may reflect Hope's early fascination with Turkey and Greece, including the interiors he sketched during his Ottoman Grand Tour.[91]

His use of mirrored glass for interiors, particularly in the Aurora Room and the Lararium, was probably influenced by contemporary practice in Paris, including the designs of Jean-Démosthène Dugourc and those illustrated by Percier and Fontaine. The use of glass may also indicate Hope's knowledge of William Beckford's Turkish Room at Fonthill House.[92] Presumably excited by seeing the reflections of Flaxman's statue of *Aurora and Cephalus* in the mirrored wall panels in the Aurora Room, Hope sought to heighten the effect by making alterations to the suite of tables in the room. The pier table and the side tables had different supports, the pier table with pairs of caryatids and the side tables with winged griffins, whereas both were altered in the same way on the back of the frame with a sheet of mirror glass inserted below the marble slabs between the back legs. This early alteration suggests that Hope decided to enhance the impact of the reflections in this intimate interior by continuing the mirrored effect down to floor level.

In common with contemporary continental fashion Thomas Hope commissioned objects in carved wood decorated to simulate patinated and gilded bronze (fig. 4-15). For example, his griffin wall lights (cat. no. 97)[93] were painted to give the impression of patinated bronze, an evocation of the classical antiquity that Hope greatly admired. The same practical technique was used for other wooden pieces he designed, including the helmet mounts (cat. no. 98) and the Egyptian seat furniture (cat. nos. 76, 77), which were also finished with a combination of bronzing and gilding. The chimaera legs on the table in the third Vase Room, described as bronze by Hope, may also have been of wood with a bronzed finish, if not of bronze.

Hope's preference for bronze mounts on his furniture, as seen on surviving pieces from his collection such as the tables from the Aurora Room (cat. nos. 68, 69) or in the Egyptian furniture (cat. nos. 76, 77), was also pragmatic and reflected his awareness of expense. He acknowledged the advantages of bronze casts for

mounts for various practical reasons, including cheap methods of production, the ease with which they could be changed or moved, and their resistance to damage and to the effects of the damp climate and smoky atmosphere of Britain.

Hope also favored furniture made of materials other than the conventional timbers of mahogany, lime, or beech. His preference for richly colored marble or stone pieces and for pietre dure may have been stimulated by the classical pieces he inherited from his father and subsequently by his interest in classical antiquities.[94] Several of the rooms at Duchess Street were furnished with slabs of imported colored marble, alabaster, or decorative mosaic, presumably placed on gilt-wood or metal stands. Westmacott mentioned three tripod tables in 1824, two in the Statue Gallery and one of *pavonazzo* marble in the Picture Gallery, and Douce praised a "fine mosaic slab" in the Indian Room, possibly on the central table illustrated in *Household Furniture*,[95] as well as more mosaic slabs in the Picture Gallery, presumably on the side tables against the walls; and a "slab of onyx alabaster" in the Lararium.[96] Gilt-wood tables, including those in the Aurora Room, had contrasting tops of black marble slabs.

As part of his campaign to experiment and innovate with furniture in the Greek Revival style, Thomas Hope commissioned some unusual British alternatives to imported stone or marble

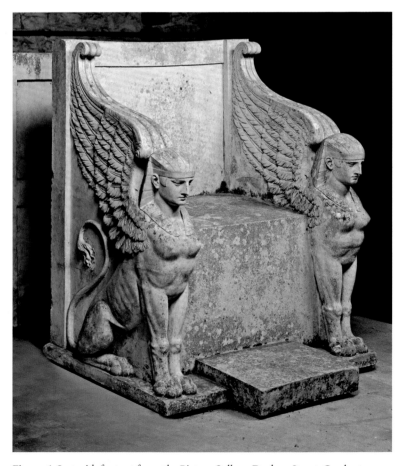

Fig. 4-16. Seat with footrest from tthe Picture Gallery, Duchess Street. Coade stone, ca. 1800. Parham House, Sussex.

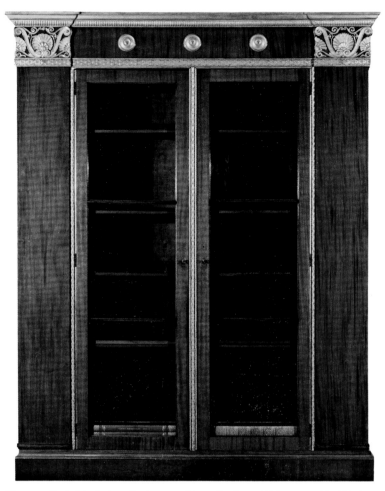

Fig. 4-17. Probably designed by Thomas Hope. Bookcase. Mahogany with gilded decoration. Christie's Images Limited 2007.

pieces. He chose furniture made of material likely to be less costly and more readily available, thus encouraging domestic production as part of his patriotic approach to design and manufacture. Examples of this combination of practicality and patriotism include the artificial stone casts that he purchased from Mrs. Coade's factory in London.[97] He placed Coade stone seats (fig. 4-16) decorated with sphinxes and lotus flowers in the Picture Gallery, described and illustrated in *Household Furniture*.[98]

The Deepdene

Although the Deepdene was described in 1826 as containing furniture "made after antique models"[99] (fig. 4-17), the interiors are not as well recorded as the picturesque exteriors. However, Hope appears to have furnished the house with a characteristically rich and distinctive combination of Empire-style furniture decorated with ormolu mounts, Egyptian revival pieces designed by Dominique Vivant Denon[100] and made by Jacob (see cat. no. 100), and Mona marble fireplaces and possibly furniture supplied by George Bullock. The only fully furnished room for which we have a watercolor impression of its vivid appearance during Hope's

occupancy is the Boudoir on the ground floor (see cat. no. 106.14). Completed by 1818, this was apparently Hope's favorite room, containing a mixture of Empire and Greek Revival furnishings with distinctive, bold colors and luxurious materials. The principal feature, an opulent day bed under a draped canopy decorated with gilded swans, with curtains hanging from gilt-metal rails on either side, is similar to designs by Percier and Fontaine and by Pierre de la Mésangère, but it also reflects Hope's fascination for exotic designs. In the center of the room was an inlaid circular table of the same model he originally designed for Duchess Street, but with a plain base. There was also a large cabinet with grilles in the upper doors, described as a china cabinet,[101] and a green Mona marble chimneypiece, probably supplied by George Bullock, sole proprietor of the quarry on Anglesey; above this hung a mirror with Empire gilt mounts.

As at Duchess Street, Hope's admiration for colored and variegated marble slabs, as well as for stone or marble stands and pedestals after classical models, must have given a grand and imposing impression in several interiors at the Deepdene. In addition to importing marbles, he also purchased examples from British quarries, including a large slab of Devonshire marble on a bookcase in the Drawing Room and chimneypieces of British marble in the Dining Room and the Egyptian Room,[102] as well as the Welsh chimneypiece in the Boudoir. The Entrance Hall contained a circular table inlaid with specimen marbles in the middle, the top of which may have been either imported or supplied by Bullock; inlaid side tables around the sides; and slabs of rare marbles set vertically in the walls.[103] More side tables with green porphyry slabs, typical of Hope's preference for strong Egyptian colors but also useful for keeping food cool, furnished the Dining Room, along with a mahogany sideboard with bronze, or possibly bronzed, mounts.[104] The wine cooler, however, was of china and may have been French, since Hope owned other pieces of china furniture, then very fashionable. His son Adrian John mentioned his father's purchase of a porcelain table for £80 at the Sèvres factory during a visit to France in 1822.[105] Hope also favored colored and patterned stoneware or porcelain seats of various shapes for particular locations, such as the chinoiserie octagonal stools on the steps of the Theatre of Arts at the Deepdene (cat. no. 106.9). These may have inspired the use of similar seats described at White Knights, Berkshire, in 1819 by Mrs. Hofland.[106] Other pieces that may have been French included a desk, described as an *escritoire*, and *boulle* cabinets in the Ante-Room and in the Lilac Room. Alternatively, these *boulle* pieces may have been supplied by George Bullock, who had developed his own version of the technique.[107] Hope's sketches of Empire desks and other furniture seen during his foreign tour of 1814 (fig. 4-18) were presumably preparatory ideas for revised schemes of furnishing at the

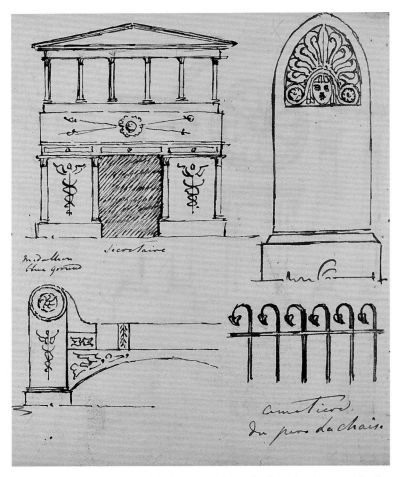

Fig. 4-18. Thomas Hope. Sketches of *secrétaire*, detail of sofa, and architectural details. From sketchbook. Royal Institute of British Architects, London, SKB 122/2, p. 80.

Deepdene, since he now preferred living in the country rather than London (see Chapter 12).

At the Deepdene, Hope created another Egyptian Room, for which he apparently purchased a suite of furniture designed by Dominique Vivant Denon and made by Jacob. These included a pair of chairs (cat. no. 100) and a day bed, presumably purchased during Hope's visit to Paris in 1814–15, since the chairs bear the stamp indicating that they were made between October 1803 and 1813. In 1819 the novelist Maria Edgeworth, who visited the house, provided a vivid description of Hope's Egyptian furniture and decoration in a letter to her stepmother: "The house is magnificently furnished but to my taste much too fine for a country house. . . . There is too much Egyptian ornament—Egyptian hieroglyphic figures bronze and gilt but all hideous. In one room called the Egyptian room there is a bed made exactly after the

model of Denon's Egyptian bed—a sofa bed broad enough for two aldermen embossed gold hieroglyphic frights all pointing with their hands distorted backwards at an Osiris or a long-armed monster of some sort who sits after their fashion on her hams and heels and hath the likeness of a globe of gold on her lappetted, scaly lappetted head."[108] The comparison with Denon's Egyptian furniture, which Hope had probably pointed out himself, is reinforced by evidence of another pair of chairs and a bed of the same design in Denon's own collection.[109]

Hope's distinctive schemes for furnishing at the Deepdene were not necessarily appreciated by his visitors, who appear to have found the lack of conventional country house furniture disconcerting. George Agar-Ellis, later 1st Baron Dover, gave a frank description of his surroundings in a letter to the Duke of Devonshire when he stayed at the Deepdene in June 1824: "The house execrable both within & without, bedaubed all over with the vilest ornaments in the vilest taste, being exclusively of Tommy's own invention. The furniture much the same as that in Dss Street—not a book to read, nor a chair to sit down upon, nor any of the ordinary comforts of civilized life—the place very pretty—so much for a specimen of my descriptive powers."[110]

In spite of this negative comment by a friend, Hope took pleasure and pride in the furniture that he designed and commissioned, right down to the smallest practical detail. This is obvious in a touching letter to his wife in which he describes a visit from the Earl of Rothes, possibly to the Deepdene shortly after he began his alterations. "I showed him all my lions; my water closet with which he was delighted; your new bed room which he approved of much; & my own room with which he was quite in rapture; the writing table; the suspended globe; the maps toppling down & going up with a spring; & of all things, my porters chair in which he did seated himself & to which if it was his own he would only have added one more improvement, a place underneath for his dog."[111]

Thomas Hope's strongly archaeological designs for furniture and interiors were personal and idiosyncratic, involving eclectic combinations of forms, motifs, and decoration. He should be admired for his immense personal achievements as a collector and patron, and above all for his determination to improve the standards of design and manufacture in Britain.

1. From Thomas Hope's introduction to *Household Furniture* (1807): 4.

2. Earl of Ilchester, ed., *Journal of the Hon. Henry Edward Fox . . . 1818–1830* (London: Butterworth, 1923): 186–87.

3. Five volumes of pen and watercolor sketches, some by Hope himself, are now in the Benaki Museum, Athens (see cat. nos. 16–34). See Fani-Maria Tsigakou, *Thomas Hope (1769–1831): Pictures from 18th century Greece* (Athens: Melissa, 1985). His travel sketchbook of ca.1812 (RIBA Drawings Collection, London, inv. no. 1978.52) includes details of furniture.

4. Cited in Watkin, *Thomas Hope* (1968): 198.

5. Two pairs of Coade stone seats with winged sphinx arms, of the same design as those illustrated in *Household Furniture*, pls. II and XIX, nos. 6, 7, but without the fringe along the front seat rail, were sold in the Deepdene sale by Humbert & Flint, 17 September 1917, lot 1061, and lot 1188, a pair with slab footrests. This second pair of seats is now at Parham House, Sussex, having been acquired in 1917 by Agnew's for Viscount Cowdray, and the pair is illustrated in Alison Kelly, *Mrs. Coade's Stone* (Upton-upon-Severn: The Self Publishing Association Ltd., in conjunction with the Georgian Group, 1990): 94.

6. *Household Furniture* (1807): 6. Hope expressed similar views in "A Letter on Instruction in Design," *The Artist* 8 (2 May 1807): 1–7.

7. *Household Furniture* (1807): 7.

8. Ibid., 8.

9. Geoffrey B. Waywell, *The Lever and Hope Sculptures, Ancient Sculptures in the Lady Lever Art Gallery, Port Sunlight* (Berlin: Gebr. Mann Verlag, 1986): 103–4, 112, cat. nos. 77, 78, 113.

10. Nicholas Penny, *Catalogue of European Sculpture in the Ashmolean Museum 1540 to the Present Day*, vol. 3 (Oxford: Clarendon Press, 1992): 104, cat. nos. 522, 523.

11. See collection of original letters and drawings, principally from C. H. Tatham to Henry Holland, 1794–96, Department of Word and Image, Victoria and Albert Museum, London, inv. no. D1479/1551-1898; Tania Buckrell Pos, "Tatham and Italy: Influences on English Neo-Classical Design," *Furniture History* 38 (2002): 58–82; Susan Pearce and Frank Salmon, "Charles Heathcote Tatham in Italy, 1794–96: Letters, Drawings and Fragments, and Part of an Autobiography," *The Walpole Society* 67 (2005): 1–91.

12. David Watkin, "Thomas Hope's House in Duchess Street," *Apollo* (March 2004): 30–39.

13. He bought sculpture, marble slabs, a marble chimneypiece, and a vase at Christie's on 31 May 1800, and on 3 April 1801 he bought Sir William Hamilton's second collection of Greek vases, followed by further purchases of sculpture at the Earl of Bessborough's sale on 7 April and at Christie's on 29 April. Waywell, *The Lever and Hope Sculptures* (1986): 42. According to Francis Douce, who visited Duchess Street before 1819, Hope retained the carpet he found in the Drawing Room, possibly because it was designed and made to fit the shape of the room. Peter Thornton and David Watkin, "New Light on the Hope Mansion in Duchess Street," *Apollo* 136, no. 307 (September 1987): 162–77. Douce's notebook, "Memoranda relating to Mr Hope's house," is in the Bodleian Library, Oxford, MS.Douce 60.

14. Hope sold various sculptures, a cinerary urn, and some marble pedestals at Christies, 27 March 1802. Waywell, *The Lever and Hope Sculptures* (1986): 42.

15. *Household Furniture* (1807): pl. XII, nos. 6, 7. Percier and Fontaine illustrated in *Recueil de décorations intérieures* (1812): pl. 16, a table of very similar design made by Jacob Frères, possibly indicating that it was made before 1803 when the name of the firm changed.

16. Tsigakou, *Thomas Hope* (1985): 32. Hope's annotated sketchbook of his journey from Rome to Paris ca.1812 is in the RIBA Drawings Collection, London, inv. no.1978.52. Further drawings by him are at the Yale Center for British Art, New Haven, inv. nos. B.1977.14.4721-4905.

17. *The Times*, 10 May 1802, p. 2, no. 5412.

18. Hope's design is in *Household Furniture* (1807): pl. XV, no. 1. Tatham drew the antique models in 1795, Department of Word and Image, Victoria and Albert Museum, London, inv. no. D.1547-98.

19. *Household Furniture* (1807): 10.

20. Ibid., pl. XLIV.

21. *The Artist* 8 (2 May 1807): 2.

22. Cited in Giles Ellwood, "James Newton," *Furniture History* 31 (1995): 147.

23. Ibid., fig. 43.

24. Flaxman's drawing of Neptune is from the *Iliad* (IV: 6). John Flaxman, *The Iliad and Odyssey* (Chicago: Art Institute of Chicago, 1919): 2135.

25. *Household Furniture* (1807): 53.

26. Sir John Soane's Museum 91/7/1, illustrated and discussed in *John Flaxman 1755–1826 Master of the Purest Line*, ed. David Bindman (London: Sir John Soane's Museum and University College London, 2003): cat. no. 65a. Subsequently identified as an early photographic facsimile and the original drawing published in *Watercolours and Drawings: The Annual Exhibition*, exh. cat., W/S Fine Art/Andrew Wyld, London (London, 2005): no. 23.

27. Hope owned copies of Tatham's books, including the second edition of *Etchings of Ornamental Architecture drawn from the Originals in Rome*, *Etchings of Fragments of Grecian and Roman Architectural Ornament* (1806), and two publications of 1811 illustrated by Henry Moses, *The Gallery of Brocklesby in Lincolnshire* and *The Gallery at Castle Howard*, all sold in the disposal of the Deepdene Library, Christies 25–27 July 1917, lot 624. Other subscribers to Tatham's first book included Flaxman, Decaix, J. M. Gandy, and Mrs. Damer, from whom Hope acquired a bust of *Mrs. Freeman as Isis*, now in the Victoria and Albert Museum.

28. Hope's sketch is illustrated in Watkin, "Thomas Hope's House" (2004): fig. 10.

29. *The Diary of Joseph Farington*, vol. 8 (New Haven and London: Yale University Press, 1982): 3154 (1–2 December 1807).

30. Dawe's 1811 portrait of Mrs. Hope with her sons is now in Nottingham University Art Gallery. The cradle illustrated in *Household Furniture* (1807): pl. XLIV, is described as mahogany with gilt-bronze ornaments emblematic of night, sleep, dreams, and hope. That shown in Dawe's portrait is of the same design but without the superstructure.

31. The earliest reference to Bogaert found so far is his employment as a subcontractor for the furniture maker Martin Foxhall in Sir John Soane's Ledger of 1786. See Simon Jervis, "Splendentia recognita: furniture by Martin Foxhall for Fonthill," *Burlington Magazine* 147 (June 2005): 378, n. 21. Bogaert was in partnership with Paul Storr as carvers and gilders, 23 Air Street, London from ca. 1805. See Geoffrey Beard and Christopher Gilbert, *The Dictionary of English Furniture Makers* (Leeds: W. S. Maney and Son, 1986). In 1807 the firm provided gilt-wood torchères for Carlton House, followed by Corinthian capitals in 1814. See *Carlton House, The Past Glories of George IV's Palace*, exh. cat. (London: The Queen's Gallery, Buckingham Palace, 1991): 210–11, and Hugh Roberts, *For the King's Pleasure: The Furnishing and Decoration of George IV's Apartments at Windsor Castle* (London: Royal Collection Enterprises, 2001): 430, n. 195.

32. *Household Furniture* (1807): 10. Bogaert may have made furniture for other clients using Hope's designs. For example, "The late Mr. Bogaert, in addition to his merits as a carver, was also equally happy in his designs for furniture and other branches of interior decoration" (George Smith, *The Cabinet-Maker and Upholsterer's Guide* [1826]: 194). Luke Foreman, a contemporary of Hope and fellow enthusiast for Empire and Egyptian furnishings, commissioned two sofas from "Bogarde" for his house in Harley Street, London, according to his wife's inventory of 1820 (private collection).

33. *Carlton House* (1991); F. J. B. Watson, "The Furniture and Decoration," in *Southill: A Regency House* (London, 1951): 19–41; "Southill Park, Bedfordshire," *Country Life* (28 April 1994): 62–67.

34. Examples of the Bacchic busts in wood, with a bronzed finish, on a bookcase with Jeremy Ltd., London, 2006, suggest that alternative versions were produced in different materials and techniques, reflecting Hope's innovative approach to design.

35. *Household Furniture* (1807): 132, 134, pl. LVII. Two large bookcases from the same commission are still in the Royal Collection, described and illustrated in Roberts, *For the King's Pleasure* (2001): 293, acct. 806. Two other bookcases survive from the Carlton House Library, a large one in Temple Newsam House, Leeds, and a smaller example in the Victoria and Albert Museum.

36. *Household Furniture* (1807): pl. XVIII, no. 5. For Morel, see Roberts, *For the King's Pleasure* (2001): 27–28. Hope's sofa, now lost, later belonged to Edward Knoblock and was illustrated in his London drawing room, at 11 Montague Place, in *Country Life* 69 (11 April 1931): 453, without the frieze on the back.

37. See Phillis Rogers, "A Regency Interior: The Remodelling of Weston Park," *Furniture History* 23 (1987): 11–34.

38. Ibid., 21.

39. *Household Furniture* (1807): pl. XXIV shows the klismos chair with scrolling ornament on the curving inside back while pl. XXVI, no. 6, shows the same chair, but with Parisian fringe around the seat, and a view of the outer back confirming that it was decorated as on the inside back. The Weston Park versions of this design cost £7 10s. Rogers, *Furniture History* (1987): 14, fig. 6.

40. See Roberts, *For the King's Pleasure* (2001): 35, for details of Bogaert's involvement at Windsor.

41. Bullock obviously knew Hope's designs, for his copy of *Household Furniture* was part of the disposal of his library in Liverpool after his death in 1819. See Clive Wainwright, introduction to *George Bullock Cabinet-Maker* (London: John Murray / H. Blairman & Sons, 1988): 46.

42. See *George Bullock Cabinet-Maker* (1988): no. 45.

43. Gandy, who had traveled to Italy with Tatham in 1794, was employed as a draftsman by Sir John Soane.

44. Hope's design is in his undated sketchbook, possibly from his French and Italian journey of 1814, in the Yale Center for British Art, New Haven, inv. no. B.1977.14.4763. For the Abbotsford cabinet, see *George Bullock Cabinet-Maker* (1988): 15.

45. H. J. C. Grierson, ed., *The Letters of Sir Walter Scott 1932–1937*, vol. 4 (Oxford: Oxford University Press, 1979): 289. Scott's cabinet was illustrated in the volume now in City Museum & Art Gallery, Birmingham, inv. no. M.3.74, inscribed "Tracings by Thomas Wilkinson, from the designs of the late Mr. George Bullock 1820," p. 85.

46. *Household Furniture* (1807): 9–10.

47. For example, in his letter to Holland of 8 August 1796 about a consignment of casts, Tatham warns that "in the originals the ornament is surprisingly under cut which you must allow for in the squeezes." Susan Pearce and Frank Salmon, "Charles Heathcote Tatham in Italy, 1794–96: Letters, Drawings and Fragments, and Part of an Autobiography," *Walpole Society* 67 (2005): 12.

48. *Household Furniture* (1807): 51.

49. Ibid., pl. XXVI, nos. 8, 9, p. 36.

50. Ibid., pl. XI, nos. 1, 2.

51. Henry Philip Hope was a collector and connoisseur known for his collection of Dutch and Flemish paintings, which he lent to his brother in 1819 for display in the new gallery at Duchess Street. The garden front of his house in Seamore Place, London, was embellished with a loggia with a Greek revival roof supported by four caryatids, shown in a watercolor in the Yale Center for British Art, New Haven, inv. no. B.1977.14.4765. In 1814 the house and some of the furniture were purchased by Welbore Ellis Agar, 2nd Earl of Normanton, and the furniture removed to Somerley, where it was recorded in the Inventory of 1874 as from Henry Philip Hope's collection.

52. The rosewood and ebony table, sold at Christie's, London, 3 July 1997, lot 60, is after Hope's design in *Household Furniture* (1807): pl. XII, nos. 1, 2, but has ram's-head masks instead of the lion's-head masks on the design. The settee with swan supports is after *Household Furniture*, pl. XL, nos. 2, 3; the design for a stool and the tripod table is very close to pls. XXV, no. 2, and LV, no. 5.

53. On the enthusiasm of Rogers for Hope's furniture and for *Household Furniture* itself, see P. W. Clayden, *The Early Life of Samuel Rogers* (London, 1887): 448–49.

54. Bogaert is probably the same person as "Bogaart," a German woodcarver who employed Francis Chantrey in 1803 to carve a pedestal for Rogers. See John Holland, *Memorials of Sir Francis Chantrey, R.A.* (Sheffield, 1851): 246–47. See *Catalogue of the very celebrated collection of works of art, the property of Samuel Rogers, Esq., deceased,* Christie and Manson, London, 28 April–29 May 1856. The pedestal was sold on 29 April, lot 294, bought by William Stuart for £10 10s, and may be that illustrated in a watercolor of his dining room at 22 St. James's Place, London. See John Cornforth, *Quest for Comfort: English Interiors 1790–1848* (London: Barrie & Jenkins, 1978): 131. Rogers also owned a sideboard, with ornaments carved by Chantrey, presumably supplied by Bogaert. See *Catalogue of the household furniture and effects of the late Samuel Rogers,* Christie and Manson, 28 May 1856, lot 4, bought by W. J. Alexander Q.C. for 18s.

55. The mahogany and bronze table, after the design in *Household Furniture* (1807): pl. XXV, no. 2, was sold at Christie's sale of works of art from Roger's collection, 5 May 1856, lot 823, bought by Agnew's, Manchester, for £18 10s. Lot 820, a pair of pier tables, with slabs of porphyry, on gilt tigers' legs, bought by Waters for £28, may also be examples of Hope's influence. Christie's catalogue of Rogers's household furniture, sold on the premises, 22 St. James's Place, London, 28 May 1856, included in the library, lot 38: "A pair of beautiful mahogany chairs, the arms supported by griffins; and a stool, with swans—en suite, of classical design," bought by William Sharpe for £11.

56. *Particulars and Conditions of Sale of the Beautiful Leasehold Residence, of Samuel Rogers, Esq., Deceased, No. 22, St. James's Place,* Christie and Manson, London, 7 May 1856, included the description of the arched recess in the first-floor anteroom.

57. Ellwood, "James Newton" (1995): 147, figs. 44, 45. Ellwood also suggests that a sofa or writing table with wedge-shaped end supports with Newton's label and now at Soho House may also be derived, much-adapted, from Hope's pl. XX, no. 2.

58. The armchairs are made after the design in *Household Furniture* (1807): pl. XXII, nos. 5, 6.

59. A pair of these, one with the label and date, numbered II and VII, is in the King's Library, Brighton Pavilion, and the other pair, numbered V and VI, is in the collection of the Victoria and Albert Museum. The Brighton pair came from the collection of Charles and Lavinia Handley-Read, better known as pioneering collectors of High Victorian furniture by William Burges and E.W. Godwin. Another pair of chairs of the same design were sold Christie's, 15 April 1982, lot 14.

60. The influence of Hope's furniture designs may also be indicated by the "2 Hope Canopy Testers" for beds supplied by Newton to the Earl of Breadalbane in 1812. See Ellwood, "James Newton" (1995): 135, 189.

61. *Household Furniture* (1807): pls. XIX, no. 4, XXV, and XXVI, no. 6. Ellwood, "James Newton" (1995): 148, fig. 47. One of the chairs is now back in Soho House and the other in the Victoria and Albert Museum.

62. Now in Sir John Soane's Museum, London.

63. *Household Furniture* (1807): 12. Hope may have been referring to the ungainly and unsophisticated applications of animal and bird monopodia, busts, and other classical details to furniture in designs illustrated by Thomas Sheraton in *The Cabinet Dictionary* (1803) and *The Cabinet-Maker, Upholsterer, and General Artist's Encyclopaedia* (1804), and by George Smith in *Collection of Designs for Household Furniture* (1808), as well as to commercial furniture produced by firms anxious to take advantage of current preoccupations with classical forms and decoration.

64. *Literary Gazette* (12 February 1831): 107.

65. By 1808, the *Supplement to the London Chair-Makers' and Carvers' Book of Prices* had a full range of classically inspired designs including Grecian couches, chairs with saber legs, and "Grecian cross fronts," ill. on p. 22, pl. 3. For an analysis of the various editions of the books of prices, see Christopher Gilbert, "London and Provincial Books of Prices: Comment and Bibliography," *Furniture History* 28 (1982): 11–20.

66. The Imperial Turkey Ottoman, or Circular Sofa, was illustrated in *The Repository of the Arts*, ser. 1, vol. 5 (January 1811): 50, pl. 5.

67. For example, in *The Repository of the Arts*, ser. 1, vol. 8 (December 1812): 353, pl. 39, is a bookcase decorated with bronze or ormolu mounts of the Muses and other symbols representing learning.

68. Numerous versions of the klismos were fashionable in France, Italy, Denmark, and other countries, as well as in Britain. See M. Gelfer-Jorgensen, *The Dream of a Golden Age: Danish Neo-Classical Furniture 1790–1850* (Humlebaek, Denmark: Rhodos, 2004). Alternative versions, one with a single back support and others with double back supports, are shown in use in Italy in 1807, see Peter Thornton, *Authentic Décor: The Domestic Interior 1620–1920* (London: Weidenfeld & Nicolson, 1984): pl. 249. British tourists in Italy were immortalized in paintings with a klismos as a symbol of classical taste, such as the portrait of Lady Clifford by Robert Fagan in 1791, *Masterpieces from Yorkshire Houses: Yorkshire Families at Home and Abroad 1700–1850* (York: York City Art Gallery, 1994): no. 43.

69. The Lowther sideboard is recorded in *Gillow's Estimate Sketch Book* (1805): no. 1761, Westminster Archives Centre. The Kinmel Park furniture remained in situ until 1929, when it was sold by Sotheby & Co. with Browne (Chester) Ltd.,

4–13 June, lots 6–10. One of the couches is now in the Victoria and Albert Museum; the other was formerly at Sheringham Hall, Norfolk, and sold in the dispersal of the Sarofim Collection, Christie's 16 November 1995, lot 143.

70. For contemporary descriptions of the fashionable interiors of the Hôtel Récamier of 1798 by L.-M. Berthault, see *Au temps des merveilleuses la société parisienne sous la Directoire et le Consultat*, exh. cat., Paris, Musée Carnavalet (Paris: Musées parisiens, 2005): 101–5, which also mentions the astonishing public interest in Mme Récamier during her visit to London in 1802. The interiors are illustrated in J. C. Krafft and N. Ransonette, *Plans, coupes, élévations des plus belles maisons et des hôtels construits à Paris et dans les environs*, 2 vols. (Paris, 1801–2).

71. *Household Furniture* (1807): 14.

72. Hope may have been familiar with some of Percier and Fontaine's designs before commissioning furniture for Duchess Street, since 54 plates of the *Recueil de décorations intérieures* were published by 1805 and all 72 by 1812.

73. Hope's sketch is in the RIBA sketchbook, 1978.52, p. 36. Durand's version is pl. 78 in his *Recueil et parallèle*.

74. *Household Furniture* (1807): 35. Bullock may have been influenced by Hope's use of this French technique, but he developed his own distinctive form of inlaid decoration in metal and in wood, using native forms rather than the classically inspired ornament favored by Hope.

75. Peter Thornton and David Watkin, "New Light on the Hope Mansion in Duchess Street," *Apollo* (September 1987): 162–77. Hope included drawings of lyres in *Costume of the Ancients*, vol. 1 (1809): 60, while his sketchbook from his Italian and French travels of ca. 1812 included a sketch of a lyre from a figure of Apollo in the Pitti Palace, Florence.

76. Pierre de la Mésangère, *Meubles et Objets de Goût* (Paris, 1803): no. 80.

77. The ebonized seat with gilt swan armrests was acquired with Henry Hope's collection at Seamore Place by the 2nd Earl of Normanton for Somerley, where it was illustrated in a view of the Picture Gallery by C. J. Walker, 1853.

78. Percier and Fontaine, *Recueil de décorations intérieures* (1802): pl. 19, is an elaborate bed accompanied by a tripod with swan supports which they designed for Mme. Moreau in Paris.

79. Examples of fashionable textiles possibly used by Hope and similar to those illustrated by Moses are illustrated in Mobilier national, *Soieries Empires*, Inventaire des collections publiques françaises no. 25 (Paris: Éditions de la Réunion des musées nationaux, 1980). The distinctive "Parisian" fringe featured several times in Ackermann's *Repository of the Arts*, for example, in July 1809 (vol. 1, no. 2, pl. 3, p. 60). Printed chintz borders in classical, Egyptian, and other fashionable designs intended for curtains and for seat upholstery, 1802–14, survive in the Duddings Pattern book. See Wendy Hefford, *The Victoria & Albert Museum's Textile Collection Design for Printed Textiles in England from 1750 to 1850* (London: V&A Publications, 1999): 25, nos. 113–123.

80. Furniture in this category includes lots 293, 297, 298, 300, 301, 302, 304 in Christie's sale, London, 18–19 July 1917.

81. A suite of seat furniture that might have belonged to Hope is the set of gilt-wood armchairs and chairs with griffin arm supports, originally in the collection of Cardinal Fesch and now at Beningbrough Hall, Yorkshire, from the collection of Muriel, Lady Murray (née Beresford Hope), four of which are labeled "Hope." Lady Murray might have inherited this suite from her grandfather, A. J. B. Hope, youngest son of Thomas Hope. I am grateful to Lucy Wood for this information taken from her forthcoming catalogue of seat furniture at the Lady Lever Art Gallery.

82. Watkin, "Thomas Hope's House" (2004): fig. 10.

83. *Household Furniture* (1807): pl. IX, nos. 3, 4, and pl. XXVI, no. 5.

84. Denise Ledoux-Lebard, *Les Ébénistes du XIXe siècle* (Paris: Les Editions de l'Amateur, 1984): 335. Four of the St. Cloud chairs are now at Malmaison.

85. One volume of Egyptian drawings and sketches, some by Hope but also including work in other hands, part of the collection from his Grand Tour, is in the Benaki Museum, Athens. See Tsigakou, *Thomas Hope* (1985): 19; Watkin, *Thomas Hope* (1968): 65.

86. Jean-Marcel Humbert, Michael Pantazzi, Christiane Ziegler, *Egyptomania: L'Egypte dans l'art occidental 1730–1930* (Paris: Réunion des musées nationaux, 1994). I am grateful to Dr. Nigel Bamforth for sharing his research into Hope's Egyptian furniture.

87. Denon, *Egypte . . .* (Paris: P. Didot, 1802): pl. 135.

88. David Kelly, "The Egyptian Revival: A Reassessment of Baron Denon's Influence on Thomas Hope," *Furniture History* 40 (2004): 83–98.

89. For example, the monumental doorways surmounted by couchant lions that he sketched during his Italian and French travels in 1812. RIBA Drawings Collection, 1978.52, p. 13.

90. Patrick Conner, ed., *The Inspiration of Egypt* (Brighton: Brighton Borough Council, 1983): 49, cat. no. 88, 52–53, cat. no. 105. Porter's Egyptian Hall, possibly remodeled for him by the young Thomas Hopper, was described in Ackermann's *Repository of the Arts* 3 (June 1810): 392–93, and in T. Faulkner, *Historical and Topographical Account of Fulham* (London, 1813): 432–34. See John Morley, *Making of the Royal Pavilion Brighton* (London: Philip Wilson, 1984), for the Egyptian Gallery mentioned in 1809.

91. Tsigakou, *Thomas Hope* (1985): 20, pl. 2; 41, cat. no. 1.

92. Hope, who knew Beckford, may have seen the Turkish Room at Fonthill House with mirrored walls separated by drapery, which was completed by 1799. Philip Hewat-Jaboor, "Fonthill House," in Derek Ostergard, ed., *William Beckford 1760–1844: An Eye for the Magnificent*, exh. cat., Bard Graduate Center, New York (New Haven and London: Yale University Press, 2001): 63.

93. *Household Furniture* (1807): pl. LIII. In terms of technique, a close parallel with contemporary work in France can be seen in the remarkable trumpeting angel after a design by Pierre-Louis-Arnulphe Duguers du Montrosier of ca. 1806. See Richard Redding Antiques, *Masterpieces of the Past* (Zurich, 2007): 12–13.

94. For the furniture that Hope inherited, see J. W. Niemeijer, "De kunstverzameling van John Hope (1737–1784)," *Nederlands Kunsthistorisch Jaarboek* 32 (1981): 127–232.

95. *Household Furniture* (1807): pl. xv, nos. 4, 5.

96. Waywell, *The Lever and Hope Sculptures* (1986): 103–4, cat. nos. 77, 78.

97. Hope purchased an Egyptian lion from Coade and Sealy between 1799 and 1813. See Kelly, *Mrs. Coade's Stone* (1990): 262–63, 271. This lion survives in a private collection.

98. *Household Furniture* (1807): pls. II and XIX, nos. 6, 7, showing seats with Parisian fringe on the front seat rail. Tatham's book illustrating the seats was available at the Coade stone factory in Lambeth, London, suggesting that they found it a profitable design source.

99. J. P. Neale, *Views of seats of noblemen and gentlemen in England, Wales, Scotland and Ireland*, ser. 2, vol. 3 (1826): 6.

100. *Dominique-Vivant Denon: l'oeil de Napoléon*, exh. cat, Musée du Louvre, Paris (Paris: Réunion des musées nationaux, 1999).

101. Neale, *Views of seats* (1826): 10. This cabinet was subsequently owned by the photographer and interior decorator Angus McBean (1904–1990).

102. Neale, *Views of seats* (1826): 6, 10, 11.

103. Ibid., 3.

104. Ibid., 6. Subsequently moved to the Hall, the side tables were acquired in 1917 by the Ashmolean Museum, Oxford. See Penny, *Catalogue of European Sculpture in the Ashmolean Museum*, vol. 3 (1992): 104, nos. 522, 523.

105. See Adrian John Hope's diary, now in a private collection. I am grateful to Daniella Ben-Arie for this reference.

106. Hope knew Mrs. Hofland, whose book on White Knights included his article on the "Art of Gardening" originally published in 1808. There were several ceramic octagonal and barrel-shaped garden seats, with chinoiserie decoration, included in Christie's *Catalogue of Objects of Art Porcelain Old English and Other Furniture removed from the Deepdene*, London, 18 and 19 July 1917, lots 169, 201, 202, 203.

107. Neale, *Views of seats* (1826): 6, 7, 11. For Bullock's *boulle* cabinets, see Wainwright, introduction (1988): nos. 41, 43.

108. Maria Edgeworth, *Letters from England 1813–44*, ed. Christina Colvin (Oxford: Clarendon Press, 1971): 197.

109. Lucy Wood and Sarah Medlam, "A pair of Egyptian Revival chairs designed by Denon," *Apollo* 145, no. 424 (June 1997): 45–47.

110. Chatsworth Archive: 6th Duke's Group, letter 988. I am most grateful to John Kenworthy-Browne for this fascinating discovery.

111. Undated letter from Thomas Hope to Louisa Hope at Duchess Street, British Museum, Add MS 54227.

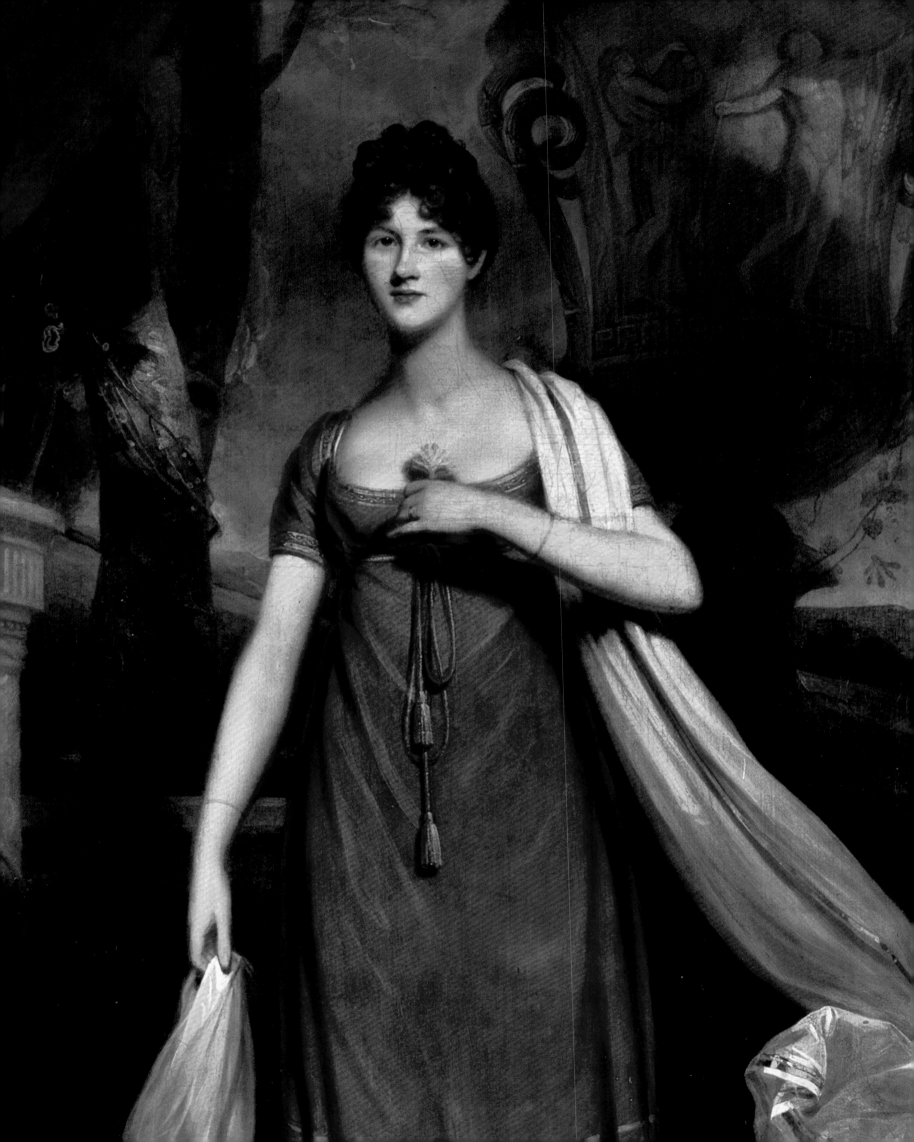

CHAPTER 5

Fashion à l'Antique: Thomas Hope and Regency Dress

Aileen Ribeiro

In ancient Greece, Costume was elevated to the rank of a Fine Art; its principles were defined; its influence on taste, on the arts, on manners and on morals, was wisely appreciated.
—*Beau Brummell,* Male and Female Costume *(1822)*[1]

Thomas Hope's interest in dress may have been formed, and was certainly stimulated, by his youthful journeys to the Ottoman Empire, which provided source material for his *Anastasius, or the Memoirs of a Greek*, an Orientalist farrago, part travelogue, part novel, heightened by the author's feverish romantic imagination.

In *Anastasius* the eponymous hero reveals his longing for the colorful costume he sees everywhere around him (Greece was under Turkish rule), and especially "one of those smart turbans of gilt brocade or shawl worn with such a saucy air, over one ear, by the Pasha's Tsawooshes [couriers or ushers], gentlemen who were seen every where, lounging about as if they had nothing to do but to sport their handsome legs, their vests stiff with gold

lace"[2]; he also covets such a vest, finally buying one in Constantinople "of velvet embroidered richly over the seams."[3]

Like his alter ego, Hope also bought colorful Ottoman clothing, and he was painted thus attired in 1798 by William Beechey (cat. no. 1), many years before Byron's famous portrait in Albanian costume.[4] Hope's outfit (an amalgam of Greek, Turkish, and Albanian dress) features a turban, two gold-embroidered velvet vests (cat. no. 2), a striped silk sash, and baggy cloth breeches.[5] It is a startling contrast to the customary wear of late eighteenth-century Western European man in his unadorned, tight-fitting sober suit, what Hope describes in *Anastasius* as "the sombre livery of Christianity."[6]

Along with many Enlightenment travelers in the Levant, Hope found there much to praise in the costume, which tended to be loose-fitting, picturesque, and relatively unchanging in style, compared to European dress, which was subject to whim and novelty. A drawing made by Hope in the late 1780s (fig. 5-1) underlines the contrast between the comfortable and modest costume of female Greek dress, and the somewhat absurd fashions—the feathered

Fig. 5-1. Thomas Hope. "Tartar Messenger, Greek lady, French Merchants Wife, Embassador's Jenissary, Greek Lady, Greek Woman, Taooishan." Drawing from the Benaki Album, vol. II, no. 27112. Benaki Museum, Athens.

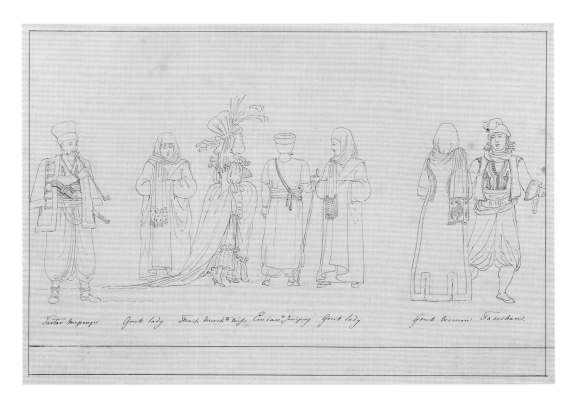

Opposite: Sir Martin Archer Shee. *Louisa Hope* (detail). Oil on canvas, 1807. The Hon. Mrs. Everard de Lisle. *Cat. no. 3.*

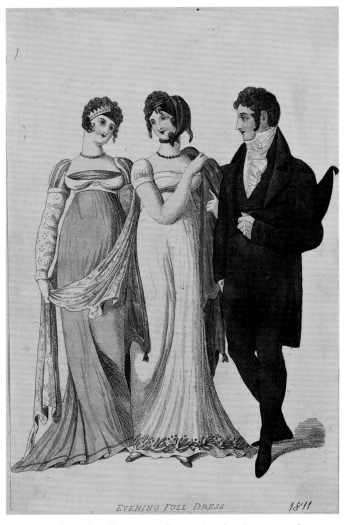

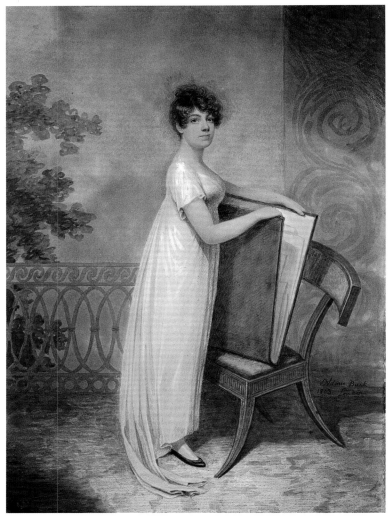

Fig. 5-2. Fashion plate: "Evening Full Dress." Colored engraving from *Le Beau Monde* (March 1808). Courtauld Institute, London.

Fig. 5-3. Adam Buck. *Portrait of a Girl with an Artist's Folio*. Black chalk and watercolor on paper, 1803. National Gallery of Ireland, Dublin, NGI 7738.

hat, the side hoops and sweeping train of the skirt—as worn by a French merchant's wife.

Yet it was the costume of ancient Greece that particularly appealed to Hope, as it did to many of his contemporaries. To the artist Thomas Baxter, in his *Illustration of the Egyptian, Grecian and Roman Costume* (1810), dedicated to Henry Fuseli, the dress of the ancient Greeks was the best, "as it is to them we owe all that is elegant or dignified in Art."[7] Hope's praise for the "beauty of form and outline" of ancient Greek architecture was an apt description of his views on the clothing of classical Greece.[8] Beau Brummell, whose *Male and Female Costume* (1822) was clearly indebted to Hope's work on classical costume, thought that the Greeks and the Romans "were the handsomest, the noblest, the most unaffected, and the best dressing; in short, the most gentlemanly people that ever were or will be."[9]

Although Brummell claimed that for men, "the looser drapery of the trowsers, the tunic and cloak are regular and steady approaches to the refined and elegant taste of antiquity,"[10] the unstructured and flowing clothing of classical antiquity was an impossibility in the modern world of the early nineteenth century, where the Industrial Revolution dictated the dark, tailored masculine suit and the starched high-collared shirt and cravat. The black formal menswear—"the most genteel and most proper"[11]— depicted in a fashion plate of 1808 from *Le Beau Monde*, entitled *Evening Full Dress* (fig. 5-2), is in marked contrast to the graceful neoclassical dresses of the women, especially the central figure in white muslin over white satin. By the early nineteenth century, clothing, perhaps for the first time, seems to emphasize conventional definitions of gender, being more overtly "masculine" and "feminine" in style and color.

The only token gestures toward the "classical" in menswear were: hairstyles cut short and curled *à la Titus*, or *à la Brutus*; the light-colored tight trousers (pantaloons) made of stretchable, often knitted fabrics, which clung to the figure and which on a well-proportioned man might suggest antique nudity (see fig. 7-26, although the effect is lessened by the fashionable hussar boots); or the way in which a voluminous riding cloak could be draped around the body in imitation of the Greek himation or the Roman toga.[12]

Otherwise, gentlemen had to content themselves with appreciating the antique style in terms of décor (classical marbles, neoclassical furnishings, and design), architecture, and an ever-increasing number of publications, from the mid-eighteenth century onward, which popularized classical culture, a sine qua non for the educated elite. Brummell went so far as to propose the foundation of a "'Club of Costume,' in which no gentleman should be admitted as a member who is not well versed both in its Grecian and Roman progress, and in its principles as a fine art."[13]

Such a Club of Costume (surely Hope would have been a founder-member had it come into being) would find an obvious source of classical inspiration in contemporary female dress, which by the end of the eighteenth century was simple in style, high-waisted, short sleeved, and fashionably made of fine white muslin that clung to the body in graceful folds like the linen *chiton* (tunic) of ancient Greece. As Edward Bertram remarks in Jane Austen's *Mansfield Park* (published in 1814), "a woman can never be too fine while she is all in white." These styles can be seen in watercolors by Adam Buck, where the figures, although slightly idealized, are nonetheless truthful regarding the details of dress and hairstyles, the latter usually curled in various "antique" styles, "shin[ing] in beautiful lustre carelessly turned round the head in the manner adopted by the most eminent Grecian sculptors."[14] Buck, an Irish-born artist who spent most of his career in London, had similar antiquarian interests to Hope's, including a serious collection of Greek vases. In his portrait of a girl with an artist's folio (fig. 5-3), the classical influence can be seen in both the sitter's white muslin dress and the klismos chair in the manner of Hope.

The rage for the antique in both the fine and the applied arts was especially pronounced in France, where a passion for the heroic days of classical antiquity was linked to the stirring political and military events set in train by the French Revolution, and the establishment in 1792 of the First Republic. The *Lady's Magazine* in 1798 published a description of a fashionable ball in Paris, taken from Helen Maria Williams, an ardent Francophile and enthusiast for the Revolution:

> . . . *stately silken beds, massy sophas, worked tapestry and gilt ornaments are thrown aside as rude Gothic magnificence, and every couch resembles that of Pericles, every chair those of Cicero—where every wall is furnished Arabesque, like the baths of Titus—and every table upheld by Castor and Pollux is covered with Athenian busts and Etruscan vases . . . every chimney iron is supported by a sphinx or a griffin. The dress of the female visitors was in perfect harmony . . . they are the most rigid partisans of Grecian modes of dress, adorned like the contemporaries of Aspasia. The loose, light drapery, the naked arm, the bare bosom, the sandalled feet, the circling zone, the golden chains, the twisted tresses, all display the most inflexible conformity to the laws of republican costume.*[15]

In England, such attention to detail in classical design and costume was not usual. History painting with classical or mythological themes had never enjoyed great popularity, as Hope noted[16]; even the revered Sir Joshua Reynolds, in his quest for "timeless" images during the 1770s, had largely failed to appeal when portraying society women *à l'antique*, in stiff, statuesque poses and meaningless white draperies. It was only when the classical became a fashion rather than an ideology that it took hold in the late 1780s, a trend aided by medical arguments in support of light, washable cottons.[17] The combination of aesthetics with health finally ensured the popularity of antique styles among Reynolds's female compatriots after his death.

If it was Hope's mission to promote in women's costume a more sustained and accurate vision of classical Greece, it was a difficult task because of the lack of specialist books in English on antique costume, as compared to the situation in France, where a considerable number of publications had appeared by the early nineteenth century.[18] Furthermore, costume that was too "Grecian" might be seen to indicate sympathy with French taste and what the *Lady's Magazine* referred to as "the malignant principle of equality."[19]

Added to this was the notion that neoclassical dress, which emphasized the bust, drew attention to bare arms, and revealed the legs through its semitransparent folds of muslin, could easily become indecorous. John Bowles in his *Remarks on Modern Female Manners* (1802) blamed the "extreme indelicacy of Female Dress in France" for the "indecent exposure which they [Englishwomen] make of their persons."[20] Although some commentators praised the female "Form [which] appears through their snow-white draperies in that fascinating manner which excludes the least thought of impropriety,"[21] a seemingly greater number took the opposite view, censuring such styles of dress for immodesty. Typical of the critical comment that flourished during the first two decades of the nineteenth century is an anonymous poem, "Dress and Address" (1819), which describes how Fashion, "in times succeeding more display'd each limb; / Gave more transparent covering to the breast, / And show'd the form of beauty half undress'd: / Took Greek and Roman statues for her plan / Exhibiting the master-piece to man."[22]

By the time Hope published his *Costume of the Ancients* (1809; cat. no. 110), the simple muslin shifts of the 1790s had given way to more complex and layered styles, such as the kind of dress with an over-tunic seen in Martin Archer-Shee's portrait of *Louisa Hope* of 1807 (cat. no. 3). This dress was possibly inspired by the thigh-length tunic and long stole worn by a "Bacchante with the thyrsus" from Hope's *Costume of the Ancients*.

Increasingly, dress had decorative draperies that referenced the overfold of the ancient Greek peplos (tunic), as can be seen when

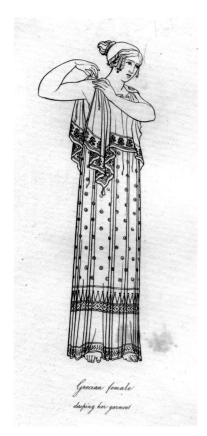

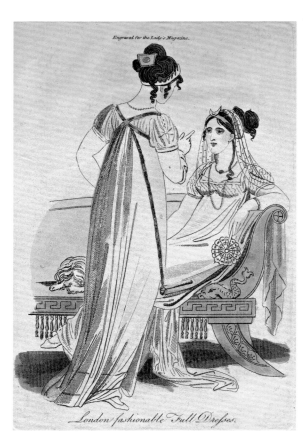

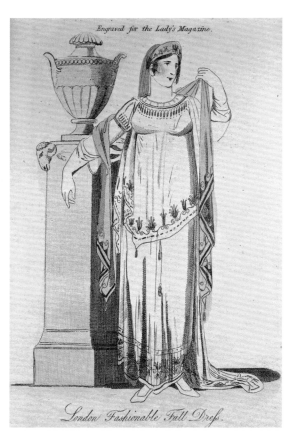

Fig. 5-4. Thomas Hope. Grecian female draping her garment. Engraving from *Costume of the Ancients*, vol. 1 (1812): pl. 63.

Fig. 5-5. Fashion plate: "London Fashionable Full Dress." Colored engraving from *Lady's Magazine* (May 1808). Museum of London 2002.139.1817.

Fig. 5-6. Fashion plate: "London Fashionable Full Dresses." Colored engraving from *Lady's Magazine* (March 1807). Museum of London 2003.139.1933.

comparing Hope's "Grecian female draping her garment" from his *Costume of the Ancients* (fig. 5-4), with a fashion plate from the *Lady's Magazine* for May 1808 (fig. 5-5). As to the latter, a "London Fashionable Full Dress" of white silk, "ornamented with a rich Greek or Etruscan border," the editor remarks: "The fashions for the present month exhibit a costume perfectly antique, the elegant simplicity of which, and the classic taste of the ornaments, do great credit to the invention of our fair countrywomen."[23]

Cashmere shawls, loose stoles, and mantles (some with tassels—see figs. 5-2 and 5-5—in imitation of ancient Greek dress had weights that held garments in the requisite draped shapes) served to emphasize the admired classical effect. "Antique" hairstyles with fillets, nets, combs, bandeaux, and veils were featured in fashion magazines. So too were turbans (popular from the 1760s onward), which received a boost from Bonaparte's invasion of Egypt in 1798 (and Nelson's victory over the French at the Battle of the Nile), events that set off a wider interest in the Near East and North Africa.

Also fashionable was jewelry in "antique" taste, such as cameos, intaglios, pearls, semiprecious stones, and gold chains, especially of fine filigree work. In the fashion plate entitled "London Fashionable Full Dresses" (fig. 5-6) from the March 1807 issue of *Lady's Magazine* (which could have been designed by

Henry Moses for Hope's *Designs of Modern Costume*—even the dog is the same), the seated figure on the classically inspired daybed wears a gold bandeau with a pearl crescent in her hair; her companion's jewelry includes "a tiara of pearls or small white beads . . . necklace and bracelets of small amber beads."[24]

In 1809 Hope published his pioneering work *Costume of the Ancients*.[25] Henry Moses, a young printmaker with a particular interest in the neoclassical,[26] engraved the designs from Hope's drawings; the idealized and schematic figures surely owe much to Flaxman, whom Hope greatly admired.[27] According to Hope, the knowledge of classical dress was increasingly essential for artists of all kinds; "without truth of costume, the story cannot be clearly told."[28] Thus it was his intention to provide "a convenient and a cheap collection of those leading features of ancient costume"[29] so that artists could aim for "that beauty of form, that sublimity of expression, that knowledge of external anatomy, that prodigious diversity in the texture of stuffs, and in the form of folds, that inexpressible elegance and that endless variety in the throw of the drapery, displayed in the finest ancient works."[30]

Such advice was also appropriate for women, so that their clothing could be improved "by the dismissal of those paltry and insignificant gew-gaws and trimmings that can only hold together through means of pins, sowings and other eye-rending con-

trivances, unknown in ancient dresses; through which the breadth and simplicity of modern female attire is destroyed and frittered away."[31] Like other critics of "female attire," both before his time and later, Hope thought that ancient Greek dress was based on "the throw of . . . drapery," a belief promoted in particular by the dress reformers later in the nineteenth century, who claimed to find the idea of sewing and other "contrivances" unaesthetic.[32]

There is some confusion in *Costume of the Ancients* regarding the interpretation of dress; this is inevitable given the absence of extant garments, the sketchy state of knowledge in Britain about the details of antique clothing, and the nature of the stylized information from the source material, which included the vases in Hope's famous collection.[33] It is not clear, for example, if—in spite of the comment above on "sowings"—Hope thought that *some* costume in ancient Greece might have been sewn, a problem that has still not been satisfactorily resolved.[34] Nor are the types of dress always clear as to definition; for example, Hope variously describes the Doric peplos (or peplum, as he calls it) as a kind of bodice, a "species of bib,"[35] and a mantle held down with "little weights or drops,"[36] but the illustrations (see figs. 5-4 and 5-9) depict it reasonably accurately as a dress with an overfold, pinned on the shoulders. Such occasional difficulties in "reading" the dress are partly explained by the fact that Hope's plates are often composite, "frequently combining in a single figure the representations of articles collected from many different originals," as being "best suited to the painter's purpose."[37]

But this is not to detract from *Costume of the Ancients*, which was the first publication in English to provide information on the clothing of classical antiquity. It was an innovative and influential work for the time, even though Hope only modestly claimed that his book was not intended for antiquarians, or "to advance erudition, but only to promote taste."[38]

Fig. 5-7. White muslin dress with bodice embroidered in a Greek key pattern (detail). Victoria and Albert Museum, London, T 733-1913. ©V&A Images.

In this it succeeded, if we are to believe the enthusiastic review in the influential journal *Ackermann's Repository of Arts, Literature, Commerce, Manufactures, Fashion and Politics* for June 1809: "To Mr. Thomas Hope's recent publication on *Ancient Costume*, is the late change in dress principally to be attributed:—indeed, to the exertions of this gentleman almost all our modern improvements in taste may be referred. It is hoped the publication alluded to will become the *vade-mecum* and toilet-companion of every lady distinguished in the circles of fashion."[39]

Whatever "the late change in dress" might have been (*Ackermann's Repository* noted that "Gothic taste" had given way "to the elegant form of Grecian antiquity"[40]), Hope's work, at the very least, ensured that the classical influence continued to be an important factor in women's costume and a source of design inspiration. Elizabeth Grant in her *Memoirs of a Highland Lady* remembered her mother, Jane, dressing for a party at the Duchess of Gordon's town house in London: "her gown was white satin trimmed with white velvet, cut in a formal pattern, then quite the rage, a copy from some of the Grecian borders in Mr. Hope's book."[41] As Elizabeth Grant noted, white was *the* choice for fashionable wear, satin for the more mature woman, muslin for young women and girls. Decorative borders in "classical" style appear on extant dresses (fig. 5-7), and such patterns were available in fashion magazines to copy. The dress worn by Elizabeth's mother would have been high-waisted and probably had short, puffed sleeves for evening; neither feature derived from classical Greek costume but belonged to the contemporary fashion aesthetic.

It is thus not surprising that even Hope's muse, his beautiful wife, Louisa, is depicted in Bone's portrait sketch of 1813 (fig. 5-8) more as a woman of fashion than as an ancient Greek nymph or goddess. Her dress is a red, high-waisted gown over a short *chemisette* bodice, and she holds up a fine woollen shawl with the popular paisley design, in a pose not unlike that of the "Grecian female" (fig. 5-9) from *Costume of the Ancients*.[42] It is tempting to think that Hope might have suggested this particular ensemble and pose to artist and sitter; we don't know, however, if he had a hand in the actual design of his wife's clothes.

In 1812, Hope privately published *Designs of Modern Costume*, with twenty plates[43] of stylish contemporary dress presumably set in the neoclassical interiors created by Hope for his house in Duchess Street. The figures pose, frozen like fashion illustrations, in a series of tableaux. Some are formal—the "beau monde" in the ballroom or the drawing room, playing cards, making music; other scenes are more intimate—family groups, women reading and engaged in needlework, mothers and children (figs. 5-10, 5-11, 5-12, 5-13). The sense of the "classical" is created more by the Flaxman–like purity of line, and by the décor and furnishings,

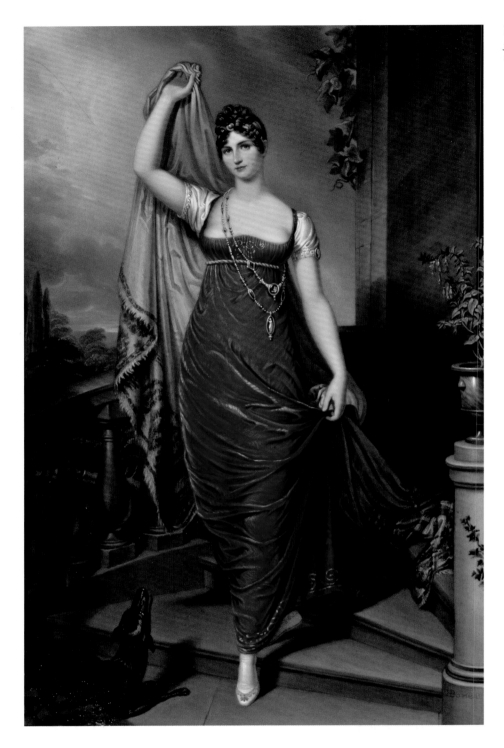

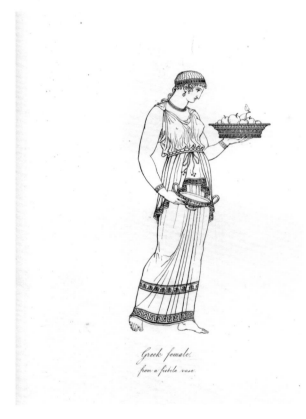

Fig. 5-8. Henry Bone. *The Hon. Mrs Thomas Hope, full face in a red velvet dress.* Oil on canvas, 1813. Christie's Images Limited 2007.

Fig. 5-9. Thomas Hope. "Grecian female." Engraving from *Costume of the Ancients,* vol. 1 (1812): pl. 106.

than by the costume depicted, which is a stylized rendering of contemporary clothing.

The men have their hair cut short and curled in imitation of classical heroes, but their clothing comprises the cutaway coat, short waistcoat, and knee breeches, all of which were de rigueur for most occasions. The children wear the simplest styles of dress, high-waisted unisex frocks of white cotton or linen. Little boys about the age of three abandoned such garments in favor of a so-called skeleton suit (presumably because it followed the shape of the body so closely), which consisted of a short jacket buttoning onto trousers; an English invention, this was one of the first costumes designed specifically for children

(see fig. 5-13), an interim outfit before the boy was properly "breeched" at five or six.

Designs of Modern Costume was mainly a showcase for women's dress in the prevailing neoclassical styles. The women have elaborate hairstyles, plaited, curled, and decorated with fillets, bandeaux, tiaras, combs, long pins, and soft turbans. Their attire is the short-sleeved dress of fine white muslin, which hangs in delicate, sculptural folds and is often embroidered in "antique" designs, such as the anthemion palmettes that "ran round the frieze of every Regency drawing-room."[44]

Apart from the decorative borders of the dress, there is no real attempt to create classical costume. The fitted bodice (sometimes

Fig. 5-10. Engraving from *Designs of Modern Costume* (1812): pl. 4.

Fig. 5-12. Engraving from *Designs of Modern Costume* (1812): pl. 12.

Fig. 5-11. Engraving from *Designs of Modern Costume* (1812): pl. 6.

Fig. 5-13. Engraving from *Designs of Modern Costume* (1812): pl. 17.

buttoned at the back) with short, tight sleeves is not Greek, nor is the flowing muslin,[45] although it purported to recall Parian marble; nor is the extremely high bust line, emphasized by new developments in corsetry that effectively divided the breasts for the first time and pushed them forward.[46] The "waistline" fluctuated considerably during the first twenty years or so of the nineteenth century; in 1812, the year of *Designs of Modern Costume*, the fashion magazine *Lady's Monthly Museum* noted that "with regret, we are obliged to inform our fair readers that the waist is returning to shortness, approaching to deformity"[47] (i.e., under the arms, a style that thrust the bosom out and was really suited only to the young and slim).

More "classical" touches in *Modern Costume* are the occasional three-quarter length over-tunics and the peplos-like draperies attached to the bodice of the dress. The author of *The Private Correspondence of a Woman of Fashion* remarked in 1814 that every woman wished to buy three yards of "Persian" (a fine silk)

to pin to her shoulders "in the vain hope of rivalling . . . the exquisite and becoming drapery of a Grecian statue."[48]

Yet, as suggested earlier, the English had never wholeheartedly taken to a more complete and consistent classicism in the way that the French had, and the "antique" could incorporate the "Orient" as well as the more usual ancient Greece and Rome. The fashion magazine *Mirror of the Graces* (1811) commented that a fashionable woman one day "may appear as the Egyptian Cleopatra, then a Grecian Helen; next morning the Roman Cornelia."[49] As early as 1799, the *Lady's Magazine* noted how dress "is daily flying from Greek simplicity to Eastern magnificence,"[50] a statement that could encompass the influence of all the Ottoman lands, including Greece, the Balkans, the Near East, North Africa, and Egypt. Inspired perhaps by the French invasion of Egypt in 1798, *Heideloff's Gallery of Fashion* for December that year illustrated an "Egyptian Dress" for evening wear, comprising a pleated muslin "underbody" beneath purple satin, embroidered in gold (fig. 5-14).

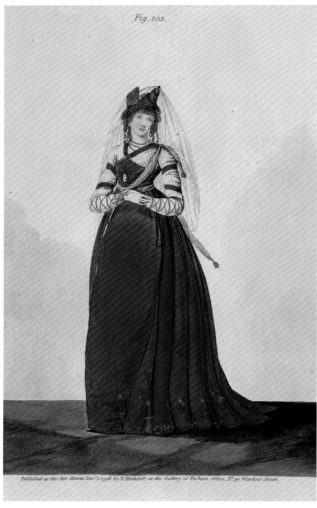

Fig. 5-14. Fashion plate: "Egyptian Dress." Hand-colored aquatint from *Heideloff's Gallery of Fashion* (December 1798): fig. 203. Yale Center for British Art, New Haven, L 218 (4).

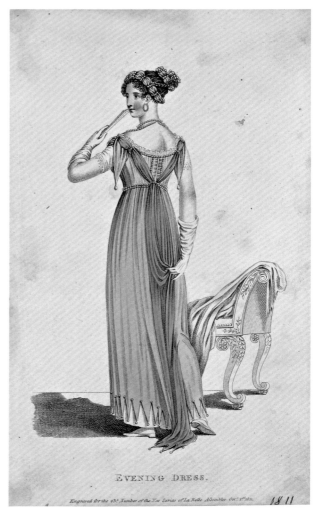

EVENING DRESS.

Fig. 5-15. Fashion plate: "Evening Dress." Colored engraving from *La Belle Assemblée* (October 1811). Courtauld Institute of Art, London.

Egyptian only in name, this curious costume relies on a range of exotic and historical visual references of the kind that fashion designers have—then and now—constantly plundered. Whereas purists like Hope deplored the eclecticism of modern architecture, "the same street shows side by side the Greek, the Gothic, the Egyptian, the Chinese and all these mixed together"[51]—a similar range of choice was welcomed by the fashion industry, hungry for novelties, both ancient and modern. For example, *La Belle Assemblée* relished the fashions for March 1807, which included "Vandyked hems," a "double demi-ruff à la Queen Elizabeth," a fur-trimmed "polish Robe of purple velvet"; accessories might be a "Peruvian scarf . . . with Indian border," "tiaras of gold, silver, steel or bugles" (glass beads), and "a most curious Egyptian amulet."[52]

Fashion plates often depict costumes that mingle the flowing draperies of the neoclassical with historical or exotic features; the 1811 "Evening Dress" from *La Belle Assemblée* (fig. 5-15) features a "Vandyked hem" (referred to above) and a similar dentillated edge to the sleeves, inspired by the lace collars in Van Dyck's portraits.

In such a confusion of sartorial influences, it is as well to remember that the basic *lines* of women's dress—high-waisted (more or less) and slim—changed relatively little during the first two decades of the nineteenth century. It is thus all the more startling to see the ungainliness of contemporary English court dress with its vast hooped skirt (a style that remained in use at the insistence of Queen Charlotte until her death in 1818), quite unsuited to the high waist of the current mode. The Marchioness of Townshend in 1806 at the queen's official Birthday (fig. 5-16) looks as though she stands in a huge, decorated lampshade, the Greek key pattern striking a somewhat incongruous note. In contrast to this disproportionate costume, lumbered with the baggage of past styles, the Emperor Napoléon (crowned in 1804) decreed that women at the French court should wear the neoclassical dress that looked so good on the elegant Empress Joséphine.

Yet French court dress also incorporated elements of historic costume, notably from the Renaissance, in tribute to Joséphine's liking for *le style troubadour* in art and fashion,[53] and the English had never abandoned their taste for fashion influenced by the

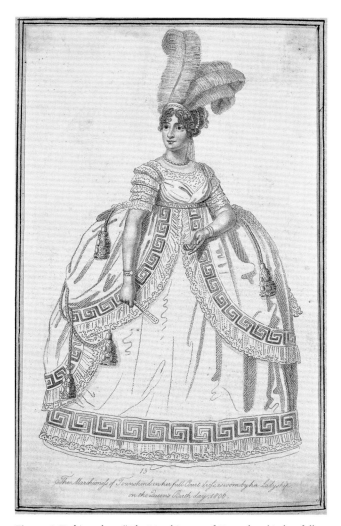

Fig. 5-16. Fashion plate. "The Marchioness of Townshend in her full Court dress worn by her Ladyship on the Queen's Birthday, 1806." Engraving from *La Belle Assemblée* (February 1806). Courtauld Institute of Art, London.

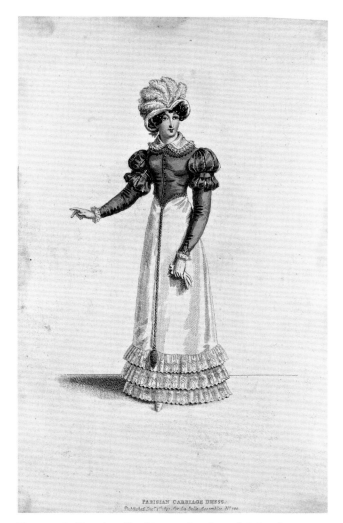

Fig. 5-17. Fashion plate: "Parisian Carriage Dress." Colored engraving from *La Belle Assemblée* (December 1820). Courtauld Institute of Art, London.

dress of the sixteenth and seventeenth centuries. By 1820 dress in both France and England had become increasingly historical in character, influenced by the novels of Sir Walter Scott in particular and by the Romantic movement in general. In a fashion plate of a "Parisian Carriage Dress" from the December 1820 issue of *La Belle Assemblée* (fig. 5-17), there is nothing left of the neoclassical in dress; only a white skirt remains, but it is widened at the hem with flounces of Mechlin lace. Instead of the classically arranged curls, we see a Renaissance-style satin hat with white marabou feathers; also sixteenth century in inspiration is the tight-fitting "Mary Stuart spencer," a short jacket (the waist at its natural level), with puffed and slashed sleeves. Only a mere eleven years earlier, such a costume had been anathematized by *Ackermann's Repository*: "the long waist, that merciless destroyer of everything that is beautiful . . . the wasp-like division of the human form, which this monstrous fashion produces, is perfectly irreconcilable with antique simplicity"[54]; such is the amnesiac force of fashion. The coup de grace for any remaining neoclassical influence in dress was the

splendor of the late Tudor costume designed for the coronation of George IV in 1821.

No stylish woman was immune from such trends, and Louisa Hope—described by Washington Irving in a letter to his sister in 1822 as "one of the loveliest women of the kingdom and one of the reigning deities of fashion"[55]—certainly kept up to date, as later portraits of her in various kinds of historic and exotic costume indicate, and she embellished her appearance with striking pieces of jewelry.[56]

Louisa Hope often combined different themes within one ensemble, as a portrait by Henry Bone of 1816 (fig. 5-18) shows. She is depicted in a dress with short sleeves slashed in Renaissance style and a front-laced bodice deriving from folk or peasant costume, a fashion increasingly popular with the rise of nationalist movements in the post-Napoleonic world; her jewelry is neo-medieval, a cross inserted in the lacings under her breast. A huge "antique" Greek mantle, with embroidered borders and corner weights, underlines the way in which a stylish woman could wear such variety in dress and still look elegant.

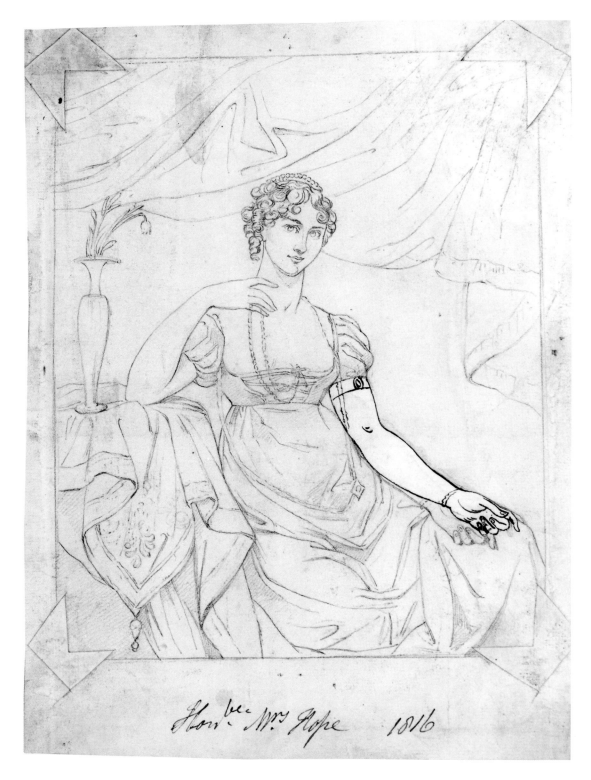

Fig. 5-18. Henry Bone. *Louisa, Viscountess Beresford*. Drawing, 1816. National Portrait Gallery, London, NPG D17720, vol. 3, p. 27.

An infinitely more accomplished portrait of Louisa by Sir Thomas Lawrence of about 1826 (fig. 5-19) shows her in a rich red velvet dress, which suggests a kind of baroque richness, as does the jeweled chain draped asymmetrically over her bodice, a popular fashion seen in Rubens's portraits. Wound around her head turban-fashion is a striped silk scarf, a style that recalls Ingres's beautiful *odalisques* and is pinned with a jeweled clasp. On her forehead is placed a *ferronnière*, a decorative band, often jeweled and very much in vogue in the Romantic period (and

named from a portrait in the Louvre, entitled *La Belle Ferronnière*, once attributed to Leonardo).

By the time the expanded version of *Designs of Modern Costume* (cat. no. 110) was published in 1823, neoclassical dress had been abandoned by women of fashion. John Nevinson correctly notes that "while Thomas Hope with the co-operation of decorators, carpenters and metal-workers was able to bring many of his neo-classical ideas to fruition, neither he nor Henry Moses was able to direct the trend of fashion."[57] Presumably Hope's idea (if he had

Fig. 5-19. Sir Thomas Lawrence. *Portrait of the Hon. Mrs. Thomas Hope.* Oil on canvas, ca. 1826. Christie's Images Limited 2007.

seriously entertained it) of reforming women's dress along classical lines had also vanished, victim of the unstoppable force of novelty that is the essence of fashion; even in periods when dress seems dominated by revivals, it can never achieve an exact recall of the past.

Yet the fact that neoclassical costume—even the less-than-wholehearted versions of it as worn in England—had such a long life must owe something to Hope's assiduous championing of the style in all the decorative and applied arts. His work on classical costume helped to provide that rare thing, an intellectual underpinning (no pun intended!) of a particular style of dress, which set in motion a serious discussion about the aesthetics of clothing generally, a subject that occupied the minds of many artists and critics as the nineteenth century progressed. The leitmotif of the later dress reform movement might be the comment made by *La Belle Assemblée* in 1807: "Dress is to beauty what harmony is to melody; it ought to set it off to advantage, to enhance its lustre; never to cover or disguise it."[58] For Hope, beauty and harmony

could best be seen in classical civilizations, particularly that of ancient Greece, a feeling echoed by Oscar Wilde: "There is not . . . a single line or delightful proportion in the dress of the Greeks, which is not echoed exquisitely in their architecture."[59]

1. George Bryan Brummell, *Male and Female Costume*, ed. Eleanor Parker (New York: Doubleday, Doran, 1932): 121.

2. Thomas Hope, *Anastasius, or Memoirs of a Greek*, vol. 1 (London: John Murray, 1819): 44.

3. Ibid., 104.

4. The portrait of Byron by Thomas Phillips is dated 1813 (British Government Art Collection). The costume, which Byron bought in 1809, belongs to the Earl of Shelburne at Bowood House; it is clear from an examination of the outfit that Phillips lengthened the silk scarf that Byron wears as a turban in order to create a more Romantic effect.

5. The voluminous breeches which Hope refers to as "shakshear" (shalwar, salvar) are thus described: "the folds of this nether garment are so ample as to make it look like a petticoat." See Hope, *Anastasius*, vol. 1 (1819): 368.

6. Hope, *Anastasius*, vol. 2 (1819): 155.

7. Thomas Baxter, *An Illustration of the Egyptian, Grecian and Roman Costume in Forty Outlines* (London: William Miller, 1810): 4. Baxter (1782–1821) was mainly a painter on china, often incorporating figures from the works of such artists as Sir Joshua Reynolds and Benjamin West.

8. Thomas Hope, *An Historical Essay on Architecture* (London: John Murray, 1835): 163.

9. Brummell, *Male and Female Costume* (1932): 123. Parker speculates that Hope may be the "literary friend" referred to by Brummell in his introductory remarks.

10. Ibid., 3. The "tunic" is an unstructured informal coat; the looser trousers (often of light colors) were first seen about 1807 in Brighton, the seaside resort popularized by the Prince Regent.

11. *Le Beau Monde* (March 1808): 183. The text adds that this evening suit can be made of either black kerseymere (a fine wool), or "black silk Florentine."

12. The himation was a large, rectangular mantle, draped in a variety of ways. As for the toga, Hope correctly notes its "semi-circular . . . form"; see Thomas Hope, *Costume of the Ancients*, vol. 1 (London: William Miller, 1809): 43.

13. Brummell, *Male and Female Costume* (1932): 129.

14. John Peller Malcolm, *Anecdotes of the Manners and Customs of London* (London, 1808): 448.

15. *Lady's Magazine* (May 1798): 212. The same journal (May 1799, 214) wondered rhetorically how a woman dressed in such a "republican costume" "can awe the humble spectator into reverence, if a mere silken fillet binds her hair, and her muslin is permitted to articulate her shape by floating in light draperies from the zone that encircles her waist."

16. Hope, *Costume of the Ancients*, vol. 1 (1809): 1; "the little ardour evinced among us in the pursuit of historical painting." Hope also pointed out that there was no English equivalent of the French Académie in Rome to encourage artists in the study of classical antiquity.

17. See, for example, William Buchan's *Advice to mothers on the subject of their own health; And on the means of promoting the health, strength and beauty, of their offspring* (London, 1803): 179, where he writes approvingly of the "attention to health, simplicity and real elegance" of women's dress. In a similar vein, see *Ackermann's Repository of Arts, Literature, Commerce, Manufactures, Fashions and Politics* (March 1809):171: "By following the style of dress and the arrangement of drapery . . . of antiquity, the present taste has happily emancipated the ladies from all the ridiculous lumber of the late fashions; from . . . powder, whalebone and cork, flounces and furbelows, and pockets and pincushions."

18. Such as, for example: M. F. Dandré-Bardon, *Costume des Anciens Peuples* (Paris, 1772); J. Grasset Saint-Sauveur, *L'Antique Rome* (Paris, 1796); N.-X. Willemin, *Choix de costumes civils et militaires des peuples de l'antiquité* (Paris, 1798–1806); J. Malliot, *Recherches sur les costumes, les moeurs, les usages réligieux, civils et militaires des Anciens Peuples* (Paris, 1804).

19. *Lady's Magazine* (May 1799): 214. *Ackermann's Repository* (March 1809): 170 noted that the "present revolution in female dress" derived "from our hostile neighbours," i.e., the French.

20. John Bowles, *Remarks on Modern Female Manners* (London, 1802): 7, 10.

21. Malcolm, *Anecdotes* (1808): 448.

22. Anonymous, *Dress and Address* (London, 1819): 16. See also *The Ton* (1819): 47 (probably by the same author), in which a heavy-handed play on words implies a link between extremes of neoclassical dress and immorality: "The loose and sparing drapery of our modern belles, the buskined ancle and *apparent* form which often becomes a *parent*, the *transparent* folds, imitative of statuary, not however in its coldness, or in its obduracy, the Grecian tiara, coëffure à la grecq, etc."

Stories of dampened muslin and lack of underwear are probably apocryphal, arising perhaps from what contemporaries perceived as a radical change in dress, which was grist to the mill of satirists and caricaturists. Women continued to wear stays (corsets), although they were lighter and less heavily whale-boned than before. There was possibly also some kind of long elasticized garment to help create the new, slim line; Susan Sibbald recalled in 1801 "invisible petticoats . . . wove in the stocking loom, and like straight waistcoats . . . drawn down over the legs . . . so that when walking you were obliged to take short and mincing steps": *Memoirs 1783–1812*, ed. Francis Paget Hett (London: John Lane, 1926): 138.

23. *Lady's Magazine* (May 1808): 216.

24. *Lady's Magazine* (March 1807): 141.

25. Enlarged editions appeared in 1812 and 1841. The copy in the National Art Library at the Victoria and Albert Museum has a presentation inscription that reads "To Mr. Fuseli. With Mr. Thomas Hope's compts. May 9. 1809."

26. Henry Moses (1782–1870) was attached to the British Museum and produced engravings of their classical antiquities; he also worked for other institutions and for private collectors in Britain and abroad.

27. "Hope . . .displayed an obsession with Flaxman's illustrations," according to Sarah Symmons, *Flaxman and Europe. The Outline Illustrations and their Influence* (New York and London: Garland Publishing, 1984): 70. In an article entitled "Observations on the theatre" in which Hope voiced his dislike of heterogeneous mixtures of costume on the stage, he urged theatre managers to buy "for the moderate sum of two guineas, an inexhaustible store of models for the costume of all classical subjects. . . . Mr. Flaxman's compositions from the *Iliad* and the *Odyssey*; in which that great artist has contrived to introduce the most correct and chaste representations of Grecian and Asiatic forms of attire": *The Director* (2 May 1807): 67.

28. Hope, *Costume of the Ancients*, vol. 1 (1809): 5.

29. Hope, *Costume of the Ancients*, vol. 1 (repr. 1812): xiii.

30. Ibid., 11–12.

31. Ibid., 12.

32. See, for example, Oscar Wilde's views that the ideal female costume should follow the lines of Greek dress, and flow from the shoulders, so that it might become "as it should be, the natural expression of life's beauty": *Pall Mall Gazette*, 28 February 1885, p. 4. The Belgian designer Henry van de Velde also wished to see contemporary women's dress inspired by the ancient Greeks: "The principles of Greek art are eternal and inalienable. It is on these eternal and inalienable foundations that we have to found the modern style"; from *Die Kunstlerische Hebung der Frauentracht* (The artistic improvement of women's clothing) (Krefeld, 1900), quoted in Radu Stern, *Against Fashion: Clothing as Art 1850–1930* (Cambridge, Mass.: MIT Press, 2004): 129.

33. Hope's obituary in *Gentleman's Magazine* (April 1831): 369, refers to *Costume of the Ancients* being sourced from vases, "many of them in Mr. Hope's own collection." It continues that both the *Costume of the Ancients* and *Designs of Modern Costume* "evinced a profound research into the works of antiquity and a familiarity with all that is graceful and elegant."

34. Some of the complexities of Greek dress, and the semantic problems associated with identifying garments, are discussed in Maureen Alden, "Ancient Greek Dress," *Costume* (2003): 1–16; but see her comment (p. 4) that "rectangles of fabric *were* draped on the body without any cutting to shape and with little or no sewing." This begs a number of questions, for there is some evidence that certain garments were woven to shape, and that some were fairly complex in construction, possibly

even in two pieces which were fastened (possibly sewn) together. I am indebted here (and generally in my comments on Greek dress) to Margaret Scott, in a personal communication.

35. Hope, *Costume of the Ancients*, vol. 1 (1809): 26.

36. Ibid., 28.

37. Ibid., xii.

38. Ibid., 10.

39. *Ackermann's Repository* (1809): 397. The author of the review was probably Brummell. Hope's work also influenced that of later antiquarians, especially with regard to costume; the Rev. Thomas Dudley Fosbroke in his *Encyclopedia of Antiquities* (1825) makes constant reference to "the elegance and taste of Mr. Hope's *Costumes [sic] of the Ancients*."

40. *Ackermann's Repository* (1809): 397.

41. Elizabeth Grant, *Memoirs of a Highland Lady 1797–1827*, ed. Angus Davidson (London: John Murray, 1950): 39. The winter of 1805–6 seems to be suggested, so it's unclear what "Mr. Hope's book" means. As the memoirs were not begun until 1845, it is possible that there may be a slip of memory here, and the reference could be either to Hope's *Household Furniture* (1807) or *Costume of the Ancients* (1809).

42. Another possible source for the pose is a "Grecian female from a fictile vase," pl. 113 in Hope's *Costume of the Ancients* (1809).

43. An enlarged version of *Designs of Modern Costume* was published in 1823; this contains the 20 plates of the 1812 edition (although in a different order), and 9 additional plates of literary and classical subjects.

44. Watkin, *Thomas Hope* (1968): 220.

It would be interesting to make an inventory of extant clothing to determine the extent of "antique" designs on women's dresses in the first two decades of the nineteenth century. My perception, having examined many of these dresses in museum collections in Europe and North America, is that there is relatively little in the way of embroidery that can be described as specifically "classical," although there are a few examples, including a white muslin dress at the Victoria and Albert Museum (inv. no. T 733-1913, fig. 5-7), that have Greek key pattern embroidery around the bodice and the sleeves. Many neoclassical white muslin dresses have embroideries similar to those in the *Costume of the Ancients*: designs of grapes, ivy leaves, ears of corn, stylized floral patterns, etc., which might suggest a classical Arcadian theme.

45. The peplos (a Doric style) was made usually of wool, especially in the archaic period; the chiton (an Ionian style) was usually made of linen. In spite of the fact that ancient Greek costume was often brightly colored and patterned, the designers of neoclassical dress chose as their inspiration the pleated white *chitones* seen on later Greek vases rather than the heavier figured peploi of the earlier period.

46. A new kind of corset was introduced in the first decade of the nineteenth century; known as the "divorce" corset, it separated the breasts by means of a triangular metal insert and pushed them upward and forward; see, for example, Thomas Lawrence's portrait of the Countess of Blessington, 1822 (London, Wallace Collection).

47. The *Lady's Monthly Museum* (September 1812): 172.

48. Harriet Pigott, *The Private Correspondence of a Woman of Fashion*, vol. 1 (London: Henry Colburn & Richard Bentley, 1832): 74.

49. *Mirror of the Graces* (London, 1811): 60.

50. *Lady's Magazine* (May 1799): 214. A satirical novel by Thomas Skinner Surr has a lengthy description of a masquerade in a grand London town house (possibly based on Duchess Street), where the long gallery is transformed into an Egyptian temple, and gardens into a Turkish seraglio; young ladies, "in the dress of Grecian slaves, were scattered in groups, some playing on musical instruments, while others danced, and others again were bearing refreshments or perfumes": *A Winter in London*, vol. 2 (London: Richard Phillips, 1806): 217.

51. Hope, *Essay on Architecture* (1835): 222.

52. *La Belle Assemblée* (1807): 105–7. Any fashion magazine of the period would have similar motley assemblages of dress and accessories.

53. A term coined by Emile Littré in his *Dictionnaire de la langue française* (1863–72); it refers to the early 19th-century vogue in France for the Middle Ages, a period ranging from the High Gothic through the 16th century.

54. *Ackermann's Repository* (June 1809): 397.

55. Herbert Huscher, "Thomas Hope, Author of Anastasius," *Keats–Shelley Memorial Bulletin*, no. 19 (London: The Keats-Shelley Memorial Association, 1968): 10.

56. Louisa Hope was noted for her jewelry, as evidenced by her portraits and from later sales of family possessions. *En secondes noces*, she seems to have been especially fond of diamonds, as her notes to Fossin (predecessor to the famous Parisian firm of jewelers Chaumet) reveal; my thanks to Diana Scarisbrick for information from the Chaumet archives.

57. Thomas Hope, *Designs of Modern Costume 1812*, intro. by John Nevinson (London: The Costume Society, 1973): 5.

58. *La Belle Assemblée* (March 1807): 123.

59. Wilde, *Pall-Mall Gazette* (1885): 4.

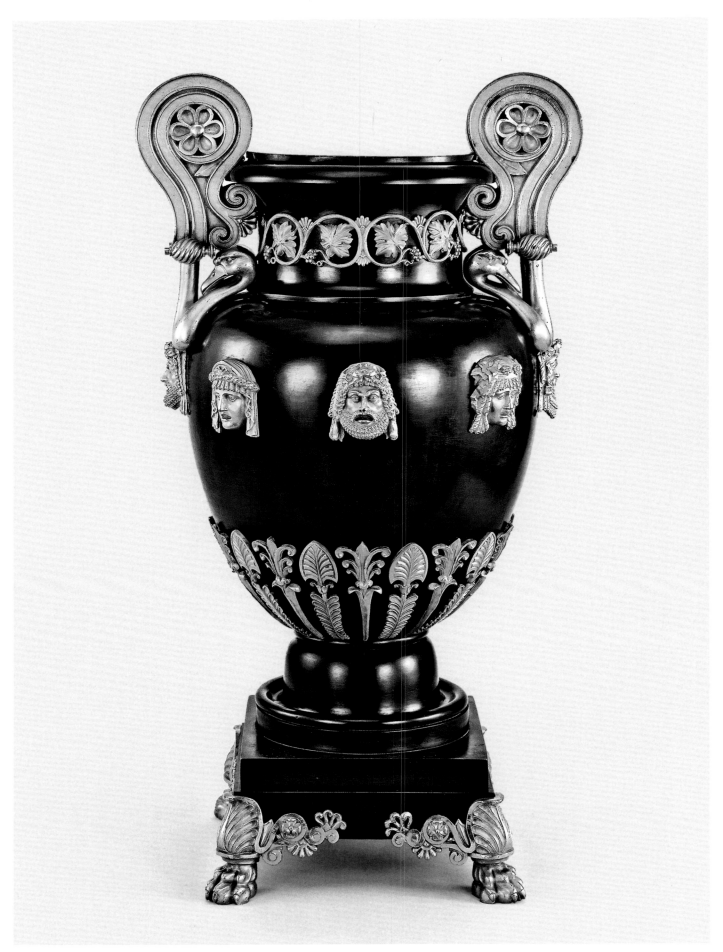

Vase, one of two probably made by Alexis Decaix and designed by Thomas Hope for his house in Duchess Street, London. Copper treated to resemble bronze, applied ormolu mounts, ca. 1802. Victoria and Albert Museum, London, M.33-1983. © V&A Images. *Cat. no. 89.*

Thomas Hope's Metalwork for Duchess Street: "Character, Pleasing Outline, and Appropriate Meaning"

Martin Chapman

Metalwork was an essential ingredient in the furnishing of Hope's house in Duchess Street. The provision of bronze and gilt-bronze objects, which included decorative vases, clocks, and lighting, as well as mounts for chimneypieces, porcelain, and furniture, made a significant contribution to Hope's general program of furnishing his house with appropriately designed pieces. This metalwork was intended to interact with the other elements of the interior, such as the furniture, sculpture, and decoration, by providing an additional layer of designs made according to Hope's own ideals. In his use of decorative bronzes, Hope was following French rather than English precedent. Since the mid-eighteenth century, gilt bronze had had a discreet but definite presence in the luxury Parisian interior. Gilt bronzes gave a brilliance and liveliness to the furnishing of the salons of Paris, which were seen at their best at night under candlelight. Following this French model, Hope not only used gilt bronze in the interiors of his London house, but he also added a measure of dark patinated bronze—a finish he admired for its association with the more stoical character of Greek and Roman antiquity and which is paralleled in the finishing of some of his furniture. Hope evidently enjoyed the interplay between this dark patinated bronze and rich gilding, because it is found throughout Duchess Street, not only in his metalwork but also on his furniture.[1]

Thomas Hope's ambition for his metalwork is expressed at length in his introduction to *Household Furniture*. Here he tells us that, during his furnishing of Duchess Street, he formulated his attitudes to design and manufacture for the ultimate purpose of improving public taste. His belief in the need to learn from antiquity without necessarily following ancient models slavishly and his faith in the supremacy of outline and the fitting use of ornament were attitudes that would directly influence his metalwork. In the final words in *Household Furniture*, he lists published works that informed his designs; he says they contain examples that give "each a . . . character, a pleasing outline and an appropriate meaning, qualities he found lacking in much contemporary design."[2] These words would resonate as the standards Hope set himself for the design and making of his metalwork, along with other decorative furnishings, for his house.

The two broad categories of metalwork made for Duchess Street were decorative bronzes and domestic silver. Both conform to Hope's so-called archaeological style which was inspired by examples of classical antiquity. Many of the designs were based on the profiles of ancient Greek vases and their decoration,[3] and some were taken from motifs found on ancient (principally Roman) architecture and carvings.[4] For his sources he drew on his personal experience of the antiquities, as well as modern design, that he saw on his tours of Europe and the Ottoman Empire in the 1790s. He claimed loudly in the introduction to *Household Furniture* that he designed these objects himself and bemoaned the fact that he could not find furnishings to suit his taste in London. He wrote with an almost audible sigh that "I was obliged to depend in great measure on my own inadequate abilities . . . and to employ that feeble talent for drawing . . . in the laborious task of composing and of designing every different article of furniture which I wanted the artisan . . . to execute."[5] When Hope mentions furniture, he is, of course, including his designs for bronzes and silver.

The story that Hope gives us about the design and making of his pieces in the introduction to *Household Furniture* is more complicated than he would have us believe. As there are several examples of metalwork and furniture illustrated in his book that he bought on the markets of London and Paris, it is clear that he did not design all the pieces himself. Some of these objects were stock models that he acquired to suit his ideals of design and craftsmanship. Determining which is a Hope design and which is a stock item in *Household Furniture* is not an easy task, and it is compounded by the use of outline engraving for the plates. As has been observed before, Hope's favored style, the Greek "archaeological" taste that he promotes so avidly in his book, is suffused with many other sources, including Roman, Egyptian, and contemporary French, but by using the technique of line engraving, most of these potential stylistic conflicts are neutralized. Without

their defining elements of shadow and color, the disparate designs in *Household Furniture* appear to be more consistent than they really were.

In publishing *Household Furniture*, Hope was following the lead of Percier and Fontaine, whose *Recueil de décorations intérieures* was issued in sections beginning in 1801. He even adapted their title. But Hope's publication differs in the relative plainness and simplicity of his designs.[6] This was intentional, as Hope was aiming to emulate the more austere form and decoration of Greek art over the more highly decorated Roman sources used by Percier and Fontaine. His *Household Furniture* would then reflect a brief moment in the history of English neoclassicism. Even without direct contacts with Paris in the years following the resumption of the war in 1804, high-style London design would give way to a more imperial Roman mode. Reflecting the prevailing militarism and massive profits made during the Napoleonic conflicts, London-made models would become closer to the more ornate designs of Percier and Fontaine. Leading examples of this imperial taste can be seen in the massive sculptural silver sold by Rundell, Bridge and Rundell to the Prince Regent and prosperous aristocrats from about 1808,[7] and in the furnishing of George IV's royal palaces, which would become far richer and more highly decorated during the 1810s and 1820s.[8]

Bronzes

The bronzes represent the more innovative and experimental design aspect of Hope's metalwork. In the introduction to *Household Furniture*, Hope tells us that designing the bronze pieces and getting them made involved a great deal of effort for him, and, sighing again, he describes the process as "slow and tedious." He continues: "Throughout this vast metropolis teeming as it does with artificers and tradesmen. . . . I have, after the most laborious search, only been able to find two men, to whose industry and talent I could . . . confide the execution of the more complicate [*sic*] and more enriched portion of my designs." He singles out his "bronzist" Alexis Decaix, who along with the carver Bogaert was one of the few London-based craftsmen he could trust to make his designs according to his exacting standards.[9] Unlike silversmithing, the making of decorative bronzes was less commonly practiced among the London luxury trades than it was in Paris. Hope and his craftsmen, therefore, had to invent solutions in the design and manufacturing of his pieces.

The most innovative designs in metalwork were the large vases Hope had made for his Duchess Street mansion. The "bronze" vase shown as plates XXXV–VI in *Household Furniture* (cat. no. 89) has already been the subject of an extensive article, but its dramatic presence deserves singling out as the most impressive of

Fig. 6-1. Thomas Hope's Egyptian slave candlesticks, probably made by Alexis Decaix. *Household Furniture* (1807): pl. XLIX (detail).

Hope's surviving metalwork designs that were based on his tenets of looking to Greek antiquity for models, employing a strong outline, and using appropriate ornament.[10] According to Hope's text in *Household Furniture*, the form and design of the handles were based on a "Greek vase of white marble in the museum at Portici."[11] He had probably seen the original in the collection at the Palazzo Reale at Portici when he visited Naples in 1802.[12] As with so many of the so-called Greek antiquities that Hope and his generation admired and collected, more recent scholarship has determined that this vase is Roman rather than Greek. It is a later Roman marble version of a Greek ceramic volute krater dating from the first century A.D.[13] However, whether Greek or Roman, it was the chaste outline of the vase that inspired Hope. By omitting the figural frieze of the marble original and choosing instead to replace it with more restrained ornament in the "Bacchanalian" masks that he drew "from antique ornaments," Hope applied his principle of not slavishly copying the original.[14] He was also working according to his program of using "appropriate ornament" by restricting the applied-gilt bronze decoration primarily to "emblems of Bacchus"—seen in the vine wreath around the neck and in the masks.[15] Although he does not reveal where this large vase was placed at Duchess Street, if Hope was following his own principles of meaning in ornament, with the emblems of Bacchus referring to wine and drinking, the vase was probably displayed in the dining room.[16]

For the execution of his bronzes, Hope chose the talents of the French immigrant Alexis Decaix, who could work to the high standards of craftsmanship that Hope must have known from his time in Paris. The modeling and chasing of the mounts on the vase are remarkably intricate and precise. The handle mounts are massively modeled, but the masks applied around the body are delicate, with contrasting areas of matte and burnished gilding to impart expression and liveliness.[17] Matte gilding was achieved by the application of salts in the final process, a subtle gilding technique exploited in Paris during the 1770s and 1780s that was only beginning to be emulated in London at this date.[18] The minutely detailed refinement in the finish of these mounts supports Hope's assertion that he laboriously sought out the finest craftsmanship available in London. The body of the vase shows an unusual method of manufacturing. Rather than being cast, as one would expect, it is raised out of hammered copper and then patinated to resemble bronze. The technique of raising was a method found more commonly in the metalworking trade for hollowware such as silver. It is possible that this technique was the result of Decaix's association with the London silversmith Garrard between 1801 and 1804 (see below) and shows how makers such as Decaix had to resort to unorthodox methods to execute Hope's designs. Like so many people of his generation, Hope was fascinated by the latest manufacturing techniques, and he was willing to go to extra lengths to see innovative processes devised or used for his pieces.

Although Decaix was a shadowy figure known only from Hope's reference in his introduction to *Household Furniture*, more is coming to light about him. The name Decaix is common in the French region of Picardy, an area known for supplying workers for the gilding trade of Paris.[19] An Alexis Decaix is documented as being born October 19, 1734, in Picardy,[20] but it is more likely that our Decaix was the one recorded as receiving his *maîtrise* (mastership) in Paris as a *fondeur*, 30 XII 1778, some forty-four years later.[21] Decaix is also mentioned as paying tax in the tenth class of *bronzier* in 1787.[22] Arriving in London at the time of the French Revolution, Decaix is first recorded in a bill to the Prince of Wales dated November 4, 1791, for £195 15s. As £162 15s of that total accounted for wages for two years and seven months, this suggests that he had been in London at least since 1789.[23] Most of his work for the prince seems to have been for cleaning and repairing ormolu light fittings in 1792–94 and again in 1801. From the spring of 1794 he is documented at 15 Rupert Street, London, where he insured his utensils, stock, and goods up to £2000 in 1805—a very large sum for those times.[24] He also appears in the trade directories of London from 1799 to 1819 as a "bronze and ormolu manufacturer." Between 1799 and 1804, he produced fashionable objects in bronze and ormolu, mainly light-

ing and inkstands, for the goldsmithing firm of Garrard. On October 9, 1800, Decaix made for Garrard a "pair of Egyptian slaves for a light on Bronze Pedestal with hieroglyphic characters," probably the same as those shown in plates XIII (no. 1) and XLIX in *Household Furniture* (fig. 6-1). Because Hope is not documented in their ledgers as one of Garrard's customers, it must be surmised that he commissioned these candlesticks directly from Decaix.[25] Decaix had connections with the architect Henry Holland from the 1790s, when he supplied work for Carlton House.[26] Probably through Holland, he supplied "bronze manufactures" for the Prince of Wales's rented house, the Grange, Hampshire, in the years 1800 to 1803.[27] He is also recorded as supplying substantial amounts of bronze work for the new Sculpture Gallery at Woburn Abbey for the 5th Duke of Bedford in 1804, and it is clear from the surviving bronze fittings there that Decaix was working to the designs of Henry Holland (fig. 6-2).[28] Decaix may have been brought to Hope's attention by Charles Heathcote Tatham, who worked for Holland from the 1790s and who was the executant architect for Hope in the remodeling of Duchess Street around 1800.[29] Along with Hope, Decaix subscribed to Tatham's *Etchings* published in 1799, an important source for the archaeological style of the time.[30] Decaix's business evidently thrived because of his large insurance policy on his business mentioned above and because by 1809 he opened a "shew room" at 43 Old Bond Street. His success, however, was short lived, as he died in 1811. Christie's sold the contents of his shop and house in August of that year. The sale of the stock reveals a wide variety of decorative goods sold by Decaix, with Asian porcelain being listed before the articles of bronze and "or-moulu."[31] His

Fig. 6-2. Door handle from the Sculpture Gallery at Woburn Abbey made by Alexis Decaix. By kind permission of His Grace the Duke of Bedford and the Trustees of the Bedford Estates.

Fig. 6-3. "Vase of bronze and gold" with mounts emblematic of Apollo. Engraving from *Household Furniture* (1807): pl. XXXIV.

Fig. 6-5. Side view of the vase in fig. 6-4.

Fig. 6-4. Vase. Engraving from *Household Furniture* (1807): pl. XXXV. The vase now in the Victoria and Albert Museum, London (fig. 6-1) was intended as the companion to that in pl. XXXIV but was "ornamented with emblems of Bacchus."

widow, Barbara Coppinger Decaix, who was of Irish ancestry, continued running the business until 1819.[32]

It is not easy to determine which of Hope's London-made bronzes were made by Decaix.[33] As the most prominent piece of metalwork illustrated in *Household Furniture*, the bronze vase(s) shown as plates XXXIV–VI are the most likely candidates (figs. 6-3, 6-4, 6-5).[34] Although the sophisticated Parisian-style finish to the gilding is very different from the workmanship of the mounts on the now lost Chinese vases, one of which is shown as plate XXXI (figs. 6-6, 6-7),[35] there is some congruence in the heaviness of the handles. The castings of both models show the quality of massiveness and solidity that characterizes London-made gilt bronzes. The difference between these objects lies more in their design. The mounts on the Chinese vase are stylized and broadly drawn, qualities that are paralleled in the ormolu objects supplied by the London firm of Vulliamy in the years that followed.[36] More significant, however, is that Hope's Chinese vase mounts have more in common with the bronze fittings supplied by Decaix for the Sculpture Gallery at Woburn. These bronze and ormolu furniture mounts and door hinges show the broad modeling of the strong reeded forms and simple rounded anthemions that also characterize the modeling of the mounts on Hope's Chinese vase(s). The link here may be that both designs were made by Henry Holland—or possibly by C. H. Tatham, who was working

for Holland. Other bronzes in *Household Furniture* that can be attributed to Decaix are the Egyptian slave candlesticks (see fig. 6-1, cat. no. 72), which are similar to those cited in the Garrard Ledgers above; the mounts on the pair of Blue John vases (pl. XIII, no. 3, cat. no. 70); possibly the hanging lamp from the Third Vase Room (pls. V, XXXVIII, cat. no. 90); and the inkstand shown as plate XI, no. 1 (see fig. 6-14). Decaix is recorded as having made a bronze table based on one in the British Museum for the Duke of Bedford. It is therefore possible that he also made some of the bronze tables shown in *Household Furniture*.[37] Hope comments at length on the bronze stand for the table made to support a *rosso antico* marble vase (*Household Furniture*, pls. XI, no. 5; XXV, no. 2; fig. 6-8, cat. no. 82), where he singles out the bronze for its cheapness and its durable qualities.

These ornaments in bronze . . . being cast, may . . . be wrought at a much cheaper rate than ornaments in other materials, only producible through the more tedious process of carving; which moreover may be indiscriminately affixed to objects in wood, or stone, or metal, or porcelaine, or any other; which thirdly, when once placed, seem liable to little or no injury or discolouring from the effects of weather or wear or carriage or dirt . . . and which finally on a desire to increase richness of their appearance, may however long they have served in their naked state, still assume a richer garb, be gilt and be burnished, seem . . . preferable to sculptured ornaments. . . .[38]

He does not, however, reveal if Decaix made this or another bronze tripod table shown as plate XVII, no. 5 (fig. 6-9), which may be after a design by J. N. L. Dunand, published in 1802.[39] That table he describes as being equipped "with hinges and sliders made to take to pieces and fold up after the manner of ancient tripods."[40]

Hope's point about bronze being appropriate decoration for a variety of destinations in the above quote applies particularly to

Fig. 6-6. "Old China jar of a rich purple hue, mounted in ormolu." Engraving from *Household Furniture* (1807): pl. XXXI.

Fig. 6-7. An ormolu-mounted Chinese porcelain vase. Gilt-bronze and sang de boeuf. Stolen from a private collection. Photograph by Miki Slingsby Fine Art Photography.

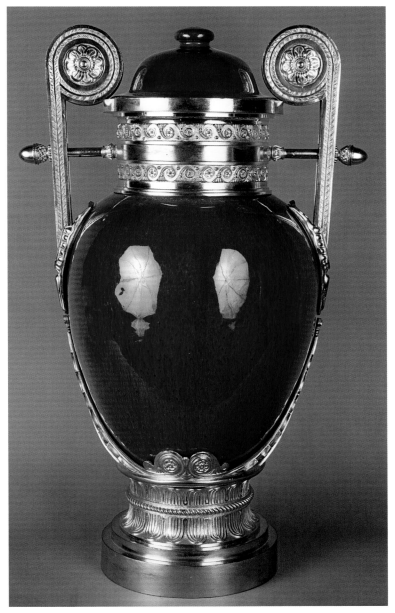

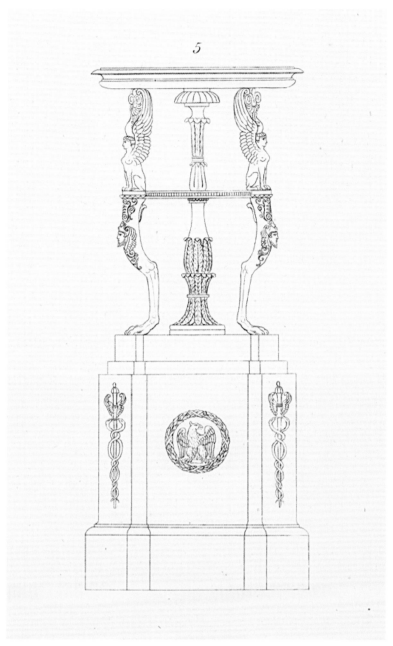

Fig. 6-8. "Flat cup of rosso antico placed on a tripod of bronze." *Household Furniture* (1807): pl. XI, no. 5 (detail). The wooden stand is also decorated with bronze mounts.

Fig. 6-9. "Bronze tripod with hinges and sliders, made to take to pieces and to fold up, after the manner of ancient tripods." *Household Furniture* (1807): pl. XVII (detail).

the bronze and gilt-bronze mounts that appear on objects in *Household Furniture*. The "comic and tragic masks" depicted on a large scale in plate XXXVII (fig. 6-10), deriving from drawings by Hope, are adapted for different uses; on the bronze vase (pls. XXXV, XXXVI, cat. no. 89) already discussed, on the Blue John vases (pl. XIII, no. 3, cat. no. 70), on the dining room chimneypiece (pl. L, LI, fig. 6-11), on the library table (pl. XI, nos. 1, 2, but possibly of carved wood rather than cast bronze, cat. no. 78), on the ends of the Lararium table (pl. XII, no. 1) on the ends of the Picture Gallery table (pl. XX, nos. 1, 2, but made of another experimental or "new" quasi-ceramic material), and on the chimneypiece in the Second Vase Room (pl. IV, fig. 6-12). Hope also used a variety of bronze profile head mounts similar to those on the

Aurora Room table (pl. XIII, no. 3, cat. no. 68), on the end of the cradle in plate XLIV (fig. 6-13), and in the pediment of the library table (depicting "the patron and patroness of Science, of Apollo and Minerva," pl. XI, no. 1, fig. 6-14). The bronze mounts on the table in the Aurora Room were probably imported from France (cat. no. 68) as were those on the "bedstead of mahogany and bronze" shown in plate XXIX (fig. 6-15), which was likely a piece of French furniture. Its elaborate mounts included "figures of Night riding on her crescent and spreading her poppies" (see Chapter 6). Similarly, the Egyptian style mounts on the Lararium chimneypiece (pl. X) and those of dancing nymphs applied to the frame (pl. XXXVII, no. 2) were also likely to have been French imports.

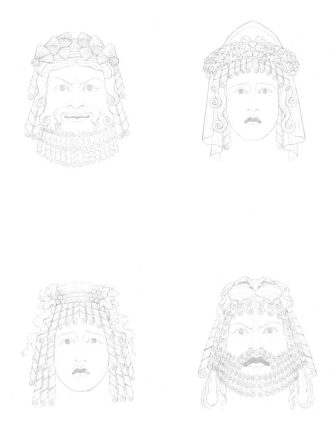

Fig. 6-10. Comic and tragic masks "taken from antique ornaments." *Household Furniture* (1807): pl. XXXVII. These models were used for mounts on several of Hope's bronzes and furnishings.

Hope may have bought several pieces of French metalwork in the late 1790s or when he visited again during the Peace of Amiens in 1802–3. It is less likely, but not impossible, that they also could have been imported into London at that time. The Isis clock displayed in the Aurora Room (pls. XIII, no. 3, VII, cat. no. 71) is French, as is possibly the pair of gilt bronze candlesticks (pls. XLIX and XV, no. 3, cat. no. 73).[41] It is apparent, then, that contrary to Hope's assertion that he designed all his pieces, he assembled his array of bronze objects and fittings for Duchess Street from a variety of sources. Although the London-made pieces may indeed have been made specifically to his design, many of them by Decaix, it is evident that he also bought Paris-made pieces as stock items.

Silver

The other main use of metalwork at Duchess Street was silver, and much of it is illustrated principally as plates XLVII, XLIX, and LII in *Household Furniture* (figs. 6-16, 6-17, 6-18). Unlike the decorative bronzes, little silver is shown integrated with the interiors. Most pieces were probably displayed in the "eating-room." One of the views of that room (pl. L; see fig. 6-11) shows a basket on a torchère flanking the chimneypiece.[42] In another view of the sideboard, in plate IX, there is a reduction of the famous classical antiquity, the Warwick Vase, which is identified as "a vase with

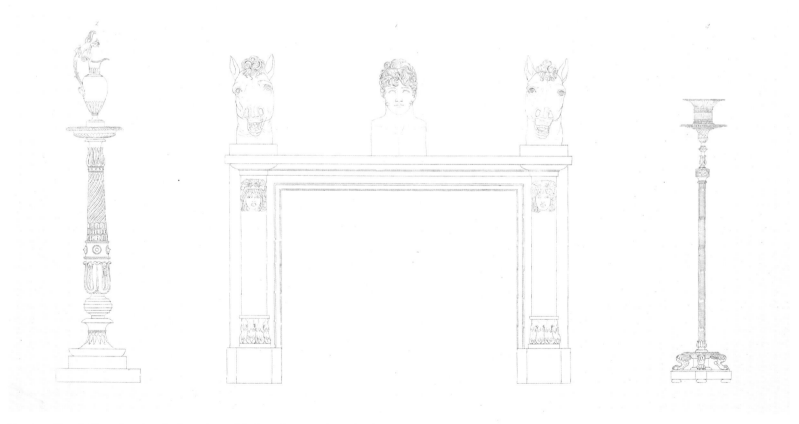

Fig. 6-11. *Household Furniture* (1807): pl. L. The model of Bacchante masks on the chimneypiece is similar to that used on the vase (see page 90).

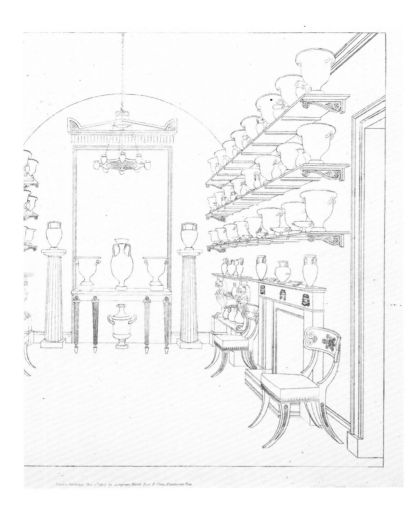

Fig. 6-12. Second Vase Room, Duchess Street, where mounts modeled as the comic and tragic masks were applied to the chimneypiece. *Household Furniture* (1807): pl. IV (detail).

Fig. 6-13. *Household Furniture* (1807): pl. XLIV, showing the end of the cradle with its profile heads and other gilt-bronze mounts emblematic "of night, of sleep, of dreams and of hope." This may be the most literal use of ornament among Hope's designs for furniture and metalwork.

Fig. 6-14. *Household Furniture* (1807): pl. XI, no. 1 (detail), showing bronze profile head mounts used in the pediment of the library table.

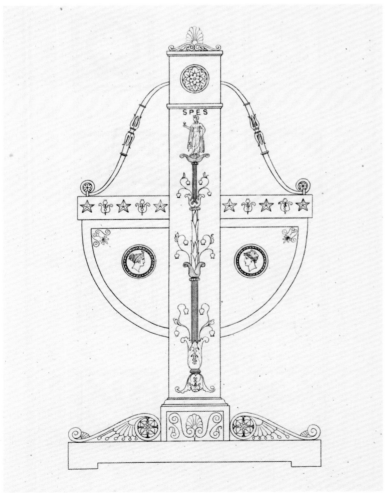

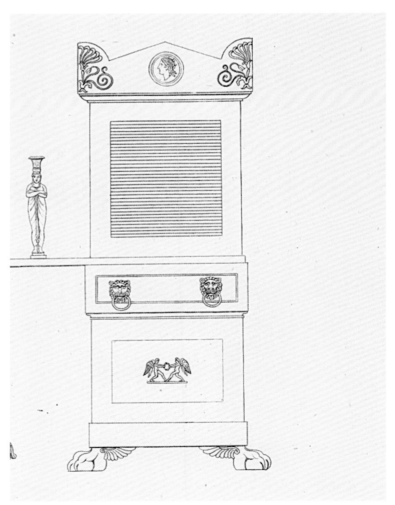

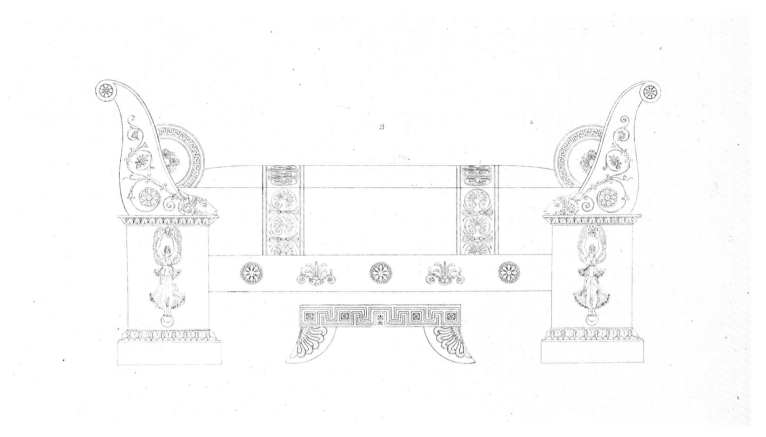

Fig. 6-15. *Household Furniture* (1807): pl. XXIX (detail), showing the bedstead of French manufacture with its elaborate bronze mounts, including "figures of the Night riding her crescent and spreading her poppies."

Bacchanalian marks" (*sic*).[43] Although several silver versions are known, it is unlikely to be the material in this case as silver Warwick vases seem to date only from 1811–12.[44] Some of the silver may, of course, have been used in the drawing rooms for serving tea or coffee.[45] The plates in *Household Furniture* show the silver mixed with bronzes and other materials of similar scale, but it is not easy to distinguish which is which because of the outline style used for the plates. The heavy quality of gilding at this period, in France known as *vermeil*, would have added to the confusion between what was bronze and what was silver.[46] Furthermore, there are some problems with the materials Hope describes in the text, where some pieces cited as of "bronze and gold" are, in fact, made of gilt and bronzed wood (pls. XXI, XXX, cat. nos. 80, 94). However, the subsequent sales of Hope silver reveal much that *Household Furniture* does not convey.[47]

As with the rest of the metalwork, it is more complex to reconstruct an accurate picture of the silver from *Household Furniture* than Hope suggests in the text. Two of the objects are recognizable as models made by the Parisian silversmithing firm of Odiot. The "sugar bason" in plate LII (fig. 6-18) decorated with Bacchus on a lion is a known Odiot model,[48] as is the tureen[49] (or two-handled covered bowl) shown in plate XLVII (fig. 6-16).[50] The ewer

(pl. LII, fig. 6-18 right) resembles the designs made by the sculptor Moitte for the silversmith Henry Auguste and later acquired by Odiot. Some of these Auguste designs were adapted for manufacture by Odiot, and perhaps that was the case here.[51] The sales of Hope's silver in 1917 and 1937 reveal that there was more French Empire silver in the Hope collections.[52]

These sale catalogues of Hope's collections have also revealed that most of the remaining silver at Duchess Street was made by the leading London silversmith Paul Storr, who ran his own business from 1796 and began his association with the royal goldsmiths Rundell, Bridge and Rundell in 1807. His ability to translate the "archaeological" style in a convincing manner was what Hope required for his silver. In addition to the silver-gilt baskets marked by Storr and dating from 1798–99 (cat. no. 101), the circular "ragout" dish, shown as plate XLVII (fig. 6-16 left and fig. 6-19), is marked by Storr for 1801. Here we have the closest evidence of Hope using one of his own designs for metalwork. The handle, based on an ancient Roman model with its distinctive fluting and ram's-head terminal (fig. 6-21), appears in a drawing by him (fig. 6-20).[53] Hope may have also had a hand in the design of other pieces marked by Storr. The large ovoid bodied hot water or tea urn with its panther spout shown in plates XLIX and

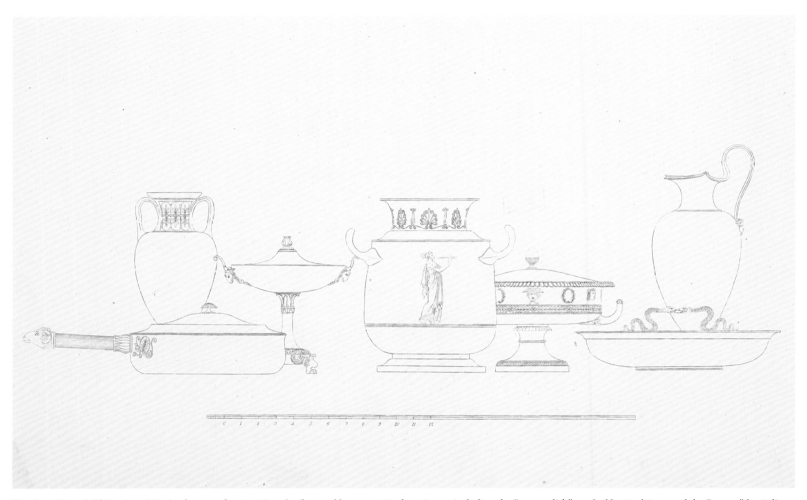

Fig. 6-16. *Household Furniture* (1807): pl. XLVII, showing Hope's silver and bronze at Duchess Street, including the "ragout dish" marked by Paul Storr and the "tureen" by Odiot.

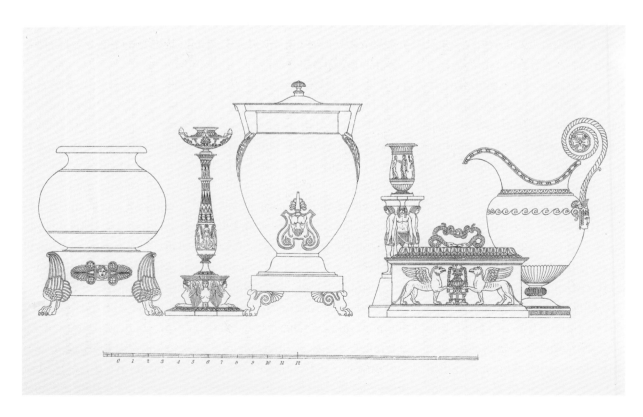

Fig. 6-17. *Household Furniture* (1807): pl. XLIX, depicting Hope's silver and bronze at Duchess Street, including the Egyptian slave candlestick probably by Decaix and the gilt-bronze antique lamp candlestick probably by the Parisian firm of LeFèvre.

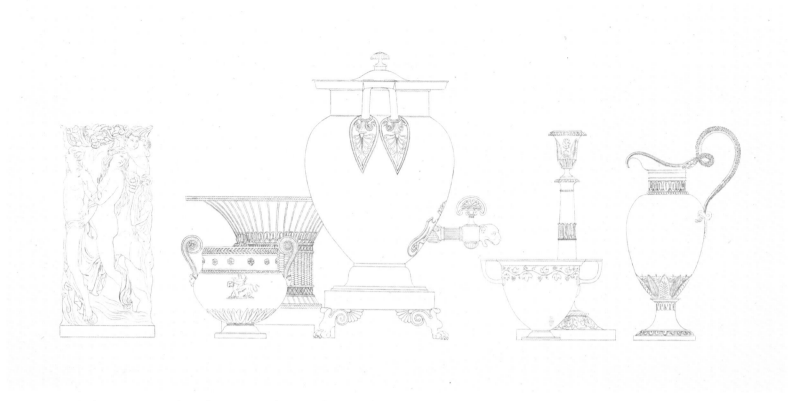

Fig. 6-18. *Household Furniture* (1807): pl. LII, showing some of Hope's silver at Duchess Street, including the Odiot "sugar bason," the Paul Storr-marked "fruit basket," and the ewer possibly after designs by Moitte and Auguste. The sculptural piece at the left is an ivory sleeve of a tankard.

LII (figs. 6-17, 6-18) has a foot very similar in design to the bronze vases in plates XXXIV–VI (figs. 6-3, 6-4, 6-5), which were also probably designed to Hope's order.

Some of the remaining silver, known to have been in Hope's collection but not illustrated in *Household Furniture*, were probably stock items. The silver-gilt hot water or tea urn with "Egyptian ornament" supported by winged figures from Rundell's Greenwich workshop (cat. no. 102) exists in other versions.[54] Made by Benjamin Smith and Digby Scott in 1805, the urn was designed by the immigrant French artist Jean–Jacques Boileau, who worked for Rundells.[55] It was to be joined by a three-piece tea service made in 1808 by Storr and a hot water or coffee jug on a tripod stand with "winged sphinx supports" similar to the urn and marked for 1806.[56] These pieces were, therefore, also dependent on Boileau's designs, even if Hope had a hand in their selection. Also marked by Storr was a set of four silver-gilt vases and covers, chased with arabesque foliage, inscribed by Rundell, Bridge and Rundell, and with marks for 1805–6. This elaborate design appears in several other versions, albeit later in date, including some in the Royal Collection.[57] Perhaps the most extraordinary piece of Hope's silver, which was not included in *Household Furniture*, is the pair of silver-gilt tazze with panther monopodia (cat. no. 103). Dating from 1808, they appear to be a Hope design and closely relate to some of Hope's furniture

(pl. XXXII). The design is derived from an "antique white oriental alabaster" tazza in the Vatican collection that was drawn by Tatham in 1795 and included in his *Etchings* of 1799.[58] As there are no other versions of this model known in silver, it is likely that Hope commissioned it to his own design, derived possibly from Tatham, to be made by Storr. Indeed, it may also have been inspired by an ancient tripod table in Hope's collection (see cat. no. 45).

Although Hope could not have provided all the designs for metalwork in *Household Furniture*, as he claimed, he certainly acted as a patron by choosing readymade or stock pieces from distinguished manufacturers in London and Paris. It is also likely that he directed the design of some pieces, such as several of the silver pieces marked by Storr. For the designs he did devise, Hope must have drawn on the experience of his extensive tours of Europe and the Near East in the 1790s. Surprisingly, he does not seem to have drawn much from his own collection of antiquities for inspiration. One possible exception is the metalwork vase shown on the left of plate XLVII (fig. 6-16), based on a Greek Attic neck amphora that resembles one in Hope's own collection.[59] He was probably also influenced by Charles Heathcote Tatham, whose studies of antiquities in Italy were published

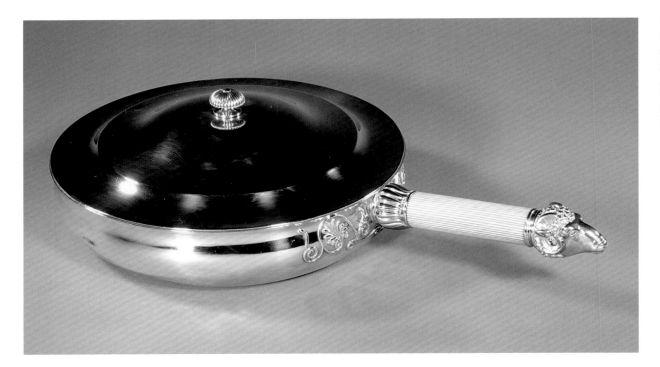

Fig. 6-19. The "ragout" dish" (mark of Paul Storr for 1801), one of a pair of silver saucepans, illustrated as part of Hope's silver in *Household Furniture* (1807): pl. XXII (fig. 6-17). Location unknown. Christie's Images Limited 2007.

Fig. 6-20. Design by Thomas Hope for a fluted handle with a ram's-head terminal similar to that on the silver ragout dish (fig. 6-19) and the arms of a chair in *Household Furniture* (1807): pl. XII. Private collection.

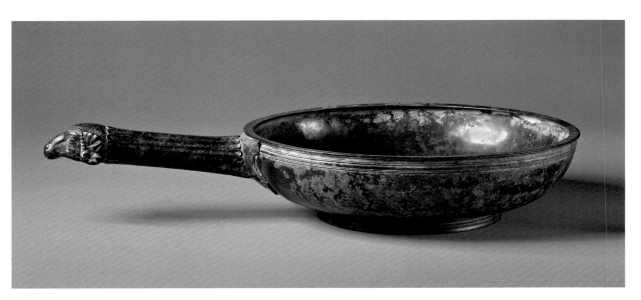

Fig. 6-21. Patera with ram's-head finial. Greek. Bronze, 5th century B.C. The Cleveland Museum of Art, purchase from the J. H. Wade Fund 1981.6.

Fig. 6-22. *Household Furniture* (1807): pl. XLVIII, showing the bronze-handled vase by Zoffoli in the center of the chimneypiece.

Fig. 6-23. Charles Heathcote Tatham. "Design for a Branch Light, proposed to be executed in silver." Engraving from *Designs for Ornamental Plate* (London, 1806). Victoria and Albert Museum, London. © V&A Images.

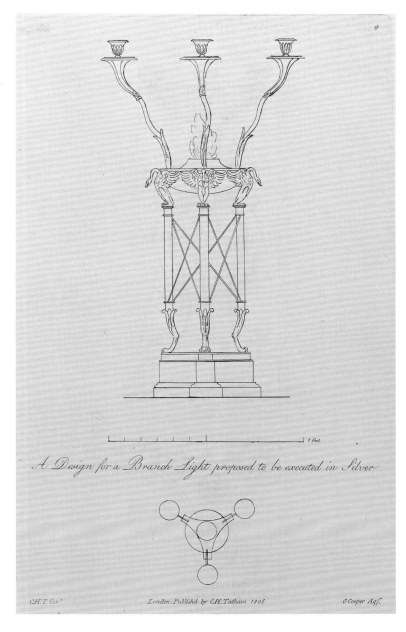

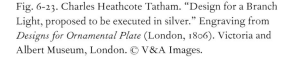

in his *Etchings* of 1799.[60] Although these prints were the primary source for the "archaeological" phase of neoclassicism around 1800, Hope does not include them in the list at the conclusion to *Household Furniture*.[61] Furthermore, Hope makes it clear from his annotations that Tatham's recently discovered drawings for the extensions to Duchess Street in 1800 were executed to Hope's own design. Hope seems to have been determined to record that the designs for Duchess Street were his own and not Tatham's.[62] It is difficult to tell who originated the designs for the objects at Duchess Street. Hope drew the tragic and comic masks that are applied so profusely to objects on his Grand Tour,[63] yet variants also appear in Tatham's *Etchings* and in *Designs for Ornamental Plate* published in 1806.[64] The winged griffons on the casket (pl. XLIX, fig. 6-17) relate to several of the early plates in Tatham's *Etchings* and may be derived from this source.[65] The pair of silver tazze mentioned above may have derived from

Tatham's *Etchings*. On the other hand, a vase supplied by the Roman metalworker Giacomo Zoffoli,[66] shown displayed on the chimneypiece in plate XLVIII (fig. 6-22), follows the form of an antique specimen in the Vatican collection that was also published by Tatham in *Etchings*.[67] So the fact that a model was published by Tatham did not necessarily mean that Hope obtained his designs from that one source.

Hope can be criticized for not acknowledging Tatham at the end of his book, and for claiming that he designed all his pieces himself when it is clear that he also bought stock items, but Hope's success lies in the strength, elegance, and clarity of the designs in *Household Furniture*. Hope's graphic abilities were remarkably well developed, as is apparent from his known surviving sketches,[68] and although Edmund Aikin and George Dawe executed the outline plates in *Household Furniture*, Hope must have supplied the original drawings.[69] By comparison,

Tatham's designs in *Ornamental Plate* (1806) show much weaker compositions with sometimes a hesitant, nervous line (fig. 6-23).[70] Hope's contribution must be seen in pulling together all the disparate elements of Duchess Street and translating them it into a clear, concise repertory of modern taste. Of this work, the metalwork is a remarkable and innovative presence in creating Hope's complete scheme of interior decoration that lived up to his expectations of "character, pleasing outline, and appropriate meaning."

1. In the Aurora (or Flaxman) Room (*Household Furniture* [1807]: pl. VII), the mounts applied to the richly gilded wood console table (pl. VIII, no. 3, cat. no. 68) were made of sober and contrasting patinated bronze and depicted the gods of Night and Sleep. In his Egyptian Room, Hope extended its use beyond metalwork by applying these two contrasting finishes on wood for the furniture and furnishings, in what he called "masses of black and of gold." The wooden stand (pl. XXI) and the chandelier (pl. XXX) also displayed these contrasting finishes of bronze and gold.

2. *Household Furniture* (1971): 138. It is also quoted as an example of what contemporary collections lacked; Watkin, *Thomas Hope* (1968): 123–24.

3. *Household Furniture*, pls. XIII, no. 3, XXIV–VI, XL, no.I, XLVII, XLIX, LII.

4. Such as the casket in *Household Furniture* (1807): pl. XLIX and the masks on pls. XXXVII, XXXVIII.

5. *Household Furniture* (1971): 8.

6. Watkin, *Thomas Hope* (1968): 210.

7. Discussed in the chapter "An Imperial Style" in Christopher Hartop, *Royal Goldsmiths: The Art of Rundell & Bridge 1797–1843* (Cambridge: John Adamson, 2005).

8. Seen in William Henry Pyne's *History of the Royal Residences* (London, 1819). See *Carlton House: The Past Glories of George IV's Palace* (London: The Queen's Gallery, Buckingham Palace, 1991).

9. *Household Furniture* (1971): 10.

10. Martin Chapman, "Thomas Hope's Vase and Alexis Decaix," *V&A Album* 4 (1985): 216–28.

11. *Household Furniture* (1807): pl XXXIV, p. 86.

12. Now in the Museo Archeaologico Nazionale, Naples, inv. no. 6779. See Chapman, "Thomas Hope's Vase" (1985): fig.13, for a similar model of vase.

13. For example, two of his most prominent pieces of sculpture, *Athena* and *Hygeia* (now both in the collection of Los Angeles County Museum of Art), which were prominently displayed in the Statue Gallery at Duchess Street, were acclaimed in Hope's time as Greek, and the *Athena* was thought to be by Phidias. Now, however, they are recognized as Roman copies of the first century A.D. of lost Greek originals.

14. *Household Furniture* (1807): 92–93, pl. XXXVII. Hope must have designed these masks himself, as his drawings for them survive in the Benaki Museum, Athens.

15. *Household Furniture* (1807): pl. XXXV.

16. Another larger version of this design of vase has emerged recently. Although the mounts are meticulously made, there are differences in the design; the feet, for example, are modeled in a more florid manner, which suggests that this version of the vase is of a later date.

17. Chapman, "Thomas Hope's Vase" (1985): figs 10, 12.

18. Martin Chapman, "Techniques of Mercury Gilding in the Eighteenth Century," *Ancient and Historic Metals* (Los Angeles: The Getty Conservation Institute, 1995): 229–38. The ormolu supplied by Vulliamy for clocks and decorative objects in these years also displays this technique. See *Carlton House* (1991): cat. no. 48.

19. S. Flachat, *L'Industrie, Exposition de 1834* (Paris: Henry Depuy, ca.1834): introduction.

20. Quoted on the Web site of *Généalogie Deloge-Godin*. This would mean that he lived to the age of 77 and was married three times. Born 19 October 1734 of Chepoix, 60, of Oise, Picardy, this Decaix married first Cecile Barticle (b.1735) on 9 January 1759 and then Marie Loisel on 19 June 1787.

21. Archives Nationales, Y.9333. The author is most grateful to Sir Geoffrey de Bellaigue for this information.

22. Archives Nationales, H2118.

23. Windsor, Royal Accounts, 25093, 25097–99; 25105.

24. Sun Assurance Records, Guildhall Library, 779765. The author is grateful to Sir Geoffrey de Bellaigue for this reference.

25. Archive of Art and Design, Victoria and Albert Museum, London, Garrard & Co., Ltd.: records, 1735–1949.

26. He received £50 on 4 October from "Mr. Holland" toward his bill of 4 November 1791. Royal Accounts 25093.

27. This is interesting in view of the fact that the prince would also commission bronzes from the London firm of Vulliamy around 1807 and then from Thomire in Paris from 1812. See *Carlton House* (1991): cat. nos. 48, 66.

28. D. Stroud, *Henry Holland: His Life and Architecture* (London: Country Life, 1966): 113. I am grateful to Philip Hewat-Jaboor for his research into Decaix's bronze work at Woburn.

29. David Watkin, "Thomas Hope's House in Duchess Street," *Apollo* 159, no. 505 (March 2004): 31–39.

30. Charles H. Tatham, *Etchings . . . of Ancient Ornamental Architecture* (London, 1799).

31. Christie's, London, *A catalogue of a valuable assemblage of rare Oriental CHINA. . . and Articles of Bronze and Or-moulu. . . at Mr. Decaix's No 43 Old Bond Street . . .*, 27–28 August 1810. Information kindly supplied by Daniella Ben-Arie.

32. The Web site www.copinger.org.uk, where she is listed under Decaix as being born in Cork.

33. For example, the candlesticks with antique lamp sockets (pl. XLIX), which were thought until recently to be English. See Jean-Dominique Augarde, "Une nouvelle vision du bronze et des bronziers sous le directoire et l'Empire," *L'Objet d'Art*, no. 398 (January 2005): 75, fig. 19.

34. *Household Furniture* (1807): 86–93, pls. XXXIV–XXXVII.

35. Ibid., pl. XXXI.

36. The ormolu made by the London firm of Vulliamy shows this weightiness and broadness at this same date. See G. de Bellaigue, "Samuel Parker and the Vulliamys, purveyors of gilt bronze," *Burlington Magazine* (January 1977): 26–38.

37. Pls. XXV, no. 2; XXII, no. 3; XIX, no. 1; XVII, no. 5; XI, no. 5; XXVI, no. 3.

38. *Household Furniture* (1807): pl. XI, no. 5.

39. J. Morley, *Regency Design* (London: Zwemmer, 1993): 385–86, fig. 286b.

40. Sold at Christie's, London, 18–19 July 1917, lot 290.

41. See Augarde, "Une nouvelle vision" (2005): no. 398, p.75, fig. 19, for a candlestick of the same model by the Parisian *bronzier* Lefèvre. Lefèvre was a less well-known figure whose work was distributed by the better-known *bronziers* Galle, Biennais, or Cahier. The author also identifies a chandelier at Woburn as being designed by Lefèvre rather than by Henry Holland. Unlikely as it may seem at the time of the war with France, there may indeed have been a connection between Holland and Lefèvre.

42. Although Hope's text says this is gilt bronze, it was probably made of silver gilt. Hope is documented as having four of these baskets in silver gilt. Unless he had more made in gilt bronze, this is an error.

43. Now in the Burrell Collection, Glasgow.

44. Timothy Schroder, *The Gilbert Collection of Gold and Silver*, exh. cat. (Los Angeles: Los Angeles County Museum of Art, 1988): 402–9, cat. no. 107.

45. Apparently these rooms were rarely used, and therefore it is more likely that these pieces were used on the family floor above. See Watkin, "Thomas Hope's House" (2004).

46. Surviving models of the triangular candlestick with the socket in the form of an antique lamp, which have recently been identified as French rather than English (pl. 49, also in plate xv, no. 3, cat. no. 73) have a very thick layer of gilding to their bronze.

47. Christie's, London, Hope Heirlooms sale, 17 July 1917, lots 89–94, 99. Christie's, London, *Old English Silver*, 7 June 1934, lots 86, 88.

48. J.-M. Pinçon and O. Gaube du Gers, *Odiot l'orfèvre* (Paris: Editions Sous Le Vent, 1990): figs. 202, 205.

49. Christie's, London, *Old English Silver*, 7 June 1934, lot 84, where it is described as a tureen and cover with the arms of Hope and the maker as J. B. C. Odiot.

50. *French Master Goldsmiths and Silversmiths from the Seventeenth to the Nineteenth Century* (New York: French and European Publications, 1966): 301, fig. 3.

51. Schroder, *Gilbert Collection of Gold and Silver* (1988): 617–21, no. 168.

52. Christie's, London, Hope Heirlooms sale, 17 July 1917, lots 89–94, 99. Christie's, London, *Old English Silver*, 7 June 1934, lots 86, 88.

53. Watkin, *Thomas Hope* (1968): fig. 47. The drawing of this handle is included in a design for a villa. This motif also appears as the arm of a chair in pl. xxii, nos. 5, 6.

54. Schroder, *Gilbert Collection of Gold and Silver* (1988): cat. no. 90 made for the Duke of Richmond, another in the collection of Earls Spencer.

55. Christie's, London, Hope Heirlooms sale, 17 July 1917, lot 52.

56. Ibid., lots 50, 51.

57. Christie's London, Hope Heirlooms sale, 17 July 1917, lot 57. C. Hartop, *Royal Goldsmiths: The Art of Rundell and Bridge 1797–1843* (Cambridge: John Adamson, 2005): no. 30, fig. 51, p. 63. N. M. Penzer, *Paul Storr* (London: Hamlyn, 1971): 182–83, pl. lii.

58. Tatham, *Etchings* (1799).

59. E. M. W. Tillyard, *The Hope Vases* (Cambridge: Cambridge University Press, 1923): no. 86, pls. 8, 9.

60. Watkin, "Thomas Hope's House" (2004); Tania Bucknell Pos, "Tatham and Italy: Influences on English Neo-Classical Design," *Furniture History* (2002).

61. *Household Furniture* (1807): 138–41.

62. Watkin, "Thomas Hope's House" (2004): 31–39.

63. Thomas Hope, "Outlines for My Costume." See cat. no. 109. Watercolor. ca. 1787–95.

64. Charles H. Tatham, *Designs for Ornamental Plate . . .* (London: Printed for Thomas Gardiner, 1806). It could be argued that this was published too late to be an influence on Hope's Duchess Street.

65. Inscribed "Ornament upon the breast plate of an antique Statue of a Roman Emperor . . ." and illustrated in Pos, "Tatham and Italy" (2002): fig. 17.

66. The cataloguing in the 1917 Christie's Hope Heirlooms sale, lots 232, 239, reveals the marks of their maker, GZF. Information kindly supplied by Daniella Ben-Arie.

67. Described in *Etchings* as "Antique vases in dark oriental Marbles, from the Collection of the Museum of the Vatican."

68. Watkin, *Thomas Hope* (1968): fig 47. Benaki Museum drawings cat. nos. 16–34.

69. Watkin, "Thomas Hope's House" (2004): 34, fig.10.

70. Tatham, *Designs for Ornamental Plate* (1806).

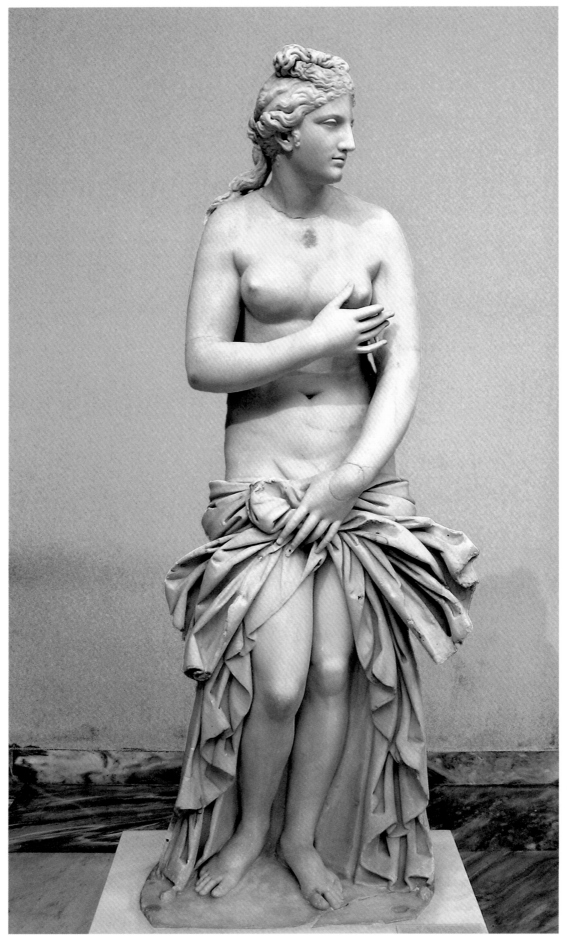

Fig. 7-1. *Aphrodite*. Roman, 1st or 2nd century A.D. Marble. National Archaeological Museum, Athens, 3524.

The Past as a Foreign Country: Thomas Hope's Collection of Antiquities

Ian Jenkins

Thomas Hope drew much inspiration for his own furniture, fashionable costume, and interior design from a detailed knowledge of antiquity. His scholarly aesthetic, however, was no mere antiquarian pursuit, no mere revival of classical taste. Grander and more complex than these, Hope's vision blended ancient with modern, familiar with exotic, classical with Oriental, nature with culture, art with morality, and life with death. At Duchess Street Hope the alchemist melded together compound elements to forge a new and eclectic whole. We see his genius at work with the room he called the Lararium and its piling up of objects representing comparative religions; we see it again in the Hindu and Moorish pictures and furnishings of the Indian Room and in Hope's Regency-Pharaonic designs and the sacred eschatology of the Egyptian Room; and we see it in the Greek temple architecture of the Picture Gallery.[1] Then there was the Aurora Room designed around a marble sculptured group of Aurora (Dawn) abducting Cephalus.[2] In Hope's outline engraving (fig. 7-2) for his book *Household Furniture*, this sculpture appears as a paradigm of refinement in modern taste, carved from white marble in Rome by John Flaxman, the leading British sculptor of the day.[3] And yet its altarlike base evokes the setting of an ancient cult image and thus seems to blur the boundary between the contemporary secular world of the Regency salon and the ancient, sacred temple. A shrinelike interior was further suggested by the furniture and fittings and from the carefully selected symbolic imagery of the room's plaster frieze and other ornament. Most striking, perhaps, were the azure, black, and orange curtains that lined the walls. At the center of each long wall these draperies parted to reveal mirrors that reflected reverse images of the sculpture. The colors of the room, in Hope's words, were intended to evoke "the fiery hue which fringes the clouds just before sunrise."[4] A classical dawn, answering the one personified in the sculpture, is summoned by Hope's phrase "rosy-fingered," borrowed from Homer. To see this poetic attempt at capturing nature simply as a neoclassical device would be to miss the timeless romance of not only this but of all Hope's interiors.

Flanking Flaxman's sculpture were two glass caskets, each one containing a velvet cushion. On one cushion there rested a marble arm, which was said to have been acquired in Rome but thought to come from one of the human Lapiths doing battle with Centaurs in the south metopes of the Parthenon.[5] In the other showcase was a stalactite, again from Greece but this time from the celebrated cave at Antiparos, which had been remarked upon by the French ambassador to Constantinople, the Marquis de Nointel, who had traveled in Greece in 1670–80. Hope had himself made a drawing of the cave (fig. 7-3), depicting it as a natural dome sheltering the plantlike forms of the giant, columnar stalactites within.[6] A piece of nature's own architecture was set beside a fragment from the greatest man-made building of antiquity, and in this juxtaposition we find an epitome of Hope's pictorial and intellectual landscape. Art and nature meet and are enshrined as equal contributors to the romantic classicism of the Duchess Street interiors.

Art was similarly married to nature in the house and grounds of the Deepdene, the country home and estate in Surrey that Hope bought in 1807 (see Chapter 12). There, for example, was the "Hope" itself, a natural bowl in the landscape that had been developed in the seventeenth century by a previous owner, Charles Howard, as a garden with terraces descending like the seats of a Greek theatre.[7] This feature, described by John Aubrey in his book on the antiquities of Surrey, must have attracted Thomas Hope to the place by its name. He was to echo this Theatre of Nature with a Greek-style Theatre of the Arts in the small mock auditorium he attached to the Sculpture Gallery at the Deepdene. In place of a seated audience he planted its steps with classical heads and cinerary urns in rows[8] (see cat. no. 106.9).

Both at Duchess Street and at the Deepdene, there is poetry in the setting out of his collections that distinguishes Hope's from other comparable house museums in contemporary London, notably those of Charles Townley and the 1st Marquis of Lansdowne, who both died in 1805. Lansdowne decorated the formal Adam interiors of his Mayfair mansion with ancient marbles in a conventional neoclassical fashion, but he failed in his own

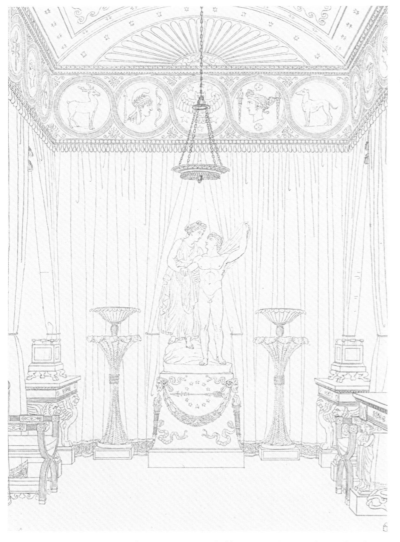

Fig. 7-2. Aurora Room, Duchess Street. *Household Furniture* (1807): pl. VII (detail).

lifetime to achieve his scheme for an additional grand gallery (fig. 7-4).[9] Townley too entertained grand designs for displaying his more extensive collection[10] but was forced in the restricted rooms of his house at Park Street, Westminster, to adopt a pinched Picturesque[11] (figs. 7-5, 7-6). He had been amassing his collections of sculpture, vases, and other antiquities since he first visited Italy in 1768 on the first of three Grand Tours. His vast archive of documentary papers and drawings now in the British Museum testifies to the sustained interest that he took not only in his own collection, but also those of other collectors in London and elsewhere in Britain.[12] Visiting in February 1804, Townley was one of the first to see Hope's newly arranged London residence, and he left us a list of the sculptures that he found there.[13] To this simple document Townley appended a rhyming couplet that seems, rather nastily, to betray a touch of jealousy:

> *Something there is more needful than expense, and something previous ev'n to taste . . . 'tis sense.*

Closer to the peculiar romance of Hope's interiors are those of Sir John Soane, who was influenced by Hope (fig. 7-7),[14] as indeed was the banker, poet, and conversationalist Samuel Rogers.[15] Rogers went to Hope's house for inspiration in arranging his own collection of Greek vases and casts of the Parthenon frieze as a setting at 22 St. James's Place for his celebrated candlelit evenings of convivial *Table Talk*. Of all contemporary establishments, only Soane's home miraculously survives, with the collections intact, at Lincoln's Inn Fields. Its witty juxtaposition of contrasts, artful use of mirrors, pictorial setting of objects, such as vases in columbar-

Fig. 7-3. Thomas Hope. The Stalactite Grotto of Antiparos. Benaki Album, vol. V, 27310. Benaki Museum, Athens.

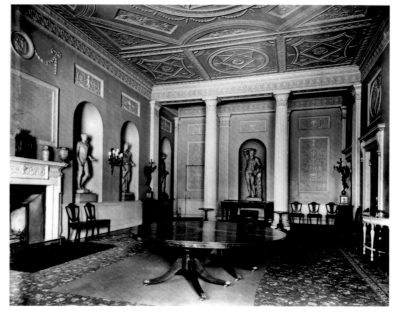

Fig. 7-4. The Dining Room at Lansdowne House photographed in 1922 for *Country Life*. The interior by Robert Adam is decorated with antique sculpture acquired in Rome from the antiquarian and painter Gavin Hamilton. Country Life Archive.

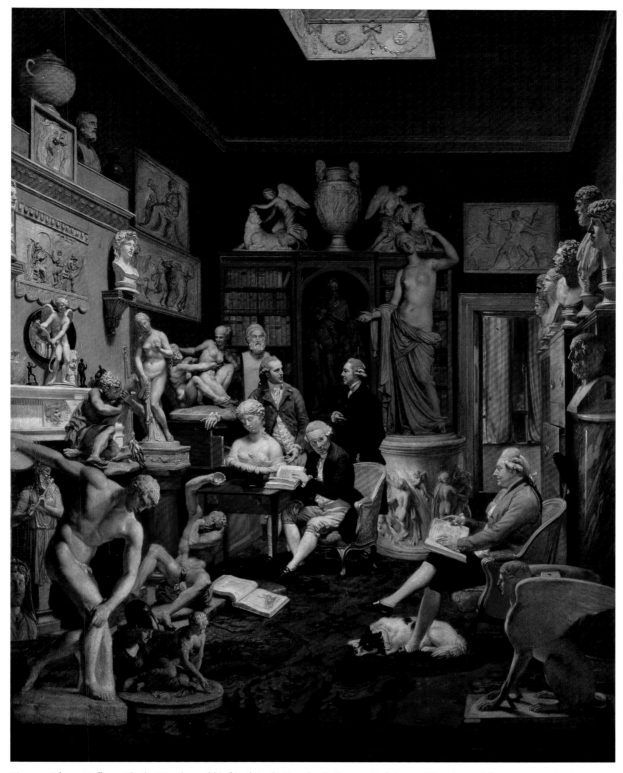

Fig. 7-5. Johann Zoffany. *Charles Townley and his friends in the Townley Gallery, 33 Park Street, Westminster*. Oil on canvas, 1781–83. Townley Hall Art Gallery and Museum, Burnley, Lancashire. The Bridgeman Art Library.

ium niches, the necromancy of its Egyptian mummy sarcophagus, the eclectic mix of archaeological cultures elegantly combined in the unifying aesthetic of Regency classicism, all serve to remind us of what we have lost at Duchess Street, ruthlessly demolished in 1851 by Hope's son and heir, Henry Thomas.

Although the house is long gone, something of its spirit can be found in *Anastasius*, Hope's novel, which provides a literary par-

allel for the Duchess Street experience.[16] The young Greek of the story explores his adolescent emotions as he discovers the natural and man-made world during travels that take him through Turkey and the colorful dominions of the Ottoman Empire—Greece, Egypt, and Syria. Anastasius was a window through which Hope's readers could enter a world that was both vast and utopian. It was a world of fancy dress, which he would re-create

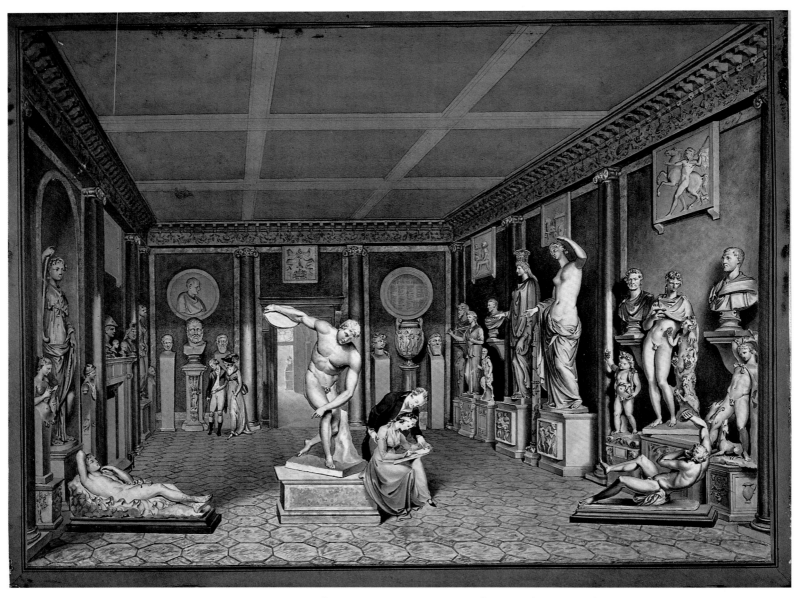

Fig. 7-6. William Chambers. *The Townley Marbles in the Dining Room of 7 Park Street, Westminster*. Watercolor, 1794. The Trustees of the British Museum, London.

in fashionable interiors occupied by people who dressed the part. Here is the essential purpose not only of Hope's book, but also of his interiors. Duchess Street, with its thematically arranged rooms, all on one upper floor approached by a grand staircase, functioned as a theater in which the make-believe lives of himself, his family, and their social set were acted out.[17] Hope was actor, impresario, scenery and costume designer, who, in his books on dress ancient and modern, showed his guests what to wear. He commissioned several fancy-dress portraits of himself and his family.[18] In 1798 Sir William Beechey painted one of Hope newly returned from his travels and decked out in Turkish dress (cat. no. 1). This mature Anastasius was, by 1824 at least, suspended in the staircase hall at Duchess Street to greet guests upon arrival.[19]

Contemplating Hope as collector and antiquary, it helps to keep Beechey's portrait of him in mind, the defining image of Hope as a visitor to the past, a foreign country. This was not the conventional souvenir of the Italian Grand Tour set in Rome, where "Signor Speranza" would have been depicted in fashionable European dress with some token souvenir of classical statuary. Instead "Ümit Bey" stands on the terrace of a Turkish palace, and in the background rise the dome and minarets of a mosque. The dress and the setting are from contemporary Ottoman Turkey, where Hope had resided and traveled and which he had himself drawn. In Anglo-Turkish relations, the year 1798 was an *annus mirabilis*. In that year Admiral Lord Nelson defeated the French at the Battle of the Nile and thus dealt a mortal blow to French efforts to capture Egypt from the Ottomans. In that same year, the British were to capitalize on their new-found favor at Constantinople by despatching Thomas Bruce, 7th Earl of Elgin, at the head of an embassy to the Turkish capital.[20] Ultimately, however, Beechey's portrait references more than the particular culture it represents. It is not only Turkish but it also belongs to a larger field of eighteenth-century fascination for the exotic, epit-

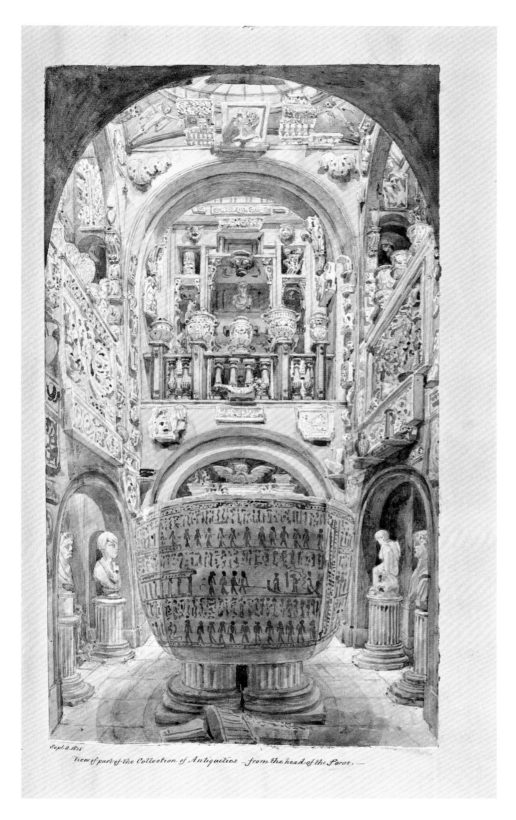

omized in the bringing to London in 1774 of Omai, the native of Tahiti, and his portraits by Joshua Reynolds.[21]

By contemporary standards, Hope's own travels were extraordinary. Most Europeans of his time did not go beyond Italy, where, for those in need of exotica, Naples and Sicily came to represent the fringe. At the age of eighteen in 1787, he embarked on the first of a set of journeys that would occupy him off and on for the next ten years and take him to Turkey, Egypt, Syria, Greece, Sicily, Spain, Hungary, Palestine, Portugal, France, Germany, and ultimately back to England. There, in 1795, other members of the Hope family of wealthy Dutch bankers (of Scottish descent) had settled in Hanover Square, London, to escape Napoléon's invasion of their homeland. Travel opened Hope's eyes to a world where ancient past and foreign present fused into one eclectic "other." No book, no picture or household interior could substitute for the experience of travel itself for, as Hope himself

Fig. 7-8. Thomas Hope. "Modern sailors contemplate a block of the Parthenon frieze over tea and tobacco." Benaki Album, vol. III, 27311. Benaki Museum, Athens.

puts it, not even in "the least unfaithful, the least inaccurate even, such as Stuart's Athens, Revett's Ionia, no adequate idea can be obtained of that variety of effect produced by particular site, by perspective, a change of aspect and a change of light."[22]

Hope was himself a considerable draftsman, and a record of his travels in 1796 and 1797 is preserved in five volumes of drawings now in the Benaki Museum in Athens.[23] The drawings are a compendium of architecture, ruins, landscape, sea and river craft, costume, interiors, and antiquities. Among these last is a study of the central block of the east frieze of the Parthenon (fig. 7-8) as yet uncollected by Elgin and still resting on the ground as part of a parapet wall.[24] In his crisp outline drawing, Hope shows the figures of the frieze standing in their classical costumes or seated on Greek furniture. Zeus, as father of the gods, occupies a throne with an armrest supported by a sphinx, an ancient forerunner of Hope's own zoomorphic Grecian furniture. Hope sets up a conversation between this ancient gathering in stone and the four

sailors in modern Turkish costume, who sit on the ground smoking pipes after taking tea. With their backs to the viewer, they face the frieze, and one of them actually points toward it. Meanwhile, one of the seated gods (Hera) and one of the standing figures look out from the frieze, not at any particular spectator but with a gaze that transcends this fleeting moment. So at Duchess Street the many ancient gods and heroes frozen there in marble would look coldly upon the modern world with unseeing eyes, unmoved by the admiring gaze of those gathered to view them.

Collecting Sculpture in Italy

Before his arrival in London in January 1795, Hope seems not to have conceived of making a collection, but before the year was out, he had left London for Rome in the company of his brothers, Henry Philip and Adrian Elias, expressly, it seems, for the purpose of buying classical sculpture.[25] No doubt they had witnessed in

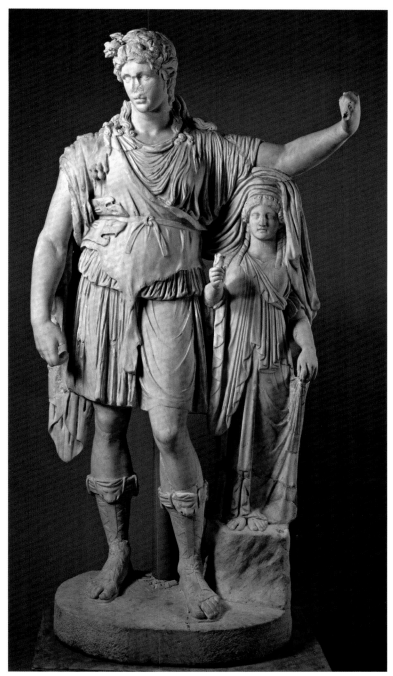

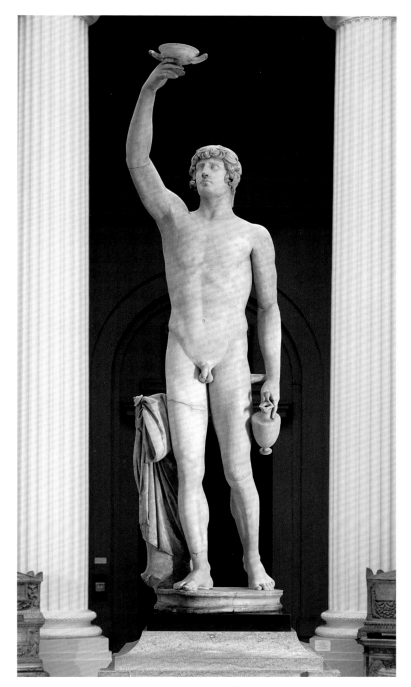

Fig. 7-9. *Dionysos leaning on a female figure* ("Hope Dionysos"). Early Imperial, Julio-Claudian Roman copy, 27 B.C.–A.D. 68, of a lost Greek original of ca. 400–350 B.C. Marble. Restored by Vincenzo Pacetti. The Metropolitan Museum of Art, New York, Gift of the Frederick W. Richmond Foundation, Judy and Michael Steinhardt, and Mr. and Mrs. A. Alfred Taubman, 1990, 1990.247.

Fig. 7-10. *Antinous*. Roman, ca. A.D. 130–138. Marble. National Museums Liverpool, Lady Lever Art Gallery, LL208.

England the well-established habit of forming a sculpture gallery, and this experience had inspired Thomas and his brothers to a new venture. In Rome of the 1790s, there were two principal sources through which classical sculpture could be bought. On the one hand, there were the collections of the old Roman aristocracy who had fallen on hard times, and there were licensed excavations on the other. Both sources could be accessed through a community of dealers, which included several British members, notably Thomas Jenkins, Gavin Hamilton, James Byres, and the Irish

painter Robert Fagan. There were also the restorer-dealers who would themselves renovate a statue and sell it on.[26] A particular favorite of Thomas Hope was Vincenzo Pacetti,[27] who restored the *Hope Asclepius*,[28] said to come from Hadrian's Villa. It is one of few Grand Tour sculptures to make the round trip between Rome and London, leaving England in the 1950s, when it was bought for a private collection in Rome. In 1796 Henry Philip bought from Pacetti the *Dionysos*, along with an archaistic statuette known then as *Bacchus and Hope* (fig. 7-9),[29] an irresistible subject

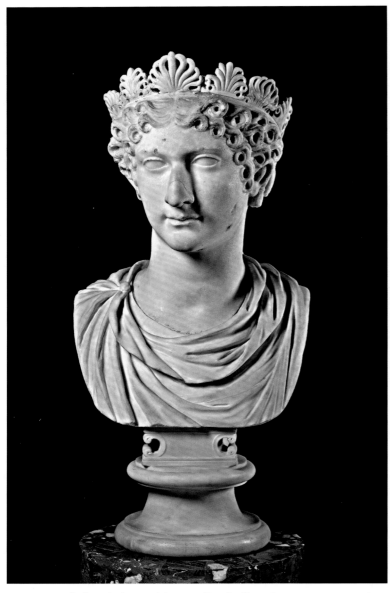

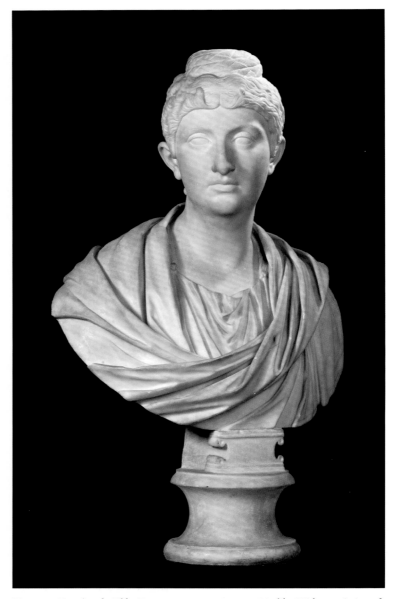

Fig. 7-11. Head of Agrippina or Livia or a Julio-Claudian princess. Roman, second quarter 1st century A.D. Marble. Ashmolean Museum, Oxford, 1917.67.

Fig. 7-12. *Faustina the Elder.* Roman, ca. A.D. 138 or 139, Marble. With permission of the Royal Ontario Museum, Toronto, 933.27.2. © ROM.

for a collector of the same name. It was said of the piece that it was acquired from the Aldobrandini Palace on the Quirinal. Adrian Elias bought the Roman copy of the *Pothos* (Desire) by Skopas,[30] which had been restored as a copy of the *Sauroctonus Apollo* by Praxiteles and which, before 1532, appears to have been in the collection of Francesco Lisca. The brothers Hope also made joint purchases, such as in 1796 that which came from the restorer Giovanni Pierantoni,[31] namely the *Antinous* statue (fig. 7-10).[32] There was also a couple restored as Apollo and the boy nymph Hyacinthus[33] and a statue of Apollo with bow and quiver.[34] Whoever the purchaser was, all the sculpture bought on this shopping trip to Rome would find its way into Thomas Hope's Duchess Street mansion.

Further purchases were made from Prince Sigismondo Chigi, who had acquired sculpture from excavations at the imperial villa of Antoninus Pius at Laurentum, south of the Roman port at

Ostia. These include the greyhound bitch and dog,[35] which may be compared with the pair in the Townley Collection of the British Museum and with that in the Vatican.[36] Most probably also from the site of the same imperial villa came a portrait of a female of the Julio-Claudian court, possibly Agrippina or Livia (fig. 7-11).[37] With it came the portraits of Antoninus Pius and of Faustina Maior (fig. 7-12).[38] The whereabouts of the former is unknown; the female bust is in the Royal Ontario Museum, Toronto.

Two of the grand highlights of the Hope collection came from Tor Boacciana on the outskirts of Ostia, where the Irish painter and antiquary Robert Fagan conducted excavations.[39] These are the over-life-size *Athena* (fig. 7-13) and the *Hygieia* (fig. 7-14).[40] Their discovery is described, in a note quoted by Waywell, as "among the ruins of a magnificent palace, and thirty feet below the surface of the ground, broken into fragments and buried immediately under the niches in which they had been

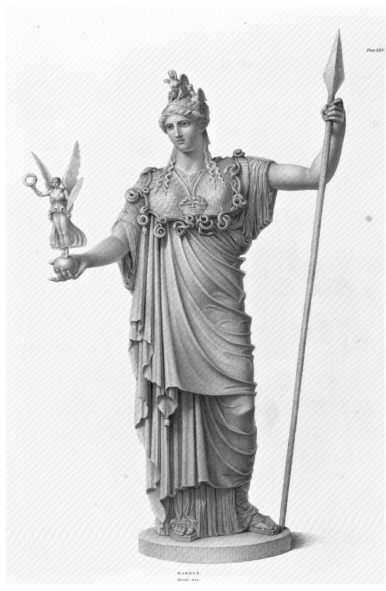

Fig. 7-13. *Athena*. Roman copy, 2nd century A.D., of a lost Greek original of ca. 440–420 B.C. Engraving from *Specimens of Ancient Sculpture* (1809). Art and Architecture Collection, Miriam and Ira D. Wallach Division of Art, Prints and Photographs. The New York Public Library, Astor, Lenox and Tilden Foundations.

once placed." The Athena is thought to be a Roman copy of the second century A.D., based on a lost Greek statue made around 440–420 B.C. The putative Greek original may be attributed to one of the pupils of Phidias, either Alkamenes or Agorakritos. The Roman copy was extensively and impressively restored as a variant of the *Athena Parthenos*, another Phidian creation. Sadly, much of the restoration was removed after the Hope sale of 1917, at which this statue fetched £7,140, the highest price of all. It was bought by Agnew acting for Viscount Cowdray. When it was sold again at Sotheby's in 1933, the value had plummeted to a mere £200. This fall in value is eloquent reminder of the economic depression that blighted America and Europe in the aftermath of World War I and, indeed, a shift in taste away from restored Roman copies and toward such Greek originals as the

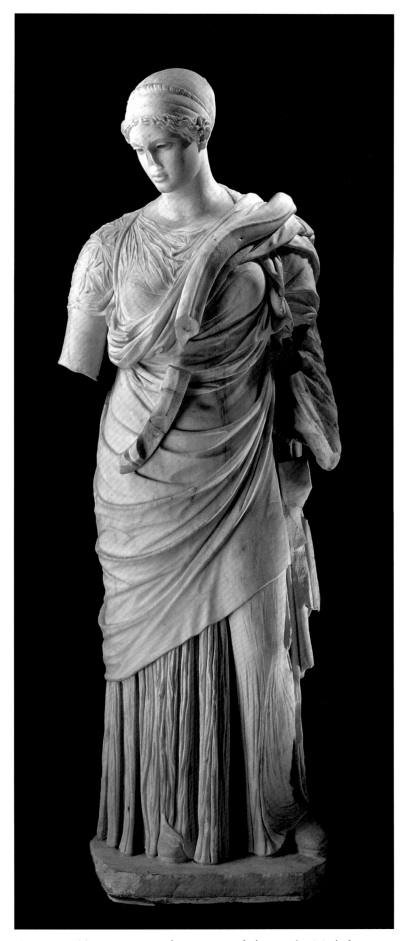

Fig. 7-14. *Hygieia*. Roman copy, 2nd century A.D., of a lost Greek original of ca. 400–350 B.C., sometimes attributed to Skopas. Marble. Los Angeles County Museum of Art, William Randolph Hearst Collection, 50.33.23.

market provided.[41] The *Athena* later passed into the estate of W. R. Hearst at San Simeon and, after his death, to the Los Angeles County Museum.

The other star piece in Hope's collection was the *Hygieia*, another Roman statue that has been dated to the second century A.D. and a copy of a lost Greek original probably of the first half of the fourth century B.C. Like the *Athena*, her head is her own and, with similar inlaid eyes and near equal stature, this goddess of healing formed a pair with the goddess of wisdom. She was bought at the Hope sale in 1917 for £4,200 by Spink acting for Sir Alfred Mond, later Lord Melchett. At the Melchett sale of 1936, the price had fallen to £598 10s, when she was purchased by Hearst and donated to the Los Angeles County Museum in 1950.

Hope at Home

In 1799 Hope bought the Duchess Street house, where his burgeoning collection was to be displayed. It is sometimes said that the acquisition of the house did not, as we might expect, detain him in England, and later that year he was again in Greece planning a tour of the Peloponnese with the Levant Trading Company's consular agent in Athens, Procopio Macri.[42] It appears, however, that the Hope of this excursion was his younger brother Henry Philip.[43] Late in 1799, it was he who carved his name and initials on a column at Delphi, having already in June of that year visited the Troad in northwest Turkey.[44]

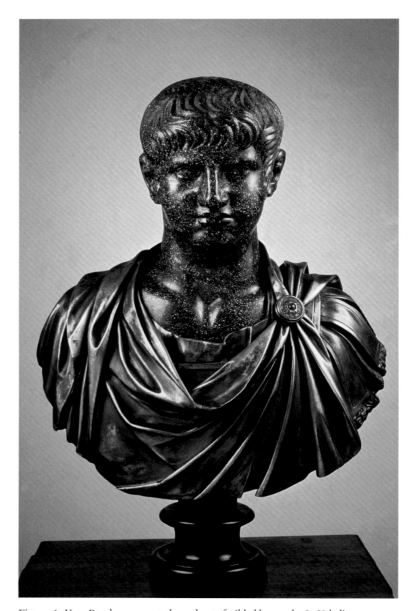

Fig. 7-16. *Nero*. Porphyry mounted on a bust of gilded bronze by L. Valadier. Not ancient; probably 16th–18th century Italian. Royal Ontario Museum, Toronto, 933.27.1. © ROM.

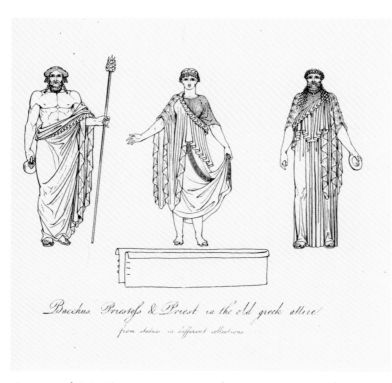

Fig. 7-15. Archaistic *Dionysos*. Roman, 1st or 2nd century A.D. Engraving from *Costume of the Ancients* (1809): pl. 55.

Thomas Hope, meanwhile, was taking advantage of the home market in antiquities. He bid successfully for sculpture at the sale of the Duke of St. Albans's pictures and antiquities at Christie's on April 29, 1801.[45] Earlier at Lord Bessborough's sale at Christie's on April 7, 1801, he had made other purchases. William Ponsonby, 2nd Earl of Bessborough, had died in 1793, and as is so often with those formed in the eighteenth century, his collection did not long survive him. Among a clutch of items Hope purchased at this sale was the *Ganymede*,[46] said to have been found in 1767 in the Campus Martius in Rome and bought from the Villa Albani. Also at Bessborough's sale, Hope acquired a colossal porphyry foot (cat. no. 46).[47] It was fashionable at the time to have a big foot, and Sir William Hamilton had presented his to the British Museum in 1784.[48]

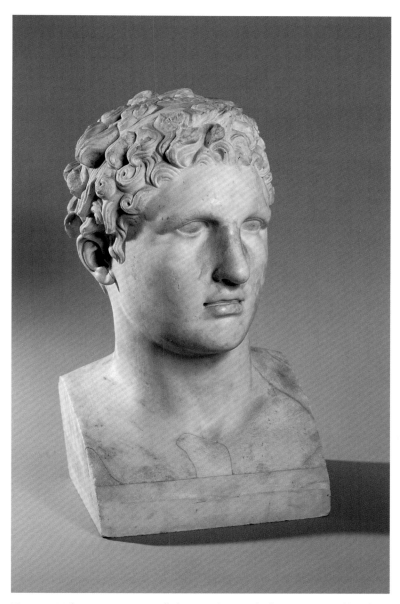

Fig. 7-17. *Meleager*. Roman copy of a lost Greek original of ca. 350 B.C. Marble. The Schroder Collection.

an egg in the other. She was said to have been excavated near Capua (cat. no. 47).[51] Such archaizing sculpture was fashionable in Hope's day and had been so since Johann Joachim Winckelmann publicized the several examples still to be found in the Albani collection in Rome. To Hope and his contemporaries these sculptures were not seen as the Roman revivals of earlier Greek styles, as they are now recognized, but were authentic Etruscan or early Greek productions viewed as sculptural examples of that noble simplicity found in archaic vase paintings. From a later period of Greek art comes a statuette of Cupid embracing Psyche that remains lost[52]; a basalt Egyptianizing lion said to come from the ruins of the Villa Jovis on Capri (cat. no. 49),[53] and a porphyry head of Nero mounted on a bust of gilded bronze by Luigi Valadier (fig. 7-16).[54] Another portrait bust, thought to have belonged to Cicero and excavated in the ruins of his villa at Formiae near Gaeta, is perhaps to be identified with a fine terminal bust of Meleager (fig. 7-17).[55] Hope also acquired a marble cinerary urn carved in the form of a covered basket, which is shown on a tripod stand in the Picture Gallery at Duchess Street (fig. 7-18).[56] Finally, there is the black basalt head mounted on a bust of *rosso antico* that has entered the collection of the British Museum. Thought by Hamilton to resemble Cicero, it is almost certainly an eighteenth-century forgery.[57]

Fig. 7-18. Urn in the form of a covered basket. Early Imperial Roman. Marble, ca. 10 B.C.–A.D. 10. The Metropolitan Museum of Art, New York, Gift of Mrs. Frederick E. Guest, 1937, 37.129a,b.

Sir William Hamilton's return to England in 1800, at the end of a thirty-six-year residence in Naples, was to provide the opportunity for further purchases. Hope's acquisition of Hamilton's vases is well known, but his purchase of sculpture from Hamilton was forgotten until recently. Hope bought sculpture at Hamilton's sale of pictures and sculpture in March 1801, where he competed in the bidding with Frederick Howard, 5th Earl of Carlisle.[49] Hope's purchases included a Roman statuette in archaic Greek style of *Dionysos*, which he illustrated in his 1809 book *Costume of the Ancients* restored with the Dionysiac staff, or thyrsus, in one hand and a drinking cup in the other (fig. 7-15). It was said to have been found in Rome. Once it belonged to Lord Melchett, but its present location is unknown.[50] There was also a Roman archaizing statuette of a goddess holding a lotus flower in one hand and

Fig. 7-19. Statue Gallery, Duchess Street. *Household Furniture* (1807): pl. 1 (detail).

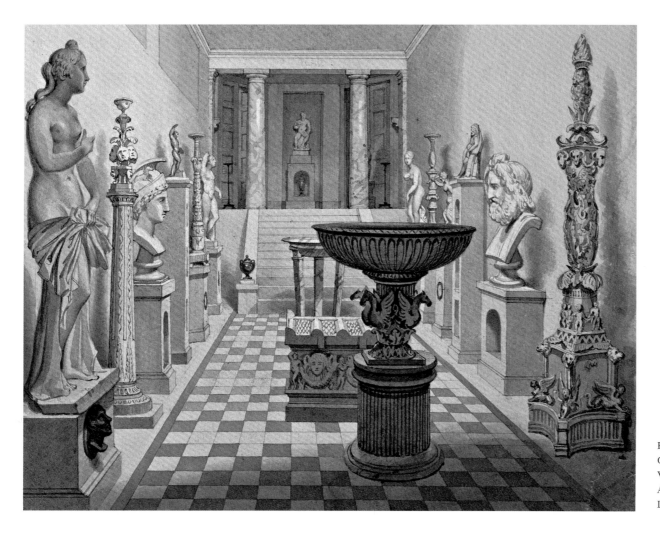

Fig. 7-20. Penry Williams. Statue Gallery at the Deepdene (detail). Watercolor, 1826. Lambeth Archives Department, Minet Library, London. *Cat. no. 106.13.*

The French occupation of Italy in 1798 would keep British travelers out of the country, until the Treaty of Amiens in 1802–3 brought a respite in hostilities that allowed Hope to make his way to Rome and eventually to Naples. In Rome part of his purpose was to negotiate the release of some of the sculpture purchased in the previous decade and confiscated by the French before it could be shipped to England. In Naples he acquired a fine statue of *Aphrodite*, about which we are unusually well informed owing to recent discoveries in the Townley archives of the British Museum.[58] These concern an *Aphrodite* with drapery around the lower part of her body in the so-called Syracuse form of the Medici type (see fig. 7-1). She is said by Charles Westmacott to have been discovered at Baiae, the pleasure park of the Emperor Nero on the Bay of Naples.[59] The statue was presented to Athens in 1920 by the Greek shipbroker Michael Embeirikos, who had acquired her at the auction sale of the Hope collection in 1917. The Westmacott provenance was to be repeated in subsequent mention of the statue but is now shown to be false. In fact it came from the ruins of ancient Minturnum on the banks of the River Garigliano, the ancient Liris on the border between Campania and Latium. It was restored with a new head by Carlo Albacini, a gifted pupil of the great restorer Cavaceppi.

Exactly how Hope came upon the *Aphrodite* is not known, but it seems certain that he snapped her up on the Naples leg of his Italian journey of 1802–3.[60] In May 1803 he was sensibly back in Paris and therefore able to cross the channel to safety, when the peace with France was broken in May. He would not again venture abroad until 1814–15,[61] when the Hopes wintered in Paris, but they were once more forced to retreat, this time by Napoléon's escape from Elba. After his final defeat at Waterloo, the Hope family set off for Europe once more, and after a slow and difficult journey, during which they were robbed, they reached Rome in April 1817. Their stay was cut short, however, by an even greater misfortune, the death of their second son, Charles, at the hands of quack doctors who attended his illness.[62]

During the years spent in England between 1803 and 1814, Hope had much to busy himself with, arranging and promoting the display of his collection, first at the London mansion and later at the Deepdene. At Duchess Street Hope's classical sculptures were arranged principally in the Statue Gallery (fig. 7-19), while others were to be found in the Picture Gallery, with its architectural detailing quoted from famous Athenian monuments and in the so-called Ante-Room.[63] In the Statue Gallery, walls were left plain and painted yellow to provide strong contrast and to bring out the contours of the sculptures. The ceiling of the room was coffered like a Greek temple and had three openings to provide light from above in the manner that was to become preferred in nineteenth-century sculpture galleries.[64] The sculpture itself, at

least to begin with, was arranged symmetrically along the long walls with statues, statuettes, busts, and cinerary urns placed to match one another, like facing like. Subjects too were matched, and thus we find *Pothos* (Desire) facing *Aphrodite*, and a bust of the Antonine emperor Lucius Verus opposite *Antoninus Pius*.[65]

As part of his architectural transformation of the Deepdene, Hope developed there a second Sculpture Gallery that extended westward from the main house (fig. 7-20). This formed part of a picturesque complex of spaces, including a great Conservatory that ran parallel to and connected with the Sculpture Gallery and, to the west of these two rooms, the so-called Theatre of Arts. In the winter of 1824–25, Hope removed to these newly laid-out rooms a large part of his classical sculpture collection,[66] and so upon his death in 1831, the collection was divided between the two houses. His heir was his eldest son, Henry Thomas Hope, also a serious collector of sculpture and one who had ideas of his own. Soon after his father's death, most of the sculpture previously returned to Duchess Street from the Deepdene, and the Sculpture Gallery there was used for other purposes. Henry shared his father's sense of self-importance but had not inherited Thomas Hope's sense of style. He carried out extensive rebuilding and refurbishment at the country house, transforming it from a rambling picturesque and in parts neo-Gothic villa into a more formal and grandiose Italianate palace. In 1849 he moved the entire collection of antiquities to the Deepdene, two years before the Duchess Street mansion was demolished. A sale of vases and other miscellaneous antiquities in 1849 was no doubt prompted by this move. Most of the sculptures were accommodated in the entrance hall, with the great pieces, modern as well as ancient, set up in its cavernous arches. The Sculpture Gallery does not appear to have been reused and, indeed, was probably demolished before the 1850s were out.[67]

Greek Vases

Turning from his sculpture, and thus avoiding the sad decline of the Hope fortunes that preceded its sale in 1917 and the eventual demolition of the Deepdene in 1969,[68] let us explore how Hope acquired his Greek vases, which were both a prominent feature of display in the Duchess Street mansion and a great influence upon his own design of furniture and costume. Hope's acquisition of Sir William Hamilton's second collection of Greek vases in 1801 was a significant event in the development of the Hope style. The ancient painted pots made for everyday use that we commonly call Greek vases had been found in Italy at least since Roman times and since the Renaissance were highly valued as curiosities by collectors and artists.[69] Although these vessels were previously thought of as Etruscan, it was gradually realized in the

eighteenth century that they should properly be called Greek. Although there had in antiquity been an Etruscan ceramic industry that produced its own version of Athenian black- and red-figured painted pottery, the Etruscans, it must be said, were better at bronze-casting, goldsmithing, and carving engraved seal stones than they were at potting. The best vases found in Italy were not Etruscan, therefore, but had either been imported in antiquity from mainland Greece or produced in southern Italy, where Greeks had founded colonies in what they themselves called Magna Graecia. In the ancient regions of Campania, Apulia, and Lucania and on Sicily, Greek settlers had brought their own pottery production with them and founded the South-Italian branch of an industry that was to flourish and persist deep into the fourth century B.C., when the mainland Greek workshops of Corinth and Athens that inspired it had long ceased to dominate the market.

Sir William Hamilton was resident in Naples as the British diplomatic representative from 1764 until 1800.[70] During that time, he had ample opportunity to collect antiquities, gathering such fruits as he was able to pluck from officially restricted royal excavations in the ancient cities of Pompeii and Herculaneum. Older than the towns buried by the eruption of Vesuvius in A.D. 79 were Greek and other tombs scattered through the countryside of southern Italy (fig. 7-21). Hamilton acquired vases directly from these tombs or from existing collections. Hamilton was by no means the first to collect vases, and a number of prominent Neapolitan intellectuals had anticipated his passion for them as curiosities of ancient handicraft and as a picture book of ancient life and beliefs.[71] Hamilton, however, made his own contribution to the understanding of Greek vases by promoting them as exemplars of ancient art, described by Winckelmann, the greatest art historian of his time, as "a treasury of ancient drawings."[72]

Hamilton's promotion of vases manifested itself in three principal ways: first, by publishing his first vase collection in four sumptuous volumes that collectively make up what may arguably be judged the most beautiful book of the eighteenth century; second, by successfully placing his first collection of vases, and indeed other antiquities, in the British Museum, where it represented the national holding of such objects and laid the foundation of the museum's current identity as a great showplace of art and antiquity; and third, in the influence that his publications had on contemporary taste, especially on the new pottery of Josiah Wedgwood and Thomas Bentley, and ultimately on the Regency Greek Revival, of which Hope was to become a leading luminary.

Hamilton sold his first collection to the British Museum in 1772 and in so doing greatly increased the value of the trade in vases. He would afterward complain that he had undersold the collection, but like an addict aware of the dangers of his own weakness, he resolved to give up the vases and succeeded in doing so for

seventeen years. Then in 1789 the compulsion took hold of him once more. How it came about is explained in a letter to his nephew and fellow collector Charles Greville, an impecunious scion of the House of Warwick. Sir William's own words tell how it was that the Hope collection of Greek vases, as it would become, was first conceived:

> A treasure of Greek, commonly called Etruscan, vases have been found within these twelve months, the choice of which are in my possession, tho' at a considerable expense. I do not mean to be such a fool as to give or leave them to the British Museum, but I will contrive to have them published without any expense to myself, and artists and antiquarians will have the greatest obligation to me. The drawings on these vases are most excellent and many of the subjects from Homer. In short, it will show that such monuments of high antiquity are not so insignificant as has been thought by many, and if I choose afterwards to dispose of the collection (of more than seventy capital vases) I may get my own price.[73]

The impulse for this new interest in vases had been a series of lucky strikes by people we would today call tomb robbers on land in the neighborhood of Nola, S. Agata dei Goti, Trebbia, Santa Maria di Capua, Puglia, and elsewhere.[74] In mentioning seventy vases, Hamilton was speaking of the best figured vessels in his collection. By the time he embarked his collection for England in 1798, the total number of figured and nonfigured vases together had risen to more than a thousand.[75] From the start, Hamilton was forced to see his second collection as a financial speculation. Never a wealthy man, he had mounting debts that were increased by ambitious improvements to his Naples residence, Palazzo Sessa, and the expense of keeping Emma Hart, who had lived with him as his mistress since 1786. The eventual sale of the collection to Hope in 1801 was the outcome of a protracted attempt to sell the collection at a profit to the monarchs of Russia and Prussia and to his kinsman William Beckford.

From the start, Hamilton planned to publish his second collection as he had his first. He did not, however, wish to repeat the expense and worry of his first attempt, caused in part by his employment of the brilliant but unreliable Pierre François Hugues, who liked to go by the name of Baron d'Hancarville.[76] Hamilton did, however, need someone to oversee the book's production, organize the drawing of the vases, the engraving of the drawings, and the drafting of the commentaries that accompanied the engravings. The texts were to be supplied by Count Italinsky, the Russian consul in Naples, and the art work was executed by Wilhelm Tischbein. He arrived as a youthful painter in Naples in the spring of 1787 in the company of Johann Wolfgang Goethe, who was on the southern leg of his Italian journey. Tischbein did not travel further, as planned, but remained in

ARCHAEOPHILORVM . SODALITIO . LONDINENSI.
GVGL . HAMILTONVS . BAL . ORD . EQVES.
D.D.D.

Fig. 7-21. Ang. Clener after Christoph Heinrich Kniep. *Sir William and Emma Hamilton witness the opening of an ancient tomb at Nola*. Engraving. 1790. © The Trustees of the British Museum.

Naples, where he was appointed director of the Neapolitan Academy of Fine Arts.

Tischbein was an ideal collaborator for Hamilton, since he shared an enthusiasm for the project in hand without overcomplicating the processes. Hamilton's aims in publishing his second vase collection remained the same as those that had motivated publication of the first collection. On the one hand, there was a desire to provide models of taste for contemporary artists and manufacturers and, on the other, he wanted to furnish antiquaries with a set of images illustrating ancient life, religion, and myth. D'Hancarville had confused matters and overwritten the text of the first publication in his ambition to create a new kind of art history based on his claims to have discovered the prehistory of human culture in ancient symbolism. Hamilton controlled the intellectual scope of the second publication himself by writing the introduction, and while Italinsky composed the commentaries, Tischbein and his students reproduced the vase paintings in simple black-and-white outline (fig. 7-22). This technique contrasted with the complex color

and chiaroscuro of images that d'Hancarville had commissioned for the first collection. At first Tischbein's best pupils at the academy were employed to trace the subjects using oiled paper. This proved too slow, so a skilled engraver was hired to draw the vase paintings directly onto a copper engraving plate. The first volume of an eventual four appeared in 1793; the fourth volume did not appear until after Hamilton's death in 1803, by which time Tischbein had even prepared plates for a fifth volume.[77]

The actual dates of publication for Hamilton's second vase collection do not agree with the dates given on the title pages and are generally later than has been supposed. Nevertheless, the plates circulated separately in advance of the volumes themselves, and Tischbein's letters to the Duchess Amalia in Weimar enclosed advance prints.[78] John Flaxman in Rome seems to have been influenced by the sight of such images when in 1792 he was working on his outline illustrations for an engraved set of scenes from the *Iliad* and the *Odyssey*.[79] Thomas Hope acquired the original drawings for these engravings[80] and also commissioned a set of illustrations to Dante's *Divine Comedy* in the same outline technique that would become Hope's preferred drawing method, both in the records he made of his travels and in his published works.[81] A Platonic aesthetic of the Enlightenment appreciation of ancient art found virtue in seeing the forms of architecture and sculpture reduced to the simple and chaste outlines of ancient vase painting.[82] Thomas Hope echoed a familiar neoclassical principle that moral worth could be found in pictorial understatement, when in 1805 he wrote to the respected Birmingham manufacturer Matthew Boulton: "Beauty consists not in ornament, it consists in outline—where this is elegant and well understood the simplest object will be pleasing: without a good outline, the richest and most decorated will only appear tawdry."[83]

Apart from the beauty of their line, Greek vases would also provide Hope with an encyclopedia of subjects of Greek myth and daily life on which he could draw in devising his own designs for furniture and costume. Not only did Hope base his designs upon vases, but the British school of history painting, from which Hope himself commissioned a number of works, also took inspiration from them. From Richard Westall, for example, in 1804 Hope ordered two historical paintings,[84] one of which, *The Expiation of Orestes at the Shrine of Delphos* (see fig. 9-4) makes direct reference to the subject of a Paestan bell-krater that Hope is said to have acquired from a M. de Paroi in Naples, no doubt when he was there in 1802–3.[85] From the dramatis personae of the vase painting, Westall selected Orestes kneeling at the Delphic tripod and the naked and beautiful Apollo fending off a Fury. Apollo was posed not as the figure in the vase painting but in the manner of the *Apollo Belvedere*. Similarly, spear-carrying Athena in Westall's painting strongly resembles the Hope *Athena*.

Fig. 7-22. W. Tischbein. Troop of a youthful Dionysus and satyrs. Scene from a Campanian red-figured bell-krater. Engraving from *Sir William Hamilton's Second Vase Collection*, vol. 1, pl. 45. The vase passed into Hope's collection and was illustrated in Tillyard's catalogue, pl. 43. © Trustees of the British Museum.

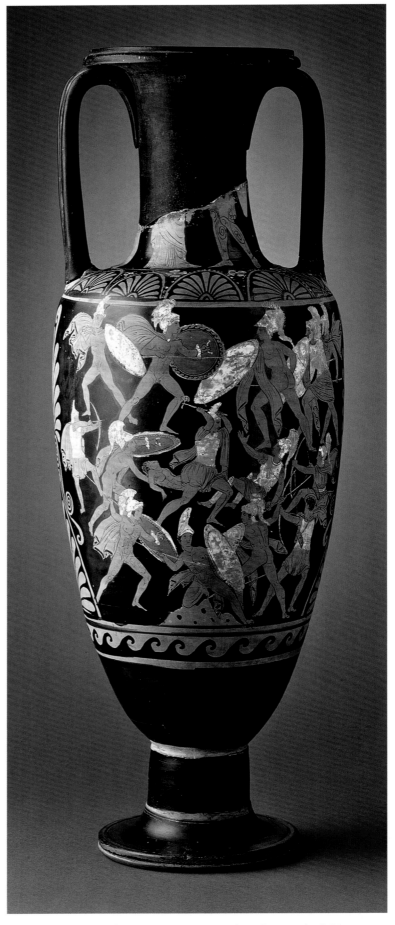

Hamilton's attempts to sell his second vase collection failed, and in 1798 he was forced to ship it to England, lest his vases should fall into the hands of the French, who were in Rome and on the brink of marching on Naples. *HMS Colossus* was hardly seaworthy, and her voyage out of the Bay of Naples in late November was to be her last.[86] Moored off the Scilly Isles in an attempt to ride out a storm, the ship drifted and foundered on a reef and broke up, spilling her precious cargo of Sir William's vases into the water. The news was shattering to Hamilton, who had been forced to leave Naples and to exchange his comfortable home for the cold and gloom of the Bourbon palace at Palermo on Sicily. At first he clung to the hope that the vases might be salvaged, but in fact very few of them were ever recovered by the islanders, and when Roland Morris relocated the wreck and led an expedition in the 1970s to dive for the cargo, all that were found were many weathered sherds. Now in the British Museum, some of these fragments have been matched to the plates in Tischbein's publication and are themselves published in an exemplary volume, the product of years of painstaking work.[87]

By November 1800, Hamilton and Emma, now his second wife, were back in England, where they found a pleasant surprise awaiting them. The intention had been to load all the best figured vases aboard *Colossus*, but the consignment got muddled and many of them had been left off the ship and were dispatched safely to England aboard another vessel.[88] Hamilton spent the winter of 1801 preparing his vases, along with his pictures and sculpture, for sale at Christie's. The vase auction never took place, for Thomas Hope stepped in at the eleventh hour and bought the collection wholesale. Hamilton had hoped to realize £5,000 but settled for £4,000[89] and the satisfaction that the collection would, as he originally intended, be kept together.

Fig. 7-23. Attributed to the Ixion Painter. Neck amphora showing a battle between Greeks and Trojans. Campanian, ca. 330–310 B.C. Los Angeles County Museum of Art, William Randolph Hearst Collection, A5933.

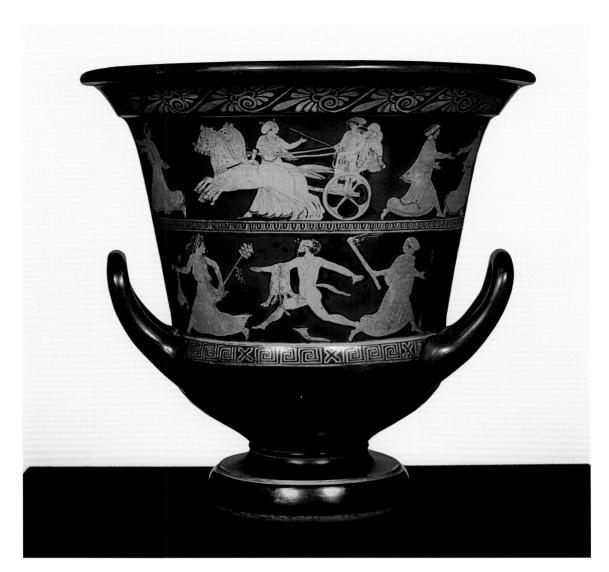

Fig. 7-24. Red-figured kalyx-krater showing the rape of the daughters of Leucippus. Athenian, ca. 440 B.C. Gulbenkian Museum, Lisbon, 682.

Exactly how many vases Hamilton had sold to Hope is unclear. In 1796 Hamilton owned about a thousand of them and, according to his statement that he lost about one third on the *Colossus*, it is estimated that about seven hundred remained. By 1806, however, we are told that Hope possessed more than fifteen hundred vases,[90] the result of further purchases as well as disposals. For example, he is said to have sold vases in 1805[91] and also to have given others to a servant, who sold them to Henry Tresham, who would in turn sell his vases to Samuel Rogers. Still others went to Frederick Howard, 5th Earl of Carlisle.[92] This shifting of collections from one to another collector is nicely described by Richard Payne Knight, who wrote a letter dated June 13, 1812, to Lord Aberdeen: "We collectors who have been preying upon each other's spoils lately like cray fish in a pond, which immediately begin sucking the shell of a deceased brother. Chinnery's vases went chiefly to Hope, Sir Harry Englefield, Rogers and myself."[93] The Napoleonic Wars had killed off the Grand Tour trade, but at home in England there flourished a market in auctions that recycled earlier collections.

The vases of William Chinnery, brother of the painter George, were sold at Christie's, on June 3 and 4, 1812. The star of the sale was lot 89, an amphora with a battle between Greeks and Trojans on one side and a wedding scene on the other (fig. 7-23). Now in the Los Angeles County Museum, the amphora was knocked down at the sale for £180 12s to "Henry" Hope, at least according to the annotation in a copy of the sale catalogue, and I take this to mean the brother, Henry Philip, rather than the cousin Henry.[94] Whether Henry Philip was buying for himself or for Thomas is not clear, but as we have seen with sculpture, it may be that a purchase of vases by Henry Philip invariably ended up with Thomas. The origin of this vase in the Chinnery collection, although remarked upon at the time,[95] has been forgotten by modern scholars. In his catalogue of the Hope vases, Tillyard repeated the false history given it by Millin and reported it as coming to Hope via the collection of the bibliomaniac James Edwards.[96] The latter certainly had a large and impressive South Italian vase, a volute-krater for which Edwards is said to have paid 1,000 guineas,[97] but this is not to be confused with the Chinnery amphora now in Los Angeles.

Other vases in the Hope collection were purchased at the sale of John Campbell, 1st Baron Cawdor, and that of Sir John Coghill,

sold at Christie's on June 18 and 19, 1819. The Coghill vases were catalogued by Hope's fellow Dutchman James Millingen.[98] The most expensive item at the Coghill sale, at £367 10s, was a fine Athenian kalyx-krater showing the rape of the daughters of Leucippus by the Dioscuri in their chariots (fig. 7-24). At the Deepdene sale of 1917, it was sold to C. S. Gulbenkian and is now in Portugal.[99] The Cawdor vases were auctioned by Skinner and Dyke on June 5 and 6, 1800,[100] at which the star piece was the so-called Cawdor Vase. This large South-Italian volute-krater went not to Hope but to Soane and now graces the courtyard window of the dining room in Sir John Soane's Museum. Soane paid £68 5s, a considerable bargain, and far less than Edwards paid for his magnificent vase of the same shape. Curiously, the Cawdor Vase, like the Chinnery amphora, has also been confused with Edwards's 1,000-guinea vase.[101] At last we can now disentangle the separate history of these three magnificent but quite distinct vases: the Chinnery amphora, now in Los Angeles; the Edwards krater, now in New York; and the Cawdor Vase, now at the Soane Museum.

Hope arranged his vases at Duchess Street on the east side of the courtyard in four rooms and illustrated them in *Household Furniture* (fig. 7-25).[102] To judge from these illustrations, the decoration of the rooms was relatively plain, but as always at Duchess Street, it was made to reflect the supposed symbolic meaning of the contents. Hope had inherited from Hamilton's generation the notion that, because they were found in tombs, vases were sacred and chiefly designed for the dead, and that the scenes upon them had mainly to do with reincarnation rites

Fig. 7-26. After G. Bracci. Imaginary tomb for J J Winckelmann. Engraving, ca. 1770. © The Trustees of the British Museum, London.

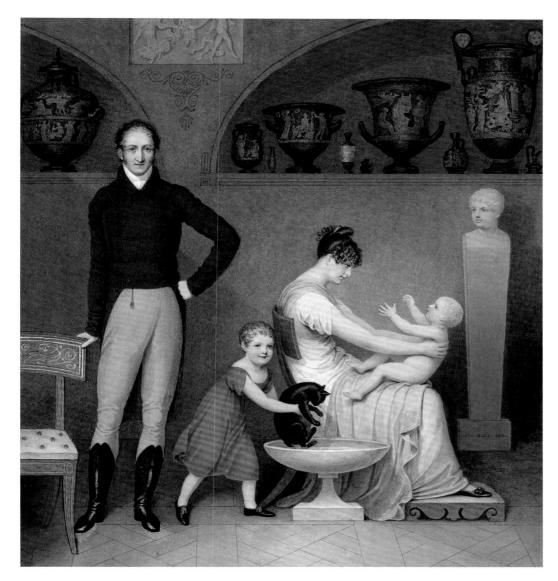

Fig. 7-27. Adam Buck: *The Artist and His Family*. Watercolor, 1813. Yale Center for British Art, Paul Mellon Collection, New Haven, B1977.14.6109.

connected to the worship of Dionysos (Bacchus) as a god of fertility. In Hope's own words: "vases relate chiefly to the Bacchanalian rites . . . connected with the representations of mystic death and regeneration."[103] Hence, he explains, the arrangement of vases in his own first Vase Room featured shelves divided by supports terminating in a head of bearded Bacchus.[104] Above these were arched recesses, intended to simulate the niches of ancient columbaria in the catacombs of Rome. Hope would have known that these niches were, anachronistically, Roman and is likely to have acquired the idea for them from Giuseppe Bracci's design for an imagined tomb of Winckelmann's featured in d'Hancarville's book of Hamilton's vases (fig. 7-26).[105] This was itself probably inspired by the Tomb of Freedmen of Livia engraved in F. Bianchini's *Camera ed inscrizioni sepulcrali dei liberti, servi ed ufficiali della Casa di Augusto* (Rome, 1727), which had been reproduced in the 1750s by Piranesi. As in Soane's later use of the same motif for vases displayed in his dining room, the columbarium niche at Duchess Street was not intended to be an archaeologically correct setting but simply an atmospheric reference to ancient sepulchres.

We feel that atmosphere more now at Sir John Soane's Museum than we do in the rather stringent record that Hope gives us of his vase rooms in *Household Furniture*. For another impression, there is the self-portrait drawn in 1813 of Adam Buck and his family (fig. 7-27). It so brilliantly captures the essence of Hope's Regency taste for vases that it was once thought to be a portrait of Hope himself.[106] In a friezelike composition, Buck introduces himself and his family as an idealized group accompanied by the terminal bust of a deceased child. Further reference to "mystic death and regeneration," to use Hope's own phrase from *Household Furniture*, can be found in the carefully selected subjects of the vases that occupy the columbaria and in the relief on the wall showing a maenad and satyr dancing with the infant Dionysos cradled in a winnowing basket. The drawing owes much to Hope and much also to Buck's own knowledge of other contemporary London vase collections, many of which he was recording at the time in a set of outline drawings that he hoped to publish as a book to rival Tischbein's publication of Hamilton's collection. This project floundered, and the original drawings passed upon Buck's death in 1833 into the library of Thomas Hope's son

Fig. 7-28. Henry Moses after H. Corbould. "Robert Smirke's Elgin Room of the British Museum looking east." Engraving from *Description of the Ancient Marbles in the British Museum*, pt. 4 (London, 1846): pl. 19. © The Trustees of the British Museum, London.

Adrian John Hope and are now in Trinity College Library, Dublin.[107] Apart from its debt to a thorough knowledge of Greek vases and to the neoclassical revival of supposed pagan beliefs, it is interesting to note that the seated woman and child in Buck's family portrait are composed in direct quotation of Nicolas Poussin's *Holy Family*! This painting, which Buck probably saw in an engraving, doubtless also appealed to him because of its neo-antique furniture, including a tripod stand.[108]

The concentrated, storelike display of Hope's vases on bracketed shelves reinforced the museum character of his vase rooms. Both the sculptures and the painted vases relied on Thomas Hope's genius for presenting them as decorative and, at the same time, "meaningful" adjuncts to his distinctive interiors. Indeed, to contemporary visitors the entire arrangement of the first floor at Duchess Street seemed more like a museum than a house.[109] Some will have had in mind the newly laid-out Louvre, which had been witnessed by many British visitors in 1802–3, during the peace of the Treaty of Amiens. As we have seen, Hope was himself in Paris in 1803 and must have visited the Louvre before

returning to England to open the house in Duchess Street to the public. Others, in comparing Hope's house with a museum, must have had the British Museum in mind, then arranged in the rooms of Montagu House. No visual records survive of what these rooms looked like, but they cannot have been as Greek as those at Duchess Street. Even George Saunders's add-on Townley Gallery, completed in 1808 and designed to accommodate the British Museum's newly acquired Egyptian and Townley marbles, was more Palladian than it was Greek.[110] The British Museum acquired its Greek temple architecture only when Robert Smirke began to rebuild it from 1823 onward, and it is tempting to see in his designs a direct influence from Hope (fig. 7-28). In Smirke's grand saloons, there are many echoes to be found of Hope's Sculpture and Picture Galleries: the coffered ceilings, top-lit by raised lanterns, the elongated Doric columns with their shallow *echinus,* the cornice over doorways on scroll brackets. All these adaptations of Greek temple architecture for a neoclassical interior were to be adopted by Smirke.

If Hope's architectural vision for a temple of the Muses has an afterlife in the British Museum, then so too does his museology. At Duchess Street with its ancient Egyptian, Chinese, Moorish, Indian, Greek, and Roman collections and symbolic decorations, there was to be found, as in the British Museum then and now, a universal history of mankind. Visitors could dine at the shrine of an Egyptian mummy, breathe the incense of the Orient burned in silver censers mounted on the walls of the Indian Room, observe the lives of the ancients painted on the body of a Greek vase, or glimpse the exotic present in a mosque painted in Hindustan. Hope plays with the boundary between ancient and modern, real life and fantasy, sacred and secular. His was an eventful museum of themed interiors and evening entertainments, a *son et lumière* experience worthy of André Malraux's *Musée Imaginaire,* where world culture stands in place of religion, where no faith is preached but all faiths may be represented.[111]

The Hope vases remained at Duchess Street until they were removed to the Deepdene by Henry Thomas in 1849, pending the demolition of 1851. The sale of a few apparently unwanted vases and other objects is reported in the same year.[112] The collection was displayed in a room adjoining the library, which became known as the Etruscan Room, and part of a complex probably added by Thomas Hope around 1826–31.[113] There in 1912 the vases were seen and catalogued by Tillyard for the monograph he published on them after their sale and dispersal.[114]

The sculpture, as we have seen, fared differently from the vases, but even Henry Thomas's arrangement of it was to be dismantled when between 1893 and 1909 Lilian, Duchess of Marlborough, took up residence in the house on a lease. She is said to have disliked the classical art in the Deepdene, and though previ-

ous occupants had welcomed visitors to view the collections, the duchess wanted none of it. When in 1917 the contents were being prepared for auction, the classical sculptures were not even found in the house but had been consigned to an ice house on the grounds and to a warren of sand caves.[115] Their excavation from the Surrey sands served only to scatter them to the winds. Unlike the vases, no complete pre-sale, illustrated catalogue had been compiled of the sculpture, and before Geoffrey Waywell's book appeared in 1986, it is fair to say that Thomas Hope's classical sculptures had been largely forgotten.

How now should we evaluate the merits of Hope's collection? Viewing his antiquities as a whole, we see nothing particularly remarkable about them; they are very much a collection of their time. Hope had none of the pioneering spirit of Hamilton in respect to his vases, or of Payne Knight and his bronzes or, notoriously, of Elgin and his Greek sculptures. It is true that Hope had rather more fine Athenian black- and red-figured vases than Hamilton did, and among them there are some remarkable pieces. Nevertheless, this is only to be expected in a second-generation collector building upon the advances made by Hamilton and his contemporaries in the understanding of ancient vase painting. Even then Hope adhered, as we have seen, to the mystical and funereal interpretation of the purpose of ancient painted vases, which was already rather old fashioned in his day. In 1822 his fellow countryman James Millingen condemned this idea of vase painting as a vain folly and complained that it had greatly retarded proper understanding. With a remarkably modern-sounding voice he wrote: "The vases of which the origin is sup-

posed to be so mysterious are no others than the common pottery intended for the various purposes of life and for ornament, like the China and the Staffordshire ware of the present day."[116]

In sculpture too there is nothing exceptional about Hope's collection. The mix of Roman portraits, representations of gods and heroes, mythical and real beasts, and decorative objects is what we have come to expect of restored marbles purchased on the Grand Tour market of Italy. Typically, there were few or no sculptures that dated from before the Roman era. Hope's collection did have its share of works carved in the self-conscious archaizing style of Roman sculpture evoking Greek originals, which became fashionable with collectors of the later eighteenth century. Here too, however, Hope was following an established trend rather than setting a new one. Like other British collectors, including Henry Blundell of Ince, Hope took his lead from Winckelmann's pioneering *History of Ancient Art* of 1764 and the archaistic sculpture Winckelmann found at Rome in the collection of his employer, Cardinal Alessandro Albani.

Such an assessment of the limitations of Hope's collecting is not intended to diminish his achievement. Rather, it enables us to acknowledge that which was truly exceptional about the man and his collection. Unsurpassed among British collectors of antiquity was Hope's sophistication and poetic sense of style in creating picturesque settings for his works of art. Never before and never again, with the possible exception of Sir John Soane's Museum, would England see such rooms as those at Duchess Street and the Deepdene, where nature, art, and morality were brought together and combined with "the ubiquitous presence of death."[117]

1. Watkin, *Thomas Hope* (1968): 93–124; David Watkin, "Thomas Hope's House in Duchess Street," *Apollo* (March 2004): 31–39; see also Chapter 2 in this volume.
2. Watkin, *Thomas Hope* (1968): 110–13; Chapter 2.
3. *Household Furniture* (1807): pl. VII.
4. Ibid., 25.
5. Geoffrey B. Waywell, *The Lever and Hope Sculptures: Ancient Sculptures in the Lady Lever Art Gallery, Port Sunlight* (Berlin: Gebr. Mann Verlag, 1986): 100, cat. no. 64.
6. Watkin, *Thomas Hope* (1968): 113–14; Fani-Maria Tsigakou, *Thomas Hope (1769–1831), Pictures from 18th Century Greece* (Athens: Melissa, 1985): 185, cat. no. 83.
7. Watkin, *Thomas Hope* (1968): 159–61.
8. Waywell, *The Lever and Hope Sculptures* (1986): 54–55; Chapter 2.
9. Tim Knox, "The King's Library and its architectural genesis," in Kim Sloan and Andrew Burnett, eds., *Enlightenment, Discovering the World in the Eighteenth Century* (London: British Museum Press, 2003): 54–57; Thorsten Opper, "Ancient glory and modern learning: the sculpture-decorated library," in Sloan and Burnett, *Enlightenment* (2003): 62–65.
10. Ruth Guilding, "Robert Adam and Charles Townley, the development of the top-lit sculpture gallery," *Apollo* 143 (1996): 27–32.
11. Brian Cook, "The Townley Marbles in Westminster and Bloomsbury,"

Collectors and Collections, British Museum Yearbook 2 (1977): 34–78; Brian Cook, *The Townley Marbles* (London: British Museum Press, 1985); Ian Jenkins, "Charles Townley's collection," in Andrew Wilton and Ilaria Bignamini, *Grand Tour, The Lure of Italy in the Eighteenth Century* (London: Tate Britain, 1996): 257–62.
12. Jenkins, "Charles Townley's collection" (1996): 262–69.
13. Cited in Waywell, *The Lever and Hope Sculptures* (1986): 48–49.
14. Watkin, *Thomas Hope* (1968): 227–28.
15. P. Clayden, *The Early Life of Samuel Rogers* (London, 1887): 448–49; Watkin, *Thomas Hope* (1968): 229.
16. Thomas Hope, *Anastasius, or the Memoirs of a Modern Greek, written at the close of the 18th century*, 3 vols. (London, 1819); Watkin, *Thomas Hope* (1968): 5–7; Chapter 13 in this volume.
17. Watkin, *Thomas Hope* (1968): 232
18. Ibid., 42.
19. National Portrait Gallery, London, inv. no. 4574; Chapter 2.
20. Arthur Hamilton Smith, "Lord Elgin and His Collection," *Journal of Hellenic Studies* 36 (1916): 163–370; William St. Clair, *Lord Elgin and the Marbles* (3rd edition, Oxford: Oxford Paperbacks, 1998): 1–34; Dyfri Williams, "Of publick utility and publick property," in Athena Tsingarida with Donna Kurtz, eds., *Appropriating Antiquity, Collections et Collectionneurs d'antiques en Belgique et en Grande-Bretagne au XIX Siècle* (Brussels: Editions Le Livre Timperman, 2002): 103–64.

21. Watkin, *Thomas Hope* (1968): 154.

22. Ibid., 83.

23. Tsigakou, *Pictures* (1985); Watkin, *Thomas Hope* (1968): 65.

24. Tsigakou, *Pictures* (1985): 97, cat. no. 29; see also 95, cat. no. 28.

25. Waywell, *The Lever and Hope Sculptures* (1986): 40.

26. Seymour Howard, "An antiquarian handlist and the beginnings of the Pio Clementino," *Antiquity Restored, Essays on the Afterlife of the Antique* (Vienna: Irsa, 1990): 142–53.

27. Hugh Honour, "Vincenzo Pacetti," *The Connoisseur* (November 1960): 174–81; Nancy Ramage, "Restorer and collector, notes on eighteenth-century recreations of Roman statues," in Elaine Gazda, ed., *The Ancient Art of Emulation, Memoirs of the American Academy in Rome*, supp. vol. 1 (Ann Arbor: University of Michigan Press, 2002): 68–71, with bibliography at n. 26.

28. Waywell, *The Lever and Hope Sculptures* (1986): 69–71, cat. no. 3.

29. Ibid., 72–73, cat. no. 6; now in the Metropolitan Museum of Art, New York.

30. Ibid., 74–75, cat. no. 9.

31. Howard, "'Pio Clementino" (1990): 151.

32. Waywell, *The Lever and Hope Sculptures* (1986): 21–22, cat. no. 5; now in the Lady Lever Art Gallery, Port Sunlight, Liverpool.

33. Ibid., 73–74, cat. no. 8.

34. Ibid., 76, cat. no. 10.

35. Ibid., 90, cat. nos. 36, 37; now in a British private collection.

36. Jenkins and Bignamini, entry for cat. nos. 204–206, in Wilton and Bignamini, *Grand Tour* (2002): 250–51.

37. Waywell, *The Lever and Hope Sculptures* (1986): 93–94, cat. no. 51; now in the Ashomolean Museum, Oxford.

38. Ibid., 94–95, cat. nos. 53, 54.

39. Waywell, *The Lever and Hope Sculptures* (1986): 41.

40. Ibid., 67–69, cat. nos. 1, 2; both are now in Los Angeles County Museum of Art.

41. Jonathan Scott, *The Pleasure of Antiquity, British Collectors of Greece and Rome* (New Haven and London: Yale University Press, 2003): 276.

42. Watkin, *Thomas Hope* (1968): 9, 99; the *Hygeia* went to the Los Angeles County Museum of Art in 1950 from the Hearst estate.

43. I am grateful to Michael Stanley for rescuing me from error here.

44. C. W. Eliot, "Lord Byron and the monastery at Delphi," *American Journal of Archaeology* 71 (1967): 290, fig. 4.

45. Waywell, *The Lever and Hope Sculptures* (1986): 42.

46. Ibid., 42, 88, cat. no. 31.

47. Ibid., 100, cat. no. 66.

48. Ian Jenkins and Kim Sloan, *Vases and Volcanoes, Sir William Hamilton and His Collection* (London: British Museum Press, 1996): 229, cat. nos. 132, 133; for others, see Carlos Picón, "Big Feet," *Archäologischer Anzeiger* (1983): 95–106.

49. Ian Jenkins, "Seeking the bubble reputation," *Journal of the History of Collections* 9 (1997): 197–99.

50. Ibid., 197, item 1; Waywell, *The Lever and Hope Sculptures* (1986): 85–86, cat. no. 27.

51. Jenkins, "Bubble reputation" (1997): 97, item 2; Waywell, *The Lever and Hope Sculptures* (1986): 85, cat. no. 26.

52. Jenkins, "Bubble reputation" (1997): 198, item 3; Waywell, *The Lever and Hope Sculptures* (1986): 86–87, cat. no. 29.

53. Jenkins, "Bubble reputation" (1997): 198, item 4; Waywell, *The Lever and Hope Sculptures* (1986): 41, n. 34; *Calouste Sarkis Gulbenkian: Uma doacao ao Museu Nacional de Arte Antiga, no 25 aniversario do Museu de Arte Gulbenkian* (Lisbon, 1994): 34–35, no. 10; now in the collection of the National Museum of Ancient Art, Lisbon.

54. Jenkins, "Bubble reputation" (1997): 198, item 5; Waywell, *The Lever and Hope Sculptures* (1986): 97–98, cat. no. 58; See Philip Hewat-Jaboor, "Fonthill House: One of the Most Princely Edifices in the Kingdom," in Derek Ostergard, ed., *William Beckford, 1760–1844: An Eye for the Magnificent*, exh. cat., Bard Graduate Center, New York (New Haven and London: Yale University Press, 2001): 54, n. 38.

55. Jenkins, "Bubble reputation" (1997): 198, item 6; Waywell, *The Lever and Hope Sculptures* (1986): 91, cat. no. 41.

56. Jenkins, "Bubble reputation" (1997): 199, item 7; Waywell, *The Lever and Hope Sculptures* (1986): 106, cat. no. 85, now in the Metropolitan Museum of Art, New York.

57. John Thackray, "The Modern Pliny: Hamilton and Vesuvius," in Jenkins and Sloan, *Vases and Volcanoes* (1996): 67, fig. 31; Jenkins, "Bubble reputation" (1997): 199, item 8; Waywell, *The Lever and Hope Sculptures* (1986): 100, cat. no. 67.

58. Waywell, *The Lever and Hope Sculptures* (1986): 76, cat. no. 11; for the new discoveries, see Ian Jenkins, "Neue Dokumente zur Entdeckung und Restaurierung der Venus Hope und anderer Venus Statuen," in Max Kunze and Stephanie-Gerrit Bruer, eds., *Wiedererstandene Antike, Ergänzungen antiker Kunstwerke seit der Renaissance* (Munich: Biering and Brinkmann, 2003): 181–92.

59. Charles Molloy Westmacott, *British Galleries of Painting and Sculpture* (London: Sherwood, 1824): 221; now in the National Archaeological Museum, Athens.

60 Watkin, *Thomas Hope* (1968): 9.

61. Ibid., 20.

62. Ibid., 21.

63. Watkin, *Thomas Hope* (1968): 101–4; Waywell, *The Lever and Hope Sculptures* (1986): 42–49; Chapter 2 in this volume.

64. Ian Jenkins, *Archaeologists and Aesthetes in the Sculpture Galleries of the British Museum* (London: British Museum Press, 1992): 41–44.

65. Waywell, *The Lever and Hope Sculptures* (1986): 45, fig. 3.

66. Ibid., 50–56.

67. Ibid., 57–61.

68. Ibid., 62–66.

69. R. M. Cook, *Greek Painted Pottery* (3rd edition, London: Methuen, 1997): 275–311; Dietrich von Bothmer, "Greek vase-painting, two hundred years of connoisseurship," *Papers on the Amasis Painter and his World* (Malibu: Getty Trust, 1987): 184–204; Vinnie Nørskov, *Greek Vases in New Contexts* (Aarhus: Aarhus University Press, 2002): 27–34.

70. Jenkins and Sloan, *Vases and Volcanoes* (1996): passim.

71. Claire Lyons, "The Museo Mastrilli and the culture of collecting in Naples, 1700–1755," *Journal of the History of Collections* 4 (1992): 1–26.

72. Johann Joachim Winckelmann, *Geschichte der Kunst des Alterthums* (Dresden, 1764): 123; Ian Jenkins, "D'Hancarville's 'Exhibition' of Hamilton's Vases," in Jenkins and Sloan, *Vases and Volcanoes* (1996): 153.

73. A. Morrison, *A Catalogue of the Collection of Autograph Letters and Historical Documents formed between 1865 and 1882 by A. Morrison: The Hamilton and Nelson Papers*, vol. 1 (1893):180.

74. Ian Jenkins, "Contemporary Minds: Sir William Hamilton's Affair with Antiquity," in Jenkins and Sloan, *Vases and Volcanoes* (1996): 52–55; Valerie Smallwood and Susan Woodford, *Fragments from Sir William Hamilton's Second Collection of Vases Recovered from the Wreck of HMS Colossus, Corpus Vasorum Antiquorum, Great Britain*, Fascicule 20, The British Museum Fascicule 10 (London: British Museum Press, 2002): 11–12.

75. Jenkins, "Contemporary Minds" (1996): 58.

76. Frances Haskell, "The Baron d'Hancarville, an adventurer and art historian in eighteenth-century Europe," in E. Cheney and N. Ritchie, eds., *Oxford, China and Italy: Writings in Honour of Sir Harold Acton* (London: Thames & Hudson, 1984): 177–91; reprinted in Haskell, *Past and Present in Art and Taste, Selected Essays* (New Haven and London: Yale University Press, 1987): 30–45; Michael Vickers, "Value and simplicity: a historical case," in Michael Vickers and David Gill, *Artful Crafts: Ancient Greek Silverware and Pottery* (Oxford: Clarendon Press, 1994): 1–32, a revised version of "Value and Simplicity: Eighteenth-century taste and the study of Greek vases," *Past and Present* 116 (1987): 98–137; Jenkins, "Contemporary Minds" (1996): 45–51; Ian Jenkins, "Talking Stones: Hamilton's Collection of Carved Stones," in Jenkins and Sloan, *Vases and Volcanoes* (1996): 93–101; Jenkins, "D'Hancarville's 'Exhibition'" (1996): 149–55.

77. Jenkins, "Contemporary Minds" (1996): 55–57; Smallwood and Woodford, *Colossus* (2002): 13–16.

78. F. von Alten, *Aus Tischbein's Leben und Briefwechsel* (Leipzig, 1872): 50–54 (letters dated 11 December 1790 and 19 March 1791).

79. Watkin, *Thomas Hope* (1968): 35; David Irwin, *John Flaxman 1755–1826, Sculptor, Illustrator, Designer* (London: Studio Vista, 1979): 68, 81–83; David

Bindman, "Studies for the Outline Engravings, Rome, 1792–93," in *John Flaxman*, ed. David Bindman (London: Thames & Hudson, 1979): 86.

80. Watkin, *Thomas Hope* (1968): 30–33.

81. Ibid., 35–36, 51–52.

82. George Cumberland, *Thoughts on Outline, Sculpture, and the system that guided the ancient artists in composing their figures and groups, etc.* (London, 1796); Vickers, "Value and Simplicity" (1987): 129 ff.; Hans-Ulrich Cain, ed., *Faszination der Linie, Griechische Zeichenkunst auf dem Weg von Neapel nach Europa*, exh. cat., Leipzig, Antikenmuseum der Universität (Leipzig: Leipzig University, 2004).

83. Watkin, *Thomas Hope* (1968): 198 (Hope to Boulton, 14 September 1805, Birmingham, Boulton Papers, ff. 2–4).

84. Ibid., 43.

85. E. M. W. Tillyard, *The Hope Vases* (Cambridge: Cambridge University Press, 1923): 137, cat. no. 267.

86. Smallwood and Woodford, *Colossus* (2002): 16–17.

87. Ibid., passim; now in the collection of the British Museum, London.

88. Jenkins, "Contemporary Minds" (1996): 58–59.

89. Morrison, *Hamilton and Nelson Papers*: 552, Hamilton to Greville, 3 April 1801.

90. A. L. Millin, *Monuments antiques inédits ou nouvellement Expliqués*, vol. 2 (Paris, 1806): 15, quoted by Tillyard, *Hope Vases* (1923): 2.

91. Adolph Michaelis, "Die Privatsammlungen antiker Bildwerke in England, Deepdene," *Archäologische Zeitung* 32 (1874): 15–16.

92. Ian Jenkins, "Adam Buck and Greek Vases," *Burlington Magazine* 130 (1988): 454.

93. R. Liscombe, "Richard Payne Knight, some unpublished correspondence," *Art Bulletin* 61 (1979): 606.

94. Photocopy of annotated copy in the library of the Greek and Roman Department, British Museum, London; it is now in the Los Angeles County Museum.

95. James Christie, *Disquisitions upon the Painted Greek Vases and their Probable Connection with the Shows of the Eleusinian and other Mysteries* (London, 1825): vi.

96. Los Angeles, inv. no. A5933; A. L. Millin, *Peintures de Vases Antiques vulgairement appelés Etrusques* (Paris: M. Dubois Maisonneuve, 1808): 94, pls. 49, 50; Tillyard, *Hope Vases* (1923): 149, cat. no. 283; A. D. Trendall, *The Red-Figured Vases of Lucania, Campania and Sicily*, vol. 2 (Oxford: Oxford University Press, 1967): 339, no. 799; *Corpus Vasorum Antiquorum Los Angeles* 1 (1977): pls. 46–47.

97. Jenkins, "Adam Buck" (1988): 455, figs. 68, 69; 457 s.v. Soane; now in the Metropolitan Museum of Art, New York.

98. James Millingen, *Peintures antiques de vases grecs de la collection de Sir John Coghill* (Rome, 1827).

99. It is now in the Gulbenkian Museum, Lisbon; Lisbon, inv. no. 682; *A Catalogue of Painted Greek Vases, Bronzes, Coins, ancient and modern Sculpture etc. The property of Sir John Coghill Bart. deceased and formed by him at a great expense during his residence a few years ago in Italy, which will be sold by auction by Mr Christie, Friday, June 18, 1819 and the following day*: 19 June, lot 109: photocopy of annotated copy in the library of the Greek and Roman Department, British Museum, London; Millingen, *Coghill* (1827): pls. 1–3; Tillyard, *Hope Vases* (1923): 65–68, cat. no. 116; John Beazley, *Attic Red-Figure Vase-Painters* (2nd ed., Oxford: Oxford University Press, 1963): 1042.1.

100. Soane Museum, inv. no. 101 L; Cawdor Sale: *Catalogue of Antique Marble Statues and Bustoes with Etruscan Vases etc.*, Skinner and Dyke, London, 5–6 June 1800: second day, lot 64; Soane Journal 4, fol. 271, 9 June 1800, for confirmation of the price; A. D. Trendall, *The Red-Figured Vases of Apulia*, vol. 2 (Oxford: Oxford University Press, 1982): 906–7, 931–32, no. 119.

101. Jenkins, *Adam Buck* (1988): 454, 457 s.v. Soane.

102. Watkin, "Thomas Hope's House" (2004): 35, fig. 14.

103. *Household Furniture* (1807): 23.

104. Ibid., 34.

105. Thackray, "The Modern Pliny" (1996): 148, cat. no. 31.

106. Jenkins, "Adam Buck" (1988): passim.

107. Ian Jenkins, *Adam Buck's Greek Vases*, British Museum Occasional Paper 75 (London: British Museum Press, 1989); now in Trinity College Library, Dublin.

108. Ian Jenkins, "Athens Rising near the Pole, London, Athens and the Idea of Freedom," in Celina Fox, ed., *London World City 1800–1840* (London: Verlag Aurel Bongers Recklinghausen, 1992): 147. The painting is now in the Detroit Institute of Arts.

109. Watkin, *Thomas Hope* (1968): 104.

110. Jenkins, *Archaeologists and Aesthetes* (1992): 102–10.

111. Watkin, *Thomas Hope* (1968): 121, 240–42.

112. Adolph Michaelis, "Museographisches—Vasen des Hrn. Hope," *Archäologischer Anzeiger* 7 (1849): 97–102.

113. Watkin, *Thomas Hope* (1968): 180–81; Waywell, *The Lever and Hope Sculptures* (1986): 60.

114. Tillyard, *Hope Vases* (1923): 2.

115. Waywell, *The Lever and Hope Sculptures* (1986): 63.

116. James Millingen, *Ancient Unedited Monuments, Painted Greek Vases from Collections in Various Countries, Principally in Great Britain* (London, 1822): iv–vi. For the changing taste and opinion of the times, see Ian Jenkins, "La vente des vases Durand (Paris 1836) et leur reception en Grande-Bretagne," in A.-F. Laurens and K. Pomian, *L'Anticomanie, La Collection d'Antiquités* (Paris: École des Hautes Etudes en Sciences Sociales, 1992): 269–78.

117. Watkin, *Thomas Hope* (1968): 242.

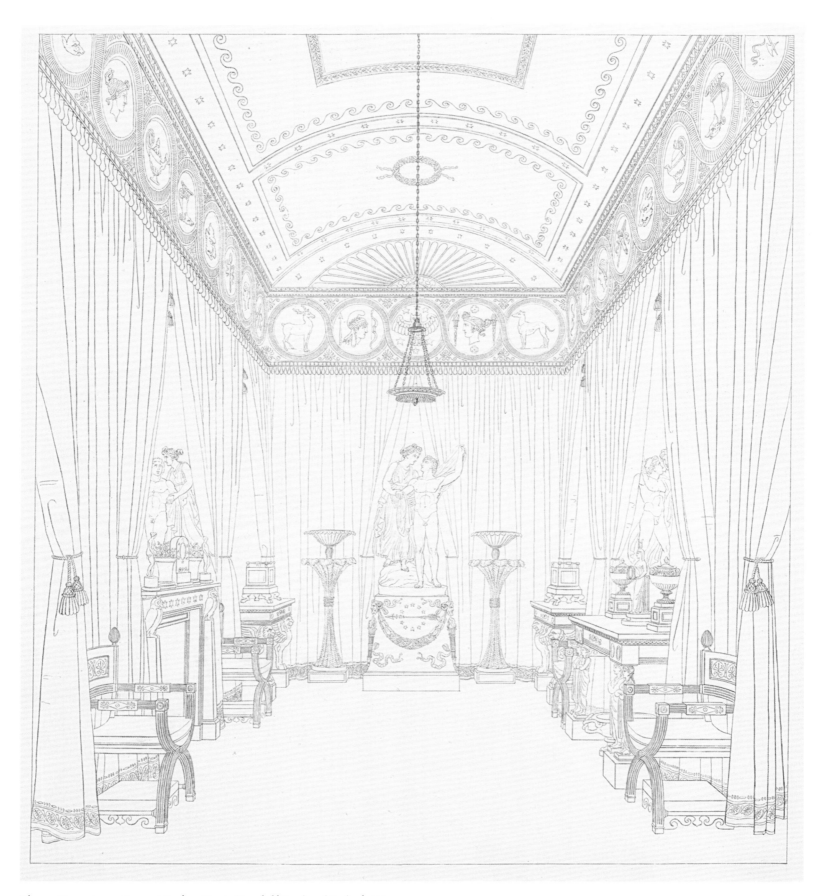

Thomas Hope. Aurora Room at Duchess Street. *Household Furniture* (1807): pl. VIII.

CHAPTER 8

Thomas Hope's Modern Sculptures: "a zealous and liberal patronage of its contemporary professors"

David Bindman

An anonymous writer in the *Annals of the Fine Arts* for 1819 claimed that "a new era is opening in sculpture, and a higher degree of merit will in future be exacted for eminence in sculpture . . . , than was required when Thomas Hope began his patriotic encouragement of English art."[1] Another contemporary, Charles Molloy Westmacott, writing in 1824, characterized Thomas Hope extravagantly as "this enlightened scholar stretched forth his fostering hand to raise the sinking child of Genius. . . . Proudly may he wear the ever-budding wreath a nation's gratitude cheerfully awards him."[2]

Despite such extravagantly flattering language, in reality Hope commissioned or bought relatively little contemporary British sculpture and demonstrated no preference for or desire to encourage native sculptors. He did buy an important life-size two-figure group from John Flaxman and commissioned another, but that was when he was still "Mr. Hope of Amsterdam" some years before he settled in London. The other important contemporary works he would eventually own were by the Dane Bertel Thorvaldsen and the Italian Antonio Canova, both artists based in Rome, as was Flaxman when Hope first encountered him. John Preston Neale, writing in the 1820s, gave a more balanced if still too flattering view of Hope without mentioning his patronage of Flaxman: "He has not only collected the rare specimens of ancient sculpture of the most flourishing periods of its existence, but has distinguished himself by a zealous and liberal patronage of its contemporary professors. Canova produced a Venus, to adorn his Gallery, and Thorvaldsen is indebted to him for opportunities of displaying his talents."[3] Other British collectors had bought works from these artists, and it was to become conventional to do so in the years after 1815, but Hope was undoubtedly a pioneer in his patronage of Flaxman and Thorvaldsen if not Canova, who was at the end of his career when Hope bought the last version of his *Venus*.

John Flaxman, 1755–1826

Hope's entry into the world of contemporary sculpture actually predated by three years his decision to form a collection of antiquities,[4] and it is unclear whether he had a setting in mind or was buying on an ad hoc basis. His first encounter was probably in Rome in 1792 with John Flaxman, then in the fifth year of his seven-year stay in Italy, although it is possible that Hope had bought a relief from the English sculptor John Deare in the previous year.[5] Flaxman had originally intended to return to England in 1790, being disappointed at the lack of interest in his work: "I could not possibly remain longer here unless I should be employed to execute a work that might establish my reputation."[6] Before he could carry out his intention, he was visited by the Earl of Bristol, who had been recommended to him by Canova, "esteemed here the best sculptor in Europe." The earl commissioned a full-size marble group *The Fury of Athamas*[7] (fig. 8-1), and he was soon followed by Thomas Hope, who first appears in an amusing letter from Flaxman's wife, Nancy, to the poet William Hayley of March 31, 1792. She lists the considerable crop of "English Gentry" now arrived in Rome, contrasting Hope with Sir John Macpherson, who "is surnam'd here the Gentle Giant . . . the *smallest* (tho' not the least conspicuous) is a Mr. Hope nephew to the great Hope of Amsterdam—He saw approv'd, & became a Patron to Flaxman's Talents—he purchas'd his Group of Cephalus & Aurora."[8] A further letter to Hayley of July 22, 1793, mentions another work that Hope commissioned, *Hercules and Hebe*[9] (fig. 8-2), a full-size conjectural reconstruction of the *Belvedere Torso* as "the marriage of Hercules and Hebe" on the basis of an idea by D'Hancarville. Nancy notes that "Hercules is [Deified?] & never for a moment ceases to admire the beauty of his Heavenly spouse. To be sure She is a divine Creature and promises to be as good as she is handsome. I think I have heard say a wife's greatest merit is 'passive Obedience,' but as this is in my opinion rather a treacherous subject, I will prudently drop it."[10]

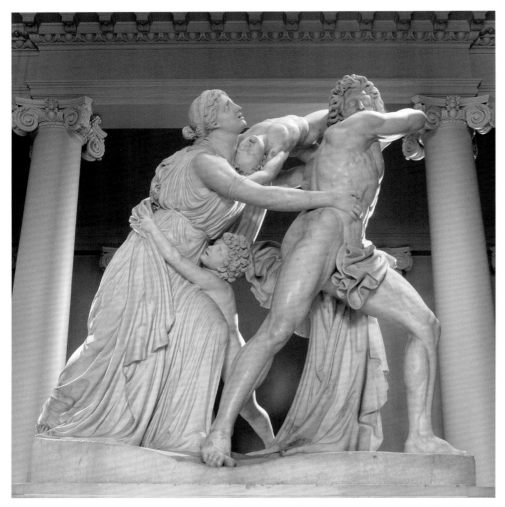

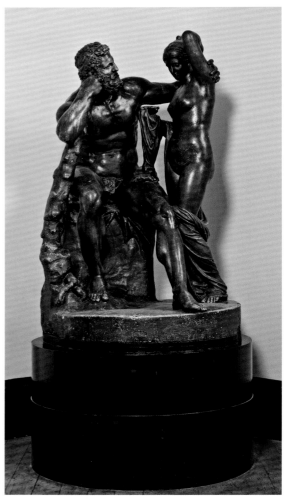

Fig. 8-1. John Flaxman. *The Fury of Athemas*. Marble, ca. 1792. Ickworth, The Bristol Collection (acquired through the National Land Fund and transferred to The National Trust in 1956).

Fig. 8-2. John Flaxman. *Hercules and Hebe*. Bronzed plaster, 1792. UCL Art Collections, University College London (on loan to Petworth House).

Flaxman claimed to have refused all other commissions in Rome, "but I have taken one [*Hercules and Hebe*] to execute in England." His idea was to make the model in Rome and then execute the marble in England after his return. His use of the future tense in the letter ("it is to be the size of the original, the figure of Hercules if it stood upright would be 8 feet") suggests that the full-size plaster, the only surviving part of the commission, was made in the London studio, where it stayed for the rest of the sculptor's life. The marble version was never completed and perhaps never begun, though Hope had advanced Flaxman a total of 341 guineas toward a total payment of 700 guineas,[11] nor was the plaster group handed over to him. Hope appears not to have pursued Flaxman to complete the work or to give back the money, as he was to do with Thorvaldsen's *Jason*. At least one other patron was admiring of the model, but Flaxman himself and probably Hope also seem to have lost confidence in a work in which, as Cunningham justly noted, "Hercules was certainly too ponderous a companion for so tender a lady."[12]

The *Aurora Abducting Cephalus* group[13] (cat. no. 55) is an altogether more vigorous and successful work. It was begun in 1789,

probably earlier than the *Fury of Athamas*, and was in an advanced stage of completion before Hope came on the scene. Although the two groups are in no sense a pair, together they established Flaxman as a sculptor with a range that could encompass both the beautiful and the sublime. *The Fury of Athamas* was an attempt to make a higher aesthetic order out of the chaotic fit of madness that drove Athamas to dash his children to the ground. Flaxman would have had in mind not only the famous Hellenistic *Laocoön* group in the Vatican but also Winckelmann's interpretation of the sculpture as conveying grandeur and emotional depth in a scene of violent death. *Aurora Abducting Cephalus*, by contrast, is a tender scene of love taken from Ovid, in which the goddess of the dawn makes her daily descent to embrace the beautiful mortal she has seduced from his wife. As Nancy Flaxman justly notes, "it is about 6 feet high, taken at the moment when Aurora descends to take up Cephalus. Sentiment is not wanting in the Composition, or taste in finishing the Parts."[14]

Behind the conception of *Aurora Abducting Cephalus* is the presence of Flaxman's mentor, Antonio Canova, with whom he was in close contact at the time. The grouping and the motif of

the impending kiss suggest that Flaxman must have seen the model or the roughed-out marble for Canova's *Venus and Adonis*[15] (fig. 8-3), modeled in gesso by July 1789, although the marble was not finished until 1794.[16] The figure and torso of Cephalus derive ultimately from the *Apollo Belvedere* or the *Apollino*, perhaps mediated through Canova's early *Apollo Crowning Himself* of 1781[17] (fig. 8-4), with which it shares a similar movement and reduced anatomy. The figure of Aurora, on the other hand, as it alights on the earth, foreshadows Canova's *Hebe* on a cloud, the first version of which[18] dates from 1796, though it has to be said that Flaxman's figure completely fails to achieve the ethereal lightness of Canova's. Flaxman also sold to Hope what Mrs. Flaxman describes as "a little medallion also, about 6 Inches in the Diameter—of Dirce sitting under a Vine & nursing the Infant Bacchus—this is beautiful to the greatest degree & finish'd like a Gem, it is admired by all & desired by many But Mr. Hope is the fortunate Purchaser."[19] It was displayed in Duchess Street at least until 1819[20] and was in the Lilac Room at the Deepdene but is now lost.

Hope also gave to Flaxman in late 1792 or early 1793 a commission for a series of drawings illustrating Dante to be engraved in outline style by Tommaso Piroli (fig. 8-5). This is one of the most significant of Hope's commissions, for it was to lead to the sculptor's European fame as an illustrator not only of Dante, but probably of Homer and Aeschylus as well.[21] Although Flaxman's drawings for Homer are usually assumed to have preceded the

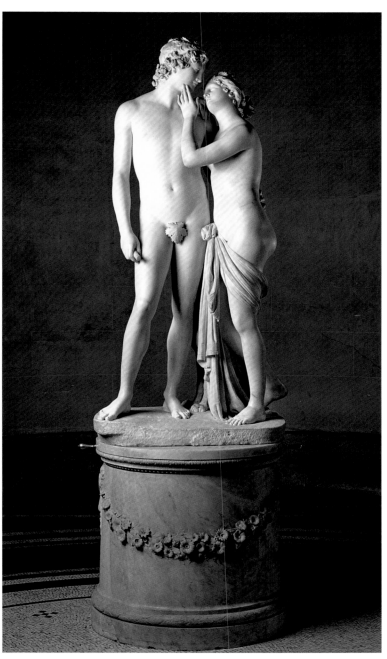

Fig. 8-3. Antonio Canova. *Venus and Adonis.* Marble, 1795. Musée d'art et histoire, Ville de Genéve, LG 4929

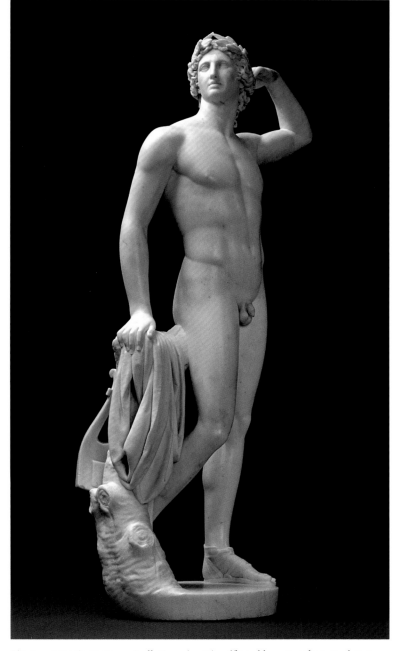

Fig. 8-4. Antonio Canova. *Apollo Crowning Himself.* Marble, 1781. The J. Paul Getty Museum, Los Angeles, 95.SA71

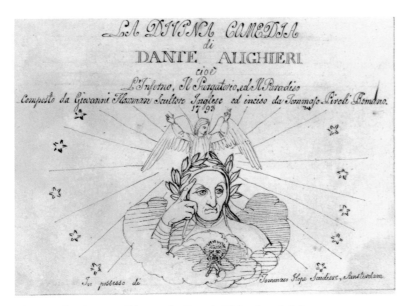

Fig. 8-5. John Flaxman. Title page for Dante's *Divine Comedy*. Ink on wove paper, 1793. Department of Printing and Graphic Arts, Houghton Library, Harvard College Library, Cambridge, 42.1353F.

Dante drawings, it is just as likely that Hope's commission came first, before Mrs. Hare Naylor's for the Homer drawings. The outline engravings by Piroli after the drawings were recognized immediately as revolutionary, despite their origin in the reproduction of Greek vase paintings, in their purity of outline and narrative clarity; their influence on nineteenth-century artists is incalculable.[22] They were regarded as being in a completely new yet "primitive" style. The Homer designs were thought to belong, in George Romney's words, to "the age, when Homer wrote," and the Dante designs to the age of the poet himself, the age of Cimabue and Giotto.[23] An indication of their later fame, and Hope's association with them, can be found in the architect C. R. Cockerell's diary for January 29, 1824: "Mrs. Naylor had employed him on Homer, Mr. Hope on Dante—these are the works by which he will live, & here is a striking example of the efficacy of patronage. It is a great happiness to an artist to be called into action by someone who he knows appreciates his peculiar forte—clearly the fruit of Flaxman's life as an artist are those works."[24]

Nancy Flaxman's letter of March 31, 1793, to Hayley announced the initial commission: "Soft my Friend—*Your own dear* Dante that old Fashion crazy Fellow with his long pinners & greasy [?] Nightcap, he is all in fashion with the gay & Simple, & much beloved indeed by the discerning few—Flaxman is making a Compleat set of drawings from his works one from each Canto being Ninety Nine The Frontispiece will make the hundredth—a compliment to the Possessor & Hope the Principal Figure. . . . They act as a Loadstone & bring the English in Shoals to the house to see them." She notes that "they are the Size of half a sheet of small writing Paper drawn with simple lines, no Shadow,

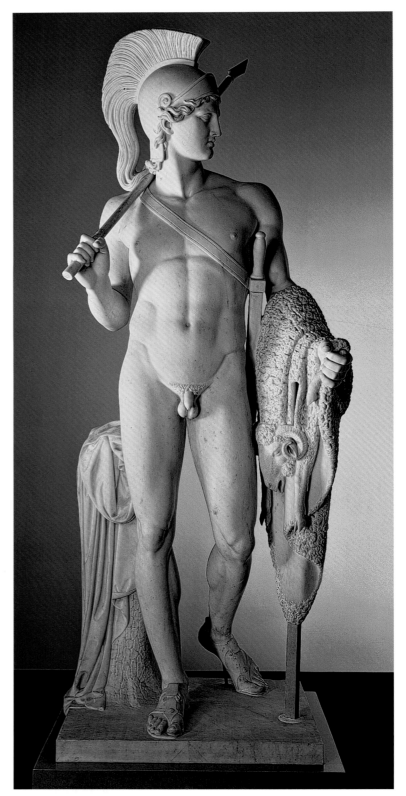

Fig. 8-6. Bertel Thorvaldsen. *Jason*. Marble, 1802–28. Thorvaldsens Museum, Copenhagen, A822.

& treated in the beautiful Gothic taste with the Sentiment of the Poet & Artist united."

In a letter of July 22, 1793, Nancy Flaxman reports progress but also difficulties with Hope: "The set of drawings from his [Dante's] Divina Comedia is now compleat (both as to numbers Grace & beauty) as are also the Copper Plates engraved from

them, but I am sorry to inform you that Mr. Hope does not mean to make them Public as he wishes to give them away himself to the chosen few whom he may think from their taste & Virtue are entitled to them, he has by a letter totally prevented Flaxman Interceding for any of his friends." It is clear, nonetheless, that Flaxman did get his hands on a few proof copies, and some did circulate at the time, probably through the weakest link in the production chain, the engraver Piroli, who in 1802 produced an unauthorized edition that makes no reference to Hope.[25]

Hope did not offer any more major figure commissions to Flaxman after the latter returned to England in 1794. Although he continued to commission much work from him and remained on cordial terms, it was now for what he and Flaxman would have regarded as secondary works, of an imitative or decorative rather than imaginative kind, such as a copy of the *Apollo Belvedere* (now lost) for the Ante-Room in Duchess Street, which was described by C. M. Westmacott as "a beautiful specimen of imitative art, very closely approaching the original. The sculptor has been most unfortunate in his marble, which is full of black veins."[26] The bust of Henry Philip Hope of 1802–3[27] (cat. no. 9) for the Dining Room is a rigorously frontal herm-type bust, which gives it an early Greek severity unusual for the period. The bust seems to have been commissioned in 1802 specifically to go on the chimneypiece of the Dining Room in Duchess Street, where, inscribed punningly ιφς⌐λς⌐πποζ (horse lover), it was placed in the center, flanked at each end by two antique-type horses' heads. Flaxman also made two chimneypieces for Duchess Street, which are described as containing "bassi-rilievi."[28]

It is probable that Hope, despite his initial enthusiasm, did not regard Flaxman as a sculptor of "Genius," of the same order as Thorvaldsen and Canova. As we will see, the *Aurora Abducting Cephalus*, though given a very prominent position in the scenography of Duchess Street, was not treated as an object of importance in its own right, as were Thorvaldson's *Jason* and Canova's *Venus*. We will also see, however, that Hope was irritated by Thorvaldsen's artistic claims but would never have asked him to take on the kinds of decorative or imitative work that Flaxman had always been prepared to undertake since making designs for Josiah Wedgwood in his youth.

Bertel Thorvaldsen, 1770–1844

Flaxman's bust of Henry Philip Hope was completed in 1803, the year in which Thomas Hope met the young Danish sculptor Bertel Thorvaldsen, whose career he was to influence decisively. Thomas Hope commissioned a marble version of one of the most magnificent of the sculptor's works, the over-life-size statue of *Jason* (fig. 8-6), and he acquired eight other marble sculptures

over a period of twenty-five years. Thorvaldsen had trained as a sculptor at the Copenhagen Academy, then the most important art school in northern Europe, and he came to Rome in 1797 to study the great works of antiquity, as Flaxman had done nine years before him.[29] He had known the German painter Asmus Jacob Carstens, whose severe and "primitive" classicism was to have an abiding effect on him, and, despite his own lack of a formal education, he had been taken up by a learned and well-connected group of Germans and Danes, many of whom were connected to the Goethe circle in Weimar.

By 1803 Thorvaldsen had little to show for his years in Rome and his close study of the Vatican collections, and he was thinking of returning to Copenhagen. He had made in plaster a monumental figure of *Jason*[30] (fig. 8-7) that attracted great approbation among his circle,[31] which was convinced, solely on the evidence of that figure, that Thorvaldsen could offer a challenge to the

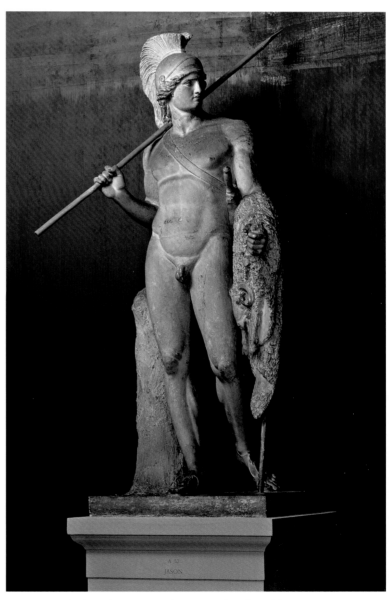

Fig. 8-7. Bertel Thorvaldsen. *Jason*. Plaster, 1803(?). Thorvaldsens Museum, Copenhagen, A52.

overwhelming dominance of Canova in the sculptural life of Rome. *Jason*'s obvious resemblance in scale and heroic subject to the latter's *Perseus,* then occupying the pedestal vacated by the *Apollo Belvedere* in the Vatican, makes it clear that such a thought was also in Thorvaldsen's mind.

Even so, as long as the figure of *Jason* remained in plaster, it could never be properly known beyond those prepared to visit the studio, and Thorvaldsen had at that point no prospect of being able to afford to give it a more permanent form. Hope immediately commissioned a marble version on seeing the work in 1803, an act that created jubilation among Thorvaldsen's supporters, for it affirmed the young's sculptor's talent and carried with it the promise of further commissions. Just as the Earl of Bristol's commission to Flaxman for the *Fury of Athamas* had persuaded the sculptor to stay in Italy for two more years, so Hope's intervention enabled Thorvaldsen to weather the next few years in Rome, by which time, despite the uncertainties caused by the French occupation, his international reputation was secured. The *Jason* was Thorvaldsen's first great work, and it is the first in a series of sculptures in which he deliberately challenged the basis of Canova's art, offering a "chaste" alternative to the sensuality and illusionism of Canova's figures, infusing them, as contemporary commentators hinted, with a "northern" spirituality.[32]

Surprisingly, Thorvaldsen did not set about with alacrity to convert the plaster into marble, despite accepting the first two payments and agreeing to finish it in two years. The initial contract, dated March 6, 1803, drawn up by Hope's agent Patrick Moir, states the sculptor's obligations with unusual precision, each stage laid out until delivery of the finished marble. According to the draft in Thorvaldsen's possession,[33] he engaged to execute "for Mr. Thomas Hope of London, in carraze [Carrara] statuary marble of the most perfect quality, following an actual model in my study near the Piazza Barberini, a statue of twelve Roman palms, representing a standing Jason, carrying in one hand his lance and in the other the Golden Fleece." It was, therefore, to follow the original plaster, and the total payment was to be 600 Roman sequins, payable in four stages. The first was for 300 Roman crowns on signature, and the second was to follow the arrival of the marble block in Rome, presumed to be within the same month (March 23, 1803), and Thorvaldsen received immediate payment for both stages. The third payment was to come after the statue was sketched out on the marble (August 27, 1804), and the fourth and last, mentioned in the letter from Moir below, on the completion of the sculpture (February 27, 1805).

The last two deadlines passed by, and on April 8, 1806—more than a year after the promised completion—Moir wrote a conciliatory letter to the sculptor [addressed unfortunately to "Sig. Enrico"][34] in which he noted Hope's expectation that the work

was coming to a conclusion, dangling a bonus payment before the sculptor and discussing also the question of payment through the banker Torlonia, and the complicated procedures required to get the sculpture out of Italy into Hope's own hands in the current political situation. Hope's idea was to have it sent in Thorvaldsen's name to Copenhagen on a Danish ship, and he was unsure whether payment should be made in Rome or in Copenhagen, because he assumed that Thorvaldsen was going to return imminently to his native country.

Nothing seems to have happened for another ten years, when in any case Rome was effectively cut off from British visitors by the French occupation. It seems likely that Thorvaldsen abandoned the project at some point after acquiring the marble, but it is unclear how far he had gotten with it. The project was brought back to life as a consequence of Hope's visit to Rome and to Thorvaldsen's studio in 1817, when Hope sat with his wife and two sons for bust portraits. The sculptor reportedly asked him to choose another work from his hand instead of something "that is nothing but a youthful work,"[35] but Hope rejected the offer, and the meeting seems to have awakened in Hope a determination to get possession of the statue he had partly paid for. On April 6, 1819, he wrote an angry letter in French to the sculptor,[36] evidently with the original contract of 1803 in his hand as he wrote. Hope's letter accused Thorvaldsen of giving feeble excuses for not completing the work while taking on and finishing "an infinite number of other works since your agreement with me." He notes that he had heard nothing up to 1816 when he came to Rome, and because Thorvaldsen then promised to finish the work without any more delay, "I abstain from delicacy and because of regard for you, Sir, to dwell on the past, and I am content to accept your promises for the future." Hope proposes menacingly to put the matter in the hands of "my good friends in the house of Torlonia and Company," with the implied threat that they would demand the return of the advances made to the sculptor for the work sixteen years earlier.

In July 1819, Hope kept up the pressure by complaining to Torlonia, by then Duke of Bracciano, who pressed Thorvaldsen to finish the marble. There are letters to the sculptor in May and August 20, 1821, the latter noting that Thorvaldsen had agreed to finish it by the end of the summer and asking when they could discuss sending the sculpture to Hope.[37] This provoked a defiant reply the next day from the sculptor, who asserted with some asperity his distance from the world of commerce inhabited by Hope and Torlonia, claiming that "in the arts of Genius time cannot be exactly limited."[38] Even so, Thorvaldsen could not have been far from completing the marble, since he only asked for another month to bring the work to perfection. Again this did not happen, and Torlonia received further complaints from Hope, as

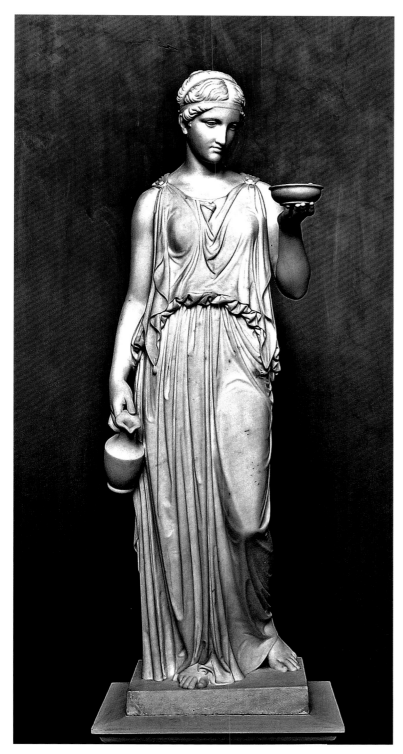

Fig. 8-8. Bertel Thorvaldsen. *Hebe*. Marble, 1806. Thorvaldsens Museum, Copenhagen, A874.

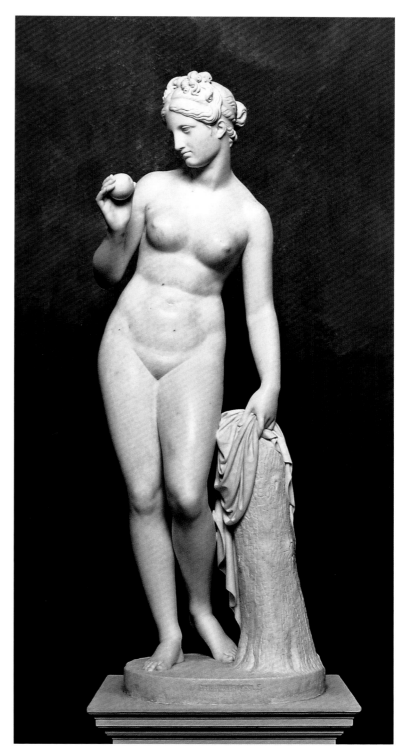

Fig. 8-9. Bertel Thorvaldsen. *Venus*. Marble, 1805. Thorvaldsens Museum, Copenhagen, A853.

he noted in a letter to the sculptor of April 15, 1823. Torlonia pleaded with the sculptor once again as late as June 12, 1826,[39] not to delay the consignment of the statue. This determined campaign by two men of immense wealth and power finally did pay off in 1828, when the statue was delivered to the Deepdene twenty-five years after it was commissioned. Hope was unable to uncrate it until the next summer, twenty-four years after it had been promised contractually.

Thorvaldsen appears to have abandoned work on the marble fairly soon after the commission, reviving it only under the intense pressure of Hope and Torlonia, at a time when he could afford to pass over most of the finishing to skilled assistants. Why did he refuse to complete a work regarded in his own circle as a masterpiece, and which, even in its plaster form, did so much for his reputation? His claim to Hope in 1817 that it was "a youthful work" suggests that he no longer thought it representative of his

best work, and this is confirmed by an amusing report of a conversation in his studio, probably before he had decided under pressure to complete it, by his friend the court jeweler Jørgen Balthasar Dalhoff.[40] Dalhoff describes how he arrived exhausted in the sculptor's studio after a long day at the academy and took a piece of chewing tobacco from a box. After a while, to Thorvaldsen's disgust, he took a second piece, which led to a reprimand from the sculptor, who took the box away. The visitor expressed surprise that Thorvaldsen had such a thing as a box of tobacco in his studio, given his well-known abstinence from all stimulants. After a long pause, Thorvaldsen replied: "Do you know why Jason was never finished even though I was paid for him? . . . I hate that statue because he was made of tobacco. I wanted to show off before I left Rome. I went daily to the Vatican and swallowed all I could of antiquity. . . . I pressed on and took tobacco all day to sharpen my sensations. Not even my smallest thought was involved in the statue as it should have been. . . . I pushed myself beyond my strength and became sick." Dalhoff replied that he had spoken to Thorvaldsen's student Freund and to other Thorvaldsen students and not one had seen him take tobacco. Thorvaldsen replied: "I never used a box then but always had the pockets of my vest full of tobacco, and chewed it so that I was always half high and sick. I would have returned to Denmark but I now had money [from Hope] and went to Florence to the Schubarts where I started to recover." Mrs. Schubart evidently taught him to give up tobacco, but more importantly taught him the way of Christ from which since then he had never departed.

Such an anecdote offers a plausible if over-dramatized explanation of what seems in retrospect a quixotic and potentially self-destructive failure to complete the *Jason* in a reasonable time. It suggests that Thorvaldsen lost confidence in the *Jason* because within a few years he began to see it as a work too closely tied to his study of the Vatican antiquities and Canova's *Perseus*, an immature student work that would not do him credit if it were shown publicly. The story also points to the fact that he underwent some kind of religious conversion after he went to Florence in 1805, one that decisively altered his beliefs about sculpture.

This is borne out by an examination of his progress in the years between 1803, when he completed the *Jason*, and after 1806, when he appears to have (temporarily as it happens) abandoned it. Works like his *Hebe* of 1806 (fig. 8-8) and the *Venus* (fig. 8-9), first modeled in 1805, evoked for German and Danish observers a strong sense of spirituality that offered a moral alternative to the worldly values associated with Canova's versions of the same subject.[41] Thorvaldsen's friend Friederike Brun, in an article in the *Morgenblatt für gebildete Stande*, noted that in Thorvaldsen's *Hebe*, "The body is slender, pure, chaste, more bud than blossom, the dress unassuming, the limbs slender O she is much too

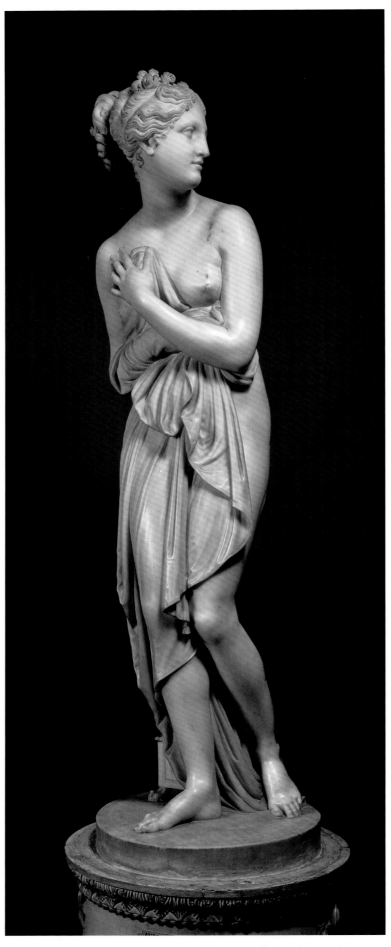

Fig. 8-10. Antonio Canova. *Venus Italica*. Marble, 1811. Galleria Palatina, Palazzo Pitti, Florence.

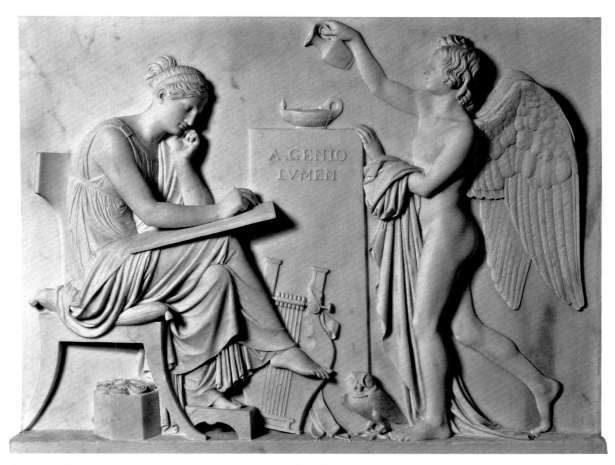

Fig. 8-11. Bertel Thorvaldsen. *A Genio Lumen*. Marble, 1808. Thorvaldsens Museum, Copenhagen, A828.

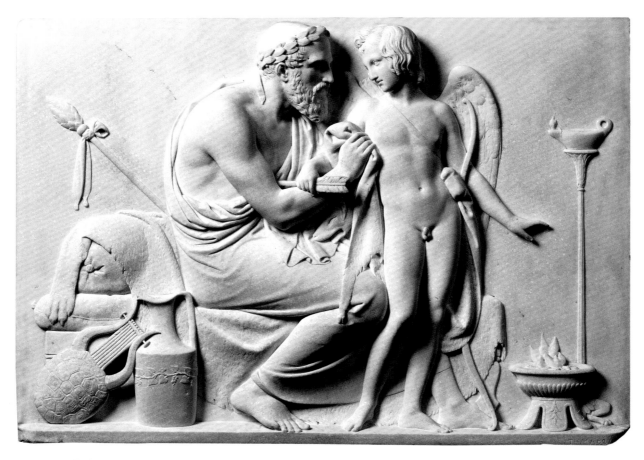

Fig. 8-12. Bertel Thorvaldsen. *Cupid Received by Anacreon*. Marble 1823 Thorvaldsen Museum, Copenhagen, A827

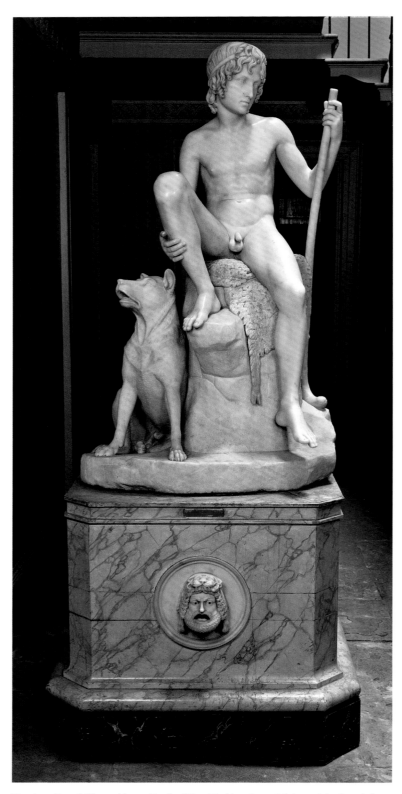

Fig. 8-13. Bertel Thorvaldsen. *Shepherd Boy.* Marble, 1823–28 (1817 original model). Manchester Art Gallery, Manchester, 1937-672.

the eighteenth century become an icon of the piety and innocence of an earlier age. Thorvaldsen's *Venus,* by contrast with Canova's *Venus Italica* (fig. 8-10), is wholly naked but adolescent in form, receiving the apple with surprise; it is hard not to see in her reception of the apple an echo of Eve and even the Virgin Annunciate. A German visitor to Thorvaldsen's studio commented on "a Venus with the apple which I could not tire of observing. There was something realistic and something spiritual in its form."[43]

For Thorvaldsen, then, the *Jason* may have begun to represent for him not only immaturity but also a youthful "paganism" that he had repudiated. There are also signs in the letters quoted, particularly the one of August 21, 1821, that he resented being at the mercy of wealthy and powerful individuals like Hope, feeling that artists inhabited a different world. Nonetheless, he did finally give in to Hope's pressure to complete the marble. He wrote in 1828, as he sent the *Jason,* an apologetic letter to Hope in which he describes movingly his attempts to overcome what he perceived as the defects of the statue: "In the course of my work, I began to see some faults in the statue, which I had not observed until then, but which became apparent little by little, as I made progress in the work. Many times I tried to correct them, and my arms always fell down, lacking power to come to a conclusion."[44] This bears out Thiele's account of Thorvaldsen's despair when he found him working on the *Jason,* remarking to the sculptor that he must be relieved to be finishing it at last. Thorvaldsen replied: "Oh, no! Sometimes as I worked, I found it good—but then it was not good—but now I can make something better!"[45]

As a further conciliatory gesture, Thorvaldsen sent with *Jason* a bust of Hope's eldest son and two marble reliefs: *A Genio Lumen* (fig. 8-11), probably modeled originally in 1808 for admission to the Accademia di San Luca, and *Anacreon and Cupid*[46] (fig. 8-12). These he described in the same letter as "a bas-relief representing Genius as the source of invention and the imagination with the living oil of ideas, and another small bas-relief dedicated to an anecdote of Anacreon." These are both works of high quality, though probably made by an assistant, and it is tempting to attribute meaning to Thorvaldsen's choice of subjects. *A Genio Lumen* (Light emanates from Genius) is an elegant affirmation of the power of genius to light up the world. Genius is represented by a winged figure pouring oil into a lamp, bringing inspiration to a Muse who stands for all the arts. It may be far-fetched to see the gift of such an object as a rebuke to Hope's materialism, but it is undeniably an affirmation of genius as the exclusive possession of the artist. *Anacreon and Cupid* might have conveyed a message more sympathetic to Hope, as a witty reference to his role in saving the youthful sculptor from neglect. The ancient and elderly poet Anacreon takes in Cupid from the cold and is rewarded by being stabbed in the heart by Cupid's dart;

good for Olympia, and one could boldly set her in a Christian chapel, with the title on the pedestal INNOCENTIA, and with the words 'Happy are those who are pure in heart!'[42] We can recognize Hebe's "innocence" as observed by Brun in the early Raphaelesque sweetness of the face and a certain "Gothic" quality in the body; the early Raphael had already before the end of

kindness and charity are rewarded by an unexpected yet revivifying love.

Hope was not able to unpack the *Jason* until the summer of 1829. On August 3 of that year he wrote a gracious reply to Thorvaldsen's letter and the receipt of the sculptures, noting that, when he took it out of the case, he realized the sculpture fully made up for the long wait: "I found it of the greatest beauty, & it was worth the long wait I had endured, & the impatience I had so long felt to possess it before my death. It is well worthy of its author, and of the reputation it has enjoyed in Europe for so long." He also made reference to the two reliefs: "The bas-reliefs are worth all the praise that my feeble voice can give them. I regard them as an honorable testimony to me of the friendship of the first sculptor of his time, and accept them with all the recognition that I owe to you."[47]

In the same letter, Hope also makes reference to the bust of Adrian John Hope (1811–1863) (cat. no. 13): "The bust of my eldest son, which was a complete surprise to me, and a most agreeable one, charms me as much for the skill of its execution as for its resemblance." He also noted that he was still in debt to Thorvaldsen for the busts that came from the 1817 sitting in Rome, and he proposed to instruct Torlonia to pay him two hundred pounds sterling for them. Although three of the four had evidently been delivered in 1822–23, it suggests that Hope had withheld payment for them as a spur to the sculptor to finish the *Jason*. The four busts[48] are not among Thorvaldsen's most compelling portraits, although the young boys, who are both of the herm type, are sympathetically characterized. Hope himself (cat. no. 10) is resolutely unidealized, suggesting that Thorvaldsen saw him at that time more as a rapacious collector than as an enlightened patron. Hope's gaze lacks any sense of looking beyond what is immediately around him, and there is a hint of anger or impatience in his countenance. His wife, Louisa (cat. no. 11), though less severe, is not strongly characterized. These portraits would seem to confirm a dislike for Hope on Thorvaldsen's part that might have been another factor in his disobliging attitude over the *Jason*.

Hope also acquired another marble sculpture by Thorvaldsen, the *Psyche* (cat. no. 144), probably as a gift from his brother Henry Philip Hope,[49] who bought it from Thorvaldsen and who also later purchased a version of the *Shepherd Boy* after Thomas's death[50] (fig. 8-13). The *Psyche*, carved later from a model of 1806, is one of a series of chastely ideal figures made by Thorvaldsen in those years, which included *Hebe* and *Venus*, and it was to have a prominent position in the setting of the Deepdene. Hope had then, after much struggle, acquired a representative group of Thorvaldsen's work, and it is clear that he was more drawn to the sculptor, despite their personality differences, than to any of his contemporaries.

Antonio Canova, 1757–1822

Hope acquired only one sculpture by Canova, but it was an exceptional one: a late work, commissioned in 1816–17, the so-called *Hope Venus*[51] (cat. no. 57). Unaccountably for such a voracious collector, he did not try to buy a work from the sculptor when he met him on either of his first two Roman visits, in 1795–96 and 1802–3, although he was offered a cast of the *Perseus*.

It seems to have been Canova who took the initiative in renewing the acquaintance with Hope on his 1815 visit to London following his triumphant role in the return to Italy of works of art from France after the fall of Bonaparte. Canova called in at Duchess Street where he noted "the most beautiful Etruscan vases, most beautiful paintings by noted masters."[52] Hope in return visited the sculptor's studio in Rome in 1817 and saw an uncompleted Venus commissioned by "a mysterious Mr. Standish."[53] When that contract fell through, Hope agreed to take it on, but in the end Canova offered Hope an entirely new version of the subject, not simply a replica of an earlier work. The *Hope Venus* differs strikingly from the three earlier Venuses that Canova completed between 1809 and 1812, the most famous of which was the *Venus Italica* (see fig. 8-10), originally commissioned by the King of Etruria to replace the *Medici Venus* taken by Bonaparte. Canova also made two other versions, for the Crown Prince Ludwig of Bavaria[54] and for Lucien Bonaparte, Prince of Canino, whose version was sold after the Restoration in France to Lord Lansdowne.[55]

To understand the way in which the *Hope Venus* differs from its predecessors, we have much contemporary commentary upon which to draw. Canova's close friend Count Cicognara, author of *Storia della Scultura*, a copy of which Canova sold to Hope in December 1816, notes that in the *Venus Italica* her dual identity as goddess in human form dictates her behavior at the moment she is represented: "This Venus . . . gets out of the bath with a sense of a shudder and modesty, and at the same time with nobility, characteristic of a lady in such a moment, who is obliged to dispose her legs and drapery to cover her naked body. The turn of her head has an infinite grace and her proportions being a little larger than the Venus de Medici, make her less woman and more goddess."[56]

The more rigorous French official Quatremère de Quincy, who saw much of Canova at the time of the sculpture's conception, tells us that Canova began to copy the *Medici Venus* as he had been asked, but abandoned it in favor of new work, "another Venus of his own invention." This new invention, Quatremère notes, completely changed the iconography, for while the Venus de Medici showed the goddess rising fully formed at birth from the waters of the sea, "by contrast Canova has attempted only to show her in the aspect and attitude of a bather, or a woman getting

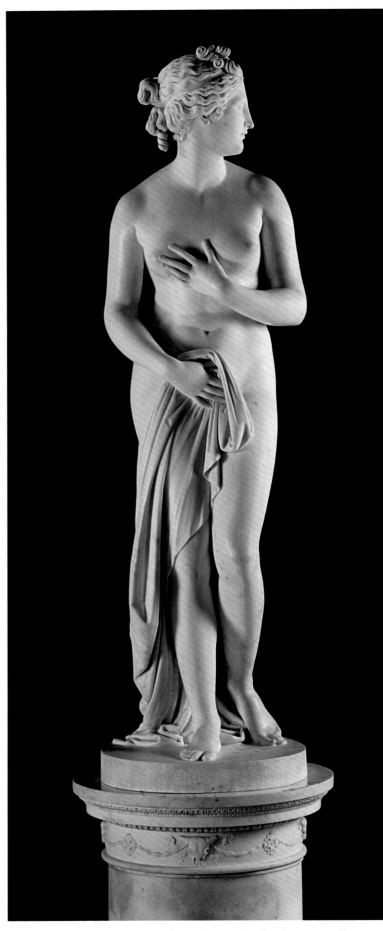

Fig. 8-14. After Antonio Canova, with Hope's original pedestal. *Venus.* Marble, ca. 1820–30. Corcoran Gallery, William A. Clark Collection, Washington D.C., 26.696A, B.

out of the bath. . . . Her figure is seen at the moment not of emergence, but fully out of the bath."[57] Her action in drying herself with a towel suggests not a goddess but a *baigneuse*, of the kind familiar to him from the French Salon.[58] One German observer, no doubt more inclined to favor Thorvaldsen, described the figure as a "Kokette" (flirt) and another as "Schlafzimmer Skulptur" (bedroom sculpture).[59]

For Quatremère de Quincy: "There is for a *purist* sensitive to this genre, a kind of dissociation between the character of ideal nobility in the person, and vulgar reality of her action. For a delicate taste a contradiction is only too evident between the elevation of the person and the action, where one can see her position to be common and vulgar."[60] The "vulgarity" that distressed Quatremère is expressed in Venus's responsiveness to the spectator's gaze as she enters into an erotically charged dialogue with the viewer. The *Medici Venus*'s hieratically modest attempt to conceal her genitals is transformed into a startled and not unappreciative reaction to an intruder coming upon her almost naked. The viewer in effect *becomes* the intruder who causes her to clutch her towel about her, an action that accentuates rather than conceals her charms. As another of Canova's biographers, Melchior Missirini, put it, Venus has "descended from heaven to give a sweet part of herself to some fortunate mortal."[61]

Quatremère de Quincy took credit for persuading the sculptor to offer a "corrected" version of his Venus, which was to be the version commissioned by Thomas Hope: "One can only believe that he wished to put it right [in response to my criticism], and we see that in repeating the Venus he altered the drapery and the action [of the figure] that gave rise to such criticism."[62] In the *Hope Venus* Canova does indeed minimize the drapery and alter the pose of the figure, reverting more to the *Medici Venus*, especially in the position of the arms. The gestures no longer suggest a sudden and provocatively ineffectual concealment of the body in response to an intruder but a calm goddesslike appraisal of the scene. Missirini also preferred the *Hope Venus* to the *Venus Italica* type, claiming that Canova "has treated the marble with such love and inspiration that one might say that this work is more like another Venus; he has now found . . . a more spiritual physiognomy and a more correct disposition of the legs."[63] Missirini also noted that in making the figure more naked than in the other versions, Canova was adopting Philostratus's idea of the Greek Venus, who in expressing shame at being seen naked, only emphasized her beautiful appearance of chastity.

The *Hope Venus* represents a deliberate shift in Canova's concept of Venus, which was almost certainly to distance himself from the persistent undertow of criticism of his illusionism and sensuality. Whereas his Italian admirers saw his work in general as a perfect marriage of nature and the ideal, his northern admirers,

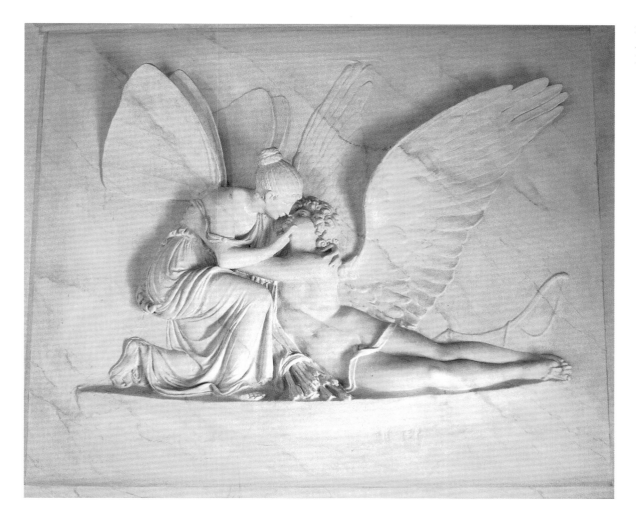

Fig. 8.15. John Deare. *Cupid and Psyche*. Plaster, 1791. Lyons Demesne, County Kildare.

from Carl Ludwig Fernow onward, worried that he favored flesh over the spirit and that in his mature years in the louche atmosphere of papal Rome he risked losing touch with the loftiness and severity of early works such as *Theseus and the Minotaur*.[64] Quatremère de Quincy took the credit for this shift, but Canova cannot have been unaware of the alternative manner offered by Thorvaldsen since the creation of the *Jason* in 1803.

It is also possible that Hope himself contributed to the outcome, for Canova in visiting Duchess Street had taken in the learned seriousness of the collection.[65] It is surely significant that Canova did not simply pass on to Hope the sculpture he had roughed out but that he designed a completely new one. Certainly Hope believed that it had been done especially for him, and he was immensely flattered that Canova had offered him an original piece even though the sculptor had one of the same subject that "is already advanced to the point of being able to be finished soon."[66] Hope repeated in more than one letter his delight in being offered "a statue that joins to its other perfections the merit of a new originality" rather than a replica of Lord Lansdowne's *Venus*.

Hope was also delighted to find that by July 1820 not only had "plusieurs amateurs" approved it as "un chef-d'oeuvre tout a fait original et nouveau," but that it was almost ready a mere year and half after Canova had agreed to make it. Hope could not help contrasting Canova's own promptness with the travails over the *Jason* though he does not mention it by name: "I am also happy in this circumstance not least because I have been unfortunate in certain other transactions that I undertook in Rome, things for which I paid fourteen or fifteen years previously and which are still not finished."[67] Hope was even more ecstatic when the work finally arrived early in 1822, and in a letter of March 11 once again expressed his pride in the uniqueness of the object he now possessed: "At last I have the pleasure of finding, admiring, and feeling all that I should for my beautiful Venus. It would be presumptuous of me to detail the perfections to you who are the author, nor do you need to know how much I appreciate the value of the work, and the noble transaction by which, through a completely new conceptions and labour, I have become the happy owner of a work more precious and more complete than that which I was promised."[68]

Hope was so enamored of his Canova *Venus* that he ordered a copy of it, so he could have one at the Deepdene, where he had moved much of the collection by the time he acquired the *Hope Venus*, as well as the original in Duchess Street. This copy[69] has the benefit of an original Hope pedestal (fig. 8-14), and it should not be confused with a copy that Hope also owned of the *Venus Italica*, made by Canova's pupil Lorenzo Bartolini, now lost.[70]

It is not clear who carved the Corcoran copy, whether it was ordered from the Canova studio or made by an English sculptor from Hope's original version.

Hope's relationships with Flaxman, Thorvaldsen, and Canova do not show him to have had much patience with the difficulties of a sculptor's modus operandi, though one can well understand his exasperation toward Thorvaldsen over the *Jason*. Flaxman was at first full of gratitude to Hope for commissioning the *Aurora Abducting Cephalus* and the *Hercules and Hebe*, but he also had to endure Hope's ill-tempered meanness when he lost money on the sum paid to him for a sculpture: "Certainly, My Dear Sir, if you had taken up at Rome the money due to you on the Apollo you ought to have had one hundred and eighty sequins in money without any deduction whatever, but since instead of taking up these 180 sequins at Rome for their value . . . you certainly suffer a loss, but you ought well to understand that on that loss of yours I am no gainer. . . . You cannot expect that I should suffer for that delay of yours."[71] In the end Hope refused to make good the debt. Flaxman and Hope remained on cordial terms, but the latter never gave Flaxman a major commission again. Thorvaldsen seems to have seen in Hope little beyond the hard-faced merchant who clung unyieldingly to his contract and was determined to accept no substitutes for the work he had paid for. But in the end they achieved a touching reconciliation; Thorvaldsen apologized to Hope for his own stubbornness, and Hope responded graciously and respectfully.[72]

With Canova the relationship was completely different. Canova was a seasoned diplomat who had negotiated the return of art treasures to Italy from France, for which the Pope had made him Marchese d'Ischia. By the time negotiations began for the *Hope Venus*, Canova had an appreciation of the depth of Hope's artistic concerns and would have seen him as being on a different level from most of the rich English trophy hunters who visited his studio in the years after Waterloo. For Hope Canova was, in addition to being a sculptor of Genius, a gentleman of high rank who kept to the letter of his contract, at least in the case of the *Hope Venus*. In Hope's dealings with contemporary sculptors, one sees clearly the difficulties he had in reconciling the two sides of his own nature, as—in his own words—"a mercantile man"[73] used to getting his own way and as a creative artist in his own right.

Miscellaneous Sculptures in Hope's Two Houses

Like many other country house owners, Thomas Hope, after he bought the Deepdene in 1807, accumulated a great many objects to fill a second house with a number of formal rooms and thirty-three bedrooms. It is clear from the accounts of visitors that there were sculptures almost everywhere in the Deepdene: Italian

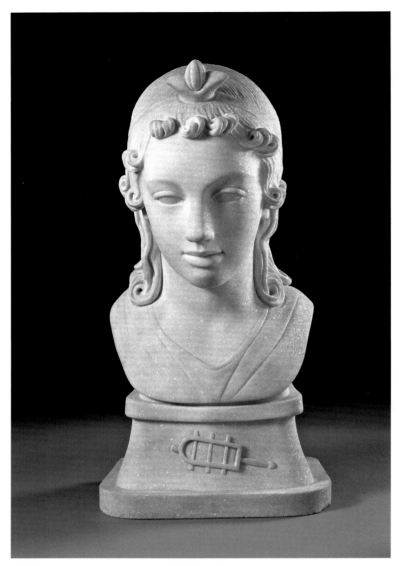

Fig. 8-16. Anne Seymour Damer. *Mrs. Freeman as Isis.* Marble, 1789. Victoria and Albert Museum, London, A.31-1931. V&A Images.

bronzes, copies in marble and plaster of canonical antiquities, busts of contemporaries, and so on. The New Library, for instance, had marble statues of Diana and Antinous, William Behnes's statue of "Mr. Hope's youngest Son caressing a rabbit," a bust of Mr. Hope's eldest son by Bartolini, busts of Wellington and Field-Marshal Lord Beresford, and busts of Napoléon and Blucher, none of which can now be identified. The Lilac Room had a "bronze gilt medallion, representing Night, by Thorvaldsen," and so on.[74] Given that many of these objects have been lost to view, even when they appeared in the 1917 sales (which in any case contained objects added by the family in the nineteenth century), it is difficult to be certain of the status of many of the objects in his collection, or indeed whether they were in his collection at all.

There were a few contemporary sculptures of significance that were not by Flaxman, Thorvaldsen, or Canova, although their paucity only emphasizes, despite the flattering words addressed to

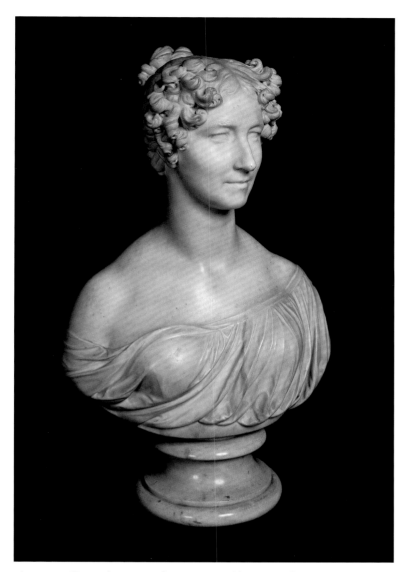

Fig. 8-17. William Behnes. *Bust of Mrs. Hope*. Marble, 1829. Collection Tim Knox and Todd Longstaffe-Gowan, London.

him cited at the beginning of this essay, a lack of interest in seeking out talented young sculptors once he had settled in England in the later 1790s. When it was sold at Christie's in 1917, Canova's *Hope Venus* was on a wooden pedestal to which was attached a marble relief of *Cupid and Psyche* signed and dated 1791 by the English sculptor John Deare.[75] This pedestal was no longer with the statue when it came to Leeds and is now lost.[76] The composition is probably recorded in a stucco version in the front hall of Lyons Demesne, County Kildare (fig. 8-15). Hope might have commissioned the sculpture from Deare during his first visit to Rome, in which case it could have been his first purchase of a contemporary sculpture.[77] In the same year, Deare was finishing off a relief of *Venus and Cupid* for the Earl of Bristol and boasted of the number of commissions he was getting at that time.[78]

Anne Seymour Damer's small marble bust of *Mrs. Freeman as Isis,* of about 1789[79] (fig. 8-16), may also have been an early purchase, although it is not recorded in Duchess Street until 1819.[80] It

is in a vaguely Egyptian style but seems not to have been in the Egyptian Room. Mrs. Damer was a prominent socialite as well as a professional sculptor, and it is very likely that she knew Hope in his early London years. Although the works have yet to be rediscovered, Hope in his later years commissioned a portrait from the sculptor William Behnes of his younger son Alexander with a rabbit,[81] which was exhibited at the Royal Academy in 1824, and a bust of Mrs. Hope, almost certainly recorded in a later version by the sculptor dated 1829[82] (fig. 8-17), which captures her often-remarked animation.

These sculptures are no more than any wealthy man of the time might have acquired, and one can add to the list a large number of copies of antiquities, some by named artists. These belong more to the setting of the two houses and will be considered in the next section.

The Display of Modern Sculpture

Duchess Street

Of the three major pieces of modern sculpture bought by Thomas Hope, Flaxman's *Aurora Abducting Cephalus* and Canova's *Venus* were displayed in the Duchess Street house, although the latter only came in the early 1820s, when Hope was thinking about moving some of the collection to the Deepdene. Thorvaldsen's *Jason* arrived in 1829 and went straight to the Deepdene.

The *Aurora Abducting Cephalus* was given a central role in the published decorative scheme for Duchess Street. It was, on its spectacular pedestal designed by Hope,[83] the focus of the Aurora Room, illustrated as plate VII (see page 130 and fig. 2-19) of *Household Furniture* (1807), the setting elaborating its role as an allegory of the diurnal round, of day following night (see Chapter 3).

The emphasis on the deeds of the Greek gods as allegories of nature suggests an awareness on Hope's part of thinking associated with the Goethe circle in Weimar, represented by such influential works as Karl Philipp Moritz's *Götterlehre* (1791), which interpreted the gods in terms of the life force that drove the generation of mankind.[84] The ensemble of the Aurora Room has, therefore, analogies with the idea of the *Gesamtkunstwerk*, the union of several art forms, found in Philipp Otto Runge's exactly contemporary designs for the paintings and setting of the *Tageszeiten* (Times of Day).[85] *Morgen* (Morning) also shows the moment at which Aurora sets foot on earth to begin the diurnal round (fig. 8-18). It also anticipates the theme of day following night in Thorvaldsen's famous circular reliefs of *Night* and *Day* of 1815, known in many versions.[86] Flaxman's own reactions to the display of his group in Duchess Street are not recorded, so we will never know whether or not he felt that his sculptural group

Fig. 8-18. Philipp Otto Runge. *Morgen*. Oil on canvas, 1808. Bildarchiv Preussischer Kulturbesitz, Berlin, 1016. Art Resource, N.Y.

had been treated with unusual sensitivity to its deeper meanings, or subsumed within another's fantasy.

The setting of the *Aurora Abducting Cephalus* makes an interesting contrast with the equally spectacular *Tempietto* erected by the 6th Duke of Bedford in Woburn Abbey to house Canova's *Three Graces*, which he commissioned in 1817. In the Aurora Room, Flaxman's group is essentially dematerialized by its setting and by the reflections in the side mirrors, so that it loses any sense of being a sculpture in its own right. The *Tempietto* has the opposite effect, of the sculpture's having been isolated from its surroundings to become the focus of the aesthetic contemplation deserving of a great work of art, notionally detached from all thoughts apart from those stimulated by the sculpture itself.[87]

Hope gave Canova a clear idea in his letter of March 11, 1822, of his own intentions for showing the *Venus* at Duchess Street: "I flatter myself that at the back of my gallery, occupying the central point of a longish perspective and among many interesting works of art, yet isolated, and turning on its pedestal, lit by beautiful daylight (for London), placed quite high, and with a rich drapery behind to bring out her white contours and delicate reflections,

her placing will not be at all inappropriate."[88] This might suggest that Hope had something like the Aurora Room in mind for the Venus, but in reality the display was rather closer in principle to the Woburn *Tempietto*. The *Venus* was imagined in the letter to be on the central axis of the Picture Gallery in Duchess Street, isolated and lighted as an object of contemplation, to be rotated on its base by the viewer. The rich drapery behind it was not, as in the Aurora Room, intended to create a sense of an image of nature, but to accentuate the contours of the figure and the texture of the marble. In the end, Hope changed his mind. An engraving in Westmacott's 1824 book shows it in the Picture Gallery, not in glorious isolation but against a wall at the far end of the gallery, opposite a copy of the *Medici Venus*[89] (see fig. 10-16).

Hope did not place Canova's *Venus* in the Statue Gallery, which was "destined solely for the reception of ancient marbles," and in Duchess Street he allowed some ancient sculptures to be placed in other settings, such as the Picture Gallery where the cohabitation of the arts was emphasized.[90] He was also aware of the distinction between original and copy, as his delight in the uniqueness of the *Hope Venus* makes clear. He did, however, have a group of contemporary copies of canonical ancient works, and these were kept in the Ante-Room, as an introduction for the visitor to the delights that would follow. There, according to Westmacott, Hope kept copies of the *Apollo Belvedere* by Flaxman,[91] the *Belvedere Mercury* by John De Vaere,[92] the *Medici Venus* and the *Medici Apollino* by Pisani,[93] an eagle in Carrara marble by Canova's pupil Antonio d'Este, as well as two antique pieces, a colossal foot (cat. no. 46), and a bust of Nero.[94]

There may well have been other modern sculptures in Duchess Street outside the ceremonial rooms, which were not recorded and which were eventually transferred to the Deepdene, but one gets the impression of a certain rigor in the placement of objects, a desire on Hope's part to keep clear a distinction between original antiques and copies, and between antique and modern works. The *Jason*, given the early date of the commission, must have been intended originally for Duchess Street, but we have no idea where he intended to put it, or whether he intended to build a room around it, creating a setting like the Aurora Room.

The Deepdene

The display of modern sculpture was significantly different at the Deepdene. As befitted a country house rather than a town house open to the public, rigorous distinctions between ancient and modern, between original and copy were less often observed. Hope moved a large number of his antique sculptures from Duchess Street to the Deepdene in 1824–25, but he left behind the most important ones, and the Canova *Venus*, presumably to

ensure continued public access to his best things.[95] Much of the Deepdene sculpture, both ancient and modern, was placed in the new wing built in 1823 to include the large Conservatory and various sculpture galleries. The wing offered a "juxtaposition of art and nature,"[96] in which neither sculpture nor vegetation could be seen separately from one another, either within the rooms or on the sightlines from one to another, except for the Sculpture Gallery, which had only one exit into the Conservatory. This Sculpture Gallery, though arranged like the one in Duchess Street, contained a number of non-antique works and copies, although, at least in the first phase, they seem to have been confined to spaces on either side of steps leading up to the far end of the gallery. These included busts of Mrs. Hope by Behnes and by Thorvaldsen and a portrait of one of Hope's sons, though not by Thorvaldsen, and also d'Este's eagle and the two Pisani copies of the *Medici Venus* and the *Medici Apollino,* which had been in the Ante-Room in Duchess Street.[97]

Neale's and Prosser's accounts of the house in 1826 and 1828, respectively,[98] enable us to track many of the modern sculptures that had been removed from Duchess Street or had come directly to the Deepdene. The copy of Canova's *Hope Venus* was in a prominent position in the entrance hall to the main house, and the Billiard Room contained Thorvaldsen's busts of Hope himself and his two sons; the bust of Mrs. Hope was, as we have seen, in the Sculpture Gallery. In the same room "on a marble pedestal between two windows was the bust of Mrs. Freeman as Isis by Damer." The Library, as mentioned above, had the Behnes statue of Hope's youngest son caressing a rabbit, a Bartolini bust of Mr. Hope's eldest son, and unattributed busts of Wellington, Lord Beresford, Napoléon, and Blucher; the Lilac Room had the gilt-bronze relief of *Night* by Thorvaldsen and Flaxman's *Birth of Bacchus* relief.[99] Thorvaldsen's relief of *A Genio Lumen* was in the new wing in a small recess between the Statue Gallery and the Conservatory, but there is no mention in the printed sources of the location of the relief of *Anacreon and Cupid.*

The Orangery and the Sculpture Gallery joined the front part of the house with the new wing, and the Library led to the back. Eventually in 1829, the Orangery and Sculpture Gallery housed the *Jason,* which was placed in a recess, probably opposite the door from the garden.[100] There it was in the company of a variety of antique copies and objects while Thomas Hope still occupied the house, and not in what would have been for it the more congenial surroundings of Duchess Street.

The crowning visual effect of the new wing was created by Thorvaldsen's *Psyche,* which was given to Hope by his brother,[101] and which was given a setting scarcely less dramatic than the

Aurora Room. Penry Williams's watercolors[102] for W. H. Bartlett and Penry Williams, *A Series of Drawings Illustrative . . . of the Deepdene, Surrey* (1826), enable us to see it displayed in a niche set into a wall at the back of a semicircular room at the top of the steps leading to the Conservatory.[103] The effect of greenery behind was, we are told by Prosser,[104] created by a mirror, which reflects back a view into the Conservatory. In front in the center of the room, directly beneath the chandelier is "a handsome marble tripod table." A watercolor of the Theatre of Arts (see cat. no. 106.11) shows the figure at the very end of a long vista all the way through the Conservatory, where it appears to float among vegetation, while the mirror suggests that the vista continues into the outside world. A close-up view from the same direction (see cat. no. 106.6) shows it at the top of the steps leading from the Conservatory, framed by a flower-filled arbor that opens to the left into the Library; to the right a closed door leads into a sculpture gallery, which is also a corridor into the front of the house. The idea that Hope's new wing, the most picturesque addition to the house with spaces given to nature and to art, was a place for reflection and contemplation is given a witty and elegant expression in the figure of Psyche as the human soul finding consolation in nature in her journey through life.

Thomas Hope's unique contribution to contemporary sculpture, despite his reputation at the time, was neither the encouragement of unknown sculptors nor the purchase of masterpieces, although he could claim both distinctions on a few occasions, but in the idea, expressed in the placing of Flaxman's *Aurora Abducting Cephalus* and Thorvaldsen's *Psyche,* that a marble sculpture could articulate the setting in which it was displayed. There it became part of a much richer and poetic composition that might involve objects of all kinds and periods, architecture, and even vegetation. This kind of display, of course, involved a denial of the autonomy of sculpture, which many sculptors would have found unacceptable at that time, but it is no disrespect to Flaxman and Thorvaldsen to mourn the loss of all that Hope had added to their sculptures in Duchess Street and the Deepdene.

Acknowledgments

I would like to express my gratitude to the many people who have helped me with this essay, especially Philip Hewat-Jaboor and the other contributors to this volume. The staff of the Thorvaldsens Museum could not have been more welcoming and helpful, and I would like to thank most warmly the director, Stig Miss, and Ernst Jonas Bencard, who scoured the archives for references to Thomas Hope.

1. *Annals of the Fine Arts for 1819* (London, 1820): 93.
2. Charles Molloy Westmacott, *British Galleries of Painting and Sculpture,* pt. 1 (London: Sherwood, 1824): 211.

3. John Preston Neale, *An Account of the Deep-Dene in Surrey; the seat of Thomas Hope, Esq.* (London, 1826): 1.

4. See Chapter 7 in this volume.

5. There is a possibility that his first purchase of a contemporary sculpture in Rome was a work by John Deare (note 77 below).

6. Letter to George Romney, 15 April 1790, Flaxman Letters, Blue Vellum volume, no. 63, Fitzwilliam Museum, Cambridge.

7. Ickworth House, Suffolk. David Irwin, *John Flaxman, 1755–1826* (London: Studio Vista, 1979): 54ff.

8. Letter to William Hayley, 31 March 1792, Boston Public Library (transcribed in G. E. Bentley Jr., "Flaxman in Italy: A Letter Reflecting the *Anni Mirabiles*, 1792–93," *Art Bulletin* 62 [December 1981]: 658–62).

9. College Art Collections, University College London, on loan to Petworth House. It eventually passed with most of the rest of his studio contents after his death to University College London. It was for many years in the corridor of the Slade School of Art and then in the Victoria and Albert Museum, before going on long-term loan to Petworth House.

10. Flaxman Letters [Autograph] 1-1935, no.3, Fitzwilliam Museum, Cambridge.

11. A draft of the contract in Hope's hand is dated 17 February 1791 (private collection).

12. Irwin, *John Flaxman* (1979): 59.

13. Lady Lever Art Gallery, Port Sunlight. Irwin, *John Flaxman* (1979): 54ff.

14. Bentley, "Flaxman in Italy" (1981): 660.

15. Villa La Grange, Geneva.

16. Giuseppe Pavanello and Giandomenico Romanelli, *Canova* (Venice, 1992): 242–49, cat. no. 123.

17. Getty Museum, Los Angeles. Pavanello and Romanelli, *Canova* (1992): 232–33, cat. no. 121.

18. Alte Nationalgalerie, Berlin. Pavanello and Romanelli, *Canova* (1992): 264, cat. no. 128 (Hermitage version).

19. Bentley, "Flaxman in Italy" (1981): 660.

20. *Annals of the Fine Arts* (1820): 97.

21. Sarah Symmons, "Flaxman and the Continent," in David Bindman, ed., *John Flaxman*, exh. cat. (London: Royal Academy, 1979): 152–82.

22. Ibid.

23. David Bindman, "John Flaxman: Sculptor and Illustrator," in Francesca Salvadori, ed., *La Divina Commedia illustrata da Flaxman* (Milan, 2004): 13.

24. Bindman, *John Flaxman* (1979): 33.

25. In the Hope Heirlooms sale, Christie's, London, 25 July 1917, the Dante drawings were lot 362, and lot 365 was "a collection of over sixty original drawings, being most of his Compositions for 'The Iliad and Odyssey of Homer' and a few Studies for 'The Tragedies of Aeschylus,' etc.," mounted in a volume. G. E. Bentley Jr., *The Early Engravings of Flaxman's Classical Designs* (New York: New York Public Library, 1964): 48. The volume of original drawings bought from Flaxman by Hope survives intact in the Houghton Library at Harvard in their original morocco binding. Hope also bought some original drawings for the *Iliad* and *Odyssey* and these are almost certainly the drawings in the Chicago Art Institute.

26. Westmacott, *British Galleries* (1824): 212.

27. Thorvaldsens Museum, Copenhagen. Bindman, *John Flaxman* (1979): cat. no. 118.

28. *Annals of the Fine Arts* (1820): 97. A life-size marble bust of Dante "Executed for Thomas Hope, Esq." was in the Hope Heirlooms sale, Christie's, London, 18 July 1917, lot 271, and brought a relatively high price, but is not otherwise recorded as a work by Flaxman and is lost.

29. There has been no biography of Thorvaldsen in English since the 19th century. For a recent biography in Italian, see Bjarne Jørnæs, *Bertel Thorvaldsen, La vita e l'opera dello scultore* (Rome, 1997).

30. Thorvaldsens Museum, Copenhagen.

31. Jørnæs, *Bertel Thorvaldsen* (1997): 47ff.

32. See Jurgen Wittstock, *Geschichte der deutschen und skandinavischen Thorvaldsen-Rezeption bis zur Jahresmitte 1819* (Hamburg: University of Hamburg, 1975).

33. "Pour Mr. Thomas Hope de Londres, en Marbre Statuaire de Carraze [Carrara], de la plus parfaite qualité, sélon un modele actuellement éxistant dans mon Étude près de la place Barberini, une Statue haute de Onze palmes Romains,

34. Printed in full in an appendix to Margrete Floryan's important article on Hope and the *Jason*: "*Jasons* skæbne: Om Thomas Hope, hans huse og hobbies," in *Meddelser fra Thorvaldsens Museum* (Copenhagen: Thorvaldsens Museum, 2003): 43–74.

35. Sandor Baumgarten, *Le crépuscule néo-classique: Thomas Hope* (Paris: Didier, 1958): 76.

36. Thorvaldsens Museum Archives, Copenhagen. Printed in full in Floryan, "*Jasons* skæbne" (2003): 66–67.

37. Ibid., 67.

38. Baumgarten, *Le crépuscule néo-classique* (1958): 76.

39. Thorvaldsens Museum Archives, Copenhagen. Floryan, "*Jasons* skæbne" (2003): 68.

40. I am grateful to Ernst Jonas Bencard for drawing my attention to this source and for helping me to translate it from the Danish. N. Dalhoff, ed., *Jørgen Balthasar Dalhoff: EetLliv I Arbedje* (Copenhagen, 1915–16): 222–23.

41. These works and the relationship between Thorvaldsen and Canova will be discussed more fully in my forthcoming book on the subject.

42. "Der Korper ist zart, rein, keusch, mehr Knospe als Bluthe; das Gewand anspruchlos, die schlanken Glieder bezeichnend. . . O sie is viel gut für den Olymp, und man konnte sie kuhnlich in eine christliche Kapelle setzen, mit dem Titel auf dem Piedestal: INNOCENTIA und mit den Worten: 'Selig, die da reinen Herzens sind!' "

43. "Eine Venus mit dem Apfel konnte ich nicht müde werden zu betrachten, es war etwas Wirkliches wie etwas uberirdisches in dieser Gestalt."

44. M. R. Barnard, *The Life of Thorvaldsen, collated from the Danish of J. M. Thiele* (London, 1865): 163.

45. J. M. Thiele, *Thorvaldsen's Leben*, vol. 1 (Leipzig, 1852): 109–10.

46. Both Thorvaldsens Museum, Copenhagen.

47. "Je l'ai trouvée de la plus grande beauté, & justifiant la haute attente que je m'en suis fait, & l'impatience que j'ai si longtems senti de la posseder avant ma mort. Elle est bien digne de son auteur, & de la reputation don't elle a depuis tant de tems joui en Europe." "Les basreliefs sont au dela de tous les eloges que ma faible voix pourrait leur donner. Je les regarde comme une temoignage bien honorable pour moi de l'amitié du premier sculpteur de son tems, & les accepte a ce titre avec toute la reconnaissance que je vous en dois." "Le buste de mon fils ainé, qui fut pour moi une entiere surprise, & de plus agreables, me charme autant pour le merite de l'execution que par sa resemblance." Floryan, "*Jasons* skæbne" (2003): 69.

48. Thorvaldsens Museum, Copenhagen. Floryan, "*Jasons* skæbne" (2003): 47, figs. 2–5.

49. Thorvaldsens Museum, Copenhagen. Thiele, *Thorvaldsen's Leben* (1853): 153. According to Thiele, the work was executed some years later than the original marble version of 1806 and was bought by "einem Bruder des Sir [*sic*] Thomas Hope."

50. The fine *Shepherd Boy* (Manchester City Art Gallery) appeared in the Hope Heirlooms sale, Christie's, London 1917, lot 269, but it did not, as John Kenworthy-Browne has demonstrated, belong to Thomas Hope. In fact it was made for William Haldimand and bought at Christie's in 1835 by Henry Thomas Hope, Hope's eldest son; John Kenworthy-Browne, "Thorvaldsen's Shepherd Boy," 1977, unpublished.

51. Leeds City Art Gallery.

52. Hugh Honour, ed., Edizione Nazionale delle Opere di Antonio Canova, vol. 1: *Scritti* (Rome: Istituto poligrafico e Zecca dello Stato, Libreria dello Stato, 1994).

53. Hugh Honour, "Canova's Statues of Venus," *Burlington Magazine* 114 (October 1972): 666.

54. Residenzmuseum, Munich.

55. For a definitive account of the circumstances behind all Canova's Venuses, see Honour, "Canova's Statues of Venus" (1972): 658–71.

56. "la sua Venere . . . esce dal bagno con quel senso nobile di brivido, di verecondia, e di nobilita nel tempo stesso,ch'e caratteristico d'una donna in tal momento, . . . costringendo a se le membra ed i panni, di totto cerca far velo al ignudo suo corpo. Il volger di testa di questa figura e di una grazia infinita, e la sua proporzione, un po' piu grande che la Medicea, la rende men donna, e piu dea."

57. "Au contraire, Canova a pretendu seulement la montrer sous l'aspect et dans l'attitude d'une baigneuse, ou d'une femme sortant du bain. . . Sa figure est vue

réprésentant Jason débout, portant d'une main sa Lance, de l'autre le toison d'or." Thorvaldsens Museum Archives, Copenhagen.

dans le moment, non de sortir, mais de paroitre a peine sortie du bain"; quoted in Quatremère de Quincy, *Canova et ses Ouvrages ou Memoires historiques sur la vie et les travaux de ce celebre artiste* (Paris, 1834): 136–40.

58. He was no doubt thinking of a work like Pajou's highly erotic *Psyche abandonnée* (Louvre), exhibited in the Salon of 1791, or even of paintings by Boucher.

59. Wittstock, *Geschichte* (1975): 129.

60. "Il y a . . . pour un *puriste* delicat en ce genre, une sorte de disparate entre le caractere de la noblesse ideale dans la personne, et celui d'une realité vulgaire dans son action. Pour un goût delicat, une contradiction trop evidente, entre l'elevation de la personne, et l'action, ou la position commune et vulgaire dans laquelle on la fait voir"; quoted in Quatremère de Quincy, *Canova et ses Ouvrages* (1834): 140.

61. ". . . ne' quali era discesa dal cielo per far dolce parte di se a qualche fortunate mortale"; quoted in Melchior Missirini, *Della Vita di Antonio Canova* (Prato, 1824): 184.

62. Quatremère de Quincy, *Canova et ses Ouvrages* (1834): 136.

63. ". . . e quella poi nel marmot condusse con tal amore ed inspirazione, che disse piu volte essere di quell'opera vie piu che dell'altra Venere satisfatto; impercioc-che gli paeva aver trovato . . . una fisonomia piu spirituale, ed un atto nelle gambe piu giuto"; Missirini, *Della Vita di Antonio Canova* (1824): 185.

64. Victoria and Albert Museum, London. Fernow wrote the first book on Canova in 1806 but already showed signs of disillusionment with the sculptor and a recognition that Thorvaldsen represented a new and better way; C. L. Fernow, *Über den Bildhauer Antonio Canova und dessen Werke* (Zurich, 1806).

65. See note 63.

66. Letter to Canova, 3 July 1820, quoted in Baumgarten, *Le crépuscule néo-classique* (1958): 242.

67. Ibid.

68. Ibid., 243.

69. Corcoran Gallery, Washington, D.C.,.

70. All that follows about the Corcoran Venus is taken from Douglas Lewis, "The Clark copy of Antonio Canova's Hope Venus," *The William A. Clark Collection*, exh. cat., Corcoran Gallery of Art, Washington (Washington, D.C.: Corcoran Art Gallery, 1978): 105–15.

71. Letter from Thomas Hope to John Flaxman, 6 December 1794, British Library, Add.Mss. 39781, f.16.

72. Barnard, *The Life of Thorvaldsen* (1865): 162–66.

73. Letter to Flaxman, Berlin, 6 December 1794, quoted in Baamgarten, *Le crépuscule néo-classique* (1958): 240.

74. John Preston Neale, *An Account of the Deep-Dene in Surrey; the seat of Thomas Hope, Esq.* (London, 1826): 9–11. The Thorvaldsen bronze is a puzzling object, because the sculptor did not work in bronze except in public monuments. The fact that it is not mentioned in any of the usual sources suggests that it was a late cast taken from a marble version.

75. Hope Heirlooms sale, Christie's, London, 18 July 1917, lot 268, signed "I. DEARE Faciebat, 1791."

76. It is presumably somewhere in the family of the purchaser, Lord Brotherton.

77. Peggy Fogelman, Peter Fusco, Simon Stock, et al., "John Deare (1759–98): A British Neo-Classical Sculptor in Rome," *The Sculpture Journal* 4 (2000): 97, 114–15, 125, figs. 24, 25.

78. John Ingamells, *A Dictionary of British and Irish Travellers in Italy, 1701–1800* (New Haven and London: Paul Mellon Centre for Studies in British Art, 1997): 288.

79. Victoria and Albert Museum, London.

80. Diane Bilbey with Marjorie Trusted, *British Sculpture 1470–2000: a concise catalogue of the collections at the Victoria and Albert Museum* (London: V&A Publications, 2002): 70–71. The bust is mentioned as at Duchess Street in *Annals of the Fine Arts* (1820): 97.

81. Humbert and Flint Sale at the Deepdene, 12–19 September 1917, lot 1150, "A 36 in. sculptured figure of a boy with a rabbit standing by a basket, by Behnes."

82. Private collection. I am grateful to Tim Knox and Todd Longstaffe-Gowan for informing me of this work.

83. It was illustrated as no. 2 on plate XIV of *Household Furniture* (1807).

84. See David Bindman, *Ape to Apollo: Aesthetics and Ideas of Race, 1700–1800* (Ithaca, N.Y.: Cornell University Press, 2002): 191–92.

85. Jörg Traeger, *Philipp Otto Runge und sein Werk* (Munich, 1975): cat. nos. 472–506.

86. *Bertel Thorvaldsen: Skulpturen, Modelle, Bozzetti, Handzeichnungen*, exh. cat. Cologne, Museen der Stadt Koln (Cologne: Museen der Stadt Koln, 1977): cat. nos. 81, 82.

87. John Kenworthy-Browne, "The Scultpure Gallery at Woburn Abbey and the Architecture of the Temple of the Graces," in Hugh Honour and Aidan Weston-Lewis, *The Three Graces*, exh. cat., National Gallery of Scotland, Edinburgh (Edinburgh: National Galleries of Scotland, 1995): 61–72.

88. Baumgarten, *Le crépuscule néo-classique* (1958): 243.

89. Westmacott, *British Galleries* (1824): betw. 222 and 223, inscribed "Thos. Hope's Picture Gallery, No. 1, J. Le Keux after G. Cattermole."

90. Geoffrey Waywell, *The Lever and Hope Sculptures: Ancient Sculptures in the Lady Lever Art Gallery, Port Sunlight* (Berlin: Gebr. Mann Verlag, 1986): 47.

91. Lot 1165 in the Hope Heirlooms sale, Humbert and Flint, London, 12–19 September 1917.

92. Ibid., lot 1167.

93. Ibid., lots 1161 and 1159.

94. Westmacott, *British Galleries* (1824): 215.

95. Waywell, *The Lever and Hope Sculptures* (1986): 50.

96. Ibid., 56.

97. Ibid., 52.

98. G. F. Prosser, *Select Illustrations of the County of Surrey* (London, 1828): n.p.

99. For the purchase of the Flaxman see p. 133, and for the Thorvaldsen see note 69.

100. Prosser, *Select Illustrations* (1828). *Jason* was "in a semicircular recess at the other end of the room ie. from the direction of the Conservatory."

101. See note 45.

102. Minet Library, Lambeth.

103. Floryan, "*Jasons skæbne*" (2003): 58–61.

104. Prosser, *Select Illustrations* (1828). "Leaving the theatre on the right hand, and passing to the left through the conservatory, which is filled with the choicest exotics, is a semi-circular division, raised by several steps above the level occupied by the plants; in a niche in the center is a beautiful statue of Psyche, by Thorwaldsen, behind which is a mirror."

Thomas Hope's Contemporary Picture Collection

Jeannie Chapel

The Hope family left the Netherlands to live in London in 1794, when Thomas Hope was twenty-five years old. They removed with them their substantial collections of works of art, including the paintings, most of which were of exceptional quality. The Dutch and Flemish pictures, collected by Thomas's father, John Hope, who had died in 1784, and John's first cousin Henry Hope (1735–1811) were particularly outstanding and well known to those who had visited their various residences in the Netherlands.[1] Much is known from contemporary inventories and catalogues about the manner in which John Hope built up his collection of both Old Masters, predominantly Italian, Dutch, and Flemish, and contemporary pictures, acquired by commission or purchase, either directly from the artist or from auctions. John Hope accumulated these works of art mostly during the 1760s and 1770s in the Netherlands and in Italy. His three sons, Thomas (1769–1831) and his two younger brothers, Adrian Elias (1772–1834) and Henry Philip (1774–1839), had been brought up in the tradition of collecting and had the means to do so, owing to the enormous sums inherited by them all as a result of the huge successes of the family banking house, Hope and Company, in Amsterdam. John Hope and particularly his eldest son, Thomas, followed remarkably similar patterns of collecting. More than 370 pictures belonging to the family were housed in London, mostly in Hopetoun House in Cavendish Square, the large house Henry Hope bought in 1795 after their arrival in England. Thomas Hope did not settle immediately in London but spent much of the middle and later years of the 1790s traveling abroad.[2]

Thomas Hope had traveled widely before the move to London. For eight years from 1787, he had what his biographer David Watkin described as "the grandest of grand tours," principally to study architecture in many different countries on the Continent and in the Middle East.[3] Unfortunately, there is little information about Hope's journey to Sicily in early 1792 with George Augustus Wallis, a landscape painter and accomplished topographical

draftsman known as "the English Poussin," despite his Scottish parentage (figs. 9-1, 9-2).[4] Both of them produced paintings and drawings; Hope himself was also a skilled draftsman and painted delightful architectural and landscape scenes (fig. 9-3).[5] At that

Fig. 9-1. George Augustus Wallis. *The Ruins of Selinunte*. Watercolor, 1792. Ashmolean Museum, Oxford, EDB 1856.

Fig. 9-2. George Augustus Wallis. *Taormina, Looking Toward Mount Etna*. Watercolor, 1792. The Huntington Library, Art Collections, and Botanical Gardens, San Marino, California, 59-55-1419.

Richard Westall. *The Sword of Damocles*. Oil on canvas, 1811. Ackland Art Museum, The University of North Carolina at Chapel Hill, Ackland Fund, 79.10.1. *Cat. no. 64.*

Fig. 9-3. Thomas Hope. "Corfu, View of the Fortress of the Port." Drawing from the Benaki Album, vol. IV, 27296. Benaki Museum, Athens.

time, Wallis was living in Rome and was widely patronized by visiting *milordi*, having established an international reputation.[6] The journey to Sicily did not last long; Hope returned to Rome by April of 1792.[7]

Hope's Patronage and Promotion of Works by British Painters

In 1799 Thomas Hope bought the house in Duchess Street, and after completion of the work on the interiors, he was able to move his existing collection the short distance from his uncle's house in Cavendish Square. He began to assemble more works of art, which would be contained in some of the most spectacular and innovative interiors created in London at that period. Over the years that followed, Hope bought and commissioned works from eminent and established painters, as well as from those less well known. In some cases, his choice of works was conservative and certainly fashionable, but he was also capable of disregarding the conventional precedents demonstrated by other collectors in order to devise and juxtapose novel arrangements for his pictures.

Hope believed strongly in a British school of painting and was determined to raise the standard of history and religious painting through the patronage and encouragement of native artists.[8] This aspiration was shared with many of his contemporaries, including William Beckford, the renowned collector and connoisseur, who claimed in 1797, the year in which his annual income was £155,000, that he wanted to spend £60,000 on works by contemporary painters. Like Hope, Beckford was considered to have been a major force in his support of young artists and

craftsmen in both England and France.[9] To advocate a national school was considered a noble and patriotic pursuit. It demanded courage to do so at a period when rapid changes were taking place in the status of artists, who were then more or less dependent on private patronage; this was particularly true for portrait painters and their ability to exhibit and sell their works. As far as subject matter was concerned, Hope thought that "on the preeminence of historical & classical compositions over low life subjects & landscapes—& some expressions of regret that so few artists patronise the former—that the tide of public taste runs entirely towards the latter; as may be seen in our exhibitions of pictures & drawings; where hardly any elevated compositions are to be found; & where the few that appear, attract no attention, find no purchasers."[10]

In 1807 Hope wrote in a weekly journal, whose contributors were mostly painters and sculptors, about the value of patrons, particularly those intent on the promotion of living British artists. He emphasized his other preoccupations, such as the teaching of art, particularly the importance of drawing and the study of Greek vase painting.[11] In 1812 John Britton, an antiquary, connoisseur, and a friend of Hope's, who was also intent on promoting contemporary painters, praised both Thomas and Henry Hope, and "a few royal, noble and distinguished personages [who] have set the laudable example of purchasing English pictures, and have manifested some courage, and much taste in appropriating them exclusive galleries, or apartments." Britton considered George III as having "led the way," followed by the Prince Regent, "and other Noblemen and Gentlemen who have shewn a disposition to emulate this noble trait of patriotism and refinement."[12]

Hope involved himself not only with major artistic institutions, such as the Royal Academy, the British Institution, and the Society of Antiquaries, which held a certain cachet in the society in which he was eager to be included, but he also supported smaller endeavors to promote both painters and sculptors.[13] He was an important patron for the art of engraving. An attempt to form a Calcographic Society was made on May 16, 1810, at a meeting of interested patrons, including Hope, the Marquis of Stafford, Sir John Fleming Leicester, Sir Abraham Hume, and Samuel Whitbread, M.P., among others. The intention was to establish a society to prevent "further depression of line engraving in this country," another particular passion of Hope's, although the attempt did not succeed.[14] Some of the same collectors were among those invited in 1824 to patronize the newly founded Manchester Institution, to which Hope sent a "very small" donation and "regretted that more urgent or proximate claims prevented his contributing more than a mite to this great but distant undertaking."[15] Hope lent pictures from his collection for students at the Royal Academy to copy, at a time when access to Old Master paintings was difficult.[16] His Titian, *The Temptation of Christ*, was much copied by students when it was at the British Institution in 1816; the *Portrait of Cesare Borgia* then attributed to Correggio was lent to the Royal Academy schools in 1821, as was Giorgione's *Judith with the Head of Holofernes* in 1825.[17] Hope also lent pictures for members of the Polygraphic Society to make exact copies mechanically for exhibitions that were held first in the Strand and later at Schomberg House, Pall Mall, in which both the original and the reproduction were displayed.[18]

The Commissions of Works from Richard Westall and Benjamin Robert Haydon

Hope clearly thought of himself as a major patron. He commissioned Richard Westall in May 1804 to paint two pictures from Greek history for 120 guineas, a large sum, although, according to Joseph Farington, he "said it should be 450 *guineas*, being more than double what Westall had charged." Hope later told Westall that he would have commissioned him further, "if work required it. . . . His fortune is not so large as supposed, but He was able to do a good deal in Art as He had not the expense of dogs and horses."[19] One of these pictures, *The Expiation of Orestes at the Shrine of Delphos* (fig. 9-4), a subject that reflected Hope's continuing interest in and passion for classical authenticity, was inspired by a composition on one of the large Greek vases in his collection.[20] Hope objected to the nudity of the Apollo figure and suggested that it "be covered in part by a thin drapery as otherways *in the Exhibition* it may be objected to. Westall proposed to paint this drapery in Water Colour & to wash it off when it is returned."[21] The picture is

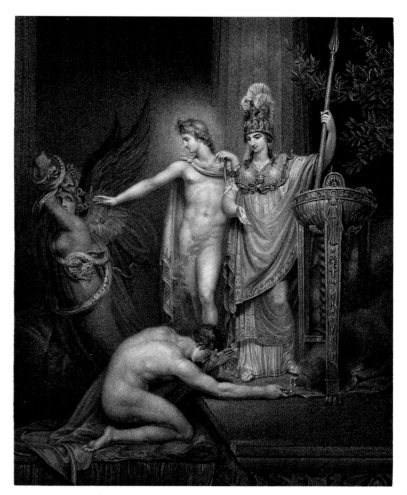

Fig. 9-4. William Bond. Engraving of Richard Westall's painting *The Expiation of Orestes at the Shrine of Delphos*. 1804. Syndics of the Fitzwilliam Museum, Cambridge.

known only from the engraving of 1810 by William Bond.[22] Hope poured scorn on Bond's work: "it seems totally useless to make any detailed remarks. . . . It is radically bad. Nothing in my opinion can make it tolerable, & I think it will be a disgrace to Mr Westalls genius & a slur upon my picture." Worse still, "the fingers & toes of Orestes, they really are shocking. . . . I hope my dear Sir you will believe that it is not for the pleasure of finding faults but of mending them, that I have been thus explicit."[23] Despite this damning condemnation and the fact that the painting was in Hope's possession, Bond dedicated the engraving to Hope's brother Henry Philip, "who has evin'd a laudable disposition to patronize the fine Arts of England."[24] The second painting for Hope by Westall, *Reconciliation of Helen and Paris, after His Defeat by Menelaus* (fig. 9-5; cat. no. 63), was exhibited at the Royal Academy the following year.[25] In May 1811 Hope asked Westall to paint a larger version of his *Damocles Discovering the Sword above His Head* (see page 150; cat. no. 64), which he had admired at the Royal Academy exhibition that year. Westall had painted this picture for Richard Payne Knight, one of his major patrons.[26]

Hope proved to be a most generous patron when in 1808 he bought *The Repose in Egypt* from the troubled painter Benjamin

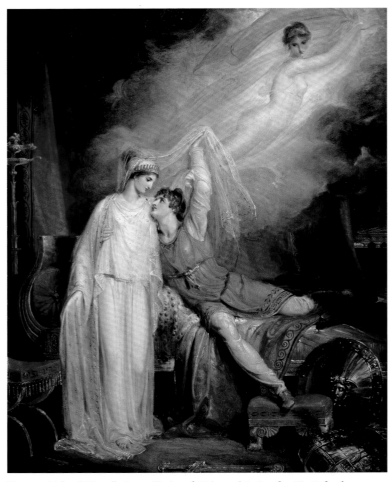

Fig. 9-5. Richard Westall. *Reconciliation of Helen and Paris, after His Defeat by Menelaus.* Oil on wood, 1805. Tate Britain, London, Purchased, 1956, T00088. *Cat. no. 63.*

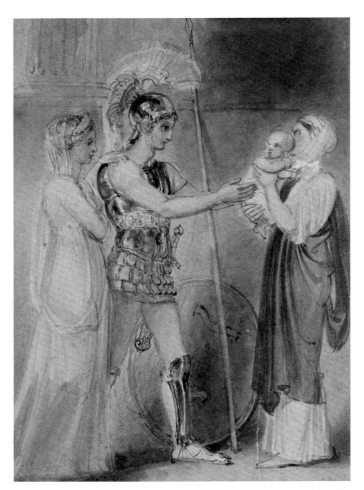

Fig. 9-6. Thomas Stothard. Study for *Hector Bidding Farewell to Andromache.* Watercolor, 1805. Victoria and Albert Museum, London. ©V&A Images.

Robert Haydon, at a time when Haydon was struggling financially.[27] The picture was begun in October 1806, took six months to paint, and was Haydon's first exhibited painting at the Royal Academy in 1807.[28] In his diary in 1809 Haydon wrote: "My Patrons would have left me, my Friends forsaken me, but now when Mr. Thomas Hope discovered the little merit it possessed, purchased, praised, and criticised it."[29] This last was a reference by Haydon to the anonymous review that Hope wrote in 1808 in *The Review of Publications of Art,* which was introduced by "the following liberal and judicious remarks, which we have received from an unknown hand." Hope praised the painting and emphasized his belief that "it has been much lamented, of late, that historical painting should hitherto have been so little practised or encouraged in this country."[30] Hope did not, however, always support Haydon; in 1812 he was the only person to vote against Haydon's picture of *Macbeth* at the British Institution. This large picture, ten by twelve feet, had been commissioned by Sir George Beaumont, Bart. of Coleorton Hall, Leicestershire, another major advocate of British painters.[31]

In the same year, Haydon described Hope as "another real patron of mine," together with Henry Phipps, 1st Earl Mulgrave,

another of his generous patrons. In his diary of January 11, 1819, Haydon wrote: "O God, I bless thee for the effectual blessing I have received at the beginning from one who was my early employer & Friend . . . my Picture was yet to do. I asked him to assist me & he sent me £200 which he said he did for the sake of the Art; & insisted I would not consider it a debt, for he knew how much the feeling of a debt incurred must impede the progress of an Artist. This was Thomas Hope & he shall not repent it."[32] On Hope's death in 1831, Haydon recognized his generosity toward him: "Thomas Hope is dead! my early Patron, and first purchaser—a good but capricious man. [He] objected to my painting Solomon the size of life, though he had given Du Bost, a French painter, 800 gs. just before for Damocles, full size. He got offended, yet when I was ill sent me 200 in the noblest manner—nothing could be nobler."[33]

To add to his collection of contemporary pictures, Hope commissioned Thomas Stothard in March 1805 to paint *Hector Bidding Farewell to Andromache* (fig. 9-6), a similar subject to one in Nero's Golden House in Rome. This is another example of Hope's choice of subject as an important element in his intensely serious scheme of classically inspired pictures to conform with

his outstanding collection of antique and neoclassical sculpture. Stothard, who also illustrated books, was employed by Hope on the decoration and furnishings at Duchess Street.[34] Although Hope was interested in a wide variety of painters, most of whom concentrated on purely historical or neoclassical subjects, he curiously did not want to buy the work of the quarrelsome neoclassical painter James Barry, whose works he refused to purchase in 1806, the year in which Barry died.[35]

Thomas Hope and Benjamin West

Benjamin West, born in Pennsylvania, worked in England from 1763 and was an obvious choice for Hope to commission. Like Hope, West was not originally part of the British establishment. He had important connections to the Court and had been the recipient of royal patronage since 1768. He was appointed Historical Painter to the King in 1772 and painted a total of more than sixty pictures for George III. This association with royalty would have appealed to Hope, together with the fact that West was president of the Royal Academy. Hope himself was an ambitious man, as can be seen by his attempt to buy himself a peerage, and he would have been attracted to West and his place in the establishment.[36] West, himself a collector, was also employed by Beckford, both as a painter and as an adviser, and commanded a powerful influence on him. West was also capable of rendering historical, classical, and mythological subjects on a large and dramatic scale.[37] He had already worked for the Hope family, and three of his pictures had traveled from the Netherlands to London in 1795.[38] In 1802 West painted a group portrait of nine members of the Hope family, commissioned by Henry Hope for his house in Cavendish Square (see fig. 1-2).[39]

In 1805 Thomas Hope commissioned three major, powerful paintings from West, which were completed in the same year. The subjects were taken from Greek history and mythology: *Narcissus and Cupids* (also called *Adonis Contemplating Cupid, Watched by Venus*) from Ovid's *Metamorphoses*, and *Thetis Bringing*

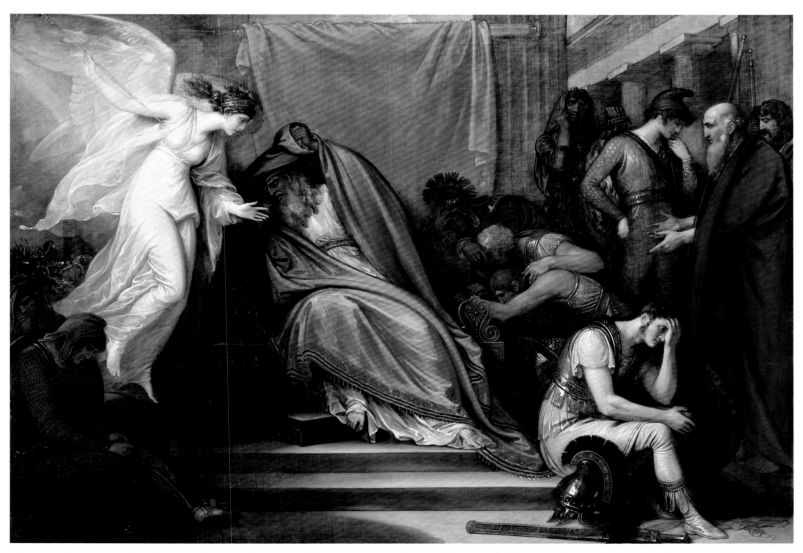

Fig. 9-7. Benjamin West. *Iris Delivering Jove's Command to Priam*. Oil on canvas, 1808. Collection of Westmoreland Museum of American Art, Greensburg, Pennsylvania. Gift of the William A. Coulter Fund, 1986.3.

Armour to Achilles, from Pope's translation of the *Iliad*. Both were exhibited at the Royal Academy in 1805, the *Thetis* picture with another of the same title.[40] For reasons not known, the third picture, *Iris Delivering Jove's Command to Priam* (fig. 9-7) of 1808, another subject from the *Iliad*, was not delivered to Hope but was offered by West to the Pennsylvania Academy in 1809 for £300.[41] An engraving of *Thetis Bringing Armour to Achilles* (fig. 9-8) by William Bond was published by John Britton in 1809 and was included in his volume *The Fine Arts of the English School* of 1812 as the first plate, with a dedication to Hope, "as a Small Compliment for his Distinguished Patronage of the Fine Arts & Literature of England."[42] The picture was engraved again in 1811 and published as plate 1 in *The Gallery of Pictures Painted by Benjamin West Esq.* by Henry Moses, with a glowing appreciation and dedication to Hope: "I feel great pleasure in taking this opportunity of publicly acknowledging how greatly I stand indebted in my profession, to your bounty and encouragement. . . . I trust I am enabled to offer you an acceptable tribute of my gratitude." He praised Hope's "well known patronage of the elder as well as rising Artists of this country." Hope wrote to Britton that he was delighted with his work on the engraving but stated, with a certain sense of caution and possible modesty, that he hoped Britton, in his dedication, would "omit any allusion to me, or my behaviour to critics, or sentiments regarding them; all which I have forgiven, I wish to be forgotten." He asked Britton to remove "the epithet literary which my two works you allude to are hardly entitled to."[43]

The Dubost Story

Hope owned two paintings of Damocles, the one by Westall mentioned above and another by the French painter Antoine Dubost.[44] The history of Hope's relationship with the highly self-opinionated Dubost was strange and unusual and led to acrimony on both sides and a public scandal in the art world. After his success with his painting of *Damocles with the Sword Suspended over His Head* (fig. 9-9), for which he won the gold medal at the Paris Salon in 1804, Dubost arrived in London the following year. Two years later, he exhibited the picture, with five others, at his house at 65 Pall Mall. The picture was for sale at the exceptionally high price of 1,500 guineas, and in June 1807, Hope, who had been considering buying the picture for a year, offered Dubost 800 guineas and the promise of further patronage. Hope also offered to raise one hundred subscribers to pay for the engraving and included in his agreement a commission for Dubost to paint a portrait of Mrs. Hope for an additional 400 guineas. This portrait, *Mrs. Thomas Hope and Son*, was exhibited at the Royal Academy in 1808, the third and last picture Dubost

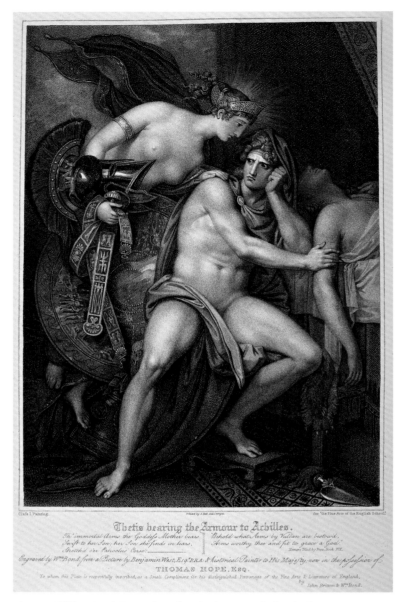

Fig. 9-8. William Bond. Engraving of Benjamin West, *Thetis Bringing Armour to Achilles*, 1809. The British Library Board, 59.f.21.

exhibited there. It received bad reviews and sparked an interminable conflict between the two men.[45] Rumors spread that the *Damocles* had been painted by the considerably more talented and famous French neoclassical painter Jacques-Louis David.[46] Hope further insulted Dubost by eradicating his signature from the picture and slicing a section off the top, as the painting was too tall to hang in his careful arrangement of the interiors of Duchess Street. In the same year, 1808, Dubost commented on Hope, "that though He possesses many good pictures, yet His collection cannot be compared with that of the Marquiss [*sic*] of Stafford & several other collections, & that He wd. obtain more reputation by disposing of all His *old pictures* & by filling His gallery with pictures to be painted by the best *Modern Artists*, by which He wd. set a great example & probably be followed by others who wd. adopt His plan."[47]

In retaliation, two years later, in 1810, Dubost painted a portrait of Thomas Hope and his wife in which he depicted Hope as a monster bear with giant hairy ears offering his wife gold and jewels, against an easily recognizable background of the Aurora Room at Duchess Street. Hope was shown with cruel words emanating from his mouth in a balloon.[48] The painting, entitled *Beauty and the Beast,* was exhibited with other works by Dubost in his house in Pall Mall, and huge numbers of an electrified public rushed there to see it. Hope, a serious person, found this representation deeply offensive, as did Mrs. Hope's brother, the Reverend

John Beresford, who, outraged, attacked it with a knife and an umbrella. A court action followed that resulted in damages awarded to Dubost of five pounds against a claim he had made for 1,000 guineas.[49] Later that year, Dubost published a pamphlet of sixty pages entitled *Hunt and Hope An Appeal to the Public by Mr. Dubost against the calumnies of the Editor of the Examiner,* which contained "An Appeal" dated July 20, 1810, a lengthy and rambling defense against his detractors. Some of the pamphlets included the correspondence in French, from June 1807 to June 1809, between Hope and Dubost before Hope stopped the publication. Under the title

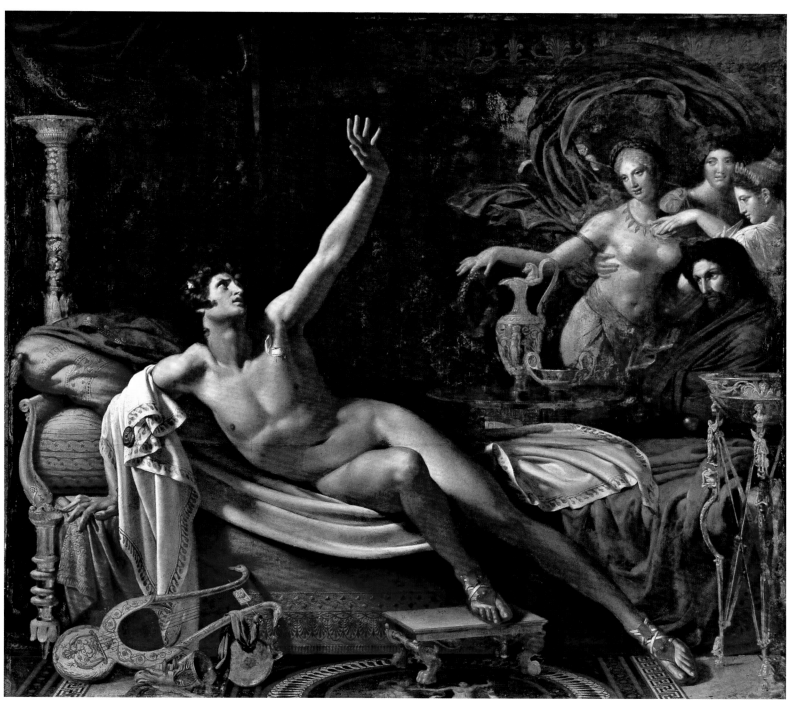

Fig. 9-9. Antoine Dubost. *Damocles with the Sword Suspended over His Head.* Oil on canvas, 1804. Chhatrapati Shivaji Maharaj Vastu Sangrahalaya, Mumbai

there appeared a drawing of two donkeys, one with a pannier marked "Examiner and Essays," the other marked "Household Furniture." Above them, in a ribbon banner, a motto reads "ASINUS ASINUM FRICAT" over the doorway of the *Examiner* building in Beaufort Buildings. Robert Hunt was one of the brothers of James Henry Leigh Hunt, the essayist and poet who edited the *Examiner* from 1808. Hunt had written in support of Hope. His "feelings were shocked to see a caricature so severe upon persons whom public report, as well as his own *private* sources of information, assured him were among the most worthy of human beings."[50] The contentious Dubost exhibited no more pictures in London, and fifteen years after this episode he died in Paris as a result of a wound sustained in a duel with an architect in the Bois de Boulogne.

Portraits by Beechey, Lawrence, and Shee

In addition to those portraits of the Hope family by Reynolds, Head, Sablet, and Dawe already mentioned in this and other essays, William Beechey, portrait painter to Queen Charlotte, painted Hope in 1798 resplendent in full Turkish dress and wearing a gold turban (cat. no. 1).[51] Hope was on friendly terms with Thomas Lawrence, president of the Royal Academy, and they served together on the publication committee of the Society of Dilettanti. Lawrence died the year before Hope, who did not attend the huge state funeral but sent his carriage to the Royal Academy, "as my present state of health prevents my attending in person."[52] Lawrence painted the Hope's second son, *Charles as a Youthful Bacchus,* about 1816.[53] He also painted Mrs. Hope, in both a full-length and a half-length portrait (see fig. 5-19), the latter in a "rich glowing red" gown, a turban, and much jewelry, which was exhibited at the Royal Academy in 1826.[54] Martin Archer Shee, later president of the Royal Academy and a friend of Hope's, also painted Mrs. Hope in 1807 (cat. no. 3).[55] In the diary of Hope's son Adrian John, there is mention on January 6, 1823, of his mother sitting to Auguste Hipolitte (or Hyppolite), the miniature and theater painter in Paris, who "put on Mama a most beautiful Turban of white and Gold."[56]

Hope's Purchases at Exhibitions and Other Genre Pictures

It is difficult to judge Hope's true reasons for his choice of contemporary pictures, whether they were principally altruistic and to promote British painters or whether they were for reasons of fashion and to impress the members of the society circles in which he and his wife moved. He may have liked to be seen paying quite high prices for pictures by some painters, a number of

Fig. 9-10. John Flaxman. *Virgilio e Beatrice.* Illustration for Dante's *Divine Comedy.* Ink on wove paper, 1793. Department of Printing and Graphic Arts, Houghton Library, Harvard College Library, 42.1353F,

whom were young and not well known, then or now. His collection contained a wide variety of subjects and included pictures bought at the annual exhibitions of the Royal Academy and the British Institution. For instance, early purchases at the lower price range included works by the young William Mulready, *A View in St. Albans* in 1806 and *Old Houses in Lambeth* in 1807. Both pictures were exhibited by Hope after he bought them, presumably in an attempt to boost Mulready's reputation.[57]

The following year, 1808, Hope bought two pictures at the British Institution, *A Dog and Hawk* by James Northcote and a *Flower Piece* by James Hewlett of Bath, which had been moved to London from the Bath Union Street exhibition and which possibly appealed to his Dutch antecedents.[58] Hope paid the extraordinary sum of 500 guineas for this large painting, which was a pendant to one of the same title painted the year before for George Granville Leveson-Gower, Marquis of Stafford, and later 1st Duke of Sutherland. This had created a stir because of the enormous price of 400 guineas for a work by a relatively unknown painter.[59] Farington reported later that Hewlett "painted another picture for which He asked 900 guineas. Hoppner out of patience sd. 'Hewlet [*sic*] ought to be smothered.'"[60] In 1809 Hope bought *The Music Lesson in the Style of Metsu* by Michael William Sharp, which won first prize at the British Institution.[61] According to Charles Molloy Westmacott, it hung in the Aurora Room at Duchess Street with *The Importunate Author. A Scene from Molière's Comedy "Les Facheux"* by Gilbert Stuart Newton.[62] Westmacott described it as a "masterly fine cabinet gem, in the richest style of art, and abounding in choice conceit, good drawing, and elaborate finish."[63]

Hope's Purchases of Drawings, Watercolors, and other Topographical Pictures

One of Hope's most important commissions followed his meeting John Flaxman in Rome in 1792. He commissioned Flaxman to produce 111 drawings, at a guinea each, to illustrate Dante's *Divine Comedy* (fig. 9-10). He decided later that they would be for private distribution only among his friends. These simple outline illustrations were engraved and published by Tommaso Piroli in an unauthorized edition in 1802.[64] Hope also collected works by British and continental watercolor painters. He was presumably interested in buying works especially to hang at the Deepdene, where they would suit their surroundings and where there was ample space in which to show them. Some of the earliest works owned by Hope were two watercolors by Abraham-Louis-Rodolphe Ducros: *View of Cascatelle at Tivoli*, a subject that Ducros had also painted for Sir Richard Colt Hoare in 1787, and *Campo Vaccino*.[65] Ducros was working in Rome at the same time as Jacob More and the Prussian Jacob Philipp Hackert, and all of them were patronized by travelers on the Grand Tour.[66]

Hope's passionate interest in architecture brought him into contact with the architect and illustrator Joseph Michael Gandy, "the English Piranesi," who was in Italy from 1794 to 1797. He too had traveled with Charles Heathcote Tatham, the architect employed by Hope in the creation of Duchess Street, and with George Augustus Wallis, who had accompanied Hope to Sicily in 1792. Gandy, who was already important as the chief recorder of the work of the architect John Soane, dedicated to Hope the first volume of *Designs for Cottages, Cottage Farms and Other Rural Buildings, and the Rural Architect*, "a name which will ensure respect wherever the Arts are known."[67] Hope bought Gandy's first extant picture, a monumental watercolor of *The Fall of Babylon*, or *Pandemonium, or Part of the High Capital of Satan and His Peers* (fig. 9-11), a subject from Milton's *Paradise Lost*, a dramatic architectural fantasy on a cataclysmic theme.[68] Hope also owned another large watercolor by Gandy of a *View of a Tomb of a Greek Warrior*, thought to be *"The Tomb of Agamemnon"* (cat. no. 62), which was exhibited at the Royal Academy in 1818 (and for which Hope designed an elaborate frame with a surrounding band of continual leaf decoration in gilt[69]), which represents the imaginary reconstruction of an ancient Greek tomb.[70] The watercolor of the *Restoration of the Temple of Athena at Sunium* by the architect Robert Smirke, from his journey there between 1801 and 1805, was also in Hope's collection by 1819, as were those listed above.[71]

Hope bought watercolors by Thomas Heaphy, who was appointed Portrait Painter to the Princess of Wales in 1803, and whose work was fashionable and sought after by serious collectors and connoisseurs.[72] Heaphy specialized in pictures of "low life," which commanded high prices. He exhibited at the annual exhibitions of the Society of Painters in Water Colours, where Hope bought *The Tired Pedlar* in 1808 and *Rustic Courtship* or *Interior of a Cottage, Presenting the Ring* in 1809.[73] A watercolor by the topographical painter William Westall of *A View in China* was purchased by Hope in Brook Street in 1808.[74] At the Watercolour Society exhibition of that year, he acquired *Suburbs of an Ancient City* (fig. 9-12), a large and severely classical and imposing watercolor by John Varley.[75] In 1809 Hope bought twelve oil

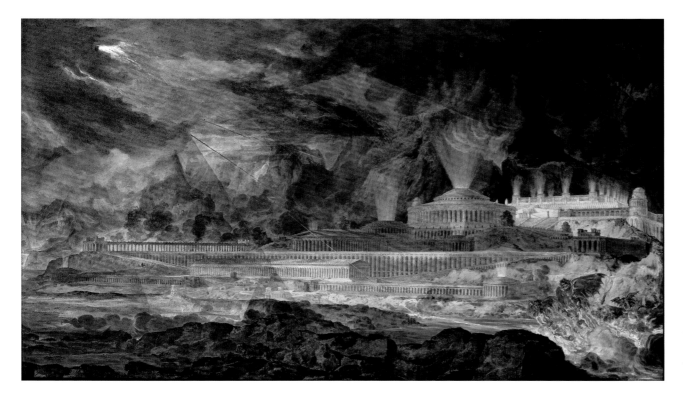

Fig. 9-11. Joseph Michael Gandy. *The Fall of Babylon*, or *Pandemonium, or Part of the High Capital of Satan and His Peers.* Watercolor, 1805. Private collection.

Fig. 9-12. John Varley. *Suburbs of an Ancient City.* Watercolor, 1808. Patrons of British Art through Friends of the Tate Gallery, London, T05764.

paintings of Ephesus and various watercolors by Luigi Mayer and other views in the Levant, executed about 1800. Most of these were purchased at the sale of Sir Robert Ainslie, later 1st Baronet, numismatist, and ambassador to the Ottoman Empire at Constantinople from 1776 to 1792, who had employed Mayer to record his travels in Sicily, Greece, Egypt, Turkey, and Asia Minor.[76] Later additions to Hope's collection of watercolors included charming illustrations of the interiors of the Deepdene by Penry Williams and of the picturesque exteriors by William Henry Bartlett of 1825 (cat. nos. 106.1–106.21) which serve as an invaluable record of the house and its environs after the earlier alterations.[77]

The Collection at Duchess Street

Considerable information as to which contemporary pictures were in Hope's collection is gleaned from accounts of the interiors at Duchess Street and at the Deepdene, his house in the country which he bought in 1807, and where latterly, many of the "modern" pictures hung. The final volume of 1820 of the *Annals of the Fine Arts* listed Hope's collection in both houses.[78] One of the earliest records of Duchess Street was made by Francis Douce, a renowned antiquarian and Keeper of Manuscripts at the British Museum, who probably visited the house in about 1812 and listed the works of art in most of the rooms.[79] Among Hope's first acquisitions for the Indian or Blue Room was a large painting by Thomas Daniell. Hope was one of the earliest patrons of Thomas and his nephew William Daniell. He commissioned *Composition: Hindu and Muslim Architecture (a Capriccio with the Taj Mahal)* in August 1799.[80] It was expressly to hang with a large Panini, *Capriccio of Roman Ruins and Sculpture with Figures,* which had been removed from the Netherlands with the

family collections.[81] These two pictures in matching frames accompanied two other large works by Thomas Daniell: *Benares: The Manikarnika Ghat* and *The Zinat ul Masjid Mosque, Darayahanj, Delhi* (cat. nos. 58, 59), which were commissioned by Hope in July 1800.[82] Hope cited four paintings by Daniell in the Indian Room, which he called the Drawing Room, "principally fitted up for the reception of four large pictures, executed by Mr. Daniel [*sic*], and representing buildings in India, of Moorish architecture"; the fourth painting cannot be identified.[83] These imposing Indian paintings, though clearly intended by Hope to make an impressive impact in terms of subject matter and scale, were considered by some to be a little strange and exotic in this context. In 1824 they were described by Westmacott as "very correct portraits no doubt, but not otherwise worth the society we find them in."[84]

The Ante-Room contained both antique and modern sculpture and a mixture of mythological subject pictures, including *Venus Chastising Cupid* by André Corneille Lens, the Antwerp neoclassical painter. This was one of two paintings that Thomas's father,

Fig. 9-13. Attributed to Guy Head. *Juno Borrowing the Girdle of Venus.* Oil on wood, 1805. Nottingham City Council, Nottingham Castle, 1894-18

Fig. 9-14. Jacques-Henri Sablet. *The First Steps*. Oil on canvas, ca. 1790. Private collection.

John Hope, commissioned from Lens in 1773 and 1774 and that Thomas inherited when his father died in 1784.[85] Douce also mentioned in this room *Juno Borrowing the Girdle of Venus* by Guy Head, a portrait painter and copyist then based in Rome (fig. 9-13).[86] Head had copied some of the Old Masters in the Hope collection in Amsterdam, having in all probability been introduced to the family by Joshua Reynolds on his visit to Flanders and the Netherlands in 1781.[87] Head also painted portraits of Thomas and "a" brother, probably Henry Philip, in Rome in 1795. Two of the history pictures by Westall also hung in this room with a painting of *Cupids Wrestling* by Henry Howard. Hope bought this painting, then called *Hylas Carried off by the Naiads*, in 1797, possibly from the Royal Academy.[88] Howard was in great demand at that time, and the choice of this work was not surprising, given Hope's endeavor to encourage British painters. Howard was later patronized, for instance, by Soane to paint the ceilings in his house at Lincoln's Inn Fields and by George Wyndham, 3rd Earl of Egremont, who was establishing an extensive and remarkable collection of paintings and sculpture at Petworth House, Sussex.

Douce listed four paintings by contemporary French neoclassical painters in the Egyptian Room. The choice of these pictures is not surprising, given their classical references and Hope's passion for works of art in the French style. Two were by Louis Gauffier. *Achilles at Scyros*, or *Achilles Discovered among the Daughters of Lycomedes* (sometimes misnamed *Vanity*), was painted in 1790 and shown at the Paris Salon in 1791. The other, *The Rest on the*

Flight into Egypt (cat. no. 60), was painted in Rome in 1792 and hung above the fireplace opposite the *Achilles*.[89] Both of these highly finished pictures were much praised.[90] In this room Douce also recorded two pictures "of Italian costume" by one of the Sablet brothers, thought to be Jacques (-Henri) Sablet. "Ruins with figures," or *The First Steps* (fig. 9-14), of about 1790 hung between the windows; the other picture was not identified.[91] Hope would inevitably have met these painters in Italy. Gauffier and the Sablet brothers, who all also painted portraits, were patronized by those in cultured and fashionable British circles, such as that of Henry Fox, 3rd Baron Holland, in Rome and Florence in the early 1790s. Sablet painted Hope's portrait in Rome in 1792, a charming composition depicting Hope in shirt sleeves playing cricket holding a long narrow bat (see fig. 1-5).[92] The only other contemporary pictures which Douce mentioned, apart from the Daniells in the Indian Room, were those in the Dining Room; a Daniell, "a fine picture of a mosque," a "beautiful" Lens picture of *Bacchus and Ariadne* painted in 1773, and a *Campagna de Roma* by Jacob More.[93] Douce recorded no modern paintings in the Picture Gallery.

The Collection at the Deepdene

Various sources provide exact information as to which pictures hung at the Deepdene at different dates.[94] In his account of the house of 1826, J. P. Neale recorded the collection in each room.[95] A much later account also listed the paintings in situ, but it was

Fig. 9-15. George Dawe. Sketch for *Andromache Imploring Ulysses to Spare Her Son*. Drawing, ca. 1810. Private collection.

published in 1850, nearly twenty years after Hope's death and therefore included pictures added to the collection by his son Henry Thomas.[96] The increasing number of Hope's purchases of contemporary pictures, some of which were of considerable proportions, must have constrained the limited space for the display of paintings rather than sculpture at Duchess Street. It must be presumed that many of the pictures were gradually removed to the Deepdene, where there would have been plenty of hanging room, particularly in the bedrooms and especially so after Hope had completed a new wing in 1823 for the display of sculpture, thus allowing more space for paintings.

The Drawing Room contained the picture by Richard Westall of *Damocles*; two of the paintings by Benjamin West, *Narcissus and Cupids* and *Thetis bringing Armour to Achilles*; and the portrait of Hope's mother-in-law, *Mrs. William Beresford and Her son John, later second Lord Decies*, by Joshua Reynolds.[97] These hung with the painting by George Dawe of *Andromache Imploring Ulysses to Spare Her Son* (fig. 9-15) bought by Hope at the Royal Academy in 1810.[98] This was an unusual departure in subject matter for Dawe, who was primarily a portrait painter. Indeed, following the purchase of this picture, Dawe's biographer commented that Hope, "who in the most liberal manner marked his approbation of Dawe's talents by favouring him with several commissions."[99] Among these were a portrait of Mrs. Hope with two of their five children, probably Henry Thomas (1808–1862) and Charles (1810–1817), painted in 1811 (see fig. 4-6) and a beautiful full-length portrait of Mrs. Hope in a red velvet dress, which was exhibited the following year at the Royal Academy.[100]

One of the most impressive pictures at the Deepdene was by John Martin, *The Fall of Babylon*, which had been bought by Hope's brother Henry Philip at the British Institution in 1819, where the picture was an enormous success.[101] Beckford visited the exhibition three times and with great excitement, "running . . . to admire *The Capture of Babylon* by Martin. He adds the greatest distinction to contemporary art. Oh what a sublime thing!"[102] A slightly unexpected inclusion in Hope's collection was a painting of a horse by George Stubbs. Hope had attempted to buy a picture by him at the posthumous auction sale of his work held in May 1807, during which "high prices were bid, one in particular for which Mr. Thos. Hope bid upwards of £200, yet she [Isabella Saltonstall, a generous patron and collector of Stubbs's works who was also bidding at high prices] wd. not let it go."[103] Undeterred, twelve years later, in 1819, Hope bought a *Portrait of a Horse with Landscape Scenery* by Stubbs, about which nothing more is known except that it was hanging at the Deepdene by the following year.[104]

A picture of *The Burgesses of Calais before Edward III with Queen Philippa Interceding* by William Hilton, a history painter and a rival of Haydon, was bought by Hope in 1809 and hung in the Library.[105] As far as is known, Hope did not buy any works by John Constable, although he did buy two pictures by his great friend, the Swiss painter John James Chalon: *View on the Boulevards* and *Gardens of the Tuileries*, which hung in the Lilac Room.[106]

Other Collectors

Hope opened Duchess Street in 1804, "by application signed by some persons of known character and taste, or the personal introduction of any friend of the family. Visitors are admitted on the Mondays during the season of the nobility being in town, between the hours of eleven and three."[107] Other collectors in London also allowed access to their works of art, notably the magnificent collection owned by the Marquis of Stafford which was available from May 1806 at his gallery at Cleveland House.[108] The gallery was designed by Charles Heathcote Tatham, the same architect who worked at Duchess Street for Hope. Other members of the aristocracy also opened their collections to interested visitors, for instance, the 2nd Earl Grosvenor at Grosvenor House and Sir John Fleming Leicester, 1st Baron de Tabley at 24 Hill Street, Mayfair.

Samuel Rogers, poet, collector, generous patron, a relative of Richard Payne Knight, and a friend of Hope's, composed unusual and elaborate interiors on a smaller scale than Duchess Street at his house, 22 St James's Place, overlooking Green Park in London. Like Hope, Rogers had inherited a large fortune in

shares from his banking family and had recently returned from Paris. The house, by James Wyatt, was built in 1802–3 with the interiors clearly influenced by Hope. They shared similar ideas and were both scrupulous in carrying out their intended designs.[109] Rogers was described as, "fitting it up with great care . . . had given much study to questions of decoration and ornament: and had designed the furniture himself, with the assistance of Hope's work on the subject."[110] He was a liberal host and opened his house to the public to view his exceptional collections of Greek and Roman vases, works by Old Masters, and British contemporary paintings and drawings.[111]

A comparable and extraordinary collection often compared to Hope's was put together for his own museum by John Soane, the architect and collector extraordinaire, who was at times at the same sales as Hope and bidding for similar objects. Like Hope, Soane was responsible for many generous acts of patronage to help artists and their families, although in both their cases, the commissioned works were not always of the very highest quality.[112] Soane believed that "the best efforts in my power have been exerted, on every occasion, to promote the interest and advantage of British artists, by giving commissions to some of the living."[113] Another comparable collection was that of Alexander Davison of St. James's Square, London. Davison, a government contractor, ship owner, financier, and friend of Nelson, commissioned eight painters, including Gainsborough, Stubbs, Wilkie, Morland, and Westall, to illustrate subjects from English history.[114] Other enlightened collectors who bought and commissioned British pictures in addition to collecting Old Masters included Richard Payne Knight; Walter Fawkes of Farnley Hall, Yorkshire, an early patron of British painters, particularly of Turner; and Sir George Beaumont, amateur landscape painter and one of the first benefactors and founders of the National Gallery.[115] Thomas Lister Parker of Browsholme Hall, Yorkshire, an antiquary, bought only British contemporary pictures after the sale of his Old Masters in 1808. Philip John Miles of Leigh Court, near Bristol, who owned pictures from the Henry Hope collection; John Julius Angerstein, whose collection formed the nucleus of the National Gallery; and Sir Thomas

Bernard, 2nd Baronet, philanthropist, benefactor, and lawyer, who helped establish the Royal Institution in 1800 and the British Institution in 1805—all had similar intentions and aspirations to Hope for the advancement of British art.

There were two completely different types of display of Hope's collection, the formal and carefully orchestrated arrangement at Duchess Street and the less contrived at the Deepdene. Hope was attracted by large scale and dramatic pictures, as well as by smaller cabinet paintings, landscapes, and genre subjects. His choice was, on the whole, conservative. It may be instructive to consider the paintings that Hope did not buy but that were available to him by purchase or patronage—works, for instance, by Turner, Wilson, Wilkie, Callcott, Bonington, or Landseer, all of which were much sought after by his fellow collectors. There was praise for Hope's ability to combine paintings of different periods and genres in the *Annals of the Fine Arts* in 1820, "*pictures* are intermixed with others, by the old and foreign masters of the same class, and do not suffer by the comparison."[116] In 1821 the American painter Charles Robert Leslie admired Hope's collection: "One of the greatest treats I ever had, was lately at Mr. Hope's Gallery, who has the finest collection in London."[117] Not all visitors were inspired by Hope's collection of contemporary pictures, however. Prince Pückler-Muskau visited Mrs. Hope in Duchess Street on June 5, 1827, and "saw her husband's collection of works of art more in detail." He was particularly impressed by the Dutch and Flemish pictures in which the collection "is peculiarly rich . . . nothing was wanting to complete the richness of the collection," yet crushingly: "Only the modern English pictures were bad."[118] This rather harsh appraisal does not take into consideration Hope's fervent and genuine desire to promote and support British painters manifested in acts of kindly generosity and resulting in his ownership of some prestigious works of art. If Hope's collection of contemporary pictures did not give the impression of being in the same class as that of his Old Masters, it was perhaps because his real passion and interest lay principally in his collections of antique and contemporary sculpture rather than in those of his pictures.

Acknowledgments

Philip Hewat-Jaboor and Daniella Ben-Arie have been sources and providers of constant information and support and are both owed an enormous debt of gratitude. I would also like to acknowledge David Bindman and David Watkin, who kindly read the essay and made helpful suggestions.

1. For details of the establishment of the collections of John Hope and Henry Hope, see Chapters 11 and 10 in this volume. Henry Hope's contemporary collection contained similar types of pictures to that of Thomas Hope. It included, for instance, pictures by Benjamin West, Richard Westall, Guy Head, and Thomas Daniell and less important works by painters common to both collections. The extent of Henry Hope's collection can be seen in the works included in the auction sales catalogues after his death, particularly that of *A Catalogue of the highly distinguished and very celebrated Collection of Italian, French, Flemish and Dutch Pictures, the genuine Property of Henry Hope, Esq. Deceased at Mr. Hope's Mansion, Cavendish Square, corner of Harley Street*, Christie's, London, on 28 and following days of June 1816.

2. See Chapter 1 in this volume.

3. David Watkin, *Thomas Hope (1769–1831) and the Neo-Classical Idea* (London: John Murray, 1968): 5.

4. C. J. Bailey, "The English Poussin—An Introduction to the Life and Work of George Augustus Wallis," *Walker Art Gallery Annual Report and Bulletin* 6 (1975–76): 35–54. Some watercolors by Wallis painted while on or after this journey survive, such as *The Ruins of Selinunte* (Ashmolean Museum, Oxford) and *Taormina looking toward Mount Etna* (Huntington Library and Art Gallery, San Marino, California). Hereafter, where known, the current locations of pictures will be listed in the footnotes.

5. See Chapter 10, n. 6.

6. From 1807 Wallis became an agent in Spain for William Buchanan, the major dealer in Old Masters. He was responsible for the importation into England of some of the finest Italian, Spanish, and Flemish pictures, such as the Raphael *Alba Madonna* (National Gallery, Washington), the *Madonna of the Basket* by Correggio, and *The Toilet of Venus* (*The Rokeby Venus*) by Velázquez (both in the National Gallery, London).

7. John Ingamells, *A Dictionary of British and Irish Travellers in Italy, 1701–1800* (New Haven and London: The Paul Mellon Centre for Studies in British Art, 1997): 521. The following year, Wallis traveled again with another collector and connoisseur, Thomas Noel Hill, 2nd Baron Berwick, of Attingham Park, Shropshire.

8. Interest in specifically British collections had started some years before when John Boydell began to reproduce British collections in 1769; see Sven H. A. Bruntjen, *John Boydell, 1719–1804. A Study of Art Patronage and Publishing in Georgian London* (New York and London: Garland, 1985).

9. See *William Beckford, 1760–1844: An Eye for the Magnificent*, ed. Derek Ostergard, exh. cat., New York, Bard Graduate Center (New Haven and London: Yale University Press, 2001).

10. Quoted from an undated letter from Hope to John Britton, MS Vault, Frederick Hilles, 8910, Box 1A, no. 8, Beinecke Library, Yale University, New Haven. The letter concerns the *Thetis* picture by West.

11. His article entitled "On Instruction in Design" appeared in *The Artist; A Collection of Essays relative to Painting, Poetry, Sculpture, Architecture, The Drama, Discoveries of Science and various other subjects*, ed. Prince Hoare 1, no. 8 (1807): 1–7. This volume and that of 1809 were reprinted in two volumes (London: John Murray, 1810).

12. John Britton, *The Fine Arts of the English School illustrated by a series of Engravings, Paintings, Sculpture, and Architecture of Eminent English Artists* (London: Longman, Hurst, Rees, Orme, and Brown, 1812): iii–iv. Britton also acknowledged his gratitude to Hope in this volume, which was "edited and partly written" by him.

13. For the list of other institutions and committees of which Hope was a member, see Watkin, *Thomas Hope* (1968): 50.

14. William Carey, *Some Memoirs of the Patronage and Progress of the Fine Arts in England and Ireland* (London: Saunders & Ottley, 1826): 133, 804. The latter reference is to Hope's subscription of £10 for the Irish sculptor John Hogan (1800–1858) to visit Rome in 1825.

15. Trevor Fawcett, *The Rise of English Provincial Art* (Oxford: Clarendon Press, 1974): 91, n. 114.

16. Until 1819 pictures were available to be copied only at the Royal Academy Schools and at Dulwich Picture Gallery. The author would like to acknowledge Mark Pomeroy, Archivist at the Royal Academy of Arts, for this information and permission to publish from letters in their collection, RAA/SEC/2/82, copyright Royal Academy of Arts, London. In another letter of 15 July 1819, Hope stressed the importance for students to benefit from "the constant study of the living model." Another committee of which Hope was a member was that for "the superintendence of Royal Academy Exhibition Models"; see Watkin, *Thomas Hope* (1968): 50.

17. The Titian is in the Minneapolis Institute of Arts, the "Correggio," once attributed to Piero di Cosimo and now to Dosso Dossi, is in the National Museum, Stockholm. The Giorgione was to be delivered by William Redmore Bigg (1755–1828), painter, restorer, and dealer of 116 Great Russell Street, Bedford Square. He restored works for Lords Lyttleton, Guilford, and Egremont.

18. Polygraphic pictures were first published in 1784 by Joseph Booth, who had established a factory in Woolwich to produce the pictures; see William T. Whitley, *Artists and their Friends in England 1700–1799*, vol. 2 (London and Boston: Medici Society, 1928): 27.

19. Entries for 4 May 1804 and 24 December 1804, Joseph Farington, *The Diary of Joseph Farington*, ed. K. Garlick et al., vol. 6 (New Haven and London: Yale University Press, 1979): 2314, 2478.

20. For further insight into this composition, see Chapter 7 in this volume.

21. Entry for 7 March 1805, Farington, *Diary*, vol. 4 (1979): 2529. The picture was exhibited at the Royal Academy in 1805, but whether it was with or without the watercolor addition is uncertain.

22. Bond was president of the Society of Engravers founded in 1803 and was known principally for his engravings after portraits by Reynolds.

23. Quoted from two letters addressed to John Britton; the first was dated 30 June 1810, but the second, written from the Deepdene, was undated. Both are in the Hilles MS correspondence in the Beinecke Library, New Haven, see n. 10.

24. The engraving, published in 1810, was illustrated in Britton, *The Fine Arts of the English School* (1812).

25. In the collection of the Tate Gallery, London.

26. Payne Knight's picture is in a private collection. Hope lent his version entitled *Dionysius and Damocles*, now in the Ackland Art Museum, Chapel Hill, North Carolina, to an exhibition of works by Westall in 1814 at the New Gallery in Pall Mall, next door to the British Institution; see *Catalogue of an exhibition of a selection of the works of Richard Westall R.A., including two hundred and forty pictures and drawings which have never been exhibited* (32). There were actually 312 exhibits. Lenders included the Earls of Oxford and Aberdeen, and Richard Payne Knight.

27. Haydon described Hope, "with his peculiar delicate and dry manner," in *The Arts and Memoirs of Benjamin Robert Haydon*, ed. Alexander P. D. Penrose (London: G. Bell & Sons, 1927): 93, 478.

28. Hope paid £150 for the picture. It measured five by seven feet, (152.4 x 213.3 cm) and is now lost. It was one of only six pictures that Haydon exhibited at the Royal Academy between 1807 and 1828. There is a study for the picture in an album of 1806 in the Prints and Drawings Department of the British Museum.

29. Entry for 14 May 1809, in *The Diary of Benjamin Robert Haydon*, ed. Willard Bissell Pope, vol. 1 (Cambridge: Harvard University Press, 1963): 64. The diary was begun in July 1808, that is, after the acquisition of the picture by Hope.

30. *The Review of Publications of Art* 2 (London: Printed for Samuel Tipper, 1 June 1808): 110–12.

31. See Felicity Owen and David Blayney Brown, *Collector of Genius, A Life of Sir George Beaumont* (New Haven and London: Yale University Press, 1988) and also Chapter 2 in this volume.

32. Pope, *The Diary of Benjamin Robert Haydon*, 11 January 1819, vol. 2 (1963): 212.

33. Ibid., 22 April 1810, vol. 1 (1963): 157, and 5 February 1831, vol. 3 (1963): 507.

34. Shelley Bennett, *Thomas Stothard and the Mechanisms of Art Patronage in England c. 1800* (Cambridge: Cambridge University Press, 1997): 34–35, fig. 30. This painting is lost, but a watercolor study for it is in the Victoria and Albert Museum, London. Flaxman was also working on the same subject at that time. P. W. Clayden, *The Early Life of Samuel Rogers* (London: Smith, Elder, 1887): 448. Stothard designed a cabinet for antiquities, ornamenting it with paintings by his own hand.

35. Watkin, *Thomas Hope* (1968): 273, n. 81. Hope owned a copy of *The Works of James Barry, Esq. . . . containing his correspondence . . . his lectures*, ed. Dr. Edward Fryer, 2 vols. (London: T. Cadell & W. Davies, 1809), together with the first publication of 1801 of Henry Fuseli's *Lectures on Painting* and John Opie's *Lectures on Painting* of 1809.

36. Watkin, *Thomas Hope* (1968): 25–26.

37. For West's decorative and other works at Fonthill, see Albert Ten Eyck Gardner, "Beckford's Gothic Wests," *The Metropolitan Museum of Art Bulletin* (October 1954): 41–49.

38. Marten G. Buist, *At spes non fracta, Hope & Co. 1770–1815, Merchant Bankers and Diplomats at Work* (The Hague: Bank Mees and Hope, 1974): 490, listed in Catalogue A, "Landscape & figures," identified as *First Interview of Telemachus with Calypso* of ca. 1772, valued at £150, and two pictures both entitled "Fable," which were possibly *The Damsel and Orlando* (Toledo Museum of Art) of 1793 and *Angelica and Medoro*, valued at £70 and £80, respectively.

39. In the Museum of Fine Arts, Boston; see Chapters 1 and 11 in this volume and Watkin, "'The Hope Family' by Benjamin West," *Burlington Magazine* 106 (December 1964): 571–73.

40. *Narcissus and Cupids* is in a private collection, U.S.A. The commission was confirmed 17 March 1805 by Farington, *Diary*, vol. 7 (1982): 2532.

41. It is in the Westmoreland County Museum of Art, Greensburg, Pennsylvania. See Helmut von Erffa and Allen Staley, *The Paintings of Benjamin West* (New Haven and London: Yale University Press, 1986): 240 (146), 252 (170), 254–55 (176) and for other versions and copies of the same subjects.

42. Britton, *The Fine Arts* (1812).

43. In an undated letter from Hope to Britton in the Hilles MS correspondence in the Beinecke Library, New Haven. In a further undated letter, Hope told Britton that he knew West well and would "therefore prefer committing to another & an other hand the task of writing an account of that picture."

44. The painting by Dubost is in the Chhatrapati Shivaji Maharaj Vastu Sangrahalaya, Mumbai, formerly the Prince of Wales Museum of Western India, and is the subject of a comprehensive article; Richard E. Spear, "Antoine Dubost's 'Sword of Damocles' and Thomas Hope: An Anglo-French Skirmish," *Burlington Magazine* 148 (August 2006): 520–27.

45. The portrait is untraced, the episode is recounted at some length in Sandor Baumgarten, *Le crépuscule néo-classique. Thomas Hope* (Paris: Didier, 1958): 78–83; he described the story as a "farce."

46. In 1917 the picture was catalogued as "French School" at the sale of the Hope Heirlooms, *Catalogue of Important Pictures by Old Masters and Family Portraits being a portion of the Hope Heirlooms removed from Deepdene Dorking, The Property of Lord Francis Pelham Clinton Hope*, sale cat., Christie's, London, 20 July 1917, lot 51 bt. Malens £57 15s.

47. Entry for 3 February 1808, Farington, *Diary*, vol. 9 (1982): 3214.

48. The words were to the effect that "I am sensible that I am a most horrible beast and all these treasures will be yours if you accept me as your husband."

49. More details of the case can be found in William T. Whitley, *Art in England 1800–1820* (Cambridge: Cambridge University Press, 1928): 173–76.

50. Quoted by Dubost on p. 10 of the pamphlet, a copy of which was kindly provided by Daniella Ben-Arie to whom the author owes an enormous debt of gratitude for much information and advice.

51. See Chapter 5 in this volume. The portrait was exhibited at the Royal Academy in 1799 and is now in the National Portrait Gallery, London.

52. Letter of 16 January 1830, LAW/5/463, copyright Royal Academy of Arts, London.

53. In the Castle Museum and Art Gallery, Nottingham.

54. Both of which are lost. Michael Levey, *Sir Thomas Lawrence* (New Haven and London: Yale University Press, 2005): 269–70.

55. The portrait was exhibited at the Royal Academy the following year; Martin Archer Shee, *The Life of Sir Martin Archer Shee*, vol. 1 (London: Longman, Green, Longman and Roberts, 1860): 319.

56. The author is grateful to Daniella Ben-Arie for pointing to the existence of the diary. The only known reference to other portraits apart from the family portraits in Hope's collection was a small *Portrait of an Artist* by Francis Hayman which was consigned on 3 March 1818 by a Mr. Webster from Dutches (*sic*) Street for sale at Christie's on 9 March 1818, *A Catalogue of a valuable assemblage of a Consignment from the Continent of Italian, Spanish, French, Flemish and Dutch Pictures*, lot 6, and was bought in at £2 3s.

57. The former, bought for £21, was exhibited at the Royal Academy in 1807. It was retouched by Mulready for Hope in 1813 with "another" for £10, presumably the latter, which was exhibited at the British Institution in 1808 and for which he paid £31. Kathryn Moore Heleniak, *William Mulready* (New Haven and London: Yale University Press, 1980): 51, 189, 190.

58. Confirmed in a letter of 5 March 1808 to Northcote from Valentine Green (1739–1813), Keeper of the British Institution, in the Getty Research Institute, J. Paul Getty Museum, Los Angeles, inv. no. 850014. The painting was sold in the Henry Hope sale of 1816, lot 74, bought by "WW" for 11 guineas. The only other reference to a picture of this title, "a picture of a Dog and / Hawke," was painted for "Mr. Poulett Powlett" for five guineas, listed in Jacob Simon, "The Account Book of James Northcote," *The Walpole Society* 57 (Leeds, 1995–96): 67.

59. The picture measured about 3 x 3 feet (ca. 91.4 x 106.6 cm). This is the only recorded occasion on which Hewlett achieved such substantial recognition for his work. See Whitley, *Art in England* (1928): 117–19.

60. 14 February 1808, Farington, *Diary*, vol. 9 (1982): 3223.

61. A painting by Sharp of *A Capriccio with a Group of Ladies and Gentlemen Examining a Bust of Antinous, with the Hope Athene and a Picture Gallery beyond to the right, and a Domed Salon to the left*, probably of 1811 (private collection, U.S.A.) shows identifiable pieces of sculpture from Hope's collection in Duchess Street, although it is not known whether the picture belonged to Hope. Thomas's brother Henry Philip bought *A Cup of Tea* by Sharp from the British Institution in 1820.

62. Hope bought the painting for £52 10s. from the British Institution in 1821. See *The Magazine of the Fine Arts and Monthly Review of Painting, Sculpture, Architecture and Engraving* I (London, 1808): 151.

63. See Charles Molloy Westmacott, *British Galleries of Painting and Sculpture* (London: Sherwood, 1824): 218.

64. For a full account of this important commission, see Chapter 8 in this volume and *John Flaxman, The illustrations for Dante's Divine Comedy*, ed. Francesca Salvadori (London: Royal Academy of Arts, 2005): 17–19, 86, 98. The inscription on the frontispiece of the 1793 version reads "Possession of Tomasso Hope Scudiere, Amsterdam." Hope sold his rights in 1807 to Longman, the publisher.

65. It is presumed that Hope bought these works while in Italy. They were listed in the 1795 manuscript inventory as "Ducos" "Landscape Water Colours" valued at £20. Both were put up for sale by "Hope," presumed to be Thomas, in the Ainslie sale, see n. 76; Christie's, London, 10 March 1809, lot 110 bought in at £3 10s. and lot 111 bought in at £4 10s., respectively.

66. Hope sold a Hackert *Romantic Scene in Italy with Figures* in 1813 with a picture by Daniell, see n. 84 for details of the sale. A similar picture *An Italian Landscape* by Robert Freebairn (1765–1808) was in Hope's collection by 1820.

67. It appeared in two volumes in 1805. The architect Edmund Aikin (1780–1820) also dedicated his volume of *Designs for Villas and other Rural Buildings* to Hope in 1808. Hope had employed Aikin to work with George Dawe to prepare the finished drawings for *Household Furniture* (1807).

68. The picture, 28 x 48 1/2 in. (71 x 123 cm), presumably bought from the Royal Academy, where it was exhibited with the latter title in 1805, is in a French private collection. See Brian Lukacher, *Joseph Gandy: An Architectural Visionary in Georgian England* (London: Thames & Hudson, 2006): 127.

69. For further comment on Hope's designs for frames, see Chapter 10 in this volume.

70. It is in a private collection and was exhibited in Christopher Woodward, *Soane's Magician The Tragic Genius of Joseph Michael Gandy*, exh. cat. (London: The Soane Gallery, 2006): [44].

71. They are listed as at Duchess Street in *Annals of the Fine Arts* (1820): 97.

72. William T. Whitley, *Thomas Heaphy* (London: Royal Society of British Artists' Art Club, 1933): 17.

73. The Society had been founded three years before. Hope paid 50 guineas and 130 guineas, respectively. The 1808 exhibition had contained thirteen pictures by Heaphy which were praised publicly by West; see Adrian Bury, "Artists of the Peninsular War," *The Antique Collector* (April 1958): 66.

74. Hope paid 50 guineas on 16 April 1808. Westall, who was taught to paint by his more famous older half-brother Richard, had been shipwrecked in the Coral Sea in 1803 on his way home, and later traveled to Canton.

75. In Tate Britain. Hope paid £42. See C.M. Kauffmann, *John Varley* (London: B. T. Batsford Ltd., in association with the Victoria and Albert Museum, 1984): 47, and exhibited in Timothy Wilcox, *The Triumph of Watercolour, The Early Years of the Royal Watercolour Society 1805–55*, exh. cat. (London: Dulwich Picture Gallery, and Manchester: Whitworth Art Gallery, University of Manchester, 2005): [31].

76. These drawings served as engraved illustrations by Thomas Milton (1743–1827) for three volumes published in 1801–4. For the sale, see *A Catalogue of the very valuable and entire Collection of Drawings and Paintings in Oil of Sir Robert Ainslie Bart. . . The Whole of which were Executed by that Ingenious Artist, MAYER, For Sir Robert Ainslie Bt., during his Travels in the Levant, his Residence at Constantinople, and his return from whence to England*, sale cat., Christie's, London, 10 March 1809, lots 33–35, 40–44, 46. Soane was also buying at this sale. Forty of these watercolors were sold in a volume in the Deepdene Library sale, *Catalogue of the Valuable Library of Books on Architecture, Costume, Sculpture, Antiquities, etc., formed by Thomas Hope, Esq., . . . being a portion of The Hope Heirlooms*, sale cat., Christie's, London, 27 July 1917, lot 431, with two further lots 432 and 433, constituting a large number of acquatints by Mayer.

77. A watercolor drawing by Paul Sandby of a *View of Box Hill from Norbury Park* (38¾ x 11¾ in. [98.4 x 29.8 cm]) of ca. 1775, which is presumed to have belonged to Thomas Hope rather than his brother Henry Thomas, was sold in the Hope Heirlooms Library sale, 27 July 1917, lot 210. It is possibly that in the Yale Center of British Art, New Haven, attributed to Thomas Sandby.

78. Five volumes were published between 1817 and 1820, edited by the architect James Elmes.

79. The manuscript was published by Peter Thornton and David Watkin, "New Light on the Hope Mansion in Duchess Street," *Apollo* 126 (September 1987): 162–76. For the plan of the rooms and contents of Duchess Street, see Chapter 2 in this volume.

80. The painting, for which Hope paid 130 guineas, measures 70 x 90 in. (178 x 229 cm) and is in a private collection in England. It was exhibited in Anna Jackson and Amin Jaffer, *Encounters The Meeting of Asia and Europe 1500–1800*, exh. cat. (London: Victoria and Albert Publications, 2004): [1.15], and is discussed in detail by Hermione de Almeida and George H. Gilpin, *Indian Renaissance: British Romantic Art and the Prospect of India* (Aldershot, U.K., and Burlington, Vt.: Ashgate, 2005): 201. Daniell chose "what he thought were the most notable examples of 'singular' Indian images," taking some from his earlier published works, such as *Oriental Scenery*, and some from his drawings on which he later based paintings or engravings. Beckford bought "an India view" by "Daniell" in May 1797, two years before Hope bought his first work by one of the Daniells. See the entry for 22 May 1797, Farington, *Diary*, vol. 3 (1979): 843.

81. The Panini had presumably been bought by one of the Hopes on an earlier journey to Italy. It was in the manuscript inventory compiled on behalf of Hope & Company Bank which was published in Buist, *At spes non fracta* (1974): 494, entitled "Campo Vaccino" by "Pannini," listed in Catalogue C, valued at £50. It is in Yale University Art Gallery, New Haven.

82. Both paintings although large (68 x 53 in. [173 x 135 cm]) are slightly smaller than the *Composition* picture. They are in the National Gallery of Modern Art, New Delhi.

83. Pl. VI in *Household Furniture* (1807) and Maurice S. Shellim, *Oil Paintings of India and the east by Thomas Daniell R.A. (1749–1840) and William Daniell R.A. (1769–1837)* (London: Inchcape & Co., 1979): 22.

84. Westmacott, *British Galleries* (1824): 217. Westmacott, a journalist and famous blackmailer, was the illegitimate second son of the sculptor Richard Westmacott the Elder (1747–1808) and Susan Molloy, landlady of the Bull and Horns pub in Fulham. He trained as a painter at the Royal Academy and became renowned as a scurrilous and libelous scandal monger. Despite his reputation, this record of Duchess Street is a valuable source for Hope's contemporary collection. He gave more attention to the Old Master paintings in the two picture galleries, but his account does include some of the more important contemporary pictures, such as by Westall. Hope also owned other paintings by Thomas Daniell, an *Interior View of Mandapam at the Meenakshi Temple* of 1808 (Durbar Hall, Victoria Memorial, Calcutta). "Hope," presumed to be Thomas, attempted to sell *Buildings near Daltri* (?) by one of the Daniells, either William or Thomas, *A Catalogue of the very valuable and entire Collection of Drawings and Paintings in Oil of Sir Robert Ainslie Bart.*, sale cat., Christie's, London, 11 March 1809, lot 112 bought in at £21. Another Daniell, *Sea Port in Asia Minor*, sold by "Hope Esq.," presumed to be Thomas, as his brother Henry Philip was named as another vendor in the same sale, *A Catalogue of a valuable collection of Italian, French, Flemish and Dutch Pictures, Property of an Amateur of Fashion*, sale cat., Christie's, London, 15 May 1813, part of lot 50 (with a Hackert) bought by the French dealer Lafontaine for 5 guineas. Thomas Hope offered *A View of Windermere* by one of the Daniells, *A Catalogue of a small assemblage of Pictures . . . the property of Thomas Stowers Esq., late of Charter-House Sq., decd.*, sale cat., Christie's, London, 25 February 1818, lot 119 bought in at 3 guineas.

85. For the inventory of John Hope's collection, see J. W. Niemeijer, "De kunstverzameling van John Hope (1737–1784)," *Nederlands Kunsthistoriches Jaarbuch* 32 (1981): 186.

86. This painting was sold in the Henry Hope sale of 1816, lot 77; bought by Turner for £22 1s. It is presumed to be the one in the Castle Museum and Art Gallery, Nottingham; see Ann Gunn, "Guy Head's 'Venus and Juno,'" *Burlington Magazine* 133 (August 1991): 510–13. I am most grateful to Ann Gunn for her assistance with this painting.

87. Head was a protégé of Reynolds and sometimes described also as a dealer. Some copies by Head of pictures in the Hope collection were sold in his posthumous sale, *A Catalogue of the valuable Collection of accurate Copies from the works of the most celebrated Masters in the Principal Galleries and Private Collections in Italy and Germany . . . by that ingenious Artist, the late Mr. Guy Head, deceased*, sale cat., Christie's, London, 13 March 1802, for instance, lot 58, *Prudence after Guido* and lot 63, *Dying Magdalen after Ludovico Carracci*. Two weeks later Hope sold a *Baccanti Group* by Head, *A Catalogue of a Capital and Valuable Collection of Italian, French, Flemish and Dutch Pictures The Property of the late Duke of St. Albans Decd. from his residence in Mansfield Street, Portland Place*, sale cat., Christie's, London, 27 March 1802, lot 95, bought by Devangnes for £12 1s. 6d. "Hope," either Thomas or his brother Henry Philip, sold a *Cupid and Psyche* by Head, *A Catalogue of a valuable collection of Italian, French, Flemish and Dutch Pictures . . . Property of an Amateur of Fashion*, Christie's, London, 15 May 1813, lot 47 bought by Martin for £5 10s.

88. It was put up for sale in the Henry Hope sale of 1816, lot 82 bought by Stewart for £33 12s., but was listed in 1820 at the Deepdene, *Annals of the Fine Arts* 4 (1820): 96. Hope also bought *The First Navigator, aided by Cupid and the Zephyrs, hailed by the Nereides* by Howard in 1798; see F. Howard, "Memoir of Henry Howard, R.A.," in *Lectures on Painting* (London: J. & H. Cox, 1848): lxiii, lxiv.

89. Hope commissioned *Generosity of the Women of Rome* from Gauffier in 1790, which is possibly that in the Musée des Beaux-Arts, Poitiers, cat. no. 61. Hope owned two other Gauffier paintings, *Hector Reproving Paris* and *Ulysses and Nausicaa* of 1798 (Musée des Beaux-Arts, Poitiers). A painting by him of *Oedipus and the Sphinx* was formerly thought to have been at the Deepdene in the Billiard Room; see Baumgarten, *Le crépuscule néo-classique* (1958): 96, and Watkin, *Thomas Hope* (1968): 44. Its place in Hope's collection has been questioned; see *Egyptomania Egypt in Western Art 1730–1930*, exh. cat. (Ottawa: National Gallery of Canada, and Paris, Réunion des Musées Nationaux, 1994–95): [103].

90. Both arrived in London from the Netherlands with the Hope collections in 1795; see Buist, *At spes non fracta* (1974): 494, listed in Catalogue C, valued at £20 and £30, respectively. They later hung in the Billiard Room at the Deepdene. The latter is in the Musée des Beaux-Arts, Poitiers.

91. The former, presumed to be "Roman rural Composition" as by "Sablé" in Catalogue C of the 1795 list and valued at £20, is that either in a private collection in Italy or the one in Forli, Municipio of 1789. The other Sablet on the 1795 list was entitled "Moon Shine" and valued at £50.

92. In the Cricket Memorial Gallery, Lords Cricket Ground, London; see Sarah Searight, *The British in the Middle East* (London: Weidenfeld & Nicolson, 1969): 168.

93. The last was sold in the Henry Hope sale in 1816, *A View near Rome*, lot 50 bought by Lippincott for £23 2s.

94. For a detailed account of the Deepdene, see Chapter 12 in this volume.

95. John Preston Neale, *Views of the Seats of Noblemen and Gentlemen in England, Wales, Scotland, and Ireland*, 2nd series, vol. 3 (London: W. H. Reid, 1826): 6–11.

96. Edward Wedlake Brayley, *A Topographical History of Surrey*, vol. 5 (London: J. S. Virtue & Co. Ltd., 1850): 86–89.

97. The Reynolds portrait of ca. 1775 is in a private collection. See David Mannings, *Sir Joshua Reynolds, A Complete Catalogue of His Paintings* (New Haven and London: Yale University Press, 2000): 85, [158], and vol. 2, 448, fig. 1129.

98. A sketch for the picture, which is in a private collection in England, has a label on the verso stating that it was for the "picture expressly for the late Thos. Hope Esq., for which he received 300 gns."

99. "George Dawe. A Biography," *Library of the Fine Arts* 1 (1831): 10–11.

100. The former is in the Castle Museum and Art Gallery, Nottingham, and the latter is known now only from an engraving and an enamel of 1813 by Henry Bone, miniaturist and enamel painter to George III. The enamel was sold at Christie's, London, 15 October 1996, lot 130. Between 1802 and 1817, Bone copied this, six other portraits, and ten Old Masters in Hope's and other collections, for him, for his brother Henry Philip, and for Henry Hope. These are recorded in Bone's Index of Drawings, vol. 4, National Portrait Gallery Archives, London (16-E-3). I am most grateful to Daniella Ben-Arie for alerting me to this source.

101. This large painting, 61 x 96 in. (182.8 x 243.8 cm), which cost 400 guineas, is in a private collection. A mezzotint engraving, differing in many of the details, was dedicated to Henry Philip Hope, "the proprietor of the original picture," and

published in October 1831, the year in which Thomas Hope died. The companion picture, *The Destruction of Herculaneum and Pompeii*, painted for the Duke of Buckingham in 1821 for 800 guineas, was severely damaged in the flood at the Tate Gallery in 1928.

102. Quoted from a letter to Gregorio Franchi of 5 February 1819 in *Life at Fonthill 1807–1822*, ed. Boyd Alexander (London: Rupert Hart-Davis, 1957): 279. The painting was included in an exhibition of Martin's work in 1822 at the Egyptian Hall in Piccadilly, the location for exhibiting single sensational pictures.

103. The sale was held by Peter Coxe on 26 and 27 May 1807. See the entry for 6 June 1807, Farington, *Diary*, vol. 8 (1982): 3060. For Miss Saltonstall, see Judy Egerton, *George Stubbs 1724–1806*, exh. cat. (London: Tate Gallery, and New Haven, Yale Center for British Art, 1984-5): [121].

104. It was purchased from the British Institution for 50 guineas.

105. It was purchased from the British Institution for 100 guineas.

106. Hope paid 50 guineas each for the Chalons at the British Institution exhibitions of 1819 and 1820. See G. F. Prosser, *Select Illustrations of the County of Surrey, Deep-dene* (London: C. and J. Rivington, 1828): n.p. This account included a greater emphasis on the sculpture collection rather than the paintings. The Chalons hung with a pair of *Fête Champêtre* pictures by Watteau.

107. Westmacott, *British Galleries* (1824): 212.

108. See Giles Waterfield, *Palaces of Art: Art Galleries in Britain 1790–1990*, exh. cat. (London: Dulwich Picture Gallery, and Edinburgh: National Gallery of Scotland, 1991–92): 74–75.

109. Rogers also employed both Flaxman and Stothard. The house was destroyed by bombing in 1940.

110. P. W. Clayden, *The Early Life of Samuel Rogers* (London: Smith, Elder & Co., 1887): 448, and see Chapter 7 by Ian Jenkins in this volume.

111. Rogers had been involved with the purchase of the Orléans collection. Seven works from his collection are in the National Gallery, London, to which he bequeathed three pictures; four more were bought at his posthumous sale in 1856. See Clayden, *Samuel Rogers* (1887): 450, and Dianne Sachko Macleod, *Art and the Victorian Middle Class* (Cambridge: Cambridge University Press, 1996): 468, for further references.

112. Soane's choice of paintings by Westall, Hilton, and Howard was similar to Hope. For Soane's collection, see Helen Dorey, "Soane as a Collector," in Peter Thornton and Helen Dorey, *A Miscellany of Objects from Sir John Soane's Museum* (London: Laurence King, 1992): 122–26.

113. See *Description of the House and Museum on the North side of Lincoln's Inn Fields, The Residence of Sir John Soane* (London: Levey, Robson and Franklin, 1835).

114. He was obliged to sell his house and auction his property in 1817 to repay a huge debt to the Treasury; the paintings and his other collections were sold, London, Stanley, 28 June 1823.

115. Leicester, described as "truly patriotic," had over one hundred works mostly bought directly from major painters, such as Fuseli, Gainsborough, West, and Hilton; see Dongho Chun, "Patriotism on display: Sir John Fleming Leicester's patronage of British Art," *British Art Journal* 4, no. 2 (Summer, 2003): 23–28.

116. Vol. 4 (1820): 93.

117. On 25 May 1821, see Tom Taylor, *Autobiographical Recollections by the Late Charles Robert Leslie, R.A.*, vol. 2 (Wakefield: EP Publishing, repr. 1978): 112.

118. H. L. H. Pückler-Muskau, *Tour in Germany, Holland and England in the years 1826, 1827 and 1828 . . . in a series of letters by a German Prince*, vol. 4 of *Tour in England, Ireland, and France, in the years 1828 & 1829 . . . by a German Prince* (London: Effingham Wilson, Royal Exchange, 1832): 46–47.

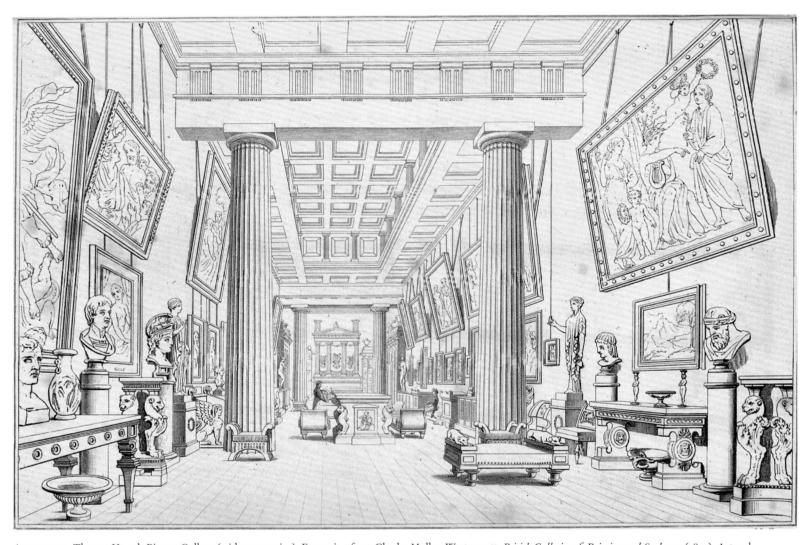

Anonymous, Thomas Hope's Picture Gallery (without curtains). Engraving from Charles Molloy Westmacott, *British Galleries of Painting and Sculpture* (1824). Art and Architecture Collection, Miriam and Ira D. Wallach Division of Art, Prints and Photographs, The New York Public Library, Astor, Lenox and Tilden Foundations.

CHAPTER 10

The Old Master Collections of John, Thomas, and Henry Philip Hope

Jeannie Chapel

The Family Background in the Netherlands

A strong tradition of cultural, economic, and artistic ties existed between Great Britain and the Netherlands from the late sixteenth century onward. Thomas Hope's Scottish ancestry is significant, given the historic links between those two countries, in particular, the exchanges of both people and ideas and the tradition of collecting by the Scots of Dutch works of art.[1] Dutch by birth and upbringing, Thomas Hope was to compound the traditions of his native country with ideas that were developing in Britain and on the continent at a critical period in the history of collecting. Thomas Hope was twenty-five years old when he left the Netherlands in order to live abroad, and he took with him a well-established understanding of collecting art of all kinds and a serious consideration of its display.

By the mid-1730s, there were about two hundred privately owned collections in the Netherlands, about half of which were housed in Amsterdam. The Dutch were accustomed to taking pride in the careful organization of their collections, which were recorded in inventories, made public through guide books, and viewed either at known visiting hours or by appointment. Collections, or cabinets, and the shops of the picture dealers were visited as a matter of course by connoisseurs and travelers of all kinds, especially by the British, who sought out seventeenth-century pictures in particular. After the middle of the eighteenth century, "most British tourists would not have considered their journey in the Netherlands complete without seeing three or four of the chief collections of pictures which were accessible to visitors in the major Dutch cities."[2] Collections, often of large numbers of pictures, were shown throughout many rooms in Dutch houses, not usually in picture galleries as such, but in the corridors and sometimes in the kitchens. These more domestic arrangements for displaying works of art in private houses acted in the place of conventional museums until 1774, when the first public picture gallery of the Republic was opened on the Buitenhof in The Hague to exhibit the collection of Willem V, Prince of Orange and Stadholder of the Netherlands.

The history of the Hope family collections is complicated for many different reasons. In some instances, there has been misunderstanding in the provenances for pictures which at some stage belonged to either John Hope (1737–1784), father of Thomas (1769–1831), or to one of his two younger brothers, Adrian Elias (1772–1834) and Henry Philip (1774–1839). Other members of the Hope family also possessed collections of pictures. John Hope's uncle Adrian Hope (1709–1781) and particularly his first cousin Henry Hope (1735–1811) were serious collectors.[3] When the Hope families moved to London in the winter of 1794, all the pictures, whether those from John Hope's inheritance or those belonging to Henry Hope or other members of the family, were all listed together, thereby creating an increasingly confused situation as to ownership.[4] Information is sparse concerning the exact movement of pictures, evidence of which is inevitably based on contemporary reports rather than on original documentation.

The importance of John Hope's collections for his three sons cannot be overestimated. His collection of pictures was created by a connoisseur of means in a somewhat random fashion and through opportunity rather than by a careful and systematic art-historical accumulation. There are many parallels between the development of his collection and that of his son Thomas. Both followed a remarkably similar pattern of purchase—privately from other collections, from auction sales, or by direct commission from an artist. John Hope appears to have had little interest in collecting drawings, nor did Thomas Hope.[5] This is surprising, because Thomas Hope was an extremely able draftsman and particularly enjoyed drawing architectural subjects and landscapes on his travels.[6]

The Hope family has been described as "considerably more cosmopolitan than the Dutch society of their time."[7] Thomas's father, John (or Jan) Hope, born on February 14, 1737, in Rotterdam, where the Hopes were then established, was an only child who had a thorough education. He went on the Grand Tour in

1760 before he joined the family bank. The journey was immensely important in the consideration of John Hope's collecting of works of art, and also for his three sons and, in turn, for their inheritance. In Rome John Hope moved in the distinguished diplomatic and artistic circles of Cardinal Alessandro Albani, Johann Joachim Winckelmann, and Giovanni Battista Piranesi, all major figures in the emerging development of neoclassical ideas and the discovery of the antique.[8] John Hope's interest and knowledge supported a vast number of purchases of objects of all kinds, and his passion for Italy later inspired his sons to share his enthusiasm. His many interests included antiquities and costume, both of which were to become major preoccupations of his son Thomas.

There is little documentation concerning John Hope's visit to France and Italy; he may also have traveled further east to the Levant. There are, however, useful annotations that were later made on the inventories for his collections; three extensive manuscript catalogues compiled in the 1770s and 1780s still exist. These catalogues constitute extremely good documentation of John Hope's collection and allow for a detailed examination of the manner in which it was formed.[9] With the aid of the invaluable published inventory of about 1782, it is possible to reconstruct a large amount of information and to establish minutely the historical sequence of John Hope's purchases after he returned from the Grand Tour.[10]

In 1758 John Hope's family moved to Amsterdam, a city of huge significance as a capital of art and commerce. During the eighteenth century, the city was critically important for the traffic of works of art, particularly pictures. The Hopes lived first on the Keizersgracht in a large canalside house described as a "merchant castle," which combined a dwelling house with a counting house and warehouse, stables, and a coach house on the same site.[11] In 1782 the family moved to another, smaller canalside house on the Herengracht (the house has subsequently been demolished). Situated on the canals, many of the houses, some of which can still be seen, contained magnificent collections in sumptuous interiors put together by successful merchants and bankers such as the Hope family. John Hope had little involvement in the Hope banking business, but he held distinguished political offices as alderman within the council. From 1765 he played an increasingly important role in the East India Company, becoming a director in 1770.[12] With his immense fortune, John Hope bought other properties, including an estate at Groenendaal in 1767, to which the adjoining property at Bosbeek was added in 1784, the year of his death. He also owned Nederhorst den Berg Castle near Hilversum and the Tapijthuis (carpet house) on the Nieuwe Vorhout in The Hague, all of which provided ample space to house and display his collections.

The Collection of John Hope and the Purchase of the Bisschop Collection

Nothing is known about what John Hope might have inherited from his extremely affluent father, also Thomas Hope (1704–1779). Thomas had held office in both the East and West India trading companies and was a supporter of the newly restored Stadholder, Willem IV, and his successor, Willem V. The elder Thomas Hope owned pictures, and some of those without provenances in John Hope's manuscript catalogues may have belonged to his parents. John Hope began to accumulate pictures from 1760 on the Grand Tour. He certainly bought in Paris and in Italy later in 1761. While there, he commissioned from Alex MacPherson a copy of the *Sleeping Venus of Urbino* by Titian in the Uffizi Gallery.[13] In Venice John Hope commissioned landscapes and bought twenty-six large canvases by Antonio Visentini, a painter, architect, engraver, and theorist.[14] In Florence he commissioned two small painted *scagliola* landscapes from Lamberto Cristiano Gori, a little-known painter but an important figure for his rare knowledge of painting on imitation marble made of gypsum.[15] These early purchases of Italian pictures indicate the breadth of John Hope's interest before the start of his serious consideration of Dutch and Flemish works.

Nearly ten years passed before John Hope's first-known purchases of pictures by Dutch artists, when in 1770 he bought *An Italian Seaport* by Jacob van der Ulft, *Sea Piece with Vessels in a Strong Breeze* by Willem van der Velde, and *Landscape with Figures and Horseman* by Jan Wynants from the sale of the collection of Joan Hendrik van Heemskerk in The Hague.[16] However, a much more substantial purchase followed, when in April 1771 John Hope and his uncle Adrian bought the entire and notable collection of 230 mostly Dutch and Flemish seventeenth-century pictures owned by Jan Bisschop and his brother Pieter of Rotterdam.[17] The Bisschop brothers were rich Mennonite merchants and close friends of the Hope family. Jan Bisschop was described by Thomas Pennant, the writer, naturalist, and traveler, after his visit of July 11, 1765, as "a man who raised himself from nothing to a vast fortune, the greatest part of which he laid out on pictures, china and other curiosities . . . a true rough Dutchman."[18] The brothers lived modestly next to their wholesale and retail haberdashery business, although their cabinet collections of objects and pictures were housed independently in a well-known and much-visited museum they founded on the Leuvehaven. This was one of the first and finest museums to be established in the Netherlands, and it became known as "the Bishops' palace." A portrait by Aert Schouman of 1753 shows the brothers in discussion over works of art with John Hope's cousin Olivier Hope.[19] Jan Bisschop died in 1771. By the terms of his will of October 23,

1770, and a later codicil of February 23, 1771, John Hope and his uncle Adrian were given the opportunity to buy the collection within three weeks, with four weeks to accept and four weeks in which to pay the price of 65,000 florins.[20] The collection was purchased on April 13, 1771, paid for by uncle Adrian Hope; John Hope had overall responsibility for it and paid the expenses. During the following two years, 1772 and 1773, John Hope sold at auction a total of 42 of the less important pictures, leaving 175 works in their possession.[21] Adrian Hope, a bachelor, died ten years later on March 9, 1781, and bequeathed his estate to two of his nephews, Henry Hope and John Hope, anticipating what was to happen in the next generation. The pictures became the property of John Hope, and in the following year he moved to the Herengracht, which would have accommodated the collection.[22]

The Purchase of the Braamcamp and Other Pictures

It was well known that pictures were for sale, to agents or independent buyers, from private cabinets. Dealers such as John Greenwood, an American painter, engraver, and resident in Amsterdam, acted as intermediaries, particularly for British and French collectors. Greenwood imported huge numbers of pictures—about 1,500—into Britain and acted as agent for many distinguished collectors, including John Stuart, 3rd Earl of Bute.[23] Greenwood wrote to Sir Lawrence Dundas of Arlington Street, London, another major collector of Dutch pictures, regarding the possibility of buying from the Braamcamp collection.[24] Gerrit (or Gerret) Braamcamp, a former wine merchant who became a massively successful timber merchant, also lived on the Herengracht, in a house called Sweedenryck. His extensive collection of more than 350 pictures contained superb examples of Dutch, Flemish, and Italian pictures. It was highly praised by Jean-François de Bastide, who called it "Le Temple des Arts," a significant description given that Thomas Hope was to emulate this idea thirty years later in the creation of Duchess Street.[25] John Hope bought eleven works of exceptional quality at the auction after Braamcamp's death. The most expensive pictures, two by Gabriel Metsu, *Man Writing a Letter* and the companion, *Woman Reading a Letter*, each cost 5,205 florins, and *The Storm on the Sea of Galilee* by Rembrandt, bought for 4,360 florins, constitute more than half the total expenditure of 22,750 florins.[26] In 1771 John Hope also bought two pictures by Gerrit Berckheyde, *The Stadthouse, Amsterdam* and *A View in Amsterdam* at a sale at Haarlem.[27] He later bought one more picture from the Braamcamp collection, a flower piece by Jacob Xavery, from the second sale of the collection in 1772.[28]

During the years that followed, John Hope bought pictures sporadically with no specific pattern of purchase. For instance, he commissioned two mythological subject pictures in encaustic wax from the Antwerp neoclassical painter André Corneille Lens. They had met in Rome, possibly through Cardinal Albani, and corresponded from 1771.[29] This was a somewhat surprising act of patronage, considering the fact that John Hope could have commissioned more accomplished or better-known painters, a characteristic he shared with his son Thomas.[30] Other commissions followed and included those for two flower and fruit pieces from Jan van Os in 1775 and for a landscape from B. P. Ommeganck in 1778.[31] John Hope bought only two pictures in 1772, a Hans Rottenhammer *Venus Rising from the Sea* and a Pieter Saenredam, which he bought privately in Haarlem; in 1773 he bought a Ludolf Backhuysen *View of a Warehouse in India*, an interesting choice of subject at the time.

John Hope had the opportunity to buy good pictures from important collections sold at auction during the mid-1770s and often paid high prices. For instance, he purchased *Triumph of Galatea* by Jan Breughel the Elder and Hans Rottenhammer and *Interior of a Village School* by Domenicus van Tol from the sale of Johan van der Marck in 1773.[32] From the sale of Jan Lucas van der Dussen, John Hope bought *Large Kitchen with Kettles, Dead Birds and Vegetables, and Hunting Dog* by Frans Snyders.[33] Three pictures were purchased from the Lambert ten Kate sale.[34] Three more were bought from the Nicolaas Nieuhoff sale in 1777.[35] Important single purchases were also made: *Assumption of the Virgin* by Anthony van Dyck from the collection of Pieter van de Copello on January 26, 1774, and *Landscape with Two Swans, Ducks, and Peacocks* by Melchior de Hondecoeter. He also bought *A Farmyard with Horses and Figures* by Paulus Potter in the same year from an unknown source.[36] A few other purchases were made between this time and his untimely death in 1785, including two works by Jan van Huysum, *Vase of Flowers on a Garden Ledge*, and its companion, *Fruit Piece*, and an Adriaen van der Werff, *Magdalen Reading in a Rocky Landscape*, from the cabinet of Jan van den Ende in Amsterdam in 1776.[37]

Jan Wubbels, Curator of the Collection, and Visitors to the John Hope Collection

These purchases would presumably have been made in consultation with Jan Wubbels, whom John Hope employed as curator. Wubbels gave considerable attention to the collection from 1772 to 1776.[38] Described as "a not-too-gifted painter of small seascapes," he was taught by Jan Matthias Cok, himself a genre and landscape painter, copier of Old Masters, and courtier, who had been a pupil of Nicolaas Verkolje.[39] Wubbels was involved in the maintenance, cleaning, hanging, and framing of the pictures and bid at auction on behalf of John Hope.[40] Wubbels was also a major art dealer in

Amsterdam and later bought eight pictures from the collection at the sale of John Hope's widow in 1785 and 156 works from other vendors. Wubbels died in 1791, and the considerable posthumous auction sale of his stock on July 16, 1792, contained 591 pictures.

John Hope was known for his generous hospitality, and his collection was much visited by foreign royalty, dignitaries, and travelers of all kinds. Dutch collections often contained many different kinds of objects, not solely pictures, but also curiosities, precious stones, shells, animals, and birds, the more rare and curious the better. It was reported by the French ambassador, Louis-Charles Desjobert, who dined with John Hope in Amsterdam in March 1778, that the house was furnished "à la française." He praised the pictures, although they were not French, and commented on the early use of the identification of them to instruct the visitor: "The names of the painters were written on pieces of cardboard in the order the pictures were hung to assist the less well-informed visitors."[41] Joshua Reynolds studied John Hope's collection many times during his visit to Flanders and the Netherlands from July to September of 1781. He described the "cabinet of Mr. Hope," without stating whether it was John Hope's collection or that of his second cousin Henry, and wrote detailed descriptions of many of the pictures.[42] Reynolds praised both the merits of the collection and the hospitality he received: "I have been more particular in the account of Mr. Hope's Cabinet, not only because it is acknowledged to be the first in Amsterdam, but because I had an opportunity (by the particular attention and civility of its possessors) of seeing it oftener, and considering it more at my leisure, than any other collection."[43]

Indeed, John Hope's collection was vastly superior to most others at that time and was compared to those of extremely distinguished collectors. For instance, it rivaled the collection of Cornelius Ploos van Amstel, a merchant, agent, printmaker, publisher, designer, and lecturer, and that of the Portuguese consul Jan Gildemeester Jansz., another resident of the Herengracht.[44] The exceptional quality and large scale of John Hope's collection was also compared to that of the Stadholder, Prince Willem V, with whom John Hope was on good terms, on both a political and a social level. The keeper of the Stadholder's collection, Tethart Philip Christiaan Haag was, like Wubbels, also a painter, particularly of animals. Prince Willem left the Netherlands for London at the same time as the Hope family, while his remarkable collection was removed by the French to Paris in 1795. Most of the pictures were returned to the Netherlands in 1815 and later bequeathed by Prince Willem's son, King Willem I, to the state; the collection has been housed in the Mauritshuis in The Hague as the Royal Cabinet of Paintings since 1822. An interesting parallel was made later in the comparison of this collection with that of the Prince of Wales, later George IV.

The Death of John Hope and the Move of His Heirs to London

John Hope lived increasingly in The Hague rather than in Amsterdam, and he died there suddenly and unexpectedly at the age of forty-seven on April 20, 1784. His will of June 24, 1769, that is fifteen years before his death, named his widow and sons as the heirs to his considerable property. The pictures remained in control of his widow, and Henry Hope, John Hope's first cousin, was in charge of the administration. Mrs. Hope sold ninety-nine of the pictures later in 1784. There remained about one hundred pictures, which accounted for less than half of John Hope's original collection.[45] It was this group of remaining pictures that was inherited by the youngest of John Hope's sons, Henry Philip, and would eventually be housed by Thomas Hope at Duchess Street, but on loan, which has led at times to confusion as to their ownership. When John Hope died, Thomas was fifteen, and he and his two younger brothers, Adrian Elias and Henry Philip, continued to live in the Netherlands for another ten years when they were not traveling.

Thomas Hope left for the Grand Tour in 1787, a lengthy journey that was vastly important in the development of his ideas of style and for his passion for architecture and collecting works of art of all kinds. His mother died on December 1, 1789, leaving her sons a massive inheritance, an estate of 345,554 florins. This, including the picture collection, was left in their joint ownership until 1794.[46] In August of that year, the threatened French invasion became a reality, at which time the family's estate—the properties and their contents, including the pictures—were valued at 790,000 florins.[47] By October 1794 all three sons had left the Netherlands. Thomas went to Berlin and later Vienna; Adrian stayed with his old tutor in Westphalia; and Henry Philip was in Brunswick, where he was partly educated, and was later in Berlin and Dresden.[48] Adrian, who had some unstated mental instability, returned to the Netherlands in 1802 and lived as a recluse between the house on the Herengracht and his villa at Bosbeek, near Haarlem. Henry Philip, described as having "an extremely kind heart and benevolent disposition," was close to Thomas throughout their lives.[49] He died a bachelor and left his collection of pictures to his nephew, Thomas's son Henry Thomas Hope.

By early 1795, the Hope family was established in London. Joseph Farington commented in his diary: "The Mr. Hopes have brought to England their fine collection of pictures, & have removed so much of their property as they said as to have left only chairs and tables behind them."[50] Henry Hope bought Hopetoun House from his kinsman the Earl of Hopetoun. It was a large property on the corner of Harley Street and Cavendish Square, into which the large consignment of 372 pictures and

other works of art brought from the Netherlands, including his own, those which had belonged to John Hope, and those belonging to other members of the family, were moved. Three manuscript lists of the collections made at the time of their removal to London survive and are an invaluable source of information.[51] It is interesting to observe from these lists which pictures were most highly regarded.[52] Those already belonging to Thomas Hope, as far as can be ascertained, remained in the house in Cavendish Square until after the alterations were completed at his Duchess Street house in 1799. Complications later arose as to the allocation of pictures, as members of the family gave or sold pictures to each other. For instance, Thomas Hope acquired, either through gift or purchase, six important pictures, which he recorded as his property later in John Hope's 1782 inventory with his initials.[53]

The three brothers were not involved in the family banking house, though between them they owned their father's share of the assets until 1813, when the partnership was broken up, and Thomas and Henry Philip each received payments of £25,000 for three years. Thus ended the Hope banking dynasty.[54] The vast income from the bank and from his inheritance allowed Thomas Hope the freedom to travel, to collect works of art, including Old Master pictures, in particular the much-prized works by Italian masters, and to commission and buy contemporary works. Francis Haskell commented that, at that time, "some of the greatest masterpieces ever painted . . . Titians and Raphaels, Correggios, Rubenses, and Guidos joined the odd family portrait or hunting scene." Of the serious collectors Haskell wrote, "the old aristocratic names were now joined by hugely rich bankers and merchants of Russian, Dutch, and German origin: John Julius Angerstein, the Hopes, the Barings."[55]

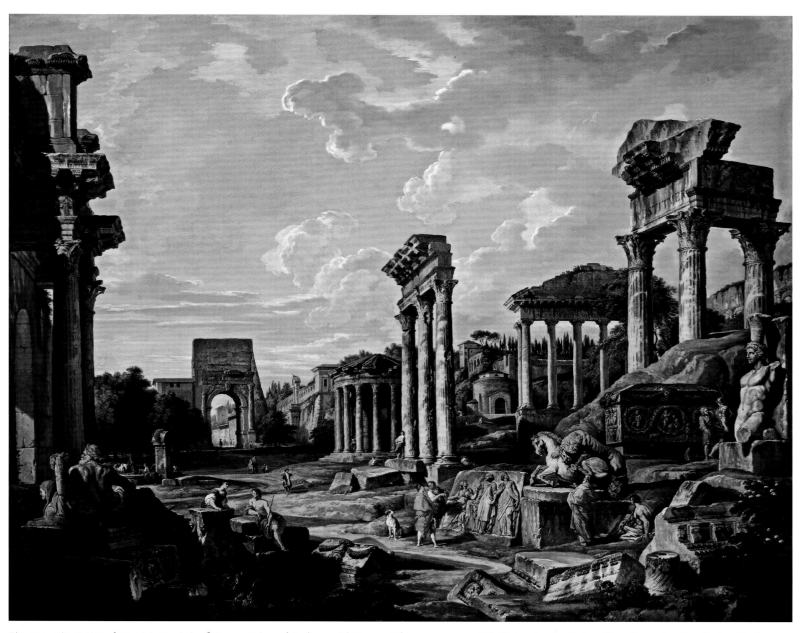

Fig. 10-1. Giovanni Paolo Panini. *Capriccio of Roman Ruins and Sculpture with Figures.* Oil on canvas, 1741. Yale University Art Gallery, New Haven, Stephen Carlton Clark, B.A. 1903, Fund YUAG 1964.41.

Fig. 10-2. Thomas Daniell. *Composition: Hindu and Muslim Architecture (a Capriccio with Taj Mahal)*. Oil on canvas, 1799. Private collection.

Early Purchases of Old Masters by Thomas Hope

Thomas Hope traveled with his two brothers once more to Italy in 1795, having been there at least twice before in the early 1790s. There they all bought works of art, separately or sometimes together, mostly antique and modern sculpture, although Thomas had not as yet established a base in London in which to

house his new acquisitions.[56] Little is known about the purchases of pictures made by Thomas Hope during his visit to Italy of 1795–96. He had already bought one Italian work, a large painting by Giovanni Paolo Panini, *Capriccio of Roman Ruins and Sculpture with Figures* (fig. 10-1).[57] Hope must have regarded this as a special picture, for in 1799 he commissioned Thomas Daniell to paint a companion piece, *Composition: Hindu and Muslim Architecture (a Capriccio with Taj Mahal)* (fig. 10-2) for 130 guineas.[58] These two pictures hung together, in matching frames, with two other Daniells, in the Indian Room at Duchess Street.[59] During this visit or on an earlier one in Rome, Hope may also have bought two pictures by Guercino, *Doubting Thomas* and *The Betrayal of Christ* (figs. 10-3 and 10-4).[60] These pictures represent a new direction in Hope's enthusiasm for important works by Old Masters, which he continued to buy in London in 1798, first at a sale of Michael Bryan, the auctioneer and immensely influential dealer for the art trade. Bryan was responsible for importing a substantial number of pictures into Britain from other agents and dealers, mostly purchased from aristocratic families in Italy and Spain. As a result of the Revolution, a number of French collections, notably that of the duc d'Orléans, were dispersed by Bryan in a series of auctions and exhibition sales in London. Together with other extremely distinguished collectors, Hope first purchased two pictures from the Orléans collection, *The Death of Adonis* by Peter Paul Rubens (fig. 10-5)

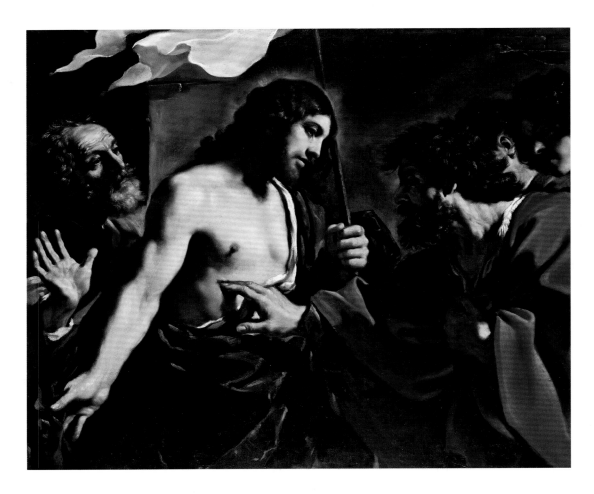

Fig. 10-3. Guercino. *Doubting Thomas*. Oil on canvas, 1621. National Gallery, London, NG 3216.

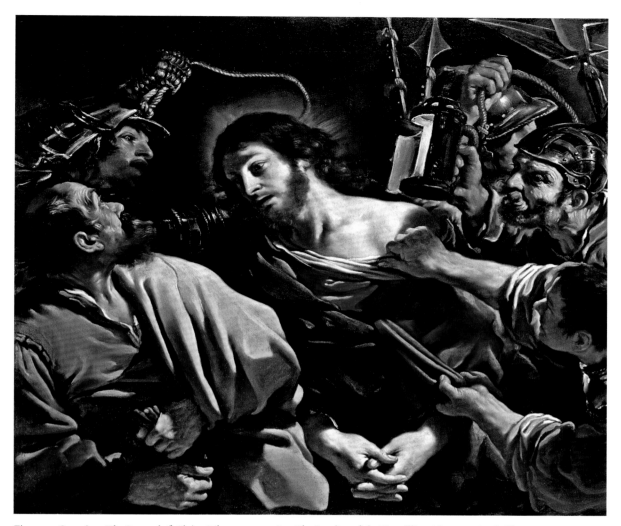

Fig. 10-4. Guercino. *The Betrayal of Christ*. Oil on canvas, 1621. The Syndics of the Fitzwilliam Museum, Cambridge, 1131.

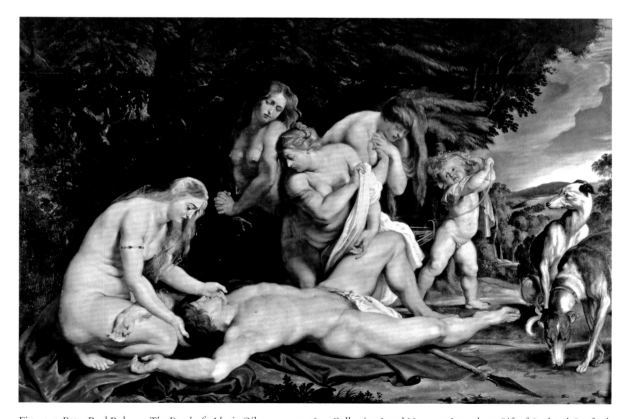

Fig. 10-5. Peter Paul Rubens. *The Death of Adonis*. Oil on canvas, 1614. Collection Israel Museum, Jerusalem, Gift of Saul and Gayfryd Steinberg, New York to American Friends of the Israel Museum, B00.0735.

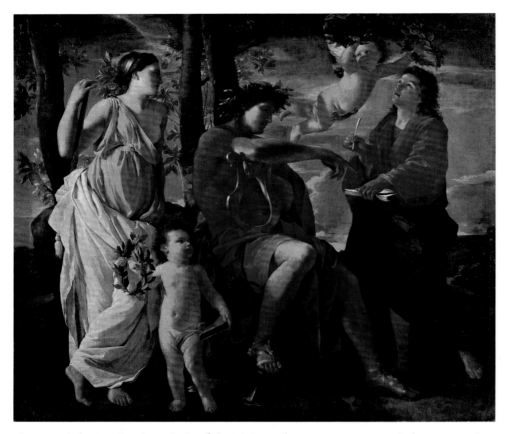

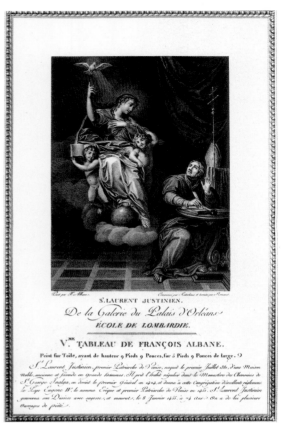

Fig. 10-6. Nicolas Poussin. *The Inspiration of the Epic Poet*. Oil on canvas, ca. 1630. Musée du Louvre, Paris. Réunion des musées nationaux / Art Resource, N.Y.

Fig. 10-7. Engraving after Albani. *The Vision of St. Lawrence Justinian*. Engraving, 1786. Witt Print Collection, Courtauld Institute, London, neg. no 982/3 (15).

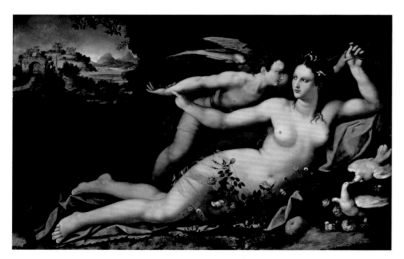

Fig. 10-8. Alessandro Allori. *Venus Disarming Cupid*. Oil on panel, 1570. Los Angeles County Museum of Art, Gift of Samuel H. Kress, 35.1,

and *Dutch Peasants Regaling* by Adrian van Ostade.[61] Some time after this sale, Hope bought *The Inspiration of the Epic Poet* by Nicolas Poussin (fig. 10-6), formerly in the collection of Cardinal Mazarin, and one that represented a hugely important addition to his collection.[62] Thomas Hope bought six more Orléans pictures for a total of 1,800 guineas from Bryan's exhibition, which took place from December 1798 to July 1799. These were *The Vision of St. Lawrence Justinian* by Francesco Albani (fig. 10-7), *Venus Disarming Cupid* by Alessandro Allori (fig. 10-8), *Portrait of Cesare Borgia* by Correggio (fig. 10-9), *The Temptation of Christ* by Titian (fig. 10-10), *Portrait of Six Tuscan Poets* by Giorgio Vasari (fig. 10-11), and *The Allegory of Wisdom and Strength* by Paolo Veronese (fig. 10-12).[63] Hope bought some exceedingly fine pictures although it is now known that not all the Bryan pictures were of a consistently high quality.[64] Possibly also in 1799, Hope bought from Bryan one of many versions of the van Dyck *Virgin and Child*, which is now in the royal collection.[65] He also bought another Orléans picture, *His Own Portrait*,

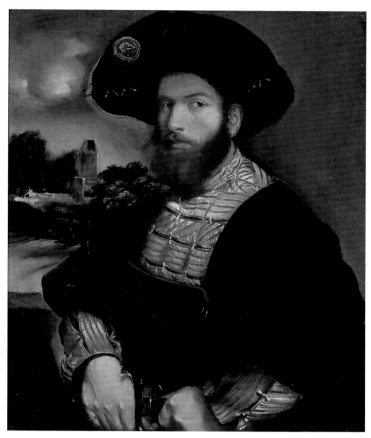

Fig. 10-9. Dosso Dossi. *Portrait of a Man Wearing a Black Beret*. Formerly attributed to Correggio as *Portrait of Cesare Borgia*. Oil on canvas, ca. 1517–19. The National Museum of Fine Arts, Stockholm, NM 2163,

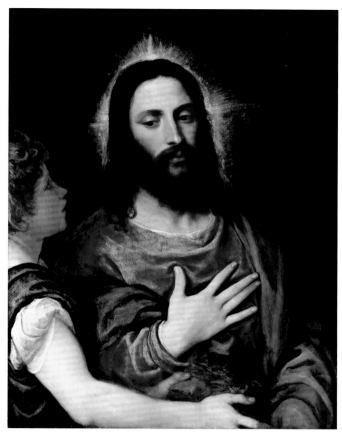

Fig. 10-10. Titian. *The Temptation of Christ*. Oil on panel, 1516–25. Minneapolis Institute of Arts, The William Hood Dunwoody Fund, 25.30,

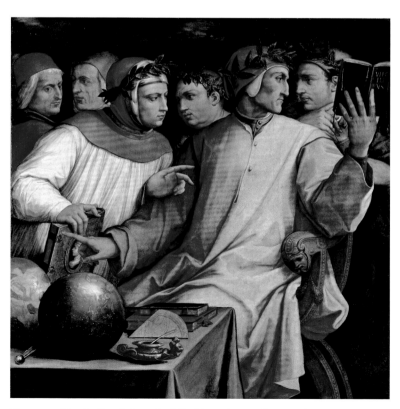

Fig. 10-11. Giorgio Vasari. *Portrait of Six Tuscan Poets*. Oil on panel, 1544. Minneapolis Institute of Arts, The William Hood Dunwoody Fund 71.24.

Between Virtue and Vice (The Choice of Hercules) by Veronese (fig. 10-13) for 60 guineas, in a sale in 1800 of the remaining Italian pictures owned by Bryan.[66]

William Buchanan, the well-known Scottish dealer whose letters provide much information on collectors of Old Masters and the pictures they preferred, wrote in 1804: "Thomas Hope is a very great admirer of the work of Paul Veronese and purchased a great many at the sale of the Orleans [*sic*]. The Rape of Europa I think will smite him dumb . . . There was a *small* one of the same subject in the Orleans but very differently treated sold for 500 Guineas—a very inferior composition to mine."[67] Buchanan recorded that Hope later owned a small *Virgin and Child* by Raphael from the same sale in 1800.[68] Another Orléans picture was added later to the collection in 1802, when Hope bought *Christ and the Woman of Samaria* by Annibale Carracci (fig. 10-14).[69] There is no further evidence to suggest that Thomas Hope retained these pictures for long, as they were known to have passed into the collection of Henry Hope by 1802 to 1803.[70]

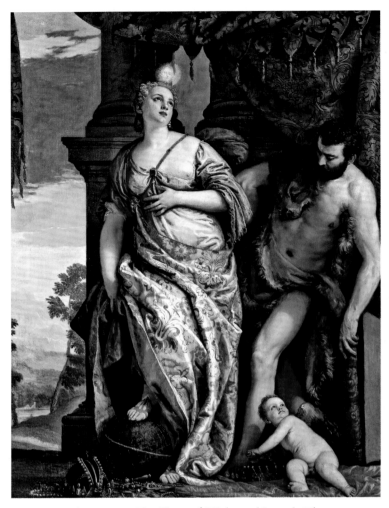

Fig. 10-12. Paolo Veronese. *The Allegory of Wisdom and Strength*. Oil on canvas, ca. 1580. Frick Collection, New York, 1912.1.128.

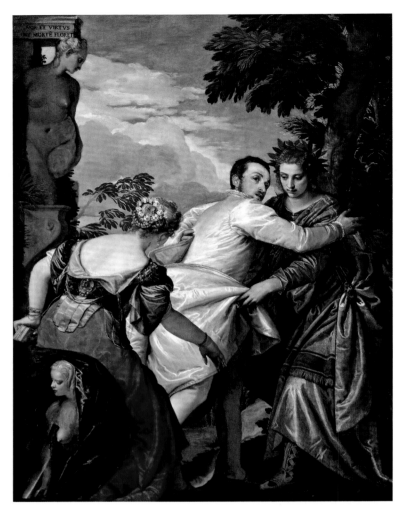

Fig. 10-13. Paolo Veronese. *His Own Portrait, between Virtue and Vice (The Choice of Hercules)*. Oil on canvas, ca. 1580. Frick Collection, New York, 1912.1.129.

The Pictures at Duchess Street

In 1799 Thomas Hope bought the house on the corner of Mansfield Street and Duchess Street.[71] He immediately began to make alterations to the house in order to accommodate and display his increasing number of works of art. Charles Heathcote Tatham, whom Hope had in all probability met in Rome, was a fortunate choice of architect for building the Picture Gallery.[72] Although Tatham received no credit from Hope, it was to be the first of future designs of picture galleries.[73] The Duchess Street house plan has been much discussed, particularly since the discovery of eleven signed and dated drawings firmly attribute the design to Tatham but with Hope's involvement.[74] A sketch-plan also exists by Francis Douce from which it is possible to establish the position of the Picture Gallery.[75] There also exists a small sketch drawing by Hope for this room, described as a "large picture gallery," showing paintings on the walls.[76] From Tatham's drawings and *Household Furniture*, a considerable amount of information can be ascertained concerning the interior spaces of the house throughout which pictures were hung, as Hope had been accustomed to in the Netherlands.[77] Hope illustrated a view of the gallery in *Household Furniture* (see fig. 2-8) showing the pictures covered with curtains to protect them from the sun.[78] A later illustration published by Charles Molloy Westmacott in 1824 shows pictures hanging along both lengths of the gallery (see page 168).[79] As far as can be ascertained, unlike his father, Hope had no curator to buy or look after his pictures at Duchess Street.

Hope's designs for picture frames can be seen in *Household Furniture*. Following the lengthy introduction and before the plates, there is an "Explanation," in which Hope wrote the history in some detail of the ornament for the border that frames the title page.[80] One plate of a wall elevation shows the lower section of a "picture-frame of mahogany and gold, strengthened at the corners by metal gilt clasps," a very plain but unusual detail.[81] Two other designs are illustrated, one of them elaborate and exotic, the other much less ornamented; both have anthemion and palmette border decoration.[82] Hope described the first design: "The top or pediment of this frame is adorned with medallions. . . . Its jambs or pilasters are ornamented with figures of dancing nymphs, holding up wreaths of myrtle."[83] From illustrations showing the

pictures in the house generally the frames were simple, "friezelike . . . decorated with stars, leaf-tip and bound fasces, and fitting in as one part of a more opulent whole."[84] Each room conformed to the style of its design and content. For instance, the frames which Hope designed for the large pictures by Thomas Daniell and Panini in the Indian Room were of mahogany and "consist of a large torus of reeds or fasces, cross-bound at intervals with ribbons," which were gilded.[85] In fact, these pictures give the appearance of being fixed flat to the wall, thereby becoming part of not movable furniture, and more like the earlier designs by William Kent and Robert Adam for interiors in which all the elements are blended together.[86] Hope employed a Flemish frame maker, Peter Bogaert, who, "was the only person of his profession in Europe whom Mr. Hope found capable of making frames in a style equal to his ideas of the necessary splendour of Household Furniture."[87]

In the Picture Gallery, it was Hope's intention to create the impression of a "temple of the arts" and to give "the appearance of a sanctuary."[88] These aspirations were not unlike those of William Beckford, collector and connoisseur par excellence, who was in the process of creating similarly unique and idiosyncratic interiors at Fonthill Abbey at exactly this period. He believed that

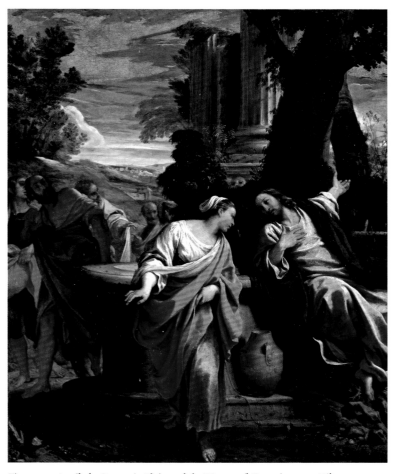

Fig. 10-14. Annibale Carracci. *Christ and the Woman of Samaria.* 1597, Oil on canvas, ca. 1590. Szépmüvészeti Museum, Budapest, 3823.

"harmony is everything in pictures, furniture etc."[89] Progress was rapid at Duchess Street; interest in it must have been extraordinary, and certainly the news of its splendor had reached France by 1800: "On s'entretient beaucoup de la superbe galerie de tableaux, de vases, de statues, de pierres gravées, etc. de l'ingénieux HOPE" (One hears much about the superb gallery of paintings, vases, statues, engraved gems, etc. of the ingenious HOPE).[90] It was reported that Hope was working on vast rooms with treasures bought in Italy, Germany, and France and that there was nothing in England that could be compared to it.

Further Purchases of Old Masters

Thomas Hope continued to buy Old Masters at auction sales for his new gallery. Italian pictures were always in demand by collectors who could afford them, and Hope's interest in works by French painters is not surprising, given his passion, like his father's, for all things French. In February 1801, Hope purchased a *Virgin and Child and St. Francis* by Pietro da Cortona, *The Marriage of St. Catherine* (presumably after the Capodimonte version) by Correggio, and *Nymphs and Satyrs* by Nicolas Poussin, all for small sums.[91] The following day, he bought a Domenichino *Virgin and Child with Saints* and *A Landscape with Piping Shepherds and a Flight into Egypt* by (now after) Claude.[92] In March of that year, Hope purchased the *Virgin, Child, and St. John Playing with a Goldfish* by Giovanni Francesco Romanelli.[93] At the same time as he was accumulating pictures, Hope was also weeding out his collection. He sold, or tried to sell, three pictures in 1802, two of which were bought in, also for small sums.[94] Difficulties of attribution and provenance are usual in the case of Old Masters, and at times clarification of exact details proves almost impossible. For example, in this context, it appears that Hope owned *A Kaag at Sea in a Fresh Breeze* by Willem van der Velde, for which there is no evidence in the Hope family collection.[95] If it had been in Thomas Hope's collection, he had sold it by 1801, by which time it was in the collection of the Duke of Bridgewater. It was this picture for which Turner famously painted the pendant *Dutch Boats in a Gale (The Bridgewater Sea Piece)* commissioned by the duke in 1801.[96]

Hope's Visits to Paris and Italy in 1802–3 and the Opening of Duchess Street in 1804

During the Peace of Amiens, Hope, like many other collectors and connoisseurs, traveled to Paris in the spring of 1802, where the recently opened Musée Napoléon would have been of enormous interest to him. Hope spent the autumn and winter in Naples and January to March of 1803 in Rome. Having had works

of art confiscated in Rome by the French, he returned home when the treaty ended abruptly in May 1803. Presumably it was while he was in Italy that Hope bought two Old Master pictures that portrayed the dying Magdalen, one by Ludovico Carracci and the other by Correggio.[97] These paintings were originally engraved for Edward Forster's publication *The British Gallery of Engravings, from pictures of the Italian, French, Flemish, Dutch and English schools, in the possession of the King, and several Noblemen and Gentlemen of the United Kingdom; with some account of each picture* published from 1807. Farington reported in that year that he had asked Benjamin West "what He thought of the first number of Forster's new publication of Prints from celebrated pictures in the collections in this country." West considered that the Carracci engraving by Anker Smith should not appear in the volume as the picture was "painted by He knew not whom, but by one at the lower end of the Bolognese school, a very poor performance."[98] Both engravings appeared, from pictures in Hope's possession, in a volume principally concerned with his collection of classical sculpture, which Hope probably intended to publish from the original engravings, completed by T. D. Fosbroke in 1810–13, for "The Outlines of Statues in the possession of Mr. Hope (never published) for which Illustrations were furnished by T. D. Fosbroke" of 1813.[99]

Hope opened Duchess Street to the public in 1804. This was according to the tradition in the Netherlands of allowing interested visitors to see private collections in town houses. Although collections were generally being made available to the public increasingly in cities across Europe from the early 1790s, this was as yet relatively unusual in Britain. It followed the precedent set by Horace Walpole at Strawberry Hill, which he made available by special ticket for visitors as early as 1774.[100] In turn, other collectors, mostly grandees and noblemen, opened their often palatial and specially built galleries in London to the public. For instance, in the summer of 1806, George Granville Leveson-Gower, the Marquis of Stafford, opened Cleveland House, where, unusually, the pictures were hung by school.[101] It is possible that a catalogue was available to visitors to Duchess Street, and it may yet exist, having been sold in the Deepdene Library sale.[102] The writer of Hope's obituary in the *Literary Gazette* of 1831 referred to "a manuscript catalogue now before us," which also gives credence to the existence of a catalogue at one time.[103]

Such was Hope's reputation as a collector that William Buchanan wrote to James Irvine, painter and dealer in Rome, on April 30, 1805: "A very fine picture of Correggio, of Claude, of Raffaelle, of Titian, Domenichino, or Rubens will bring more money in England than anywhere else, because the very rich and great Collectors, as Stafford, Angerstein, Hope etc. will make a point of finding room for such."[104] Hope did not, however,

acquire all the pictures he wanted. In 1807 William Beckford wrote that Hope was "mad with the desire to purchase" the Altieri Claudes *Landscape with the Father of Psyche Sacrificing to Apollo* of 1662 and its later pendant, *Landscape with the Arrival of Aeneas at Pallanteum*, which Beckford had acquired in 1799 for a huge sum and after enormous difficulty managed to import them.[105] Indeed, it had been thought that the pictures had been purchased by Hope; Joseph Farington wrote the year before that the painter and dealer Robert Fagan had bought them for 400 guineas, "It is supposed for Mr. Hope."[106]

The Deepdene and Further Purchases and Sales by Thomas and Henry Philip Hope

Thomas Hope married Louisa Beresford in 1806 and in the following year acquired the estate of the Deepdene in Surrey.[107] This large country house provided him with further opportunities for the display of all his collections, although, as far as can be ascertained, his collection of contemporary pictures was mostly housed there. Hope possibly considered the Deepdene as a convenient means of housing those works that were excess or not suitable for Duchess Street. He entertained on a large scale at the Deepdene, and as at Duchess Street, he gave considerable attention to the interiors of the house. Among the decorations were those based on examples in the Vatican that were then fashionable; Beckford did the same at Fonthill Splendens. Hope bought *Six Cupids after Raphael* after those "in the Vatican apartments, exquisitely finished by Michael Angelo Maestri, at Rome."[108] These were used for decoration in the boudoir and in a bathroom at the Deepdene. Maria Edgeworth, the novelist, a close friend of Hope's and a frequent visitor to both Duchess Street and the Deepdene, described: "In another room there is a really curious collection of Raphaels designs of ornaments for the Vatican—from Titus's baths."[109]

Thomas and his brother Henry Philip bought and sold more pictures during these years. For instance, Thomas Hope sold a Garofalo *Holy Family*, and Henry Philip offered for sale a Poussin *Moses Striking the Rock*, a replica of the picture formerly in the Orléans collection.[110] After Henry Hope's death in 1811, Thomas Hope bought two pictures from the first sale of his estate: *David and Bathsheba* by Willem van Mieris and *Roman Charity* by Adriaen van der Werff.[111] Henry Philip continued to sell pictures from his collection, which was then still housed in Cavendish Square with that of Henry Hope. Both collections were described in a somewhat waspish fashion by Louis Simond, a Frenchman who had long resided in America. He wrote that they were crammed in and in a "bad situation;—every side of every apartment being covered with pictures, light or no light."[112] He thought highly of the quality and condition of Henry Philip's

collection: "Mr. Hope is particularly rich in Flemish pictures, executed by the best masters for that family of princely merchants, during the last 200 years"—a mistaken assumption that was continually repeated regarding these pictures. In 1813 Henry Philip sold seven pictures, all Old Masters except for a Guy Head and all for small sums.[113] "Hope," presumably Thomas, sold two Old Masters, also for small sums.[114]

Thomas Hope made another visit to the continent in September 1815. He and his wife traveled to France and Italy but returned to England after the death of their son in Rome in 1817. Nothing is known about his purchases during these travels, but in all probability he concentrated more on the sculpture collection. Following this visit, Hope began to make alterations at the Deepdene. Possibly as a consequence, he bought fewer pictures and gradually began to reduce his collection from 1818 by sending minor pictures to be sold at Christie's. These were consigned from Duchess Street by a Mr. Webster and auctioned under that name. Webster sent two small pictures on March 3, 1818.[115] Another, a Hobbema *Landscape with Cottages and Figures*, was sent by him for auction on February 12, 1823, and sold as his property.[116] In the sale catalogues there is a Webster recorded at "Claridge & (?)Ivisons," who bought many inexpensive pictures from 1816 to 1820, including from the sale of Henry Hope of 1816.[117]

Hope and the British Institution

It is not surprising that Hope was one of the founding members of the British Institution for Promoting the Fine Arts in the United Kingdom in 1805, given his passionate interest in precisely these aims and the fact that he had opened Duchess Street for interested visitors the year before. Other original subscribers included similar ardent collectors, Lord Northwick, Sir George Beaumont, John Julius Angerstein, and Henry Hope. Together they funded the £7,000 necessary to create the institution and purchase the required premises. The intention was primarily to allow amateur or student painters to copy, on a different scale, Old Master pictures, or parts of them, as well as to exhibit contemporary works for sale.[118] This pioneering establishment offered important opportunities to display works of art not normally available to the public, and it proved to be highly influential for the increasing appreciation and awareness of Old Masters.[119] It was not until 1824, nearly twenty years later, that the National Gallery was established. By 1815 the objectives of the British Institution had broadened into holding exhibitions of Old Masters loaned by private collectors, including the royal family. The first exhibition devoted to Dutch and Flemish Old Masters opened that year, and the pictures were exhibited against walls of a "particularly gaudy red."[120] Thomas Hope lent *The Assump-*

tion of the Virgin by Van Dyck, and Henry Philip lent eighteen works.[121]

In the following year Thomas Hope lent to the exhibition of Italian and Spanish Old Masters: *The Temptation of Christ* by Titian and two Veroneses, *His Own Portrait, between Virtue and Vice (The Choice of Hercules)* and *The Allegory of Wisdom and Strength*.[122] Thomas and Henry Philip also lent to the 1818 and 1819 exhibitions. In 1818 Thomas lent two Guercinos, *The Betrayal of Christ* and the companion picture, *The Incredulity of St. Thomas*, and a Guido Reni, *Salvator Mundi*.[123] In 1819 he lent a Salvator Rosa *View of Castellamare (The Soothsayers)*, a duplicate of Lord Stafford's picture and a Rubens *Landscape, Storm*, now called *The Shipwreck of Aeneas on the Strophades*.[124]

The Collection of Henry Philip Hope

In 1819 Henry Philip, for reasons not known, decided to lend his eldest brother, Thomas, his collection of almost one hundred Dutch and Flemish Old Masters that he had inherited from their father. This widely acclaimed collection rivaled that of the Prince

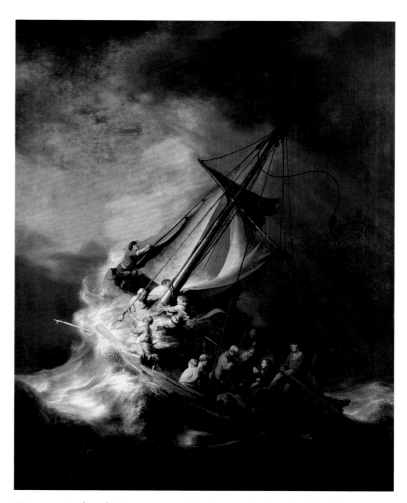

Fig. 10-15. Rembrandt Harmensz. van Rijn. *Storm on the Sea of Galilee*. Oil on canvas, 1633. Stolen from the Isabella Stewart Gardner Museum, Boston. © Isabella Stewart Gardner Museum / The Bridgeman Art Library, P21S24.

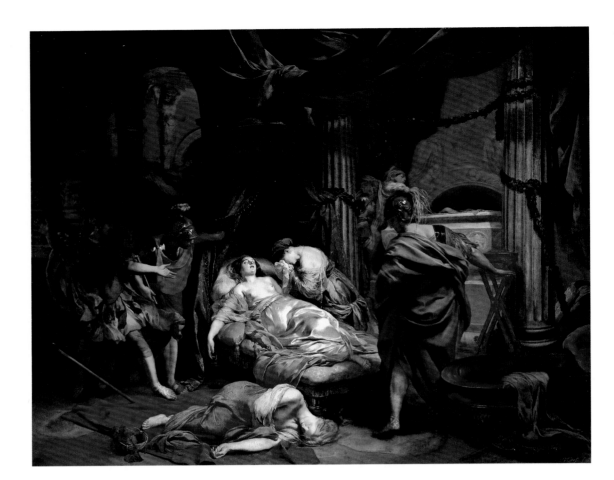

Regent, much in the same way that it had been compared to the Stadholder's collection when it was in the Netherlands in their father's time. The pictures had hung in the house formerly belonging to Henry Hope in Cavendish Square and were now to be housed at Duchess Street; they included, for instance, the Rembrandt *Storm on the Sea of Galilee* (fig. 10-15) and *Death of Cleopatra* by Gerard de Lairesse (fig. 10-16).[125] The pictures in general were probably not widely known, although two of the most important had appeared in a publication in 1818, *The British Gallery of Pictures selected from the most admired productions of the Old Masters in Great Britain* compiled in 1808 by Henry Tresham R.A., painter, collector, and dealer, and William Young Ottley, writer and collector.[126] The volume, dedicated to George III, contained engravings executed by Peltro William Tomkins and included two engraved works from the collection of Henry Hope and two from that of Henry Philip, *Doubting Thomas* by van der Werff and *The Village Festival* by Philips Wouwermans.[127]

Henry Philip had also inherited twenty pictures from his second cousin, Henry Hope, thus creating further complications concerning the division of pictures belonging to Henry Hope and to Thomas and Henry Philip. These pictures, which included for instance, *Cottages in a Wood* by Meindert Hobbema (fig. 10-17), were listed in a codicil in English added to Henry Hope's will, dated April 11, 1809.[128] Some of these pictures were sold in the Henry Hope sale in 1811, the rest were retained in Henry Philip's collection, now merged with that of Thomas Hope. They remained with the family until the 1890s, when they were sold with many other works from the family collections (see Chapter 15).

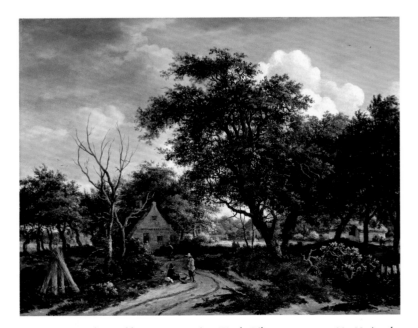

Fig. 10-17. Meindert Hobbema. *Cottages in a Wood*. Oil on canvas, ca. 1660. National Gallery, London, Salting Bequest, NG 2570.

The Flemish Gallery at Duchess Street

The crisis in the banking world in 1819 seemed not to effect the Hope family despite Beckford's gloomy impression: "France is a volcano, and so is England: everywhere one hears subterranean rumblings that bode ill. In the Exchange there are horrible fears. Hope, Baring [Alexander, later first Baron Ashburton], Rothschild [Nathan Meyer Rothschild], all are in confusion: they've been forced to sell millions at great loss to face certain bills which the Bank refuses to discount."[129] In the same month, Maria Edgeworth wrote from Duchess Street that Thomas Hope's brother had given (actually lent) him "a fine collection of Flemish pictures. The pictures are now piled seven deep in the gallery or passage leading to our bedchamber with their faces to the wall. Mr. Hope has built a gallery on purpose for them."[130] Work began that autumn and by March 9, 1822, Edgeworth reported: "Mr. Hope's new gallery of Flemish pictures given to him by his brother is beautifully arranged and most of the pictures excellent but I am not going to plague you with a catalogue."[131] It was designed by Hope with William Atkinson, an architect who later gained a reputation for conversions within existing buildings and who since 1818 had been engaged on the restructuring of the Deepdene for Hope.

Robert William Billings, architectural draftsman, and also bookseller, publisher, and restorer of churches, drew the new "Flemish" gallery (cat. no. 107, fig. 10-18). The drawing, the date of which is unknown but executed some time before the demolition of Duchess Street in 1851, may have been intended for an architectural publication, given that Billings was articled to the antiquary and topographer John Britton at the age of thirteen for seven years and for whom he made topographical drawings.[132] His drawing gives a very specific impression of the appearance of the gallery and the hang of the pictures.[133] The gallery was furnished and lit by a raised clerestory; it had only one door and the only window overlooked the garden. No further clues are available from any of the contemporary publications as to exactly where it was situated within the house. A view of the gallery was published in the first and only volume of *The Magazine of the Fine Arts and Monthly Review of Painting, Sculpture, Architecture and Engraving* of 1821, and two engravings by John Britton and Augustus Charles Pugin appeared in their publication of 1825–28, but with different dimensions from those in the account by Westmacott.[134] From these illustrations Hope's invention of a screen raised on a bookcase, on which ten cabinet pictures hung on hinges on each side, can be seen.[135]

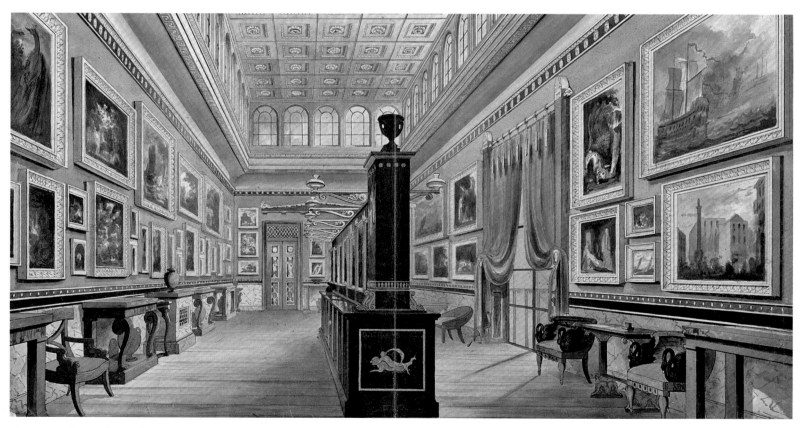

Fig. 10-18. Robert William Billings. *The Flemish Picture Gallery, the Mansion of Thomas Hope, Duchess Street, Portland Place* (detail). Watercolor, before 1851. The Metropolitan Museum of Art, New York, The Elisha Whittelsey Collection, The Elisha Whittelsey Fund, 1963, 63.617.2. *Cat. no. 107.*

The Collections of Thomas and Henry Philip Hope at the Deepdene

In the early 1820s, Hope made further alterations at the Deepdene. These were recorded by Ackermann, who made no reference to the interiors in his account of the house but commented that "considerable improvements" were in train.[136] The pictures had been more or less divided between Duchess Street and the Deepdene, with the Old Masters mostly remaining at Duchess Street and the contemporary pictures displayed at the Deepdene. At this time, most commentators were more concerned with the sculpture collection than the pictures, although J. P. Neale gave room-by-room listings of the picture collection in 1826 after Hope had completed a new wing at the Deepdene in 1823.[137] Twenty-nine surviving watercolors also give a remarkable impression of the appearance of the house; the interior views were executed by Penry Williams (cat. no. 106).[138] The pictures at the Deepdene were also listed room by room by Britton after the house had been rebuilt, from 1836 to 1841, and therefore included works belonging to Thomas's son Henry Thomas. This useful document reveals that most of the pictures were portraits or contemporary works, with one or two earlier pictures, some Dutch and Flemish, and those by Panini, and views of Venice by Francesco Guardi and Michele Marieschi.[139]

Gustav Waagen, the famous and much-respected German art historian and director of the Berlin museum, visited Duchess Street in 1835 after the collection had passed to Hope's eldest son, Henry Thomas. Waagen described Duchess Street as "a real museum" and "very much regretted that the predecessor of the present owner, who was so distinguished for his acquirements, his enthusiasm for the arts, and who collected the greater portion of this museum, was long since dead."[140] Waagen mistakenly thought that most of the Dutch and Flemish collection of pictures, which he described as "crowded together," were "originally painted by the artist for the great family of Hope." He found some of the pictures "more or less injured, and deprived of the fine harmony, which is one of their greatest charms." This was mostly caused by overcleaning, although he praised the overall range of pictures, "so that an opportunity is afforded of acquiring a very correct knowledge of that school."[141] This account was repeated almost exactly in his later volume.[142]

Another visitor, Johann David Passavant, a painter and later director of the Städel Museum, Frankfurt, came to England in the early 1830s to see British collections and to visit archives. His comments concentrated mostly on the paintings from the Orléans collection and did not list the "rich collection of Dutch pictures." Continuity of ownership was considered to be important for he repeated the claim that "Many of these were originally painted by the several masters for this very family; or at any rate have never exchanged owners since their first production."[143]

"Ruling passion still": The Death of Thomas Hope and the Dispersal of the Collections

Thomas Hope died on February 2, 1831, at Duchess Street. In his will he left his two houses and their contents to his wife for her life and then to their eldest son, Henry Thomas.[144] Henry Thomas continued his father's tradition of making the house available for public viewing (by written application on Mondays during the season), and he, in his turn, added to the collection.[145] The writer in *The Art-Union* of 1846 praised the quality of the pictures in both galleries at Duchess Street: "we find ourselves inclined to verbosity in giving way to our rapturous feelings." The pictures were listed, and despite an interval of fifteen years since Hope's death, it is another interesting account of how much of the collection remained in situ.[146] By 1850 it is possible to trace the pictures in another record of some detail in the account by Brayley, who had worked with John Britton.[147] The pictures were moved from Duchess Street on the completion by Henry Thomas of his new dwelling at 116 Piccadilly in 1851, and they remained there until his death in 1862. His widow, Anne Adèle Bichat (d.1884), inherited the pictures despite family wrangles. She maintained the contemporary collection at the Deepdene, while the Dutch and Flemish pictures were loaned to the South Kensington Museum (later the Victoria and Albert Museum) from 1868 to 1898. The first catalogue printed for the collection listed ninety-three pictures when they belonged to Henry Thomas's widow.[148] Another catalogue was printed the following year.[149] A further and larger catalogue was produced in 1891, by which time the collection contained eighty-five pictures (eighty-three were exhibited). By that time, the pictures had been inherited by Lord Henry Francis Hope Pelham-Clinton-Hope (1866–1941), later 8th Duke of Newcastle, the grandson of Henry Thomas and second son of his daughter Henrietta Adela Hope (d.1913), who had married Henry Pelham Alexander (1834–1879), later 6th Duke of Newcastle in 1861.

Lord Francis, as he became known, decided to sell the heirlooms that he had inherited from his grandmother. Given that he was a bankrupt since 1894 and a tenant for life of the Hope settled estates, which were run by trustees for the Gresham Life Assurance Society, he needed the consent of the trustees and the court to do so. Against the family's wishes and following a number of applications to the High Court Chancery Division to sell, permission was granted on July 26, 1898. The pictures were bought for

£121,550 by the dealer Asher Wertheimer of New Bond Street, London, with another dealer, Otto Gutekunst of Colnaghi's, who paid off their half between 1898 and 1901.[150] A rather grand and fully illustrated catalogue based on the previous catalogues but with photographs of the eighty-three pictures was distributed in 1898.[151] Many of the pictures were bought by American collectors and museums.

A second application was made to the Court on April 15, 1910, to sell a further twenty, mostly Dutch, pictures from the Deepdene. These were valued by Lionel Cust, the Keeper of the National Portrait Gallery, and sold to Charles Fairfax Murray, a painter, collector, entrepreneur, and dealer, for £24,750.[152] Fairfax Murray was at that time working for another dealer, Agnew, through whom he sold the pictures jointly with Colnaghi.[153] This sale was followed by the more major and devastating final dispersal in July 1917 of all the Hope heirlooms, which ended the Hope family connection with what had been a magnificent and vastly important collection of paintings. By the time of the sale, the best pictures had been more or less filleted, echoed in the *The Times* report: "The pictures . . . are not what the art world is crowding to see. Pictures equally good hang in these [Christie's] rooms two or three times a month."[154] The sales of sculpture were reported in some detail but no further mention was made of the picture sales.[155]

Maria Edgeworth wrote of Hope's death following an illness that he had seemed better: "So much better that he went out on the leads of the house had his arm chair carried out there and sat to examine and direct what some workmen should do who were repairing the skylight or roof over the new picture gallery. Think of that being the cause of his death—Ruling passion still."[156]

Acknowledgments

I am exceedingly grateful to Philip Hewat-Jaboor and Daniella Ben-Arie for their endless supply of information, continual support, and good humor throughout the course of the research for this essay. Dr. J. W. Niemeijer was extraordinarily generous and kind with his time and material concerning John Hope's collection and taught me how to pronounce Hope, as Hope(r). Tineka Pugh's help and enthusiasm with the translation from Dutch is sincerely appreciated. Alastair Laing and David Watkin read the essay and contributed suggestions, for which I am extremely grateful. I would also like to thank most warmly the following friends and colleagues for their invaluable help: Julia Armstrong Totten and Patricia Teter at the Getty Research Institute; Hans Buijs, Conservateur at the Fondation Custodia, Paris; Duncan Bull, Dawson Carr, Burton Fredericksen, S. A. C. Dudok van Heel, Lynda Macleod at Christie's; Pippa Mason, Janie Munro, and Faith Raven.

1. See Julia Lloyd Williams, *Dutch Art and Scotland: A Reflection of Taste*, exh. cat. (Edinburgh: National Gallery of Scotland, 1992):14–16.
2. Hugh Dunthorne, "British travellers in eighteenth-century Holland: Tourism and the Appreciation of Dutch culture," *British Journal for Eighteenth-century Studies* 5, no. 1 (Spring 1982): 81.
3. For the family history, see Chapter 11 in this volume, by Daniella Ben-Arie, to whom the author owes a huge debt of gratitude for help in understanding this complex situation and for a considerable amount of material and advice.
4. Marten G. Buist, *At spes non fracta, Hope & Co. 1770–1815. Merchant Bankers and Diplomats at Work* (The Hague: Bank Mees and Hope, 1974): 486–94.
5. Unlike Richard Payne Knight, a well-known collector and Hope's contemporary, who bought Old Master drawings from the 1790s; see *The Arrogant Connoisseur: Richard Payne Knight 1751–1824*, ed. Michael Clarke and Nicholas Penny (Manchester University Press, 1982): 98.
6. See David Watkin and Jill Lever, "A Sketch-book by Thomas Hope," *Architectural History* 23 (1980): 52–59. The drawings in the sketchbook of ca. 1812 are described as being "of exceptional delicacy." See also Fani-Maria Tsigakou, *Pictures from Eighteenth Century Greece: Thomas Hope (1769–1831)* (Athens: Melissa, 1985). Many of his drawings were in the Deepdene Library sale, *Catalogue of the Valuable Library of Books on Architecture, Costume, Sculpture, Antiquities, etc., formed by Thomas Hope, Esq., . . . being a portion of The Hope Heirlooms*, sale cat., Christie's, London, 27 July 1917, for instance, lot 395: "A Collection of Watercolour drawings, Pen-and-Ink sketches, Architectural Plans, etc., relating to Egypt and the Near East"; lot 396, "A Collection of about eighty beautiful original drawings of Views in and near Constantinople, Alexandria, Jerusalem, and other parts of the Near East"; and lot 397, "A Collection of Pen-and-Ink drawings of Views, Architectural Details, etc., of the Near East,'" bound in three volumes.
7. ". . . particulièrement cosmopolite d'esprit comparée à la société hollandaise de son temps." See Michiel C. Plomp, *Collectionner, Passionnément, Les Collentionneurs hollandais de dessins au XVIIIe siècle*, vol. 1 (Paris: Fondation Custodia, 2001): 191, n. 274. Alastair Laing very kindly drew my attention to this two-volume publication on Dutch 18th-century collectors of drawings, which contains considerable material on the period during which John Hope was collecting.
8. See Chapter 1 in this volume for more information on the period. There is some confusion in the travel details of John Hope and his cousin Olivier Hope (1731–1783), who was in Italy at the same time; see John Ingamells, *A Dictionary of British and Irish Travellers in Italy, 1701–1800* (New Haven and London: The Paul Mellon Centre for Studies in British Art, 1997): 520–21.
9. One of these catalogues was published in full by J. W. Niemeijer, "De kunstverzameling van John Hope (1737–1784)," *Nederlands Kunsthistoriches Jaarbuch* 32 (1981): 127–226, with a summary in English, 231–32. The catalogues, not identified as such and entitled "Schilderyen," the Dutch word for pictures, were in the Deepdene Library sale, lot 474, "Schilderyen Collection. Three Sale Catalogues of this Collection, with prices, half calf, Amst., 1773-7-8- Also Three Manuscript Catalogues referring to the same Collection, with signature of Thomas Hope, sm. folio (6)." They were purchased by E. Parsons of London and reappeared at a sale of the dealer Anton W. M. Mensing (1866–1936), *Catalogue de livres illustrés sur les arts . . . provenant d'une collection importante d'Amsterdam*, sale cat., Frederick Muller, Amsterdam, 18 April 1947, lots 2097, "Bisschop, Jan *Catalogus*," and 2098, "Hope, H. Ph., *Catalogus*," and were bought on behalf of Fritz Lugt (1884–1970), the great collector and art historian. Lugt subsequently loaned them to the Rijksbureau voor Kunsthistorische Documentatie (RKD) in The Hague, where they are on deposit. There is no reference at the RKD for this material which is accessed through the Lugt collection.
10. Niemeijer, "De kunstverzameling van John Hope" (1981):172–204. The first and unpublished manuscript, Catalogue I, "Cabinet Schilderyen," dated Amsterdam 24 April 1771, is signed "J. Hope." It is the catalogue of the Bisschop collection that John Hope and his uncle Adrian bought in that year. It also acted as the account book for the purchases with further costs and expenses and later acquisitions by John Hope until 1781. Catalogue II, "Catalogus van het Cabinet

Schilderyen & andere Rariteiten," is a comprehensive and extensive record of John Hope's own collection until 1783 and includes drawings, enamels, miniatures, antique and modern cameos, sculptures in marble, stone and ivory, lacquer, porcelain, and other items. The third and posthumous, catalogue III, "Catalogus van het Cabinet Schilderijen," dated 20 April 1785, John Hope having died in 1784, is the inventory of the pictures that would remain to his widow, Philippina Barbara van der Hoeven (ca. 1738–1789). A manuscript list in Dutch of the joint collection, with later additions, of 30 March 1781, the time of the transfer, and an incomplete list of the twenty picture s left to Henry Philip Hope by Henry Hope in 1810, is in the Nottingham University Archives, Department of MSS and Special Collections, uncatalogued material in an incorrectly marked envelope "Hope. catalogue of precious stones," 2413, a copy of which was kindly supplied by Daniella Ben-Arie.

11. See Johan E. Elias, *De Vroedschap van Amsterdam 1578–1795*, vol. 1 (Haarlem: Loosjes, 1903–5): 933–34.

12. For further information on the history of the Hope bank and family, see Buist, *At spes non fracta* (1974) and *The Oxford Dictionary of National Biography*, ed. H. C. G. Matthew and Brian Harrison, vol. 28 (Oxford: Oxford University Press, 2004): 3–6.

13. This was listed as by "Hamilton" in Buist, *At spes non fracta* (1974): 490, Catalogue B valued at £60, and sold in the Henry Hope sale, *A Catalogue of an assemblage of Capital Flemish and Dutch Pictures and a part of the magnificent collection of that distinguished Connoisseur and Patron of the Arts, Henry Hope Esq. Deceased*, sale cat., Christie's, London, 6 April 1811, lot 13 *Cumbent Venus: a pleasing copy*, sold for 9 guineas. Little is known about MacPherson but he may be Guiseppe Macpherson (1726–ca. 1780), a pupil of Pompeo Batoni and portrait painter of the British on the Grand Tour, miniaturist and copyist in Florence, who painted copies of artists' self-portraits in the Grand Ducal collection, as mentioned in Jane Roberts, "George III's Acquisitions on the Continent," in *The Wisdom of George the Third*, ed. Jonathan Marsden (London: Royal Collection Enterprises, 2005): 111.

14. Eleven of which were sold as by Canaletto in the Deepdene sale of pictures, *Catalogue of Important Pictures by Old Masters and Family Portraits being a portion of the Hope Heirlooms removed from Deepdene Dorking, The Property of Lord Francis Pelham Clinton Hope*, sale cat., Christie's, London, 20 July 1917, lots 77–80, some of which were similar to the Venetian views by Marieschi, six of which were in the Deepdene sale, lots 103–108.

15. Alastair Laing kindly pointed out the importance of Gori, the sole pupil of Don Enrico Hugford (1695–1771), in the art of painting on *scagliola* (an imitation of real marble) in Florence, see John Fleming, "The Hugfords of Florence," pt.1 , *The Connoisseur* 136 (October 1955):106–10. This technique became a lost art with Gori's death. He was also an important collector, some of whose pictures were acquired by William Young Otley (1771–1836).

16. *Catalogus van een uitmuntend en fraai Cabinet Schilderyen*, sale cat., Rietmulder, The Hague, 29–30 March 1770, lots 121, which was sold by John Hope's widow in 1785; 123, now in an English private collection; and 143. I am extremely grateful to Julia Armstrong Totten for a copy of this catalogue and for recognizing the last two pictures listed, neither provenance for which is listed by Niemeijer.

17. The collection was first published by Gerard Hoet and Pieter Terwesten, *Catalogus of naamlyst van schilderyn: met derzelver pryzen etc.*, vol. 2 (The Hague: Pieter Geraard van Baalen, 1740–52):527–35. This was based on a printed catalogue of the collection dating from 1768, a copy of which is in the Rijksmuseum Library, not seen due to the current temporary dislocation of the Library. The collection was comprehensively catalogued by E. Wiersum, "Het Schilderijen-Kabinet van Jan Bisschop te Rotterdam," *Oud-Holland* (Amsterdam, 1910): 161–86. Of the original 230 pictures listed by Wiersum, only 37 were in the Hope family collection by the 1860s.

18. Thomas Pennant, *Tour on the Continent 1765*, ed. G. R. de Beer (London: printed for the Ray Society, 1948): 151.

19. The portrait, in the collection of the Duke of Atholl at Blair Atholl, Perthshire, was fortuitously identified by Dr. Niemeijer while on holiday in Scotland and published by him; see J. W. Niemeijer, "A Conversation Piece by Aert Schouman and the founders of the Hope Collection," *Apollo* 108 (September 1978): 182–89.

20. A florin was the same value as a guilder. This purchase was preceded and possibly inspired by the sale of the entire and much coveted collection of Govert van

Slingelandt (d. 1767), whose proposed posthumous auction sale at The Hague for 18 May 1768 was canceled in order that the collection of forty pictures (he only ever owned forty at one time to maintain the quality of the collection) be sold by his widow to the then twenty-year-old Stadholder, Prince Willem V for 50,000 florins. That purchase became the foundation of the royal collection, see Niemeijer, "De kunstverzameling van John Hope" (1981): 146.

21. The first sale was of thirty works, *Catalogus van een Fray Kabinet Schilderyen, Tekeningen, en Prenten; Door de voornaamste Italiaansche, Fransche, Nederlandsche en Hollandsche Meesters*, sale cat., de Winter, Yver, Amsterdam, 20 January 1772. The second included twelve pictures, *Catalogus van een Fraay Kabinet met Konstige Gekleurde en Ongekleurde Tekeningen. Alle door de voornaamste Hollandsche Meesters; zinto veele Jaaren, met veel Lundigheid en Moeite, byeen verzamelt en hagelaten door den Heer Gerard van Rossen . . . en Mr. Pieter Boyer*, sale cat., de Winter, Yver, Amsterdam, 8 February 1773.

22. The house later became the home of the Six family, see Niemeijer "De kunstverzameling van John Hope" (1981): 141.

23. Greenwood was in Amsterdam from after May 1758 to 1763 in business with the Dutch dealer Pieter Fouquet (1729–1800). He traveled in Germany with Jan Wubbels, John Hope's curator, in search of pictures; see Lothar Brieger, *Aus meinem Leben, von Wilhelm Tischbein* (Berlin: Propyläen-verlgag, 1922): 104. Greenwood became an auctioneer in London in 1786, with premises in the Haymarket and Leicester Square. See William T. Whitley, *Artists and their Friends in England, 1700–1799*, vol. 2 (London and Boston: Medici Society, 1928): 261. For Bute, see Francis Russell, *John, 3rd Earl of Bute: Patron and Collector* (London: Merrion Press for the Roxburghe Club, 2004).

24. Letter of 5 October 1762 from Amsterdam, quoted in Denys Sutton, "The Dundas Pictures," *Apollo* 86 (September 1967): 205–6.

25. Jean-François de Bastide, *Le Temple des Arts ou Le Cabinet de M. Braamcamp* (Amsterdam: Chez Marc Michel Rey, 1766) includes a description and catalogue raisonné in room order. See also the summary in English in Clara Bille, *De Tempel der Kunst of het Kabinet van den Heer Braamcamp*, vol. 1 (Amsterdam: J. H. de Bussy, 1961): 219–39, and vol. 2: "Notes to the Catalogue of Paintings," pp. 87–135.

26. From here on, the location of pictures where known or last seen will appear in the footnotes. Gerret Braamcamp sale, *Catalogus van het uitmunted kabinet schilderyen*, sale cat., van der Schley, Yver, Amsterdam, 31 July 1771, lots 125, 126, 172. Both Metsus are in the National Gallery of Ireland, Dublin; the Rembrandt was stolen from the Isabella Stewart Gardner Museum, Boston on 20 March 1990, as was *A Lady and Gentleman in Black* attributed to Rembrandt, which had been in the Hope family collection. The other pictures bought in the sale were *St. John Preaching in the Wilderness* by Bartholomeus Breenbergh (on loan to the Art Institute of Chicago), lot 26 for 925 florins; *Portrait of ? Sir John Chichester* by Corneille de Lyon (formerly as by Holbein, and entitled *Earl of Chichester*) (Sterling and Francine Clark Art Institute, Williamstown), lot 83 for 200 florins; *Interior. A Woman Drinking with Two Gentlemen* by Pieter de Hooch (Musée du Louvre), lot 87 for 420 florins; *Figures in an Interior* by Eglon van der Neer (private collection, U.S.A.), lot 147 for 560 florins; *The Assumption of the Virgin* by Hans Rottenhammer in the style of Tintoretto (later placed but not sold in the Henry Hope sale, 6 April 1811, lot 18 bought Seguier (i.e., bought in) £27 6s., and in Christie's sale, 23 May 1812, lot 81 also bt. in 18½ gns., see n. 111), lot 187 for 505 florins; *Interior with St. Jerome Reading* by Hendrik van Steenwyck (formerly as by Dürer), lot 59 for 220 florins; *Still Life with Swan and Game before a Country Estate* by Jan Weenix (National Gallery, Washington), lot 257 for 935 florins; also *Dead Stag and Partridges*, lot 261 for 705 florins; and *The Rustic Wedding* by Philips Wouvermans (Harold Samuel collection, Corporation of London), lot 279 for 3,510 florins. All these pictures, with the exception of the van Steenwyck, were inherited by Thomas Hope's brother Henry Philip and later hung at Duchess Street.

27. He bought two more van der Veldes of the same title and of the same dimensions on 15 April 1772 (both in an English private collection) and owned a total of eighteen Berckheydes by 1782, five of which are currently traced, *The Wood Gate at Haarlem* (Museum Ridder Smidt van Gelder, Antwerp), *The Departure of the Falcon Hunt* (The Mauritshuis, The Hague), *View of the Binnenhof in The Hague with the So-called Rittersaal* (Thyssen-Bornemisza collection, Madrid), *The Binnenhof and Gevangenpoort, The Hague* (private collection), and *The Hof Vijver from the Korte Vijverberg, The Hague* (private collection).

28. *Catalogus van een fraay Kabinetje Konstige Schilderyen*, sale cat., Posthumus, Yver, Amsterdam, 27 January 1772, lot 18 bought by "J Hoope" for 255 florins, was sold by Hope's widow in 1785.

29. Alain Jacobs, *A. C. Lens, 1739–1822*, exh. cat. (Antwerp: Koninklijk Museum voor Schone Kunsten, 1989): 60 states that Lord Alexander Wedderburn, later Lord Loughborough (1733–1805), also imported his work into England.

30. John Hope paid Lens 105 florins for *Minerva* in 1773 and 505 florins for *Venus punishing Cupid* in 1774; the latter was sold in the Henry Hope sale, *A Catalogue of the highly distinguished and very celebrated Collection of Italian, French, Flemish and Dutch Pictures, the genuine Property of Henry Hope, Esq. Deceased at Mr. Hope's Mansion, Cavendish Square, corner of Harley Street*, sale cat., Christie's, London, 28 June 1816, lot 78 bought by "WW' for £26 15s. 6d. It is likely that neither survived owing to the deterioration of the material.

31. He owned two pairs of van Os pictures; all were shipped to London in 1795.

32. Johan van der Marck sale cat., de Winter, Yver, Amsterdam, 25 August 1773, lots 274 and 329.

33. Now in a private collection, *Catalogus van Fraaye Schilderyn . . . Jan Lucas van der Dussen*, sale cat., Slebes, Yver, Amsterdam, 31 October 1774, lot 1.

34. Jan van der Heyden, *The Church, Maarsen* (National Trust, Polesden Lacey); Jan Victor *Jacob and Joseph*; and Jan Weenix, *Dog, Dead Hare, Barking Dog, and Peacock*, Lambert ten Kate sale cat., Yver, Berck, Amsterdam, 29 May 1776, lots 51, 129, and 136.

35. He bought *Italian Landscape with Figures and Waterfall* by Jan and Andries Both (National Gallery of Ireland, Dublin), *Cows and Herdsmen by a River* by Aelbert Cuyp (Frick Collection, New York), and *Bathsheba in the Bath* by Nicolaas Verkolje; *Catalogus van een Uitmuntend en Overheerlyk Kabinet*, sale cat., van der Schley, de Winter, Yver, Amsterdam, 14 April 1777, lots 21, 39, and 214. John Hope later bought *Arcadian Landscape* by van Huysum from the dealer Pieter Fouquet (1729–1800), which Fouquet had bought at the Nieuhoff sale.

36. The van Dyck is in the National Gallery, Washington; the whereabouts of the Hondecoeter is unknown (Witt mount, Brunner Gallery, Paris, n.d.); the Potter is in the Philadelphia Museum of Art.

37. The former van Huysum was exhibited in *Temptations of Flora: Jan van Huysum 1682–1749*, Delft and Houston, 2006–7 (F28) (with Noortman Master Paintings, Maastricht), and the latter is in a private collection. I am most grateful to Duncan Bull for this information.

38. He was also referred to as Jean Weubels or Weubbels, see the letters to Reynolds quoted in *Sir Joshua Reynolds: A Journey to Flanders and Holland*, ed. Harry Mount (Cambridge: Cambridge University Press, 1996): 210–11. No pictures by Wubbels are recorded in John Hope's collection.

39. See Roeland van Eijnden and Adriaan van der Willigen, *Geschiedenis der Vaderlandsche Schilderkunst*, 3 (Haarlem: A. Loosjes, Pz., 1820; reprint, Amsterdam, 1976): 414.

40. See Niemeijer, "De kunstverzameling van John Hope" (1981): 148. John Hope presumably also bought pictures directly from him, such as the Veronese *Bathsheba in the Bath* from "J. W." in 1776. It is the only Italian Old Master picture in the 1782 inventory. Another Italian picture, *Venus and Adonis* by Giuseppe Chiari (formerly attributed to Carlo Marratta) (Chhatrapati Shivaji Maharaj Vastu Sangrahalaya, Mumbai, formerly the Prince of Wales Museum, Bombay), came to London in 1795 and was listed in Catalogue A of the 1795 insurance lists.

41. "Il a fait mettre sur des morceaux de carton les noms des peintres suivant l'ordre dans lequel sont rangés les tableaux, ce qui est fort commode pour les ignorants"; Louis Desjobert, "Voyage aux Pays Bas en 1778 par Louis Desjobert . . . publié par le Vic. de Grouchy," *De Navorscher* 59 (Amsterdam: C. L. G. Veldt, 1910): 13, 15. Desjobert also wrote that the collection had been bequeathed to John Hope on condition of a payment of 60,000 florins from the other inheritors, although no further reference to this has been found.

42. The account of this journey was first published in Edmond Malone, *The Works of Sir Joshua Reynolds*, 2 vols. (London: Printed for T. Cadell, jun. & W. Davies, 1797), a posthumous edition and reprinted many times. A copy in three volumes of 1801 was sold in the Deepdene Library sale, lot 466. The most recent and careful analysis of Reynolds's journey, and particularly of the visit to John Hope's collection, is by Mount, *Sir Joshua Reynolds* (1996): 95–106. In n. 465, p.170, the distinction is made between the collections of Henry and John Hope.

43. Ibid., 112. For other notable and distinguished visitors to the collection, see Niemeijer "De kunstverzameling van John Hope" (1981): 149.

44. For Ploos van Amstel, see the summary in English by Patricia Wardle in Theodore Laurentius, J. W. Niemeijer and G. Ploos van Amstel, *Cornelius Ploos van Amstel, 1726–1798: kunstverzamelaar en prentuitgever* (Assen: Van Gorcum, 1980): 308–36.

45. Three quarters of which came from the Bisschop collection. The sale catalogue, compiled by Pieter Yver and Jan Wubbels, gives no indication as to the owners, *Catalogus van een Kabinet met Konstige en Fraaije Schilderyen*, sale cat., van der Schley, Yver, Amsterdam, 10–11 August 1785. The sale contained Italian, French, Brabant, and Dutch masters, mostly sold at moderately low prices, and realized 16,247.10 florins before the costs were deducted.

46. A notary act of 18 June 1794 finally divided the inheritance.

47. According to a notarial document of 18 June 1794, see Sandor Baumgarten, *Le crépuscule néo-classique. Thomas Hope* (Paris: Didier, 1958): 25.

48. A note in French from John Williams Hope (1757–1813) to an unidentified "monsieur le Baron" of 11 October 1794. Municipal Archives of Amsterdam, Hope & Co. Bank Archive, 735 (2905). Inventory compiled by A.M. Bendien and J. C. A. Blom.

49. Henry William Law and Irene Law, *The Book of the Beresford Hopes* (London: Heath Cranton, 1925): 72.

50. Entry for 27 January 1795, *The Diary of Joseph Farington*, ed. K. Garlick et al., vol. 2 (New Haven and London: Yale University Press, 1978): 297.

51. Compiled on behalf of the Hope & Co. Bank, they were published by Buist, *At spes non fracta* (1974): 486–94. The original "Catalogus van schilderijen in huizch van Henry Hope in Harley Street in Londen. Met de getaxeerde en verzekerde waarden. 1795" is in the Municipal Archives of Amsterdam, Hope & Co. Bank Archive 735 (2895). Each picture has an insurance value. "Catalogue A of Pictures in the House No 1 the corner of Harley Street, belonging to Mr Henry Hope, on which is insured Twelve thousand Pounds" lists 187 pictures with a total actual valuation of £24,915. These pictures belonged to Henry Hope and some probably also to John Williams Hope. Catalogue B of the same title, but with an insurance value of £10,000, lists 148 pictures with a total valuation of £12,515. These were mostly the Dutch and Flemish pictures which Henry Philip had inherited from his father, and therefore included those from the Bisschop and Braamcamp collections. Catalogue C, also of the same title, with an insurance value of £4,000, lists 55 pictures with a total valuation of £4,010. Many of these pictures remained in the possession of Thomas Hope and were sold at the Deepdene sale in 1917.

52. The pictures with the highest insurance values of £1,000 were a portrait of the Cologne bankers: *The Family of Everhard Jabach* by Charles Le Brun (whereabouts unknown, one of two versions, the other was destroyed in Berlin in 1945), which belonged to Henry Hope and sold by him in 1816; and the much-praised picture *Woman at a Window with a Rabbit in Her Hand* by Gerrit Dou (private collection, North America). Other high values of £500 and over were placed on the more coveted works, particularly by Italian masters, and those by Claude, Poussin, Rubens, Rembrandt, Teniers, and Murillo.

53. See Niemeijer, "De kunstverzameling van John Hope" (1981): 169, n. 87. These were *Officer Writing a Letter* by Gerard ter Borch (Philadelphia Museum of Art), *The Assumption of the Virgin* by van Dyck (National Gallery, Washington), *Landscape with Cattle and a Horse* by Karel Dujardin (on loan to the Mauritshuis, The Hague from the Instituut Collectie Nederland, formerly mistakenly identified by Niemeijer as in the Philadelphia Museum of Art), *The Offering of the Wise Men* by Cornelius van Poelenburgh (whereabouts unknown), *Cattle and Sheep in a Stormy Landscape* by Potter (National Gallery, London), and *The Incredulity of St. Thomas* by Adriaen van der Werff (Milwaukee Art Museum).

54. In 1813 the Hopes sold their share of the capital to Alexander Baring (1774–1848), later first Baron Ashburton, the son of the merchant banker, Sir Francis Baring (1740–1810), first Baronet, who was also a collector of Dutch pictures and founder of Baring Brothers & Co. bank. It was from the important collection of Dutch art belonging to Alexander Baring's brother Sir Thomas (1772–1848) that the Prince of Wales bought eighty-six pictures for £24,000 for Carlton House in 1814, thereby hugely enhancing the Royal collection.

55. Francis Haskell, *Rediscoveries in Art: Some Aspects of Taste, Fashion and Collecting in England and France* (Oxford: Phaidon Press, 1980): 47–48.

56. Farington, however, reported that the family was living at 2 Hanover Square in 1795. The history of the various Hope residences in London is complicated; see Chapter 11 by Daniella Ben-Arie in this book. For the fascinating history of the Hope collections of sculpture, see Geoffrey B. Waywell, *The Lever and Hope Sculptures: Ancient Sculptures in the Lady Lever Art Gallery, Port Sunlight* (Berlin: Gebr. Mann Verlag, 1986): 40–42. See also Chapter 7 by Ian Jenkins in this volume.

57. Now in Yale University Art Gallery. It does not appear in the John Hope inventory but was owned by Thomas before his arrival in London, entitled "Campo Vaccino" on the 1795 inventory in Catalogue C.

58. The Daniell is in a private collection in England. It was exhibited in Anna Jackson and Amin Jaffer, *Encounters The Meeting of Asia and Europe 1500–1800*, exh. cat. (London: Victoria and Albert Publications, 2004): [1.15], and discussed in detail in Hermione de Almeida and George H. Gilpin, *Indian Renaissance: British Romantic Art and the Prospect of India* (Aldershot, England and Burlington, Vermont: Ashgate, 2005): 201.

59. See David Watkin, *Thomas Hope 1769–1831 and the Neo-classical Idea* (London: John Murray, 1968): 99, 110.

60. The former is in the National Gallery, London, and the latter is in the Fitzwilliam Museum, Cambridge; both were previously in the collection of Cardinal Ginetti.

61. Bryan claimed he had bought the Rubens (Israel Museum, Jerusalem) from the descendants of the Brandt family for whom it was painted; see *A Catalogue of all that Valuable and Magnificent Collection of Italian, French, Flemish, and Dutch Pictures The Property of Mr. Bryan*, sale cat., Coxe, Burrell & Foster, London, 19 May 1798, lots 57 and 37, for which Hope paid 1,350 guineas and 47 guineas, respectively. The van Ostade was last recorded in the van Marle and Bignell sale, The Hague, 1 September 1942, lot 23 as *A Bagpiper Playing to Peasants outside a Country Inn*.

62. Now in the Musée du Louvre. Lot 36 was recorded as having been purchased by Lord Suffolk for 100 guineas in that sale; see Anthony Blunt, *The Paintings of Nicolas Poussin, A Critical Catalogue* (London: Phaidon, 1966): 124. It had been in the collection of the Earl of Carlisle (1748–1825), who was actively involved with the Duke of Bridgewater and Earl Gower in the purchase and sales of the Orléans pictures.

63. *A Catalogue of the Orléans Italian Pictures . . . At Mr. Bryan's Gallery No. 88 Pall Mall 1798-99* and *A Catalogue of the Orléans Italian Pictures . . . At the Lyceum in the Strand*, both in London. The Albani was bought for 150 guineas; the Allori, originally listed as by Bronzino (Los Angeles County Museum) for 150 guineas; the Correggio, once attributed to Piero di Cosimo and now to Dosso Dossi (National Museum, Stockholm) for 500 guineas; the Titian (Minneapolis Institute of Arts) for 400 guineas; the Vasari (Minneapolis Institute of Arts) for 100 guineas; and the Veronese (Frick Collection, New York) for 500 guineas.

64. See Jordana Pomeroy, "The Orléans Collection: Its impact on the British Art World," *Apollo* 145i (February 1997): 26–31.

65. The whereabouts of Hope's version is unknown. It was sold, *The Property of Thomas Hankey Esq. deceased, collected during the course of a number of years by John Bernard Esq. of the North side of Bedford Square*, sale cat., Christie's, London, 7 June 1799, lot 45 bought by Bryan for £52 10s. Waagen described Hope's picture as "good, but not important"; G. F. Waagen, *Treasures of Art in Great Britain*, vol. 2 (London: John Murray, 1854): 114.

66. Now in the Frick Collection, New York. The *Catalogue of the Remaining Part of the Orléans Collection of Italian Paintings which were exhibited last year at Mr. Bryan's Gallery, in Pall Mall, and at the Lyceum in the Strand, for sale by Private Contract . . . at Mr. Bryan's Gallery in Pall Mall*, sale cat., Coxe, Burrell & Foster, London, 14 February 1800, lot 53.

67. The following month, he wrote again that he had been told that "Thomas Hope was excessively fond of the works of P. Veronese." Letters of 27 April, 29 April, and 4 May 1804, quoted in Hugh Brigstocke, *William Buchanan and the 19th Century Art Trade: 100 Letters to His Agents in London and Italy* (London: The Paul Mellon Centre for Studies in British Art, 1982): 283, 287, 296, 324. The Orléans *Rape of Europa* is in the National Gallery, London.

68. Lot 58, *Madonna and Infant Christ*, sold for 150 guineas. William Buchanan, *Memoirs of Painting, with a chronological history of the Importation of Pictures by the Great Masters into England since the French Revolution*, 1 (London: Printed for R. Ackerman, 1824): 46, noted a small picture valued at 200 guineas, "afterwards

passed into the collection of Thomas Hope Esq."; and George Redford, *Art Sales. A History of Sales of Pictures and other works of art*, vol. 1 (London: Bradbury, Agnew & Co., 1888): 73–76, gave the same value of 200 guineas. Henry Hope owned two Raphael Madonnas, one of which came into his collection in 1795 and both of which were sold in his sale of 1816. One, the MacIntosh Madonna, is in the National Gallery, London.

69. Now in the Szépmüvészeti Museum, Budapest. *A Catalogue of a most superb and truly valuable Collection of pictures . . . of Italian, Flemish, Dutch and French Schools being the united cabinet of Sir Simon Clarke, Bart. and George Hibbert Esq.*, sale cat., Christie's, London, 15 May 1802, lot 47 for £262 10s. From the same sale Hope bought *The Assumption of the Virgin* by Rubens (Royal collection), marked in the Christie's archive catalogue "Mr. Dupre's" (?Daniel Dupré [1751–1817], the painter who left Amsterdam to live in Rome) against lot 56, bought for £430 10s. Both pictures were sold in the Henry Hope sale, 29 June 1816, lot 77; the Carracci was bought by Buchanan for £98 14s. The Rubens, lot 79, was bought by Lord Yarmouth for the Prince Regent for £262 10s.

70. This is a characteristic example of how, at times, the question of identification of the two collections of Thomas and Henry Hope was extremely complex and confusing. See Chapter 11 by Daniella Ben-Arie.

71. For a detailed description and history of Duchess Street, see Chapter 2 by David Watkin in this volume.

72. While in Rome, Tatham had supplied Henry Holland, his patron and employer, with detailed drawings of Greco-Roman ornament. For a recent publication of these drawings, which are in the Department of Paintings, Drawings, and Prints at the Victoria and Albert Museum, see Susan Pearce and Frank Salmon, "Charles Heathcote Tatham in Italy, 1794–96: Letters, Drawings and Fragments, and Part of an Autobiography," *The Walpole Society* 67 (Leeds, 2005): 1–91.

73. Hope too was fascinated by designs for galleries, his sketchbook of ca. 1812 contains a plan and sections of a "gallery for end of house in the style of Ld Lansdownes library—but with green house along side"; see Watkin and Lever, "A Sketch-book by Thomas Hope" (1980): 53, pl. 37a. Hope also owned the catalogue for the Stafford collection by John Young in two volumes of 1825, Tatham's designs for Brocklesby Park and Castle Howard, and also his volumes of etchings of ornamental architecture and others, all of which were sold at the Deepdene Library sale.

74. See Peter Thornton and David Watkin, "New Light on the Hope Mansion in Duchess Street," *Apollo* 126i (September 1987): 162–76, and David Watkin, "Thomas Hope's house in Duchess Street," *Apollo* 159 (March 2004): 31–39.

75. The drawing is in a notebook, "Memoranda relating to Mr. Hope's house," Bodleian Library, Oxford, MS Douce e.60. Douce also listed the pictures thus providing further evidence of paintings not otherwise recorded, such as, in the Picture Gallery, two works by Domenichino, a *St. Sebastian* "from the Aldobrandini" collection and a *St. Cecilia*, and also a portrait of *Marc Antonio Raimondi, the Engraver* by Raphael (possibly that in the collection of Dr. Alejandro Pietro, Caracas, Venezuela in 1944).

76. Since it was stolen from the collection of John Harris, the location of this drawing is currently not known.

77. *Household Furniture* (1807).

78. Ibid., pl. II.

79. See Charles Molloy Westmacott, *British Galleries of Painting and Sculpture*, pl. I (London: Sherwood, 1824): 211–40. He also listed the pictures in each room, some of which do not appear in other contemporary descriptions of the collection or in the Deepdene sale, for instance, a *Virgin and Child in a Landscape* by Perugino in the "New Gallery." Westmacott noted the forty-five Old Masters then in the Picture Gallery as almost all large and "in the very first class of art." Although following the introduction there is a statement that justified the delay in production because of "certain criticisms on a few of the Paintings in different galleries, originally published in the Monthly Magazines," and declared it was "the first and only attempt to combine one General Historical and Critical Catalogue" (p. viii). This is possibly a reference to a previous account of the collection in the *Monthly Magazine*, see *Annals of the Fine Arts* 4 (1820): 93; the volume has not been found.

80. This border "is copied from the frame of a picture, representing a Turkish personage." A profile of which is illustrated in *Household Furniture* (1807): pl. XIII, no. 1.

81. Ibid., pl. IX.

82. Pl. XXVI, no. 2, pl. XXVII, and pl. XL, no. 5. None of these designs, as far as is known, was executed.

83. See Pippa Mason, *"Designs for English Picture Frames,"* exh. cat. (London: Arnold Wiggins & Sons Ltd., 1987): [41].

84. Paul Mitchell and Lynn Roberts, *A History of European Picture Frames* (London: Paul Mitchell in association with Merrell Holberton, 1996): 67.

85. See Paul Mitchell and Lynn Roberts, *Frameworks: form, function and ornament in European portrait frames* (London: Paul Mitchell in association with Merrell Holberton, 1996): 341.

86. The author is most grateful to Pippa Mason for most helpful advice and discussion on the subject of frames.

87. According to the French painter Antoine Dubost. See his pamphlet, *Hunt and Hope An Appeal to the Public by Mr. Dubost against the calumnies of the Editor of the Examiner* (London: J. Compton, 1810): 37. Peter Boegart (or Boeger(t) or Boeges), Carvers & Gilders of 23 Air Street, Piccadilly, London in 1809–11, had supplied furniture to the Prince of Wales in 1795; see *Dictionary of English Furniture Makers 1660–1840*, ed. Geoffrey Beard and Christopher Gilbert (Leeds: W. S. Maney & Son Ltd., for the Furniture History Society).

88. See *Household Furniture* (1807): 21.

89. See letter of 15 April 1796 in Alfred Morrison, *Catalogue of The Collection of Autograph Letters and Historical Documents formed between 1865 and 1882 by A. Morrison: The Hamilton and Nelson Papers*, vol. 1 (London: Printed for private circulation, 1893): 219; quoted in Jeannie Chapel, "William Beckford: Collector of Old Master paintings, Drawings, and Prints," *William Beckford, 1760–1844: An Eye for the Magnificent*, ed. Derek Osterbard, exh. cat., New York, Bard Graduate Center (New Haven and London: Yale University Press, 2001): 238.

90. "Nouvelles Etrangères—Londres," *Magasin Encyclopédique* iv 34 (July–August 1800): 114.

91. *A Catalogue of the Renowned and valuable Collection of Pictures of John Purling, Esq. Deceased*, of 68 Portland Place, sale cat., White, London, 16 February 1801, lot 6 for 10 guineas, lot 18 for 11 guineas, and lot 52 for 155 guineas. The Poussin, *A Nymph Sleeping Surprised by Satyrs*, was in the Henry Hope sale, 29 June 1816, lot 55, bought by Delahante for £152 5s. and is now in the National Gallery, London as after Poussin.

92. Sale as above of 17 February, lots 81 for 38 guineas and 102 for 365 guineas. Waagen described the Claude, now in the National Gallery of Victoria, Melbourne, as "old and very pleasing copy of the fine picture"; Waagen, *Treasures* (1854): 114. It is an almost exact replica of that in the Gemäldegalerie, Dresden; see Ursula Hoff, *European Paintings of the 19th and Early 20th Centuries in the National Gallery of Victoria* (Melbourne: National Gallery of Victoria, 1995): 57. Note 2 of this entry records "Doggett's Repository of Mr Hope's Pictures, 16 Market Street, 1822, no. 43 [not seen]." This reference remains a mystery. It appears that the only Doggett at this address and time was the storage space used by auctioneers in Boston, Mass.

93. It was sold by LaBorde, *Property of a Man of Fashion, distinguished for his superior taste, and purchased . . . during his residence abroad*, sale cat., Christie's, London, 7 March 1801, lot 57 bought by "Hope Jnr.," presumed to be Thomas, the senior Hope being Henry, for £52 10s.

94. *A Catalogue of a Capital and Valuable Collection of Italian, French, Flemish and Dutch Pictures . . . The Property of the late Duke of St. Albans Decd. from his residence in Mansfield Street, Portland Place*, sale cat., Christie's, London, 27 March 1802, lot 95, Guy Head *Baccanti Group* bt. Devangnes £12 1s. 6d., lot 96 Rubens *Baccanti Group* bt. in 17 guineas, and lot 102 Padovanino *Assemblage of Gods* bt. in 8 guineas.

95. Now in the Toledo Museum of Art, Ohio. John Hope had supposedly bought it at the sale of Pieter Locquet, the Amsterdam collector; *Schilderyen, door de beste Italiaansche, Fransche, Brabandsche en Nederlandsche meesters*, sale cat., de Bosch, Yver, Amsterdam, 22 September 1783, lot 370, but it was actually bought by Wubbels for "Rijfsnijder" for 2,200 florins.

96. See M. S. Robinson, *Van der Velde*, vol. 2 (London: National Maritime Museum, Sotheby's Publications, 1990): 828–29. The Turner is in a private collection on loan to the National Gallery, London.

97. The Carracci was said by Douce to have come from the Palazzo Giustiniani.

98. Entry for 14 December 1807, Farington, *Diary*, vol. 8 (1978–84): 3169.

99. The Correggio engraving by J. B. Raven, executed in Rome and dated 1792, is possibly from the *Dying Magdalen* (whereabouts unknown). The picture was in the Hope family collections which came to London in 1795, see Buist, *At spes non fracta* (1974):493, Catalogue C valued at £300, and presumed to be that sold at the Deepdene sale, lot 83. The painting by Carracci of the Magdalen was sold at the Deepdene sale, lot 82 and was last recorded in the sale of Lady Ratan Tata at York House, Twickenham, Chancellors of Richmond, 25 October 1922, lot 546. Both volumes cited are in the Victoria and Albert Museum Library, London. The Fosbroke volume (MSS 37.B.90) contains no engravings of paintings. The other does, "HOPE MARBLES A volume containing 34 copper plates engraved from works of art in the possession of T. Hope Esq.," n.d. (MSS 110.H.14). Both volumes possibly originated from the library of John Britton, and see Waywell, *The Lever and Hope Sculptures* (1986): 37–38, 48.

100. See Clive Wainwright, *The Romantic Interior: The British Collector at Home 1750–1850* (New Haven and London: Paul Mellon Centre for Studies in British Art, 1989): 79.

101. See Francis Haskell, *The Ephemeral Museum: Old Master Paintings and the Rise of the Art Exhibition* (New Haven and London: Yale University Press, 2000): 47, and Giles Waterfield, *Palaces of Art: Art Galleries in Britain 1790–1990*, exh. cat. (London, Dulwich Picture Gallery, and Edinburgh, National Gallery of Scotland, 1991–92): 74–75.

102. In the Deepdene Library sale, lot 316, "5 Scrap Books containing cuttings etc. and MS. notes on his Collections." See also Watkin, *Thomas Hope* (1968): 100 and Waywell, *The Lever and Hope Sculptures* (1986): 40, who referred to it as the "parlour catalogue."

103. *Literary Gazette*, 12 February (1831): 107.

104. See Brigstocke, *William Buchanan* (1982): 396. In this instance Buchanan could have been referring to either Henry or Thomas Hope. Thomas Hope owned a copy of the catalogue of the Angerstein collection and that of Sir John Fleming Leicester. Both catalogues were sold in the Deepdene Library sale.

105. Both pictures belong to the National Trust, Fairhaven collection, Anglesey Abbey. Quoted in *Life at Fonthill 1807–1822*, ed. Boyd Alexander (London: Rupert Hart-Davis, 1957): 48; and see Jeannie Chapel, in *William Beckford* (2001): 239–40.

106. Entry for 9 October 1798, Farington, *Diary*, vol. 3 (1978–84): 1066.

107. See Chapter 12 by David Watkin for the history and description of the Deepdene.

108. Sold by Edwards in *A Catalogue of the very valuable and entire Collection of Drawings and Paintings in Oil of Sir Robert Ainslie Bart.*, sale cat., Christie's, London, 10 March 1809, lot 92 for £5 7s. 6d.

109. Maria Edgeworth, *Letters from England 1813–1844*, ed. Christina Colvin (Oxford: Clarendon Press, 1971): 197–98. Several celebrated frescoes from the Vatican and four representations of arabesque decoration in the boudoir and "The Bath" were also listed by G. F. Prosser, *Select Illustrations of the County of Surrey*, Deep-dene (London: C. and J. Rivington, 1828): n.p.

110. *A Catalogue of a Valuable Assemblage of Pictures sold by Order of the Assignees of Mr Michael Bryan etc.*, sale cat., Christie's, London, 26 May 1810, respectively, lot 49 bought by Bartie for £126 and lot 63 bought in for 200 guineas. It was sold later in the Henry Hope sale of 28 June 1816, lot 66 for £21 10s. as "after Poussin." The Orléans picture is now on loan to the National Gallery of Scotland.

111. Henry Hope sale, 6 April 1811, the former, lot 40 for £157 10s., was last recorded in the Bachstitz Gallery, The Hague, in 1921. The price for both pictures was crossed out in Christie's archive copy of the catalogue. The picture reappeared as by Poelenburgh offered for sale by Henry Philip Hope, *A Catalogue of a truly valuable assemblage of Pictures of superior merit recently consigned from the Continent*, sale cat., Christie's, London, 23 May 1812, lot 80 bought in for £9 19s. 6d. The latter, by van der Werff, lot 48, bought for £215 5s, is now in the Royal collection. Henry Philip also tried to sell a Rottenhammer in the style of Tintoretto, *The Assumption of the Virgin*, in this sale, lot 81 bought in for £18 10s. It had been in the Henry Hope sale, 6 April 1811, lot 18 bought by Seguier, i.e., bought in for £27 6s., the sum crossed out in the Christie's archive copy of the catalogue.

112. Louis Simond, *Journal of a Tour and Residence in Great Britain during the years 1810 and 1811*, vol. 1 (Edinburgh: Printed by J. Ballantyne & Co. for A. Constable & Co., 2nd ed., 1817): 109–12.

113. *A Catalogue of a valuable collection of Italian, French, Flemish and Dutch Pictures . . . Property of an Amateur of Fashion*, sale cat., Christie's, London, 15 May 1813, lots 40, 42, 44, 46, 47, 48, 66.

114. Sale as above, Schiavone *Head of a Nymph*, lot 60, and the companion, L. Giordano *Head of a female*, lot 61. The former had come with the family collections from Holland in 1795; see Buist, *At spes non fracta* (1974): 494; Catalogue C valued at £20.

115. *A Catalogue of a valuable assemblage of a Consignment from the Continent of Italian, Spanish, French, Flemish and Dutch Pictures*, sale cat., Christie's, London, 9 March 1818, lot 57: S. Ricci in the Style of Guido, *The Daughter of Herodias*, bought in for 3 guineas, and lot 109, Reni *Nessus and Deianira*, bought in for 24 guineas.

116. *A Catalogue of the very select and pleasing Collection of Italian, French, Flemish and Dutch Pictures chiefly formed on the Continent*, sale cat., Christie's, London, 22 March 1823, lot 50 bought by Charles Harris for £6.

117. It is possible that this Webster was an employee of Hope as a "Webster" is referred to on two occasions in the diary of Adrian Elias Hope (MS of 1822–34 in a private collection). Or he may have been —— Webster Esq. of 153 Sloane Street, London, who had an account with John Smith (1781–1855), the much respected dealer, author, and connoisseur of 137 New Bond Street, who specialized in the sale of Dutch and Flemish paintings. The account for 1818 included repairing, regilding frames, cleaning, and revarnishing, for landscapes, a "Head" (presumably Guy Head [1753–1800], the portrait painter who copied Old Masters belonging to Hope), and drawings, one by Westall, works by whom Hope also owned. John Smith Daybook A (1812–21): 559, Victoria and Albert Museum Library, MSS 86.CC.1. It is also possible that Webster may have been a picture frame dealer, which would account for him buying works for very small sums in order to secure the frames. Unlike most of his contemporary collectors, Hope did not have an account with Smith. A small leatherbound note-book belonging to Smith, "Rough Notes of pictures in collections of Lord Derby etc. (and T Hope)" of 1836 (Victoria and Albert Museum Library, MSS 86.BB.23) appears not to contain any remarks on Thomas Hope's collection. Smith's great opus of nine volumes (one was a supplement volume), *A Catalogue Raisonné of the works of the most eminent Dutch, Flemish, and French painters . . .* 8 pts. (London: Smith & Son, 1829–42) contains a great number of works owned by both Thomas Hope and Henry Philip, some with provenance, current valuation, and exhibition details. A copy was sold in the Deepdene Library sale.

118. The purpose was to produce copies that could not be mistaken for the original in order to reassure the owners. Hope himself had copies in enamel made of pictures in his own and other collections, listed in 1820 in *Annals of the Fine Arts* 4 (1820): 97: "A variety of beautiful enamels after Correggio, Guido, Raffaelle, Domenichino, and modern portraits." These were executed by Henry Bone (1755–1834), miniature and enamel painter to George III, and are recorded in Bone's Index of Drawings, vol. 4, National Portrait Gallery Archives, 16-E-3. I am indebted to Daniella Ben-Arie for alerting me to this source.

119. For the history of the British Institution, see Peter Fullerton, "Patronage and pedagogy: the British Institution in the early nineteenth century," *Art History* (March 1982): 59–72.

120. See Trevor Fawcett, *The Rise of English Provincial Art: Artists, Patrons, and Institutions outside London, 1800–1830* (Oxford: Clarendon Press, 1974): 127.

121. The van Dyck is in the National Gallery, Washington. Those lent by Henry Philip were two works by Metsu, *Man Writing a Letter*, and the companion, *Woman Reading a Letter* (National Gallery, Dublin), and *Woman at a Window with a Rabbit in Her Hand* by Dou (private collection, North America), which "won particular admiration and was held to constitute the artist's masterpiece." See Haskell, *The Ephemeral Museum* (2000): 65.

122. The Titian is in the Minneapolis Institute of Arts and both Veroneses are in the Frick Collection, New York.

123. Both Guercinos were painted for Bartolommeo Fabri of Cento; the former is in the Fitzwilliam Museum, Cambridge, the latter in the National Gallery, London. Henry Philip lent eleven pictures, including two works, *Backgammon Players* and *Corps de Gardes* by David Teniers, *Doubting Thomas* by van der Werff (Milwaukee Art Museum), and two small van der Veldes, *Fishing Buss in a Breeze* and *Hoeker in a Strong Wind* (both English private collection).

124. For the Rosa, see Lady (Sydney) Morgan, *The Life and Times of Salvator Rosa*, vol. 2 (London: H. Colburn, 1824): 367–69. The Rubens is in the Gemäldegalerie, Berlin, as is the *Landscape with the Tower of Steen* by Rubens, which was in the Hope family collection. That year Henry Philip lent one work *Dutch Courtship* by Adrian van Ostade, presumed to be *Cottage Doorway: Offering a Present* (exh. Colnaghi, June 1935).

125. The former was stolen from Isabella Stewart Gardner Museum in 1990, and the latter is in the Art Gallery of Ontario, Toronto.

126. In the Victoria and Albert Museum Library, MSS 100.D.16.

127. The former, bought by John Hope from the Bisschop collection, is in the Milwaukee Art Museum, and the latter, from the Braamcamp collection, is in the Harold Samuel collection, the Corporation of London. For a list of the most important works in the collection of Henry Philip, see the Appendix.

128. 10 April on the reverse, revised to 30 December 1810. A loose sheet in Catalogue II, see n. 10, entitled "Schedule or Catalogue of Dutch and Flemish Pictures which I have in contemplanation [*sic*] to bequeath by my Will or some Codicil thereto to Henry Philip Hope Esq. such Pictures with a Copy of this Catalogue to be delivered by him by my Executors after my decease," lists the pictures with measurements. These pictures are listed in the Appendix. The Hobbema is in the National Gallery, London.

129. Letter of 1 March 1819; see Alexander, *Life at Fonthill* (1957): 290.

130. Letter of 30 March 1819; see Edgeworth, *Letters from England* (1971): 189.

131. Ibid., 363.

132. See Jane Thomas, *Watercolours by R. W. Billings (1813–1874)*, ex. cat. (Aberdeen: Aberdeen Art Gallery, 1996). The interior of the gallery is discussed fully in Chapter 12 by David Watkin.

133. See cat. no. 107. The drawing is in the Metropolitan Museum of Art, New York, and reproduced in Watkin, *Thomas Hope* (1968): pl. 41. Some pictures can be identified such as on the upper right hand side: the van der Velde *Council-of-War on Board the Eendracht on 24 May 1665* (Fritz Lugt collection, Fondation Custodia, Paris) with, below, a slightly altered *View of the Campo Vaccino* by Johannes Lingelbach (Kunsthalle, Karlsruhe) and, opposite, *Landscape with Two Swans, Ducks and Peacocks* by Hondecoeter (Brunner Gallery, Paris, n.d.).

134. See J. Britton and A. C. Pugin, *Illustrations of the Public Buildings of London* (London: John Weale, 2nd ed, W. H. Leeds, 1838): 346–47 and ills., and Westmacott, *British Galleries* (1824): 323–40.

135. This idea was later imitated by Soane on three of the walls in the confined space of his new Picture Room at 14 Lincoln's Inn Fields, London, in 1824.

136. Rudolph Ackermann, *The Repository of Arts, Literature, Fashions, Manufactures etc.*, 3rd series, vol. 1, no. 6, 1 June 1823 (London: Ackermann, 1809–29): 311–13.

137. John Preston Neale, *Views of the Seats of Noblemen and Gentlemen in England, Wales, Scotland, and Ireland*, 2nd series, vol. 3 (London: W. H. Reid, 1826): 6–11.

138. The volume, a "History and Description of the Deepdene," was intended by Britton as a tribute to Hope but never completed; see John Britton, "Illustrations of the Deepdene, Seat of T. Hope Esqre.," of 1825–26, a volume of drawings in the Minet Library, Lambeth, London, S.3247/185/188.

139. John Britton, manuscript list of contents of the Deepdene, Yale Center for Studies in British Art, New Haven, Hope Architectural Collection, Box Deep-Dene 1, MS B1977.14. Watkin, *Thomas Hope* (1968): 47, points out that it was unusual at this date to own works by Guardi. He also mentions a pair of *Fête Champêtre* pictures by Watteau in the Lilac room at the Deepdene (p. 179), for which no further reference has been found. See also Francis Haskell, "Francesco Guardi as *vedutista* and some of his patrons," *Journal of the Warburg and Courtauld Institutes* 23 (1960): 258.

140. See G. F. Waagen, *Works of Art and Artists in England*, vol. 2 (London: John Murray, 1838): 325–43.

141. Ibid., 327–28.

142. See Waagen, *Treasures*, vol. 2 (1854): 112–25, which has minor alterations in the terminology and some additions, such as an altarpiece by Manzuoli di San Triano (*sic*) of *The Annunciation*.

143. J. D. Passavant, *Tour of a German Artist in England*, vol. 1 (London: Saunders & Otley, 1836): 223–27, and vol. 2, p.181. It was first published in German in 1833.

144. Will of 5 May 1818, Somerset House, vol. Tebbs, 1831, vol. 1, no. 153, f.5 and a codicil of 9 April 1824 left his two brothers "specified works of art"; see Law, *The Beresford Hopes* (1925): 69.

145. For instance, the additions of *A Cavalier with Lady and Figures* by Gonzales Coques and a Poussin *Holy Family* were noted by Waagen, *Treasures* (1854): 125. Anna Jameson, *Companion to the most celebrated Private Galleries of Art in London* (London: Saunders & Otley, 1844): xxxii, stated that Henry Thomas bought pictures from the sale of the Duke of Lucca in 1840.

146. "Visits to Private Galleries. No. X. The Collection of H. T. Hope Esq., Duchess-street, Portland-place," *Art-Union* VIII (1 April 1846): 97–98. Among the 52 pictures listed in the "Italian Gallery" were two by Domenichino, *Christ Bound* (*Christ at the Column*) (Barbara Piasecka Johnson collection in 1997) and *The Infant Christ*, which is presumably the *Young Christ with Emblems of the Cross*, a drawing for which by "Mr. Wilkin Jnr." was in the Phillips sale, *A small collection of Pictures of the First Class*, 30 April 1813, lot 38 "from the picture in the possession of Thomas Hope." Both pictures were in the Deepdene sale.

147. Edward Wedlake Brayley, *A Topographical History of Surrey*, vol. 5 (London: J. S. Virtue & Co. Ltd., 1850): 86–89.

148. *A Catalogue of Pictures of the Dutch and Flemish Schools lent to the South Kensington Museum, The Property of Mrs Henry Thomas Hope* (London: Printed by George E. Eyre and William Spottiswoode for Her Majesty's Stationery Office, 1868). An addition to the collection was *A Woman Peeling Apples, by Her Side a Spinning Wheel* by Nicolas Maes (Gemäldegalerie, Berlin), which had been bought by "Hope" at the sale of Count Pourtales, Phillips, London, 20 May 1826, lot 120 for 130 guineas and exhibited in 1868 (26) in the catalogue cited above but with no attribution.

149. A beautifully illustrated annotated copy of this catalogue, in which some of the pictures are not identified by artist, is in the library of the J. Paul Getty Museum (22589392-B).

150. See Frank Herrmann, "Peel and Solly: Two Nineteenth Century Art Collectors and their Sources of Supply," *Colnaghi: Art. Commerce. Scholarship. A Window onto the Art World - Colnaghi 1760–1984*, exh. cat. (London, 1984): 38.

151. *The Hope Collection of Pictures of the Dutch and Flemish Schools with descriptions reprinted from the catalogue published in 1891 by the Science and Art Department of the South Kensington Museum* (London: Privately printed at the Chiswick Press, 1898). Copies survive in the Victoria and Albert Museum Library Photograph Collection (506, reg. nos. 184-266.1906), the National Gallery Library, and the Frick Art Reference Library, New York.

152. I am most grateful to Paul Tucker for his help with information on Charles Fairfax Murray. These pictures included, for instance, the two Veroneses; *A Landscape with Piping Shepherds and a Flight into Egypt* after Claude (National Gallery of Victoria, Melbourne); *The Inspiration of the Epic Poet* by Poussin (Musée du Louvre); *View of the River Y, Amsterdam in the Distance*, now called *The Frigate Brielle on the Maas at Rotterdam by Backhuysen* (Rijksmuseum, Amsterdam); *The Falcon Chase* by Dujardin (Michaelis collection, Old Town House, Cape Town); two pictures by van Huysum of *Vase of Flowers on a Garden Ledge* (with Noortman Master Paintings, Maastricht, 2007) and its companion, a *Fruit Piece* (private collection); and a portrait by Reynolds of Hope's mother-in-law *Lady Decies and Son, John, later 2nd Lord Decies* of ca. 1775 (private collection).

153. Agnew Joint Stockbook, 10 June 1910. I am most grateful to the archivist Jane Hamilton for her help with the Agnew records.

154. *The Times*, 19 July 1917: 9. The sale contained many of the Old Master pictures not mentioned or traced in the collection elsewhere, such as a *Holy Family* by Carracci, *Charity* by van Dyck, *Judith* by Giorgione (although this had been lent to the students at the Royal Academy for copying purposes in 1825), *St. Michael overthrowing Satan* and a *Female Saint* by Raphael (sold Christie's, London, 22 April 2005, lot 62 as Circle of Girolamo da Carpi, *A Young Woman Holding a Flower with an Extensive Landscape beyond*), *Supper at Emmaus* and a *Holy Family, Virgin and Child with Saints Zacharias, Elizabeth and John the Baptist* (sold at the Deepdene sale as *Holy Family*) by Jacob Jordaens (National Gallery, London), and *Holy Family with St. Catherine* by Titian, *Angelica and Medoro* by Guercino, which was listed by Douce, and many more.

155. Some of the pictures by Berckheyde from the Hope collection were later included in the exhibition *Tentoonstelling van Oude Meesters* by Frederick Muller and Co. in Amsterdam in 1918, for instance, nos. 15, 16, 17, 18. I am most grateful to Julia Armstrong Totten for a copy of this catalogue.

156. Edgeworth, *Letters from England* (1971): 499.

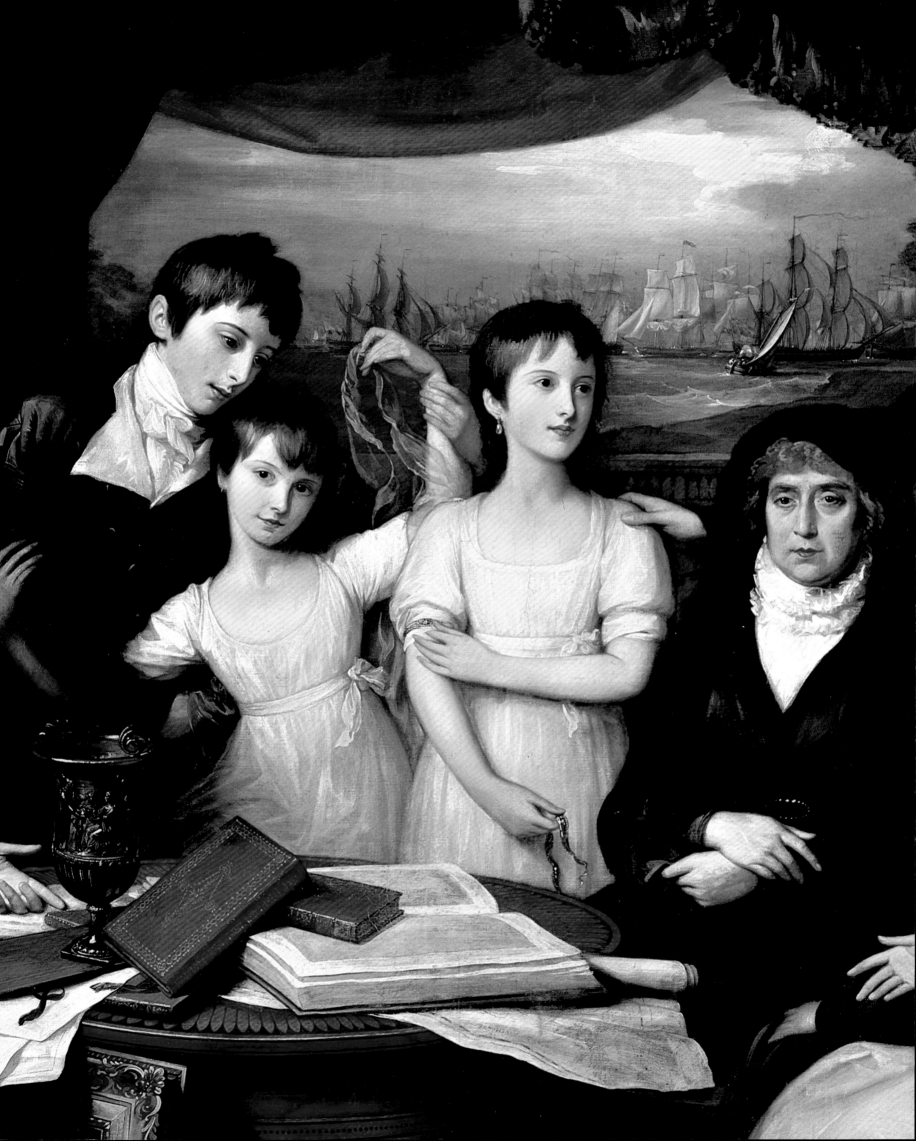

CHAPTER 11

The Hope Family in London: Collecting and Patronage

Daniella Ben-Arie

For the Fine Arts, London is now much and deservedly distinguished. The commotions on the Continent have operated as a hurricane on the productions of genius, and the finest works of ancient and modern times have been torn out of their old situations.[1]

London Guidebook, 1802

Late eighteenth-century London was "avowedly the first commercial city in the world,"[2] and as the heart of Europe's political, economic, and social life, it became the refuge for those fleeing this "hurricane," or revolutionary war, that was tearing through the Continent.[3] London was also at the very center of patronage and collecting in England and was home to leading artists and craftsmen, architects and designers, some of whose work would eventually be commissioned by the Hopes. The art market had evolved into a well-established network of auction houses that were a hive of activity, selling off British collections as well as those being imported for sale from Italy, France, and Holland. A large number of erudite, wealthy, and sophisticated connoisseurs and collectors, both natives and foreigners who lived in the city and were often well known to each other, competed for the finest objects.

This was the city into which "le celebre Henri Hope, réfugié à Londres,"[4] arrived in October 1794, bringing with him an extensive collection of paintings, furniture, marbles, curiosities in ivory and bronze, glasswork, silver, porcelain and earthenware, books, manuscripts, drawings, and prints. Henry (ca. 1735–1811), patriarch and head of the family bank, Hope and Company, was a cousin to the brothers Hope: Thomas (1769–1831), Adrian Elias (1772–1834), and Henry Philip (1774–1839), whose collections were also packed into the cargo that he brought over from Amsterdam.[5] Although Thomas is the focus of this exhibition, he was not the only collector of note in his family. His father, John (1737–1784), had amassed a collection of paintings, which is discussed in Chapter 10 and which was eventually inherited by his

sons and his first cousin Henry Hope.[6] John was a man of sophisticated taste, and his collection also comprised small-sized sculptures in ivory, wood, and bronze; a few larger-sized marbles; objects in lacquer; marble micro-mosaic tops; silver; mathematical instruments; porcelain; and cameos.[7] As with the paintings, these too were inherited by his sons and Henry. In London "le celebre" Henry's collection was recognized for its quality and scope, and it was commented upon and visited by his contemporaries. Unlike some who had to flee the Continent in the 1790s, the Hopes did not need to disperse their collection in order to raise money. On the contrary, Henry's extensive preparations for the relocation of the family business and the collections allowed them to benefit from other people's turmoil. Henry, Thomas, Adrian Elias, and Henry Philip all used the auction houses to augment their already considerable collections. Eventually Thomas Hope's own sons, Henry Thomas (1808–1862), Adrian John (1811–1863), and Alexander James Beresford (1820–1887), would build their own collections. This chapter will examine this thread of connoisseurship and collecting in the various Hope family members in the context of the London art market and the various collectors against whom they were competing.

By the time Henry Hope arrived in London in 1794, he was already a well-established collector and patron of the arts. In the 1760s, he had acquired a house on the Keizersgracht, one of the smartest addresses in Amsterdam, and between 1785 and 1788 he completed the construction of his country house, Paviljoen Welgelegen, on the outskirts of Haarlem "at vast expence, (not less it is said, than fifty thousand pounds sterling,"[8] whose interior was "more like a palace than the seat of a private gentleman" (see cat. no. 15).[9] A contemporary view of the house shows that it was constructed in the most avant-garde French neoclassical style after designs by the French architect Jean Francois de Neufforge[10] and construed as a collaboration between Henry Hope and Triquetti, alias Michel, Baron de Triqueti, who was Sardinian consul at The Hague as well as an amateur architect. The Fleming Jean Baptiste Dubois was employed as the executant architect.[11]

Some of the large number of pictures that were brought to London were initially displayed here, as were sculptures that Henry had commissioned from leading contemporary craftsmen, such as the Italian Francesco Righetti, who executed for him twelve lead casts painted in imitation of marble after ancient and contemporary models for Welgelegen's external embellishment.[12] In the interior Henry probably installed the chimneypiece by Giovanni Battista Piranesi that had originally been made for Thomas's father, John Hope, during the latter's time in Rome but which had remained unwrapped upon delivery.[13] In its new setting, the chimneypiece would have exemplified "l'excessive richesse du propriétaire."[14]

Henry, merchant and banker, was born in Boston, studied in England, and in 1762 was invited to Amsterdam to join his uncles Thomas (1704–1779) and Adrian (1709–1781) as a partner with his first cousin John in the Hope and Company bank. All three of his partners would eventually die within a five-year period, but despite this and the upheavals surrounding the removal of the business to London, Hope and Company flourished under Henry's guidance. He was as highly regarded in his personal life as he was in his professional capacities, and despite his position and eminence, he was "one of the very rare exception of being spoken well of by everybody, and deserving it."[15]

When John died in 1784, his fortune and his collection were left to his wife, Philippina Barbara van der Hoeven, and their three sons.[16] Thomas had already reached his majority when his mother died in 1789, and Henry was made guardian to his two brothers, Adrian Elias and Henry Philip, in order to prevent the separation of the estate. As part of their paternal legacy, the paintings, drawings, prints, and books remained the property of the three sons until they were eventually divided in 1794. At that time Thomas inherited his father's money and the house on the Heerengracht in Amsterdam, and Adrian Elias and Henry Philip inherited the paintings, drawings, prints, and the library, as well as the remaining property. Their maternal legacy included silver, marbles, ivories, palm wood and bronze sculptures, Japanese lacquer, Sèvres and Meissen services, and "diverse varieten." Thomas, as the eldest son, received most of the important pieces of silver.[17] He also inherited the curiosities in ivory and lacquer, marble busts, mathematical instruments, and four apparently ancient mosaic table tops from his father's house in Amsterdam. Some of these objects would eventually be displayed by Thomas in his Duchess Street house; a few were even included as engravings in *Household Furniture* in 1807 (cat. no. 113). From his mother, Adrian Elias inherited the remaining porcelain, including a 240-piece Meissen service, as well as a fountain cooler in silver and two of the micro-mosaic marble tops from the house at The Hague, and all the furniture from the Amsterdam house. Henry

Fig. 11-1. Manifest of goods shipped by Messrs Hope & Co on board the *Unity* . . . at Amsterdam bound for London . . . ff. 1r & 1v. 1794. The Baring Archive, London, NP1.A1.20.

Philip received the furniture from the house at The Hague, along with the family house of Bosbeek (cat. no. 14).

In 1794, amid concern about the approaching French army, Henry prepared for his family's departure from Holland with the help of his counterpart in London, the banker Sir Francis Baring, 1st Baronet. He wound up his business in Amsterdam and organized two ships, the *Unity* and the *Hope,* to transport the possessions "being the Contents of our Houses & no article of Merchandise among it"[18] (fig. 11-1). Simultaneously, Thomas, Adrian Elias, and Henry Philip were arranging their own passage "setting out for Brunswick."[19] A total of 199 cases, chests, and trunks, valued at £57,500 and containing the works of art and household goods that Henry and his three cousins had collected and inherited, were transported to London.[20] In October 1794, Henry himself finally emigrated, and by January of the following year was well enough established that the antiquarian and writer Daniel Lysons reported his visit to "Mr. Hopes of Amsterdam" to Joseph Farington, remarking that they had

"brought to England their fine collection of pictures, & have removed so much of their property as they said as to have left only chairs and tables behind them."[21]

The London Art Market

Shortly after their respective arrivals in London, Henry, Thomas, and Henry Philip started adding works to their collections, by buying at auction, by private contract purchases through dealers, or by direct commissions from artists. While Henry was living in London from 1794, the brothers continued with their frequent trips to the Continent. Despite the purchases that they made during these travels, they continued to use the auction sales to augment their collection; they bought pictures, sculpture, and antiquities, as well as selling those that were extraneous to their needs.[22] The precedent for this had been set by their father, whose collection was not inherited but partly formed through his purchases at auction, particularly at those of well-known collections.

Turn-of-the-century London was home to a thriving art market, where a vast number of sales were held and where one commentator recorded that the auction rooms were "daily crowded by personages of the first rank."[23] Although he may have overestimated their frequency, and although some of the sales contained only household fixtures and furnishings, many of the sales were indeed of the highest caliber. Here were sold the finest paintings, sculpture, bronzes, books, and vases, as well as architectural fragments and antiquities, the chattels of both native and foreign collections. The Hopes primarily made purchases at the more important sales, but there is evidence that they made also purchases at relatively run-of-the-mill sales, buying porcelain and furnishings for household use. The most prolific auction house through which they conducted their purchases was Christie's, named after its founder James Christie and later run by his son James. Operating from rooms at 91 Pall Mall, the auctioneer was regarded for "his extraordinary oratorical talents,"[24] which were well employed to embellish the threadbare descriptions that often appeared in the catalogues.

The Hopes also frequented other auction houses and dealers, including Skinner and Dyke in Spring Gardens, Michael Bryan in Savile Row and Pall Mall, and a Mr. White. They also used the services of Peter Coxe, who sold works both as a group with the auctioneers Burrell and Foster in Pall Mall and by himself at Mr. Squibb's room in Saville Passage. The Scottish dealer William Buchanan, whose commercial activities would extend to the Hopes, proclaimed that "a very fine picture of Correggio, of Claude, of Raffaelle, of Titian, Domenichino, or Rubens will bring more money in England than anywhere else, because the very rich and great Collectors, as Stafford, Angerstein, Hope etc. will make a point of finding room for such."[25] The Hopes were not competing against only a few individuals, such as the merchant John Julius Angerstein at 100 Pall Mall or George Granville Leveson-Gower, 2nd Marquess of Stafford, later the 1st Duke of Sunderland, for the "Stafford Gallery" in Cleveland Row. Extant auction catalogues indicate the full extent of aristocrats and plutocrats, dealers and merchants, artists and architects, connoisseurs and dilettantes, who made up the pool of buyers against whom the Hopes directly competed.

Among these buyers were the architect and collector Sir John Soane at 12 Lincoln's Inn Fields, who bought marble sculpture to add to his collection of antiquities; the connoisseur, writer, and numismatist Richard Payne Knight at Whitehall; and the collector of antiquities Charles Townley, who lived at 7 Park Street (later 14 Queen Anne's Gate) and who had accumulated "the finest collection of antique statues, busts, &c. in the world."[26] Artists and craftsmen included the sculptor Joseph Nollekens in Mortimer Street and the painters George Chinnery and Sir Peter Francis Bourgeois, who would eventually create the Dulwich Picture Gallery. Wealthy merchants, bankers, politicians, and landowners included Sir Francis Baring, and General George Stainforth, as well as the speculator and investor Francis Egerton, 3rd Duke of Bridgewater, who at Cleveland (later Bridgewater) House in Cleveland Row had "perhaps, the finest [collection] in England"[27]; John, 2nd Earl of Ashburnham at 29 Dover Street; John Campbell, 1st Marquess of Breadalbane, at Foley House in Chandos Street; and Lord Yarmouth, later Francis Charles Seymour-Conway, 3rd Marquess of Hertford, at 16 Charles Street, Berkeley Square, who was also buying on behalf of the Prince of Wales, later George IV. Art historian and dealers included Michael Bryan, William Buchanan, William Comyns, William Dermer, David Seguier and his son William, who also became the first keeper of the National Gallery, and the Woodburns, a family of dealers, headed by their father, John.

Before examining what the Hopes purchased, it is important to mention the difficulty in determining exactly which Hope is being referred to in the auction catalogues, where often only the surname is noted. This is particularly problematic with the pictures, because they appeared to share ownership of the pictures or to exchange works or make gifts of their purchases to each other. This question of ownership also occurs with some of the sculpture. At the 1819 sale of Sir John Coghill, one of the "Hopes" purchased sixteen lots, including "four pieces of marble, which probably served as supporters of an ancient *thronos*, such as those frequently represented on Greek vases.[28] They are richly ornamented and with great taste, and very highly finished."[29] Two pairs of throne legs were eventually sold by Thomas's eventual

Fig. 11-2. Throne leg. Roman, first half 2nd century A.D. Luna marble. Fitzwilliam Museum, Cambridge, GR 14.1917, 15.1917, 16.1917, 17.1917.

held by named consignors from well-known collections. Among the sales that he attended was that of Willem Carl, Baron van Nagel van Ampsen, Dutch envoy to England, whose collection contained "select and beautiful cabinet pictures, the undoubted works of the most celebrated esteemed Dutch and Flemish masters,"[34] and at the sale of Charles Alexander de Calonne, the French finance minister, whose pictures were "regarded as one of the finest in Europe," and were intended for his house on Piccadilly.[35] Both Nagel and de Calonne had, like Henry, sought refuge in London. Henry also bought at the sales of Hendrik Fagel II and his grandson Hendrik Fagel III, whose collection at The Hague was of "such a beautiful and perfect assemblage";[36] from John Purling at 68 Portland Place, "whose accurate judgement, pure taste and liberality in purchasing, rendered his cabinet equal to most of the private galleries in Europe"[37]; from the merchant, politician, and collector George Hibbert M. P. in Portland Place; from Sir Simon Haughton Clarke, 9th Baronet, in Gloucester Place, who had a "superb and truly valuable" collection[38]; and from William Petty, 1st Marquess of Lansdowne, in Lansdowne House, Berkeley Square, who had both a fine number of pictures as well as extensive collection of marbles.[39]

Hibbert and Clarke's sale was considered "next to the Orleans, to be a kind of leading collection,"[40] and here Henry purchased Peter Paul Rubens's *Assumption of the Virgin*[41] and Annibale Carracci's *Christ and the Samaritan Woman*.[42] At the sale of the Marquess of Lansdowne, he bought Nicholas Berghem's *The Sybil's Temple*, which, once in Henry's possession, was described as "one of the finest in this country both in execution and composition."[43] He also bought at the sales of dealers, such as Bryan from whom he purchased Sir Joshua Reynolds's portrait of *Mrs. Billington*,[44] and a Bartolomé Esteban Murillo, *The Madonna and Infant Saviour*, whose auspicious provenance included de Calonne,[45] and from the posthumous sale of the painter Guy Head,[46] where for one picture he paid the astounding amount of £420 for what was presumably a copy by Head after Rubens.[47] It is evident that Henry was buying not just to plug holes in his collection. By the time of the purchases from Bryan, he already owned two Holy Families by Murillo, as well as at least four by Reynolds. The vast number of auctions meant that collectors in England, specifically in London, now had access to the "possession of some of the finest pictures in the world."[48]

heir in 1917, but no contemporary records survive to show which Hope they belonged to (fig. 11-2).[30]

The most widely publicized of the picture sales that Henry and Thomas attended was that formed by Philippe d'Égalité, duc d'Orléans, and which was being sold by his eventual heirs. This collection of Italian pictures was sold by private contract by Bryan starting on December 26, 1798, and continued for several months.[31] Henry and Thomas were among the many prolific collectors invited to the private viewing on the opening morning. That England's keenest and wealthiest collectors bought with such abundance was seen as vindication that "the great and general interest which this collection has raised in England; and at the same time disproves the assertion which foreigners had till then made, that we were a nation possessing no love for the Fine Arts, nor any knowledge of them."[32] The pictures that Thomas purchased numbered either seven or eight and are discussed in detail in Chapter 10, and his cousin Henry acquired another eight or nine. Henry's most expensive paintings depicted *Lot and His Daughters*, then attributed to Diego Velázquez but now considered to be by Orazio Gentileschi.[33] When these pictures were sold by Henry's heirs sixteen years later, their Orléans provenance was trumpeted.

As has been mentioned, Henry already had a collection comprising fine works by the most prestigious Old Master artists, so it is not surprising that he bought only at the most prestigious sales

Thomas Hope and the London Art Market

One further fascinating aspect becomes evident when examining the sale catalogues of this period, and that is just how widely Thomas used the auction sales to fill the gaps in his own collection of ancient sculpture, Greek vases, and architectural fittings. In

1799, the same year that Thomas acquired Duchess Street, he bought at auction architectural fragments and fittings, bronzes, marbles, and vases, which must have been intended for his new house.[49] His purchases included three marble chimneypieces, for which he paid just over £22.[50] The sales that he attended were interspersed with his frequent trips to the Continent, and it is extraordinary that he was able to do this while at the same time overseeing the decoration of his new house. In 1800 he bought five lots in a sale of marbles in which Sir Richard Westmacott bought eleven lots, and Nollekens seven.[51] In 1801 Thomas Hope was buying with greater frequency as the completion of Duchess Street grew near. He bought at the sale of Aubrey Beauclerk, 5th Duke of St. Albans, held on the premises in St. James's Place[52] and at both sales held by Frederick Ponsonby, 3rd Earl of Bessborough, who was Henry's neighbor in Cavendish Square.[53] Here Hope purchased bronzes and small-sized marble figures and vases, as well as a marble dog and a colossal porphyry foot (cat. no. 46). Again, competition for the finest objects was fierce. In the second of Bessborough's sales, the most competitive bidding came from Thomas, who bought six objects; Soane purchased ten, Townley nine, and Frederick Howard, 5th Earl of Carlisle, walked away with eight lots. Thomas's largest single acquisition was at Sir William Hamilton's sale of "a small, but most capital assemblage of antique busts, bas-reliefs, and other valuable marbles," where he purchased fourteen lots, of which several were eventually illustrated by him in *Household Furniture* in 1807.[54] This sale is discussed in Chapter 7.

Even though Thomas had purchased Hamilton's second collection of vases *en bloc* in 1801, he also continued to accumulate further vases privately. In 1802 he was competing against the artist Henry Tresham, Rogers, Soane, and Chinnery.[55] In 1805 either Thomas or Henry Philip consigned for sale a group of Greek vases, marble busts, alabaster vases, "rare" inlaid marble slabs, and a series of engravings by Johann Heinrich Wilhelm Tischbein, thirty-one lots in total.[56] Having already completed the interiors at Duchess Street and having not yet purchased the Deepdene, Thomas may have considered these surplus or perhaps just not of sufficiently high quality. From this selection, cousin Henry acquired the Tischbein engravings,[57] "a beautiful Nolan tazza of the finest varnish, and a mystical figure of an ass, with a pair of vases strap'd as panniers, highly curious," as well as three other vases, one in alabaster, a pair of marble slabs "inlaid with various beautiful specimens of lava, and giallo border," and another in *nero antico*.

In 1809 Sir Robert Ainslie, who held the position of British ambassador to Constantinople between 1776 and 1792, sold a series of original drawings by the artist Luigi Mayer, whom he had employed to record his travels.[58] Among the items Thomas purchased were twelve oil paintings of Ephesus.[59] In this same sale, one of the Hopes consigned a *Venus and Vulcan* by Sir Henry Cheere,[60] small-size copies of the Medici and Borghese vases, a "superb tazza," and three pictures, including a Thomas Daniell capriccio of Delhi.[61]

Henry Philip and Adrian Elias Hope and the London Art Market

On March 27, 1802, Thomas Hope consigned marbles to be sold by Christie's as part of the collection of the Duke of St. Albans at the duke's house in Mansfield Street, Portland Place.[62] One of the other consignors at this sale was Henry Philip, who left fourteen lots for sale to Thomas's nine.[63] This included sculpture in alabaster: "an exquisite pair of alabaster figures, the Apollo Belvidere, and Venus de Medicis, delicately and beautifully executed" bronzes: "Hercules and Antaeus, antique,"[64] and ivories: "a beautiful ivory cup, richly embellished with boys, carved in alto-relief, and supported by an infant Bacchus, in ivory."[65] Some of these had formed part of Henry Philip's inheritance in the 1780s.

Throughout this period, Henry Philip sold objects piecemeal, such as a landscape after Claude in 1804[66] and a vase in *rosso antico*, "a small model from the antique," and a copy of a bust of Antinous the following year.[67] But it was while Henry Philip was living at 3 Seamore Place in 1813, a residence discussed below, that the dispersal of the major part of his collection started. He was moving house at this period, but exactly why he decided to sell so much is unclear. Between February 18 and March 11, he sold his "very extensive and valuable library,"[68] followed by his prints and drawings between March 18 and 26,[69] and a further collection of prints and miniatures on May 1.[70] On May 15, he was one of the consignors to a sale of a "valuable collection of Italian, French, Flemish and Dutch pictures,"[71] although in reality the paintings that he sold were not impressive.[72]

In that same year, the collection of Adrian Elias was imported for sale from Amsterdam and offered for sale on April 30 at Christie's in London.[73] Among the objects was an "exceedingly valuable assemblage of antique marbles, painted Greek vases." As well as making purchases from their brother's sale, both Thomas and Henry Philip took the opportunity to consign some of their own possessions. Thomas sold "a slab of bianco e nero antico, with beading of or-moulu, 50 inches by 24, and elegantly carved and painted stand to ditto"[74] and "a pair of carved and gilt frames for marble slabs."[75] He bought a figure of Minerva[76] and a "very curious globular vase, painted, with 4 heads of Isis, so placed as to designate the colures of the sphaere, a very uncommon specimen."[77] Henry Philip bought two pairs of "paintings on vellum, views of the antiquities of Rome, fan mounts"[78] and a marble "slab of the

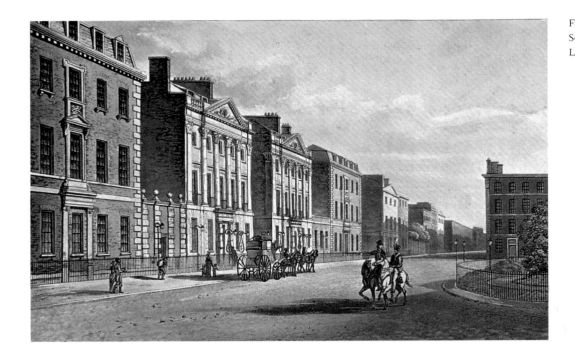

verde di Corsica."[79] Other buyers at the sale included West-macott, Tresham, and Sir Henry Charles Englefield, 7th Baronet.

Henry Hope in Cavendish Square

During his visit in January 1795, the antiquarian Daniel Lysons would inevitably have seen some of the 372 paintings and other works of art at 1 Harley Street, Cavendish Square, the address at which Henry lived between 1795 and his death in 1811.[80] He lived here with his niece Anne; her husband, John Williams Hope; and their children.[81] The Harley Street house had been purchased from Henry's distant cousin James Hope Johnstone, 3rd Earl of Hopetoun, who was still living there in 1794 and who had inherited the house from his father, John Hope, 2nd Earl of Hopetoun.[82] The sale of the house was a fait accompli that was precipitated by the financial crisis that enveloped his family in the 1790s and the need to relieve the debt created by deaths of its elder members.[83] The house had originally been built as part of a development by James Brydges, 1st Duke of Chandos, who planned to build a single house on the north side of Cavendish Square.[84] His initial plans were not realized, and two separate houses were constructed instead, one on each corner on the north side of the square. The duke took the one on the corner of Harley Street as his own residence in 1734 and named it Chandos House.[85] Extant undated drawings by Robert Adam for Hopetoun House, as it eventually came to be known, show what the house may have looked like during occupation by the Earls of Hopetoun.[86] The drawings show a series of structural alterations and extensions to an existing structure. Except for one drawing entitled "front of the Earl of Hopetouns House towards Harley

Street as executed" of an eight-bay house with its front elevation on Harley Street and with a façade of approximately 102 feet in length,[87] it is uncertain exactly what work was carried out. A Thomas Malton aquatint of 1794, the year of Henry's arrival in London, gives some indication of how the house appeared and seems to conform to one of the Adam drawings (figs. 11-3, 11-4).[88] It has frequently, and must now be assumed erroneously, been suggested that Henry added a wing to the house soon after his

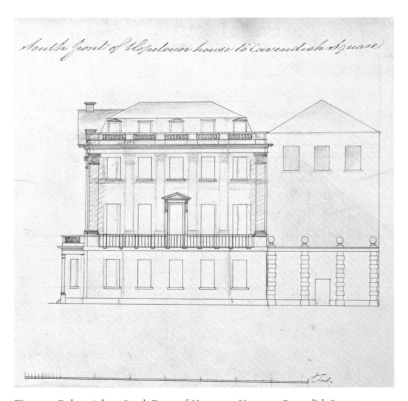

Fig. 11-4. Robert Adam. South Front of Hopetoun House to Cavendish Square. Drawing, undated. Sir John Soane's Museum, London, Adam 29/84.

arrival in 1795 in order to accommodate the large number of pictures that he had brought with him, but I have not found any evidence to support this.[89]

As Henry's residence in Amsterdam had been on "perhaps the finest street absolutely in Europe,"[90] so too was Cavendish Square a well-chosen location. It was certainly a large-sized house and was rated with Harcourt House, which stood on the west side of the square and was occupied by George Simon, 2nd Earl of Harcourt, as the highest in the square.[91] His neighbors were among London's political and artistic elite. Some, such as politician, landowner, and collector Frederick Ponsonby, 3rd Earl of Bessborough, had collections to rival his own.[92] Henry lived in magnificent style "suitable to the splendour of his situation,"[93] and as he had entertained at Welgelegen so he continued in London. The poet Samuel Rogers, who lived at 22 St. James's Place and who was a friend of Thomas's, recalled attending a "great party given in Cavendish Square" at which he engaged in gossip with Frances Villiers, Countess of Jersey, one-time mistress of George IV when he was still Prince Regent: "She had something particular to tell me; so, as not to be interrupted, we went into the gallery. As we were walking along it, we met the Prince of Wales, who, on seeing Lady Jersey, stopped for a moment, and then, drawing himself up, marched past her with a look of the utmost disdain. Lady Jersey returned the look to the full; and, as soon as the Prince was gone, said to me with a smile, 'Didn't I do it well?'"[94] Farington records several such entertainments, or routs. In one conversation he mentions "that I had been told the dinners given by Mr. Henry Hope of Cavendish Square, were magnificent. Lord Dunstanville [the political writer, Francis Basset, 1st Baron de Dunstanville and Basset] said he had dined there but did not think; there was expense enough, but a Dutch clumsiness prevailed in the manner of conducting the entertainment; Sir Francis Baring's dinners were in a better style."[95] Perhaps he was referring to Henry's habit of lighting fires even in hot weather: "He thinks they purify the air, has a fire morning and evening even in this weather."[96]

As was the practice at Welgelegen, applications could be made to examine "Mr. Hope's magnificent collection in Cavendish Square."[97] The German traveler Christian August Gottlieb Goede was one such visitor to the house at some point between 1802 and 1803.[98] Despite not being able to see all the pictures, he was still able to admire the "large richness of this beautiful collection" and considered it to be one of the "most magnificent" in London, comparing it with the collection at Buckingham House, and those of the 3rd Duke of Bridgewater, the 1st Marquess of Lansdowne, Welbore Ellis Agar of 29 New Norfolk Street, and Charles Townley.[99]

Along with Henry's collection of Old Master and contemporary paintings, the house contained an extensive collection of Danish, French, German, and English pottery and porcelain. This included a number of Wedgwood pieces that Henry had commissioned as early as 1787, when the vogue for buying English objects spread through the Continent.[100] This interest had also extended to Henry's cousin John Hope for his collection in Holland, who had commissioned sculpture from Colin Morison, the Scottish sculptor living in Rome, and hard stones after the antique from Thomas Parsons of Bath.[101] Extant sale records also show that Henry's interest in Wedgwood's designs was replicated by his cousin Thomas, who ordered pieces from the Greek Street showrooms in London. Thomas's first purchase from Wedgwood was recorded as early as 1790, when he was only twenty years old. This was in the middle of his Grand Tour, when he was first beginning to commission and collect works of art and long before the family's removal to London in 1794.[102] Among his acquisitions was a dinner service in the Etruscan style, his first purchase in 1790. He would also commission one of the earliest copies of the Barberini or Portland Vase, as it had then come to be known, and which was delivered to him on June 13, 1793.[103]

The house in Harley Street was primarily fitted with Continental furnishings and fittings, as well as some small-sized sculptures, bronzes, and marble slabs displayed on carved and gilt frames. In the hallway stood a clock by Cummins of London supported by two figures of Hope—the punning reference beloved by all the family. The scope of his painting collection, which he had brought with him to London, inherited, bought at auction, and commissioned, is so extensive that it cannot fully be appreciated in this essay. It is worthwhile, however, to consider briefly some of the more important pieces.

Like his cousin Thomas, Henry was patron of the artist and historical painter Benjamin West, who lived at 14 Newman Street. Henry owned six paintings by West, including a portrait showing nine members of his family that hung on the wall of his dining room (page 192, fig. 1-2).[104] On March 7, 1802, Farington recorded that "West is painting a large family picture for Mr. Hope of Cavendish Square," for which Henry was prepared to pay him 500 guineas.[105] Sitting alongside Henry in the painting are his sister Henrietta Maria Goddard and the rest of his family that lived with him in Harley Street. This included Henrietta's daughter Anne,[106] her son-in-law John Williams, and five of her grandchildren, three boys—Henry Junior (b. 1785), Adrian (b. 1788), John Francis (b. unknown)—and two girls, Henrietta Dorothea Maria (b. 1790) and Elizabeth (b. 1794). The sixth and youngest child, William Williams (1802–1855), who would go on to build a magnificent collection of his own, was born in the year of the commission and therefore not included.[107] The precedent for a painting of this type in Henry's collection is the Aert Schouman portrait of 1753 of *Jan and Pieter Bisschop and Olivier Hope*, which

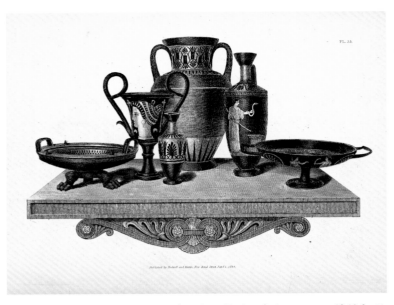

Fig. 11-5. Henry Moses. *Ancient Vases from the Collection of Sir Henry Engelfield; by Sir Henry Engelfield* (London, 1819): pl. 35:5. Art and Architecture Collection, Miriam and Ira D. Wallach Division of Art, Prints and Photographs, The New York Public Library, Astor, Lenox and Tilden Foundations.

vase on the table is virtually identical to one illustrated by Thomas in *Household Furniture* and may have been among those objects inherited from John.[115] The West portrait hung in a room filled with many other family pictures, including the celebrated *Thomas Hope* by Sir William Beechey (see cat. no. 1).[116]

Among the other paintings in Henry's collection was a portrait, *Catherine II of Russia* by Dmitry Levitsky, which had been presented by the tsarina to Henry in about 1788 (fig. 11-6).[117] It was seen by him as "a striking instance of the magnanimity and magnificence of the exalted personage,"[118] and by way of thanks Henry sent a gift of one hundred guineas to the artist. Also represented were works by Joshua Reynolds, who had traveled through the Austrian Netherlands, the United Provinces, and Rhineland in 1781, and who had spent time in Amsterdam and Haarlem with both John and Henry.[119] *Snake in the Grass, or A Nymph and Cupid*[120] had been presented to Hope by Reynolds and had previously hung at Welgelegen "maid un regard vif et brilliant s'échappe à travers ses doigs: tel on voit vers l'aube du

hung in the cabinet on the second floor of his house. It was from the Bisschop's collection that many of the Hope pictures had come; this is discussed further in Chapter 10.[108]

In West's portrait, an architectural model of Henry's country house, Welgelegen, stands behind the family and differs slightly from contemporary engraved images.[109] A "model of the country house," presumably Welgelegen, was brought over on the ship the *Unity* in 1794, and it is possible that this is the one in the painting.[110] It is also likely that the rest of the objects incorporated by West were from Henry's collection. The painted Greek vase decorated with a female holding a staff, or thyrsus, and a serpent over an altar was eventually acquired by the antiquary and writer Sir Henry Charles Englefield, 7th Baronet, who lived at 5 Tilney Street and in whose collection it was engraved by Henry Moses in 1819 (fig. 11-5).[111] How this vase came into Englefield's possession has not been established. In 1805 he is recorded as purchasing two lots of vases consigned by a member of the Hope family,[112] and at the sale of Adrian Elias in 1813 he bought seven lots.[113] By the time Moses engraved Englefield's vases in 1819, he had already published twice with Thomas; in 1809 and in 1812.[114] Of the other objects in the painting, a portrait of Adrian Hope (1709–1781), which rests against the circular table, may be one of the pair by Cosmo Alexander that Henry owned. The Hopes had been Alexander's main patron during the artist's tour of Rotterdam, The Hague, and Amsterdam between 1763 and 1764. The seascape behind the figures has not yet been identified with a specific work in Henry's collection, but it could easily have been any number of this subject, of which he owned many examples. The

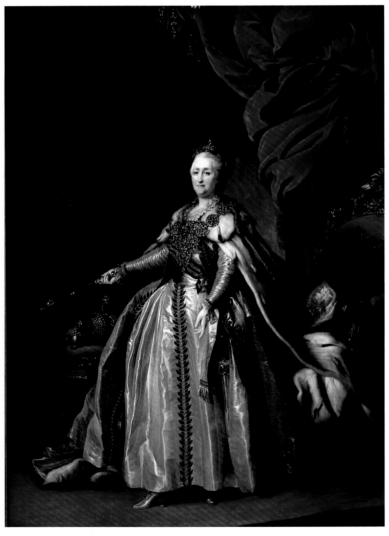

Fig. 11-6. Attributed to Dimitrii Levitsky. *Catherine II of Russia*. Oil on canvas, ca. 1788. Hillwood Estate, Museum and Gardens, Bequest of Marjorie Merriweather Post, 1973, 51.56.

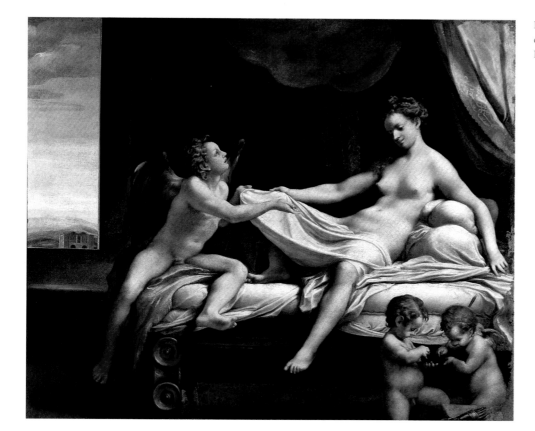

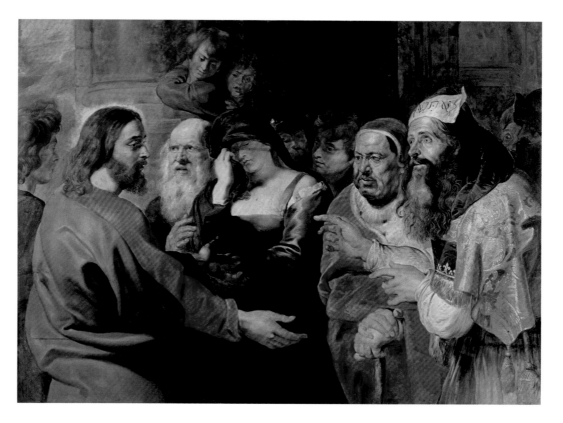

Fig. 11-7. Antonio Correggio, *Danaë*. Oil on canvas, 1531. Borghese Gallery, Rome. Art Resource, NY.

Fig. 11-8. Peter Paul Rubens. *The Woman Taken into Adultery*. Oil on canvas. Musées Royaux des Beaux-Arts de Belgique, Brussels, 3461.

jour un rayon du soleil s'échapper à travers un nuage" (but a lively and piercing look penetrates his fingers, much the way a ray of sun penetrates a cloud just before dawn).[121]

As far as the Spanish school was represented, Henry had ten Bartolome Esteban Murillos in his collection, "a master not be had in England, and if the subjects are good, and finely painted,

will sell very high, and what is of as much consequence very readily."[122] Italian painters included Antonio Correggio, whose celebrated *Danaë* from the Orléans collection was "one of the principal beauties of the gallery" (fig. 11-7).[123] Adrian van Ostade's *Cottage Interior* was among the pictures that represented the Dutch school, and in his collection of Flemish pictures were

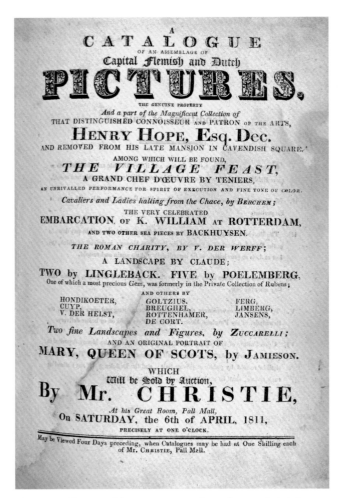

Fig. 11-9. Title page of the Henry Hope sale catalogue. Christie's, London, 6 April 1811. Christie's Images Limited 2007.

Peter Paul Rubens's *The Woman Taken into Adultery* (fig. 11-8),[124] which had been purchased by Henry in Antwerp and hung at Welgelegen—"les têtes sont remplies d'expression et de vérité; mais le ton de couleur est livide, et les figures dénuées d'élégance" (their heads abound with expression and are realistically depicted, but the colors are pallid, and the figures devoid of elegance)—and Sir Anthony van Dyck's *Paris*, in which Paris holds an apple in one hand and a staff in the other.[125]

The Dispersal of Henry Hope's Collection

When Henry died in 1811, his will stipulated that his collection be divided among various family members.[126] His sister, Henrietta Maria Goddard, and John Langston, husband of Henry's late niece Sarah Goddard, were left the pictures already in their possession. With minor bequests to Thomas at Duchess Street and Adrian Elias, who was then living in Amsterdam, as well as to his great nieces and nephews, the bulk of the estate, including the house in Harley Street, another in East Sheen, and their contents (except where otherwise specified), was inherited by John

Williams Hope, his nephew by marriage. His name would revert to John Williams after Henry's death.[127]

In a codicil to his will, Henry bequeathed twenty of his paintings to his cousin Henry Philip who was then living at 3 Seamore Place.[128] These twenty pictures were of Dutch and Flemish origin, and except for three that had been bought by Henry at auction in London, the remainder had been brought over by ship in 1795 as part of the collection that had been inherited from John Hope or that had hung at Welgelegen. As it must now be clear, exactly which member of the Hope family owned which pictures is extremely complicated to establish, but it seems that Henry Philip owned outright some of the works that were recorded during Henry's lifetime in his collection in Harley Street.[129]

Henry's collection would eventually be dispersed in a series of sales, of which the first was held shortly after his death on April 6, 1811, at which time fifty-eight mainly Dutch and Flemish pictures were sold for £2933 (fig. 11-9).[130] Eleven of the pictures offered in this sale were those that had been left to Henry Philip in the codicil of 1809.[131] Those pictures not offered for sale by Henry Philip eventually went to Thomas for display in the new gallery at Duchess Street. There is no obvious rationale for those that were dispersed or those that were kept in the family: the pictures in both groups were either inherited from John, belonged to Henry at Welgelegen, or were acquired at auction in London.

The 1811 sale was attended by some of the most eminent collectors of the day. Thomas bought at least two of the paintings, including Adriaan van der Werff's *Roman Charity*[132] and William van Mieris's *Bathsheba*,[133] although it is possible that he purchased one more picture.[134] The single largest purchaser in 1811 was Alexander Baring, 1st Baron Ashburton. The death of Henry signaled for Ashburton far more than just the break-up of a great collection, for within two years he bought Hope and Company from the brothers.[135] Of the eight paintings that Ashburton bought, at least five came from John's collection and at least seven had been displayed in Harley Street, two of which had been bequeathed to Henry Philip. Lord Yarmouth, later the 3rd Marquess of Hertford, bought the single most expensive painting, David Teniers's *Country Fete*, on behalf of the Prince Regent, later George IV: "for spirit of execution and clearness of tone, this picture is unrivalled."[136] The painting cost him £525. At the time of the 1811 sale, Yarmouth also happened to be a neighbor of Henry Philip in Seamore Place.[137] Many pictures were bought by dealers including Thomas Brooks, who was also a carver and a gilder and who had bought three pictures that were eventually advertised for sale at 45 Whitefriargate as belonging to "Mr. Hope."[138]

In June 1816, the remaining pictures were sold on the premises in Cavendish Square.[139] Over three days 286 pictures realized

£14,466. At this sale, as they had done in other family sales, various members of the family took the opportunity to dispose of minor pictures from their collection. At least four of those sold here were originally from Duchess Street. As in 1811, many collectors avidly competed for the finest works. The highest price was received for Rubens's *The Woman Taken into Adultery*, which realized £2,100 and was purchased on behalf of the wealthy merchant Sir Philip John Miles, M.P., for his collection at Leigh Court.[140] Miles bought at least eleven other Italian, French, and Spanish paintings and left the Dutch and Flemish pictures to others. Lord Yarmouth, who was specifically interested in the Netherlandish art, bought eight paintings in 1816, having already purchased the Teniers in 1811. At least three of these were for the Prince Regent and included Rubens's *Assumption of the Virgin*,[141] Ferdinand Bol's *Portrait of the Burgomaster Pancras, and His Wife*,[142] and Anthony van Dyck's *Gaston, Duke of Orléans*.[143] Yarmouth also bought three other Van Dycks. It has been suggested that originally all four of the Van Dycks sold here may have been acquired for the Prince Regent, who then decided to keep only one.[144]

Another buyer at the sale was the great collector and connoisseur George Watson Taylor,[145] who had already bought one of Henry's Jacob van der Ulst's pictures in 1811.[146] Watson Taylor would go on to amass a superb collection of pictures, as well as important French furniture, bronzes, and sculpture. He is interesting, however, not just because of the number of works he purchased in 1816, but also because by 1820 he was living in Henry's former residence in Harley Street.[147] Philipp von Neumann, secretary at the Austrian Embassy based at Chandos House, next door to Thomas's house in Duchess Street, attended a dinner at Watson Taylor's new residence in 1821 observing that "the splendour of this equals that of those belonging to the great nobles."[148] In 1816, however, Watson Taylor was residing at 5 Savile Row when he acquired eight pictures.[149] One of his purchases included Charles le Brun's celebrated *Family Portrait of Everhard Jabach*,[150] which had been brought over by Henry from his collection at Amsterdam. Watson Taylor also eventually acquired the pair of Van Dyck portraits of *Paul de Vos* and his wife, *Isabella van Waerbeke*, which had been bought by Yarmouth in 1816.[151]

Samuel Rogers, who had his own impressive collection in St. James's Place, was familiar with Henry's collection, having been an occasional guest at Harley Street.[152] Apart from a painting by Murillo, his purchases were all by Italian artists. According to one account, Rogers "actually crawled on his hands and knees" to obtain Paolo Veronese's *Mary Magdalene Anointing the Feet of Christ*.[153] It can be assumed, however, that Rogers would have coveted much more than just the paintings. As descriptions of his own house make clear, he had several objects copied from

"Hope's Book of Furniture," including "an elegant mahogany circular stand, on three bronze lions' legs, surmounted by sphinxes, and triangular plinth."[154] He had also incorporated into a house a "mahogany arched recess, copied from Mr. Hope's design."[155]

The dealer Philip Hill, having bought objects in 1811, returned to buy eight more in 1816. A few months after the 1816 sale, Farington related a problem that arose around one of these purchases: Claude Lorrain's *A Landscape with Figures and Cattle Descending to Pass a Ford*.[156] It is worth quoting in full:

> *I went at the desire of Sir Thos. [Lawrence] to look at a picture by Claude . . . He [Hill] gave something more than £100 for it, but having cleaned it, he had sold it to Mr. Gray of [blank] street, for £1000.—Mr. Gray had since it was taken to his house, shewn it to persons who said it was not by Claude, but a copy from him by Patel.—Gray is now unwilling to keep the picture, and says that he has understood that the picture belonged to Sir Felix Agar, & not to Hill, but Sir Thos. Lawrence shewed me a note from Hill, respecting the sale of the picture to Mr. Gray, which note Sir Thos. put into the hands of Mr. Gray & it fully manifested that the picture belonged to Hill.*[157]

Having examined it, Farington believed the picture to be by Claude.

Over ten days in July 1816, the furnishings and fittings of the Harley Street house were sold.[158] These included "rare Italian marble; a few articles of small sculpture; Parisian clocks and candelabra of bronze and or-moulu," a collection of Continental and English porcelain, and the remainder of the pictures. The cabinetmaker George Bullock, who at the time of the sale was living at and working from 4 Tenterden Street, Hanover Square, and about whom a professional connection with Thomas is discussed in Chapter 4, bought about forty-five pieces here. In December 1816, Henry's prints were being disposed of.[159] The following year, his extensive library, the last remainder of this magnificent collection, was finally sold.[160]

Adrian Elias Hope (1772–1834) and Henry Philip Hope (1774–1839)

After spending some time in London in 1795, Thomas returned to his travels in the company of Adrian Elias and Henry Philip, and they were recorded together in Rome between 1795 and 1796. The three brothers were extremely close and not only bought works of art individually but also made joint purchases, such as the statue of *Antinous* (see fig. 7-10) that was eventually displayed at Duchess Street.[161] In fact, all of their acquisitions from this trip, regardless of who bought them, were recorded at Thomas's house by 1804.[162] One of the reasons for this may have been due

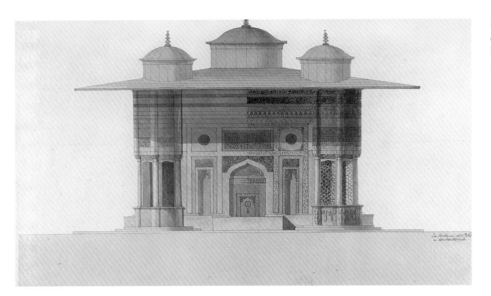

to the very different temperaments of the brothers. Adrian Elias was considered unpredictable and "rather strange," a trait that had been evident to his family from an early age.[163] By 1802 he had returned to Amsterdam to a house on the Heerengracht 61, and to his father's estates of Groenendaal and Bosbeek.[164] Henry Philip, "the angel of the family—an excellent heart & amiable disposition," was the most peripatetic of the three brothers and he traveled extensively (fig. 11-10).[165] Even during his residence in London, he moved with some frequency from renting rooms at 63 Harley Street in 1802[166] to living at 23 Baker Street between 1805 and 1806[167] and then at 150 New Bond Street between 1807 and 1809.[168] It seems likely that it would not have suited Henry Philip's circumstances to cart around large marble sculptures with some frequency. It is only in 1810, when Henry Philip moved into 3 Seamore Place, where he lived for five years, that anything is recorded about the contents of his residence.[169] In any case, the close relationship between Thomas and Henry Philip is well documented and may also account for this arrangement. Thomas commissioned a bust of Henry Philip from the sculptor and designer John Flaxman (cat. no. 9), which was installed on his dining room mantelpiece in Duchess Street between two horse heads. Like Thomas, Henry Philip was an accomplished draftsman, and like his brother he recorded the sites of his travels.[170] As with Beechey's portrait of Thomas, Henry Philip was depicted in Ottoman costume in a picture started by Sir Thomas Lawrence but largely completed by Sir Martin Archer Shee, who became Henry Hope's neighbor when he moved into Romney's house in Cavendish Square in 1799 (fig. 11-11).[171]

A view of the house in Seamore Place drawn by Henry Philip in 1818 when he was already living elsewhere shows that it was designed in the Greek Revival style (fig. 11-12). At three bays wide, its most notable feature was the back elevation, whose balcony of four caryatid figures holding wreaths by their side in turn supported a foliage-filled veranda above.[172] For Henry Philip its

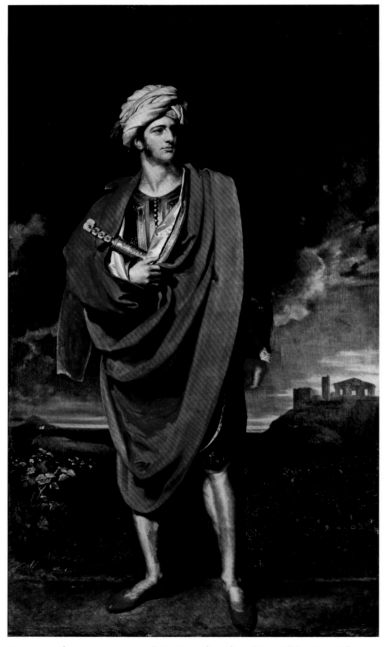

Fig. 11-11. Thomas Lawrence and Martin Archer-Shee. *Henry Philip Hope*. Oil on canvas, 1805. Trustees of the Chhatrapati Shivaji Maharaj Vastu Sangrahalaya formerly Prince of Wales Museum of Western India, Mumbai.

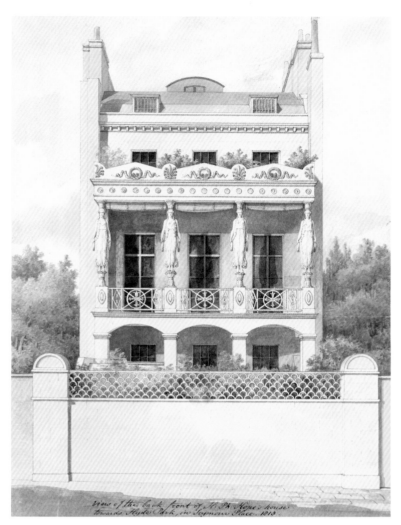

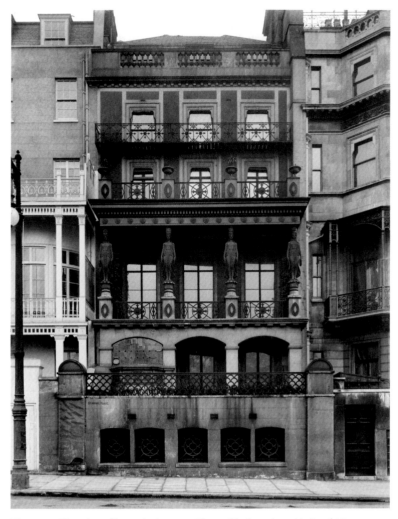

Fig. 11-12. Henry Philip Hope. View of the rear elevation of Henry Philip Hope's house towards Hyde Park in Seamore Place. Watercolor with pen and ink over graphite, 1818. Yale Center for British Art, Paul Mellon Collection, New Haven, B.1977.14.4765.

Fig. 11-13. Elevation of house in Seamore Place with alterations. National Monuments Record Office, Swindon, C39/55 Batsford.

precedent was in the "cariatides d'Athènes" drawn by him during a visit to Athens in the 1790s.[173] This balcony looked west onto Park Lane and Hyde Park beyond and was eventually remodeled by John Buonarotti Papworth, who added two stories in 1835 (fig. 11-13). By 1815 Henry Philip sold the house to another noted collector, Welbore Ellis Agar, 2nd Earl of Normanton, who appears to have also acquired some of the contents with his purchase.[174] The brothers' similarity in taste extended beyond their interest in antique sculpture, and surviving examples of the furniture from Seamore Place bear a close resemblance to Thomas's published designs in *Household Furniture* (see fig. 4-14). It seems likely that this furniture would have been supplied for Henry Philip by his brother Thomas.[175]

Henry Philip is probably best known, however, for his extensive collection of precious stones, including the infamous Blue Diamond, or Hope Diamond, as it is now known.[176] This was mounted by Henry Philip as a medallion with a border of diamonds in an arabesque pattern, although how he actually acquired the gem is not known. The Orléans collection also fur-

nished the brothers with more than pictures and one of the highlights of his jewelry collection was an indigo-colored sapphire from the same source.[177] The jewels were stored in a mahogany cabinet specially designed by Joseph Bramah, who had been trained as an engineer and who found success as a locksmith but had worked as a cabinetmaker when he first arrived in London. The cabinet's lid was decorated with a silver plate engraved with Henry Philip's arms.[178]

Between 1816 and 1819, Henry Philip once again moved with some frequency,[179] but by 1820 he had settled into 25 New Norfolk Street, where he remained until 1834.[180] He had acquired the house from the banker and noted art collector Abraham Wildey Robartes. Number 25 overlooked the park and in keeping with its neighbors was embellished with verandas, or bays, on the rear elevation.[181] The orientation of the houses was eventually changed so that the rear façade, which faced west to the park, became the front façade. A drawing that is recorded as being of 3 Seamore Place after Papworth's alterations is actually of the three-bay Norfolk Street house, drawn by Henry Philip, showing the

Fig. 11-14. Henry Philip Hope. Facade of three-bay late Georgian house on Norfolk Street. Ink and wash, 1818. Yale Center for British Art, Paul Mellon Collection, New Haven, B1977.14.4766.

distinctive delicate elegant scrolled tracery of the balconies (fig. 11-14).[182] Extant photographs show a brick elevation with five stories, the fifth perhaps a later addition.

From 1836, and for the last years of his life, Henry Philip resided at 1 Connaught Place, which had originally been built about 1810 and had been purchased by him from Sir Augustus d'Este, son of the Duke of Sussex and Lady Augusta De Ameland, for whom the house was built.[183] A perspective view shows a four-story corner house, with balconies projecting from the principal rooms and looking toward Hyde Park, with an arched portico entrance to the side.[184] The sitting room "looking towards the park" contained a "black and white marble library table," as well as old and modern glass, bronzes, and porcelain in display cabinets. On a *secrétaire* stood "two large Chinese carved and open worked ivory balls with crimson silk tassels" displayed under glass shades. Henry Philip owned "a beautiful ivory crucifix," which was kept in a mahogany case next to the chimney and may have been the same one owned by Thomas at Duchess

Street (see cat. no. 99).[185] His cameos and intaglios were kept in a shagreen case with silver embellishments, and his collection of snuffboxes was displayed in a black japanned box. His collection of medals included those belonging to Napoléon Bonaparte, and an onyx vase with enamel mounts was, over optimistically, attributed at the time to Benvenuto Cellini.[186] Some of these objects of vertu, bronzes, and china were among those Henry Philip had inherited from his father, John. In the back drawing room stood a mahogany cabinet that had been specially designed to hold his jewels.[187]

When Henry Philip died in 1839, his nephews inherited the bulk of his collection. At his death, however, and contrary to his expressed wishes, fighting broke out among his three nephews, Henry Thomas, Adrian John, and Alexander James Beresford, regarding ownership of the precious stones. This resulted in a protracted lawsuit that was widely reported upon at the time.[188]

Other Members of the Hope Family in London

When the Hopes arrived in London in 1794, they already had less notable family members living in the city. Sir Charles Pole, who was related to the Hopes by marriage, had moved into 2 Mansfield Street in 1795,[189] four years before Thomas's acquisition of number 1, which was then still occupied by General Robert Clerk. Henry's sister Henrietta Maria, widow of John Goddard, was by 1799 living in a house filled with pictures belonging to her brother[190] at 18 Upper Harley Street.[191] In 1808 John Langston, M. P., the husband of Henry's late niece Sarah Goddard, moved into 13 Cavendish Square, situated on the west side of the square.[192] He had previously lived at 7 Clifford Street, and in the year of his move to Cavendish Square he held a sale of his "genuine collection of original pictures."[193] After moving, he partially rebuilt his collection through gifts made to him by Henry,[194] who would eventually bequeath to him "all my pictures which are placed in his house."[195] Henry's third niece was Henrietta Goddard, who in 1792 had married the naval officer and politician Sir Charles Morice Pole, 1st Baronet, and they resided together at 10 Chandos Street.[196] One further address that needs to be considered is 2 Hanover Square. In a series of accounts entered into John Flaxman's books between July 1795 and October 1803, Thomas Hope's address is noted as number 2, even though it is known that he purchased the Duchess Street house in 1799.[197] On March 8, 1797, Farington writes he will be visiting the "Hopes in Hanover Square to see the collection of pictures—There are many very fine," and he then supplies a summary list of some of them. The question of whether any Hopes actually lived here remains problematic as no Hope is listed in the rate books or court guides for the period 1794 to 1800 as having lived either in the square or in

the vicinity of it. The only reference for Thomas prior to his purchase of 1 Mansfield Street is at 12 Berkeley Square in 1799.[198] To add to the confusion, the pictures described by Farington were also recorded with Henry Hope at 1 Harley Street. It is particularly strange as, for example, Levitsky's *Catherine II of Russia* was a gift to Henry and it seems unlikely that it would have been displayed in anyone else's collection.[199] Unfortunately, there is no satisfactory explanation as yet.

Henry Thomas Hope (1808–1862)

Henry Thomas's combined inheritance from his father and his uncle Henry Philip included a large amount of money,[200] the house in Duchess Street, the Deepdene, and the contents of the houses, as well as eventual ownership of the Blue Diamond and other jewels.[201] Among his many interests and occupations, he was a Member of Parliament, chairman of the Eastern Steam Navigation Company, and one of the founders of the *Art Union* (an institution of art patronage founded to encourage interest in the arts) in 1836. Despite including a glowing tribute to the Duchess Street house in the *Art Union* magazine in 1846,[202] Henry Thomas was already preparing to build himself a house at

Fig. 11-15. 116 Piccadilly, London. Photograph by Sir John Summerson. Reproduced by permission of English Heritage, NMR, B42/1467.

116 Piccadilly on the corner with Down Street.[203] This new house was to be built in "the most superb style,"[204] in contrast to Duchess Street, whose interiors must have looked tired and old fashioned by the 1840s. Between 1846 and 1850, he maintained residences at both Duchess Street and at 84 Piccadilly. After Duchess Street was demolished in 1936, he remained at his second residence until the completion of number 116 in 1852.[205]

The house at 116 Piccadilly was built in 1849–51 by the English architect and archaeologist Thomas Leverton Donaldson, working with the French architect Pierre-Charles Dusillon (fig. 11-15).[206] The façade was an idiosyncratic addition to those already standing and has been hailed as "the first edifice that illustrated a serious French influence on Victorian architecture."[207] On its Piccadilly side, the house had five double bays, which contained inlaid panels of Caen stone, metal, and colored marble between and above the windows.[208] Henry Thomas literally put his mark all over this house: the letter H appeared in the railings "among the richest and best executed to be found in London"[209]; the pediments above the windows contained his arms, and in the interior the oak doors were decorated with carved shields containing his initials. Much of the decorative work was ordered from French craftsmen on the continent; colored marbles were inset into the floors and walls.[210] The total cost to Henry Thomas was £30,000, which was practically the entire cash inheritance that he received from his father. Even though he had shown total disdain for his father's house by authorizing its demolition and thereby destroying Thomas's carefully conceived interiors, he filled his new house with the collection that he had inherited, which included Antonio Canova's *Venus* (cat. no. 57), Bertel Thorvaldsen's *Jason* (see fig. 8-6), and the collection of paintings.[211] Despite having inherited a large number of antique sculptures from his father, Henry Thomas relegated these to the Deepdene and began to purchase different examples for the Piccadilly house. The collection that he eventually formed was important enough for him to be regarded as a "serious collector" of sculpture in his own right.[212] Like his father, he also opened his house for viewings and applications could be made "on Mondays, from April to July, by cards obtainable by introduction to the owner." After his death, his house and collection passed to his French wife, Adele Bichat,[213] and by 1869 the house was occupied by the Junior Athenaeum Club.[214] It was eventually demolished in 1936.

Adrian John Hope (1811–1863)

Adrian John was the middle son of Thomas and Louisa Hope. His interest in the arts was cultivated from a young age when his parents traveled with him and his brothers on the Continent. During his travels, and in imitation of his father, he drew the sites that he

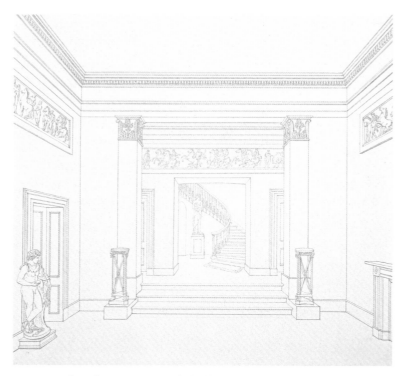

Fig. 11-16. Alexander Roos. Entrance hall of house in Carlton Gardens. Drawing, ca. 1837. Yale Center for British Art, Paul Mellon Collection, New Haven, B1977.14.4816.

visited and recorded them in his extant diary.[215] He comes across as a precocious youth whose observations on the art, architecture, and sculpture that he saw, and the theater and parties that he attended, fill his journal. During a visit to the Sèvres factory with his father, he exclaimed that "It was the first I ever saw and perhaps the finest I ever shall see."[216] And he was only eleven at the time!

He met Dominique Vivant Denon in Paris and, in the company of his parents, explored his collection of curiosities: "one mummie &c. . . . I saw the Head of A man 4 thousand years old—that had hear [sic] on it."[217] At his father's death in 1831, he was bequeathed £30,000,[218] and in 1836 he married the Frenchwoman Countess Matilda Rapp, daughter of Napoléon's aide-de-camp.[219]

The couple moved into 4 Carlton Gardens soon after their marriage, and they are recorded as living there between 1837 and 1846,[220] although in reality they appear to have resided primarily in Paris from 1842.[221] The previous tenant had been the banker William G. Coesvelt, who was now selling his own magnificent collection of pictures in 1837 and returning to the Continent.[222] They must have known him personally, as Coesvelt had been made a manager of the Hope and Company firm in Amsterdam in 1811.[223]

Carlton Gardens had been built between 1827 and 1833, at the same time as Carlton House Terrace, and was designed by John Nash and erected by James Pennethorne.[224] An exterior view of the house shows a four-story elevation, with the basement story out of view and with a canted three-bay porch.[225] It has now been established that before Adrian John took occupancy of the house, he commissioned Alexander Roos, a recent immigrant, to remodel its interior.[226] A series of architectural drawings and elevations are attributed to Roos. Relief panels, probably in marble, were set into the walls, and classical sculpture was displayed alongside Regency or Empire furnishings (fig. 11-16).[227] In the dining room, a pair of side tables with lion monopodia that sat

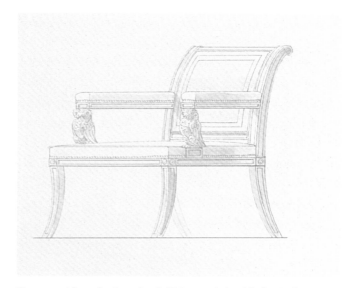

Fig. 11-17. Alexander Roos (probably). Armchair with ebonized supports carved in the shape of owls. Drawing, ca. 1837. Yale Center for British Art, Paul Mellon Collection, New Haven, B1977.14.4833.

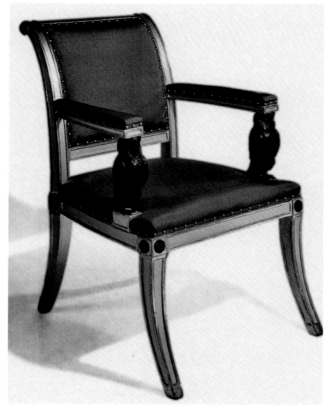

Fig. 11-18. Alexander Roos (probably). Armchair with ebonized supports carved in the shape of owls. Gilded wood, early 19th century. Private collection.

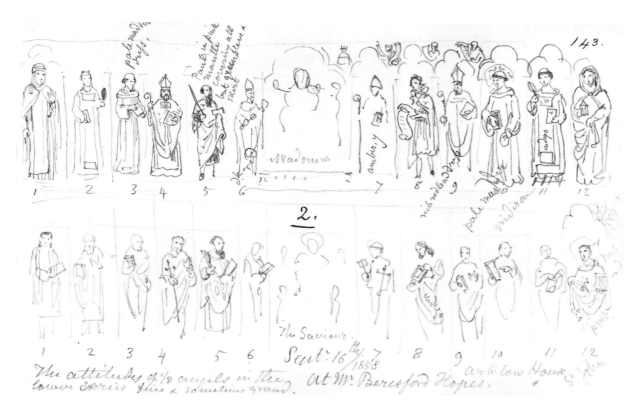

Fig. 11-19. Sir George Scharf. "Septr. 16th/1858. At M^r. Beresford Hopes. Arklow House" with a sketch of one of his paintings. National Portrait Gallery, London, Heinz Archive, 53 f. 143.

between the windows looks nearly identical to those in the picture gallery at Duchess Street.[228] The use of contrasting colors was also employed; the windows had Pompeian red hangings and the walls were pale blue. A room designated as "Mr. Coesvelt's bedroom" bears a close resemblance to the watercolor of Thomas's boudoir at the Deepdene and contained a canopied bed with wall hangings, a large wardrobe to the one side, opposite which stood a chimneypiece and mirror. Only two of the chimneypieces from Carlton Gardens are known to have survived the demolition of the house in 1932.[229] The first, from the anteroom on the first floor is carved in *griotte d'Italie*, a red-colored marble quarried near Carcassone.[230] This chimneypiece was mounted with gilt-bronze medallions showing classical female heads, with vases, meandering vines, and swans decorating the jambs. The second chimneypiece to survive came from the octagonal drawing room.[231] During discussions regarding its acquisition for the Victoria and Albert Museum, the chimneypiece was described as the "finest specimen of a sculptured marble Regency fireplace they have ever seen" but was sold for an absurdly small sum where the "original cost must have been out of proportion to this."[232] One of the pieces of furniture designed for the house, also probably by Roos, was a recently discovered armchair with ebonized supports carved in the shape of owls that conform to the extant drawings (figs. 11-17, 11-18).[233] Once again the comparisons with his father's interior are evident; this type of owl appears on the jambs of the Aurora Room chimneypiece at Duchess Street.[234]

From 1846 Adrian John lived on the quai d'Orsay in a house built about 1840 by Theodore Charpentier,[235] although whether he maintained a London residence between 1847 and 1858 is unknown. By 1859 he had moved into a house at 12 Langham Place, Portland Place, where he lived until his death. Eventually his collection was sold by his son Adrian Elias (1845–1919).[236]

Alexander James Beresford Beresford-Hope (1820–1887)

Alexander James Beresford was Thomas Hope's youngest son. He inherited 1 Connaught Place from Henry Philip and lived here between 1841 and 1888.[237] He was a Conservative M. P. and a supporter of the Church of England and undertook to build at his own expense William Butterfield's masterpiece, All Saint's Church, Margaret Street, in London (1849–59), the model church of the Ecclesiastical Society. A prominent public figure, he was also an author with an extensive interest in the arts and architecture, and he wrote perceptively about his father's artistic achievement. His marriage to Lady Mildred Cecil, eldest daughter of James, 2nd Marquess of Salisbury, and sister of the 3rd Marquess, brought him to the highest level of English society.

Sir George Scharf, art historian and first director of the National Portrait Gallery, visited Alexander at his house in London[238] and at his country estate, Bedgebury, in Kent (fig. 11-19).[239] Except for a collection of family portraits that he had inherited, Alexander collected early Renaissance paintings, including one attributed to Jan van Eyck "on wood & quite Sienese in character." His collection also included marbles, bronzes, ivory and wood carvings, porcelain, and many fine jewels from Henry Philip, which were all sold at auction in 1886.[240]

In a letter of May 7, the artist and dealer Charles Fairfax Murray wrote to his friend William Spanton: "The other day I saw the Beresford Hope coll.n the pictures are not much with 2 exceptions but the other things are wonderful. I want the Orleans sapphire myself but people tell me it will fetch thousands so I have given up the idea for the present!"[241] His library was sold in 1892[242] and contained correspondence between Flaxman and his own father, which has recently been traced to a private collection.[243]

"London, a place which contains such an infinite number of matchless curiosities,"[244] was a home to three generations of Hopes. By moving there, they managed to avoid that which had befallen some of their contemporaries fleeing the Napoleonic wars. Thomas's children were to be the last patrons and collectors of note in the family. By 1851 Duchess Street had been demolished, as Henry Thomas moved into his fashionable up-to-date house on Piccadilly. Despite the destruction of the interior decorations of Duchess Street, the contents of the house survived and remained with the family at the Deepdene. Henry Thomas's daughter Henrietta Adela (1843–1913) married Henry Pelham Alexander, 6th Duke of Newcastle, and it was decided that since their eldest son would inherit the Newcastle title, their second son would inherit the Hope collection. Unfortunately for the Hopes, this second son, Henry Francis Hope Pelham-Clinton-Hope, or Lord Francis Hope, as he was known, proved to be a total liability to the family. He was profligate and was eventually declared bankrupt, and it became inevitable that he would begin selling off his inheritance. By the 1890s, the beginning of the wholesale dispersal of Thomas's collection was put in place, and in 1898, just short of the one hundred years since Thomas had commenced work on Duchess Street, the most important pictures were sold to the dealer Asher Wertheimer. In that same decade another branch of the family was also selling off their inheritance when Adrian John's collection was sold by his son Adrian Elias (1845–1919). At the same time, Lord Francis removed himself from the Deepdene and rented out the furnished house, first to the Dowager Duchess of Marlborough and later to Almeric Paget. By 1917 practically everything that remained in the family from the collections of John, Henry, Thomas, Henry Philip, and Adrian Elias was sold in a series of sales held by Christie's in July, and by Humbert and Flint in September. The "hurricane" that had first brought these collectors, and their collections, to London had taken hold again.

Acknowledgments

In the preparation of this chapter I would like to thank Philip Hewat-Jaboor, Jeannie Chapel, Richard Garnier, Eileen Harris, Joseph Friedman, Lynda McCloud, and Henriette Manners.

1. *Picture of London for 1802, being a correct guide* (London, 1802): 211.
2. Christian A. G. Goede, *The Stranger in England; or, Travels in Great Britain. Containing remarks on the politics, laws, manners, customs, and distinguished characters of that country; and chiefly its metropolis: with criticisms on the stage. The whole interspersed with a variety of characteristic anecdotes. from the German of C. A. G. Goede*, vol. I (London, 1807): 34.
3. Celina Fox, ed., *London—World City 1800–1840* (New Haven and London: Yale University Press, 1992).
4. *Gedenkstukken der Algemeene Geschiedenis van Nederland van 1795 tot 1840 uitgegeven door Dr. H. T. Colenbrander. Eerste deel. Nederland en de Revolutie 1789–95* ('S-Gravenhage: 1908): 366 (letter no. 267).
5. Johan E. Elias, *De Vroedschap van Amsterdam 1578–1795*, vol. 2 (Haarlem, 1905): 935–36.
6. PRO Kew: PROB 11/1531. Some of John Hope's pictures were left by Henry Hope, in a codicil to his will, to his cousin Henry Philip.
7. For a complete discussion and analysis, see J. W. Niemeijer, "De kunstverzameling van John Hope (1737–1784)," *Nederlands Kunsthistorisch Jaarboek* 32 (1981): 127–232.
8. Samuel Ireland, *A Picturesque Tour through Holland, Brabant, and part of France; made in the autumn of 1789* (London, 1790): 111.
9. Charlton Byam Wollaston to his sister Mary Frampton, 13 June 1791, published in *The Journal of Mary Frampton, from the year 1779 until the year 1846*, ed. Harriot Georgiana Mundy (London: Sampson Low & Co., 1885): 38.
10. L. H. M. Quant, *Paviljoen Welgelegen 1789–1989* (Haarlem: Schuyt, 1989): 43–44. De Neufforge published his architectural engravings in *Recueil élémentaire d'Architecture* (Paris, 1757–68, 1772–80). The portico at Welgelegen is closely based on one of his designs.
11. Prints and Drawings Department, Yale University, New Haven: The Hope Architectural Collection, B1977.14.4901–4905. The Haarlem-based artist Hubert Schouten painted views of Welgelegen shortly after construction had been completed. The engraved plates were made by Christian von Mechel (1737–1817) and his assistants Christian Haldenwang and Benjamin Comte. Hubert's son, G. J. Schouten, was commissioned ca. 1835 to paint another Hope house, called Bosbeek. For other views on Welgelegen, see Ireland, *A Picturesque Tour* (1790): opp. 111, which he says was "made on the spot." Welgelegen is now the home of the Provincial Executive of the province of North Holland. For a complete history of the house, see Quant, *Paviljoen Welgelegen* (1989).
12. These included copies after *Lacoön*, *Venus de Medici*, *Apollino*, and Giambologna's *Mercury*.
13. Niemeijer, "De kunstverzameling van John Hope" (1981): 209, cat. no. 370.
14. *Voyage Philosophique et Pittoresque, sur les rives du Rhin, a Liège, dans la Flandre, le Brabant, la Hollande, etc. fait en 1790 par George Forster*, vol. 2 (Paris, 1790): 396. It has always been assumed that Henry Hope installed the chimneypiece in the library at Welgelegen although there is no written record of it being here before the 20th century. It was removed to the Rijksmuseum in 1962. I would like to thank Reinier Baarsen for this information. See plate III in *Diverse Maniere d'Adornare I Cammini ed ogni altra parte degli edifizi desunte dall'architecturra Egizia, Etrusca, e Greca, con un ragionamento aologetico in difesa dell'architettura Egizia, e Toscana opera del cavaliere Giambattista Piranesi architetto* (Rome, 1769): "Le Cariatidi l'arcitrave e gli altri pezzi di marmo sono avanzi di opere antiche dal Cavaliere Piranesi uniti insieme a formare il presente camino, che si vede in Olanda nel gabinetto del Cavaliere Giovanni Hope." Also see John Wilton-Ely, *Piranesi* ([London]: Arts Council of Great Britain 1978): 101.

15. Mr. Pratt, *Gleanings through Wales, Holland and Westphalia, with views of Peace and War at Home and abroad. To which is added Humanity; or the rights of nature. A Poem revised and corrected*. vol. 2 (London, 1797): 75.

16. As well as giving away part of the collection to her sisters, nieces, sister-in-law, and brother-in-law, Philippina sold off part of John's collection at auction, some porcelain being sold 22–24 June 1785 and some of his paintings between 10 and 11 August 1785.

17. Some of the silver was sold by Lord Francis Hope, Christie's, London, 17 July 1917; Duke of Newcastle, Christie's, London, 7 June 1937, lots 83, 91, 92. See Niemeijer, "De kunstverzameling van John Hope" (1981): 163.

18. I would like to thank the Baring Archive for permission to quote from their papers. Northbrook Business Papers NP1. A1.18 (10 October 1794).

19. Northbrook Business Papers NP1. A1.18 (3 October 1794), f. 2ʳ.

20. Northbrook Business Papers NP1. A1.19 (7 October 1794). A series of chests were marked "TH" and valued at £18,170.

21. Recorded by Farington on 27 January 1795, in *The Diary of Joseph Farington*, ed. K. Garlick et al., vol. 2 (New Haven and London: Yale University Press, 1978): 296–97.

22. Niemeijer, "De kunstverzameling van John Hope" (1981): 155.

23. *The Stranger in England*, vol. I (1807): 111.

24. Ibid.

25. William Buchanan to Irvine, 30 April 1805, in *William Buchanan and the 19th century art trade: 100 letters to his agents in London and Italy*, ed. Hugh Brigstocke (privately published, 1982): 396.

26. *Picture of London* (1802): 216.

27. Ibid., 212.

28. *A catalogue of a truly capital, select, and highly valuable collection of painted Greek vases, bronzes, coins, ancient and modern sculpture, and miscellaneous articles of virtu, the property of Sir John Coghill, Bart. deceased, and formed by him at great expense during his residence a few years ago in Italy*, Christie's, London, 18–19 June 1819. First day, lots 32, 34, 96, 99, 103, 117. Second day, lots 9, 74, 96, 107, 109, 112, 117, 121, 141.

29. Bought on the first day, lot 32.

30. These are presumably the ones in the Fitzwilliam Museum, Cambridge. They were sold at Christie's, London, 23–24 July 1917, lot 205, and are catalogued in Geoffrey B. Waywell, *The Lever and Hope Sculptures* (Berlin: Gebr. Mann Verlag, 1986): 112, without reference to the 1819 sale.

31. The sale was held at 88 Pall Mall and at the Lyceum, in the Strand. See the series of advertisements in the *Times*, 25 December 1798, no. 4365, p. 1, until *Times*, 5 December 1799, no. 4658, p. 4; Buchanan, *Memoirs of Painting* (1824): 9–24; George Redford, *Art Sales. A History of Sales of Pictures and other Works of Art*, vol. 1 (London, 1888): 69–76. Some of the less important pictures were later sold at auction.

32. Buchanan, *Memoirs of Painting* (1824): 21–22.

33. Ibid., 146. It cost him 500 guineas.

34. *The genuine, capital, and valuable collection of select and beautiful cabinet pictures, the undoubted works of the most celebrated esteemed Dutch and Flemish masters; in the highest state of preservation; the property of His Excellency the Baron Nagel, Ambassador from the States of Holland, &c. . . . with many other scarce and valuable pictures*, sale cat., Christie's, London, 21 March 1795.

35. *A catalogue all that noble & superlatively capital assemblage of valuable pictures, drawings, miniatures, and prints, the property of the Right Hon. Charles Alexander de Calonne, late Prime Minister of France; selected with equal taste, judgement, and liberality during his residence in France; and his travels through Italy, Germany, Flanders, and Holland, and while in England; at the immense expense of above sixty thousand guineas, there is also included a small elegant collection of cabinet pictures, bequeathed to him by the late Monsieur d'Arveley, High Treasurer of France; forming together the most splendid collection in Europe, which were intended for a magnificent gallery at his late house in Piccadilly. Comprising the inestimable works of the most admired masters of the Roman, Florentine, Bolognese, Venetian, Spanish, French, Dutch, and English schools*, sale cat., Skinner and Dyke, London, 23–28 March 1795; Buchanan, *Memoirs of Painting* (1824): 11, 217–56.

36. *The catalogue of all that perfect and beautiful assemblage of cabinet pictures, the property of the Greffiers Fagel, selected with infinite taste and judgement, brought from the Hague to England. Which will be sold by auction*, sale cat., Peter Coxe, Burrell, and Foster, at Mr. Squibb's Great Room, Saville Passage, Conduit Street, London, 22–23 May 1801.

37. *The renowned and valuable collection of Italian, Venetian, Flemish, and Dutch pictures, late the property of John Purling Esq. deceased; whose accurate judgement, pure taste and liberality in purchasing, rendered his cabinet equal to most of the private galleries in Europe, and exhibits a magnificent assemblage of the works of Raphael, Correggio, Carracci, Guido, Domenichino, P. da Cortona, Parmegiano, Titian, Tintoretto, S. Ricci, P. Veronese, C. Maratti, Claude, Poussin, Murillo, Cuyp, Rubens, Teniers, Wouvermans, P. Potter, Venderwerff, Vandevelde, Berghem, Ferg, Zuccarelli, Wilson, &c. . . . no. 68, Portland Place*, sale cat., White, sold on the premises, London, 16–17 February 1801.

38. *A catalogue of a most superb and truly valuable collection of pictures, containing admirable and celebrated specimens, chef d'oeuvres of the principal masters of the Italian, Flemish, Dutch, and Flemish schools, being the united cabinet of Sir Simon Clarke, Bart. and George Hibbert, Esq. selected by them with distinguished taste, and at a considerable expence, out of the collections of the Duke of Orleans, Mr. Gildemester of Amsterdam, Mr. de Calonne, Mr. Woodhouse, &c. &c.*, sale cat., Christie's, London, 14–15 May 1802.

39. *All that well-known and valuable collection of capital paintings, the property of the late most noble the Marquis of Lansdowne, which have long been considered as one of the great ornaments of Lansdowne House, comprising the best efforts of those admired masters, Rubens, Claude, Leonardo da Vinci, Ludovico Caracci, Correggio, Salvator Rosa, Guido, Guercino, Velasquez, Procaccini, &c. Nicolo Poussin, Gaspar Poussin, Paulo Veronese, Titian, Teniers, Berghem, Vernet, Bassan, &c. Canaletti, Paulo Panini, Rembrandt, Albert Durer, Jordaens, Gonsalvez, Murillo, Vanderveldt, &c. . . . on the premises, Lansdowne House, Berkeley Square*, sale cat., Peter Coxe, Burrell and Foster, sold on the premises, London, 19–20 March 1806.

40. Buchanan to Stewart, 4 May 1804, in Brigstocke, *William Buchanan* (1982): 293.

41. Now in the Royal Collection 34. Bought on second day of sale, Christie's, London, 14–15 May 1802, lot 56, for £430 10s.

42. Now in the Budapest, Szépművészeti Museum 3823. Bought on second day of sale, Christie's, London, 14–15 May 1802, lot 47.

43. Now in the Fritz Lugt Collection, Fondation Custodia, Paris. Sold second day, Peter Coxe, Burrell and Foster, London, 19–20 March 1806, lot 41; Edward Foster, *The British Gallery of Engravings, from pictures of the Italian, Flemish, Dutch and English schools, now in the possession of the King, and several noblemen and gentlemen of the United Kingdoms: with some account of each picture*. (London, 1807): pl. 20.

44. Now in the Beaverbrook Art Gallery, New Brunswick, Canada. It was sold on the third day, lot 43, for £325 10s: *A catalogue of all that valuable and magnificent collection of Italian, French, Flemish, and Dutch pictures, selected with singular taste and admitted judgement, the property of Mr. Bryan and comprising the original works and great performances of the following masters*, sale cat., Peter Coxe, Burrell, and Foster, at Mr. Bryans Gallery, Pall Mall, London, 17–19 May 1798.

45. Sold third day, 17–19 May 1798, lot 55, for £304.10s.

46. *A catalogue of the valuable collection of accurate copies, from the works of the most celebrated masters, in the principal galleries and private collections in Italy and Germany, executed with great spirit, unremitted diligence, and infinite merit; as also, three capital original pictures, by the most ingenious artist, the late Mr. Guy Head, deceased, during a residence of sixteen years on the continent. The above assemblage will be found highly interesting to the lovers of fine arts, as comprising many admirable and faithful copies from chef d'œuvres of the great Italian and other masters, which have, since, suffered irreparable injury during the late revolutions on the continent*, sale cat., Christie's, London, 13 March 1802.

47. 13 March 1802, lot 108.

48. Foster, *The British Gallery of Engravings* (1807): 5.

49. *A catalogue of a capital and elegant assemblage of marble chimney pieces, executed by eminent artists, in a superior stile, many of them with columns, and suitable enrichments, and are particularly adapted for drawing rooms, eating parlors, libraries, bed chambers, &c. &c. Two very neat monuments of a moderate size, with carved urns. And a few models in terra cotta*, sale cat., Christie's, London, 25 July 1799.

50. Christie's, London, 25 July 1799, lots 8, 12, 18.

51. Waywell, *The Lever and Hope Sculptures* (1986): 42. *A catalogue of a small assemblage of capital and valuable marbles, recently consigned from Italy; consisting of a few fine statues, bustos, and bas-reliefs, particularly a capital antique bas-relief; a mythological subject with many figures; valuable tables of (antique) mosaic, porphyry, and verd antique; a large vase of porphyry; a ditto of green basalt; Italian marble chimney pieces tastefully executed, &c. &c.*, sale cat., Christie's, London, 31 May 1800. Hope bought lots 17, 26, 34, 39, 41.

52. Waywell, *The Lever and Hope Sculptures* (1986): 42; *A catalogue of a small pleasing collection of pictures . . . bronzes; remarkably fine alabaster figures, . . . antique marble statues, cinerary urns, &c. property of His Grace the Duke of St. Alban's (who is removed to Mansfield Street.)*, sale cat., Christie's, on the premises, the west side of St. James's Place, 29 April 1801, lots 88, 92, 93.

53. Waywell, *The Lever and Hope Sculptures* (1986): 42, only mentions the sale held on 7 April 1801: *Catalogue of the well-known, and truly valuable collection of antique statues, bustos, Aegyptian, and other vases, bas-reliefs, &c. (including a few capital pictures, reserved from the late valuable collection,) the property of a noble Earl, deceased, (no less distinguished for his exquisite taste and judgement in the fine arts, than for his liberality in collecting.)* [Earl of Bessborough], sale cat., Christie's, sold on the premises at Roehampton, 7 April 1801. Bessborough had already held another sale from which Hope also made purchases: *A catalogue of the well known and truly capital collection of pictures, forming an assemblage of the great and most admired masters of the Italian, French, Flemish, and Dutch schools . . . formed by the late Earl of Besborough, deceased, no less distinguished for his exquisite taste, than for his liberality in collecting*, sale cat., Christie's, London, 5–7 February 1801.

54. *A select part of the capital, valuable, and genuine collection of pictures. The property of the Rt. Hon. Sir W. Hamilton, K.B. . . . also, a small, but most capital assemblage of antique busts, bas-reliefs, and other valuable marbles, particularly a bust of Nero, in porphyry; an exquisite bas relief of Bacchus, and the goddess metal and an Ægyptian lion in basalt*, sale cat., Christie's, London, 27-28 March 1801. For an analysis of Hope's purchases see Ian Jenkins, "Seeking the Bubble Reputation," *Journal of the History of Collections* 9, no. 2 (1997): 191–203.

55. *A most valuable, curious and highly interesting collection of Etruscan or Greek vases and antique bronzes, formed at infinite expence, and with indefatigable research, during a course of thirty years, by the late Mr. James Clark, antiquary, of Naples, dec. well known for his superior intelligence in the various branches of the antique. In this collection, are some vases of Nola, particularly valuable from their size, variety, and curious paintings; a few Sicilian and others, of the most beautiful and elegant designs, and many pieces truly deserving the attention of the learned antiquary and curious collector. Among the bronzes are two antique figures in the Egyptian style, particularly fine and well preserved; an antique balance, and other rare articles*, sale cat., Christie's, London, 9 June 1802.

56. *A catalogue of a genuine, superb and truly valuable assemblage of vases, marbles, and other objects of virtù, the property of, and collected by a man of fashion, during a recent visit to Rome and Naples: comprising a numerous collection of singularly-fine Etruscan vases . . .* , sale cat., Christie's, London, 29 March 1805.

57. Henry was not noted for his collection of prints and drawings. He had even turned down the chance to buy Joshua Reynolds's prints, despite having met him and owning several works by this master, on account that "has never collected prints or drawings." Farington, *Diary*, vol. 2 (1978): 306 (19 February 1795).

58. *A catalogue of the very valuable and entire collection of drawings and paintings in oil, of Sir Robert Ainslie, Bart. The whole of which were executed by that ingenious artist, Mayer, for Sir Robert Ainslie, during his travels in the Levant, his residence at Constantinople, and his return from thence to England . . . also, a few marbles*, sale cat., Christie's, London, 10–11 March 1809.

59. On the first day he purchased oil paintings that comprised lots 33, 34, and 35, and the drawings that comprised lots 40, 41, 42, 43, 44, 46, 92.

60. "A beautiful small sitting figure of Vulcan, in statuary by Sir H. Cheere," lot 97, and "a small sitting figure of Venus, the companion, very fine," lot 98, Christie's, London, 10–11 March 1809. These appeared on the market in 2004 and are now in an English private collection and on loan to the Victoria and Albert Museum.

61. Lots 97, 98, 99, 100 on the first day and lots 110, 111, 112 on the second day.

62. Waywell, *The Lever and Hope Sculptures* (1986): 42. *A catalogue of a capital and valuable collection of Italian, French, Flemish and Dutch pictures, valuable antique marbles in groupes, statues, bustoes, basso relievos, fine bronzes; particularly a dine antique statue of Leda; a ditto of Hercules; and a small draped statue of Minerva. The property of the late Duke of St. Albans, Dec. brought from his Grace's late residence, in Mansfield Street, Portland Place*, sale cat., Christie's, London, 27 March 1802.

63. Thomas consigned lots 1, 40–42, 44–45, 95–96, 102. Henry Philip consigned lots 13–24, 38, 46.

64. Christie's, London, 27 March 1802, lot 23.

65. Ibid., lot 15.

66. *A catalogue of a valuable collection of Italian, French, Flemish & Dutch pictures, a few drawings and prints, framed and glazed: the property of gentleman, deceased, brought from his seat in the country*, sale cat., Christie's, London, 26–27 April 1805, lot 18.

67. *A capital, very select and valuable assemblage of chiefly Italian pictures, of the very finest class and merit; the genuine property of a gentleman, . . . also, a few capital and highly-finished Flemish and Dutch pictures, the property of the same person, in exquisite preservation*, sale cat., Christie's, London, 24 May 1806.

68. *A catalogue of the very extensive and valuable library of Henry P. Hope, Esq. among which is a very rare and singular collection of canon and civil law; likewise containing books of prints, (most generally of very superior impressions) Also, a few diplomatic manuscripts*, sale cat., Leigh and Sotheby, London, 18 February 1813, and seventeen following days. This sale sold for £3837.1.6.

69. *A catalogue of the valuable collection of prints and drawings of Henry P. Hope, Esq. consisting of elegant specimens of the Italian, French, Dutch and English engravers; including scarce British portraits by the following artists, Pass, Delaram, Glover, Hollar, Faithorne, R. White, Williamson, &c. (with many proofs.) Likewise a choice selection of original drawings in Indian ink and water colours, being views in Rome, Holland, etc. by R. Rogman, A. Rademaker, Haeckert, V. Haan, Pronk, A. Beyer, etc. Also containing the superb publication of the Farnese Gallery, and the ornaments of the Vatican after Raphael, elaborately coloured from the original picture*, sale cat., Leigh and Sotheby, London, 18 March 1813, and seven following days. They sold for £777.0.6.

70. *An assemblage of prints, and high-finished miniature paintings, after the frescoes at Herculaneum and in the Vatican. A few original grand historical drawings: proofs by Morghen: and various loose prints*, sale cat., Christie's, London, 1 May 1813.

71. *A catalogue of a valuable collection of Italian, French, Flemish and Dutch pictures, the property of an amateur of fashion, among which are specimens of the following great and celebrated masters*, sale cat., Christie's, London, 15 May 1813.

72. Christie's, London, 15 May 1813, lot 46. The most expensive painting realized £25.

73. *A catalogue of an exceedingly valuable assemblage of antique marbles, painted Greek vases, of large size and unusual forms; a few fine works of modern sculpture. Also, two fine shafts of columns of red Egyptian granite, and of giallo antico, in a very perfect state; a variety of slabs, and a few chimney pieces, the property of a gentleman of distinguished taste collected by him in Italy*, sale cat., Christie's, London, 30 April 1813. Christies Archives, Day Book March 1811–May 1818, f. 25, undated entry written between 3 and 13 March 1813: They brought "twenty one packages or large Heavey cases" to Christie's "in six cart loads . . . 2 carts more with cases. 8 pictures 11 pieces."

74. Christie's, London, 30 April 1813, lot 113.

75. Ibid., lot 117.

76. Ibid., lot 48. In a visit to the Deepdene in 1826, Neale records seeing on the side tables of the old library "small marble statues of Minerva and Flora." See J. P. Neale, *Views of the Seats of Noblemen and Gentlemen in England, Wales, Scotland, and Ireland*, 2nd ser. vol. 3 (1826): 9.

77. Ibid., lot 59.

78. Ibid., lots 2, 3.

79. Ibid., lot 69.

80. A manuscript list of the pictures brought to 1 Harley Street is in the Amsterdam Municipal Archives 735/2895. It is divided into three catalogues designated "A," "B," and "C," signed by Henry Hope and dated 17 December 1795. Catalogue A valued at £12,000 lists 185 pictures. Catalogue B valued at £10,000 lists 129 pictures, and Catalogue C valued at £4000 lists fifty-three pictures. The average price per picture was about £65, £78, and £75, respectively. The lists are reproduced in Marten G. Buist, *At spes non fracta: Hope & Co. 1770–1815, Merchant Bankers and Diplomats at Work* (The Hague: Bank Mees & Hope NV, 1974): 486–94.

81. *Picture of London* (1802): 212–13. See Buist, *At spes non fracta* (1974): 245, 615, for a discussion of John Williams's acquisition of Talleyrand's library of more than 10,000 volumes.

82. Westminster City Archive (WCA) St. Marylebone Rate Books, 1794–95. The rate book was assessed on 23 May 1795 and indicates that sometime during that year Henry took over occupancy.

83. I would like to thank Patrick Caddel, archivist at Hopetoun House, East Lothian, for this information.

84. Information on the history of the house during Chandos's ownership is from C. H. Collins Baker and Muriel I. Baker, *The Life and Circumstances of James Brydges First Duke of Chandos, Patron of the Liberal Arts* (Oxford: Oxford University Press, 1949): 265–89.

85. He moved here from his house in St. James's Square, formerly Ormonde House.

86. In the sale of Henry's nephew Alexander James Beresford Beresford-Hope held at Sotheby's, 27–30 July 1892, lot 732, the plans and views of Hopetoun House, bound in a volume, were sold to Sir A. Hayter; Soane Museum (SM) Drawings, vol. 29 (83–91); Walter L. Spiers, *Catalogue of the Drawings and Designs of Robert and James Adam in Sir John Soane's Museum* (Cambridge: Chadwick Healey Ltd., 1979); David King, *The Complete Works of Robert & James Adam and Unbuilt Adam* (Oxford and Woburn: Architectural Press, 1991; repr. 2001).

87. SM 29(83).

88. Richard Horwood's map of 1813 also shows that the footprint of the house extended northwards, with a garden behind. This may confirm that the recessed addition to the east side of the building that was hinted at in one of the Adam drawings was constructed. Richard Horwood, *The A to Z of Regency London. A facsimile of Richard Horwood's Maps*, intro. by Paul Laxton (Lympne Castle: Harry Margary in association with Guildhall Library, 1985).

89. Niemeijer, "De kunstverzameling van John Hope" (1981): 168. He mistakenly mentions that it was Henry who built a new gallery in "Duchess Street, Portland Square." Niemeijer must have been referring to Thomas, who had two galleries built, one in 1799 and the other in 1819. This inaccuracy has often been repeated; including the most quoted source in Buist, *At spes non fracta* (1974): 50.

90. Mr. Nugent, *The Grand Tour; or a Journey through the Netherlands, Germany, Italy and France*, vol. I (London, 1778): 70; quoted by S. Baumgarten, *Le crépuscule Néo-Classique: Thomas Hope* (Paris, 1958): 15, n. 22.

91. WCA St. Marylebone Rate Book 1795. They paid £600 per annum.

92. WCA St. Marylebone Rate Book 1796. His closest neighbor in the square was Lady Langham (possibly/probably the wife of the politician Sir James Langham, 7th Bt. [1736–1795]), at number 12, and the politician Rowland Burdon, M.P. (1756–1838) on the Harley Street side, at number 2. By 1796 his neighbours included Charles Cocks, 1st Baron Somers (1725–1806), William Plumer, M.P. (1736–1822), Lady Mackworth (possibly/probably the wife of Sir Herbert Mackworth, 1st Bt., M.P. [1737–1791]), the politician Sir Grey Cooper, Bt. (ca. 176?–1801), Charles Anderson Pelham, 1st Baron Yarborough (1749–1823), Thomas Grosvenor (1764–1851), army officer and nephew of Richard, 1st Earl of Grosvenor, Sir David Lindsay 4th Bt. (ca. 1732–1797), Shute Barrington, Bishop of Durham (1734–1826), John Rushout, 1st Baron Northwick (1738–1800), father of the great collector and art connoisseur; George Augustus North, 3rd Earl of Guildford (1757–1802), and the painter George Romney (1734–1802).

93. "Memoir Of The Late Mr Henry Hope" (obituary), *Gentleman's Magazine* 81, pt.1 (March 1811): 293.

94. *Recollections of the Table-Talk of Samuel Rogers*, ed. Rev. Alexander Dyce (New Southgate: M. A. Rogers, 1887): 267–68.

95. Farington, *Diary*, vol. 10 (1982): 3756 (18 September 1810).

96. Ibid., vol. 9, 3277 (15 May 1808).

97. Foster, *The British Gallery of Engravings* (1807): pl. 4. This was also true of many other London collections, including the Duke of Bridgewater, Sir Simon Clarke, Walsh Porter in Argyle Place, Welbore Ellis Agar in Norfolk Street, Park Lane, Richard Payne Knight, and Charles Townley.

98. *England, Wales, Irland und Schottland. Errinnerungen an Natur und Kunst aus einer reife in den Jahren 1802 und 1803 von Christian August Gottlieb Goede*, vol. 4 (Dresden, 1805): 98–122. Goede was only able to record part of the collection due to two rooms being closed. I would like to thank Marijke Booth for translating this for me.

99. Goede, *The Stranger in England; or, Travels in Great Britain*, vol. 3 (London, 1807): 19.

100. Henry purchased a series of Jasperware vases from the Wedgwood manufactory that were made specifically for him. See Wedgwood MS 15422-16, 21 May 1787, noted in Diana Edwards, "Thomas Hope's Wedgwood Purchases," *Ars Ceramica* 13 (1996): 24–29; Eliza Meteyard, *The Wedgwood Handbook. A Manual for Collectors* (London, 1875): 272–73.

101. Niemeijer, "De kunstverzameling van John Hope" (1981): cat. nos. 372–375 for Parsons and 380 and 384 for Morison.

102. David Watkin, "Hope and Wedgwood" (unpublished essay, 1998); Edwards, "Thomas Hope's Wedgwood Purchases (1996): 25.

103. Ibid., 27. Thomas Hope's vase is now in the Wedgwood Museum, Barlaston, Stoke-on-Trent. The original Portland Vase is in the British Museum.

104. Now in the Museum of Fine Arts, Boston, inv. no. 06.2362. I would like to thank Joseph Friedman for pointing out to me the inventory of 1 Harley Street in the Frick Art Reference Library *"Pictures of H. Hope, Esqr. Cavendish Square M.S.S. catalogue, 1810."*

105. David Watkin, "'The Hope Family' by Benjamin West," *Burlington* 106 (1964): 571–73. Farington had initially written that these were to be a series of individual half portraits. Also see 3 March 1804, in Farington, *Diary*, vol. 6 (1979): 2259–60.

106. The marriage of Anne and John Williams was an unhappy one, with Anne being "much disgusted at not being more noticed & distinguished in England than she is." Recorded 31 March 1797 in Farington, *Diary*, vol. 3 (1979): 789–90.

107. William Williams Hope lived at Rushton Hall, Northamptonshire, as well in various residences in London and 131-3 (now. no. 57) rue Saint-Dominique, in Paris, where his house was disparagingly referred to as "little Versailles." His extensive collection was dispersed in a series of sales held by Christie and Manson, London, 14–16 June 1849; and in Paris on 4–9, 11–12, 14–16 June 1855 and 11 May 1858.

108. Now at Blair Atholl. J. W. Niemeiyer, "A Conversation Piece by Aert Schouman and the Founders of the Hope Collection," *Apollo* 108 (September 1978): 182–89.

109. This is pointed out by Watkin, "The Hope Family" (1964): 572.

110. Northbrook Business Papers NP1. A1.20, in a chest numbered 52 and marked "B."

111. Henry Moses, *Vases from the Collection of Sir Henry Englefield* (London, 1820), pl. 35:5. The vase was sold as lot 41 on the second day of Englefield's sale: *valuable and highly interesting collection of painted Greek vases of Sir Henry Charles Englefield, Bart. deceased, which are known to the public by the very elegant engravings made there from by Mr. Moses, under the direction of the late proprietor; Together with unpublished plates, from vases in the collection*, sale cat., Christie's, London, 6–8 March 1823.

112. Lots 28 and 35 in *A catalogue of a genuine, superb and truly valuable assemblage of vases, marbles, and other objects of virtù, the property of, and collected by a man of fashion, during a recent visit to Rome and Naples: comprising a numerous collection of singularly-fine Etruscan vases*, sale cat., Christie's, London, 29 March 1805.

113. Sold Christie's, London, 30 April 1813, lots 19, 29, 35, 55, 62, 63, 65.

114. Moses worked with Thomas Hope on *Costume of the Ancients* (1809) and *Designs of Modern Costume* (1812; 2nd ed., 1823). He also dedicated an 1814 publication to him.

115. *Household Furniture* (1807): pl. XLVIII.

116. Now in the National Portrait Gallery, London. Beechey lived in Great George Street, Hanover Square.

117. Now at Hillwood Museums and Gardens, Washington, D.C.

118. Hope, in Amsterdam, to Baron Sutherland in St. Petersburg, 4 December 1789, quoted in Buist, *At spes non fracta* (1974): 104–5.

119. *Sir Joshua Reynolds. A Journey to Flanders and Holland*, ed. Harry Mount (Cambridge: Cambridge University Press, 1996): 95–101, n. 465. Sir Joshua made the visit in 1781 but only published it in 1797. Also see *The Letters of Sir Joshua Reynolds*, ed. John Ingamells and John Edgecumbe (New Haven and London: Yale University Press, 2000): 100–102, n. 7. There has been some uncertainty as to whether the pictures seen were those in the collection of John or Henry, both of whom lived in Amsterdam.

120. Sir Joshua Reynolds, or Studio, now in a private collection.

121. *Voyage Philosophique et Pittoresque* (1790): 409–11.

122. Buchanan to Irvine, Letter 15, 6 August 1803, in Hugh Brigstocke, ed., *William Buchanan and the 19th century art trade: 100 letters to his agents in London and Italy* (privately published, 1982). Brigstocke, *William Buchanan* (1982): 98.

123. Now in the Borghese Gallery, Rome. See William Buchanan, *Memoirs of Painting with a chronological history of the importation of pictures by the great masters into England since the French revolution*, vol. 1 (London 1824): 62.

124. Now in the Musées Royaux des Beaux-Arts, Brussels, inv. no. 3461.

125. Now in the Wallace Collection, London, inv. no. P85.

126. Farington, *Diary*, vol. 11 (1983): 3884 (26 February 1811). "Memoir Of The Late Mr Henry Hope" (obituary), *Gentleman's Magazine* 81, pt. 1 (March 1811): 292–93; "Mr. Henry Hope" (obituary), *Times*, 5 March 1811, no. 8236, p. 4; "Deaths in and near London: Henry Hope" (obituary), *Monthly Magazine* 31, no. 211 (1 April 1811): 282–83. PRO Kew: PROB 11/1531, the will of Henry Hope, signed 13 January 1811, proved 1812.

127. For history of occupation after Henry's death, see St. Marylebone Rate Books, 1812–19.

128. The codicil to his will contained "a catalogue of Dutch and Flemish pictures which I have in contemplation to bequeath . . . to Henry Philip Hope Esqr. Such pictures with a copy of this catalogue to be delivered to him by my executors after my decease," dated 13 December 1810. These pictures were also listed in *Catalogus van het Cabinet Schilderijen & ander Rariteiten* (cat. 2 in the RKD) as "Dutch and Flemish pictures which I have in contemplation to bequeath by my will or some codicil thereto to Henry Philip Hope Esq. Such pictures with a copy of this catalogue to be delivered to him by my executors after my decease," originally dated 11 April 1809 but altered to read 30 December 1810. Also see in Nottingham University Archives, Department of Mss and Special Collections, no. 2413 (uncatalogued material) with annotations made to the pictures inherited by Henry Philip.

129. *An Account of all the pictures exhibited in the rooms of the British Institution, from 1813 to 1823, belonging to the nobility and gentry of England* (London 1824): 162–63, no. 28, 184–85, no. 1. Henry Philip is named in the catalogue of the British Institution exhibition as the owner of pictures that had been first in Henry's possession and later in Thomas's, including Rembrandt's *The Storm on the Sea of Galilee* (stolen from the Isabella Stewart Gardner Museum, Boston) and Gabriel Metsu's *Man Writing a Letter* (in the National Gallery of Ireland, Dublin, inc. no. 4536).

130. *A catalogue of an assemblage of capital Flemish and Dutch pictures, the genuine property and a part of the magnificent collection of that distinguished connoisseur and patron of the arts, Henry Hope, Esq. dec. and removed from his late mansion in Cavendish Square. Among which will be found, The Village Feast, a grand chef d'œuvre by Teniers, an unrivalled performance for spirit of execution and fine tone of color. Cavaliers and Ladies Halting from the Chace, by Berchem; the very celebrated embarcation of K. William at Rotterdam, and two other sea pieces by Backhuysen. The Roman Charity, by V. der Werff; a landscape by Claude; two by Lingleback. Five by Poelemberg, one of which a most precious gem, was formerly in the private collection of Rubens; and others by Hondikoeter, Cuyp, V. der Helst, Goltzius, Breughel, Rottenhamer, Ferg, Limberg, Jansens, de Cort. Two fine landscapes and figures, by Zuccarelli; and an original portrait of Mary, Queen of Scots, by Jamieson*, sale cat., Christie's, London, 6 April 1811. Also see Christie's Archive, King Street, Day Book March 1811–May 1818. Entered 29 March 1811, for sale 6 April 1811, "from Mr [Ansen] Pall Mall 58 pictures the property of Mr Hope."

131. See the Appendix in this volume, which lists the twenty pictures left by Henry to Henry Philip.

132. Now in the Royal Collection.

133. This painting was thought to be of *Vertumnus and Pomona* when in Henry's collection and may have been the one consigned for sale by Henry Philip, Christie's, London, 23 May 1812, lot 80.

134. See Charles Molloy Westmacott, *British Galleries of Painting and Sculpture*, pt. 1 (London: Sherwood, 1824): 232, 238, for the Van Os fruit and flower pieces. The cost for a "fruit piece," lot 47 in 1811, was deducted from £2933.4.6, the total amount made at the sale, along with lots 40 and 48, which were the two that Thomas had definitely bought himself.

135. He bought lots 38, 39, 41, 42, 43, 53, 54, 56.

136. Now in the Royal Collection.

137. WCA Rate Books 1811.

138. Arthur G. Credland, *Artists and Craftsmen of Hull and East Yorkshire* (Kingston upon Hull: Hull Museums and Art Gallery, 2000): 119. I would like to thank Frances Collard for pointing this out to me.

139. *A catalogue of the highly distinguished and very celebrated collection of Italian, French, Flemish and Dutch pictures, the genuine property of Henry Hope, Esq: deceased. Which will be sold by auction, by Mr. Christie, at Mr. Hope's mansion, Cavendish Square, corner of Harley Street*, sale cat., Christie's, London, 27–29 June 1816.

140. It was sold on the third day, 27–29 June 1816, lot 99; Young, *A Catalogue of the Pictures at Leigh Court* (1822): no. 6, illus.

141. Sold from "cabinet and drawing rooms, first floor," third day, 27–29 June 1816, lot 79.

142. Now in the Royal Collection, inv. no. 1155. Sold from "cabinet and drawing rooms, first floor," third day, 27–29 June 1816, lot 85.

143. Now in the Musée Condé, Chantilly, inv. no. 125. Sold from the "anti room and drawing rooms, ground floor," first day, 27–29 June 1816, lot 84. The Van Dyck eventually left the Royal Collection in 1829 as a gift from George IV to the duc d'Orléans, later King Louis-Philippe of France.

144. John Ingamells, *The Wallace Collection Catalogue of Pictures IV. Dutch and Flemish* (1992): 101.

145. Watson Taylor's own collection was housed in the Cavendish Square house, as well as at Erlestoke Mansion, Wiltshire. After his death the collection, including many of the pictures that he had purchased from Henry Hope, was dispersed in a series of sales. See Christie's, London, 9 March 1818; ibid., 13–14 June 1823; ibid., 28 May 1825; George Robins, 30 March–1 June 1832; ibid., 9 July–1 August 1832, and Redford, *Art Sales* (1888): 123.

146. Christie's, London, 6 April 1811, lot 32.

147. WCA Marylebone Rate Book 1820, f. 1, rent of £800. Watson Taylor owned a pair of views by John Seguier that showed a view from the house looking south into Cavendish Square. These were sold as lots 120 and 121 on the 15th day of his sale, 25 July 1832. Their present location is unknown.

148. *The Diary of Philipp von Neumann 1819–1850*, vol. 1, ed. and trans. E. Beresford Chancellor (London, 1928): 56. According to Chancellor, Watson Taylor paid £20,000 for the house and more than £48,000 in decorations and repairs.

149. Christie's Archive, King Street, Day Book, 1 April 1816 [Day Book, November 1811–May 1818].

150. Last recorded in home of Mr. F. W. H. and Lady Prudence Loudon, at Olantigh, near Wye, Kent. Sold from the "staircase," first day, 27–29 June 1816, lot 90.

151. The portrait of Mr. de Vos was destroyed in a fire in 1890; the portrait of Mrs. de Vos is in the Wallace Collection, London, inv. no. P16.

152. Samuel Rogers's collection was sold posthumously in a series of sales at Christie's. Henry's pictures were sold with *The very celebrated collection of works of art the property of Samuel Rogers, Esq., deceased; comprising ancient and modern pictures; drawings and engravings; Egyptian, Greek, and Roman antiquities; Greek vases; marbles, bronzes, and terra cottas, and coins; Also, the extensive library; copies of Rogers's Poems, illustrated; the small service of plate and wine*, sale cat., Christie's, 28 April–10 May 1856. His other sales were held by Christie's, London, 7 May 1856, 20 May 1856, 26–27 May 1856, and 28 May 1856.

153. *The Athenaeum* (29 December 1855); quoted in Frank Hermann, *The English as Collectors. A Documentary Sourcebook* (London: John Murray, 1999): 253. It was sold by Hope's executors from the "anti room and drawing rooms, ground floor," first day, 27–29 June 1816, lot 62.

154. Sold by Rogers, seventh day sale, 28 April–10 May 1856, lot 823.

155. See the description of his residence, 22 St. James's Place, which is published in the sale catalogue, Christie's, London, 7 May 1856.

156. Sold from the "anti room and drawing rooms, ground floor," first day, 27–29 June 1816, lot 80.

157. Farington, *Diary*, vol. 14 (1984): 4896 (3 September 1816).

158. *A catalogue of the elegant and modern household furniture, capital large French and English pier and chimney glasses; seasoned bedding, and every description of bedroom furniture; complete drawing-room suits of silk damask, and sattin furniture; noble slabs of rare Italian marble; a few articles of small sculpture; Parisian clocks*

and candelabra of bronze and or-moulu; a chamber finger and barrel organ, by Flight and Robson, of peculiar sweet tone, with stops to give the effect of a full orchestra; sideboard of plate, table service of Dresden, Vienna, Danish & French porcelain; choice wines, consisting of old port, Madeira, sherry, red and white clarets, Hermitage, Burgundy, and Champagne, very old hock, tockay, malmsey, Malaga, Cyprus, &c. Fine table and bed linen, including dining cloths of unusual dimensions, and numerous valuable effects, the genuine property of Henry Hope, Esq. which will be sold by auction (without reserve) by Mr. Christie, on the premises, corner of Harley Street, Cavendish Square, sale cat., Christie's, London, 3-6 and 10 July 1816, and, A catalogue of the remainder of the elegant and modern household furniture, capital large French and English pier and chimney glasses; slabs of rare Italian marbles; seasoned bedding, and every description of bed-room furniture; dining room tables, chairs, sideboards, library furniture, including capital telescopes by Dolland and Short; a few articles of small sculpture; Parisian clocks and candelabra of bronze and or-moulu; and the numerous contents of the kitchen and offices, the genuine property of Henry Hope, Esq. which will be sold by auction, by Mr. Christie, on the premises, corner of Harley Street, Cavendish Square, sale cat., Christie's, London, 11-13, 16-17 July 1816. See also Christie's Archive, King Street, Day Book, March 1811–May 1818. Entered 27 July 1816, f. 265.

159. A catalogue of prints and fine books of prints, the property of Henry Hope, Esq. removed from Cavendish Square. To which is added, a small and genuine collection, consigned from Germany, sale cat., Sotheby's, London, 5-7 December 1816.

160. A catalogue of the elegant library of H. H. of Cavendish Square. Mr. Saunders, London, 10-15 March 1817.

161. John Ingamells, A Dictionary of British and Irish Travellers in Italy 1701–1800 (New Haven and London: Yale University Press, 1997): 521; Waywell, The Lever and Hope Sculptures (1986): 40 passim. The figure of Antinous is now in the Lady Lever Art Gallery, Port Sunlight, inv. no. 208.

162. Ingamells, Dictionary of British and Irish Travellers (1997):522; Waywell, The Lever and Hope Sculptures (1986): 19–20, 40, 72–73, 78. Henry Philip purchased the Dionysus and Idol now in the Metropolitan Museum of Art, New York, inv. no. 1990.247 and the Hermaphrodite now in the Lady Lever Art Gallery, Port Sunlight, inv. no. 13. Adrian Elias purchased an Apollo, location unknown, and an Athlete, unidentified.

163. Northbrook Business Papers NP1. A1.2 (26 Jan. 1790), f. 3ᵛ.

164. Nottingham University Archives, Department of Mss and Special collections, Ne 6 G 4/16 and Ne 6 G 4/18. An inventory taken at his death shows that the only objects of pecuniary value were 'three golden bowls studded with various coloured stones'. Also see Elias, De Vroedschap van Amsterdam, vol. 2 (1905): 935.

165. Northbrook Business Papers NP1. A1.2, John Williams to Baring (26 Jan. 1790), ff. 3ᵛ-4ʳ; Ingamells, Dictionary of British and Irish Travellers (1997): 520; Times, 3 December 1844, no. 18784, p. 6. He also visited parts of the Ottoman Empire, while his business interests took him on annual trips to the Netherlands.

166. Boyle's New Fashionable Court and County Court Guide, and Town Visiting Directory (London, 1843). Boyle's 1802. He was renting as the WCA Rate Books indicate that the rates were paid by "James Mills, for tenants."

167. Boyle's January 1805. He was renting as the WCA Rate Books indicate that the rates were paid by "Mrs. Charlotte Charlton."

168. Boyle's 1807-9. A Richard Robinson also listed as living here.

169. Boyle's by January 1810. His name only appears in the WCA Rate Books for the period 1811-14.

170. Prints and Drawings Department, Yale University, New Haven: The Hope Architectural Collection, B1977.14.4727-4743, 17 watercolor drawings by Henry Philip Hope. These included views of Constantinople and an aqueduct at Alexandria Troad.

171. Kenneth Garlick, Sir Thomas Lawrence: A Complete Catalogue of Oil Paintings (Oxford: Phaidon, 1989): no. 146, as whereabouts unknown. The painting has been traced to the Prince of Wales Museum, Mumbai, inv. no. 22.4614. Garlick states that the painting was incomplete at Lawrence's death and remained in his studio, dated 1805. Andrew Wilton attributes the painting to Shee.

172. Department of Prints and Drawings, Yale University, New Haven: The Hope Architectural Collection, B1977.14. 4765, ink and watercolor drawing; A photograph of the house was published in "The Empire Style in England–II," The Architectural Review 30 (December 1911): 324.

173. Department of Prints and Drawings, Yale University, New Haven: The Hope Architectural Collection, B1977.14. 4737.

174. WCA Rate Books, f. 28. Rent of £220. The connection to Henry Philip is recorded in an 1874 inventory of Somerley, the country house that the 2nd Earl acquired from Henry Baring in 1828. See Hampshire Record Office 21.M.57 2nd Earl Box "D," "Catalogue of pictures, engravings and furniture at Somerley 1874," vol. 1. According to his document, at least 11 objects and possibly a further 8, came from Henry Philip in Seamore Place.

175. There are other similarities in the taste of the brothers. Like his brother Thomas, who was a patron of the firm Rundell, Bridge and Rundell, Henry Philip paid them over £350 for unspecified work undertaken for him (Barings Ledger no. 100024 [1818–1819], ff. 139v–139r).

176. This is now in the Smithsonian Institution, Washington D.C. See Henry William Law and Irene Law, The Book of the Beresford-Hopes (London: H. Cranton, 1925): 70–72; Ian Balfour, Famous Diamonds (3rd ed., London: Christie's Books, 1997): 124–35, in which he recounts the history of the diamond.

177. A. H. Church, Precious Stones considered in their Scientific and Artistic Relations. With a Catalogue of the Townshend Collection of Gems in the South Kensington Museum ([London]: Chapman and Hall Ltd., 1891): 101–11.

178. A Catalogue of the Collection of Pearls and Precious Stones formed by Henry Philip Hope, Esq. Systematically arranged and described by B. Hertz (London: printed by William Clowes and Sons, 1839). The jeweler Bram Hertz compiled a catalogue of Henry Philip's collection that contained a description of the jewels accompanied by drawings of them. Chauncey Hare Townshend (1798–1868) eventually acquired at least 55 from Henry Philip's collection, now in the Victoria and Albert Museum, London.

179. According to the WCA St. Marylebone Rate Books, 1816–1818, he was living at 10 Cavendish Square, on the north side. In 1819 he was living at 30 Norfolk Street with a Sir William Cummins.

180. Boyle's 1820. By 1821 it becomes New Norfolk Street.

181. Photograph by Bedford Lemere in N.M.R.O. The street was eventually known as Dunraven Street. For a complete history, see Survey of London, XL. The Grosvenor Estate in Mayfair. Part II. The Buildings (London: Athlone Press, 1980): 194, 282–83, pl. 48, a-c; pl. 73 a-b.

182. Department of Prints and Drawings, Yale University, New Haven: The Hope Architectural Collection, B1977.14.4766.

183. Boyle's 1836–39. Also see Department of Prints and Drawings, Yale University, New Haven: The Hope Architectural Collection, B1977.14.4767–4770. For more on the history of the house, see A History of the County of Middlesex, ed. T. F. T. Baker, vol. 9 (Oxford University Press, 1989), or The Victoria History of the County of Middlesex, vol. 9, ed. C. R. Elrington (Oxford: Oxford University Press, 1989).

184. Department of Prints and Drawings, Yale University, New Haven: The Hope Architectural Collection, B1977.14.4767–4770.

185. Westmacott, British Galleries (1824): 219.

186. PRO Kew PROB 11/1927. The medals were bequeathed to William Carr, Viscount Beresford, and the vase to his wife, Louisa Hope, later Viscountess Beresford.

187. Department of Prints and Drawings, Yale University, New Haven: The Hope Architectural Collection, B1977.14.4770. Times, 3 December 1844, no. 18784, p. 6.

188. Law, The Beresford Hopes (1825): 114. He asks them to "cherish and cultivate a fraternal regard and affectionate feeling for each other." See Times, 3 August 1843, p. 7, "Hope vs. Hope"; 3 December 1844, no. 18784, p. 6. There were three suits issued by his nephews regarding ownership of the jewels. Eventually Alexander James Beresford brought a claim against Henry Thomas to recover the cabinet of diamonds and stones estimated to be worth £50,000.

189. WCA Marylebone Rate Book 1795; Boyles 1796: 105. Boyles January 1814 edition.

190. PRO Kew: PROB 11/1531, f. 142.

191. WCA St. Marylebone Rate Book 1799.

192. WCA St. Marylebone Rate Book 1808.

193. Boyle's 1793–1807. A catalogue of a genuine collection of original pictures, brought from the country, to the owner's mansion, no. 7, Clifford Street, comprising the works of the following masters, viz. Philip Wouvermans, Ruysdael, J. Both, J. Miel,

Vandycke, Guido, P. de Cortona, The Poussins, and others equally interesting., sale cat., Mr. White, London, 17 May 1809, containing 39 lots. On the same day "will be sold by auction the above freehold mansion."

194. PRO Kew: PROB 11/1531, f. 142.

195. John Young recalled in 1822 how Henry, on discovering Nicholas Poussin's *The Plague at Athens* hanging on Langston's gloomy staircase where its "merits appear to have been very imperfectly appreciated," and from where it was "rescued by the penetrating eye of Mr. Hope, in whose collection justice was done to its merits." Despite its apparent merits, the painting is no longer attributed to Poussin but is considered a work of Michael Sweerts and is now in Los Angeles County Museum of Art, inv. no. AC1997.10.1. See John Young, *A Catalogue of the Pictures at Leigh Court, Near Bristol; the seat of Philip John Miles, Esq. M.P. with etchings from the whole collection. Executed by permission of the proprietor, and accompanied with Historical and Biographical Notices* (London, 1822): no. 19, illus. Following Langston's death, the contents of his house was sold by Harry Phillips, London, 15–17 June 1812. Only the third day of this catalogue survives: "capital paintings by esteemed masters. Collected by the late J. Langston, Esq." A copy of this catalogue owned by George Watson Taylor describes the owner not as John Langston but as "the late Henry Hope." Presumably these pictures were part of those bequeathed by Henry to Langston in 1811 although it should be noted that none of them can be identified with those in Henry's collection. This information on Watson Taylor's catalogue is taken from Provence Index. J. Paul Getty Trust, 2001 <www.getty.edu>.

196. An Admiral Pole is recorded in *Boyles Court Guide* living here between 1798 and 1814. Henry would eventually bankroll Pole's parliamentary aspirations by making him the running partner for John Langston.

197. BM Add Mss. 39784BB, f. 12.

198. *Boyle's* 1799.

199. If the Hanover Square house is a separate residence, then the following can be concluded: It contained paintings listed in all three insurance lists that were made of 1 Harley Street in 1795. All of the pictures are eventually returned to Harley Street.

200. ING Barings' General Ledger Account books no. 100035 (June 1832–December 1833): f 251v.

201. For infighting between brothers, and his mother Louisa, and eventual break up of collection, see Law, *The Beresford Hopes* (1825): 115–19.

202. Gustave F. Waagen, *Works of Art and Artists in England*, vol. 2 (838): 324–43, "Visits to Private Galleries X. The collection of H.T. Hope, Esq., Duchess-Street, Portland-place," *The Art Union* 8 (1 April 1846): 97–98.

203. Boyles. Having undertaken alterations to the Deepdene and purchasing Castle Blayney. Many objects from the Deepdene, along with those he inherited, were removed to Castle Blayney. See Nottingham University Archives, Department of Mss and Special collections Ne 6 I 1/5, "Inventory and Valuation of furniture, ornamental items, pictures, books, plate, jewellery, linen, and other effects, at the castle at Castleblayney, Co. Monaghan, in Ireland, the property of the late Mrs. Hope, made for the purpose of administration" (1884): ff.1r–121v.

204. *The British Metropolis* (1851): 100.

205. *Boyle's* 1846–50. In 1851 this was "yet uncompleted." *The British Metropolis* (1851): 133. He must have been living at 84 Piccadilly.

206. Engraved in *The Builder* 7 (20 October 1849): 498. For photographs of the house before demolition in 1936, see H.-R. Hitchcock, *Early Victorian Architecture in Britain*, vol. 2 (London and New Haven: Yale University Press, 1954): pl. VII 17, and in NMRO NBR B42/1467, taken by Sir John Summerson.

207. Hitchcock, *Early Victorian Architecture* (1954): 108.

208. These were sketched by Sir George Scharf (1820–1895) in 1863. See his sketchbooks in the National Portrait Gallery Heinz Archive. SSB 66, ff. 66, "at Mr. Hope's House in Piccadilly. June 8th. 1863."

209. See engraving in *The Builder* 7 (20 October 1849): 499; *A New Survey of London: fully developing its antiquity, history, and arch, palatial and ecclesiastical structures, public buildings, social, literary, and scientific institutions, various galleries of art, parks, pleasure gardens, and conservatories, trade and manufactures, government and municipal arrangements, railways, canals, and water supply, and its geography, geology, and natural history. Illustrated by a newly constructed whole sheet map, and more than two hundred finely executed engravings of the most interesting subjects*

in the metropolis and its vicinage, vol. 1 (London, 1853): 730; John Timbs, *Curiosities of London, exhibiting the most rare and remarkable objects of interest in the Metropolis; with nearly fifty years' personal recollections* (1855): 488–89; another edition (1868): 551.

210. *The Builder* 7 (20 October 1849): 493–94, 498–99.

211. *The British Metropolis* (1851): 133–34; *New Survey of London* 1 (1853): 411–13; *ILN* 32 (3 April 1858): 352. After his death, the pictures were loaned to the South Kensington Museum. See "The Hope Collection of Dutch and Flemish Pictures," *The Art Journal* 7 (1 October 1868): 224.

212. Waywell, *The Lever and Hope Sculptures* (1986): 60–61.

213. After death of Henry Thomas, Anna Adele lived at 35 Belgrave Square, the Deepdene, and Castle Blayney. For an inventory of her London residence, see Nottingham University Archives, Department of Mss and Special Collections, Ne 6 I 1/8, "An Inventory of heirlooms (furniture and effects) at 35, Belgrave Square (late) the property of Mrs. A. A. Hope deceased 24th. February 1887." The house was filled with Hope objects that presumably made their way from Duchess Street or the Deepdene via Piccadilly to Belgrave Square.

214. *Boyle's* 1869.

215. Adrian John Hope's Diary, Mss, private collection. It contains entries made intermittently between 1822 and 1834.

216. Adrian John Hope's Diary, on his way to Versailles in July 1822.

217. Ibid., August 1822.

218. Law, *The Beresford Hopes* (1825): 69.

219. An acrimonious separation ensued in 1854, the details of which were summarized in the broadsheets when he sued for custody of their children in the French and English courts.

220. *Boyle's* 1837–April 1846.

221. *Times*, 25 December 1854, no. 21933, p. 10.

222. *Times*, 11 May 1837, no. 16413, p. 8.

223. Coesvelt was an extremely accomplished collector and held at least five sales of works from his collection between 1834 and 1847. For more on Coesvelt's employment with Hope and Company, see Buist, *At spes non fracta* (1974): 66 passim.

224. Simon Bradley and Nikolaus Pevsner, *The Buildings of England. London 6: Westminster* (New Haven and London: Yale University Press, 2003): 444.

225. Department of Prints and Drawings, Yale University, New Haven: The Hope Architectural Collection, B1977.14.4819–4814. Also see John Harris, "Lo Stile Hope e la Famiglia Hope," *Arte Illustrata* 6, nos. 55–56 (December 1973): 326–30.

226. Richard Garnier, "Alexander Roos (c.1810–1881)," *The Georgian Group Journal* 15 (2006): 11–68. Garnier argues that Roos also undertook work for Henry Thomas at the Deepdene from 1836 to 1841 and for Alexander James at Arklow House, Connaught Place, ca. 1839, as well as for their mother, Louisa, at Bedgebury Park.

227. Department of Prints and Drawings, Yale University, New Haven: The Hope Architectural Collection, B1977.14.4816.

228. Ibid., B1977.14.4818.

229. In the Victoria and Albert Museum, London, inv. no. A.57-1932. See Department of Prints and Drawings, Yale University, New Haven: The Hope Architectural Collection, B1977.14.4824–4825. Diane Bilbey & Marjorie Trusted, *British Sculpture 1470 to 2000* (London: V&A Publications, 2002): 270, cat. no. 413. It was saved from demolition in 1932 by T. Crowther & Sons and presented to the Victoria and Albert Museum in the same year.

230. Bilbey & Trusted, *British Sculpture* (2002): 270. It is suggested that it may have been made by the Carron Company in Falkirk.

231. Victoria and Albert Museum, London, inv. no. A.56-1932. Ibid., 442, cat. no. 387.

232. When these were saved a mahogany and bronze sideboard, location unknown, possibly from 4 Carlton Gardens, was also offered to Victoria and Albert Museum. V&A acquisition file in AAD 1932/8580.

233. In a private collection U.S.A. Ink and wash drawing, Department of Prints and Drawings, Yale University, New Haven: The Hope Architectural Collection B1977.14.4833.

234. See also "a marble chair of the gymnasiarch from Stuart's Athens," published in Henry Moses, *A Collection of Antique Vases, Altars, Paterae, tripods, Candelabra, Sarcophagi, &c.* (London, 1811): pl. 147.

235. Department of Prints and Drawings, Yale University, New Haven: The Hope Architectural Collection, B1977.14.4848–4858 for the house on the rue

Pigale, Quai d'Orsay, and B1977.14.4859–4876 for Colmar, the Chateau de Wildenstein and a house on the rue Plumer, Paris.

236. *Catalogue of the renowned collection of pictures by old masters, formed by the late Adrian Hope, Esq.; also a few by Modern Artists*, sale cat., Christie, Manson & Woods, London, 30 June 1894. These were consigned from Adrian Elias's residence in Chesterfield Gardens. See Christie's Library and Archives, King Street, *Christie's Day Book no. 26. J. K.* 1894-5, no. 78k.; Hermann, *English as Collectors* (1999): 434. The library was sold by Sotheby's in 1896; *Times*, 18 April 1896, no. 34868, p. 12; *Catalogue of the valuable collection of engravings after Sir E. Landseer and the old Italian masters, the property of Adrian Hope, Esq.*, sale cat., Christie, Manson & Woods, London, 3 July 1894, lots 1–45; *Catalogue of old Venetian glass, old German glass & ware, antique painted Italo-Greek, Greek, and Etruscan vases, and a few specimens of antique glass, the property of Adrian Hope, Esq.*, sale cat., Christie, Manson & Woods, 13 July 1894, lots 1–91. Adrian Elias moved to 55 Prince's Gate, where he lived until 1909, in which year he held a sale of *Empire decorative objects*, sale cat., Christie, Manson & Woods, London, 26 March 1909.

237. *Boyle's* January 1841–88. The house is referred to as Arklow House from 1855, when 1 Connaught Place is combined with no. 2. For more on the history of the house, see *A History of the County of Middlesex*, vol. 9, ed. T. F. T. Baker (Oxford: Oxford University Press, 1989) or *The Victoria History of the County of Middlesex*, vol. 9, ed. C. R. Elrington (Oxford: Oxford University Press, 1989).

238. NPG Heinz Archive, Scharf Sketch Books, SSB 53, 15–16 September 1858, ff. 136–148. Scharf Sketch Books, SSB 96, 16 February 1878, ff. 73–74. Also see Gustav Friedrich Waagen, *Galleries and Cabinets of Art in Great Britain* (Murray 1857): 189–92.

239. Alexander inherited Bedgebury on his stepfather's death in 1854. Scharf's recorded visits to Bedgebury occurred on 7 August 1863. See NPG Heinz Archive, SSB 67, ff. 21ʳ-22ᵛ, and again in September 1877, SSB 95, ff. 59ᵛ-69ʳ. See Department of Prints and Drawings, Yale University, New Haven: The Hope Architectural Collection, B1977.14. 4834–4839 for drawings of the house and 4840–4847 for its contents and interior decoration. Also see Law, *The Beresford Hopes* (1925): 178 passim.

240. *The collection of jewels and works of art of the Right Hon. A. J. B. Beresford Hope, M. P., comprising choice examples of Mediaeval and Renaissance art, marbles, bronzes, carvings in ivory and wood, mosaics, Limoges enamels, Majolica and Palissy Ware; fine Oriental Sèvres, Dresden, and other Porcelain; Italian and French decorative furniture, &c; comprising also the greater portion of the celebrated collection of jewels and precious stones formed by the late Henry Philip Hope, Esq.; including Le Saphir Merveilleux, formerly the property of Egalite, Duke of Orleans; the King of Candy's catseye, the Mexican sun opal, the gigantic pearl, and other historic gems, for some years past exhibited at the South Kensington Museum*, sale cat., Christie, Manson and Wood, London, 12–14 May 1886. The jewels comprising lots 1–126, several of which were bought back by members of the Hope and Beresford-Hope families. The three-day sale realized £13,972.17.6; *Catalogue of the collection of pictures, chiefly of the early Italian & Flemish schools, of the Rt. Hon. A. J. B. Beresford-Hope, M. P.*, sale cat., Christie, Manson & Woods, London, 15 May 1886.

241. This information has been provided by Paul Tucker.

242. *Catalogue of a portion of the library of the late right Hon. A. J. B. Beresford-Hope, . . . removed from Bedgebury Park, Kent, and from the Albany, Piccadilly, consisting of important books, in the various branches of English and foreign literature; books of prints and architectural treatises; first editions of standard authors; topography, principally related to the southern counties, &c.*, sale cat., Sotheby's, London, 27–30 July 1892, for £2027.8; The remnants of his collection were sold Christie, Manson & Woods, London, 10 May 1888, lot 114; Sotheby's, London, 28–29 May 1888; 8–9, 11–15 June 1888; Redford, *Art Sales* (1888): 435.

243. Ibid., lot 730, "a collection of eight autograph letters from T. Hope to J. Flaxman, mounted in a vol. red morocco extra g.e. 1804, &c." Also see compositions and plates by John Flaxman of Homer's *Iliad* as well as Dante's *Paradiso, Purgatorio* and *Inferno*, lots 384, 385, 386.

244. *Picture of London* (1802): n.p. (preface).

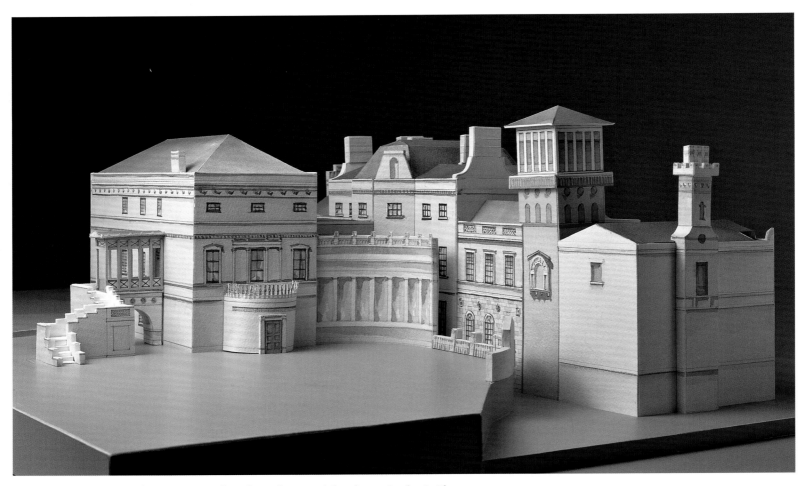

Fig. 12-1. Model of the Deepdene, Surrey, seen from the northeast. Made by Thomas Gordon Smith.

CHAPTER 12

The Reform of Taste in the Country: The Deepdene

David Watkin

In the hills above the Deepdene, near Dorking in Surrey, Thomas Hope was responsible for creating one of the most inventive and arresting country houses and gardens of its time (figs. 12-1–12-5). Hailed by the leading garden theorist John Claudius Loudon[1] as "the finest example in England of an Italian villa, united with the grounds by architectural appendages,"[2] the Deepdene was as challenging a product of Picturesque theory as Sir John Soane's house and museum in Lincoln's Inn Fields. It is thus appropriate that the leading topographical writer and publisher John Britton should have written books on both houses in the 1820s: *History of the Deepdene: The Union of the Picturesque in Scenery and Architecture with Domestic Beauties* and *The Union of Architecture, Sculpture, and Painting . . . with descriptive accounts of the House and Galleries of John Soane.*

Although the history of the Deepdene that Britton began in 1821 remained unpublished, incomplete manuscript drafts survive that form our chief source of knowledge of the house and its grounds.[3] Britton's aim was to show how the Picturesque could be achieved in the country at the Deepdene and in town at John Soane's architecturally experimental house and museum in Lincoln's Inn Fields.

In May 1807, the year after his marriage and the publication of *Household Furniture,* Hope bought the Deepdene, a substantial classical mansion of red brick, built in 1769–75 for the future 10th Duke of Norfolk from designs by William Gowan, a London surveyor. It was dramatically placed on a narrow shelf halfway up the side of a broad, steep valley.[4] In the mid-seventeenth century, the wooded hill that forms a great U-shaped enclosure immediately behind and above the house had been laid by the Honorable Charles Howard as a kind of "amphitheatre garden" with stepped terraces, grottoes, vineyards, and orange trees. This Italianate garden set amid the picturesque undulations of a spectacularly beautiful part of Surrey took its place in a remarkable seventeenth-century flowering of Italianate sensibility in the similar Surrey garden at Chilworth Manor, Albury Park, and especially the garden laid out by John Evelyn at Wotton House. Hope was keenly aware of these gardens, and Britton's *History of the Deep-*

dene contained chapters on the history of previous owners of the property. All this made Hope receptive to the recent theories on garden designs of Sir Uvedale Price, Richard Payne Knight, and Humphry Repton, the last two of whom, as we shall see, believed that a little Italian formality near the house might in certain circumstances be welcome.

In a letter to the antiquarian Aubin Louis Millin in Paris, Hope explained that his collection had not grown recently because, "I have only been occupied with my tulips in the country. It is there where I live by preference. For London is in many respects (except for its immensity) inferior to many other capitals: but our countryside is truly beautiful."[5] Thus, having created a striking city palace in Duchess Street, an eclectic effort owing much to the Parisian interiors of Percier and Fontaine, Hope, the product of urban Amsterdam, had become entranced by the English countryside, even if he still saw it as a setting for his native tulip.

For transforming the house at the Deepdene, Hope used as his executant architect the prolific if relatively undistinguished William Atkinson, whom he chose presumably because he found Atkinson a complaisant figure, ready to adapt himself to his patron's unusual demands. Hope was toying with the existing house at least as early as August 1815, when he ordered for it a pair of Greek Ionic capitals from the Coade Stone factory; in the following month he ordered four Coade stone *paterae* for the Deepdene.[6] Atkinson carried out most of his work at the Deepdene in 1818–19 and 1823, whether it involved new buildings in the grounds or additions to the existing house, which Hope had left largely intact.[7] The eclectic and asymmetrical forms with which Hope united his house to its gardens lay in a Picturesque tradition of which John Nash and Jeffry Wyatville had been the principal recent exponents.

Behind these architects lay the examples of Horace Walpole and Richard Payne Knight, two wealthy amateurs who created unique houses for themselves with professional assistance, respectively Strawberry Hill, Middlesex (1753–90), and Downton Castle, Herefordshire (1772–78). Among the first deliberately asymmetrical buildings of their kind, both houses either grew or

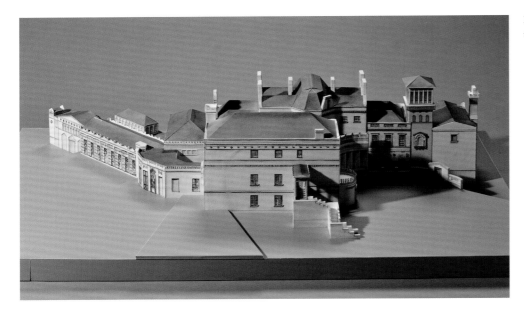

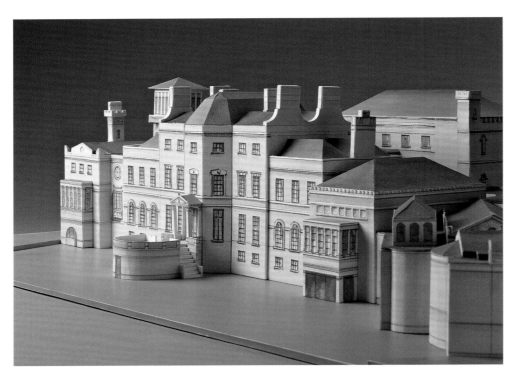

Figs. 12-2, 12-3, 12-4. Views of the Deepdene model seen from the southeast, the northwest, and the south.

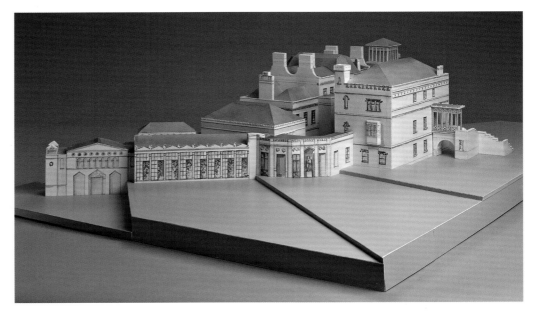

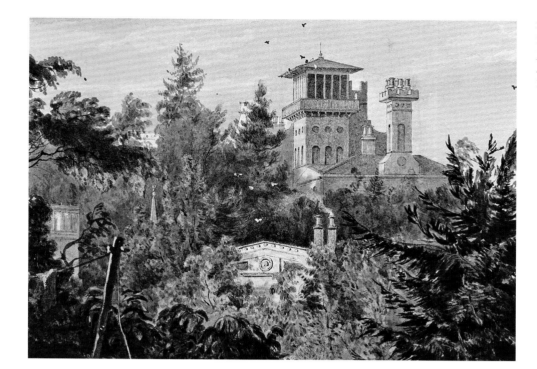

Fig. 12-5. William Henry Bartlett. "House from the Drying Grounds" (detail). Watercolor, 1818–19. From John Britton, *Illustrations of the Deepdene, Seat of T. Hope Esqre* (1825–26): pl. 36. Lambeth Archives Department, Minet Library, London. *Cat. no. 106.1.*

seem to have grown over a period of time and were an integral part of their landscape and garden settings. In the 1780s John Nash came into the circle of both Payne Knight and Uvedale Price, who published the influential *Essay on the Picturesque* (1794).[8] In 1796 Nash entered a partnership with the greatest landscape designer of his day, Humphry Repton, and together they created an episodic, scenic blend of architecture and landscape, typified by Luscombe Castle, Devon (1800–1804), for the banker Charles Hoare. With its irregular skyline, prominent conservatory, and fluid plan in which the windows, all extending down to the floor, are placed to catch views, Luscombe is a composition that is subordinate to the beautiful valley in which it sits. Nash's principal rival was Wyatville, whose masterpiece in this vogue was Endsleigh, Devon (1910), an extensive cottage *orné* for the 6th Duke of Bedford. Its scattered informal grouping, with canted wings punctuated with loggias and French windows, is absorbed into its romantic wooded site in the Tamar valley to allow nature to have the last word.

New Entrance Wing, Belvedere Tower, and Offices

When Hope carried out his first alterations to the Deepdene in 1818–19,[9] he also created the main, or north, entrance lodge on the Dorking to Reigate Road, which he designed in a Tuscan vernacular style like something from Ledoux's Ville Idéale de Chaux of 1804. From here, according to John Preston Neale, who wrote of his visit in 1825, the visitor already had "a fine view of the luxuriantly wooded knoll, on the sides of which one sees the upper parts of the house, with its ornamental parapets, and lofty turrets, rising amidst the foliage."[10] Having driven southward along the straight drive for about a quarter mile, the visitor turned suddenly to the right under a heavily castellated Gothic archway built by Hope to carry over his private drive a public road that crossed his estate. The archway was Gothic in flavor on one front and Norman on the other, with the arms of Hope and Beresford boldly carved on each.

Thence the drive passed behind the stables and then, making a great loop out to the foot of the amphitheatrical valley, returned to halt before the entrance to the house. Here Hope added a new entrance wing in front of the southeast entrance of the existing late eighteenth-century house (fig. 12-6). This had been in red brick, which became unfashionable, so Hope stuccoed it in 1824. In the meantime, he concealed its junction with the old house by building a theatrically placed quadrant screen wall, in front of which he placed a bronze cast of the *Wrestlers* from the Tribuna of the Uffizi. In this whole disparate, almost casual composition, the largely abstract design of the entrance wing, with its inventive, geometrical character, contrasted with the pretty Pompeiian gallery, or loggia, leading from Mrs. Hope's rooms on the first floor to a pine grove. This was supported on an arch approached by an external staircase in three broken flights adorned with antique vases, architectural fragments, and *cippi*, small columnar blocks, inscribed and serving as boundary markers or gravestones.

All this was novel enough, but the most memorable feature of the new southeast entrance was the Italianate belvedere tower that Hope built over the new staircase linking the existing house to his monumental new dining room. He added this dining room at the north end of the northwest garden front to balance the new library that he built at the south end.[11] The Italianate tower was

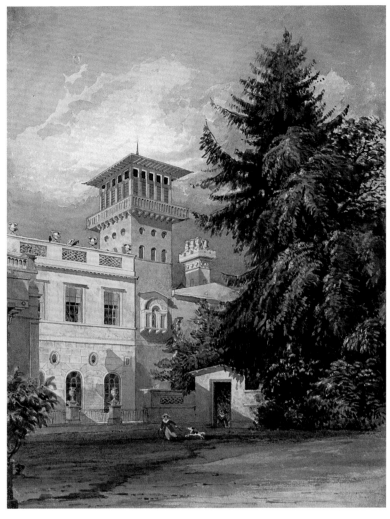

Fig. 12-6. William Henry Bartlett. "Entrance Court looking towards Tower." Watercolor, 1818–19. From John Britton, *Illustrations of the Deepdene, Seat of T. Hope Esqre* (1825–26): pl. 45. Lambeth Archives Department, Minet Library, London. *Cat. no. 106.4.*

introduced forms of buildings in their compositions that were well suited to the poetic feeling obvious in the works of those great masters." Discussing an appropriate setting for this villa, Papworth urged that a "variety of prospect and scenery might be obtained, necessary to harmonise with an edifice of this design." As to the planning, he explained that "the apartments arranged for the painter's accommodation are equally well disposed for a library, or for a collection of works of art."[15]

In the gardens before the northwest front of the house was another tower, which rose dramatically at the end of a pathway shaded by the fronds of cactus and pine. Its canted sides rose to a balcony supported on heavy brackets, giving the appearance of machicolation, the corbelled parapets in fortifications. The whole was surmounted by a tall domed *tholos*, or cupola. Near Hope's principal Italianate belvedere tower was another, smaller one visible from the entrance court. In fact, this was an unusually massive chimney stack over the new dining room, its six chimney pots disguised as oil jars. Uvedale Price had recommended giving careful attention to the roofline of buildings; Soane fashioned the chimney stacks of his own house as Clerk of the Works at Chelsea in the form of large raisin jars in 1815; the oil-jar form was later popularized in John Claudius Loudon's *Encyclopaedia of Cottage, Farm and Villa Architecture and Furniture* (1833). The principal elevation of the dining-room wing below this great chimney was itself of considerable novelty. It was dominated by an enormous bay window defined by a stark grid of six piers and surmounted by a pediment adorned with the heavy acroteria, the

accurately described by John Neale, probably after consultation with Hope, as "a curious open tower, constructed in the Tuscan or Lombard style."[12] Loudon later described it as recalling the "watch towers common in smaller villas and farmhouses in several parts of Tuscany."[13] The first of its kind in British architecture, with its heavy balcony and broadly projecting flat eaves, it stands as an isolated pointer in the medley of Regency taste to the bulkier campaniles that were so soon to adorn later nineteenth-century country houses from Walton House, Surrey (1835–39), by Sir Charles Barry, to Osborne House, Isle of Wight (1845–48), by Thomas Cubitt.

One of the few contemporary parallels to Hope's loggia-topped Italianate tower is that in the unexecuted "villa, designed as the residence of an artist" (fig. 12-7), published by the architect and garden designer John Buonarotti Papworth.[14] Papworth explained the thinking that lay behind this unusual asymmetrical composition as an attempt to re-create "the painter's style of buildings," his models being "Claude Lorrain, Poussin, and other celebrated landscape-painters of the seventeenth century, [who]

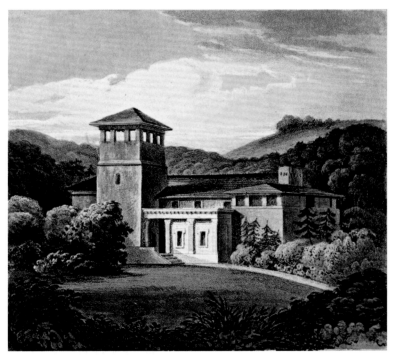

Fig. 12-7. John B. Papworth. Villa, designed as the residence of an artist. From *Rural Residences* (1818). Marquand Library of Art and Archaeology, Princeton University Library.

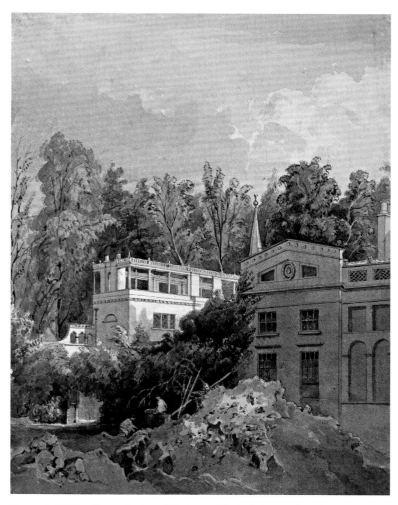

Fig. 12-8. William Henry Bartlett. "Kitchen and Dairy." Sepia and wash, 1818–19. From John Britton, *Illustrations of the Deepdene, Seat of T. Hope Esqre* (1825–26): fol. 33. Lambeth Archives Department, Minet Library, London. *Cat. no. 106.5b.*

ears at the bottoms of architectural pediments, which became popular in furniture design at this period.

Standing in the entrance court, the visitor would have been aware that behind him, where the ground sloped steeply away from the house, Hope had chosen to place a T-shaped collection of buildings comprising kitchen, dairy, and offices (fig. 12-8). This notion of grouping the offices on an abrupt descent, embowered by trees, so that they form with the house itself an irregular and picturesque composition, owed something to Uvedale Price. He had urged that "in general, nothing contributes so much to give both variety and consequence to the principal building, as the accompaniment, and, as it were, the attendance of the inferior parts in their different gradations."[16]

Hope chose to surmount the flat roof of the dairy with an unusual loggia, which again owes something to Price, who recommended flat roofs because "the edge of the sloping roof . . . is incapable of receiving decorations." Price went on to point out how Sir John Vanbrugh at Blenheim Palace, "having probably been struck with the variety of outline against the sky in many

Gothic and other ancient buildings . . . has raised on the top of that part, where the slanting roof begins in many houses of the Italian style, a number of decorations of various characters."[17]

Moreover, the whole group of dairy, kitchens, and offices at the Deepdene incorporated a little spire for which the inspiration was probably the spirelets in the romantic groups of hill-top buildings that Gilbert Laing Meason was to illustrate in his book *Landscape Architecture of the Great Painters of Italy* (1827). Meason assembled sixty drawings of buildings in painted Italian landscapes to provide guidance to modern architects in the design of irregular buildings. Following the opinions of Payne Knight, he assumed that the painted buildings were based on real ones that had been gradually altered from ancient Roman times up to the Renaissance.

The link between Hope and Meason was confirmed in 1829 by Loudon who claimed, of the house and offices at the Deepdene, that Hope had "combined in them all the finest parts of what may be called the landscape architecture and sculpture of Italy, has formed a whole, the greatest praise that we can bestow on which is to say that it will delight such men as Sir Uvedale Price and Gilbert Laing Meason." London went on to claim, most unexpectedly: "It is, in short, an example of what the Germans call the ecstatic in architecture," though what aesthetic term in the German language he had in mind is far from clear. His greatest praise of the Deepdene was to remark that it was so unique that "there is not one English architect who would of his own accord have designed such a house; nor, if he had designed it, could he have found more country gentlemen by whom it would have been understood or carried into execution, than the Gard. Mag. would find readers if it were published in Greek."[18]

It was partly because he felt that Hope's achievement should be emulated more than it was that Loudon chose to popularize it in the *Gardener's Magazine* and in his *Encyclopaedia*. However, it is only fair to confess that some knowledge of Picturesque theory was required to appreciate what Hope was trying to achieve at the Deepdene, for the novelist Maria Edgeworth found in 1819 that "the house [was] like some of the views in Athenian Stuart of Turkish buildings, grotesque and confused among trees in no one particular taste."[19] Moreover, the northwest garden front, most of which was composed of the red brick house of 1768, must have always been awkward, which is why it was not included in the watercolors in Britton's history.

Hope's Essay "On the Art of Gardening"

Hope's acquisition in 1807 of a country house in a stunningly beautiful natural setting apparently encouraged him to familiarize himself with the most up-to-date theories on garden design. This

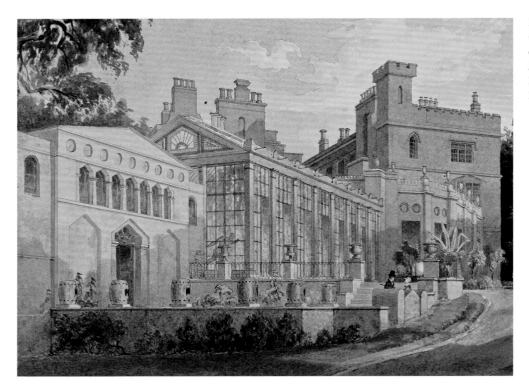

task must have included studying the writings of the connoisseur and country-house owner Richard Payne Knight, notably his *Analytical Enquiry into the Principles of Taste* (1805), which influenced Hope's essay "On the Art of Gardening," published in 1808.[20] We know from an account in Ackermann's *Repository of Arts*[21] that Hope turned his attention to the southwest end of the house in 1823, throwing out a wing at an angle of 45 degrees to the body of the house (fig. 12-9). This formed a bizarre unit containing orangeries, conservatory, Sculpture Gallery, and Theatre of Arts, forming the perfect epitome of Regency taste. To begin with, the house itself had gone through an astonishing change of style at the southwest angle, where it suddenly switched to Gothic (fig. 12-10). This will remind us that Payne Knight had claimed that "the best style of architecture for irregular and picturesque houses . . . is that mixed style, which characterizes the buildings of Claude and the Poussins. . . . [It] admits of all promiscuously, from a plain wall or buttress, of the roughest masonry, to the most highly wrought Corinthian capital."[22]

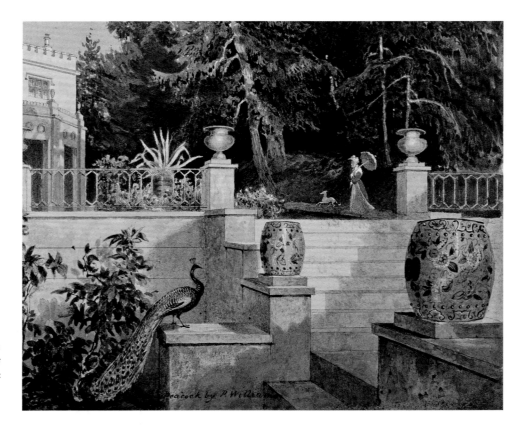

We can interpret this southwest wing of the Deepdene as a three-dimensional version of the wish that Hope had forcibly expressed in "On the Art of Gardening" that "the cluster of highly adorned and sheltered apartments that form the mansion . . . shoot out as it were, into . . . ramifications of arcades, porticoes, terraces, parterres, treillages, avenues, and other such still splendid embellishments of art, calculated by their architectural and measured forms, at once to offer a striking and varied contrast with, and a dignified and comfortable transition to, the more undulating and rural features of the more extended, more distant, and more exposed boundaries."[23] In this essay, Hope followed the revolution affected by Payne Knight and Uvedale Price, who introduced a vigorous, even rough, "naturalness" in place of the placid artificiality of the landscaped parks of Lancelot "Capability" Brown, which featured what Payne Knight condemned as "shaven lawns." Knight and Price, as is not always acknowledged, had followed Sir William Chambers who had invented a fictive account of the gardens of the Chinese, claiming that "Their regular buildings they generally surround with artificial terraces, slopes, and many flights of steps; the angles of which are adorned with groupes of sculpture and vases, intermixed with all sorts of artificial water-works, which, connecting with the architecture, serve to give it consequence, and add to the gaiety, splendor, and bustle of the scenery."[24]

Taking up the pleas of Uvedale Price for "variety" and "intricacy," Hope went on to argue that, "if we wish for variety, for contrast, and for brokenness of levels, we can only seek it in arcades and in terraces, in steps, balustrades, regular slopes, parapets." He added sternly: "we cannot find space for the rock and the precipice."[25] This was a rebuke to Payne Knight, who he thought had gone too far in depicting his ideal Picturesque house as almost unapproachable across a primitive wooden foot bridge and set in a rough landscape, littered with boulders and fallen trees.[26] At the same time, Hope had been attracted by the charm of the formal gardens of Italy that he had seen on his extensive Grand Tour. He thus openly admired "the suspended gardens within Genoa and of the splendid villas about Rome . . . those striking oppositions of the rarest marbles to the richest verdure; those mixtures of statues, and vases, and balustrades, with cypresses and pinasters, and bays; those distant hills seen through the converging lines of lengthened colonnades; those ranges of aloes and cactuses growing out of vases of granite and of porphyry scarce more symmetric by art than these plants are by nature."

As Neale observed of the southwest range at the Deepdene in 1826, "The foreground is very irregular, and descents are made by small flights of steps, with vases on the pedestals."[27] This disposition perhaps echoed the truth of Payne Knight's claim in 1805 that "the hanging terraces of the Italian gardens . . . if the house be placed upon an eminence, with sloping ground before it, may be employed with very good effect. . . . Such decorations are, indeed, now rather old fashioned; but another revolution in taste which, is probably at no great distance, will make them new again."[28] The house itself now echoed the same sudden contrasts of height, level, shape, and style as the gardens, moving with astonishing versatility from Gothic to Roman, from Greek to Italian, from a style combining elements of both to another style of such originality, notably that of the exterior of the Theatre of Arts, that it can be pinned down to neither. The function of this whole setting was likewise the result of a new and varied synthesis. The rooms were filled with plants, and the gardens with sculpture and Chinese pots. The fountain was moved indoors, or at any rate into the conservatory, and the conservatory opened into the library.

Conservatory and Sculpture Galleries

A glance at the plan (fig. 12-11) makes clear the unique distribution of spaces in Hope's southwest wing, which created a world of enchantment where the finest antique and modern sculpture was enlivened by the sound of murmuring water from the fountain and the scent from flowering plants and orange trees. Hope moved much of his collection of sculpture here in 1824 and built four galleries of very different shapes to contain it, the two largest rooms being primarily intended for antique sculpture, the other two mainly for neoclassical statues and modern replicas. Remarkably, they were all linked by and opened into the Conservatory, filled with exotic plants, which was itself terminated in a domed apse housing Bertel Thorvaldsen's *Psyche* (fig. 12-12, cat. no. 56). This apse led into a room of irregular plan, described by Hope as an "Orangery and Sculpture Gallery," which contained Thorvaldsen's *Jason*, a copy by Lorenzo Bartolini of the *Florentine Boar*, and oriental porcelain jars.[29]

At the southwest end, the Conservatory also opened into the Theatre of Arts, which, by a remarkable conceit, was another sculpture gallery inspired in plan by ancient Roman theaters, though with antique busts taking the place of humans on the semicircular seats (fig. 12-13). A cinerarium in the third row of seats bore a modern inscription: "To the gods and shades of Demetrius, sweetest son, who lived eight years," which Hope must have found moving as his own son Charles had died in Rome aged seven. In the center at the top was an Antinous and nearby a fine head of Agrippina or Livia.[30] Opening off the Theatre of Arts was the fourth and smallest sculpture gallery, a closet containing Thorvaldsen's *A Genio Lumen*[31] and minor antique pieces. The façade of the Theatre of Arts was in a highly inventive style with triangular-headed windows and doors, possibly inspired by two

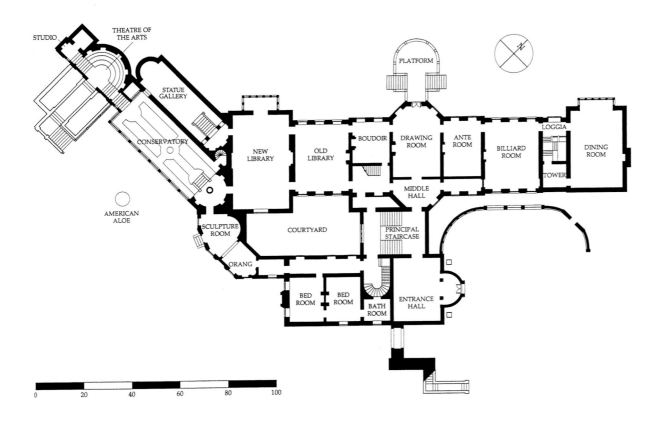

Fig. 12-11. Thomas Gordon Smith. Plan of the Deepdene, Surrey.

obscure sources, one antique and one Romanesque, illustrated by Hope in his *Historical Essay on Architecture*.[32]

The Statue Gallery, apsed at each end, with its walls painted a buff color, was top-lit through a clerestory of round-headed windows (fig. 12-14). It lacked the austere purity of the Statue Gallery at Duchess Street, for Hope freely combined in it ancient and modern works, overlaid with a sentiment of love, woodland, and death, which might again have been related to the death of his young son.[33] Freestanding in the middle of the Sculpture Gallery was a child's sarcophagus decorated with children holding garlands, perhaps in memory of Charles. It may even have been ordered by Hope in Rome following his son's death, for it was a free copy of an antique sarcophagus in the Vatican. Guarded by ancient busts of Athena and Jupiter, it was flanked by symbols of ancient sacred ritual, the tripod and the tazza, or shallow cup. The family theme was continued by two busts of Mrs. Hope and one of either Charles or his elder brother Henry Thomas (cat. nos. 7, 11, 12; see Chapter 8 in this volume). The figures of Aphrodite, Eros and Psyche, and Apollo and the candelabra may have symbolized love and everlasting light, while numerous other figures, including Pan, Silenus, and satyrs, personified the spirit of the woodland and country and may have referred to the final resting place of the ashes of Charles in the mausoleum that Hope built for him on the grounds of the Deepdene in 1818.[34] Presiding over the gallery from a flight of steps at one end, seated on a rock on a high pedestal, was a Silenus, a satyr

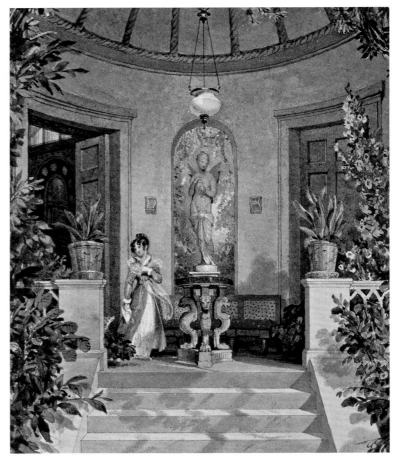

Fig. 12-12. Penry Williams. "Circular Conservatory" (detail). From John Britton, *Illustrations of the Deepdene, Seat of T. Hope Esqre* (1825–26): fol. 81. Lambeth Archives Department, Minet Library, London. *Cat. no. 106.10.*

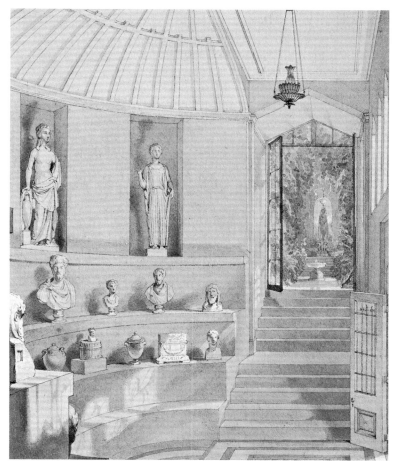

Fig. 12-13. Penry Williams. "Theatre of Arts" (detail). Watercolor, 1823. From John Britton, *Illustrations of the Deepdene, Seat of T. Hope Esqre* (1825–26): fol. 84. Lambeth Archives Department, Minet Library, London. *Cat. no. 106.11.*

sometimes described as a son of Hermes or Pan, the Greek god of flocks and shepherds. On the right of the room was another statue of Silenus, depicted as Herakles.

Visit of C. R. Cockerell

We are fortunate to have an account of the Deepdene and of Thomas Hope himself in a manuscript written and illustrated in 1823 by the young C. R. Cockerell,[35] the most learned classical architect of nineteenth-century Britain (fig. 12-15). He was to become a most imaginative architect, creating such public buildings in the 1840s as the Ashmolean Museum at Oxford and the branch offices of the Bank of England, notably the one at Liverpool. These represented a sculptural interpretation of ancient Greek architecture enriched by Cockerell's knowledge of Renaissance and, most particularly, Mannerist buildings.

In August 1823, when Cockerell visited the Deepdene, he was still engaged in the customary commissions of those days, which were for country houses, a field in which he struggled, not entirely successfully, to apply his unique archaeological knowledge.

He was designing an ambitious new dining room for Alexander Baring, later 1st Lord Ashburton, at Grange Park, Hampshire. Built in 1809 in the Greek Revival manner from designs by William Wilkins, Grange Park was the most complete templar house in Europe. However, Cockerell objected to the interpretation of Greek architecture expressed by contemporary architects such as Wilkins and his own old master, Sir Robert Smirke, who believed that all one had to do to be Greek was clap a giant portico onto a square box of a house. Cockerell even criticized his own Greek Revival designs for a house in Ireland, Lough Crew, complaining that, "I shall never get entirely out of Smirke's manner in my first works."[36] We find him making the following notes in April 1823 on his designs for the dining room at Grange Park: "[I] wanted to make this room as pure in architecture as poss[ibl]e as classical by figures recalling such associations. drive at novelty, to avoid commonplace . . . searched all my books [for] novelty, originality of conceptions—yet appropriate, hardiness, unfettered fancy."[37] He attempted "the Ionic of Pompeia" for this room but eventually selected his favorite Greek Ionic from the Temple of Apollo Epicurius at Bassae.

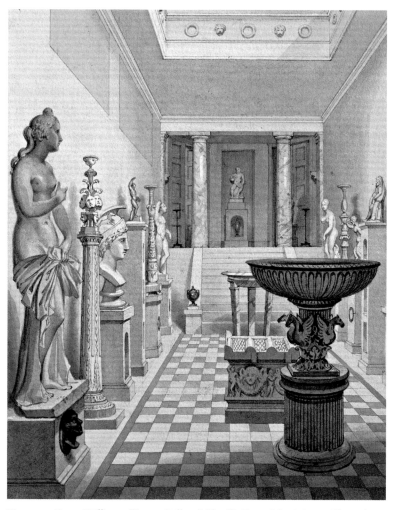

Fig. 12-14. Penry Williams. "Statue Gallery" (detail). From John Britton, *Illustrations of the Deepdene, Seat of T. Hope Esqre* (1825–26): fol. 87. Lambeth Archives Department, Minet Library, London. *Cat. no. 106.13.*

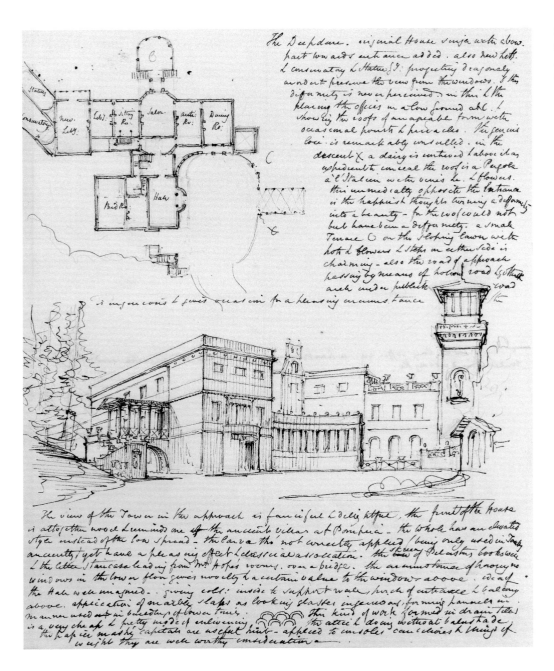

It is significant that in this context he "asked Millingen for hints," for James Millingen was a serious classical scholar and Etruscan archaeologist, resident for many years in Rome and Naples, where he acquired works of ancient art for British collectors. One of his clients in Rome in 1814 was Hope's friend, the poet Samuel Rogers,[38] who had modeled the interiors of his London house at 22 St James's Place on Hope's house in Duchess Street.[39] Millingen published three pioneering studies of Greek vase painting between 1813 and 1822, all of which were owned by Thomas Hope.[40]

It can be no coincidence that when Cockerell was fortunate enough to spend three days with Thomas Hope at the Deepdene in August 1823, he traveled there and back in the company of Millingen. It seems likely that Millingen, who like Hope was of Dutch descent,[41] had arranged the visit, and it is tempting to suppose that he may have told Cockerell that the Deepdene provided

another basis for a modern classical house rather than the overfamiliar but still inappropriate Greek temple. Cockerell and Millingen were immediately plunged on arrival into the kind of grand house party that Mrs. Hope liked. Guests included her cousin and future husband, Field Marshal Viscount Beresford; Lady Anne Beresford, the Countess of Westmeath; and a daughter of the Duke of Clarence, later King William IV. However, Cockerell recorded in his diary: "[I] walked over the House. saw new Library, statue gallery, Statue Theatre, conservatory. Lunched. saw Flaxman's beautiful drawings many different compositions of Iliad rejected by him & not published, very precious . . . dined . . . looked over Mr. Hope's vols: of sketches 10 or 12 small volumes. nicely done in ink."

Cockerell noted that on the following day, Sunday, the party went to church at Dorking, and that he and Hope had a "beautiful walk after in grounds of Deepdene. Mr. Hope exceedingly com-

plaisant. Novelty has a vast effect in arch[itectur]e. we are sick to see the same thing repeated & over again what has been seen any time these 100 yrs. The Deepdene attracts in this respect exceeding but if the Pompeian style can be so cultivate[d] as to practice well it may supercede the Templar style in which we have so long worked." He considered that "The view of the Tower in the approach is fanciful & delightful. the front of the House is altogether novel & reminds me of the ancient villas at Pompeii."

After his return to London, he recorded that "Mr. Hope in answer to a letter of mine respecting the excellent adaptation of Pompeian style at the Deepdene, says if that style & that of Alhambra were united an effect of enchantm[en]t might be produced & at half [the] expense of those gloomy stately mansions & whence they have no escape but to run to Gothicism. but these are words. we want practical rules derived from sense, economy in distribution & materials & just association of ideas."42

It is thus clear that, though Cockerell's achievement was not to lie in the field of country house design, he believed at this point in the 1820s that the Pompeiian model provided a possible solution for the future. It is thus fascinating to note that, on his visit to Paris in October 1824, Cockerell called on François Mazois, who was the leading authority on the latest excavations at Pompeii. Not surprisingly, Hope's library contained François Mazois' *Le Palais de Scaurus, ou, Description d'une maison romaine . . .* (1819), which was dedicated to Napoléon's architect Charles Percier, who was personally known to both Hope and Cockerell. Ever hypercritical, Cockerell recorded after his meeting with Mazois that he "shewed me many private Houses, villas, &c. projets after Italian model, open & ill calculated to our climate."43 Hope also owned the first two volumes (1812–24) of *Ruines de Pompéi* by François Mazois and Franz Gau, of which the second volume, devoted to "Habitations," provided representations and reconstructions of Roman interiors, including furniture, mosaics, lamps, and wall paintings, some of which were reproduced in lavish color plates. Two more volumes by Franz Gau, published in 1829 and 1838, were followed by the remarkable Maison Pompéienne, Avenue Montaigne, Paris (1855), built from designs by Alfred-Nicolas Normand for Prince Jérôme Napoléon.

However, it should not be thought that Cockerell interpreted the Deepdene exclusively as an example of the use of the Pompeiian villa rather than the Greek temple as a model for modern domestic architecture. He was well aware that the asymmetric dynamics of the Deepdene were a response to the latest Picturesque theory, for he described the "conservatory and statue [gallery], projecting diagonally in order to preserve the view from the windows," explaining that "this deformity is never perceived." He similarly observed that

*in this and the placing the offices in a low ground about & showing the roofs of an agreeable form with occasional points & pinnacles, the genius loci is remarkably consulted. in the descent a dairy is contrived & above it as an expedient to conceal the roof is a Pergola à l'italien with vines &c & flowers. this immediately opposite the Entrance is the happiest thought turning a deformity into a beauty for the roof could not but have been a deformity. a small Terrace on the sloping lawn with pots & flowers & steps on either side is charming—also the road of approach passing by means of hollow road & gothic arch and a publick road, is ingenious & gives occasion for a pleasing circumstance.*44

He also thought that in the entrance court the quadrant "screen of Pilasters looks well" but showed himself a child of Soane in his worry that Hope had surmounted this screen with prominent *antefixae* in the form of antique masks. He was concerned that by using these classical motifs in a purely decorative way in a secular context, Hope ignored their origin in sacred architecture. In exactly the kind of literal criticism indulged in by Soane, Cockerell pointed out that "strictly speaking the larva scenic masks tragic are only applicable to Tombs, also the sarcophagus lintels of doors is totaly inapplicable to domestic purposes & proper for tombs only." Although he explained that "this is inexcusable in a person having all opportunities of instruction, & architecture is essentially art of association," he could not resist adding that "the larva tho' not correctly applied (being only used in Tombs anciently) yet have a pleasing effect & classic association."

Cockerell admired the novelty of the main entrance block for having a plain ground floor, despite the curved entrance, because he felt that "the circumstance of having no windows in the lower floor gives novelty & a certain value to the windows above." Other pleasing details in the entrance court were "the little staircase leading from Mrs. Hope's rooms over a bridge" and the Italianate use of curved tiles to form an openwork parapet in the wing on the right: "This kind of work formed in drain tiles is a very cheap & pretty mode of enlivening the attic & doing without balustrade." Unfortunately, Cockerell said almost nothing about the interiors at the Deepdene, to which we should now turn.

Interiors

It would be extremely difficult to attempt a "virtual reality" tour of the interiors of the Deepdene, as we can with the house in Duchess Street, for we have no clear idea of their appearance. A glance at the plan (see fig. 12-11) suggests a spatially unadventurous and even cramped arrangement in which rooms opened into each other, mostly surviving from the old house. Hope's chief contribution was to refurbish these with such features as new statuary marble chimneypieces and double doors with panels enlivened by classical figures in brass inlay. Britton's *History of*

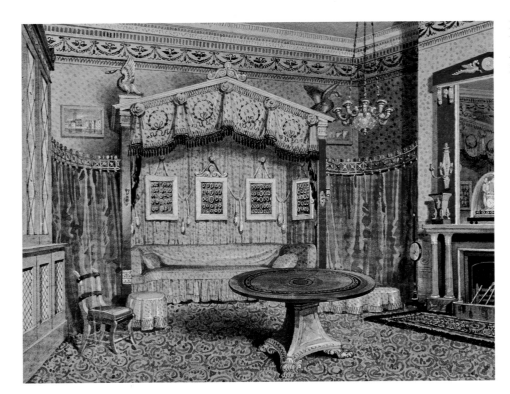

Fig. 12-16. Penry Williams. "Boudoir" (detail). Watercolor. From John Britton, *Illustrations of the Deepdene, Seat of T. Hope Esqre* (1825–26): fol. 93. Lambeth Archives Department, Minet Library, London. *Cat. no. 106.14.*

the Deepdene thus included few illustrations of the interiors, most of them depicting the exteriors and the grounds, which were presumably more important to Hope. Cockerell, so enthusiastic about the exteriors, was remarkably dismissive of the interiors, observing, "Mr. H. indulges sadly in the colfichet style of French school, he has no eye for the harmony of colors & in this respect his taste is heavy & inharmonious, tinsely, tawdry."[45] The word "colfichet," meaning "trinket" or "bauble," may suggest Rococo ornament to us, but Cockerell seems to have used it to denote the Empire style in France. The age gap of almost twenty years between Hope and Cockerell probably meant that Cockerell, as the younger man, found this style unacceptable as "yesterday's style."

Certainly, the two principal interior views in Britton's *History of the Deepdene*—of the Boudoir and the chimneypiece in the Old Library (figs. 12-16 and 12-17), both in the old house—were rather more in the manner of Percier and Fontaine than of Hope at Duchess Street. The Boudoir had a chimneypiece of green Mona marble, flanked by coupled columns with gilt-bronze capitals and bases and surmounted by a chimney-glass in a massively architectural frame in a contrasting color. Of dark red marble, or scagliola, this pedimented frame featured more decorative mounts in gilt bronze. The Mona marble quarry on the Isle of Man was owned and administered by the leading cabinetmaker George Bullock,[46] and it is tempting to suppose that Bullock may have had a hand in furnishing the Deepdene and in making the circular monopodium table in this room (cat. no. 39; see Chapter 4 in this volume). Bullock was noted for his insistence on using native British marbles and woods, which would have been attractive to Hope, who believed in supporting British artists.

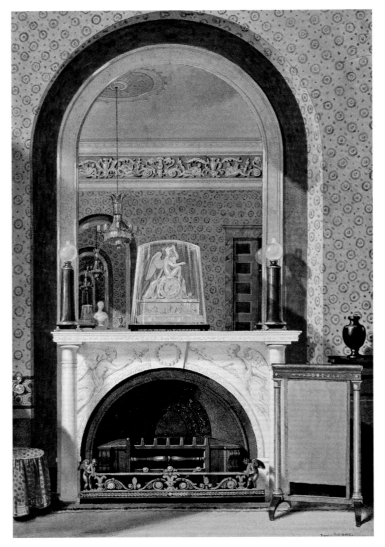

Fig. 12-17. Penry Williams. "Library Chimney-piece." Watercolor. From John Britton, *Illustrations of the Deepdene, Seat of T. Hope Esqre* (1825–26): fol. 90. Lambeth Archives Department, Minet Library, London. *Cat. no. 106.15.*

The day bed in the Boudoir, which featured a gilded pediment of its baldaquin-like canopy flanked by swans, is similar to furnishings in Paris designed by Percier and Fontaine. Within its curtained recess hung five frames that contained wax impressions from classical gems. Tent beds, with their martial themes, were popular in Napoleonic Paris, and tent rooms were also introduced to England in the 1830s by Gandy-Deering at Shrubland Park, Suffolk, and by J. B. Papworth at Cranbury Park, Hampshire. The colors in the Boudoir at the Deepdene were powerful, as we would expect from Hope, and were mainly in four different shades of red—for the canopy of the day bed; for its flanking draperies; for the frame of the overmantel mirror; and for the carpet, which was of the fitted type that had become fashionable during the Regency.

In the Old Library, Hope inserted a statuary marble chimneypiece of which Hope was presumably proud, since a whole watercolor was devoted to it in Britton's history. Indeed, it has been shown to be almost certainly imported by Hope from Paris.[47] With its figures of fame in the form of winged victories holding torches and flanking a wreath, the chimneypiece was similar to those illustrated in an album of *Modèles de Marbrerie* published in Paris by Brance in 1825–26. This included several designed by "M. Fedel" for a "M. Hope," doubtless a reference to the architect Achille-Jacques Fédel, who had been trained at the Ecole-des-Beaux-Arts. The two columnar lamps on the chimneypiece could be of the French spring-driven type introduced by Bernard-Guillaume Carcel in 1798.[48]

More French furniture was contained in the Egyptian Room at the Deepdene in the form of a suite comprising a pair of elaborate chairs[49] (cat. no. 100) and a sofa bed, all made in 1809 by the firm of Jacob-Desmalter from designs by the leading figure in Egyptian studies in France, Dominique Vivant, Baron Denon.[50] The astonishingly inventive mahogany chairs, with elaborate gilt-bronze mounts, feature lion monopodia, arms ending in serpent heads, and raked backs which were not an Egyptian form. The accompanying Egyptian bed incorporated bas reliefs of a figure of Isis and thirteen half-kneeling figures with arms raised.

Adjacent to the Egyptian Room at the Deepdene was a bathroom containing four representations of Raphael's decorations in the Vatican *logge* and a bath in a mirrored recess. Maria Edgeworth also described how in the staircase hall the first-floor landing was supported by "a resigned female Caryatide of white stucco whose head in eternal pillory supports a heavy staircase, while her feet stand on a globe so small that it never could support her."[51] It seems that some time between 1826 and 1831 Hope formed a room for the display of vases, which partly occupied the site of the former servants' hall and opened from the library. It

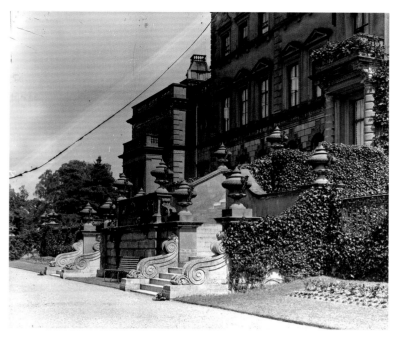

Fig. 12-18. Garden front, the Deepdene, Surrey, photographed in 1899. From *Country Life* 5 (20 May 1899): 628. Country Life Picture Library, L9602-5.

became known as the Etruscan Room[52] and retained more of the flavor of Thomas Hope's work than any other interior at the time the house was demolished in 1969. The semicircular opening of its marble chimneypiece was flanked by pairs of bearded Bacchus terms, while mirrors, shutters, painted cornice, and doors inlaid with figures and wreaths in brass also survived.

Renaissance Revival at the Deepdene

After Thomas Hope's death in 1831, the Deepdene was transformed into an Italianate Renaissance villa by his son Henry Thomas Hope in 1836–41[53] (figs. 12-18 and 12-19). His architect was the German-Italian Alexander Roos, who had been a pupil in Berlin of Karl Friedrich Schinkel, the greatest classical architect of nineteenth-century Germany. The rebuilding of the house led to the removal of Thomas Hope's additions, although in some drawings it was proposed that his campanile-type tower, of which he must have been justly proud, be retained. It is conceivable that the idea for Italianizing the whole house originated with Thomas Hope himself, who, as we have seen, had earlier praised "the suspended gardens within Genoa and of the splendid villas about Rome" in his essay "On the Art of Gardening." This enthusiasm anticipates the imposing new entrance front of the Deepdene, enriched with *logge* and surmounted by belvedere towers echoing those of the Villa Medici in Rome, an effect that can be well appreciated from photographs published in *Country Life* in 1899.[54] This lavish remodeling, which included an arcaded, two-storied entrance hall housing much of Thomas Hope's collection of sculpture, was doubtless financed by the

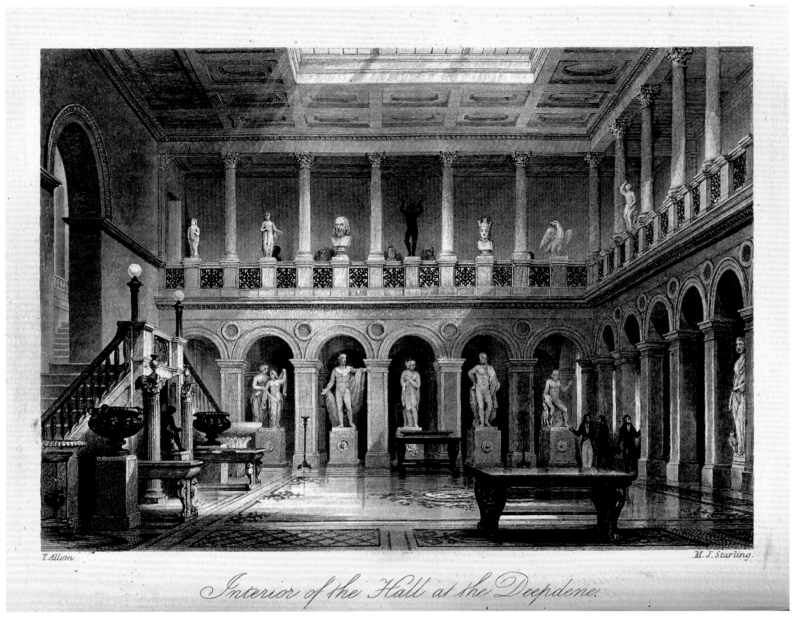

Interior of the Hall at the Deepdene.

Fig. 12-19. Hall, the Deepdene, Surrey. Engraving, 1836–40. From Brayley and Britton, *Topographical History of Surrey*, vol. 5 (1848).

sum of about £193,000, which Henry Thomas inherited along with his two surviving brothers, in 1834 on the death of his uncle Adrian Elias Hope.[55]

We have already noted how Thomas Hope's asymmetrically placed Italianate tower had anticipated similar features in the work of Sir Charles Barry, so it is striking that his son's more complete Italianization of the house was also echoed by Barry from the 1830s at such houses as Trentham, Nottinghamshire, and Kingston Lacy, Dorset. Both Thomas Hope and Charles Barry had been preceded by William Beckford, whose first design of about 1824 for the Lansdown Tower at Bath was close in profile and detail to that at the Deepdene. As executed from designs by Henry Goodridge in 1824–27, the Lansdown Tower became more Greek in character.[56] Such a combination of Greek detail with

Picturesque composition is central to an understanding of much of the work of Alexander Roos's master Schinkel and of Alexander "Greek" Thomson. Thus, parallels to Hope's organization of an asymmetrical composition round the pivot of a belvedere tower, as at the Deepdene, can be seen in buildings by Schinkel such as Schloss Glienicke, Berlin (1824–32), and Tor House, Isle of Bute (1856–57), by Thomson.

When Benjamin Disraeli, the future Conservative prime minister, stayed with his wife at the Deepdene in October 1836, he wrote to his sister: "In the midst of romantic grounds and picturesque park [Henry Thomas] Hope has built, or rather is still building, a perfect Italian palace, full of balconies adorned with busts. On the front a terraced garden, and within a hall of tesselated pavement of mosaics, which is to hold his choicest marbles."[57] In

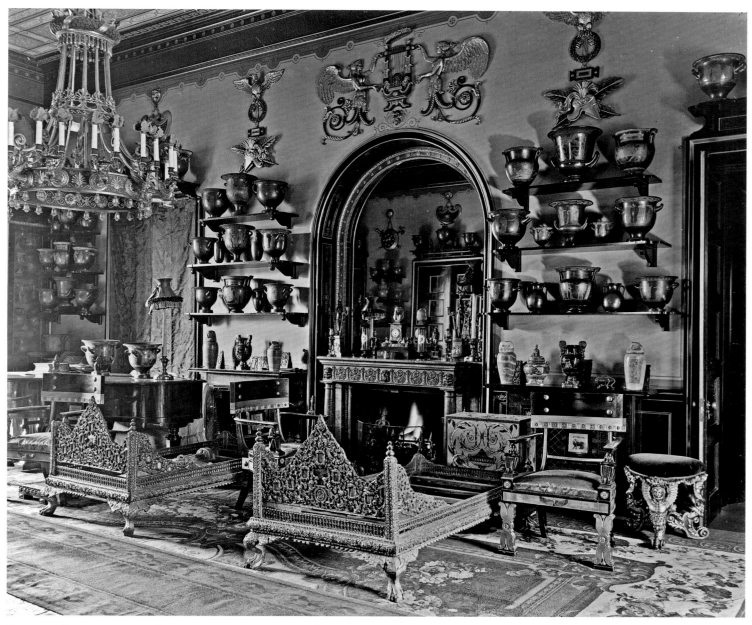

Fig. 12-20. The Vase Room, Deepdene, Surrey, 1899. From *Country Life* 5 (20 May 1899): 628. Country Life Picture Library, L9602-5.

1844 Disraeli dedicated *Coningsby,* the first of his great trio of political novels, to his friend, Henry Hope, explaining in the dedication that the novel was "conceived and partly executed amidst the glades and galleries of Deepdene." It was at the Deepdene that the romantic and picturesque political movement called Young England was born, so that Benjamin Disraeli did here for the Italian Revival what Walter Scott had for the Gothic at Abbotsford.

The unprecedented and irregular forms that Hope gave to the additions he made to the Deepdene, and which his son largely removed, can be appreciated in the new model made of the house (cat. no. 105, figs. 12-1, 12-4). This shows it as the acme of the Picturesque with Hope's Italianate belvedere tower recalling the "Watch towers common on smaller villas and farm houses in sev-

eral parts of Tuscany,"[58] which was the first of its kind in British architecture. Unfamiliar with English country life, Hope extended and remodeled this house in a way that puzzled contemporaries but that we may see as architecturally experimental, like Sir John Soane's house and museum in Lincoln's Inn Fields, of which a visitor observed tartly in 1837: "It looks no better than a temporary experimental trial or model of what was intended to be executed on a larger scale."[59]

We could see Hope's mold-breaking and fragmentary work as part of a recurring if rare phenomenon in architectural history.[60] For example, the Erechtheion, built on the Acropolis in Athens in about 421–405 B.C. with a strange plan in the form of an irregular T, has been characterized by a modern archaeologist as "a building with a fragmented plan, with numerous enclosures and

porches and entrance-ways."[61] But it is to the villa architecture of the Roman world that we should look for illuminating parallels. The Emperor Hadrian's Villa at Tivoli (A.D. 118–134),[62] partly designed by himself, anticipated both something of the scattered character of the Deepdene as a piece of landscape architecture and also its eclectic stylistic references, and the villa at Piazza Armerina, Sicily (ca. A.D. 315–325), also sported what has been summarized as a "disjointed and irrational plan."[63] The demolition of Hope's unique and extraordinary house in 1968–69,[64] following the dispersal of its magnificent contents in 1917, must thus be counted as one of the great losses of English architectural and cultural history.

1. On Loudon, see Melanie Louise Simo, *Loudon and the Landscape: From Country Seat to Metropolis 1783–1843* (New Haven and London: Yale University Press, 1988).

2. John Claudius Loudon, *Encyclopaedia of Cottage, Farm and Villa Architecture and Furniture* (London: Longman, 1833): 783–84.

3. Two MS volumes survive in the RIBA Library and the Minet Library Archives, Lambeth. The RIBA volume, *History, etc., of the Deepdene*, contains an uncompleted biographical and descriptive text, together with a plan of the house and 36 illustrations, which are mostly preparatory sketches for the 29 more finished watercolors in the Minet Library volume, *Illustrations of the Deepdene*. This contains, in addition, an introduction, a plan of the estate, and a number of architectural drawings by Alexander Roos and possibly by Thomas Hope William Atkinson. Though not published in this form, the description was used as the basis for the account of the Deepdene in vol. 5 of John Britton and Edward Brayley, *A Topographical History of Surrey* (London, 1841–48). Sixteen duplicates of watercolors in the Minet Library are in the Mellon Collection, Yale Center for British Art, New Haven.

4. See a painting (now at Lords Cricket Pavilion) attributed to Theodor de Bruyn, "Prospect of Dorking with the Deepdene," ca. 1700–1772, illustrated in John Harris, *The Artist and the Country House* (London: Sotheby Parke Bernet: 1979): fig. 366.

5. Hope to Millin (Paris, Bibliothèque Nationale, Nouv. Acqu. 3231, f.115, London, 29 September 1815) (my translation).

6. Alison Kelly, *Mrs. Coade's Stone* (Upton-on-Severn: Self Publishing Association, 1990): 152, 167.

7. Hope paid Atkinson £1000 on 14 December 1822 (ING Bank [London Branch] NV, Ledger no. 100027, 1821–23, Thomas Hope, f. 177v).

8. Expanded in the final edition as *Essays on the Picturesque, as Compared with the Sublime and the Beautiful*, 3 vols. (London: Mawman, 1810).

9. This work can be dated to 1818–19 on the basis of a calendar illustration of the house for September 1818 and an account in a letter of Maria Edgeworth in the following April; Watkin, *Thomas Hope* (1968): 163–64.

10. John Preston Neale, "The Deep-Dene, Surrey," *Views of the Seats of Noblemen and Gentlemen . . .*, 2nd ser., vol. 3 (London: Sherwood, Gilbert, and Piper, 1826): 4.

11. Although Cockerell's perspective drawing of the house in 1823 (see below, n. 29) shows the tower, and his accompanying sketch plan includes the new library at the other end of the northwest front, his drawing surprisingly omits the dining room, even though it had presumably been built in 1818.

12. Neale, "The Deep-Dene" (1826): 10.

13. Loudon, *Encyclopaedia* (1833).

14. John B. Papworth, *Rural Residences . . . With Some Observations on Landscape Gardening* (London: Ackermann, 1818): pl. xvii.

15. Ibid., 69–70.

16. Uvedale Price, *Essays on the Picturesque*, vol. 2 (London: Mawman, 1810): 180.

17. Ibid., 212–13.

18. *Gardener's Magazine* 5 (1829): 589–90.

19. Maria Edgeworth to her mother, Elizabeth, 12 April 1819; *Letters from England, 1813–44*, ed. Christina Colvin (Oxford: Clarendon Press, 1971): 201.

20. In *Review of the Publications of Art* 2 (1808): 198–205. He published it again in 1819 as the preface to the lavish publication on the Duke of Marlborough's house and gardens at White Knights, Berkshire. This book had been written by Soane's friend Barbara Hofland, who had contributed at his request extensive "pictorial and poetical remarks" to the final edition in 1835 of his monograph on the Soane Museum, *Description of the House and Museum on the North Side of Lincoln's Inn Fields*.

21. *Repository of Arts* 1 (1823): no. vi.

22. Richard Payne Knight, *An Analytical Inquiry into the Principles of Taste* (1805; 4th ed., London: Payne and White, 1808): 225.

23. Introduction by Thomas Hope (dated 1808) in Barbara Hofland, *A Descriptive Account of the Mansion and Gardens of White-Knights* (London: Printed for the Duke of Marlborough by W. Wilson, 1819): 11–13.

24. William Chambers, *A Dissertation on Oriental Gardening* (London: W. Griffin, 1772): 16.

25. Hope, Introduction (1819).

26. Richard Payne Knight, *The Landscape, a Didactic Poem in Three Books. Addressed to Uvedale Price, Esq.* (1794; 2nd ed., London: Bulmer, 1795), pl. 1, engraved by Thomas Hearn. Knight praised the setting of a house which leads the visitor to "view the craggy cliff's tremendous height; / Or, by the murmuring rivulet's shady side, / Delights to shew the curling waters glide, / Beneath reflected rocks, or antique towers" (Book I, lines 30–33).

27. Neale, "The Deep-Dene" (1826): 7.

28. Payne Knight, *Analytical Enquiry* (1808): 221–22.

29. Thorvaldsen's *Psyche* and *Jason* are in the Thorvaldsens Museum, Copenhagen.

30. Now in the Ashmolean Museum, Oxford.

31. Now in the Thorvaldsen Museum, Copenhagen.

32. John Morley, *Regency Design 1790–1840* (London: Zwemmer, 1983): 116.

33. See Geoffrey Waywell, *The Lever and Hope Sculptures: Ancient Sculptures in the Lady Lever Art Gallery, Port Sunlight* (Berlin: Gebr. Mann Verlag, 1986): 54.

34. It was consecrated by John, Bishop of Raphoe, in the presence of John Poulter, Commissary Bishop of Winchester, as a burial place of Charles William Hope and his family and descendants, 29 June 1819 (Surrey History Centre, Ref. 2971/4/2).

35. The documents in which Cockerell recorded his impressions of Hope are his diaries for 1821–35; see David Watkin, *The Life and Work of C. R. Cockerell* (London: Zwemmer, 1974); for "Ichnographica Domestica," Cockerell's illustrated notes on the planning of private houses, see John Harris, "C.R. Cockerell's 'Ichnographica Domestica,'" *Architectural History* 14 (1971): 5–29. The diaries are now in the possession of the RIBA Library, but "Ichnographica Domestica" was broken up in 1988 and sold at Sotheby's, although 55 pages were acquired by the RIBA. His description of Deepdene with plan and perspective view is in the Getty Library 88-A691, inv. no. 860689.

36. Watkin, *Cockerell* (1974): 169.

37. C. R. Cockerell, Diary, 23 April 1823, cited in Watkin, *Cockerell* (1974): 173.

38. See Peter W. Clayden, *The Early Life of Samuel Rogers* (London: Smith, Elder, 1887): 448–49.

39. John R. Hale, *The Italian Journeys of Samuel Rogers* (London: Faber, 1967): passim.

40. His numerous publications also included *Some Remarks on the State of Learning and the Fine Arts in Great Britain* (London, 1831).

41. He was the second son of Michael Millingen, a Dutch merchant who had settled in London.

42. C. R. Cockerell, Diary, 18 August 1823.

43. C. R. Cockerell, Diary, 18 October 1824 (Watkin, *Cockerell* [1974]: 88.

44. C. R. Cockerell, "Ichnographica Domestica" (1971): 71.

45. C. R. Cockerell, Diary, 17 August 1823.

46. See Clive Wainwright, "George Bullock and His Circle," in *George Bullock Cabinet-Maker* (London: Murray and Blairman & Sons, 1988): 21–22.

47. Peter Thornton, *Authentic Decor, The Domestic Interior 1620–1920* (London: Weidenfeld and Nicolson, 1984): 208.

48. Ibid.

49. Acquired in 1995 by the Victoria and Albert Museum and the National Museums and Galleries on Merseyside.

50. See Lucy Wood and Sarah Medlam, "A pair of Egyptian Revival chairs designed by Denon," *Apollo* (June 1997): 45–47. Denon owned an identical pair of chairs, but with mounts of silver rather than gilt-bronze. Their whereabouts is now unknown.

51. Maria Edgeworth, *Letters from England* (1971): 197.

52. E. M. W. Tillyard, *The Hope Vases* (Cambridge: Cambridge University Press, 1923): 2.

53. Useful information about this phase of the history of the house is contained in a series of drawings that are bound in with the Minet Library volume of Britton's *History of the Deepdene* and others in the Mellon Collection, Yale Center for British Art, New Haven. For an analysis of all these, see Richard Garnier, "Alexander Roos (c. 1810–1881)," *Georgian Group Journal* 15 (2006): 11–68. The designs for the Deepdene at the Minet Library that I attributed to Thomas Hope and William Atkinson in *Thomas Hope* (1968), pls 71 and 82–86, are all attributed by Garnier to Alexander Roos, despite their markedly different drawing techniques.

54. "Deepdene, Dorking, The Seat of Lord William Beresford," *Country Life* (20 May 1899): 624–29. Two photographs of the Drawing Room and the Vase Room showing objects from Hope's collection, taken for this article but not included in it, were published in John Martin Robinson, *The Regency Country House from the Archives of Country Life* (London: Aurum Press, 2005): 186–89.

55. Henry William and Irene Law, *The Book of the Beresford Hopes* (London: Heath Cranton, 1925): 113.

56. See Christopher Woodward, "Beckford's Tower in Bath," in Derek Ostergard, ed., *William Beckford, 1760–1844: An Eye for the Magnificent*, exh. cat., New York, Bard Graduate Center (New Haven and London: Yale University Press, 2001): 279–95.

57. *Lord Beaconsfield's Correspondence with His Sister, 1832–52* (London: John Murray, 1886): 164.

58. John Claudius Loudon, *Encyclopaedia of Cottage, Farm, and Villa Architecture* (London, 1833).

59. Anon., "The Soanean Museum," *Civil Engineer and Architects' Journal*, vol. 1 (1837–38): 44.

60. For an analysis of Deepdene in this context, see my "The Deepdene: 'Grotesque and Confused'?," in Barry Bergdoll and Werner Oeschlin, eds., *Fragments, Architecture and the Unfinished: Essays Presented to Robin Middleton* (London and New York: Thames and Hudson, 2006): 139–46.

61. Robin Rhodes, *Architecture and Meaning on the Athenian Acropolis* (Cambridge: Cambridge University Press, 1995): 136.

62. William MacDonald and John Pinto, *Hadrian's Villa and Its Legacy* (New Haven and London: Yale University Press, 1995).

63. William MacDonald, *The Architecture of the Roman Empire*, vol. 2: *An Urban Appraisal* (New Haven and London: Yale University Press, 1986): 274.

64. After use as a hotel between the two World Wars, the house became British Railway offices until 1966, during which time it was deplorably treated. Its subsequent demolition caused surprisingly little stir.

ANASTASIUS.

His eye-strings broke, his features fell, and his limbs stiffened for ever. All was over! Alexis was no more!

London, Published by John Murray, Albemarle Street & R. Bentley, 1836.

Fig. 13-1. W. Cawse. *The Death of Alexis.* Engraving from 1831 edition of Thomas Hope's *Anastasius.*

The Tragic Mask of Anastasius/Selim: A New Introduction to Hope's Novel

Jerry Nolan

Thomas Hope began *Anastasius* with a vividly written portrait of Anastasius's father:

> *My family came originally from Epirus: my father settled in Chio. His parentage was neither exalted nor yet low. In his own opinion he could boast of purer blood than any of the Palae-ologi, the Cantacusenes, and the Comneni of the present day. 'These mongrels descendents,' he used to observe, 'of Greeks, Venetians, and Genoese, had only picked up the fine names they flourished about in, when the real owners dropped off: he wore his own;' and signor Sotiri saw no reason why he should not, when he went forth into public, toss his head, swing his jubbee, like a pendulum, from side to side, and shuffle along in his papooshes, with all the airs of quality.*[1]

Yet by the end of the first chapter, Anastasius had left his father and his family behind in Chios to embark on a life of precarious self-invention and adventuring across the Orient during the closing years of the eighteenth century. Throughout the long narrative in three volumes, Hope—the displaced Dutchman with Scottish ancestry who chose to live in England—drew together diverse strands to create a most convincing portrait of a "young Greek" who learns much about life from his traveling, and most of all finally from the experience of becoming a father himself.

When he embarked on writing his only novel, Hope probably did not realize that he was penning a work that would gain many readers, including a vociferous minority who would even doubt his authorship of the work. In the correspondence with John Murray during the pre-publication period of *Anastasius*, Hope expressed anxiety about the slow progress of his special venture. In the John Murray archive may still be found the evidence that Hope became impatient with John Murray at the very slow process of the publication—a letter dated January 12, 1819, from the Deepdene:

> *I have been intending for some time past to write to you, and always put it off, in hopes of having the pleasure of seeing you in Town. . . . I do not wish any longer to delay stating how very slowly the printing of A. goes on. . . . I do not understand anything of the business of printing; but I should think that by not waiting to send me a new sheet to correct until the preceding one*

has been revised and perhaps printed off, some more dispatch might be obtained. I have thus far only revised twelve chapters; and there are in all forty eight, or sixty per volume.[2]

By January 11, 1820, Murray was writing to Oliver & Boyd: "I was not aware that *Anastasius* from an unknown author would have sold so well—it is nearly out of print." (The author was unknown and unnamed in the 1819 edition.) In 1820 it was Murray's turn to complain in another letter to Oliver & Boyd about delays in the appearance of the second edition: "*Anastasius* has been retarded by the Author & I am yet fearful that it can not be ready before the end of the Month." On April 9, 1820, Murray triumphantly wrote to Oliver & Boyd: "*Anastasius* . . . next week." Perhaps Murray was the one who persuaded Hope to declare himself as author in the second edition. The announcement that the author was Hope, "the Furniture and Costume Man," was greeted with widespread incredulity. Hope's somewhat contorted attitude to fully unmasking himself as the author of *Anastasius* has fueled generations of skeptics, ancient and modern, even to the point of their not believing that Hope was the actual author.

In the first edition (cat. no. 108), Hope posed as the editor of a recently found manuscript, which, though he claimed it was ill written and full of erasures, was being brought to public notice for its interest to people who were interested in the regions "once adorned by the Greeks, and now defaced by the Turks." The editor went on to emphasize that the weeds in the work were so closely interwoven with its flowers "that only some of the rankest among the former could be plucked out, without detriment to the latter." This point was used to justify the editor's accompanying notes at the back of the volumes explaining Turkish words and allusions to Eastern customs in an effort to help the reader "respecting the constantly shifting scene of action, to which we are conveyed by the restless writer of these unvarnished *confessions*."

In the second edition of the novel, in 1820, Hope's name was not printed on the title page; the 1819 editor's preface had disappeared (never to be reprinted) and, probably on the advice of Murray, a new preface appeared signed by Hope from Duchess Street and dated April 25, 1820. Here new forms of apologies,

hesitations, and diversions resurfaced. The new preface was headed by a dedication, in most effusive tone, to his wife, Louisa: "to you the sole partner of all my joys and sorrows; to you, whose fair form but shrines a mind far fairer, I inscribe not these pages. Composed of materials collected ere I knew you, ere I was inspired by your virtues or could portray your perfections." He then referred to his "unpruned performance" to the reading public at large before drawing attention once more to the whole work's having being the result of personal observation of those ever interesting regions "once adorned by the Greeks and now defaced by the Turks." Hope could not resist voicing the reservation that he "shall not be considered as identifying myself with all the opinions which the peculiar nature of the work has obliged me to bestow upon my hero." Hope did not specify the extent of the "pruning," that is, the rewriting of certain passages in the second edition; however, the changes did not alter much narrative but greatly enhanced the verve of the prose.

On the novel's first publication, there was much approval but in a disparaging review that appeared with the title "On *Anastasius*. By—Lord Byron," Christopher North argued, by facetiously invoking chapter and verse, that "the reader at all acquainted with Byron's manner of thinking, must trace his mind in every page of *Anastasius*."[3] This line of attack provoked Hope to state unequivocally and uncharacteristically that, even though he did acknowledge the help and advice of friends, he was in reality the sole author of the novel, which was based on his own extensive travels in the East "long before Lord Byron's admirable productions appeared . . . and need scarcely add, though I do so explicitly, that I am the sole author of *Anastasius*."[4]

Some of the initial responses from reviewers of *Anastasius* amounted to little more than extensive plot listings of the places visited by the adventurous and ruthless bandit Anastasius, who was deemed guilty of a succession of crimes and villainies throughout the Ottoman Empire. One of the earliest articles about the novel became the prototype of the popular detailed plot summaries masquerading as reviews.[5] Perhaps some, or even many, of the nineteenth-century readers did read Hope's novel for "information" about goings-on throughout the Ottoman Empire. One can now only guess at the number of readers for whom Henry Crabb Robinson spoke in his conclusion that *Anastasius* was "a book of perverted talent and abused strength, of which I retain a disagreeable impression though I have happily forgotten the facts."[6]

In the twentieth century, by which time Hope's literary legacy had virtually disappeared from public view, the two pioneering scholars who blazed the trail for his rediscovery, Sandor Baumgarten and David Watkin, showed limited interest in the *literary* subtleties of the character development of Anastasius. Baumgarten summarized his overall impression as "Un Don Juan En Prose." In the instance of David Watkin, there was a frank admission that a critical literary account of *Anastasius* was outside the scope of his brilliantly pioneering book on Hope as a very special kind of "Furniture and Costume man" indeed.[7] More recently, Watkin described the character of Anastasius as a "Byronic hero" before going on to confess his own impatience with the character of Anastasius, who "having exhausted himself and it must be confessed, the reader, he dies at the end of the novel aged only thirty five"; but Watkin did admit to a measure of enthusiasm for the novel's descriptions of the exotic clothes at times worn by the protagonist, and of the décor of the rooms of the house of the Greek Mavroyeni in Constantinople.[8] The main difficulty with such an approach to Hope's novel is that it overlooks masked depths in the tale of Anastasius's spiritual development, which form a philosophical groundswell throughout the narrative of *Anastasius*. In brief, far too much attention has been paid to the succession of geographical places described and far too little attention has been paid to the sequence and stages of Anastasius's inner progress as a Greek traveler in the Orient.[9]

Probably few modern readers will manage much enthusiasm for the passion of the first readers of *Anastasius*, who were intent on the accuracy or lack of accuracy on the details collected about life, art, warfare, and so on throughout the Ottoman Empire during the 1790s when the author had traveled there. But what might well engage a modern reader is the symphonic-like treatment of the intense drama of Anastasius Sotiri, the youngest son of a large wealthy family, born during the 1760s on the Greek island of Chios. The first stage of Anastasius's progress is his decision to leave home for a life of adventure after an unhappy love affair with daughter of the French consul for whom his father worked as *drougeman*, or interpreter. The experience of Constantinople first provides Anastasius with an important understanding of the world because what most strikes Anastasius in the midst of the surviving visual grandeur is the mortifying awareness of the differences existing between defeated Greek Christians and triumphant Turkish Mohammedans. Anastasius crosses a Rubicon, fleeing for his life from a fanatical mob, when he darts into a mosque and, in a supreme moment of danger and self-awareness, declares himself to be a Muslim convert: "on the spot, and in the very mosque, I went through the various forms which marked the reclaimed infidel. . . . The seemingly bold measure had long been preparing in petto, and the unexpected dilemma to which I was reduced, may only be said to have fixed the period of its execution. . . . I had only been watching for the opportunity to throw off the contemptuous appellation of Nazarene, and to become associated with the great aristocracy . . . with a pang I quitted for the strange sound of Selim, my own and beloved name of Anastasius, given to me by my father."[10]

The challenging ambiguity of feeling and thought at the heart of the conversion of Anastasius into Selim is superbly caught by Hope in his vivid depiction of the Muslim convert's rite of passage into a bewildering world, where he quickly succeeds in being accepted as a Mamluke under the patronage of the Bey: "Wide views, noble prospects, vast plans of fortune and fame all at once, as if the drawing of a curtain, expanded my enraptured view."[11] After the death of his wife, the Lady Khadidge, shortly after their marriage in Egypt, Selim throws himself into a life of negotiation and warfare as an Ottoman soldier in search of new roles: "I was not only from a boy become a man, but a Greek a Mohammedan, and for a person of no note whatsoever an individual who had filled no inconsiderable part in the world's drama."[12] But what he lost as a result of his conversion to Islam is first brought home to Selim when he is rejected by Spiridon, his oldest friend back in Chios: "My abode has become a desert, my life a scene of solitude, my very existence a blot in creation."[13] After he has departed from Chios, now "the place of my shame," with a portion of financial inheritance, the mercenary soldier Anastasius/Selim develops a tragic sense of life: "seeking my fortune in strife, not harmony; making havoc, not culture, the means of my support . . . in a wild wandering flight from one career to another; sometimes prosperous, and oftener unfortunate; now in unavailing plenty, and now again in pinching want."[14] No wonder Anastasius/Selim, in his adventure-tossed situation, smiles knowingly when he hears about the latest armchair Western fashion for admiring a Frenchified Moselemin "who ate an omelette au lard, drank champaign, and wore a portrait of his Circassian mistress."[15]

An intense love affair between Anastasius/Selim and the Greek Euphrosyne is life-enhancing but short-lived.[16] Before Euphrosyne dies, a child is born of the union, the boy Alexis. Although physically separated from Alexis by traveling to Baghdad "fallen from its ancient splendour," Anastasius/Selim begins to imagine his child as "a polar star" and a "magnet whose attraction I felt even when steering in a contrary direction."[17] Eventually a solitary Anastasius/Selim experiences the East as "the eternal desert" out of which he must depart for the future good of his angel child.[18] After much searching, the five-year-old Alexis is found and travels at his father's side through Italy—Naples, Rome, Arezzo, Spoleto, and Venice, with all these cities in stages of visible decline. Alexis dies in Trieste: "Lest he might feel ill at ease on my lap, I laid him down in my cloak, and kneeled by his side to watch the growing change in his features."[19] After the death of Alexis (fig. 13-1), Anastasius/Selim buries the body of his child within the prison of the Lazaretto, where both had been imprisoned for quarantine purposes. With the all-consuming adoration of his lost son now deeply rooted in his heart, Anastasius/Selim reflects that "the golden link by which the past had been connected with the future had been broken."[20] In a mood of tragic detachment, Selim/Anastasius recalls his roving life as a soldier in Cairo, a warrior in Wallachia, a close ally of the Wahhabees near Mecca and Medinah, and a merchant on the Bosporus. At about the age of thirty-five, Anastasius/Selim dies in Austria in the company of a German companion, Conrad, who helps in the writing of his memoirs.[21]

On the novel's last page, Hope as the editor felt it necessary to add a special note to the effect that the whole episode of the father's emotions on the occasion of his son's death became more credible after the recent publication of Mariner's account of similar reactions from Finow, King of the Tonga Islands.[22] This note was not repeated in the second edition or any further edition, which means that Hope finally admitted to himself that such a mask thrown over the strong emotions in his novel had become redundant. In the more compact two-volume edition of the 1830s, the endnotes, which contained so much scattered information about places and customs, were turned into discreet footnotes, which unknowingly underplayed Hope's passion for the lore of Ottoman culture. The key episode of the death of Alexis was illustrated for later editions in an engraving by W. Cawse, which captured graphically one of the novel's key scenes (fig. 13-1).

Retrospectively, it becomes clear that the emotions stirred within Anastasius/Selim by the death of Alexis were strongly rooted in the death of his beloved second son, Charles, who died at the age of seven in Italy, a few years before the publication of *Anastasius*. Charles's ashes were buried at the Deepdene in ground over which Hope erected a mausoleum, where his own body was buried in 1831 next to his much mourned son (fig. 13-2).[23]

Fig. 13-2. Sir Thomas Lawrence. *Charles Hope as Bacchus*. Oil on canvas, 1816. Manuscripts and Special Collections, The University of Nottingham.

So why does Anastasius/Selim in the final stages of the story seek so desperately to return with his son from the East to the West? If one views the character's passionate, obsessive, and ultimately futile quest as a metaphor for Hope's view of the plight of European civilization, we may catch a glimpse of the quintessence of an "Orientalism" that managed to escape the nets of Edward Said in his highly influential survey and cultural dissection of much Western writing about the Orient, all of which led him to accuse many Western writers of being guilty of exploitive colonialism.[24] Hope's Orientalism took the form of a story about a man who was a curious mixture of some elements of the colonized (Anastasius) and of the colonizing (Selim), a Christian Greek and a Muslim Turk. While Hope clearly celebrated the opening of the doors of Oriental perception for his Selim, the genetic marks of the ancient Greeks remain within Anastasius/ Selim. Hope praised the ancient Greek for the readiness "which they showed under every kind of pressure, to assume every corresponding form, and to adapt themselves to every situation." Anastasius as Selim had his eyes opened to the beauties of Oriental cultures and his heart to the loves and friendships that he formed among Turks, Greeks, and Arabs, but Selim as Anastasius has to acknowledge his Greek origins, which has helped him to grasp the tragedy of the entire world. The novel was subtitled "Memoirs of a Greek." There can be little doubt that Anastasius/Hope finally identified with the spirit of the ancient Greeks rather than with modern Greeks, many of whom were so in thrall to their Ottoman masters. A dying irony in Hope's story is that the memory of Anastasius/Selim is revered as "a young Greek" by the staunch Roman Catholic Austrians who live near his grave but who know nothing about Selim, and to whom Anastasius had been generous during his final days on this earth.

Hope planned to follow the novel with an essay on beauty, "because the greatest human bliss which we are destined to enjoy in a future world will probably consist of the contemplation of all the beauties—all the harmonies—all the harmonies . . . of the universe."[25] The truth is that Hope was never an Imperialist Orientalist in the Said sense of the word but in essence was an European Classical Hellenist in profound sympathy with the project of liberal and social political reform across Europe, including England, which placed him somewhat at a tangent to the Philhellenists like Byron who focused much attention on one particular war for Greek independence from the Ottomans.[26] In a recent essay, Resat Kasaba has suggested that the many deaths recorded in *Anastasius* might well be understood as an aspect of Hope's increasing despair at the refusal of Europeans to learn from the universal ideals of Greek civilization, a cultural failure that would surely lead down the cul-de-sac of embittered nationalisms.[27] In contrast to the fate of Anastasius/Selim, Hope in his own life and work sketched many scenes from Ottoman life and culture and assembled collections of furniture and costumes, as well as designing both in neoclassical ways that brought together the cultures of East and West, a passion for harmony that he longed to communicate to future generations. Beautiful remnants of Hope's life and work have at last been collected in this exhibition for a fresh understanding of this solitary and elusive man who was both an aspiring world philosopher in *Essay of the Origins and Prospects of Man* and a very accomplished novelist, whose only novel *Anastasius* awaits widespread rediscovery, perhaps in its first one-volume edition, that could well excite a new generation of readers, who might well see in the vividly recorded experiences of Anastasius/Selim an imaginative resonance for twenty-first century readers who still search for convincing metaphors for interdependent cultural harmonies between the East and West.[28]

1. Thomas Hope, *Anastasius or, Memoirs of a Greek*, vol. 1 (London: John Murray, 1819): 1. In the first note, the editor describes "jubbee" as a "flowing gown, generally worn in the Levant by men of sedentary habits and professions," p. 357. In the present essay, all quotations and page reference are taken from the famous first edition of the novel.

2. My thanks to Virginia Murray of John Murray Archive for assistance in this research. For further information about the production, circulation, and reception of *Anastasius*, see the University of Cardiff 2004 Web site www.british-fiction.cf.ac.uk/

3. *Blackwood's Edinburgh Magazine* (September 1821): 200–206.

4. Ibid. (October 1821): 312.

5. *Monthly Review 91* (January–February 1920): 1–16, 131–41.

6. Quoted in Sandor Baumgarten, *Le créspuscule Neo-Classique: Thomas Hope* (Paris: Didier, 1958): 251. Baumgarten listed many of Hope's contemporaries who praised the novel, including Walter Scott, Thomas Carlyle, Lord Byron, William Thomas Beckford and John Keats. Baumgarten himself strongly sensed that *Anastasius* was the work that contained most of the keys required to fathom the mind of Thomas Hope. In Andrew Nicholson, ed., *The Letters of John Murray to Lord Byron* (Liverpool: Liverpool University Press, 2007): 351, appears the following: "Hope was here today & is much gratified by yr. approbation of Anastasius," 24 October 1820.

7. Watkin, *Thomas Hope* (1968): 238.

8. See David Watkin and Fani-Maria Tsigakou, "A Case of Regency Exoticism: Thomas Hope and Benaki Drawings," *Cornucopia* 5 (1993–94): 52–59.

9. Another essay in another place probably needs to be written to spell out for those interested why *Anastasius* cannot be conveniently and convincingly pigeonholed as a Byronic hero, as he has so often been categorized. Would a Byronic hero have fathered, loved, and mourned a son like Alexis before going on to reflect on the philosophical significance of the young boy's death? When Hope responded to the suggestion that the work was by Byron, he made the point that his own traveling in the Ottoman Empire occurred "well before Byron's admirable productions appeared."

10. *Anastasius*, vol. 1 (1819): 196–204.

11. Ibid., vol. 1, 301–4.

12. Ibid., vol. 2, 128.

13. Ibid., vol. 2, 239–40.

14. Ibid., vol. 2, 243.

15. Ibid., vol. 2, 411–12.

16. Ibid., vol. 3, 300ff.

17. Ibid., vol. 3, 125.

18. Ibid., vol. 3, 306.

19. Ibid., vol. 3, 402ff.

20. Ibid., vol. 3, 417.

21. Ibid., vol. 3, 452.

22. See William Mariner, *An Account of the Tonga Islands in the South Pacific*, 2 vols. (London: John Murray, 1817).

23. Hope commissioned Thomas Lawrence to paint the young Charles a year or so before his death as a radiantly smiling boy with a curled lock, a little Bacchus with a panther's skin over his right shoulder, and a bunch of grapes being lifted in his left hand. Lawrence's portrait is now in the possession of the Trustees of the 11th Duke of Newcastle on display in the Nottingham Art Gallery. See Herbert Huscher, "Thomas Hope, author of Anastasius" in *Keats-Shelley Memorial Bulletin* 19 (1968): 2, 133, for very apt comment on the crucial link between Charles and Alexis.

24. See Edward W. Saïd, *Orientalism: Western Conceptions of the Orient* (London: Routledge & Kegan Paul, 1978), where there is no awareness of Hope's existence in the long lists of Western writers who recorded their impressions of the Orient.

25. For Hope's idealistic view of the ancient Greeks, see chap. 38 in *Essay on Origins and Prospects of Man*, vol. 3 (London: John Murray, 1831): 307–28.

26. See Huscher, "Thomas Hope" (1968): 13. "He feared for England a kind of social upheaval and revolution as he had witnessed in France unless there were far-reaching social reforms."

27. See Resat Kasaba, "The Enlightenment, Greek Civilisation and the Ottoman Empire: Reflections on Thomas Hope's Anastasius," *Journal of Historical Sociology* 16 (March 2003): 1–21.

28. Recently published wide-ranging studies of post-Saïd Orientalism persist in ignoring Hope as a profound chronicler of and thinker about the Orient. See, as examples, P. and J. Starkey, eds., *Interpreting the Orient: Travelling in Egypt and the Near East* (Reading: Ithaca Press, 2001), and Ash Cirakman, "From the 'Terror of the World' to the 'Sick Man of Europe': European Images of the Ottoman Empire from the Sixteenth Century to the Nineteenth," *European Legacy* 9, no. 5 (2004). A significant gap, therefore, continues to remain in the ongoing discussion of "Western Conceptions of the Orient."

AN

ESSAY

ON

THE ORIGIN AND PROSPECTS

OF

M A N.

BY THOMAS HOPE.

IN THREE VOLUMES.

VOL. I.

LONDON:
JOHN MURRAY, ALBEMARLE STREET.

1831

CHAPTER 14

Hope's Philosophical Excursus

Roger Scruton

Thanks to pioneering studies by Sandor Baumgarten and David Watkin,[1] we know a great deal about Thomas Hope's role in promoting the neoclassical aesthetic, about his enormous gifts as designer, draftsman, and architectural historian, about his influential conception of landscape and gardening, and about his awkward but imposing presence in a society that greeted his wealth, taste, and literary talent with envy and respect. A certain amount has been written about Hope's curious novel, *Anastasius,* which saw fourteen editions in several languages in the author's lifetime and played a not inconsiderable role in shaping contemporary interest in Islamic culture. This interest, which was to be both misrepresented and roundly condemned by the late Edward Saïd in his attack on "Orientalism,"[2] was testimony to the intellectual and moral curiosity of the times, of which Hope was a particularly impressive example.[3] Hope was an aesthetic prodigy and a man of extraordinary energies, who managed to combine a demanding social calendar, a large family, and passionate connoisseurship with a voracious reading habit in all the languages, ancient and modern, required of a scholar.

However, there is one aspect of Hope's output that has been neglected by recent studies—although covered in a short and somewhat facetious chapter by Baumgarten—and that is the *Essay on the Origin and Prospects of Man* (cat. no. 115). Published in three volumes in 1831, a few weeks after Hope's death, the book was written in a peculiar stream-of-consciousness style indicative of the author's desire to get his philosophy on paper while his failing health allowed. It is hard to think of this work as making a significant contribution either to science or to philosophy; nevertheless, it displays the enormous breadth of Hope's learning and interests. It is also remarkable as an early attempt to found a philosophy of man in biological science and to found biology in the laws of physics. Although the theories offered are frequently eccentric or quaint, they testify not only to Hope's wide reading in science and philosophy, but also to a serious study of plants and animals, as well as of human beings in the various societies and climates that he had known.

The *Essay* is not an easy read: Latinate syntax and subordinate clauses are used to extend sentences for page after page, with at least two sentences surpassing two thousand words before reaching their main verb.[4] However, there is a certain exhilaration to be gained from Hope's breathless and mountain-climbing prose, which aspires always to peaks beyond his reach but refuses, however exhausted, to abandon the ascent. I offer only the briefest survey of a work that no one, to my knowledge, has attempted to describe in full.

The *Essay* begins by rejecting the Cartesian search for certain foundations for our knowledge. (Hope gives his own version of Lichtenberg's retort to the famous *cogito ergo sum,* namely that Descartes is entitled to assert only that there is thinking, not that there is something that thinks.) It is not certainty that human beings need but a view of the universe that will enable them to understand their place within it. Hence, we must explore the fundamental structure of matter and the forces that govern change. The little globe on which we find ourselves is only one of uncountably many, spread through space and time, and ordered by causation. We ourselves are individuals, identical in time from one moment to the next, even though we are constantly remade, incorporating new matter and expelling the old. One of the fundamental requirements of philosophy, therefore, is to understand our own identity through time. Hope worries in a very modern way over the relation between space and time, toys with Aristotelian thoughts about the paradoxical nature of time, and at one point seems half willing to concede that time is unreal. He also rashly opposes the science of his day, denying that gravitation is a force of attraction and coming close to the modern idea of a force-field: indeed, he attempts to include gravitation and electricity (electromagnetism, as we would call it) in a single theory, as separate manifestations of a single field of force. This is one of several places where Hope's argument dimly anticipates the unified field theory of modern physics.

Hope is concerned to show the smallness of our world among the infinity of worlds unknown to us. He emphasizes the impossibility of understanding the origins of the universe, and the need

to rest our beliefs on far-reaching conjectures. In the second volume, Hope moves on to explore the nature of life, arguing vigorously against the view associated with the theologian William Paley, that the perfect harmony between the predicaments faced by living organisms and their ability to overcome them, is evidence of design. As Hope puts it, the wants of living creatures and their ability to satisfy those wants arise from a single cause. In other words, that which created the need also created the answer to it. Hope takes here the first step toward recognizing the profound truth later grasped by Darwin in all its far-reaching subversiveness. You explain the ability of animals to survive, not by seeing them as designed to do so, but by recognizing that the forces that shaped their environment also adapted them to survive in it. Hope combines this core scientific insight with an eccentric biology of his own, arguing that living organisms maintain their structure by absorbing "silica" from the atmosphere—a theory that he embellishes with many curious observations.

The modern reader is likely to be struck both by the impetuous self-confidence of Hope's theories and by the minute botanical and zoological observations advanced in support of them. Particularly impressive is his theory of the nervous system, whose role in governing mental activity he accurately perceived, while mistakenly conceiving communication along the nerves in hydraulic, rather than electrical, terms. Had his life taken another course from the one that he chose, Hope might have become a distinguished naturalist, a reputable precursor of Darwin.

Hope distinguishes animals from vegetables not, as Aristotle had done, through the ability of animals to move themselves, but in a more modern way, through the presence or absence of sensation. He acknowledges the difficulty in defining what a sensation is but argues that we are sufficiently familiar with the thing itself to dispense with a definition of the word. He proposes a theory of the mind, as a kind of memory bank for the storing of sensations, and he allows that animals (or at any rate the higher animals) have minds, just as we do. His theory of mind draws heavily on the "association of ideas," as Locke and Locke's disciple Condillac had expounded it. But Hope treats the minds of animals as sharing important features with the minds of humans, and sees both as subject to invariable biological laws. Whether he could be called a "physicalist," in the modern sense of that term, is doubtful: mind, for Hope, is an intrusion into the physical world that leaves us with many a mystery unexplained. Nevertheless, he believes that our mental processes are all governed, in the end, by the laws that set the universe in motion, that we humans therefore do not have free will but only "freedom of action," by which he means the ability to carry out decisions that arise in us from causes we do not control. And, in one of the few notices that the *Essay* has ever

received—a savage review by Carlyle in the *Edinburgh Review* of 1831—Hope is denounced as a "materialist."[5]

Hope recognizes that the distinction between "brutes" and humans is a distinction between two types of animal. Nevertheless, we are not *merely* animals, destined to live in the present moment and to pass away, leaving no remainder. Animal minds are organized by instinct, whose perfection and infallibility is paid for by an inability to adapt or to learn. Our minds are organised differently, by rational reflection. Unlike instinctive creatures, we make mistakes; but we also learn from them. Hence, we humans have prospects that are radically distinct from those of the "brutes," and it is these prospects that Hope refers to in the title of his essay. The third volume of his work is, therefore, devoted to expounding the distinctive features of the human condition, such as moral judgment, self-consciousness, sympathy, and all the forms of life that derive from these. Although the argument is frequently hasty and unprepared, there is no doubt that Hope had thought long and hard about the human condition and had been an acute observer of the social and political transformations that had changed the face of Europe. His intention in the third volume is to show how, from the laws that govern matter, we can deduce both an account of the institutions best suited to our life on earth and a plausible conception of the life to come. He offers, therefore, both a political philosophy and an eschatology.

The public conscience was awakening, at the time Hope wrote, to the vulnerability of animals and to the human habit of treating them callously. Hope spells out the reasons for thinking that animals suffer pain as we do when injured or tormented. However, like Schopenhauer, whose magnum opus, *The World as Will and Representation*, first appeared in 1816, Hope argued that the sufferings of animals, while real, are of a different order from human suffering. Pain accompanied by rational reflection on its source is a state of mind far more horrible than anything suffered by an unreflective brute. And while animals can feel fear and rage, they know nothing of the peculiar emotional suffering that Hope calls passion, by which a human being can be thwarted and destroyed.

The joys of humans involving anticipation and reflection are also of another kind from the joys of animals, and human communities are unlike herds or packs in that they are founded on the distinctively human state of mind that we call "sympathy." Hope argues with a considerable degree of plausibility that animals cannot experience sympathy, even if they can become attached to each other in the unthinking way of the herd. Sympathy is the capacity to feel another's pain or another's joy, so as to be prompted to alleviate the one and amplify the other.

Sympathy is the root of the social order, by which we emerge from the state of nature into the political condition. Hope's polit-

ical philosophy is clearly influenced by Hobbes and Locke, and also by the Founding Fathers of the American Constitution. Like Hobbes, he regards the state of nature as a state of war of all against all, from which we emerge only by discarding our hunter-gatherer habits and entering into a social contract with our neighbors. This social contract authorizes us to punish those who take advantage of it while privately evading its terms, and it is the true foundation of legitimate government. It removes the absolute freedom that we enjoy in the state of nature, which is really no more than an indefinite license to pursue our own desires, and replaces it with something far more valuable, which is political liberty.

Why should we enter such a contract? Although Hope endorses Hobbes's view, that it is in our interest to do so, he also believes that there is another motive, which is that of benevolence. Benevolence is natural to human beings, since it springs from sympathy; and equally natural is morality—the disposition to order our lives according to ideas of right and wrong. And from these two motives springs our desire to enter into agreements with our neighbors, to strike deals to our mutual advantage, and to cooperate on building a safe and free society.

Hope defends representative government, in terms that recall those used by Burke, but he sees political representation as simply one instance of a general phenomenon. Representation is something like a primary mental operation, one that is unique to human beings. It is through representation that language develops. At first we express ourselves in cries and groans; after a while, however, we devise words to stand for our inner ideas. The habit arises of using one thing to represent another, in order to simplify the many transactions of society, and to make commerce possible. Thus gold represents value and bank notes represent gold. In a similar way we are supposed to believe, parliamentarians represent people.

Hope has many interesting, though somewhat random, things to say about the government of modern societies, in particular about the need to temper luxury and excess and to cater to the needs of the poor. He offers, *en passant*, a philosophical defense of the "neoclassical idea," arguing that symmetry and meter are intrinsically appealing to rational beings and form the basis not merely of decoration, music, poetry, and dance, but also of social cooperation in all its forms.[6] Rhythm makes work lighter, company more enjoyable, surroundings more intelligible. It rests the eye and the mind, and it forms the reliable background to our social endeavors.

However, Hope's real purpose in volume 3, once he has got the problems of politics off his chest, is to move on to our final destiny and salvation, concerning which he has a theory as singular as any that he toyed with in the earlier chapters. First he considers the problem of evil. Only one thing is intrinsically evil, and that is

suffering, which is indeed the true definition of evil. Yet all suffering is the effect of "decombination," whereby things become disproportionately joined, so as to disintegrate and jar against each other. (This idea too can be seen as a reflection of the neoclassical approach to proportion.) Thus "the same opposite elements which, in certain proportions relative to each other produce good, utility, benefit and happiness, when in proportion relative to each other different from these former ones, produce evil, detriment and suffering."[7]

Evil, so defined, existed prior to the Fall of Man, being an incipient imbalance in the natural order that can lead at any time to destruction. Since we are part of nature and governed by nature's laws, this tendency to evil is something that we experience in ourselves. Evil, for us, is a disintegrating force; it is the constant "decombination" of the good things that we assemble in our search for perfection. It is, therefore, natural for us to believe that we will one day be released from evil; that the perfection toward which we strive will come about in a condition of bliss. This condition is not to be found in this world. But the universe is infinitely vast and contains other worlds, other possibilities, and even worlds outside the spatial and temporal constraints with which we are familiar. It is in such a world that we shall find salvation.

But in what form? Will we be individuals there as we are here below? Hope looks back to his previous discussions and finds in them a refutation of the ordinary belief in life after death. Our bodies here below are in a state of constant flux and "decombination." Bits fall away to become parts of other bodies, and to reassemble them after death would be to cause a hopeless confusing of individuals, who will not be individuals at all but fragments of a shapeless aggregate. This is one of several difficulties that, if I understand him, Hope discerns in the idea of individual survival. Instead, he suggests, we must see life after death as a transcending of individuality, a combining with the angelic host, which overcomes all divisions of the world that we know and absorbs us into the universal harmony.

That somewhat Vedic vision is one that Hope strives, in a perfunctory way, to reconcile with the Christian scriptures, before going on to consider the doctrines of immortality that we have inherited from the Greeks. He argues meanwhile that the wisdom of the Greeks was brought to them from India, an idea that he took, David Watkin has suggested to me, from the self-styled Baron d'Hancarville.[8] Hope's discussion of Greek and Roman civilization, with which he rambles to a conclusion, is by no means the least interesting section of a book that, for all its quirkiness, displays a fascinating attempt to look back over a lifetime's reading and experience in the urgent desire to make sense of it. Hope concludes by exhorting us "to produce as much beauty, sensible and intellectual, as we can; and to live in the

hopes that when, with this life, the substances more coarse, more confused, and with their beauties still mixing more deformities, that fed it, fall away,—when radiance alone remains and wafts our spirit to more exalted globes—we shall from a higher and more central point of view, in the tranquil contemplation of the harmonies of worlds innumerable, enjoy a felicity without bounds in time or place."[9]

Carlyle's contemptuous review of the *Essay* helped to ensure its neglect. And one cannot entirely dissent from Carlyle's description of the book, as one in which "all sciences are heaped and huddled together, and the principles of all are, with a childlike innocence, plied hither and thither, or wholly abolished in case of need." However, Carlyle failed to understand or to sympathize with Hope's design, which was to establish a scientific anthropology and to restore the human species to its proper place in the natural order. Carlyle was deeply hostile to science in any case, disparaged all forms of thought that were tainted by the tradition of British empiricism, and dismissed Hope as he dismissed so many of his contemporaries, for failing to be German, a failure that was all the more to be regretted in a man who had such a promising start in life as a Dutchman. As Carlyle expressed the point: "If the fact, that Schlegel, in the city of Dresden, could find an audience for such high discourse, may excite our envy; this other fact, that a person of strong powers, skilled in English and master of its Dialect, could write the *Origins and Prospects of Man*, may painfully remind us of the reproach, that England has now no language for meditation; that England, the most calculative, is the least meditative, of all civilised countries."

Only 250 copies of the *Essay* were printed, of which 229 were sold and 10 given away. It is presumably not on account of Carlyle's huffing and puffing that so few of these copies now exist. Their disappearance has led Baumgarten to suspect the author's family of having done their best to suppress the book, on account of the heretical views of the afterlife, as well as the transparent aestheticism (which can also be read as a kind of immoralism) with which it ends. The idea of immortality without individuality was certainly shocking to the ordinary Christian believer, and the poet laureate Robert Southey expressed his distaste in a letter to Harriet Taylor of July 15, 1831, protesting the thought of being eternally mingled with David Hume and Leigh Hunt, not to speak of the Jews, the Philistines, the Scotch, and the Irish. Hope's family cannot have been as hostile to his last literary ambitions as Baumgarten supposes, however. For the copy in which Southey came across this eccentric theory of the afterlife, one of the few now in existence, can be found in the London Library. On the title page, in the poet's hand, is the inscription "Robert Southey, Keswick. 5 July 1831, from the Author." Presumably it was sent to Southey after Hope's death by an obedient member of the family.

1. Sandor Baumgarten, *Le crépuscule Néo-Classique: Thomas Hope* (Paris: Didier, 1958); Watkin, *Thomas Hope* (1968).

2. Edward W. Saïd, *Orientalism: Western Conceptions of the Orient* (London: Routledge & Kegan Paul, 1978).

3. As noted by J. C. M. Nolan, in Chapter 13, Saïd makes no mention of Hope in *Orientalism*. This is not surprising, given Saïd's polemical purpose.

4. The cumbersome syntax of Hope's essay is attributed by Herbert Huscher to Hope's legal training and to the Ciceronian Latin taught in the Dutch university of Leiden. See Herbert Huscher, "Thomas Hope, author of *Anastasius*," in *Keats-Shelley Memorial Bulletin* 19 (1968): 2–133. I am grateful to Jerry Nolan for drawing my attention to this source, the only place, so far as I know, in which Hope's *Essay* receives serious praise.

5. Thomas Carlyle, "Characteristics," *Edinburgh Review* 14 (December 1831).

6. Thomas Hope, *An Essay on the Origin and Prospects of Man*, vol. 3 (London, 1831): 154–57.

7. Ibid., 181.

8. Pierre-François Hugues ("Baron d'Hancarville"), *Recherches sur l'origine, l'esprit et les progrès des arts de la Grèce, etc.*, 3 vols. (London, 1785). For an illuminating discussion of this book, the author of which (Pierre-François Hugues, 1719–1805) was a distinguished archeologist, traveler, and friend of Winckelmann, Sir William Hamilton, Payne Knight, and many other influential figures, see David Watkin, *Sir John Soane: Enlightenment Thought and the Royal Academy Lectures* (Cambridge: Cambridge University Press, 1996): chap. 5.

9. Hope, *An Essay on the Origin and Prospects of Man* (1831): 382–83.

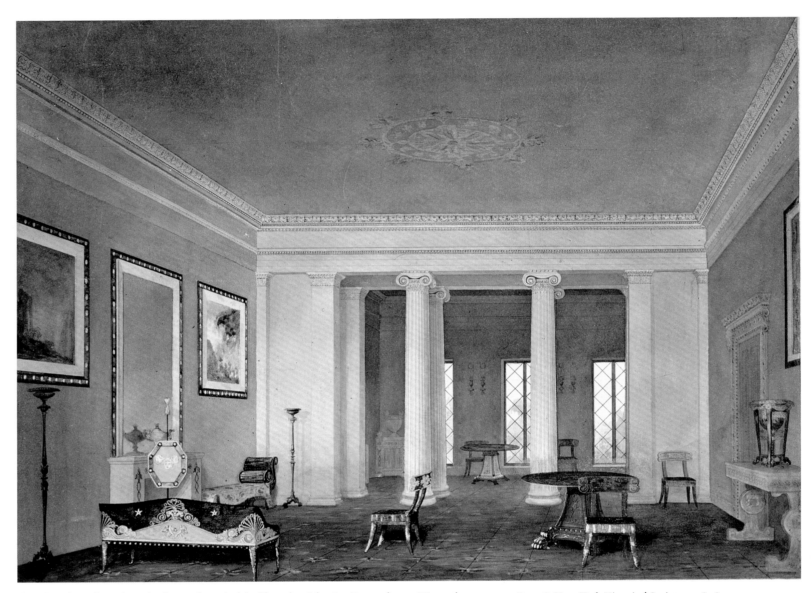

Fig. 15-1. Alexander Jackson Davis. Greek Revival double parlor, John Cox Stevens house. Watercolor on paper, 1845–48. New-York Historical Society, 1908.28.

CHAPTER 15

The Afterlife of Hope: Designers, Collectors, Historians

Frances Collard and David Watkin

The Nineteenth Century: America, France, England

The continuing interest demonstrated in Hope's furniture designs by designers, craftsmen, and patrons after his death may be explained by the restrained yet truly classical nature of his furniture. This was appreciated by such influential writers as John Claudius Loudon, an admirer and promoter of Hope's Deepdene. In his *Encyclopaedia of Cottage, Farm and Villa Architecture*, first published in 1833 and reprinted several times without substantial changes until the 1860s, Loudon cited Hope's publications, some of which he had borrowed from a bookseller, among his list of sources. He also illustrated four chair designs from *Household Furniture*, praising them for their beauty and freedom from historical associations, which therefore made them appropriate for men of taste.[1] Hope had, of course, chosen to publish his furniture designs in clear drawings with measurements in order to facilitate their imitation. However, according to the doctrines of Modernism, styles are so much the outcome of a particular set of social and economic circumstances that they cannot, indeed should not, be echoed in other periods. To adopt this view is to ignore the fact that good furniture, for example, has a permanent appeal, so that in Italy and France furniture to eighteenth-century designs has been manufactured continually up to the present day, wisely out of the sight of art historians. It is probably true that Empire-style furniture has also been made without any serious break from the early nineteenth century onward.

Hope exercised great influence on American furniture design in the first half of the nineteenth century and beyond. Catherine Voorsanger has shown[2] how the "Modern Grecian Style" that appeared in New York about 1825 was an assertive interpretation of forms drawn from Thomas Hope and George Smith, evolving toward 1830 to the elimination of surface ornament in favor of bold outlines, rich veneers, and simple geometries. Resembling Biedermeier furniture, it also reflected the first waves of German immigration and was so widespread that it became a kind of national style. When he republished in 1996 pattern books on household arts originally published in Baltimore in 1840 by John

Hall, an English immigrant, the architect Thomas Gordon Smith pointed out Hope's influence, noting his importance in using the tripod base of the Roman candelabrum for the base of a circular table, which "freed it from its associations with lighting."[3] The klismos chair and other examples of Hope's furniture, including the monopodium table, a pole screen, and a tripod, furnished a double parlor in the John Cox Stevens House, New York (1845–48), designed in an elegant Greek Revival style by the architect Alexander Jackson Davis (fig. 15-1).

This association between Hope's classical furniture designs and rooms perceived as part of the masculine domain was reinforced by the American writer and rural architect Alexander Jackson Downing, who illustrated the klismos chair with two other Hope chair designs in *The Architecture of Country Houses*, first published in 1850, recommending them for library chairs.[4] Whole suites of Hope's furniture were suggested for classical interiors as a slightly chilly alternative to fashionable styles such as the Gothic Revival.

Even at the Great Exhibition in London in 1851, when the prominent displays included the Medieval Court by A. W. N. Pugin and galleries devoted to nationalism and naturalism, Hope's classical furniture was praised. A notable example of his inlaid monopodium table, in ebony and silver, fitted with a silver vase in the center of the top, was exhibited by the silversmith C. F. Hancock of Bruton Street (fig. 15-2). It was described by contemporaries as recalling "the 'Hope' fashion, as it was set by the predecessor of the present distinguished amateur."[5] This example of Hope-inspired design was highly appropriate because Purnell Bransby Purnell, to whom the table and vase were presented in 1851, was a prominent collector of classical antiquities.[6]

Turning to France, we find that a significant feature of taste in the 1860s was for neo-Greek furniture, which was the significant style of the decade, particularly in Paris, and involved all the decorative arts including metalwork and jewelry.[7] The idea of reviving Greek art originated in the 1850s with influential critics such

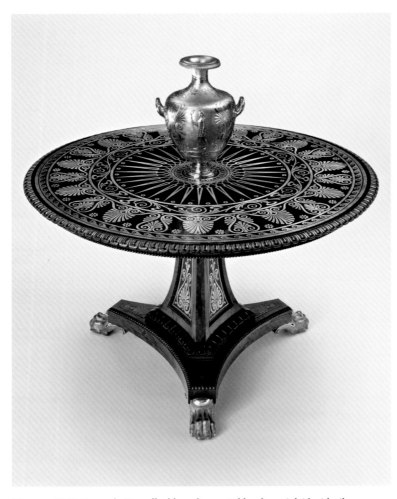

Fig. 15-2. C. F. Hancock. Purnell table and vase. Table: ebony inlaid with silver; vase silver, 1850–51. Victoria and Albert Museum, London, M.46-2003, M.47-2003. V&A Images.

as Félix Duban, architect of the Salle de Melpomène (1860–63) at the École des Beaux-Arts in Paris. Henri-Auguste Fourdinois had studied with Duban before joining his father's cabinetmaking firm, although most of his later work was in a neo-Renaissance manner. Also influential was Victor Marie-Marie-Charles Ruprich-Robert, an architect trained at the École des Beaux-Arts who published a pattern book on neo-Greek style.[8] This furniture was bold and striking, featuring gryphons, heavy pendant rings, pairs of wings, and female busts. Prototypes of furniture in the neo-Greek style were displayed at the Exposition Universelle of 1867 in Paris, from which later variants in simpler, more commercial styles were produced.

The theatrical quality of much Empire-style furniture, whether designed by Percier and Fontaine or by Hope, appealed to painters who willingly used the furniture as props, particularly in fashionable later nineteenth-century portraits. The kitsch, the costly, and the camp recur in the story of the Regency Revival, an early instance being a watercolor of 1876 by Giovanni Boldini, titled *Il Pianoforte*.[9] In a palatial neo-Empire painted room, a girl in the dress of the 1870s sits on a klismos chair at a remarkable

Empire-style piano, its legs crowned with winged sphinx heads of gilt bronze. She is being ogled by a winsome youth decked out in a kind of Regency costume and hairdo. Such watercolors were made popular in engravings by Felix Milius, as was Boldini's similar painting *The Letter*.[10]

Interest in Hope's designs by consumers, designers, and furniture makers continued in the 1860s and 1870s.[11] The so-called Queen Anne Revival was also stimulating an eclectic enthusiasm for late eighteenth- and early nineteenth-century furniture design in the 1870s, so that in Walter Crane's illustrations for *Beauty and the Beast* of about 1873–74 (fig. 15-3), characters are sitting incongruously on Thomas Hope revival furniture.[12] Large and successful furniture-making firms such as Holland & Son used Hope's designs, including figures from *Costume of the Ancients*, as inlaid or painted decoration on their furniture. Public interest in Regency and Empire furnishings became even more apparent in the 1880s, when designs were illustrated in the trade journal *The Cabinet Maker & Art Furnisher* on August 1, 1884, as well as being recommended for consumers, particularly women, by that doyen of home-furnishing advice Mrs. Haweis in her books *The Art of Decoration* (1881) and *Beautiful Houses* (1882).[13]

In January 1895, *The Cabinet Maker & Art Furnisher* devoted several pages to illustrations of Hope's designs from *Household Furniture*, recommending them because "the Empire style comes to us in much the same way that it came at the beginning of the century."[14] Firms such as Edwards and Roberts of Wardour Street produced furniture directly after Hope's designs, such as the magnificent chair of mahogany with a brass inlaid lyre back of 1892–99,[15] and combined these with other pieces in the Empire style[16] (fig. 15-4). Typical of the ensembles into which pieces by such makers as Edwards and Roberts were incorporated was a bedroom decorated in the 1890s at Minley Manor, Hampshire. The house had been built in the French Renaissance manner in the 1850s by Henry Clutton, but a guest bedroom was now transformed in the French Empire style with prints of Napoléon on the walls.[17] James McNeill Whistler collected pieces of Sheraton and Empire furniture, original and reproduction, incorporating some of these in his Paris studio in the 1890s.[18] John Singer Sargent also owned Empire furniture, including a circular table with Egyptian term figures, which he included in several portraits, notably that of Sir George and Lady Ida Sitwell and family in 1900.[19]

The availability of casts from old mounts assisted those interested in producing furniture in Hope's style.[20] Certain designs were more popular than others, probably because they epitomized classical styles while being sufficiently restrained to fit into a range of different interiors. The armchair with X-frame legs, based on the classical curule, different versions of which were illustrated by Hope in the Aurora Room and in *Household Furniture*,[21]

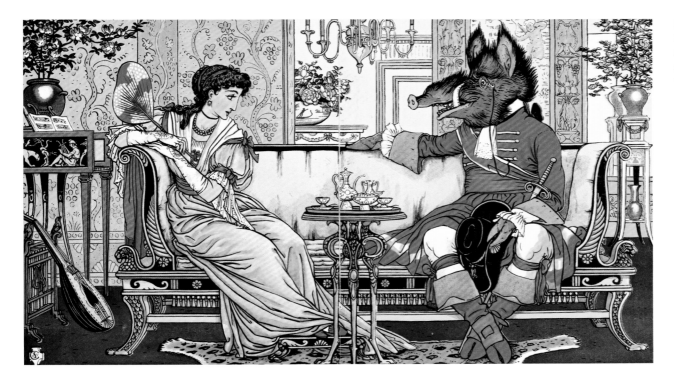

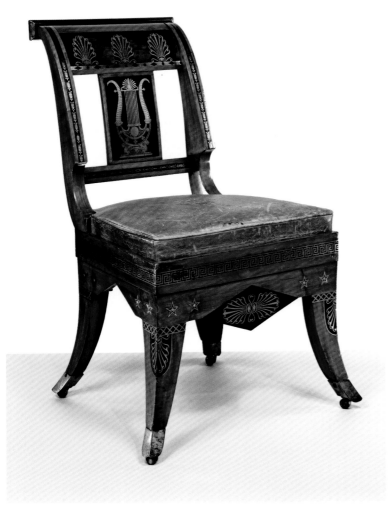

Fig. 15-4. Chair after a design published by Thomas Hope, with the label of furniture makers Edwards and Roberts. Engraving, ca. 1892. Victoria and Albert Museum, London, W.29-1976. V&A Images.

was produced by several firms for different clients. These included the painter Sir Herbert Herkomer, who created the Romanesque Arts and Crafts fantasy of Lululaund in Bushey, Hertfordshire (1886–94), and Willie James, owner of West Dean, Sussex, a house frequently visited by Edward VII as Prince of Wales and from 1901 as king.[22]

Early Twentieth-Century England

The rich, costly, and durable materials of Empire-style furniture, and its association with wealth and display, were all qualities that particularly appealed to the Edwardians. Empire suites thus became popular in the new luxury hotels and liners of about 1900, such as the Hotel Cecil,[23] the Carlton,[24] and Norman Shaw's Piccadilly Hotel. These were equally fashionable in the United States of America, including the Waldorf Hotel in New York City, which had Empire-style rooms as early as 1895. The style made an unusual entry into commercial architecture in the now-demolished United Kingdom Provident Association, Aldwych, London, built in 1906 by Henry Thomas Hare.[25] The domed general office and the first-floor hall, with lavish decorative details, including a pentelic marble frieze with figures in gilt bronze by Lynn Jenkins, have the flavor of the French Empire style and of Hope.

A very different and more serious phase was ushered in by the architects Charles Reilly and Sir Albert Richardson.[26] Reilly, an influential professor of architecture at the Liverpool School of Architecture, promoted a combination of French Beaux-Arts and American classicism, although his Students' Union at Liverpool of 1910 is a handsome essay in an English neo-Grecian style. The

Regency Revival was promoted by his friend Stanley Adshead, who went into partnership with Stanley Ramsey, a pupil of Reilly, with whom he produced a model estate for the Duchy of Cornwall at Kennington in 1913–14. Sir Giles Gilbert Scott and his brother Adrian designed a Hopeian house at 129 Grosvenor Road, of 1913–15, for the Honorable Sir Arthur Stanley, M.P., an unmarried son of the 17th Earl of Derby.[27] He sent Giles Scott to Pompeii to study antique domestic architecture, and he commissioned Scott to design neo-antique furniture for the house.[28] It had a neo-antique stoa open to the Thames, but men who ran the barges invaded it and stole the cushions.[29]

In the meantime, Albert Richardson played a key role in drawing attention to Thomas Hope as a model for modern designers. In 1911 he was the first to publish plates from Hope's *Household Furniture,* as well as surviving pieces of Hope's furniture. These appeared in two articles in the *Architectural Review,* in which he praised Hope for raising furniture design to "a living and first rate art, closely allied to architecture."[30] This was part of Richardson's ambition to break away from what he saw as the sentimental insularity of the Arts and Crafts movement and to reintroduce the English to the intellectual clarity of continental neoclassical architecture and design. To promote this aim, he published more pioneering articles on the "Néo Grec Style" of Jean-Charles Krafft, Jacques-Ignace Hittorff, and Karl Friedrich Schinkel,[31] culminating in his monumental folio on British classical architecture from the 1730s to the 1880s as a consistent tradition that he intended to revive.[32]

The Deepdene Sale in 1917

The sale of Thomas Hope's collection at the Deepdene in the middle of World War I, at one of the most traumatic moments in European history, was a turning point in the appreciation of his achievement and in what we might call his afterlife. Comparatively few people had seen his furniture since his death in 1831,[33] but the dispersal of his collections, which began in 1917 and ended in 1937, gave access to it for a new generation of international collectors, private and public, on both sides of the Atlantic. These included three figures we have already introduced: the American playwright Edward Knoblock, Sir Albert Richardson, and Lord Gerald Wellesley, both architects, and also the Italian art historian Mario Praz. Buyers also included many of the better-known furniture dealers, including L. Harris, H. Blairman, and H. & J. Simmons.

Edward Knoblock (fig. 15-5), who played an important role as an early collector of Hope's furniture, was born in New York and educated first in Berlin and then for four years at Harvard, where he studied French and English literature.[34] He was intended for

Fig. 15-5. Sir John Lavery. *Portrait of Edward Knoblock.* Oil on canvasboard, ca. 1930. National Portrait Gallery, London, 6471. By courtesy of Felix Rosentiel's Widow & Son Ltd., London on behalf of the Estate of Sir John Lavery.

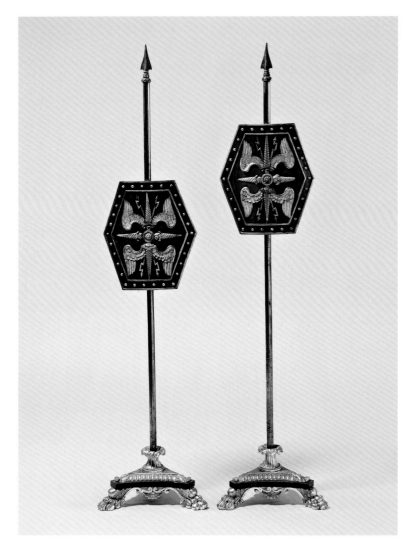

Fig. 15-6. After a design published by Thomas Hope. Pair of pole firescreens. Painted rosewood, brass, steel, ca. 1802. National Gallery of Victoria, Melbourne, Australia, Felton Bequest, 1953, 1346.4.

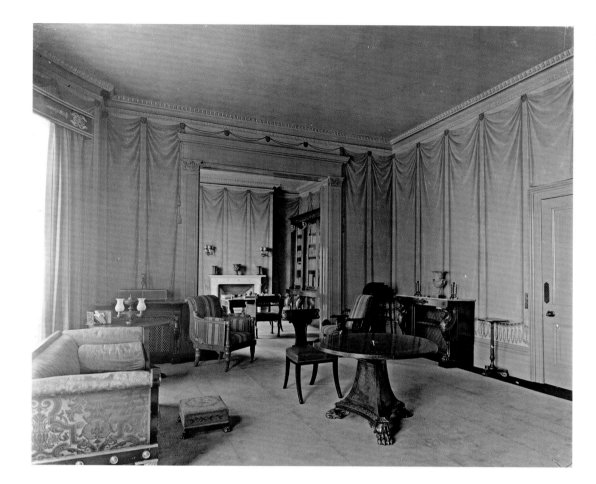

Fig. 15-7. The Painted Library, Beach House, Worthing, photographed in 1921. Country Life Picture Library, L8827-4.

the family firm of architects but settled in 1897 in London, where he became a playwright. He had a great success with *Kismet* in 1911 and also collaborated with Arnold Bennett on *Milestones*, a play about three generations of the same family, first produced at the Royalty Theatre in 1912. Henry James said to him: "You first discovered yourself in England, just as I first did myself." However, in 1912 he took an apartment in the Palais Royal in Paris, the garden square designed by Victor Louis in the 1780s, which he said was then "looked upon by French people as decayed and antiquated." He claimed that "I was among those first to 'resuscitate' it," which he did by furnishing his apartment in the late Directoire and Retour de l'Egypte manner, "then still considered a bastard style."[35]

Knoblock took a set of rooms in Albany in April 1914, which he described as "that oldest and most sedate of bachelor chambers in London. I had always wanted to live there."[36] In the set with the "bow-window and balcony facing Vigo Street," he aimed to create authentic Empire Revival interiors with the help of the architect Maxwell Ayrton. The English counterpart of his rooms in the Palais Royal, they included "a Récamier couch and various cabinets—all, of course, solemn Regency," with "walls marbled in deep sienna and varnished,"[37] and divided into panels by Greek key friezes, and curtains sporting palmette borders.

Knoblock was an extensive purchaser of Thomas Hope's furniture at the Deepdene sale in 1917 (fig. 15-6). The result was described, somewhat ironically, by his friend Arnold Bennett, in his novel *The Pretty Lady* (1918), in which Knoblock appears as "G. J. Hoape." Bennett, who was of a generation to find Hope rather strong meat, wrote in a chapter called "The Albany":

> *[Hope] had furnished his flat in the Regency style of the first decade of the nineteenth century, as matured by George Smith, "upholder extraordinary to His Royal Highness the Prince of Wales." The Pavilion at Brighton had given the original idea to G.J., who saw in it the solution of the problem of combining the somewhat massive dignity suitable to a bachelor of middling age with the bright, unconquerable colours which the eternal twilight of London demands. . . . Here was the clash of rich primary colours, the perpendiculars which began with bronze girls' heads and ended with bronze girls' feet or animals' claws, the vast flat surfaces of furniture, the stiff curves of wood and a drapery, the morbid rage for solidity which would employ a candelabrum weighing five hundredweight to hold a single wax candle; it was a style debased, a style which was shedding the last graces of French Empire in order soon to appeal to a Victoria determined to be utterly English and good . . . a formidable blue chair whose arms developed into the grinning heads of bronze lions . . . the unique bookcase which bore the names of "Homer" and "Virgil" in bronze characters on its outer wings.[38]*

More importantly, Knoblock shortly set out his Hope furniture at Beach House, Worthing, an elegant villa of 1820 by J. B. Rebecca, which he had bought at the end of the war. He remodeled, redec-

orated, and refurnished this in 1918–21 with Maxwell Ayrton as architect, creating the first Hope revival interior after the Deepdene sale. Knoblock described how "I split my interests between architecture and authorship . . . not resting till every moulding and door-knob in the place was of the correct period." As a result, "the place ended by my not possessing *it* but by its possessing me," so that he came to feel that "the fortune I put into Beach House I should have spent in running a theatre." Nonetheless, he was justifiably proud of it as a "perfect example of the Regency days—a museum which I might ultimately bequeath to the town."

The Painted Library (fig. 15-7), with wall decoration of simulated drapery and Parisian fringe, contained not only the monopodium table with an inlaid top and plain support, but also other furniture from the Deepdene, including the bookcase and one of Denon's Egyptian armchairs. Knoblock's enthusiasm for the monopodium table resulted in his ownership of another version, with inlaid top and base, which might have been originally in his chambers in Albany. By 1931 this version was in the back drawing room of his London home, 11 Montagu Place,[39] and finally in his last home, 21 Ashley Place, London.[40]

Beach House was publicized in the influential pages of *Country Life* in 1921[41] by the twenty-one year-old Christopher Hussey, who, as we shall see, was to be a major figure in the twentieth-century rediscovery of Thomas Hope. Indeed, this article, the first ever published on a Regency house in *Country Life*, also contained the first full account of Thomas Hope, while John Martin Robinson has claimed that "the photographs show Hope's collection redeployed in a modern Thomas Hope interior which has remained an influential architectural inspiration ever since."[42]

John Cornforth also hailed Beach House as "the first major statement of the Empire Revival,"[43] so that the dispersal of Knoblock's collection of Hope furniture is a great loss. Discovering that Hope's mother was a Van der Hoeven, Knoblock developed a strong emotional sympathy with Hope, because his own paternal grandmother was a Verhoeven. He confessed that, as a consequence, "I sometimes wonder whether further back I may not have some of the same blood in my veins as Thomas Hope."[44]

A parallel to Knoblock in France was the bachelor scholar and collector Paul Marmottan, who used his private fortune to acquire paintings, furniture, and other objets d'art from the Empire period. His aim, like that of Knoblock and, as we shall see, of Mario Praz in Italy, was to create an Empire setting in his own house. He was moved by a feeling of kinship with the Napoleonic régime, particularly in its cultural and administrative aspects, the courts of Napoleonic Italy having a special fascination for him as a lover of Italy.[45] After his death, his house and its contents, through the terms of his will, became the Musée Marmottan. Beginning to collect in the 1880s at a time when the art of the

Empire was widely discredited, Marmottan acquired three paintings by Louis Gauffier,[46] an artist whose work had also appealed to Hope. Gauffier owned pieces of early neoclassical and Directoire furniture, which he included in his paintings. Marmottan made a special study of his work and published a major article on him.[47] He also bought a 1795 portrait of Cacault, the French ambassador to Rome and Florence,[48] by J.-L. Sablet, who painted Thomas Hope playing cricket in 1792 (see fig. 1-5).

The Italian literary and art historian Mario Praz was consciously indebted to both Knoblock and Marmottan, as is clear from the chapter he devoted to memories of them in his book *On Neoclassicism*.[49] Praz is important as a pioneer in collecting watercolors of Empire interiors, which he published in his key work on the history of interior decoration. Here he used his study of psychology and poetry to explain the extraordinary hold that such watercolors have over us.[50]

Praz visited Knoblock in September 1937 in his house at Ashley Place, having discovered him as a collector of Hope furniture through the writings of Margaret Jourdain, to whom we shall shortly return. Praz knew that in the 1920s Knoblock had become a film impresario in Hollywood, where he moved in the circle of Douglas Fairbanks, Charlie Chaplin, and Mary Pickford and renewed his friendship with Somerset Maugham and Hugh Walpole. Praz initially wondered whether Knoblock, as "an expert in theatrical production, [would] have been able to compete with the skill of the baroque architects who knew how to create an illusion of amplitude and breathtaking space in surroundings on a very small scale?" However, he was reassured on arrival at Ashley Place by "that sense of a charming deception which one feels in contemplating a stage scene from the wings, a half-dark scene, with the curtain lowered, a fictitious room."[51] Praz had responded with sensitivity to the world inhabited by Knoblock, of whom a close friend wrote that "his knowledge of everything connected with the Theatre was astounding, from the history of furniture and costume to stage-management and the art of acting."[52]

A student of psychology and perception, Praz claimed that "the ultimate meaning of a harmoniously decorated house is to mirror man, but to mirror him in his ideal being; it is an exaltation of the self . . . a museum of the soul."[53] Praz was influenced by Walter Benjamin, the German writer on aesthetics and literature, who argued: "The interior is not only the universe, but also the sheath of the private man. To inhabit means to leave traces. . . . The detective novel is born, which sets out to search for these traces. *The Philosophy of Furniture* [an essay by Edgar Allan Poe] and his mystery stories show Poe as the first physiognomist of the interior."[54]

Praz must have sympathized with Knoblock as an operator in the imaginative world of stage and film production who valued

the associations of the objects he had collected with episodes in both his own life and in that of Thomas Hope, to whom, as we have seen, Knoblock had persuaded himself that he was related. One of the associations of the Deepdene sale for Knoblock was that he went to it direct from having been "invalided home from a Hospital ship off the Turkish coast," where he "had hung between life and death for many weeks." He described himself at the sale as "a miserable figure," yet "forgetful for the moment of all the senseless slaughter across the Channel."[55] He found that acquiring objects of such high quality acted as a tonic so that he felt that "this sale saved my life, almost as much as the admirable surgeon had done in those far away Mediterranean waters." Moreover, returning to military service, he was sustained by the thought that all these treasures were awaiting his return. He also claimed to enjoy a special kinship with his Hope pieces on the grounds that they had passed directly from Hope's own family to him at the Deepdene sale, without any intermediate owners.

The most complete expression of such an associative approach to collecting came in Mario Praz's remarkable autobiography.[56] This is cast in the unusual form of a tour of the magnificent apartment in the Palazzo Ricci in Rome in which he housed his striking collection of Regency and Empire objects. Each piece recalls a chain of personal recollections; a typical example was the reference to his massive bookcase flanked by bearded male figures, which may have been designed by Thomas Hope. Recalling his memories of Knoblock and his wartime acquisitions of Hope's furniture, Praz wrote of the sale at the Deepdene in 1917 that pieces such as the monumental bookcase with sphinx heads and lion monopodia (see fig. 4-15)[57] "had fallen to Knoblock for a ridiculously low sum during a period when people were afraid of bombings and had no wish whatever to buy furniture."[58]

Like Marmottan and Knoblock, Praz wanted his collection to become a permanent museum after his death. In Praz's case, it would be an expression of "his yearning for a lost 'united' Europe of royal and noble families,"[59] for he was a conservative who wrote: "As long as there are four walls that still keep the aroma of that vanished Europe, it is among those walls that we wish to die."[60] His collection was bought after his death by the Galleria Nazionale di Arte Moderna in Rome, which installed it as the Museo Mario Praz in his apartment at the Palazzo Primoli in 1995.

The 1920s and 1930s: Regency and Modernism

The sympathies of Knoblock were accompanied by the scholarly study of Regency furniture and of Thomas Hope by Margaret Jourdain. She was engaged to write articles for *Country Life* by its proprietor, Edward Hudson, and was the redoubtable companion from 1919 until her death in 1951 of the novelist Ivy Compton-

Burnett. In a book on late Georgian furniture and decoration, Miss Jourdain illustrated pieces of Hope furniture from Knoblock's collection, just five years after his acquisition of them at the Deepdene sale.[61] She followed this with a fuller account of Hope in her monograph on Regency furniture,[62] whereas further evidence of the continuing fascination with Hope was the publication in 1937 by John Tiranti, Ltd., of the plates, though not the text, of his *Household Furniture and Interior Decoration*.

Interest in Regency and Empire styles had already been promoted by the appearance of a massive volume published by *Country Life* in 1931, *Buckingham Palace, its Furniture, Decoration and History*, by H. Clifford Smith and Christopher Hussey, who acknowledged in the preface help from Albert Richardson. The book was dedicated to Queen Mary, who had done much to reinstate Regency interiors and furniture in the royal palaces that had been displaced and rejected by subsequent changes of taste. This book was followed by a monograph on the Royal Pavilion at Brighton by its director, Henry Roberts. Also dedicated to Queen Mary, the book helped make extravagant aspects of Regency taste seem broadly acceptable in the modern world.[63]

Richardson owned a set of wall lights purchased at the Deepdene sale (see cat. no. 95), as well as a pair of griffon wall lights (cat. no. 97) and a picture frame. Although he created carefully arranged thematic interiors in which to incorporate his furniture at Avenue House, Ampthill, Bedfordshire, he may have found that the wall lights did not fit, for aesthetic reasons or because of size, and he moved them to 31 Old Burlington Street, London.[64] Apart from Richardson and Knoblock, others who bought at the Deepdene sale in 1917 included Irene Law, Thomas Hope's great-granddaughter, and Lord Gerald Wellesley, later 7th Duke of Wellington. Mrs. Law and her husband, Henry, subsequently published a well-documented study of members of the Hope family that contained the fullest account so far of Thomas Hope's life and achievements.[65]

Lord Gerald Wellesley, an architect, decorator, and collector, was a friend of Knoblock and another member of the group of Hope enthusiasts of the early twentieth century. They were influential in introducing Hope's furniture to both public and private collections through their generosity in lending to exhibitions, as well as by allowing their furniture to be illustrated in contemporary periodicals, such as *Country Life* (figs. 15-8, 15-9).[66] He also owned one of the monopodium tables (fig. 15-10), as well as two startling black-and-gold wall lights from the Egyptian Room at Duchess Street (see cat. no. 95), some Egyptian figures and a pair of marble obelisks from the Deepdene. As a recognized authority on the Regency period, he was consulted in 1945 by Leigh Ashton, director of the Victoria and Albert Museum, about the possibility of acquiring furniture from the Knoblock collec-

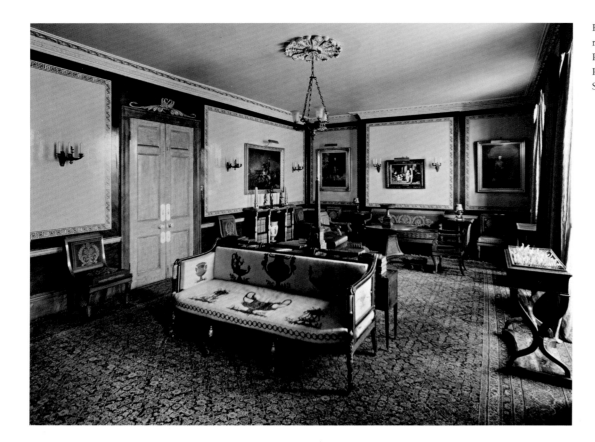

Fig. 15-8. Lord Gerald Wellesley's drawing room at 11 Titchfield Terrace, London. Photographed in the 1920s by Sims Photographers LTD. Trustees of Stratfield Saye Preservation Trust, 2793A.

tion, and Wellesley strongly recommended the acquisition of the bookcase and the Denon armchairs from the Deepdene. Unfortunately, his advice was not followed, presumably for lack of funds or lack of display space for the bookcase. He had also advised the museum regarding the successful acquisition of an example of the inlaid monopodium table in 1936.[67]

Lord Gerald Wellesley, who was in the diplomatic service from 1908 to 1919, was briefly a pupil of Harry Stuart Goodhart-Rendel, Grenadier Guards Officer, landowner, brilliant and idiosyncratic classical architect, and Roman Catholic convert, who traveled around in a chauffeur-driven Rolls Royce, sporting an astrakhan coat and an eyeglass.

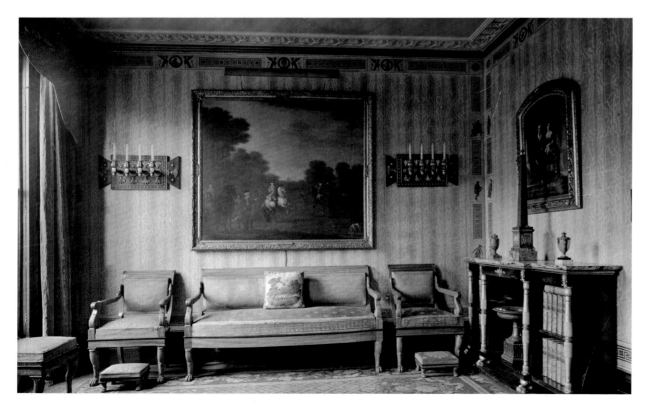

Fig. 15-9. Lord Gerald Wellesley's drawing room at 11 Titchfield Terrace, London, photographed in 1931. Country Life Picture Library.

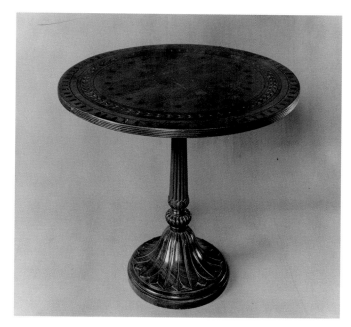

Fig. 15-10. After a design published by Thomas Hope. Monopodium table with inlaid top on foliate base. Trustees of Stratfield Saye Preservation Trust, 2793A.

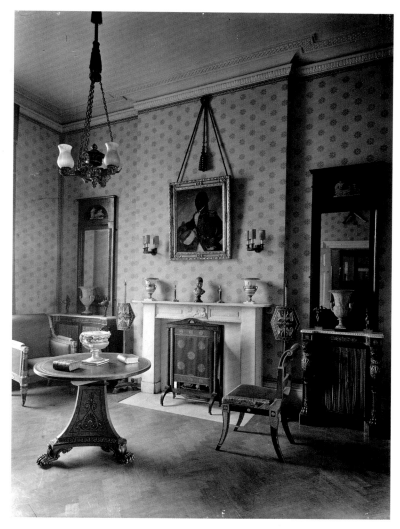

Fig. 15-11. Front drawing room at 11 Montague Place, London, as furnished by Edward Knoblock, photographed in 1931. Country Life Picture Library, 2793A.

Becoming a partner in 1921 of Trenwith Wills, a pupil of Reilly and of Sir Albert Richardson, Wellesley created Regency interiors for himself about 1930 at 11 Titchfield Terrace, Albert Road, Regent's Park, which were clearly influenced by Knoblock (fig. 15-11).[68] Wellesley's empathy for this period was fully understandable in view of his regard for his famous ancestor, the

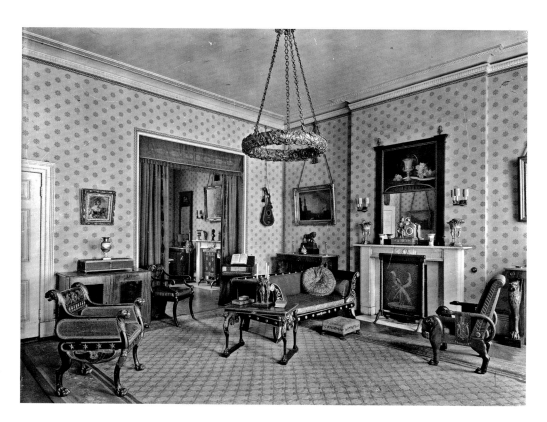

Fig. 15-12. Back drawing room at 11 Montague Place, London, as furnished by Edward Knoblock, photographed in 1931. Country Life Picture Library, 10500-9.

great Duke of Wellington, the "iron duke." Christopher Hussey, who shared a house with Wellesley in the country, illustrated Titchfield Terrace in a remarkable article on the interiors of four "Regency" houses, the others being Wellesley's at 17 Park Square East, for H. Venning; Goodhart-Rendel's at 13 Crawford Street; and Knoblock's at 11 Montagu Place (figs. 15-11, 15-12).[69]

Wellesley and Trenwith Wills also rebuilt Hinton Ampner House, Hampshire, for Ralph Dutton in 1936–37,[70] in a style appropriate to his collection of eighteenth-century and Regency furniture, which included pieces in the manner of Hope.[71] Dutton, a wealthy bachelor and connoisseur who was keenly interested in Hope, published a book on English interiors[72] in which he included engravings from Hope's *Designs of Modern Costume* (1812), including one on the title page. The dust jacket featured an aquatint of the room known as the Green Pavilion at Frogmore House, built by James Wyatt in Windsor Great Park for Queen Charlotte in the 1790s. This illustration was taken from Pyne's *Royal Residences* (1819), an early use of this important source for knowledge of Regency interiors. Dutton claimed perceptively that the furnishings of Carlton House, also known from *Royal Residences*, "represented a new sentiment in the arrangement of rooms."[73]

His friend Wellesley, who owned Hope furniture, published a well-informed article on Hope and Regency furniture in 1937, in which he described the introduction to Hope's *Household Furniture* as "perhaps the most important apologetic for the whole Regency style existing."[74] He even went so far as to claim that "as the poetry of Shakespeare is to the rest of Elizabethan poetry, so the furniture of Thomas Hope is to the rest of Regency furniture."[75] Becoming known in private circles as "the iron duchess" on inheriting the Wellington dukedom in 1943, he proceeded to decorate in suitably Regency styles the iron duke's country seat, Stratfield Saye, Hampshire.[76] Similar work was subsequently carried out at Sheringham Hall, Norfolk, a chaste classical villa of 1810–13 by Humphry Repton, which was decorated and furnished in the Regency Revival manner from 1954 to 1958 by its bachelor squire, Thomas Upcher. With furniture such as the gryphon wall lights, inspired by Hope's *Household Furniture* (pls. XXX, LIII), these interiors were duly recorded by Christopher Hussey in *Country Life*.[77]

One of the most striking examples of what we might call the "Anglo-Franco-American Empire Revival taste" on the eve of World War II had been the dining room at the Holme, Regent's Park (1939), for Mrs. Marshall Field, later the Honorable Mrs. Peter Pleydell-Bouverie.[78] This glittering essay in white, silver, and gold, created in a Regency villa designed by Decimus Burton in 1817, was designed by Stéphane Boudin of the Paris firm of Jansen. Mrs. Field's brother, Edward James, employed the decora-

tor Mrs. Dolly Mann, a friend of Knoblock's,[79] to create extravagant neo-Regency effects at Monkton on the estate of West Dean House in Sussex. This style had already made an effortless transference to the gloss and glass of 1920s and 1930s Art Déco. A classic example with a serious neoclassical tone is Mulberry House, 36 Smith Square, a Lutyens house of 1911 in which two rooms were transformed for Lady Melchett by Darcy Braddell in 1931.[80] They contained decorations by Glynn Philpot and C. S. Jagger, including jazz-modern neo-Greek murals in silver foil and a bronze relief depicting "Scandal," combined with Greek Doric columns and a genuine Greek head—the perfect setting for an early Evelyn Waugh novel. Categorizing such contemporary taste as "Vogue Regency," Osbert Lancaster suggested that Regency furniture was compatible with modern design. He thus claimed that "today, the more sensible of modern architects realise that the desperate attempt to find a contemporary style can only succeed if the search starts at the point where Soane left off."[81]

Osbert Lancaster was reflecting views expressed by Christopher Hussey, who wrote in 1929 about Regency furniture at Southill Park and drew attention to Hope's *Household Furniture*, stressing Hope as a "progressive" figure who was "tired of the inanities of prevailing fashions." Hussey thus claimed to see a "striking similarity between some of the pieces illustrated here and recent 'modern' furniture." The context is that *Country Life* always sought to illustrate new country and town houses, as well as old ones. All the new ones had been traditional in design, so the new International Modern houses presented Hussey with something of a problem. He and the designers, architects, and patrons with whom he associated had a genuine feeling for Thomas Hope as someone with whom twentieth-century man could feel an affinity. Hope had rejected the trivial ornament of his day, arguing that ornament should only be used when it had a meaning, and that furniture should have a solid architectural quality. Hussey emphasized the square solemnity of Hope's furniture in a fascinating attempt to make Regency design look modern. This was a case of special pleading in which Hussey saw the Hope he wanted to see, for how could one seriously hail as modern and functional someone who, like Hope, justified his ambitious design for a curtain pelmet as a "trophy of Grecian armour; applicable to the cornice of a window curtain"?[82]

Nonetheless, Hussey enlarged on this modernist theme two years later in the article on four modern Regency houses that we have already noted. Here he felt obliged to rescue Regency from the low popularity rating that it held in 1931. He mildly ridiculed the fact that it was "felt to be something 'daring,'" that "friends murmur 'how exciting' or raise their eyebrows slightly" at a style that had associations with Regency "bucks" and "the wicked goings on of the Regent's cronies." Hussey complained that it

Fig. 15-13. Ronald Fleming's London
sitting room with the Aurora Room table,
photographed in 1927 by E. J. Mason.
© The Condé Nast Publications Ltd.

was thus considered as morally debased, artificial, and "heavy and tasteless," by comparison with the work of Adam. Rejecting those who today often regarded it as "ugly," he urged that "the Regency designers were the modernists of a hundred and thirty years ago." He referred to their "impatience with triviality" which led them to seek remedies in "solidarity and simplicity." He thus saw a "kinship between Regency and modern taste (the product of similar social conditions)," even describing Lord Gerald Wellesley's drawing room at Park Square East for H. J. Venning as "frankly modern."

Hussey claimed Hope's *Household Furniture* as the "bible and Roll of Battle Abbey in one to all Regency bucks," although, oddly, he mistakenly believed that it illustrated interiors at the Deepdene. He argued that "it must always be remembered that Regency was the last recognizable style that furniture designers employed before the great *débâcle* of Victorianism. It is thus one of the natural points for departure into the future, and quite the best. For it is sane, civilised and formal, imparting to the experimental designer a healthy horror of the amorphous, the grimly functional and the merely 'fun.'"[83]

Ten years after the Deepdene sale, examples of Hope's furniture were on public display in London in 1928 and 1929 to encourage and stimulate other collectors.[84] The Olympia Exhibition in 1928 included Lord Gerald Wellesley's monopodium table and Richardson's griffon wall lights. The exhibition at Lansdowne House in 1929 featured Knoblock's monopodium table with a plain base, his armchair by Denon, and a pair of pole screens. Also

on display was Hope's table from the Aurora Room, which had been owned in 1924 by the decorator Ronald Fleming (fig. 15-13).[85]

In fact, the hopes for a modern classicism of such individuals as Hussey, Lancaster, and the architect Raymond Erith were dashed when it became increasingly clear that the Modern movement was to reject any sympathies for earlier and classical design. Gloom was heightened by the massive demolition of Georgian and Regency buildings in London between the wars, although this doubtless drew the attention of the public to their merits, on the principle that we never appreciate anything until it is taken away from us. The destruction of Nash's Regent Street, the very heart of Regency London, was the subject of an entire chapter of a book on town planning by the architect Arthur Trystan Edwards.[86] As early as 1914, he had written an article praising Adshead and Ramsey's newly completed Duchy of Cornwall Estate, Kennington. In lamenting the demolition of Regent Street, he defended stucco, so long condemned as "sham," and described the street as "the most beautiful street in the world." In a second edition of *Good and Bad Manners in Architecture* in 1944, he claimed that his chapter had been responsible for creating "the Regency cult."

However, the London County Council had decided in 1926 to demolish a great neoclassical masterpiece, Waterloo Bridge, built in 1811–17 from designs by John Rennie. Its cubic austerity and powerful Greek Doric elements made it the architectural equivalent to some of Thomas Hope's more massive and archaeological furniture. *Country Life* ran an appeal to save the bridge to which it

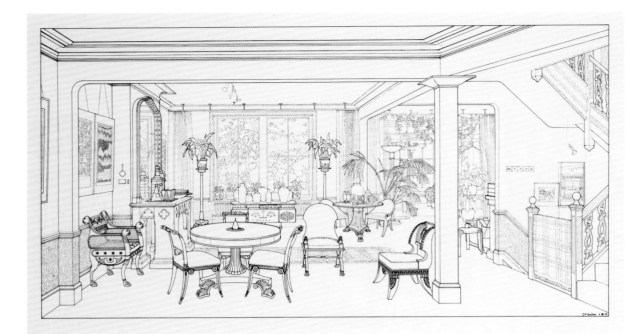

Fig. 15-14. Philip Smithies. James Stirling's London sitting room with Hope furniture. Ink on film, 1999. Collection of Lady Stirling.

devoted a special number in 1926 in which Sir Reginald Blomfield hailed it as simply "the finest bridge that has ever been built."[87] This went even further than Albert Richardson's praise of it as one of the outstanding buildings of its time in his *Monumental Classic Architecture* (1914). It was nonetheless demolished in 1938.

Christopher Hussey, in the meantime, had become increasingly interested in the Picturesque movement of the eighteenth and early nineteenth centuries, in which Thomas Hope had also played a significant part. In his major study of the Picturesque of 1924,[88] Hussey described the Deepdene briefly, as he was to do later in a book on country houses in which he included a chapter on Scotney Castle, Kent, which he had inherited in 1952.[89] This was a romantic house, built in 1837-44 from designs by Anthony Salvin as a Picturesque assembly related to its landscape, along lines of which Hope would have approved. Hussey could discover little about the Deepdene, writing that "there are reasons for believing he [Hope] began [it] not long after purchasing the property in 1802, although the date usually given is twenty-seven years later."[90]

The reasons for the revival of interest in the arts of the Regency and Empire are multifarious. They include the glamour of objects associated with royal and princely families, connections that appealed to those who, like Mario Praz, despaired at the destruction of the old social order in Europe after 1914. For Marmottan, as we have seen, the romantic appeal of Napoléon, his family, and his courts was important; Knoblock regarded himself as a descendant of Hope; Mrs. Henry Law, who actually was a descendant, was certainly proud of that but even more of the fact that her maternal grandmother was, in consequence, Lady Mildred Cecil, a daughter of the 2nd Marquess of Salisbury; while Lord Gerald Wellesley saw himself as contributing to the world

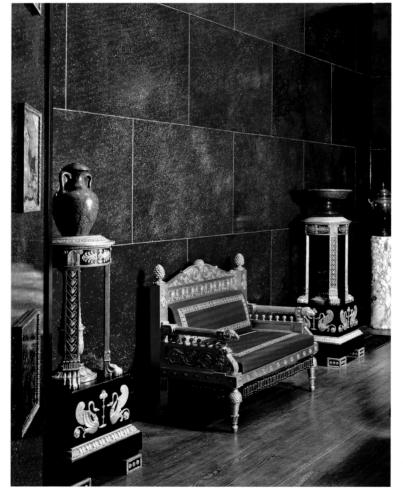

Fig. 15-15. A London drawing room, photographed in 2006 by Massimo Listri for *Architectural Digest*.

of his predecessor, the great Duke of Wellington. The understanding and promotion of Regency design was also seen by writers such as Hussey as a means of civilizing the potentially threatening aspects of modernism.

From the 1930s to the Present Day

In 1934 Gavin Henderson, 2nd Lord Faringdon, inherited Buscot Park, Berkshire, which he filled with a magnificent collection of furniture and works of art, including a pair of armchairs and a couch, from the Egyptian Room at Duchess Street, as well as a pair of torchères (cat. no. 88), also by Thomas Hope.[91] Since this late Georgian house had been completely remodeled in the Victorian period, Faringdon employed the architect Geddes Hyslop to return it in the late 1930s to a classical form, so that the furniture could be displayed in a stylistically sympathetic setting that would also be appropriate as having the character of a private house not a public museum. Since Buscot was given to the National Trust in 1948 and opened to the public, Hope's striking furniture has become familiar to many thousands of visitors.

Lord Faringdon was advised by the photographer and interior designer Angus McBean, who was one of the many enthusiasts for Hope's furniture after World War II. McBean owned a cabinet that had been illustrated in the watercolor by Penry Williams of the Boudoir at the Deepdene (cat. no. 106.14), as well as a pair of bacchante masks. Fellow collectors included James Watson-Gandy-Brandreth, who bought the bookcase from Knoblock's collection in 1946 (see fig. 4-15); and the influential dealer in architectural drawings and books Ben Weinreb, who owned a second cabinet (see fig. 4-16).[92] The year 1958 saw the appearance of the first book devoted solely to Hope, published as an unillustrated paperback.[93] The doctoral dissertation of Sandor Baumgarten, a Hungarian scholar, it was written in a flowery style and concentrated on Hope as a literary figure but contained much valuable bibliographical and documentary information. Clifford Musgrave, director of the Royal Pavilion, Brighton, for which he acquired some Hope objects, published a book on Regency furniture with a chapter entitled "Thomas Hope and Classical Purity."[94] The doctoral dissertation on Thomas Hope by David

Watkin, nominally supervised by Nikolaus Pevsner but effectively so by John Harris, attempted to cover Hope's contributions to all the arts. Published as a monograph in 1968,[95] it was followed four years later by the major international exhibition *The Age of Neo-Classicism* at the Victoria and Albert Museum and the Royal Academy in London. Ample attention was here given to Hope, including a re-creation of the Aurora Room at Duchess Street with its contents.

The architect Sir James Stirling was, surprisingly, a collector of furniture by Thomas Hope and George Bullock, although this had no recognizable influence on his own brutalist architecture (fig. 15-14). Mark Girouard explained that Stirling "had become interested in Hope because he had a new appreciation of the monumental and was about to develop this in his own architecture. The Hope chairs, with their statuesque simplicity and swooping curves, were like individual monuments designed for Regency drawing rooms."[96] Stirling's collection included two chairs after Hope's design with lyres inlaid in the back as well as Knoblock's monopodium table (see cat. no. 92). Mark Girouard quoted Stirling as confessing in 1984 that he liked Hope's chairs because "they are extreme, outrageous, over the top, eccentric, and much more gutsy than anything French Empire. There's absolutely no feeling of restraint or lack of confidence. But they aren't huge in scale either." Girouard pointed out: "On other occasions he cited them as examples of the fact that monumentality was a matter of presence, rather than of size." The interest taken in Hope's designs by this high profile modernist architect was as important as the fact that he owned examples of Hopeian furniture.[97]

Finally, an infinitely more serious figure in Hope studies is the scholar and collector Philip Hewat-Jaboor, whose former London apartment (fig. 15-15) contained key objects from Duchess Street, all illustrated in *Household Furniture*: the pair of exotic wall lights from the Egyptian Room purchased by the future Duke of Wellington at the Deepdene Sale in 1917; the pedimented cabinet containing Greek vases from the "Room Containing Greek Fictile Vases," a Chinese *sang-de-boeuf* vase, ornamented with delicately chase gilt-bronze mounts designed by Hope; and a pair of gilded and painted stands modeled on Roman altars and made to support Chinese fish tanks.

1. John Claudius Loudon, *Encyclopaedia of Cottage, Farm and Villa Architecture* (London: Longman, 1857; repr. Shaftesbury: Donhead, 2000): 1098–99. Functional and attractive smaller pieces, such as the lion monopodium tables of the type used by Hope to furnish the Picture Gallery, were naturally more attractive to manufacturers and to consumers. An example of this table, in a less conventional material, was available in papier mâché from one of the largest manufacturers, illustrated in Charles Frederick Bielefeld, *On the Use of the Improved Papier-Mâché in the Furniture, Interior Decoration of Buildings, and in Works of Art* (London: Papier Mâché Works, 1840): 17.

2. Catherine Voorsanger, "Nineteenth-Century American Cabinet Makers and Their European Connections," *Nineteenth-Century Designers and Manufacturers*, Furniture History Society Symposium, London, 3 February 2001.

3. Thomas Gordon Smith, *John Hall and the Grecian Style in America* (New York: Acanthus Press, 1996): xiii.

4. Alexander Jackson Downing, *The Architecture of Country Houses* (New York: Appleton, 1861; repr. New York: Dover, 1969): 425, figs. 215–217. Copies of *Household Furniture* were available in America by 1819, and probably earlier, when a copy was given to the Boston Athenaeum. Copies were also advertised in the

New-York Daily Advertiser (1 January 1819) and in *The New-York Columbian* (8 January 1819). Frances Collard is grateful to Michael Brown, Museum of Fine Arts, Houston, for these references.

5. *The Crystal Palace and Its Contents* (London: W. M. Clark, 1851): 229–30. Whereas the form of this table and the ornamental panel of inlaid silver on the triangular base were taken from Hope's design, the silver inlay on the table top and the decoration of the vase were taken from *Vases from the Collection of Sir Henry Englefield Bart* (London: Priestley and Weale, 1819, 2nd ed., 1848), engraved by Henry Moses.

6. Purnell of Stancombe Park, Gloucestershire, owned not only a Wedgwood copy of the Portland vase and many other Wedgwood vases, but also a very large collection of Greek, Roman, and Egyptian antiquities, which was dispersed by Sotheby's in 1872. He was one of the buyers at the Samuel Rogers sale.

7. Marc Bascou, "Neo-Greek Furniture," *Nineteenth-century Designers and Manufacturers,* Furniture History Society Symposium, London, 3 February 2001.

8. *La Flore ornementale*, 2 vols. (Paris, 1866–76).

9. Sold at Christie's, London, 27 November 1984.

10. Mario Praz, *On Neo-Classicism* (London: Thames and Hudson, 1969): pls. 70, 71.

11. For example, Richard Whytock and Co., a large Edinburgh firm of furnishers, offered "Neo-Grec" drawing room and boudoir furniture in their *Hand-Book of Estimates for House Furnishing* (ca. 1870).

12. Mark Girouard, *Sweetness and Light: The "Queen Anne" Movement 1860–1900* (Oxford: Clarendon Press, 1977): pl. 134.

13. Designs for Empire furniture taken from the books of Thomas Hope and of Percier and Fontaine, although only the latter were acknowledged, were included in Robert Brook, *Elements of Style in Furniture and Woodwork* (London: The Author, 1889).

14. *The Cabinet Maker & Art Furnisher* 15 (January 1895): 178. This trade journal had previously published designs by Percier and Fontaine and contemporary designs in the Empire style (November 1894): 117–23.

15. *Household Furniture* (1807): pl. XXIV, no. 2. The chair is now in the Victoria and Albert Museum, London.

16. A suite of dining room furniture with an American provenance, including two of the lyre back chairs after Hope's plates VI, XXIV, and XXVI in *Household Furniture*, made by Edwards and Roberts, was sold Christie's, New York, 30 January 1988, lots 487–493.

17. Nicholas Cooper, *The Opulent Eye: Late Victorian and Edwardian Taste in Interior Decoration* (London: Architectural Press, 1976): pl. 94.

18. Frances Collard, *Regency Furniture* (Woodbridge: Antique Collectors' Club, 1985): 242.

19. Richard Ormond and Elaine Kilmurray, *John Singer Sargent: The Later Portraits* (New Haven and London: Yale University Press, 2003): xxix, 44–47.

20. Frederick Litchfield, *Illustrated History of Furniture* (London: L. Truslove, 1892): 206.

21. Pl. xx.

22. Sir Herbert Herkomer's armchair, a later version of Hope's design, which he used as a studio prop, was sold at Bonham's London, New Bond Street, 29 June 2004, lot 152. Willie James's example was illustrated in Percy Macquoid, *A History of English Furniture*, (London: Lawrence and Bullen, 1904-8): 247, fig. 238, and may be one of the pair given by his son, Edward, to Brighton Pavilion. Contemporary furniture retailers supplying reproductions of the X-frame chair included Gregory & Co., 19 Old Cavendish Street, London, and W. J. Mansell, 266 Fulham Road.

23. Collard, *Regency Furniture* (1985): 253.

24. Ibid., 254.

25. Illustrated in *The Builder* (10 August, 1907): 171–72, and *Architectural Review* (September 1907): 125–41.

26. Simon Houfe, *Sir Albert Richardson—The Professor* (Luton: White Crescent Press, 1980).

27. Illustrated in *Architectural Review* 38 (October 1915): 80–81.

28. Jill Lever, *Architects' Designs for Furniture* (London: Trefoil Books, 1982): 120–21.

29. Later the home of Sir Oswald Mosley, it was subsequently the White Elephant Club.

30. Albert Richardson, "The Empire Style in England," *Architectural Review* (November 1911): 255–63; (December 1911): 315–25.

31. *Architectural Review* (July 1911): 25–29; (February 1912): 61–79; (November 1913): 93–94; (January 1914): 7–10; (September 1914): 52–58; and (December 1914): 102–10.

32. *Monumental Classic Architecture in Great Britain and Ireland during the 18th and 19th centuries* (London: Batsford, 1914).

33. However, it is evident from guidebooks to Dorking and Surrey that the house and grounds were open to visitors on application during the lifetime of Mrs. Anne Hope, widow of Henry Thomas Hope, who lived there until her death in 1882 (Waywell, *The Lever and Hope Sculptures* [1986]: 61). Access became more restricted during the occupancy of the house by Lillian, Dowager Duchess of Marlborough, from 1893 to 1909, although photographs of the exterior were published in *Country Life* 5 (20 May, 1899): 624–28.

34. Obituary, *The Times*, 20 July 1945.

35. Edward Knoblock, *Round the Room* (London: Chapman & Hall, 1939): 163–64.

36. Ibid., 195.

37. Ibid.

38. Arnold Bennett, *The Pretty Lady* (1918; repr. London: The Richards Press, 1950): 37–39, 45. The chair and the bookcase described here are related to objects bought by Knoblock at the Deepdene sale.

39. The interiors at Montagu Place were illustrated in E. Beresford Chancellor, *Life in Regency and Early Victorian Times* (London: Batsford, 1926): pls. 9, 10, where he also reproduced plates from Hope's *Household Furniture* and *Designs of Modern Costume*.

40. This version of the monopodium table was illustrated in Nancy McClelland, *Duncan Phyfe and the English Regency 1795–1830* (New York: W. R. Scott, 1939): pl. 55. Knoblock wrote a foreword on the Regency style to this book on the major American cabinetmaker Duncan Phyfe (1768–1854). The monopodium table with inlaid base, photographed by *Country Life* in 1931 in Knoblock's back drawing room at 11 Montagu Place, had a replacement top covered with leather. After his death, the sale of his collection at Sotheby's, 8 March 1946, included lots 136–140, identified as bought from the Deepdene in 1917. Lot 138 was a "A Monopodium Library table, circular top and support inlaid in ebony with stars and anthemions, carved lion paw feet 3' 6" diameter." This was bought for £100 by Mrs. Gilbert Russell, possibly Maud Russell, who furnished Mottisfont Abbey, Hampshire, with Regency pieces and gave the house to the National Trust in 1957.

One of Knoblock's two monopodium tables, with a label from 21 Ashley Place, London, was sold at Sotheby's, London, 5 October 1973, lot 152 (see cat. no. 92). An example, with inlaid top and plain base, was sold at Christie's, London, 16 November 1995, lot 345, from the collection of Ian Phillips of Charlton Mackrell Court, Somerset, who had owned the Jacob chairs.

41. Christopher Hussey, "Beach House, Worthing, Sussex," *Country Life* (29 January 1921): 126–33. See also J. Guthrie and A. Dale, *Beach House, Worthing* (1947).

42. John Martin Robinson, *The Regency Country House from the Archives of Country Life* (London: Aurum Press, 2005): 191.

43. John Cornforth, *The Inspiration of the Past: Country House Taste in the Twentieth Century* (London: Viking, 1985): 58.

44. Knoblock, *Round the Room* (1939): 59.

45. See Denys Sutton, "L'Europe sous les Aigles," (*Apollo*, June 1976): 458–63.

46. *The Saluci Family* (1800), *An Officer of the Cisalpine Republic* (1801), and *View of Vallombrosa near Florence* (1799); see Hector Lefuel, *Catalogue du Musée Marmottan* (Paris 1934): 70, 80, 147.

47. Paul Marmottan, "Le peintre Louis Gauffier (1762–1803)," *Gazette des Beaux-Arts* 13 (1923): 281–300.

48. Lefuel, *Catalogue* (1934): 108–9, and *Gazette des Beaux-Arts* (October 1927).

49. Originally published as *Gusto Neoclassico* (Florence: Sansoni, 1940; 2nd ed., 1959), trans. Angus Davidson as *On Neoclassicism* (London: Thames and Hudson, 1969) and dedicated by Praz to the memory of Paul Marmottan, Henri Lefuel, and Edward Knoblock.

50. *La filosofia dell'arredamento* (Milan: Longanesi, 1945), which appeared in an expanded form as *An Illustrated History of Interior Decoration* (London: Thames and Hudson, 1964).

51. Praz, *On Neo-Classicism* (1969): 292–93.

52. John Vere, Introduction to *Kismet and Other Plays by Edward Knoblock* (London: Chapman & Hall, 1957): [7].

53. Praz, *Illustrated History of Interior Decoration* (1969): 24–25.

54. Walter Benjamin, *Schriften*, vol. 1 (Frankfurt, 1955): 415–16. See Praz, *Illustrated History of Interior Decoration* (1969): 28.

55. Knoblock, *Round the Room* (1939): 58.

56. *Casa della Vita* (Milan: Mondadore, 1958). It was published in abridged form as *The House of Life* (London: Methuen, 1964).

57. Now at the Bowes Museum, Barnard Castle, Durham.

58. Praz, *The House of Life* (London: Methuen, 1964): 40. However, the antiquities fetched extremely high prices.

59. Patricia Corbett, "Mario Praz Museum, Rome," *Apollo* (December 1996): 13–14.

60. Mario Praz, *Illustrated History of Interior Decoration* (1964): 67.

61. *English Decoration and Furniture of the later XVIIIth century, 1760–1820* (London: Batsford, 1922), fig. 21, the monopodium table, and figs. 339 and 426, one of the pair of Egyptian armchairs designed by Denon. The sale catalogue of Knoblock's collection by Sotheby's, London, on 8 March 1947 identified lots 236–40 as purchased by him at the Deepdene sale in 1917. Besides the table and pair of armchairs, these included the large bookcase from the Deepdene, now at the Bowes Museum, a *secretaire* bookcase with Gothic astragals in the upper glazed doors and Egyptian caryatids on the sides, and a pair of torchères with circular marble tops on fluted uprights linked by X-frames with lion's-paw feet.

62. *Regency Furniture, 1795–1820* (London: Country Life, 1934). Margaret Jourdain published revised editions of this book in 1948 and 1949, and Ralph Fastnedge published an expanded version (London: Country Life, 1965).

63. *A History of the Royal Pavilion, Brighton, with an Account of Its Original Furniture and Decoration* (London: Country Life, 1939).

64. They are illustrated in A. E. Richardson, "The Empire Style in England, I and II," *Architectural Review* 30 (November 1911): 255–63; (December 1911): 315–25. The wall lights, bequeathed by Sir Albert to Brighton Museum and now in the King's Library in the Pavilion, were hung in the ground floor showroom of Lenygon and Morant at 31 Old Burlington Street, London, where Richardson had an office from 1946. See John Cornforth, *The Inspiration of the Past: Country House Taste in the Twentieth Century* (Harmondsworth: Viking, 1985): 49, pl. 41. Frances Collard is grateful to Brian Mitchell for his help on Lenygon and Morant.

65. *The Book of the Beresford-Hopes* (London: Heath Cranton, 1925). Mrs. Law was of great help to David Watkin when he was writing his monograph on Hope of 1968.

66. Evidence from Lord Gerald Wellesley's photograph album at Stratfield Saye, Hampshire, suggests that his monopodium table had an inlaid top and plain pedestal, which he may have altered. Illustrations of his London home at 11 Titchfield Terrace, published in *Country Life* in 1931, show an inlaid table top on a different monopodium with foliate base and fluted support.

67. Victoria and Albert Museum Archive, Nominal File Mrs A.E.N. Jordan, memo to H. Clifford Smith, Keeper, Department of Woodwork, from Ralph Edwards, Assistant Keeper, 21 January 1936. Clifford Smith's memo to Eric Maclagen, Director of the museum, recommending the purchase on 23 January 1936, commented that the museum was unable to buy at the Deepdene sale in 1917 because the purchase grant was withdrawn during World War I.

68. See John Cornforth, *London Interiors from the Archives of Country Life* (London: Aurum Press, 2000): 146–47.

69. Christopher Hussey, "Four Regency Houses," *Country Life* (11 April 1931): 450–56.

70. Christopher Hussey, "Hinton Ampner House, Hampshire," *Country Life* (7 and 14 February 1947): 326–69, 374–77. Dutton rebuilt the house again in 1963 after it had been gutted by fire in 1960 (*Country Life* [10 June 1965]: 1424–28).

71. See Margaret Jourdain, "Mr. Ralph Dutton's Collection of Regency Furniture," *Country Life* (6 December 1946): 1102–6.

72. *The English Interior: 1500 to 1900* (London: Batsford, 1948).

73. Ibid., 139.

74. Lord Gerald Wellesley, "Regency Furniture," *Burlington Magazine* (May 1937): 233–40.

75. Ibid., 239.

76. On this, see the article by his friend, James Lees-Milne, "Stratfield Saye House," *Apollo* (July 1975): 8–18.

77. 31 January and 7 February 1957.

78. "A House in Regent's Park," *Country Life* (20 April 1940): 416–18, and John Cornforth, *London Interiors* (2000): 148–53.

79. See Knoblock, *Round the Room* (1939): 175.

80. Charles Reilly, "Mulberry House, Westminster," *Country Life* (6 June 1931): 736–38, and Cornforth, *London Interiors* (2000): 28–32.

81. Osbert Lancaster, *Homes Sweet Homes* (London: John Murray, 1939): 74.

82. *Household Furniture* (1807): 138, pl. LX.

83. Christopher Hussey, "Four Regency Houses," *Country Life* (11 April 1931): 456.

84. *Daily Telegraph Exhibition of Antiques and Works of Art*, Olympia, London, 19 July–1 August 1928. *Illustrated Catalogue of the Loan Exhibition of English Decorative Art at Lansdowne House*, 17–28 February 1929, published by *The Collector*. The displays at the Olympia Exhibition were arranged by Margaret Jourdain, who was already familiar with Knoblock's collection of Hope furniture.

85. Alan Powers, "Ronald Fleming and Vogue Regency," *Decorative Arts Society Journal* 19 (1995): 5–58. He owned the Hope pier table now in the Victoria and Albert Museum, for which he devised an interior scheme with modern pictures, red floors, white walls, and waxed pine bookcases, featured in "A Mews Flat in Belgravia," *Vogue* 69, no. 7 (April 1927): 76–77, 103. His papers are in the Archive of Art and Design, Victoria and Albert Museum, London, inv. no. AAD1-1981.

86. *Good and Bad Manners in Architecture, an Essay on Social Aspects of Civic Design* (London: Philip Allan, 1924).

87. *Country Life* (12 June 1926): 814.

88. *The Picturesque: Studies in a Point of View* (London: G. P. Putnam, 1927).

89. *English Country Houses: Late Georgian 1800–1840* (London: Country Life, 1958). As a boy at school, David Watkin poured over this book on its publication, and it stimulated him five years later to try to solve the mystery of the Deepdene, about whose dates and even appearance virtually nothing was then known.

90. Ibid., 21.

91. *The Faringdon Collection, Buscot Park* (London: Curwen Press, for the Trustees of the Faringdon Collection, 1964).

92. Angus McBean's empire style interiors in his London home were described in *House and Garden* 7 (November 1952): 50–53. James Watson-Gandy-Brandreth was encouraged to collect Regency furniture by Margaret Jourdain; for details of their friendship, see Hilary Spurling, *Secrets of a Woman's Heart: The Later Life of Ivy Compton-Burnett, 1920–1969* (London: Hodder and Stoughton, 1984): 195, 245–46, 248, 294. His collection was sold at Christie's, South Kensington, 13 September 2005, lots 726–872. Ben Weinreb's cabinet was sold at Christie's, London, 14 August 1988, lot 176.

93. Sandor Baumgarten, *Le crépuscule Néo-Classique: Thomas Hope* (Paris: Didier, 1958).

94. Clifford Musgrave, *Regency Furniture 1790 to 1830* (London: Faber & Faber, 1961, rev. ed., 1970): 43–54.

95. Watkin, *Thomas Hope* (1968).

96. Mark Girouard, *Big Jim: The Life and Work of James Stirling* (London: Chatto & Windus, 1998): 197; see also Howard Shubert, "James Stirling: Sympathetic Echoes," *Architecture and Ideas* 3 (Winter/Spring 2001): 78–83.

97. On this point, see Michael Hall, "Stirling Wit and Passion," *Country Life* (31 August 2000): 50–53.

CATALOGUE
OF THE EXHIBITION

Family and Grand Tour

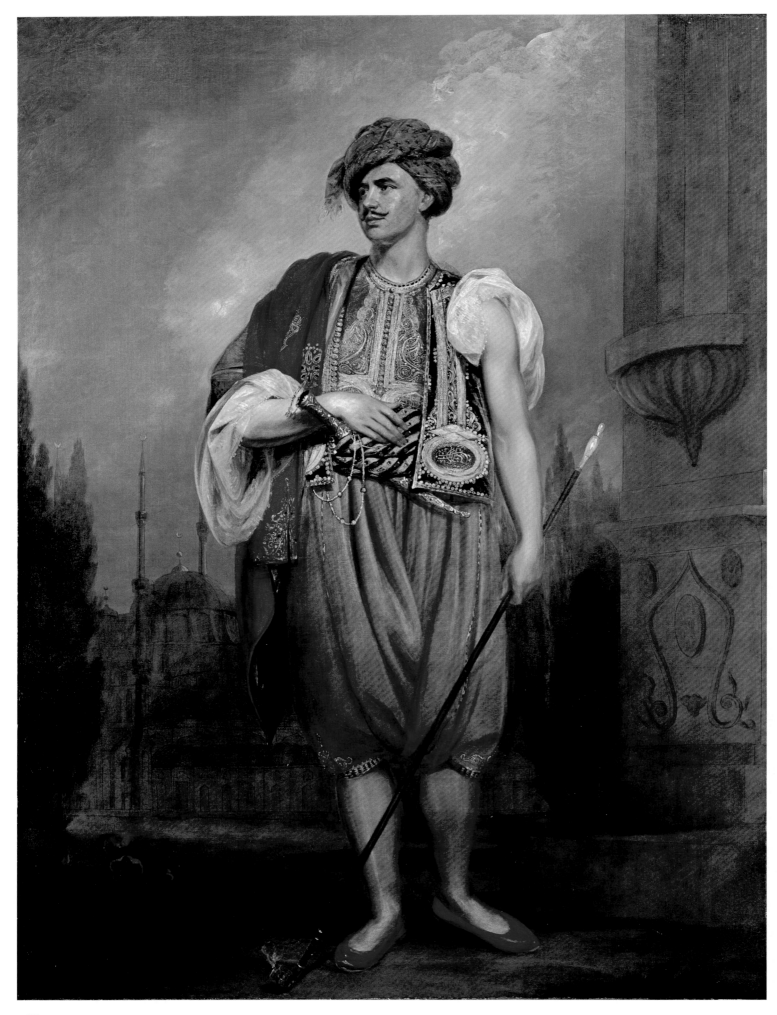

[1]

1. *Thomas Hope*

Sir William Beechey (1753–1839)
English, 1798
Oil on canvas
87¼ x 66½ in. (221.5 x 168.7 cm)
National Portrait Gallery, London, NPG 4574

PROVENANCE: Thomas Hope, by descent, Lord Francis Hope Pelham-Clinton-Hope; sold Christie's, London, 20 July 1917, lot 50; bought by Tyler for £147, acting for Henry Pelham Archibald Douglas, 7th Duke of Newcastle; sold Christie's, London, 7 July 1967, lot 105; bought by Leggatt for the National Portrait Gallery, London

EXHIBITIONS: Royal Academy, London (1799), no. 272; World Culture and Modern Art, Munich (1972), no. 309.

LITERATURE: "Pictures of H. Hope, Esqr., Cavendish Square," ca. 1810; Westmacott, *British Galleries* (1824): 215; Walker, *Regency Portraits*, vol. 1 (1985): 262–63; Law, *The Beresford Hopes* (1925): 31; Watkin, *Thomas Hope* (1968): 42, 65, 101, 273, n. 69.

2. *Two Waistcoats*

Ottoman, before 1798
Velvet, with metal braid, gold sequins, silk and metal thread embroidery
Front panel: 25⅗ x 17⅖ in. (65 x 44 cm)
Waistcoat: 21⅗ x 19¼ in. (55 x 50 cm)
National Portrait Gallery, London, D31702, D31703

PROVENANCE: Thomas Hope; by descent, Irene Law; given by her to the National Portrait Gallery in 1968.

LITERATURE: Richard Walker, *Regency Portraits*, vol. 1 (1985): 262.

Between 1796 and 1797, Thomas Hope traveled through the Ottoman Empire, which included modern-day Turkey, Greece, Syria, and Egypt. In 1798, shortly after his return to London, he commissioned Sir William Beechey to paint his portrait.[1] Despite becoming one of the great proponents of classical design and of the supremacy of Greek art and architecture above all others, Hope is not depicted in a traditional Grand Tour image as a learned traveler in a *capriccio* scene among the architectural splendors of Rome, or even showing off his purchases of newly excavated antique sculpture. Instead, Beechey painted the romantic traveler in an exotic costume standing before one of several mosques he saw on his tour through the vast Ottoman Empire. This portrait of Hope was one of nine paintings exhibited by Beechey at the Royal Academy in 1799: "Mr. Hope in a Turkish Dress."[2]

The origin of his costume—with trousers cut just below the knee, a heavily embroidered waistcoat, loose-fitting shirt sleeves (one rolled up to his shoulder), a cloak, and a dagger tucked into a brightly colored striped sash around his waist—is certainly Ottoman. But it is more difficult to determine exactly which part of this extensive empire is represented. It has been suggested that this is the dress of a *levent*, or a man, usually of non-Muslim origin, who had been recruited into the Ottoman fleet from the Aegean Islands and other coastal Balkan areas. The costume dates from the reign of Selim III (1789–1807), the period during which Hope spent considerable time in Constantinople, where these sailors had their barracks and from whom he could easily have acquired the

[2]

costume.[3] It has also been proposed that the outfit could be Albanian in origin, as seen in drawings of a soldier by the Dutch artist Jean-Baptiste Vanmour, who lived in Constantinople for thirty-eight years. His sketches depicting the empire's subjects in their national dress show just how cosmopolitan the city was.[4] The embroidery on Hope's waistcoat comes from modern Greece or Albania. It is remarkable that the green waistcoat and red undergarment of this exotic costume, which Hope brought back as a memento or an exotic souvenir, have survived to this day.

Hope believed that the dress was that of a *caleondgi*, or Turkish sailor, which he recorded in his drawings of people in local costume made during his Grand Tour.[5] These sketches have survived, along with others that depict architectural details, people, landscapes, and buildings. In his painting, Beechey included a mosque with minarets, which may have been based upon Hope's panorama of Constantinople and on the buildings it depicted, such as the Fatih Mosque.[6] No information exists about the relationship between the artist and Hope, but it is possible that Hope, being stubborn, opinionated, and strong-willed, may well have directed Beechey to use his drawings as prototype.

It is interesting to note that this distinctive self-portrait was at first displayed in the dining room of Hope's cousin Henry's house in Cavendish Square and was only later removed to his home in Duchess Street.

1. None of Beechey's account books for this period has survived. Opie told Farington in January 1795 that Beechey had just raised his price to 30 guineas a head, but that his pictures, unlike those by Lawrence and Hoppner, were of "mediocre quality as to taste & fashion, that they seemed only fit for sea captains & merchants." Farington, *Diary*, vol. 2 (1979): 289–90.
2. RA 1799, cat. no. 272.
3. I am indebted to Jennifer Scarce and Iakovos Z. Aktsoglou for sharing with me their thoughts on the origin of Hope's outfit.
4. These are in the Rijksmuseum, Amsterdam. See Melis H. Seyhun and Arzu Karamani, eds., *An Eyewitness to the Tulip Era. Jean-Baptiste Vanmour*, exh. cat. (Amsterdam: Rijksmuseum; Beşiktaş, Istanbul: Kosbank, 2003).
5. A series of Thomas Hope's drawings has survived in the Benaki Museum, Athens. See cat. nos. 16–34.
6. I would like to thank Fani-Maria Tsigakou for helping me in my search.

D B - A

3. *Louisa Hope*

Sir Martin Archer Shee (1769–1850)
English, 1807
Oil on canvas
92¼ x 52 in. (234 x 132 cm)
The Hon. Mrs. Everard de Lisle
London only

PROVENANCE: Thomas Hope; by descent, [?] Adrian Elias Hope; by descent, Mrs. Astley Smith; by descent, John de Lisle; the Hon. Mrs. Everard de Lisle.

EXHIBITIONS: Royal Academy, London (1808), no. 58.

LITERATURE: Farington, *Diary*, vol. 9 (1982): 3256–57 (10 April 1808); 3260–61 (17 April 1808); Shee, *The Life of Sir Martin Archer Shee*, vol. 1 (1860): 319–20; Law, *The Beresford Hopes* (1925): 31; Watkin, *Thomas Hope* (1968): 42.

The Honorable Louisa Beresford married Thomas Hope in April 1806. She had already turned him down once but was "afterwards persuaded by her friends not to refuse so splendid a prospect."[1] Just one month after their marriage, the Hopes held such a "grand rout" at their house in Duchess Street that many of the invited guests "never reached the door."[2] As Louisa Hope, she would become a noted hostess of great taste, holding "superbe" parties at both their London house and their country estate, the Deepdene.[3] Her friends described her as "one of the loveliest women of the Kingdom and one of the reigning deities of fashion,"[4] "uncommonly pretty,"[5] and "good humoured and unaffected."[6]

In 1807 her husband had just published his influential book of Regency design, *Household Furniture*, and had just acquired the Deepdene. In that same year he commissioned Sir Martin Archer Shee, R.A., to paint Louisa's portrait. Shee was a neighbor of Hope's older cousin Henry, having moved to Cavendish Square in 1799. The portrait was displayed at the Royal Academy in 1808, but Shee felt, much to his dismay, that its position was not prominent enough, and he tried unsuccessfully to get it changed.[7] Louisa is shown wearing the high-waisted, short-sleeved dress that was to become so popular during this period, inspired by the attire of ancient Greece that Thomas promoted, and her hair is fashioned

into tight curls. This portrait was painted at least two years before Thomas published his *Costume of the Ancients* in 1809 and five years before his *Designs of Modern Costume* appeared in 1812, a book for which Louisa would act as model. Hope's aim in writing these books was to educate the British gentlewoman in "some useful hints for improving the elegance and dignity of her attire."[8]

Louisa is pictured standing near an ancient marble statue and vases in a *capriccio* scene that might refer to the Deepdene, which Thomas had just acquired. She saw the advantages of being "courted, and recherché in society," supported by her husband to whom she supplied "lasting pleasure and comfort."[9] Louisa's social ambitions were extensive. She went so far as to write on behalf of her husband to the Duke of Wellington in search of a peerage, reminding him that "Our family connections as Hopes and as Beresfords are, we believe, quite unobjectionable, and the fortune of our house, I need not say to you, is more than sufficient to maintain the dignity of any honour."[10] Her pleas did not succeed.

For a woman who so enjoyed being "adorned and set off to every advantage,"[11] it is hardly surprising that Louisa was the subject of quite a number of portraits, although no works of her with Thomas were ever commissioned.[12] Sir Thomas Lawrence, George Dawe, and Henry Bone painted her, and her likeness was also captured in commissions by the sculptors William Behnes and Bertel Thorvaldsen (see cat. no. 11). Unlike some of the more extravagant outfits of "solid gold, with rare birds flying in different directions out of her head,"[13] which she was seen wearing in real life, in her portrait commissions she dressed *à la greque* or *à la romaine*, the costumes promoted by her husband.

In addition to a portrait of Louisa, Shee also painted a portrait of her father, William de la Poer Beresford, Lord Decies and Archbishop of Tuam, which hung in the Ante-Room at Duchess Street.[14] Shee would also complete the portrait of Henry Philip Hope in Ottoman dress that was begun by Lawrence in 1805 but remained "abt. ½ finished," along with 150 other portraits left in Lawrence's studio at his

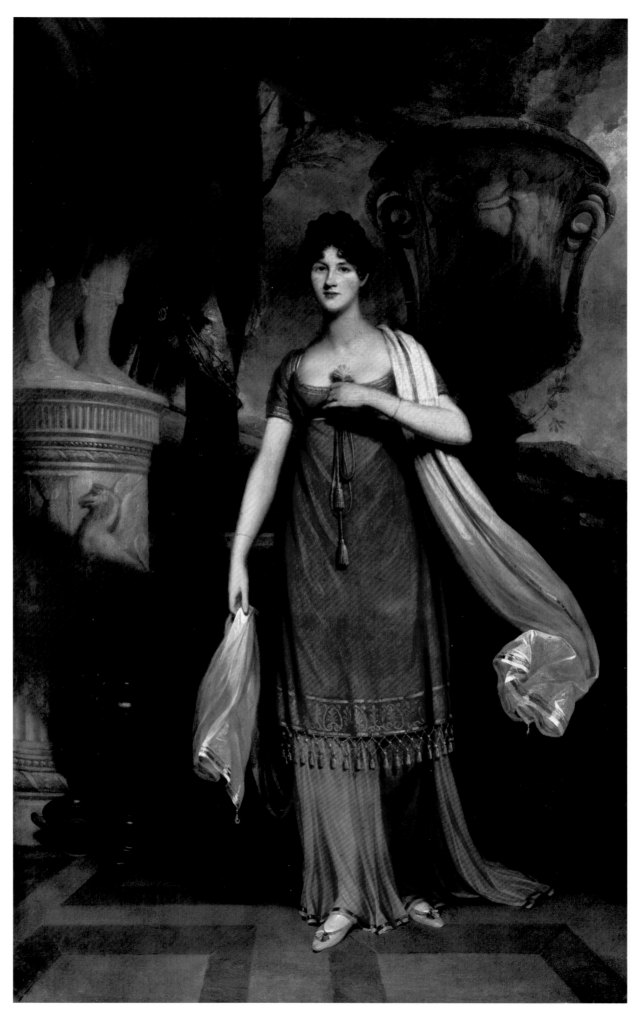

death.[15] Louisa's fabulous collection of jewels—diamonds, emeralds, pearls, and rubies—was only modestly represented in Shee's portrait, since the picture was executed shortly after their marriage, when her jewelry collection was still in its infancy. Certainly, within a few years it had grown considerably, not just through the generosity of her husband but also that of her wealthy bachelor brother-in-law, Henry Philip, to whom she was close and who had an outstanding collection of his own in his London house. Eventually, from the publication proceeds of *Anastasius,* Thomas would buy her what would become known as the "Anastasius Pearls."[16] At one party she arrived "écrasée sous les poids de pierreries et des perles" (crushed under the weight of precious stones and pearls).[17] When Thomas died in 1831, he left his wife a wealthy widow with a life interest in the Deepdene. In the following year she married her first cousin, William Carr Beresford, Viscount Beresford.

1. Farington, *Diary,* vol. 7 (1982): 2754 (9 May 1806). Her dowry was £3,000, which her father, the Archbishop of Tuam, apparently delivered the day after the wedding to Thomas, who promptly handed it over to his wife.
2. Quoted in Law, *The Beresford Hopes* (1925): 28.
3. Quoted in S. Baumgarten, *Le crépuscule* (1958): 245.
4. Washington Irving, quoted in Baumgarten, *Le crépuscule* (1958): 254.
5. Earl of Ilchester, *Journal of the Honourable Henry Edward Fox,* 1923, quoted in Baumgarten, *Le crépuscule* (1958): 253.
6. Noted by Mary Berry in her journal, 4 April 1810, quoted in Watkin, *Thomas Hope* (1968): 18.
7. Recorded in Farington, *Diary,* vol. 9 (1982): 3256–67, 3260–61 (10 and 17 April 1808); Royal Academy, London (1808): no. 58 as "Mrs. T. Hope."
8. Hope, *Costume of the Ancients* (1809): 12.
9. Law, *The Beresford Hopes* (1925): 36–37.
10. An undated letter sent by Louisa to the Duke of Wellington, quoted in ibid., 63.
11. Ibid., 37.
12. The only image of the two together was painted by Antoine Dubost as a satirical attack on Thomas Hope, with whom he had fallen out. See Chapter 9 for full details of this affair.
13. Lady Granville, 1823 at Brighton Pavilion, quoted in Watkin, *Thomas Hope* (1968): 23.
14. Westmacott, *British Galleries* (London, 1824): 213.
15. Garlick, *Sir Thomas Lawrence* (1989): 107. I would like to thank Andrew Wilton for confirming the attribution to Shee. This portrait has been traced to the Prince of Wales Museum, Bombay.
16. Law, *The Beresford Hopes* (1925): 37.
17. Watkin, *Thomas Hope* (1968): 20.

DB-A

4. *Thomas Hope*

Henry Bone (1755–1834)
English, 1813
Enamel
Inscription on back: "Thos Hope Esqr / London Jan 1813 / Painted by Henry Bone R.A. / Enamel Painter in Ordinary / to His Majesty and Enamel / painter to H. R. Highness / Prince Regent after a / drawing by A. Pope."
4½ x 4 in. (11.4 x 10.2 cm)
Hubert de Lisle

PROVENANCE: Thomas Hope; by descent, Henrietta Hope, Lady Haversham; by descent, joint heirs Mildred Astley Smith and Ambrose de Lisle; by descent, Hubert de Lisle.

LITERATURE: Law, *The Beresford Hopes* (1925): 31, illus. facing p. 31; Watkin, *Thomas Hope* (1968): 42, 273, n. 68.

5. *Henry Hope*

Henry Bone (1755–1834)
English, 1804
Enamel
2 in. oval (5 cm)
Inscription on back: "Henry Bone pinx . . . Oct 1804"
Towner Art Gallery, Eastbourne

PROVENANCE: [Hope family]; by descent, Irene Law; bequeathed to Towner Art Gallery, Eastbourne.

LITERATURE: *Bone Drawings,* vol. 1, p. 91; Walker, "Henry Bone's Pencil Drawings" (1998–99): 330.

6. *John Hope*

Henry Bone (1755–1834)
English, 1805
Enamel
2¾ in. oval (7 cm)
Inscription on back: "The late John Hope Esq. painted by / Henry Bone. ARA Enamel Painter to HRH the Prince of Wales Sept 1805"
Towner Art Gallery, Eastbourne

PROVENANCE: [Hope family]; by descent, Irene Law; bequeathed to Towner Art Gallery, Eastbourne.

7. *The Honourable Louisa Hope, later Viscountess Beresford*

Henry Bone (1755–1834)
English, 1814
Enamel
Inscription on back: "The Hon Mrs. Hope / London July 1814 / Painted by Henry Bone RA / Enamel Painter in Ordinary / to His Majesty and Enamel / Painter to His R. H. the / Prince Regent after / Miniature by Mrs. Mee."
5 x 5¾ in. (12.4 x 16 cm)
Hubert de Lisle

PROVENANCE: Thomas Hope; by descent, Henrietta Hope, Lady Haversham; by descent, joint heirs Mildred Astley Smith and Ambrose de Lisle; by descent, Hubert de Lisle

8. *Henry Philip Hope*

William Essex (1784–1869)
English, 1840
Enamel
Inscription on back: "Henry Philip Hope / Now time has led him to his end, / Goodness and he fill up one monument (Shakespeare). Painted by W. Essex 1840 / Enamel painter in Ordinary to Her Majesty."
Towner Art Gallery, Eastbourne

PROVENANCE: [Hope family]; by descent, Irene Law; bequeathed to Towner Art Gallery, Eastbourne.

Members of the Hope family arrived in London from their native Amsterdam in October 1794. They brought with them by ship their extensive art collection, much of which had been formed by the merchant banker John Hope, father of three sons— Thomas, Henry Philip, and Adrian Elias— and by his cousin Henry Hope for his house in Amsterdam and Welgelegen in Haarlem. John had died in 1784, leaving Henry as head of the Hope bank and as guardian to his sons. It was Henry who, with the help of his business contacts in London, had arranged the family's flight. Upon arrival he acquired a house in Harley Street,

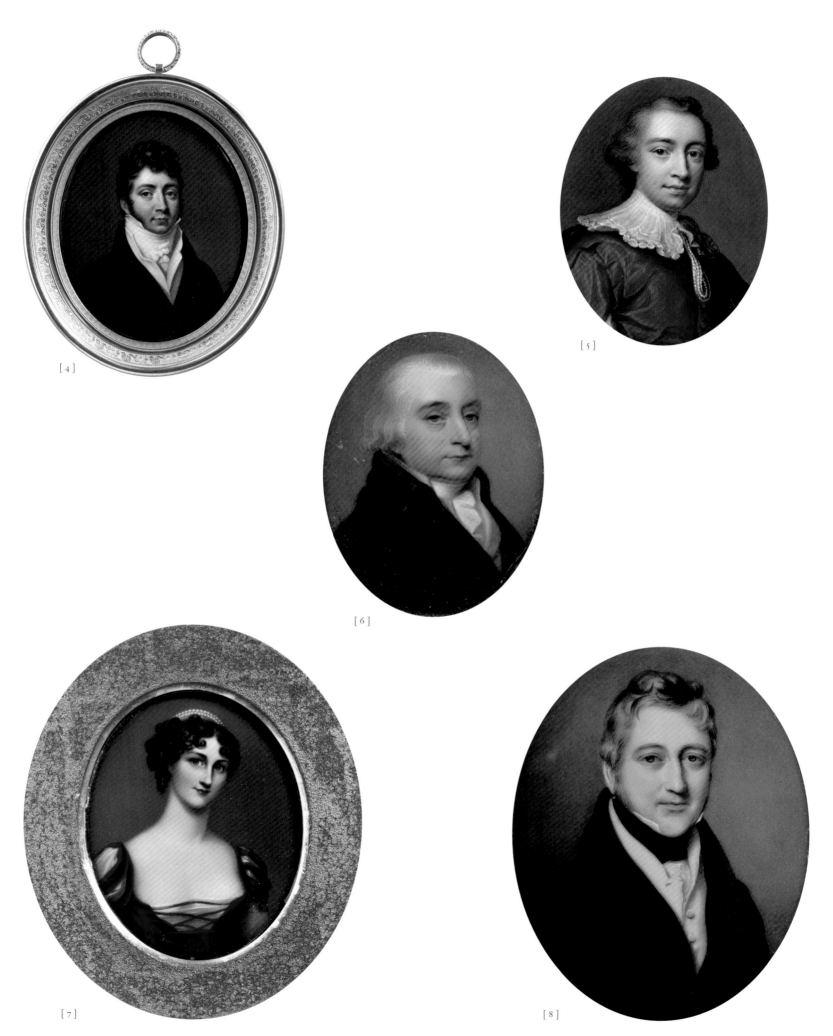

[4]

[5]

[6]

[7]

[8]

Cavendish Square, from another cousin, the Earl of Hopetoun.

By 1802, when Henry Bone was commissioned to paint enamel portraits of the family, the eldest son, Thomas, had acquired the house in Duchess Street, remodeled it, and was in the process of fitting it out. Bone had moved to London in 1779 and used his home in Berners Street to hold exhibitions of his new work.[1] The Hopes were ardent supporters of Bone and collectors of his enamels, as were some of the greatest Regency patrons, including the Prince of Wales, later George IV, who appointed him his official Enamel Painter in 1801.[2] Many of Bone's preliminary drawings survive, providing valuable information as to which Hope commissioned the portraits, as well as being a record of enamels now lost.[3] In addition to those shown in this exhibition, Bone painted several other portrait enamels for the family, many of them copies of the original portraits commissioned by Thomas Hope, including one after Sir William Beechey's portrait of Thomas,[4] George Dawe's portrait of Louisa,[5] and Guy Head's portrait of Henry Philip.[6]

On occasion paintings were delivered to Bone's studio to facilitate quick copying, although it is more likely that he would have visited the house in Duchess Street to make his drawings. His first visits were before the publication of *Household Furniture* in 1807, so it is unfortunate that he decided not to record his impression of the interiors of the house. The enamels themselves, however, are important historical records where the original paintings have long since disappeared, as in the case of the Dawe and Head portraits mentioned above. One of Bone's drawings may be of even greater significance in connection with the bitter argument that raged between Thomas Hope and the French painter Antoine Dubost; see Chapter 9. Among the extant Bone drawings is a sketch of Louisa Hope dated 1808 and recorded as being after Dubost.

The enamel portraits in the exhibition clearly depict two generations of the Hope family. It was the elder Henry Hope who commissioned the portrait of his cousin John; both men are shown wearing powdered wigs, already long out of fashion by the date of their commission. Thomas, Henry Philip, and Louisa are wearing the most fashionable contemporary dress, with Louisa once again showing off her fine taste in clothes and her collection of jewelry. Thomas and Henry also collected Bone portraits of family members not represented here, including John Williams Hope and Admiral Sir Charles Pole, both of whom lived in London, as well as replica copies after the Old Masters that were a staple of Bone's oeuvre.

These enamels were displayed at Duchess Street in the Flemish Picture Gallery and the Egyptian Room, as well as at the Deepdene after it was acquired in 1807.

1. Foskett, *British Miniature Painters*, vol. 1 (1972): 171–72.
2. Walker, "Henry Bone's Pencil Drawings" (1998–99): 306–67.
3. They have been pasted into bound volumes in the Heinz Archives, National Portrait Gallery, London. Also see Walker, "Henry Bone's Pencil Drawings" (1998/1999): 305–67.
4. This enamel after the Beechey original is in the Pera Museum, Istanbul.
5. Dawe's painting on which this is based was exhibited at the Royal Academy in 1812. Bone made a copy in 1813 that was described by Westmacott, *British Galleries* (1824): 234: "A very choice and highly-finished portrait, full of grace, and beaming with intelligence, brilliant in colour and animated effect." The enamel was last seen for sale at Christie's, London, 15 October 1996, lot 130.
6. Guy Head had painted a portrait of Thomas Hope and one his brothers in Rome in 1795. Henry Bone's copy is dated 1802. The enamel is now in the Musée Cognac-Jay, Paris.

DB-A

9. *Henry Philip Hope*

John Flaxman (1756–1826)
1802–3
Marble
24 in. (54.2 cm)
Inscription (in Greek): Φιλιππος (horse lover)
Thorvaldsens Museum, Copenhagen, G 271

PROVENANCE: Thomas Hope; by descent, Lord Francis Hope Pelham-Clinton-Hope; sold Humbert & Flint, London, 17 September 1917, lot 1130, for £21; Thorvaldsens Museum, Copenhagen.

EXHIBITION: Royal Academy, London (1802), no. 959: bust of HPH, possibly the plaster from which the marble was carved.

LITERATURE: Flaxman account book, 20 October 1803; *Household Furniture* (1807): pl. L, no. 1; Douce MS (1812): f.4; Croft-Murray, "An Account Book of John Flaxman" (1939–40): 80; Watkin, *Thomas Hope* (1968): 118, fig. 16; Bindman, *John Flaxman* (1979): 105, no. 118; Irwin, *John Flaxman* (1979): 186–87.

Flaxman's bust of Henry Philip Hope of 1802–3[1] is unusual in Flaxman's work in that it is a rigorously frontal herm-type bust, a type associated with early Greek severity. This archaic form seems to have been entirely due to Thomas Hope's taste, for he wrote at length on his preference for the herm type in *Household Furniture*, despite the fact, as noted in the entry for his own bust of 1817 (cat. no. 10), that he was sculpted by Thorvaldsen with the bust supported on a traditional socle, which he described as being in "the more prevailing Roman fashion":

I avail myself of the occasion of the bust represented in this plate [i.e., of Henry Philip Hope], to notice an error of taste, into which have fallen some English sculptors: no doubt in imitation of the French sculptors of the last century; since the practice which I allude to seems sanctioned by no ancient example whatever, of a pure style of art. I mean the fashion of representing, in a bust, the head, not looking strait forward, and in the same direction with the chest, but turned over the shoulder, and looking sideways: a position which, except in the busts of Caracalla, no longer belonging to the pure style of ancient art, is, I believe, found in no ancient busts, that did not origi-

nally form part of entire statues, and are only preserved as fragments of such.

In a production of the pencil, which can only exhibit a face in a single aspect, if the most striking or most favourable view of that face be not a direct front view, there may, in the eligibility of bringing the features more in profile, be a very good reason for turning the head somewhat over the shoulder. Nay even in a work of the chisel, if it be an entire statue, the peculiar attitude or action of the body may present a sufficient motive for giving such a turn to the head. But if a mere bust, which we may easily view in every possible aspect, by ourselves moving round it, in place of being allowed to leave this task entirely to the beholder, be made itself to turn its face away from our sight, though it have not a body, to account for this less easy and less usual position of the head, the portrait loses all claim to naturalness and truth; it forfeits the appearance of dignified simplicity, which is so essential and so fascinating, for an air of inane and pompous affectation; and it moreover, from the different direction given to the face and to the chest, can seldom be so situated as not to look ill placed and awkward.

I shall beg to add that the Grecian method of cutting the chest square, and placing its whole mass immediately on a term or other solid support seems much preferable to the more prevailing Roman fashion of rounding off that chest, and balancing its center only on a slender and tottering pivot.[2]

The bust was commissioned to go on the chimneypiece of the Dining Room in Duchess Street, where it was inscribed with a pun referring to his brother's name, Philip, or Φιλιππος, meaning horse lover, and was placed in the center, flanked at each end by two antique-type horses' heads; these are now lost but may have been sculpted by Flaxman (see fig. 6-12).[3]

1. Bindman, ed., *John Flaxman* (1979): cat. no. 118.
2. *Household Furniture* (1807): 120.
3. Ibid., pl. L. A "pair of life-size horses' heads in zinc" was sold at Humbert & Flint, 17 September 1917, lot 1082.

DB

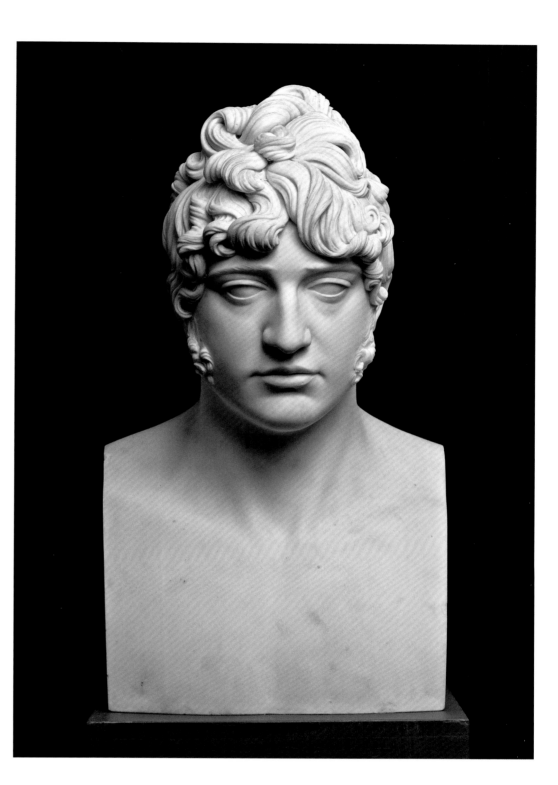

Thorvaldsen's Portrait Busts of Thomas Hope, His Wife, and Two Children

10. *Thomas Hope*

Bertel Thorvaldsen (1770–1844)
1817–ca. 1823
Marble
21¼ in. (55.4 cm)
Thorvaldsens Museum, Copenhagen, A823

PROVENANCE: Thomas Hope; by descent, Lord Francis Hope Pelham-Clinton-Hope; sold Humbert & Flint, London, September 1917, probably lot 1137; [. . .]; Thorvaldsens Museum, Copenhagen.

LITERATURE: Sass, *Thorvaldsens Portraetbuster* vol. 1 (1963): 281–301; *Apollo* 81 (repr. 1963): 341; Watkin, *Thomas Hope* (1968): 38, fig. 8; Arts Council of Great Britain, *The Age of Neo-classicism* (1972): 284–85, no. 443; *Thorvaldsens Museum* (1995): 83; Jornaes, *Bertel Thorvaldsen* (1997): 100; Floryan, "*Jasons* skaebne Om Thomas Hope" (2003): 47, 49.

11. *Louisa Hope*

Bertel Thorvaldsen (1770–1844)
1817–ca. 1823
Marble
23 in. (58.5 cm)
Thorvaldsens Museum, Copenhagen, A824

PROVENANCE: Thomas Hope; by descent, Lord Francis Hope Pelham-Clinton-Hope; sold Humbert & Flint, London, September 1917, lot 1126, 1129, or 1136; Thorvaldsens Museum, Copenhagen.

LITERATURE: Prosser, *Select Illustrations* (1828): n.p.; *Thorvaldsens Museum* (1995): 83.

12. *Henry Thomas Hope*

Bertel Thorvaldsen (1770–1844)
1817–ca. 1823
Marble
18⅗ in. (47.2 cm)
Thorvaldsens Museum, Copenhagen, A825

PROVENANCE: Thomas Hope; by descent, Lord Francis Hope Pelham-Clinton-Hope; sold Humbert & Flint, London, 17 September 1917, lot 1128; Thorvaldsens Museum, Copenhagen.

LITERATURE: Prosser, *Select Illustrations* (1828): n.p.; *Thorvaldsens Museum* (1995): 83.

13. *Adrian John Hope*

Bertel Thorvaldsen (1770–1844)
1817–ca. 1823
Marble
16⅖ in. (41.5 cm)
Thorvaldsens Museum, Copenhagen, A826

PROVENANCE: Thomas Hope; by descent, Lord Francis Hope Pelham-Clinton-Hope; sold Humbert & Flint, London, 17 September 1917, lot 1128; Thorvaldsens Museum, Copenhagen.

LITERATURE: Prosser, *Select Illustrations* (1828): n.p.; *Thorvaldsens Museum* (1995): p. 83.

These four busts were all made in marble from original models begun by Thorvaldsen at a sitting of the family in his studio on their visit to Rome in 1816–17. This sitting took place at a time when a certain frostiness existed between Hope and the sculptor because of the latter's failure to complete the statue of *Jason* that Hope had commissioned some fourteen years earlier. This frostiness is perhaps reflected in Hope's somewhat dour and unsympathetic expression in the bust, although his wife and the young boys, whose portraits are both of the herm type, are sympathetically characterized. Three of the busts were evidently delivered to Hope in 1822–23, but for some reason the bust of Henry Thomas Hope was withheld and surrendered to Hope only when the sculptor finally delivered the *Jason* in 1828. In Hope's letter thanking the sculptor for sending the *Jason,* two relief sculptures, and the bust of Henry Thomas, he remarks that it was a surprise to get the bust and commended the quality of execution and the resemblance. He also noted that he was still in debt to Thorvaldsen for the busts, and having withheld payment as a spur to the sculptor to finish the *Jason,* he proposed to instruct the banker Torlonia to pay Thorvaldsen £200 sterling for them.

It is intriguing that the busts of the children should be of the herm type while the parents follow the more common eighteenth-century form, with a socle, or base. Although Thorvaldsen is not consistent in his practice, the herm type is more often associated with artists and the socle with people in public life. There is perhaps a comment here in the contrast between the boys' innocence and the stern worldliness of their father. In discussing Flaxman's bust of his brother Henry Philip Hope (see cat. no. 9) in *Household Furniture*, Hope argued strongly for the herm type in portrait busts, which he found to be "much preferable to the more prevailing Roman fashion of rounding off that chest, and balancing its centre only on a slender and tottering pivot."[1] Yet he accepted the latter form in his own bust ten years later.

1. *Household Furniture* (1807): 120. DB

276

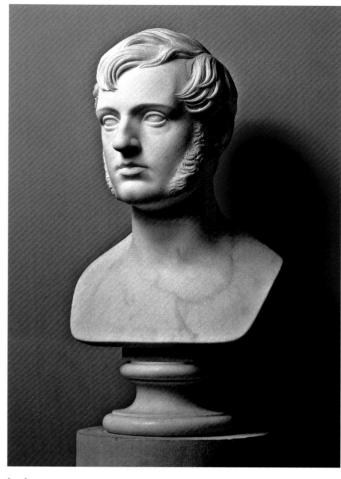

[10]

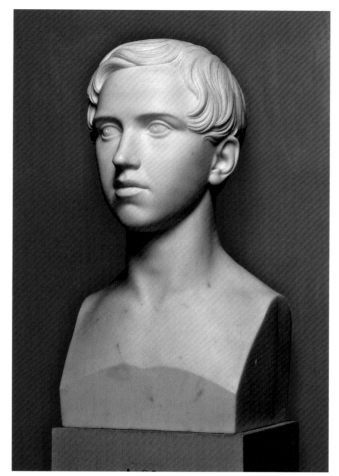

[11]

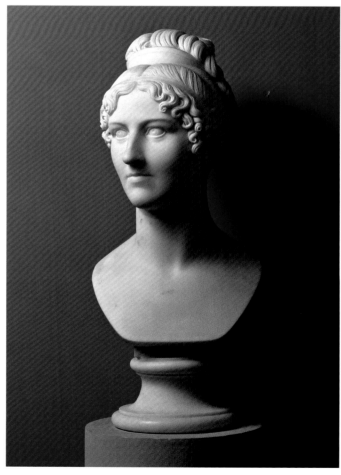

[12]

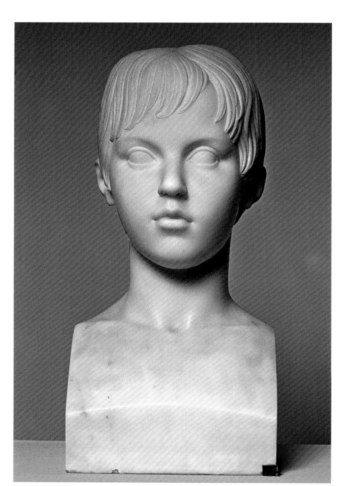

[13]

14. *Bosbeek*

Etheldreda Beresford-Hope (d. 1876)
English, 1871
Watercolor
9⅖ x 13½ in. (24 x 34.2 cm)
Signed E.B.H. and dated 1871
Hubert de Lisle

PROVENANCE: [Hope family] by descent, Henrietta Hope, Lady Haversham; by descent, joint heirs Mildred Astley Smith and Ambrose de Lisle; by descent, Hubert de Lisle.

The estate of Groenendaal, near Haarlem, was bought in 1767 by Thomas Hope's father, John, who in 1784, just before his untimely death, added to it the adjacent property of Bosbeek, where a modest, three-storied red-brick villa of five bays below a hipped roof stood on the edge of the estate.[1] It was here, as well as in his father's houses in Amsterdam and The Hague, that Thomas Hope passed his youth, surrounded by the important collection formed by his father. This watercolor was painted by Etheldreda Beresford Hope (Mrs. Marwood Tucker), daughter of Thomas Hope's youngest son, Alexander Beresford Hope.

In 1794 Bosbeek passed to the youngest of Thomas's brothers, Henry Philip Hope as part of the division of family property among the three brothers. By 1802, the middle brother, Adrian Elias Hope, had returned from Germany to Holland, where he lived on Henry Philip's estates of Bosbeek and Groenendaal and in a house on the Heerengracht in Amsterdam. On Henry Philip's death in 1839, Bosbeek passed to Thomas Hope's second son, Adrian John.[2]

G. J. Schouten was commissioned to paint Bosbeek about 1835, his father, Hubert Schouten, having painted views of Welgelegen for Henry Hope shortly after its completion in 1788.[3]

1. Law, *The Beresford Hopes* (1925): 270.
2. Ibid., 119.
3. The Hope Architectural Collection, Yale University, B1977.14.4877–4900.

DW

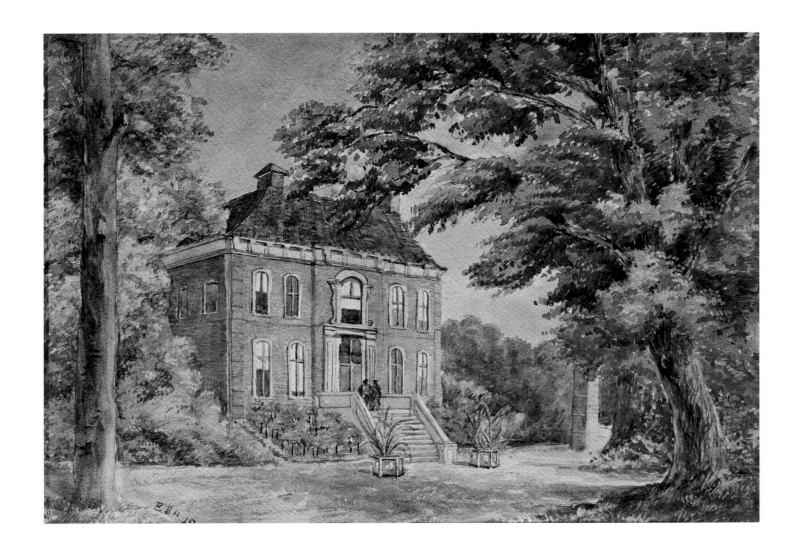

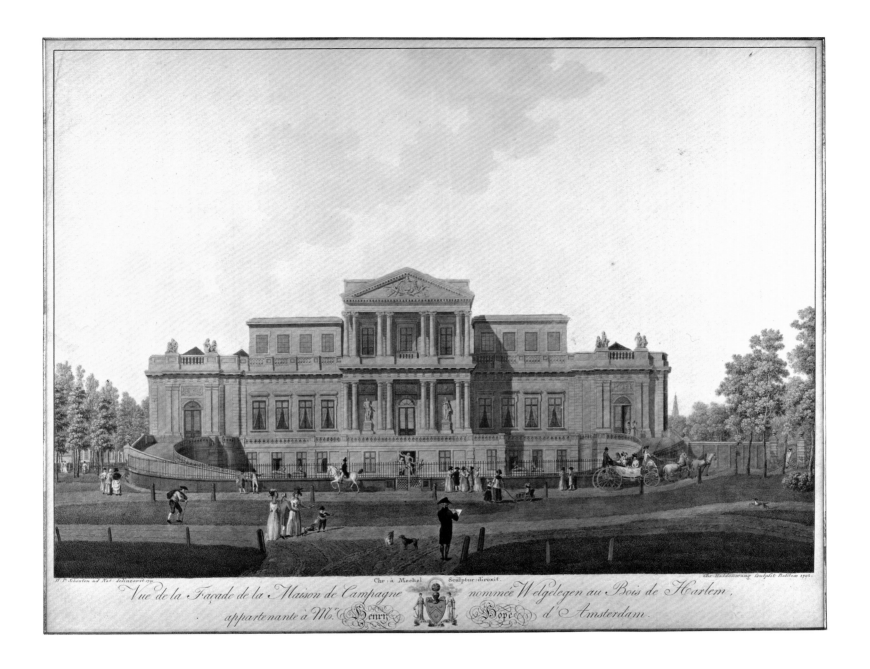

Vue de la Façade de la Maison de Campagne nommée Welgelegen au Bois de Harlem, appartenante à M.ʳ Henry Hope d'Amsterdam.

15. *Welgelegen*

H P Schouten in 1791, Mechel sculptor
Dutch, 1791
Engraving
16¼ x 23¼ in. (41.1 x 59 cm)
Inscribed: "Vue de la Façade de la Maison de Campagne
nomme Welgelegen au Bois du Harlem, appartenant a
M. Henry Hope d'Amsterdam"
Hubert de Lisle

PROVENANCE: [Hope family]; by descent, Henrietta
Hope, Lady Haversham, by descent, joint heirs Mildred
Astley Smith and Ambrose MP de Lisle; by descent,
Hubert de Lisle.

This palatial mansion, built near Haarlem
in 1785–88 by Thomas Hope's cousin
Henry Hope, was a major precedent for
Hope as a house-cum-museum. Henry
Hope, born in Boston, Massachusetts,
where his father had emigrated in 1730, was
educated in England and entered the Lon-
don banking firm of Gurnell Hoare & Co.
He was invited to Amsterdam in 1762 to
join the Hope family bank with his cousin
John Hope, Thomas's father, in which year
it began trading under the name of Hope &
Company, instead of Thomas and Adrian
Hope. Henry Hope, the real genius in
building up the prosperity of the family
bank, was painted by Sir Joshua Reynolds,
who visited Amsterdam to admire his
magnificent collection of Old Master

paintings.[1] In 1769 Henry Hope bought a
farmstead in the Haarlemerhout, but he
demolished it in 1784 and replaced it with
the mansion Paviljoen Welgelegen.[2]

Inspired by engravings of designs by the
French architect Jean-François Neufforge,
Welgelegen was the outcome of collabora-
tion between Henry Hope and his friend
and neighbor in Amsterdam, Michel, Baron
de Triqueti, Sardinian consul at the Hague,
with the Fleming Jean Baptiste Dubois as
executant architect. Resembling a templar
public building rather than a private house,
Welgelegen was built to house Hope's col-
lection of antiquities and paintings, one of
his models being Cardinal Albani's celebrated
villa in Rome, built as both a residence and
a museum from designs by Carlo Marchionni

from 1746 to 1763. Stylistically a rare example of the Louis XVI style in contemporary Holland, Welgelegen contains a huge two-storied picture gallery that forms the center of the house. Then the only art gallery of its kind in Holland, it lacks a domestic atmosphere but has the scale and character of the great public museums of the nineteenth century; as such, it was a precedent for Thomas Hope's own gallery in Duchess Street. Thomas left Holland as Welgelegen was nearing completion and presumably saw it on one of the several return visits he made to Amsterdam between 1787 and 1795 when he settled in London.

Thomas Hope would have known Welgelegen's monumental chimneypiece, which his father, John, a sophisticated collector, had bought in Rome from Piranesi in the 1760s.[3] On John Hope's death at the age of forty-seven in 1784, the chimneypiece was acquired by Henry Hope, who installed it in the library at Welgelegen. Typically for Piranesi, it combined antique fragments, herms, and other ornaments with modern work to form a rich and suggestive whole. Thomas Hope would praise "Piranesi's works in general; and particularly his vases, candelabra, and chimneypieces," in the bibliography to *Household Furniture*.[4] His father's chimneypiece is flanked by torches crowned with pine cones, a symbolical allusion to fire, which was echoed in Hope's own chimneypiece in the Indian Room at Duchess Street.[5]

The rich plasterwork of the interiors at Welgelegen, notably in the Gallery and Music Room, probably accomplished by Italian craftsmen, also has a Piranesian flavor in the crisp detail of its fertile ornament. The gilded wrought-iron balustrade in the Gallery is adorned with similar ornament, including the radiant head and lyre of Apollo, god of the arts, as well as globes surmounted by anchors symbolizing hope. Hope also commissioned twelve lead statues, mainly neo-antique, from Francesco Righetti, an assistant to Canova and one of the most popular sculptors in late eighteenth-century Rome. Visitors to the house included Thomas Jefferson in 1788 as the guest and client of Henry Hope.

Hope commissioned Benjamin West to paint a large portrait group of his family, which is a striking memorial to his role as patron and collector.[6] It includes a large architectural model of Welgelegen, a Greek red-figured vase, and a carved bronze urn standing on an unusual circular table, which is bordered with a neo-Egyptian lotus ornament painted or inlaid in bright red. A bachelor, Henry Hope made over Welgelegen in 1807 to his heir John Williams, who had married his niece, Ann, and changed his name to John Williams Hope. In 1808 Williams Hope sold Welgelegen to Louis Bonaparte, who had become King of Holland. It serves today as the Provinciehuis Noord Holland.

1. Now lost, the portrait is known from a contemporary engraving by C.H. Hodges.
2. See Ben-Arie, "The Hope Family in London" (1989), and Quant, *Paviljoen Welgelegen* (1989).
3. Today in the Rijksmuseum, Amsterdam. See Piranesi, *Diverse Maniere* (1769): pl. 2; Lawrence, *Piranesi as Designer* (2007).
4. *Household Furniture* (1807): 52.
5. Ibid., pls. VI, XVII.
6. Today in the Museum of Fine Arts, Boston. See Watkin, "The Hope Family" (1964): 571–72.

DW

"Drawings by T. Hope"

PROVENANCE: Executed by Thomas Hope; by descent, Lord Francis Hope Pelham-Clinton-Hope; sold Christie's, London, 25–27 July 1917, lots 395–397, all three lots were bought in; acquired by B.T. Batsford; sold ca. 1930 by Batsford; three of these volumes were in possession of Damianos Kyriazis, who bequeathed them to the Benaki Museum, Athens; two volumes purchased by Antonis Benakis; Benaki Museum, Athens.

In 1978, during the course of a general reorganization of the Benaki Museum Library, this writer discovered five handsome folio-size volumes, bound in full contemporary brown Russia and gilt-tooled. Only two of these are inscribed, on the spine: "DRAWINGS BY T. HOPE." Three of the volumes are in Hope's library binding, displaying the Hope family motto and armorial bearings embossed in gilt on both covers. The coat of arms, together with other decorative details, shows the globe with a small part missing, while a Latin inscription that runs around it reads: AT SPES NON FRACTA (but hope is not broken). The other two volumes are in a nearly identical binding but lack the coat of arms.

The five volumes contain 525 drawings, whose subjects exactly coincide with the description in an undated sale catalogue (ca. 1930) of "*100 Old, Rare or Unique Illustrated Books, Collections of Original Drawings, Designs, Engravings etc., offered for Sale by B.T. Batsford, Ltd.*"[1] Moreover, a pen drawing of a "View of the Seraglio," which is included in one of the Benaki volumes, is identical to the one in the Deepdene Album (pl. 19).

From the large number and completeness of the drawings, it is probable that Hope intended to publish them, although, sadly, for whatever reason, he did not do so in the end. The story of how the drawings made their way to the Benaki Museum began over seventy years ago, as I realized from a series of letters exchanged between the museum's founder, Antonis Benakis, and B.T. Batsford Ltd. In his letter dated September 22, 1930, Benakis wrote: "Our Minister, Mr. Caclamanos, has written to inform me that you have a collection of

drawings by Thomas Hope, for which you are asking £120. As I am interested in this collection, and would like to acquire it, if possible, for the Nation, would you kindly give me all the information you can, on the subject, informing me, at the same time, whether you could see your way to make a reduction in the price, which I cannot help thinking rather high."[2]

From Benakis's last letter, dated November 8, 1930, we understand that he had to decline the opportunity because he considered the price too high. A sixth volume, containing *Drawings of Ancient Costumes by Hope*, was also included in the Batsford sale catalogue of 1930. This volume is now in the Gennadius Library in Athens (see cat. no. 109), to which it was bequeathed by the prominent Greek collector Damianos Kyriazis, a close friend of Antonis Benakis and one of the most important donors to the Benaki Museum. Since three of the five volumes came to the Benaki Museum from the Kyriazis bequest, we may assume that Damianos Kyriazis bought part of the set so that the two friends could share the expense.

The contents of the five volumes in the Benaki Museum are as following: volume I (folio, 51 x 38 cm) comprises 66 drawings on 33 leaves (41.5 x 36 cm), mostly in pen and sepia ink and a few in wash or tinted. The subjects are architecture and peasant life in Hungary and Bulgaria, Roman remains in the Balkans, ancient remains on the Bosphorus, plans of Constantinople and various monuments of that city, Byzantine churches, mosques, Turkish palaces, tombs, fountains, specimens of Islamic architecture, and details of decoration in the Ottoman capital.

Volume II (folio, 51 x 38 cm) comprises 121 drawings on 33 leaves (49.5 x 36 cm), in pen and sepia ink. The subjects are: Turkish palaces in Constantinople with details of ceilings, grilles, etc., Turkish state barges and pleasure-boats, everyday and military dress of the Turkish court, with turbans, headdresses, etc. of different nationalities in Constantinople, Hellenistic ruins, friezes, reliefs, etc., views of Greek islands, coastal landscapes in Greece, Greek costumes, peasant groups, etc.

Volume III (folio, 51 x, 38 cm) comprises 71 drawings on 33 leaves (49.5 x 36 cm), in pen and sepia ink. The drawings vary in size from 19.5 x 29 cm to 22 x 29 cm, and two or three are pasted together on the same page. The subjects are: views in Greece, including Athens, Hydra, and Mycenae with its treasuries, Greek landscapes, ancient remains, reconstructions and plans; views of Antiphellus; views of Jerusalem and its sepulchral monuments; Syrian, Bedouin, and Egyptian costumes, turbans, headdresses, peasant types, etc.; Nile craft and the catacombs of Alexandria.

Volume IV (folio, 51 x 38 cm), lettered on the back "EGYPTIAN DRAWINGS," comprises 150 drawings and sketches in pen and ink, pencil, wash and color, mounted on 106 leaves. The drawings vary in size from 26.5 x 34.5 cm to 21.5 x 113 cm. This is a more heterogeneous collection, ranging from unfinished sketches to finished and colored drawings, as well as a few engravings. Some of the drawings are by hands other than Hope's, as, for example, inventory numbers 27250–27251 and 27292, which are signed by Fauvel. The subjects are: views and large, folding panoramas of Constantinople and the Golden Horn; plans, details and interiors of the Sultan's Palace; Turkish inscriptions; Turkish pavilions; sketches and panoramas of Ephesus; views of the Greek islands of Delos, Tenos, Naxos, Aegina, Rhodes, Zante, Corfu, Ithaca; ruined temples; maps and plans of Athens, Piraeus, Athenian monuments; views of various towns in the Peloponnesus, e.g., Corinth, Nemea, Nauplion, the temple at Bassae and types of Aegean craft. Also, the tombs of Antiphellus on the coast of Asia Minor, Egyptian landscapes, mosques, palaces, interiors, architectural details, etc., with the Sphinx and the Pyramids, peasant groups, camels, etc.

Volume V is of a larger format (folio, 65 x 45 cm). It contains 117 drawings on 62 leaves (63 x 42.5 cm), of large, minutely detailed pencil panoramas of Turkish and Greek landscapes, including Constantinople and its palaces and citadels on the Bosphorus; views of Greece including Athens, Mount Athos, Antiparos, Nauplia, Rhodes, etc.; also Tyre, Jerusalem, Alexandria, and Gizeh. Then follows a series of finished watercolors of landscapes, bridges, aque-ducts, monuments, ancient walls, mosques, and palaces in the vicinity of Constantinople; views of Alexandria in Troas; views of Paros, Tenos, Hydra, Mycenae, Nauplion, and Bucharest. There are also wash drawings of Greek landscapes and details of mosques and palaces in Constantinople and Turkey, based on rough sketches appearing in earlier volumes.

All the captions, which in many cases run into several pages of text, are written mostly in bad English, together with misspelled French. A number of drawings are inscribed with titles and captions in French. These may be attributed to the French draftsmen L.-S. Fauvel and Michel-François Préault (or Préaux), both of whom were employed by Hope.[3] Reproductions of the 105 drawings of Greek subjects included in the five volumes were published in 1985.[4]

The clarity and precision of these drawings would be manifested in Hope's later publications, notably *Household Furniture* (1807), *Costume of the Ancients* (1809), and *Designs of Modern Costume* (1812). The drawings testify not only to Hope's superb draftsmanship, but also to his talent for capturing the atmosphere of remote places, a facility he proved later in his novel, *Anastasius* (1819). His well-known declaration— "I resided . . . in Constantinople . . . saw Rhodes, Egypt, Syria, and every other place, which I have attempted to describe minutely in *Anastasius*"[5]—is verified by his drawings in the Benaki Museum.

Hope visited Greece in late 1796 to 1797 during his Grand Tour of the Ottoman Empire, of which Greece then formed part, not yet being an independent state. It is not possible to re-create his exact itinerary in Greece because no journals of his travels have been found and his drawings are undated. However, one third of the drawings are numbered serially, allowing us to suggest that he crossed central Europe as far as Bulgaria and then went to Constantinople, after which he visited the Aegean islands and probably Athens. An archive of letters at the historical archives of the Benaki Museum from Fauvel to Mr. Cousinéry, the French consul in Salonica between April 1795 and May 1801, contains the following account of the activities of a "Mr. Hope":

[October 7, 1799] The day before yesterday, arrived here M. Hope. He seemed to have little curiosity. He is lodged at the imperial-british Consulate; I accompanied him to Philopappos and to the tomb of M. Tweddell, the temple of Theseus, without him asking the slightest question. [December 6, 1799] I believe that you have heard of the death of the brother of Mme Roque, the Consul Macris on his voyage with Mr. Hope. Twenty years of service for the English nation deserves some recognition for his sister and his family." [April 24, 1800]. "Préaux remains here, working for Hope.[6]

It seems likely that the "Mr. Hope" referred to here is Thomas's brother Henry Philip, who visited Athens in October 1799, when he was guided around the city by the draftsman, Louis François Sebastien Fauvel. A renowned French consul and a treasure hunter, Fauvel was a supplier of antiquities to comte de Choiseul-Gouffier, French ambassador to the Ottoman Empire from 1784 to 1792. The collection of drawings includes several drawings by Fauvel, as well as commissioned drawings from Préault (or Préaux), who went to Athens in 1798 as draftsman to the English traveler John Tweddell. After Tweddell's death in Athens and burial in the Theseion, Préaux stayed on for a short time, supplying souvenir views of the city to foreign travelers. In October and November 1799, Henry Philip Hope made a tour of the Peloponnese (Morea), in the company of Procopio Macri, the Levant Company's consular agent in Athens and father of Teresa Macri, Byron's "Maid of Athens."

Hope's drawings at the Benaki Museum constitute a fascinating corpus of rare visual documents, which shed light on various facets of his style and draftsmanship. However, for researchers into the Greek past, the large corpus of "Greek" drawings in this collection is of multiple importance, beyond the enchantment and the aesthetic pleasure these works evoke. Indeed, the entire corpus of drawings, watercolors, oil paintings, and prints with Greek subjects produced by artists-travelers who visited the country in past centuries is considered a pool of visual documents that makes a significant contribution to our knowledge

of Greece in those times. Greek museums and historical institutions have undertaken ambitious projects to locate and record works by artist-travelers who visited the country in previous centuries, in the belief that all and any visual records of the country are fundamental tools for studying its past.

The representations of some artists may lack fidelity because of unfamiliarity with the subjects and aesthetic preconceptions. For example, the nostalgic quest for antiquity, pervasive in the eighteenth century, is apparent in the antiquarian disposition that runs through Hope's depictions of Greek costume and the elegant gestures and poses of his figures. However, it is to his credit that his choice of subjects is not entirely motivated by adulation of antiquity, since it covers a remarkably broad spectrum, which includes Byzantine and later monuments, as well as local costumes and representations relating to the current period.

The Hope collection also represents monuments in Greece that have now vanished, such as the "Athonias School," founded on Mount Athos by Patriarch Cyril V in 1749 (Benaki Museum, inv. no. 27307); the monument had never been recorded before and was destroyed by fire early in the nineteenth century. Similarly important are Hope's drawings of Hellenic antiquities outside Greece, such as the tombs at Antiphellus (see cat. no. 32), most of which have disappeared, as well as of famous Byzantine monuments of Constantinople, which have been altered or vanished (e.g., the Boukoleon Palace, cat. no. 23). The originality of the collection is heightened by Hope's unusual interest in Ottoman and Mameluke architecture and costume. In summary, it may be said that the corpus of drawings provides modern researchers with a visual panorama of the Ottoman Empire in the eighteenth century that is as unique as it is reliable.

1. Watkin, *Thomas Hope* (1968): 277, pl. 19.
2. A. Benaki letter to B. T. Batsford, 22 September 1930, Benaki Library Archives
3. See Beschi, "Nuovi disegni di L. S. Fauvel" in Prontera, *Geographia Storica della Grecia Antica* (1991): 24–45.
4. Tsigakou, *Thomas Hope* (1985).
5. In a letter of 9 October 1821, *Blackwood's Edinburgh Magazine* (1821): 212.

6. "(7 Octobre 1799) Avant-hier arriva ici M. Hope, il paraît peu curieux, il est logé au Consulat impéro-breton; je l'ai accompagné à Philopappos et au tombeau de M. Tweddell, le temple de Thésée, sans qu'il m'ait fait la moindre question - (6 Décembre 1799) Je crois que vous avez su la mort du frère de Mme Roque, le Consul Macris dans son voyage avec Mr. Hope: 20 ans de services pour la nation anglaise méritent quelques egards pour sa sœur et sa famille (24 Avril 1800) Préaux reste ici, travaille pour Hope."

16. *Windmill on the Island of Paros*[1]

Thomas Hope
ca. 1787–95
Watercolor on paper
Inscribed: "Mill at Paros with eight wings and intermediate sails"
7½ x 5¼ in. (19 x 14.5 cm)
The Benaki Museum, Athens, 27342, vol. V

LITERATURE: Watkin, *Thomas Hope* (1968): 65, 277; Tsigakou, *Hope* (1985): 179, 228, cat. nos. 79, 80.

This drawing provides a telling record of one of the most characteristic structures on the Greek islands. Although they are functional buildings, the windmills and dovecotes of the Greek islands acquired a special architectural style and were artistically enhanced, despite their humble aspect.

Like most of Hope's drawings in the Benaki Museum collection, this is a monochrome in pencil and pen and ink, washed over by diluted India ink, a method used by most eighteenth-century topographers because it provided an ideal kind of drawing for the engraver to reproduce. Despite the conventional rendering of the foliage, one cannot but praise the transparent manner in which Hope captures the effect of the shadows of the windmill's sails on the walls of the building.

1. Inv. no. 27342 (in vol. V); drawn on the same sheet as 27343-27344. The preliminary drawing for this and the following two are to be found in vol. II, inv. no. 27132a (pen drawing 43 x 28.5 cm). The related inscription reads: "Mill at Paros with 8 wings and little sails between each wing." In the finished version Hope added two figures standing in front of the windmill.

F-MT

17. *Dovecote on the Island of Tinos*[1]

Thomas Hope
ca. 1787–95
Watercolor on paper
7½ x 5¼ in. (19 x 14.5 cm)
Inscribed: "Dove cot at Tino"
The Benaki Museum, Athens, 27343, vol. V

LITERATURE: Tsigakou, *Thomas Hope* (1985): 191, 228, cat. nos. 86, 87.

Tenos is the fourth largest of the Cyclades, an archipelago of some fifty-six islands, large and small, stretching out to the south of Attica. The islands, which enjoyed continuous prosperity from the splendid culture of the third millennium B.C., were ceded to the Venetians when Constantinople fell to the Franks in 1204. Tenos has a distinctive charm, with lush vegetation, unusual for the Cyclades, and numerous ornate dovecotes. The dovecote depicted here is drawn with the same precision and charm as the windmill. Hope has added delicately drawn incidental figures.

1. Inv. no. 27343 (in vol. V); drawn on the same sheet as 27342–27344. The preliminary drawing for this is inv. no. 27132b (see above) and is inscribed: "Pigeon House of Tenos. The lattice work made of bricks." In the finished version Hope added three figures.

F-MT

18. *View of the Town of Paros*[1]

Thomas Hope
ca. 1787–95
Watercolor on paper
7¾ x 11⅗ in. (19.5 x 29.5 cm)
Inscribed: *"Town of Paros"*
The Benaki Museum, Athens, 27344, vol. V

LITERATURE: Tsigakou, *Thomas Hope* (1985): 187–88, 228, cat. nos. 84, 85.

Paros is the third largest island in the Cyclades. The view shows Paroikia, the island's capital, which lies on the west coast and is also its main port. It occupies the same site as the ancient city, and its oldest quarter, more or less at the center of the town, is clustered around the Castle hill (Kastro). The formation of the traditional settlements on the islands—which are composed of houses with small openings, creating a single wall like a fortress—is directly related to climatic and historical conditions of the period, as well as to security from piratical raids.

This drawing is a rare visual record of the island's architecture, because the town of Paros changed radically from the end of the eighteenth century onward, when, as a result of the Napoleonic Wars, the inhabitants acquired wealth that enabled them to build new and bigger houses. In this typical view, all topographical and architectural details are rendered convincingly; the sea in the foreground is executed with care, and the boats and ships impart a narrative quality to the vista.

1. Inv. no. 27344 (in vol. V); drawn on the same sheet as 27342-43. The preliminary drawing for this is inv. no. 27132c (see above) and is inscribed: "View of the Town of Paros."

F-MT

19. *Architectural Details from a Mosque at Ephesus*

Thomas Hope
ca. 1787–95
Watercolor on paper
17½ x 11⅖ in. (44.5 x 29 cm)
Inscribed: "Details of the Moorish Mosch at Aya Solouk"
The Benaki Museum, Athens, 27374, vol. V

Ephesus on the coast of Asia Minor was a legendary city; its Temple of Artemis ranked as one of the Seven Wonders of the Ancient World. In the sixth century A.D. Emperor Justinian built a monumental basilica to honor the sojourn and death of the Apostle St. John in Ephesus. Byzantine tradition makes Ephesus the scene of the death of the Virgin Mary.

The city was captured in 1090 and destroyed by the Seljuk Turks, but the Byzantines succeeded in retaking it and rebuilt it on the neighboring hills around the church of St. John. Henceforth, it was commonly called Hagios Theologos (the Holy Theologian, i.e., St. John the Divine), or in Turkish Aya Solouk. In 1375 the Seljuk ruler Isa built a mosque beneath St. John's basilica; the Isa Bey Mosque was constructed from ancient materials and marble columns that had been removed from the harbor at Thermae. Hope's drawing depicts architectural details of this mosque.

F–MT

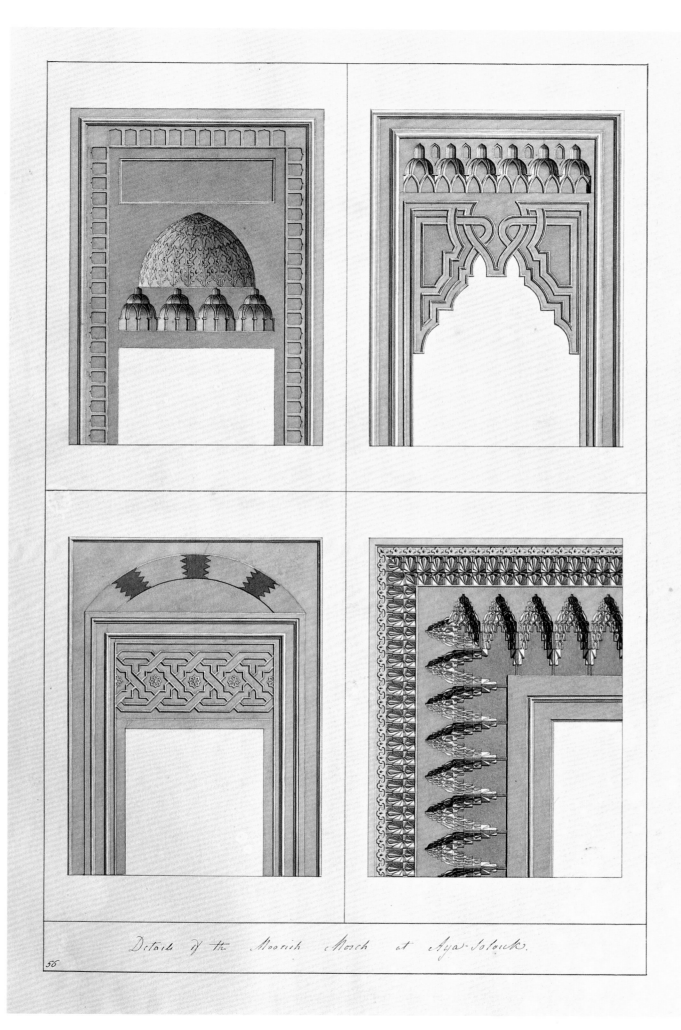

Details of the Moorish Mosch at Aya-Solouk.

56

20. *View of the Town of Naxos through the Portal of the Archaic Temple*

Thomas Hope
ca. 1787–95
Pen and watercolor on paper
17¼ x 11⅖ in. (44 x 29 cm)
Inscribed: "Doorway of the unfinished Temple on the Rock at Paros."
The Benaki Museum, Athens, 27375, vol. V

LITERATURE: Tsigakou, *Hope* (1985): 195, 213, 229; cat. nos. 90, 102.

The preliminary drawing for this[1] is inscribed "Unfinished Doorway of a Temple at Paros—according to Tournefort, 10 Ft high (dans oeuvre) 11 ft 3 inches (French moat) according to Tournefort." The Frenchman Pitton de Tournefort was the author of the travel book *Relation d'un voyage du Levant fait par ordre du Roi* (Paris, 2 vols., 1717), in which the relevant passage (vol. I, pp. 219–20) reads as follows: "A gunshot away from the island, very near the castle, rises a small rocky shelf on which one sees a very beautiful marble gateway among some large fragments of the same stone and some pieces of granite: the Turks and the Christians took away the rest: it is said that these are the debris of the palace of Bacchus; but they appear to be more the remains of a temple of this god. This gateway, which is only three pieces of white marble, is very tasteful in its simplicity: two pieces form the door jambs and the third the lintel: of the narrow three piece flap, the middle one was taken away. The doorway depicted in the book is 18 feet high, and 11 feet and three wide: the lintel is four feet thick; the jambs are three feet and a half wide and four feet thick: all these marbles were sheeted in copper; as one can still find pieces among the ruins."[2] On the opposite page is an engraving with a similar view, inscribed "Porte d'un ancien Temple de Bacchus qui se voit sur un Ecüeil auprès de Naxe."

In both the drawing and the finished watercolor, Hope has mistakenly placed the scene on the island of Paros instead of Naxos, probably because of the windmills that figure conspicuously on the outskirts of the town. The temple gateway shown here is the hallmark of the capital of Naxos.

Preserved in situ and popularly known as "Portara" (Big Door), the gateway belonged to an unfinished archaic temple (sixth century B.C.) dedicated to Apollo. In local tradition, the spot is believed to be Ariadne's palace, where she encountered Bacchus.

This is one of the most effective landscape compositions in the Benaki collection of Hope's Greek drawings. It is well structured and dramatic in the way that the gigantic doorway, through which the town is visible, is placed in the immediate foreground. The monumental architectural construction is used as a pictorial device that creates an appropriate frame for the view of Naxos in the background, as a kind of vignette. Hope's ability to draw a minute panorama of the town, in which all architectural elements are rigorously exact, is remarkable. Equally remarkable is his coloration—touches of brown and gray wash are sufficient to suggest the warmth of the sunny day and the glow of the clear sky, which invest the view with a poetic quality.

1. Inv. no. 27134 (in vol. I) (pen and sepia drawing, 43 x 29 cm).
2. "A une portée de fusil de l'isle, tout près du château s'éleve un petit écueil, sur lequel on voit une très belle porte de marbre parmi quelques grosses pièces de la même pierre, & quelques morceaux de granit: les Turcs & les Chrétiens ont emporté le reste: on dit que ce sont les débris du palais de Bacchus; mais il y a plus d'apparence que ce sont les restes d'un temple de ce dieux. Cette porte qui n'est que de trois pièces de marbre blanc est d'un grand goût dans la simplicité : deux pièces en font le montant, & la troisième le linteau: le feuil étoit de trois pièces, on a emporté celle du milieu. La porte dans œuvre a 18 pieds de haut, sur 11 pieds trois pouces de large : le linteau est épais de 4 pieds; les montans ont trois pieds & demi de largeur sur quatre pieds d'épaisseur : tous ces marbres étoient cramponez avec du cuivre ; car on en trouve encore des morceaux parmi ces ruines."

F-MT

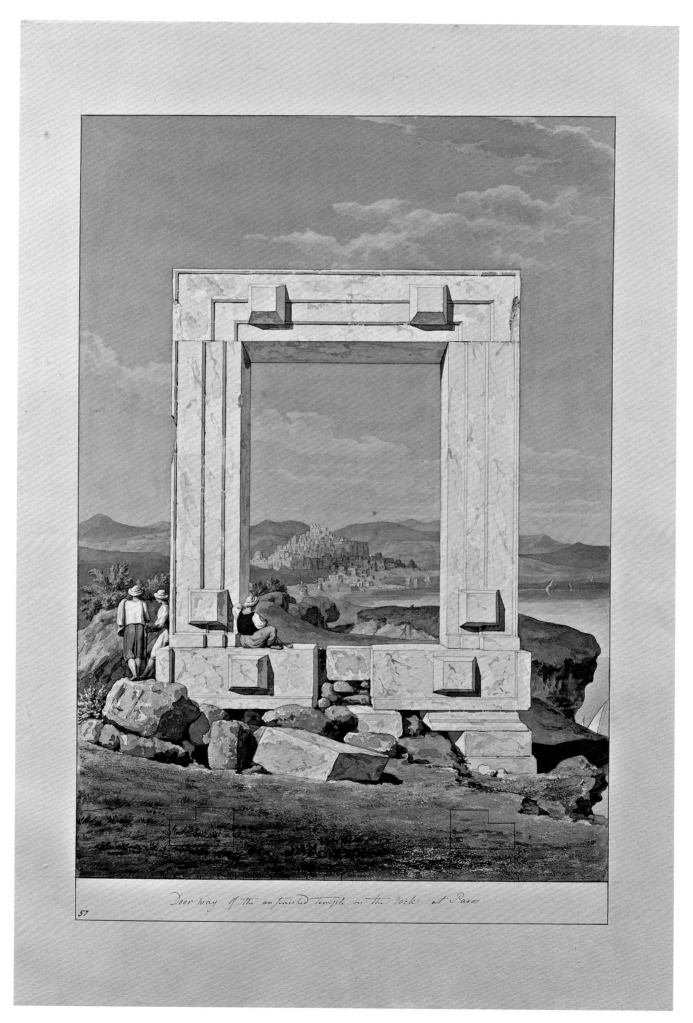

Door way of the unfinished temple on the rock at Paros

57

21. *Greek Dancing Boys*

Thomas Hope
ca. 1787–95
Sepia on paper
11⅖ x 17 in. (29 x 43.5 cm)
Inscribed: "Greek or Taooshan Dancing Boys"
The Benaki Museum, Athens, 27117, vol. II

Literature: Tsigakou, *Thomas Hope* (1985): 63, 219, cat. no. 12.

Taooshan or *Taooshin* means "little rabbits," a name applied to boy singers and dancers who entertained the sultan's court. A group of boys in the same costume and dancing is depicted in another drawing in the same volume.[1] Of interest are the classical poses of the figures, as in all the costume drawings in the Hope collection. Here, as in most of the drawings featuring headdresses in the Benaki collection,[2] all the heads have classical profiles, bringing to mind the faces in Hope's book *Costume of the Ancients*. It should be noted that the same antiquarian disposition runs through the images of all travel publications of the period, as for example in Count de Forbin's *Voyage dans le Levant* (Paris, 1819), where, in the plate entitled "Woman of Santorini" the woman is represented in frontal pose with her head in profile in order to enhance the ancient Greek roots, which the author underlines in the accompanying caption: "the nobility of her features recalls models that inspired Phidias."

Noteworthy too is the careful and meticulous rendering of the various garments and intricate accessories of the costume, which has the quality of a dressmaker's pattern. This is an elegant scene in a slightly rococo style, reinforced by the graceful poses of the young dancers.

1. The preliminary drawing is inv. no. 27116, pen on paper, 29 x 43.5 cm; inscribed: "Embass Jenissary— Caleondgi—Greek dancing boys."
2. E.g., inv. nos. 27109, 27110, 27113, 27131.

F–MT

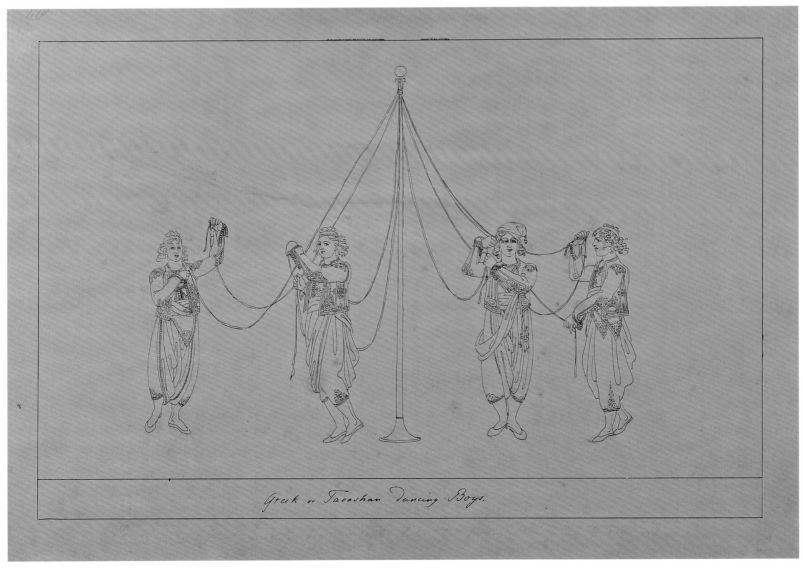

Greek or Taooshan Dancing Boys.

22. *Ancient Altar on the Coast of Asia Minor*[1]

Thomas Hope

ca. 1787–95

Pencil pen and brown watercolor on paper

8½ x 11⅖ in. (21.5 x 29 cm)

Inscribed: "Ancient altar on one of the Canina rocks called Pompei Pillar"

The Benaki Museum, Athens, 27328, vol. V

The ancient city of Cyanide, on the coastal road between Kaş and Demure, was one of the most important centers of Lycia in Asia Minor. It prospered mainly in Roman times, as the ruins in the area attest. Indeed, it is a votive Roman altar that is illustrated here, decorated with garlands and bucrania. It is dedicated to Emperor Augustus (30 B.C.– A.D. 14) in an inscription of three lines: AUGUSTO–DDUS–PONTE, of which the last two are remnants of words that have been erased.

1. Drawn on the same sheet as 27329. The preliminary drawing for this is inv. no. 27065 in vol. I (pen and sepia drawing; 21.5 x 28.5 cm; inscribed: "Ancient Altar on a Rock at the mouth of the Black Sea called Pompey's Pillar"). The same altar figures in inv. no. 27059 in vol. I. (Sepia drawing 21.5 x 14 cm) and in inv. no. 27334 in vol. V (watercolor; 21.5 x 14 cm). Both works carry the same inscription: "Altar called Pompey's Pillar on one of the Cyanian Rocks."

F-MT

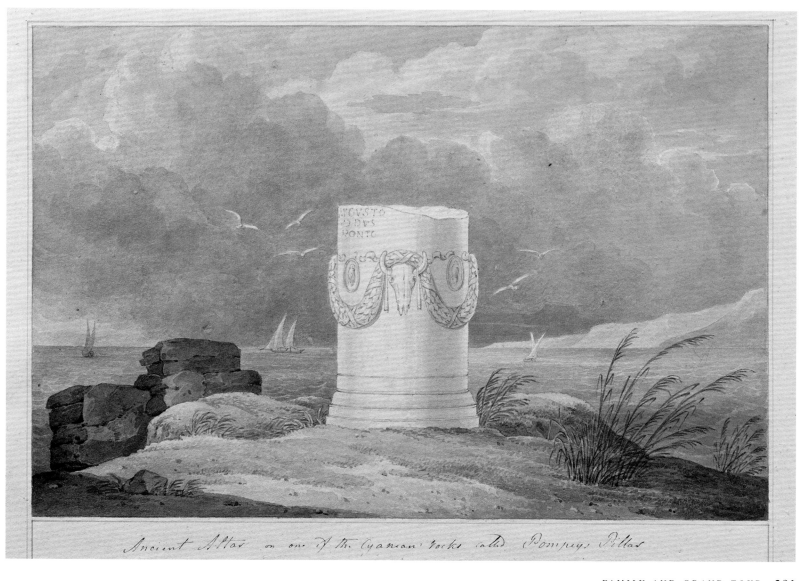

Ancient Altar on one of the Cyanian rocks called Pompeys Pillar

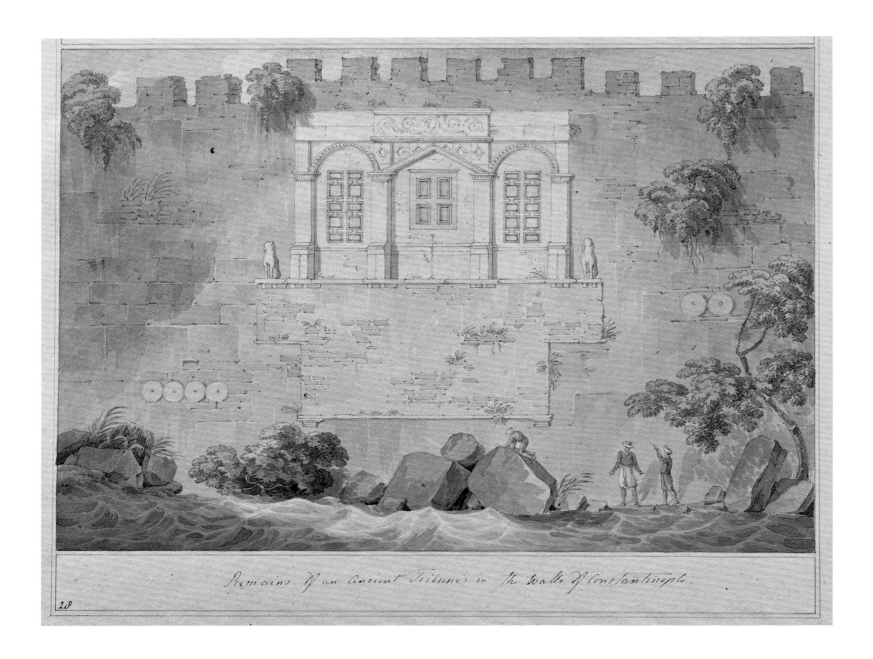

Remains of an Ancient Tribune in the Walls of Constantinople.

28

23. *Remains of the Palace of Boukoleon*[1]

Thomas Hope
ca. 1787–95
Pencil and brown watercolor on paper
8½ x 11⅖ in. (21.5 x 29 cm)
Inscribed: "Remains of an Ancient Tribune in the Walls of Constantinople"
The Benaki Museum, Athens, 27329, vol. V

This drawing is of paramount importance because it relates to one of the most prominent Byzantine monuments in Constantinople, the Palace of Boukoleon (Bucoleon, Boukoleon, or Bouclé), which is all that the remains of one of the seaside pavilions of the palace originally built by Constantine the Great. The name Bouclé, whose etymology is uncertain, designated in ninth- and tenth-century texts a stretch of shore, a harbor, and, occasionally, a terrace overlooking the harbor. It also identifies a group of buildings known in the tenth century as "The Palaces of Bouclé," which rose above the sea wall and were connected to the imperial palace.[2]

Hope's drawing of the east loggia of the palace shows a fine, well-proportioned con-

struction featuring three, large, marble-framed windows and the shell of a great vaulted room behind them, with elaborate marble ornaments and two handsome statues of lions at the ends. All that remains today of this legendary monument are four openings, discernible above the ruins of the fortification wall of Constantinople.

1. Drawn on the same sheet as 27328. The preliminary drawing for this is inv. no. 27064 in vol. I (sepia drawing; 21.5 x 28.5 cm; inscribed: "Tribune of White Marble inserted in the Walls of Constantinople towards the Sea").
2. For the location of the palace, much debated by scholars of the Byzantine monuments of Constantinople, see C. Mango, "The Palace of the Boukoleon" (Paris: Cahiers Archéologiques, 1997): 45–50, no. 45. I am indebted to Professor Ch. Bouras, who indicated to me the above reference.

F-MT

24. Granite Obelisk in the Hippodrome, Constantinople

Thomas Hope
ca. 1787–95
Sepia drawing on paper
17 x 11⅖ in. (43.5 x 29 cm)
Inscribed: "Porfiry column, called—Granite Obelisk in the hippodrome—fragment of a white marble column in the Cisterna basilica"
The Benaki Museum, Athens, 27066, vol. I

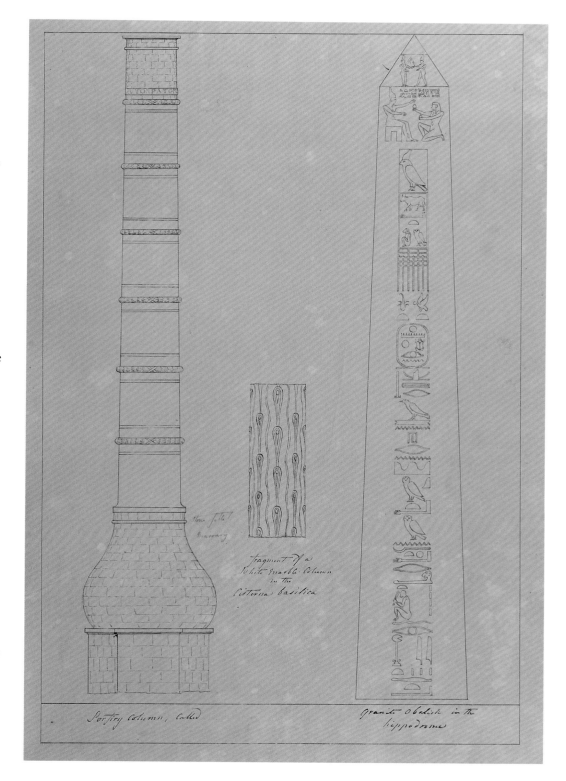

The colossal pink granite obelisk depicted on the right of this drawing is the famous Egyptian obelisk in the Hippodrome (now at Meydani Square) in Constantinople.[1] The enlargement of the ancient hippodrome built by Emperor Septimus Severus in A.D. 203, was the first major construction project of Emperor Constantine I (A.D. 324–337), after he decided in the first year of his reign to transfer the capital of the Roman Empire to Byzantium, to which he gave his name (Constantinople). The hippodrome was then used not only as a stadium but also as a meeting place for representatives and supporters of the four Byzantine political parties. The central track (*spina*) was decorated in the fourth century, probably by Constantine, with obelisks and columns from Egypt and Greece, respectively, three of which still survive: the Egyptian obelisk, the serpentine column, and the column of Constantine VII Porphyrogenitus.

The Egyptian obelisk was one of a pair erected by Pharaoh Tuthmosis III (1479–1425 B.C.) at the Temple of Amun at Karnak, Thebes (modern-day Luxor). Originally at least 28 meters tall, what survives, as erected here by Emperor Theodosius in A.D. 390, is only about two thirds of its original height. It stands on a Roman base carved with sculptural reliefs of Theodosius and his family, including representations of the transportation and raising of the obelisk.

The "Porfiry Column" on the left side of the drawing can be identified as the column of Constantine I, originally erected at the center of his Forum to please the senate. Known in Turkish as "Çemberlitaş" (the

hooped column) from the metal rings added about 1700, it was composed of ten, now reduced to six, porphyry drums. Surmounted by a capital that originally carried a statue of Constantine as Apollo, it was removed from the Forum after the Turkish conquest of Constantinople and later set up at the side of the road known today as Divanyolu, near the Cistern of the Thousand and One Columns, not very far from the "Basilica

Cistern." This may be the reason why Hope includes here, together with the two obelisks, a fragment of this monument, which is depicted between the two obelisks with the indication: "fragment of a white marble column in the cisterna basilica."

1. See Iverson, *Obelisks in Exile*, vol. 2 (1961): 9–33.

F-MT

25. *Fountain Before the Outer Gate of the Seraglio, Constantinople*

Thomas Hope
ca. 1787–95
Watercolor on paper
11⅖ x 17½ in. (29 x 44.5 cm)
Inscribed: "Side view of the fountain before the outer gate of the Seraglio"
The Benaki Museum, Athens, 27354, vol. V

LITERATURE: Tsigakou, *Thomas Hope* (1985): 17; Kara Pilehvarian, Urfalioglu, and Yazicioğlu, *Fountains in Ottoman Istanbul* (2000): 66–69.

A series of drawings in volume I[1] relating to this particular fountain is inscribed: "fountain before the outer Gate of the Seraglio; in a pen and watercolor drawing,[2] Hope succeeded, with a hint of color, in conveying an idea of the resplendent polychromy of the tiles decorating the façade. The inscription reads: "Marking the parts that are in white marble, in porfiry, in azure & in gold."

The fountains of Istanbul occupy a special place in hydraulic architecture, where in most cases they express the desire of the members of the Ottoman elite to gain fame and blessings by inspiring the prayers of those who use the fountains. Their architecture is important because it reflects not only the level of technology, but also the fashion and taste of their time.

The fountain depicted here is the street fountain of Ahmet III (1703–1730), called the Ahmet Fountain (in Turkish "Ahmet Çeşmesi"), which is located in front of the imperial gate of Topkapi Palace, residence of the sultans until the mid-nineteenth century and now a museum. This fountain is considered one of the loveliest fountains in Constantinople and has an inlaid marble inscription with verses likening it to the fountains of Paradise.

This drawing, in which the extreme delicacy of execution suggests etching, is a fascinating example of the liveliness and dexterity of Hope's line and his particular enthusiasm for the penetrating study of architectural forms and details.

1. Inv. nos. 27076, 27077, 27082.
2. Inv. no. 27082.

F-MT

26. *Architectural Details from Various Mosque Fountains, Tombs, etc., at Constantinople*

Thomas Hope
ca. 1787–95
Watercolor on paper
11⅖ x 17½ in. (29 x 44.5 cm)
Inscribed: "Details of Turkish or Seracenic Architecture in various Moschs, fountains, tombs &c at Constantinople"
The Benaki Museum, Athens, 27359, vol. V

Some of the details depicted here[1] are identified in an inscription that reads: "No 1 Turkish capital in the cortile of Sultan Mohammed Djami 2 & 3, 4,5, Turkish friezes, either carved in plain white marble, or relieved in gold and ajure ground- 6,7, & 8 Turkish guillochades or Scrollwork generally painted in different colors relieved by gilding. 9 Battlements or Acroteria of Turkish Monuments: 10 & 11 capital and cornice of a simpler style. 12 Coin of a fountain at Iskiudar 13: d. in perspective 14 Capital of Do. 15. Cornice of Do]."

According to these indications, the architectural details depicted here can be identified as follows: Top row: "Upper part of alcove" – "Capital and cornice of a simpler style" – "Capital of door" – "Alcove." At the center: "Corner of a fountain at Iskiudar." Middle row: "Turkish capital in the cortile of Sultan Mohammed Djami" –

"Turkish friezes either carved in plain white marble, or relieved in gold and azure ground – "Turkish guillochades or scrollwork generally painted in different colors relieved by gilding" – "Battlements or Acroteria of Turkish monuments" – "Capital." Bottom row: "Turkish friezes" – Turkish guillochades" – "Cross-section of the Fountain depicted above" – "Cornice of door."

Notable are Hope's knowledge of the materials used and his interpretations of the techniques of working them. Combining his calligraphic draftsmanship and scientific accuracy, it also demonstrates his enthusiasm for the sources of decorative motifs and details.

1. Inv. no. 27075 (in vol. I); pen drawing on paper, 29 x 43.5 cm.

F-MT

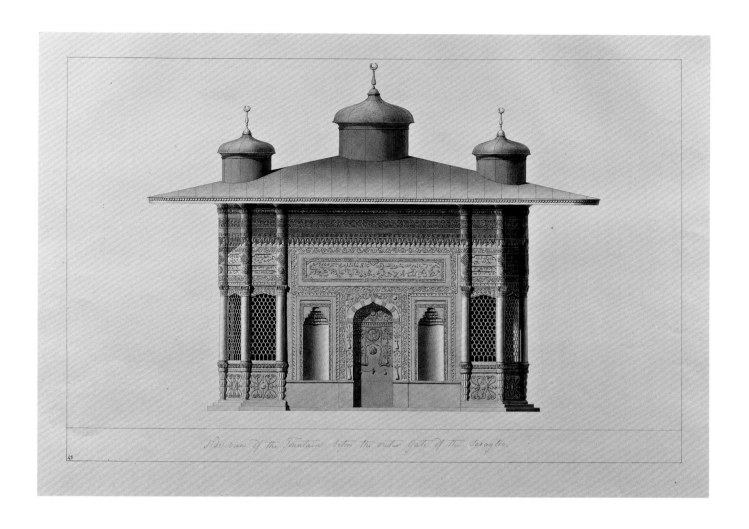

Side view of the Fountain before the outer Gate of the Seraglio.

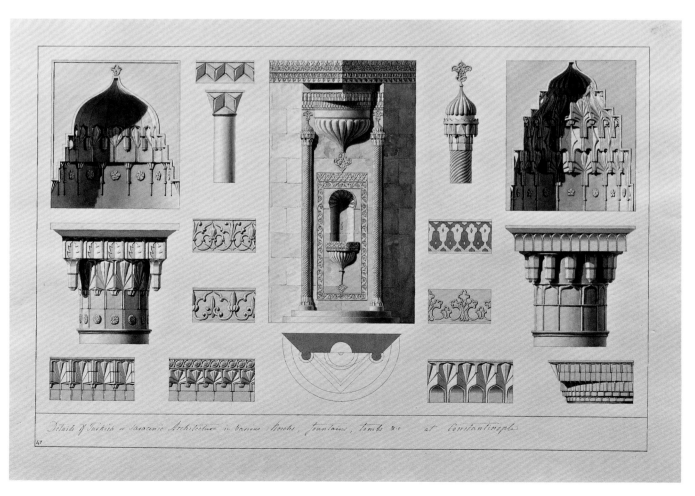

Details of Turkish or Saracenic Architecture in various Mosks, Fountains, Tombs &c at Constantinople

27. Turkish Boats

Thomas Hope
ca. 1787–95
Pen and watercolor on paper
11⅖ x 17½ in. (29 x 44.5 cm)
Inscribed: "Turkish boats or Caïques"
The Benaki Museum, Athens, 27360, vol. V

Depictions of these boats are to be found in two drawings in volume II.[1] Their inscriptions read: "Sultan's pleasure Boats" and "Pleasure Boats for three pr. of oars at Constantinople." The "Sultan's pleasure Boats," elegant and opulent barges, were highlights at the tulip festivals that began to be organized annually in the reign of Ahmet III (1703–30). They were described admiringly by the various foreign ambassadors who participated in these events as guests: "The court appears floating on the water of the Bosporus or the Golden Horn in elegant caiques covered with silken tents," wrote the French ambassador Louis de Villeneuve, who was in Constantinople in 1717.[2]

In similar drawings showing the mechanisms of boats, Hope provides detailed information about the way in which they operated, including the number of oars and the positions of the rowers. This drawing, like the previous one, testifies not only to his flexible pen, but also to the fact that his line is so definite and precise that the mere hint of color is sufficient to enhance the subject.

1. Mounted together on sheet 36 x 49.5 cm; inv. nos. 27105, 27106.
2. See Freely, *Istanbul* (1996): 250–51.

F-MT

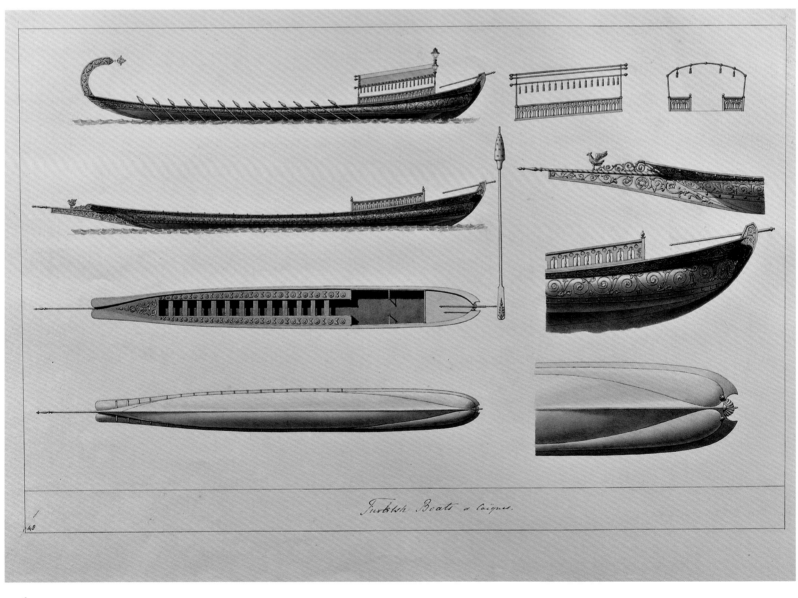

28. Quarters of Sultana Validé in the Summer Seraglio at Constantinople[1]

Thomas Hope
ca. 1787–95
Watercolor on paper
8½ x 11⅖ in. (21.5 x 29 cm)
Inscribed: "Saloon of the Sultan Validé in the summer Seraglio"
The Benaki Museum, Athens, 27367, vol. V

LITERATURE: Tsigakou, *Thomas Hope* (1985): 21.

The "Summer Seraglio" referred to here must be the "Summer Harem," an open complex of kiosks and pavilions on the Marmara side of the Saray Point, built by Sultan Selim III (1789–1807) whose interest in the arts of Europe led him to restore parts of the Seraglio and its surrounding gardens in a Westernizing manner. For this purpose, he brought to Istanbul the Austrian Jacob Ensle, brother of the imperial gardener of Schönbrunn. As Freely relates, "Ensle who had a lodge in the palace gardens, often invited guests to visit him and if the court was away he would take his guests on a tour of the Summer Harem. . . . One of his guests was Edward Daniel Clarke . . . who describes the Summer Harem as being 'a small quadrangle,' exactly resembling that of Queens' College Cambridge."[2] E. D. Clarke describes the Valide Sultan's apartment, which Selim III built for his mother Mihrişah: "Nothing can be imagined better suited to theatrical representation than this chamber. . . . It is exactly such an apartment as the best painters of scenic decoration would have selected, to afford a striking idea of the pomp, the seclusion, and the magnificence of the Ottoman court. . . . At the upper end is the throne, a sort of cage, in which the Sultana [valide] sits, surrounded by latticed blinds; for even here her person is held too secret to be exposed to the common observation of slaves and females of the Charem. A lofty flight of broad steps, covered with crimson cloth, leads to this cage, as to a throne . . . To the right and left of the throne, and upon a level with it, are the sleeping apartments of the Sultan Mother, and her principal females in waiting. The external windows

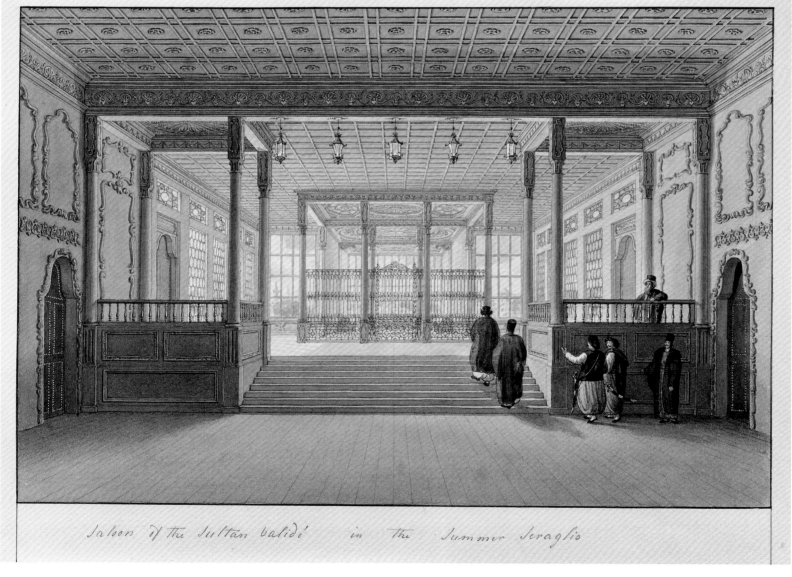

Saloon of the Sultan Validé in the Summer Seraglio

of the throne [room] are all latticed: on one side they look towards the sea, and on the other into the quadrangle of the Charem; the chamber itself occupying the whole breadth of the building, on the side of the rectangle into which it looks. The area below the latticed throne . . . is set apart for attendants, for the dancers, for actors, music, refreshments, and whatsoever is brought into the Charem for the amusement of the court."

This drawing is an outstanding example of Hope's virtuosity of line and economy of means. He manages to bring to life the extravagant atmosphere of the interior of an Ottoman palace, to which only privileged travelers of the day had access. The sumptuous architectural details are rendered with unique skill, allowing him to reveal its spaciousness, to capture the depth of the shallow alcoves, to articulate the curves, and describe the highly ornate wooden ceiling with relief rosettes. Everything is achieved by the simple combination of pen and brown ink. The view from the window, of Constantinople in the distance, is executed with subdued green wash. What the viewer values is the astounding accuracy and economy with which the whole scene is realized.

1. Drawn on the same sheet as 27368.
2. Freely, *Inside the Seraglio* (1999): 221–23.

F-MT

29. *Room in a Turkish Palace, Constantinople*[1]

Thomas Hope
ca. 1787-1795
Watercolor on paper
8¾ x 11⅖ in. (22 x 29 cm)
Inscribed: "Room in a Turkish palace"
The Benaki Museum, Athens, 27368, vol. V

LITERATURE: Tsigakou, *Thomas Hope* (1985): 20.

The lengthy inscription to the preparatory drawing for this watercolor[2] provides details that enliven the scene for the viewer: "Turkish room. Sopha scarlet cloth & gold fringe. Cushions silk stuff with velvet flowers. Elbow cushion of gold brocade in the cushers. Small Octagon table inlaid in mother of pearl. Little niches containing things of common use: cups, essence phiale etc. in glass compositives etc. Master smoking his nargilé. Servant attending his master behind the balustrade of the sopha."

As in the previous drawing, Hope creates a historical visual document that is both accurate and appealing to the viewer's imagination, and he also displays his versatility of pen and brilliant mastery of drawing. The superb vista of Constantinople and the Golden Horn, commanded by the window at the back, is conveyed by using washes of green watercolor, through which he achieves the subtlest effects. All the elements of the room are rendered with fine subdued coloring and a striking delicacy of line.

1. Drawn on the same sheet as 27367.
2. Inv. no. 27102 (see above).

F-MT

30. *Sepulchral Monument near the Great Mosque at Üsküdar*[1]

Thomas Hope
ca. 1787–95
Watercolor on paper
8¾ x 11⅖ in. (22 x 29 cm)
Inscribed: "Octagon Turbé with open trellice work dome & evergreens inside, near the great Mosch of Iskiudar"
The Benaki Museum, Athens, 27372, vol. V

LITERATURE: Goodwin, *A History of Ottoman Architecture* (1971): 287–89.

The suburb of Üsküdar is on the Asiatic side of Constantinople. Known as Scutari, after the homonymous palace that stood there in Byzantine times, it was the starting place for mercantile missions into Asia in that period, and remained important during Ottoman times. The monument depicted is the tomb (Turbé) of Vizier Şemsi Ahmet Paşa, which is incorporated in the mosque of that name, built by the great Ottoman architect Sinan in 1580–81 at the mouth of the Bosphorous in Üsküdar. This elegant funerary monument opens into the mosque, from which it is divided by a green grille, an unusual and attractive feature.

This drawing has a charming topographical picturesque quality, combining power of construction and detailed observation. The Turbé, with its felicitous proportions and surrounding buildings, is realistically represented, and the group of static figures lends a theatrical effect to the scene.

1. Drawn on the same sheet as 27373.

F-MT

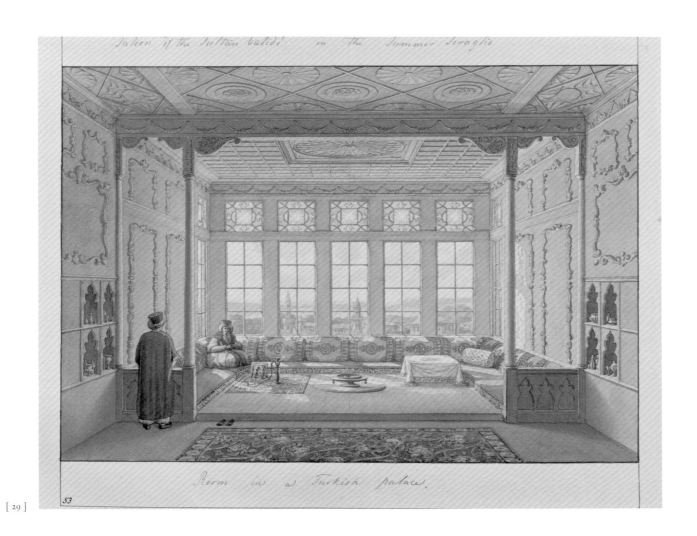

Saloon of the Sultan Validé in the Summer Seraglio

Room in a Turkish palace.

[29]

53

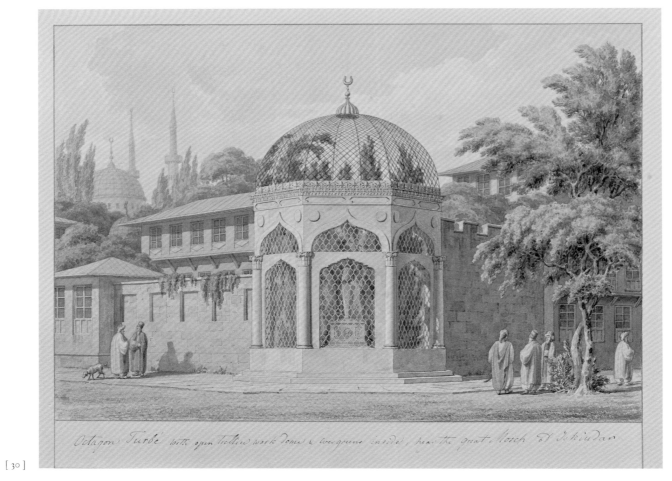

Octagon Turbé with open trellis work dome & evergreens inside, near the great Mosch of Schiúdar

[30]

31. *Mausoleum of the Favourite Horse of Sultan Mourad*[1]

Thomas Hope
ca. 1787–95
Watercolor on paper
8¾ x 11⅖ in. (22 x 29 cm)
Inscribed: "Mausoleum of the favourite horse of Sultan Mourad, in the great burying ground at Uskiudar"
The Benaki Museum, Athens, 27373, vol. V

The preliminary drawing for this[2] is inscribed "Mausoleum of a favorite horse of Sultan Mourad in the burying ground of Iskiudar." In this drawing, testifying to Hope's firm and confident draftsmanship, the mausoleum and the various tombstones, which are such characteristic features of Ottoman cemeteries, are brilliantly rendered. Thanks to the successful treatment of the foliage and the pleasant atmospheric effect, Hope has created a scene that conveys a remarkable freshness, despite the solemnity of the subject.

1. Drawn on the same sheet as 27372.
2. Inv. no. 27088 (in vol. I); pen drawing 49.5 x 36 cm.

F-MT

32. *Tombs at Antiphyllus in Lycia, Asia Minor*[1]

Thomas Hope
ca. 1787–95
Watercolor on paper
11⅖ x 17¼ in. (29 x 44 cm)
Inscribed: *"Antiphellus"*
The Benaki Museum, Athens, 27376, vol. V

LITERATURE: Burckhardt, "Hurttuwetti von Myra und die sogen" (2004): 145–62.

Volume III includes a series of drawings of tombs of ancient Antiphyllus,[2] the modern Kaş, a small, arc-shaped peninsula on the south coast of Asia Minor, in the heart of Lycia. In this archaeologically interesting region there are extensive necropolises with large, marble, chest-shaped sarcophagi. Since most of the tombs have been destroyed, Hope' drawings are visual documents of unique importance for archaeologists.[3]

This is a well-composed view in which nothing is generalized, not even the more distant features. The handling of distance is skillful, with a feeling of spaciousness. All the tombs depicted are well observed and extraordinarily accurate. The figures are well placed, well drawn, and alive. The tomb of colossal dimensions, at the center of the composition, the three smaller tombs filling the right corner, and the adjacent figure of the young man, beautifully dressed and carefully posed, in order to provide the sense of scale, constitute stagy elements. However, theatricality was the typical characteristic of this necropolis, which offered the visitor an almost surreal spectacle of a host of temple-shaped sarcophagi along the entire coastline of the peninsula.

1. A similar drawing to this is inv. no. 27315 in vol. V (sepia drawing 39 x 60 cm, inscribed: "Large tomb in Antiphellos").
2. Inv. nos. 27157, 27161a,b.
3. Archaeologists to whom I presented Hope's Lycean drawings at the Third International Symposium on Lycia, held in Antalya in November 2005, informed me that they overturn present archaeological evidence for the region.

F-MT

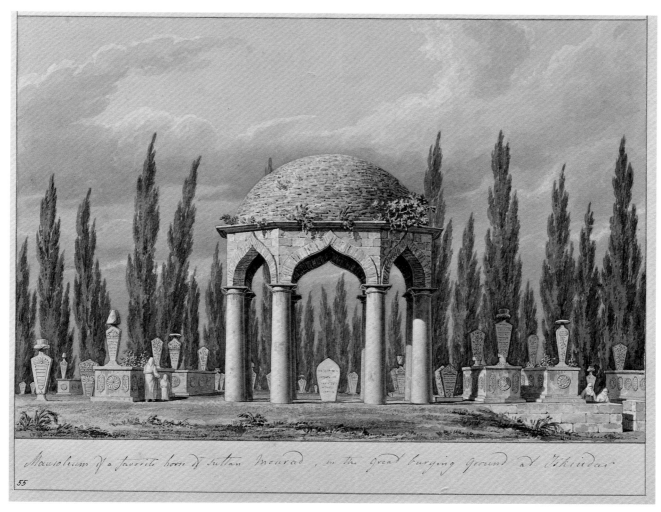

[31]

Mausoleum of a favorite horse of Sultan Mourad, in the Great burying Ground at Ushiudar

55

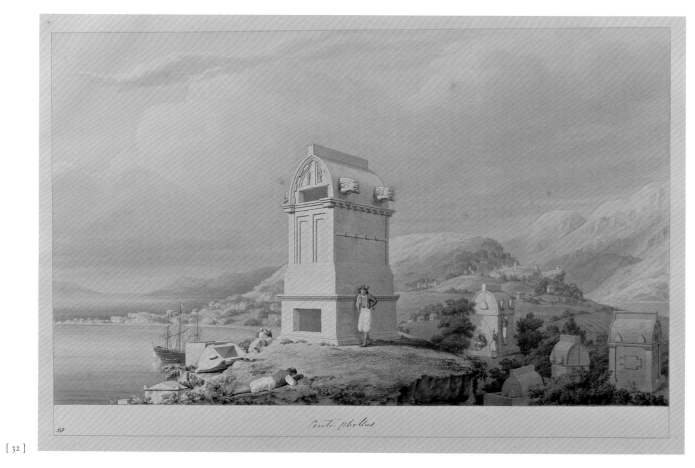

[32]

Anti-phellus

50

33. *Boats on the Nile*

Thomas Hope
ca. 1787–95
Sepia and watercolor on paper
4¾ x 17 in. (12 x 43 cm)
Inscribed: "Boats on the Nile"
The Benaki Museum, Athens, 27176, vol. III

This is drawn on the same sheet as inventory number 27177. The majority of Hope's drawings from Egypt are bound together in volume IV, which is lettered on the spine "EGYPTIAN DRAWINGS."

Hope was in Cairo in 1797, the year before Napoleon's North African campaign, which led to the monumental *Description de l'Egypte*. The exotic scene recorded by Hope reveals his skills as a miniaturist, for he appears capable of drawing figures no more than a few millimeters in size but nevertheless active and lively. The boats and their contents are also depicted in admirable microscopic exactness.

F-MT

34. *Boats and Villages on the Nile*[1]

Thomas Hope
ca. 1787–95
Sepia and watercolor on paper
4¾ x 17 in. (12 x 43 cm)
Inscribed: "Boats, mosques and village (with its dove cotes on the Nile)"
The Benaki Museum, Athens, 27177, vol. III

This is drawn on the same sheet as 27176. The same type of sailing boat with the indications "Djerims" appears in another drawing in the same volume.[1] In this example of Hope's topographical picturesqueness and flexibility of line, the architectural details and the features of the boats are meticulously rendered down to the slightest detail.

1. Inv. no. 27217b (pen and ink on paper, 16 x 23 cm).

F-MT

[33]

[34]

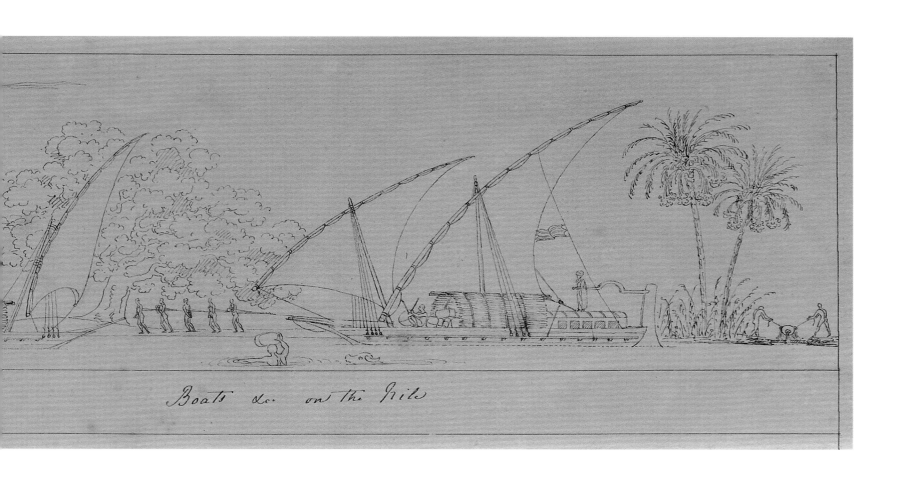

Boats &c. on the Nile

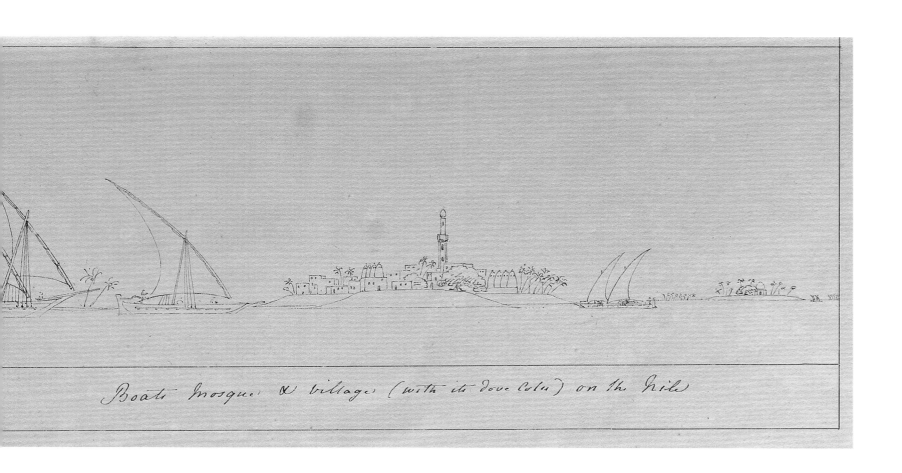

Boats, mosque, & village (with its dove cote) on the Nile

Greek and Roman Antiquities

35. *Maiden*

Roman, late first century B.C. or early first century A.D., with restorations
Marble
48½ x 15¾ x 9⅞ in. (123 x 40, as restored, x 25 cm, excl. restored right arm)
National Museums Liverpool, Lady Lever Art Gallery, LL19
London only

PROVENANCE: Thomas Hope; by descent, Lord Francis Hope Pelham-Clinton-Hope; sold Christie's, London, 23–24 July 1917, lot 239; bought by F. Partridge for £315; William Hesketh Lever, 1st Lord Leverhulme; Lady Lever Gallery.

LITERATURE: *Household Furniture* (1807): pl. 2; *Costume of the Ancients* (1809): pl. 32 (2nd ed., 1812): pl. 60; Fosbroke, "The Outlines of Statues" MS (1813); *Magazine of the Fine Arts* 1 (1821); Westmacott, *British Galleries* (1824): 228; Fosbroke, *Encyclopedia of Antiquities* (1825): pl. 2; Hope Marbles MS (n.d.): pl. 18; Michaelis, *Ancient Marbles in Great Britain* (1882): 289, no. 32; Waywell, *The Lever and Hope Sculptures* (1986): 20–21, nos. 4, 81, p. 81, fig. 17; Connor, *Roman Art in the National Museum of Victoria* (1978): 32–33; Fullerton, *The Archaistic Style in Roman Statuary* (1990): 32, no. IC1, fig. 5; Zagdoun, *La sculpture archaïsante dans l'art hellénistique*, vol. 1 (1989): 72–73, 198–99, no. 359.

A heavily draped female stands erect with her left leg slightly advanced. She wears a long, half-sleeved chiton, or tunic, visible in the schematically crinkled fabric above the feet and on the arms, where small folds radiate from lines of buttons. A mantle is draped over the chiton, snugly contouring the outlines of the legs and reaching to the ankles. The garment is fastened at both shoulders with overfolds cascading down the front, back and sides. The parallel scheme of the mantle's edges is drawn in a precise, geometrical fashion, inscribed between long parallel lines that oppose each other symmetrically to form rows of identical zigzags. Double rows of similar folds descend from waist level at both front and back, ending in weights that pull the mantle's pleats into neat verticals.

The girl's coiffure forms a flat cap of incised wavy tresses radiating from the crown with very fine lines engraved between them; a triple row of snail curls frame the face over the brow. At the back, her long fan of hair is chopped off in a razor-sharp, straight edge, and three locks, drawn from behind the ears, course down the neck and onto the chest.

The image shows a *kore*, the Greek word that means "maiden" and also denotes draped female sculptures of the archaic period. Carved in a pseudo-archaic style, this statue intentionally imitates art forms of the second half of the sixth century B.C., after that fashion had gone out of common use in late classical times— about 480 B.C.[1] The archaic character stems from the sculpture's simulation of the earlier style in the stiff frontal pose, precise treatment of clothing, hand-held offerings, and hairstyle.

Tell-tale anomalies and anachronisms betray its later origin. Unlike genuine archaic *korai*, the Hope work shows more elongated proportions, and the zigzag folds of the mantle hang well below the knees— far longer than in genuine archaic works. The unrealistic rigidity of textiles and their painfully repetitive zigzag pleating are also typical archaistic mannerisms. The sculptor shows only superficial acquaintance with the formal language of a bygone style, as demonstrated by the peculiar hairdressing, with button curls encircling the entire head (on authentic archaic works they stop at the ears). A lifeless fixity in the expression of the fleshy face, the exaggeratedly bulbous, almond-shaped eyes, and the stylized ears all counter the vital spirit of genuine archaic heads.

In a *nemus* (forest) surrounding a lake in the Alban Hills in central Italy, there was once an ancient, rustic sanctuary devoted to the goddess of the hunt, and this marble forms part of a series that replicates a cult statue of Diana Nemorensis.[2] Preserved examples of the type reveal that originally she extended both arms outward, holding in her right hand a pomegranate flower and in her left a pomegranate fruit (a symbol of fertility).[3]

The restorer added the foreparts of the sandaled feet, profiled each toe, reattached the head, and repaired the upper part of the tress at the right side of the neck. He also added the section with the broad, coarse nose and wide lips. To authenticate this addition, the sculptor artificially encrusted the lower lip. Archaic statues with one arm outstretched, the other by the side, often held offerings of a religious nature. Here, the restorer added a pomegranate bud (later changed into a mirror) in the right hand and an *oinochoe* (wine jug) in the left.

The statue would perfectly suit a temple-like setting. If installed on a podium within the shrine of a garden peristyle, perhaps with an altar sited before its approach, the marble would suggest cultic importance. Its reference to a specifically venerated statue would have increased its esteem.[4] Hope grasped its sacred symbolism by installing the marble in an appropriate setting in the Picture Gallery, decorated as a sanctuary (*Household Furniture*, plate 11). During the first century B.C. and early first century A.D., there was a fervor for wholesale copying or adaptation of Greek art. Roman tastes favored the more famous statues of the classical period (see cat. nos. 36–39, 43), whereas they displayed little interest in archaic works. The Hope marble is of special significance because, unlike the majority of examples—usually seen in reliefs or on decorative objects—it is one of relatively few statues carved in this highly mannered style.

1. For discussions and bibliography on the origin, definition, and development of the archaistic style, see Harrison, *Archaic and Archaistic Sculpture* (1965): 61–66; Pollitt, *Art in the Hellenistic Age* (1986): 175–84. Also see Connor, *Roman Art in the National Museum of Victoria* (1978): 32–33. For *kores* in the archaic manner, see also Augusta Richter, *Greek and Roman Antiquities in the Dumbarton Oaks Collection* (1956): 29–32, no. 16, pls. 11, 12; Zagdoun, *La sculpture archaïsante*, vol. 1 (1989): 11–22. For comparison, see Richter, *Korai* (1968).

2. Coinage of 43 B.C., showing a triple-bodied image, set in a cypress grove, is thought to represent the statue. It has been been considered either as a reflection of a late sixth-century B.C. work or a late Republican archaistic creation. For discussions of the appearance and date of the cult statue, see: Fullerton, *The Archaistic Style in Roman Statuary* (1990): 15–17. 21–22, 36, fig. 1; Lily Kahil and Noëlle Icard, "Artemis," in *Lexicon iconographicum mythologiae classicae*, vol. 2 (Zurich and Munich: Artemis, 1984): 677–78, nos. 730–732; Erika Simon, "Artemis/Diana," in *Lexicon iconographicum* (1984): 797, no. 2b; p. 824, no. 193; p. 825, nos. 217–221. Fullerton has established a stylistic typology of the four types of archaistic statuary, which he connects to the cult image. For the category of the Hope statue, see: Fullerton, *The Archaistic Style* (1990): 32–33 Type IC, nos. 1–5, figs. 5–7. See also Zagdoun, *La sculpture archaïsante* (1989): 72–76.

3. Richter, *Greek and Roman Antiquities in the Dumbarton Oaks Collection* (1956): 29, no. 16, pl. 12. Muthmann, *Der Granatapfel* (1982).

4. See an archaistic statue of Artemis (Naples Museum, inv. no. 6008), which was found in a garden shrine with an altar; Ward-Perkins and Claridge, *Pompeii AD 79* (1976): 93, no. 94; Jashemski, *The Gardens of Pompeii Herculaneum*, vol. 2 (1993): 184, no. 357.

EA

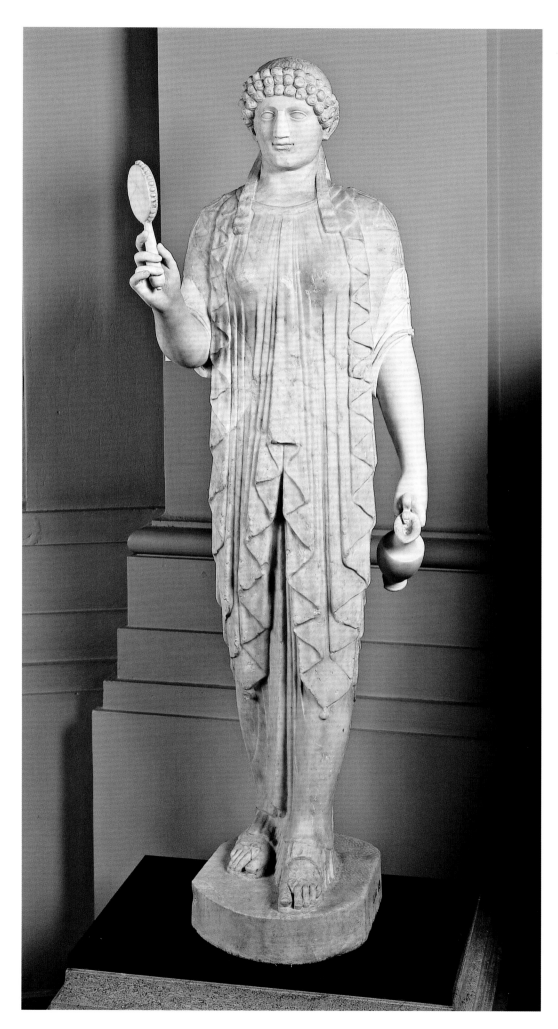

36. *Aphrodite or a Nymph*

Roman, mid-2nd century A.D., with 18th-century restorations
Marble
55⅛ x 25⅗ x 11¾ in. (140 x 65 x 30 cm)
National Museums Liverpool, Lady Lever Art Gallery, LL20
London only

PROVENANCE: Possibly bought by Thomas Hope at the sale of the Duke of St. Albans's collection; Christie's, London, 29 April 1801, lot 92; Thomas Hope, Theatre of Arts, the Deepdene; by descent, Lord Francis Hope Pelham-Clinton-Hope; Christie's, London, 23–24 July 1917, lot 243; bought by F. Partridge for £63; William Hesketh Lever, 1st Lord Leverhulme; Lady Lever Art Gallery.

LITERATURE: Fosbroke, "The Outlines of Statues" MS (1813): fig. 14; Westmacott, *British Galleries* (1824): 222; Fosbroke, *Encyclopedia of Antiquities* (1825): pl. 3; Hope Marbles MS (n.d.): pl. 24; Waywell, *The Lever and Hope Sculptures* (1986): 18–19, no. 1, 78, no. 14, fig. 14.

A matron stands firmly on her left leg, the right slightly bent at the knee with the foot turned outward. Her left arm is akimbo, while her right is at her side, the hand resting on a large, draped vase set upon a pedestal. There is a strong visual bisection: the torso is naked, but a mantle, loosely gathered at the hips, covers the lower body. She is shod in sandals, whose thin soles are discernible; their straps were originally picked out in paint. A cloak wraps across the figure's back, draping the left arm to the right side and forming at her waist a broad, triangular overfold. The treatment of the drapery shows a further distinction: sweeping upward from the right leg, her garment falls along the left in a rich pattern of narrow folds, heightening the impression of solidity. These verticals also balance the powerful horizontal division of the statue at the hips.

The statue is one of many copies of the Venus Marina type, which may derive from a Greek original of Aphrodite, created in the fourth century B.C.[1] The theme was a favorite in Roman times, and since two primary characteristics of Roman ideal sculpture were repetition ad nauseam and adaptation, the myriad representations reveal great flexibility in dress, statuary supports, and identity. Water nymphs, guardians spirits of sweet and sour water, were often surrogates for the deity.[2] Many examples were found in Ostia, the ancient port of Rome, situated at the mouth (*ostium*) of the river Tiber, where such reverence is understandable.[3] Remains of an ancient strut linking the body to a support demand a prop, of which the restored version offers a good idea: a tall, square pillar, topped with an overturned vase.

The head was once separated from the body, but the identical style, surface condition, and proportions, as well as the perfect match of the hair tresses between the neck and torso, indicate that they are related. Inclining her head to the viewer's right, the figure displays a coiffure imitating that of the famous Capitoline statue of Aphrodite.[4] Abundant locks, parted in the middle and confined with a fillet, are combed upward into an elaborate topknot; another section is gathered into a bun at the nape, and two long curls snake down the shoulders. Free and easy treatment of rippling locks makes a date around the mid-second century A.D. plausible, and this agrees with the style of drapery folds, which are cut to a slightly exaggerated depth to achieve a bold play of light and shadow.[5]

The finished marble was produced by the workshop of Bartolomeo Cavaceppi (1717–1799), who included it among his illustrations in *Raccolta d'antiche statue busti bassirilievi ed altre sculture restaurate da Bartolomeo Cavaceppi scultore romano*, vol. 1 (Rome, 1768).[6] The most celebrated—and certainly the most prolific—restorer of late eighteenth-century Rome, Cavaceppi concentrated almost exclusively on patching antiques, a profession that made him immensely rich. Here, however, there is little evidence of the sculptor's interference, save for mending broken parts, reattaching the head with an insertion for the neck, and restoring the support (subsequently altered).

The marble has been carved with energy but not great artistry. Anatomical detail is sketchy and the drapery scheme, although not bereft of animation, is basically reduced to broad, flat surfaces at left and a mass of vertical pleats at right, depriving the figure of organic realism. The sculptor's perfunctory treatment of the back and the shallowness reveal that this marble was intended to be seen exclusively from the front. Water deities figured prominently in the décor of Roman baths, where they helped to create a relaxing ambience, and the statue's optimum view would perfectly suit a display against a wall or in a niche of such an establishment.[7]

1. The standard work on the Venus Marina formula, containing copious illustrations, shows a wide spectrum of variations in the draping and supports. See Becatti, *Ninfe e divinità marine* (1971). For a recent bibliography and a discussion on the date and identity of the Greek original, see Delivorrias, Berger-Doer and Kossatz-Deissmann, "Aphrodite" (1984): 65–67, nos. 554–568; Schmidt, "Venus" (1997): 201, nos. 66–68, with adaptations of Roman date. The best preserved statue is in the Museum at Ostia, inv. no. 110: Becatti, *Ninfe e divinità marine* (1971): 17–18, no. 1, pls. 1–6; Delvorrias, "Aphrodite" (1984): 66, no. 554. A fillet or diadem was the usual head adornment. An alternative support type shows a dolphin, nose-downward above a rock, sometimes with a boy on its back. For Aphrodite's

association with water, see Pirenne-Delforge, *L'Aphrodite grecque* (1994): (XII) 433–37.

2. Various water deities have been suggested; see Becatti, *Ninfe e divinità marine* (1971): 39-58; Delivorrias, "Aphrodite" (1984): 65.

3. For the six Ostian examples, see Becatti, *Ninfe e divinità marine* (1971): 17–18, nos. 1–5; p. 21, no. 17.

4. For the Capitoline Aphrodite, see Delivorrias, "Aphrodite" (1984): 52–53, nos. 413–418. This coiffure also appears with the statuary formula of the goddess crouching at her bath (the Doidalses' type): ibid., 104–6, nos. 1018 –1043.

5. Cf. the treatment of the drapery on a statue of Athena: Raeder, *Die statuarische Ausstattung* (1983): 71, no. I 53, pl. 15. Cf. the carving of the hair with that of the caryatids; see ibid., 83–84, 213–21, nos. I 76–79, pls. 8, 9.

6. Plate 22. The caption reads: "Presentemente posseduta da Milord Hope in Inghilterra." The engraving shows the figure with its current head and a support in the form of a palm trunk. The change of prop was probably necessitated by damage during transport to England. For the statue's history while in the hands of the Hope family, see Waywell, *The Lever and Hope Sculptures* (1986): 19. For the restorer, see Howard, *Bartolomeo Cavaceppi* (1982); *Bartolomeo Cavaceppi* (1994); Kreikenbom, "Cavaceppis Maximen der Antikenrestaurierung" (1999): 85–92.

7. Manderscheid, *Die Skulpturenausstattung* (1981): 30–31; Marvin, "Freestanding sculptures from the Baths of Caracalla" (1983): 377–80. In general, see Nielsen, *Thermae et Balnea* (1990); Yegül, *Baths and Bathing* (1992).

EA

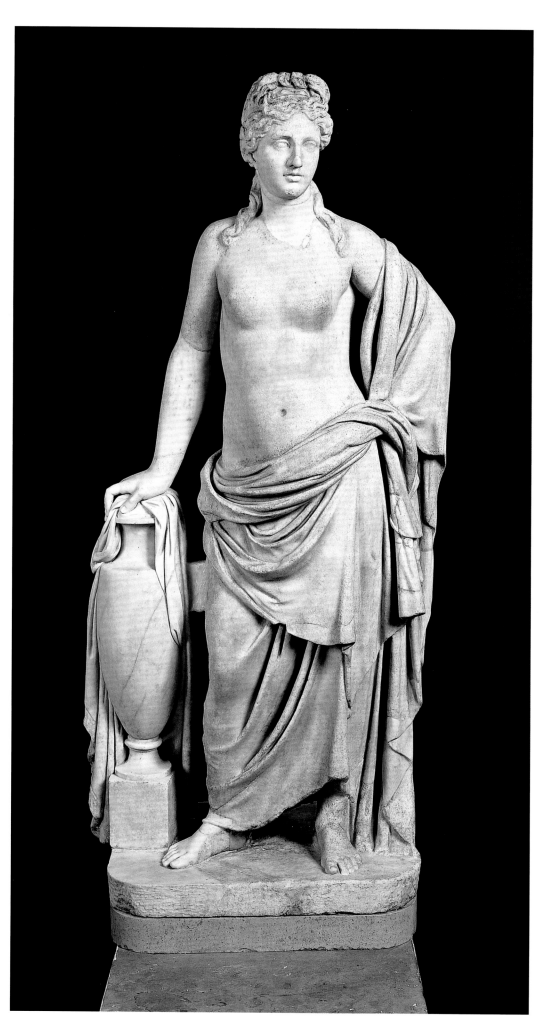

37. *Papposilenus Seated on a Rock*

Roman, late 2nd century A.D., with 18th-century
restorations
Marble
36⅗ x 39 x 15 x 21¼ in. (93 cm from top of modern
ped.; 99 cm incl. ped. x 38 x 54 cm)
National Museums Liverpool, Lady Lever Art Gallery,
LL14
London only

PROVENANCE: Possibly bought by Thomas Hope at
Christie's, London, 31 May 1800, lot 41; Thomas Hope,
Statue Gallery, Duchess Street; by descent, Lord Francis
Hope Pelham-Clinton-Hope; sold Christie's, London,
23–24 July 1917, lot 236; bought by F. Partridge for
£262.10; William Hesketh Lever, 1st Lord Leverhulme;
Lady Lever Art Gallery.

LITERATURE: Douce MS (1812): possibly the "sitting
Silenus, ancient" recorded in the Drawing Room; Fos-
broke, "The Outlines of Statues" MS (1813): figs. 18, 19;
Westmacott, *British Galleries* (1824): 222; Hope Marbles
MS (n.d.): fig. 27; Waywell, *The Lever and Hope Sculp-
tures* (1986): no. 3, p. 10, no. 23, p. 83, figs. 18, 19; Alexia
Latini, "Eracle Epitrapezio" (1995): 142; Ensoli, "Eracle
Epitrapezio" (1995): 348; Ensoli, "Vecchio Sileno" (1995):
384–85, nos. 6, 14, fig. 1.

Papposilenus was an old *silen* (a minor woodland deity with equine features), who was the foster father and faithful companion of Dionysus, god of nature and wine. Sitting upright on a stony ledge, he presses his left foot back against the rock; the right is advanced. His toned physique, tending to fat around the middle, shows a mature athlete. The prototype for the pose and body is the Heracles *Epitrapezius* ("seated at table"), a masterpiece by Lysippus (fl. 360–310 B.C.), from Sicyon in the Peloponnese.[1] The original, which may have been designed as a table ornament, showed the middle-aged hero settled on a rock and gazing upward; his left hand held a club and his right a drinking cup. Heracles, a notorious drinker, was part of Dionysus's entourage, so the *Epitrapezius* formula, which faithfully represented older men animated by the joys of wine, was ideally suited for this other famous toper.[2] The old rogue sports a long flowing beard and thick moustache; his ears are bent forward. On his bald pate, he wears a wreath of ivy leaves and corymbs of berries tied with a broad fillet, which falls to the shoulders.

The marble offers an excellent example of eighteenth-century restoration practices.[3] English collectors were, in financial terms, the arbiters of aesthetics; and for them classical sculptures were essentially glorified furnishings. Incomplete marbles, however beautiful, were not acceptable, so eighteenth-century restorers were forced to transform "ruins" into perfect sculptures. Reconciling the ideals of the artists with the demands of the buyers resulted in a paradox, whereby antique fragments were preserved only through interference, in other words, restoration.

In the Papposilenus, modern additions were used only to fill gaps created when breaks were smoothed to facilitate attachments. Examination of the legs reveals how the sculptor carefully reassembled the salvageable pieces. Both thighs were re-attached to the body by marble patchworks with smooth seams. The upper right thigh is essentially ancient, but the lower limb, foot, and front of the plinth are modern; the flush connection, dissimilar marble, and surface condition make this apparent.

Whereas the left thigh is original, color variation and uniform joins below the knee prove that the mid-calf is new. The original lower calf was reconnected to the foot at the ankle by a mosaic of repairs. Since it is integral to the ancient section of the plinth, the foot is genuine.

Papposilenus's head has been broken off and rejoined to the neck by a marble disc with even seams. Their marble types, surface conditions, proportions, and quality are all consistent. One detail—the perfect alignment of the fillet on the left side of the neck and on the shoulder—clinches the conclusion that these individual parts originally belonged to the same, ancient sculpture.

Lysippus's sculptures of Heracles dominated the artistic climate of the late fourth century B.C., and his statues were the most widely copied until the end of antiquity. This was precisely because the sculptor had the empathy and marvelous talent to invest this hero with the human dimension of aging. Lysippus's Heracles inspired many works. The rarity value of the Hope statuette, dated to the late second century A.D., lies in its dignified presentation of Papposilenus, who was usually depicted as a buffoon.[4]

In the eighteenth century, the restoration of antiquities was a respected art, and the skill of a true master craftsman is manifest in the Hope marble. Even in its fragmentary state, the sculptor recognized its superb quality: the expertly modeled musculature and the powerfully realistic face. He did his work with care. The repaired arms (belied by the smooth seams at the shoulders) accurately indicate their original positions; Papposilenus offers a *skyphus* (drinking cup) in one hand and probably held a wine jug in the other, as if to say "The man who does not enjoy drinking is mad." (Euripides, *Cyclops*, 169). The parted lips and the arched right eyebrow, hinting at mischief, show a zest for life and all its pleasures. The ancient sculptor of the Hope marble created a unique masterpiece, and thanks to the restorer's "Herculean" effort, it can still be appreciated today.

1. For the sculptor, see Moreno, "Lysippos (I)" (2004): 27–39. For the formula, the debate over its description in ancient literature and its transmission through small-scale copies and variants, see Palagia, "Herakles" (1988): 774–75, nos. 957–983, p. 793; Latini, "Eracle Epitrapezio" (1995): 140–47, nos. 4, 17 1,2.

2. For variations on the scheme, see Ensoli, "Eracle Epitrapezio" (1995): 347–51, nos. 6, 9. Little evidence exists for this combination of the old satyr with the Heracles type: a drawing of a statue once in the Palazzo Mattei, Rome, and a heavily restored statue in the Capitoline Museums, inv. no. 709: Ensoli, "Vecchio Sileno" (1995): 384–87, no. 6.14, figs. 1, 2, no. 16, 14, 1. Lysippos carved a portrait of Socrates, who was assimilated with Papposilenus; see: Palagia, "Herakles" (1988): 120; Maurizio Di Puolo, "Socrates" (1995): 328, no. 6. 62; Ensoli, "Vecchio Sileno" (1995): 385, fig. 3. For Heracles as a symposiast with drinking vessel and club, see Palagia, "Herakles" (1988): 777–79, nos. 1008–1065. For Heracles intoxicated, see ibid., 770–71, nos. 875–887. For Heracles as part of the Dionysiac retinue, see Boardman, "Herakles" (1990): 154–60, nos. 3206–3291.

3. For the examination of the restorations, see Müller-Kaspar, *Das sogenannte Falsche am Echten* (1988) 70–73, 76–77, 79–80. In general, see Müller-Kaspar, "Cavaceppi zwischen Theorie und Praxis" (1999): 93–99.

4. See, e.g., the formula of the drunk old Silen, supported by a young satyr: Simon, "Silenoi" (1997): 116, nos. 48–50. For the dating cf. the carving of the beard with a portrait of the Emperor Commodus and the Triton heads, dating to A.D. 191–192, see Fittschen and Zanker, *Katalog der römischen Porträts* (1994): 85–90, no. 78, pls. 91–94.

EA

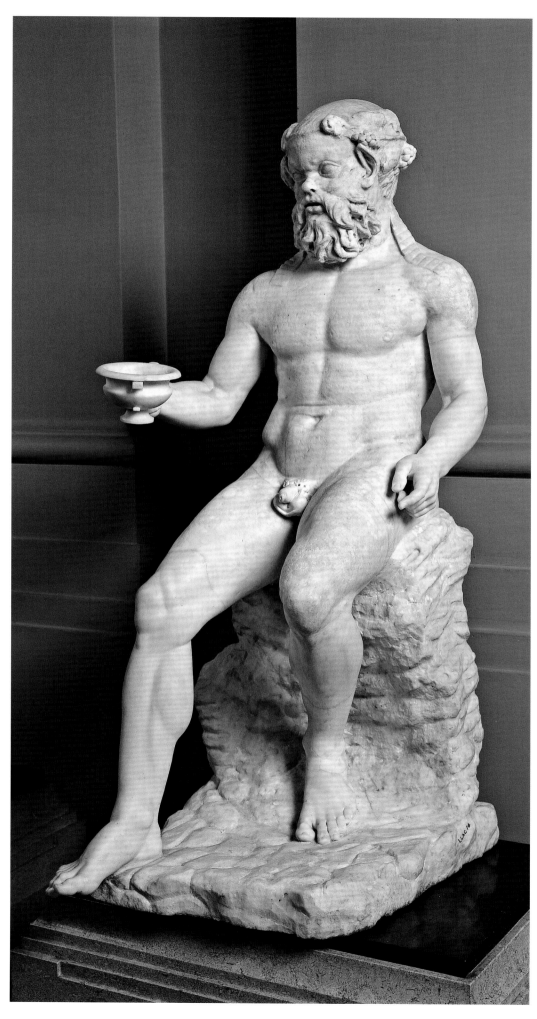

38. *Hermaphrodite*

Flavian, ca. 70–A.D. 100, with 18th-century restorations
(? Parian) marble
41 x 42¼ x 8 x 8⅗ in. (104 cm from top of modern
pedestal; 108.5 cm incl. pedestal and modern restora-
tions x 20.5 cm excluding restored arms x 22 cm)
National Museums Liverpool, Lady Lever Art Gallery,
LL13
London only

PROVENANCE: Probably bought by Henry Philip
Hope from Vincenzo Pacetti, in Rome, ca. 1796;
Thomas Hope; by descent, Lord Francis Hope Pelham-
Clinton-Hope; sold Christie's, London, 23–24 July 1917,
lot 242; bought by F. Partridge for £120.15; William
Hesketh Lever, 1st Lord Leverhulme; Lady Lever Art
Gallery.

LITERATURE: Fosbroke, "The Outlines of Statues"
MS (1813): fig. 24; Fosbroke, *Encyclopedia of Antiquities*
(1825): pl. 16; Hope Marbles MS (n.d.): pl. 11; Westma-
cott, *British Galleries of Paintings and Sculpture* (1825):
222; Waywell, *The Lever and Hope Sculptures* (1986):
no. 2, pp. 19–20, no. 15, p. 78, fig. 24; Wrede, "Zu
Antinous, Hermaphrodit und Odysseus" (1986): 130,
pl. 17,1; Ajootian, "Hermaphroditos," in *Lexicon icono-
graphicum mythologiae classicae*, vol. 5 (1990): 271, no. 5b.

Hermaphrodite was thought to be the divine offspring of Aphrodite and Hermes (god of speed and messenger for the other gods)—a mythical idea in which the virtue and beauty of both sexes were harmoniously fused. One eighteenth-century wit declared it the only happy couple she ever saw.[1] The unambiguous rendering of dual sexual features ensures its identity, and although only the core of the marble—torso and thighs—is ancient, enough remains to show that the nude figure stood on the left leg, the right drawn back with the left hip jutting outward in an elegantly curved pose. The pert breasts, narrow waist, and hips are decidedly feminine, whereas the male genitalia are insignificant.

The type of the Hope torso, perhaps a creation of the second century B.C., showed Hermaphrodite with the left arm lowered and the right raised; what attributes the figure held are unknown.[2] More complete examples depict a square handkerchief, placed like a flat cap on the crown.[3] This head covering is an emblem of Dionysus's retinue, among whom Hermaphrodite figured; ladies and effeminate young men also wore it. Remnants of an ancient strut on the side of the left leg suggest that a water vessel, covered in drapery, was originally present. In classical iconography, Hermaphrodite is quite naturally aligned with its mother, Aphrodite, who often appeared with such a container.[4] There are few ancient representations of this formula, probably because of the rather ugly head-dress and the figure's insipid pose.[5]

Statuary played an important role in creating an ambience, and many statuettes with themes relating to the natural world were designed to be exhibited in Roman gardens. Dionysiac figures, including rustic and debauched Papposilenus (cat. no. 37) predominated.[6] Sylvan marbles were artfully clustered together amid a profusion of flowers and plants. The overall effect mattered more than craftsmanship. Roman buyers were quite satisfied with mediocre products, often enlivened by touches of paint.

Thomas Hope acquired his Hermaphrodite statue from the restorer-dealer Vincenzo Pacetti.[7] Smooth seams clearly distinguish the restorations. Although Pacetti's task required augmenting less than half of the figure, his additions were crucial to its interpretation. The restored right breast recognizes the statue's bisexuality. The smooth-faced, comely head with its ideal features and elaborate, wiglike coiffure make the figure a *doppelgänger* for Aphrodite (cf. cat. no. 36)—at least from the waist up. Thick tresses, sculpted in a display of bravura, are pulled back in undulating parallel waves on either side of the middle part, framing the visage; a fanciful, central braid rises at the crown in a large topknot, its ends falling to left and right. Other tresses lie in a fat crescent-roll bun at the nape, from which heavy loops of hair course down the neck onto the shoulders and back. A thin fillet passes through the hair.

Hermaphrodite gracefully lifts up a tress. The gesture is archaeologically correct, since images of the semideity securing a short headdress exist, and it also relates to the celebrated formula of Aphrodite *Anadyomene* ("emerging from the sea"). She has just been born from the sea and is wringing out her wet hair.[8] Pacetti referred his Hermaphrodite to a sylvan milieu; the figure carries a three-lobed, delicately veined leaf and stands beside a tree stump, complete with a knot and peeling bark. These woodland symbols allude to the bisexual's birth and nurture in the idyllic forest and caves of Mount Ida in central Crete, as related in ancient literature (Ovid, *Metamorphoses* IV, 293).

In assessing this work of art, the quality of the antiquity, its eighteenth-century restoration and the success of that combination must be considered. Pacetti's amazing talent transformed a fragment of an unattractive, ancient statue type, whose subject was held in low esteem in classical times, into a delightful work of art. The statue hints at the magical atmosphere of ancient Arcadia, the pastoral paradise evoked in ancient Roman gardens. The reconstruction may be somewhat misleading, but for a late eighteenth-century clientele, completeness and elegance were thought more important than historical accuracy or authenticity, and in this case, the viewer must certainly agree with their taste.

1. Lady Townshend is quoted in Haskell and Penny, *Taste and the Antique* (1988): 234–35.

2. The standard work on the subject is Delcourt, *Hermaphroditea* (1966). For the ancient literary sources, recent examination of the type and bibliography, see Ajootian, "Hermaphroditos" (1990): 270–85. For the few examples of nude, standing Hermaphrodites, see ibid., 271, nos. 5–11. The Berlin statue, Staatliche Museen SK 193, is the best preserved example of the formula; see ibid., 271, no. 5; Wrede, "Zu Antinous, Hermaphrodit und Odysseus" (1986): 130–32, pl. 17,1. Wrede suggests a creation date of 350 B.C. The Hope marble is smaller and has a more feminine body than the Berlin work. Demand for depictions of Hermaphrodite was very great in the second century B.C. See Ajootian, "Hermaphroditos" (1990): 282.

3. For the heads, see ibid., 271, no. 5a, c. The head covering is variously named *claft, calautica, kekryphalos,* or *mitra.* As an attribute of the Dionysiac circle, see Wrede, "Die Tanzenden Musikanten von Mahdia" (1988): 100–101, n. 13, with further bibliography. For examples of Hermaphrodite assimilated with Dionysus and among members of the god's retinue, see Delcourt, *Hermaphroditea* (1966): 29–32; Ajootian "Hermaphroditos" (1990): 282, nos. 77, 78. The head scarf as a feminine accessory; see Delcourt, *Hermaphroditea* (1966): 35–36. In *The Speech concerning the Response of the Soothsayers* (21,44), Cicero condemned a man for his foppish dress, which included a *mitra*; see Watts, *Cicero* (1923): 375.

4. For examples of Hermaphrodite assimilated to Aphrodite and in the circle of the goddess, see Delcourt, *Hermaphroditea* (1966): 23–28; Ajootian, "Hermaphroditos" (1990): 277, nos. 60–62. The Berlin statue shows this support: ibid., 271, no. 5. It appears with images of Aphrodite; e.g. the "Esquiline Venus," Capitoline Museums, no. 1141, and Delivorrias, "Aphrodite" (1984): 61, no. 500.

5. According to Pliny the Elder (*Natural History* 34, 80), Polycles created a bronze "noble Hermaphrodite." To which statuary scheme the author refers is uncertain, but on the evidence of the few copies extant, it was probably not the Berlin/Hope type. We know neither the time nor the native place of this Polycles. The bronze could be associated with the formula of the sleeping Hermaphrodite; see Ajootian, "Hermaphroditos" (1990): 276–77, IV A, no. 56.

6. See the marble garden of the house of M. Lucrezio: Zanker, "Die Villa als Vorbild des späten pompejanischen Wohngeschmacks" (1979): 496–98, fig. 29. For other garden statuary with Dionysiac figures, see Dwyer, *Pompeian Domestic Sculpture* (1982): 123–26. Ancient testimonia, an inscription, and some find-spots indicate that such androgynous images also decorated gymnasia, baths, and theaters; see Ajootian, "Hermaphroditios" (1990): 270–71, I 1–4, 283.

7. For the provenance, see Waywell, *The Lever and Hope Sculptures* (1986): 20, n. 6. For Pacetti, see *Grand Tour* (1996): 216, no. 163; Cipriani, "Camillo Pacetti" (2000): 273–75. Both works contain copious references.

8. See a group of small bronzes, variations on a nude Hermaphrodite dancing, in: Ajootian, "Hermaphroditos" (1990): 272, no. 12. For the gesture, see also: Delcourt, *Hermaphrotitea* (1966): 25. For Aphrodite *Anadyomene,* see Delivorrias, Berger-Doer, and Kossatz-Deissmann, "Aphrodite" (1984): 54–57, nos. 423–455 (naked); 76–77, nos. 667–687 (semi-draped); 105, no. 1027 (crouching).

EA

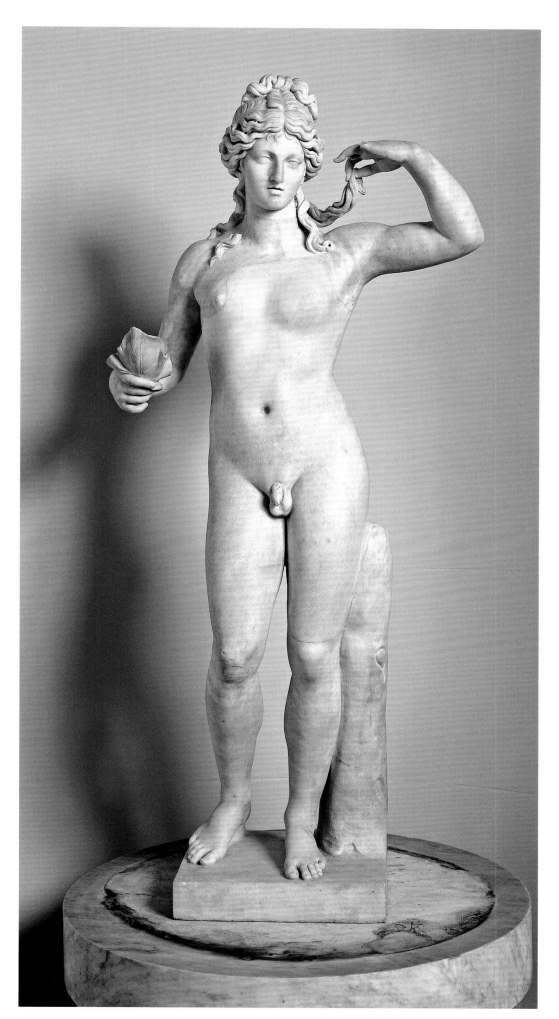

39. *Torso of Pothos*

Roman, 1st century B.C.–first century A.D.
Marble
45⅞ in. (116.5 cm)
National Museum of Ancient Art, Lisbon, MNAA 745

PROVENANCE: Acquired by one of the Hope brothers; Thomas Hope; by descent, Lord Francis Hope Pelham-Clinton-Hope, sold Christie's, London, 23–24 July 1917, lot 247; bought by Gudenian for £1837.10; Calouste Gulbenkian; donated by him in 1949.

LITERATURE: Townley Papers (1804); Guattani, *Memorie Enciclopediche Romane*, vol. 1 (1806–7): 91, no. 6; *Household Furniture* (1807): pl. 1; Douce MS (1812); Fosbroke, "The Outlines of Statues" MS (1813): fig. 13; Westmacott, *British Galleries* (1824): 221; Hope Marbles MS (n.d.): pl. 14; Waywell, *The Lever and Hope Sculptures* (1986): 74–75, fig. 13; Beaumont, *As 50 melhores obras de arte en museus Portugueses* (1991): 97–98; Gulbenkian, *Uma doa cao ao Museu Nacional de Arte Antiga* (1994): 32–33.

This torso is a fine copy of a statue of Pothos by the Greek master sculptor, Scopas of Paros (fl. 360–335 B.C.).[1] Pothos, the personification of erotic desire, was an attendant on Aphrodite, goddess of love. Although only the trunk and partial legs survive, the stance and movement of the figure are perfectly clear. The youth stood on his right leg, which is preserved to just below the knee. His left leg, broken at mid-thigh, would have been relaxed, slightly advanced, and crossed in front of the right ankle. The arm stumps indicate that the left limb extended upward and the right was lowered. The pose, starting from the elevated left shoulder and ending at the strongly jutting right hip, produces a languorous curve that flows through the body.

Sculptural and glyptic evidence give a good impression of the lost original. Scopas envisaged Pothos as an effeminate youth with legs crossed, leaning strongly leftward against a long staff; the right arm was bent across the body toward the prop. Drapery swathed the upper left arm and fell vertically toward a goose, a symbol of Aphrodite, which squatted beside his right foot. Pothos's head inclined upward to his left, the mouth half open in an expression of longing. His long, wavy hair, which is combed up at the sides from a central part and knotted at the crown, recalled the coifs of the goddess. Ancient sources reveal that Scopas created two statues of Pothos—one for Megara, the other for Samothrace.[2] The figure's sideways orientation proves that, in either sanctuary, it would have been part of an ensemble whose main figure was Aphrodite. Which locale venerated this Pothos type remains unknown.

The torso has an intriguing history. It was first recorded—and restored—in Renaissance times, as Apollo *Sauroctonos* (the sun god as lizard-slayer), based on the original marble by the fourth-century B.C. Greek sculptor Praxiteles.[3] This Renaissance identification, presumably on the evidence of the fragment's strong torsion, was very perceptive, since both the Scopaic Pothos and the Praxitelean Apollo share an androgynous appearance and pronounced, body tilt. When Thomas Hope acquired the marble, it had been slightly altered.[4] While leaving the earlier restoration virtually intact, the sculptor modified details to conform better to the Apolline statuary type.

Romans greatly admired Greek sculptures from the fifth and fourth centuries B.C., and their art market was quick to respond to demand for copies of famous masterpieces; adaptations were also welcomed.[5] Although Scopas and Praxiteles are frequently cast as rivals in ancient literature, on the Hope torso the distinct approaches of the two sculptors blend together harmoniously.[6] The dynamic twist of the silhouette is definitely Scopaic, but the soft modeling of the musculature is typically Praxitelean. Subtle transitions of light and shadow define the long, rhythmic bend of the median line and undulating planes of the chest, stomach and the abdominal partitions. The torso is best dated between the first centuries B.C. and A.D., a period when sculptures attained far higher standards than in subsequent times. Hope recognized its superior quality by displaying it, together with his best sculptures (cat. nos. 36–38, 40, 41, 43), in his specially designed Statue Gallery at Duchess Street.[7]

Fragmentary antiquities have not always been commercially acceptable; if unrestored, many ended in the lime kiln. A "purist" attitude toward antiquities—the norm by the mid-twentieth century—denounced earlier restorations of ancient marbles.[8] But the volatilty of taste is proverbial, and dismantling modified ancient marbles shows a lack of sensitivity to stylistic diversity; this is at odds not only with eighteenth-century tastes, but also with the eclectic predilections of the Romans.

The current condition of the Pothos torso, "liberated" from the distraction of its repairs, may be ideal. Certainly, it shows the exquisitely sensuous quality of the adolescent male form to great advantage, and for the twenty-first-century viewer, interest can be focused on a quick aesthetic evalua-

Fig. 39-1. T. D. Fosbroke. "The Outlines of Statues in the Possession of Mr. Hope" MS (1813): fig. 13.

tion. Nevertheless, the removal of its later additions entailed destruction of part of the work's true history. Restorations of antiquities are not superfluous appendages; together with the ancient fragments, they form works of art, rich in cultural insights. For Hope's Pothos, all this has been irrevocably lost to posterity.

1. For the sculptor, see Vorster, "Skopas (II)" (2004): 391–97. For a complete discussion of the statuary type, best represented by a copy in the Capitoline Museums, inv. no. 2417, and its many copies, see Stewart, *Skopas of Paros* (1977): 144–46, pl. 45a,c. Also Bažant, "Pothos I" (1994): 502–3, nos. 12–26; Todsico, *Scultura greca del IV secolo* (1993): 80, 85–86, pl. 150. The basic formula could vary. Pothos is often winged; the staff could be tipped with different attributes; the goose could be omitted and the hairdressing and drapery altered. Pothos was also metamorphosed into Hermaphrodite or Eros.
2. Pausanias (*Guide to Greece* I 43. 6.), an account of his travels around the country during the mid-second century A.D., states that, in the sanctuary of the Aphrodite Praxis at the Agora of Megara, there was an old statue of the goddess, together with two statues by Praxiteles, and three statues, including the Pothos, by Scopas. Pliny the Elder (*Natural History* 36.25), an encyclopedic compendium of the mid-first century A.D., writes that Scopas created an Aphrodite and Pothos for Samothrace, which were worshiped with sacred ceremonies. For the literary sources and debate over the locale of the Pothos formula, see Stewart, *Skopas of Paros* (1977): 107–10, 111, 127, no. 4, 130, no. 26, fig. 7; ibid., *Greek Sculpture* (1990): 184, 284–86; Bažant, "Pothos I" (1994): 502–3, nos. 12. 13. Stewart proposes that the prop could have been an addition of Roman copyists; originally, Pothos may have leaned against Aphrodite with his left arm gripping her shoulder from behind.
3. For Apollo *Sauroctonos*, see Lambrinudakis et al., "Apollon" (1984): 199, no. 81; *Greek Sculpture* (1990): 178–79, pl. 509. In this restoration, one should imagine the god in a similar pose to the Pothos, his left arm leaning against a tall tree trunk; he teases a lizard, which scurries up the stump, intending to kill it with an arrow held in his other hand. Pierre Jacques first drew the marble, then in the collection of Francesco Liscam before 1532; see Bober, *Essays Presented to Rudolf Wittkower* (1967): 120, fig. 1.
4. The restorer-dealer is not known; see Waywell, *The Lever and Hope Sculptures* (1986): 75. The sculptor replaced the head, removed the lyre (an illogical addition of the earlier restorer), and modified the left hand's fingers into a gesture to attract the reptile's attention.
5. For the Roman penchant for replicating Greek statuary types, see the discussion by Marvin, "Copying in Roman Sculpture" (1993): 161–88.
6. See Stewart, *Skopas of Paros* (1977): 3; *Greek Sculpture* (1990): 285–86.
7. *Household Furniture* (1809): pl. I.
8. On this topic, see especially the discussion by Ramage, "Cavaceppi and Modern Minimalism" (2003): 167–70.

EA

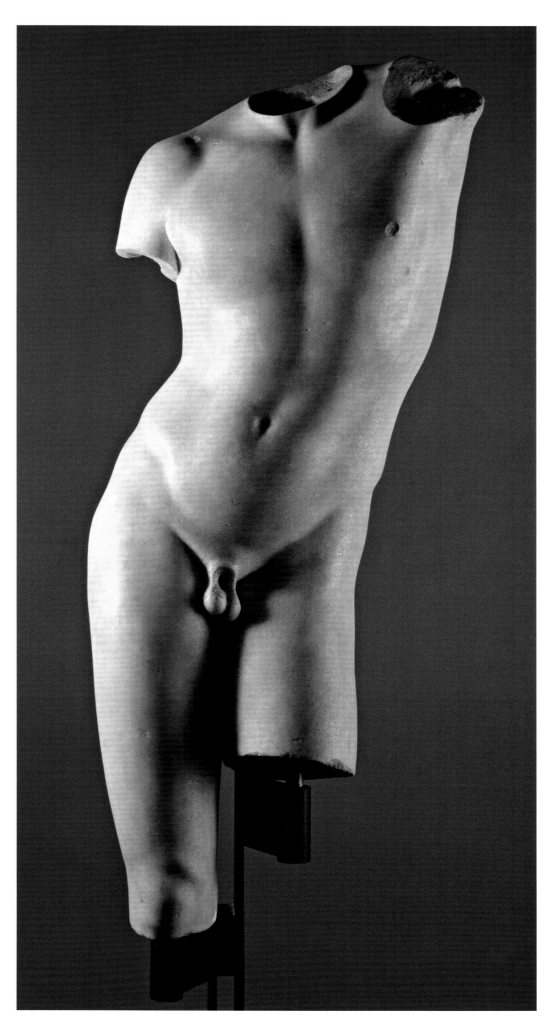

40. *Cinerarium*

Roman, late 1st century A.D., with 18th-century
restorations
Marble
As restored: 20¾ x 19⅗ x 17¾ in. (52.7 x 49.8 x 45.2 cm)
National Museums Liverpool, Lady Lever Art Gallery,
LL40

PROVENANCE: Probably sold by Bartolomeo Cava-
ceppi to the 2nd Earl of Bessborough; purchased by
Thomas Hope from Bessborough, Christie's, London,
7 April 1801, lot 70, for £63; by descent, Lord Francis
Hope Pelham-Clinton-Hope; sold Christie's, London,
23–24 July 1917, lot 195; bought by Partridge for
£241.10; William Hesketh Lever, 1st Lord Leverhulme;
Lady Lever Art Gallery.

LITERATURE: Piranesi, *Vasi, Candelabri* (1778):
pl. 6A; *Household Furniture* (1807): pl. 1; Hope Marbles
MS (n.d.): pl. 29; Fosbroke, "The Outlines of Statues"
MS (1813): fig. 30; Waywell, *The Lever and Hope Sculp-
tures* (1986): no. 17, pp. 26–27, no. 83, p. 104; Sinn,
Stadtrömische Marmorurnen 1987): 2–3, n. 16.

Fig. 40-1. T. D. Fosbroke. "The Outlines of Statues in
the Possession of Mr. Hope" MS (1813): fig. 30.

The front of this cinerarium, a receptacle
designed to contain a person's ashes after
cremation, contains a profiled panel with a
standard epitaph. It reads: DIS · MANIB(US) ·
C(AIO) · PERPERNAE / C(AII) · F(ILIO) ·
SER(GIA TRIBU) · GEMINO: C(AIUS) ·
PERPER(NA) / AGATHOPVS · ET · SATVRNINA
/ ET · FORTUNATA · H(EREDES) / LIB(ERTI) ·
FEC(ERUNT) · V(IXIT) · A(NNOS) · LXVIII
(To the gods and shades of Caius Perperna
Geminus, son of Caius, of the Sergian tribe,
Caius Perperna Agathopus and Saturina
and Fortunata, freedmen and women and
heirs, made this. He lived sixty eight
years.)[1] The inscription informs us that
Geminus's freedmen, former slaves called
libertini, erected the memorial to their one-
time master.[2]

Profuse ornament fills the pictorial field.
At each corner, a Siren with outspread
wings perches atop a ram's head. The
entrancing songs of Sirens, usually depicted
as woman-headed birds, were believed to
lure mariners to their destruction on rocky
coasts. These mythical temptresses have a
long history in ancient sepulchral art.[3]
Here, a thick garland of fruit and leaves is
suspended by ribbons from their tresses. In
the lunette of the swag, two birds plunder
the berries, while below, in the corners, two
larger birds peck at the ends of the ribbons.

Romans of all social classes favored cre-
mation until the mid-second century A.D.
A cinerarium was normally housed in the
niche of a large undergound communal
tomb, which, because of its many alcoves,
resembled a *columbarium* (dovecote). Origi-
nally, the back of the ash chest was left
rough, since the marble's placement
allowed only the front side to be seen.[4] A
semicircular chest, therefore, had economic
benefits, as it required both less stone and
less labor to manufacture than a cinerarium
in the round.[5]

In the decorative repertory of Roman
funerary art, garlands were ubiquitous;
flora, often with accompanying bird life,
echo the wish expressed in many epitaphs
that the departed's grave should be sur-
rounded by lush vegetation.[6] Relatives also
offered wreaths at grave sites. Carved fes-
toons—reflections of these funerary obser-
vances—show a multitude of decorative

supports, but the Sirens seen in the Hope
marble have no known counterparts. The
chest's shape indicates an origin after 50
A.D. Its drillwork extensively undercuts the
swag's leaves and fruit, which are connected
by a delicate lattice of thin marble bridges.
This treatment typifies the tastes of the late
first century, when the popularity of cineraria
stimulated demand for decorative novelty
and variety.[7] The absence of personalized
imagery proves that this piece was purchased
ready-made; the inscription provides our
only clue to the deceased's identity.

This monument's skillful craftsmanship
and innovative use of the Sirens more than
compensate for its modest size and com-
pletely justify the interest and emulation of
later artists and antiquarians. The cinerar-
ium was found in tombs in Siena in the
early eighteenth century, from where it
entered a local antiquarian's collection.[8]
The restorer-dealer Bartolomeo Cavaceppi
bought it and had it transported to Rome,
where his workshop added features to
increase the marble's perceived value.[9] The
ash chest was advertised—with an illustra-
tion showing Cavaceppi's additions to the
chest's reverse and its new base and lid—in
a prestigious series of plates first published
as *Vasi, candelabri, cippi, sarcophagi, tripodi*
I (Rome, 1778) by the engraver Giovanni
Battista Piranesi.[10] Around the curving
back, the sculptor carved an elegant acan-
thus and palmette motif, whose tendrils are
disposed around acanthus flowers. The
chest was set on a high base, which is richly
embellished with cornucopiae, tendrils, and
flowers. The lid's sides are decorated with
exotic sphinxes *couchant*, echoing the
chest's Sirens. Deliberate distressing of the
sphinx heads and paws helps to unify the
pieces visually and lends an authentic
touch. Apparently, the cinerarium of Caius
Perperna Geminus had special resonance
for Thomas Hope, who frequently intro-
duced antique elements into his domestic
schemes, embellished the sides of a sofa
with an acanthus motif taken from the
reverse side of the cinerarium (cat. no. 82).[11]

1. Bormann, *Inscriptiones Aemiliae*, vol. 11, 1 (1888): 334,
no. 1812. In line one, the tall form of the "I" and in line
three the two long "T's" were chiseled for decorative

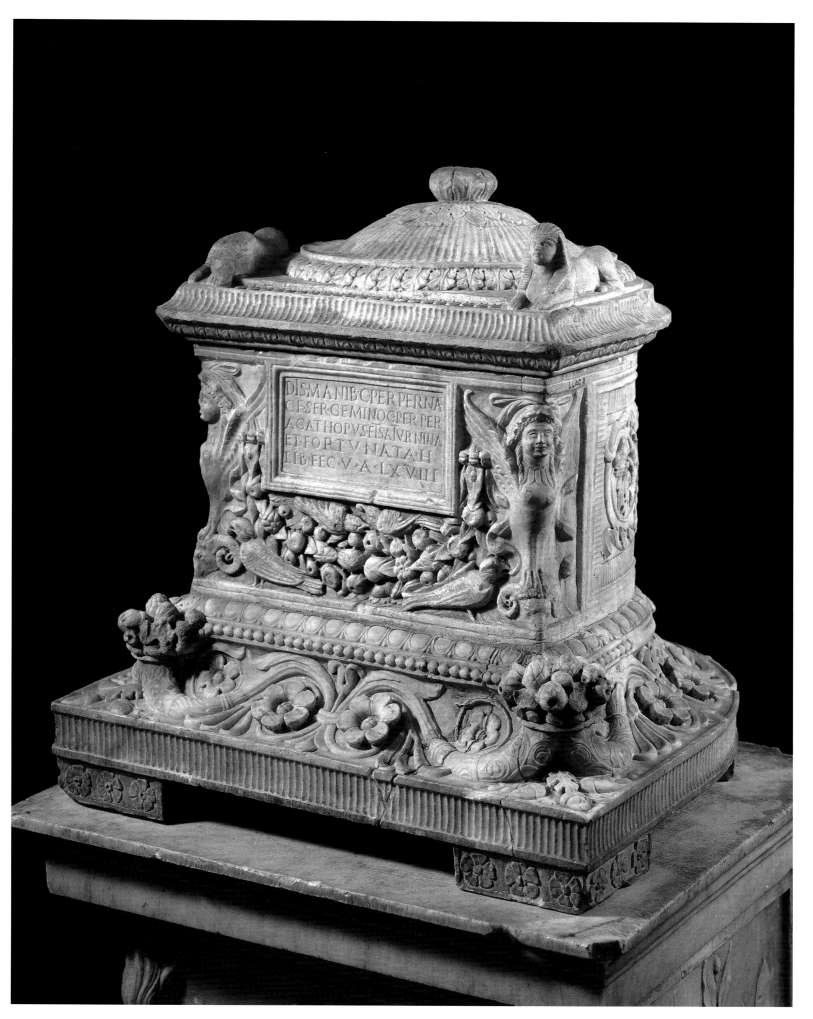

effects. The A and E at the end of line one are linked up. Such a ligature—a combination of the elements of two or more letters into a single written unit—was usually determined by spatial constraints, but it could also serve aesthetic purposes. See Keppie, *Understanding Roman Inscriptions* (1991): 20–21. The name "Perperna" is found at Volterra (near Pisa in Tuscany), but the reference to the Sergian tribe suggests a Roman origin for the urn. "Tribes" were territorial divisions, corresponding roughly to wards in our cities. See Cristofani, *Siena* (1979): 174, no. 141h.

2. For the legal relationship between patrons and freedmen, see Duff, *Freedmen in the early Roman empire* (1928): 36–49. Freedmen often arranged for memorials to their patrons: ibid., 100–102.

3. Sirens appear as mourners, musicians, and singers at funerals: Hofstetter, "Seirenes" (1997): 1101–2, 1104; also Pollard, *Birds in Greek Life and Myth* (1977): 188–91.

4. For *columbaria*, see Toynbee, *Death and Burial in the Roman World* (1971): 113–16.

5. Sinn, *Stadtrömische Marmorurnen* (1987): 29, 32. Semicircular chests first appear in the mid-first century A.D., but become common toward the end of that century.

6. For the significance of garlands and the different types of swag supports, see ibid., 56–61. For flora in funerary contexts, see also Lattimore, *Themes in Greek and Latin Epitaphs* (1942): 129–31; Toynbee, *Death and Burial in the Roman World* (1971): 94–100, 265.

7. The integration of the inscription plate into the frame of the front panel is typical of cineraria from the third quarter of the first century A.D. For the characteristics and style of cineraria of this time, see Sinn, *Stadtrömische Marmorurnen* (1987): 31–34; examples of this date may be seen in Sinn's catalogue entries, ibid., 137–63, nos. 179–285. Little external evidence exists for dating the works. Cf. the carving of the garland of a *cinerarium* in the Civico Museo Archeologico, Milan, inv. no. A 1073, dated Neronian to early Flavian (A.D. 54–79): ibid., 137, no. 179, pl. 38a.

8. It was recorded in the collection of Adriano Sani in 1733 by Giovanni Antonio Pecci, who had sent drawings from this collection to the antiquarian Anton Francesco Gori. The illustrations are contained in the Biblioteca Marucelliana, Florence (B III 66 cc. 247-346); see Cristofani, *Siena* (1979): 159. Pecci's drawing of the Hope ash chest is c. 262v, n. 42; it incorrectly shows the marble as rectangular, but there are no indications of recarving at this date. For Sani's collection, see: ibid., 171–76, 174, no. 141h (Pecci's illustration).

9. For Cavaceppi and his large-scale atelier, see cat. no. 36.

10. Plate 6A. This illustration helpfully shows the chest in its restored state; confirms the provenance of Siena; and names Cavaceppi as the restorer. For other examples of *cineraria* recarved in post-classical times, see: Sinn, *Stadtrömische Marmorurnen* (1987): 2–3, nn. 16, 17.

11. For other examples, see *The Age of Neo-Classicism* (1972): 776–79, nos. 1659–1655.

EA

41. *Candelabrum*

Roman, 1st century–2nd century A.D., with 18th-century restorations
Marble
National Museums Liverpool, Lady Lever Art Gallery, LL16
London only

PROVENANCE: Thomas Hope, Statue Gallery, Duchess Street; by descent, Lord Francis Hope Pelham-Clinton-Hope; sold Christie's, London, 23–24 July 1917, lot 184; bought by Partridge for £304.10; William Hesketh Lever, 1st Lord Leverhulme; Lady Lever Art Gallery.

LITERATURE: *Household Furniture* (1807): pl. 1; Fosbroke, "The Outlines of Statues" MS (1813): fig. 29; Moses, *A Collection of Antique Vases…* (1814); Michaelis, *Ancient Marbles in Great Britain* (1882): 292–93, no. 43; Waywell, *The Lever and Hope Sculptures* (1986): no. 8, pp. 22–23, no. 73, p. 102, fig. 29.

In antiquity candelabra supported small terracotta lamps with oil or burning coals for illumination.[1] This candelabrum is pieced together so ingeniously from varied ancient and modern parts that it is nearly impossible to distinguish original sections from restoration. The square base, set on a podium with vertical fluting and horizontal mouldings, displays panels showing ceremonial objects. Fantastic animals decorate the corners; above crouching sphinxes with outspread wings project lion-griffin heads with twisted goats' horns (such animal foreparts are known as protomes).

A cluster of large leaves covers the transition from the base to the shaft, forming a baluster that bulges below and is slender above. Four horizontal members make up the stem. The lowest section is an ancient, round altar, which rests on a square plinth embellished with oak leaves and a top band of vertical fluting.[2] Four erotes, or cupids, holding heavy fruit swags encircle the altar, and ribbons flutter in the background. The workmanship of these heavily sculpted festoons suggests an origin in the late first or early second century A.D.

The ancient shaft rises from a restored spray of water leaves, and above this, acanthus leaves extend vertically up the stem; on their tips perch lightly poised cranes, some pecking at reptiles. Higher still, rich acanthus foliage spirals up assymetrically, mixing with ivy tendrils spreading delicately over the top of this segment. There is marked sensitivity in the rendering and disposition of the flora and fauna. Their rich plasticity, emphasized by strongly contrasting light and shade in the foliage, enlivens the surfaces; stylistically, this work belongs to the first half of the first century A.D.[3] A capital with rams' heads crowns the shaft and supports an architrave.[4] Leafy festoons loop through their horns and bunches of ribbons fill the lunettes.

To increase the lamp stand's height and grandeur, the fourth part was added to crown the shaft; it is a complete fabrication of the late eighteenth century. A triple row of varied foliage comprises the base. Palm leaves, looking dry and brittle, fan out stiffly from the stem. Above a column ascends intertwined with vegetal sprays, from which fierce-looking lion protomes project. The terminal feature, a typical broad disc intended to hold the lamp, is pleasingly embellished with a tongue pattern.

Fig. 41-1. T. D. Fosbroke. "The Outlines of Statues in the Possession of Mr. Hope" MS (1813): fig. 29.

Romans used candelabra for lighting temples and both private and public buildings; they were also set up in the open air for festivals and funerals. It is doubtful that their dim, smoky light provided effective illumination. Because they were considered luxury items, intended either for the Roman elite or for communal interiors, the quality of workmanship on such objects was usually above average. In the first centuries B.C. and A.D., large ornate pieces of marble furniture were produced for a Roman clientele by Athenian workshops operating in the traditions of late Hellenistic decorative sculpture (see cat. no. 45).

Overall, the Hope candelabrum is a well-planned and convincing pastiche, incorporating an antique shaft (one of very few extant examples) and an altar section with modern infills that conform to canonical, ancient features.[5] This ensemble should be seen as essentially a neoclassical sculpture. Decorative accessories such as candelabra were favored candidates for imaginative reconstruction. The renowned Giovanni Battista Piranesi was the most celebrated artist in this field, as witnessed by his corpus of *Vasi, candelabri, cippi, sarcophagi, tripodi* (Rome, 1778). Piranesi's approach was simple: he collected disparate antique fragments, culled from many sources, and combined them with modern components to fabricate spectacular candelabra and other articles. In this Hope marble, we see inventiveness surpassing mere restoration, for there is a desire to create a lampstand far more ornate and fanciful than any ancient example. Piranesi truly believed that the restorer's task was not simply to document an antiquity in its fragmentary state, but to re-create—and even surpass—its lost splendor.[6] That vision and ambition resulted in this extraordinary sculpture.

1. The definitive study is Cain, *Römische Marmorkandelaber* (1985). For the evolution of the use of candelabra in public buildings to decorative objects in private villas, see ibid., 12–21.
2. For a similar altar, see Gusman, *L'art décoratif de Rome* (1908): pl. 32. For the dating, cf. the treatment of the swag with a cinerarium in the British Museum, no. 2355: Sinn, *Stadtrömische Marmorurnen* (1987): 203, no. 365, pl. 59.
3. For shafts decorated with foliage at the base, see examples in Cain, *Römische Marmorkandelaber* (1985):

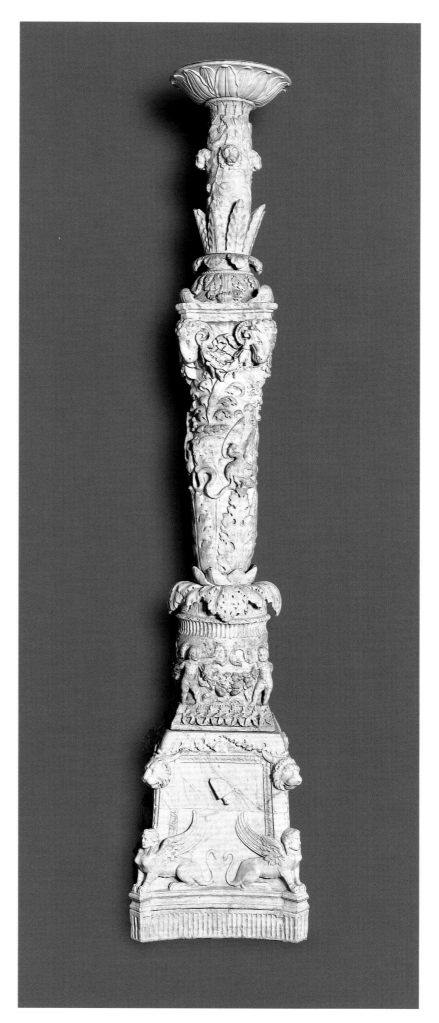

pls. 88, 3; 89, 3. For the dating, cf. a pilaster in the Metropolitan Museum of Art, New York, acc. no. 10.210.28; see Mathea-Förtsch, *Römische Rankenpfeiler und –Pilaster* (1999): 133, no. 96, pl. 20.1,2.

4. The sculptor evinces an admirable knowledge of figured capitals. See examples in von Mercklin, "Figuralkapitelle" *Jahrbuch des Deutschen* (1925): 203–6, nos. 494–505, figs. 947–950. Also the discussion in Cain, *Römische Marmorkandelaber* (1985): 58.

5. For the form of Hope base, cf. Cain, *Römische Marmorkandelaber* (1985): 47–48, Type IV a,b: Beilage=addition 3, 3.4. Large, outspread acanthus leaves usually form the transition from base to shaft: e.g., a candelabrum base in the Museo Nazionale Romano, inv. 1186: ibid., 179, no. 84, pls. 57.1, 2, 4. The ancient altar agrees in shape and typology with an ancient shaft showing gamboling figures in the British Museum, inv. no. 2516: see ibid., 161, no. 38, pl. 88.2.

6. *Diverse maniere d'adornare i cammini ed ogni altra parte degli edifizi desunte dall'architettura egizia, etrusca e greca* (Rome, 1769): 33. See especially Wilton-Ely, *The Mind and Art of Giovanni Battista Piranesi* (1988). Wilton-Ely's numerous authoritative publications on Piranesi and 18th-century Rome are fundamental to the understanding of the artist.

EA

42. *Vitellius*

Roman, 18th century
Porphyry, alabaster
28 x 15½ x 12⅖ in. (71.5 x 39.5 x 31.5 cm)
Calouste Gulbenkian Museum, Lisbon, 683
London only

PROVENANCE: William Beckford, entrance hall, Fonthill, from whose collection sold, Philips, Fonthill, Wiltshire, 19–22 August 1801, third day sale, lot 57; bought by Thomas Hope; by descent, Lord Francis Hope Pelham-Clinton-Hope; sold Christie's, London, 23–24 July 1917, lot 224, bought by Gudenian for £735; Calouste Gulbenkian; Museu Calouste Gulbenkian.

LITERATURE: Douce MS (1812): f. 4; Westmacott, *British Galleries* (1824): 228; Waywell, *The Lever and Hope Sculptures* (1986): 98, no. 59, pl. 67.1; Figueiredo, *European Sculpture*, vol. 2 (1999): 104–6; Hewat-Jaboor, "Fonthill House" (2001): 54, 68, n. 38; Ostergard, *William Beckford* (2001); Fittschen, *Die Bildnisgalerie in Herrenhausen bei Hannover* (2005): 222, no. C53.

Portraiture was one of Rome's outstanding contributions to the visual arts; the Romans were interested in faithfully conveying aspects of individual character as revealed by details of the subject's personal appearance and demeanor. The over-life-size portrait is of a man in late middle age, his beefy face set in a pugnacious scowl with downturned mouth and deeply contracted brow. Massive jowls make the head bottom-heavy, the nose is large and aquiline, and rolls of flesh bulge from the bull neck. His cropped hair is combed into a series of curls, which recede at the brow and temples, emphasizing the peaked dome of the head, which is topped with a meager tuft of hair.

The Hope head is a copy of a marble known as the *Grimani Vitellius,* named after its first owner, Cardinal Domenico Grimani, who in 1523 bequeathed his entire, important collection of antiquities to the republic of Venice.[1] No other ancient portrait has so successfully captured the imagination of artists and connoisseurs alike; replicas exist for every period since its discovery in the Renaissance, making this the most copied ancient portrait in history.[2]

Identification of the portrait as the Emperor Vitellius speaks more of the art trade's desire to name unknown portraits than of any firm evidence.[3] Certainly, this antiquity is an outstanding example of Roman portraiture of the mid-second century A.D., but the sitter has never been recognized. Untitled portraits, however well carved, were of only minor interest to collectors, while those of famous characters were prized as vivid illustrations of ancient personalities, thus commanding higher prices.

Shortly after its discovery in the sixteenth century, the Grimani portrait was denominated as the Emperor Vitellius and the title stuck. It is often difficult to separate fact from fiction in assessing the life and reign of this Emperor, who ruled Rome in 69 A.D. Maligned in ancient sources as gluttonous and cruel, he may have been a victim of a hostile biographical tradition, established by the Emperor Vespasian, who killed and succeeded him.[4] Nevertheless, this choleric image—the embodiment of self-indulgence and depravity—corresponds perfectly with ancient literature's account of this emperor.

The top-heavy head and neck, turned to its left, are set on a disproportionately small bust, emphasizing their gross fleshiness. The sculptor dressed his subject for combat to suggest military prowess. Above the plain breastplate appears the ruffled neckline of a tunic; a cloak is draped over the right shoulder. The left shoulder carries a leather strap for attaching the breastplate and the backplate of the cuirass.[5]

Copies of the *Grimani Vitellius* occur in all sizes and media. Here the highly polished skin surface contrasts effectively with the hair's rough texture. Always desirable for its decorative qualities, porphyry's rich, ruby-red hue would have been particularly apt to depict the florid countenance of Vitellius. According to an account by the gossipy historian, Suetonius (XVII, 2), the emperor had "a face usually flushed from hard drinking."[6] The bust is carved in costly opaque alabaster, heavily fractured because of the brittle quality of the stone.

Thomas Hope may have chosen his Vitellius for a number of reasons: its iconographic interest, its colorful appearance, and very probably its revealing psychological dimension. Unlike many replicas of the

Grimani Vitellius, this example exudes an undeniable impression of raw strength, brutality and sheer overindulgence—equal to the potency of the original. Whereas the marble prototype offered neutral skin tones, however, the hard, rubescent porphyry not only delineates sharply defined features— the strong, jutting double chin, the determined set of the mouth—but it also seems to endow the work with an air of defiance. It is indeed tragic that the sole legacy of a man who once ruled the mighty Roman Empire, if only for a year, was to be remembered in the form of an an obese old man, recording every wrinkle, sag, and furrow of a life spent in dissipation.

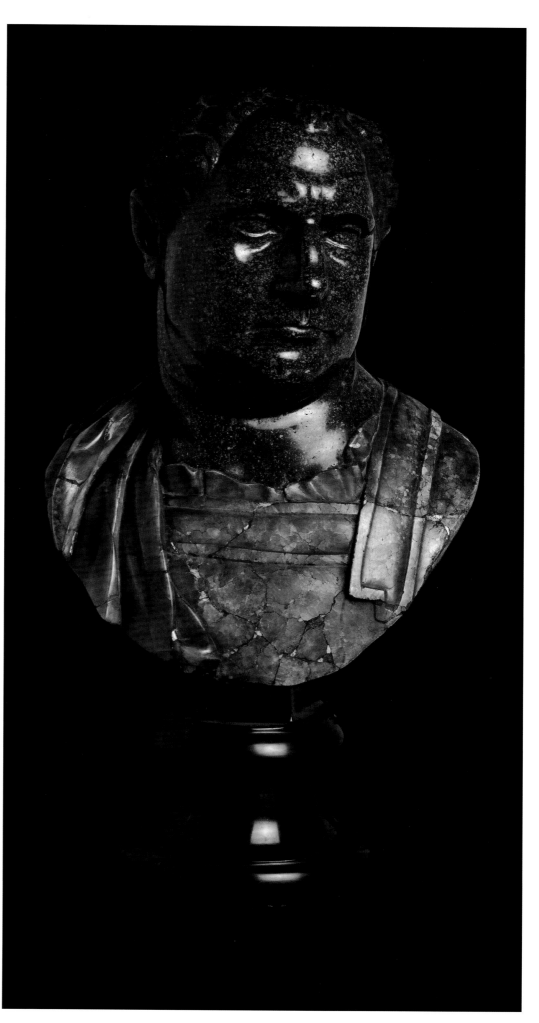

1. For the history of the Grimani Vitellius, verification of its antiquity, and its vicissitudes in scholarly research, see Fittschen, *Die Bildnisgalerie* (2005): 187–94. Cardinal Grimani may have acquired the marble from excavations on the site of his palace on the Via Rasella in Rome ca. 1505: see p. 191.

2. For the influence of the Grimani Vitellius and its many copies in various media, see: ibid., 194–234, Lists A–K, pls. 54–67. See also Cuzin, Gaborit, and Pasquier, *D'après l'antique* (2001): 298–311. Fittschen's replica lists show that an overwhelming number of copies are identified as the emperor. The scholar dates the original to A.D. 130–140.

3. The only authentic likenesses of Vitellius are his coin portraits, which differ both in profile and hairstyle from the Grimani marble: Fittschen, *Die Bildnisgalerie* (2005): 193–94, pl. 66.3.

4. The ancient sources are available in the Loeb Classical Library series. *Suetonius*, vol. 2 (1914): Book VII, 247–77. Tacitus, *The Histories*, vol. 2 (1925): Book II, chap. 89; Book III, 305–479. *Dio's Roman History*, vol. 8 (1925): Book LXIV, 221–57.

5. The Grimani Vitellius has a nude bust. For body armor, see Bishop and Coulston, *Roman military equipment* (1993): 59, 85–87, 117.

6. Nista, "Sculpture in Porphyry" (1989): 35–46. Two other examples of copies in porphyry are in the Lansdowne collection, Bowood House, England, and the Kunsthistorisches Museum, Vienna, inv. no. I 134: Fittschen, *Die Bildnisgalerie* (2005): 213 C 6; 223 C 62. Also Malgouyres and Blanc-Riehl, *Porphyre* (2003). For the alabaster bust, see Di Leo, "Alabaster" (1985): 52–55. Two other examples of this combination of expensive stones are at Versailles, inv. no. MV 7101; inv. no. MV 6185: Fittschen *Die Bildnisgalerie* (2005): 209, A 19; 223, C 58.

EA

43. *Satyr's Head*

Roman, mid-2nd century A.D.
Marble
27⅗ in. (70 cm)
Calouste Gulbenkian Museum, Lisbon, 681
London only

PROVENANCE: Thomas Hope, Statue Gallery, Duchess Street; by descent, Lord Francis Hope Pelham-Clinton-Hope; sold Christie's, London, 23–24 July 1917, lot 232; bought by Gudenian for £861; Calouste Gulbenkian; Museu Calouste Gulbenkian, Lisbon.

LITERATURE: *Household Furniture* (1807): pl. 1; Hope Marbles MS (n.d.): pl. 9; Townley, 1804; Fosbroke, "The Outlines of Statues" MS (1813): fig. 15; Westmacott, *British Galleries* (1824): 222; Brayley-Britton, *A Topographical History of Surrey* (1841–48): 87; Michaelis, *Ancient Marbles in Great Britain* (1882): 279, no. 1; Furtwängler, *Masterpieces of Greek Sculpture* (1895): 329 n. 5; Waywell, *The Lever and Hope Sculptures* (1986): 91, no. 40, p. 78, fig. 15.

Fig. 43-1. T. D. Fosbroke. "The Outlines of Statues in the Possession of Mr. Hope" MS (1813): fig. 15.

In classical mythology, satyrs were impish creatures with goat characteristics who dwelt in the woods and formed a major contingent of Dionysus's entourage. The sixth-century B.C. Greek poet Hesiod (Fragment 94) described them best as "good for nothing and mischievous," fond only of wine and every kind of sensual pleasure. The life-size head of a handsome youth is certainly not human, as the sharply pointed ears, prominently pushed forward, indicate. The creature's lips are slightly parted and dimples appear at the corners, suggestive of its naughty nature.

The coif is clearly divided; at the crown, the hair is lightly chiseled into a smooth cap of wavy strands that lie close against the scalp; by contrast a profusion of long, loose curls surrounds the face and falls onto the nape. Forelocks (mostly lost), spring upward at the center of the low forehead, adding an animal touch. They are reminiscent of the budding goat horns satyrs often possess. The restored bust shows a *pardalis* (panther skin) slung over the right shoulder like a sash and tied into a knot with two paws hanging down. The panther, Dionysus's sacred animal, was customary garb for these woodland beings, to accentuate their feral nature. Rolled edges of the pelt are richly worked into a series of notches indicating cuts in the skin.

Often, satyrs are shown carousing or in the agitated—even violent—throes of Dionysiac worship. But this head is based on the type called *Anapaumenos* (at rest), created by the Athenian sculptor Praxiteles (fl. 375–335 B.C.).[1] He conceived the creature languidly leaning an elbow against a tree trunk, the other arm akimbo and the legs crossed. The Hope satyr appears rather pensive, taking a momentary respite from his roguish pranks. Myriad replicas attest to the appeal this more human, contemplative type of satyr exerted on ancient Romans. Displaying a copy of a prestigious masterpiece established its owner as a person of taste and discernment. That was the very same mindset of eighteenth-century English gentlemen such as Thomas Hope, who used his collection of antiquities as a passport into English high society.

The great nineteenth-century scholar of classical marbles, Adolf Michaelis, praised the marble as unusually refined and "one of the best satyr heads I know."[2] In the treatment of the hair, the ancient sculptor's handling of the stone shows certainty and command of the medium. He carved the unruly mane of hair with a great deal of drill work to separate the tresses, incisions to mark the individual strands, and deep drill holes to punctuate some curls. Such workmanship signals a dating to early Antonine times, the mid-second century A.D. (see cat. no. 36).[3]

As Michaelis rightly recognized, the Hope satyr is, indeed, a work of great artistic value—far beyond the hackneyed copies churned out in ancient sculpture workshops. Thomas Hope appreciated its aesthetic merit as well, proudly illustrating it on a multicoloured tripod (cat. no. 45), setting it on a wide pedestal, enhanced with vegetal ornament. Unlike Praxiteles' satyr, who jauntily cocks his head to the side, the Hope head faces forward with the gaze directed downward, superbly capturing the creature's mood of dreamy reverie.

1. For the sculptor, see Geominy, "Praxiteles (II)" (2004): 305–19. For a collection of copies of the type, discussion and dating of the original and the literary sources, see Gercke, *Satyrn des Praxiteles* (1968): 22–68, 71–84; Corso, *Prassitele* (1988): 79–80; Todisco, *Scultura greca del IV secolo* (1993): 76–77, pls. 135, 136; Simon, "Silenoi" (1997): 1130, no. 213. More than 100 replicas are widely distributed throughout the Roman world. Some heads include a pinecone wreath. For a good overview of Praxiteles' work, see Ajootian, "Praxiteles" (1996): 91–129. Many scholars identify the satyr Anapaumenos with the satyr Periboetos (famed), among Praxiteles's bronze works and praised by Pliny the Elder (*Natural History* 34. 69).
2. *Ancient Marbles in Great Britain* (1882): 279, no. 1. Eugenie Sellers-Strong also admired the head; see Furtwängler, *Masterpieces of Greek Sculpture* (1895): 329, n. 5.
3. For a similar stylistic approach cf. a portrait of Antoninus Pius (A.D. 138–161) in the Vatican, Sala dei Busti 284 Inv. 703, see Fittschen, *Die Prinzenbildnisse antoninischer Zeit* (1999): 19, n. 139, pl. 122 c-d. Also note the comparable hairstyle of the winged male personification on the column of that emperor in L. Vogel, *The Column of Antoninus Pius* (1973): fig. 6.

EA

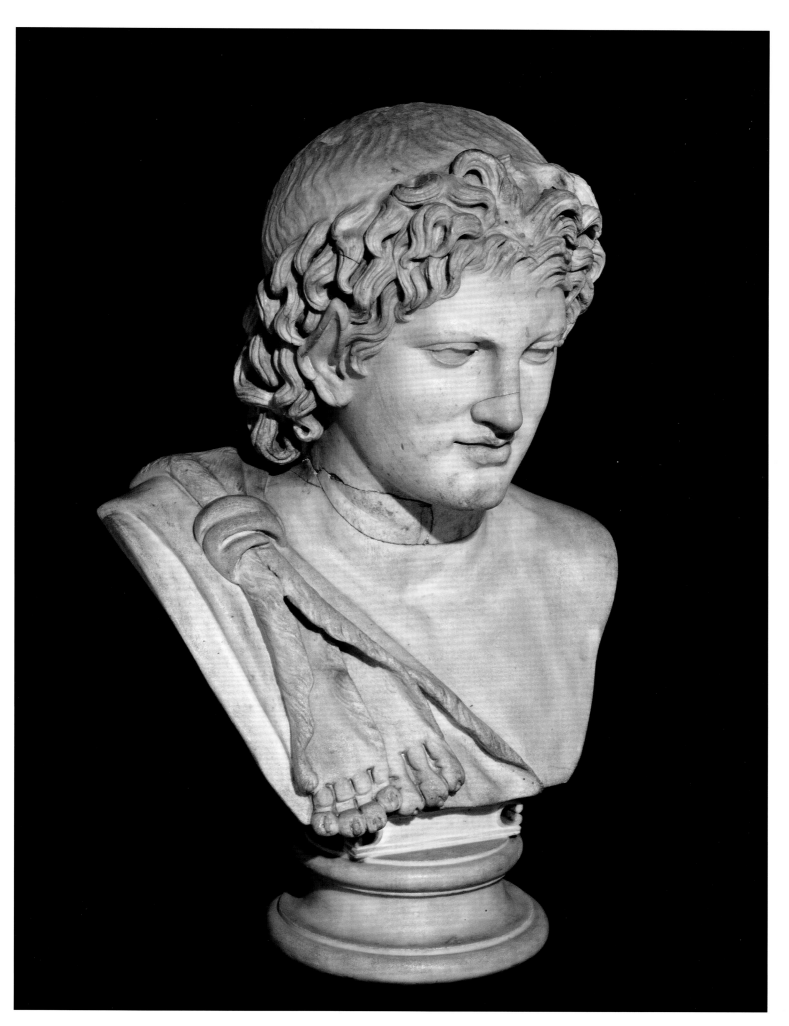

44. Vase

Roman, late 18th century
Marble
13¾; 12 in.; 10½ in. (incl. plinth 34.8 cm; diam. at top
26.8 cm)
National Museums Liverpool, Lady Lever Art Gallery,
LL36

PROVENANCE: Thomas Hope; by descent, Lord Francis
Hope Pelham-Clinton-Hope; sold Christie's, London,
23–24 July 1917, one of two items in lot 208, bought by
Partridge for £105; William Hesketh Lever, 1st Lord
Leverhulme; Lady Lever Art Gallery

LITERATURE: *Household Furniture* (1807): pls. II, XX,
no. 1; *Hope Marbles MS* (n.d.): pl. 20; Fosbroke, "The
Outlines of Statues" MS (1813): fig. 36; Waywell, *The
Lever and Hope Sculptures* (1986): no. 21, p. 28; no. 101,
p. 109, fig. 36.

This vessel is carved in the shape of a bell-shaped bloom standing upright and springing from a support of roots. The elongated body is elegantly worked into a series of vertical ribs that flare out at the rim into a stylized pattern of large petals. Each petal is carved in the form of a delicate lobe; a lower ring of smaller petals inserted at regular intervals between the larger ones produces a scallop edge. The deep bowl narrows at the base, joining a corolla of pendant leaves that provide a transition to the foot. Here an extraordinary display of branching, gnarled roots spread their tendrils atop simulated mountain rock, which is stippled to resemble a pitted surface. The vase is not a shape that would have been carved in ancient times; it echoes the spirit of Giovanni Battista Piranesi and sprang from the tradition of post-antique, fantasy vases that were especially popular in the eighteenth and early nineteenth centuries.[1] Its bowl and foot were fashioned separately in order to impart a greater appearance of antiquity.

Hope considered the blossom to be a lotus—even though its form bears no resemblance to that flower—and placed its illustration between two canopic vases to lend it an Egyptian air. A lotus is, of course, a water lily rooted in wet mud whose long stem rises to the surface of the pond or lake, where its large circular leaves and starlike flowers float. In fact, the Hope flower more closely resembles an alpine *haberlea rhodopensis,* the stylized sunflowers that appear on other sculptures of the late eighteenth century.[2]

Piranesi's ideas, disseminated through his many prestigious publications, especially *Vasi, candelabri, cippi, sarcophagi, tripodi* (Rome, 1778), offered numerous possibilities for highly original creations, and Thomas Hope showed considerable flair in adapting Piranesi's eclectic methods to his own decorative motifs.[3] Struck by this marble's strange design, Hope placed it on a table in his Picture Gallery in Duchess Street, displayed in solitary splendor, as shown in *Household Furniture* (see fig. 2-8). In the preface to this fashion-setting volume, Hope wrote of his ambition to exhibit in his residence "those monuments of antiquity which shew the mode in which the forms of nature may be most happily adapted to the various exigencies of art." This marble interpretation of a botanical drawing—roots and all—captures the spirit of a flower, rather than its naturalistic image, perfectly reflecting Hope's own idiosyncratic adaptations of organic form.[4]

1. Hilgers, *Lateinische Gefässnamen* (1969): pls. 1–4; *Atlante delle forme ceramiche* (1981). For post-classical pastiches of vases, some incorporating ancient parts and some totally modern works, see Moses, *A Collection of antique vases* (1814): pls. 28–49; Grassinger, *Römische Marmorkratere* (1991): 223–24; *Antike Marmorskulpture auf Scholß Broadlands* (1994): 112–14, nos. 42–45, figs. 119-206. Connoisseurs, including Charles Townley, owned such works, e.g., an urn worked by Piranesi from an ancient capital; see Cook, *The Townley Marbles* (1985): 49–50; inv. no. 2409, fig. 46.
2. Cf. the flower decoration of Charles Townley's famous *Clytie,* the bust of a woman emerging from a calyx of leaves, reworked in the 18th century; see Walker, *Roman Art* (1991): 19, fig. 13.
3. In *Household Furniture* (1807): 52, Thomas Hope specifically singles out Piranesi's *Vasi* publication as one inspiration. For Hope's other flights of fantasy, see candelabra, each composed of a flower issuing from a bunch of ostrich feathers; ibid., pl. XXIV, no. 5; *The Age of Neo-classisicism* (1972): 777, no. 1652.
4. P. 17. The vase is illustrated a second time in *Household Furniture* (1807): pl. XX, no. 1.

EA

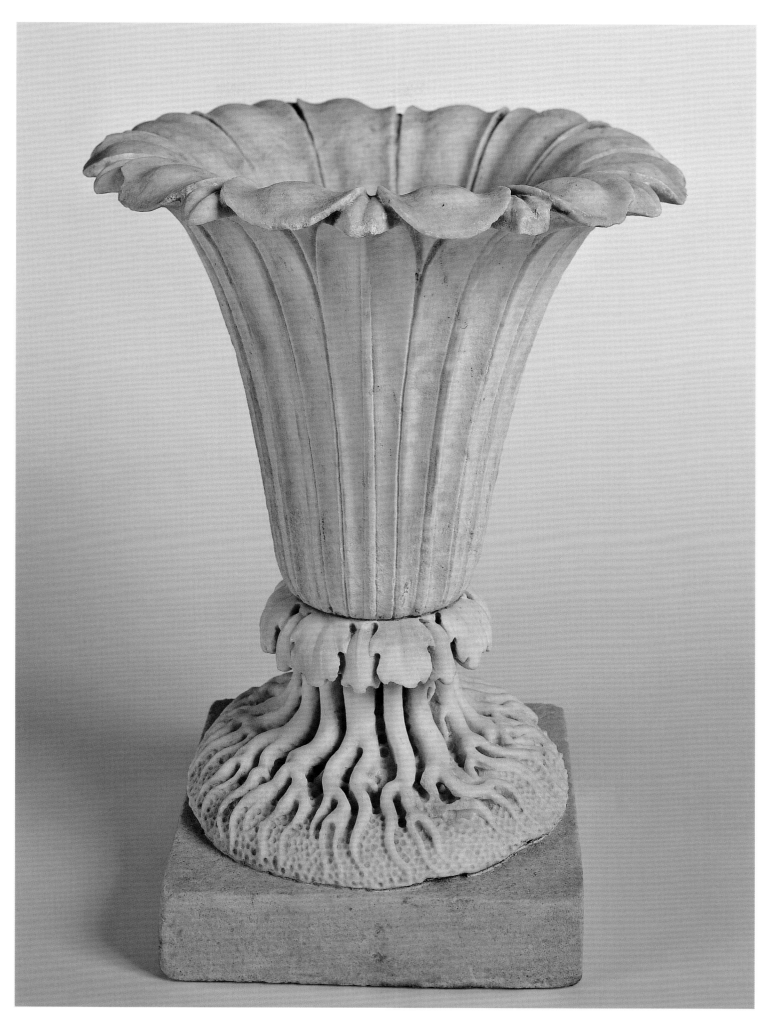

45. *Tripod Table*

Roman, late 17th–18th century
Marble, *Breccia cenerina, alabastro verdignolo listano,
alabastro fiorito*
39 x 25 in. diam. (99 x 63.5 cm)
The Schroder Collection
London only

PROVENANCE: Thomas Hope; by descent, Lord Francis
Hope Pelham-Clinton-Hope; sold Christie's, London,
23–24 July 1917, lot 187; bought by Durlacher for
£199.1; The Schroder Collection.

LITERATURE: Hope Marbles MS (n.d.): pl. 9; Westmacott, *British Galleries* (1824): 228; Fosbroke, *Encyclopedia of Antiquities* (1825): pl. 13; Waywell, *The Lever and Hope Sculptures* (1986): nos. 77, 78, 103–4; Moss, *Roman Marble Tables* (1988): 41 n. 67.

A circular table top of *breccia cenerina* rests on the middle support: a fluted Ionic column fashioned from *alabastro fiorito*, a soft, easily carved limestone.[1] Works made of this stone were esteemed in antiquity, not only because the material's relative rarity commanded a high price, but also because it was exacting to work. Successfully carving the very soft stone required an artisan of great technical virtuosity, using techniques normally associated with gem cutting.

The column has a white marble base and capital, the latter enriched with a stylized flower bud; it is surrounded by a trio of legs made of *alabastro verdignolo listano* worked into graceful S-brackets. Fierce panther heads, menacingly baring their teeth, emerge from acanthus leaves and tail off in elaborate volutes. Below their rounded breasts, a ring marks the transition from animal to botanical decoration. The tripod is set on a stepped plinth of alternating marble types; the first tier of *breccia cenerina*, matching the table top, rests on a broad white marble socle.

Tripods with round table leaves of perishable material were common in Greek households, and in Roman times this type became the most common form of marble furniture.[2] Virtually every Roman three-legged table is supported by legs from which animal heads and chests spring; the protomes, including panthers, swans and lions, were fashioned from a variety of precious materials. The late first century A.D. Roman poet Juvenal described such a piece in one of his *Satires* (XI 120–27), writing of a table resting on a rampant, snarling leopard made of solid ivory.

Ancient table legs are monolithic and consist of the beasts' heads and necks, tapering into animal legs and paws; the awkward join between the two elements is usually masked by a ruff of acanthus leaves. In Hope's example, the legs are divided at the rings; the substitution of vegetation for animal legs manifests this part to be post-classical.[3] The robust panther heads and chests are ancient, however; the tectonically ordered features are carved to an unusually high standard, especially the muzzles. Unusual classical sculptures of polychrome marbles caught the fancy of later sculptors for replication, and the Hope tripod was assembled in post-antique times from disparate marbles, incorporating three ancient protomes.

Tripods supporting round surfaces were primarily placed in the center of peristyles for domestic garden furniture. Since the most conspicuous parts were table leaves and animal legs, these were worked in the finest materials—usually imported stones.[4] The taste for marble pieces such as tables and candelabra (cat. no. 41) flourished in the late first century B.C. and first century A.D. Luxurious furnishings attested to the wealth and status of Roman owners, and the fashion for ostentatious display was just as prevalent in eighteenth-century England. This tripod is impressive in both size and splendor. The sculptor's alternation of contrasting colors fully exploits the decorative value of the stones. A Roman host was judged by his sumptuous *objets d'art*, which added to the atmosphere of elegance and exclusivity in his home. Hope, too, used luxurious furniture to showcase precious antiquities; on this tripod he had illustrated the beautiful, white marble head of a satyr (cat. no. 43) in his Statue Gallery.

1. I would like to thank Annamaria Giusti for the identification of the marble types. For *breccia cenerina*, see Sironi, "Breccia Cenerina" (2001): 165, no. 21. For *alabastro fiorito*, see Maria Cristina Marchei in ibid. (2001): 142–45, no. 5. For *alabastro listanto*, see Marchei, "Alabastro fiorito" (1992): 50, fig. 8.
2. The tripod table was invented in the fourth century B.C. See Moss, *Roman Marble Tables* (1988): 37–38. For many examples of round tables with three animal legs, see ibid., Type 9, 37–43; 54; 705–793, nos. C1–C118. See also Richter, *The Furniture of the Greeks* (1966): 111–12, figs. 567–580; Cohon, *Greek and Roman Stone Table Supports* (1984): pl. A. See Moss, *Roman Marble Tables* (1988): 55–104, for the variety of materials.
3. There are very few exceptions to the rule; see Moss, *Roman Marble Tables* (1988): 39, n. 59. Cf. also Cohon, *Greek and Roman Stone Table Supports* (1984): Type II 47–58, where the ancient animal leg terminates above in a volute. The late 18th-century sculptor Francesco Franzoni carved a panther grotesque, represented before an elaborate vegetal design, see Cohon, *Greek and Roman Stone Table Supports* (1984): 110, 432, app. 3, no. 2. See also the fabrication by Jacopo da Vignola of a table with marble table supports and a table top of rare colored marbles: Gonzáles-Palacios, *Il tiempo del gusto* (1984): fig. 157. Examples of table legs, restored in post-classical times, exist in museums through out the world. For example, Thomas Hollis had a table leg restored from fragments and mounted on a new base; see: Budde and Nicholls, *Catalogue of the Greek and Roman Sculpture* (1967): 110, no. 181, pl. 61.
4. Moss, *Roman Marble Tables* (1988): 101–2, 328–32.

EA

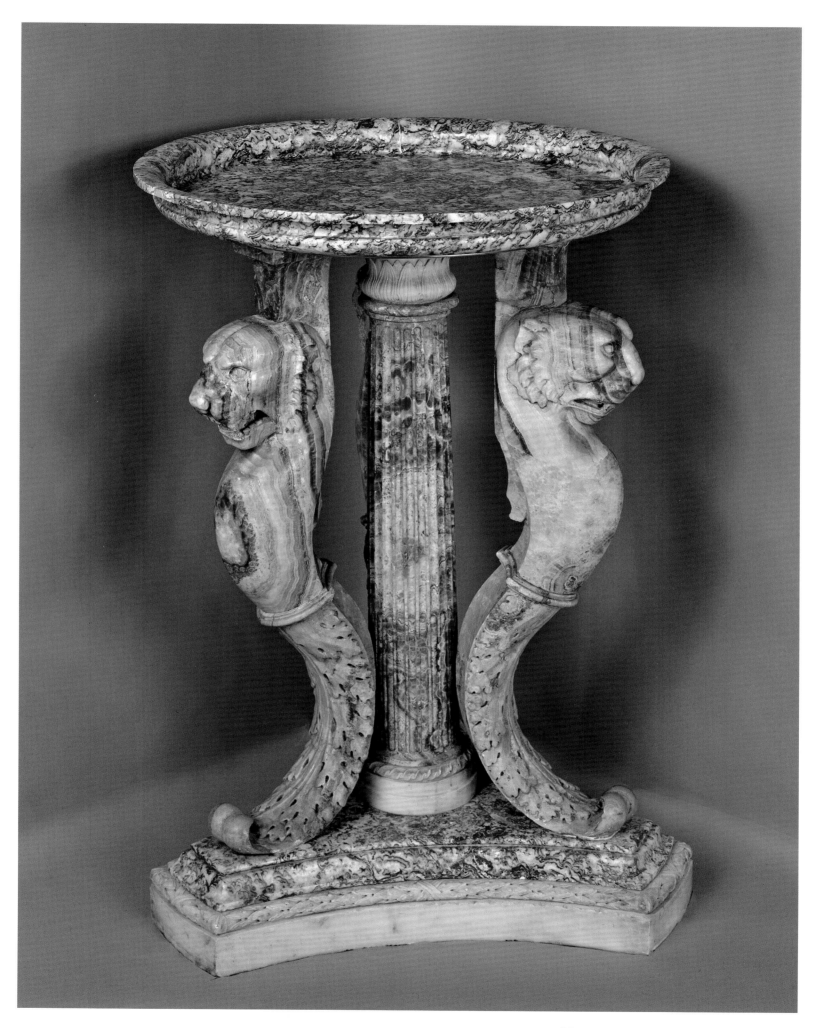

Egyptian and Egyptianizing Sculpture

In ancient Rome, Egyptian statues and figurines were imported and used in new and very different ways from their original contexts, so that figures of different dates that served a number of functions were placed in both domestic and temple contexts. In their new environment, the Egyptian objects lost their original meanings but gained new identities within Roman culture. Ancient Romans soon began to produce their own versions and interpretations of Egyptian sculpture and cult objects, to which later European collectors were drawn, as can be seen in the collections in Italy of Cardinal Albani and the Borghese family and in England in those of Thomas Hope and William Petty, the 1st Marquess of Lansdowne. Indeed, collectors in the eighteenth and nineteenth centuries had much in common with ancient Roman advocates of Egyptian material culture, finding the forms of Egyptian sculpture exotic and even brutal when compared to their classical counterparts. The richly colored stones were sometimes used as an integral part of the decorative schemes of rooms. Hope, for example, painted his Egyptian Room at Duchess Street with the characteristic blues and yellows used in Egyptian temple and tomb architecture.

The Egyptian and Egyptianizing sculptures collected by Hope are typical of objects that were either popular or developed specifically during the Roman or Ptolemaic Period. Like their Roman counterparts from Italy, such items were displayed wholly out of context, often deviating considerably from the Egyptian originals that they copied. It is perhaps a testimony to the appeal of Egyptian culture that such objects could be adopted and then adapted by foreign cultures, even if their forms might have surprised Egyptian artists who made the originals and puzzled the Egyptian priests.

46. *Colossal Foot*

Probably Roman, 3rd–4th century A.D.?
Imperial Egyptian porphyry
19⅖ x 15 x 34⅗ in. (49 x 38 x 88 cm)
Wellcome Institute for the History of Medicine and
Shefton Museum, Newcastle upon Tyne

PROVENANCE: Bought by Thomas Hope for £99 15s at
the 2nd Earl of Bessborough sale, 7 April 1801, lot 46;
by descent, Lord Francis Hope Pelham-Clinton-Hope;
Christie's, London, 23–24 July 1917, lot 229; bought by
Spink for £52.10; sold Sotheby's, 23 July 1925, lot 104;
bought by Sir Henry Wellcome for £40; given/loaned
to the University of Newcastle on Tyne in 1982.

EXHIBITIONS: Spink & Son, *Exhibition of Antique
Sculpture* (1919), no. 31; Spink & Son Ltd., *Greek and
Roman Antiquities* (n.d.), no. 18.

LITERATURE: Douce MS (1812): f. 2; Westmacott,
British Galleries (1824): 214; Spink & Son, *Exhibition of
Antique Sculpture* (1919): 17, no. 31; Spink & Son Ltd.,
Greek and Roman Antiquities (n.d.): 14, no. 18; Delbrueck,
Antike Porphyrwerke (1932): 68–69, fig. 21; Vermeule,
AJA 59 (1955): 141; Vermeule and Von Bothmer, "Notes
on a New Edition" (1959): 333, no. 12; Watkin, *Thomas
Hope* (1968): 36–37; Sotheby's, *Classical Antiquities from
Private Collections in Great Britain* (1986): cat. no. 55,
pl. XI; Waywell, *The Lever and Hope Sculptures* (1986):
100, no. 66, pl. 67, 2–3; Thornton and Watkin, "New
Light on the Hope Mansion" (1987): 163.

A large sculpture in the form of a right
foot, once the centerpiece of the Ante-Room
in Thomas Hope's house in Duchess Street,
elicited these comments from contemporary
visitors: Francis Douce described it as a
"colossal foot of porphyry in the middle of
the room said to be votive and ancient,"[1]
and Charles Molloy Westmacott called the
"votive foot in red porphyry . . . a singu-
larly fine specimen of colossal sculpture,
displaying great anatomical perfection in
the artist."[2]

Red porphyry is a stone native to Egypt
that was quarried at Gebel Dokhan, which
the Romans called Mons Porphyrites in the
Eastern Desert. Abandoned remnants from
the Roman quarries can still be seen at the
site, often carved to a high degree of com-
pleteness. The stone was highly prized by
the ancient Romans, so there are a small
number of examples during the Republican
Period; its use arose during the reigns of

Claudius and Trajan and continued until
the reign of Diocletian.[3] Some examples of
porphyry Roman sculptures, such as the
carved snake on a basin from the temple of
Isis at Benevento,[4] were associated with
Egyptian cult centers. Sarcophagi, vessels,
statues, and even inscriptions in porphyry
have also been found.[5]

Parallels in Egypt include a votive marble
foot on a pedestal, dedicated by a man
named Isidorus to one of the gods at a
sanctuary in Ras el Soda, a district in east-
ern Alexandria.[6] Such votives were made in
honor of Isis, Serapis, and Asclepius in the
Roman world, and it is no coincidence that
these particular deities were often grouped
together in a sanctuary. Votive feet were
not exclusive to Egypt and these particular
deities; other examples have been found
outside Egypt and at sanctuaries of other
gods.[7] Such feet were typically life-size
and manufactured in marble or limestone.
Their inscriptions are in Greek or Latin,
and although clearly associated on a num-
ber of occasions with Egyptian gods, such
objects should be seen as part of the Roman
rather than Egyptian tradition and are typi-
cally found in temples of classical rather
than Egyptian style. The use of porphyry
for the Hope foot was probably meant to
evoke an Egyptian provenance. It is likely
that its original context was either a villa or
an Egyptian sanctuary, perhaps one associ-
ated with Serapis or Isis.

The date of the foot is uncertain; it may
have been made in the third or fourth cen-
tury A.D. or perhaps in more recent times.[8]
If the foot is ancient, it is likely to date to
the first two centuries of Roman rule, when
Egyptian cults enjoyed a special promi-
nence in Italy. The dating problem arises
through a lack of parallels for the piece, a
problem exacerbated by the renaissance of
carving in colored stones during the seven-
teenth and eighteenth centuries, when
copies of Roman portraits and vessels were
produced in porphyry, often with a high
polish in the manner of the Hope foot.[9]
However, the foot seems to make more
sense within a Roman context rather than a
more recent European context. Both the
stone and the subject matter have parallels
in Egyptian sanctuaries in Italy, and the

piece would make perfect sense within such
a setting.

It is easy to see why this particular sculp-
ture would be attractive to a collector such
as Thomas Hope. The object offers a study
that would have been of general interest in
the early eighteenth century, as noted by
Westmacott, and its execution in an Egypt-
ian stone popular during this period would
increase its appeal. Contemporary knowl-
edge that the sculpture had originally func-
tioned as a votive offering, as Douce
pointed out, must also have given the piece
a context. It was perhaps no coincidence
that many of the Egyptian sculptures
copied in the eighteenth century were
Roman in date and often deviated from the
original Egyptian canons, incorporating
features that were more akin to classical
art.[10] In this particular instance the veins
and muscles indicated on the foot give it a
naturalistic appearance.[11]

1. Douce, MS (1812).
2. Westmacott, *British Galleries* (1824): 214.
3. Borghini, *Marmi Antichi* (1997): 274, no. 116.
4. Müller, *Il Culto di Iside* (1972): 98–99, no. 289, pl. 32.2.
5. Malgouyres, *Porphyre* (2003): 26–67.
6. Bianchi, "Images of Isis" (2005): 476.
7. Castiglione, "Tables votives" (1967): 239–52.
8. Malgouyres, *Porphyre* (2003): 35.
9. Ibid., 106–81.
10. Ashton, *Roman Egyptomania* (2005): 180–82.
11. There is plaster restoration to the top of the ankle/leg.
See Delbrueck, *Antike Porphyrwerke* (1932): 68–69.

S-AA

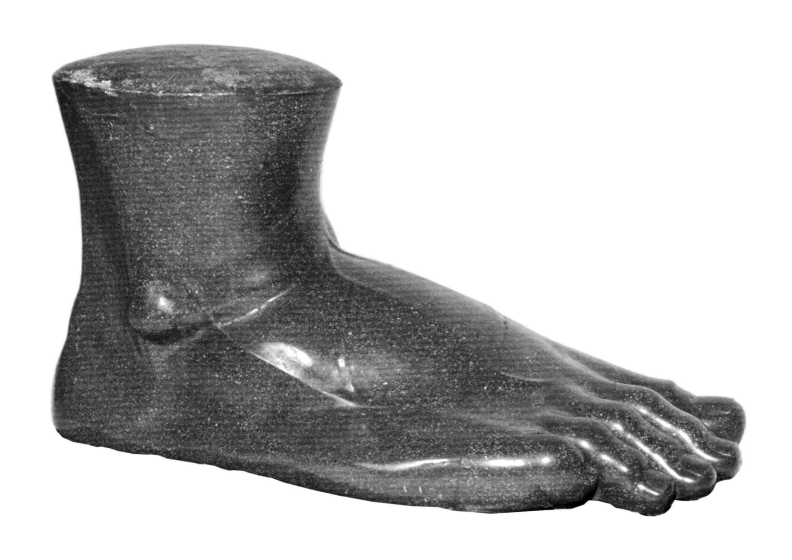

47. *Isis*

Roman, late 1st–early 2nd century A.D.; 18th-century restoration
Marble
24 in. (61 cm)
Phoenix Ancient Art, Geneva and New York
Not in exhibition

PROVENANCE: Sir William Hamilton; his sale, Christie's, London, 27–28 March 1801, lot 41; bought by Thomas Hope for £21; by descent, Lord Francis Hope Pelham-Clinton-Hope; sold, Christie's, London, 23–24 July 1917, lot 215; bought by Mrs. Goetze for £178.10; Alfredo Turchi, Rome; English private collection, 1979; sold Sotheby's, New York, 9 June 2004, lot 30; Phoenix Ancient Art, Geneva and New York.

LITERATURE: Thomas Hope, *Costume of the Ancients* (1809): pl. 23; (2nd ed., 1812): pl. 58; Westmacott, *British Galleries* (1824): 222; Fosbroke, *Encyclopedia of Antiquities* (1825): pl. 17; Hope Marbles (n.d.): pl. [19]; de Clarac, *Musée de sculpture antique et moderne*, vol. 5 (1826-53): pl. 990, no. 2569A; Michaelis, *Archäologische Zeitung*, vol. 32 (1874): 16, no. 19; Michaelis, *Ancient Marbles in Great Britain* (1882): 290, no. 37; Reinach, *Repertoire de la statuaire grecque et romaine*, vol. 1 (1897): 611, no. 8; *Archäologischer Anzeiger* (1935): 683; Waywell, *The Lever and Hope Sculptures* (1986): 86, no. 28, fig. 21; Jenkins, "'Seeking the Bubble Reputation" (1997): 197, ill.

Another Egyptianizing sculpture was housed in the Statue Gallery at Duchess Street, where it was correctly recorded by Westmacott as a figure of Roman Isis.[1] Carved from marble, with the right arm and head now missing, this was described by Hope as "nymph in the old style of attire: from a small statue in my possession."[2] It originally featured paler marble for the bare arms, neck, and head. The subject stands on a rounded base with her right leg forward and her left foot positioned behind; this stance is either Egyptian or more likely an echo of Greek sculpture from the archaic period. During the Hellenistic and Roman Periods, several archaizing movements produced statues that copied the more formal styles of earlier periods. Egyptian striding statues always step forward onto their left foot. If the artist was copying an Egyptian original, he confused this feature. It

seems more likely, however, that the Hope *Isis* is a product of the Roman archaizing tradition.

The statue can be identified as a representation of Isis by the lotus held in the right hand and also by the locks of hair, which fall onto the shoulders. Unlike the more usual corkscrew locks that became associated with Isis during the Roman Period, the hair on this example emulates the loose, long ringlets found on archaic *korai* (maidens) and is tied at the back into a pony tail. The subject wears Greek dress in the form of a chiton and himation; and once again, unusually for Isis, the figure's garment is not knotted. The central fold of the dress, however, is suggestive of the knotted costume worn by Egyptian royal women and priestesses and became associated with Isis; it is partially covered here by the cloak. The stylized folds of the cloak combined with the clinging drapery of the undergarment support the idea that this statue reflects earlier styles. The breasts are prominent underneath the almost transparent clothing but, unlike some later statues of Isis, are not bare.

The fact that this statue does not conform to the usual representations of Isis from the Roman Period helps to date it, because it relates to early to mid-first century Roman representations of the goddess Isis, in particular the archaizing statue of Isis from Pompeii now in the National Museum, Naples (fig. 47-1); such statues were produced before the Roman iconography for the goddess had been fully established.[3] It is likely that Hope's statue of the goddess Isis served as a cult figure in an Egyptian temple of the first century A.D. Its archaizing style is similar to the statue of Isis from her temple at Pompeii, although the appearance of the lotus suggests a second-century date. There are parallels for this motif on statues dated to the Hadrianic Period (A.D. 117–138).

The cult of Isis was another example of the Romans adapting Egyptian iconography for their own purposes. Ironically, the original images of a female figure wearing a knotted costume and corkscrew locks represented Ptolemaic royal women, and thus a member of the very dynasty that was declared an enemy of Rome during the

reign of Octavian/Augustus. Following the Roman conquest of Egypt in 30 B.C., many statues were brought to Italy as souvenirs of the campaign to serve the subsequent Egyptian cults that developed in Rome from the mid-first century A.D. It is easy to see why European collectors would be attracted to such images; they had been tailor-made for Orientalist tastes but in fact meant very little in Egyptian terms.

1. Westmacott, *British Galleries* (1824): 222.
2. Hope, *Costume of the Ancients* (1805).
3. Ashton, *Roman Egyptomania* (2003): 49–63.

S-AA

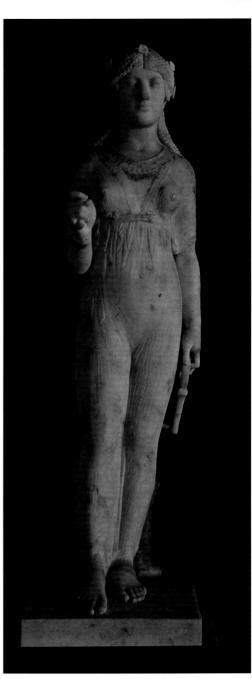

Fig. 47-1. Archaizing Statue of Isis. Marble. National Museum, Naples.

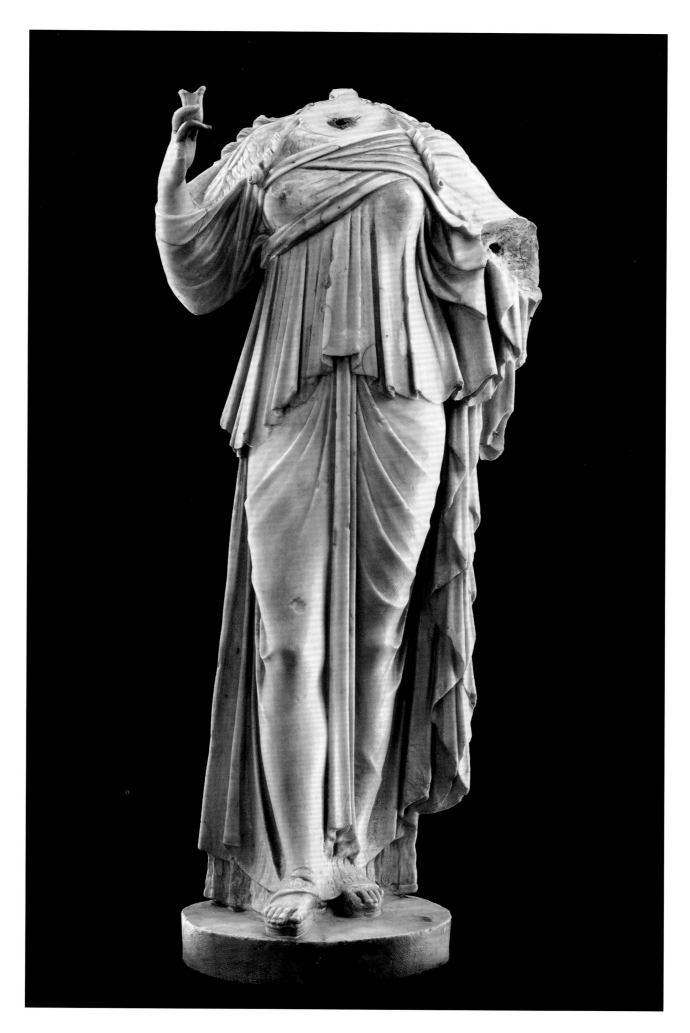

48. *Pharaoh*

Roman, 1st century A.D.
Alabaster (*alabastro fiorito*)
39¼ in. (99.7 cm.)
Chen Art Gallery, Torrance, California

PROVENANCE: Thomas Hope; by descent, Lord Francis Hope Pelham-Clinton-Hope; Christie's, London, 23–24 July 1917, lot 260; bought by Cory for £136.10; sold anonymously by Parke-Bernet, New York, 23–25 September 1954, lot 303; C. Ruxton and Audrey B. Love, from whose collection sold Christie's, New York, 20 October 2004, lot 537.

LITERATURE: *Household Furniture* (1807): pl. VIII; Prosser, *Select Illustrations of the County of Surrey, Deep-dene* (1828); Michaelis, *Ancient Marbles in Great Britain* (1882): 288, no. 25; Watkin, *Thomas Hope* (1968): 48; Waywell, *The Lever and Hope Sculptures* (1986): 56.

Thomas Hope also owned a more traditional form of Roman-Egyptian sculpture in the statue of a pharaoh that he displayed prominently in the Egyptian Room at Duchess Street, where it can be seen in an illustration positioned on top of a pyramidal base designed for it, presumably a reference to its Egyptian style.[1] This striding statue of an Egyptian ruler is carved from a type of alabaster called *alabastro fiorito,* which comes in a variety of different colors ranging from red and brown to yellow.[2] It is thought that this stone was quarried in Asia Minor (Turkey) and is not unlike the Egyptian alabaster that was found in the Nile Valley; the main difference between the two types is that the grain of *alabastro fiorito* has a more linear appearance than the Egyptian version.[3]

Unlike the Isis figure, this statue is wholly Egyptian in style, as indicated by the back pillar to the mid-shoulder level and the garment traditionally used in representations of the kings of Egypt. The subject wears a plain kilt and nemes head cloth with a partially carved uraeus (rearing cobra) on the brow; this symbol was believed to protect the subject, and it also indicates that he is of royal status. The styling of the headcloth, which is modeled around the shape of the skull, with a prominent fold forming the lappets, is copied from a statue found at the Emperor Domitian's villa at Monte Circeo.[4] The figure strides forward onto his left leg in the traditional Egyptian stance, and in his hands he holds enigmatic bars (whose function is uncertain). The tiered base is unusual in Egyptian sculpture. Another unusual feature is the heavily modeled torso, which shows clearly defined muscle groups. A closer look at the back of the statue reveals that the pigtail on the headdress is unevenly carved and unfinished. Another anomaly is that the buttocks are not evenly positioned and appear naked rather than being covered by the kilt. This may suggest that the artist was more familiar with the conventions used for classical male figures, which are typically shown naked or semiclad with drapery.

The statue also appears to lean forward and slightly to its right, another trait of Egyptian-style sculpture produced in Rome, like the statues of the Emperor Domitian at the sanctuary of Isis at Benevento and a group of marble statues of Egyptianizing figures from the Emperor Hadrian's villa at Tivoli.[5] The headdress also deviates from the more usual shape of the nemes headcloth, and the snake is either unfinished or misunderstood by the artist. The facial features copy a form of "portrait" that was common in the fourth to first century B.C., during the rules of the Thirtieth and Ptolemaic Dynasties.[6] The eyebrows are naturalistic; the eyelids are heavy; the nose is small and straight and the mouth is forced into a smile. The features do not form an identifiable portrait type of a Roman emperor, and it is possible that the sculpture was not intended to be a portrait of a specific ruler. The stone used for this representation and the carving anomalies suggest that this sculpture was made and found in Italy.

There are other examples, of similar proportions, of this type of generic "pharaoh" from Italian contexts. A larger statue carved in basalt was found at the Syrian sanctuary on the Janiculum in Rome.[7] This particular example copies a Twenty-sixth Dynasty original, as revealed by the teardrop muscles around the navel. Three other examples, with crowns, from the Villa Cassius date to the second century

A.D.[8] Their proportions are relatively unlike Egyptian originals, and the two complete examples twist where the sculptor has struggled to incorporate the back pillar and negative space between the stride. A slightly larger statue, probably dating to the Hadrianic Period, shares Roman features with the Hope pharaoh. The statue, which is in a private collection, is made from steatite, and like the Hope statue, some features are asymmetrical. The facial features also attempt to copy Ptolemaic examples, but the slight curl of the upper lip and the way in which the nose is carved reveal a non-Egyptian hand.[9]

By A.D. 130 this type of representation had become associated with the Egyptian cult of Hadrian's deceased male lover Antinous. As with some of the early representations of Domitian as pharaoh, the images of Antinous often bear his portrait. The new use of this form of statue made little sense in the Egyptian tradition but shows an innovative development during the Roman Period. The statues of Antinous as pharaoh are from Hadrian's villa at Tivoli.[10] The high polish and greater deviation from the traditional Egyptian canons suggest that this group is later in date than the Hope Pharaoh, which can probably be dated to the late first century A.D., perhaps more specifically around the time of the Emperor Domitian who was a great patron of Egyptian cults in Italy. Such statues were Roman copies, probably of originals that had been imported to Italy after the Roman conquest of Egypt. They often appear in pairs as mirror images, which meant that one statue would stride forward onto its right foot in a manner not seen in Egypt.[11]

Since similar statues were produced in the eighteenth century, it has been suggested that the Hope pharaoh might be modern,[12] although at this time artists created "Egyptian" statues with a more naturalistic stance, often without a back pillar.[13] The popularity of the Antinous statues may have influenced collectors of earlier Roman "pharaohs" to select this form of sculpture for their collections. There is no question that the Hope pharaoh fits more comfortably within the Roman-Egyptian repertoire, as in the reign of the Emperor Domitian,

which saw a renaissance of Egyptian cults in Italy. Perhaps the best-known sanctuary renovation during this reign was the Iseum Campense in Rome, and Egyptian statues were also found at the emperor's villa and the sanctuary of Isis at Benevento, as already noted. It was perhaps the relatively classical features of this type of Roman-Egyptian statue that appealed to Hope as a collector, for two of his other "Egyptian" sculptures had been adapted by the Romans for a Western audience.

1. Hope, *Household Furniture* (1807): pl. VIII. It was later moved to the Deepdene where Prosser recorded "Egyptian figures in dark-veined marble," suggesting a pair.

2. Borghini, *Marmi Antichi* (1997): 142–43, no. 5.

3. Ibid., 141–42, no. 4.

4. Roullet, *Egyptian and Egyptianizing Monuments* (1972): 101–2, no. 157, fig. 176.

5. Grenier, *La Décoration statuaire* (2003): 176–85.

6. Ashton, *Roman Egyptomania* (2003): 13–23, and "The Ptolemaic Royal Image" (2003): 213–24.

7. Manera and Mazza, *Le collezioni egizie* (2001): 51, no. 10.

8. Roullet, *Egyptian and Egyptianizing Monuments* (1972): nos. 141–43, figs. 160–62. They are now housed in the Vatican Museums.

9. Bianchi, *Cleopatra's Egypt* (1988): 250–51, no. 138.

10. Ashton, *Hadrian: Emperor and Pharaoh* (forthcoming, 2007).

11. See, for example, the colossal granite statues of Antinous from Hadrian's Villa at Tivoli, now in the Vatican Museums.

12. Michaelis, *Ancient Marbles in Britain* (1882): 288, no. 25.

13. Borghini, *Marmi Antichi* (1997): 142–43, no. 5.

S–AA

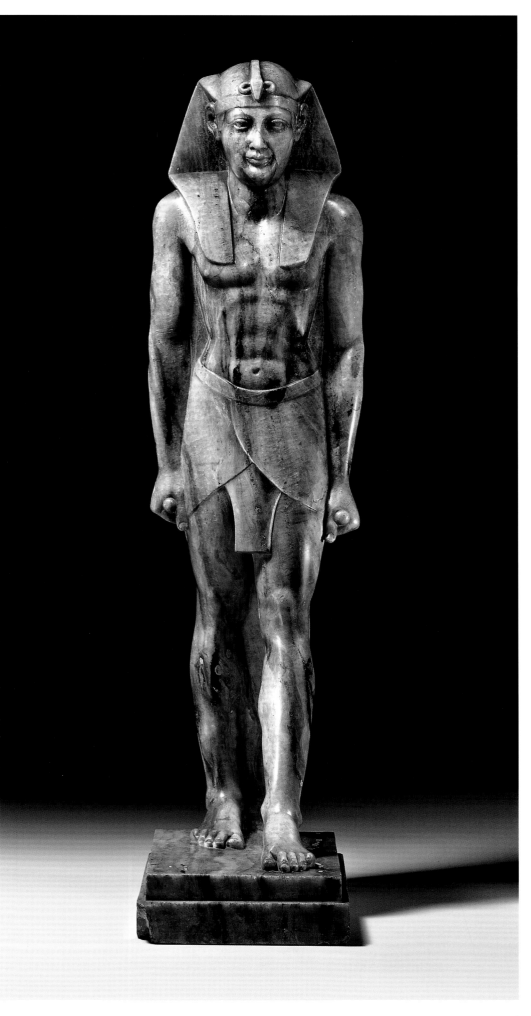

49. *Lion*

Egyptian, Ptolemaic Period (323 B.C –30 B.C.) or 18th century
Basalt, Imperial Egyptian porphyry
13 x 32⅖ in. (33 x 82 cm)
National Museum of Ancient Art, Lisbon, MNAA 760

PROVENANCE: Sir William Hamilton; sold by him, Christie's, London, 27–28 March 1801, second day, lot 44; bought by Thomas Hope for £57.15; by descent, Lord Francis Hope Pelham-Clinton-Hope; Christie's, London, 23–24 July 1917, lot 176; bought by Kevorkian for £630; acquired by Calouste Gulbenkian; donated by him in 1951 to National Museum of Ancient Art, Lisbon.

LITERATURE: *Household Furniture* (1807): pl. XVI, no. 2; Westmacott, *British Galleries* (1824): 215; Desroches-Noblecourt, *Les Animaux dans l'Egypte Ancienne* (1978); Waywell *The Lever and Hope Sculptures* (1986): 41, n. 34; Jenkins, "Seeking the Bubble Reputation" (1997): 198, ill.; *Calouste Sarkis Gulbenkian* (2001): 34–35, no. 10.

The dating of this basalt figure of a recumbent lion is problematic, for it could have been produced either during the ancient Roman Period in Egypt or in the eighteenth century. It was housed in the Egyptian Room at Duchess Street, where, as Westmacott noted, "under a table lies a lion of the same material [i.e. basalt]."[1] The surface of the sculpture shows signs of a dark waxy deposit, probably boot polish, which was often added to darken stone sculptures in the eighteenth, nineteenth, and early twentieth centuries. The porphyry base, specially cut for the lion, must be an eighteenth-century addition, for it is not usual with ancient Roman examples. We cannot know whether the base was made for Hope or whether he believed it was ancient.

A recognized group of Roman copies of Egyptian statues carved from the same stone as the Hope lion dates to the Hadrianic Period (A.D. 117–138) and is associated with Hadrian's villa at Tivoli.[2] This dark green stone, often described as gray, was used by Egyptian sculptors from the Old Kingdom and remained in common use for statuary throughout Egyptian history, but particularly during the later periods.[3] An imported human-headed sphinx of the Egyptian king Amasis was brought to

Rome, probably in the first century A.D., and was subsequently copied.[4] To add to the confusion, artists often copied Roman copies of Egyptian originals during the eighteenth century. This was the case at the Villa Borghese, where there are two basalt sphinxes whose features differ slightly; the overwhelming distinction is that one has claws on its feet, a characteristic that suggests it is a modern copy.

The Hope lion is extremely well preserved, but there is a break running along the front, which separates the front legs from the body, and a fine crack running along the chest. The tail is wrapped around the lion's right haunch, and the ribs are visible on both sides. The lion has a stylized mane covering his chest with a more naturalistic representation of the mane on top of the head. The ruff around his chin and neck is reminiscent of the Twenty-fifth Dynasty manes of royal sphinxes, which are copies of Middle Kingdom sculptures. The carving of the face is stylized and the eyes are prominent, with folds of skin beneath and around the muzzle. There is a particularly noteworthy feature at the mouth, which may suggest that this sculpture was made considerably later than the Roman Period. The mouth is carved, but in the center is a small round buttonlike attribute, which is suggestive of the end of a pipe. It is possible that the model for this sculpture was a lion that had been turned into a fountain.[5] The Romans seem to have been particularly fond of using representations of Egyptian gods in this way, a practice that continued into the eighteenth and nineteenth centuries.[6] It is possible that this sculpture was produced during one of these later periods as a copy of a Roman original. Unlike human figures, it is difficult to distinguish modern representations of animals from ancient ones. None of the Roman examples I have studied have this feature at the mouth. The naturalistic carving of the mane at the top of the head is a feature of lions made during the New Kingdom and Late Period; this suggests that the sculptor used more than one source for his model.[7]

In Egypt lions were placed in pairs at entrances to temples and sanctuaries. Often associated with the ruling king as symbols

of power and force, the lions were typically positioned with crossed paws and with their heads turned toward the viewer. However, during the Late and Ptolemaic Periods, lions were more often shown in the stance of the Hope lion, facing forward with front paws placed on the ground. It is highly likely that this statue was one of a pair. If it is Roman in date, it could have been used as part of the decoration of an Egyptian sanctuary in Italy. The sculptor seems to have used different forms as a model. Such objects were also keenly collected during the eighteenth century and served as guards of doorways in villas such as at the Villa Borghese, or they were made to form a pair with an original ancient statue.

1. Westmacott, *British Galleries* (1824): 215.
2. Ashton, *Roman Egyptomania* (2004): 176–85.
3. De Putter and Karlshausen, *Les Pierres utilisées* (1992): 51–54.
4. Roullet, *Egyptian and Egyptianizing Monuments* (1972):133 no. 279, fig. 291.
5. Lembke, *Das Iseum Campense in Rom* (1994): pls. 29–30.1 and 2.
6. Ashton, *Roman Egyptomania* (2003): 174–75.
7. See, for example, the two lions with crossed paws from the Iseum Campense in Rome; Roullet, *Egyptian and Egyptianizing Monuments* (1972): 131–32, nos. 273, 274, figs. 279–283.

S–AA

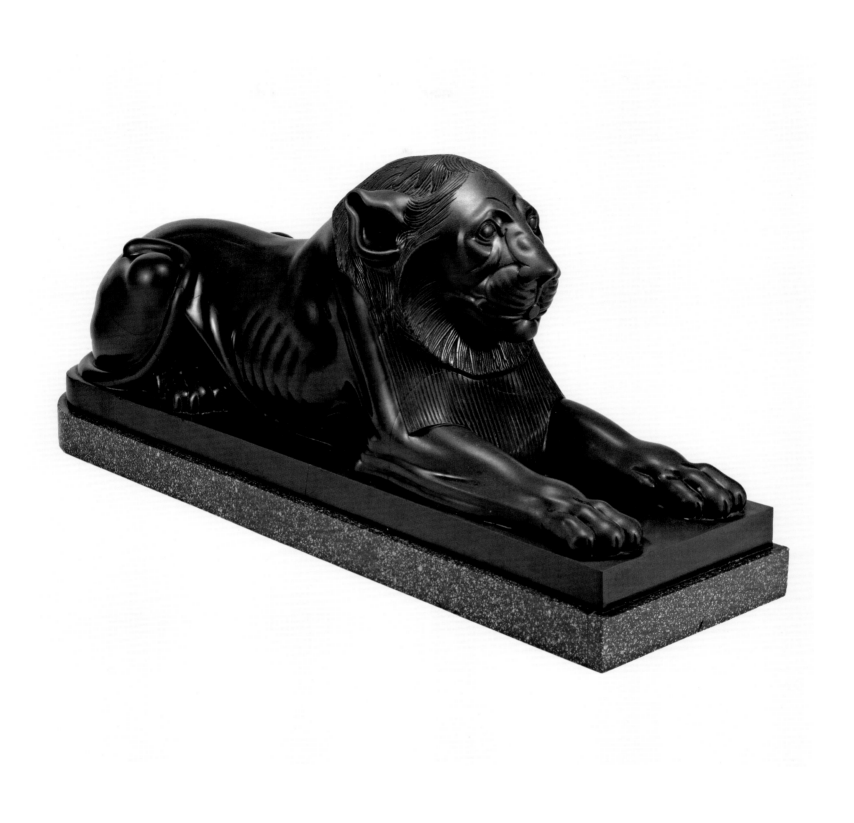

50. *Djed Hor*

Egyptian, Ptolemaic Period (323 B.C.–30 B.C.)
Basalt
21¼ x 5¼ in. (54 x 14.5 cm)
Inscribed with hieroglyphic text
Calouste Gulbenkian Museum, Lisbon, 403
London only

PROVENANCE: Thomas Hope, by descent, Lord Francis Hope Pelham-Clinton-Hope; sold Christie's, London, 23–24 July 1917, lot 173; bought by [Dugantz] for £388.10; acquired by Calouste Gulbenkian; Museu Calouste Gulbenkian.

LITERATURE: *Household Furniture* (1807): pl. VIII; Westmacott, *British Galleries* (1824): 216; British Museum, *Ancient Egyptian Sculpture Lent by C. S. Gulbenkian* (1937): 8–9, 20–21, cat. no. 11, pls. XV, XVI; National Gallery of Art, *Egyptian Sculpture from the Gulbenkian Collection* (1949): 29, cat. no. 21, illus. p. 63; Palacio Pombal, Oeiras, *Obras de Arte da Coleccao Calouste Gulbenkian* (1965): no. 21.

The basalt statue of the priest Djed Hor[1] in the Hope collection is a Ptolemaic original made at some time between the death of Alexander the Great in 323 B.C., when Ptolemy I took control of Egypt, and the death of Cleopatra in 30 B.C. The fact that the statue is inscribed on the base with the name of its subject, Djed Hor, suggests an earlier rather than a later date during this long period. Statues after the third century B.C., including those of rulers, are rarely inscribed; the only exception seems to date from the end of the Ptolemaic Period, during the reign of Ptolemy XII, whose representation as king of Egypt is accompanied by a Greek inscription. Because this type of "portrait," which mimics that of the rulers, was common throughout the entire Ptolemaic Period, it is difficult to date Hope's piece with any certainty.

Priests were extremely important during the Ptolemaic Period and seem to have enjoyed an increase in power during the early part of this dynasty. The royal family depended on the Memphite priesthood in particular to advise on religious policy and presentation to Egyptians. The Ptolemaic Period as a whole saw an expansive program of Egyptian temple building, and decrees such as the Rosetta, more famous for its part in cracking the hieroglyphic code, illustrate the relationship between the royal house and the native Egyptian priesthood.

Hope's statue of Djed Hor wears a type of headdress known as a bag wig, which was extremely common in the early Ptolemaic Period, often appearing on representations of priests.[2] The face is modeled in the usual Ptolemaic fashion, with rounded cheeks, a forced archaizing smile, narrow eyebrows, and eye lines around the lids. The torso is softly modeled and has a fleshy rather than toned appearance. The two hands are held flat against a *naos* (shrine), which rests on the subject's knees. Inside the shrine is a standing figure of Osiris, the Egyptian god of the afterlife, shown in his usual mummiform stance, wearing the atef crown; his arms, crossed over his breast, hold a crook and flail.

The surface of the statue is roughly finished, with tool marks visible over much of the surface. No drapery is shown, although the subject would have worn a short kilt; the feet and hands are fully rendered, but there is little other finished detail, apart from the facial features and the inscription at the sides of the base. To the modern viewer this statue is unfinished, but surface polishing seems not to have been important during the Late and Ptolemaic Periods, when a number of statues, both private and royal, were left with tool marks visible on the surface; in some the feet and hands were not fully carved.[3]

Statues of this form first appeared during the Eighteenth Dynasty but seem to have increased in number during the Late and Ptolemaic Periods. Priests were shown either standing or kneeling with a figure of the god with whom they were associated in a small shrine. In this way the priest awarded honor and protection to the god, and it was assumed that the deity would reciprocate by offering protection of the suppliant.[4] Many priests were shown with a representation of Osiris in the shrine, a form known as Osiriphoros figures and often associated with the commemoration of the deceased.[5]

Roman versions of this form of statue were produced in Egypt and copies were made in Italy, presumably representing the Egyptian priests there who served cults of their gods. The closest parallel is a basalt kneeling *naophoros* (shrine bearer) with the image of Osiris, dating to the Late Period and identical in form to Hope's statue but larger, measuring 98 centimeters (38¾ in.) and finished more completely.[6] Other examples of this form of statue have been found in Rome, and a number were restored in the seventeenth century, supporting the idea that *naophoroi* were popular with collectors.[7]

Seated on a pedestal in front of one of the dummy side doors of the Egyptian Room, it reflected a second similar basalt of Djed Hor.[8]

1. See Westmacott, *British Galleries* (1824): 216.
2. Cf. Ashton, "Ptolemaic Royal Sculpture" (2001): 84–85, no. 7.
3. Clearly to the owner of this statue, the facial features, inscription, and god within the shrine were the necessary elements to present. The marks indicate that a point chisel was used on this statue, while the final step would have been to sand the surface down to create a polished finish.
4. Bianchi, *Cleopatra's Egypt* (1988): 128, no. 33.
5. See, for example, Bothmer, *Egyptian Sculpture of the Late Period* (1960): nos. 28, 38, 44.
6. Now in the National Museum, Naples, the statue is thought to have come from Rome; it appeared in an inventory of the Farnese Collection in 1568. See Roullet *Egyptian and Egyptianizing Monuments* (1972): 113, no. 194 and figs. 221, 222.
7. Ibid., 113–15, nos. 195–200, figs. 223–230.
8. Now in the British Museum, London.

S-AA

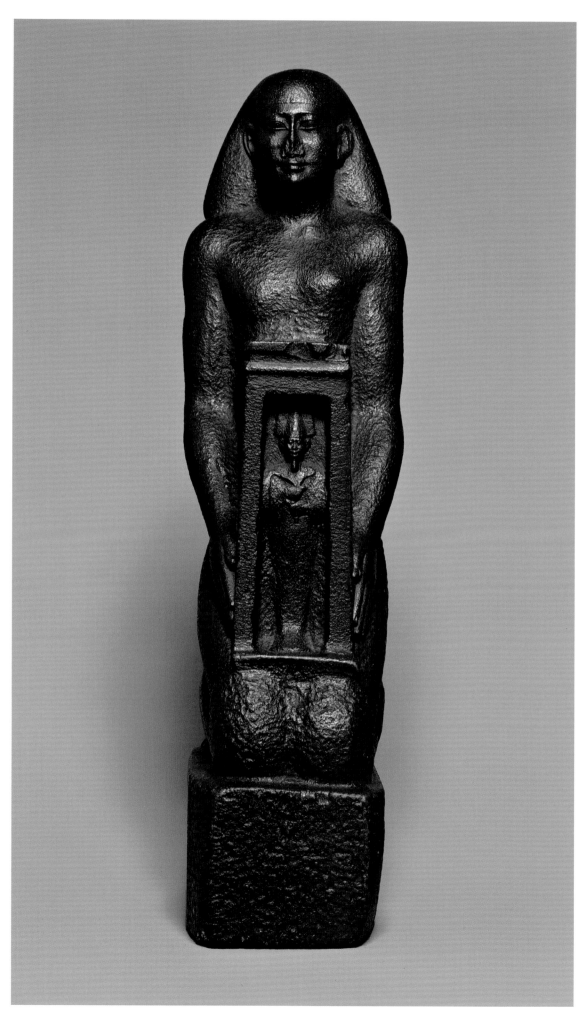

51. *Two Canopic Jars*

Egyptian, Third Intermediate Period (1069–664 B.C.)
Alabaster
National Museums Liverpool, Lady Lever Art Gallery,
X.2155, X.2156

PROVENANCE: Thomas Hope; by descent, Lord Francis
Hope Pelham-Clinton-Hope; sold Christie's, London,
23–24 July 1917, lot 172; bought by F. Partridge for
£215.5; William Hesketh Lever, 1st Lord Leverhulme;
Lady Lever Art Gallery.

LITERATURE: Hope, *Household Furniture* (1807):
pl. VIII; Douce MS (1812): f. 2; Hope Marbles MS (n.d.):
pl. 30; Westmacott, *British Galleries of Painting and
Sculpture* (1824): 216; Waywell, *The Lever and Hope
Sculptures* (1986): 17, figs. 35, 36.

The four so-called canopic jars from the
Egyptian Room at Duchess Street, three of
them inscribed, are carved from Egyptian
alabaster and are of different sizes. Douce
observed of them in 1812: "figures of canopy
in the corners on pedestals, with the head of
a fox, a hawk, an ape and a man. These are
all very good," while Westmacott recorded
"four canopuses in Oriental alabaster,
antique, three of these very singular relics
of antiquity have hieroglyphs on their bod-
ies."[1] The two jars loaned to this exhibition
are the jackal-headed Duamutef and the
falcon-headed Qebehsenuef.[2] (The two
other jars are the human-headed Imsety and
the baboon-headed Hapy.) The animal and
the identity were not always fixed, for Dua-
mutef and Qebehsenuef seem to have been
interchangeable. Together these four figures
represented the four sons of Horus, and in
each of the jars a specific part of the viscera
would be placed and protected. Even when
internal organs were replaced in the body,
the jars were sometimes still used as sym-
bols of protection. Statues of the sons of
Horus can also be found at the corners of a
coffin to protect the deceased. The Hope
jars date to the Third Intermediate Period,
as indicated by the taller vessel form and
the four different heads. During earlier
periods, simple jars were used or squatter
forms of vessels with human heads.

The appeal of such objects for the collec-
tor is easy to understand, for the stone is
quite spectacular with its translucent quali-
ties, and the different forms of heads would
have added to their attraction. The contents
of such objects were probably removed
before being sold to collectors, though
examples in many museums contain rem-
nants of their original fillings. Although
such vases were made to contain the viscera
of mummified corpses, they were mistakenly
identified by classical writers as representa-
tions of Canopus, the pilot of Menelaus who
was buried near the Egyptian coastal city of
Canopus. There was said to have been a cult
dedicated to Canopus, and the Romans
believed that a vase with a human head was
associated with this mythical Greek charac-
ter. There appears to be no actual link
between what we now call Canopic jars and
Canopus, but the name has stuck.[3]

Once again we find a subject matter that
was relevant and appealing to the Romans,
who manufactured cult statues in the form
of Osiris-Canopus and Isis-Canopus.[4]
Recent scholarship has shown that the
Egyptians saw such vases not as links to
Canopus or indeed as jars used for viscera,
but rather as relics. It seems possible that
the Roman priests, like the classical histori-
ans and early Egyptologists, misinterpreted
this Egyptian cult object. This new god
became a popular icon in both Egypt and
Italy, and there are many examples in clay
and stone. Coins were also minted with
images of the jars on the reverse.[5] One
such example minted in Alexandria during
the reign of the Emperor Hadrian suggests
that there was a shrine or temple dedicated
to Osiris and Isis in a jar. Stone versions of
such cult statues were found at the temple
of Isis at Ras el Soda in Alexandria. Egyp-
tian priests holding such effigies have also
been found off the coastline of Alexandria
and at Benevento in Italy, demonstrating
that the cult was extremely popular during
the first century A.D.[6]

1. Westmacott, *British Galleries* (1824): 216.
2. According to a label accompanying the vases, these
two vases were among the first Egyptian objects to
arrive in France in 1719, when they were engraved for
Jean-Bernard Montfaucon.
3. Taylor, *Death and the Afterlife in Ancient Egypt*
(2001): 65.
4. Bianchi, *Cleopatra's Egypt* (1988): 248-249, no. 136.
5. Ashton. *Roman Egyptomania* (2003): 70–71, nos. 37, 38.
6. Ibid., 68–69, no. 36.

S-AA

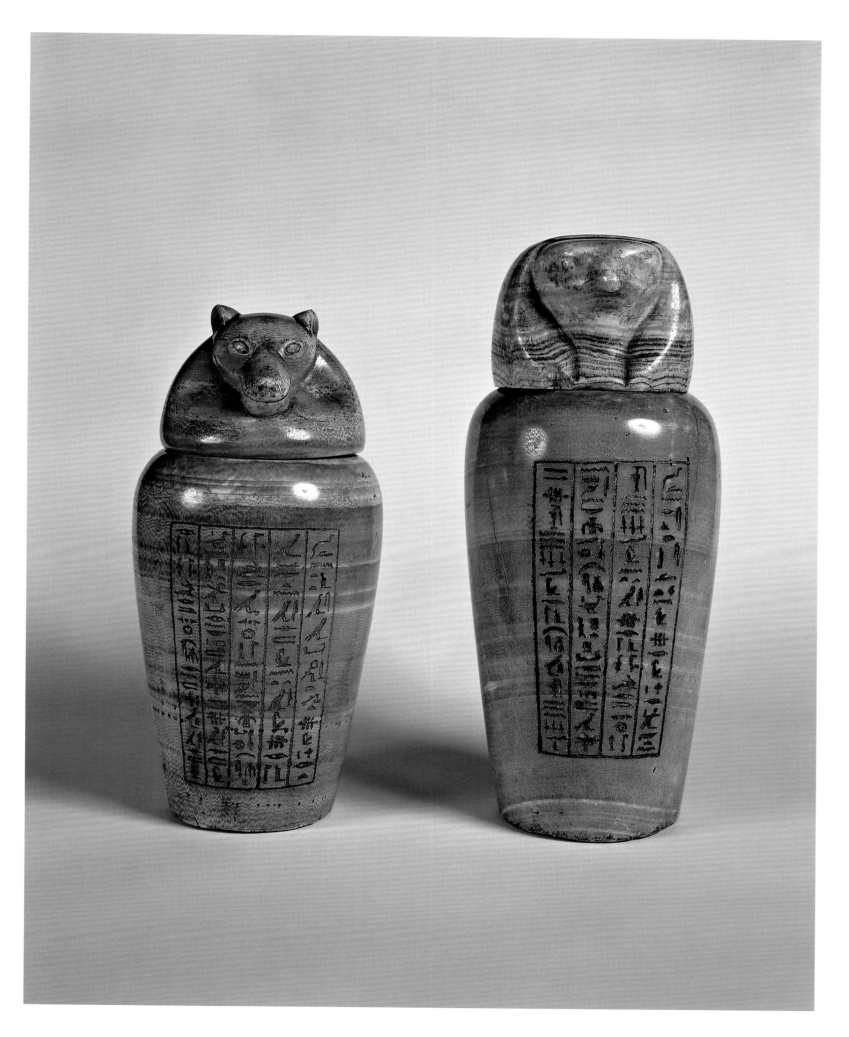

Classical Vases

52. Bell-Krater: Apollo Riding a Swan

Attributed to the Meleager Painter
Greek, early 4th century B.C.
Terra-cotta
12⅗ x 13⅗ x 14¼ in. (32 x 34.5 x 36 cm)
Trustees of the British Museum, GR 1917.7-25.2
London only

PROVENANCE: Sir William Hamilton; bought by Thomas Hope; by descent, Lord Francis Hope Pelham-Clinton-Hope; sold Christie's, London, 23–24 July 1917, lot 98; bought by Spink for £84; The British Museum, London.

LITERATURE: Tischbein, *Collection of Engravings*, vol. 2 (1793): pl. 22; Tillyard, *The Hope Vases* (1923): 96–97, no. 162, pl. 26; Metzger, *Les représentations dans la céramique attique du IVe siècle* (1951): 171, no. 26, pl. 24,2; Beazley, *Attic Red-Figure Vase-Painters* (1963): 1410, no. 16; Lambrinudakis and Bruneau, "Apollo" (1984): 227, no. 343; Hermary, Cassimatis, and Vollkomer, "Eros" (1986): 903, no. 611; Carpenter, Mannack, and Mendonca, *Beazley Addenda* (1989): 374; Queyrel, "Mousa, Mousai" (1992): 673, no. 154; Jenkins and Sloan, *Vases and Volcanoes* (1996): 186, no. 62b; Curti, *La bottega del pittore di Meleagro* (2001): 40–41, table 7.8; 46, table 11; 45; 113, no. 31, pl. 30; Kathariou, *Workshop of the Meleager Painter* (2002): 17, 217, no. Mel 38, fig. 36A, pl. 16B.

Many Greek vessels had been found in tombs, and Thomas Hope re-created their original setting in his house on Duchess Street by placing them in cupboards and shelves in his tomblike rooms as reminders to visitors of their sepulchral significance (see *Household Furniture* [1807]: pls. III, v).

Greeks drank their wine diluted with water—a favorite proportion was one part wine to three parts water—mixed at the table in large, wide-mouthed bowls, called kraters, from which the cups were filled. A bell-krater takes its name from its inverted bell shape. The Hope example, with its round, slightly upcurved handles, is typical of bell-kraters from the third quarter of the fifth century B.C. on, when manufacture of this type grew considerably.[1] By the end of that century and throughout the next, it was the most common large vase shape produced in the Attic red-figured technique. Laurel leaves embellish the bell-krater's flared lip; the body sits on a simple foot, with the figures set above a ground line of running meander pattern, interspersed with checkerboard squares. On the reverse, there are three figures draped in mantles; these figures are customary for obverse decoration (see cat. no. 53).

The scene shows Apollo, god of light and music, descending to earth mounted on a swan; he plays the lyre, his customary musical instrument. The deity wears a mantle, elaborately laced boots, and a wreath of laurel, his sacred plant, confined by a diadem. At the center, a large palm tree with outspread fronds springs from a small mound of earth. To its right, a seated woman, also holding a lyre, turns toward the approaching deity. She wears a chiton with a richly embroidered border and bodice, a crown, and jewelry.

Farther to the right stands a nude satyr, a creature combining human and goat characteristics; he wears a wreath and holds a *thyrsus* (staff) entwined by vine and ivy and usually tipped with either a pinecone or leaves. Stepping forward, he offers Apollo a fillet (in white, now flaked); the crescent moon appears above his outstretched arm. Left of Apollo, another woman—dressed and coiffed like her companion, but with a fillet in her hair—places her foot on a rock

and stoops to retrieve another fillet with her left hand. A hare crouches beneath the swan.

Unusual iconography was popular in the fourth century B.C. Here the palm (a rare Apolline attribute) clearly identifies the setting as Delos, where Apollo was born under such a tree. The swan relates to an episode just before the god's birth, when the island was encircled seven times by a flock of swans.[2] The identity of the two ladies has been debated. They are Muses (goddesses of poetry, the arts, and the sciences), since Apollo was Musagetes, leader of the Muses.[3] The satyr's presence is quite typical, as he was a follower of the god Dionysus, associated with wine and a favorite subject of fourth century B.C. vase painters (cf. cat. no. 53).[4]

Red-figure vase painting, in which lighter figures are set against a black background, was invented around 530 B.C. and became very popular during the course of the fifth and fourth centuries. In the modern analysis and attribution of Athenian vases, we owe much to the brilliant Sir John Beazley (1885–1970). Through close study and connoisseurship, he created a classification of works produced by individual painters and workshops that forms the cornerstone of today's knowledge. His system of analyzing formal details and repetitions of identical mannerisms pinpointed the subtleties of each painter's unique style.

Beazley attributed this vase to the Meleager Painter, who takes his name from portrayals of scenes of the hunting hero.[5] This artist and his workshop, active in the early decades of the fourth century B.C., decorated a wide variety of pottery shapes—especially large kraters.[6] Many works were discovered in northern and southern Italy; the Hope vase was unearthed in S. Agata dei Goti, in the southern province of Benevento.[7] Among the "trademarks" of the Meleager Painter are a fondness for lavish textiles, spiral curls before the ears, and prominent eyes (rendered in profile), whose large pupils, set directly under the upper lids, also join to the lower lids. Heads are rather crude and the drawing is naïve. Here the palm tree sways unsteadily, and Apollo is not actually mounted on the swan; instead, his head and legs seem to be stuck on. Yet the movement

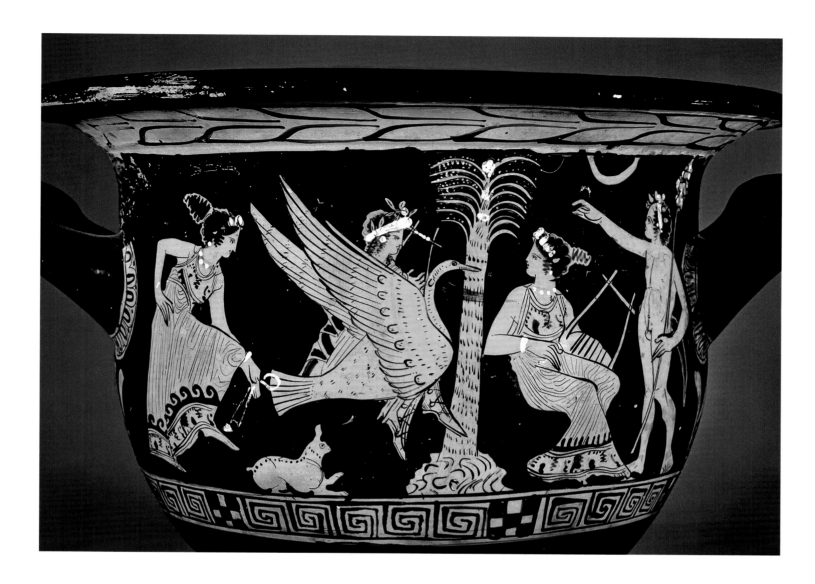

of both fowl and folk is convincingly spritely, and the impressionistic brush work adds a vibrancy and charm to the scene.

1. For the two types of bell-kraters, see Moore, *Attic Red-Figured and White-Ground Pottery* (1997): 31–33.
2. For the interpretation of the scene as Apollo's birth on Delos with literary sources, see Curti, *La bottega del pittore di Meleagro* (2001): 78; Pollard, *Birds in Greek Life and Myth* (1977): 145–46. The palm tree is an infrequent Apolline attribute; see Lambrinudakis and Bruneau "Apollo" (1984): 214. Some scholars recognize the scene as Apollo's annual return from the land of the Hyperboreans (a legendary race of Apollo worshipers living in a paradise in the far north) to Delphi; see Metzger, *Les représentations dans la céramique attique* (1951): 168–75; Lambrinudakis and Bruneau, "Apollo" (1984): 227–29, nos. 343, 344, 320; Zaphiropoulou, "Hyperboreoi" (1997): 641–43, nos. 1–5. The palm tree is not indigenous to Delphi. For the god's return from the Hypberboreans, see a scene with a different mode of transport (a griffin) and a different setting (minus palm tree): Metzger, *Les représentations dans la céramique*

attique (1951): 169–70, nos. 21–23; Lambrinudakis and Bruneau, "Apollo" (1984): 229–30, nos. 365, 368.
3. First proposed by Beazley, *Attic Red-Figure Vase-Painters* (1963): 1410.16. Curti, *La bottega del pittore di Meleagro* (2001): 78, follows Beazley. Also Queyrel, "Mousa, Mousai" (1992): 673 no. 154. The ladies on the Hope vase cannot be maenads (female participants in rites of Dionysus, the god of wine and ecstasy), because they do not carry *thyrsi* (cf. cat. no. 53). Apollo does appear with maenads, see Lambrinudakis and Bruneau, "Apollo" (1984): 273, nos. 717–722. See also a vase in the British Museum, inv. no. E 232, showing Apollo on a swan, received by a satyr, a seated woman, and a maenad with her *thyrsus*: ibid., 227, no. 344.
4. The Meleager Painter was especially fond of Dionysiac scenes, see: Curti, "Apollo" (1984): 79–80.
5. For the Meleager Painter, see Beazley, *Attic Red-Figure Vase-Painters* (1963): 1408–15; idem, *Paralipomena* (1971): 490; Carpenter, Mannack, and Mendonça, *Beazley Addenda* (1989), 187–88; 374; Curti, *La bottega del pittore di Meleagro* (2001): passim; Kathariou, *Workshop of the Meleager Painter* (2002).
6. On the evidence of vase shapes, Kathariou distinguishes three periods within the workshop's activity. Her analysis of the development of bell-kraters claims

that during the middle period (395–385 B.C.), the atelier produced: smaller vessels; simpler drawing on both the main sides and subsidiary decoration of the vases; as well as fewer figures on the reverse; see ibid., 16–20. For the atelier's stylistic evolution and chronology see: ibid., 71–78. For Curti's analysis of the chronology and attributions of vessels to different painters of the atelier on the evidence of stylistic differences, see *La bottega del pittore di Meleagro* (2001): 39–55. Curti ascribes the obverse of the Hope vase to Painter A II and the reverse to Painter B I. The beginning of Painter A II's activity corresponds with the workshop's middle phase (400–395 B.C.), to which the Hope vase belongs; ibid., 46–48, Table 11. For the large production of bell-kraters, linked with the work of Painter A II: ibid., 61. For the distinction of various hands in the decorative motifs: ibid., 65–67, fig. 7.
7. For the provenance, see Jenkins and Sloane, *Vases and Volcanoes* (1996). For distribution of the vases by the Meleager Painter on the Italian peninsula, notably at Spina in the Po river delta, see: Curti, *La bottega del pittore di Meleagro* (2001): 97–103, table 21, fig. 11. Also see: Kathariou, *The Workshop of the Meleager Painter* (2002): 81–86.

EA

53. Bell-krater: Dionysus Rising

Greek, early 4th century B.C.
Terra-cotta
13 x 13⅖ x 13¾ in. (33 x 34 x 35 cm)
Trustees of the British Museum, GR 1917.7-25.1

PROVENANCE: Sir William Hamilton; bought by Thomas Hope in 1801; by descent, Lord Francis Hope Pelham-Clinton-Hope; sold Christie's, London, 23–24 July 1917, lot 76; bought by Spink for £94.10; The British Museum, London.

LITERATURE: Tischbein, *Collection of Engravings*, vol. 1 (1793): pl. 32; Tillyard, *The Hope Vases* (1923): 97–99, no. 163, pl. 26; Metzger, "Dionysos chthonien d'après les monuments figurés de la période classique" (1944–45): 296–313, fig. 1; Metzger, *Les représentations dans la céramique attique du IVe siècle* (1951): 262–65, no. 16; Berard, *Anodoi* (1974): 103–15, pl. 10, fig. 35; Lonis, *Guerre et religion en Grèce* (1979): 238–39, no. 3, fig. 8; Gasparri and Veneri, "Dionysos" (1986): 496, no. 868; Metzger, "Le Dionysos des images éleusiniennes du IVe siècle" (1995): 21, fig. 15 (A); Jenkins and Sloan, *Vases and Volcanoes* (1996): 186, no. 62a.

In the center of the scene, a dome-shaped mound of earth enclosing a cave is indicated by a broad, wavy line upon which a laurel branch sprouts. Within the grotto stands a clean-shaven youth visible from head to mid-shin. A wreath of small leaves crowns his long hair, and a cloak drapes around his waist and over his left arm. A *thyrsus* rests against his right shoulder. His raised left palm salutes a small Nike (victory), who flutters toward him, one hand raised in greeting. Four figures outside the cavern observe this meeting. At the right, a maenad attired in a richly decorated chiton and fillet stands on a stepped platform, her left hand supporting a *thyrsus* and her right offering a tray laden with fruit and flowers.

To the left of the mound, a nude, bearded *silen* (a minor woodland deity with equine ears and tail) leans against the cave, turning his head toward the encounter as he cradles a *thyrsus* capped with blossoms. A fillet holding thick foliage encircles his head. To his right, a second maenad, dressed like the first save for a crown, seemingly climbs a rocky promotory; she bends forward attentively. Below her,

Dionysus sits on a drapery-covered seat, holding a *thyrsus* in one hand and a fillet in the other. His distinctive accoutrements include a garland, a fillet, and a fringed *mitra*, or head scarf.[1]

The onlookers watch a youth emerging from the ground. Scholars have disagreed about his identity, but his unique head gear and *thyrsus*, both exclusive to Dionysus, clearly indicate that he is an exact counterpart of the god seated on the left. Both figures are placed on the same level—visually equating the deity's two manifestations. Dionysus is depicted not only adult and complete, but also *Anodos* (rising up), a youngster emerging each year in blossoming springtime.[2] He embodies pullulation and his staff grows with him. Inside the grotto, the boy-god's *thyrsus* sprouts a meager leaf signifying the onset of spring; outside, the mature god, shown with a fuller physique, displays a staff in full bloom. He and his entourage welcome the return of the burgeoning god; the lush foliage of their *thyrsi*, abundant floral crowns, and promised fruit herald his advent—the victory of spring over winter, as signified by Nike.

The vase, similar in style to catalogue number 52, is dated to the beginning of the fourth century B.C.[3] Dionysus *Anodos* and the full-grown divinity within a single pictorial field appear to be unique but in line with that period's taste for atypical iconography. This was a time of transitions in subject matter. Earlier painters portrayed heroic, mainly military themes, reflecting the Peloponnesian Wars (431–404 B.C.), a conflict between the two leading city-states, Athens and Sparta. But in its aftermath, Attic painters turned increasingly toward mythology, especially Dionysiac themes.

Here an uncrowded composition focuses on the central grotto. Figures occupy—or emerge from—different levels, and overlapping elements, such as the satyr who seems to lean both against the cave and the curving contour of the vase, suggest depth without use of perspective. The figures strike graceful, languorous poses and, as in the Meleager Painter's works (cf. cat. no. 52), garments are richly embellished. In the fourth century B.C., an increase in poly-

chromy became commonplace, and the Hope vase shows enhancement with white and yellow. Its artist painted all faces in profile, but his diverse attitudes and expressive gestures enliven the composition.

This krater, like the other, was found in S. Agatha dei Goti, suggesting that Athens maintained lively trade with Italy at this time. During the fourth century B.C., red-figure vase painting was relegated in status to a minor art and free painting became the major field. Many artists abandoned the old medium and embraced the new artistic form. Yet the thematic innovation and the stylistic vigor of the Hope vessel demonstrate that traditional vase painting could still offer inventiveness and vitality.

1. For the *mitra*, see the entry for cat. no. 38, n. 3.
2. For the interpretation as Dionysus *Anodos*, see Metzger, *Les représentations dans la céramique attique* (1951): 262–65, no. 16; Gasparri and Veneri, "Dionysus" (1986): 496, no. 868. There is a close parallel on a red-figure bell-krater in Berlin, Staatliche Museen. F 2646. This depicts the emergence of a female (either Aphrodite or Ariadne), who is greeted by Dionysus and his followers; see Metzger, *Les représentations dans la céramique attique* (1951): 75–76, no. 17, pl. v/5; Gasparri and Veneri, "Dionysus" (1986): 496, no. 867. For the interpretation of the scene as an initiate's rite of passage into the Dionysiac mysteries, see Berard, *Anodoi* (1974): 103–15, pl. 10, fig. 35.
3. For verbal communication from John Beazley to Metzger, see Metzger, *Les représentations dans la céramique attique* (1951): 262, no. 16.

EA

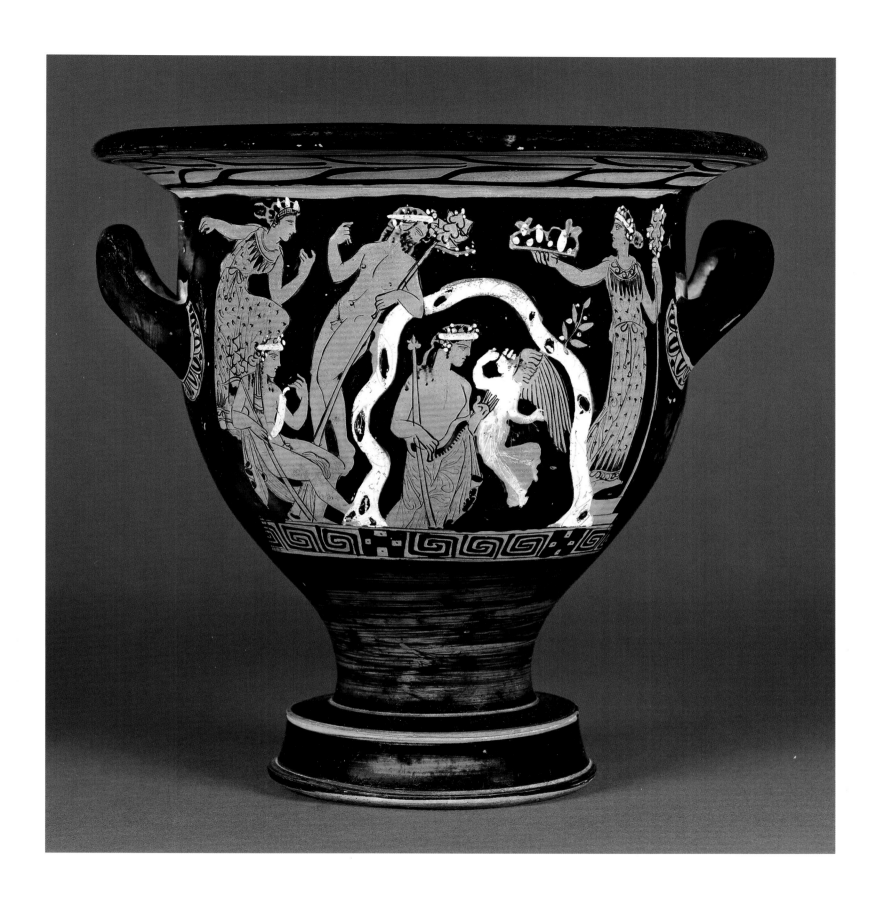

54. *Bell-krater: Orestes at Delphi*

Attributed to Python
South Italian, third quarter 4th century B.C.
Terra-cotta
22⅖ x 20 in. diam. (57 x 51 cm)
Trustees of The British Museum, GR 1917.12-10.1
London only

PROVENANCE: Sir William Hamilton; bought by Thomas Hope in 1801; by descent, Lord Francis Hope Pelham-Clinton-Hope; sold Christie's, London, 23–24 July 1917, lot 134, bought by Spink for £1134; acquired by the British Museum in December 1917.

LITERATURE: Millin, *Monuments Antiques* (1802): pls. LXVII, LXVIII; "The Orestes Vase. Hope Heirloom Bought by British Museum," *Times*, 10 December 1917, no. 41657, p. 11; Tillyard, *The Hope Vases* (1923): 267, pl. 36; Trendall, *Paestan ottery* (1936): 60, no. 108, pls. 17, 19 b; Trendall, "Paestan Pottery: a revision and a supplement" (1952): 9, no. 147; Trendall, "Pestani, Vasi" (1966): 90–91, figs. 103–4; Trendall and Webster, *Illustrations of Greek Drama* (1971): 46–47, no. III.I. 11; Kossatz-Deissmann, *Dramen des Aischylos auf west-griechischen Vasen* (1978): 105 K 36; 112, pl. 21.2; Demargne, "Athena" (1984): 1015, no. 626; Williams, *Greek Vases* (1985): 64, fig. 74a; Touratsoglou, Kolonia, and Valakou et al., *Democracy and classical culture* (1985): 88, no. 79; Prag, *The Oresteia* (1985): 49–50, pl. 33a; McPhee, "Elektra I" (1986): 715, no. 52; Sarian, "Erinys" (1986): 832, no. 52; Trendall, *The Red-Figured Vases of Paestum* (1987): 145–46, no. 244, pl. 91; Kahil and Icard-Gianolio, "Leto" (1992): 263, no. 70; Sarian and Machaira, "Orestes" (1994): 72, no. 23.

In 443 B.C., the Athenians established their first and only colony, Thurioi, in Great Greece (Megale Hellas in their parlance and later Magna Graecia to the Romans). The settlers no doubt included potters, and South Italian schools of red-figure painting sprang up from about this time. Although they owed their origins to Athens, the schools soon developed styles of their own. Among such regional schools, Paestum in northwest Lucania started producing red-figure ware around 350 B.C.[1] Slowly Italian demand for Athenian wares (see cat. nos. 51, 52) dwindled.

The red-figured vases of South Italy display a love for the theater. Here the painter's depicts Orestes at Delphi, drawing on the tragedy of *The Eumenides,* the final play of the *Oresteia* trilogy by the fifth century B.C. playwright Aeschylus. According to his version of the myth, Apollo, speaking through the Oracle at Delphi, orders Orestes to avenge the murder of his father, Agamemnon, by killing his mother, Clytaemnestra, and her lover, Aegisthus. Having done the bloody deed and now pursued by the Furies (female personifications of vengeance) for matricide, the hero seeks refuge at Delphi and protection from his guardian, Apollo. At the god's urging, Orestes goes to Athens to plead his case. There Athena, goddess of war, casts the deciding vote for his acquittal and transforms the Furies into Eumenides or "kindly ones."

At the center of the scene, Orestes, nude but for a cloak, an amulet over his right shoulder, and shod in sandals, holds a short sword in his left hand and cradles two spears in his left arm in order to defend himself from the Furies. He kneels before the omphalos, a navel-shaped stone marking the world's center, and an enormous tripod denoting Apollo's prophetic powers. Orestes looks to the viewer's left at his co-protector; Athena, clad in a chiton or tunic, himation, and a plumed helmet, bears a large aegis and a spear. To the right of Orestes, Apollo, wreathed in laurel and holding his lyre, steps toward the suppli-cant; he wears laced sandals and has a bracelet on his left wrist and amulets over his right shoulder and around his left thigh. Behind the god stands a laurel tree with

three fillets and two votive tablets suspended from its limbs. High in the sky, the sun's rim appears just below the decorative upper border of the vessel.

Two Furies dressed in hunting costumes threaten Orestes with poisonous serpents. One, in bust form, hovers above the tripod; another appears as a winged figure at far right, her way barred by Apollo. The scene's upper left and right corners feature busts of Orestes's sister, Electra, and his friend Pylades, respectively.[2] Overall, the painting fuses the three crucial episodes from Aeschylus's tragedy: Orestes's flight to Delphi, when Apollo tells him to approach Athena for pardon; Apollo's protection of Orestes against the Furies; and the protagonist's appeal to Athena for clemency.[3]

Arthur D. Trendall attributes the vase to Python, a leading Paestan vase painter.[4] Active during the third quarter of the fourth century B.C., he had a marked preference for bell-kraters. Typical mannerisms include elaborate drapery and hair styles, often arranged in densely tendriled locks. Python also enjoyed enlivening his painting with additional colors—yellow, orange, white, red, and purple. Python's standard vase designs, comprising more than one hundred bell-kraters, show two-figure compositions on the reverses; their formulaic shape and decoration are exceedingly monotonous. But on the Orestian vessel, we see Python at his most ambitious. The vase is imposingly large, decorated with an elaborate painting on the front, and instead of perfunctory draped youths (see the reverses of cat. nos. 51, 52), the back shows Dionysus and his followers.

Some of Python's poses are awkward. The strange position of Orestes's feet makes him appear to float rather than kneel on the omphalos; Apollo's protective gesture lacks conviction; and the Fury at right barely fits her confined space. Sir John Beazely uncharitably condemned this work as a "monstrosity"—an opinion shared by Arthur Trendall. True, there is nothing artistically refined about the overcrowded, heavy-set figures (e.g., the Fury's extravagant wings), excessive detail, or confused composition. Its colors are florid, the menace of avenging Furies is melodramatic and

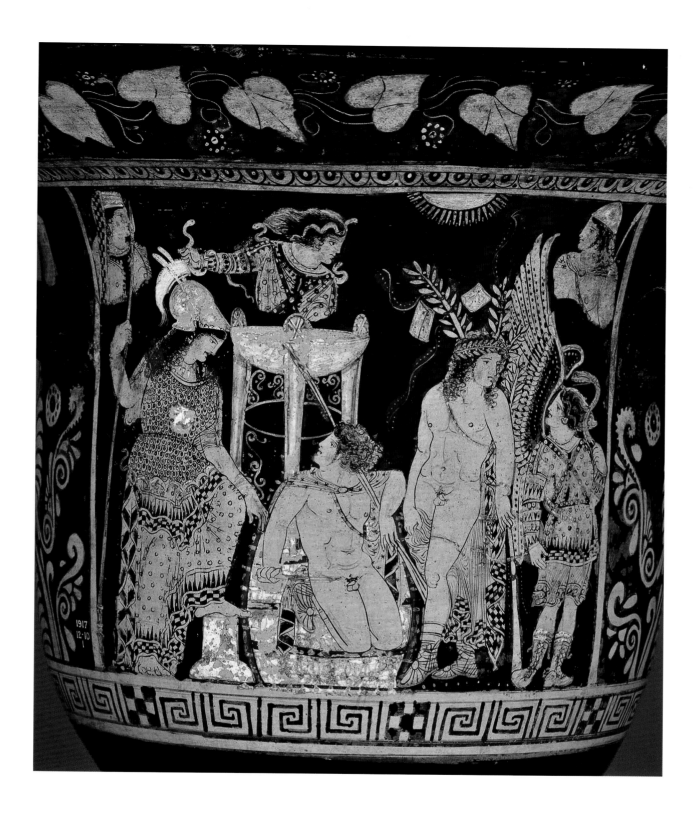

the compression of the most powerful episodes of a tragedy into the limits of a single vase is pure theater. Yet in his poignant distillation of a tragedy, this is Python is at his most impressive.

1. Trendall, *Red Figured Vases of South Italy and Sicily* (1989), provides a comprehensive attribution to painters and groups of South Italian ware similar to what Sir John Beazley composed for Athenian pottery. For the general characteristics of Paestan red-figure vases, see Trendall, *The Red-Figured Vases of Paestum* (1987): 11–21.

2. There has been some dispute concerning the identity of the female bust. For a possible identification as Clytaemnestra, see Sarian and Machaira, "Orestes" (1994): 72, no. 23. For Leto, Apollo's mother, see Kahil and Icard-Gianolio, "Leto" (1992): 263, no. 70. For Electra, see McPhee, "Elektra I" (1986): 715, no. 52. The pairing with Pylades fits best with an identification as Electra.

3. For a discussion of the iconography of *The Eumenides* on vase painting, see Prag, *The Orestia* (1985): 48–50. He establishes a figural group, comprising Orestes, Apollo, and a Fury; extra dramatis personae, such as Athena and another Fury, could be added. For a list of examples, see ibid., 143–46, E1-9. Also the discussion with a list of illustrations by Kossatz-Deissmann, *Dramen des Aischylos* (1978): 102–17.

4. For Python, see Trendall, *The Red-Figured Vases of Paestum* (1987): 136–72. The scholar specifically compares the Hope vase in shape, decoration, style and composition to the Alcmene krater, which is signed by Python; see ibid., 139–42. Python and Asteas were the two principal Paestan vase painters and worked in the same atelier. For Python's standard bell-kraters, see ibid., 150–67. For his elaborate vases, see: Trendall, *The Red Figured Vases of South Italy and Sicily* (1989): 143–50, nos. 241–250.

EA

Contemporary Paintings and Sculpture

55. *Aurora Abducting Cephalus*

John Flaxman (1755–1826)
English, 1789–92
Marble
57⅛ x 40⅕ x 26⅖ in. (145 x 102 x 67 cm.)
National Museums Liverpool, Lady Lever Art Gallery,
LL713
London only

PROVENANCE: Thomas Hope; by descent, Lord Francis
Hope Pelham-Clinton-Hope; sold Christie's, London,
18–19 July 1917, lot 270; bought by Partridge for £73.10;
William Hesketh Lever, 1st Lord Leverhulme; presented
by 2nd Viscount Leverhulme to Lady Lever Art Gallery
in 1929.

EXHIBITIONS: London, International Exhibition
(1862); *The Age of Neo-Classicism*, Royal Academy and
Victoria and Albert Museum, London (1972), no. 365.

LITERATURE: British Library Add MSS 39780 ff 47v,
50v, letter from Flaxman to his parents; *Household
Furniture* (1807): pl. VII; Douce MS (1812); Westmacott,
British Galleries (1824): 217, 219; Watkin, *Thomas Hope*
(1968): 31, 110–13, pl. 3, fig. 13; *The Age of Neo-Classicism*
(1972): 236–37, no. 365; Irwin, *John Flaxman* (1979): 54,
58; Bindman, *John Flaxman* (1979): 28; Bentley, "Flaxman
in Italy" (1981): 658–62; Wiebe et al., *Benjamin Disraeli*,
vol. 3 (1987): 301; Whinney, *Sculpture in Britain* (1988):
342–44; Clay et al., *British Sculpture in the Lady Lever
Art Gallery* (1999): 9–11.

The *Aurora Abducting Cephalus* belongs to a small group of works of classical subjects in the general manner of Canova on which Flaxman embarked in Rome in the late 1780s and which enabled him to delay his return to England until 1794. The Earl of Bristol, apparently on Canova's recommendation, had commissioned a full-size marble group, *The Fury of Athamas*,[1] and he was followed by Thomas Hope, who in Nancy Flaxman's words "saw, approv'd, & became a Patron to Flaxman's Talents—he purchas'd his Group of Cephalus & Aurora."[2]

The *Aurora* group was begun in 1789, probably before the *Fury of Athamas*, and was in an advanced stage of completion before Hope came on the scene. Although the two groups are in no sense a pair, together they established Flaxman as a sculptor with a range that could encompass both the beautiful and the sublime. *Aurora Abducting Cephalus*, in contrast to the violent action of the former group, is a tender scene of love, taken from Ovid, in which the goddess of the dawn makes her daily descent to embrace the beautiful mortal she has seduced away from his wife. In Nancy Flaxman's words, "it is about 6 feet high, taken at the moment when Aurora descends to take up Cephalus, Sentiment is not wanting in the Composition, or taste in finishing the Parts."[3]

Hope did not treat the *Aurora Abducting Cephalus* as an independent sculpture, and instead of placing it in the Statue Gallery in Duchess Street in the company of antiquities, he made it the centerpiece and leitmotif of perhaps the most dramatic room setting in the whole house. On its spectacular pedestal designed by Hope,[4] it was the focus of the Aurora Room, illustrated as plate VII of *Household Furniture* (1807), the setting elaborating its role as an allegory of the diurnal round, of day following night. Hope described it as follows:

The central object in this room is a fine marble group, executed by Mr. Flaxman, and repre-senting Aurora visiting Cephalus on Mount Ida. The whole surrounding decoration has been rendered, in some degree, analogous to these personages, and to the face of nature at the moment when the first of the two [Aurora], the goddess of the morn, is supposed to announce approaching day. Round the bottom of the room still reign the emblems of night. In the rail of a black marble table are introduced medallions of the god of sleep and of the goddess of night. The bird consecrated to the latter deity perches on the pillars of a black marble chimney-piece, whose broad frieze is studded with golden stars. The sides of the room display, in satin curtains, draped in ample folds over pannels of looking-glass, and edged with black velvet, the fiery hue which fringes the clouds just before sunrise: and in a ceiling of cooler sky blue are sown, amidst a few still unextinguished luminaries of the night, the roses which the harbinger of day, in her course, spreads on every side around her.

The pedestal of the group offers the torches, the garlands, the wreaths, and the other insignia belonging to the mistress of Cephalus, disposed around the fatal dart of which she made her lover a present. The broad band which girds the top of the room, contains medallions of the ruddy goddess and of the Phrygian youth, intermixed with the instruments and the emblems of the chace, his favourite amusement. Figures of the youthful hours, adorned with wreaths of foliage, adorn part of the furniture, which is chiefly gilt, in order to give more relief to the azure, the black, and the orange compartments of the hangings.[5]

1. Ickworth House, Suffolk. Irwin, *John Flaxman*
(1979): 54f.
2. Letter to William Hayley, 31 March 1792, Boston
Public Library. Transcribed in Bentley, "Flaxman in
Italy" (1981): 658–62.
3. Ibid., 660.
4. It was illustrated as no. 2 on pl. XIV of *Household
Furniture* (1807).
5. Ibid., 25–26.

DB

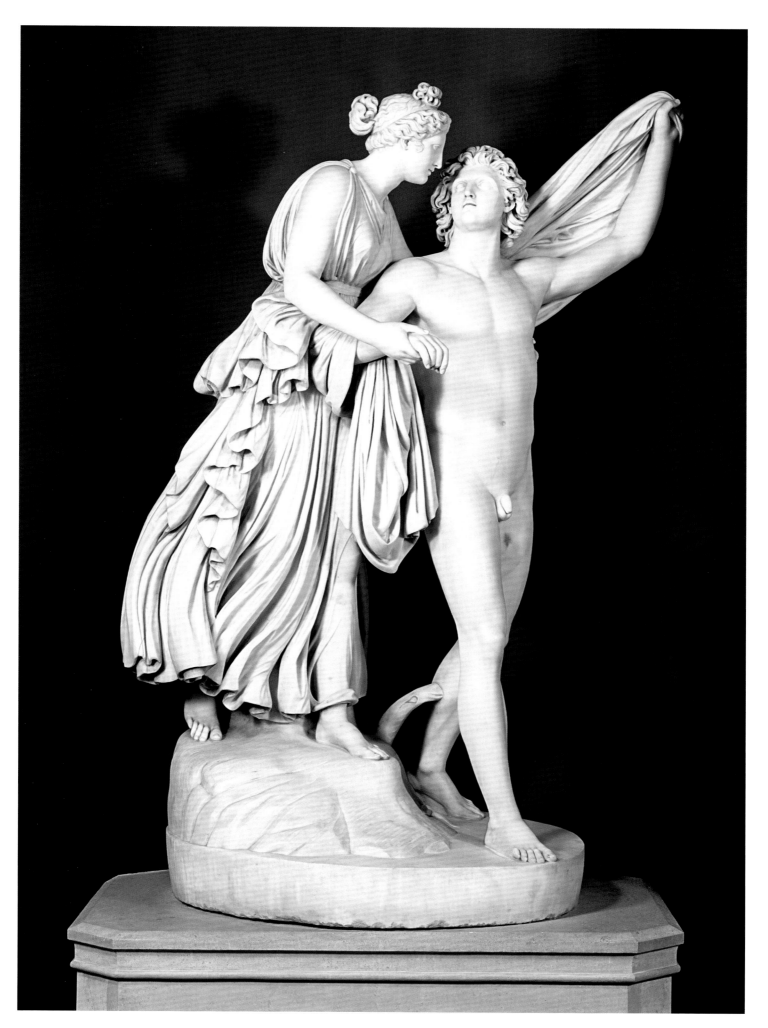

56. *Psyche*

Bertel Thorvaldsen (1770–1844)

Danish, 1806 (original model)
Marble
52 in. (132 cm)
Thorvaldsens Museum, Copenhagen, A821

PROVENANCE: Thomas Hope; by descent, Lord Francis Hope Pelham-Clinton-Hope; sold Humbert & Flint, London, 17 September 1917, lot 1163; Thorvaldsens Museum, Copenhagen.

LITERATURE: Neale, "The Deep-Dene, Surrey" (1826): 8; Prosser, *Select Illustrations* (1828): n.p.; Passavant, *Tour of a German Artist in England* (1836): 224; Thiele, *Thorvaldsen's Leben* (1853): 153; Jornaes, *Bertel Thorvaldsen* (1977): 79; *Thorvaldsen Museum* (1995): 83, no. A821; *Thorvaldsen Museum Bulletin* (2003): illus. p. 61; Floryan, "*Jasons* skæbne: Om Thomas Hope" (2003): 60–61.

Hope probably acquired this marble as a gift from his brother Henry Philip Hope,[1] who bought it from Thorvaldsen. The *Psyche* was, according to Jornaes,[2] carved in 1807–9 from a model of 1806 and is the prime surviving version, apart from the plaster model,[3] and the only marble with a provenance going back to the sculptor. It is one of a series of chastely ideal figures, such as *Hebe* and *Venus,* made by Thorvaldsen in response to Canova's earlier treatments of the same subjects. Hope's commissioning of the *Jason* in 1803 suggests that, initially at least, his taste was more inclined to the simplicity of Thorvaldsen's work than to the sensuality and dynamism of Canova's, although he was, of course, persuaded later to buy Canova's great *Hope Venus* (cat. no. 57).

The *Psyche* was given an important place in the scenic effect of the Deepdene. The watercolors in *A Series of Drawings Illustrative . . . of the Deepdene, Surrey* (1826) by W.H. Bartlett and Penry Williams show it set into a niche in a wall at the back of a semi-circular room at the top of the steps leading to the Conservatory (see cat. no. 106.10).[4]

The effect of the greenery behind the sculpture was described by Prosser in 1828. "Leaving the theatre on the right hand, and passing to the left through the conservatory, which is filled with the choicest exotics, is a semi-circular division, raised by several steps above the level occupied by the plants; in a niche in the center is a beautiful statue of Psyche, by Thorwaldsen, behind which is a mirror."[5] (The mirror reflected back a view into the Conservatory.) The sculpture thus complemented the idea that Hope's new wing, with its spaces devoted to nature and to art, was a place for reflection and contemplation, expressed in the figure of Psyche as the human soul finding consolation in nature in her journey through life.

1. Copenhagen, Thorvaldsens Museum. Thiele, *Thorvaldsens Biographi* (1854): 153. According to Thiele, the work was executed some years later than the original marble version of 1806 and was bought by "einem Bruder des Sir [sic] Thomas Hope."
2. Jornaes in *Bertel Thorvaldsen* (1977): 79.
3. Thorvaldsens Museum, inv. no. A26.
4. Floryan, "*Jasons* skæbne" (2003): 58–61.
5. Prosser, *Select Illustrations* (1828).

DB

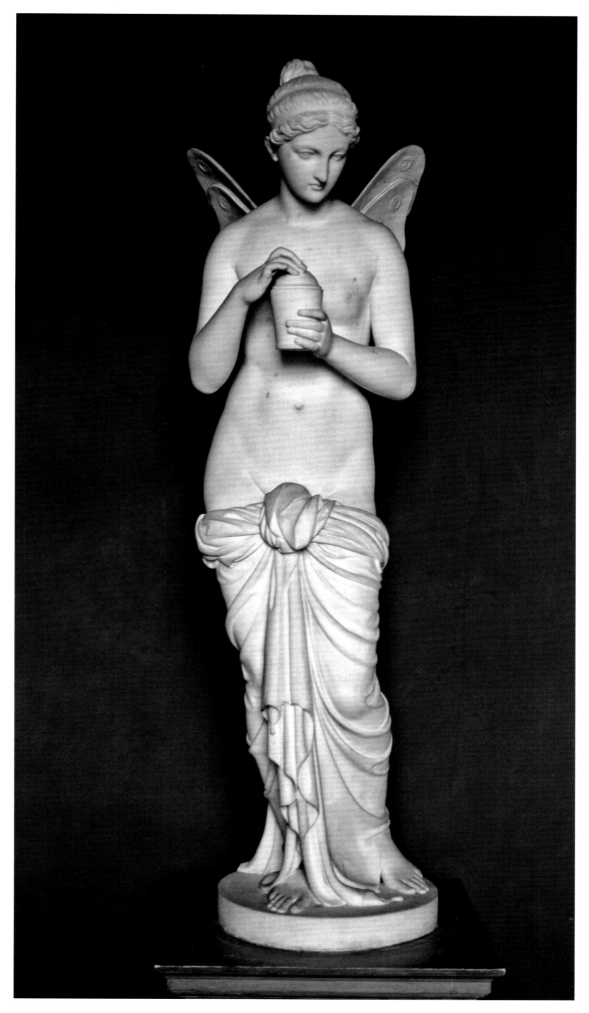

57. *Venus*

Antonio Canova (1757–1822)
Italian, 1817–20
Marble
70⅛ in. (178 cm)
Leeds Museums and Galleries (City Art Gallery),
21.3/59
London only

PROVENANCE: Thomas Hope; by descent, Lord Francis Hope Pelham-Clinton-Hope; sold Christie's, London, 18–19 July 1917, lot 268; purchased by Edward Allen Brotherton, later Lord Brotherton, for Roundhay Hall, Leeds, for £1155; inherited by his niece-in-law, Dorothy Una Ratcliffe, in 1930; given by her in 1959 to the City of Leeds.

EXHIBITION: *The Age of Neo-Classicism*, Royal Academy and Victoria and Albert Museum, London (1972), no. 327.

LITERATURE: *Magazine of the Fine Arts*, vol. 1 (1821): engraving; Cicognara, *Biografia di Antonio Canova* (1823): 67; Teotochi, *Opere di scultura e di plastica di Antonio Canova*, vol. 3 (1823): 15–16; Missirini, *Della vita di Antonio Canova* (1824): 185; Westmacott, *British Galleries* (1824): between 222 and 223, 229; Quatremère de Quincy, *Canova et ses Ouvrages* (1834): 136; Passavant, *Tour of a German Artist in England* (1836): 224; *Art Union* (1 April 1846): 97; Waagen, *Treasures of Art in Great Britain* (1854): 389, cat. no. 333; Baumgarten, *Le crépuscule* (1958): 87–89, 241–43, app. VII, no. 6; Honour, "Canova's Statue of Venus" (1972): 658–70; *The Age of Neo-Classicism* (1972): 211–12, no. 327 (contains an extensive bibliography); Clark, "The Clark Copy of Antonio Canova's Hope Venus" (1978): 105–15; Pavanello and Romanelli, *Canova* (1992): 290.

It is surprising that Thomas Hope, with his great wealth and interest in classical sculpture, should have bought only one work by Canova and that one late in his collecting career. He did not try to buy anything from the sculptor when he met him on either of his first two Roman visits, in 1795–96 and 1802–3, although he was offered a cast of the *Perseus*.

Canova called in at Duchess Street on his 1815 visit to London,[1] and Hope in return visited the sculptor's studio in Rome in 1817, when he saw an uncompleted Venus commissioned by "a mysterious Mr. Standish."[2] When that contract fell through, Hope agreed to take it on, but the sculptor offered Hope not a replica of an earlier composition but an entirely new version of the subject. The *Hope Venus* differs strikingly from the three earlier Venuses that Canova completed between 1809 and 1812, the most famous of which was the *Venus Italica*, originally commissioned by the King of Etruria to replace the *Medici Venus*, which had been taken by Bonaparte from the Uffizi Gallery in Florence. Canova also made two other versions—one for the Crown Prince Ludwig of Bavaria, now in the Residenzmuseum, Munich, and one for Lucien Bonaparte, Prince of Canino. The latter was sold after the Restoration in France to Lord Lansdowne and is now in Hearst Castle in California.[3] The differences between the *Hope Venus* and its predecessors are discussed at length in this catalogue (see Chapter 8), so they are only briefly summarized here.

Canova evidently began to copy the *Medici Venus* as he had been asked, but he abandoned it in favor of new work of his own invention. This new invention, according to Quatremère de Quincy, instead of showing the goddess rising fully formed at birth from the waters of the sea, like the *Medici Venus*, "show[s] her in the aspect and attitude of a bather, or a woman getting out of the bath."[4] The "vulgar reality" that distressed Quatremère and others is expressed in Venus's responsiveness to the spectator's gaze and her not unappreciative reaction to an intruder coming upon her almost naked. Under such critical pressure, the sculptor offered a "corrected" version of his Venus, which was to be the version commissioned by Thomas Hope.[5] In the *Hope Venus*, Canova minimizes the drapery and alters the pose of the figure in the direction of the *Medici Venus*, especially in the position of the arms. The gestures no longer suggest a sudden and provocatively ineffectual concealment of the body in response to an intruder but a calm goddesslike appraisal of the scene; even Canova's most fervent supporters, including Melchior Missirini, thought the *Hope Venus* was a great improvement on the *Venus Italica* type.

It was probably a genuine compliment to Hope on Canova's part that he did not simply pass on the sculpture he had roughed out, but that he designed a completely new work. Certainly Hope was immensely flattered that Canova had offered him an original piece, even though the sculptor had one of the same subject, which "est deja avancée au point de pouvoir etre bientot terminée" (it is already advanced to the point that it will soon be finished).[6] Hope repeated in more than one letter his delight in being offered "une statue qui ajoute à ses autres perfections le merite d'une originalité nouvelle" (a statue that adds to its other perfections the merit of a new originality) rather than a replica of Lord Lansdowne's *Venus*.

Hope was also delighted to find that apart from the approval of "plusieurs amateurs," it was almost ready a mere year and half after Canova had agreed to make it, by contrast with the continuing delays over Thorvaldsen's *Jason*.[7] In a letter of March 11, Hope expressed his pride in the uniqueness of the object he now possessed.[8] Hope indeed was so enamored of the *Venus* that he ordered a copy of it, so that he could have one at the Deepdene as well as the original in Duchess Street. This copy is now in the Corcoran Gallery of Art, Washington, and it is not clear whether it was ordered from the Canova studio or made by an English sculptor from Hope's original version.

The *Hope Venus*, when it was sold at Christie's in 1917, stood on a wooden pedestal to which was attached a marble relief of *Cupid and Psyche* signed and dated 1791 by the English sculptor John Deare.[9] This was no longer with the statue when it came to Leeds and is now lost.

Hope gave Canova a clear idea in his letter of March 11, 1822, of his own intentions for showing the *Venus* at Duchess Street. It was to go at the back of the gallery, where it would occupy the central point of a long perspective, isolated and able to be turned on its pedestal, with a rich drapery behind to set off its contours and reflections.[10] However, an engraving in Westmacott's 1824 book shows it in the Picture Gallery, not in glorious isolation but against a wall at the far end of the gallery, opposite a copy of the *Venus de Medici*.[11]

1. Honour, *Scritti* (1994): 390.
2. Honour, "Canova's Statues of Venus" (1972): 666.
3. For a definitive account of the circumstances behind all Canova's Venuses, see ibid., 658–71.
4. Quatremère de Quincy, *Canova et ses Ouvrages* (1834): 136–40.
5. Ibid., 136.
6. Letter to Canova, 3 July 1820, quoted in Baumgarten, *Le crépuscule* (1958): 242.
7. Ibid.
8. Ibid., 243.
9. Hope Heirlooms sale, Christie's, London, 18 July 1917, lot 268, signed: "I DEARE Faciebat, 1791."
10. Baumgarten, *Le crépuscule* (1958): 243.
11. Westmacott, *British Galleries* (1824): between 222 and 223, inscribed: "Thos. Hope's Picture Gallery, No. 1, J. Le Keux after G. Cattermole."

DB

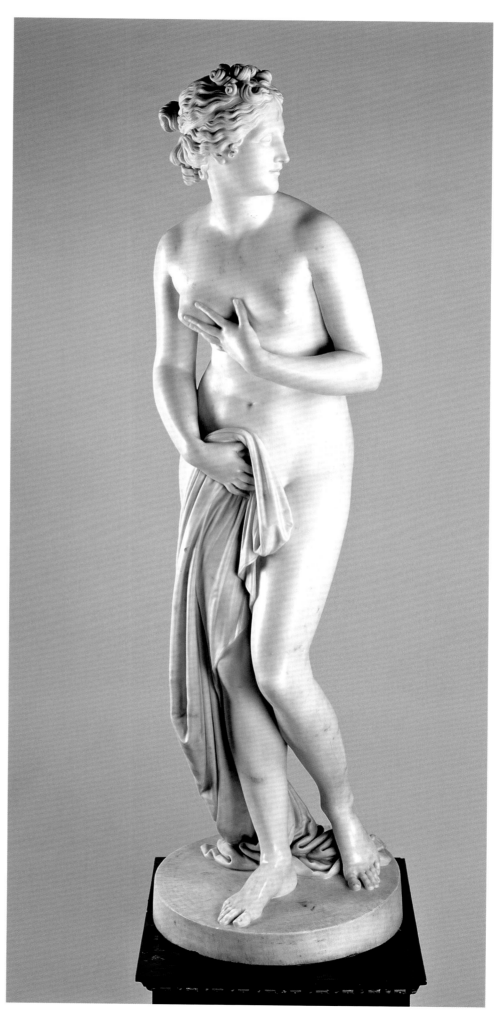

58. *Benares: The Manikarnika Ghat*

Thomas Daniell (1749–1840)
English, ca. 1800
Oil on canvas
68 x 53 in. (173 x 135 cm)
National Gallery of Modern Art, New Delhi, 1403

PROVENANCE: Commissioned from the artist by
Thomas Hope; [...]; Messrs. Appleby of London; sold
by them to National Gallery of Modern Art, New Delhi
in 1956.

LITERATURE: Farington, *Diary,* vol. 4 (1979): 1418
(8 July 1800); *Household Furniture* (1807): pl. VI; Douce
MS (1812); *Annals of the Fine Arts* 4, no. 12 (1820): 96;
Westmacott, *British Galleries* (1824): 217; Prosser, *Select
Illustrations* (1828): n.p.; Watkin, *Thomas Hope* (1968):
47, 99, 110; Shellim, *Oil Paintings of India* (1979): 22, 55,
no. TD40.

59. *The Zinat ul Masjid Mosque, Darayahanj, Delhi*

Thomas Daniell (1749–1840)
English, ca. 1800
Oil on canvas
68 x 53 in. (173 x 135 cm)
National Gallery of Modern Art, New Delhi, 1404

PROVENANCE: Commissioned from the artist by
Thomas Hope; [...]; Messrs. Appleby of London; sold
by them to National Gallery of Modern Art, New Delhi,
in 1956.

LITERATURE: Farington, *Diary,* vol. 4 (1979): 1418
(8 July 1800); *Household Furniture* (1807): pl. VI; Douce
MS (1812); *Annals of the Fine Arts* 4, no. 12 (1820): 96;
Westmacott, *British Galleries* (1824): 217; Watkin,
Thomas Hope (1968): 47, 99, 110; Shellim, *Oil Paintings
of India* (1979): 22, 55, cat. no. TD39.

These two pictures, commissioned in July 1800 by Thomas Hope, one of Daniell's earliest patrons, hung at Duchess Street with another larger and more contrived commissioned picture by Daniell, *Composition: Hindu and Muslim Architecture (a capriccio with the Taj Mahal).*[1] These pictures were expressly intended to hang with a large Panini, *Capriccio of Roman Ruins and Sculpture with Figures,* which was already in the Hope collection when the family moved from the Netherlands in 1795.[2] In *Household Furniture,* Hope referred to four paintings by Daniell in the Indian Room, which he called the Drawing Room, "principally fitted up for the reception of four large pictures, executed by Mr. Daniel [*sic*], and representing buildings in India, of Moorish architecture"; the fourth painting cannot be identified.[3] The room was lavish, the pictures much praised. In 1820 they were described as possessing "an architectural and lineal fidelity, truly useful to the Student, and pleasing to the Amateur," and in 1824 Westmacott wrote: "The decorations of this apartment are in the most costly style of Oriental splendour"; the only Indian element was the work of Daniell. All had matching frames and were described as in the Ante-Room at the Deepdene by 1828.[4]

Thomas Daniell, with his orphaned nephew, William Daniell, who was his assistant, then aged nineteen, and who called him "Un," left England in 1785 for India via Java and the China coast to work as draftsmen and engravers. They executed a vast number of works recording innumerable sites and cities. It is known from William Daniell's journal that they traveled by boat up the Ganges from Calcutta. They visited Benares twice, in December of 1788 and again a year later, where Daniell recorded the Manikarnika Ghat, which is a sacred place; it is traditionally held that those cremated there will be freed from the cycle of life and death.[5] (Ghat means steps or landing stage, of which there are many in Benares.)

In February and March 1789, the Daniells were in Delhi, where they visited another sacred place for pilgrims and the largest mosque in India, the Jama Masjid, originally called Masjid-i-Jahanuma, or "the Mosque commanding a view of the World." It contains precious relics, particularly those of the Prophet Mohammed. Built in six years from 1650, the mosque has four tapering minarets, 130 feet high, surrounding three domed structures of black and white marble. It commands an imposing site and has three double-storied gateways to a courtyard that can hold 25,000 people. The Daniells sailed to Madras to visit southern India in 1792, and after an abortive attempt to return home via Muscat and Egypt, they traveled to England again via China two years later with a huge volume of sketches and watercolors. This was an invaluable source for the oil paintings that followed; some had already been worked up into finished pictures, and many were exhibited at the Royal Academy and the British Institution. Others acted as the basis for the six volumes of *Oriental Scenery or Views in Hindostan of the Architecture, Landscape & Antiquities* published from 1795 to 1808. Each volume contained twenty-four plates and proved an enormous success.[6] The works are, and were then, considered hugely important, being accurate depictions, with only some slight variations, of the monuments the Daniells visited. Their works were immensely popular and were sought after by collectors in India and England, including William Beckford; George Wyndham, 3rd Earl of Egremont at Petworth; Warren Hastings, first Governor General of Bengal; and Sir Richard Colt Hoare of Stourhead.

1. I am most grateful to Antony M. Hoare for information concerning these pictures. Commissioned in August 1799 for 130 guineas, the picture was sold as *The Taj Mahal at Agra* by W. Daniell in the Christie's sale of the Duke of Newcastle at Clumber, 4 June 1937, lot 25, and is now in a private collection in England.
2. Now in the Yale University Art Gallery with the title *A Capriccio with the Roman Forum.*
3. *Household Furniture* (1807): 24, pl. VI. On p. 52, Hope listed "Daniell's Indian views" as among the "different works, either representing actual remains of antiquity, or modern compositions in the antique style, which have been of most use to me in my attempt to animate the different pieces of furniture here described"; ibid., 51.
4. Prosser, *Select Illustrations* (1828): n.p.
5. Legend has it that Vishnu dug a pit with his chakra, and the sweat created during his meditation filled the pit. Shiva shook his head and his jeweled earring fell into the pit, hence the name Manikarnika.
6. A copy was in the Deepdene library sale, *Catalogue of the Valuable Library of Books on Architecture, Costume, Sculpture, Antiquities, etc., formed by Thomas Hope, Esq., . . . being a portion of The Hope Heirlooms,* sale cat., Christie's, London, 25 July 1917, lot 196. Hope also owned other paintings by Thomas Daniell; see Shellim, *Oil Paintings of India* (1979): 22 and TD65.

JC

60. *Rest on the Flight into Egypt*

Louis Gauffier (1762–1801)
French, 1792
Oil on canvas
Signed and dated lower left
31½ x 45¼ in. (80 x 115 cm)
Musées de Poitiers, 975.1.1

PROVENANCE: Hope family collection by 1795; by descent, Lord Francis Hope Pelham-Clinton-Hope; sold Christie's, London, 20 July 1917, lot 55; bought by Dykes for £36 15s.; anon. sale Versailles, Palais des Congrès, 8 December 1974, lot 141, 40,000 francs; acquired for the Musées de Poitiers in 1975.

EXHIBITIONS: Brussels, *De Watteau à David* (1975): no. 133; *Pá Klassisk Mark: Málare I Rom pá 1780-talet*, Stockholm (1982): no. 38; *Europa und der Orient, 1800–1900*, Berlin (1989): no. 25; *Egyptomania: Egypt in Western Art 1730–1930*, Paris, Vienna, Ottawa (1994–95): no. 103.

LITERATURE: 1795 Insurance list, cat. C; *Household Furniture* (1807): pl. VIII; Douce MS (1812); Westmacott, *British Galleries* (1824): 215; Watkin, *Thomas Hope* (1968): 44, 116; Buist, *At spes non fracta* (1974): 494.

The picture was painted in Rome, where Hope probably met Gauffier and where he presumably commissioned the artist to paint this and other pictures. It hung over the chimneypiece in the Egyptian Room at Duchess Street.[1] This picture was one of two works by Gauffier shipped to London from the Netherlands in 1795 with the Hope family collections, and it was then valued at £20 on the insurance list.[2] It was much praised, described as "beautiful" by Douce in his account of the collection in about 1812, and "finely drawn and sweetly coloured" by Westmacott. There is a study for the painting in the Musée de la Ville, Poitiers, and a small oil sketch in a private collection in Paris.[3] Hope owned a small painting on copper by Jan van Huysum of a *Classical Landscape with the Rest on the Flight into Egypt* of about 1737, equally Egyptian in the detail, but in that case the imposing and large-scale architectural elements of a sphinx on a plinth, obelisk, and ruin overwhelm the figures.[4] It had belonged to Hope's father and later hung in the picture gallery at Duchess Street with the collection inherited by and belonging to Hope's brother Henry Philip.

1. I would like to thank Anne Péan, Conservateur du patrimoine, Responsable des collections du XVIe au XVIIIe siècle, Musées de Poitiers, for information regarding these pictures. It can be seen in the engraving of the Egyptian Room in *Household Furniture* (1807), pl. VII, and was mentioned in the Douce MS, published in Thornton and Watkin, "New Light on the Hope Mansion" (1987): 164.
2. See Buist, *At spes non fracta* (1974): 494, "Repose in Egypt" listed in Catalogue C.
3. See *Egyptomania* (1994–95): 103.
4. One of a pair in Peterborough Museum and Art Gallery, inv. no. 193791108.1/2.

JC

61. *Ulysses and Nausicaa*

Louis Gauffier (1762–1801)
French, 1798
Oil on canvas
Signed and dated
47½ x 63½ in (121 x 162 cm)
Musées de Poitiers, 969-4-1

PROVENANCE: Thomas Hope by 1826; by descent, Lord Francis Hope Pelham-Clinton-Hope; sold Christie's, London, 1917, 20 July, lot 52, bought by Cohen for £68 5s.; Sotheby's, London, 12 February 1969, lot 3, 600 francs, bought by Musées de Poitiers.

LITERATURE: Neale, "The Deep-Dene, Surrey" (1826): 6; Prosser, *Select Illustrations* (1828), n.p.; Brayley and Britton, *Topical Survey of Surrey* (1841–48); Watkin, *Thomas Hope* (1968): 44; Moulin, "Musée de Poitiers" (1970): 45, n. 6; Cuzin, "Nouvelles acquisitions des musées de province" (1972): 466, and repr. p. 467, fig. 9; *Egyptomania* (1994–95): 194.

Painted in Florence, this subject of the shipwrecked Ulysses being received by Nausicaa is taken from Greek mythology and is one of the series of Ulysses pictures by Gauffier. It is one of five known pictures by Gauffier that Hope owned. The others are earlier: *Generosity of the Roman Women* (1790) was shown in the Paris Salon in 1791 with *Achilles Discovered among the Daughters of Lycomedes* (sometimes misnamed *Vanity*), which hung in the Egyptian Room at Duchess Street opposite *The Rest on the Flight into Egypt* and was later in the Billiard Room at the Deepdene.[1] Hope also owned *Hector Reproving Paris,* which was also sold in the Hope Heirlooms sale and has subsequently disappeared.[2]

Born in Poitiers, Gauffier won the Grand Prix in Paris in 1784 and departed for Rome, where he studied at the Académie de France. There he painted mostly historical subjects and stayed until 1793, with the exception of a brief return to Paris in 1789. He lived in Florence from 1793, where he painted travelers on the Grand Tour and moved in Russian and English society circles, particularly that of Henry Fox, 3rd Baron Holland. Gauffier painted charming conversation pieces, small single or group portraits in interiors or in landscape settings. He also painted magnificent landscapes from nature, often from a height, with sweeping panoramas, such as those of the Certosa of Vallombrosa and the Valley of the Arno. He died at the age of thirty-nine in Florence, three months after the early death of his wife, the portrait painter Pauline Châtillon, a former student of his and of Drouais. Gauffier was known to make copies of his pictures for his own keeping.

1. The first was known to have been commissioned by Hope and painted in Rome and is thought to be that sold in Paris, Jauffret sale, 29 April 1811, lot 17, bought by Marthe or Mautre. It was purchased for the Musée Nationaux in Paris, Hôtel Drouot sale of 25 June 1943, lot 130, deposited at the Musée de Bordeaux in 1946, and transferred to the Musée des Beaux-Arts, Poitiers, in 1949. The location of the *Achilles* picture is not known. It came to England with the Hope collections in 1795 and was in the Hope Heirlooms sale, Christie's, 20 July 1917, lot 54, bought by Kahn for £36 15s., a signed and dated sketch for which was with Didier Aaron in 1989.
2. Sale of 20 July 1917, lot 53, bought by Roe for £31 10s. A drawing is in the Musée des Beaux-Arts, Montpellier. Another painting, *Oedipus and the Sphinx,* was formerly thought to have hung at the Deepdene in the Billiard Room but is now considered not to have been in Hope's collection.

JC

62. *View of a Tomb of a Greek Warrior, thought to be "The Tomb of Agamemnon"*

Joseph Michael Gandy R.A. (1771–1843)
English, before 1818
Pen and ink and watercolor on paper
29½ x 51⅛ in. (75 x 130 cm)
Private collection

PROVENANCE: Thomas Hope; by descent, Lord Francis Hope Pelham-Clinton-Hope; sold Christie's, London, 20 July 1917, lot 3; bought by Campbell for £110 5s.; [...]; bought, as by an "improbable German artist," by the present owner from a sale at Sotheby's, London, in the 1960s.

EXHIBITIONS: Possibly Royal Academy, London (1818), no. 926; *Joseph Michael Gandy (1771–1843)*, Architectural Association, London (1982), no. B3; *Soane's Magician*, London, Sir John Soane Museum (2006), no. 44.

LITERATURE: *Annals of the Fine Arts* 4, no. 12 (1820): 97, as "Design for a Cenotaph"; Brayley and Britton, *Topographical History of Surrey* (1841–48): 87; Watkin, *Thomas Hope* (1968): 47; Architectural Association, *Joseph Michael Gandy* (1982): no. B3, ill. p. 18; Woodward, *Soane's Magician* (2006): no. 44; Lukacher, *Joseph Gandy* (2006): 34–35, ill. no. 29.

It is not known exactly how or when Hope acquired this watercolor. It was formerly thought to have been the picture called *A Cenotaph*, which Gandy exhibited at the Royal Academy in 1804 (no. 958). John Harris has suggested that Hope may have commissioned the picture and that it was previously wrongly identified, given that the iconography represents the imaginary reconstruction of an ancient Greek tomb, the burial place of Agamemnon of Mycenae, the sacred king, rather than a design for an empty tomb.[1] This watercolor is related to an earlier work by Gandy of a *Sepulchral Chamber* (1800), in which similar acroteria heads appear.[2] In his manuscript treatise "The Art, Philosophy, and Science of Architecture," Gandy listed some subjects and patrons, among which were "Sepulchral Chapel, Allnutt; another, Hope."[3]

Hope also bought Gandy's first extant exhibited picture, a magnificent watercolor of *The Fall of Babylon*. It was shown at the Royal Academy in 1805 entitled *Pandemonium, or part of the high capital of Satan and his peers*. Gandy had been contemplating the subject, from the first book of Milton's *Paradise Lost*, since 1796 when he was in Rome.[4] This astonishing rendition is a triumph of architectural and natural elements fused to create an impression of the capital of hell. A second version of the picture was exhibited at the Royal Academy in 1831. In 1805 Gandy published *Designs for Cottages, Cottage Farms and Other Rural Buildings, and the Rural Architect*, the first volume of which was dedicated to Hope with the citation, "a name which will ensure respect wherever the Arts are known." Both these works were listed at Duchess Street in the *Annals of the Fine Arts* in 1820.[5] This is the only known reference to their existence in the Hope collection, unless they are presumed to be "Subject from Miltons Paradise Lost / water color" and "Companion picture to above," which were at the Deepdene when John Britton visited sometime after about 1841, thus indicating that they had lost their identity by that date.[6]

Gandy trained in the office of James Wyatt from 1786 and studied in Rome from 1794 to 1797. He traveled to Italy with Charles Heathcote Tatham, the architect employed by Hope in the creation of Duchess Street, and he was a close friend of George Augustus Wallis, the landscape painter and accomplished topographical draftsman who had traveled with Hope to Sicily in early 1792. Gandy entered the office of John Soane in 1798 as a draftsman employed to render his architectural designs by means of perspective views, which Gandy exhibited almost continually at the Royal Academy between 1789 and 1838.

1. I am immensely grateful for the invaluable assistance of John Harris in writing this catalogue entry. The carving on the sarcophagus illustrates a Greek galley, a possible reference to Agamemnon's return to Nauplia after a fierce storm. John Harris further points out that the ornamental acroteria heads seen in the middle ground of the picture are similar to those that appeared in the Deepdene garden and on the temple there designed between 1818 and 1823, see Watkin, *Thomas Hope* (1968): opp. p. 154, fig. 56, before the alterations made by Alexander Roos (ca. 1810–1881). Hope probably designed the picture frame.

2. In the Canadian Centre for Architecture, Montreal, and reproduced in Lukacher, *Joseph Gandy* (2006): 32, nos. 27, 28.

3. The list on the inside cover of vol. 5, under the title "Drawings to be made," has the names of the patrons who commissioned them, including Gandy's friends Richard Westmacott, the sculptor; furniture designer George Bullock; and John Foster, the Liverpool architect, and also the collector William Beckford. The full list is found in Lukacher, *Joseph Gandy* (2006): 210, n. 49. John Allnutt of Mark Lane and 6 Cedars Road, Clapham Common, London, a wine merchant, had a strong interest in architectural history and drawings. He had a serious collection of Old Master pictures and his choice of contemporary paintings was very similar to that of Hope and included works by Westall, Daniell, West, Smirke, and Stothard; he also owned Turner's views of Fonthill Abbey. He financed Gandy's father and his first patron, John Martindale, when they were in difficulty. Allnutt also bought "Interior Subterranean Temple" (above which is written "Tomb of Hephaestus" in Gandy's treatise list) and one of these, *Interior of a Grecian Temple of Doric architecture, adorned with statues and sculptured friezes; a lamp burning and censers smoking*, was included in one of the sales following Allnutt's death, Christie's, London, 19 June 1863, lot 315, bought by Atkins for £33 12s. Three of the original eight volumes of the treatise, written after 1832, survive in the Gandy Family Papers in the RIBA British Architectural Library, Drawings and Archives Collections, Victoria and Albert Museum, London (GAFam/4/1). He wrote to his father on 23 January 1796 that he had made two sketches "or rather Architectural designs from Milton which I intend exhibiting and engraving when I arrive in England. One is the Throne of God as described by Milton, and the other Pandemonium with a view of Hell"; he thought they would sell well as prints. The letters to his father also indicate Gandy's deep interest in the catacombs and mausolea since his arrival in Rome the year before where he won a special prize for a design for a sepulchral chapel at the Accademia di San Luca in 1795. The letters to his father, 26 April 1794 to 4 March 1797, are in the RIBA, as above, in one volume, GaFam/1/1.

4. The picture, 28 x 48½ in. (71 x 123 cm) is in a French private collection. See Lukacher, *Joseph Gandy* (2006): 111–12, 115, ill. no. 125. Lukacher states on p. 10 that Hope bought two pictures from Gandy in 1806, but following recent correspondence with the compiler of this entry, he now considers this to have been only a possibility.

5. The journal was edited, from 1816 to 1830, by the architect James Elmes, perhaps better known for his writing on architectural subjects and as equally passionate as Hope for the advancement of the fine arts. He was responsible for "A letter to T. Hope . . . on the insufficiency of the existing establishments for promoting the fine arts" in *The Pamphleteer* 3 (1813).

6. They hung in Room no. 9 (gray) with some undistinguished pictures; see John Britton, List of contents of the Deepdene, MS B1977.14, British Art Center, New Haven. I am most grateful to Professor Lukacher for prompting me to look again at this source.

JC

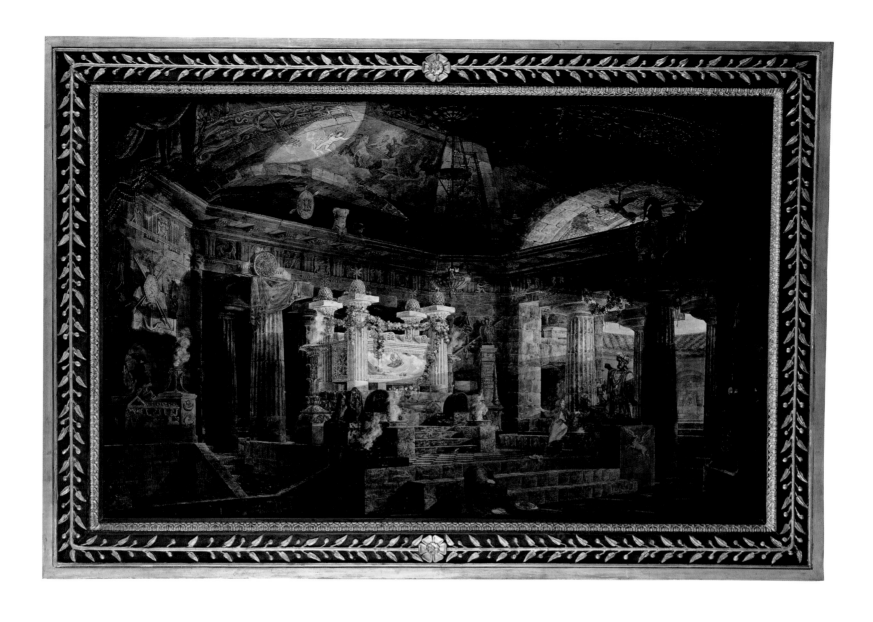

63. *The Reconciliation of Helen and Paris after His Defeat by Menelaus*

Richard Westall R.A. (1765–1836)
English, 1805
Oil on wood
50 x 39¾ in. (127 x 101 cm)
Tate Britain, London, T00088/103
London only

PROVENANCE: Commissioned from the artist by Thomas Hope, 1804; [...]; Coulter Galleries, York, by 1948–50; sold to Appleby Brothers, London; bought from them by the Tate Gallery in 1956.

EXHIBITION: Royal Academy, London (1805), no. 90.

LITERATURE: *Annals of the Fine Arts* 4, no. 12 (1820): 95; Westmacott, *British Galleries* (1824): 213; Watkin, *Thomas Hope* (1968): 43, pl. 14.

According to Joseph Farington, Westall "had been with Thomas Hope, who in consequence of having seen his picture in the exhibition had ordered two Historical pictures from him,—the price of that size 120 guineas,—but would give more if work required it."[1] It must be presumed that this was a reference to the commission by Hope in May 1804 to paint this picture and *The Expiation of Orestes at the Shrine of Delphos*, which was exhibited at the Royal Academy the following year and is now known only from an engraving of 1810 by William Bond. The engraving was inscribed by John Britton and Bond to Hope's brother Henry Philip when it was published in 1812.[2] The two paintings hung together in the Ante-Room at Duchess Street in 1824.

Westall took the subject of this picture from Book III of the *Iliad*, and it illustrates Paris, the son of Priam, King of Troy, reunited with Helen, wife of Menelaus of Sparta, after his defeat by Menelaus. Venus, seen departing, had carried Paris from the battlefield back to Troy.[3]

1. Farington, *Diary*, vol. 6 (1979): 2314 (4 May 1804), 2478 (24 December 1804).
2. Britton, *The Fine Arts of the English School* (1812). The composition was based on a large Greek vase in Hope's collection. For further comment on this picture, see Chapter 9.
3. A watercolor sketch of the picture in Leeds City Art Gallery (19¼ x 15 in. [48.8 x 38.1 cm]) has slight differences, and the figure of Venus is reversed. Michael Vickers of the Ashmolean Museum suggested in 1981 that the model for the figure of Helen was from a statue, formerly in Hope's collection, which the Ashmolean acquired in two parts in 1917.

JC

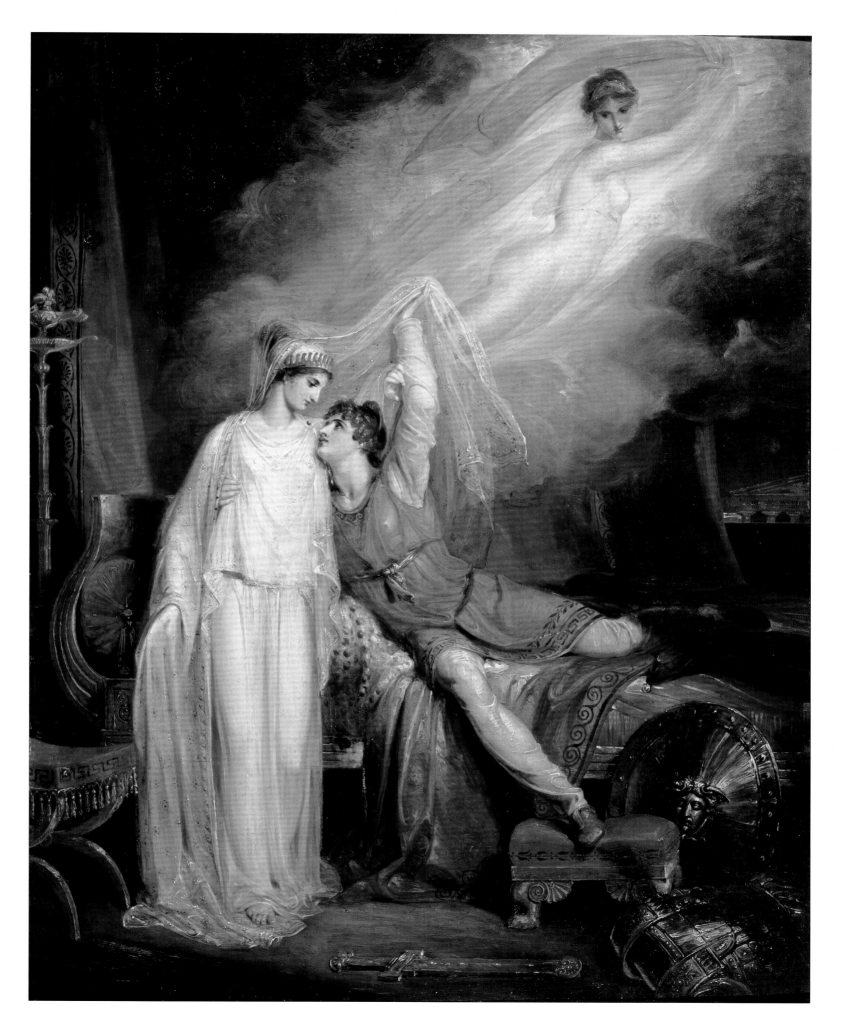

64. *The Sword of Damocles*

Richard Westall R.A. (1765–1836)
English, 1812
Oil on canvas
Signed and dated in black oil paint in the foreground on the footstool.
51³⁄₁₆ x 40⁹⁄₁₆ in. (130 x 103 cm)
Lent courtesy of the Ackland Art Museum, The University of North Carolina at Chapel Hill, Ackland Fund, 79.10.1
New York only

PROVENANCE: Commissioned by Thomas Hope, May 1811; by descent, Lord Francis Hope Pelham-Clinton-Hope; sold Christie's, London, 20 July 1917, lot 72; bought by Kahn for £16 16s.; [...]; Sotheby's Parke-Bernet, New York, 9 October 1974, lot 230; sold for $4,250; Shepherd Gallery Associates, Inc., New York and Christopher Wood, London, by 1978; acquired by Ackland Art Museum, University of North Carolina at Chapel Hill, in 1979.[1]

EXHIBITIONS: New Gallery, Pall Mall, London (September 1814), no. 32, entitled *Dionysius and Damocles*.

LITERATURE: Farington, *Diary*, vol. 11 (1983): 3941 (30 May 1811); "Catalogue of an exhibition of a selection of the works of Richard Westall..." (1814): no. 32; review, *New Monthly Magazine* 2 (September and October 1814): 141–42, 248–49; *Annals of the Fine Arts* 4, no. 12 (1820): 95; Neale, "The Deep-Dene, Surrey," vol. 3 (1826): 10; Prosser, *Select Illustrations* (1828): n.p.; Watkin, *Thomas Hope* (1968): 43–44, 177, pl. 15.

Hope owned two paintings of Damocles. He had bought an earlier work of the same subject by the French neoclassical painter Antoine Dubost in 1807, which had led to an astonishing and prolonged public quarrel. Following the exhibition of Westall's *Sword of Damocles* at the Royal Academy in 1811, Hope commissioned him to paint a larger version of the one that had been bought there by Richard Payne Knight, another renowned collector with similar interests and a generous patron of Westall's. Knight owned nine of his pictures.[2] The subject of this picture is taken from the history of the elder Dionysius of Syracuse. The work was highly praised when it was included in an extensive exhibition of 312 of Westall's works (240 of which had not previously been exhibited) in 1814, when the prolific painter was at the height of his achievement. Hope's other two paintings by Westall hung at Duchess Street, while this picture hung in the Drawing Room at the Deepdene and was listed as being there in 1820.[3]

Westall was an immensely popular painter, and his work was included in many of the most important collections in the country; he himself had a collection of Old Master paintings, including works by Rembrandt, Poussin, van Dyck, Titian, and Velázquez, as well as works by Reynolds. Some of these were sold together with his own paintings at Phillips on March 8 and 9, 1813, and at Westall's house, 54 Charlotte Street, Fitzroy Square, London, on July 6, 1815.

1. I am most grateful to Carol C. Gillham, Assistant Curator for Collections at the Ackland Art Museum for information concerning the painting and for the fact that a reproduction of it appeared on the cover of the journal *Practical Diabetes International* in 2003.
2. Payne Knight paid 150 guineas for his picture, which is now in a private collection. See Clarke and Penny, *The Arrogant Connoisseur* (1982): 107, no. 205, ill. pl. 45.
3. *Annals of the Fine Arts* 4, no. 12 (1820): 95.

JC

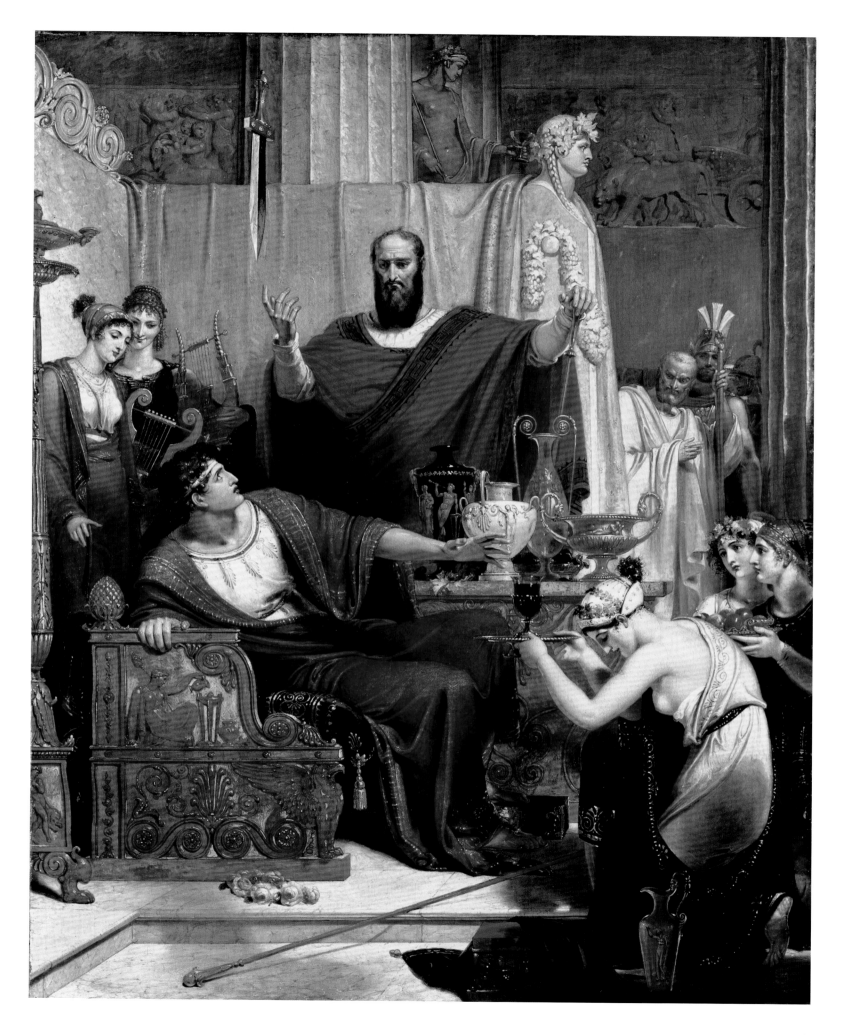

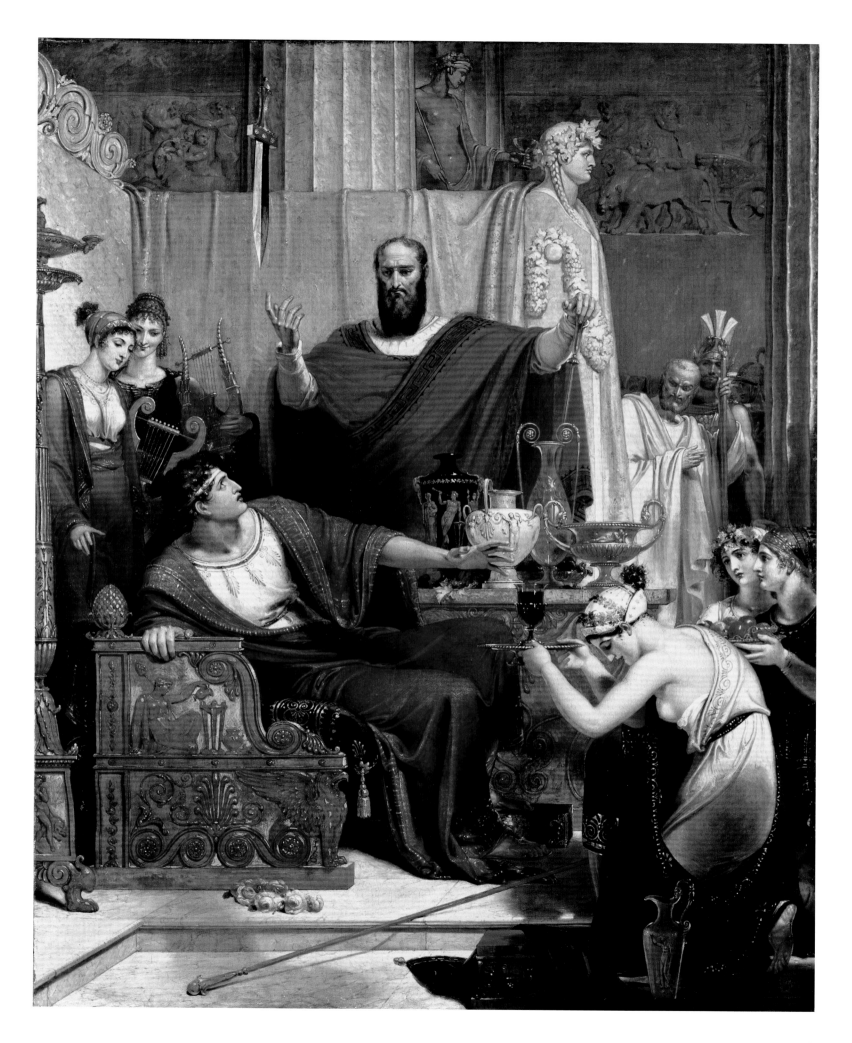

THEME 6

Furniture and Metalwork

The catalogue entries in the following section are arranged, as far as is possible, in the order in which the furniture and metalwork appear in Thomas Hope's *Household Furniture and Interior Decoration* (1807).

In addition to interiors, *Household Furniture* records objects that actually existed, having been either made under the supervision of Thomas Hope or acquired by him. He was a sophisticated and skilled patron with a zeal to improve taste, but it is not clear how much assistance he received in achieving his goal. He could draw more than competently, as is apparent from the "Gennadius" drawings, and he should be given considerable credit for the original objects published under his name. It seems likely, however, that in finalizing the designs, he benefited from professional intervention. Hope's word apart, there is scant evidence to suggest that he was totally responsible for the furniture and works of art published under his name. It is possible, for example, that Charles Heathcote Tatham played a role here, as he had done with the interiors at Duchess Street. Hope also owned (and published in *Household Furniture*) French pieces, notably metalwork, as well as Italian and antique objects. The visual evidence in Hope's book and the observations made by Francis Douce, who visited the house in 1812, do not rule out the likelihood that some of the furniture was purchased.

Hope's furniture and metalwork have a touch of inspiration and individuality, however, which ultimately suggests the inspired control of one man's mind.

The furniture and metalwork fall into three categories:

1. Pieces securely documented as from Duchess Street are catalogued as "after a design published by Thomas Hope," together with a date of "ca. 1802" and a Duchess Street provenance. The house was open to the public in 1802 and was presumably largely furnished by this time.

2. Pieces that the compilers feel are likely to have been at Duchess Street, despite the lack of a fully documented history, are designated "presumably Duchess Street."

3. Pieces close to or made after designs published by Hope, but for which there is no evidence of their being in Hope's collections, are recorded as such.

65. *Armchair*

After a design published by Thomas Hope
English, early 19th century
Mahogany, upholstery of a later date
Mark: "II" stamped on back rail and seat
35 x 25 1/16 x 20 7/8 in. (89 x 63.65 x 53 cm)
Fitzwilliam Museum, Cambridge, M.4.1992
Not in exhibition

PROVENANCE: [...]; the late Mrs. Marjorie Beatrix Fairbarns; Christie's, London, 9 July 1993, lot 87, bought by H. Blairman & Sons, on behalf of Fitzwilliam Museum, Cambridge.

LITERATURE: *Household Furniture* (1807): pl. II, nos. 3, 4, pl. XI; Britton and Pugin, *Illustrations of the Public Buildings* (1825): pls. 2, 3; Watkin, *Thomas Hope* (1968): fig. 41 (watercolor of Flemish Picture Gallery; see cat. no. 107).

The Fitzwilliam chair is very close to the one recorded in *Household Furniture*, plate XI, numbers 3 and 4 (fig. 65-1), described as "Front and side of an arm-chair."[1] The same model is also depicted in R.W. Billings's watercolor of the Flemish Picture Gallery at Duchess Street (cat. no. 107); in the same view published by J. Britton and A. Pugin; and perhaps also in the elevation.[2] In addition, Hope owned variants of this chair without arms; see *Household Furniture*, plate II (see fig. 2-8).

Four other versions of the present chair are known to survive. Two of the three seen by the compiler vary in detail from the exhibited chair. The first example[3] differs in that the vertically striated supports to the winged lionesses terminate at the backs of their tails. A second chair, reportedly in the same collection as the first, has not been examined. A third chair[4] is seemingly identical in design to the one exhibited here. It has been said that the final version is from the collection of Hope's contemporary and admirer Samuel Rogers.[5] The Rogers chair has a plain but full-length support beneath the lioness and a less rounded top rail, and it is arguably not as finely executed (see also cat. no. 93).

The carving of the winged lionesses on the Fitzwilliam chair has a crispness observed on other Hope furniture, such as catalogue numbers 66 and 85, both of which have secure connections to Hope's own collection. It seems reasonable to suggest, therefore, that the carving on these pieces might be attributed to Peter Bogaert.[6] The same degree of excellence can be observed on the base to a pedestal[7] illustrated in *Household Furniture*, plate XXIV, number 6 (see fig. 65-2).

Hope's winged-lioness arm supports on this series of chairs may derive from a design in plate 5 of Percier and Fontaine's *Recueil de Décorations Intérieures*. The lionesses themselves are based on the celebrated Egyptian examples that Hope would have seen in Rome, and which he also used as embellishments on the settees from the Egyptian Room (see cat. no. 76).

Although the Fitzwilliam chair lacks an early provenance, the superior quality of the carving, together with the closeness of the design to the plate in *Household Furniture*, does not rule out the possibility that this may have been one of Hope's own pieces.

1. *Household Furniture* (1807): 29.
2. *Illustrations of the Public Buildings of London* (1825): pls. 2, 3.
3. With H. Blairman & Sons in 1984; now in an American private collection.
4. Currently with Gurr Johns, London.
5. Sold Christie's, London, 8 June 2006, lot 96. Although the provenance given by Christie's is unequivocal, it should be noted that the chairs with which they associate the one they offered had "griffins" supporting the arms, not winged lionesses. For Samuel Rogers, see Chapter 4 in this volume and cat. no. 93.
6. See Chapter 4.
7. Sold Christie's, London, 22 May 1986, lot 149, and now in an English private collection.

ML

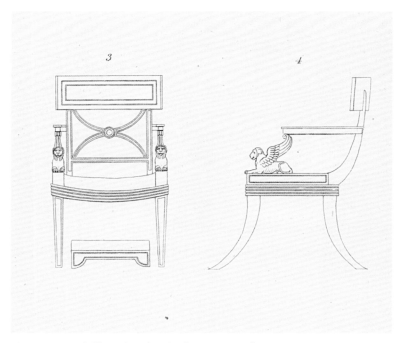

Fig. 65-1. *Household Furniture* (1807), pl. XI, nos. 3 and 4.

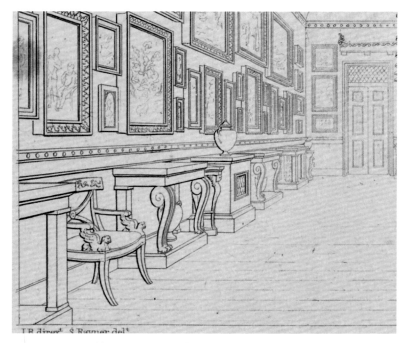

Fig. 65-2. *Household Furniture* (1807), pl. XXIV, no. 6 (detail).

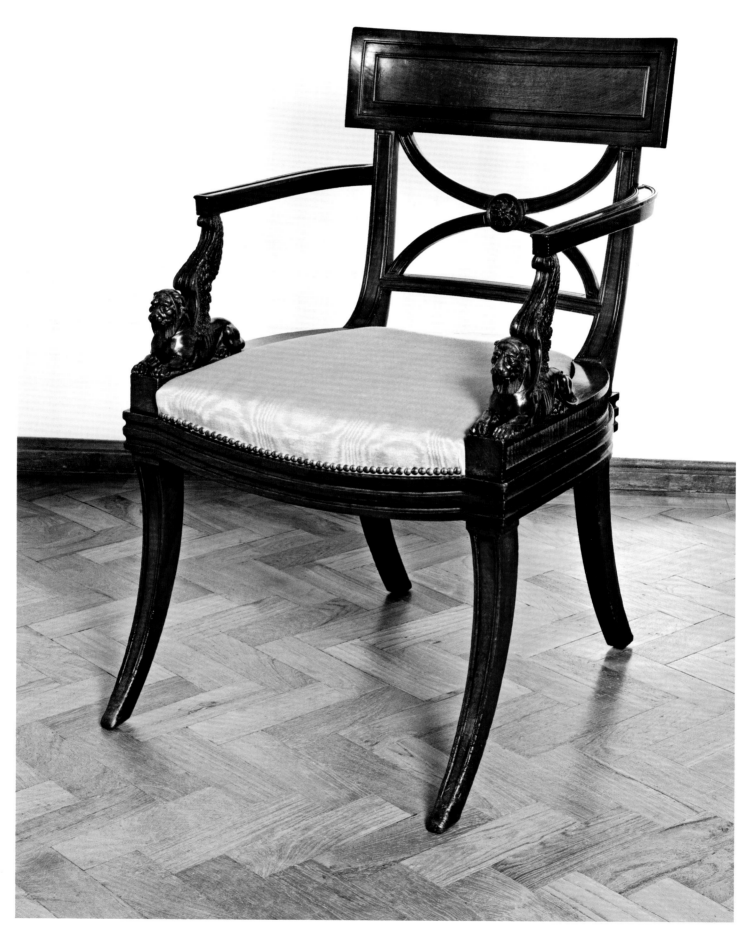

66. Table

After a design published by Thomas Hope
English, ca. 1802
Mahogany, green porphyry
Mark: "PURCHASED FROM THE DEEPDENE SALE 1917"
(on label on cross-brace beneath top).
31⅓ x 52¾ x 24⅗ in. (79.5 x 134 x 62.4 cm)
Ashmolean Museum, Oxford
London only

PROVENANCE: Thomas Hope, Duchess Street and later at the Deepdene; by descent, Lord Francis Hope Pelham-Clinton-Hope; sold Humbert & Flint, 14 September 1917, lot 827 (a pair); bought by C. F. Bell, on behalf of the Ashmolean Museum.[1]

LITERATURE: *Household Furniture* (1807): pl. XII, nos. 6, 7; Neale, "The Deep-Dene, Surrey" (1826): 6 as "side tables . . . [with] green porphyry slabs"; Humbert & Flint, 12–14, 17–19 September 1917, sale cat., photograph of the Great Hall.

This table, one of a pair, is illustrated in *Household Furniture*, plate XII, numbers 6 and 7 (fig. 66-1), "End and front of a table."[2] The location of the pair at Duchess Street is unknown, but they may have been the "side-tables . . . [with] green porphyry slabs" in the Dining Room at the Deepdene in 1826.[3] In 1917 the tables were sold from the Great Hall on the ground floor, described as: "A PAIR OF 4ft. 6in. HALL TABLES, with green porphyry tops, on heavy carved unpolished mahogany supports"; they sold for £50.

The overall form of the Ashmolean tables can be directly compared to a table shown in plate 13 of Percier and Fontaine's *Recueil de Décorations Intérieures*, the "Vue perspective de la chambre à coucher de Cit. V. à Paris," and again in plate 16 showing the "Face et profile d'une Table exe-cutée par les frères Jacob."[4] The principal design source for the ends of both the French and English tables appears to have been the much-admired ancient bath made of *rosso antico*, known as the "Tomb of Agrippa," now incorporated into the tomb of Pope Clement XII in the Corsini Chapel in the Basilica of SS Giovanni e Paolo, Rome. Before this, the tomb stood in the portico of the Pantheon, also in Rome.[5] The anthemion and scroll details, however, may come from a source such as the *rosso antico* seat in San Giovanni in Laterano, Rome. Hope would doubtless have known these antique marbles from his time in Rome, which he first visited in 1795.

Hope's most significant source, however, is most likely to have been Charles Heathcote Tatham's *Etchings . . . of Ancient Ornamental Architecture*, in which he illustrates in plate 95 a side view of the "Grand antique bathing vase in one piece of red porphyry now used as the Sarcophagus of Pope Clement XII" (fig. 66-2); the end and section are illustrated in the preceding plate. Tatham also illustrates in plate 79 the "Ancient Seat of rosso antico marble used anciently in a Bath" (fig. 66-3), and in plate 76 an "Antique seat of parian marble in a chapel near Rome" (fig. 66-4); both make bold use of a carved anthemion in their ends.[6]

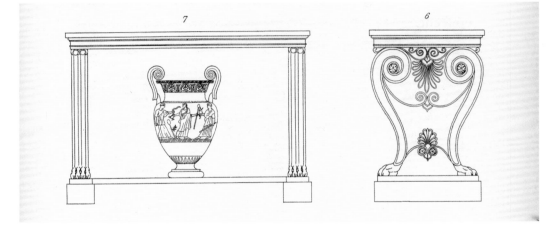

Fig. 66-1. *Household Furniture* (1807), pl. XII, nos. 6 and 7.

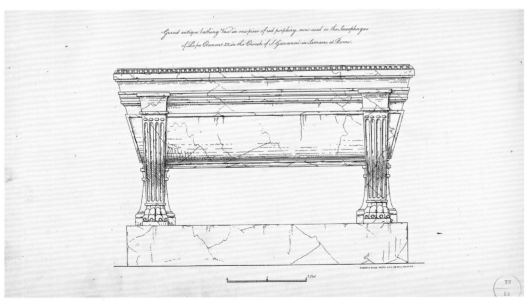

Fig. 66-2. Charles Heathcote Tatham. "Grand antique bathing vase in one piece of red porphyry, now used as the Sarcophagus of Pope Clement XII. From *Etchings... of Ancient Ornamental Architecture* (1799): pl. 95. Art and Architecture Collection, Miriam and Ira D. Wallach Division of Art, Prints and Photographs, The New York Public Library Astor, Lenox, and Tilden Foundations.

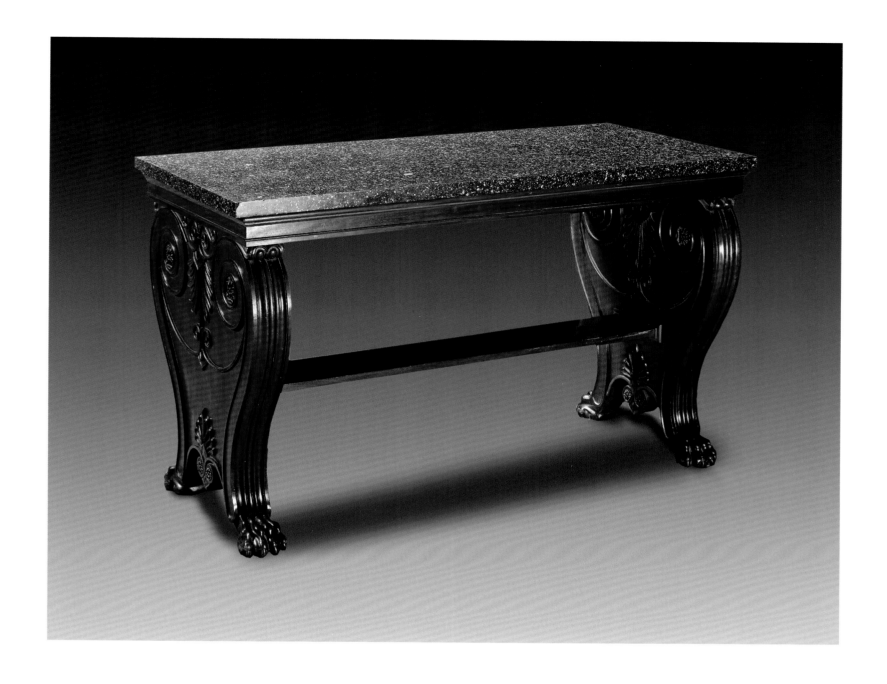

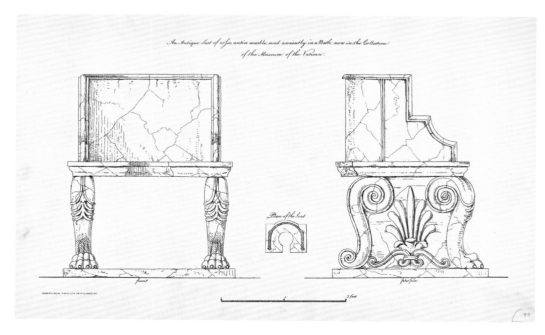

Fig. 66-3. Charles Heathcote Tatham. "Ancient Seat of rosso antico marble used anciently in a Bath." From *Etchings…of Ancient Ornamental Architecture* (1799): pl. 79. Art and Architecture Collection, Miriam and Ira D. Wallach Division of Art, Prints and Photographs, The New York Public Library Astor, Lenox, and Tilden Foundations.

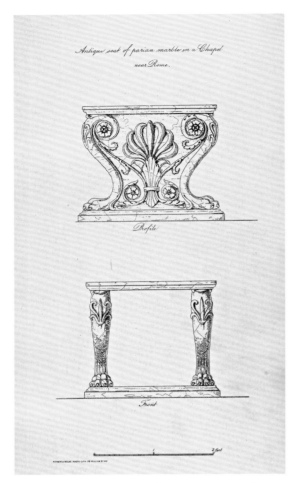

Fig. 66-4 Charles Heathcote Tatham. "Antique seat of parian marble in a chapel near Rome." From *Etchings…of Ancient Ornamental Architecture* (1699): pl. 76. Art and Architecture Collection, Miriam and Ira D. Wallach Division of Art, Prints and Photographs, The New York Public Library Astor, Lenox, and Tilden Foundations.

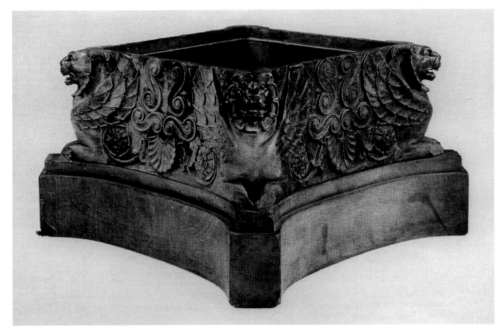

Fig. 66-5. Regency mahogany plinth. Christie's Images Limited 2007.

The tables are massive in form, with perfectly proportioned end supports for the porphyry tops, which have slightly curved front edges and were probably cut from antique columns. The vigorously wrought scrolls and the undercut, applied carving[7] on the table ends may be the work of the carver Bogaert, who was praised by Hope as one of the two craftsmen "whose industry and talent I could in some measure confide the execution of the more complicate [*sic*] and more enriched portion of my designs."[8]

In their present form, the Ashmolean tables have lost their original plinths (see fig. 66-5) and have later horizontal supports between either end of each table. Hope's publication inspired a smaller and weaker, commercially produced table, with inlaid rather than carved details but raised on plinths as originally intended.[9]

1. Penny, *Catalogue of European Sculpture*, vol. 3 (1992): nos. 522, 523. The Ashmolean also acquired "Four low chairs of figured ash with deeply curved top rails, scrolled, bowed, and pierced lyre-shaped splats. . . Probably designed by Thomas Hope," ibid., app. II; see Humbert and Flint sales cat., 1917, lot 919: "Four circular back inlaid walnut chairs with loose seats in green plush."
2. *Household Furniture* (1807): 30.
3. Neale, "The Deep-Dene, Surrey" (1826): 6.
4. For a stool by Jacob Frères with a similar profile, see Ledoux-Lebard, *Le Mobilier Français du XIXeme Siècle* (2000): pl. XVII (top left).
5. This source is engraved after a drawing by Antoine Desgodetz in *Les Edifices Antiques de Rome* (1682): pl. v, ill. by Piranesi in *Opere Varie* (1750): pl. 6, and used by Robert Adam as the inspiration for hall seats for Shelburne House (see Harris, *The Furniture of Robert Adam* [1973]: 94, figs, 111, 112).
6. For discussion of Hope's relationship with Tatham, see Watkin, "Thomas Hope" (2004): 31–39; see also Chapters 2 and 4 in this volume.
7. A feature noticed by Tatham on antique carving, such as in his drawing of capital ornament detail; Victoria and Albert Museum, inv. no. D.1948-98; reproduced in Pearce and Salmon, "Charles Heathcote Tatham in Italy" (2005): fig. 18. See also Chapter 4 in this volume.
8. *Household Furniture* (1807): 10.
9. See Collard, *Regency Furniture* (1985): 99. George Smith used a similar end support on a dressing table published in *Collection of Designs for Household Furniture* (London, 1808): 72. Hope himself owned a small "casket" based on the Tomb of Agrippa; it is illustrated in *Household Furniture*, pl. x. Also based on this tomb is the Regency-period inkstand (one of a pair), exhibited by Mallett; see *The Age of Matthew Boulton* (2003): 106–9.

ML

67. Sofa End

After a design published by Thomas Hope
English, ca. 1802
Mahogany[?]
36 x 5⅞ x 30⅝ in. (91.4 x 15 x 77.7 cm)
Private collection
Not in exhibition

PROVENANCE: Presumably Thomas Hope; [...];
London art market [Richardson?], 1960s, when acquired
by the present owner.

This robustly conceived carved mahogany sofa end[1] is one of a pair in the lender's collection. In their present configuration, they have been used to form the ends of an upholstered bench. The carved ends can be seen in their original formation as part of the seating in the "Third room Containing Greek Vases" at Duchess Street (*Household Furniture* [1807]: pl. v, here fig. 2-14). A detail of the "End of the sofa in the room, Plate 5" appears in pl. XXIX; see fig. 6-15). It is clear from the visible shadow that the detail embellishing the right angle at the base, probably applied carving and clearly shown in fig. 6-15, has been lost.

The form of the extravagant, carved wings is based on the supports for antique thrones, such as the one illustrated by Charles Heathcote Tatham in plate 81 of *Etchings* (fig. 67-1). A more literal use of this classical source can be found in plate 6 of Percier and Fontaine's *Recueil...*, and in Hope's winged sphinx-headed "stone seats" recorded in the Picture Gallery at Duchess Street (*Household Furniture*, pl. II, see fig. 2-8). These seats, which may have been made of Coade stone,[2] are illustrated in two views in plate XIX, numbers 6 and 7. Hope clearly admired this feathery motif, which can also be seen on the wall lights (cat. no. 97).

Despite the lack of an early documented provenance, one should be reasonably confident that this object was originally at Duchess Street.

1. The compiler has not had the opportunity to examine this object.
2. See Chapter 4 in this volume, fig. 4-16.

ML

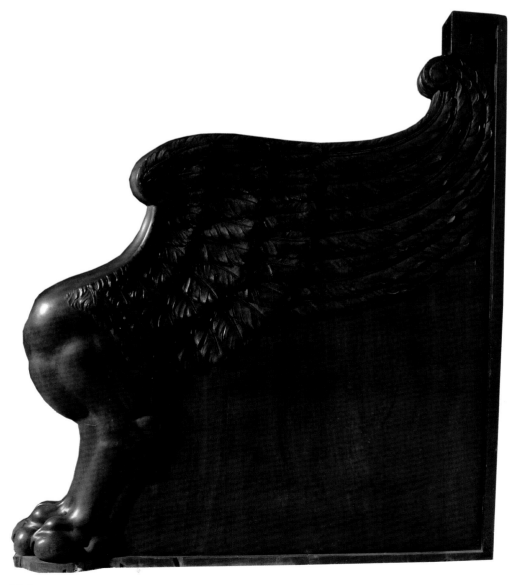

[67]

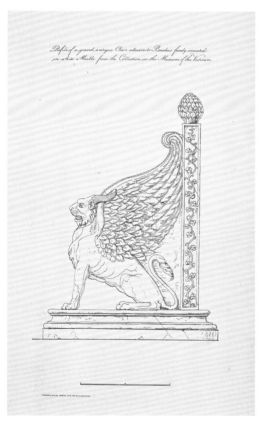

Fig. 67-1. Charles Heathcote Tatham. Throne support. From *Etchings...of Ancient Ornamental Architecture* (1799): pl. 81. Art and Architecture Collection, Miriam and Ira D. Wallach Division of Art, Prints and Photographs, The New York Public Library Astor, Lenox, and Tilden Foundations.

68. *Table*

After a design published by Thomas Hope
English, ca. 1802
Gilded wood, bronze, mirror glass, *nero di belgo* marble
35½ x 60 x 20½ in. (90.1 x 152.4 x 52 cm)
Courtesy of the Trustees of The Victoria and Albert
Museum, London, W.19.1976. Purchased with a dona-
tion from Mrs. George Levy in memory of her father,
Philip Blairman

PROVENANCE: Presumably Thomas Hope, Duchess
Street; [...]; Ronald Fleming;[1] Mrs. Payne Thompson, by
1929; [...]; Arthur Boys, by 1946; [...]; Philip and Celia
Blairman; by descent to their children; from whom
acquired by the Victoria and Albert Museum in 1976.[2]

EXHIBITIONS: *Loan Exhibition of English Decorative
Art at Lansdowne House*, London (1929), no. 506, lent by
Mrs. Payne Thompson; *The Regency Exhibition*, Royal
Pavilion, Brighton (1946), no. 84, lent by Arthur Boys;
The Age of Neo-Classicism, Victoria and Albert
Museum, London (1972), no. 1650.

LITERATURE: *Household Furniture* (1807): pl. VII;
Westmacott, *British Galleries* (1824): 217; *Catalogue of
Loan Exhibition of English Decorative Art at Lansdowne
House* (1929): no. 506; Boys, "The Regency Exhibition
at the Royal Pavilion, Brighton" (1946): 252, fig. 4;
Musgrave, *Regency Furniture* (1961): fig. 15B; Watkin,
Thomas Hope (1968): 112, 208, 256; *The Age of Neo-
Classicism* (1972), no. 1650; Wilk, *Western Furniture
from 1350 to the Present* (1996): 138.

This table originally stood opposite the
chimneypiece in the Aurora Room at
Duchess Street, which took its name from
John Flaxman's *Aurora Abducting Cephalus*
(see cat. no. 55). The table was flanked by
the pair of tables, of which catalogue num-
ber 69 is one; the arrangement, partially
reconstructed in the 1972 exhibition *The Age
of Neo-Classicism* at the Victoria and Albert
Museum (fig. 68-1) can be clearly seen in
Household Furniture (see fig. 70-1). Hope's
own description of the room reveals the
background against which the table would
have been seen: "The whole surrounding
decoration has been rendered, in some
degree, analogous to [*Aurora Abducting
Cephalus*] and to the face of nature at the
moment when the first of the two, the god-
dess of the morn, is supposed to announce
approaching day."[3] The colors of the room's
hangings were "azure, black, and orange,"
which gave relief to the furniture, which was
"mostly gilt."[4] Writing in 1812, the antiquar-
ian Francis Douce observed that the "judi-
cious disposition of the looking glasses
behind curtains has a truly magical effect."[5]

Hope described the iconography of the
table: "Females, emblematic of the four
horae or parts of the day, support its rail, the
frieze of which contains medallions of the
deities of night and sleep."[6] The caryatids
supporting the table from the Aurora Room,
reminiscent of the figures designed for the
Erechtheion on the Acropolis in Athens,
appear identical to those on a table supplied
by Jacob Desmalter in 1808 for Caroline
Murat and now at Versailles.[7] A direct
source of inspiration, however, may have
been the "Meuble en acajou . . . Les figures
en bronze" shown by Jean-Charles Krafft in
a view of "Décorations de la Chambre à
coucher de Madame Récamier, rue du Mont-
Blanc, exécuté, en 1798, par Berthauld,
Architecte."[8] A center table, with caryatid
supports arranged like those on the Murat
table, appears in the penultimate plate of
Henry Moses's *Modern Costume*.

A Regency-period mahogany table based
directly on Hope's design for catalogue
number 68 was on the London art market in
1968.[9] The relative weakness in design and
execution of this commercially produced
table contrasts significantly with identified
Hope-commissioned furniture.

1. See Powers, "Ronald Fleming and Vogue Regency"
(1995): 51.
2. See Wilk, *Western Furniture from 1350 to the Present*
(1996): 138–39 (entry by Frances Collard).
3. *Household Furniture* (1807): 25.
4. Westmacott, *British Galleries* (1825): 217, a descrip-
tion of the "Star Room." These details are also
recorded by Hope in *Household Furniture* (1807): 26.
5. Quoted in Thornton and Watkin, "New Light on the
Hope Mansion in Duchess Street" (1987): 169.
6. *Household Furniture* (1807): 30.
7. See Ledoux-Lebard, *Le Mobilier Français du XIX^e
Siècle* (2000): 271. In Nouvel-Kammerer, *Symbols of
Power* (2007): no. 94; the table is dated ca. 1813. The
evolution of the distinctive range of furnishings pub-
lished by Hope occurred simultaneously with develop-
ments in France led by Percier and Fontaine. While
Hope was, arguably, developing an English version
of the "Empire" style, it seems certain that ideas were
traveling both ways across the Channel.
8. Krafft and Ransonette, *Plans, Coupes, Elévations* (1801).
9. With W. R. Harvey, then in Chalk Farm, London.

ML

Fig. 68-1. Partial recon-
struction of arrangement
of the Aurora Room at
Duchess Street in 1972
exhibition *The Age of
Neo-Classicism*. Photo-
graph, Victoria and Albert
Museum.

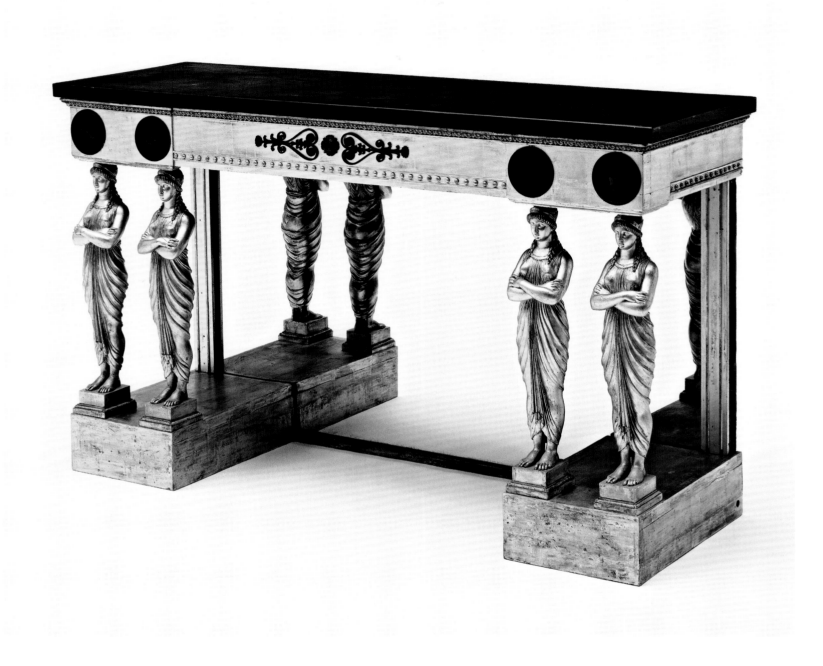

69. Table

After a design published by Thomas Hope
English, ca. 1802
Gilded wood, bronze, mirror glass, *nero di belgo* marble
35½ x 53 x 18 in. (90.2 x 134.6 x 45.7 cm)
The Huntington Library, Art Collections, and Botanical
Gardens, 95.2

PROVENANCE: Presumably Thomas Hope, Duchess
Street and later at the Deepdene; by descent Lord Francis
Hope Pelham-Clinton-Hope; sold Humbert & Flint,
14 September 1917, lot 825 (a pair); [...]; Christie's,
London, 7 July 1994, lot 131; bought by H. Blairman
& Sons, from whom acquired by Huntington.

LITERATURE: *Household Furniture* (1807): pls. VII, XV,
no. 3; Wilk, *Western Furniture from 1350 to the Present*
(1996): 138, fig. 2.

The Huntington table and its (untraced) pair were originally installed in the Aurora Room at Duchess Street. The room is illustrated in *Household Furniture*, plate VII (see fig. 2-19). A front view of the table appears in plate XV (see fig. 69-1), described as: "No. 3. Table, on which stands a glazed case or shade, between two candlesticks [cat. no. 73]." By 1917 the tables were in the Great Hall on the ground floor of the Deepdene, described in the catalogue as: "A PAIR OF 4ft. 6 in. GILDED HALL TABLES, with black marble tops on chimera supports"; they sold for £20.

Winged figures supporting console tables, which derived from antique forms, are featured frequently in French Empire period furniture.[1] Although such supports were also drawn by Tatham,[2] the direct source for the winged chimeras on the Huntington table may be the table in a design for painted panels that appears as plate 17 in Percier and Fontaine's *Recueil de Décorations Intérieures*. The same Percier and Fontaine table appears to be the inspiration for the Hope-designed version that appears as the final plate in Henry Moses's *Modern Costume* (fig. 69-2).

The Huntington table has the same gilding as another table from the Aurora Room, now in the Victoria and Albert Museum (see cat. no. 68). Both tables have the same details in the frieze and plinths; they retain their original black marble tops and have bronze mounts, apparently by the same hand, perhaps imported from France.[3] Each of the two tables, which are similarly constructed, has undecorated fillets behind the gilt pilasters; these would have been covered by the wall hangings that lined the Aurora Room.

1. See, for example, Grandjean, *Empire Furniture* (1966): pl. B, a table at Malmaison.
2. See, for example, Pearce and Salmon, "Charles Heathcote Tatham" (2005): fig. 61.
3. See Chapter 6 in this volume.

ML

Fig. 69-1. *Household Furniture* (1807): pl. XV.

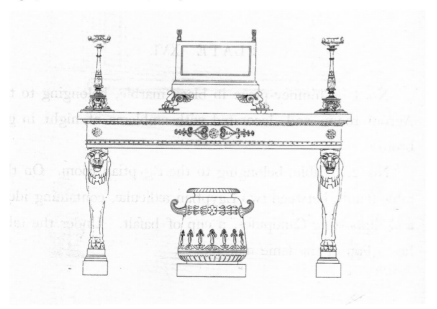

Fig. 69-2. Henry Moses. Final plate. *Designs of Modern Costume* (1812). Stephen Calloway.

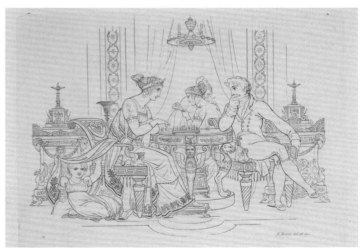

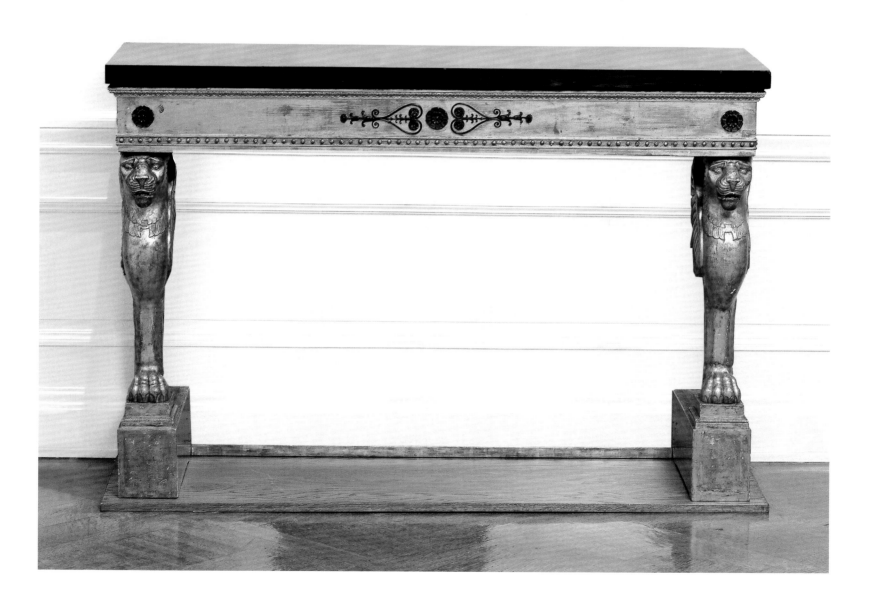

70. *Pair of Vases*

After a design published by Thomas Hope
English, ca. 1802
Blue John (Derbyshire fluorspar, fluorite), ormolu, glass
14¾ x 8¼ in. across the handles (37.5 x 23 cm)
Private collection

PROVENANCE: Presumably Thomas Hope, Duchess Street and later at the Deepdene; by descent Lord Francis Hope Pelham-Clinton-Hope; sold Christie's, London, 18–19 July 1917, lot 252a; bought by Gooden & Fox, London for £120.15; [...]; Christie's, London, 15 May 1969, lot 18; Howard of Davies Street, London; private collection.

LITERATURE: *Household Furniture* (1807): pl. XIII; Chapman, "Thomas Hope's Vase and Alexis Decaix" (1985): 227.

Documented through the Hope Heirlooms sale of 1917, these vases were part of the furnishings of Duchess Street and are shown flanking the Isis clock on the table in the Aurora Room in plate XIII of *Household Furniture* (see fig. 70-1).[1] They are simplified versions of the vases shown as plate XXXIV, number 4 (see fig. 6-3). Made of the mineral Blue John, a banded fluorite also known as Derbyshire fluorspar that was made famous by Matthew Boulton's experiments with ormolu-mounted objects in the period 1768 to 1782, the vases have the swan-necked handles that follow the model for the vases in plate XXXIV, number 6, but again they appear to be simpler in execution. The bacchante mask mounts also follow the general character of the comic and tragic masks shown in plate XXXVII (see fig. 6-10). A remarkable feature is the pair of opaque glass eyes, which must be a reference to the obsidian eyes found on classical antiquities. The design of the ormolu stands with their incurving corners and ribbed panels does not appear in the *Household Furniture*. It is unlikely that Hope, who ostensibly supplied the drawings for *Household Furniture*, or the engravers Edmund Aikin and George Dawe would have missed these features.[2] As they are in the Louis XVI style, it is possible that they are replacements made between the late nineteenth and early twentieth century, when this type of ormolu stand for porcelain and marble vases was popular.

1. However, they are not shown on that table in the perspective of the room in plate VII. The model, without the mask mounts, also shows up as plate LI, no. 1.
2. Watkin, *Thomas Hope* (1968): 51.

MC

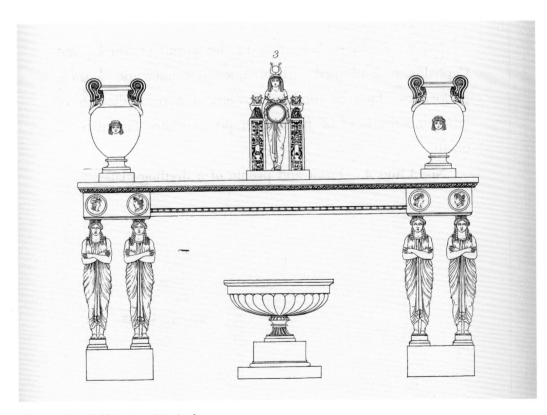

Fig. 70-1. *Household Furniture* (1807), pl. XIII, no. 3.

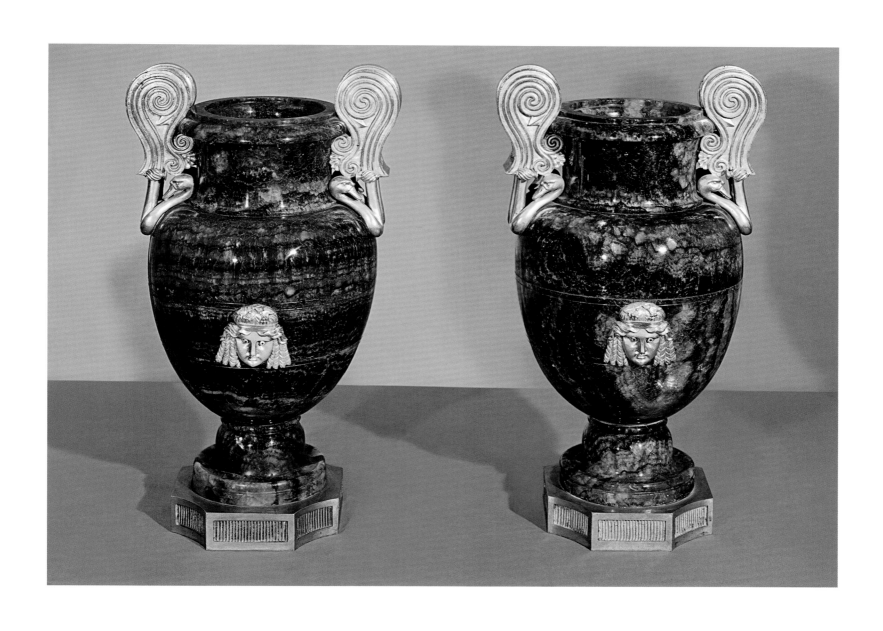

71. *Clock*

French, early 19th century
Rosso antico marble, gilt and patinated bronze, enamel
18¾ x 11¼ x 7⅞ in. (50 x 30 x 21 cm)
The Trustees of the Faringdon Collection, Buscot
Park, Oxfordshire
London only

PROVENANCE: 2nd Lord Faringdon.

LITERATURE: *Household Furniture* (1807): pls. VII, XIII,
no. 3.

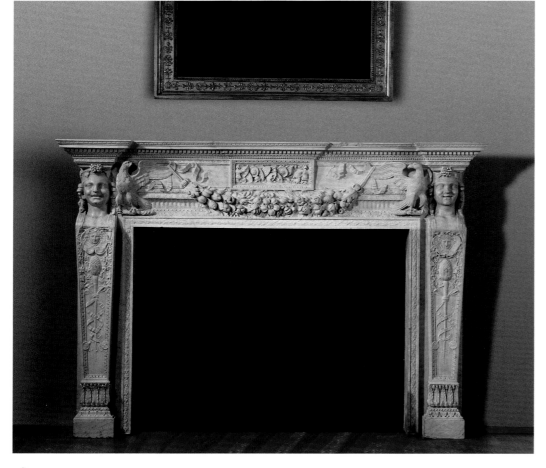

Shown in plates VII and XIII of *Household Furniture* (see figs. 2-19 and 70-1), the Isis clock displayed on the larger console table in the Aurora Room is cited by Hope as "a clock, carried by a figure of Isis, or the moon, adorned with her crescent." Hope included the clock as part of the general iconography of the room, which Watkin describes as being remarkably consistent.[1] Themed around Aurora, the goddess of the morning depicted in Flaxman's sculpture, "the whole surrounding decoration has been rendered analogous to . . . the moment when . . . the goddess of the morn is supposed to announce approaching day." The clock with its figure of Isis participates in this program by representing the moon; the table upon which the clock stands has figures of *horae* related to the times of the day and bronze mounts with "the deities of night and sleep."

In Hope's published version of this ancient Egyptian-style clock, which is seen in more detail in plate XIII, the figure of Isis is depicted with her emblems of cow horns and the solar disk on her head. She is flanked by "pylons" topped with cow-headed jars, the goddess's attributes. The panels are decorated with obelisks and hieroglyphs. Although it is reputed to have come from Duchess Street, the exhibited clock differs from Hope's published model, lacking not only "the crescent," or cow, horns above Isis and the solar disk, but also the cow-headed jars. It is, however, possible, as with the large bronze vase (cat. no. 89), that differences existed between the executed object and the design in *Household Furniture*, so it remains unclear if this was Hope's clock or not.

There are many versions known of this model, none of which appears to have the cow-horn emblem and solar disk as shown in *Household Furniture*, but many of which include the cow-headed jars. Most are identified as being French, with French movements, and one is by the famous *bronzier* Ravrio.[2] Parts of the design are indebted to Piranesi's etchings of Egyptian-style chimneypieces in *Diverse Manieri* of 1769 (fig. 71-1). The cow-headed jar motif appears in one of Piranesi's designs,[3] and more Egyptian-style details may also derive from this source. Piranesi had already been involved in the Hope family circle through the design of the famous chimneypiece for John Hope in Holland, which was also published in *Diverse Manieri*.[4] Beyond Hope's citations of Piranesi as a source at the conclusion to *Household Furniture*, however, there is no documentary evidence as to who designed this model of clock.

1. Watkin, *Thomas Hope* (1968): 112.
2. One version published in Ottomeyer and Proeschel, *Vergoldete Bronzen*, vol. 1 (1986): 336, no 5.3.2, includes the cow-headed jars and their trapezoidal panels. It is by the Parisian *bronzier* Ravrio and has a clock movement by Mesnil. There are other versions with movements by French clockmakers, such as that by Lépine (see Kjellberg, *Encyclopédie de la Pendule Française* [1997]: 381C.), while the often-cited version at the Royal Pavilion, Brighton (inv. no. DA340252) is catalogued as being English (Web site for Brighton and Hove Museums). None has the cow horns and solar disk as depicted in *Household Furniture*.
3. Ely, *Giovanni Battista Piranesi*, vol. 2 (1992): no. 864.
4. Ibid., 823.

MC

Fig. 71-1. Giovanni Battista Piranesi. John Hope's chimneypiece. Rijksmuseum, Amsterdam, BK-15449.

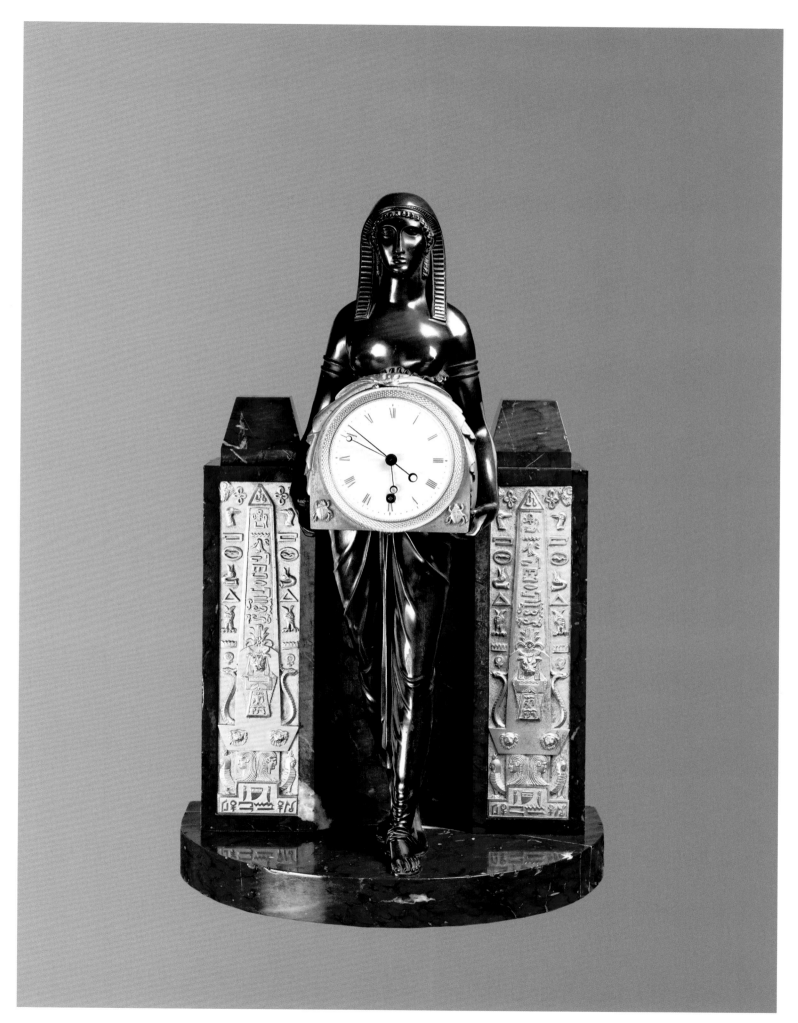

72. *Pair of Candlesticks*

After a design published by Thomas Hope
Probably made by Alexis Decaix (ca. 1753–1811)
English, ca. 1802
Patinated bronze, ormolu, marble
11½ in. (29 cm)
Private collection

PROVENANCE: [...]; sold Christie's, London, 6 July 1995, lot 88; sold to Jeremy's for client.

LITERATURE: *Household Furniture* (1807): pl. XIII, no. 1 (see also pl. XLIX).

This model of candlestick is included in *Household Furniture* as part of the metalwork shown in plate XLIX (see figs. 6-1, 6-17) and again on the table in the Lararium, or Boudoir, in plate XIII, number 1. There are design variations in the depictions that appear in *Household Furniture*. In plate XLIX (see fig. 6-1) the candlestick has a sloping base similar to the pedestals on the objects in the Egyptian Room (pl. VIII, fig. 2-15), whereas in plate XIII (cat. no. 70-1) the model is shown on an open base of ormolu, as in this example.

Hope's "bronzist" Decaix is documented as supplying "a pair of Egyptian Slave candlesticks for a light" to the goldsmith Garrard in October 1800.[1] Although the description continues "on Bronze pedestal with hieroglyphic characters," a design more in keeping with the iteration of the model in plate XLIX. It is probable that this pair was made by Decaix, even though Hope does not appear among Garrard's clients at this date. The workmanship is English rather than French, seen most readily in the sturdiness and heaviness of the ormolu stand. Decaix could have supplied to Hope directly rather than through Garrard. Indeed the pair documented as being supplied by Decaix to Garrard in 1800 may have been to Hope's design.

1. Victoria and Albert Museum, Archive of Art and Design, Garrard & Co., Ltd. records, 1735–1949.

MC

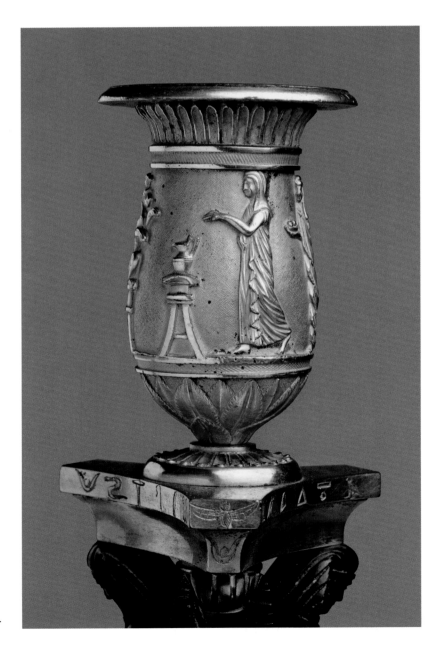

Detail of cat. no. 72.

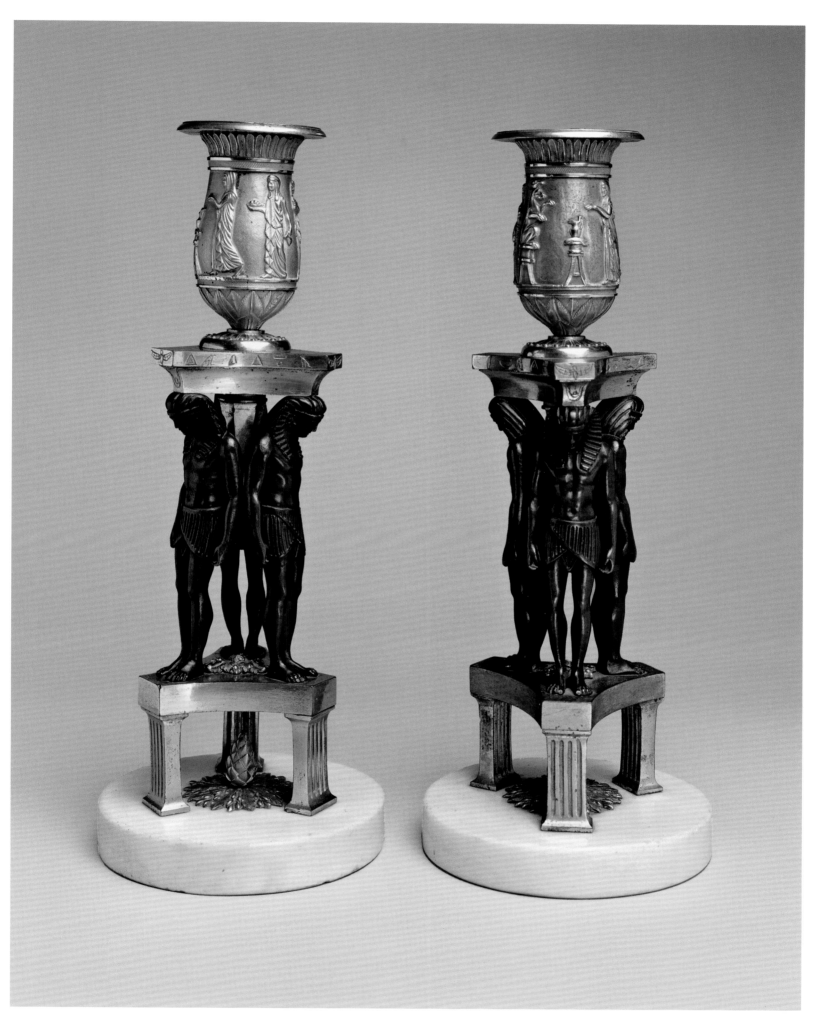

73. *Pair of Candlesticks*

After a design published by Thomas Hope
Possibly made by Lefèvre, Paris, *bronzier*
English or French, ca. 1802
Gilt bronze
Marks: Each numbered 1 and 0.
12½ in. (32 cm)
Private collection

PROVENANCE: [...], Paris art market; William Iselin; private collection.

LITERATURE: *Household Furniture* (1807): pls. xv, no. 3, and XLIX.

Designed after an antique oil lamp with flaming finials, this model is shown in plates XV and XLIX in *Household Furniture* (see fig. 6-17). Several versions of this design are known, one formerly at Slane Castle, Ireland[1] and a pair in the Grande Chancellerie de la Légion d'Honneur, Paris, which is thought to be French and by the *bronzier* Lefèvre.[2] When a pair appeared on the London market in 1995, it was thought to be English and possibly even by Decaix.[3]

The question as to whether objects were made in London or Paris may be posed for much of Hope's metalwork. In this case, the design of the shaft densely covered in ornament is more French Empire in style than Hope's more austere models, and it seems likely that the original version was made in Paris by Lefèvre. It could have

then been bought by an English patron, perhaps during the Peace of Amiens of 1802–3, and then copied in England.

Another interesting connection is the architect Henry Holland, who is credited with supplying the six-light chandelier at Woburn that has recently been recognized as being by French *bronzier* Lefèvre.[4] Given Holland's close ties to French design and designers, it is possible that Holland was importing gilt bronzes from Paris or even getting them made there to his design. As Hope was in Holland's larger circle, there may have been some link between the two for these objects.

There is a discrepancy in the dimensions of the candlesticks, between 18 inches quoted in the Hope Heirlooms sale of 1917 and 12½ inches for this pair and for the pair sold at Christie's, London, in 1995. The larger dimension of the pair in the Hope sale may have been because it was fitted for electricity.

1. O'Brien and Guinness, *Great Irish Houses and Castles* (1992): 161. Others were sold at Christies, London, 16 November 1995, lot 318, and Christie's, London, 17 April 1997, lot 16.
2. Augarde, "Une nouvelle vision" (2005): no.398, pp. 71, 75, fig. 19.
3. Christie's, London, 6 July 1995, lot 9 "a pair of Regency ormolu and bronze candlesticks after a design by Thomas Hope and attributed to Alexis Decaix."
4. Augarde, "Une nouvelle vision" (2005): 71.

MC

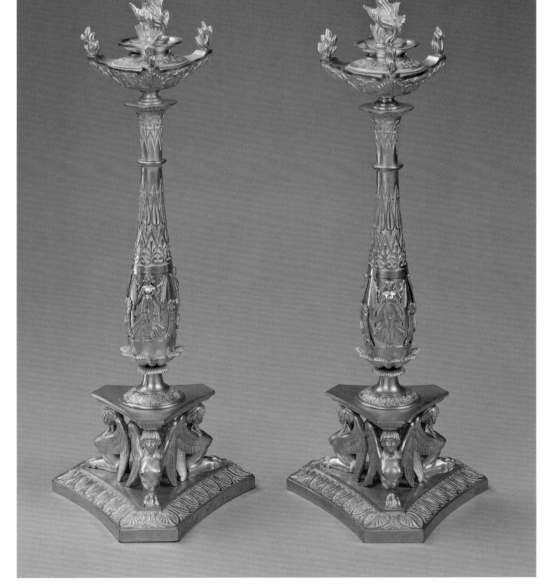

Fig. 74-1. *Household Furniture* (1807): pl. xv. (detail).

74. *Table*

After a design published by Thomas Hope
English, early 19th century
Bronzed and gilded beech and pine; marble of later date
30½ x 43½ x 27⅛ in. (77.5 x 110.5 x 68.9 cm)
Private collection
London only

PROVENANCE: [...]; with Mallett's, London, 1972, from whom acquired by present owners.

LITERATURE: *Household Furniture* (1807): pl. XV, no. 2

This table corresponds closely with plate XV, number 2, in *Household Furniture* (fig. 74-1). Hope records the table as "belonging to the music room, and adorned with an antique lyre."[1]

When Francis Douce visited Duchess Street in 1812, he made a plan of the principal rooms, together with notes of some of the contents. In the center of the Drawing Room was a "Table with lyres." Based on Douce's description of the chairs in this room as "Parisian," Thornton and Watkin speculate that the lyre table depicted in *Household Furniture* might also be French. The exhibited table, however, is certainly of English manufacture.[2]

It should be noted that there is elaborate carving both on the insides of the end supports (as, for example, on the Ashmolean tables, cat. no. 66) and on the stretcher; neither of these features is apparent from the plate in *Household Furniture*. In the absence, to date, of another candidate, the quality of the present table (which has been restored and to which a replacement marble top has been added), together with its closeness to Hope's published design, does not rule out the possibility that this may indeed have been the table from Duchess Street.

1. *Household Furniture* (1807): 31. Plate LVI illustrates three lyres "imitated from the antique: the third is taken from a very fine fragment of a Greek fictile vase, in my possession" (p. 49). Another carved wooden lyre can be seen illustrated in situ at the Deepdene by *Country Life* in 1899; see Robinson, *The Regency Country House* (2005): 189.
2. Thornton and Watkin, "New Light on the Hope Mansion" (1987): 162, 168–69.

ML

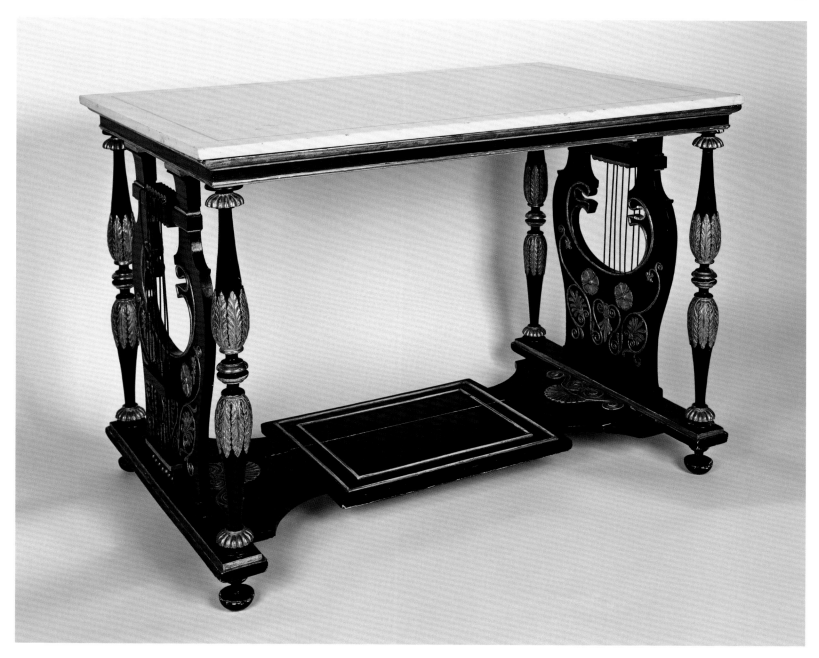

75. *Pair of Tables*

After a design published by Thomas Hope
English, early 19th century
Mahogany
33 x 20 x 20 in. (83.8 x 50.8 x 50.8 cm)
Courtesy of the Trustees of The Victoria and Albert
Museum, London, W.35 and A-1946
New York only

PROVENANCE: [...]; by repute, the Dukes of Newcastle,
Clumber Castle, until 1937; Messrs E. Miney, from whom
acquired by the Victoria and Albert Museum, 1946.

LITERATURE: *Household Furniture* (1807): pl. XV, no. 1,
pl. LV, no. 1; Jourdain, *Regency Furniture* (1934): 68,
fig. 17; ibid., rev. ed. (1965): 21, fig. 21.

Fig. 75-1. A.C.P. Caylus. *Recueil d'Antiquités
égyptiennes, Etrusques, Grècques et Romaines* 1
(1752): pl. XCV, no. II.

The design of these tables is based on the type of Roman marble tripod table, several of which Hope himself owned (see, for example, cat. no. 45).[1] The precise source for the exhibited tables may, however, be an authority commended by Hope; the profile of the leg is very close to one described as Roman, illustrated by A.C.P. Caylus (see fig. 75-1).[2]

The exhibited table conforms closely with the "Tripod table, supported by chimeras," *Household Furniture*, plate XV (see fig. 69-1). A similar table, reproduced in *Household Furniture*, plate II (see fig. 2-8), if not an ancient marble version (see cat. no. 45), may have been placed in the original Picture Gallery.[3] Another tripod table can be seen to the front right in a later view of the Picture Gallery at Duchess Street illustrated in *The Magazine of Arts*, 1821. *Household Furniture*, plate XXXII, illustrates a "Tripod table, in mahogany and gold"[4] of comparable form to catalogue number 82; this was sold at Christie's on July 20, 1917, lot 297, bought by L. Harris[5] for £17 17s. It is instructive to compare this second Hope tripod to the "Antique Tripod of Oriental Alabaster from the Collection in the Museum of the Vatican" published in Tatham's *Etchings*; one can see how designs created under Hope's influence both manipulate and elaborate on their classical progenitors.

Hope's frequent use of animal motifs in the plates of *Household Furniture* reflects his taste for the more decorative elements of Roman classical design, as opposed to the greater purity of Grecian furniture forms, which he also admired. It is the voluptuous aspect of Roman classicism that also predominates in the French Empire style.

The vigorous carving on these stands appears consistent with that found on furniture retaining a documented association with Hope. If it were possible to confirm the posited Newcastle provenance, however, then an unassailable connection to Duchess Street could be established.

1. Christie's, London, 23 July 1917, lot 186, "Roman Tripod Drinking-Table, or Delphic . . . with *alabastro fiorito* chimeras."
2. *Recueil d'Antiquités égyptiennes*, vol. 1 (1752): pl. XCV, no. II. At the back of *Household Furniture*, Hope mentions "Caylus's Antiquities." See also cat. no. 81.
3. *Household Furniture* (1807): 31. A plan of the base of this table is in *Household Furniture*, pl. LV (not LIV, as stated in Hope's text), no. 1.
4. Ibid., 38. This tripod was illustrated in situ at the Deepdene by *Country Life* in 1899; see Robinson, *The Regency Country House* (2005): 186.
5. Probably the antique dealer Lionel Harris, listed at 50 Conduit Street, London, W1. Harris was also the buyer in 1917 of cat. nos. 76, 77, etc.

ML

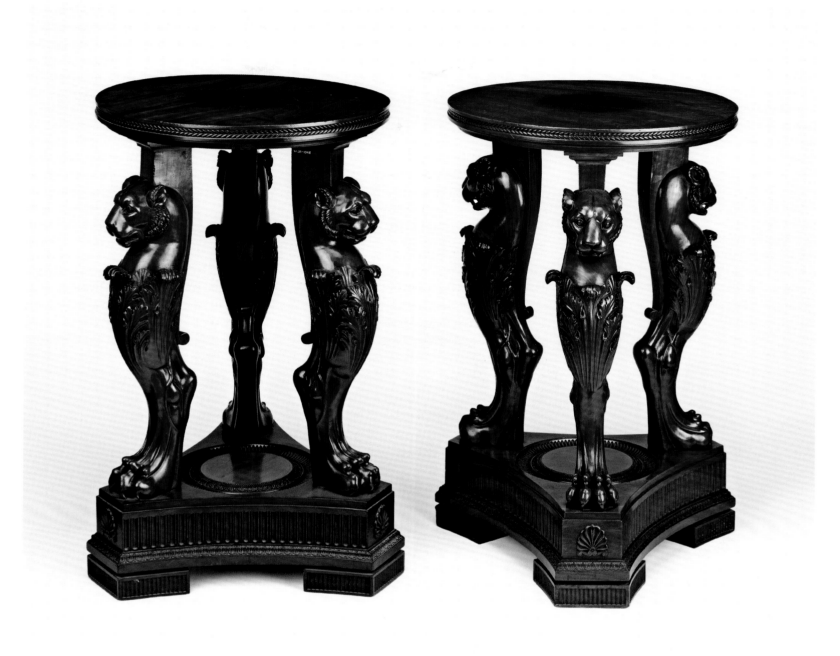

76. Settee

After a design published by Thomas Hope
English, ca. 1802
Bronzed and gilded beech, with restoration, bronze
28⅜ x 65¼ x 26¹/₁₆ in. (72.1 x 166.9 x 66.2 cm)
The Trustees of the Faringdon Collection, Buscot
Park, Oxfordshire

PROVENANCE: Thomas Hope at Duchess Street, later
at the Deepdene; by descent, Lord Francis Hope Pelham-
Clinton-Hope; sold Christie's, London, 18 July 1917, lot
306, bought L. Harris for £24 3s.; [...]; Thistlethwayte
family, Southwick House, one settee and two armchairs;
J. W. Blanchard; H. Blairman & Sons, 1954, from whom
acquired by 2nd Lord Faringdon, for Buscot Park (now
a property of the National Trust).

EXHIBITIONS: *The Age of Neo-Classicism*, Victoria
and Albert Museum, London (1972), no. 1654; *Piranesi*,
Hayward Gallery, London (1978), no. 282.

LITERATURE: *Household Furniture* (1807), pls. VIII,
XVII, no. 4, XLVI; Symonds, "Thomas Hope and the
Greek Revival" (1957): 230, fig. 15; Musgrave, *Regency
Furniture* (1961): 52, pl. 21; Hayward, *World Furniture*
(1965): 204, pl. 757; Watkin, *Thomas Hope* (1968): 115,
256, pl. 39; *The Age of Neo-Classicism* (1972): 778,
no. 1654.

77. *Pair of Armchairs*

After a design published by Thomas Hope
English, ca. 1802
Bronzed and gilded beech, with restoration, bronze
46¾ x 28¼ x 24½ in. (118.6 x 71.7 x 62.2 cm)
The Trustees of the Faringdon Collection, Buscot
Park, Oxfordshire
London only

PROVENANCE: Thomas Hope at Duchess Street, later at
the Deepdene[1]; by descent, Lord Francis Hope Pelham-
Clinton-Hope; sold Christie's, London, 18 July 1917,
lot 306; bought L. Harris for £24 3s.; [...]; Thistle-
thwayte family, Southwick House, one settee and two
armchairs[2]; J. W. Blanchard; H. Blairman & Sons, 1954,
from whom acquired by 2nd Lord Faringdon, for Buscot
Park (now a property of the National Trust).

EXHIBITIONS: *The Age of Neo-Classicism*, Victoria
and Albert Museum, London (1972), nos. 1654, 1655
(two armchairs and settee); *The Inspiration of Egypt*,
Brighton Museum, 1983, no. 86b (armchair); *The Treasure
Houses of Britain*, National Gallery of Art, Washington
(1985), no. 525 (settee and one armchair); *Europa und der
Orient*, Martin-Gropius-Bau, Berlin (1989), 1/78 (settee);
London World City 1800–1840, Villa Hugel, Essen (1992),
no. 286 (one armchair).

LITERATURE: *Household Furniture* (1807): pls. VIII,
XLVI, nos. 2, 3; Douce MS (1812); *The Cabinet Maker
and Art Furnisher* 15, no. 175 (January 1895); R. Symonds,
"Thomas Hope and the Greek Revival," *Connoisseur* 140
(1957): 230, fig. 16; Watkin, *Thomas Hope* (1968): 115,
211, 256, pl. 40; *The Age of Neo-Classicism* (1972): 778,
no. 1655, pl. 133a; Conner, *The Inspiration of Egypt*
(1983): 47, no. 86B.

This iconic suite[3] is illustrated in situ at
Duchess Street in *Household Furniture*, plate
VIII (see fig. 2-15), with a settee appearing
in an end and side view, plate XVII, numbers
3 and 4, and an armchair, similarly, in plate
XLVI, numbers 2 and 3. In describing the
armchairs, Hope wrote: "The crouching
priests supporting the elbows are copied
from an Egyptian idol in the Vatican[4]: the
winged Isis placed in the rail is borrowed
from an Egyptian mummy-case in the Insti-
tute [now Museo Civico] at Bologna: the
Canopuses[5] are imitated from the one in
the Capitol: and the other ornaments are
taken from various monuments at Thebes,
Tentyris, &c."[6] Despite the distinctly
Egyptianizing motifs applied to the chairs,
their overall form remains closely rooted
to contemporary European design.

This un-Egyptian quality is equally evi-
dent with the settees (which might better be
described as couches), one of which is in
the Faringdon Collection and the other,
together with the second pair of armchairs,
is at the Powerhouse Museum in Sydney

(see fig. 77-1).[7] The overall design and
details such as the feet derive from classical
Greek or Roman forms. The recumbent
lionesses, however, are based on ancient
Egyptian examples, which since 1562 have
been (almost constantly) at the base of the
steps leading to the Piazza del Campidoglio
in Rome. It is possible that the castings used
on the Faringdon settee were executed by
Giuseppe Boschi[8]; those on the settee at the
Powerhouse are modern replicas. Tatham
made a drawing in 1795 after a "Design by
Giuseppe Boschi Copied from the cele-
brated Egyptian Lions in Basalt"
(fig. 76-1).[9] The figures on the ends of the
settees represent the gods Anubis, with the
jackal head, and Horus, with the hawk
head.[10] Gervase Jackson-Stops has
observed that these images may derive from
the *Mensa Isiaca*.[11]

Hope's description of the Egyptian
Room is a valuable reminder of the back-
ground against which this idiosyncratic
suite would have been seen, as well as of
the importance of color in the Duchess
Street interiors: "The ornaments that adorn
the walls of this little canopus are, partly,
taken from Egyptian scrolls of papyrus;
those that embellish the ceiling, from
Egyptian mummy cases; and the prevailing
colours of both, as well as of the furniture,
are that pale yellow and that blueish green
which hold so conspicuous a rank among
the Egyptian pigments; here and there
relieved by masses of black and gold."[12]

The continental nature of the suite[13] was
recognized in 1917 by Christie's, which

Fig. 76-1. Design by Giu-
seppe Boschi, "copied from
the celebrated Egyptian
Lions in Basalt." Victoria
and Albert Museum,
London. © V&A Images.

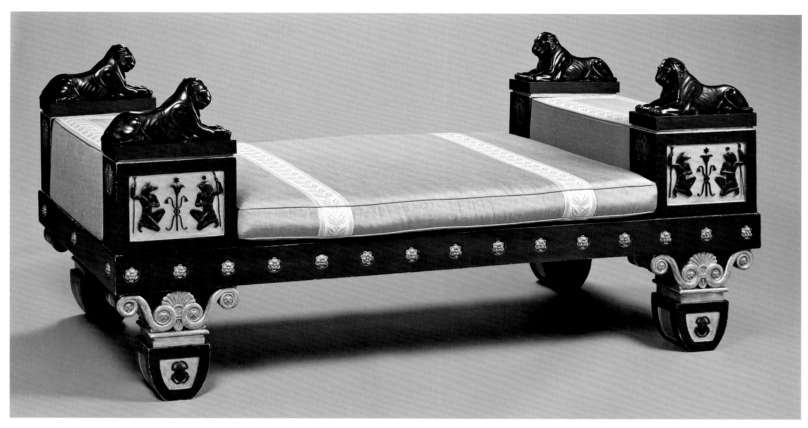

[76]

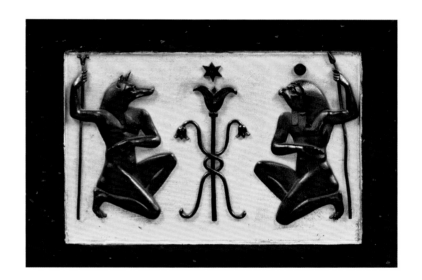

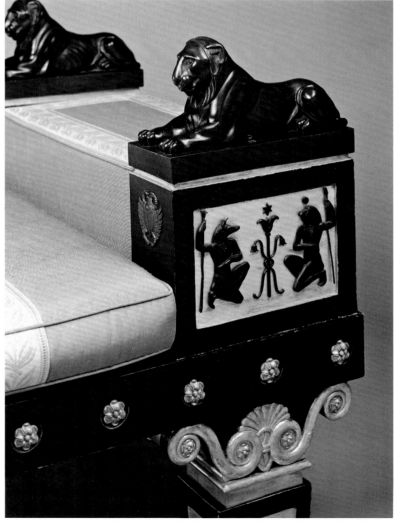

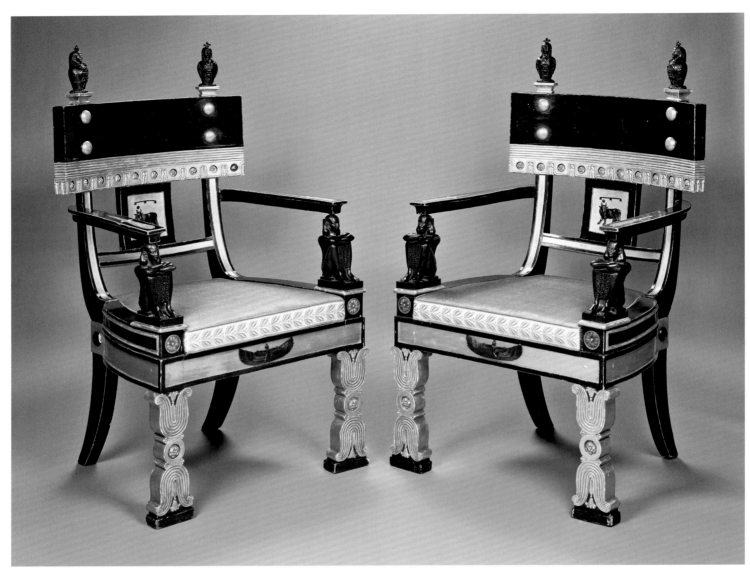

described it and other lots recorded in *Household Furniture* as "Empire Furniture." Whether or not the upholstery was original cannot now be ascertained, but in 1917 it was of "yellow silk brocade."

The furnishings of the Egyptian Room (see also cat. no. 78) are, arguably, among the most ambitious published in *Household Furniture*, and they reflect Hope's view of the mania for things Egyptian that swept Europe following Napoleon's military campaign (1798–1801) and the subsequent publication of Dominique Vivant Denon's *Voyages dans la Basse et la Haute Egypte* (1802).

1. Three of the four armchairs are illustrated in situ by *Country Life* in 1899; see fig. 12-20; Robinson, *The Regency Country House* (2005): 188–89. The gilt-bronze rosettes above the front legs of the chairs, present by 1899, may not be original. It is also possible that the scarabs on the settees were added after Hope's original commission. Neither of these elements appears in *Household Furniture*.

2. The Southwick Estate has a long history in the Norton and Thistlethwaite families, stretching back to the early 17th century. The purchaser of the Egyptian furniture was probably Colonel Evelyn Thistlethwayte, who bought Southwick Park from his nephew in 1931; the house was requisitioned during World War II and later passed into the hands of Hugh Borthwick-Norton, who made disposals, some through Christie's, in the early 1950s.

3. The suite was among the few items of furniture specifically mentioned by Francis Douce in 1812 when he visited Duchess Street; see Thornton and Watkin, "New Light on the Hope Mansion" (1987): 164. The architect and collector of Regency furniture James Stirling described Hope's furniture as "extreme, over the top, eccentric and gutsy," perhaps a fitting epithet for this most distinctive group of seating furniture (quoted in Girouard, *Big Jim* [1998]: vii).

4. See Ashton, *Egyptomania* (1994): 189, fig. 2. The same figures are used on the fender in Hope's Lararium at Duchess Street; see *Household Furniture* (1807): pl. x.

5. In 1899 two of the chairs appear to have lost these elements, but they were probably merely detached as those now present appear to be original; see Robinson, *The Regency Country House* (2005): 188–89.

6. *Household Furniture* (1807): 44.

7. The provenance: Thomas Hope at Duchess Street, later at the Deepdene; by descent, Lord Francis Hope

Pelham-Clinton-Hope; sold Christie's, London, 18 July 1917, lot 306, bought by L. Harris for £24 3s.; [...]; Sir Alfred Ashbolt, Tasmania, ca. 1920; thence by descent; sold at unidentified auction, Melbourne, 1940s; [...]; H. R. Mitchell, 1950s; Mrs. M. Drummond, Sydney; P. Drummond, Sydney; sold Lawson's, Sydney, 3 July 1984, lots 877 and 878; bought by Powerhouse Museum, Sydney. Exhibitions: *Egyptomania*, Louvre, Paris (1994) [then Ottawa and Vienna], nos. 100–101 (settee and one armchair); *Regency: British Art & Design 1800–1830*, Art Gallery of South Australia (1998), no. 45; *Piranesi as Designer*, Cooper-Hewitt (2007). Literature: *Household Furniture* (1807): pl. VIII, XLVI, nos. 2, 3; Douce MS (1812); *The Cabinet Maker and Art Furnisher* 15, no. 175 (January 1895): illus.; Watkin, *Thomas Hope* (1968); *Egyptomania* (1994–95): 189, 191; Watson, "Hope . . . and glory" (1990); Watson, "A gentleman of the sphinxes" (1992): 40–43; Menz, *Regency: British Art & Design 1800–1830* (1998): no. 45.

8. For Boschi, see *Dizionario Biografico degli Italiani* (1971): XIII, p. 197. The same lionesses form chimney ornaments; see *Household Furniture* (1807): pl. XLVI.

9. Victoria and Albert Museum, inv. no. D.1518-98; reproduced in Pearce and Salmon, "Charles Heathcote Tatham in Italy" (2005): fig. 43.

10. It seems reasonable to suggest that the principal bronze elements that dominate the embellishment of

Details of cat. no. 77.

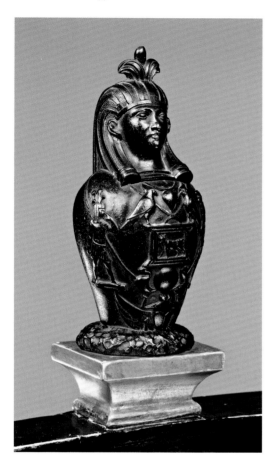

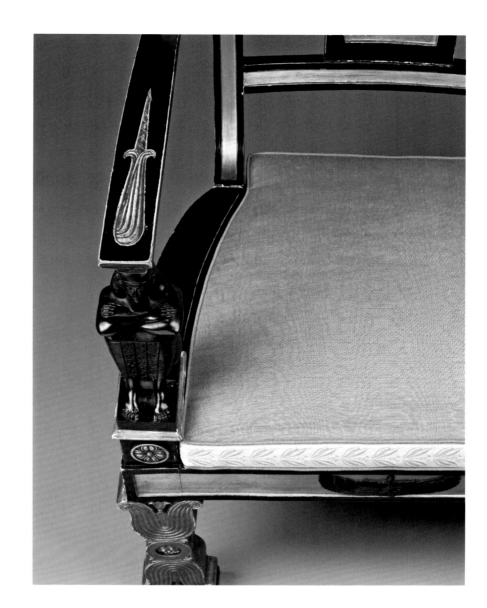

this suite are Grand Tour objects, available for general sale. The smaller and arguably more finely cast elements are perhaps English and by Decaix. It is instructive to compare, for example, bronze fittings supplied by Decaix in 1804 to the Duke of Bedford for the Temple of Liberty at Woburn Abbey.

11. *The Treasure Houses of Britain*, under no. 525. The brass, silver, and enamel *Mensa Isiaca*, also known as the Bembine Table of Isis, now in the Museo Egizio, Turin, was probably the work of an egyptianizing Roman sculptor. For further details, see *Egyptomania* (1994): no. 13.

12. *Household Furniture* (1807): 26–27. Westmacott uses virtually the same description in *British Galleries* (1824): 214.

13. See, for example, a "Grand fauteuil de bureau" designed by Percier and manufactured by Jacob with a similar profile to the exhibited chairs, reproduced in Ledoux-Lebard, *Le Mobilier Français du XIXeme Siècle* (2000): 283, pl. G.

ML

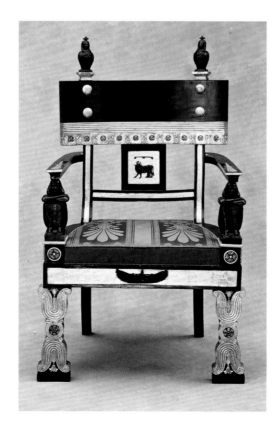

Fig. 77-1. Armchair after a design published by Thomas Hope. English, ca. 1802. Ebonized and gilt beech and oak with bronze and gilt. Powerhouse Museum, Sydney.

78. *Table*

After a design published by Thomas Hope
English, ca. 1802
Ebonized and gilded deal; micro-mosaic
The top, Italian, ca. 1795, attributed to Giacomo Rafaelli
33 x 51 x 26 in. (83.75 x 129.4 x 66 cm)
Carlton Hobbs LLC

PROVENANCE: Thomas Hope at the Deepdene; by descent, Lord Francis Hope Pelham-Clinton-Hope; Humbert & Flint, 17 September 1917, lot 1053; [...]; Doughnut Corporation of America; gift of Adolph Levitt to Hickory Museum of Art, 1949; Brunk Auctions, Asheville, North Carolina, September 2003, lot 260; art market; Carlton Hobbs LLC.

LITERATURE: Hope, *Household Furniture* (1807): pls. II and XX, nos. 1 and 2; *Magazine of the Fine Arts* 1 (1821); *Art Union* (1 April 1846): VIII, p. 97 ("a mosaic table" is described); Hobbs, *The Thomas Hope Table* (2007).

This ebonized and gilded table stood in the original Picture Gallery at Duchess Street, illustrated in plate II of *Household Furniture* (fig. 2-8) and also in plate XX, numbers 1 and 2 (fig. 78-1): "Side of a table" and "End of the same table." The table is seen occupying the same position in 1824, and Westmacott refers to "two singularly beautifully Mosaic Tables, one of which is particularly rich in ornamental design," perhaps the present table.[1]

In 1917, when it was sold from the Etruscan Room at the Deepdene, the table was described as: "a 4ft 3 in OBLONG FLORENTINE MOSAIC MARBLE TOP TABLE, on ebonised standards with carved gilt enrichments"; it fetched £101. That this is indeed the table sold from the Deepdene is confirmed by the survival of the mosaic top and by the dark paint that survived beneath a white surface, which was removed during recent conservation.

The standard end supports are inspired by the legs found on Roman and Etruscan marble thrones and sarcophagi, themselves derived from examples depicted on Athenian vases from the sixth century B.C. The supports have alternating male and female classical masks, which can be compared to one reproduced in pl. XXXVII of *Household Furniture* (see fig. 6-10) and to those employed on vases.[2]

The masks are molded in quasi-ceramic material. The same male tragic masks are found on a pair of torchères supplied in 1812 to Queen Charlotte for the Crimson Drawing Room at Buckingham Palace (fig. 78-2). The similarity of these torchères to a pair supplied to Carlton House in 1807, which were provided by Peter Bogaerts and Paul Storr (fig. 78-3), might point to Bogaert's involvement with the Picture Gallery table.

Thomas Hope inherited several micro-mosaic and marble slabs from his father,[3] but the present micro-mosaic top does not seem to be among them. Made in Rome, probably by Giacomo Rafaelli, about 1795, it is similar in scale to three other tops in the collection of the Duke of Northumberland at Syon Park and another top in the collection of the Hermitage Museum.[4]

Fig. 78-1. *Household Furniture* (1807), pl. XX, nos. 1 and 2.

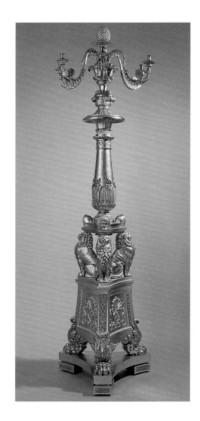

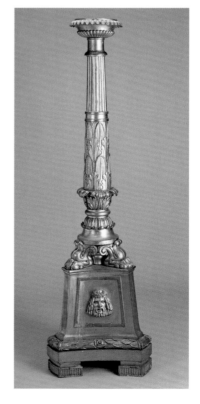

Fig. 78-2 (far left). Regency torchère. Giltwood, 1807. The Royal Collection © HM Queen Elizabeth II, RCIN 588–1-2.

Fig. 78-3 (left). Regency torchère. Giltwood, 1810. The Royal Collection © HM Queen Elizabeth II, RCIN 45–1-2.

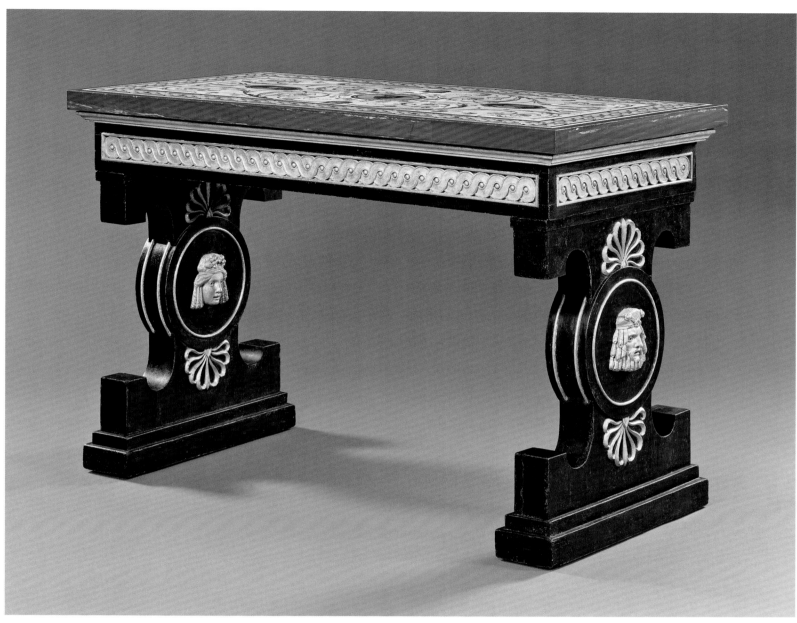

[78]

1. Westmacott, *British Galleries* (1824).
2. For a classical mask of comparable form in the Naples Museum, in marble, see *Pompeii AD 79* (1976): no. 78.
3. See Niemeijer, "De kunstverzameling van John Hope" (1981): 127–232.
4. Unpublished correspondence from Dottore Anna Maria Massinelli, Florence, August 2005.

ML/PHJ

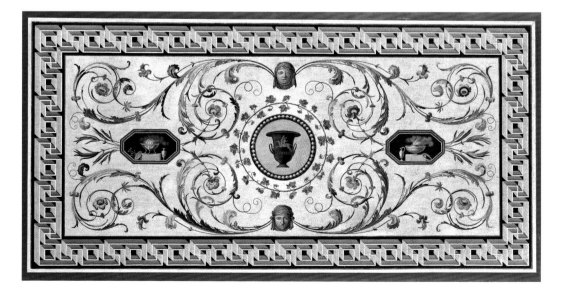

79. *Armchair*

After a design published by Thomas Hope
English, early 19th century
Mahogany
37¼ x 24½ x 23½ in. (94.5 x 61.5 x 59.6 cm)
On loan to the National Trust of Scotland from a
private collection

PROVENANCE: [...]; Sir James Stirling; thence by
descent.

LITERATURE: Hope, *Household Furniture* (1807):
pl. xx, nos. 3 and 4.

This chair is based on plate xx, numbers 3 and 4, in *Household Furniture* (fig. 79-1). Versions with different decoration to the backs and arms are shown in situ in the Aurora Room (*Household Furniture*, pl. VII; see fig. 2-19). No documented example of this frequently found model has been traced, although at one time those belonging to the Edward James Foundation, on loan to Brighton Museum, were thought to have come from the 1917 Hope sale at Christie's.[1] The pattern was described by Hope as "after the manner of the ancient curule chairs."[2] This form of X-frame "curule" chair also enjoyed considerable popularity in France at the time; see, for example, a chair (with a straighter back) by Henri Jacob[3] and another, dated about 1800, in the Musée des Arts Décoratifs, Paris.[4]

The exhibited model appears to have revived in popularity during the later nineteenth-century Regency revival. Several examples, some bearing stamped four- or five-digit numbers typically used by Victorian manufacturers, have been noted. Makers' marks include those for Gregory & Co., W. J. Mansell, and Marsh, Jones and Cribb. These later chairs often have gouged lines embellishing the arms, rather than the vertical striations shown in *Household Furniture*.

1. *The Age of Neo-Classicism*, Victoria and Albert Museum, London (9 September–19 November 1972), no. 1653. One of these chairs, which do not in fact form a true pair, belonged to Edward James's father, William; see Macquoid, *A History of English Furniture* (1908): fig. 238.
2. *Household Furniture* (1807): 33.
3. Ledoux-Lebard, *Le Mobilier Français du XIXᵉ Siècle* (2000): 369.
4. See Janneau, *Les Sièges* (1974): fig. 324.

ML

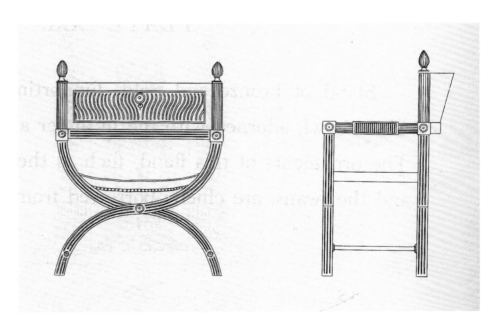

Fig. 79-1. *Household Furniture* (1807): pl. xx, nos. 3 and 4.

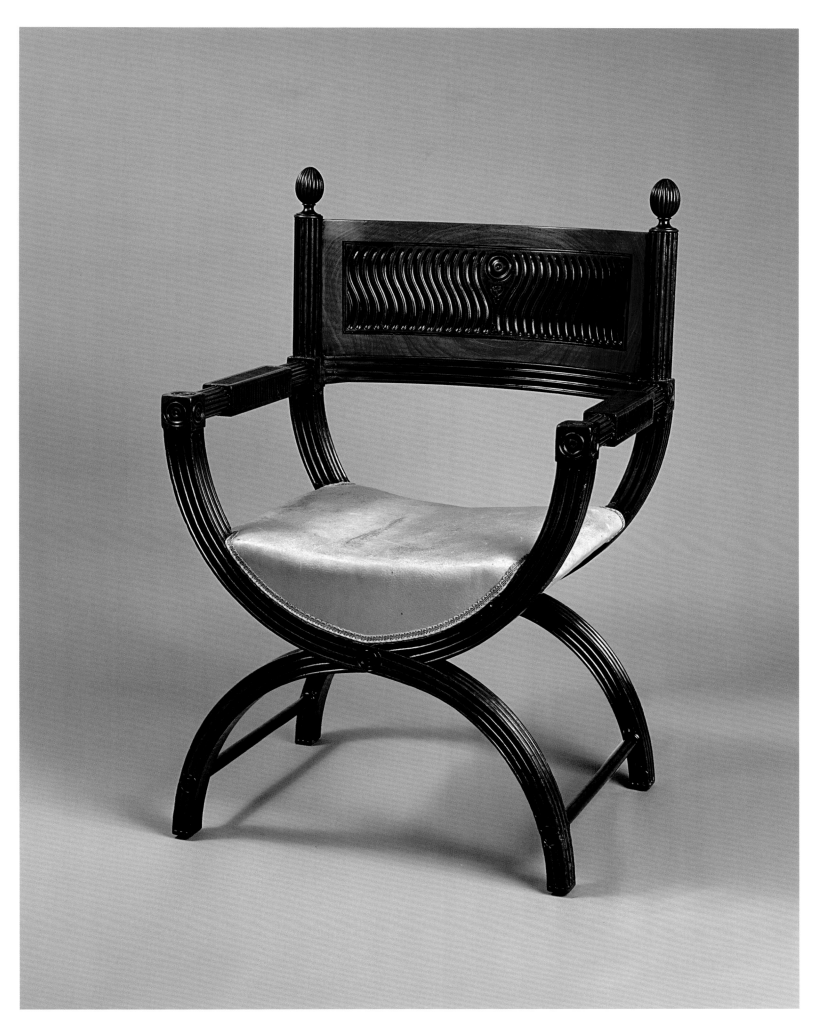

80. *Pair of Stands*

After a design published by Thomas Hope
English, early 19th century
Bronzed and gilded pine and limewood, with restorations
to decoration and feet of later date
51 x 21¼ in. (129.4 x 54 cm)
Private collection

PROVENANCE: [...]; Christie's, London, 19 April 1990,
lot 82; Fernandes and Marche; Hyde Park Antiques;
Sotheby's, London, 9 July 1993, lot 198 (unsold);
H. Blairman & Sons, from whom acquired by present
owner.

LITERATURE: Hope, *Household Furniture* (1807):
pl. XXI.

Plate XXI in *Household Furniture* (fig. 80-1) illustrates a "Stand of bronze and gold," the ornaments on which, such as the "Iris, the water-leaf, and the swans, are chiefly borrowed from the aquatic reign."[1] The form, which ultimately derives from that of a classical tripod stand,[2] or *athénienne*, was also taken up by Percier and Fontaine; in *Recueil de Décorations Intérieures* a similar stand appears in plate 17, number 3. The embellishment of the legs on Hope's stands echoes, in simplified form, pilaster ornaments like those illustrated in plates from Tatham's *Etchings . . . of Ancient Ornamental Architecture*.

There is no clue as to where this pair of stands (only one exhibited in London) may have been used at Duchess Street, but their grand scale would seem to suggest a prominent public position rather than the private apartments. As with the Music Room table (cat. no. 74), the absence to date of any comparable survivals justifies speculation that these stands, which correspond closely with the published design, once belonged to Hope. This suggestion is perhaps strengthened by the quality of the carving (which compares favorably with documented carved and decorated furniture, such as those in cat. nos. 81 and 88) and by the bold and idiosyncratic design of the stands.

Apart from specific praise for the carving skill of Bogaert,[3] no documentation survives that allows attribution of Hope's own furniture to particular makers. There is, however, a set of bronzed and gilded chairs

after the model shown in *Household Furniture*, plate XXII, numbers 5 and 6 (see fig. 4-12) by James Newton.[4] Perhaps significantly, one of the chairs bears the date 1806, one year before the publication of Hope's influential work. It is possible that these stands, and other decorated furniture exhibited here, were supplied by Newton.[5]

1. *Household Furniture* (1807): 34.
2. A stand of related form appears in Visconti, *Il Museo Pio-Clementino* (1782): VII, pl. XLI, "Tripode d'Apollo." Hope commends "Visconti's Museo Pio-Clementino" at the end of *Household Furniture*. For other stands, see Soros, *James "Athenian" Stuart* (2006): figs. 11, 10; designs attributed to Pierre-Adrien de Paris, ca. 1770.
3. See Chapter 4 in this volume.
4. See Ellwood, "James Newton" (1995): 147, figs. 44 and 45.
5. See Chapter 4.

ML

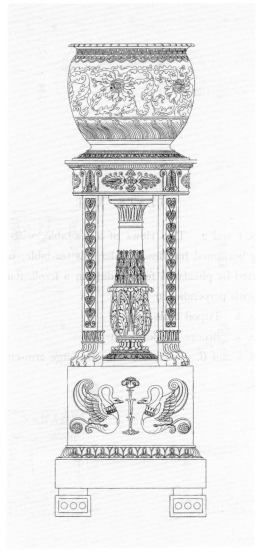

Fig. 80-1. *Household Furniture* (1807): pl. XXI.

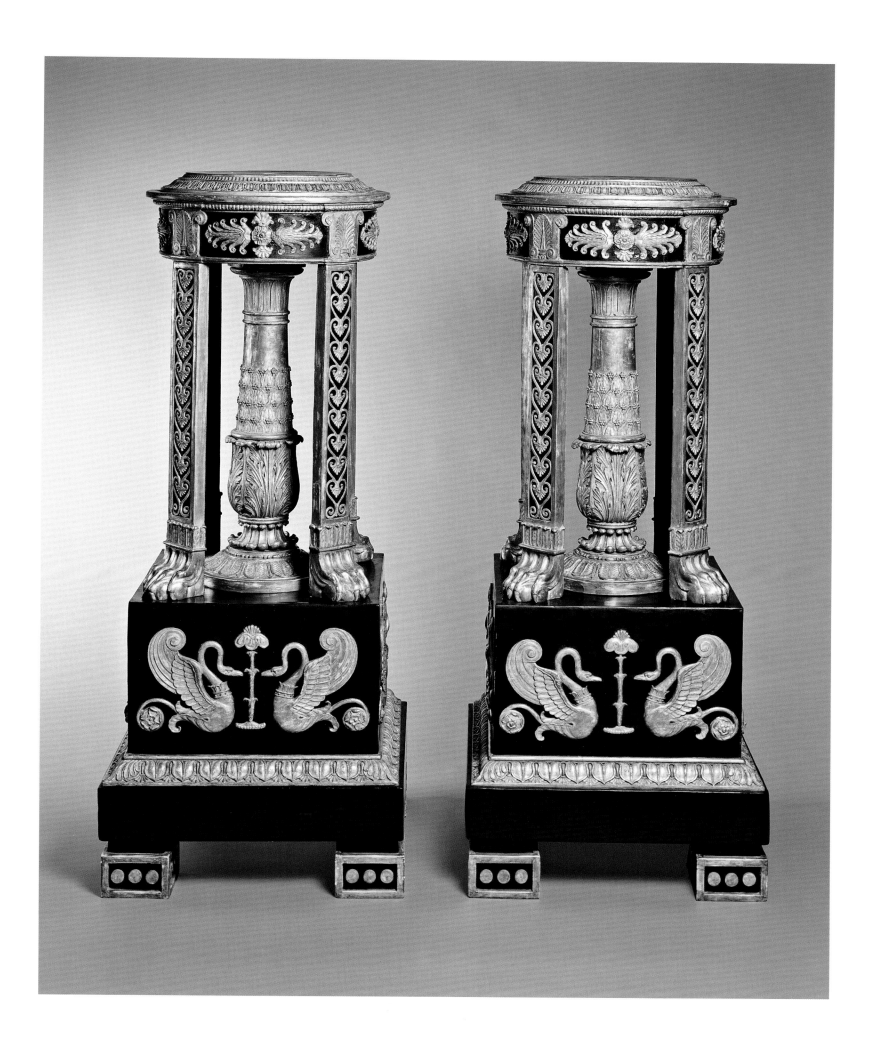

81. *Settee*

After a design published by Thomas Hope
English, ca. 1802
Gilded beech and limewood
40¾ x 44½ in. (103.4 x 113 cm)
Private collection

PROVENANCE: Presumably Thomas Hope, Duchess Street and later at the Deepdene; by descent, Lord Francis Hope Pelham-Clinton-Hope; sold Christie's, London, 18 July 1917, lot 293; bought by Bridge for £9 9s.; [...]; Gorringe's, Lewes, Sussex, 5–7 June 2001, lot 1204; bought by H. Blairman & Sons and Jeremy Ltd., from whom acquired by the present owner.

LITERATURE: *Household Furniture* (1807): pl. XXII, nos. 5 and 6.

This settee seems certain to be one from "a pair of Empire gilt settees, carved with ram's heads and honeysuckle ornament, the seats covered with green velvet—3 ft 9 in. wide" sold in 1917 at Christie's. The catalogue states that these are illustrated in plate XXII of *Household Furniture* (see fig. 4-12). Although it is clear that this plate depicts chairs of very similar ambition, there are considerable differences. First, the offered lot was two settees, not "large arm-chair[s]" as described in the text.[1] The pedimented back and the carved and spindle-topped sides are also notable variances. The scrolling panels that decorate the sides appear to be taken directly from the cinerarium (cat. no. 40).

The reeded shaft of each arm on the settee, which terminates in a ram's head, derives from a Roman example published by A.C.P. Caylus[2]; the same motif appears on Hope's "ragout dish" (*Household Furniture*, pl. XLVII; see fig. 6-20).[3]

There is no evidence to establish if the present settee was at Duchess Street before it went to the Deepdene, as seems probable, nor for what context it was conceived. Without doubt, however, the exceptional quality of the settee's carving and the angular Anglo-Empire style of its design conform to the standards that can be identified with furniture known to have belonged to Hope. If it could be established, as seem plausible, that Bogaert carved in gilt wood as well as mahogany, then the settee might well have emanated from his workshop.[4]

1. *Household Furniture* (1807): 34.
2. *Recueil d'Antiquités égyptiennes*, vol. 1 (1752): pl. XCII, fig. IV.
3. A dish of this pattern, originally one from a pair supplied to Hope in 1801 by Paul Storr, was sold at Christie's, London, 10 November 1993. It was stolen in 2006 from an English private collection.
4. See cat. no. 84, note 3 below.

ML

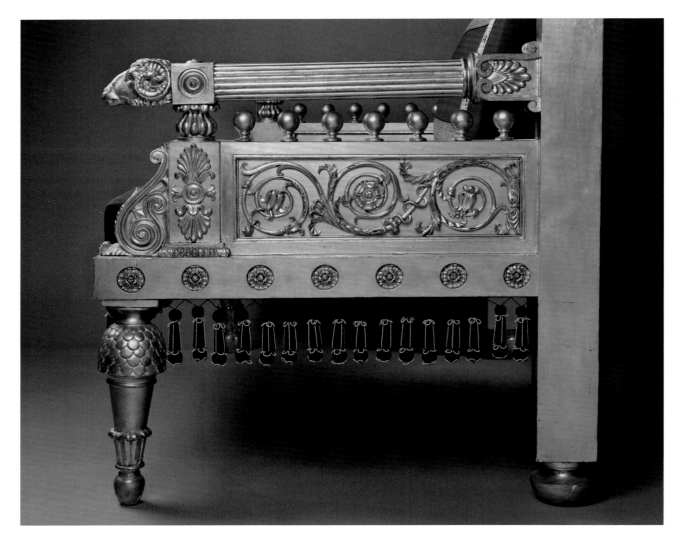

Fig. 81-1. A.C.P. Caylus. *Recueil d'Antiquités égyptiennes, Etrusques, Grècques et Romanes* 1 (1752): pl. XCII, fig. IV.

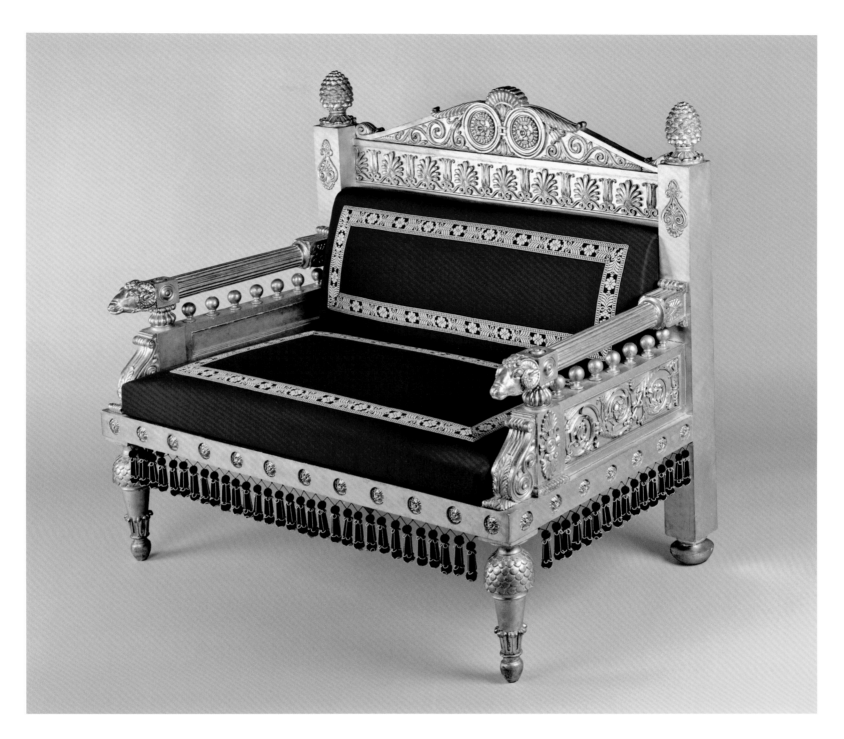

82. *Table*

After a design published by Thomas Hope
English, early nineteenth century
Bronze, mahogany, and *lumachella rossa* marble
30⅜ x 21 in. (77.1 x 53.3 cm)
Private collection

PROVENANCE: Henry Philip Hope; acquired with the purchase of Seamore (later Seymour) Place, together with other contents, during the first quarter of the 19th century; thence by descent.

LITERATURE: *Household Furniture* (1807): pl. XXV, no. 2, LV, no. 5; Hussey, "Somerley, Hampshire—III" (1958): 202–3, figs. 2 and 4.

Henry Philip Hope, like Thomas a collector and patron of the arts,[1] had several pieces of furniture based on designs published by his brother. The present example, which has scrolled decoration behind the legs and scrolled feet beneath its base, corresponds closely with the "Tripod table" in *Household Furniture* (1807), plate XXV, number 2 (fig. 82-1); the plan appears in plate LV, number 5.

By 1874 the table was at Somerley, Hampshire, recorded as "No. 8 ~~2~~ 1 round mahogany tables on Bronze legs. [in a different hand] one removed to Central Lobby Formerly in Seamore Place and the property of Mr. H. Hope."[2] The same table (and possibly the second) can be seen clearly in photographs of interiors at Somerley published in *Country Life*.[3] Among the other furniture illustrated at Somerley, and formerly at Seamore Place, is a "Round Gilt Pedestal Inlaid table supported on 3 Griffins"[4] and a "Rosewood Table with Gilt Ram's [*sic*] Heads."[5]

The form of the Henry Hope tripod table derives from the one from the Temple of Isis at Pompeii, now in the Museo Nazionale, Naples.[6] Following in-depth scientific analysis undertaken in 1997, however, this tripod is now known to owe its appearance to later construction.[7] Often designed as a washstand, this type of tripod enjoyed considerable popularity in France and elsewhere in mainland Europe.[8]

1. See Chapter 11 in this volume.
2. "Conservatory and Colonnade," *Inventory of the Furniture &c. at Somerley*, vol. 1 (1874) (private collection;

also at Hampshire Record Office, 21.M. 57, 2nd Earl Box D): 97.
3. Hussey, "Somerley, Hampshire—III" (1958): 202–5, figs 2, 4, 5; the table is also possibly identified in an 1853 watercolor illustrated in fig. 3 of the same article.
4. Ibid., figs. 2, 4.
5. Ibid. The Somerley rosewood table was offered at Christie's, London, 3 July 1997, lot 60; several variants, lacking provenance, have been recorded including one first offered at Christie's, London, 25 May 1972, and acquired in 1989 by the Henry E. Huntington Library and Art Gallery, San Marino, California.
6. This tripod had become familiar through its publication by Piranesi in *Vasi, Candelabri*, vol. 2 (1778): pl. 44. For an illustration of the tripod, see Hayward, *World Furniture* (1965, 1979): fig. 34. Earlier, ca. 1764, this same tripod inspired a stand designed by James Stuart for Spencer House; see Soros, *James "Athenian" Stuart* (2006): fig. 10–77. The Pompeii tripod was also the source for the bronze tripod, surmounted by a "flat cup of rosso antico" illustrated in *Household Furniture* (1807): pl. XI, no. 5; one of a pair, this was sold at Christie's, 20 July 1917, lot 290 for £65 3s. to L. Harris. The supports of the bronze tripod in *Household Furniture*, pl. XVII, no. 5, is another example based on a classical prototype, of which an example was offered by Axel G. Weber, November 1977.
7. See Cuzin et al., *D'après l'antique* (2001): cat. no. 154.
8. See, for example, Percier and Fontaine, *Recueil de Décorations Intérieures* (1809): pl. 33, and *The Age of Neo-Classicism* (1972): no. 1827 (a font). A particularly fine interpretation is a table by Jacob Frères made for Empress Joséphine at Malmaison and now in the collection of the Hermitage; see Gerstein, *France in Russia* (2007): no. 14.

ML

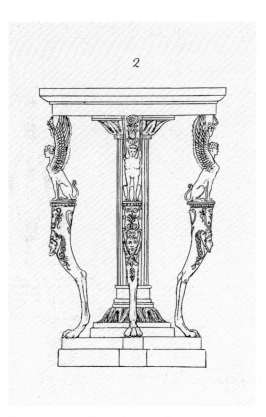

Fig. 82-1. *Household Furniture* (1807): pl. XXV, no. 2.

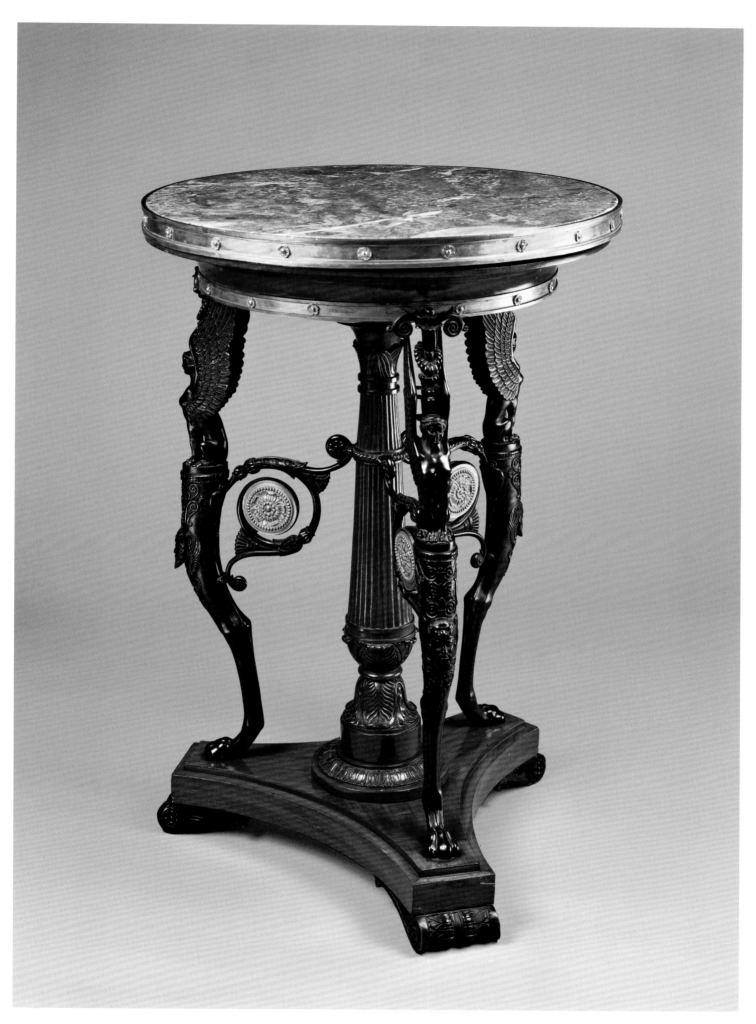

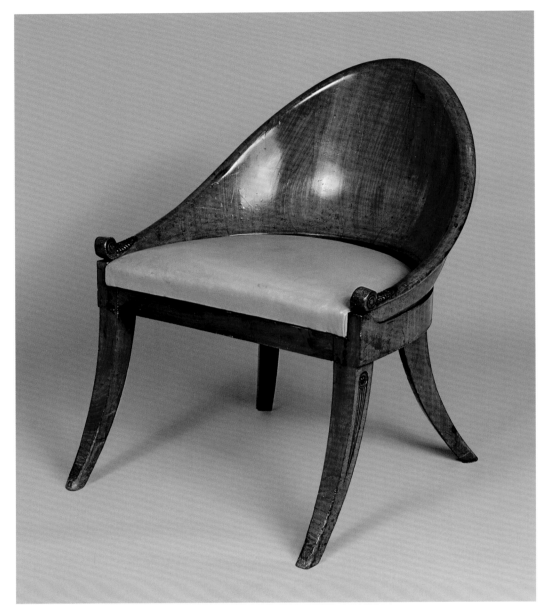

84. *Table*

After a design published by Thomas Hope
English, ca. 1802
Mahogany
29½ x 36 x 25 in. (74.8 x 91.4 x 63.5 cm)
Courtesy of the Trustees of The Victoria and Albert Museum, London, W.1.2004. Purchased with the assistance of the National Art Collections Fund and the Brigadier Clark Fund.

PROVENANCE: Thomas Hope, Duchess Street and later at the Deepdene; by descent, Lord Francis Hope Pelham-Clinton-Hope; by descent, Henry Edward Hugh Pelham-Clinton-Hope, 9th Duke of Newcastle; Diana, Duchess of Newcastle (died 1998) at Cortington Manor, Wiltshire; Woolley and Wallis, Wiltshire, 13 May 2003, lot 13; bought by H. Blairman & Sons; private collection[1]; Victoria and Albert Museum.

LITERATURE: *Household Furniture* (1807): pl. XXXVI, no. 7; Billings's watercolor; Britton and Pugin, *Illustrations of the Public Buildings of London* (1825): pl. 2; Department for Culture, Media and Sport, *Export of Works of Art*, 2003–2004, case 5: 29–30.

This table is illustrated in *Household Furniture*, plate XXVI, number 7. Although its first position at Duchess Street is not known, by 1819 a table of this pattern, and possibly a second, were in the newly constructed Flemish Picture Gallery. The details of the table depicted at the further end in R. W. Billings's watercolor (see cat. no. 107) cannot be clearly discerned, but the one in the foreground appears to be parcel-gilt. The same interior is reproduced by J. Britton and A. Pugin.[2]

If Hope's admiration for Bogaert is taken at face value, then the carving of the end supports of this table should be taken as the benchmark for measuring Bogaert's hand and ability.[3]

Although no precise source has been identified for the crouching-lion supports, the conception is very familiar in classical prototypes, as in Charles Heathcote Tatham, *Etchings of Ancient Ornamental Architecture*, where he illustrates similarly conceived supports for a porphyry bath in the Borghese Palace (fig. 84-1). Another noteworthy example is Tatham's drawing of an "Antique fragment . . . supposed to have been the elbow to a consular Chair."[4]

83. *Chair*

After a design published by Thomas Hope
English, early 19th century
Mahogany
30¼ x 24½ x 28½ in. (76.8 x 62.2 x 72.3 cm)
On loan to the National Trust for Scotland from a private collection

PROVENANCE: [. . .]; Sir James Stirling; thence by descent.

LITERATURE: *Household Furniture* (1807): pl. XXVI, no. 5.

A side view showing a chair of this design appears in *Household Furniture* (1807), plate XXVII, number 5. The same model may also be depicted in R.W. Billings's watercolor of the Flemish Picture Gallery (see cat. no. 107).

As with other undocumented furniture in the present exhibition, the closeness of the chair, one of a pair, to the published illustration, together with its quality and purity of design,[1] permits the suggestion that it indeed originated in Hope's collection at Duchess Street. No other chair of this pattern has been recorded.

1. In some of his seat furniture, Hope came closest to interpreting, in three dimensions, the linear quality of Greek design. Compare, for example, the klismos chair on a Greek stele in the National Museum, Athens (illustrated in Gelfer-Jorgensen, *Herculanum paa Sjaelland* [1988]: fig. 5), with *Household Furniture* (1807): pl. XXV, no. 4. John Flaxman, who received particular praise for his composition at the end of *Household Furniture*, incorporated elegant klismos chairs into his design; see, for example, *John Flaxman, R.A.* (1979): front cover; see also Chapter 4 in this volume.

ML

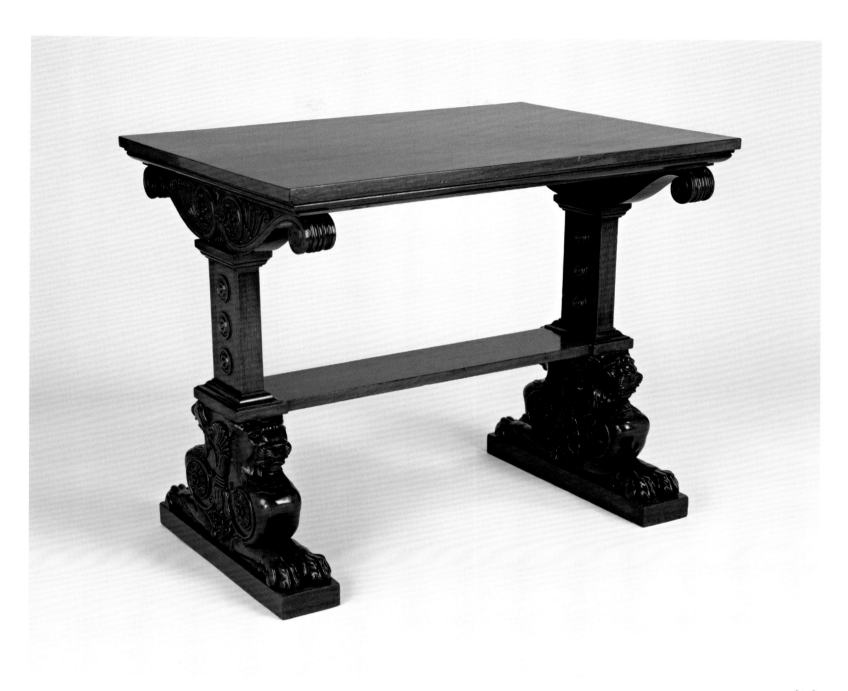

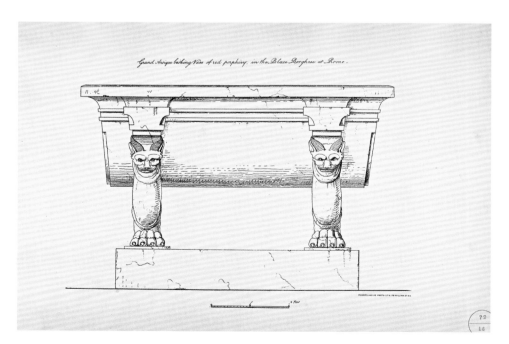

Fig. 84-1.Charles Heathcote Tatham. "Supports for a porphyry bath in Borghese Palace." From *Etchings…of Ancient Ornamental Architecture* (1799): pl. 4. Art and Architecture Collection, Miriam and Ira D. Wallach Division of Art, Prints and Photographs, The New York Public Library Astor, Lenox, and Tilden Foundations.

1. Following a temporary export ban, the table was acquired by the Victoria and Albert Museum; see *Fiftieth Report of the Reviewing Committee, Export of Works of Art 2003–2004*, London: DCMS, 2004, case 5, pp. 29–30.
2. *Illustrations of the Public Buildings of London* (1825): pl. 2.
3. The assumption is made, without supporting evidence, that Bogaert carved in mahogany. It should be observed, however, that the carving on some of the gilded wood furniture is also of exceptional quality (see cat. no. 81). In 1807 Bogaert and Paul Storr provided carved and gilt candelabra for Carlton House. It is also thought that Bogaert was, by 1809, providing models for Paul Storr to manufacture in silver (see Chapter 6). This latter suggestion certainly infers that Bogaert, or someone in his workshop or studio, such as Francis Chantrey, who had trained with a carver and gilder, would have been capable of finely carving limewood for some of the applied embellishments on Hope's furniture. For Bogaert, see Beard and Gilbert, *The Dictionary of English Furniture Makers* (1986): 83, and Chapter 6 in this volume; see also under cat. no. 93, for Chantrey.
4. Victoria and Albert Museum, inv. no. D.1508-98; see Pearce and Salmon, "Charles Heathcote Tatham in Italy" (2005): fig. 39.

ML

85. *Monopodium*

After a design published by Thomas Hope
English, ca. 1802
Mahogany; the top restored
24⅞ x diam. 11⅞ in. (63.2 x 30.2 cm)
Private collection

PROVENANCE: Presumably Thomas Hope; by descent, Lord Francis Hope Pelham-Clinton-Hope; possibly sold Humbert & Flint, London, 12–14 and 17–19 September 1917, lot 921 (part); [...]; Steinitz, Paris, 2005; bought by H. Blairman & Sons, on behalf of the present owner.

LITERATURE: *Household Furniture* (1807): pls. XXVI, no. 5, and LV, no. 6.

The "little round monopodium or stand, of which the top, through means of a slider and a screw, is capable of being raised or lowered at pleasure,"[1] is illustrated in plate XXVI, number 5, of *Household Furniture*

(see fig. 85-1), the plan appears in plate LV, number 6. Lot 291 of the Deepdene sale included "A 14 in. circular mahogany coffee table, on carved pillar and triangular base with scroll feet and ormolu mounts, and a 14½ in. adjustable ditto on carved pillar with triangular base"; it is the second table that may be identical with the one exhibited here. The top is probably an old restoration, which would account both for its design, which is simpler than in the engraving, and for its smaller diameter.

The construction of the table's mechanism corresponds precisely to the drawing and description in *Household Furniture*, and the carving, as with the documented Ashmolean tables (cat. no. 66) and the Victoria and Albert Museum table (cat. no. 84), appears to have the quality of carving associated with Bogaert in the present publication.

1. *Household Furniture* (1807): 36.

ML

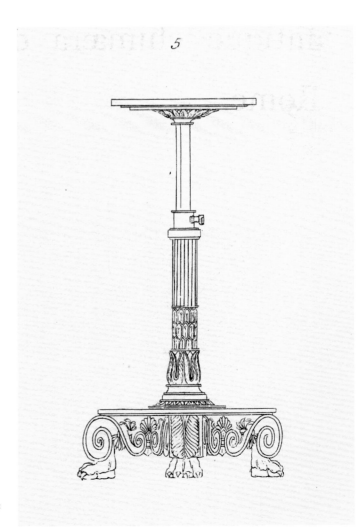

Fig. 85-1. *Household Furniture* (1807): pl. XXVI, no. 5.

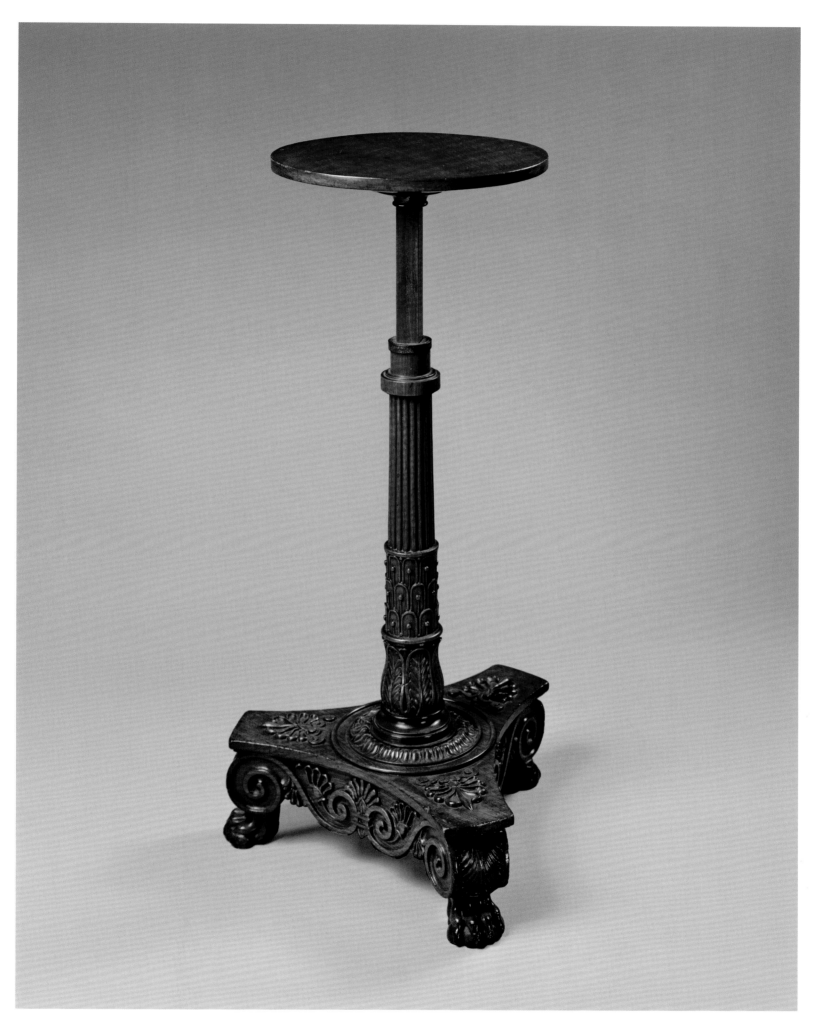

86. "Recess" or Cabinet

After a design published by Thomas Hope
English, ca. 1802
Mahogany
21 x 26¾ x 5 in. (53.3 x 67.9 x 12.7 cm)
Private collection

PROVENANCE: Presumably Thomas Hope; [...];
Kenneth S. Harris; Sotheby's, Chicago, 20 June 1999,
lot 427, bought by H. Blairman & Sons, on behalf of
the present owner.

LITERATURE: Hope, *Household Furniture* (1807) pls. V
and XXVII, no. I.

The nomenclature for this small cabinet, illustrated in *Household Furniture,* plate XXVII, number I (fig. 86-1), is taken from Hope's own description, which implies that he owned more than one example of this pattern: "Recesses in the shape of ancient hypogea, or niches for cinerary urns, destined for the reception of small sepulchral vases."[1] The same "recess" is shown above the fireplace in the "Third Room Containing Greek Vases" (*Household Furniture,* pl. V; see fig. 2-14), and variants in the "Room Containing Greek Fictile Vases" (*Household Furniture,* pl. III; see fig. 7-25).

Despite the fact that it has no documented history, it seems logical to speculate that this small-scale, idiosyncratic, and beautifully manufactured piece, with exquisite carving probably by Bogaert, originally formed part of Thomas Hope's furnishings at Duchess Street.[2]

1. *Household Furniture* (1807): 37.
2. It should be noted, however, that as early as 1804, Samuel Rogers displayed his Greek vases in recesses "copied from Mr. Hope's design"; see Scott, *The Pleasures of Antiquity* (2003): 240, n. 10.

ML

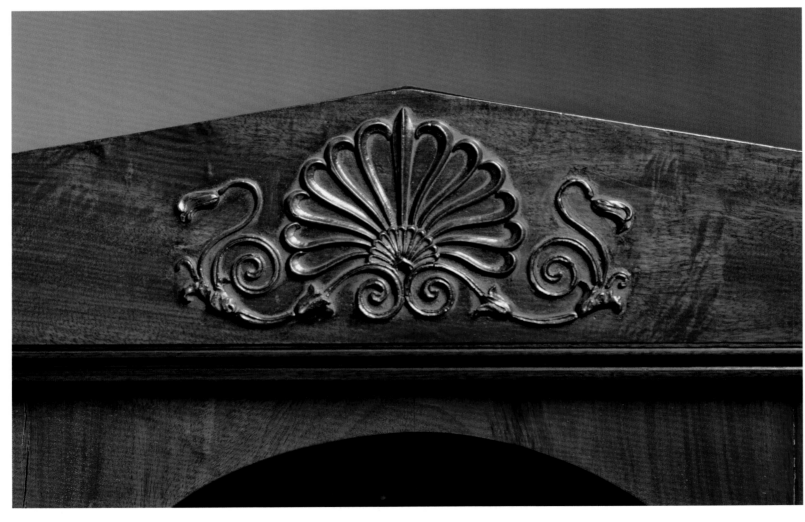

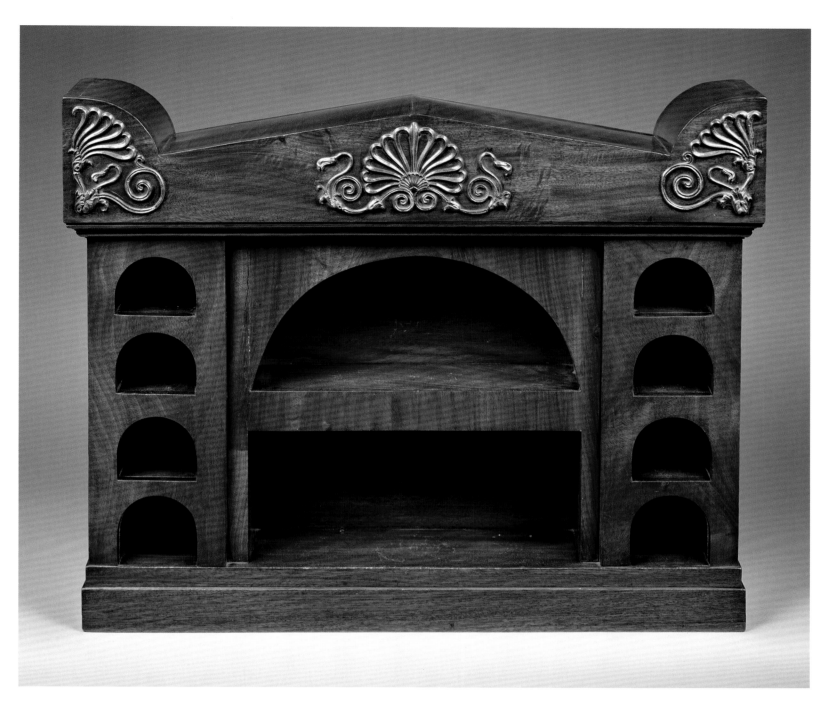

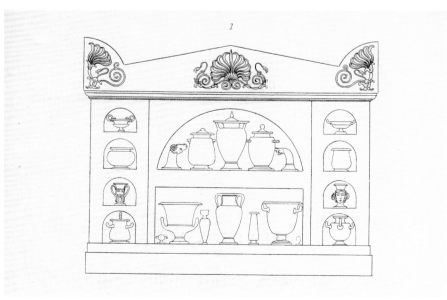

Fig. 86-1. *Household Furniture* (1807): pl. XXVII, no. 1.

87. *Pair of Greyhounds*

After a design published by Thomas Hope
English, ca. 1802
Bronze, ormolu
28 in. (71 cm)
Leeds Museums and Galleries (Temple Newsam), 1967.
0024.0038.0001
One in London, the pair in New York

PROVENANCE: Presumably Thomas Hope, Duchess Street and later at the Deepdene; by descent, Lord Francis Hope Pelham-Clinton-Hope; sold Christie's, London, 18–19 July 1917, lot 237; bought by Col, later Sir, Edward Allen Brotherton for £173.5; by descent, Dorothy Una McGrigor Phillips, by whom bequeathed 1967 to Temple Newsam, Leeds.

LITERATURE: Hope, *Household Furniture* (1807): pl. XXVIII, nos. 2, 3; *Magazine of Fine Arts* (1821); Gilbert, *Furniture at Temple Newsam House and Lotherton Hall* (1978): 146, 441, no. 569, illus.; White, "Two Bronze Dogs from the Hope Collection" (1986): 23–25.

These bronze greyhounds (only one exhibited in London) were applied to the footboards of a pair of couches which are shown in *Household Furniture* as plate XXVIII, numbers 2 and 3 (fig. 87-1). Hope describes one of them in the text accompanying the plate as "a greyhound lies watching on the footboard, after the manner of similar animals on Gothic sarcophagi." Their presence added a somewhat romantic eclecticism to the essentially classical tenor of Duchess Street. If it were not for their refined finish, they would have seemed incongruous when women dressed in the Greek manner were gathered at Duchess Street, as shown in Henry Moses's *Designs for Modern Costume* of 1812. However, Hope had solid classical precedents in his own collection of antiquities, a pair of greyhounds that apparently had been discovered in the ruins of the villa of the Emperor Antoninus Pius at Laurentum near Rome.[1] The couches themselves, which were subsequently illustrated in the Picture Gallery in 1821,[2] have not been identified as surviving.[3]

An attribution to the metalworker Decaix for these large figural bronzes does not seem likely from what we know of his objects. If Decaix did not cast the large vase(s) in bronze (cat. no. 89), he would have hardly have cast these more sizable pieces. The sophisticated modeling and confident execution of these greyhounds suggest the work of an accomplished sculptor and foundry. Probably for that reason, it has been suggested that these dogs are French.[4] It is more likely, however, that they were made or modeled by one of the sculptors associated with Hope, such as Francis Chantrey, who is known to have supplied work for Hope.[5]

1. Christie's, London, Hope Heirlooms sale, 24 July 1917, lots 226, 227. Michaelis, *Ancient Marbles in Great Britain* (1882): 287. Now in a private collection.
2. *Magazine of Fine Arts* (1821).
3. The greyhounds were catalogued as sculpture and were already separated by the time of the sales in 1917.
4. Gilbert, *Furniture at Temple Newsam* (1978): 146, 441, no. 569.
5. Watkin, *Thomas Hope* (1968): 52. The author is grateful to Martin Levy for this suggestion.

MC

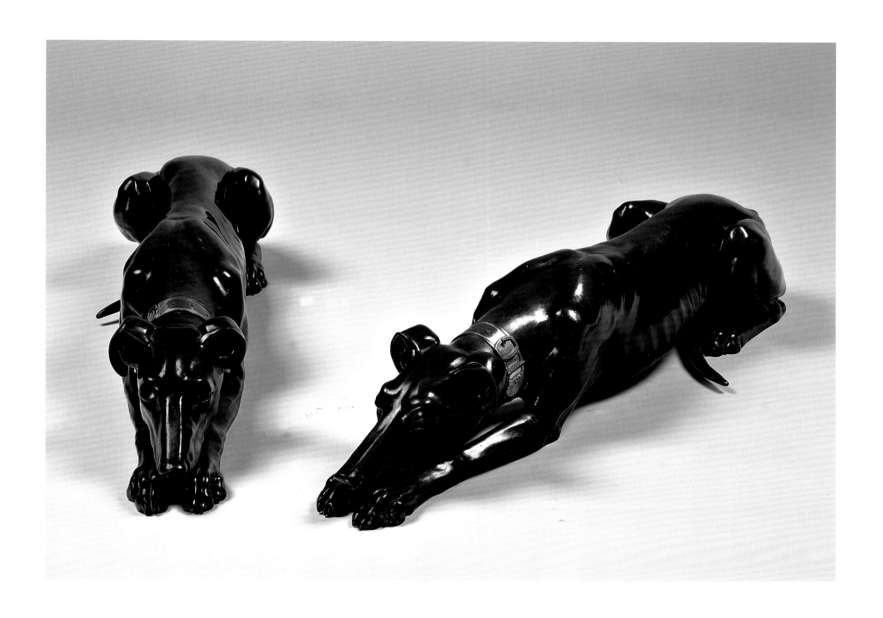

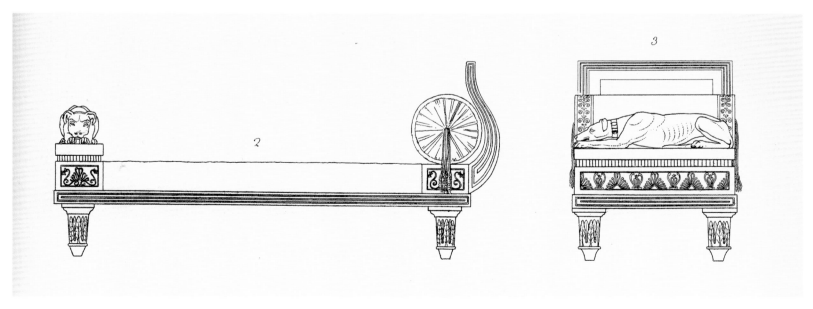

Fig. 87-1. *Household Furniture* (1807): pl. XXVIII, nos. 2 and 3.

88. *Pair of Stands*

After a design published by Thomas Hope
English, early 19th century
Ebonized and gilded wood; decoration restored
63½ x 17 in. (161.2 x 43.1 cm)
The Trustees of the Faringdon Collection, Buscot
Park, Oxfordshire
Not in exhibition

PROVENANCE: [...]; "sale of Crowther stock by Henry
Spencer, 1969," bought by Peter Hone; Angus McBean[1];
2nd Lord Faringdon, Buscot Park.

LITERATURE: *Household Furniture* (1807): pl. L, no. 2.

A "Roman" stand of this precise design, perhaps an imaginative variation on one published by Visconti,[2] is illustrated in *Household Furniture*, plate L, number 2 (see fig. 6-11). Hope also owned several classical Roman candelabra himself, and these too might have provided inspiration for the present model.[3]

Despite their arguably lesser quality, the closeness of the stands to the published illustration[4] permits the suggestion that they may have originated in Hope's collection at Duchess Street. No other stand of this pattern has been recorded.[5]

1. See Chapter 15 in this volume.
2. *Il Museo Pio-Clementino* vol. 5 (1782): pl. III.
3. See Waywell, *The Lever and Hope Sculptures* (1986): pls. 16, 17.
4. Another pair of bronzed and gilded wooden stands corresponding closely to *Household Furniture*, pl. XXII, no. 4, is in an English private collection; see Collard, *Regency Furniture* (1985): 94. The same model, described as "a pair of bronze torchères of Classical design," was sold from the Deepdene by Christie's on 20 July 1917, lot 291.
5. As a result of William Atkinson's involvement at the Deepdene from 1818, it has been suggested that his frequent collaborator, the cabinetmaker George Bullock (whose workshop was sold up in 1819), might also have been involved with Hope. Collard in Chapter 4 mentions the Mona marble fireplaces, and further evidence may be gathered from the stand recorded (front left) in 1826 in the Statue Gallery at the Deepdene by P. Williams (see fig. 12-14). By comparison with the pair of candelabra belonging to the Walker Art Gallery, Liverpool (see National Art Collections Fund, *Review* [1990]: no. 3519), an attribution to Bullock's workshop is plausible.

ML

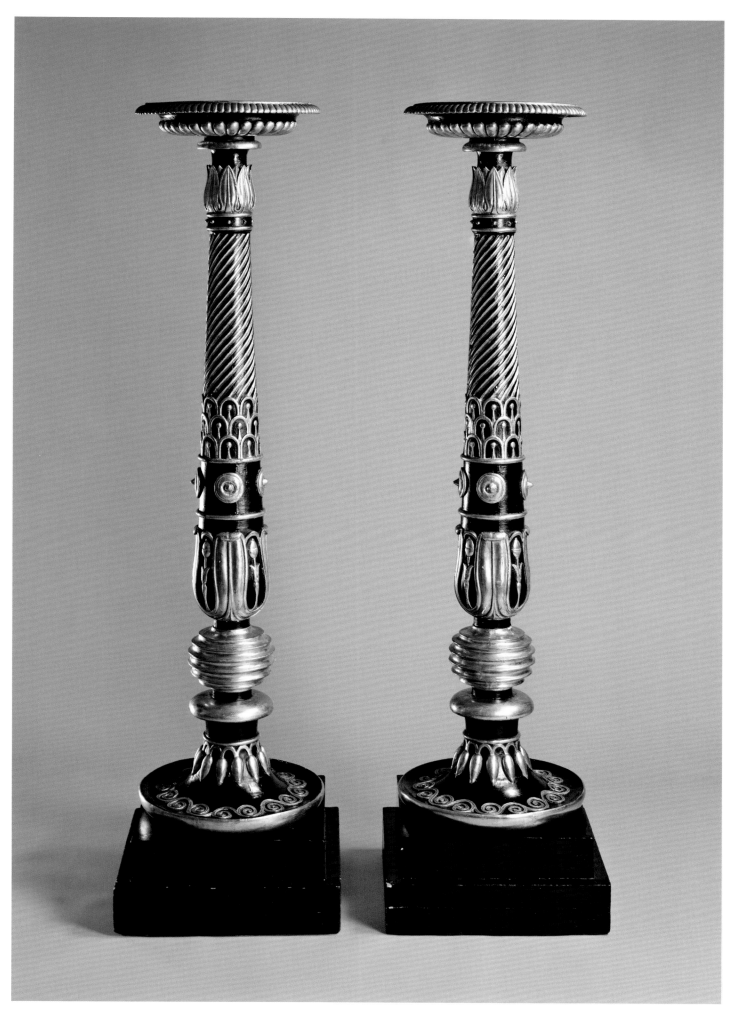

89. *Vase*

After a design published by Thomas Hope
Probably made by Alexis Decaix (ca. 1753–1811)
English, ca. 1802
Patinated copper, ormolu
23¼ x 13⅕ x 13⅕ in. (59 x 33.5 x 33.5 cm)
Marks: Each section notched three times
Courtesy of the Trustees of The Victoria and Albert
Museum, London, M.33-1983

PROVENANCE: Presumably Thomas Hope; [...];
Sotheby's, London, 1982, lot 70; H. Blairman & Sons,
London; Victoria and Albert Museum.

LITERATURE: *Household Furniture* (1807): pls. XXXV,
XXXVI, XXXVII; Douce MS (1812): f. 4; Chapman,
"Thomas Hope's Vase and Alexis Decaix" (1985):
216–28; Archive of Art & Design, MA/1/B1600,
H. Blairman & Sons papers filed on RP/1983/80;
Sotheby's, London, 12 November 1982, lot 70.

This vase is the most imposing piece of
metalwork published by Hope in *Household
Furniture* that survives today. Originally,
two plates in *Household Furniture*, XXXV
and XXXVI, were devoted to one of a least
two versions of the vase (see figs. 6-4 and
6-5),[1] and along with the details of the
masks in plate XXXVII (fig. 6-10) and the
ornament from the cover in plate XLI, number 8 (see fig. 89-1), it is one of the most
extensively covered objects in Hope's book.
It was probably made by Hope's preferred
metalworker Alexis Decaix, who according
to Hope's own words was one of "two
men, to whose industry and talent I could
in some measure confide the execution of
the more complicate [*sic*] and more enriched
portion of my designs"[2]

Although there is no documentary
evidence that Decaix made this vase, the
physical evidence of the mounts points to
a manufacturer familiar with eighteenth-
century Parisian techniques for making gilt
bronzes. The refined chasing of the mask
mounts and the delicate matted surface
were sophisticated processes employed in
the Parisian workshops where Decaix was
trained and practiced.[3] As mentioned in
Chapter 6, unexpected methods of manu-
facture were used to make the body of this
vase. Rather than being cast in bronze as its
surface suggests, it is made out of hand-

raised copper that was patinated to resem-
ble bronze, a manufacturing technique used
in the English metalworking trade for mak-
ing silver and copper hollowware. Because
Decaix is known to have supplied pieces for
Garrard at this time, it is tempting to won-
der whether the body of the vase was made
in Garrard's silversmithing workshop.
Decaix's business was expanding at this date
(he would open a Bond Street "shew room"
in 1809) and he may not have had bronze
casting capability for an object of this size.

For the design, it is likely that Hope had
a direct hand in supplying the form and
ornament. Hope tells us in the notes to plate
XXXIV that he was inspired by an antique
source, which he described as a "Greek
vase of white marble in the museum at
Portici."[4] That vase, now in the Museo
Archaeologico in Naples, is what is known
today as a volute krater.[5] Hope may have
noted the form of the vase when he visited
Naples in 1802. Although that vase is now
recognized as a late Roman marble copy of
a lost Greek ceramic original, it gave Hope
the outline and the design of the handles.
He omitted, however, the Bacchanalian
frieze of the original and thus supported his
stance of not producing slavish copies, as
he stated in the introduction to *Household
Furniture*. The comic and tragic masks he
added instead, shown in full detail in plate

XXXVII, were also Hope's inspiration if not
his design, as drawings in his hand exist of
these types of masks from his Grand Tour
between 1787 and 1795.[6]

The vase today differs in one significant
aspect from the published design, which is a
plain, flat lid instead of the more elaborate
domed cover applied with anthemions and a
depressed pine-cone knop shown in the
plates of *Household Furniture* (and also as a
plan of the cover in pl. XLI, no. 11). This
can only be explained by its being an earlier
or different version of the vase. The flat lid
is not a replacement, as the metal is of the
same type as the body of the vase and of
the same composition.[7] As with other
pieces surviving from Duchess Street,
therefore, this indicates some variations
from Hope's published designs.

1. The pendant is illustrated in *Household Furniture*
(1807): pl. XXXIV. As different sections of the vase are
notched three times, it is possible that three versions of
the vase were originally made.
2. *Household Furniture* (1807): 10.
3. Decaix received his *maitrise* (mastership) as a Parisian
founder in "30 xii 1778." Archives Nationales, Y.9333.
4. *Household Furniture* (1807): 39.
5. Inv. no. 6779.
6. Refer to the Hope drawings in Benaki Museum,
Athens.
7. See Chapman, "Thomas Hope's Vase" (1985): 228,
n. 24.

MC

Fig. 89-1. *Household Furniture*
(1807): pl. XLI, no. 8.

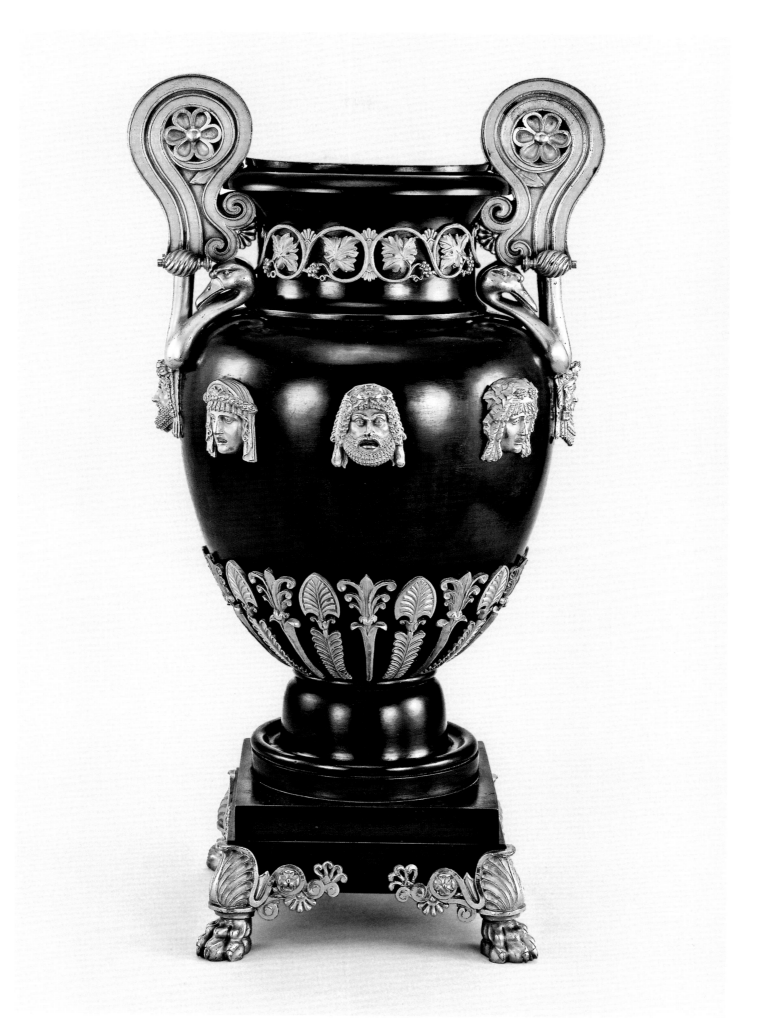

90. *Hanging Lantern*

After a design published by Thomas Hope
Possibly made by Alexis Decaix
English, ca. 1802
Bronze, ormolu
14½ in. diam. (36.8 cm)
Private collection

PROVENANCE: Presumably Thomas Hope; [...];
Christie's, London, 22 April 2004, lot 110.

LITERATURE: *Household Furniture* (1807): pls. V and
XXXVIII.

This lantern, hung on chains from the ceiling in the "Third Room Containing Greek Vases" at Duchess Street, is shown in that room in plate V (see fig. 2-14) and again in a more detailed plan view in plate XXXVIII in *Household Furniture* (fig. 90-1). The room and its furnishings are described by Hope in the text to plate V as being "of a quiet hue and of a sepulchral cast, analogous to the chief contents of this room." The design is indeed austere, a simple dished form, cast with a circular band of ivy motif, rope-twist rings, and an applied mask of the Medusa in ormolu. The form is based on the shield of Minerva presented by Perseus in the classical legend.

It is possible that Hope drew on the Medusa mask carved on the marble tripod in his own collection for the model or perhaps from bronze lamps in the royal collection at Portici, near Naples.[1] Despite its very strong, uncompromising design, the finish to the Medusa mask, which seems to be made of lacquered rather than gilded brass, has little in common with the meticulous execution of the masks for the large vase (cat. no. 89) and thus brings into question if this was made by Hope's metalworker Decaix. The lantern lacks its original chains for suspension.

1. *The Hope Collection, The Lady Lever Art Gallery*, London, fig.33.

MC

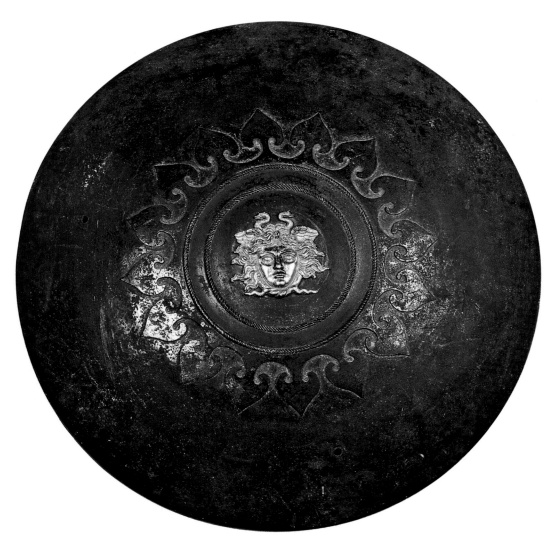

Fig. 90-1. *Household Furniture* (1807): pl. XXXVIII.

418

91. *Table*

After a design published by Thomas Hope
English, early 19th century
Mahogany, ebony, silver, bronzed wood
28⅜ x 41⅛ in. diam. (72.1 x 105.7 cm)
Courtesy of the Trustees of The Victoria and
Albert Museum, London, W.13-1936. Purchased
from Mrs. A. E. N. Jordan
New York only

PROVENANCE: [...]; Mrs A. E. N. Jordan, from whom
acquired by the Victoria and Albert Museum, 1936.

LITERATURE: *Household Furniture* (1807): pl. XXXIX,
nos. 1 and 2; Jourdain, *Regency Furniture 1795–1820*
(1934; rev. ed. 1948): 67, figs. 15, 16; Musgrave, *Regency
Furniture* (1961): fig. 13.

Plate XXXIX in *Household Furniture* (fig. 91-1)
illustrates the "Top and elevation of a
round monopodium or table in mahogany,
inlaid in ebony and silver."[1] It should be
noted that the top is plain in the center and
that the pedestal is decorated, as is the case
with this table. Several other tables close
to this design survive, but each has slight
differences and none has a secure Hope
provenance.[2]

Thomas Hope himself owned two and
possibly three examples. Lot 298 in the 1917
Christie's auction was "An Empire circular
mahogany table, the top inlaid with star
ornament and a wreath of foliage in ebony
and silver, on triangular stand with black

claw feet—*42 in diam. Illustrated in Hope's
'Household Furniture and Interior Decoration,
1807,' Plate 39*"; it was bought by L. Harris
for £17 17s. A second table owned by Hope,
with a plain base and decoration in the cen-
ter of the top, as well as around the edge,
was at the Deepdene (see fig. 12-16). A
plate in Henry Moses's *Modern Costume*
shows a closely related table with different
decoration in the base and, apparently, a
more simply decorated top.

Although none of Hope's tables has been
positively identified, it is possible that one
of the two tables owned by Edward Knoblock
once belonged to Hope. A photograph
showing Knoblock's dining room at Ashley

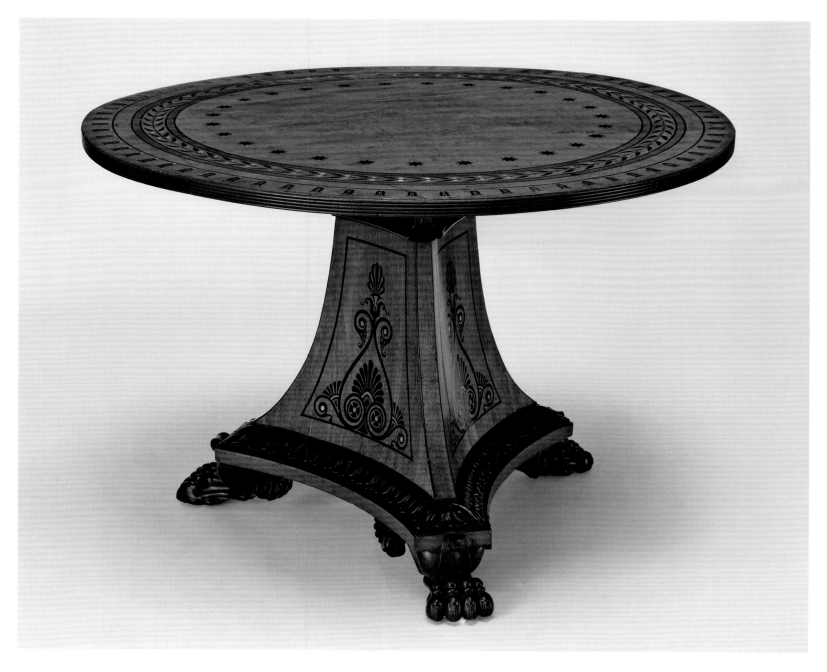

Place[3] (fig. 91-2) records a table with a fully decorated top and base. This may be the same table that bears a label "Property/of/Edward Knoblock…" and is now in a private collection, on loan to the National Trust of Scotland (cat. no. 92).[4] The second Knoblock table, first recorded in 1922,[5] was exhibited at Lansdowne House in 1929[6]; this may be the same table that was exhibited in 1963 by Temple Williams at the Antique Dealers' Fair and is probably identical with the one later in the collection of Ian Phillips.[7] A third Knoblock table, with a decorated base, described as the "Deepdene 'Monopodium'" was recorded in 1931 at 11 Montagu Place; it appears to have a lip of cross-banding, perhaps around an inset leather top.[8]

A fifth table, with applied gilded mounts on the pedestal and a fully decorated top, is in the collection of the Art Institute of Chicago.[9] And, finally, a sixth table, possibly not one of those already mentioned, was recorded in the library at Stratfield Saye in 1948; it had a decorated base, but it is not possible to deduce from the photograph how the top was treated.[10]

The design of this model, with its pedestal ultimately derived from the base of a classical candelabrum, may owe as much to Renaissance tables for its form. The three-sided base, animal feet, and inlaid top bear comparison, for example, to a table dating from about 1530 and made by Fra Damiano da Bergamo after a design attributed to Giacomo Vignola.[11]

Although the table in the Victoria and Albert Museum has no known early history, it corresponds more closely to the illustration in *Household Furniture* than any other recorded example.

1. *Household Furniture* (1807): 40.
2. The monopodium table published by Hope exerted considerable influence over contemporary designers and furniture makers. One frequently encounters circular tables with triangular pedestals manufactured during the Regency period and later. One of the better known examples is the table purchased by the Earl of Wemyss from the Bullock sale, Christie's, 3–5 May 1819, lot 83 ; see *George Bullock* (1988): no. 33. Bullock is known to have owned *Household Furniture*; see *George Bullock* (1988): 46.
3. See McClelland, *Duncan Phyfe and the English Regency* (1939, 1980): pl. 55. This table may have been sold, with other Knoblock furniture with a Hope provenance, by Sotheby's, 8 March 1946, lot 138.
4. Sold Sotheby's, 5 October 1972, lot 152; bought by Frank Partridge.
5. See Jourdain, *English Furniture* (1922): fig. 321.
6. *Loan Exhibition of English Decorative Art at Lansdowne House* (17–28 February 1929), no. 532.
7. Sold Christie's, London, 16 November 1995, lot 345.
8. Hussey, "Four Regency Houses" (1931): 450–58, fig. 6.
9. See Maxon, *The Art Institute of Chicago* (1970): 233.
10. Hussey, "Stratfield Saye" (1948): 1218–21, fig. 3; its present location is unknown.
11. Ajmar-Wollheim and Dennis, *At Home in Renaissance Italy* (2006): 225, cat. no. 110.

ML

Fig. 91-1. *Household Furniture* (1807): pl. xxxix.

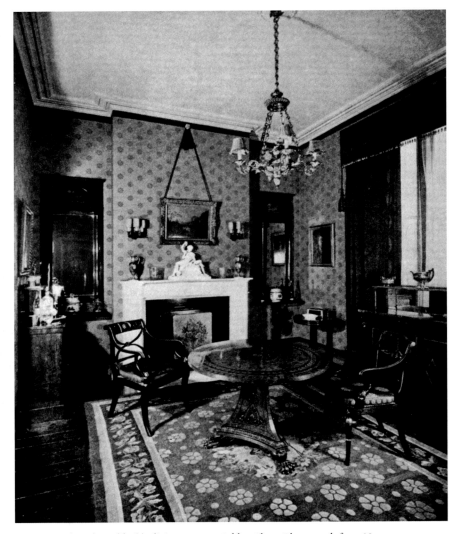

Fig. 91-2. Edward Knoblock's dining room at Ashley Place. Photograph from Nancy McClelland, *Duncan Phyfe and the English Regency 1795–1835* (1939): pl. 55.

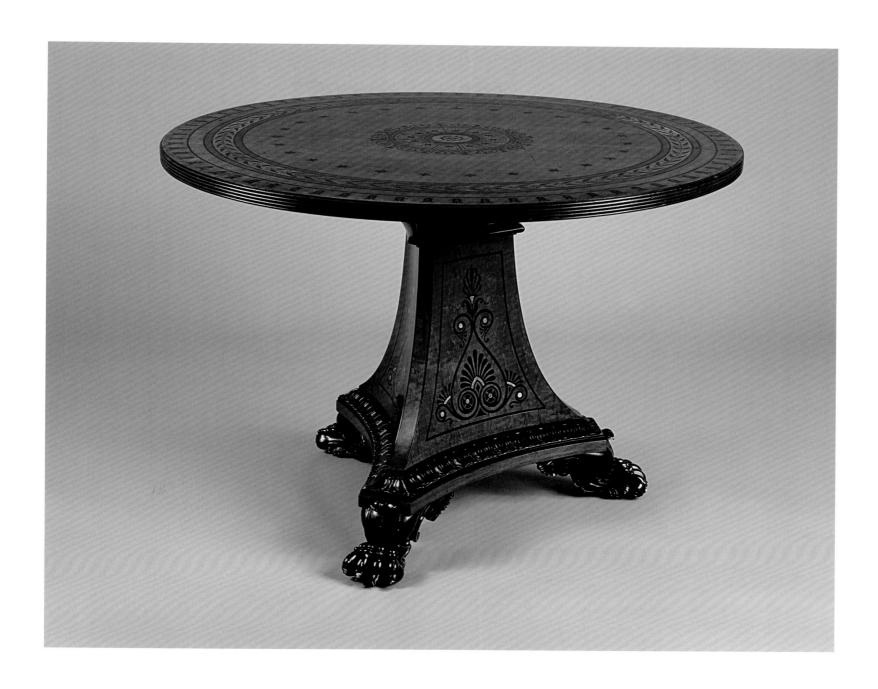

92. *Table*

After a design published by Thomas Hope
English, early 19th century
Mahogany, ebony, silver
28⅓ x 41¾ in. diam. (72 x 106 cm)
Mark: Property / of / Edward Knoblock / 21 Ashley
Place / London SW1
On loan to the National Trust for Scotland from a
private collection
London only

PROVENANCE: […]; Edward Knoblock, 21 Ashley
Place, London; […]; Sotheby's, 5 October 1973, lot 152,
bought by Frank Partridge; from whom acquired by
James Stirling; thence by descent.

LITERATURE: *Household Furniture* (1807): pl. XXXIX,
nos, 1 and 2; perhaps Knoblock, *Round the Room* (1939):
pl. 55.

This table may be the one recorded in
Edward Knoblock's dining room at Ashley
Place (see fig. 91-2). For more details of
surviving tables of this pattern, several of
which may have belonged to Knoblock, see
catalogue number 91.

ML

93. *Stool*

Perhaps based directly on a stool supplied to Thomas
Hope, or after his published design
English, early 19th century
Mahogany, with brass castors; upholstery of a later date
18½ x 25 x 14½ in. (47 x 63.4 x 36.8 cm)
Private collection

PROVENANCE: [...]; Sotheby's, New York, 15 April
1994, lot 141; bought by Devenish, from whom acquired
by present owners.

LITERATURE: *Household Furniture* (1807): pl. XL,
nos. 2 and 3.

Despite differences in detail, the design
of this stool corresponds to the overall
form of one illustrated in *Household Furni-
ture*, plate XL, numbers 2 and 3 (fig. 93-1):
"Side and front of a stool; the elbows
formed by swans, on a plinth ornamented
with Grecian scroll, emblematic of waves."[1]
The rosettes on the sides of this stool con-
trast with the symbolism envisaged by
Hope.

Although of excellent quality, it can be
argued that the carving displays less bravura
than that on furniture known to have been
in Hope's collection and associated with the
work of Peter Bogaert (see cat. nos. 66 and
84). It is possible, on the other hand, that
this rather large stool once belonged to the
"Banker Poet" Samuel Rogers.[2] When the
contents of 22 St. James's Place were sold
by Christie's on May 28, 1856, lot 38, from
the library, was: "A PAIR OF BEAUTIFUL
MAHOGANY CHAIRS, the arms supported by
Griffins;[3] and a stool, with swans—en suite,
of classical design."

Rogers fitted up his house with great
care and, according to a discussion said to
have taken place in 1803, "designed the fur-
niture himself, with the assistance of Hope's
work on the subject."[4] The mantelpiece in
the drawing room was executed by Flaxman,
who superintended the general decoration
of the walls and ceiling. Stothard designed
a cabinet for antiquities, ornamenting it
with paintings by his own hand. . . . Some
of the wood-carving in the dining-room
was executed by Chantrey. . . . The furni-
ture and decoration followed the Greek

models, and one of the striking features
of the house was its large and beautiful
collection of Greek vases."[5]

In conversation, Francis Chantrey[6] asked
Rogers if he remembered that, "about
twenty-five years ago, a journeyman came
to [his] house, from the woodcarver em-
ployed by [him] and Mr. Hope, to talk
about these ornaments, and that [he] gave
him a drawing to execute them by?" On
receiving an affirmative response from
Rogers, Chantrey declared: "Well, *I* was
that journeyman."[7] Chantrey is known, to
have been apprenticed early in his life to a
Sheffield-based carver and gilder named
Ramsay (or Ramsey).[8] It would appear that
Chantrey later worked for Bogaert before
establishing his independent career as a

sculptor. Perhaps some of Hope's furniture
was in practice carved by Chantrey, even if
supplied under Bogaert's name.

Swans are a recurring feature in French
Empire furniture but less common in Eng-
land. It is reasonable, therefore, to presume
some cross-channel influence. Percier and
Fontaine, for example, designed seat furni-
ture with "beaded" swans for the Empress
Joséphine at Saint Cloud, including the ele-
gant *fauteuil en gondole*, several of which
were manufactured by Jacob Desmalter.[9]
The design for an "Imperial Ottoman, or
Circular Sofa," published in 1811 by Rudolph
Ackermann, incorporates swans at either
end and may be an early example of the
influence of Hope's publication on com-
mercial furniture production.[10]

Fig. 93-1. *Household
Furniture* (1807):
pl. XL, nos. 2 and 3.

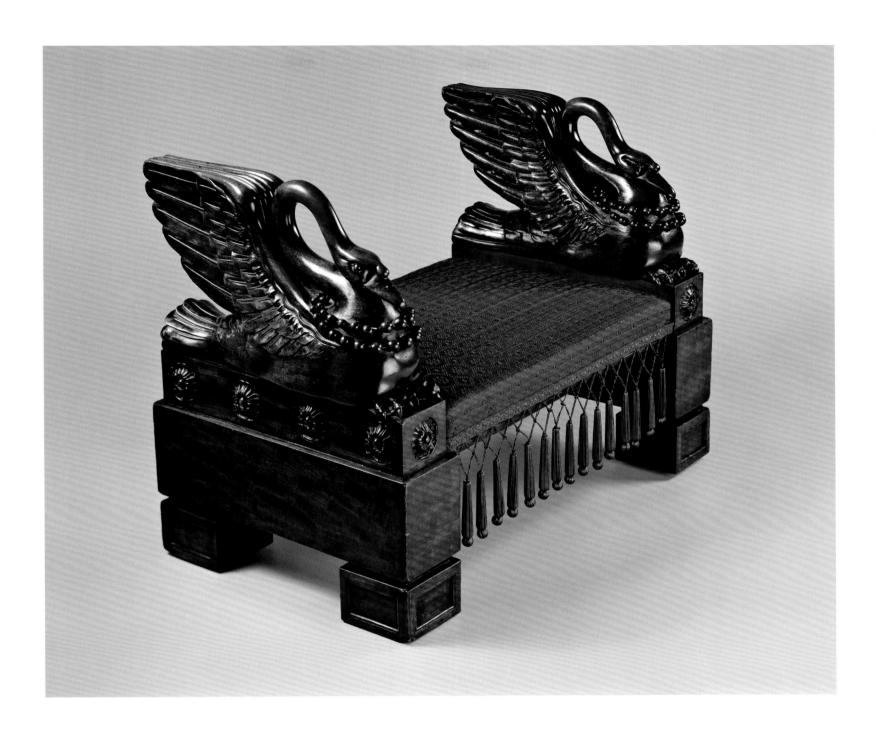

1. *Household Furniture* (1807): 40.

2. See Chapter 4 in this volume.

3. One of the armchairs was said to have been the one sold by Christie's, London, 8 June 2006, lot 96; see cat. no. 65, note 5.

4. This recollection implies, confusingly, that the furniture predates the 1807 publication of *Household Furniture*. On the other hand, the memory may have been specifically of "THE CHANTREY PEDESTAL. The carving on this pedestal was executed in mahogany by Mr. Chantrey, in 1803, when unknown and in poverty, being employed by Bogaert, a German, at the rate of five shillings a day"; Rogers Sale, second day, Christie's, London, 29 April 1856, lot 294; bought by Stuart for 10 gns. Perhaps the Hope-inspired furniture followed.

5. Clayden, *The Early Life of Samuel Rogers* (1887): 448–49.

6. See Gunnis, *Dictionary of British Sculptors* (1968): 91–96.

7. *Recollections of the Table-Talk of Samuel Rogers* (1856): 158.

8. Robert Ramsay (or Ramsey), a carver and gilder, is recorded in 1787 and 1808 at addresses in Sheffield; see Beard and Gilbert, *Dictionary of English Furniture Makers* (1986): 726.

9. See Ledoux-Lebard, *Le Mobilier Français du XIX^e Siècle* (2000): 335.

10. *The Repository of Arts* (1811): no. 25.

ML

94. *Chandelier*

After a design published by Thomas Hope
English, ca. 1802
Gilded wood, iron (with restorations)
The Metropolitan Museum of Art, New York, Robert
Lehman Collection, 1975 (1975.1.2494)
Not in exhibition

PROVENANCE: Presumably Thomas Hope, Duchess
Street and later at the Deepdene; by descent, Lord Francis
Hope Pelham-Clinton-Hope[1]; [...]; by repute, "a house
in Surrey not far from Deepdene"[2]; with Messrs. Pratt
& Sons, 1959; from whom acquired by Robert Lehman
and donated to the Metropolitan Museum.

LITERATURE: *Household Furniture* (1807): pls. XXX
and LIII; Joy, "The Elegancies of Antique Form" (1959):
94–95.

This large-scale chandelier appears to have
been conceived for a grand space at
Duchess Street, but *Household Furniture*
neither gives the location nor shows it in
situ. Illustrated in plate XXX (fig. 94-1), it is
described as a "Chandelier of bronze and
gold; ornamented with a crown of stars
over a wreath of night-shade."[3] Plate LIII,
number 3 (fig. 97-1) shows one of the
"Griffins of the chandelier, pl. 30."[4] The
griffin design is also used, on a larger scale,
on wall lights (see cat. no. 97).

As is frequently the case with Hope's
furniture (and in the work of earlier
designers and architects working in the
neoclassical tradition), the chandelier
employs readily understood symbolism in
its embellishments. As David Watkin has
written of the present chandelier, with
reference to the illustration in *Household
Furniture*, "a thick wreath of Deadly
Nightshade was surmounted by a diadem of
stars—a visual pun suggesting the victory
of light over dark."[5]

The protruding griffins supporting
candle holders relate closely to those on a
chandelier illustrated in plate 12 of Percier
and Fontaine's *Recueil de Décorations
Intérieures*. It is not clear whether Hope's
use of these elements, which are also seen
on French wall lights, preceded or followed
Percier and Fontaine.

Plate XLII in *Household Furniture*
(fig. 94-2) illustrates an elegant "bronze and
gilt chandelier, ornamented with drops,
prisms, &c. of cut glass," which is of more
conventional form than the example exhib-
ited here.

1. Illustrated in situ by *Country Life* in 1899; see Robin-
son, *The Regency Country House* (2005): 188. Since 1899
the arrangement of the lighting nozzles has been altered
to its original configuration, and the decoration inside
the lower rim has also been changed.
2. Joy, "The Elegancies of Antique Forms" (1959): 94–95.
3. *Household Furniture* (1807): 38.
4. Ibid., 48.
5. Watkin, *Thomas Hope* (1968): 195.

ML

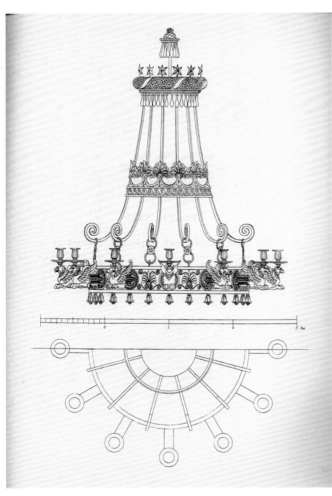

Fig. 94-1. *Household Furniture* (1807): pl. XXX.

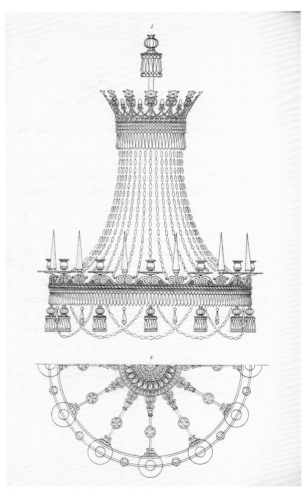

Fig. 94-2. *Household Furniture* (1807): pl. XLII.

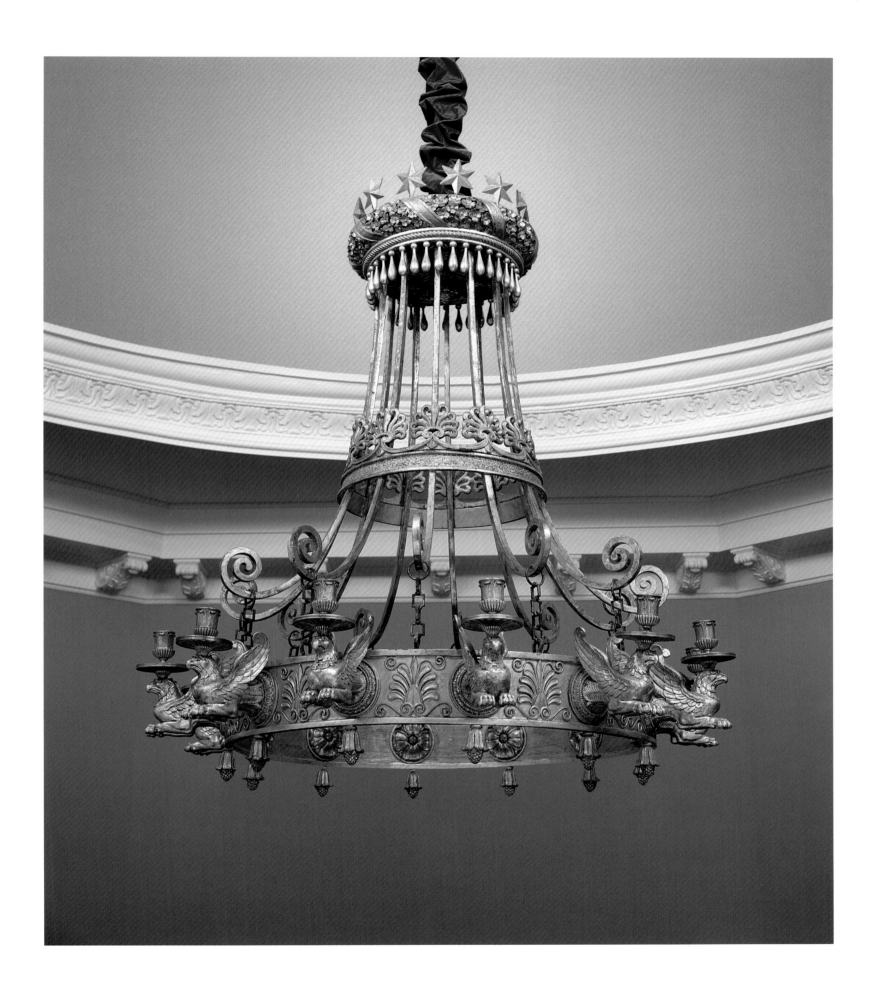

95. *Pair of Wall Brackets*

After designs published by Thomas Hope
English, ca. 1802
Bronzed, painted, and gilded wood; the chain of later date
15¾ x 19¾ x 1½ in. (40 x 50 x 4 cm)
Royal Pavilion and Museums, Brighton and Hove, 34025516

PROVENANCE: Presumably, in part, Thomas Hope, Duchess Street and later at the Deepdene; by descent, Lord Francis Hope Pelham-Clinton-Hope; sold Humbert & Flint, London, 14 September 1917, lot 946; [...]; Sir Albert Richardson,[1] by whom bequeathed to the Royal Pavilion, Brighton.

EXHIBITIONS: *The Inspiration of Egypt*, Brighton Museum V (1983): no. 86F.

LITERATURE: *Household Furniture* (1807): pls. VI, VIII, XLIII, no. 3; Watkin, *Thomas Hope* (1968): 110; Conner, *The Inspiration of Egypt* (1983): 49, no. 86F.

By the time these wall light elements were sold in 1917, for £7 5s., they had taken on their present configuration. Described as "A PAIR OF CARVED GILT SNAKE WALL BRACKETS suspended from which are two painted and gilt star pattern ornaments, and two black and gilt brackets with four gilt carved wood candle holders, with ebonized and gilt shields under," these were, in fact, made up of various elements.

The lowest shield-shaped sections (exhibited here) are similar in form to part of the wall lights from the Drawing Room at Duchess Street, illustrated in *Household Furniture*, plate VI (see fig. 2-18), but they differ in detail.[2] Related designs are found in the "Gennadius" drawings (cat. no. 109; here fig. 95-1). The pattern for the shield derives from the classical *pelta* (a shield in the shape of a half moon), which was popular with such eighteenth-century architects as James Stuart[3] and Robert Adam. The central sections have the same shaped back plates as the wall lights from the Egyptian

Room at Duchess Street, illustrated in plate VIII of *Household Furniture* (see fig. 2-15). The same design, based on a classical "tabula ansata (tablet with handles)," appears in *Household Furniture*, plate XLIII (fig. 95-2; see also cat. no. 96). It seems likely that the two remaining upper sections are of a later date. Their design and use of color have no parallels
in documented elements from Duchess Street, and it is not known when and under whose tenure they came to be at the Deepdene.

In their present form, these wall decorations are perhaps more representative of the Regency revival than the taste of Thomas Hope.

1. See Chapter 15 in this volume.
2. Shields more closely following the illustration in *Household Furniture* are shown in situ at the Deepdene by *Country Life* in 1899; see Robinson, *The Regency Country House* (2005): 188–89.
3. "Stuart's Athens" was another of the authorities commended by Hope at the conclusion of *Household Furniture*.

ML

Fig. 95-1. Thomas Hope. Standing figure holding a basket of fruit and a cup. Drawing from "Outlines for My Costume," one of the two volumes of illustrations for *Costume of the Ancients* (1809): pl. 84. Gennadius Library, American School of Classical Studies at Athens. *Cat. no. 109.*

Fig. 95-2. *Household Furniture* (1807): pl. XLIII.

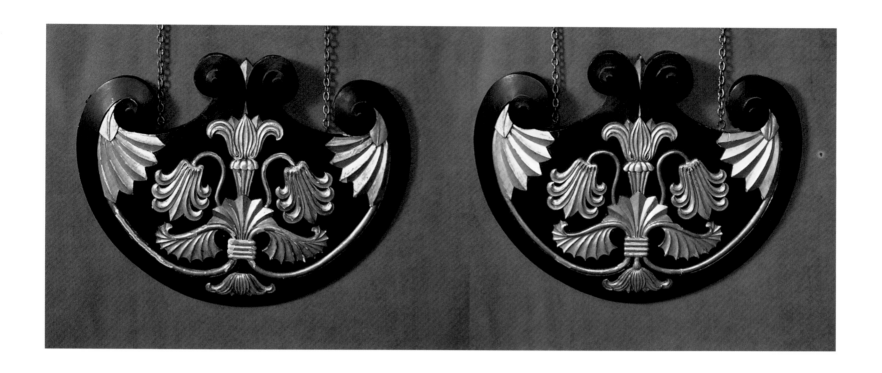

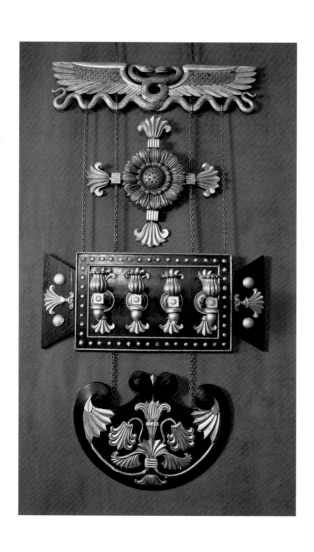

96. *Pair of Wall Lights*

After a design published by Thomas Hope
English, ca. 1802
Bronzed and gilded limewood; the chains and related
elements of later date
13¼ (including chains, 55½ in.) x 29⅛ x 13¼ in. (34.9 x
75.1 x 33.6 cm)
Private collection

PROVENANCE: Presumably Thomas Hope, Duchess
Street; [...]; Gerald Wellesley, 7th Duke of Wellington[1];
thence by descent; H. Blairman & Sons, from whom
acquired by the present owner.

LITERATURE: *Household Furniture* (1807): pls. VIII,
XLIII, no. 3; Watkin, *Thomas Hope* (1968): 256; Conner,
The Inspiration of Egypt (1983): 49, no. 86E.

These wall lights broadly correspond with
those shown in *Household Furniture*, plate
XLIII (see fig. 95-2), and more than likely
were used somewhere in Hope's London
house. In their restored form, the exhibited
wall lights are like those shown in the
Egyptian Room in plate VIII of *Household
Furniture* (see fig. 2-15).

It is clear that not all the furniture origi-
nally at Duchess Street was illustrated in
Household Furniture. For instance, Hope
does not illustrate the fourth walls in the
interiors (pls. I–VIII). Moreover, there is the
unresolved question of how the less public
rooms were fitted out.[2] It has been sug-
gested that some of the plates in Henry
Moses's *Modern Costume* (see cat. no. 111)
depict domestic scenes at Duchess Street,
but this remains speculation.[3]

Each room would have required ade-
quate lighting, and Hope paid great atten-
tion to this subject. He wrote:

*The artificial lights, which our habitations
require at night, in order to render the sur-
rounding objects visible, cannot be prevented
from themselves, in some measure, becoming
the predominant visible object. Hence the
greatest attention should be adhibited to place,
not only the different groups, but the different
lights composing each group . . . as may prevent
their presenting, in any point of view, and
indistinct and confused glare. Cluttered and
often zig-zagged as are the branches of the
girandoles, in most of our public places and
private rooms, the lights which they carry not
only diffuse less general splendour, but look
individually less distinct and less grand, than
if they were made to range on long horizontal
lines, at equal distances from each other.*[4]

It is evident that the present wall lights con-
form squarely with Hope's principles.

1. Illustrated in 1931 at 11 Titchfield Terrace, see Collard,
Regency Furniture (1985): 268. For Gerald Wellesley, see
Chapter 15 in this volume.
2. See Chapter 15.
3. See Chapter 4.
4. *Household Furniture* (1807): 42.

ML

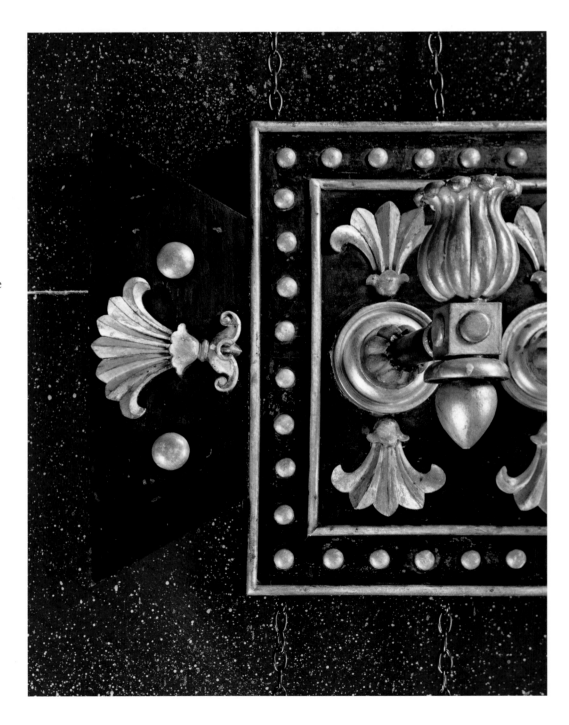

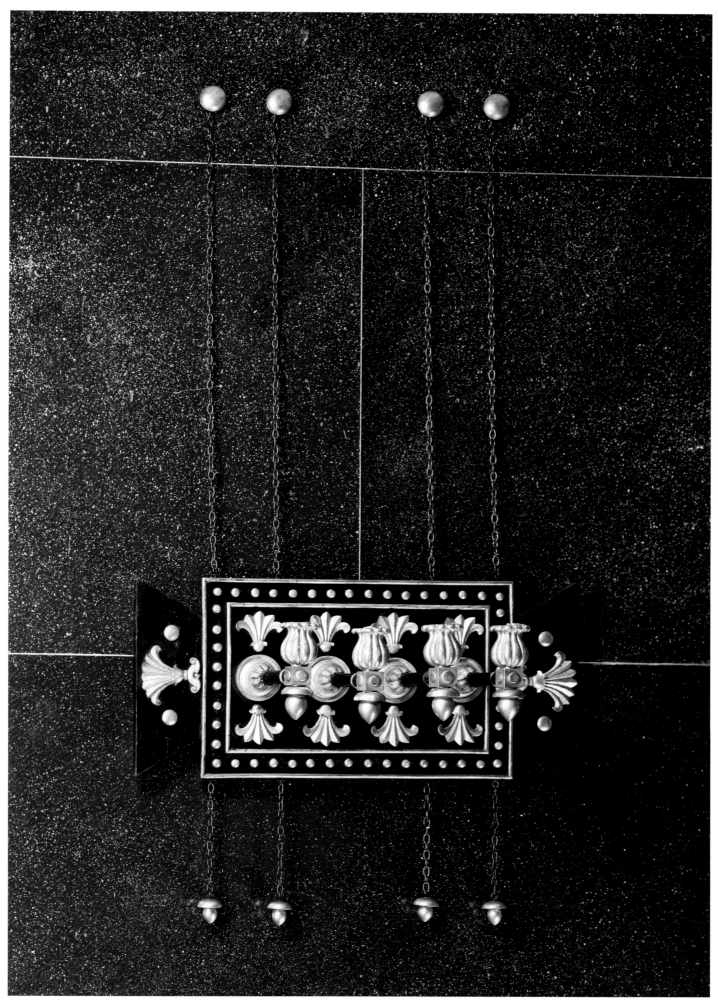

97. *Pair of Wall Lights*

After a design published by Thomas Hope
English, ca. 1802
Bronzed limewood, later lacquered brass nozzles
12½ x 7 x 14 in. (31.7 x 17.8 x 35.5 cm)
Private collection

PROVENANCE: Presumably Thomas Hope, Duchess
Street; [...]; Sir Albert Richardson by 1928; thence by
descent; H. Blairman & Sons, from whom acquired by
the present owner.

EXHIBITIONS: *The Daily Telegraph Exhibition of
Antiques and Works of Art*, Olympia, London, 19 July to
1 August 1928, no. F102 (lent by Prof. A. E. Richardson).

LITERATURE: Similar to *Household Furniture* (1807):
pl. xxx (arms of chandelier), pl. LIII, no. 3; *The Daily
Telegraph Exhibition of Antiques and Works of Art*
(1928): no. F102.

The design of these wall lights corresponds
closely with the smaller-scale detail for a
chandelier in *Household Furniture*, plate LIII
(fig. 97-1). The winged griffins also closely
resemble those in Percier and Fontaine's
"Lustre exécuté dans la Maison du C.
Ch.... à Paris."[1] Another bronzed wall
light, with a candle nozzle corresponding
to the illustration in *Household Furniture*,
was formerly in the collection of Gerald
Wellesley (fig. 15-9).[2] This latter wall light
has a back plate that is a variant of those in
catalogue number 96.

 If not all the wall lights used at Duchess
Street are illustrated in *Household Furniture*,
it seems reasonable to speculate that some
of those acquired soon after the Deepdene
sale by early collectors of Regency furni-
ture, such as Gerald Wellesley and Albert
Richardson, despite a lack of firm docu-
mentation, were originally part of Hope's
own furnishings.

Fig. 97-1. *Household Furniture* (1807): pl. LIII (detail).

1. *Recueil de Décorations Intérieures* (1809): pl. 12.
2. Having passed by descent, this wall light was
acquired by H. Blairman & Sons and is now in a private
collection, formed in the tradition of Wellesley,
Richardson, and Knoblock.

ML

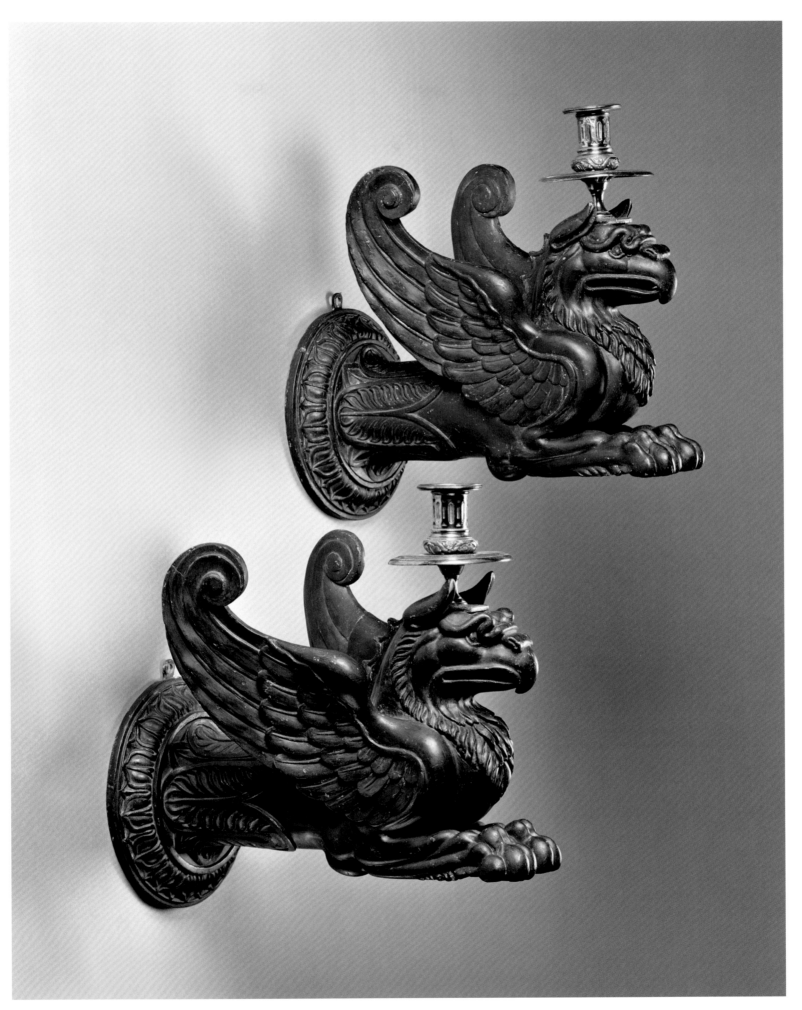

98. *Pair of Helmets*

After designs by Thomas Hope
English, early 19th century
Bronzed and gilded limewood
16 x 16 in.; 16 x 13 in. (40.6 x 40.6 cm; 40.6 x 33 cm)
Private collection

PROVENANCE: [...]; London art market, 1950s;
Jean Chelo, Paris; private collection; Jeremy Ltd.,
from whom acquired by the present owner.

LITERATURE: *Household Furniture* (1807): pls. XLV, LX;
Hope, *Costume of the Ancients* (London, 1809, 1812):
pls. XXX, LXXV.

The designs of these helmets are very close to those in the undated "Gennadius" drawings for costume (cat. no. 109, fig. 98-1) and to the resulting illustrations in Hope's *Costume of the Ancients*, plates 30 and 75. In *Household Furniture*, the left-facing helmet here is very similar to one suggested for a door in plate XLV (fig. 98-2). Comparable helmets, conceived as wall decoration, were also published by Percier and Fontaine.[1]

Two similar left-facing helmets, in gilt bronze, are perhaps an addition to an unattributed cabinet supplied by Samuel Wyatt for Soho House, Birmingham, probably originally designed in plainer form.[2]

The exhibited helmets are most likely to have formed part of an architectural scheme; glue marks and centering pins on the reverse sides suggest that they were attached to paneling, perhaps on a door. The best evidence for their likely Hope provenance is the appearance of similar carved helmets among the architectural elements displayed in 1899 on the walls of the Deepdene.[3]

1. *Recueil de Décorations Intérieures* (1812): pl. 55.
2. Sold Christie's, London, *Great Tew Park*, 27–29 May 1987, lot 149; the cabinet is now in the collection of the City Museum and Art Gallery, Birmingham. The compiler is grateful to Glennys Wild for her thoughts on this cabinet, communicated by e-mail, 23 January 2007.
3. See Robinson, *The Regency Country House* (2005): 188–89.

ML

Fig. 98-1. Drawing from "Outlines for My Costume," one of the two volumes of illustrations for *Costume of the Ancients* (1809). Gennadius Library, American School of Classical Studies at Athens.

Fig. 98-2. *Household Furniture* (1807): pl. XLV.

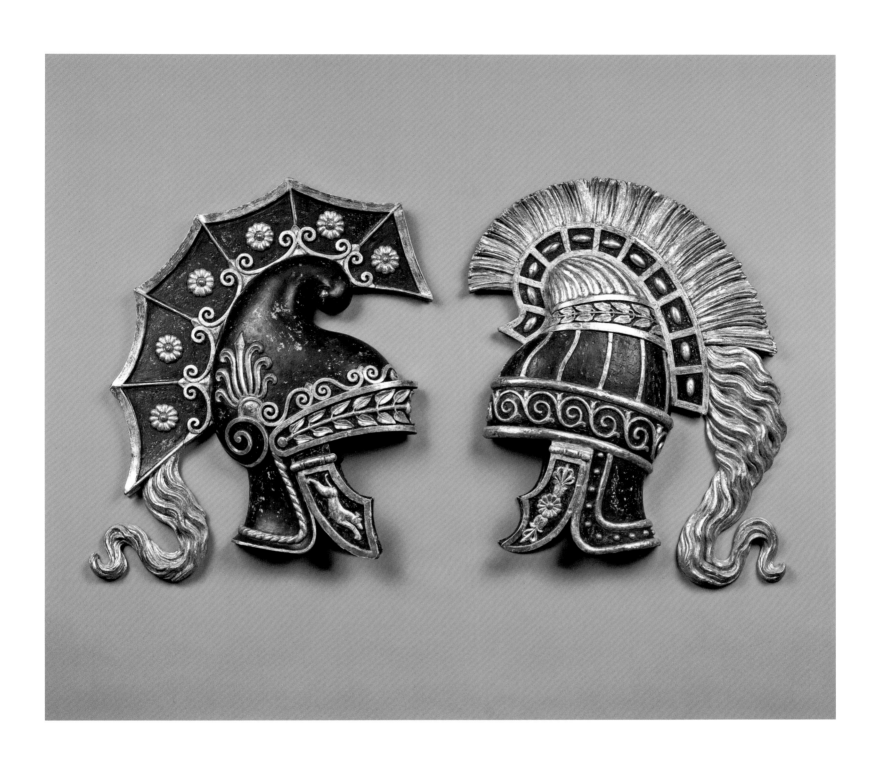

99. *Crucifix*

Flemish, second half 17th century
Ivory, ebony
29 x 16 in. (73.6 x 40.6 cm)
Hubert de Lisle

PROVENANCE: John Hope; Thomas Hope; by descent, Henrietta Hope, Lady Haversham; by descent, joint heirs Mildred Astley Smith and Ambrose de Lisle; by descent, Hubert de Lisle

LITERATURE: RKD Catalogue II: Catalogus van het Cabinet Schilderijen & Andere Rariteiter, cat. 318; Westmacott, *British Galleries* (1824): 219; Watkin, *Thomas Hope* (1968): 121; Niemeijer, "De kunstverzameling van John Hope" (1981): 210.

It has long been a common misconception that all of the contents engraved for and illustrated in Thomas Hope's seminal publication *Household Furniture and Interior Decoration* in 1807 were pieces that had been designed by him for his Duchess Street interiors. However, it is now known that some of the furniture and metalwork was, in fact, French in origin and had been acquired through various sources (see Chapters 4 and 6). What has also become apparent is that a number of these pieces were inherited objects, bequeathed to Thomas and his brothers by his father, John Hope, and his mother, Philippina Barbara van der Hoeven. During his life John had built up an impressive collection of paintings, drawings, marbles, pietre dure, and silver, as well as many small sculptures in ivory, wood, and bronze. At his death in 1784, John's wife inherited the collection. At her death in 1789 it was divided between maternal and paternal legacies, with Thomas inheriting, among other things, the curiosities in ivory and lacquer, marble busts, mathematical instruments, and some ancient mosaic table tops from his father's house in Amsterdam.[1] This ivory crucifix on a wooden cross was one of the objects inherited by Thomas that he decided to display in the Duchess Street house.[2]

When Charles Molloy Westmacott visited the house in 1824, he remarked on this "splendid carving, in ivory,"[3] displayed in a room called the Lararium, which Thomas himself described as a "Closet or boudoir fitted up for the reception of a few Egyptian, Hindoo, and Chinese idols and curiosities."[4] In fact, this room also appears to have been the receptacle of another piece that Thomas had inherited, an equestrian figure of Marcus Aurelius, which is illustrated in *Household Furniture*. David Watkin in his essay on the Duchess Street interior (Chapter 2) has suggested that this room, among other symbolic gestures, was akin to a family shrine. On the shelf, an unusual stepped superstructure of the chimneypiece, stood a pair of Empire greyhounds on pink marble plinths, a pair representing Diana of the Ephesians, and a relief carved in *rosso antico* depicting Bacchus and Ariadne. Hope's other inherited objects were scattered throughout the house: the bronze figure of a bull on a pedestal, for example, was displayed in the Indian Room, and a group of his antique and modern mosaic tables may well have been those documented in the Picture Gallery.

The crucifix is certainly Flemish in origin and dates to the second half of the seventeenth century. The identity of the carver is uncertain, although similarities to both the work of Francois Bossuit[5] and Matthieu van Beveren[6] have been noted; the crucifix was attributed to the hand of Bossuit when it was in the collection of Hope's father, John.

1. Niemeijer, "De kunstverzameling van John Hope" (1981): 127–32.
2. "Een crucifix zynde een stervende Christus, van Ivoir; hagende aan een Mahoniehoute kruis, staande op een Uitgehouwen voet. Door Francois Bossuit; zynde het beeld 22, het geheel stuk 83," in cat. no. 381 in Niemeijer, "De kunstverzameling van John Hope" (1981): 210.
3. Westmacott, *British Galleries* (1824): 219.
4. *Household Furniture* (1807): pl. X.
5. Christ on a cross in wood and ivory in *Cabinet de l'art* (1727): pl. XVI.
6. *Le Siècle de Rubens* (1965): 352.

DB-A

100. *Armchair*

Designed by Baron Dominique Vivant Denon
(1747–1825)
Manufactured by Jacob-Desmalter (fl. 1803–18)
French (Paris), probably before 1818
Mahogany, gilt-bronze
33½ x 27⅕ x 25⅗ in. (85 x 69 x 65 cm)
Marks: "JACOB D/R MESLEE" on the front rail
Courtesy of the Trustees of The Victoria and Albert
Museum, London, W.6-1996. Purchased with the assistance of the National Art Collections Fund and the
Heritage Lottery Fund.

PROVENANCE: [...]; probably Thomas Hope, by 1819,
a pair; by descent, Lord Francis Hope Pelham-Clinton-
Hope; sold Christie's, London, 18 July 1917, lot 140;
bought by Clark; [...]; Edward Knoblock, Montague
Terrace; his sale, Sotheby's, London, 8 March 1946, lot
137; bought by Ian Phillips; his sale, Christie's, London,
16 November 1995, lot 344; bought by a private
collector[1]; Victoria and Albert Museum.

LITERATURE: Letter in Colvin, *Maria Edgeworth*
(1971): 197; Jourdain, *English Furniture of the Later
XVIIIth Century* (1922): 223, figs. 339; p. 260, fig. 426
(detail); Macquoid and Edwards, *Dictionary of English
Furniture*, vol. 1 (1926): fig. 171 (described as English);
"Beach House, Worthing, Sussex" (1921): 132, fig. 13;
"Four Regency Houses" (April 1931): 453, fig. 7;
Knoblock, *Round the Room* (1939): frontis. and p. 64;
Ledoux-Lebard, *Les Ebenistes Parisiens du XIX siècle*
(Paris, 1965): 279; Watkin, *Thomas Hope* (1968): 79–80,
pl. 37; Praz, *On Neoclassicism* (1972): 296, pl. 38;
Collard, *Regency Furniture* (1984): 265; Department
of National Heritage, *Export of Works of Art 1995–96*,
case 19: 37–38; "Acquisitions in British Museums and
Galleries" (1997): 74–80, illus. p. 78; Wood and Medlam,
"Acquisition in Focus" (1997): 45–47.

The uncertain history of this chair, one of
a pair, has recently been explored.[2] According to Wood and Medlam, it is not clear
when these chairs came into the collection
of Thomas Hope. They speculate, on the
basis of a letter from Maria Edgeworth to
her stepmother discussing a bed *en suite*,
that the two chairs were at the Deepdene
by 1819. It is not in doubt that identical
chairs were designed by Denon (for himself), but it is argued by Wood & Medlam
that the model corresponds with the
"Deux fauteuils en bois d'acajou, incrusté
d'argent, copiés d'après les formes d'objets
du même genre dessinés à Thèbes par

Mr Denon" (two armchairs of mahogany
inlaid with silver, copied from objects of
the same type drawn at Thebes by Mr.
Denon) included in Denon's sale in 1827.
The principal difference is that Denon's
chairs were inlaid with silver, which suggests that Hope ordered or purchased his
own suite.[3] The distinct form of the
Denon's chair model[4] is comparable to the
ancient Egyptian anthropomorphic couch
depicted in "Fragments d'hiérolyphes de
grandeur naturelle," which he published in
1802 (fig. 100-1).[5]

There can be no doubt that either Hope
or his descendants[6] owned these chairs. In
the Christie's sale on July 18, 1917, they
were sold as lot 140: "A PAIR OF EMPIRE
MAHOGANY ARM-CHAIRS, carved with leopards and swans' heads inlaid with lines in
brass, and mounted with Egyptian ornament of or-moulu"; the buyer, for £21, was
Clark. Although these chairs have several
times been published as English, on this
occasion Christie's use of the description
"Empire" is correct in indicating their
French manufacture.[7]

If the reasonable assumption that
Thomas Hope owned these chairs is
accepted, then they represent a rare survival of articles acquired when furnishing
the Deepdene. They also seem to demonstrate his respect for Denon in particular
and more generally for French Empire
design and manufacture. The significance
of the two chairs today is their iconic status, not only within the revival of taste for
the Egyptian influence in the early nineteenth century, but also for their association
with interest in the Regency period shown
early in the twentieth century.

1. Following a temporary export ban, the chair, one
from a pair, was acquired by the Victoria and Albert
Museum; see Forty-second Report of the Reviewing
Committee, *Export of Works of Art 1995–96* (London:
DCMS, 1996): case 19, pp. 37–38. The second chair was
acquired by the National Museums and Galleries on
Merseyside.
2. See Wood and Medlam, "Acquisition in Focus"
(1997): 45–47.
3. Ibid., 46.
4. There is a well-known bronze by Mouton depicting
Napoléon seated in a chair with similar legs and arms;
see Hubert and Ledoux-Lebard, *Napoléon portraits contemporains* (1999): 198–200.

Fig. 100-1. Details of an anthropomorphic couch. From "Fragments
d'hiéroglyphes de grandeur
naturelle" in *Voyage dans la Basse et
la Haute Egypte* (Paris, 1802): pl. II,
pl. 113.

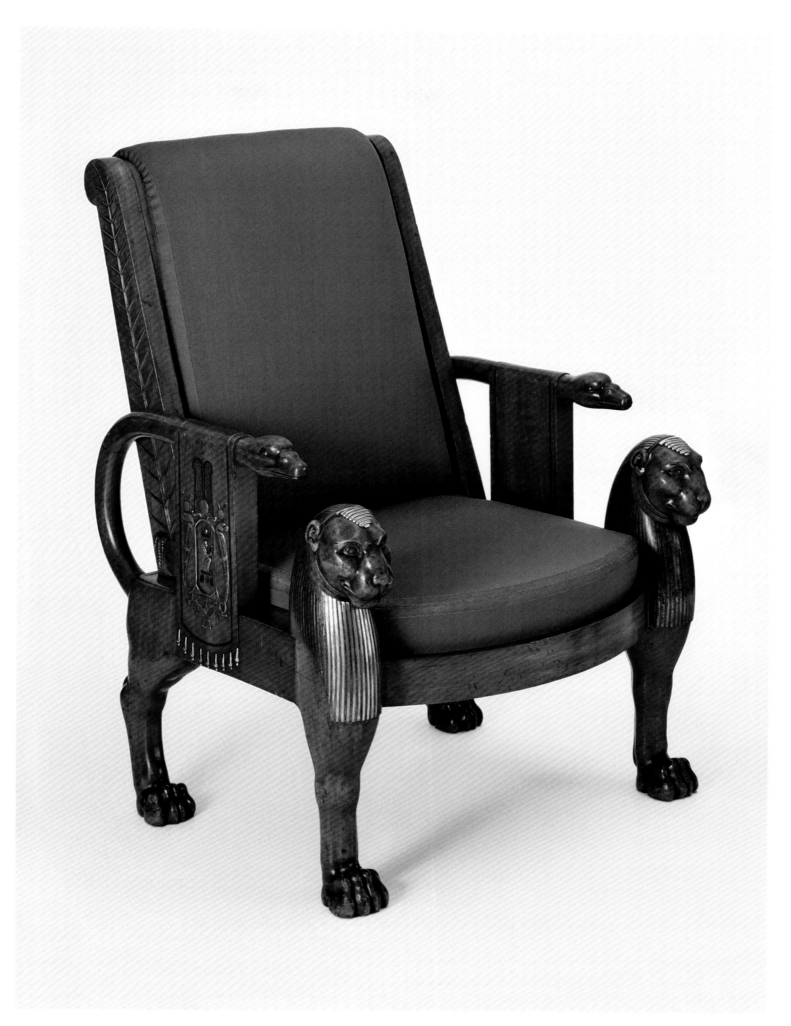

5. *Voyages dans la Basse et la Haute Egypte* (1802): pl. II, pl. 113. See also Baker, *Furniture in the Ancient World* (1966): fig. 143, for a surviving couch. A miniature bronze chair dating from the 26th–29th Dynasty (664–380 B.C.), of related form, is in the Metropolitan Museum of Art, acc. no. 89.2.416.

6. By the time of the 1917 sale, there was a considerable quantity of Empire furniture at the Deepdene. Moreover, as early as 1812, Douce suggests, accurately or otherwise, that Hope owned Parisian chairs and sofas at Duchess Street; see Thornton and Watkin, "New Light on the Hope Mansion in Duchess Street" (1987): 167. Based on Douce's observation, Thornton and Watkin speculate that Hope's chairs with lyres decorating the backs, shown in the Drawing Room (*Household Furniture* [1807]: pl. VI and pl. XXIV, no. 2) might be French. But a surviving example of this model, inlaid with ebony and lacking provenance, appears to be of English manufacture; see Hall, "Stirling Wit and Passion" (2000): 50–53, fig. 2.

7. For example, Jourdain, *English Furniture* (1922): fig. 339.

<div align="right">ML</div>

101. *Basket*

Paul Storr, silversmith, after a design published by Thomas Hope
English, London, 1798–89
Silver gilt
6 x 10¼ in. diam. (15.2 x 26 cm)
Marks: Arms of Hope on the interior base, PS for Paul Storr, and London marks for 1798/9.
Mr. Alexander Stirling and Mr. Robert Stirling

PROVENANCE: Thomas Hope; by descent, Lord Francis Hope Pelham-Clinton-Hope; sold Christie's, London, 17 July 1917, lot 55 (one of four); bought by S. J. Phillips, London, for £128.12.6; […]; Mr. Alexander Stirling and Mr. Robert Stirling.

LITERATURE: *Household Furniture* (1807): pls. L, LII.

This model of a silver basket is shown in *Household Furniture* in two different iterations, as a "fruit basket" in plate LII (see fig. 6-18) and as a "flower basket, in gilt bronze" in plate L (see fig. 6-11). Since no gilt-bronze versions of this model have come to light, Hope was either referring to the torchère or candelabrum on which it stood or he was mistaken about the material. Without a complete view of the Dining Room at Duchess Street or an account of how the Hopes dined, the context of the silver is uncertain. The display of the basket on the torchère in plate L, which shows parts of the "Eating room," suggests that Hope was interested in using his silver as decorative objects, as well as for dining.

Closely observed as a woven cane basket, this version in silver gilt was ostensibly used for serving or displaying fruit at the dessert course. According to the description of lot 55 in the 1917 Hope Heirlooms sale, the basket was originally one of four made by the silversmith Storr.[1] Further examples of this model are known, including a pair with handles made by Storr in 1803.[2]

1. "Four circular dessert-baskets with basket pattern vases and wide spreading wire sides with corded edges-10¼ in. wide, by Paul Storr, 1798, 147 oz." Bought by S. J. Phillips for £128.12.6d.
2. Moss, *The Lillian and Morrie Moss Collection* (1972): 220–21, pl. 157.

<div align="right">MC</div>

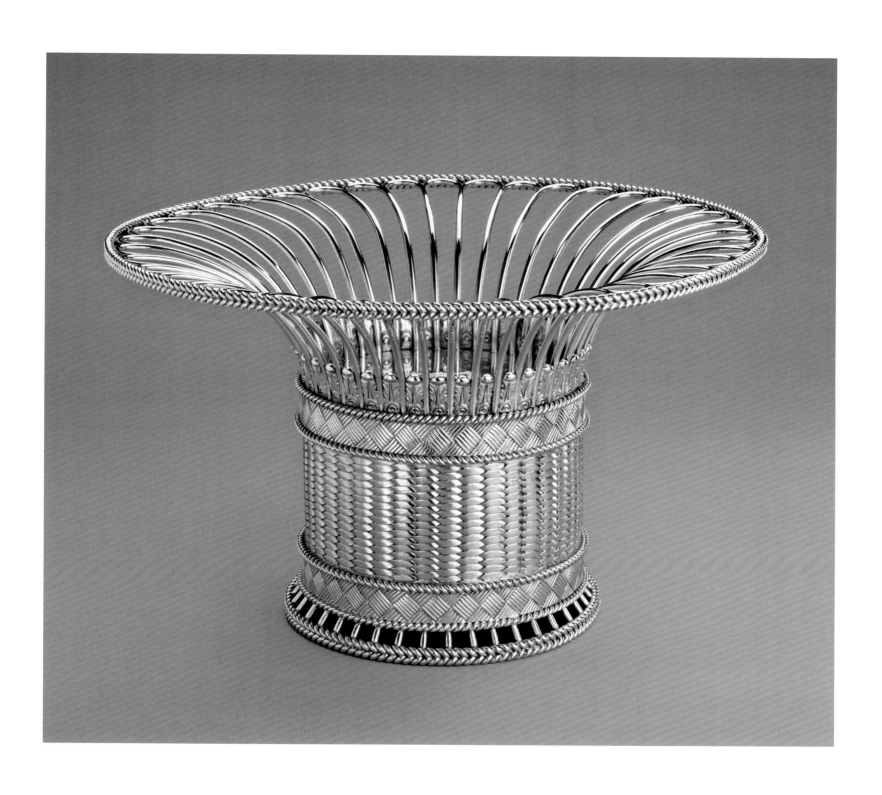

102. *Tea Urn*

Digby Scott and Benjamin Smith II, silversmiths,
for Rundell, Bridge & Rundell, retailing gold and
silversmiths
English, London, 1805/6
Silver gilt
Marks: RUNDELL, BRIDGE ET RUNDELL AURIFICES REGIS
ET PRINCIPIS WALLIAE FECERUNT, D.S.B.S. for Digby
Scott and Benjamin Smith and letter K for 1805/6.
15 x 16½ in. (38.1 x 42 cm)
Private collection

PROVENANCE: Possibly Thomas Hope; by descent,
Lord Francis Hope Pelham-Clinton-Hope; sold
Christie's, London, 17 July 1917, lot 52; bought by
Comyns for £108.18.1; […]; Sotheby's, New York,
8 April 1986, lot 123; Sotheby's; New York, 19 October
1994, lot 260.

From the description in the Hope Heirlooms sale "a tea urn . . . the plinth chased with Egyptian ornament—1805, 212 oz. 10 dwt," it is probable that this was the tea urn from Hope's Duchess Street house.[1] The design is probably that of the French immigrant artist and designer Jean Jacques Boileau, who had previously worked for Henry Holland on Carlton House.[2] Boileau drew on a repertory of designs, similar to those used by the French silversmiths Odiot and Biennais, of plain, burnished, shallow, hemispherical forms contrasted with heavy bands of ornament and massive figural details. In this case, to the classical repertory is added a smaller measure of ancient Egyptian ornament on the plinth. Although no drawings survive for this model, there are two of Boileau's surviving drawings that relate to the design of this tea urn.[3] According to the 1917 Hope Heirlooms sale catalogue, this tea urn was part of a tea service "of Empire design," also marked by Storr for 1808.[4] As Boileau was probably the designer and as there are several versions of this tea urn of similar dates known, Hope's involvement in the manufacture of this example can only have been as patron.[5]

1. Christie's, London, Hope Heirlooms sale, 17 July 1917, lot 52. At 212 ounces this tea urn is closest in weight among the different versions known of this model (although a different weight of 214 ounces is cited in an unpublished inventory of silver from the Deepdene in "Inventory of Jewels and Plate made at Cavendish Square"; 1911, Nottingham University Library, 2124).
2. Jervis, *Dictionary of Design and Designers* (1984): 72.
3. Schroder, *The Gilbert Collection* (1988): 338–41, no. 90.
4. Christie's, London, Hope Heirlooms sale, 17 July 1917, lots 50, 51.
5. Two others are the Gilbert Collection, see note 3 above, and the Victoria and Albert Museum, see Hartop, *Royal Goldsmiths* (2005): no. 10.

MC

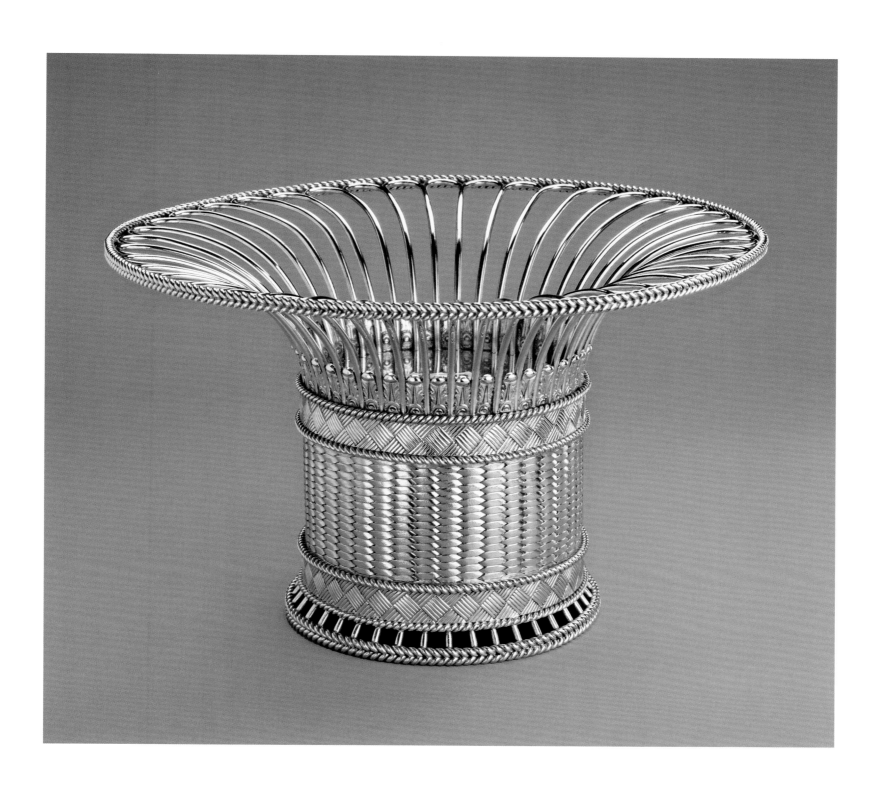

102. *Tea Urn*

Digby Scott and Benjamin Smith II, silversmiths,
for Rundell, Bridge & Rundell, retailing gold and
silversmiths
English, London, 1805/6
Silver gilt
Marks: RUNDELL, BRIDGE ET RUNDELL AURIFICES REGIS
ET PRINCIPIS WALLIAE FECERUNT, D.S.B.S. for Digby
Scott and Benjamin Smith and letter K for 1805/6.
15 x 16½ in. (38.1 x 42 cm)
Private collection

PROVENANCE: Possibly Thomas Hope; by descent,
Lord Francis Hope Pelham-Clinton-Hope; sold
Christie's, London, 17 July 1917, lot 52; bought by
Comyns for £108.18.1; [...]; Sotheby's, New York,
8 April 1986, lot 123; Sotheby's; New York, 19 October
1994, lot 260.

From the description in the Hope Heir-
looms sale "a tea urn . . . the plinth chased
with Egyptian ornament—1805, 212 oz. 10
dwt," it is probable that this was the tea urn
from Hope's Duchess Street house.[1] The
design is probably that of the French immi-
grant artist and designer Jean Jacques
Boileau, who had previously worked for
Henry Holland on Carlton House.[2] Boileau
drew on a repertory of designs, similar to
those used by the French silversmiths Odiot
and Biennais, of plain, burnished, shallow,
hemispherical forms contrasted with heavy
bands of ornament and massive figural
details. In this case, to the classical reper-
tory is added a smaller measure of ancient
Egyptian ornament on the plinth. Although
no drawings survive for this model, there
are two of Boileau's surviving drawings
that relate to the design of this tea urn.[3]
According to the 1917 Hope Heirlooms sale
catalogue, this tea urn was part of a tea
service "of Empire design," also marked by
Storr for 1808.[4] As Boileau was probably
the designer and as there are several versions
of this tea urn of similar dates known,
Hope's involvement in the manufacture of
this example can only have been as patron.[5]

1. Christie's, London, Hope Heirlooms sale, 17 July
1917, lot 52. At 212 ounces this tea urn is closest in
weight among the different versions known of this
model (although a different weight of 214 ounces is
cited in an unpublished inventory of silver from the
Deepdene in "Inventory of Jewels and Plate made at
Cavendish Square"; 1911, Nottingham University
Library, 2124).
2. Jervis, *Dictionary of Design and Designers* (1984): 72.
3. Schroder, *The Gilbert Collection* (1988): 338–41, no. 90.
4. Christie's, London, Hope Heirlooms sale, 17 July 1917,
lots 50, 51.
5. Two others are the Gilbert Collection, see note 3 above,
and the Victoria and Albert Museum, see Hartop, *Royal
Goldsmiths* (2005): no. 10.

MC

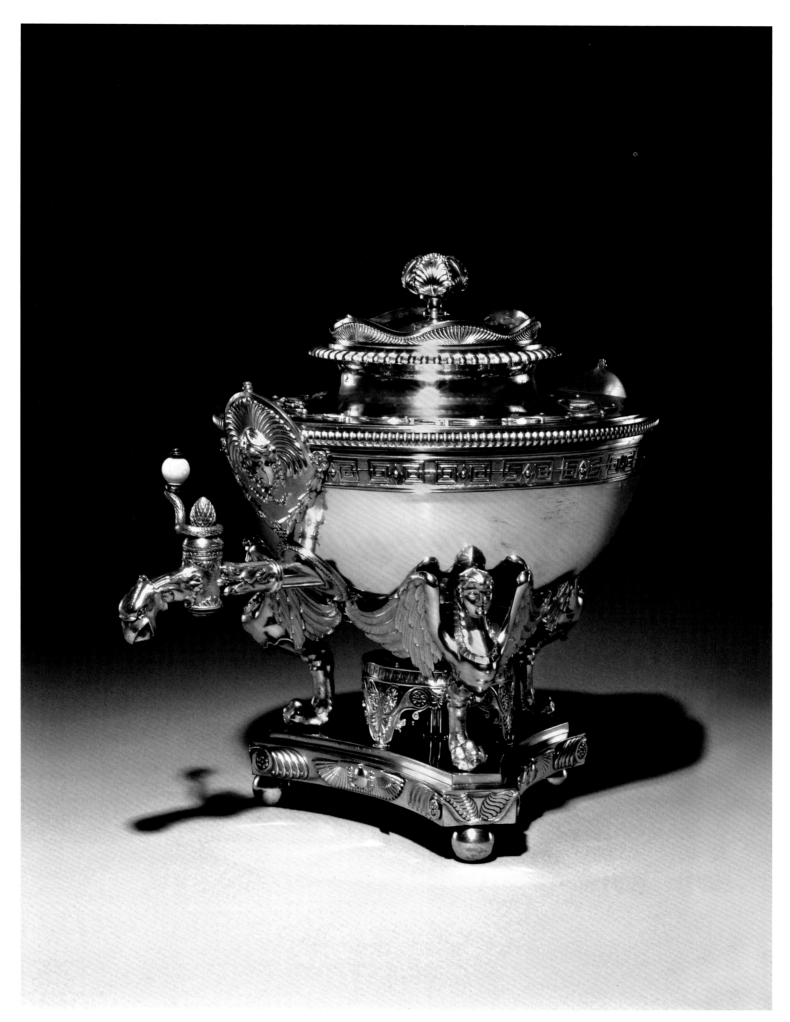

103. *Pair of Tazze*

English, London, 1808–9
Paul Storr, silversmith, probably for Rundell, Bridge
and Rundell, retailing gold and silversmiths
Silver gilt
9½ in. diam. (24 cm)
Marks: Arms of Hope, London marks for 1808/9, PS
for Paul Storr, silversmith
Private collection
Not in exhibition

PROVENANCE: Presumably Thomas Hope; by descent,
Lord Henry Francis Hope Pelham-Clinton-Hope;
Christie's, London, 17 July 1917, lot 56[1]; bought by
Willson for £76.13; [...]; private collection; anonymous
sale, Christie's, London, 4 February 1946, lot 29; sale,
Sotheby's, London, 15 October 1970, lot 84.

LITERATURE: Penze, *Paul Storr* (1954); Brett, *Sotheby's
Directory of Silver* (1986): 252, no. 1133.

Made subsequently to the furnishing of
Duchess Street and the publication of
Household Furniture in 1807, this pair of
circular stands nevertheless continues the
"archaeological" taste promoted by Hope.
It follows the panther tripod form already
found in the designs of *Household Furniture*,
in plate xv, number 1 (see fig. 69-1), and
plate II, and realized in the pair of mahogany
tripod tables (cat. no. 75), a form that must
derive from antique models, including a
marble tripod in Hope's own collection
(cat. no. 48) and the antique tripod in the
Vatican published by Tatham in *Etchings…*
of 1800 and drawn by him in 1795.[2]

1. "A pair of circular tazze, of classical design, sup-
ported by caryatid figures of lions, on triangular bases"
by Paul Storr, 1808–9, 9½ in. diam., 127 oz. 15.
2. "Tatham and Italy" (2002): 66, fig. 6.

MC

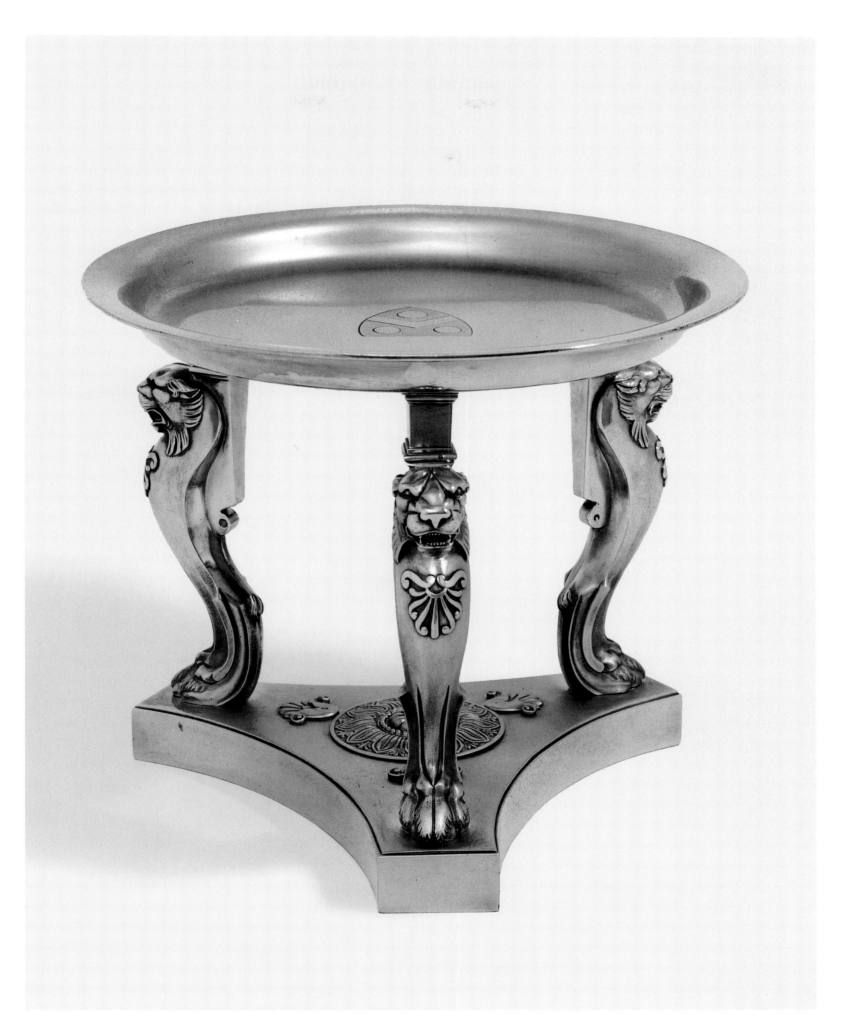

104. *Tea and Coffee Service*

John Bridge, probably for Rundell, Bridge and Rundell,
retailing gold and silversmiths
English, London, marks for 1828–29
Silver gilt, ivory
Coffee pot: 12 in. (30.4 cm)
Marks: John Bridge, London marks for 1828–89, on
bases and covers
Private collection

PROVENANCE: Thomas Hope; by descent, Lord Francis
Hope Pelham-Clinton-Hope; Christie's, London,
17 July 1917, lots 47, 48; bought by Willson for £27.19.2;
Richard Minoprio, his sale, Sotheby's, London, 20 June
1974, lot 114; Christie's, London, 11 June 2003, lot 32.

LITERATURE: Clayton, *The Collector's Dictionary of
Silver and Gold* (1985), fig. 657; Brett, *The Sotheby's
Dictionary of Silver* (1986): no. 1165; *The Glory of the
Goldsmith* (1989): no. 157, p. 204; Lomax, *British Silver
at Temple Newsam* (1992): 150; Hartop, *Royal Goldsmiths*
(2005): 133, fig. 130, cat. no. 59.

This tea and coffee service is engraved with
the arms of Hope impaling Beresford, for
Thomas Hope and his wife, Louisa, fifth
daughter of William de la Poer Beresford,
1st Lord Decies, whom he married in 1806.
It comprises a coffeepot on a stand with a
lamp, an ivory-handled teapot on a stand, a
sugar basin, and a creamer. The sides of the
coffee- and teapots are chased with panels
depicting Poseidon riding a chariot and
Amphitrite astride a seahorse, mythological
rulers of the sea who were appropriate
emblems of England's naval might.[1] This
patriotic allusion, common enough in Run-
dell's magnificent silver made in the years
prior to and following Waterloo, does not
seem to be part of the general program for
Hope's silver, although he had also
acquired a pair of wine coolers with panels
of the same subjects made the previous
year.[2] More appealing to Hope perhaps was

the association with the sculptor John Flax-
man, who probably modeled the panels.
Flaxman who supplied designs to the gold-
smith Rundell from 1805 had also been one
of Hope's favorite artists (see Chapter 8)
since the 1790s.

It is interesting to see in this silver serv-
ice how Hope has subscribed to the more
modified classicism of the 1820s. Although
the forms are still derived from classical
precedents found in such details as the
snake handles, the massive monopodia feet
on the coffeepot stand, and the large
anthemion ornament on the teapot stand,
shapes have become softer and the details
more broadly drawn than the silver of the
early years of the century.

1. Hartop, *Royal Goldsmiths* (2005): 133, fig. 130, cat. 59.
2. Christie's, London, Hope Heirlooms sale, 17 July
1917, lot 49.

MC

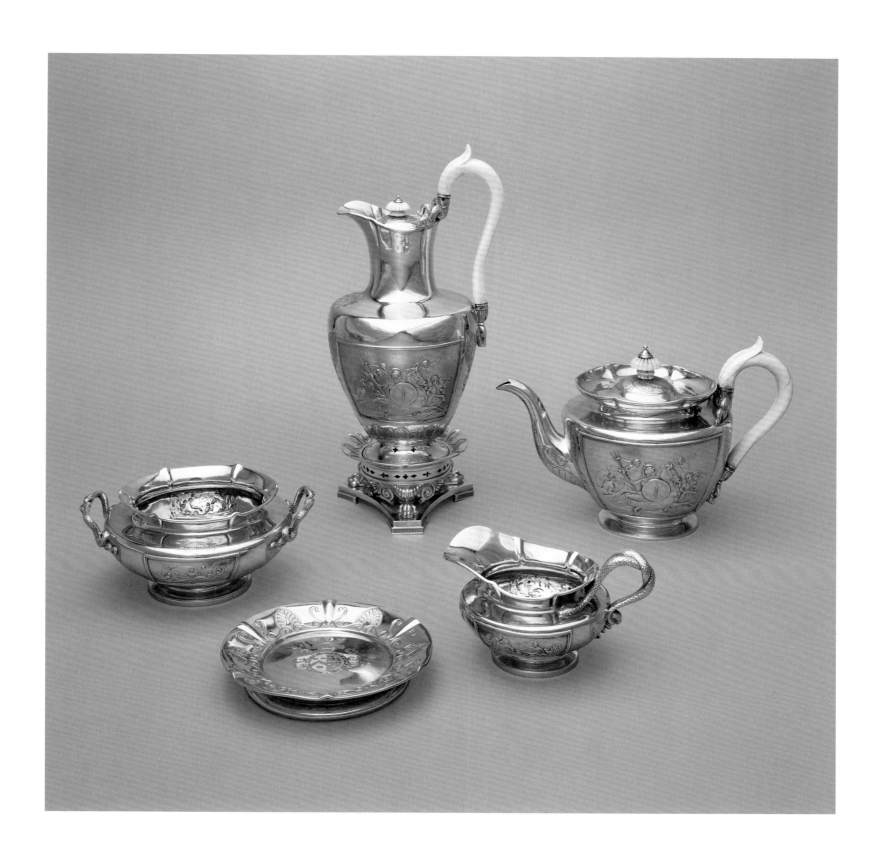

The Deepdene

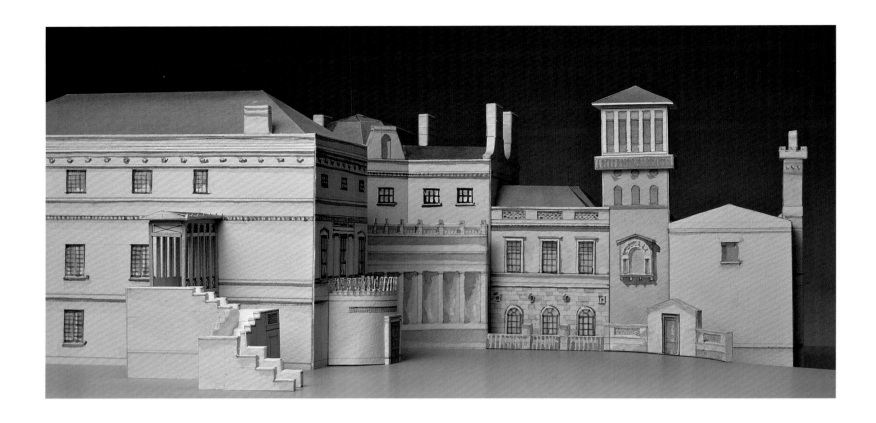

105. *Model of the Deepdene*

Jonathan Lacrosse, Miriam Zamona, and Thomas Gordon Smith

2003–5

Styrofoam board, watercolor paper, graphite and watercolor

8 x 34⅞ x 25 in. (20.3 x 88.6 x 63.5 cm); scale ⅛ in. to 1 foot

Thomas Gordon Smith

After a discussion with this writer, Thomas Gordon Smith, a professional architect and architectural historian, studied the plans and drawings of the Deepdene in the Minet Library and in the Hope Architectural Collection at Yale in order to produce an accurate model of the house as remodeled by Thomas Hope. One of the merits of the model is that it explains what is not clear from the charming watercolors made in the 1820s by W.H. Bartlett and Penry Williams to illustrate John Britton's history of the house. Evident in the model is the awkward junction between the symmetrical house built in 1769–75 from designs by William Gowan, a London surveyor, and the asymmetrical and Picturesque additions made by Thomas Hope in 1818–19 and in 1823 with William Atkinson as his executant architect. Bartlett and Williams had skated

over this problem, but we can now understand the house as a whole, including the complicated roof junctions that Hope's additions necessitated.

We can take in at a glance the lengthy panorama that extends from Hope's loggia-topped Italianate tower at one end of the composition to the no less inventive façade of his Theatre of Arts at the other end with its triangular-headed door and window openings. Moving from right to left we see the Pompeiian Gallery over an arch, a feature admired by C.R. Cockerell, which gave Mrs. Hope access to the gardens from her first-floor rooms, down a flight of steps. At the other end of this range, Hope unexpectedly turned Gothic as a prelude to the diagonally placed sequence of Conservatory and Sculpture Galleries.

DW

106. 21 Illustrations of the Deepdene

William Henry Bartlett and Penry Williams
From John Britton, "Illustrations of the Deepdene,
Seat of T. Hope Esqre., 1825–26"
Watercolor and pen and wash on paper
London Borough of Lambeth, Archives Department

PROVENANCE: Thomas Hope; by descent, Lord Francis
Hope Pelham-Clinton-Hope; sold Christie's, London,
25 July 1917, lot 199; sold Sotheby's, London, 26 May
1960; bought by Mr. Stanley Crowe, London bookseller,
who sold it to the Minet Library, London Borough of
Lambeth.

LITERATURE: Watkin, *Thomas Hope* (1968): passim;
Thornton, *Authentic Decor* (1984): 208–9, pls. 279, 280;
Girouard, *Life in the English Country House* (1984): 229,
pl. XXII; Waywell, *Lever and Hope Sculptures* (1986):
passim; Morley, *Regency Design* (1993): 49, 115–18, 242,
287, pl. V–VI, LV, 60, 62, 64, 219; Guilding, *Marble
Mania* (2001): 29, cat. no. 36.

1. William Henry Bartlett
"House from the Drying Grounds"
Watercolor

2. William Henry Bartlett
"Entrance Front"
Watercolor

3. William Henry Bartlett
"Dining-room Wing and Tower"
Watercolor

4. William Henry Bartlett
"Entrance Court, looking towards Tower"
Watercolor

5a. William Henry Bartlett
"The Stables, an old Oak"
Sepia and wash

5b. William Henry Bartlett
"Kitchen and Dairy"
Sepia and wash

6. William Henry Bartlett
"Terrace before the Drawing-Room"
Watercolor

7. William Henry Bartlett
"Gothic Wing and Loggia to Mrs. Hope's Apartments"
Sepia and wash

8. William Henry Bartlett
"Theatre of Arts, Conservatories, and Gothic Wing"
Watercolor

9. William Henry Bartlett and Penry Williams
"Steps to the Theatre of Arts"
Watercolor

10. Penry Williams
"Circular Conservatory"
Watercolor

11. Penry Williams
"Theatre of Arts"
Watercolor

12. William Henry Bartlett
"View from Theatre of Arts"
Watercolor

13. Penry Williams
"Statue Gallery"
Watercolor

14. Penry Williams
"Boudoir"
Watercolor

15. Penry Williams
"Library Chimney-piece"
Watercolor

16. Penry Williams
"View from the Long Conservatory"
Watercolor

17. William Henry Bartlett
"Entrance Lodge"
Sepia and wash

18. William Henry Bartlett
"Castellated Archway of Approach, West Side"
Sepia and wash

19. William Henry Bartlett
"Tower before the North-West Front"
Watercolor

20. William Henry Bartlett
"The Dene and Flower Gardens from the Terrace"
Watercolor

21. William Henry Bartlett
"Holm Wood and Distant Country from the Terrace"
Watercolor

Painted in 1825–26, these twenty-one
illustrations were early commissions in
the careers of two successful watercolor
painters, William Henry Bartlett and Penry
Williams (Theatre of Arts).[1] Bartlett, who
was responsible for all but five of these
beautiful images of the Deepdene, had
shown precocious talent as a boy and was
apprenticed at the age of fourteen to the
publisher and topographical writer John
Britton. Britton was responsible for the
uncompleted manuscript "History of the
Deepdene: The Union of the Picturesque
in Scenery and Architecture with Domestic
Beauties," for which the watercolors were
painted. He recorded in 1848 that it "was
not intended for publication,"[2] but he does
not tell us whether Hope commissioned
it or why it was not completed. Parts of
four of its six chapters were written, but
regrettably the one entitled "Description
of the Mansion and its Contents" was not
even begun.

Hope bought the Deepdene estate, near
Dorking, Surrey, in 1807 and remodeled the
Georgian house in 1818–19 and 1823. All
of the exterior views, painted soon after
the second remodeling, were by Bartlett,
and Williams painted five interior views as
well as the peacock in "Steps to the Amphi-
theatre." After painting these, Williams,
who had studied under Henry Fuseli at the
Royal Academy schools, settled in 1827 in
Rome, where he became known for his
romantic landscapes.

A bibliophile, antiquarian, and architec-
tural enthusiast, John Britton was a close
friend of John Soane, the first architect to
produce a monograph on his own house,
Pitzhanger Manor.[3] Soane subsequently
commissioned Britton to publish the first
history of his house and museum in Lincoln's
Inn Fields, with a text largely by W.H. Leeds.[4]
The title of this book, *The Union of Architec-
ture, Sculpture, and Painting,* echoes that of
Britton's proposed book on the Deepdene,
suggesting that the two books were seen as
demonstrating how the Picturesque could
be achieved in the country and in town.
Britton had already written a similar work

on Fonthill Abbey for William Beckford, a figure known well to both Hope and Soane.[5]

The watercolors of the Deepdene by Bartlett and Williams are virtually the only record of many of the most striking additions that Hope made to the house before it was completely rebuilt by his son in 1836–41 and demolished in 1968. These include the southwest wing with the Conservatory and Sculpture Galleries, as well as the interiors of which, sadly, there are very few: if only Williams had depicted the extravagant Egyptian Room and its contents, described with amazement by Maria Edgeworth in 1819!

These illustrations are a product of the rise of the Picturesque watercolor in eighteenth-century British architecture, a tradition that went back as early as the claim by John Vanbrugh in 1709 that, through judicious planting, the ancient Woodstock Manor in the park at Blenheim could be made to resemble "one of the most agreeable objects that the best of Landskip painters can invent."[6] This

reference to the relationship between real landscape and fictive buildings in paintings by Claude and Gaspard Dughet was far-sighted, for it became an influence on British architecture and landscape and on their representation in paintings and watercolors.[7] Even someone who had created an actual building now frequently translated it back into painted form before appreciating its full effect.

A parallel tradition was established by the production of watercolors of the interiors of private houses, the earliest of which included those commissioned by Horace Walpole from a number of topographical artists to illustrate his account of his own house, Strawberry Hill.[8] This practice subsequently flourished in watercolors and aquatints of interiors in numerous topographical publications, notably those of Rudolph Ackermann,[9] including *The Microcosm of London* (London, 1808–10), of William Henry Pyne in *The History of the Royal Residences* (1819),[10] and in John Britton's *Illustrations of the Deepdene*. The watercolors by artists commissioned by

such entrepreneurs as Pyne, Ackermann, and Britton, were, of course, Picturesque works of art in their own right.

1. Now at the Minet Library, Lambeth, these were sold in 1917. See *The Library from Deepdene, Dorking, Being a Portion of the Hope Heirlooms*, Christie's, London, 25 July 1917, lot 199: "A collection of about 35 Original Water-Colour drawings of Deepdene . . . painted chiefly by W.H. Bartlett under the direction of John Britton, with MS. Introduction by the latter, *morocco extra* (broken), 1825–26."
2. In an appendix to vol. 2 of *The Auto-Biography of John Britton* (1848).
3. *Plans, Elevations and Perspective Views of Pitzhanger Manor-House* (1802).
4. *The Union of Architecture, Sculpture, and Painting* (1827).
5. *Graphical and Literary Illustrations of Fonthill Abbey, Wiltshire* (1823).
6. *Complete Works of Sir John Vanbrugh*, vol. 4 (1928): 29–30.
7. Watkin, *The English Vision* (1982): chap. 5.
8. *Description of the Villa of Mr. Horace Walpole . . . at Strawberry-Hill* (1784; repr. 1964). See Smith, *Eighteenth-Century Decoration* (1993): 334–37.
9. See Samuels, "Rudolph Ackermann" (1974).
10. Watkin, *Royal Interiors of Regency England* (1984).

DW

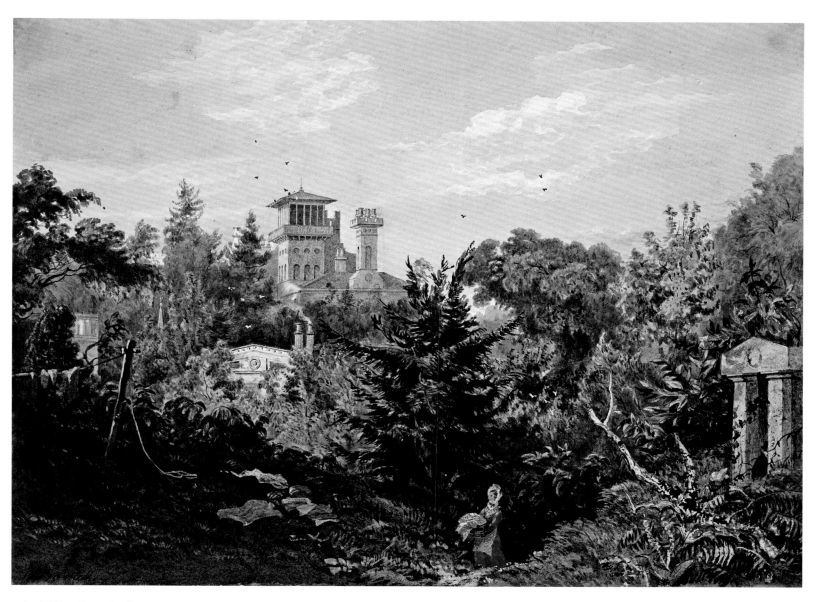

106.1. William Henry Bartlett
"House from the Drying Grounds"
Watercolor, 13 x 9½ in.

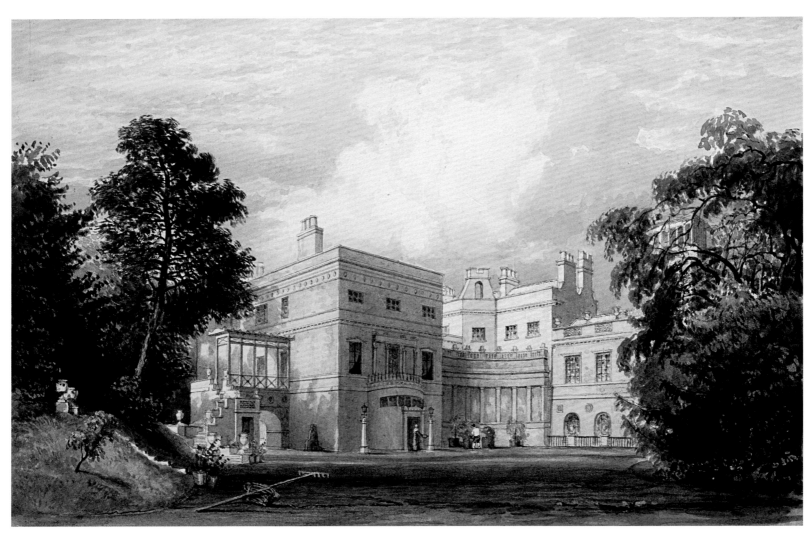

106.2. William Henry Bartlett
"Entrance Front"
Watercolor, 10 x 6½ in.

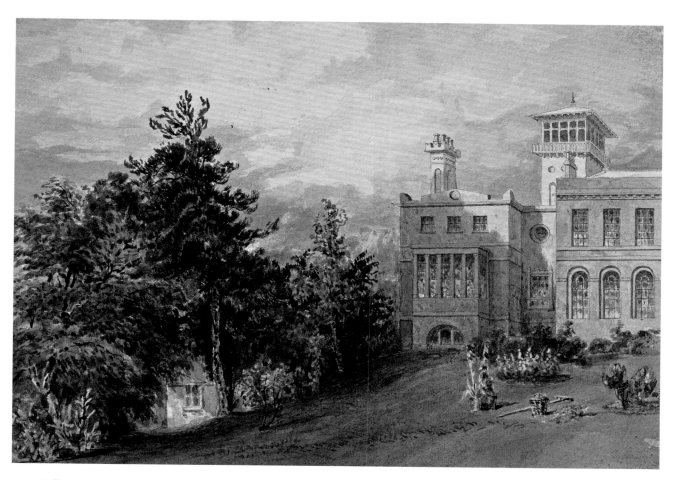

106.3. William Henry Bartlett
"Dining-room Wing and Tower"
Watercolor, 6¾ x 4⅞ in.

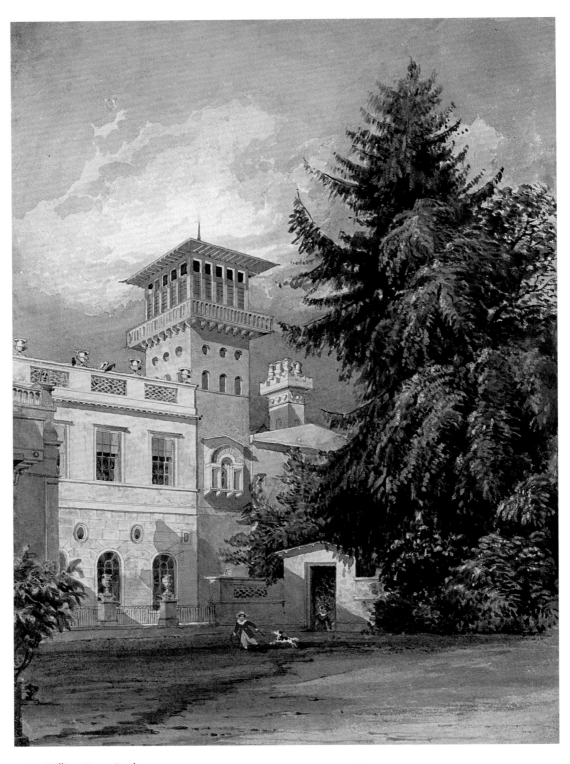

106.4. William Henry Bartlett
"Entrance Court, looking towards Tower"
Watercolor, 7⅛ x 4¾ in.

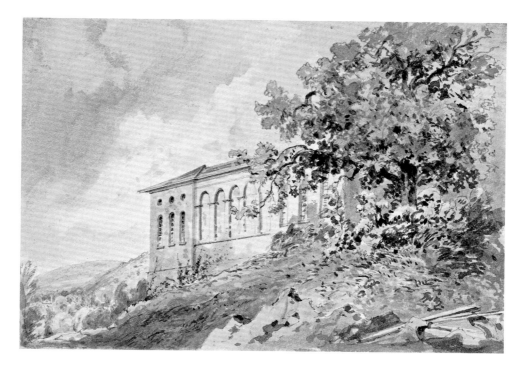

106.5a. William Henry Bartlett
"The Stables, an old Oak"
Sepia and wash

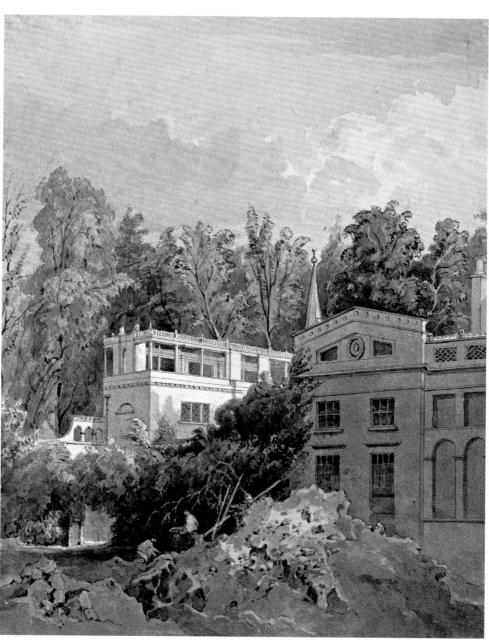

106.5b. William Henry Bartlett
"Kitchen and Dairy"
Sepia and wash, 7⅛ x 4¾ in.

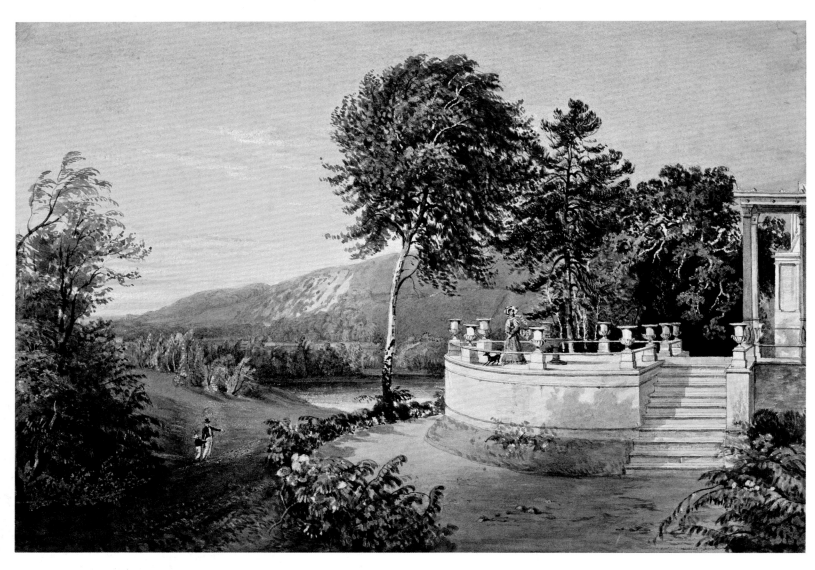

106.6. William Henry Bartlett
"Terrace before the Drawing-Room"
Watercolor, 11⅜ x 7¾ in.

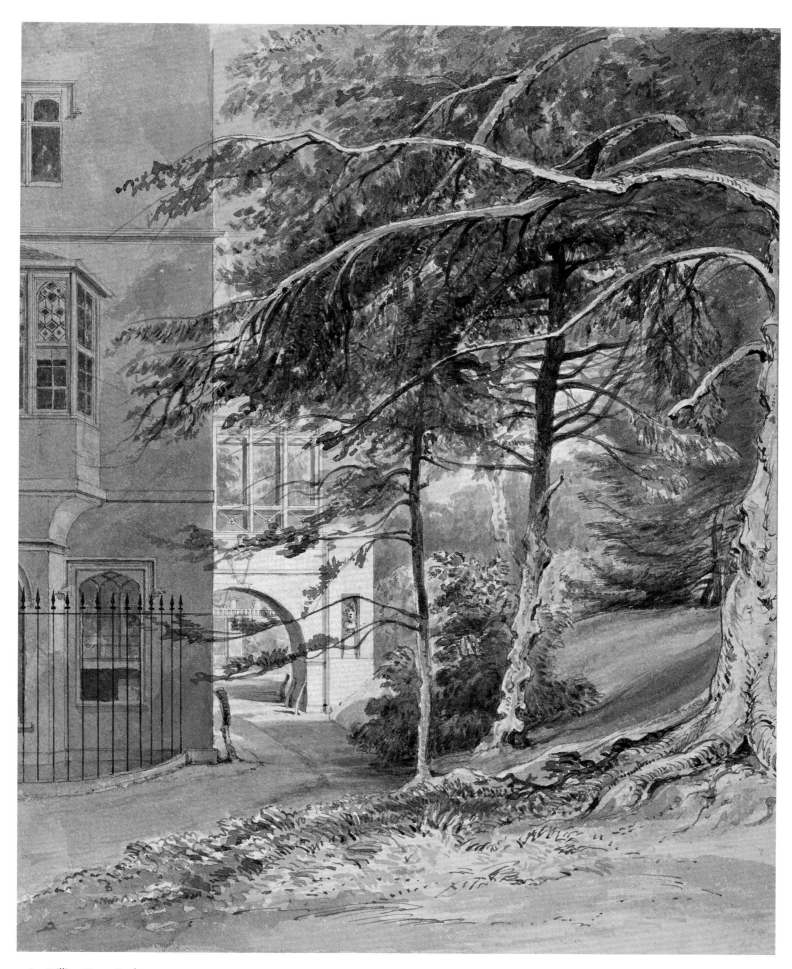

106.7. William Henry Bartlett
"Gothic Wing and Loggia to Mrs. Hope's Apartments"
Sepia and wash, 10 x 8¼ in.

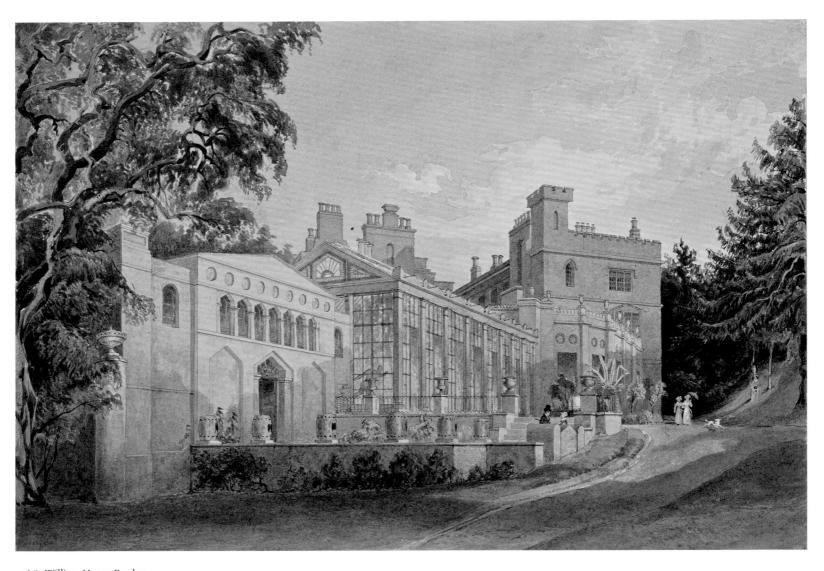

106.8. William Henry Bartlett
"Theatre of Arts, Conservatories, and Gothic Wing"
Watercolor, 13⅞ x 8⅛ in.

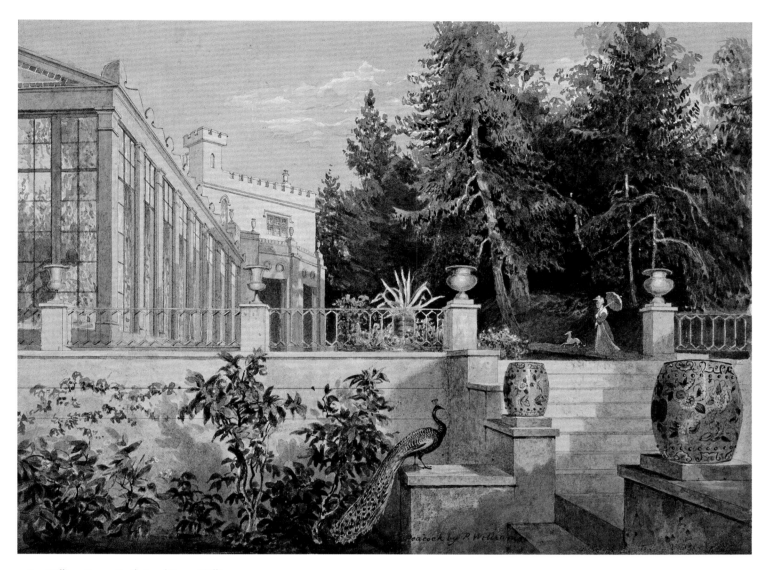

106.9. William Henry Bartlett and Penry Williams
"Steps to the Theatre of Arts"
Watercolor, 11 x 8⅛ in.

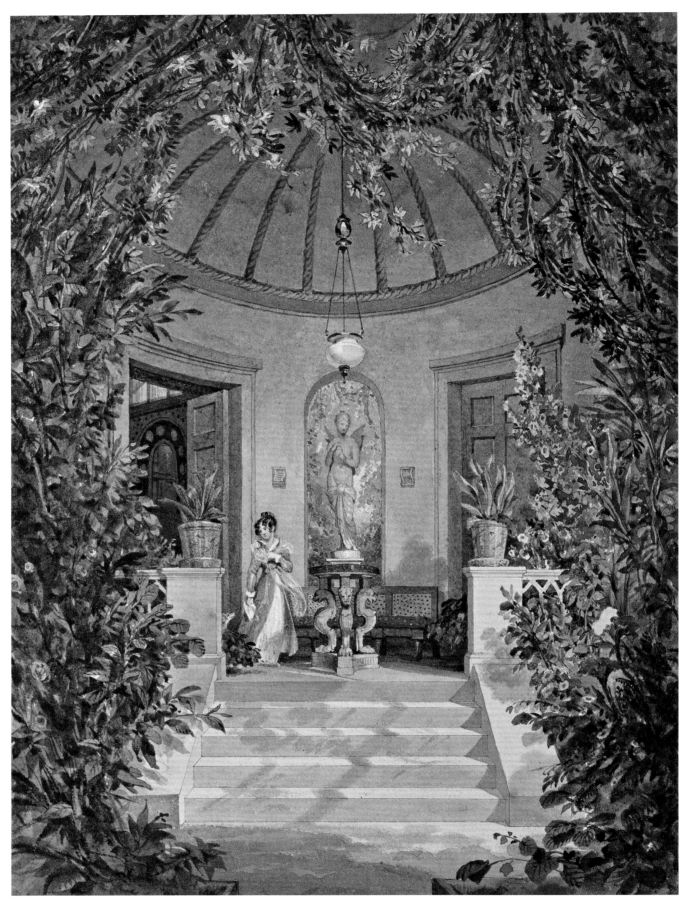

106.10. Penry Williams
"Circular Conservatory"
Watercolor, 9¼ x 7 in.

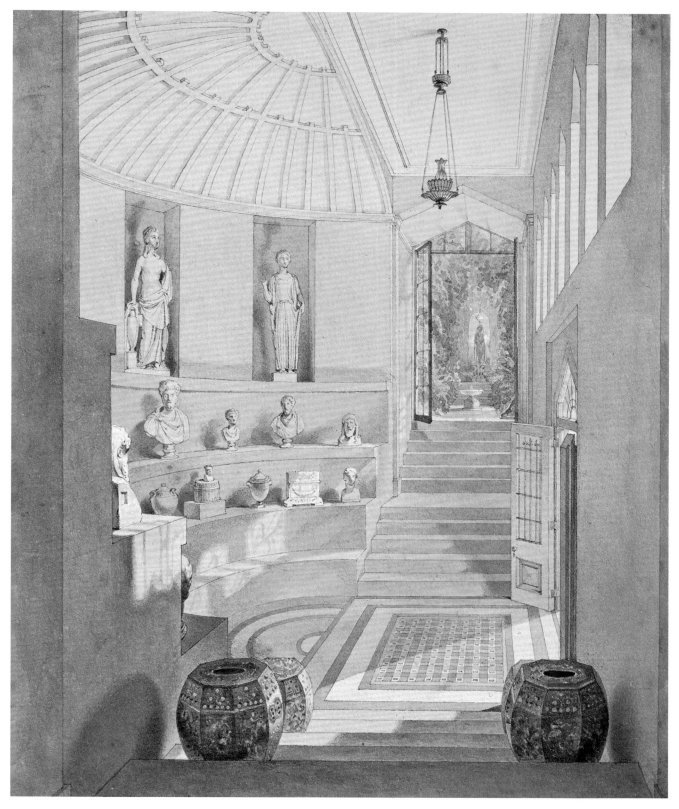

106.11. Penry Williams
"Theatre of Arts"
Watercolor, 8¼ x 7 in.

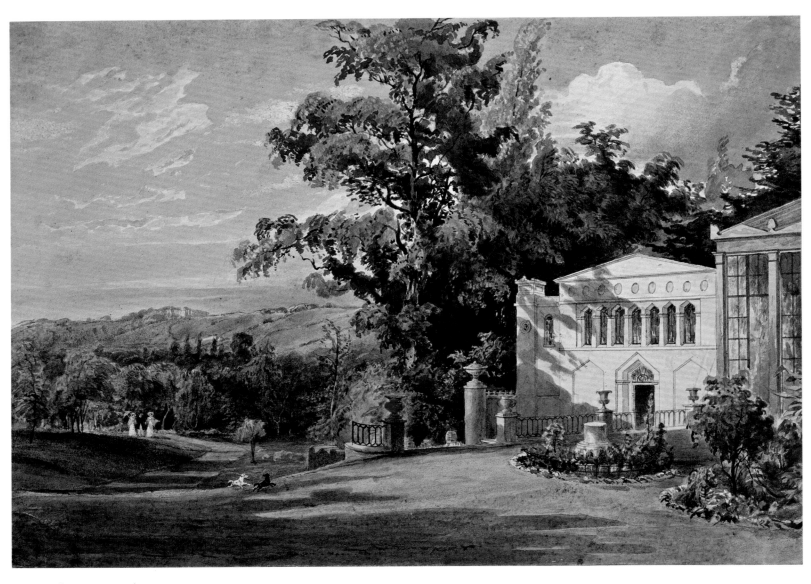

106.12. William Henry Bartlett
"View from Theatre of Arts"
Watercolor, 10¼ x 7½ in.

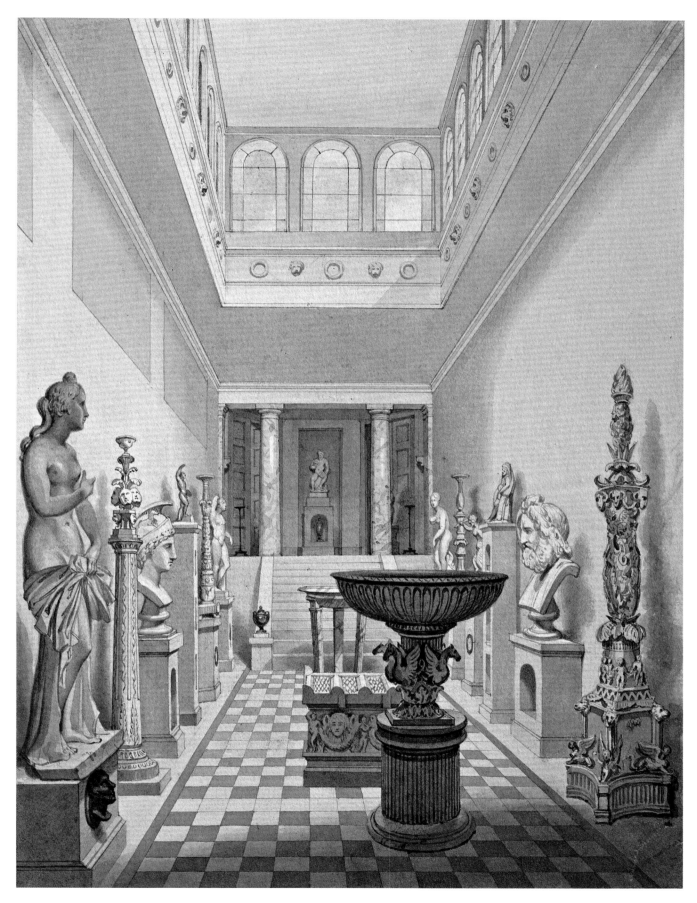

106.13. Penry Williams
"Statue Gallery"
Watercolor, 9⅛ x 7 in.

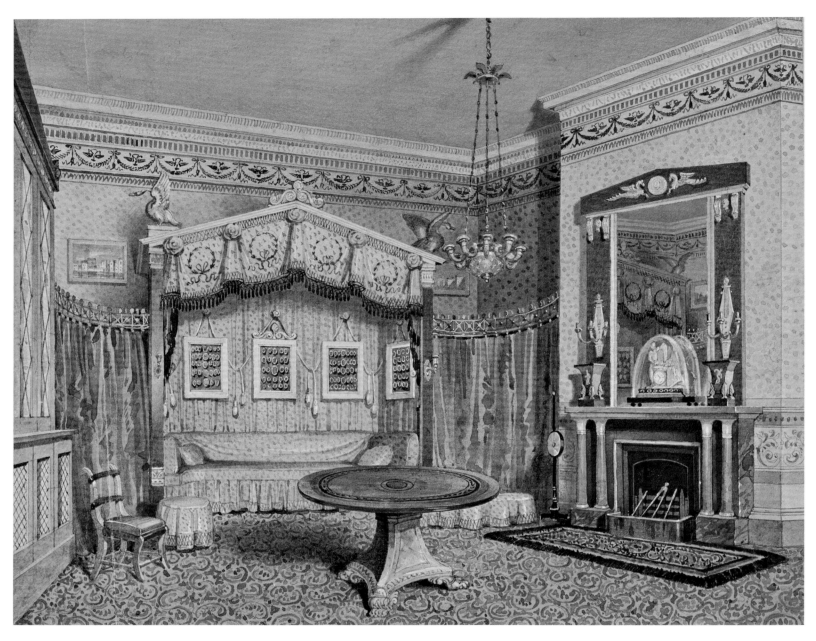

106.14. Penry Williams
"Boudoir"
Watercolor, 10⅞ x 7 in.

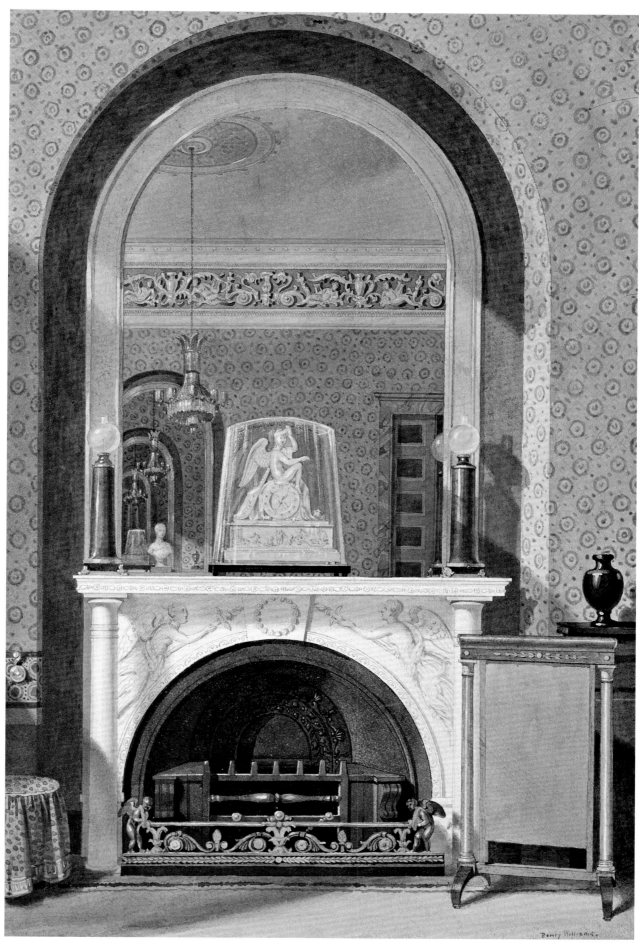

106.15. Penry Williams
"Library Chimney-piece"
Watercolor, 10⅞ x 7½ in.

106.16. Penry Williams
"View from the Long Conservatory"
Watercolor, 9⅜ x 6⅞ in.

106.17. William Henry Bartlett
"Entrance Lodge"
Sepia and wash, 7⅛ x 7½ in.

106.18. William Henry Bartlett
"Castellated Archway of Approach, West Side"
Sepia and wash, 9¼ x 6⅞ in.

106.19. William Henry Bartlett
"Tower before the North-West Front"
Watercolor, 8 x 6¼ in.

106.20. William Henry Bartlett
"The Dene and Flower Gardens from the Terrace"
Watercolor, 7⅛ x 6⅛ in.

106.21. William Henry Bartlett
"Holm Wood and Distant Country from the Terrace"
Watercolor, 13½ x 9⅜ in.

Books, Drawings, and Watercolors

107. *The Flemish Picture Gallery, the Mansion of Thomas Hope, Duchess Street, Portland Place*

Robert William Billings (1813–1874)
English, ca. 1830
Watercolor
23¼ x 32¾ in. (59.1 x 83.2 cm)
The Metropolitan Museum of Art, The Elisha Whittelsey Collection, The Elisha Whittelsey Fund, 1963, 63.617.2

PROVENANCE: Purchased from Stanley Crowe, London, by the Metropolitan Museum of Art, New York, in 1963.

LITERATURE: Watkin, *Thomas Hope* (1968): pl. 41.

This watercolor records the Flemish Picture Gallery designed by Thomas Hope with his executant architect, William Atkinson, a pupil of James Wyatt. Begun in 1819, the gallery was completed by 1822,[1] at which time Atkinson was already employed by Hope on alterations at the Deepdene.[2] The gallery was expressly built to house the collection of about one hundred paintings, mostly Dutch and Flemish, inherited by Hope's brother, Henry Philip, who loaned them to Hope. It is not known when Billings, a sculptor, bookseller, publisher, and restorer of churches, drew the new gallery, but it was most likely executed as a record of the interior before the demolition of Duchess Street in 1851; given that Billings was an accomplished illustrator, it could also have been intended for possible inclusion in a publication. It is assumed to be an accurate representation of how the gallery looked, particularly so as some of the paintings and furnishings are identifiable. The watercolor is identical to an engraving of the gallery entitled "Mansion of Thomas Hope, Esq." and described as "a Flemish picture gallery . . . a long and lofty picture gallery" to the north "extending round three sides of the court" with the Statue Gallery and Vase Rooms on the first floor of Duchess Street. The sharp definition of the engraving enables a better reading of the details of the paintings and other contents of the

gallery.[3] A later description of the gallery and contents appeared in the *Art-Union*, an account that also listed some pictures belonging to Hope's son Henry Thomas.[4]

From the age of thirteen, Billings was apprenticed to John Britton, an antiquarian, connoisseur, and friend of Thomas Hope and adviser to Sir John Soane for his collection. Billings was one of many illustrators who worked with Britton, and he was vastly important for his contribution to the recording of architectural antiquities. His circle included Joseph Michael Gandy and W. H. Bartlett, both of whose work was featured in Hope's collection. Billings was in contact with John Constable in 1832–33, possibly with the intention of helping him improve his engravings for *English Landscape Scenery*, the first number of which was published in 1830.[5] Billings illustrated architectural publications and worked as a topographical illustrator for Britton until 1833. From 1838 he published his own volumes on churches and cathedrals, such as those on Carlisle (1840) and Durham (1843). Among other architectural works published by Billings, four volumes of *The Baronial and Ecclesiastical Antiquities of Scotland* (1845–52) are highly regarded and contain 240 splendid and evocative illustrations with text. This publication was the first record of its kind of Scottish medieval and Renaissance architecture.[6] Billings exhibited architectural designs at the Royal Academy from 1845 until 1872, including interiors, exteriors, a warehouse, and Scottish country houses. He concentrated on his architectural practice from 1852 and completed restoration work at Edinburgh Castle, Stirling Castle, and various country houses, including the baronial mansion Castle Wemyss, Renfrewshire (now demolished).

Billings was said to have plagiarized the work of the architect and civil engineer Edward Cresy and was accused of doing so by him. Cresy published *An Analytical Index to An Historical Essay on Architecture by the late Thomas Hope* in 1836 as part of a series entitled The Library of the Fine Arts.[7] This followed the posthumous publication of Hope's two-volume essay, first published in 1835. Edited by his son Henry Thomas, the book contained twelve engravings of Hope's

drawings executed during his Grand Tour in Italy and Germany, possibly in 1812.[8] The sketchbook contains a plan of a gallery at Lansdowne House in London, "with green house along side," which was designed by George Dance from 1788 to 1791.

1. It was described by Westmacott, *British Galleries* (1824): 230–40.
2. For further assessment of the work done by Atkinson at the Deepdene, see Garnier, "Alexander Roos" (2005): 11–68.
3. Another engraving shows sections of the gallery, the elevations of the end, and long walls, see Britton and Pugin, *Illustrations of the Public Buildings of London* (1825): 1, pls. 2, 3.
4. *Art-Union* 8 (1 April 1846): 97–98.
5. See Beckett, *John Constable* (1975): 163.
6. A copy was in the Deepdene library sale, *Catalogue of the valuable library of books on architecture, costume, sculpture, antiquities, etc., formed by Thomas Hope, Esq.*, sale cat., Christie, Manson & Woods, London, 25 July 1917, lot 84.
7. See Burfield, *Edward Cresy* (2003): 81. I am indebted to Hermione Hobhouse for drawing my attention to this volume.
8. See David Watkin and Jill Lever, "A Sketchbook by Thomas Hope," *Architectural History* 23 (1980): 52–59.

JC

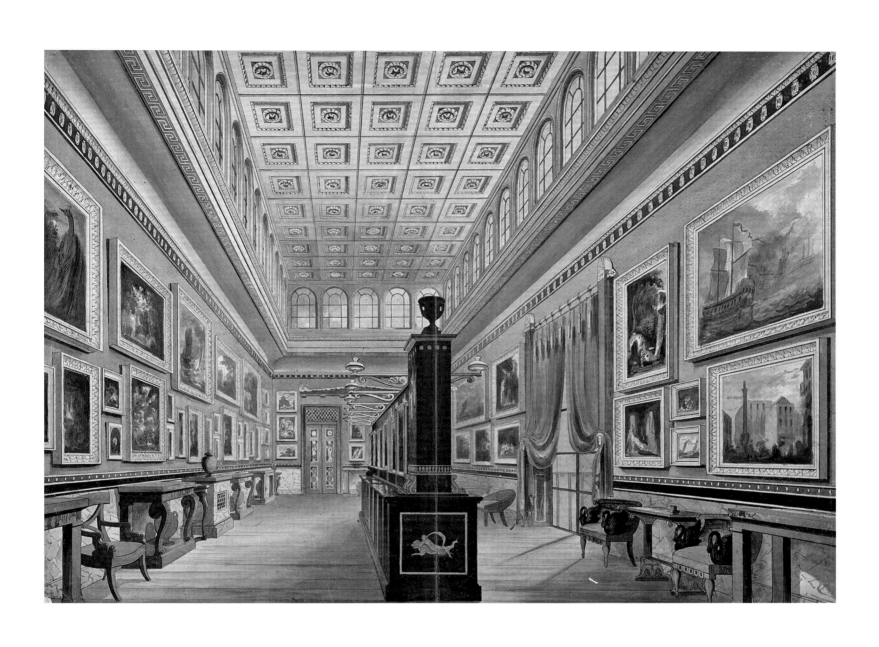

108. *Anastasius, or, Memoirs of a Greek, 3 volumes*

Thomas Hope
London: John Murray, 1819
Hubert de Lisle

PROVENANCE: [Thomas Hope]; by descent, Henrietta Hope, Lady Haversham; by descent, joint heirs Mildred Astley Smith and Ambrose de Lisle; by descent, Hubert de Lisle.

This romantic novel by Thomas Hope caused something of a sensation when it was first published anonymously in 1819, and for a while it was thought to be the work of Lord Byron. Hope's authorship was not revealed until the slightly revised third edition appeared in 1820, although even then Hope's name did not appear on the title page but at the end of a preface, signed from Duchess Street. He explained there that his aim in describing the Ottoman Empire was that of "adding . . . to the information, respecting the ever interesting region once adorned by the Greeks"; that the plot was merely "a fictitious superstructure"; and that "the form of biographical memoirs" was "adopted solely with the view of affording greater facility for the introduction of minute and characteristic details." Hope later claimed that during his Ottoman Grand Tour he had resided in every place "which I have attempted to describe minutely in *Anastasius*."[1] The novel was often regarded as travel writing of the kind that is still so popular today.

The first edition, of 750 copies, was promoted by John Murray as "the first 3-decker novel at a guinea-and-a-half." The second and third editions, which appeared in 1820, both ran to 1,250 copies; the latter edition included a map. In 1827 the fourth edition, now in two volumes, ran to 750 copies. After Hope's death, there were further editions, in 1831, 1836, and 1849, including a volume in the Murray's Standard Novels series and in a two-volume set with three engravings by W. Cawse. An edition appeared in New York in 1820, along with fourteen pages of footnotes explaining some of the terms used, and again in 1831 and 1832. The novel was published in Paris in 1820, 1844, and 1847, and in 1821 it appeared in German and Flemish translations.[2] A facsimile of the Baudry Foreign Library edition of 1931 appeared in the series of Elibron Classics paperbacks during 2001. It may be said to have become Hope's most widely read work.

ANASTASIUS,

OR,

MEMOIRS OF A GREEK;

WRITTEN AT THE CLOSE OF

THE EIGHTEENTH CENTURY.

BY THOMAS HOPE, ESQ.

IN THREE VOLUMES.
VOL. I.

FOURTH EDITION.

LONDON:
JOHN MURRAY, ALBEMARLE-STREET.
MDCCCXXVII.

1. In a letter of 9 October 1821, *Blackwood's Edinburgh Magazine* 10 (October 1821): 212.
2. For bibliographical details of some of the editions of *Anastasius*, see Baumgarten, *Le crépuscule* (1958): 260–61.

JN, DW

476

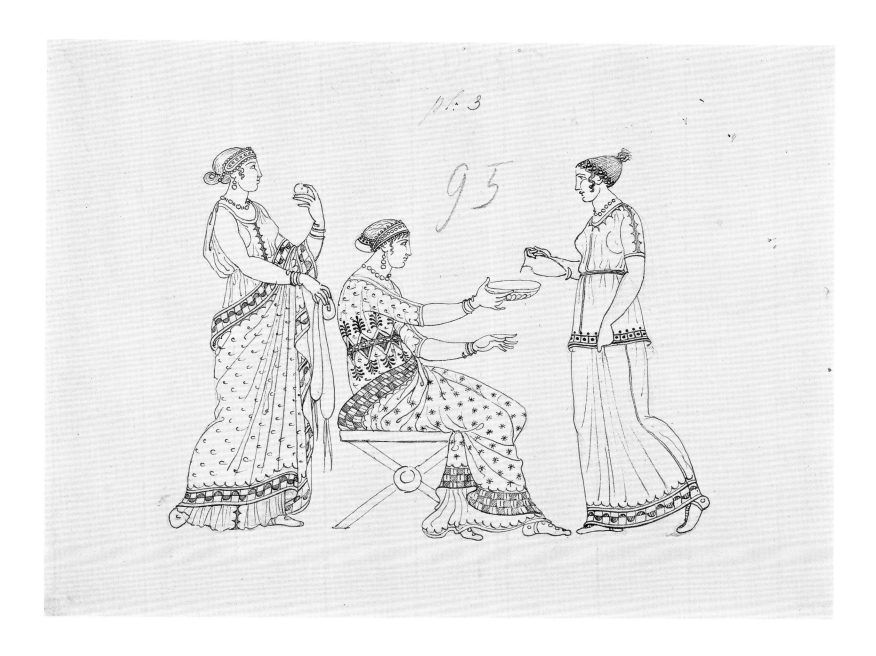

109. *"Outlines for My Costume"*

Thomas Hope
Pen and pencil, and pencil and sepia drawings
Approximately 6 x 10 in. (15 x 25 cm), pasted on heavier
paper in a volume bound in tan leather measuring
9½ x 11½ in. (24 x 29 cm)
The Gennadius Library, American School of Classical
Studies at Athens

PROVENANCE: Thomas Hope; by descent, Lord Francis Hope Pelham-Clinton-Hope; sold Christie's, London, 25–27 July 1917, lot 315; bought in; sold Batsford's ca. 1930; John Gennadius; bequeathed to Gennadius Library, Athens.

This is one of two volumes[1] in the Gennadius Library containing preliminary drawings for *Costume of the Ancients* by Thomas Hope. The volume on exhibition has ninety-seven drawings, mainly of ancient Greek and Roman costume and objects, along with some examples of Egyptian, Assyrian, and Etruscan clothing. The "Outlines" deals mainly with full-length costumed figures, but there are also drawings of hairstyles, footwear, armor and weapons, furniture, and more. Most of the drawings are briefly identified. Some drawings have additional sketches on the same page, such as pattern and ornament, but on the whole they relate closely to the images in *Costume of the Ancients* and demonstrate Hope's interest in both line and decoration.

1. It has been suggested by Frances Van Keuren (personal communication) that the second volume of drawings (Arch 1047.3) may not be by Hope. I am grateful to Professor Van Keuren for sharing her thoughts on this point, for her help in discussing the "Outlines" with me, and for sending me copies of her two articles on Hope: "Thomas Hope" (2005–6) and "Thomas Hope's *Costume of the Ancients*" (forthcoming).

AR

110. *Costume of the Ancients*

Thomas Hope
London: William Miller, 1809
5⅛ x 9¾ in (14.7 x 24.4 cm)
Hubert de Lisle

PROVENANCE: [Thomas Hope]; by descent, Henrietta Hope, Lady Haversham; by descent, joint heirs Mildred Astley Smith and Ambrose de Lisle; by descent, Hubert de Lisle.

The first edition of *Costume of the Ancients* appeared in 1809, in two volumes containing two hundred plates, mostly engraved by Henry Moses.[1] In 1812 a considerably expanded edition with one hundred extra plates, mainly by Moses, came out from the same publisher, also in two volumes; the introductory text was slightly rewritten. As Hope explained in the introduction, his main aim was to remedy what he saw as a lack of knowledge of ancient costume, both for the educated person and, more specifically, for the stage and for artists who needed visual information in order to depict "the sublimer scenes of history and mythology."[2]

It was Hope's belief that examples of classical Greek and Roman art offered the artist "the happiest mixture of beautiful naked forms with grand features of attire and armour."[3] Dress was not to be seen in isolation but as an integral part of ancient civilization as a whole. In *Costume of the Ancients*, which also included fashionable, military,[4] and official dress, Hope decided to illustrate such items as pontifical insignia, chariots, furniture, musical instruments, lamps, vases, architectural orders, decorative patterns, sarcophagi, and so on. In this he was helped by having a fairly extensive library of costume books,[5] as well as by using his own large "assemblage . . . of Grecian fictile vases" and "several curious specimens of ancient art not hitherto published."[6] Most of the plates in *Costume of the Ancients* are of full-length Greek and Roman figures, especially the "Grecian females" and bacchantes that decorated many of his vases. To Hope, the dress of ancient Greece[7] was both innovative and graceful, and that of women in particular claimed resonance with

contemporary fashion, especially as seen in Moses's elegant engravings.

The overall effect is decorative rather than informative regarding the details of dress, not helped (except in aesthetic terms) by Hope's decision to make many of his plates composite, "frequently combining in a single figure . . . articles collected from many different originals."[8]

For this reason, the sources for the illustrations in *Costume of the Ancients* are either not listed or are mentioned in the most general terms. Where the sources can be identified, Hope "regularly enriched the ornaments on costumes, and altered the style of his prototypes."[9] This obviously raises questions about the accuracy of Hope as a historian (see Chapter 5), but in all fairness Hope admitted that he was not a classical scholar and that his main aim was to advance knowledge of Greek and Roman costume as part of fashionable taste and style.[10] The drawings in the "Outlines" and the engravings in *Costume of the Ancients* create lively images of the lines of classical dress with a heightened, almost theatrical sense of antiquity, which is perhaps more successful than either overly antiquarian zeal or the largely meaningless draperies of many contemporary artists.

Hope's pioneering book (at least in an English context) was widely admired and used. Beau Brummell's *Male and Female Costume* borrowed both text and plates from *Costume of the Ancients*. A further edition of Hope's work was published in 1841, ten years after his death, with an additional "twenty-one engravings of marbles and antiques collected by the late Thos. Hope, Esq., and now preserved either in the gallery at Deepdene, or in London."

1. Hope noted that Moses "has engraved the greatest number of my drawings"; Thomas Hope, *Costume of the Ancients*, vol. 1 (1809): 53. Two other engravers involved were "F. Burnett" and "R. Roffe." I have been able to find nothing about Burnett and little about Roffe, except that according to Bénézit he was "actif à Londres entre 1806 et 1835" (Bénézit, *Dictionnaire critique et documentaire* [1999]).
2. Hope, *Costume of the Ancients*, vol. 1 (1812): x.
3. Ibid., vii.
4. Hope seems to have been particularly interested in military costume, especially admiring "the variety and the magnificence" of Roman military insignia; ibid., 45.

The existence of a pair of painted and gilt helmets (cat. no. 99) taken from *Costume of the Ancients* (pl. 5: "Phrygian helmets, bow, bipennis quiver, tunic, axe and javelin") suggests that objects other than furniture might have been inspired by Hope's work.
5. "Valuable library of books on architecture, costume, sculpture, antiquities, etc., formed by Thomas Hope, Esq.," sold at auction by Christie, Manson & Woods, London, 25–27 July 25 1917. Hope's books on ancient costume included such well-known works as the comte de Caylus's *Recueil d'Antiquités Egyptiennes, Etrusques, Grecques et Romaines* (1752–57), A. Lens's *Le Costume des Peuples de l'Antiquité* (1785), N. X. Willemin's *Choix de Costumes Civils et Militaires des Peuples de l'Antiquité* (1798–1802), and J. Malliot's *Recherches sur les costumes, les moeurs, les usages réligieux, civils et militaires des Anciens Peuples* (the 1809 edition). I am grateful to David Watkin for sending me his copy of the sale catalogue.
6. Hope, *Costume of the Ancients*, vol. 1 (1809): ix.
7. Compare, for example, with Malliot's *Recherches sur les costumes* (1804), where the emphasis is on Roman dress, a suitable inspiration for French military prowess, and the classically inspired coronation of Napoléon in December 1804. Hope owned the second edition of Malliot's work (see note 5), which influenced a number of his plates of Roman dress, furniture, chariots, and so on. At least one example of a direct copy from Malliot can be found in Hope's plate "Poops & prows of Roman gallies" (*Costume of the Ancients* [1812]: pl. 280), which is taken from Malliot (*Recherches sur les costumes*, vol. 1 [1804]: LXXXI). Roman costume (with the possible exception of the toga) is generally easier to understand and to "read" in art; it is therefore not surprising that in *Costume of the Ancients*, Hope's account of the clothing of ancient Rome is clearer and more accurate than the more complex dress of ancient Greece.
8. Hope, *Costume of the Ancients*, vol. 1 (1812): xii.
9. See Frances Van Keuren's article (forthcoming) in *The Magazine Antiques* on Thomas Hope's *Costume of the Ancients*.
10. Hope, *Costume of the Ancients*, vol. 1 (1809): 10.

AR

COSTUME

OF

THE ANCIENTS.

———

BY

THOMAS HOPE.

———

LONDON:

PRINTED FOR WILLIAM MILLER,
ALBEMARLE-STREET,
BY W. BULMER AND CO. CLEVELAND-ROW,
ST. JAMES'S.
1809.

111. *Designs of Modern Costume, &c.*

Engraved by Henry Moses (English, ca. 1782– 1870)
London: Henry Setchell & Sons [1811–12?]
6½ x 8¼ in. (16.5 x 21 cm)
Stephen Calloway, London

112. *A Series of Twenty-nine Designs of Modern Costume*

Engraved by Henry Moses (English, ca. 1782– 1870)
London: James Appleton, Queen's Row, Halworth, n.d.
(dated in pencil 1823)
8½ x 7⅞ in. closed; 8½ x 15¾ in. open (21.5 x 19.5 cm;
21.5 x 40 cm)
Stephen Calloway, London

In all probability, Hope's serious engagement with costume, ancient and modern, began in 1806 following his marriage to Louisa Beresford, who took a considerable interest in fashionable dress. It seems likely that the success of *Costume of the Ancients* inspired Hope to commission Henry Moses "to prepare drawings of modern costume in contemporary settings such as the ballroom at Duchess Street, and to depict in them the furniture, vases etc in the Hope collection"[1]; the result was *Designs of Modern Costume* (1812), which was published with twenty plates. Moses may in fact have been preparing these plates at the same time as those for *Costume of the Ancients*, since an extant impression of one of the nine "fancy pieces" from the latter book is dated on the plate 1808. In 1823, a new edition of

Designs was published under the title *A Series of Twenty-nine Designs of Modern Costume*, which contained the twenty plates of the 1812 edition, although in a different order, and nine additional plates of various classical and literary subjects not specifically related to costume.

Henry Moses was an engraver with a particular interest in classical art and design[2]; his Flaxman-like linear style was in harmony with the neoclassical aesthetic popularized by Hope and affected most of the applied arts, including dress and interior design. Although we know little about Moses, it seems clear that there was a mutual respect between artist and patron. Hope's obituary in *The Gentleman's Magazine* made a specific reference to Moses as being "that eminent master in that style," i.e., "figures

engraved in outline."[3] And Moses's *Collection of antique vases, altars, paterae, tripods, candelabra, sarcophagi &c, from various museums and collections* (1814), with 170 plates, was dedicated to Thomas Hope.

Moses's *Designs of Modern Costume* depict fashionable families and friends in domestic interiors and larger groups in society playing cards, drinking tea, and making music, or at the theater and in the ballroom. The men wear conventional formal clothing—double-breasted coat and knee-breeches—but the women's dress appears more "classical" in harmony with the surroundings, Hope's own classically inspired décor and furnishings. Moses's concentration on women here—presumably at the behest of his patron—may have some didactic purpose, perhaps to encour-

age a purer taste in dress *à l'antique* than was the case in England, in contrast to France, where political ideology linked to an interest in classical culture had ensured the greater impact of the style.

Thus, there is a clear influence of *Costume of the Ancients* here, both in the details of dress—a similar use of decorative "antique" borders, the elaborate plaited and knotted hairstyles often arranged beneath stiff fillets or tiaras—and in the loose over-bodices (a misinterpretation of the overfold of the ancient Greek peplos). Yet the aesthetic of contemporary fashion cannot be ignored, and most of the women wear very high-waisted dresses of white muslin[4] with short sleeves, following the sense of the dress in vogue in the first decade of the nineteenth century but adding more overtly "classical"

details. In short, Moses depicts an idealized and more "uniform" dress in the classical taste, which Hope no doubt wished that fashionable women would adopt. In 1812 (the date of *Designs of Modern Costume*), this might have been possible, but it was no longer so by 1823, when the enlarged edition appeared and when there was a growing trend toward more complex female costume, often with "historical" features.

1. Nevinson, Introduction, *Designs of Modern Costume 1812* (1973): 1–2. Nevinson speculates that Hope might have "had the book privately printed . . . [to give] away to his friends or to the selected visitors who were permitted to visit the Duchess Street house." David Watkin points out that "half of the twenty plates of 1812 contain furniture derived from this source [i.e. Duchess Street], and three of the nine plates added in 1823" (Watkin, *Thomas Hope* [1968]: 221). Two copies of bound sets of the 20 plates survive; the location of

one is unknown; the other is in the collection of Stephen Calloway.

2. Moses was employed as one of the engravers attached to the British Museum; among his Publications resulting from this work was *Select Greek and Roman Antiquities from Vases, Gems and other Subjects* (1817).

3. *The Gentleman's Magazine* 101, no. 1, April 1831: 369.

4. White muslin was, according to both native and foreign commentators, the preferred choice of English-women from the late 18th century onward. See, for example, Goede, *Memorials of Nature and Art* (1808): 59.

AR

113. *Household Furniture and Interior Decoration*

Thomas Hope
Red morocco binding with an anthemion border and Hope's arms in the center
London: Longman, Hurst, Rees & Orme, 1807
Museu Calouste Gulbenkian, Lisbon

PROVENANCE: Thomas Hope; by descent, Lord Francis Hope Pelham-Clinton-Hope; his sale, sold Christie's, 25–27 July 1917, lot 401; bought by Kevorkian for £7; Calouste Gulbenkian; Museu Calouste Gulbenkian, Lisbon.

In this book of startling originality, a wealthy Dutchman, still only in his thirties, had the supreme self-confidence to challenge the English to reform their taste by publishing as a guide for them the interiors of his London mansion, together with drawings of their furnishings, which he provided with measurements to facilitate their imitation.[1] Obsessed by the heady romance of classical vocabulary, Hope sought to create a meaningful language that would re-create for modern purposes what he called "that prodigious variety of details and of embellishments, which, under the various characters and denominations of imitative and of symbolic personages, of attributes and of insignia of gods and of men, of instruments and of trophies, of terms, caryatides, griffins, chimaeras, scenic masks, sacrificial implements, civil and military emblems, &c. once gave to every piece of Grecian and Roman furniture so much grace, variety, movement, expression, and physiognomy."[2]

What is astonishing is that Hope's endeavor to influence taste in this direction was so successful that someone as intelligent as the antiquarian and publisher John Britton could claim in 1827, exactly twenty years after the publication of Hope's manifesto, that "To Mr. Hope we are indebted, in an eminent degree, for the classical and appropriate style, which now generally characterizes our furniture and ornamental utensils. . . . *Household Furniture and Interior Decoration* has not only improved the taste of cabinet-makers and upholsterers, but

also that of their employers."[3] This statement was made in the prestigious book on John Soane's house and museum, which Britton published at the request of Soane, who was a close friend.

Hope had been influenced, as he explained, by the plates of "décorations intérieures" published from 1801 by Napoléon's architects Percier and Fontaine. Hope followed their example by giving measurements of the pieces of furniture and, more significantly, by adopting their newly fashionable technique of outline engravings that he commissioned from Edmund Aikin and George Dawe. Hope was aware that this deprived the representations of the interiors and furnishings of "the strong contrast of the light and of the shaded parts . . . the harmonious blending, or the gay opposition of the various colours," but he explained that to have provided the book with colored and shaded illustrations would have led to an "enhancing of its price to such a degree as must have defeated its principal purpose."[4] In other words, it would have put the volume beyond the pockets of the designers and craftsmen he was anxious to influence. As a concession to popular taste, some of his furniture and perhaps some of the interiors at Duchess Street appeared in plates engraved for him by Henry Moses in *Designs of Modern Costume* (1812), reprinted with additional plates as *A Series of Twenty-nine Designs of Modern Costume* (1823).

Hope's *Household Furniture and Interior Decoration* was a lavish and unusual publication, with a title page incorporating novel sans-serif lettering and a Turkish border, both of which are described and explained in Chapter 3. A nineteen-page introduction is followed by sixty plates of outline engravings of which eight depict whole interiors, the remainder being chimneypieces, doors, furniture, and household objects of which many, but far from all, were designed by Hope himself. The book concludes, unusually, with a valuable bibliography.

The objects illustrated by Hope were imitated in influential publications by furniture designers, such as George Smith in his *Collection of Designs for Household Furniture and Interior Decoration* (1808); Richard

Brown in *The Rudiments of Drawing Cabinet and Upholstery Furniture* (1822), where he cited Hope, Percier, and Smith as influences; and Peter and Michael Angelo Nicholson in *The Practical Cabinet Maker, Upholsterer and Complete Decorator* (1826). Henry Moses dedicated to Hope a book entitled *A Collection of Vases, Altars, Paterae, Tripods, candelabra, sarcophagi &c, from various museums and collections* (1814), in which he provided examples of Greek ornament and decoration for the benefit of designers of furniture and interiors.[5]

1. For this copy, see *The Library from Deepdene, Dorking being a Portion of the Hope Heirlooms*, Christie's, London, 26 July 1917, lot 401.
2. Hope, *Household Furniture* (1807): 9.
3. Britton, *The Union of Architecture, Sculpture and Painting* (1827): 22–23.
4. Ibid., 15.
5. Interest in Hope's *Household Furniture* by designers, collectors, and curators led to the publication of a facsimile of it, though without the text, in 1937 (London: Tiranti); this was reprinted in 1946 and again in 1970 with an introduction by Clifford Musgrave. A facsimile with Hope's text and an introduction by David Watkin was published in 1971 (New York: Dover Publications).

DW

114. *Observations on the Plans and Elevations designed by James Wyatt, Architect, for Downing College, Cambridge; in a Letter to Francis Annesley, Esq., M.P.*

Thomas Hope
London: D. N. Shury, 1804
Hubert de Lisle

PROVENANCE: [Thomas Hope]; by descent, Henrietta Hope, Lady Haversham; by descent, joint heirs Mildred Astley Smith and Ambrose de Lisle; by descent, Hubert de Lisle.

Hope was responsible for a great controversy in Cambridge in 1804 with the publication of his pamphlet condemning in the strongest terms the designs for Downing College by James Wyatt, who had occupied since 1796 the important royal office of Surveyor General and Comptroller of the Office of Works. The controversy also had repercussions in London where in the same year, 1804, Hope had offended some members of the Royal Academy by issuing tickets of admission to view his house in Duchess Street. Furthermore, Wyatt was a prominent member of the Royal Academy, which elected him president in 1805.

Wyatt's designs for the college, made many years earlier in an old-fashioned Palladian manner, were easy prey for the well-informed but waspish pen of Hope, who sought an up-to-date design in the purest Grecian style, which was quite beyond Wyatt's knowledge and skills. Hope confessed that in Wyatt's designs he was unable to find "one striking feature, one eminent beauty. Neither elevations nor sections display a single instance of fancy, a single spark of genius, to make up for their many faults. Everything alike in them is trite, common place, nay, often vulgar."[1] In short, Hope wished that, "instead of the degraded architecture of the Romans, the purest style of the Greeks had been exclusively adhibited."[2]

With his extensive travels and study of architecture, Hope was also in a position in *Observations* to point as a model for Downing College sources unknown to Wyatt, such as the pioneering Brandenburg Gate in Berlin, built in 1789–93 from designs by Carl Gotthard Langhans along the lines of the Propylaea on the Acropolis in Athens. Hope also referred to the young scholar architect, William Wilkins, who had just returned to Cambridge from a three-year tour of Greece, Asia Minor, and Italy, bringing with him, as Hope pointed out, "designs of a Greek temple," which he intended to publish. Wilkins had as yet built nothing, but, largely as a result of Hope's support, he won the commission for the new college that rose from his novel Grecian designs in 1807–20.[3]

OBSERVATIONS

ON THE

PLANS AND ELEVATIONS

DESIGNED BY

JAMES WYATT,

ARCHITECT,

FOR

DOWNING COLLEGE,

𝕮𝖆𝖒𝖇𝖗𝖎𝖉𝖌𝖊;

IN A LETTER TO

FRANCIS ANNESLEY, ESQ. M.P.

BY

THOMAS HOPE.

———————

PRINTED BY D. N. SHURY, BERWICK STREET, SOHO, LONDON.

◆

1804.

Hope's study of animals and of biological science, which was to culminate in his *Essay on the Origin and Prospects of Man* (1831), was presaged in his description of Grecian Doric in *Observations* as "a body in its youth and vigor, full of sap and substance; with limbs marked by rare, but striking divisions"; he contrasted this with Roman Doric which was "a body in deep decline, where bones, joints, tendons, cartilages, and muscles, arteries and veins, destroy at every inch the smoothness of the surface."[4]

It is possible that Hope was invited to intervene at Downing College by some of the Cambridge scholars now known as the Cambridge Hellenists, in particular the Professor of Medicine at Downing, Sir Busick Harwood, a Fellow of the Society of Antiquaries. However, to publish so forceful an attack on designs for a Cambridge college by the favorite architect of King George III, Hope can only have been prompted by a passionate adherence to the architectural standards he believed were right. He was ahead of contemporary taste, for a decade later, when a new building program began in England after the Napoleonic Wars, most public buildings were to be in the pure and dignified Greek Revival style that Hope had advocated so forcefully.

1. Hope, *Observations on the Plans and Elevations designed by James Wyatt, Architect* (1803): 33.
2. Ibid., 16.
3. See Sicca, *Committed to Classicism* (1987).
4. Hope, *Observations* (1803): 19.

DW

115. *An Essay on the Origin and Prospects of Man*

Thomas Hope
London, 1831
Hubert de Lisle

PROVENANCE: [Thomas Hope]; by descent, Henrietta Hope, Lady Haversham; by descent, joint heirs Mildred Astley Smith and Ambrose de Lisle; by descent, Hubert de Lisle.

Because Thomas Hope's papers have been lost, there is little surviving evidence to help us relate his imposing philosophical essay to the development of his mind and experience during his career. His major three-volume philosophical work, published shortly after his death (one volume exhibited), thus comes as something of a surprise to us, and perhaps not a very welcome one to his family who, according to tradition, tried to suppress it. Its influence was necessarily extremely limited, because only 229 copies of it were ever sold.[1]

We know that during 1830, the last full year of Hope's life, much of his time was taken up in the preparation of the book. By the end of this labor, he was in a weak condition, fell seriously ill in January 1831, and died on February 2. We cannot know whether he might have made the book clearer and more comprehensible with more time and better health. As Roger Scruton complains in Chapter 14 of this volume, some sentences in the book in its present form ramble on for more than two thousand words before reaching their main verb.

In the arts, Hope's firm neoclassical position led him to argue that symmetry and meter had an intrinsic appeal to rational beings, so that they actually formed the basis of decoration, music, poetry, and dance. Similarly, as a child of the Enlightenment rather than of the Romantic movement, he was influenced by such writers as Hobbes, Locke, and the Founding Fathers of the American Constitution. He was writing at a time when he was faced with significant developments in the natural sciences as well as the eighteenth-century rationalist attack on Christianity. The complicated political critic and social philosopher, Thomas Carlyle, had to deal with the same issues, to which he added moral condemnation of the condition of the poor. Becoming a leading concern in the nineteenth century, this had the potential for destabilizing society. It is thus interesting that one of the few notices the *Essay* has ever received, apart from Scruton's, is that by Carlyle, who condemned Hope as a materialist in the *Edinburgh Review* in 1831. In accordance with Hope's wishes, a copy of the book was sent after his death to

AN

ESSAY

ON

THE ORIGIN AND PROSPECTS

OF

MAN.

BY THOMAS HOPE.

IN THREE VOLUMES.

VOL. I.

LONDON:
JOHN MURRAY, ALBEMARLE STREET.
1831

Robert Southey, Poet Laureate from 1813, although we know that he would not have welcomed Hope's departure from Christianity in his doctrine of immortality without individuality.

It is a striking indication of Hope's scientific interests that he was elected in 1805 to the Royal Institution, which had been founded in 1799 by the American-born scientist and statesman Benjamin Thompson, Count Rumford. The aim of the Royal Institution was to promote the study and advancement of science, particularly in the hope of harnessing it to improve the lives of ordinary people. Under its distinguished successive directors, Sir Humphry Davy and Michael Faraday, it became known for the public lectures held on its premises in Albemarle Street, London, on natural history, chemistry, and geology, as well as on the arts.[2]

Scruton notes that, with his wide reading in science and philosophy and his serious study of plants and animals, Hope's book was "remarkable as an early attempt to found a philosophy of man in biological science and to found biology in the laws of physics." With all its complexities, the work nonetheless serves to increase our respect for Hope as a scholar with a highly original mind that ranged over vast areas of knowledge and thought.

1. See Chapter 14 in this volume.
2. See Thomas, *Michael Faraday and the Royal Institution* (1991).

DW

116. *An Historical Essay on Architecture by the Late Thomas Hope. Illustrated from Drawings Made by Him in Italy and Germany*

Thomas Hope
London: John Murray, 1835
Hubert de Lisle

PROVENANCE: [Thomas Hope]; by descent, Henrietta Hope, Lady Haversham; by descent, joint heirs Mildred Astley Smith and Ambrose de Lisle; by descent, Hubert de Lisle.

Hope's two posthumously published books, *Essay on the Origin and Prospects of Man* and *An Historical Essay on Architecture*, are both a great surprise, the former because of its weird construct of biological science, the latter because half of its text and most of its ninety-seven illustrations are devoted to Romanesque buildings, mainly in Italy and the Rhineland, with a small number devoted to Gothic. Of its 561 pages, less than thirty are devoted to Greek architecture, of which he had previously been so powerful an advocate, but now he failed to grasp the implications of the recent discoveries of the role that polychromy had played in it.

Hope's *Historical Essay on Architecture* was published in 1835 (one volume exhibited), four years after his death, by his eldest son, Henry Thomas Hope, who apologized that the book had defects because it "has not had the advantage of revision or reconstruction by the Author."[1] Nonetheless, since he explained that the text and illustrations "were intended for publication . . . in a shape similar to the present," we must probably accept that the book, with its curious balance of subject matter, represented Thomas Hope's intentions.

Essentially a continental figure, an outsider, in the generally insular world of London society, Hope naturally wrote from a European perspective. His writings benefited from his unique world view, so that his *Historical Essay on Architecture* is one of the first histories of architecture in English to include Asia Minor, Egypt, and Greece, and the first to discuss building traditions in India, Russia, and China. Topics include Early Christian, Moorish, and Byzantine architecture, the use of brick and marble, and the origins of the pointed arch.[2]

Compiling the work in the years toward 1830, Hope was also aware of how ideas about what contemporary architecture should be had moved on considerably from those current in the world of the eighteenth-century Grand Tour world in which he had been brought up. He recognized the growing sympathy with Gothic architecture, particularly in its constructional aspects, studying the writings of English antiquarians such as John Milner and of continental scholars, including Séroux d'Agincourt and Carl Friedrich von Wiebeking. A deist rather than a conventional Christian, Hope found that the identification of Gothic with Christianity made it unsuitable as a solution to the problems facing nineteenth-century architects. Nonetheless, he wrote perceptively of its construction, observing it was "like carcasses of vertebral animals, those various parts necessary for the general substance and stay of the body—the bones, and ribs, and spine, were moulded into long slight masses, distant from each other, and left between them intervals filled up by yielding flesh and thin integuments."[3]

Although he still followed eighteenth-century writers such as Winckelmann in considering Roman architecture as debased, Renaissance as imitation, and Baroque as over-decorated, Hope's independent mind led him to anticipate the new emphasis, particularly in Germany, on Byzantine and Romanesque as preferable to Gothic. The architect Heinrich Hübsch, in his book *In welchem Style sollen wir bauen?* (1828),[4] promoted the round-arched style, known as Rundbogenstil, which appealed to many as a compromise between antiquity and the Middle Ages. The plates in Hope's *Historical Essay on Architecture* were shortly to provide architects with many helpful models of such work.

The *Historical Essay on Architecture* was probably the most widely read of Hope's books during the course of the nineteenth

AN

HISTORICAL ESSAY

ON

ARCHITECTURE.

BY

THE LATE THOMAS HOPE.

ILLUSTRATED FROM

DRAWINGS MADE BY HIM IN ITALY AND GERMANY.

———————

LONDON:
JOHN MURRAY, ALBEMARLE STREET.
MDCCCXXXV.

century, its encyclopedic yet eclectic approach anticipating such works as *The Grammar of Ornament: Illustrated by Examples from Various Styles of Ornament* (1856) by Owen Jones. French and Italian translations of Hope's book were published between 1839 and 1856; its illustrations harmonized with the Rundbogenstil of the 1830s and 1840s, especially in the work of the architects Leo von Klenze and Friedrich von Gärtner; it was discussed by Gottfried Semper in Germany, Daniel Ramée in France, and John Claudius Loudon, Edward Freeman, and John Ruskin in England.

1. Hope, *Historical Essay on Architecture* (1835): xi.
2. See Stephens, "In Search of the Pointed Arch" (1996): 133–58.
3. Ibid., 349–50.
4. Herrmann, *In What Style Should We Build?* (1992).

DW

117. *Etchings, representing the Best Examples of Grecian and Roman Architectural Ornament drawn from the Originals, and chiefly collected in Italy, before the late Revolutions in that Country*

Charles Heathcote Tatham (1772–1842)
London: Priestley and Weale, 1826 (fourth edition)
19 x 11⅘ x 1½ in. (48.2 x 30.1 x 3.2 cm)
Courtesy of the Trustees of The Victoria and Albert Museum, London, 52E93

Charles Heathcote Tatham published his first book in 1799/1800.[1] Based on objects of which many had been excavated at Pompeii, Herculaneum, Tivoli, and Rome, the book enjoyed great success, which led to a second edition in 1803 and a third in 1810, while a German translation was published in Weimar in 1810. In 1806 Tatham published a similar work,[2] which was republished together with his first book in 1826 in the single volume catalogued here.[3]

The books owed their origin to the mission on which Henry Holland sent his draftsman, Tatham, to Rome in 1794 to collect antique decorative fragments and make drawings of them for use in architectural and furniture design.[4] Published by Tatham as etchings, these included candelabra, friezes, chairs, altar pedestals, tripods, urns, tazze, and vases. As well as being an architect, Tatham was an able designer of neo-antique ornamental metalwork. He also had a significant relation with leading cabinetmakers, notably his brother, Thomas, and John Linnell. Catching the mood of the moment, his books exercised great influence on Regency designers, not least on Thomas Hope himself. For example, Tatham had adopted the novel outline technique of illustration in 1799 before Hope's *Household Furniture* was published in 1807. Pioneered by Wilhelm Tischbein in 1791–95 in his engravings of Greek vases in the collection of Sir William Hamilton, this method was immediately taken up by John Flaxman and by Percier and Fontaine, while Hope was to acquire many of Hamilton's vases in 1801.

Given the importance of Tatham to Hope, including acting as architect at Duchess Street, it is surprising that Hope did not include his books in the bibliography of *Household Furniture*, even though he had subscribed to the first edition of Tatham's *Etchings of Ancient Ornamental Architecture*. The sale of the library at the Deepdene in 1917 also included the second edition of this work as well as Tatham's *Etchings representing Fragments of Grecian and Roman Architectural Ornaments* (1806), *Designs for Ornamental Plate* (1806), and his monographs of 1811 on his galleries at Castle Howard and Brocklesby.[5] The last two were illustrated with elegant engravings

ETCHINGS,

REPRESENTING THE BEST EXAMPLES

OF

ANCIENT ORNAMENTAL

ARCHITECTURE;

DRAWN FROM THE ORIGINALS

IN

 # ROME,

AND OTHER PARTS OF ITALY,

DURING THE YEARS 1794, 1795, AND 1796.

THIRD EDITION.

By CHARLES HEATHCOTE TATHAM, ARCHITECT;

MEMBER OF THE ACADEMY OF SAINT LUKE AT ROME,
AND OF THE INSTITUTE AT BOLOGNA.

ERAT AUTEM ANTIQUITÙS INSTITUTUM, UT A MAJORIBUS NATU, NON AURIBUS MODO,
VERUM ETIAM OCULIS DISCEREMUS, QUÆ FACIENDA MOX IPSI, AC PER VICES
QUASDAM TRADENDA MINORIBUS, HABEREMUS.

PLIN. EPIST. XIV. LIB. VIII.

LONDON:

PRINTED FOR THOMAS GARDINER, BOOKSELLER, PRINCES - STREET, CAVENDISH SQUARE,

BY JOHN BARFIELD, WARDOUR - STREET,

PRINTER TO HIS ROYAL HIGHNESS THE PRINCE OF WALES.

MDCCCX.

by Henry Moses, whom Hope employed for his *Designs of Modern Costume* (1812).

Twenty-one years before the discovery of Tatham's drawings for Duchess Street in 2003, John Harris observed perceptively of Tatham that "his technique was emulated and his published works plagiarised by Thomas Hope in his *Household Furniture* of 1807, and knowing of Tatham's possible association with Charles Percier, the *Recueil de décorations intérieures* by Percier and Fontaine in 1812 may well owe much to Tatham's examples."[6] One hitherto ignored example of the anticipation by Tatham of striking features of interiors at Duchess Street is his design, dated "Rome July 1795," for a chimneypiece surmounted by three marble busts "copied from the antique."[7] He supplied Holland with individual prices for the chimneypiece and all its decorative elements, but its novel disposition was adopted by Hope for the dining room chimneypiece at Duchess Street. Even more significantly, Tatham's centrally placed bust of Euripides has the severe frontal pose of the Greeks, rather than being angled in the manner of Roman and later sculptors. Hope followed the same practice in the neo-Greek bust of his brother Henry Philip, which he commissioned from Flaxman in 1803 for the central position on his own chimneypiece, stressing the antique precedent in *Household Furniture*.[8]

1. *Etchings of Ancient Ornamental Architecture* (1799–1800).
2. *Etchings representing Fragments of Grecian and Roman Architectural Ornaments* (1806).
3. For full publishing details of Tatham's books, see *British Architectural Library*, vol. 4, S–Z (2001): 2058–65.
4. See Pearce and Salmon, "Charles Heathcote Tatham" (2005): 1–91.
5. *The Library from Deepdene, Dorking, Being a Portion of the Hope Heirlooms*, sale cat., Christie's, London, 27 July 1917, lot 624.
6. Harris, "Precedents and Various Designs Collected by C. H. Tatham" (1982): 63, n.3.
7. Pearce and Salmon, "Charles Heathcote Tatham" (2005): fig. 49.
8. Hope, *Household Furniture* (1809): 46.

DW

118. *Recueil de décorations intérieures, comprenant tout ce qui a rapport à l'ameublement … composé par C. Percier et P.F.L. Fontaine, éxecuté sur leurs dessins*

Charles Percier (1764–1838) and Pierre-François Fontaine (1762–1853)
Paris: Didot, 1812
17⅞ x 12⅖ x 1⅖ in. closed (45.5 x 31.5 x 3.5 cm)
Courtesy of the Trustees of The Victoria and Albert Museum, London, 57P24

The plates in this work by Napoléon's architects, Charles Percier and Pierre-François Fontaine, were first published in 1800/1801 in twelve parts, each containing six plates.[1] They were reissued more than once, on one occasion in a colored edition, before receiving their final form with a letterpress in 1812. This edition influenced the design of furniture and interiors in Europe and North America throughout the nineteenth century and was translated into Italian in 1843 and German in 1900. The engravings depicted work that Percier and Fontaine had carried out in lavish private houses and in imperial palaces for Napoléon, notably at the Louvre, the Tuileries, and Malmaison.

The appearance and title of Hope's book *Household Furniture and Interior Decoration* (1807), as well as his designs, were influenced by Percier and Fontaine's *Recueil de décorations intérieures*, which he alluded to indirectly in the introduction to his book as "that publication which at present appears at Paris on a similar subject, directed by an artist of my acquaintance, Percier."[2] Hope regretted, however, that his own book "could not, under all the existing circumstances . . . [be] a work at all comparable, in point of elegance of designs and of excellence of execution" with the French publication. Nonetheless, he chose not to include this first edition of the *Recueil*[3] in the bibliography to *Household Furniture*, from which, even more surprisingly, he excluded Charles Heathcote Tatham's *Etchings of Ancient Ornamental Architecture* (1799/1800), both omissions presumably made to stress the originality of his own contribution.

Rather surprisingly, Percier and Fontaine stressed at both the beginning and the end of the lengthy "Discours Préliminaire," which prefaced the *Recueil*, that their aim in publishing their designs was not to provide designers with models for imitation. This was in marked contrast to Hope's purpose in *Household Furniture*, although he shared the Frenchmen's condemnation of the increasing use by craftsmen of shoddy rather than permanent materials, as well as their admiration for the fact that in recent architecture and interior design "des lignes

RECUEIL

DE

DÉCORATIONS INTÉRIEURES,

COMPRENANT TOUT CE QUI A RAPPORT

A L'AMEUBLEMENT,

COMME

VASES, TRÉPIEDS, CANDÉLABRES, CASSOLETTES, LUSTRES, GIRANDOLES,
LAMPES, CHANDELIERS, CHEMINÉES, FEUX, POÊLES, PENDULES, TABLES,
SECRÉTAIRES, LITS, CANAPÉS, FAUTEUILS, CHAISES, TABOURETS,
MIROIRS, ÉCRANS, ETC. ETC. ETC.

COMPOSÉ PAR C. PERCIER ET P. F. L. FONTAINE,

EXÉCUTÉ SUR LEURS DESSINS.

~~~~~~~~~

## A PARIS,

CHEZ LES AUTEURS, AU LOUVRE;

P. DIDOT L'AINÉ, IMPRIMEUR, RUE DU PONT DE LODI, N° 6;

ET LES PRINCIPAUX LIBRAIRES.

M. DCCCXII.

simples, des contours purs, des formes correctes, le mixtiligne, remplacèrent le contourné et l'irrégulier."[4] As Percier and Fontaine were the first to write of "décoration intérieure," so Hope was among the first to use the phrase "interior decoration" in English.

1. For the publishing history of the *Recueil*, see *British Architectural Library*, vol. 3 (1999): 1424–25.
2. Hope, *Household Furniture* (1807): 14.
3. It was the 1812 edition of the Percier and Fontaine's *Recueil*, not that of 1801, which was included at the Deepdene library sale in 1917 (Christie, Manson & Woods, London, 27 July 1917, lot 592).
4. Percier and Fontaine, *Recueil de décorations intérieures* (1812): 4.

<div align="right">DW</div>

## 119. *Horatius Opera*

Binding designed by Thomas Hope; made by Staggemeier & Welcher
Paris: Didot, 1799
Straight grain morocco, watered silk ends
Marked with initials TH
20 x 14⅓ x 1¾ in. (50.6 x 36.4 x 4.5 cm)
British Library, London, C.180.cc4

PROVENANCE: Presented by Thomas Hope to the Royal Institution, London, on 27 March 1805.

LITERATURE: T. F. Dibdin, *Bibliographical Decameron*, vol. 2 (1817): 205; Nixon, "English Book Bindings" (1972): 386.

Hope gave this specially bound copy of the collected works of Horace to the Royal Institution, London, on March 27, 1805, to mark his election to it in that year. Valuing the book highly for its much admired illustrations by his friend Charles Percier, engraved by Girardet, he had had another copy in his own library.[1] In the list of sources on which he had drawn for his own designs, Hope praised this book as "Didot's folio Horace, with vignettes by Percier; some of which offer exquisite representations of the mode in which the ancient Romans used to decorate their town and country houses."[2] In Percier's illustrations for the vivid account of Roman life, high and low, in the later first century B.C., in the poems of Horace, he included painted interiors furnished with tables featuring animal monopodia legs, chairs of the klismos form, chairs with winged-lion supports, elegant curved couches, and lamps. Close to furniture and interiors executed by Percier and his partner, Fontaine, for Napoléon, these were all to be paralleled in Hope's own work. A bold star-studded frame enclosing the illustration to the second book of *Carmina* was also close to Hope's frames to pictures in the Egyptian Room at Duchess Street.

The artist John Flaxman was a pioneer in depicting neo-antique furniture, some of it inspired by that shown in Greek vase paintings. Indeed, Percier was probably indebted to Flaxman's illustrations to Homer of 1792–93, which had included klismos chairs, tripods and stands, and beds or couches. For example, in Percier's vignette heading the second book of *Satires*, the outline of a table and its method of delineation are similar to "Ulysses at the Table of Circe" from Flaxman's *Odyssey*. Hope acquired Flaxman's original drawings for his illustrations to Homer's *Iliad* and *Odyssey*, proudly showing them to C.R. Cockerell on his visit to the Deepdene in 1823.

Hope had commissioned Flaxman to make outline illustrations of Dante as early as 1792 in Rome, at a time when Percier and Flaxman were in close contact.[3] In Flaxman's anonymous review of Hope's *Household Furniture*, he went so far as to regret that "the richness of effect in the colours, and light and shadow, are entirely lost in a publication of mere outlines," wishing that "vignettes had been introduced of shadowed engravings of the same kind with those beautiful designs by Percier in Didot's *Horace*."[4] Flaxman may have published his review of *Household Furniture* anonymously to avoid annoying his patron by criticizing his outline engravings; the use by both Hope and Flaxman of the word "vignette" to describe Percier's engravings suggests they may have discussed them together.

1. The Deepdene library sale, Christie, Manson & Woods, London, 26 July 1917, lot 405, "Horatius. Opera, Vellum Paper, *12 beautiful vignettes after Percier, Russia, g.e. Paris, P. Didot, 1799.*"
2. Hope, *Household Furniture* (1807): 53.
3. Flaxman corresponded with Percier in 1791, addressing him in 1802 as "carissimo antico" (Watkin, *Thomas Hope* [1968]: 210).
4. *Annual Review* 7 (1809): 632.

<div align="right">DW</div>

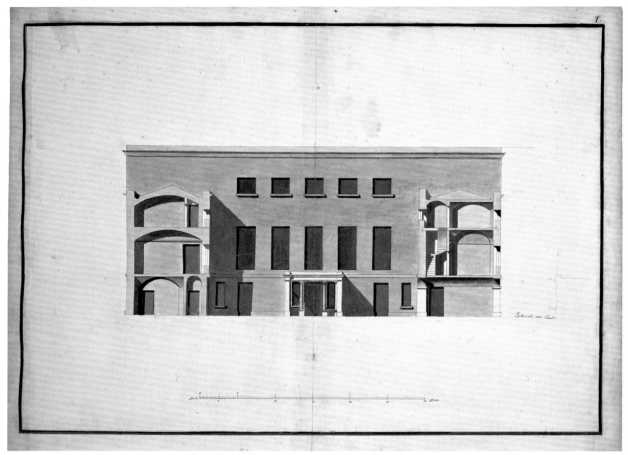

[ 120 ]

Five Drawings by
Robert Adam and Charles
Heathcote Tatham for
Duchess Street, London[1]

These designs of about 1770 by Robert
Adam, or his office, and of June 1799 by
Charles Heathcote Tatham are for the large
house in Duchess Street, London, which
Hope bought in 1799. Those by Tatham are
valuable because they contain annotations
by Hope that show his hands-on approach
to design. This important commission led
Tatham to be employed as architect for
three major galleries between 1800 and
1807: for the Earl of Carlisle at Castle
Howard, Yorkshire; for the Marquess of
Stafford at Cleveland House, St. James's,
London; and for the Earl of Yarbrough at
Brocklesby Park, Lincolnshire.

1. These drawings were bound in an album for Thomas
Hope, which was sold at the Deepdene library sale in 1917
(Christie, Manson & Woods, London, 27 July 1917, lot
644) and again in New York in 2003 to the present owner
("Scientific Books from the Illinois Institute of Technol-
ogy," Christie's, New York, 25 February 2003: lot 9).

120. *Duchess Street, entrance
front and section through the
wings*

Office of Robert Adam
ca. 1770
Ink and colored wash
25¼ x 19½ in. (64 x 49½ cm)
Private collection, courtesy of Hobhouse Ltd.

PROVENANCE: Thomas Hope; by descent, Lord Francis
Hope Pelham-Clinton-Hope; sold Christie's, 25–27 July
1917, lot 644; […]; sold Christie's, New York, 25 Febru-
ary 2003, lot 9; private collection.

LITERATURE: Watkin, "Thomas Hope" (2004): 31–39.

This shows the austerity of Adam's façade
and his segmentally vaulted ceilings forms
from tiles or flat bricks, a recent French
method of fireproof construction.

DW

121. *Plan of Duchess Street
showing proposed additions*

Charles Heathcote Tatham (1772–1842)
1799
Ink and colored wash
24¼ x 21⅓ in. (61.5 x 54 cm)
Private collection, courtesy of Hobhouse Ltd.

The plan in black, including the Eating
Room, is that of the house by Robert
Adam; the additions designed by Tatham
and Hope are shown in red. The small
rooms in the wing opposite the proposed
Library became the Vase Rooms.

DW

496

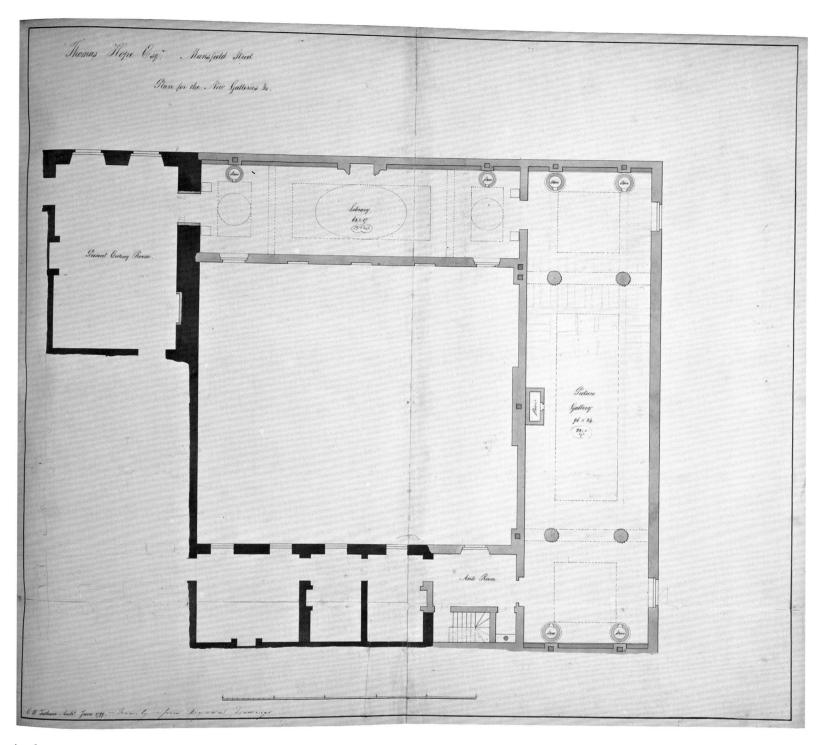

## 122. Section through the proposed library and one end of the picture gallery

Charles Heathcote Tatham (1772–1842)
1799
Ink and colored wash
21 x 12¾ in. (53.5 x 32.5 cm)
Private collection, courtesy of Hobhouse Ltd.

The room labeled "Library" became the Statue Gallery in execution, and its walls were painted yellow. The blue color shown here was used for the walls of the Drawing Room, or Indian Room, which were described by Hope as "sky blue."

DW

## 123. Section through the Picture Gallery at Duchess Street

Charles Heathcote Tatham (1772–1842)
1799
Ink and colored wash
20⅞ x 12⅗ in. (53 x 32 cm)
Private collection, courtesy of Hobhouse Ltd.

This is shown with the walls painted a soft red, which became popular as a background for pictures at this time. Anticipating the interiors of public museums in the nineteenth century, the room was well lit from its enormous clerestory, then a novelty, and also well heated by the stoves, which are clearly visible.

DW

## 124. Cross section of the Picture Gallery at Duchess Street

Charles Heathcote Tatham (1772–1842)
1799
Ink and colored wash
21½ x 13⅖ in. (54.5 x 33.5 cm)
Private collection, courtesy of Hobhouse Ltd.

Hope saw himself as having taken a leading role in the innovative form of this gallery, as shown by his addition after Tatham's signature: "from my own design, afterwards altered with respect to the lights." The Greek Doric columns, which are fluted and baseless, an early revival of this form, suggested the sacred character of a Greek temple.

DW

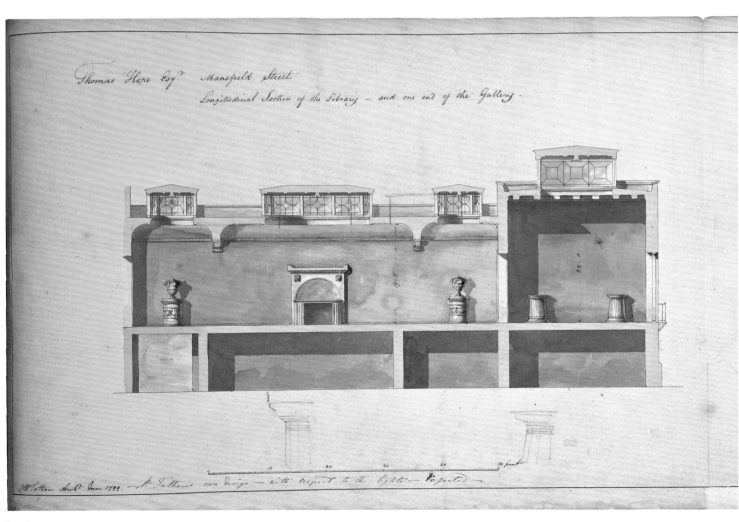

[ 122 ]

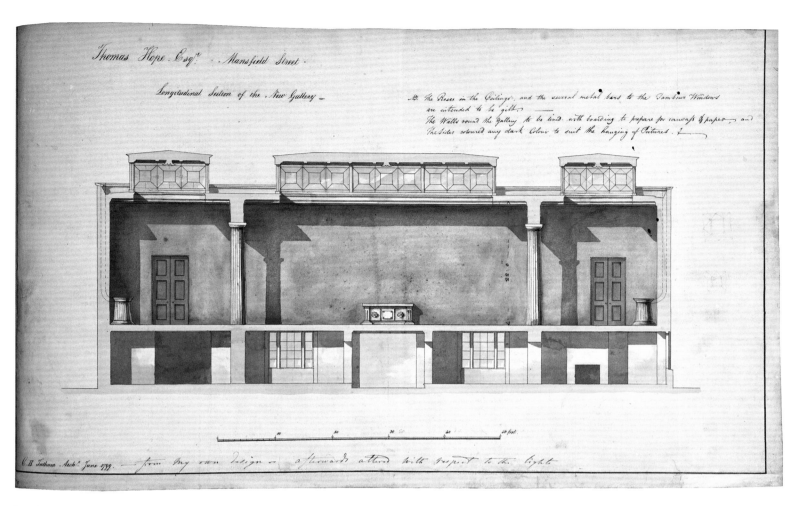

[ 123 ]

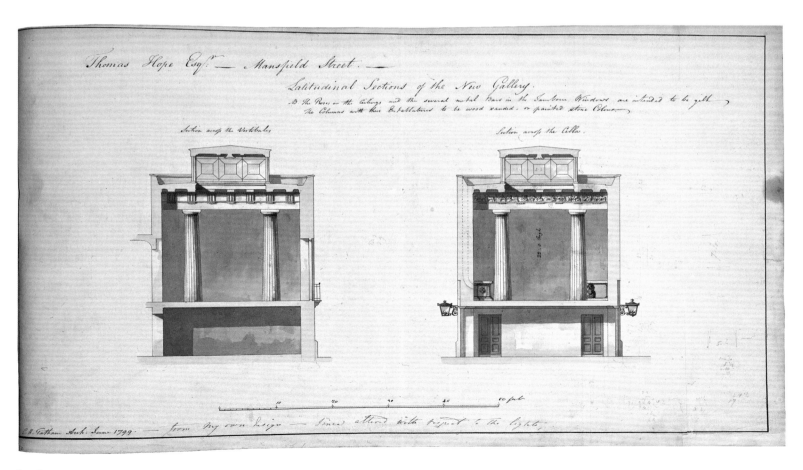

[ 124 ]

**125.** *A Disquisition upon Etruscan Vases; displaying their probable connection with shows at Eleusis, and the Chinese Feast of the Lanterns, with explanations of a few of the principal allegories depicted on them*

James Christie (1773-1831)
London: William Bulmer for T. Beckett, 1806
Contemporary blue crushed morocco, large Greek-style roll-tooled border on sides, central gilt armorial of Hope of Craighall
Inscribed "To Thos. Hope Esq. from the author."[1]
14.52 x 10.35 in. (36.9 x 26.3 cm)
Private collection

PROVENANCE: Thomas Hope; by descent, Lord Francis Hope Pelham-Clinton-Hope, Christie's, London, 25–27 July 1917, lot 107; […]; Christie's, South Kensington, 29 November 2006, lot 54; private collection.

James Christie, son of the founder of the auctioneers Christie's, which he ran from 1803, was educated at Eton and was the author of several learned works written at a time when the study of Greek figured vases was in its infancy.[2] He had 100 copies of his *Disquisition upon Etruscan Vases* printed for distribution to his friends, including John Soane, William Beckford, and Thomas Hope, whose vases were illustrated in the book. Among his other works were *Essay on that Earliest Species of Idolatry, the Worship of the Elements* (Norwich, 1814), of which Hope and Soane owned copies, and *Essay on the Mysteries of Eleusis, translated from the French by J. D. Price. With observations by James Christie* (London, 1817).

Christie was a friend of the celebrated collector of antiquities Charles Townley,[3] in whose London house Pierre-François Hugues ("baron d'Hancarville") wrote his great work, *Recherches sure l'origine, l'esprit et les progrès des arts de la Grèce; sur leur connexion avec les arts et la religion des plus anciens peuples connus; sur les monuments antiques de l'Inde, de la Perse, du reste de l'Asie, de l'Europe et de l'Egypte,* 3 vols. (London, 1785).[4] Along with Richard Payne Knight, d'Hancarville argued for the centrality of sexual origins in the generation and creation myths found in ancient art and religion. Influenced by the opinions current in the circle of Christie, Payne Knight, and d'Hancarville, Hope described how he placed his vases, "partly connected with the representations of mystic death and regeneration" in "recesses, imitating the ancient Columbaria, or receptacles of Cinerary urns."[5]

1. See the Deepdene library sale cat., Christie, Manson & Woods, London, 25 July, 1917, lot 107.
2. On Christie, see Watkin, *Sir John Soane* (1996): 274–78.
3. On their connection, see Navari, *Greece and the Levant* (1989): 347.
4. On Townley and his world, see Jenkins, *Archaeologists and Aesthetes* (1992): passim.
5. Hope, *Household Furniture* (1807): 22–23.

DW

AUT SPES NON FRACTA

# Appendix

Ludolf **Backhuysen**
*The Frigate Brielle on the Maas at Rotterdam*, 1689 (originally *Sea Piece*
    or *View of the River Y, Amsterdam in the Distance*) (Rijksmuseum,
    Amsterdam, inv. no. 2539)
*View of a Warehouse in India*

Cornelius **Bega**
*Interior. Villagers Drinking and Sleeping* (sale Christie's 23 December 1937,
    lot 296; bought by Duits for £79 16s.)
*Interior. Villagers Drinking and a Fiddler Playing*, ca. 1663 (formerly Widener
    collection, Philadelphia)

Gerrit **Berckheyde** (those traced of a total of 12 )
*The Wood Gate at Haarlem* (Museum Ridder Smidt van Gelder, Antwerp)
*The Departure of the Falcon Hunt* (The Mauritshuis, The Hague)
*View of the Binnenhof in The Hague with the so-called Rittersaal*, ca. 1690
    (Thyssen-Bornemisza collection, Madrid)
*The Binnenhof and Gevangenpoort, The Hague*, 1694 (Private collection)
*The Hof Vijver from the Korte Vijverberg, The Hague*, 1695 (Private collection)

Jan and Andries **Both**
*Italian Landscape with Figures and Waterfall*, ca. 1645–50 (National Gallery
    of Ireland, Dublin)

Bartholomeus **Breenbergh**
*St. John Preaching in the Wilderness*, 1643 (on loan to the Art Institute
    of Chicago)

Giuseppe **Chiari**
(formerly attributed to Carlo Marratta) *Venus and Adonis* (Chhatrapati
    Shivaji Maharaj Vastu Sangrahalaya, Mumbai, formerly the Prince of
    Wales Museum of Western India, Bombay)

Aaelbert **Cuyp**
*Cows and Herdsmen by a River*, 1650s (The Frick Collection, New York)

Dirck van **Deelen**
*Interior of a Church*, 1629 (sale Sotheby's Parke Bernet London, 22 February
    1984, lot 52; sold for £22,000)

Gerrit **Dou**
*Woman at a Window with a Rabbit in Her Hand* (Private collection,
    North America)
*Woman Asleep, a Figure Tickling Her Nose*, ca. 1660–65
    (Private collection, Switzerland)

Carel **Dujardin**
*Landscape with Cattle and a Horse*, early 1660s (on loan to The Mauritshuis,
    The Hague, from the Instituut Collectie Nederland, formerly thought to
    have been in the Philadelphia Museum of Art)
*Falcon Chase* in the manner of Wouvermans and Berchem (Michaelis
    Collection, Old Town House, Cape Town, South Africa)

Cornelius **Dusart**
*A Merry Company in a Peasant's House*, 1684 (formerly Johnson collection,
    Philadelphia)

Anthony van **Dyck**
*The Assumption of the Virgin*, 1628–29 (National Gallery of Art, Washington)

Pieter Constant la **Fargue**
*A Market Scene*

Pieter **Gyssels**
*A Dutch Fair*, 1687 (Antwerp Museum)
*Still Life with a Dead Swan, Peacock, Small Birds, etc.*, 1686 (Klein sale,
    Frankfurt, 31 October 1911, lot 14)

Jan van der **Heyden**
*The Church, Maarsen* (National Trust, Polesden Lacey)
*A View in Amsterdam* (Gemäldegalerie, Berlin)
*A View of the Jesuit Church of St. Andreas, Düsseldorf*, 1666 (Private collection)

Meindert **Hobbema**
*Cottages in a Wood*, ca. 1660 (National Gallery, London)

Melchior de **Hondekoeter**
*Landscape with Two Swans, Ducks, and Peacocks* (Brunner Gallery, Paris, n.d.)

Pieter de **Hooch**
*Interior. A Woman Drinking with Two Gentlemen*, 1658 (Musée du Louvre, Paris)

Jan van **Huysum**
*Rest on the Flight to Egypt*, ca. 1737 (Peterborough Museum and Art Gallery)
*A Woman Refusing a Wreath*, ca. 1737 (Peterborough Museum and
    Art Gallery)
*Vase of Flowers on a Garden Ledge*, 1730 (with Noortman Master Paintings,
    Maastricht, 2007)
*Fruit Piece* (companion to above), 1730 (Private collection)

Gerard de **Lairesse**
*Death of Cleopatra*, ca. 1686 (Art Gallery of Ontario, Toronto)

André Corneille **Lens**
*Minerva*, 1773
*Venus Chastising Cupid*, 1774

Hendrik van **Limborch**
*Hercules Presenting the Infant Ajax to Jupiter* (sold as by J. Verkolje [*sic*] in 1917)

Johannes **Lingelbach**
*View of the Campo Vaccino* (Kunstalle, Karlsruhe)

Jan van der **Liss**
*The Bath of Diana*

Corneille de **Lyon**
(formerly attributed to Holbein) *Portrait of* [*?*]*Sir John Chichester*, ca. 1515 (Sterling and Francine Clark Art Institute, Williamstown, Massachusetts)

Gabriel **Metsu**
*Man Writing a Letter*, ca. 1663 (National Gallery of Ireland, Dublin)
*Woman Reading a Letter* (companion to above), ca. 1663 (National Gallery of Ireland, Dublin)
*A Lady at Her Toilet*, ca. 1660 (The Frick Collection, New York)

Circle of **Metsu**
*The Letter Writer Surprised* (sale Christie's New York, 6 April 1989, lot 43; sold for $10,450)

Frans van **Mieris**
*A Gentleman Offering Fruit to a Lady* (H. Schickman Gallery, New York 1968, whereabouts unknown 1981)
*The Old Violinist*, 1660 (Private collection, Boston)

Willem van **Mieris**
*The Chicken Seller* and *The Vegetable Seller* (Sotheby's Monaco, 18 June 1992, lot 42, both sold for 499,500 FF.)
*Judgement of Paris*
For *Bathsheba*, see **Poelenburgh**

Lodowyck de **Moni**
*The Fortune Teller* (sale Sotheby's, 21 June 1967, lot 181; bought by Sternberg for £220)

Eglon van der **Neer**
*Figures in an Interior*, 1678 (Private collection, United States)

Caspar **Netscher**
*A Lady at a Window Feeding a Parrot and a Gentleman with a Monkey* (Columbus Museum of Art, Ohio)

Jacob **Ochtervelt**
*Violinist and Two Serving Women*, ca. 1663–65 (Manchester City Art Galleries)

Balthazar Paul **Ommeganck**
*Landscape with Cows and Goats*

Adriaen van **Ostade**
*Cottage Doorway. Offering a Present* (exhibited Colnaghi, June 1935)
*A Cottage Doorway with a Woman Cleaning Mussels*, 1673 (National Gallery of Art, Washington)
*Dutch Peasants Regaling* or *A Bagpiper Playing to Peasants outside a Country Inn*, 1659 (Witt mount, sale van Marle & Bignell, 1 September 1942, lot 23)

Cornelis van **Poelenburgh**
(formerly attributed to Willem van Mieris) *Bathsheba Attended by Her Maidens, Seated a Fountain*, 1760 (Bachstitz Gallery, The Hague, as in the collection F. von Gans, Frankfurt, 1921)
*Nymph and Triton* (*Glaucus on the Sea Shore*) (Bachstitz Gallery, The Hague)
*The Offering of the Wise Men*
*Holy Family in a Landscape*

Paulus **Potter**
*A Farmyard with Horses and Figures*, 1647 (Philadelphia Museum of Art)
*Cattle and Sheep in a Stormy Landscape*, 1647 (National Gallery, London)
*Landscape with Cattle, Three Standing and One Resting* (Henry Hirsch of 23 Park Lane, London sale, Christie's, 1934, lot 141; bought by Jurgens)

**Rembrandt**
*The Storm on the Sea of Galilee*, 1633 (stolen from the Isabella Stewart Gardner Museum, Boston, 1990)

Hans **Rottenhammer**
*Assumption of the Virgin*, in the style of Tintoretto

Jacob van **Ruisdael**
*River with a Wooden Bridge in a Rocky Landscape* (Sterling and Francine Clark Institute, Williamstown, Massachusetts)

Godfroy **Schalken**
*The Smoker: Candlelight Effect* (whereabouts unknown, the second of three versions of the one in the Musée des Beaux-Arts, Lyon, or sale Dorotheum, Vienna, 23–24 September 1970, lot 97)

Pieter van **Slingeland**
*A Hermit Reading* (Private collection, Belgium)
(formerly attributed to van Tol) *A Woman with a Pitcher Drawing Water from a Well* (Witt mount, D. Hoogendijk, Amsterdam)

Frans **Snyders**
*Large Kitchen with Kettles, Dead Birds and Vegetables, and Hunting Dog* (Private collection)

Jan **Steen**
*"Easy Come, Easy Go,"* 1661 (Museum Boijmans van Beuningen, Rotterdam)
*A Christening* (companion to above) (Gemäldegalerie, Berlin)
*The Dancing Couple*, 1663 (National Gallery of Art, Washington)

David **Teniers**
*Soldiers Playing Backgammon*, 1647 (Ludwig Neumann sale, Christie's, 4 July 1919, lot 19)
*Soldiers Smoking* (companion to above), 1647

Gerard **Ter Borch**
*A Lesson on the Theorbo* (Isabella Stewart Gardner Museum, Boston)
*Three Soldiers Making Merry*, ca. 1656 (Private collection)
*Officer Writing a Letter*, ca. 1658–59 (Philadelphia Museum of Art)

Dominicus van **Tol**
*Interior of a Village School*

Jacob van der **Ulft**
*View of the Stadhuis, Amsterdam*, 1657 (Amsterdams Historisch Museum)
*Roman Ruins and Procession* (sale Sotheby's New York, 9 June 1983, lot 35)

Adriaen van der **Velde**
*The Farm*, 1666 (Gemäldegalerie, Berlin)
*Landscape with Cattle and Figures*, 1651 (Philadelphia Museum of Art)

Willem van der **Velde**
*The Council-of-War on Board the Eendracht on 24 May 1665*, ca. 1665 (Fritz Lugt collection, Fondation Custodia, Paris)
*Fishing Buss in a Breeze*, ca. 1672 (Private collection, England)
*Hoeker in a Strong Wind*, ca. 1670 (Private collection, England)

Jan **Vermeer**
*The Glass of Wine*, ca. 1661–62 (Gemäldegalerie, Berlin)

Paulo **Veronese**
*Bathsheba in the Bath*

Jan **Victor**
*Jacob and Joseph*

Jan **Weenix**
*Dead Stag and Partridges*
*Dog, Dead Hare, Barking Dog, and Peacock*
*Still Life with Swan and Game before a Country Estate* (National Gallery of Art, Washington)

Adriaen van der **Werff**
*Magdalen Reading in a Rocky Landscape*
*The Incredulity of St. Thomas*, 1710 or 1719 (Milwaukee Art Museum)
*Lot and His Daughters* (variant of the Sanssouci picture, anon. sale Christie's, 8 April 1925, lot 91; bought by Greenstreet for 34 gns., not to be confused with another of the same title sold in 1898 by Wertheimer)

Philips **Wouvermans**
*Hawking Party* (Private collection)
*The Rustic Wedding*, mid to late 1650s (Harold Samuel collection, Corporation of London)

Jan **Wynants**
*Landscape with Figures and Horseman*

PICTURES LEFT BY HENRY HOPE TO
HENRY PHILIP HOPE IN 1810

Ludolf **Backhuysen**
*The Embarkation of King William the Third*, presumed to be *The Frigate Brielle on the Maas at Rotterdam* (originally *Sea Piece* or *View of the River Y, Amsterdam in the Distance*), 1689 (Rijksmuseum, Amsterdam, inv. no. 2539)

Nicolaas **Berchem**
*Landscape with Figures and Cattle: The Temple of the Sibyl at Tivoli* (Fritz Lugt collection, Fondation Custodia, Paris)

Aaelbert **Cuyp**
*The Angel Appearing to the Shepherds* (sold in Henry Hope sale, Christie's, London, 6 April 1811, lot 35)

**Denner**
*Miniature Portrait* (possibly sold in Hope Heirlooms sale, Christie's, London, 20 July 1917, lot 33)

**Dietricht**
*Theatrical Scene by Moonlight* (sold in Henry Hope sale, Christie's, London, 6 April 1811, lot 51)

Philip van **Dyck**
*Two Ladies at a Window with a Parrot*, 1717 (Private collection, Germany)

**Ferg**
*Joseph Sold to the Ishmaelites* (sold in Henry Hope sale, Christie's, London, 6 April 1811, lot 42)
*Rebecca and Abraham's Servant at the Well* (sold in Henry Hope sale, Christie's, London, 6 April 1811, lot 43)

Hubert **Goltzius**
*Landscape with Vertumnus and Pomona* (sold in Henry Hope sale, Christie's, London, 6 April 1811, lot 25)

Bartholomeus van der **Helst**
*Portrait of a Man in a Broad-rimmed Hat* (sold in Henry Hope sale, Christie's, London, 6 April 1811, lot 28)
*Portrait of a Woman in a Large Ruff* (companion to the portrait above; sold in Henry Hope sale, Christie's, London, 6 April 1811, lot 29)
*The Arrest of the de Witts* (Gemäldegalerie, Berlin)

Meindert **Hobbema**
*Cottages in a Wood*, ca. 1660 (National Gallery, London)

Cornelis van **Poelenburgh**
*A Pair of Female Portraits, habited as two of the Seasons* (sold in Henry Hope sale, Christie's, London, 6 April 1811, lot 27)
*Circular Landscape* (possibly sold in Henry Hope sale, Christie's, London, 27–29 June 1816, lot 19)

**Rembrandt**
(now attributed to Rembrandt) *Portrait of an Officer*, 1636 (Private collection, Switzerland)
*A Young Woman with a Heron's Plume in Her Hair*, 1636 (Huntington Library and Art Gallery, San Marino, California)
Or possibly *A Lady and Gentleman in Black* (stolen from the Isabella Stewart Gardner Museum, Boston, 1990)
*Landscape. A Plain Traversed by a River with Buildings on Its Banks*

David **Teniers**
*Flemish Feast* (Royal collection, England)

Adriaen van der **Werff**
*Roman Charity (Cimon and Pero)*, 1718 (Royal collection, England)

# Bibliography

## THOMAS HOPE'S BOOKS, ARTICLES, AND DRAWINGS

Five volumes containing 350 "Drawings of views, landscapes, costumes, and monuments in Greece, Asia Minor, Syria and Egypt," 1787–95. Benaki Museum, Athens, Department of Prints and Drawings.

*Observations on the Plans and Elevations designed by James Wyatt, Architect, for Downing College, Cambridge, in a letter to Francis Annesley, Esq., M.P. by Thomas Hope.* London: D. N. Shury, 1804.

Review of Royal Academy exhibition. *Morning Post*, 5 May 1804.

Review of Damer's bust of Nelson. *Times*, 5 May 1804.

*Household Furniture and Interior Decoration Executed from Designs by Thomas Hope.* London: Longman, Hurst, Rees, & Orme, 1807. Reprinted London: John Tiranti Ltd., 1937 and 1946; reprinted with a preface by Clifford Musgrave, London: Alex Tiranti, 1970; republished by David Watkin as *Regency Furniture and Interior Decoration: Classic Style Book of the Regency Period*, New York: Dover, 1971.

"On the Structure of Our Theatres." *The Director* (1807): vol. 1, 171–76, 240–47; vol. 2, 329–36 (see also *The Review of Publications of Art* 4 [1808]: 306–14 and *La Belle Assemblée* [1809]: vol. 2, 272a–b; vol. 3, 111b–112b).

Letter on the ballet. *The Director* 2 (1807): 65–68.

"The Utility of Remains of Antiquity." *The Director* 2 (1807): 198–205.

"On Instruction in Design." In Prince Hoare, ed., *The Artist; A Collection of Essays relative to Painting, Poetry, Sculpture, Architecture, The Drama, Discoveries of Science and various other subjects* 1, no. 8 (2 May 1807): 1–7. Reprinted in two vols. London: John Murray, 1810.

"B. R. Haydon's Rest on the Flight into Egypt." *The Review of Publications of Art* 2 (1 June 1808): 110–12.

"On the Art of Gardening." *The Review of Publications of Art* 2 (1808): 133–44. Reprinted with an introduction by Thomas Hope in Barbara Hofland, *A Descriptive Account of the Mansion and Gardens of White-Knights.* London: W. Wilson, 1819, pp. 3–13.

"On Grecian and Gothic Architecture." *The Review of Publications of Art* 4 (1808): 297–303.

Drawings for *Costume of the Ancients.* 2 vols., 1809. Athens: Gennadius Library.

*Costume of the Ancients.* 2 vols. London: William Miller, 1809.

Thomas Hope's Italian sketchbook, ca. 1812. RIBA Library Drawings Collection, London.

*Anastasius: or Memoirs of a Greek; written at the close of the eighteenth century.* 3 vols. London: John Murray, 1819.

"Letter from Thomas Hope, Esq., Author of Anastasius." *Blackwood's Edinburgh Magazine* 10 (10 October 1821): 212.

*An Essay on the Origin and Prospects of Man.* 3 vols. London: Murray, 1831.

*An Historical Essay on Architecture by the late Thomas Hope: illustrated from Drawings made him in Italy and Germany.* 2 vols. London: John Murray, 1835.

## MANUSCRIPT SOURCES

Unknown location: Letter from Thomas Hope to Lord Glenbervie, 1812.

Agnew Archives, London: London Day Book, no. 29; Joint Stockbook 1910; Picture Stock Book, nos. 9, 10; Young and Agnew Stock Book; Show Room Book, no. 2.

Amsterdam Municipal Archives: 735/2895, Catalogues A, B & C., signed and dated, 17 December 1795, by Henry Hope: "Catalogue A of pictures in the House no. 1 the corner of Harley Street, belonging to Mr. Henry Hope, on which is ensured twelve thousand pounds"; "Catalogue B of pictures in the House no. 1 the corner of Harley Street, belonging to Mr. Henry Hope, on which is ensured ten thousand pounds"; "Catalogue C of pictures in the House no. 1 the corner of Harley Street, belonging to Mr. Henry Hope, on which [is ensured] £4000."

Archive of Art & Design, Blythe Road, London: MA/1/B1600, H. Blairman & Sons (1938–92); papers filed on RP/1983/80*; MA/1/H1954, Dr. W. L. Hildburgh (1912–72); papers filed on RP/1931/5989; RP/1974/185 Apsley House (1972–77); MA/1/J795, A. E. N. Jordan (1936–39); RF/1995/2355, Reviewing Committee on Export of Works of Art. Objection to export: pair of empire armchairs by Jacob Desmalter (1995–96); RF/1996/177, Acquisition: purchase. Armchair made by Jacob Desmalter, ca. 1803–13, purchase from Christie's (1996–99).

Assay Office, Birmingham: Boulton Papers: Hope to Boulton, 14 September 1805, ff. 2–4.

Beinecke Library, Yale University, New Haven: Thomas Hope to John Britton, n.d., MS Vault, Frederick Hilles, 8910, Box 1A, no. 8.

Benaki Museum Historical Archives, Athens: Letters between Louis François Sebastien Fauvel and Mr. Cousinéry, April 1795–May 1801.

Bibliothèque Nationale, Paris: Nouv. Acqu. 3231, f. 115: Thomas Hope to Millin, London, 29 September 1815.

Bodleian Library, Oxford: Douce Collection, E60, Francis Douce, "Memoranda relating to Mr. Hope's house," ca. 1812; Mss. Montagu, d. 7, f. 512, letter from Thomas Hope to Mr. Humphrey, 3 December 1806.

British Library, Manuscript Department, London: Add Ms 39784BB, Flaxman Papers, The Account Book of John Flaxman, 1794–1814; Add Ms 25657, ff. 1r–13v, Architectural sketches in pencil with notes from Thomas Hope regarding his *Historical Essay on Architecture*, 1835; Add Ms 29320, ff. 25r–26v, Letter from Thomas Hope, 18 May 1810; Add Ms 39780, Flaxman Papers, ff. 47v and 50v, letter to his parents, and f. 57, letter relating to *Torso Belvedere restored as the Marriage of Hercules and Hebe*; Add. Ms. 39781, Flaxman Papers, f. 16, letter from Thomas Hope to John Flaxman, 6 December 1794; Add Ms 54227 H, ff. 23r–24r & ff. 25r–26r, Two letters from Thomas Hope to his wife, Louisa.

British Museum Central Archive, London: 14/5/7 Townley Papers, "Marbles at Mr. Thos. Hope's," February 1804.

Centre for Kentish Studies: U1590/C368/6, Letter from Thomas Hope to Lord Stanhope.

Frick Art Reference Library, New York: *Pictures of H. Hope, Esqr. Cavendish Square M.S.S. Catalogue, 1810.*

Gennadius Library, American School of Classical Studies, Athens: John Flaxman review of *Household Furniture*, f. 7.

Hampshire Record Office: 21.M.57 2nd Earl Box "D," *Catalogue of pictures, engravings and furniture at Somerley 1874*, vol. 1.

ING Barings, London: Bank Accounts and General Ledger Account books; private correspondence.

Minet Library Archives, Lambeth: S/3247/185/188, John Britton's "Illustrations of the Deepdene, Seat of T. Hope Esqre., 1825-6" by W. H. Bartlett and Penry Williams, 1825–26; S/3247/185/188, John Britton, History and Description of the Deepdene.

Museo Civico Bassano, Manoscritti Canoviani: Ep. Canova, 178–180, 1153–1157, 3505–3506, 5497: Various letters from Thomas Hope and Antonio Canova, dating 11 March 1798–14 September 1799; 15 April 1817–3 July 1820; 17 January 1821; 11 March 1822; 4 December 1802.

National Art Library, Victoria and Albert Museum, London: Mss of *Hope's Garland*; MSL/1979/5116/135, Letter from Thomas Hope to John Britton, 181[?]; MSL/1979/5116/136, Letter from Thomas Hope to James Christie, 14 June 1813; MSL/1979/2610, Letter from Thomas Hope, 16 September 1825; MSS 37.B.90, "The Outlines of Statues in the possession of Mr. Hope (never published) for which illustrations were furnished by T. D. Fosbroke," 1813; MSS 110.H.14, "HOPE MARBLES." A volume containing 34 copper plates engraved from works of art in the possession of T. Hope Esq., n.d.; MSS L.626-1984, "Voyage Philosophique et Pittoresque, sur les rives du Rhin, à Liége, dans

la Flandre, le Brabant, la Hollande, etc. fait en 1790 par George Forster, l'un des compagnons de Cook; traduit de l'Allemand, avec notes critiques sur la physique, la politique et les arts, par Charles Pougens. Tome premier. A Paris: Voyage Philosophique et Pittoresque, sur les rives du Rhin, à Liége, dans la Flandre, le Brabant, la Hollande," 2 vols., 1790.

National Monuments Record Office, Swindon: Files on buildings containing photographs.

National Portrait Gallery, Heinz Archive, London: Scharf Sketch Books, SSB 53, ff. 136–148 (15–16 September 1858); SSB 66, ff. 66, (8 June 1863); SSB 67, ff. 21r–22v; SSB 95, ff. 59v–69r (September 1877); SSB 96, ff. 73–74 & ff. 136–148; bound drawings by Henry Bone.

Nottingham University Archives, Department of Mss and Special Collections: Ne 6 I 1/9, "Inventory of the heirlooms furniture and effects at 'Deepdene' Dorking late the property of the late M^rs. A. A. Hope (deceased)" (24th February 1887); Ne 6 I 1/3, "Catalogue of the Deepdene library in two parts," 1865; Ne 6 I 1/2/1-3, "Catalogue of the principal sculptures, antiquities and pictures at Deepdene," 1859; 2008, "Report by Messrs. Lofts & Warner as to condition of statuary in cave at the Deepdene," by Messrs. Dawson Ainslie & Garle, 19 Surrey Street, W.C. (19 November 1910); 2008, an insurance policy no. 1625814; 2008, "silver plate being heirlooms belonging to the Hope estate handed over to Lord Francis Hope pursuant to the order of the court of 11 May 1903 on the seventeenth day of October 1907"; Ne 6 I 1/6, "Inventory of furniture, pictures, plated articles, linen, china, glass, articles of vertu &c. contained in Clumber House . . . September 1885"; Ne 6 I 1/10, "Catalogue of pictures forming the 'Clumber Collection' the property of His grace the Duke of Newcastle," 1891; Ne 6 I 4/1-2, "Catalogue of pictures being part of the Clumber Collection. The property of His Grace the Duke of Newcastle," 1872, printed; Ne 6 I 1/5, "Inventory and Valuation of furniture, ornamental items, pictures, books, plate, jewellery, linen, and other effects, at the castle at Castleblayney, Co. Monaghan, in Ireland, the property of the late M^rs. Hope, made for the purpose of administration," ff.1r–121v, 1884; Ne 6 I 1/11, "re. Hope. Schedule of furniture and effects to be sent to Castleblayney under order of court," 1895; Ne 6 I 2/9/4, "Estate of Lord Francis Hope P. C. Hope," "Particulars of sale of furniture etc. in the castle," January 1927; Ne 6 I 1/8, "An Inventory of heirlooms (furniture and effects) at 35, Belgrave Square (late) the property of M^rs. A. A. Hope deceased 24^th February 1887"; NEX 129, "Lord Francis Hope's failure," *The Sheffield Telegraph* (16 July 1894); NEX 231, "Lord F. Hope's failure" (1 August 1902); NEX 232, "Lord Francis Hope's financial troubles"; NEX 309, "The Hope Heirlooms. Court Sanctions Sale," *The Morning Post*, 16 April 1910; NEX 367, "The Breaking up of Estates. Lord Francis Hope and the Effect of the Land Taxes"; NEX 483, article relating to sale of heirlooms, 15 June 1917, W.G., "The Hope Heirlooms"; Ne C 14383, press cutting from *The Star*, 23 February 1889; 2124 (uncatalogued),

"Inventory of Jewels and Plate made at Parr's Bank, Cavendish Square," 1911; 2413 (uncatalogued), "Historische catalogus van het cabinet Schilderijen van J:B": a manuscript list with later additions, of 30 March 1781, and an incomplete list of the twenty pictures left to Henry Philip Hope by Henry Hope in 1810. It is in an envelope incorrectly marked "Hope catalogue of precious stones"; 2417 (uncatalogued), "two diaries of Jarmain Hope," 1852–55; Ne 6 G 4/2, "Deeds relating to Hope pedigree"; Ne 6 G 4/9, "Deed of assignment and transfer of House of Hope 1813 Sept. 3."; Ne 6 G 4/15, "Henry Tho^s. Hope Esq^re with the Right Honble John Lord Decies and others executors of the late Tho^s. Hope Esq^re," "Deed of confirmation of accounts and of covenant for release" [a summary of Thomas Hope's bequests] (3 July 1832); Ne 6 G 4/16, Inventory of property at Bosbeek at death of Adrian Elias Hope, 1834; Ne 6 G 4/17, Adrian Elias Hope, 14 January 1835; Ne 6 G 4/18, "memorandum property sworn to on the demise of Adrian Elias Hope Esq."; Ne 6 G 4/20, "Disposal by my will and testament of Bosbeek and Groenendaal in Holland" [Henry Philip Hope]; Ne 6 G 4/21, "Directions &c of persons mentioned in my codicil. February 1839 H. Ph. H."; Ne 6 G 4/22, In the Excrship of the late H P Hope Esq. "Your opinion requested on behalf of Mr Adrian Hope" (July 1840); Ne 6 G 4/23, "Case to be submitted to the English lawyers"; Ne 6 G 4/24, Letter to Henry Thomas Hope at Duchess Street, dated 24 January 1840; D 2480, Inventory and Valuation of the heirlooms of the 8th duke of Newcastle at Harrowlands, Dorking (Inventory no. 1. The Heirlooms, formerly at Castle Blayney, Ireland and Inventory no. 2. The remainder, being subsequent purchases by Lord Francis Pelham Clinton Hope now becoming heirlooms), dated January 1927, made by Tyler & Co., Surveyors and Vlauers, 45 Holborn Viaduct, EC1; Ne X 101, "Collection of porcelain, pottery, enamels, &c. contributed by Mrs. H. T. Hope, to the Midland Counties Art Museum, at Nottingham Castle."

Public Record Office, Kew: PROB 11/1783, Will of Thomas Hope, 26 March 1831; PROB 11/1531, Will of Henry Hope, 11 March 1812; PROB 11/1927, Will of Henry Philip Hope, 5 May 1840; PROB 11/2139, Will of The Rt. Honorable Louisa Viscountess Beresford, 17 September 1851.

RIBA Library Drawings Collection—British Architectural Library, Royal Institute of British Architects at the Victoria and Albert Museum, London: Illustrations for John Britton's "History, etc., of the Deepdene. Seat of Thos. Hope Esqr. 1821–6."

Rijksbureau voor Kunsthistorische Documentatie, The Hague: Catalogue I: *Catalogus van het Cabinet Schilderijen* (Notitie der schilderjen van Alerron J Hope om te verkopen), dated 20 April 1785; Catalogue II: *Catalogus van het Cabinet Schilderijen andere Rariteiten*; Catalogue III: *Cabinet Schilderijen*. Account book, Amsterdam, 24 April 1771, signed J. Hope.

Royal Academy Archives, London: RAA/SEC/2/82: Letter from Thomas Hope dated 15 July 1819.

Sir John Soane's Museum, London: *Adam Drawings*, vol. 14, nos. 57, 58, drawings for Clerk House, 1 Mansfield Street [Duchess Street], London (drawing room); *Adam Drawings*, vol. 18, no. 65, sketch design for Clerk House, 1 Mansfield Street, London; *Adam Drawings*, vol. 23, nos. 160, 230, drawings showing chimneypiece for Clerk House, 1 Mansfield Street, London; *Adam Drawings*, vol. 24, nos. 280–284, drawings showing decorations for window shutters for Clerk House, 1 Mansfield Street, London; *Adam Drawings*, vol. 44, nos. 1–9, elevations, sections and plans for Clerk House, 1 Mansfield Street, London; *Adam Drawings*, vol. 28, nos. 83–91, elevations, sections and plans for Hopetoun House, 1 Harley Street, Cavendish Square; Private Correspondence, I/I/H/22; Soane Case 170, fol. 238, unpublished notes by Soane entitled "Extracts, Hints etc for Lectures on Architecture by J Soane 1813 to 1818."

Surrey County Council, Kingston upon Thames: A series of photos of the Deepdene dated ca. 1960.

Surrey History Centre: A collection of photographs and other material relating to the house and grounds of the Deepdene, including 2971/4/2, consecration of the mausoleum, 29 June 1819; CC916/1–7, relating to the demolition of the Deepdene and grounds, 1951–87; 4348/3/12/13, watercolor of the Deepdene by John Hassell, 1823; 2971/4/3, loan of paintings to the South Kensington Museum, 13 February 1891.

Westminster City Archive, London: St. Marylebone Ratebooks (1771–1851).

Yale Center for Studies in British Art, New Haven: The Hope Architectural Collection, B1977.14.4721–4726: Drawings by and after Thomas Hope; The Hope Architectural Collection, B1977.14.4727–4743: Watercolor drawings by Henry Philip Hope; The Hope Architectural Collection, B1977.14.4744–4764: Drawings by Thomas Hope; The Hope Architectural Collection, B1977.14.4767–4770: Architectural drawings of Arklow House, Connaught Place; The Hope Architectural Collection, B1977.14.4765: Architectural drawings of 3 Seamore Place; The Hope Architectural Collection, B1977.14.4771–4773: Engravings of Duchess Street, London; The Hope Architectural Collection, B1977.14.4774: Designs for furniture and wall decoration; The Hope Architectural Collection, B1977.14.4775–4800: Watercolor drawings and views of the Deepdene, Surrey; The Hope Architectural Collection, B1977.14.4801–4808: Engravings of the Deepdene, Surrey; Hope Architectural Collection, Deep-Dene 1: Manuscript list of contents of the Deepdene by John Britton; The Hope Architectural Collection, B1977.14.4809–4833: Architectural drawings and details of furniture at Adrian John Hope's house at 4 Carlton Gardens; The Hope Architectural Collection, B1977.14.4834–4847: Views of Bedgebury House including designs for furniture; The Hope Architectural Collection, B1977.14.4877–4900: Watercolor views of Boschbeek and Groenendaal; The Hope Architectural Collection, B1977.14.4901–4905: Views of Henry Hope's residence, Welgelegen, Haarlem.

## SELECTED HOPE FAMILY SALE CATALOGUES

*A catalogue of an assemblage of capital Flemish and Dutch pictures, the genuine property and a part of the magnificent collection of that distinguished connoisseur and patron of the arts, Henry Hope, Esq. dec. and removed from his late mansion in Cavendish Square...*, Christie's, London, 6 April 1811.

*A catalogue of the very extensive and valuable library of Henry P. Hope, Esq. . . . .*, Leigh and Sotheby, London, 18 February–11 March 1813.

*A catalogue of the valuable collection of prints and drawings of Henry P. Hope, Esq. consisting of elegant specimens of the Italian, French, Dutch and English engravers . . .*, Leigh and Sotheby, London, 18–26 March 1813.

*A catalogue of an exceedingly valuable assemblage of antique marbles, painted Greek vases, of large size and unusual forms . . .*, Christie's, London, 30 April 1813.

*An assemblage of prints, and high-finished miniature paintings, after the frescoes at Herculaneum and in the Vatican . . .*, Christie's, London, 1 May 1813.

*A catalogue of a valuable collection of Italian, French, Flemish and Dutch pictures, the property of an amateur of fashion . . .*, Christie's, London, 15 May 1813.

*A catalogue of the highly distinguished and very celebrated collection of Italian, French, Flemish and Dutch pictures, the genuine property of Henry Hope, Esq: deceased. Which will be sold by auction, by Mr. Christie, at Mr. Hope's mansion, Cavendish Square, corner of Harley Street*, Christie's, London, 27–29 June 1816.

*A catalogue of the elegant and modern household furniture..., the genuine property of Henry Hope, Esq. which will be sold by auction (without reserve) by Mr. Christie, on the premises, corner of Harley Street, Cavendish Square*, Christie's, London, 3–6 July 1816.

*A catalogue of the remainder of the elegant and modern household furniture . . .*, Christie's, London, 11–13, 16–17 July 1816.

*A catalogue of prints and fine books of prints, the property of Henry Hope, Esq. removed from Cavendish Square . . .*, Sotheby's, London, 5–7 December 1816.

*A catalogue of the elegant library of H. H. of Cavendish Square*, Mr. Saunders, London, 10–15 March 1817.

*A catalogue of . . . the beautiful collection of pictures of the very highest class, of William Williams Hope, Esq., partly from Rushton Hall, Northamptonshire . . .*, Christie & Manson, London, 14–16 June 1849.

*Catalogue du riche mobilier objets d'art & de curiosité . . . dépendant de la succession de feu M. W. Hope*, sold at rue Saint-Dominique-St Germain, no. 131, Paris, 4–9, 11–12, 14–16 June 1855.

*Catalogue de tableaux anciens des écoles flamande, hollandaise et francaise provenant de la galerie de M. W. Hope*, sold at Hotel des commissaires-priseurs, rue Drouot, no. 5, Paris, 11 May 1858.

*Catalogue of the collection of jewels and works of art of the Right Hon. A. J. B. Beresford Hope, M. P., comprising choice examples of Mediaeval and Renaissance art, marbles, bronzes, carvings in ivory and wood, mosaics, Limoges enamels, Majolica and Palissy Ware; fine Oriental Sèvres, Dresden, and other Porcelain; Italian and French decorative furniture, &c; comprising also the greater portion of the celebrated collection of jewels and precious stones formed by the late Henry Philip Hope, Esq.; including Le Saphir Merveilleux, formerly the property of Egalité, Duke of Orleans; the King of Candy's catseye, the Mexican sun opal, the gigantic pearl, and other historic gems, for some years past exhibited at the South Kensington Museum*, Christie, Manson & Woods, London, 12–14 May 1886.

*Catalogue of the collection of pictures, chiefly of the early Italian & Flemish schools, of the Rt. Hon. A. J. B. Beresford-Hope, M. P.*, Christie, Manson & Woods, London, 15 May 1886.

*Also, a pair of candelabra, the property of Rt. Hon. A. J. B. Beresford Hope, M.P., deceased*, Christie, Manson & Woods, London, 10 May 1888.

[Rt. Hon. A. J. B. Beresford-Hope], Sotheby's, London, 28–29 May 1888.

[Rt. Hon. A. J. B. Beresford-Hope], Sotheby's, London, 8–9, 11–15 June 1888.

*Catalogue of a portion of the library of the late right Hon. A. J. B. Beresford-Hope, . . . removed from Bedgebury Park, Kent (and from the Albany, Piccadilly)*, Sotheby's, London, 27–30 July 1892.

*Catalogue of the renowned collection of pictures by old masters, formed by the late Adrian Hope, Esq. . . . .*, Christie, Manson & Woods, London, 30 June 1894.

*Catalogue of the valuable collection of engravings after Sir E. Landseer and the old Italian masters, the property of Adrian Hope, Esq.*, Christie, Manson & Woods, London, 3 July 1894.

*Catalogue of old Venetian glass, old German glass & ware, antique painted Italo-Greek, Greek, and Etruscan vases, the property of Adrian Hope, Esq.*, Christie, Manson & Woods, London, 13 July 1894.

*Important pictures of the Early English School and works by old masters . . . Adrian C. F. Hope [More House, 34 Tite Street], Esq. deceased*, Christie, Manson & Woods, London, 25 June 1904.

*Empire decorative objects of Adrian E. Hope, Esq. who is giving up his residence, 55 Prince's Gate, SW*, Christie, Manson & Woods, London, 26 March 1909.

*Catalogue of old English & foreign silver & silver-gilt jewels, miniatures & enamel portraits being a portion of the Hope heirlooms removed from Deepdene, Dorking the property of Lord Francis Pelham Clinton Hope*, Christie, Manson & Woods, London, 17 July 1917.

*Catalogue of objects of art, porcelain, old English and other furniture being a portion of the Hope heirlooms removed from Deepdene, Dorking the property of Lord Francis Pelham Clinton Hope*, Christie, Manson & Woods, London, 18–19 July 1917.

*Catalogue of important pictures by old masters and family portraits being a portion of the Hope heirlooms removed from Deepdene, Dorking the property of Lord Francis Pelham Clinton Hope*, Christie, Manson & Woods, London, 20 July 1917.

*Catalogue of the celebrated collection of Greek, Roman & Egyptian sculpture and ancient Greek vases being a portion of the Hope heirlooms removed from Deepdene, Dorking the property of Lord Francis Pelham Clinton Hope*, Christie, Manson & Woods, London, 23–24 July 1917.

*Catalogue of the valuable library of books on architecture, costume, sculpture, antiquities, etc., formed by Thomas Hope, esq., author of "The Costume of the Ancients," "Anastasius, or Memoirs of a Greek," etc., etc. being a portion of the Hope heirlooms removed from Deepdene, Dorking the property of Lord Francis Pelham Clinton Hope*, Christie, Manson & Woods, London, 25–27 July 1917.

*The property of the honourable Lord Francis Pelham Clinton Hope. The Deepdene, Dorking, Surrey. . . . The contents of the mansion embracing the costly appointment of 40 bed rooms, billiard room, statue gallery, nine reception rooms, halls and numerous offices*, Humbert & Flint, 12–14, 17–19 September 1917.

*By directions of Lord Francis Hope. The Castle, Castleblayney, Co. Monaghan, Ireland. Catalogue of the antique furniture . . .*, John Gillespie, solicitor and estate agent, Hope estate offices, Castleblayney. Harry Molloy, auctioneer and valuer, Castleblayney, 16–18, 20–22 September 1926.

## PUBLISHED SOURCES, WEB-BASED

John Murray Archive, University of Cardiff: www.british-fiction.cf.ac.uk.

John Orbell, "Hope Family (per. c. 1700–1813)," Oxford Dictionary of National Biography: www.oxforddnb.com.

John Orbell, "Thomas Hope (1769–1831)," Oxford Dictionary of National Biography, Oxford University Press: www.oxforddnb.com.

Mary S. Millar, "Henry Thomas Hope (1808–1862)," Oxford Dictionary of National Biography: www.oxforddnb.com.

J. Mordaunt Crook, "Alexander James Beresford Beresford Hope (1820–1887)," Oxford Dictionary of National Biography: www.oxforddnb.com.

## PUBLISHED SOURCES

*A Catalogue of Pictures of the Dutch and Flemish Schools Lent to the South Kensington Museum, The Property of Mrs. Henry Thomas Hope*. London: Printed by George E. Eyre and William Spottiswoode for Her Majesty's Stationery Office, 1868.

*A Catalogue of the Collection of Pearls and Precious Stones formed by Henry Philip Hope, Esq. Systematically arranged and described by B. Hertz*. London: Printed by William Clowes and Sons, 1839.

"A Collection of Silver-Gilt assembled by Mr. and Mrs. Frederick Poke." *Connoisseur* (June 1957): 24–25.

*A New Survey of London*, vol. 1. London, 1853.

Ackermann, Rudolph. *The Repository of Arts, Literature, Fashions, Manufactures etc*. London: Ackermann, 1809–29.

"Acquisitions in British Museums and Galleries made with the help of the Heritage Lottery Fund and the National Heritage Memorial Fund since January 1995," *Burlington Magazine* 139 (January 1997): 74–80.

*The Age of Neo-Classicism*. Exh. cat. London: Arts Council of Great Britain, 1972.

Aikin, Edmund. *Designs for Villas and Other Rural Buildings* (dedicated to Thomas Hope). London: 1808.

Aikin, Edmund. *An Essay on the Doric Order of Architecture*. London: London Architectural Society, 1810.

Airlie, Mabell, Countess of. *Lady Palmerston and Her Times*. 2 vols. London: Hodder and Stoughton, 1922.

Ajootian, Aileen. "Hermaphroditos." In *Lexicon iconographicum mythologiae classicae*, vol. 5. Zurich and Munich: Artemis, 1990, pp. 270–85.

Ajootian, Aileen. "Praxiteles." In *Personal Styles in Greek Sculpture*. Ed. by Olga Palagia and Jerome Jordan Pollitt. Cambridge: Cambridge University Press, 1996, pp. 81–129.

Alden, Maureen. "Ancient Greek Dress." *Costume* 37 (2003): 1–15.

Almeida, Hermione de, and George H. Gilpin. *Indian Renaissance: British Romantic Art and the Prospect of India*. Aldershot, U.K., and Burlington, Vt.: Ashgate, 2005.

Alten, Friedrich von. *Aus Tischbein's Leben und Briefwechsel*. Leipzig: E. A. Seemann, 1872.

*An Account of all the pictures exhibited in the rooms of the British Institution, from 1813 to 1823, belonging to the nobility and gentry of England*. London: Priestley and Weale, 1824.

*Ancient Egyptian Sculpture lent by C. S. Gulbenkian*. Exh. cat. London: British Museum, 1937.

Anglesey, Marquess of, ed. *The Capel Letters*. London: Jonathan Cape, 1955.

Anonymous. "'Athena' Hope und Winckelmanns Pallas." *Kaiserlich Deutsches Archäologischen Institut Jahrbuch* 28 (1912–13).

Anonymous. "A Correct Catalogue of the Works of Mr West." *Public Characters of 1805* (1804): 559–69.

Anonymous. "George Dawe. A Biography." *Library of the Fine Arts* 1 (1831): 10–11.

*Antike Marmorskulptur auf Scholß Broadlands*. Monumenta Artis Romanae, vol. 21. Mainz am Rhein: Philipp von Zabern, 1994.

*Antiquity Explained, and Represented in Sculptures*. 2 vols. London: J. Tonson and J. Watts, 1721–22.

Arbuthnot, Harriet. *The Journal of Mrs. Arbuthnot*. 2 vols. Ed. by Bamford, Francis, and the Duke of Wellington. London: Macmillan, 1950.

Archer, Mildred. "Architecture of the Oriental Genius: with the Daniells in South India." *Country Life* 153 (8 November 1973).

Archer, Mildred. *Early Views of India: The Picturesque Journey of Thomas and William Daniell, 1786–1794*. New York: Thames and Hudson, 1980.

Architectural Association. *Joseph Michael Gandy (1771–1843)*. Exh. cat. London: Architectural Association, 1982.

*Art Treasures in England: The Regional Collections*. Exh. cat. Ed. by Jane Martineau. London: Royal Academy of Arts, 1998.

Ashton, Sally-Ann. "The Ptolemaic Royal Image and the Egyptian Tradition." In Edward William John Tait, ed. *"Never had the like occurred": Egypt's View of Its Past*. London: University College, 2003.

Ashton, Sally-Ann. *Roman Egyptomania*. London: Golden House Publications, 2005.

*Atlante delle forme ceramiche. Enciclopedia dell'arte antica classica e orientale*. Rome: Istituto delle Enciclopedia Italiana, 1981.

*Au temps des merveilleuses: la société parisienne sous le Directoire et le Consulat*. Exh. cat. Paris: Musées de la Ville de Paris, 2005.

Aubrey, John. *The Natural History and Antiquities of the County of Surrey*, vol. 4. London: E. Curll, 1718–19.

Augarde, Jean-Dominique. "Une nouvelle vision du bronze et des bronziers sous le directoire et l'Empire." *L'Objet d'Art* (January 2005).

Bailey, C. J. "The English Poussin: An Introduction to the Life and Work of George Augustus Wallis." *Walker Art Gallery Annual Report and Bulletin* 6 (1975–76): 35–54.

Baker, C. H. Collins, and Muriel I. Baker. *The Life and Circumstances of James Brydges First Duke of Chandos, Patron of the Liberal Arts*. Oxford: Clarendon Press, 1949.

Baker, Hollis S. *Furniture in the Ancient World*. London: Connoisseur, 1966.

Baker, T. F. T. *A History of the County of Middlesex*, vol. 9. Oxford: Oxford University Press, 1989.

Ballantyne, Andrew. "Specimens of Antient Sculpture: Imperialism and the decline of art." *Art History* 25, no. 4 (September 2002).

Balston, Thomas. *John Martin*. London: Duckworth, 1947.

Baltimore Museum of Art. *Classical Taste in America, 1800–1840*. Baltimore: Baltimore Museum of Art, 1993.

Banks, Thomas. *Annals of Thomas Banks*. Ed. by C. F. Banks. Cambridge: Cambridge University Press, 1938.

Barberini, Maria. *Bartolomeo Cavaceppi scultore romano (1717–1799)*. Ed. by Maria Giulia and Carlo Gasparri. Exh. cat. Rome: Fratelli Palombi, 1994.

Bartels, Heinrich. *Studien zum Frauenporträt der augusteischen Zeit; Fulvia, Octavia, Livia, Julia*. Munich: Feder, 1963.

Baumgarten, Sandor. *Le crépuscule Néo-Classique: Thomas Hope*. Paris: Didier, 1958.

Baxter, Thomas. *An Illustration of the Egyptian, Grecian and Roman Costume in Forty Outlines*. London: William Miller, 1810.

Baïant, J. "Pothos I." In *Lexicon iconographicum mythologiae classicae*, vol. 7. Zurich and Munich: Artemis, 1994, pp. 502–3.

Beard, Geoffrey and Christopher Gilbert, eds. *The Dictionary of English Furniture Makers 1660–1840*. Leeds: Furniture History Society and W. S. Maney, 1986.

Beaumont, Alice M. *As 50 melhores obras de arte em Museus Portugueses, Lisbon*. Lisbon: Chaves Ferreira, 1991.

Beazley, John Davidson. *Attic Red-Figure Vase-Painters*, vol. 2. 2nd ed. Oxford: Clarendon Press, 1963.

Beazley, John Davidson. *Paralipomena: Additions to Attic Black-figure Vase-Painters and to Attic Red-figure Vase-Painters*. 2nd ed. Oxford: Clarendon Press, 1971.

Becatti, Giovanni. *Ninfe e divinità marine. Ricerche mitologiche iconografiche e stilistiche*. Studi Miscellanei 17. Rome: De Luca, 1971.

Beckett, R. B., ed. *John Constable: Further Documents and Correspondence*, vol. 18. London: Tate Gallery and Suffolk Records Society, 1975.

*Bell's Weekly Messenger*, no. 1828 (10 April 1831).

Bellaigue, G. de. "Samuel Parker and the Vulliamys, purveyors of gilt bronze." *Burlington Magazine* 117 (January 1977): 26–38.

Bénézit, Emmanuel. *Dictionnaire critique et documentaire des peintres, sculpteurs, dessinateurs et graveurs*. 14 vols. Paris: Editions Gründ, 1999.

Bennett, Shelley. *Thomas Stothard and the Mechanisms of Art Patronage in England c. 1800*. Cambridge: Cambridge University Press, 1997.

Bentley, Gerald E. Jr. *The Early Engravings of Flaxman's Classical Designs: A Bibliographical Study*. New York: New York Public Library, 1964.

Bentley, Gerald E. Jr. "Flaxman in Italy: A Letter Reflecting the *Anni Mirabilis*, 1792–93." *Art Bulletin* 62 (December 1981): 658–62.

Beresford Chancellor, E. *Life in Regency and Early Victorian Times*. London: Batsford, 1926.

Beresford Hope, Alexander. *The English Cathedral of the Nineteenth Century*. London: John Murray, 1861.

*Bertel Thorvaldsen: Skulpturen, Modelle, Bozzetti, Handzeichnung*. Exh. cat. Cologne: Museen der Stadt Koln, 1977.

Beschi, L. "Nuovi disegni di L. S. Fauvel nella collezione di Thomas Hope." In F. Prontera, *Geographia Storica della Grecia Antica: Tradizioni e problemi*. Rome, 1991, pp. 24–45.

Bilbey, Diane, with Marjorie Trusted. *British Sculpture 1470–2000: A concise catalogue of the collections at the Victoria and Albert Museum*. London: V&A Publications, 2002.

Bille, Clara. *De Tempel der kunst of het kabinet van den Heer Braamcamp*. Amsterdam: J. H. de Bussy, 1961.

Bindman, David, *John Flaxman*. London: Thames and Hudson, 1979.

Bindman, David, ed. *John Flaxman 1755–1826: Master of the Purest Line*. Exh. cat. London: Sir John Soane's Museum and University College London, 2003.

Bindman, David, and Hannah Hohl, eds. *John Flaxman: Mythologie und Industrie*. Exh. cat. Kunsthalle, Hamburg. Munich: Prestel, 1979.

Bindman, David. "John Flaxman: Sculptor and Illustrator." In Salvadori, *John Flaxman* (2005).

*Biographie Universelle*, vol. 19. Paris, 1857.

Birnbaum, Martin. "An Essay on John Flaxman with Special Reference to His Drawings." *International Studio* 65 (1918). Reprinted in *Catalogue of an Exhibition of Original Drawings by John Flaxman, R.A.*, 1918.

Birnbaum, Martin. *Jacovleff and Other Artists. . . .* New York: P. A. Struck, 1946.

Birnbaum, Martin. "John Flaxman." In *Introductions. Painters, Sculptors and Graphic Artists*. New York: F. F. Sherman, 1919.

Birnbaum, Martin. *Original Water-Colour Drawing by William Blake to Illustrate Dante*. Exh. cat. New York: Scott and Fowles, 1921.

Bishop, Morchand, ed. *Recollections of the Table Talk of Samuel Rogers*. London: Richards Press, 1952.

Bizzarro, Tina. *Romanesque Architectural Criticism: A Prehistory*. Cambridge: Cambridge University Press, 1992.

Blunt, Anthony. *The Paintings of Nicolas Poussin: A Critical Catalogue*. London: Phaidon, 1966.

Boardman, John. "Herakles." In *Lexicon iconographicum mythologiae classicae*, vol. 5. Zurich and Munich: Artemis, 1990.

Bolton, Arthur T. *The Architecture of Robert and James Adam*. 2 vols. London: Country Life, 1922.

Borghini, Gabriele, ed. *Marmi Antichi*. Rome: De Luca, 1997, 2004.

Bormann, Eugen. *Inscriptiones Aemiliae, Etruriae, Umbriae latinae, Corpus inscriptionum latinaru*, vol. 11. Berlin: G. Reimerum, 1888.

Bothmer, Bernard. *Egyptian Sculpture of the Late Period*. Exh. cat. Brooklyn: Brooklyn Museum, 1960.

Bothmer, Dietrich von. "Greek vase-painting, two hundred years of connoisseurship." *Papers on the Amasis Painter and His World*. Malibu: Getty Museum Publications, 1987, pp. 184–204.

Boyle, M. *Boyle's New Fashionable Court and County Court Guide, and Town Visiting Directory*. London, 1843.

Boys, A. "The Regency Exhibition at the Royal Pavilion, Brighton." *Country Life* 100 (1946).

Brayley, Edward Wedlake, with J. Britton and E. W. Brayley Jr. *A Topographical History of Surrey*. 5 vols. London, 1841–48.

Brett, Vanessa. *The Sotheby's Dictionary of Silver*. London: Sotheby's, 1986.

Brewer, James Norris. *Introduction to . . . The Beauties of England and Wales*. London: Harris et al., 1818.

*British Architectural Library, Early Printed Books 1478–1840*, vol. 4. Munich: K. G. Saur, 2001.

*British Critic* 32 (1809): 441, 445, 447, 452. Review of Hope's *Household Furniture*.

British Museum. *Dept. of Greek and Roman Antiquities*. London, 17 June–31 August 1987.

Britton, John. *Architectural Antiquities of Great Britain*, vol. 2. London: Longman, Hurst, Rees and Orme, 1809.

Britton, John. *The Auto-Biography of John Britton*. London: The Author, 1848.

Britton, John. *The Fine Arts of the English School illustrated by a series of Engravings, Paintings, Sculpture, and Architecture of Eminent English Artists*. London: Longman, Hurst, Rees, Orme, and Brown, 1812.

Britton, John. *Graphical and Literary Illustrations of Fonthill Abbey, Wiltshire*. London: The Author, 1823.

Britton, John. *The Union of Architecture, Sculpture and Painting . . . The House and Galleries of John Soane*. London: The Author, 1827.

Britton, John, and A. C. Pugin. *Illustrations of the Public Buildings of London*. 2 vols. London: J. Taylor, 1825–28.

Broos, Ben P. J. *Great Dutch Paintings from America*. Exh. cat. The Hague: Waanders, 1990.

Brown, David Blayney, Robert Woof, and Stephen Henbron. *Benjamin Robert Haydon 1786–1846, Painter and Writer, Friend of Wordsworth and Keats*. Exh. cat. London: The Wordsworth Trust, 1996.

Brown, Richard. *Rudiments of Drawing Cabinet and Upholstery Furniture*. 2nd ed. London, 1822.

Buchanan, William. *Memoirs of Painting with a chronological history of the importation of pictures by the great masters into England since the French revolution*. 2 vols. London, 1824.

Buchanan, William. *William Buchanan and the 19th-Century Art Trade: 100 letters to his agents in London and Italy*. Ed. by Hugh Brigstocke. London: Art Documents, 1982.

Buckrell Pos, Tania. "Tatham and Italy: Influences on English Neo-Classical Design." *Furniture History* 38 (2002): 58–82.

Budde, Ludwig, and Richard Nicholls. *A Catalogue of the Greek and Roman Sculpture in the Fitzwilliam Museum, Cambridge*. Cambridge: Cambridge University Press, 1967.

*The Builder* 7 (1 December 1849), 572; (20 October 1849): 493–94, 498–99, 534. Relates to Henry Thomas Hope's house on Piccadillly.

Buist, M. G. "The Sinews of War: The Role of Dutch Finance in European Politics (1750–1815)." In *Britain and the Netherlands*. Vol. 6, *War and Society*. Ed. by A. C. Duke and C. A. Tamse. The Hague, 1977.

Buist, Marten G. *At spes non fracta: Hope & Co. 1770–1815, Merchant Bankers and Diplomats at Work*. The Hague: Bank Mees and Hope, 1974.

Burfield, Diana, *Edward Cresy 1792-1858, Architect and Civil Engineer*. Shaun Tyas: Donington, 2003.

*Cabinet de l'art de Sculpture par le fameuse Sculpteur Francis can Bossuff. Executé en Yvoire ou Ebauché en Terre Graveés d'apres les desseins de Barent Graaf*. Amsterdam, 1727.

Cain, Hans-Ulrich. *Römische Marmorkandelaber*. Mainz am Rhein: Philipp von Zabern, 1985.

*Calouste Gulbenkian Museum*. Lisbon: Calouste Gulbenkian Foundation, 2001.

*Calouste Sarkis Gulbenkian: Uma doacao ao Museu Nacional de Arte Antiga, no. 25 aniversario do Museu de Arte Gulbenkian*. Lisbon: Calouste Gulbenkian Foundation, 1994.

Carey, William. *Some Memoirs of the Patronage and Progress of the Fine Arts in England and Ireland*. London: Saunders & Ottley, 1826.

*Carlton House: The Past Glories of George IV's Palace*. Exh. cat. London: The Queen's Gallery, Buckingham Palace, 1991.

Carpenter, Thomas H., Thomas Mannack, and Melanie Mendonça. *Beazley Addenda*. 2nd ed. Oxford: Oxford University Press, 1989.

Carstens, A. J. *Die Argonauten*. Rome, 1796.

Castiglione, L. "Tables votives à empreintes de pied dans les temples d'Égypte." In *Acta Orientalia Academiae Scientiarum Hungaricae* 20 (1967): 239–52.

*Catalogue of an exhibition, containing an extensive selection of the finest specimens of the old masters, in the cabinets and galleries of the United Kingdom*. London: British Gallery of Pictures, 1812.

*Catalogue of an exhibition of a selection of the works of Richard Westall R.A., including two hundred and forty pictures and drawings which have never been exhibited*. London: Printed by Joyce Gold, 1814.

*Catalogue of Loan Exhibition of English Decorative Art at Lansdowne House*. Exh. cat. London: Harrison and Sons, 1929.

*Catalogue of Pictures of the Dutch and Flemish Schools Lent to the South Kensington Museum by Sir Francis Pelham Clinton-Hope*. London: Eyre & Spottiswoode, 1891.

Caylus, A.-C.-P., Comte de. *Recueil d'antiquités Égyptiennes, Étrusques et Romaines*. Paris, 1767.

Caylus, A.-C.-P., Comte de. *Tableaux tirés de l'Iliade et de l'Odysée d'Homère et de l'Enéide de Virgile*. Paris, 1757.

Chapman, Martin. "Techniques of Mercury Gilding in the Eighteenth Century." *Ancient and Historic Metals*. Malibu: The Getty Conservation Institute, 1995, pp. 229–38.

Chapman, Martin. "Thomas Hope's Vase and Alexis Decaix." *V&A Album* 4 (1985): 216–28.

Cicognara, L. *Biografia di Antonio Canova*. Venice, 1823.

Cipriani, Angela N. "Camillo Pacetti." In *Art in Rome in the Eighteenth Century*. Ed. by Joseph J. Rishel and Edgar Peters Bowron. Philadelphia: Philadelphia Museum of Art, 2000.

Cirakman, Ash. *From the Terror of the World to the Sick Man of Europe: European Images of the Ottoman Empire from the 16th to the 19th century*. New York: Peter Lang, 2002.

Clarac, Comte Frédéric de. *Musée de sculpture antique et moderne*, vol. 5. Paris, 1826–53.

Clark, D. "The Clark Cope of Antonio Canova's Hope Venus." In *The William A. Clark Collection*. Exh. cat. Washington: Corcoran Gallery of Art, 1978.

Clarke, Michael, and Nicholas Penny, eds. *The Arrogant Connoisseur: Richard Payne Knight 1751–1824*. Manchester: Manchester University Press, 1982.

*Classical Antiquities from Private Collections in Great Britain*. London: Sotheby's, 1986.

Clay, Andrew, Edward Morris, Sandra Penketh, and Timothy Stevens. *British Sculpture in the Lady Lever Art Gallery*. Liverpool, 1999.

Clayden, Peter W. *Rogers and His Contemporaries*, vol. 1. London: Smith, Elder & Co., 1889.

Clayden, Peter W. *The Early Life of Samuel Rogers*. London: Smith, Elder & Co., 1887.

Clayton, M. *The Collector's Dictionary of Silver and Gold of Great Britain and North America*. 2nd ed. Woodbridge: Antique Collectors' Club, 1985.

Cleveland, Duchess of. *The Life and Letters of Lady Hester Stanhope*. London: John Murray, 1914.

Cleveland Museum of Art. *Still-Life from the Netherlands, 1550–1720*. Exh. cat. Cleveland: Cleveland Museum of Art, 1999–2000.

Clifford, Timothy. "Vuillamy Clock & British Sculpture." *Apollo* 132 (October 1990): 226–37.

Clifford, Timothy. "'Thomas Hope's Shepherd Boy.'" *Connoisseur* 175 (September 1970): 12–16.

Cobbe, F. P. *Beresford of Beresford: Eight Centuries of a Gentle Family*, part III. Leek, 1893.

Cohon, Robert. *Greek and Roman Stone Table Supports with Decorative Reliefs*. Ann Arbor: University Microfilms, 1984.

Collard, Frances. *Regency Furniture*. Woodbridge: Antique Collectors' Club, 1985.

Collard, Frances. "The Taste for Regency and Empire Furniture in the later Nineteenth Century." *V&A Album* 3 (1984): 302–10.

Colvin, H. M. *A Biographical Dictionary of British Architects, 1600–1840*. 3rd ed. New Haven and London: Yale University Press, 1995.

Compton, Michael. "The Architecture of Daylight." In *Palaces of Art: Art Galleries in Britain, 1790–1990*. Ed. by Giles Waterfield. London: Dulwich Picture Gallery, 1991.

Conner, Patrick, ed. *The Inspiration of Egypt: Its Influence on British Artists, Travellers and Designers, 1700–1900*. Exh. cat. Brighton: Brighton Borough Council, 1983.

Connor, Peter. *Roman Art in the National Museum of Victoria*. Melbourne: National Gallery of Victoria, 1978.

Cook, Brian. "The Townley Marbles in Westminster and Bloomsbury." *Collectors and Collections, British Museum Yearbook* 2 (1977): 34–78.

Cook, Brian. *The Townley Marbles*. London: British Museum, 1985.

Cook, R. M. *Greek Painted Pottery*. 3rd ed. London: Routledge, 1996.

Corbett, Patricia. "Mario Praz Museum, Rome." *Apollo* (December 1996): 13–14.

Cornforth, John. *The Inspiration of the Past: Country House Taste in the Twentieth Century*. London: Viking, 1985.

Cornforth, John. *London Interiors: From the Archives of "Country Life."* London: Aurum Press, 2000.

Cornforth, John. *English Interiors 1790–1848: The Quest for Comfort*. London: Barrie & Jenkins, 1978.

Corso, Antonio. *Prassitele: Fonti epigrafiche e letterarie Vita e opera*. Rome: De Luca, 1988.

Cristofani, Mauro, ed. *Siena, le origini: testimonianze e miti archeologici*. Florence: L. S. Olschki, 1979.

Croft-Murray, Edward, ed. "An Account Book of John Flaxman, R.A. (B.M., ADD.MSS.39,784. B.B.)." *Walpole Society* 28 (1939–40): 51–93.

Crozet, René. "Le peintre Louis Gauffier." *Bulletin de la Société de l'art français* (1941–44): 100–113.

Cumberland, George. *Thoughts on Outline, Sculpture, and the system that guided the ancient artists in composing their figures and groups, etc.* London: Printed by W. Wilson, 1796.

Curl, James Stevens. *The Egyptian Revival. Ancient Egypt as the Inspiration for Design Motifs in the West*. Abingdon, Oxon: Routledge, 2005.

Curti, Francesca. *La bottega del pittore di Meleagro*. Rome: Giorgio Bretschneider, 2001.

Cust, Lionel Henry, and Sidney Colvin. *History of the Society of Dilettanti*. 2nd ed. London: Macmillan, 1914.

Cuzin, Jean-Pierre P, Jean-René Gaborit, and Alain Pasquier. *D'après l'antique*. Paris: Réunion des musées nationaux, 2001.

*The Daily Telegraph Exhibition of Antiques and Works of Art*. Exh. cat. London: Daily Telegraph, 1928.

Dalhoff, N., ed. *Jørgen Balthasar Dalhoff: et liv I arbedje*. Copenhagen, 1915–16.

Dallaway, J. *Of Statuary and Sculpture among the Antients. With some account of specimens preserved in England*. London: John Murray, 1816.

Darval, Peter. "Adam Buck and His London Family." *Burlington Magazine* 131 (November 1989): 775–76.

"Deaths in and near London: Henry Hope." *Monthly Magazine* 31, no. 211 (1 April 1811): 282–83.

*De beeldhouwkunst in de eeuw van Rubens*. Exh. cat. Brussels: Museum voor Oude Kunst, Brussels, 1977.

De Divitis, Bianca. "New Drawings for the Interiors of the Breakfast Room and Library at Pitzhanger Manor." *Architectural History* 48 (2005): 164.

"[The Deepdene] [Duchess of Marlborough at Deepdene]," *Country Life* 5 (1899): 624–28.

Defauconpret, A.-J.-B. *Londres en mil huit cent vingt*. Paris, 1821.

Delcourt, Marie. *Hermaphroditea: Recherches sur l'être double promoteur de la fertilité dans le monde classique*. Brussels: Latomus Revue d'Études Latines, 1966.

Delecluze, Étienne Jean. *Louis David, son école et son temps*, Paris: Didier, 1855.

Delivorrias, Angelos, Gratia Berger-Doer, and Anneliese Kossatz-Deissman. "Aphrodite." In *Lexicon iconographicum mythologiae classicae*, vol. 2. Zurich and Munich: Artemis, 1984.

Demargne, Pierre. "Athena."In *Lexicon iconographicum mythologiae classicae*, vol. 2. Zurich and Munich: Artemis, 1984.

de Montaiglon, Anatole, ed. *Correspondance des Directeurs de l'Académie de France à Rome*. 18 vols. Paris, 1887–1912.

de Montfaucon, Bernard. *Antiquity Explained, and Represented in Sculptures*. 2 vols. London: J. Tonson and J. Watts, 1721–22.

Denon, Dominique-Vivant. *Voyages dans le Basse and La Haute Egypte, pendant les Campagnes de Général Bonaparte*. Paris: P. Didot, 1802.

De Putter, T., and C. Karlshausen. *Les Pierres utilisées dans la sculpture et l'architecture de l'Égypte pharaonique*. Paris: Connaissance de l'Egypte Ancienne, 1992.

*Description of the Villa of Mr. Horace Walpole . . . at Strawberry-Hill*. Strawberry-Hill, 1784; reprinted London: Gregg Press, 1964.

Desgodetz, Antoine. *Les Edifices Antiques de Rome*. Paris: Coignard, 1682.

Desjobert, Louis. "Voyage aux Pays Bas en 1778 par Louis Desjobert . . . publié par le Vic. de Grouchy." *De Navorscher* 59 (1910).

Desroches-Noblecourt, Christiane. *Les Animaux dans l'Egypte Ancienne*. Lyon, 1978.

de Vries, Jan, and Ad van der Woude. *The First Modern Economy: Success, Failure, and Perseverance of the Dutch Economy, 1500–1815*. Cambridge: Cambridge University Press, 1997.

Dibdin, Thomas Frognall. *The Bibliographical Decameron*. London: The Author, 1817.

Didier Aaron Gallery. *A Timeless Heritage*. New York: Didier Aaron Gallery, 1987.

Di Puolo, Maurizio. "Socrates." In Moreno, *Lisippo* (1995).

*Dio's Roman History*, vol. 8. Trans. by E. Cary. New York: Macmillan, 1925.

Disraeli, Benjamin. *Lord Beaconsfield's Correspondence with His Sister*. London: John Murray, 1886.

*Dizionario Biografico degli Italiani*, vol. 13. Rome: Fondata da Giovanni Treccani, 1971.

Dobrée, Bonamy, and Geoffrey Webb, eds. *The Complete Works of Sir John Vanbrugh*, vol. 4. London: Nonesuch Press, 1928.

*Dominique-Vivant Denon: l'oeil de Napoléon*. Exh. cat. Paris: Réunion des musées nationaux, 1999.

Douglas, Sylvester. *Diaries of Sylvester Douglas, Lord Glenbervie*. London, 1928.

Dubost, Antoine. *Hunt and Hope*. London, 1810.

Dunthorne, Hugh. "British Travellers in Eighteenth-Century Holland: Tourism and the Appreciation of Dutch Culture." *British Journal for Eighteenth-Century Studies* 5, no.1 (1982).

Dutton, Ralph. *The English Interior: 1500 to 1900*. London: Batsford, 1948.

Dwyer, Eugene J. *Pompeian Domestic Sculpture: A Study of Five Pompeian Houses and Their Contents*. Rome: Giorgio Bretschneider, 1982.

Dyce, Rev. Alexander, ed. *Recollections of the Table-Talk of Samuel Rogers*. London: E. Moxon, 1856, 1887.

Edgeworth, Maria. *Letters from England, 1813–44*. Ed. by Christina Colvin. Oxford: Clarendon Press, 1971.

Edwards, Diana. "Thomas Hope's Wedgwood Purchases." *Ars Ceramica* 13 (1996): 24–29.

Edwards, Edward. *Lives of the Founders of the British Museum*, 2 parts. London: Trübner and Company, 1870.

Edwards, Ralph. *Shorter Dictionary of English Furniture, from the Middle Ages to the Late Georgian Period*. London: Country Life, 1964.

*Egyptian Sculpture from the Gulbenkian Collection*. Exh. cat. Washington, D.C.: National Gallery of Art, 1949.

*Egyptomania: Egypt in Western Art, 1730–1930*. Exh. cat. Ottawa: National Gallery of Canada; Paris, Réunion des musées nationaux, 1994–95.

Eijnden, Roeland van, and Adriaan van der Willigen. *Geschiedenis der Vaderlandsche Schilderkunst*, vol. 3. Haarlem, 1820; reprinted Amsterdam, 1976.

Elias, Johan E. *De Vroedschap van Amsterdam 1578–1795*. 2 vols. Amsterdam, 1903–5.

Eliot, C. W. "Lord Byron and the Monastery at Delphi." *American Journal of Archaeology* 71 (1967).

Elliot, R. C. "Historic and Stately Homes." *Sunday Mirror*, 20 May 1966.

Ellwood, Giles. "James Newton." *Furniture History* 31 (1995): 129–205.

Elmes, James. "A letter to T. Hope . . . on the insufficiency of the existing establishments for promoting the fine arts." *The Pamphleteer* 3 (1813).

Ensoli, Serena. "Eracle Epitrapezio." In Moreno, *Lisippo* (1995).

Ensoli, Serena. "Vecchio Sileno." In Moreno, *Lisippo* (1995).

Erffa, Helmut von and Allen Staley. *The Paintings of Benjamin West*. New Haven and London: Yale University Press, 1986.

*Eternal Egypt; Masterworks of Ancient Art from the British Museum*. Exh. cat. Montreal: Montreal Museum of Fine Arts, 2005.

*Europa und der Orient*. Berlin: Martin-Gropius-Bau, 1989.

Evans, Joan. *History of the Society of Antiquaries*. Oxford: Society of Antiquaries, 1956.

*Examiner*, 8 July 1810, 427; 16 Dec. 1810, 794–95, 30 Dec. 1810, 828–29; 12 May 1811, 300.

*Exposition Nicolas Poussin*. Exh. cat. Paris: Réunion des musées nationaux, 1960.

Farington, Joseph. *The Diary of Joseph Farington*. 17 vols. New Haven and London: Yale University Press, 1978–98.

Fawcett, Trevor. *The Rise of English Provincial Art: Artists, Patrons, and Institutions outside London, 1800–1830*. Oxford: Clarendon Press, 1974.

Feltham, John. *Picture of London for 1802, being a correct guide*. London: Phillips, 1802.

Ferdinando Arisi. *Gian Paolo Panini e i fasti della Roma del '700*. 2nd ed. Rome: Bozzi, 1968.

Fernow, C. L. *Über den Bildhauer Antonio Canova und dessen Werke*. Zurich, 1806.

Fiftieth Report of the Reviewing Committee, *Export of Works of Art 2003–2004*. London: Department for Culture, Media and Sport, 2004.

Figueiredo, Maria Rosa. *European Sculpture*, vol. 2. Lisbon: Calouste Gulbenkian Foundation, 1999.

*The Fine Art of Cricket*. London: The Lords, 1997.

Fittschen, Klaus. *Die Bildnisgalerie in Herrenhausen bei Hannover. Zur Rezeptions- und Sammlungsgeschichte antiker Porträts*. Göttingen: Vandenhoeck & Ruprecht, 2005.

Fittschen, Klaus, and Paul Zanker. *Katalog der römischen Porträts in den Capitolinischen Museen und den anderen kommunalen Sammlungen der Stadt Rome*, vol. 3. Mainz am Rhein: Philipp von Zabern, 1983, 1994.

Flaxman, John (as anonymous). *The Annual Review* 7 (1809): 632.

Floryan, Margrete. "*Jasons* skæbne: Om Thomas Hope, hans huse og hobbies." In *Meddelser fra Thorvaldsens Museum*. Copenhagen: Thorwaldsens Museum, 2003, pp. 43–74.

Fogelman, Peggy, and Peter Fusco, Simon Stock, et al. "John Deare (1759–98): A British Neo-Classical Sculptor in Rome." *The Sculpture Journal* 4 (2000).

Forster, Edward. *The British Gallery of Engravings*. London: W. Miller, 1807.

Forster, Edward. "The British Gallery of Engravings, with some account of each picture, and a life of the artist." *Review of Publication of Art* 1 (1808): 22–45, 364–82.

Forster, Edward. *The British Gallery of Pictures selected from the most admired productions of the old masters in Great Britain . . .* London, 1818.

Fosbroke, Thomas Dudley. *Encyclopedia of Antiquities*. 2 vols. London, 1825.

Foskett, Daphne. *A Dictionary of British Miniature Painters*, vol. 1. London: Faber and Faber, 1972.

Foster, V. H. L. *The Two Duchesses*. London, 1898.

Fox, Celina, ed. *London: World City 1800–1840*. New Haven and London: Yale University Press, 1992.

Frankl, Paul. *The Gothic: Literary Sources and Interpretations through Eight Centuries*. Princeton: Princeton University Press, 1960.

Ed. by Douglas Fraser *et al. Essays Presented to Rudolf Wittkower*. London: Phaidon, 1967.

Fredericksen, Burton B., and Frederico Zeri. *Census of Pre-Nineteenth Century Italian Painting in North American Public Collections*. Cambridge, Mass.: Harvard University Press, 1972.

Fredericksen, Burton, ed. *Index of Paintings Sold in the British Isles during the Nineteenth Century*. 4 vols. Oxford: Clio, ca. 1988.

Freely, John. *Inside the Seraglio*. Istanbul, 1999.

Freely, John. *Istanbul. The Imperial City*. London: Viking, 1996.

Freeman, Edward. *A History of Architecture*. London: J. Masters, 1849.

Fremantle, Elizabeth Wynne, and Eugenia Wynne. *The Wynne Diaries*, vol. 3. Oxford: Oxford University Press, 1935.

*French Master Goldsmiths and Silversmiths from the Seventeenth to the Nineteenth Century*. New York: French and European Publications, 1966.

Fuch. "Zum Antinoos Hope und zum 'Cacciatore.'" In *Archäologischer Anzeiger*. Berlin: Kapilotinischen Museum, 1966.

Fullerton, Mark. *The Archaistic Style in Roman Statuary*. Leiden: Brill, 1990.

Fullerton, Peter. "Patronage and Pedagogy: The British Institution in the Early Nineteenth Century." *Art History* (March 1982): 59–72.

Furtwängler, Adolf. *Masterpieces of Greek Sculpture*. London: William Heinemann, 1895.

Gandy, J. M. *Designs for Cottages, Cottage Farms and other Rural Buildings, & The Rural Architect*. 2 vols. London: J. Harding, 1805 (dedicated first volume to Thomas Hope).

Garlick, Kenneth. *Sir Thomas Lawrence: A Complete Catalogue of the Oil Paintings*. Oxford: Phaidon, 1989.

Garnier, Richard. "Alexander Roos (c. 1810–1881)." *The Georgian Group Journal* 15 (2006): 11–68.

Gasparri, Carl, and Alina Veneri. "Dionysos." In *Lexicon iconographicum mythologiae classicae*, vol. 3. Zurich and Munich: Artemis, 1986.

*Gedenkstukken der Algemeene Geschiedenis van Nederland van 1795 tot 1840 uitgegeven door Dr. H. T. Colenbrander. Eerste deel. Nederland en de Revolutie 1789–95*. 'S-Gravenhage, 1908.

Geffen, Rona, ed. *The Calouste Gulbenkian Museum*. Fort Lauderdale: Woodbine Books, 1995.

Gelfer-Jorgensen, Mirjam. *The Dream of a Golden Age: Danish Neo-Classical Furniture 1790–1850*. Humlebæk: Rhodos, 2004.

Gelfer-Jorgensen, Mirjam. *Herculanum paa Sjaelland*. Copenhagen: Rhodos, 1988.

Geominy, Wilfred. "Praxiteles (II)." In *Kunstlerlexikon der Antike* 2 (2004).

*George Bullock Cabinet-Maker*. London: Murray and Blairman & Sons, 1988.

Gercke, Peter. *Satyrn des Praxiteles*. Hamburg: Hamburg University, 1968.

Gerstein, Alexandra, et al. *France in Russia: Empress Josephine's Malmaison Collection*. Exh. cat. London: Fontana, 2007.

Gilbert, Christopher. "London and Provincial Books of Prices: Comment and Bibliography." *Furniture History* 18 (1982): 11–20.

Gilbert, Christopher. *Furniture at Temple Newsam House and Lotherton Hall*. 2 vols. Leeds: National Art Collections Fund, 1978.

Girouard, Mark. *Big Jim: The Life and Work of James Stirling*. London: Chatto & Windus, 1998.

Girouard, Mark. *Life in the English Country House*. New Haven and London: Yale University Press, 1978.

Girouard, Mark. *Sweetness and Light: The "Queen Anne" Movement 1860–1900*. Oxford: Clarendon Press, 1977.

Gloag, John. *A Social History of Furniture Design*. London: Cassell, 1966.

*The Glory of the Goldsmith: Magnificent Gold and Silver from the Al-Tajir Collection*. London: Christie's, 1989.

Goede, Christian A. G. *England, Wales, Irland und Schottland. Errinnerungen an Natur und Kunst aus einer reife in den Jahren 1802 und 1803 von Christian August Gottlieb Goede*, vol. 4. Dresden, 1805.

Goede, Christian A. G. *Memorials of Nature and Art Collected on a Journey to Great Britain during the Years 1802 and 1803*. 3 vols. Trans. by T. Horne. London, 1808.

Goede, Christian A. G. *The Stranger in England; or, Travels in Great Britain*. 3 vols. London, 1807.

Goethe, Johann. *Zur Farbenlehr*. Weimar, 1810.

Gonzáles-Palacios, Alvar. *Il tiempo del gusto. Le arti decorative in Italia fra classicismi e barocco*, vol. 2. Rome: Longanesi, 1984.

Goodison, J. W., ed. *Catalogue of Paintings in the Fitzwilliam Museum, Cambridge, Italian School*. Cambridge: Printed for the Syndics of the Fitzwilliam Museum, 1960–77.

Grandjean. Serge. *Empire Furniture*. London: Faber & Faber, 1966.

Grant, M. H. *Jan van Huysum, 1682–1749*. Leigh-on-Sea: F. Lewis, 1954.

Grassinger, Dagmar. *Römische Marmorkratere*. Monumenta Artis Romanae, vol. 18. Mainz am Rhein: Philip von Zabern, 1991.

Grenier, J-C. *La Décoration statuaire du "Serapeum" du "Canope" de la Villa Adriana*. Rome: Monumenti, Musei e Gallerie Pontificie École Française de Rome, 1990.

Guattani, Giuseppe Antonio. *Memorie Enciclopediche Romane sulle belle arti, antichita, &c.* 5 vols. Rome, 1806–7.

Guattani, Giuseppe Antonio. *Monumenti inediti di Roma*. Rome, 1806–7.

Guilding, Ruth. *Marble Mania: Sculpture Galleries in England 1640–1840*. Exh. cat. London: Sir John Soane's Museum, 2001.

Guilding, Ruth. "Robert Adam and Charles Townley, the development of the top-lit sculpture gallery." *Apollo* 143 (1996): 27–32.

Gunn, Ann. "Guy Head's 'Venus and Juno.'" *Burlington Magazine* 133 (1991): 510–13.

Gunnis, Rupert. *Dictionary of British Sculptors 1660–1851*. Rev. ed. London: The Abbey Library, 1968.

Gusman, Pierre. *L'art décoratif de Rome de la fin de la République au IVe siècle*, vol. 1. Paris: Ch. Eggimann, 1908.

Guthrie, J., and A. Dale. *Beach House, Worthing*. Worthing: Aldridge Bros., 1947.

Hale, John R. *The Italian Journeys of Samuel Rogers*. London: Faber, 1967.

Hall, Michael. "Stirling Wit and Passion." *Country Life* 207 (31 August 2000): 50–53.

*Handbook of the Collections of Yale University Art Gallery*. New Haven and London: Yale University Press, 1992.

Hare, Augustus. *Life and Letters of Maria Edgeworth*. 2 vols. London: E. Arnold, 1894.

Harris, Eileen. *Furniture of Robert Adam*. London: Tiranti, 1963.

Harris, Eileen. *The Genius of Robert Adam, His Interiors*. New Haven and London: Yale University Press, 2001.

Harris, James, 1st Earl of Malmesbury. *Diaries and Correspondence*. 4 vols. London, 1844.

Harris, John. *The Artist and the Country House*. London: Sotheby Parke Bernet, 1979.

Harris, John. "C. R. Cockerell's 'Ichnographica Domestica.'" *Architectural History* 14 (1971): 5–29.

Harris, John. "Lo Stile Hope e la Famiglia Hope." *Arte Illustrata* 6, nos. 55, 56 (December 1973): 326–30.

Harris, John. "Precedents and Various Designs Collected by C.H. Tatham." In *In Search of Modern Architecture: A Tribute to Henry-Russell Hitchcock*. Ed. by Helen Searing. Cambridge, Mass., and London: MIT Press, 1982.

Harris, John. *Regency Furniture Designs from Contemporary Source Books, 1803–1826.* London: Tiranti, 1961.

Harrison, Evelyn Byrd. *Archaic and Archaistic Sculpture.* Princeton: American School of Classical Studies, 1965.

Hartop, Christopher. *Royal Goldsmiths: The Art of Rundell and Bridge 1797–1843.* London: John Adamson, 2005.

Haskell, Frances. "The Baron d'Hancarville, an adventurer and art historian in eighteenth-century Europe." In *Oxford, China and Italy: Writings in Honour of Sir Harold Acton.* Ed. by Edward Chaney and Neil Ritchie. London: Thames and Hudson, 1984, pp. 177–91.

Haskell, Francis. *The Ephemeral Museum: Old Master Paintings and the Rise of the Art Exhibition.* New Haven and London: Yale University Press, 2000.

Haskell, Francis. *Past and Present in Art and Taste, Selected Essays.* New Haven and London: Yale University Press, 1987.

Haskell, Francis. *Rediscoveries in Art: Some Aspects of Taste, Fashion and Collecting in England and France.* Oxford: Phaidon Press, 1980.

Haskell, Francis, and Nicholas Penny. *Taste and the Antique. The Lure of Classical Sculpture 1500–1900.* New Haven and London: Yale University Press, 1988.

Hayward, Helena, ed. *World Furniture.* London: Hamlyn, 1965.

Hermann, Frank. *The English as Collectors: A Documentary Sourcebook.* London: John Murray, 1999.

Hermary, Antoine, Hélène Cassimatis, and Rainer Vollkomer. "Eros." In *Lexicon iconographicum mythologiae classicae,* vol. 3. Zurich and Munich: Artemis, 1986.

Herrmann, Frank. "Peel and Solly: Two Nineteenth Century Art Collectors and Their Sources of Supply." In *Colnaghi: Art, Commerce, Scholarship: A Window onto the Art World.* Exh. cat. London: Colnaghi, 1984.

Herrmann, Wolfgang. *Gottfried Semper: Theoretischer Nachlass an der ETH Zürich: Katalog und Kommentare.* Basel: Birkhäuser, 1981.

Hilgers, Werner. *Lateinische Gefässnamen.* Düsseldorf: Rheinland, 1969.

Hitchcock, Henry-Russell. *Early Victorian Architecture in Britain.* 2 vols. New Haven: Yale University Press, 1954.

Hoare, Prince. *Epochs of the Arts: including Hints on the Use and Progress of Painting and Sculpture in Great Britain.* London: John Murray, 1813.

Hoare, Prince, ed. *The Artist: A Collection of Essays relative to Painting, Poetry, Sculpture, Architecture, The Drama, Discoveries of Science and various other subjects.* London, 1807; reprinted London: John Murray, 1810.

Hobbs, Carlton. *The Thomas Hope Table, A Rediscovered Masterpiece.* New York: 2007.

Hodges, William. *Travels in India, 1780–83.* London, 1793.

Hoet, Gerard, and Pieter Terwesten. *Catalogus of naamlyst van schilderyn: met derzelver pryzen etc.,* vol. 2. The Hague, 1740–52.

Hoff, Ursula. *European Paintings of the 19th and Early 20th Centuries in the National Gallery of Victoria.* Melbourne: National Gallery of Victoria, 1995.

Hoff, Ursula. *European Paintings before 1800 in the National Gallery of Victoria.* Melbourne: National Gallery of Victoria, 1995.

Hofstetter, Eva. "Seirenes." In *Lexicon iconographicum mythologiae classicae,* vol. 8. Zurich and Munich: Artemis, 1997.

Holland, John. *Memorials of Sir Francis Chantrey, R.A.* Sheffield, 1851.

Honour, Hugh. "Canova's Statue of Venus." *Burlington Magazine* 114 (1972): 658–70.

Honour, Hugh. "Vincenzo Pacetti." *The Connoisseur* (November 1960): 174–81.

Honour, Hugh, ed. *Edizione Nazionale delle Opere di Antonio Canova.* Vol. 1, *Scritti.* Rome: Istituto poligrafico e Zecca dello Stato, Libreria dello Stato, 1994.

"The Hope Collection of Dutch and Flemish Pictures." *Art Journal* 7 (1 October 1868): 224.

*The Hope Collection of Pictures of the Dutch and Flemish Schools with descriptions reprinted from the catalogue published in 1891 by the Science and Art Department of the South Kensington Museum.* London: Privately printed at the Chiswick Press, 1898.

Hope, Lord Francis, and E. M. W. Tillyard. *The Hope Vases.* Cambridge University Press, 1923.

Horwood, Richard. *The A to Z of Regency London: A Facsimile of Richard Horwood's Maps.* Lympne Castle: Harry Margary in association with Guildhall Library, 1985.

Howard, F. "Memoir of Henry Howard, R.A." In *Lectures on Painting.* London: J. & H. Cox, 1848.

Howard, Seymour. "An Antiquarian Handlist and the Beginnings of the Pio Clementino." In *Antiquity Restored, Essays on the Afterlife of the Antique.* Vienna: Irsa, 1990, pp. 142–53.

Howard, Seymour. *Bartolomeo Cavaceppi, Eighteenth Century Restorer.* New York and London: Garland Press, 1982.

Hubert, Gérard, and Guy Ledoux-Lebard. *Napoléon portraits contemporains bustes et statues.* Paris: Arthena, 1999.

Huscher, Herbert. "Thomas Hope, Author of Anastasius." *Keats Shelley Memorial Bulletin* 19 (1968): 2–13.

Hussey, Christopher. "Beach House, Worthing, Sussex." *Country Life* 48 (29 January 1921).

Hussey, Christopher. *English Country Houses: Late Georgian.* London: Country Life, 1958.

Hussey, Christopher. "Four Regency Houses." *Country Life* 68 (11 April 1931): 450–56.

Hussey, Christopher. "Hinton Ampner House, Hampshire." *Country Life* (7 and 14 February 1947): 326–69, 374–77.

Hussey, Christopher. "Mount Clare—II. Roehampton. The Residence of Mr. Lancelot Hugh Smith." *Country Life* 77 (2 February 1935).

Hussey, Christopher. *The Picturesque: Studies in a Point of View.* London, 1923; rev. ed. London: Cassell, 1983.

Hussey, Christopher. "Somerley, Hampshire." Parts I–III. *Country Life* 123 (January 1958): 108–11, 156–59, 202–5.

Hussey, Christopher. "Stratfield Saye, Hampshire—IV." *Country Life* 103 (10 December 1948): 1218–21.

Ilchester, Earl of, ed. *Elizabeth Lady Holland to Her Son 1821–1845.* London: John Murray, 1946.

Ilchester, Earl of, ed. *Journal of the Honourable Henry Edward Fox.* London: Thornton Butterworth, 1923.

*ILN (Illustrated London News),* 3 April 1856, 352; 4 July 1857, 22.

Ingamells, John. *A Dictionary of British and Irish Travellers in Italy, 1701–1800.* New Haven and London: Yale University Press for the Paul Mellon Centre for Studies in British Art, 1997.

Ingamells, John, and John Edgcumbe, eds. *The Letters of Sir Joshua Reynolds.* New Haven and London: Yale University Press, 2000.

Ingamells, John. *The Wallace Collection: Catalogue of Pictures.* Vol. 4, *Dutch and Flemish.* London: Trustees of the Wallace Collection, 1992.

Ingram, T. L. "A Note on Thomas Hope of Deepdene." *Burlington Magazine* 122 (1980): 427–28.

Inwood, Henry William. *The Erechtheion at Athens: Fragments of Athenian Architecture and a Few Remains in Attica, Megara and Epirus.* London: James Carpenter, 1827.

Ireland, Samuel. *A Picturesque Tour through Holland, Brabant, and Part of France, made in the autumn of 1789.* London: T. and J. Egerton, 1790.

Irwin, David. *English Neo-Classical Art: Studies in Inspiration and Taste.* Greenwich, Conn.: New York Graphic Society, 1966.

Irwin, David G. *John Flaxman 1755–1826, Sculptor, Illustrator, Designer.* London: Studio Vista, Christie's, 1979.

Jackson, Anna, and Amin Jaffer. *Encounters: The Meeting of Asia and Europe 1500–1800.* Exh. cat. London: V&A Publications, 2004.

Jackson-Stops, Gervase, ed. *The Treasure Houses of Britain: Five Hundred Years of Private Patronage and Collecting.* Exh. cat. New Haven and London: Yale University Press, 1985.

Jackson-Stops, Gervase. "Southill Park, Bedfordshire," *Country Life* (28 April 1994): 62–67.

Jaffé, Michael. "The Death of Adonis by Rubens." *Duits Quarterly* 2 (1967).

Jameson, Mrs. A. B. (anon.). *Diary of an Ennuyée.* London: Henry Colburn, 1826.

Janneau, Guillaume. *Les Sièges.* Paris: Jacques Fréal, 1974.

Jenkins, Ian. "Adam Buck and the Vogue for Greek Vases." *Burlington Magazine* 130 (June 1988): 448–57.

Jenkins, Ian. *Adam Buck's Greek Vases.* British Museum Occasional Paper 75. London: British Museum Press, 1989.

Jenkins, Ian. *Archaeologists and Aesthetes in the Sculpture Galleries of the British Museum.* London: British Museum Press, 1992.

Jenkins, Ian. "Charles Townley's collection." In Wilton and Bignamini, *Grand Tour* (1996): 257–62.

Jenkins, Ian. "La vente des vases Durand (Paris 1836) et leur reception en Grande-Bretagne." In A.-F. Laurens and K. Pomian, *L'Anticomanie, La Collection d'Antiquités.* Paris: Éditions de l'École des Hautes Études en Sciences Sociales, 1992, pp. 269–78.

Jenkins, Ian. "Neue Dokumente zur Entdeckung und Restaurierung der Venus Hope und anderer Venus Statuen." In *Wiedererstandene Antike, Ergänzungen antiker Kunstwerke seit der Renaissance.* Ed. by Max Kunze and Stephanie-Gerrit Bruer. Munich: Biering and Brinkman, 2003, pp. 181–92.

Jenkins, Ian. "Seeking the Bubble Reputation." *Journal of the History of Collections* 9, no. 2 (1997): 191–203.

Jenkins, Ian, and Kim Sloan. *Vases & Volcanoes. Sir William Hamilton and His Collection.* London: British Museum Press, 1996.

Jervis, Simon. *Dictionary of Design and Designers.* London: Penguin Books, 1984.

Jervis, Simon. "Haarlem and Bordeaux. Neo-classicism & Enlightenment." *Burlington Magazine* 131 (December 1989): 868–69.

Jervis, Simon. "Splendentia recognita: furniture by Martin Foxhall for Fonthill." *Burlington Magazine* 147 (June 2005): 376–82.

*John Singleton Copley 1738–1815, Gilbert Stuart 1755–1828, Benjamin West 1738–1820 in America and England.* Exh. cat. Boston: Museum of Fine Arts, 1976.

Jomard, E. F., ed. *Description de l'Egypte.* 20 vols. Paris: Imprimerie impériale, 1809–28.

Jørnæs, Bjarne. *Bertel Thorvaldsen: La vita e l'opera dello scultore.* Rome, De Luca, 1997.

Jørnæs, Bjarne, ed. *Bertel Thorvaldsen: Untersuchungen zu seinem Werk und zur Kunst seiner Zeit.* Cologne, 1977.

Joubin, André. "L'Athéna Hope." *Académie des Inscriptions, Monuments et Mémoires* 3 (1896).

Jourdain, Margaret. *English Decoration and Furniture of the Later XVIIIth Century.* London: Batsford, 1922.

Jourdain, Margaret. *Regency Furniture 1795–1820.* London: Country Life, 1934.

Joy, E. T. "'The Elegancies of Antique Form.'" *Connoisseur* 143 (March 1959): 94–95.

Kahil, Lily, and Noëlle Icard-Gianolio. "Leto." In *Lexicon iconographicum mythologiae classicae,* vol. 6. Zurich and Munich: Artemis, 1992.

Kasaba, Resat. "The Enlightenment, Greek Civilisation and the Ottoman Empire: Reflections on Thomas Hope's Anastasius." *Journal of Historical Sociology* 16 (March 2003): 1–21.

Kathariou, Kleopatra. *The Workshop of the Meleager Painter and His Era: Remarks on the Attic Pottery of the First Quarter of the 4th Century B.C.* (Modern Greek with English summary). Thessaloniki: University Studio Press, 2002.

Kauffmann, C. M. *John Varley.* London: B. T. Batsford, in association with the Victoria and Albert Museum, 1984.

Kelly, Alison. *Mrs Coade's Stone.* Upton-on-Severn: Self Publishing Association in conjunction with The Georgian Group, 1990.

Kelly, David St. Leger. "The Egyptian Revival: A Reassessment of Baron Denon's Influence on Thomas Hope." *Furniture History* 40 (2004): 83–98.

Kelsall, Charles. *A Letter from Athens addressed to a Friend in England.* London, 1812.

Kenworthy-Browne, John. "The Sculpture Gallery at Woburn Abbey and the Architecture of the Temple of the Graces." In *The Three Graces: Antonio Canova.* Edinburgh: National Galleries of Scotland, 1995.

Keuren, Frances Van. "Thomas Hope (1769–1831): An Interdisciplinary Champion of Greek Design." *International Journal of the Humanities* 3, no. 4 (2005–6).

King, David. *The Complete Works of Robert & James Adam and Unbuilt Adam.* Oxford and Woburn: Architectural Press. 1991; reprinted 2001.

Kjellberg, Pierre. *Encyclopédie de la Pendule Française.* Paris: Les Éditions de l'Amateur, 1997.

Knight, Richard Payne. *An Analytical Inquiry into the Principles of Taste.* London, 1805; 4th ed. London: Payne and White, 1808.

Knight, Richard Payne. *The Landscape, a Didactic Poem in Three Books. Addressed to Uvedale Price, Esq.* London, 1794; 2nd ed. London: Bulmer, 1795.

Knoblock, Edward. *Round the Room.* London: Chapman & Hall, 1939.

Kossatz-Deissmann, Annaliese. *Dramen des Aischylos auf westgriechischen Vasen.* Mainz am Rhein: Philipp von Zabern, 1978.

Kraemer, Ruth S. *Drawings by Benjamin West and his son, Raphael Lamar West.* New York: Pierpont Morgan Library, 1975.

Krafft, J. C.-H., and N. Ransonnette. *Plans, coupes, élévations des plus belles maisons et des hôtels construits à Paris et dans le environs.* 2 vols. Paris, 1801–2.

Kreikenbom, Detlev. "Cavaceppis Maximen der Antikenrestaurierung." In *Von der Schönheit weissen Marmors. Zum 200. Todestag Bartolomeo Cavaceppis.* Ed. by Thomas Weiss. Exh. cat. Mainz: Philipp von Zabern, 1999.

Kruft, Hanno-Walter. *A History of Architectural Theory from Vitruvius to the Present.* London and New York: Zwemmer, 1994.

Labarc, L. W., and W. J. Bell, eds. *The Papers of Benjamin Robert Franklin,* vol. 9. New Haven and London: Yale University Press, 1966.

Lambrinudakis, Wassilis, and Philippe Bruneau. "Apollo." In *Lexicon iconographicum mythologiae classicae,* vol. 2. Zurich and Munich: Artemis, 1984.

Lambrinudakis, Wassilis, et al. "Apollon." *Lexicon iconographicum mythologiae classicae,* vol. 1. Zurich and Munich: Artemis, 1984.

Lang, S., and N. Pevsner. "The Egyptian Revival." *Architectural Review* 119 (May 1956): 243–54.

*Lansdowne House.* Sale cat. London: Christie, Manson & Woods, 1929.

Lattimore, Richard. *Themes in Greek and Latin Epitaphs.* Urbana: The University of Illinois Press, 1942.

Lauder, Thomas Dick. *Sir Uvedale Price on the Picturesque,* Edinburgh: Caldwell, Lloyd. 1842.

Law, Henry William, and Irene Law. *The Book of the Beresford Hopes.* London: Heath Cranton, 1925.

Lawrence, Sarah E. ed., *Piranesi as Designer.* Exh. cat. New York: Cooper-Hewitt, National Design Museum, 2007.

Le Camus de Mézières, Nicolas. *The Genius of Architecture.* Santa Monica: Getty Center, 1992.

Ledoux, Claude-Nicolas. *L'architecture considérée sous le rapport de l'art, des moeurs et de la législation.* Paris: Perronneau, 1804.

Ledoux-Lebard, Denise. *Le Mobilier français du XIXe siècle.* Paris: Éditions de l'Amateur, 2000.

Ledoux-Lebard, Denise. *Les Ébénistes du XIXe siècle, 1795–1889.* Paris: Éditions de l'Amateur, 1984.

Ledoux-Lebard, Denise. *Les Ébénistes parisiens du XIX siècle 1795–1870.* Paris: Librairie Gründ, 1951.

Leigh, Samuel. *Leigh's New Picture of London.* 3rd ed. London: The Author, 1819.

Lembke, Katje. *Das Iseum Campense in Rom: Studien über den Isiskult unter Domitian.* Heidelberg: Verlag Archäologie und Geschichte, 1994.

*Le Siècle de Rubens.* Exh. cat. Brussels: Musées Royaux des Beaux Arts de Belgique, 1965.

L'Estrange, Rev. A., ed. *The Friendships of Mary Russell Mitford.* 2 vols. London: Hurst and Blackett, 1882.

Leveson Gower, Hon. F., ed. *Letters of Harriet, Countess Granville.* London: Longmans Green, 1894.

Levey, Michael. *Sir Thomas Lawrence.* New Haven and London: Yale University Press, 2005.

Levy, Martin. "George Bullock's Partnership with Charles Fraser, 1813–1818, and the Stock-in-Trade Sale, 1819." *Furniture History* 25 (1989): 145–213.

Lewis, Douglas. "The Clark Copy of Antonio Canova's Hope Venus." *The William A. Clark Collection.* Washington, D.C.: Corcoran Gallery of Art, 1978.

Lewis, Lady Theresa. *Journals and Correspondence of Miss Berry.* London: Longmans, 1865.

Lewis, Lesley. *Connoisseurs and Secret Agents in 18th-Century Rome.* London: Chatto & Windus, 1961.

*L'Inspiration du Poète de Poussin: Essai sur l'allégorie du parnasse.* Ed. by Marc Fumaroli. Exh. cat. Paris: Réunion des musées nationaux, 1989.

Liscombe, Rhodri. "Richard Payne Knight, some unpublished correspondence." *Art Bulletin* 61 (1979): 606.

Liscombe, Rhodri. *William Wilkins 1778–1839.* Cambridge: Cambridge University Press, 1980.

Lomax, James. *British Silver at Temple Newsam and Lotherton Hall.* Leeds: Leeds Art Collections Fund and W.S. Maney and Son, 1992.

*London Chronicle* (7 December 1810): 550–51.

Lonis, Raoul. *Guerre et religion en Grèce à l'époque classique: recherches sur les rites, les dieux, l'idéologie de la victoire.* Paris: Belles Lettres, 1979.

*Lord Leverhulme . . . A Great Edwardian Collector and Builder.* Exh. cat. London: Royal Academy, 1980.

Loudon, John Claudius. *Encyclopaedia of Cottage, Farm and Villa Architecture and Furniture.* London: Longman, 1833.

Loudon, John Claudius. *Gardener's Magazine* 4 (1828); 5 (1829): 589–90; 12 (1836): 621.

Lovell, Ernest J. Jr., ed. *Lady Blessington's Conversations of Lord Byron,* Princeton: Princeton University Press, 1969.

Lukacher, Brian. *Joseph Gandy: An Architectural Visionary in Georgian England.* London: Thames and Hudson, 2006.

Lyons, Claire. "The Museo Mastrilli and the Culture of Collecting in Naples, 1700–1755." *Journal of the History of Collections* 4 (1992): 1–26.

Lysons, Daniel. *The Environs of London.* 2 vols. London: P. Cadell and W. Davies, 1811.

Macquoid, Percy, and Ralph Edwards. *The Dictionary of English Furniture.* London: Country Life, 1926.

Macquoid, Percy. *A History of English Furniture: The Age of Satinwood.* London: Lawrence & Bullen, 1908.

*Magazine of the Fine Arts and Monthly Review of Painting, Sculpture, Architecture and Engraving* 1 (1821): 151.

Mahaffy, Henrietta. "The Important Deepdene Bookcase." Unpublished essay. Bowes Museum, n.d.

*The Making of the Classical Museum: Antiquarians, Collectors and Archaeologists.* Exh. cat. Dublin: University College, 2003.

Malcolm, John Peller. *Anecdotes of the Manners and Customs of London.* London: Longman, Hurst, Rees and Orme, 1808.

Malone, Edmond. *The Works of Sir Joshua Reynolds.* 2 vols. London, 1797.

Manderscheid, Hubertus. *Die Skulpturenausstattung der kaiserzeitlichen Thermenanlagen.* Berlin: Gebr. Mann, 1981.

Manera, Fausta, and Claudia Mazza. *Le collezioni egizie del Museo Nazionale Romano.* Milan: Electa, 2001.

Manning, Owen. *History and Antiquities of the County of Surrey.* 3 vols. London: J. White, 1804–14.

Mannings, David. *Sir Joshua Reynolds: A Complete Catalogue of His Paintings.* 2 vols. New Haven and London: Yale University Press, 2000.

Mansel, Philip. "The Grand Tour in the Ottoman Empire 1699–1826." In Starkey, *Unfolding the Orient* (2001).

Marceau, Henri, ed. *Benjamin West, 1738–1820.* Philadelphia: Pennsylvania Museum of Art, 1938.

Mariner, William. *An Account of the Tonga Islands in the South Pacific.* 2 vols. London: John Murray, 1817.

Marmottan, Paul. "Le peintre Louis Gauffier." *Gazette des Beaux Arts* 13 (1923): 281–300.

Marvin, Miranda. "Freestanding sculptures from the Baths of Caracalla." *American Journal of Archaeology* 87 (1983): 377–80.

Marvin, Miranda. "Copying in Roman Sculpture: The Replica Series." In *Roman Art in Context: An Anthology.* Ed. by Eve D'Ambra. Upper Saddle River, N.J.: Prentice Hall, 1993.

Mathea-Förtsch, Marion. *Römische Rankenpfeiler und -Pilaster.* Mainz: Philipp von Zabern, 1999.

Mauriche-Beaupré, Charles. "Un mobilier de G. Jacob dessiné par Hubert Robert." *Bulletin des Musées de France* (April 1934): 76–80.

Maxon, John. *The Art Institute of Chicago.* New York: Harry M. Abrams, 1970.

McClelland, Nancy. *Duncan Phyfe and the English Regency 1795–1835.* New York: William R. Scott, 1939; reprinted New York: Dover Publications, 1980.

McPhee, Ian. "Elektra I." In *Lexicon iconographicum mythologiae classicae,* vol. 3. Zurich and Munich: Artemis, 1986.

Mécholuan, Henry, ed. *Amsterdam XVIIe siècle: marchands et philosophes, les bénéfices de la tolérance.* Paris: Autrement, 1993.

Melville, Lewis. *Life and Letters of William Beckford.* London: William Heineman, 1910.

Melville, Lewis, ed. *The Berry Papers, being the correspondence, hitherto unpublished, of Mary and Agnes Berry.* London: John Lane, 1914.

"Memoir of the Late Mr Henry Hope." *Gentleman's Magazine* 81, pt.1 (March 1811): 292–93.

Menz, Christopher. *Regency: British Art & Design 1800–1830.* Exh. cat. Adelaide: Art Gallery of South Australia, 1998.

Mercer, Doris. "The Deepdene, Dorking: Rise and Decline through Six Centuries." *Surrey Archaeological Collections* 71 (1977): 111–38.

Mercklin, Eugene von. "Figuralkapitelle." *Archäologischer Anzeiger: Jahrbuch des Deutschen Archäologischen Instituts* 40 (1925): 203–6.

Meteyard, Eliza. *The Wedgwood Handbook: A Manual for Collectors.* London, 1875: 272–73.

Metzger, Henri. "Dionysos chthonien d'après les monuments figurés de la pèriode classique." In *Bulletin de Correspondance Hellénique* 68–69 (1944–45).

Metzger, Henri. "Le Dionysos des images éleusiniennes du IV e siècle," *Revue Archeologique* (1995).

Metzger, Henri. *Les Représentations dans la céramique attique du IVe siècle.* Paris: E. De Boccard, 1951.

Michaelis, Adolf. *Ancient Marbles in Great Britain.* Cambridge: Cambridge University Press, 1882.

Michaelis, Adolph. "Die Privatsammlungen antiker Bildwerke in England, Deepdene." *Archäologische Zeitung* 32 (1874).

Michaelis, Adolph. "Museographisches: Vasen des Hrn. Hope." *Archäologischer Anzeiger* 7 (1849): 97–102.

Milizia, Francesco. *Memorie degli architetti antichi e moderni.* 2 vols. Rome, 1768.

Millin, Aubin Louis, ed. "Nouvelles Etrangères—Londres." *Magasin Encyclopédique* 4, no. 34 (July–August 1800): 114.

Millin, Aubin Louis. *Monuments Antiques, Inédites ou nouvellement expliqués.* 2 vols. Paris, 1802–6.

Millin, Aubin Louis. *Peintures de Vases Antiques vulgairement appelés Etrusques.* Paris: Dubois, M. Maisonneuve, 1808.

Millingen, James. *Ancient Unedited Monuments: Painted Greek Vases from Collections in Various Countries, Principally in Great Britain.* London, 1822.

Millingen, James. *Peintures antiques de vases grecs de la collection de Sir John Coghill.* Rome: Romanis, 1817.

Millingen, James. *Some Remarks on the State of Learning and the Fine Arts in Great Britain.* London, 1831.

Milner, John. "On the Rise and Progress of the Pointed Arch." In *Essays on Gothic Architecture.* London: J. Taylor, 1800.

Missirini, Melchior. *Della vita di Antonio Canova.* Prato, 1824.

"Mr. Henry Hope." *The Times,* 5 March 1811, p. 4.

Mobilier national. *Inventaire des collections publiques françaises.* Vol. 25, *Soieries Empires.* Paris: Réunion des musées nationaux, 1980.

Moore, Mary B. *Attic Red-Figured and White-Ground Pottery in the Athenian Agora.* Results of Excavations Conducted by the American School of Classical Studies at Athens, vol. 30. Princeton: The American School of Classical Studies at Athens, 1997.

Moore, Thomas. *Memoirs, Journal and Correspondence of Thomas Moore.* 8 vols. Ed. by Lord John Russell. London: Longman, Brown, Green and Longmans, 1853–58.

Moreno, Paul, ed. *Lisippo: L'arte e la fortuna.* Milan: Fabbri Editori, 1995.

Moreno, Paul. "Lysippos (I)." In *Kunstlerlexikon der Antike,* vol. 2. Ed. by Rainer Volkommer. Munich and Leipzig: K. G. Saur, 2004.

Morley, John. *Regency Design, 1790–1840.* London: Zwemmer, 1983.

Morris, E. *Lady Lever Art Gallery, Port Sunlight. Catalogue of Foreign Paintings, Drawings, Miniatures, Prints, Tapestries and Post Classical Sculpture.* Merseyside: Merseyside County Council, 1983.

Moser, Stephanie. *Wondrous Curiosities: Ancient Egypt at the British Museum.* Chicago: University of Chicago Press, 2006.

Moses, Henry. *A Collection of Antique Vases, Altars, Paterae, Tripods, Candelabra, Sarcophagi &c.* London: J. Taylor, 1814.

*Designs of Modern Costume,* with engravings by Henry Moses. London: Privately printed, 1812. Enlarged version published as *A Series of Twenty-nine Designs of Modern Costume drawn and engraved by Henry Moses, Esq.* London: E & C. McLean, 1823. Reprinted with an introduction by John Nevinson, London: Costume Society, [1973].

Moses, Henry. *The Gallery of pictures painted by Benjamin West.* London, 1811.

Moses, Henry. *A Series of Twenty-nine Designs of Modern Costume.* London: James Appleton, 1823.

Moses, Henry. *Vases from the Collection of Sir Henry Englefield.* London: Printed for Rodwell and Martin, 1820.

Moses, Henry. *The Works of Antonio Canova, in sculpture and modelling.* 3 vols. London: Prowett, 1824–28.

Moss, Christopher Frederick. *Roman Marble Tables.* Princeton: Princeton University Press, 1988.

Moss, Morrie A. *The Lillian and Morrie Moss Collection of Paul Storr Silver.* Miami: Roskin Book Productions, 1972.

Mount, Harry, ed. *Sir Joshua Reynolds: A Journey to Flanders and Holland.* Cambridge: Cambridge University Press, 1996.

Müller-Kaspar, Ulrike. "Cavaceppi zwischen Theorie und Praxis. Das Trakat 'Dell'arte di ben restaurare le antiche sculture'. . . " In *Von der Schönheit weissen Marmors. Zum 200. Todestag Bartolomeo Cavaceppis.* Ed. by Thomas Weiss. Exh. cat. Mainz: Philipp von Zabern, 1999.

Müller-Kaspar, Ulrike. *Das sogenannte Falsche am Echten, Antikenergänzungen im späteren 18. Jhdts in Rom.* Bonn: Dissertation Rheinische Friedrich-Wilhelms-Universität zu Bonn, 1988.

Mundy, Harriot Georgiana, ed. *The Journal of Mary Frampton, from the year 1779 until the year 1846.* London: Sampson Low & Co., 1885.

Murray, John. *Memoir and Correspondence of John Murray,* vol. 2. London: John Murray, 1891.

Musgrave, Clifford. "In Search of Thomas Hope." *The Antique Collector* 43 (August 1972).

Musgrave, Clifford. *Regency Furniture, 1800 to 1830.* London: Faber and Faber, 1961.

Muthmann, Friedrich. *Der Granatapfel, Symbol des Lebens in der Alten Welt.* Fribourg: Office du Livre, 1982.

National Gallery of Victoria. *Decorative Arts from the Collections of the National Gallery of Victoria.* Melbourne: National Gallery of Victoria, 1980.

Navari, Leonora. *Greece and the Levant: The Catalogue of the Henry Myron Blackmer Collections of Books and Manuscripts.* London: Maggs Bros., 1989.

Neale, John Preston, "The Deep-Dene, Surrey." *Views of the Seats of Noblemen and Gentlemen in England, Wales, Scotland, and Ireland,* 2nd ser., vol. 2. London: W. H. Reid, 1826.

Neilson, Katharine B. *Selected Paintings and Sculpture from the Yale University Art Gallery.* New Haven and London: Yale University Press, 1972.

Neumann, Philipp von. *The Diary of Philipp von Neumann 1819–1850.* Trans. and ed. by Chancellor, E. Beresford. 2 vols. London, 1928.

Nielsen, Inge. *Thermae et Balnea: The Architecture and Cultural History of Roman Public Baths.* Aarhus: Aarhus University Press, 1990.

Niemeijer, J. W. "A Conversation Piece by Aert Schouman and the founders of the Hope Collection." *Apollo* 108, no. 199 (September 1978): 182–89.

Niemeijer, J. W. "De kunstverzameling van John Hope (1737–1784)." *Nederlands Kunsthistorisch Jaarboek* 32 (1981): 127–232.

Nixon, Howard M. "'English Book Bindings LXXXII. Binding by Staggemeier & Welcher 1805." *Book Collector* 21, no. 3 (Autumn 1972): 386.

Noble, Percy. *Anne Seymour Damer: A Woman of Art and Fashion, 1748–1828.* London: K. Paul, Trench, Trübner. 1908.

Noon, Patrick J. "English Portrait Drawings & Miniatures." *YCBA* (1979): 93–96.

Nordens, Frederick Lewis. *Travels in Egypt and Nubia.* London: Printed for Lockyer Davis and Charles Reymers, 1757.

Nørskov, Vinnie. *Greek Vases in New Contexts.* Aarhus: Aarhus University Press, 2002.

North, Christopher. "On Anastasius. By—Lord Byron." *Blackwood's Edinburgh Magazine* 10 (September 1821): 200–206.

Novotny, Fritz. *Painting and Sculpture in Europe, 1780 to 1880.* Harmondsworth: Penguin Books, 1960. Rev. ed. 1978.

Nugent, Mr. *The Grand Tour, or a Journey through the Netherlands, Germany, Italy and France*, vol. 1. London, 1778.

Obituaries of Thomas Hope. *Times*, 4 February 1831. *Examiner*, 6 February 1831. *Gentleman's Magazine* 101, pt. 1 (1831). *Literary Gazette* (12 February 1831): 107. *Monthly Magazine* (1831): 515.

O'Brien, Jacqueline, and Desmond Guinness. *Great Irish Houses and Castles.* London: Weidenfeld & Nicholson, 1992.

*Old Master Paintings: An Illustrated Summary Catalogue.* Zwolle: Waanders Uitgevers; The Hague: Rijksdienst Beeldende Kunst, 1992.

"The Orestes Vase. Hope Heirloom Bought by British Museum." *The Times*, 10 December 1917, no. 41657: 11.

Ostergard, Derek, ed. *William Beckford, 1760–1844: An Eye for the Magnificent.* Exh. cat. New Haven and London: Yale University Press, 2001.

Ottomeyer, Hans, and Peter Proeschel. *Vergoldete Bronzen*, vol. 1. Munich: Klinkhardt & Bierman, 1986.

Owen, Felicity, and David Blayney Brown. *Collector of Genius, A Life of Sir George Beaumont.* New Haven and London: Yale University Press, 1988.

Palacio Pombal, Oeiras, *Obras de Arte da Coleccao Calouste Gulbenkian.* Oeiras: Palacio Pombal, 1965.

Palagia, Olga. "Herakles." In *Lexicon iconographicum mythologiae classicae*, vol. 4. Zurich and Munich: Artemis, 1988.

Papworth, John B. *Rural Residences . . . with Some Observations on Landscape Gardening.* London: Ackermann, 1818.

Passavant, Johann. *Kunstreise durch England und Belgien.* Frankfurt, 1833.

Passavant, Johann David. *Tour of a German Artist in England with notices of private galleries, and remarks on the state of art.* 2 vols. London: Saunders & Otley, 1836.

Pavanello, Giuseppe, and Giandomenico Romanelli. *Antonio Canova.* Venice: Marsilio, 1992.

Pearce, Susan, and Frank Salmon. "Charles Heathcote Tatham in Italy, 1794–96: Letters, Drawings and Fragments, and Part of an Autobiography." *Walpole Society* 67 (2005): 1–91.

Pennant, Thomas. *Tour on the Continent 1765.* Ed. by G. R. de Beer. London: Printed for the Ray Society, 1948.

Penny, Nicholas. *Catalogue of European Sculpture in the Ashmolean Museum 1540 to the Present Day.* Vol. 3, *British.* Oxford: Clarendon Press, 1992.

Penrose, Alexander P. D., ed. *The Autobiography and Memoirs of Benjamin Robert Haydon.* London: G. Bell & Sons, 1927.

Penzer, N. M. *Paul Storr, The Last of the Goldsmiths.* London: Batsford, 1954.

Percier, Charles, and P.-F.-L. Fontaine. *Choix des plus célèbres Maisons de Plaisance de Rome et de ses environs.* Paris: Didot, 1809.

Percier, Charles, and P.-F.-L. Fontaine. *Palais, Maisons et autres édifices modernes, dessinés à Rome.* Paris: Didot, 1798.

Percier, Charles, and P.-F.-L. Fontaine. *Recueil de décorations intérieures, comprenant tout ce qui a rapport à l'ameublement . . . composé par C. Percier et P. F. L. Fontaine, éxecuté sur leurs dessins.* Paris: Didot, 1812.

Percy, Joan. *In Pursuit of the Picturesque: William Gilpin's Surrey Excursion.* Surrey: Surrey Garden Trust, 2001.

Pevsner, Nikolaus. *Some Architectural Writers of the Nineteenth Century.* Oxford: Clarendon Press, 1972.

Philip, P. "Continental Influences on English Furniture," pt. 2, "From the late 17th Century to the Victorian Age." *Antique Dealer and Collector's Guide* (June 1973), 112–17.

Philip, P. "Regency Rosewood and Empire Eccentricities." *Antique Dealer and Collector's Guide* (July 1981): 35–38.

Picón, Carlos, et al. *Art of the Classical World in the Metropolitan Museum of Art.* New Haven and London: Yale University Press, 2007.

Picón, Carlos. "Recent Acquisitions." *Metropolitan Museum Bulletin* 49.2 (Fall 1991): 10–11.

Pigott, Harriet. *The Private Correspondence of a Woman of Fashion.* 2 vols. London: Henry Colburn & Richard Bentley, 1832.

Pinçon, Jean-Marie, and Olivier Gaube du Gers. *Odiot Orfèvre.* Paris: Sous le Vent, 1990.

Piranesi, Giovanni Battista. *Diverse maniere d'adornare i cammini.* Rome: Generoso Salomoni, 1769.

Piranesi, Giovanni Battista. *Opere varie.* Rome, 1750.

Piranesi, Giovanni Battista. *Vasi, candelabri*, vol. 2. Rome, 1778.

Pirenne-Delforge, Vinciane. *L'Aphrodite grecque. Contribution à l'étude de ses cultes et de sa personnalité dans le panthéon archaique et classique* in Kernos Supplément. Athens and Liège: Centre International d'Étude de la Religion Grecque Antique, 1994.

Plomp, Michiel C. *Collectionner, Passionnément, Les Collentionneurs hollandais de dessins au XVIIIe siècle*, vol. 1. Paris: Fondation Custodia, 2001.

Plon, Eugène. *Thorvaldsen, his life and work.* London: Richard Bentley, 1874.

Pomeroy, Jordana. "The Orléans Collection: Its Impact on the British Art World." *Apollo* (February 1997): 26–31.

Pope, Willard Bissell, ed. *The Diary of Benjamin Robert Haydon*, vol. 1. Cambridge, Mass.: Harvard University Press, 1963.

Powell, G. H., ed., *Reminiscences and Table Talk of Samuel Rogers.* London, 1903.

Powers, Alan. "Ronald Fleming and Vogue Regency." *Decorative Arts Society Journal* 19 (1995): 51–58.

Pownall, Thomas. "Observations on the Origin and Progress of Gothic Architecture and on the Corporation of Free Masons supposed to be the Establishers of it as a regular Order." *Archaeologia* 9 (1789): 110–26.

Prag, A. J. N. W. *The Oresteia. Iconographic and Narrative Tradition.* London: Aris & Phillips Ltd., 1985.

Pratt, Mr. *Gleanings through Wales, Holland and Westphalia, with views of Peace and War at Home and abroad. To which is added Humanity; or the rights of nature. A Poem revised and corrected*, vol. 2. London: T. N. Longman, 1797.

Praz, Mario. *Gusto Neo-Classico.* Florence: Sansoni, 1940.

Praz, Mario. *An Illustrated History of Interior Decoration: From Pompeii to Art Nouveau.* London: Thames and Hudson, 1964.

Praz, Mario. *On Neo-Classicism.* London: Thames and Hudson, 1969.

Preyss, A. "Athena Hope und Pallas Albani." *Kaiserlich Deutsches Archäologischen Institut Jahrbuch* 27 (1912).

Price, Uvedale. *Essays on the Picturesque, as Compared with the Sublime and the Beautiful.* 3 vols. London: Mawman, 1810.

Prosser, G. F. *Select Illustrations of the County of Surrey, Deep-dene.* London, 1828.

"The Ptolemaic Royal Image and the Egyptian Tradition." In *"Never had the like occurred": Egypt's View of Its Past.* Ed. by Edward William John Tait. London: University College, 2003.

Pückler-Muskau, H. L. H. *Tour in Germany, Holland and England in the years 1826, 1827 and 1828 . . . in a series of letters by a German Prince*, vol. 4. London, 1832.

Pye, John. *Patronage of British Art.* London: Longman, Brown, Green, and Longmans, 1845.

Quant, L. H. M., et al. *Paviljoen Welgelegen 1789–1989: Van buitenplaats van de bankier Hope tot zetel van de princie Noord-Holland.* Haarlem: Kunsthistorisch Institut van de Rijksuniversiteit Leiden, 1989.

Quatremère de Quincy, M. (Antoine-Chrysostôme). *Canova et ses Ouvrages ou Mémoires historiques sur la vie et les travaux de ce célèbre artiste.* Paris: A. Le Clère, 1834.

Quatremère de Quincy, M. (Antoine-Chrysostôme). *De l'Architecture égyptienne.* Paris: Barrois, 1803.

Raeder, Joachim. *Die statuarische Ausstattung der Villa Hadriana bei Tivoli.* Frankfurt am Main and Bern: Peter Lang, 1983.

Ramage, N. "The Pacetti Papers and the Restoration of Ancient Sculpture in the 18th Century." In *Von der Schönheit weissen Marmors: Zum 200. Todestag Bartolomeo Cavaceppis*, vol. 2. Ed. by T. Weiss. Mainz, 1999.

Ramage, Nancy Hirschland. "Cavaceppi and Modern Minimalism: The De-restoration of Roman Sculpture." In *Wiedererstandene Antike Ergänzungen antiker Kunstwerke seit der Renaissance*. Ed. by Max Kunze and Axel Rügler. Munich: Biering & Brinkmann, 2003.

Ramage, Nancy. "Restorer and collector, notes on eighteenth-century recreations of Roman statues." In *The Ancient Art of Emulation, Memoirs of the American Academy in Rome*, supp. vol. 1. Ed. by Elaine Gazda. Rome, 2002, pp. 68–71.

Ramée, Daniel. *Architecture de Ledoux*. 2 vols. Paris: Lenoir, 1847.

Ramée, Daniel. *Le Moyen-Age monumental et archéologique: Introduction Générale*. Paris: Paulin, 1843.

Reade, Brian. *Regency Antiques*. London: Batsford, 1953.

Redford, George. *Art Sales. A History of Sales of Pictures and Other Works of Art*. 2 vols. London: Bradbury, Agnew, 1888.

Reinach, Salomon. *Repertoire de la statuaire grecque et romaine*, vol. 1. Paris, 1897.

Reitlinger, Gerald. *The Economics of Taste*. Vol. 2, *The Rise and Fall of objets d'art prices since 1750*. London: Barrie & Rockliff, 1963.

Renier, G. J. *Great Britain and the Establishment of the Kingdom of the Netherlands 1813–1815*. London: G. Allen & Unwin, 1930.

"Review of 'Art of Gardening.'" *Review of Publications of Art*, no. 2 (1808): 133–44, 198–205.

Reynolds, Sir Joshua. *Discourses on Art*. Ed. by R. R. Wark. New Haven and London: Yale University Press, 1997.

Rhodes, Robin. *Architecture and Meaning on the Athenian Acropolis*. Cambridge: Cambridge University Press, 1995.

Ribeiro, Aileen. *The Art of Dress: Fashion in England and France 1750–1820*. New Haven and London: Yale University Press, 1995.

Ribeiro, Aileen. "Muses and Mythology: Classical Dress in British Eighteenth-Century Female Portraiture." In *Defining Dress: Dress as Object, Meaning and Identity*. Ed. by Amy de la Haye and Elizabeth Wilson. Manchester: Manchester University Press, 1999, pp. 104–13.

Richardson, Albert. "The Empire Style in England." *Architectural Review* (November 1911): 255–63; (December 1911): 315–25.

Richardson, Margaret, and MaryAnne Stevens, eds. *John Soane: Architect of Space and Light*. Exh. cat. London: Royal Academy of Arts, 1999.

Richter, Gisela M. A. *Ancient Furniture: A History of Greek, Etruscan and Roman Furniture*. Oxford: Clarendon Press, 1926.

Richter, Gisela M. A. *The Furniture of the Greeks, Etruscans and Romans*. London: Phaidon, 1966.

Richter, Gisela M. A. *Greek and Roman Antiquities in the Dumbarton Oaks Collection*. Cambridge, Mass.: Harvard University Press, 1956.

Richter, Gisela M. A. *Korai: Archaic Greek maidens: a study of the development of the Kore type in Greek sculpture*. London: Phaidon, 1968.

Riley, James C. *International Government Finance and the Amsterdam Capital Market, 1740–1815*. Cambridge: Cambridge University Press, 1980.

Roberts, Hugh. *For the King's Pleasure: The Furnishing and Decoration of George IV's Apartments at Windsor Castle*. London: Royal Collection, 2001.

Roberts, W. *Sir William Beechey, R.A.* London: Duckworth; New York: Scribner, 1907.

Robertson, Martin. *Greek, Etrsucan and Roman Vases in the Lady Lever Art Gallery, Port Sunlight*. Liverpool: Liverpool University Press, 1987.

Robinson, Henry Crabb. *Diary, Reminiscences and Correspondence of Henry Crabb Robinson*. 3 vols. Ed. by T. Sadler. London: MacMillan, 1869.

Robinson, John Martin. *The Regency Country House: From the archives of Country Life*. London: Aurum Press, 2005.

Rogers, Phillis. "A Regency Interior: The Remodelling of Weston Park." *Furniture History* 23 (1987): 11–34.

Rosenberg, Pierre, and Louis-Antoine Prat. *Nicolas Poussin 1594–1665*. Exh. cat. Paris: Réunion des musées nationaux, 1994–95.

Roullet, Anne. *The Egyptian and Egyptianizing Monuments of Imperial Rome*. Leiden: Brill, 1972.

Royal Pavilion, Art Gallery, and Museums. *Guide to the Regency Exhibition*. Brighton: Royal Pavilion, 1946.

Ruskin, John. "The Poetry of Architecture." in *Architectural Magazine* 4 (1837): 505–8, 555–60.

Ruskin, John. *The Works of Ruskin*. 39 vols. London: George Allen, 1903–12.

Said, Edward W. *Orientalism: Western Conceptions of the Orient*. London: Routledge & Kegan Paul, 1978.

Salvadori, Francesca, ed. *John Flaxman: The Illustrations for Dante's Divine Comedy*. Exh. cat. London: Royal Academy of Arts, 2005.

Samoyault, Jean-Pierre. *Meubles entrés sous le Premier Empire*. Paris: Réunion des musées nationaux, 2004.

Samuels, Allen. "Rudolph Ackermann (1764–1834)." Ph.D. thesis, Cambridge University, 1974.

Sass, Else Kai. *Thorvaldsens portrætbuster*. 3 vols. Copenhagen: Selskabet til udgivelse af danske mindesmærker, 1963–65.

*The Satirist or Monthly Meteor* 1 (1808): 47, 117–18, 143, 148, 252, 254.

Saumarez Smith, Charles. *Eighteenth-Century Decoration: Design and the Domestic Interior in England*. London: Weidenfeld and Nicolson, 1993.

Schlegel, von, August Wilhelm. *Sämmtliche Werke*, vol. 9. Leipzig, 1846.

Schmidt, Eva. "Venus." in *Lexicon iconographicum*, vol. 8. Zurich and Munich: Artemis, 1997.

Schroder, Timothy. *The Gilbert Collection of Gold and Silver*. Los Angeles: Los Angeles County Museum of Art, 1988.

Scott, Jonathan. *The Pleasures of Antiquity, British Collectors of Greece and Rome*. New Haven and London: Yale University Press, 2002.

Searight, Sarah. *The British in the Middle East*. London: Weidenfeld & Nicolson, 1969.

Semper, Gottfried. *The Four Elements of Architecture and Other Writings*. trans. by Harry Mallgrave and Wolfgang Herrmann. Cambridge: Cambridge University Press, 1989.

Seymour, Charles Jr. *Early Italian Paintings in the Yale University Art Gallery*. New Haven: Yale University Press, 1970.

Shee, Martin Archer. *Elements of art, a poem in six cantos; with notes and a preface, including strictures on the state of the arts*. London: Printed for W. Miller by W. Bulmer, 1809.

Shee, Martin Archer. *The Life of Sir Martin Arthur Shee*. 2 vols. London: Longman, Green, Longman and Roberts, 1860.

Shellim, Maurice S. *The Daniells in India and the Waterfall at Papanasum*. Calcutta: The Statesman, 1970.

Shellim, Maurice S. *Oil Paintings of India and the East by Thomas Daniell R.A. (1749–1840) and William Daniell R.A. (1769–1837)*. London: Inchcape & Co., 1979.

Sibbald, Susan. *Memoirs, 1783–1812*. Ed. by Francis Paget Hett. London: John Lane, 1926.

Sicca, Cinzia. *Committed to Classicism: The Building of Downing College, Cambridge*. Cambridge: Downing College, 1987.

Simo, Melanie Louise. *Loudon and the Landscape: From Country Seat to Metropolis 1783–1843*. New Haven and London: Yale University Press, 1988.

Simon, Erika. "Silenoi." In *Lexicon iconographicum mythologiae classicae*, vol. 8. Zurich and Munich: Artemis, 1997.

Simond, Louis. *Journal of a Tour and Residence in Great Britain during the years 1810 and 1811*, vol. 1. 2nd ed. Edinburgh and London, 1817.

Sinn, Frederike. *Stadtrömische Marmorurnen*. Mainz am Rhein: P. von Zabern, 1987.

Sismondi, J. C. L. S. de. *Epistolario*. Ed. by C. Pellegrini. Florence, 1933–55.

Sitwell, Sacheverell. *Conversation Pieces: A Survey of English Domestic Portraits and Their Painters*. London: Batsford, 1936.

Smallwood, Valerie, and Susan Woodford. *Fragments from Sir William Hamilton's Second Collection of Vases Recovered from the Wreck of HMS Colossus, Corpus Vasorum Antiquorum, Great Britain, Fascicule 20, The British Museum Fascicule 10*. London: British Museum Press, 2000.

Smith, Arthur Hamilton. "Lord Elgin and His Collection." *Journal of Hellenic Studies* 36 (1916): 163–370.

Smith, George. *Collection of Designs for Household Furniture and Interior Decoration*. London: J. Taylor, 1808; reprinted New York: Praeger, 1970.

Smith, John. *A Catalogue Raisonné of the works of the most eminent Dutch, Flemish, and French painters . . . 8 parts*. London: Smith & Son, 1829–42.

Smith, Sydney. Review of Hope's *Household Furniture*. Edinburgh Review 10 (1807).

Soane, John. *Description of . . . The Residence of John Soane, Architect*. London: James Moyes, 1830.

Soane, John. *Plans, Elevations, and Perspective Views of Pitzhanger Manor-House*. London: Pitzhanger Manor, 1802.

"The Soanean Museum." *Civil Engineer and Architects' Journal* 1 (1837–38): 44.

Society of Dilettanti. *Antiquities of Ionia*. London: Bulmer & Co., 1797.

Society of Dilettanti. *Ionian Antiquities*. London: Spilsbury and Haskell, 1769.

Soros, Susan Weber, ed. *James "Athenian" Stuart: The Rediscovery of Antiquity*. Exh. cat. New Haven and London: Yale University Press, 2006.

Specimens of Antient Sculpture, selected from several collections in Great Britain, by the Society of Dilettanti. Vol. 1, London, 1809; vol. 2, London, 1835.

Spiers, Walter L. Catalogue of the Drawings and Designs of Robert and James Adam in Sir John Soane's Museum. Cambridge: Chadwick Healey Ltd. 1979.

Spink & Son. An Exhibition of Antique Sculpture, Vases, Bronzes &c. London: Spink & Son, 1919.

Spink & Son. Greek and Roman Antiquities. London: Spink & Son, 1924.

St. Clair, William. Lord Elgin and the Marbles. 3rd ed. Oxford: Oxford University Press, 1998.

Starkey, Paul and Janet, eds. Interpreting the Orient: Travelling in Egypt and the Near East. Reading: Itacha Press, 2001.

Stephens, Suzanne. "In Search of the Pointed Arch: Freemasonry and Thomas Hope's 'An Historical Essay on Architecture.'" Journal of Architecture 1, no. 2 (Summer 1996): 133–58.

Strien-Chardonneau, Madeleine van. Le voyage de Hollande: récits de voyageurs français dans les Provinces Unies 1748–1795. Paris: Voltaire Foundation, 1994.

Stroud, D. Henry Holland: His Life and Architecture. London: Country Life, 1966.

Stuart, James, and Nicholas Revett. The Antiquities of Athens. 3 vols. London: John Haberkorn and John Nicholls, 1762–94.

Surr, Thomas Skinner. A Winter in London. 3 vols. London: Richard Phillips, 1806.

Survey of London. Vol. 30, Parish of St James Westminster. Pt. 1, South of Piccadilly. London: Athlone Press, 1960. Vol. 40, The Grosvenor Estate in Mayfair. Pt. 1, The Buildings. London: Athlone Press, 1980.

Symmons, Sarah. Flaxman and Europe. The Outline Illustrations and their Influence. New York and London: Garland Publishing, 1984.

Symonds, R. W. "Some Aspects of Regency Furniture." Antique Collector (September–October 1948).

Symonds, R. W. "Thomas Hope and the Greek Revival." Connoisseur 140 (December 1957).

Tatham, Charles Heathcote. Designs for Ornamental Plate. London: Printed for Thomas Gardiner, 1806.

Tatham, Charles Heathcote. Etchings of Ancient Ornamental Architecture drawn from the Originals in Rome and other Parts of Italy during the years 1794, 1795, and 1796. London: The Author, 1799–1800.

Tatham, Charles Heathcote. Etchings representing Fragments of Grecian and Roman Architectural Ornaments. London: Printed for T. Gardiner by John Barfield, 1806.

Tatlock, R. R. A Record of the Collection in the Lady Lever Art Gallery, Port Sunlight, formed by the First Viscount Leverhulm. London: Batsford, 1928.

Taylor, John H. Death and the Afterlife in Ancient Egypt. London: British Museum Press, 2001.

Teotochi, I. Albrizzi. Opere di scultura e di plastica di Antonio Canova. Pisa, 1823.

Thiele, J. M. The Life of Thorvaldsen. Ed. by M. R. Barnard. London: Chapman and Hall, 1865.

Thiele, J. M. Thorvaldsens Biographi, vol. 2. Copenhagen, 1854.

Thiele, J. M. Thorvaldsen's Leben nach den eigenhändigen Aufzeichnungen, nachgelassenen Papieren und dem Briefwechsel des Künstlers von Just Mathias

Thiele. Deutsch unter Mitwirkung des Verfassers von Henrik Helms. 3 vols. Leipzig: C. B. Lorck, 1852–56.

Thieme, U., and Becker, F. Allgemeines Lexikon der bildenden Künstler. 37 vols. Leipzig: E. A. Seeman, 1953–62.

Thomas, John Meurig. Michael Faraday and the Royal Institution: The Genius of Man and Place. London: Institute of Physics Publishing; New York: Hilger, 1991.

Thornton, Peter. Authentic Decor: The Domestic Interior, 1620–1920. London: Weidenfeld and Nicolson, 1984.

Thornton, Peter, and David Watkin. "New Light on the Hope Mansion in Duchess Street." Apollo 126, no. 307 (September 1987): 162–77.

Thornton, Peter, and Helen Dorey. A Miscellany of Objects from Sir John Soane's Museum. London: Laurence King, 1992.

Timbs, John. The British Metropolis. London, 1851.

Timbs, John. Curiosities of London, exhibiting the most rare and remarkable objects of interest in the Metropolis; with nearly fifty years' personal recollections. London: D. Bogue, 1855; rev. ed., 1868.

Todisco, Luigi. Scultura greca del IV secolo: Maestri e scuole di statuaria tra classicità ed ellenismo. Milan: Longanesi, 1993.

Touratsoglou, Yiannis, Rozina Kolonia, and Nikoleta Valakou et al. Democracy and Classical Culture. Exh. cat. Athens: Ministry of Culture and Sciences, Direction of Prehistoric and Classical Antiquities, 1985.

Traeger, Jörg. Philipp Otto Runge und sein Werk. Munich: Prestel, 1975.

Trendall, Arthur Dale. "Paestan Pottery: a revision and a supplement." British School at Rome 20 (1952).

Trendall, Arthur Dale. Paestan pottery: a study of the red-figured vases of Paestum. London: British School at Rome, 1936.

Trendall, Arthur Dale. "Pestani, Vasi." In Enciclopedia dell'arte antica, classica e orientale, vol. 6. Rome: Istituto della Enciclopedia Italiana, 1966.

Trendall, Arthur Dale. The Red-Figured Vases of Paestum. Hertford: Stephen Austin and Sons, 1987.

Trendall, Arthur Dale. Red Figured Vases of South Italy and Sicily: A Handbook. London: Thames and Hudson, 1989.

Trendall, Arthur Dale, and T. B. L. Webster. Illustrations of Greek Drama. London: Phaidon, 1971.

Tresham, Henry. "Hope's Garland." Satirical tract. London, 1804.

Tsigakou, Fani-Maria. Thomas Hope (1769–1831). Pictures from 18th-century Greece. Athens: Benaki Museum and the British Council, 1985.

Tweddell, John. Remains of the late John Tweddell. London: J. Mawman, 1815.

Vermeule, C. C. AJA 59 (1955): 141.

Vermeule, C. C., and von Bothmer, Dietrich. "Notes on a New Edition of Michaelis: Ancient Marbles in Great Britain." AJA 63, pt. 3 (1959).

Vickers, Michael. "Value and Simplicity: A Historical Case." In Michael Vickers and David Gill, Artful Crafts: Ancient Greek Silverware and Pottery. Oxford: Clarendon Press, 1994, pp. 1–32.

Vincent, Jean Anne. "Thomas Hope: Regency's Designing Dilettante." Contract Interiors (November 1953): 113, 102–9, 144, 146, 148, 150.

Visconti, Giambattista. Il Museo Pio-Clementino, vol. 7. Rome, 1782.

"Visits to Private Galleries no. X. The collection of H. T. Hope, Esq., Duchess-street, Portland Place." Art Union (1 April 1846): 97–98.

Vorster, Christiana. "Skopas (II)." In Kunstlerlexikon der Antike, vol. 2. Ed. by Rainer Volkommer. Munich and Leipzig: K. G. Saur, 2004.

Waagen, Gustav Friedrich. Galleries and Cabinets of Art in Great Britain. London: John Murray, 1857.

Waagen, Gustav Friedrich. Kunstwerke und Künstler in England. 2 vols. Berlin, 1837–38.

Waagen, Gustav Friedrich. Treasures of Art in Great Britain. 3 vols. London: John Murray, 1854.

Waagen, Gustav Friedrich. Works of Art and Artists in England. 2 vols. London: John Murray, 1838.

Wainwright, Clive. "George Bullock and His Circle." In George Bullock Cabinet-Maker (1988): 21–22.

Wainwright, Clive. The Romantic Interior: The British Collector at Home 1750–1850. New Haven and London: Yale University Press for the Paul Mellon Centre for Studies in British Art, 1989.

Walker, Richard. "Henry Bone's Pencil Drawings in the National Portrait Gallery." Walpole Society 61 (1998–99): 305–67.

Walker, Richard. Regency Portraits, vol. 1. London: National Portrait Gallery, 1985.

Ward-Perkins, John, and Amanda Claridge, Pompeii AD 7. Exh. cat. London: Carlton Cleeve, 1976.

Waterfield, Giles. Palaces of Art: Art Galleries in Britain 1790–1990. Exh. cat. London: Dulwich Picture Gallery, 1991.

Watkin, David. The Age of Wilkins: The Architecture of Improvement. Exh. cat. Cambridge: Fitzwilliam Museum, 2000.

Watkin, David. "Charles Kelsall: The Quintessence of Neo-Classicism." Architectural Review 140 (August 1966): 109–12.

Watkin, David. "The Deepdene: 'Grotesque and Confused?'" In Fragments, Architecture and the Unfinished: Essays Presented to Robin Middleton. Ed. by Barry Bergdoll and Werner Oeschlin. London and New York: Thames and Hudson, 2006, pp. 139–46.

Watkin, David. "Deepdene, Surrey." Country Life (1 November 2007): 92–95.

Watkin, David. The English Vision: The Picturesque in Architecture, Landscape and Garden Design. London: John Murray, 1982.

Watkin, David. "'The Hope Family' by Benjamin West." Burlington Magazine. 106 (December 1964): 571–73.

Watkin, David. The Life and Work of C. R. Cockerell. London: Zwemmer, 1974.

Watkin, David. The Rise of Architectural History. London: The Architectural Press, 1980.

Watkin, David. The Royal Interiors of Regency England: From Watercolours First Published by W. H. Pyne. London: Dent, 1984.

Watkin, David. Sir John Soane: Enlightenment Thought and the Royal Academy Lectures. Cambridge: Cambridge University Press, 1996.

Watkin, David. Thomas Hope (1769–1831) and the Neo-Classical Idea. London: John Murray, 1968.

Watkin, David. "Thomas Hope's House in Duchess Street." *Apollo* (March 2004): 30–39.

Watkin, David. *The Triumph of the Classical: Cambridge Architecture, 1804–1834.* Exh. cat. Cambridge: Fitzwilliam Museum, 1977.

Watkin, David, and Fani Maria Tsigakou. "A Case of Regency Exoticism: Thomas Hope and the Benaki Drawings." *Cornucopia* 1, no. 5 (1993–94): 52–59.

Watkin, David, and Jill Lever. "A Sketch-book by Thomas Hope." *Architectural History* 23 (1980): 52–59.

Watson, Anne. "'A gentleman of the sphinxes': Thomas Hope and the Egyptian Revival." *Australian Antique Collector* (January–June 1992): 40–43.

Watson, Anne. "Hope . . . and glory." *Powerline* (October–November 1990).

Watson, Francis. "The Furniture and Decoration." *Southill, A Regency House.* London: Faber & Faber, 1951.

Waywell, Geoffrey B. *The Lever and Hope Sculptures. Ancient Sculpture in the Lady Lever Art Gallery, Port Sunlight and a Catalogue of the Ancient Sculptures formerly in the Hope Collection, London and Deepdene.* Monumenta Artis Romanae, XVI, Classical Sculpture in Private Collections. Ed. by Hans-george Oehler. Berlin: Gebr. Mann Verlag, 1986.

Weale, John. *A New Survey of London . . .* , vol. 1. London: Weale, 1853.

Webster, Mary. "Flaxman as Sculptor." In Bindman, *John Flaxman* (1979).

Wellesley, Lord Gerald. "Regency Furniture." *Burlington Magazine* 70 (May 1937): 233–40.

Wertheimer, Asher. *The Hope Collection of Pictures of the Dutch and Flemish Schools with descriptions reprinted from the catalogue published in 1891 by the Science and Art Department of the South Kensington Museum.* London: Chiswick Press, 1898.

Westmacott, Charles Molloy. *British Galleries of Painting and Sculpture, the first part.* London: Sherwood, 1824.

Whinney, Margaret, and Rupert Gunnis, *The collection of models by John Flaxman, R.A. at University College London; a catalogue and introduction.* London: Athlone Press, 1967.

Whinney, Margaret. *Sculpture in Britain 1530–1830.* 2nd ed. London and New York: Penguin Books, 1988.

White, Adam. "Two Bronze Dogs from the Hope Collection." *Leeds Art Calendar* 98 (1986): 23–25.

Whitehead, Violet. "'A Flaxman Panel in Dorking." *The Journal of the Dorking Local History Group* (1998): 40–41.

Whitehead, Violet. "Missing Persons or Vestiges of Hope Gone." *Local History Group Newsletter*, new ser., no. 2 (Autumn 1985): 8.

Whitley, William T. *Artists and Their Friends in England 1700–1799*, vol. 2. London and Boston: Medici Society, 1928.

Whitley, William T. *Art in England 1800–1820.* 2 vols. Cambridge: Cambridge University Press, 1928.

Whitley, William T. *Thomas Heaphy.* London: Royal Society of British Artists' Art Club, 1933.

Wieb, M. G., J. B. Conacher, J. Matthews, and M. S. Millar, eds. *Benjamin Disraeli: Letters 1838–1841.* Toronto: University of Toronto Press, 1987.

Wiersum, E. "Het Schilderijen-Kabinet van Jan Bisschop te Rotterdam." *Oud-Holland* (1910): 161–86.

Wilcox, Timothy. *The Triumph of Watercolour: The Early Years of the Royal Watercolour Society, 1805–1855.* Exh. cat. Dulwich Picture Gallery and the Whitworth Art Gallery, University of Manchester. London: Philip Wilson, 2005.

Wilk, Christopher, ed. *Western Furniture: 1350 to the Present Day in the Victoria and Albert Museum, London.* London: Philip Wilson in association with the Victoria and Albert Museum, 1996.

Williams, D. E. *Life and Correspondence of Thomas Lawrence.* 2 vols. London: Colburn and Bentley, 1831.

Williams, Dyfri. *Greek Vases.* London: British Museum Press, 1985.

Williams, Dyfri. "Of publick utility and publick property." In *Appropriating Antiquity, Collections et Collectionneurs d'antiques en Belgique et en Grande-Bretagne au XIX Siècle.* Ed. by Athena Tsingarida with Donna Kurtz. Brussels: Le Livre Timperman, 2002, pp. 103–64.

Williams, Julia Lloyd, Christopher Smout, and Deborah Howard. *Dutch Art and Scotland: A Reflection of Taste.* Exh. cat. Edinburgh, National Galleries of Scotland, 1992.

Wilton-Ely, John. *Giovanni Battista Piranesi: The Complete Etchings*, vol. 2. San Francisco: Alan Wofsy Fine Arts, 1994.

Wilton-Ely, John. *The Mind and Art of Giovanni Battista Piranesi.* London: Thames and Hudson, 1988.

Wilton-Ely, John. *Piranesi.* Exh. cat. London: Arts Council of Great Britain, 1978.

Wimpffen, Baronne de, ed. *Lettres de Mme Reinhard à sa Mère, 1798–1815.* Paris: A. Picard, 1900.

Winckelmann, Johann Joachim. *Anmerkungen über die Geschichte der Kunst des Alterthums.* Dresden: Waltherischen Hof Buchhandlung, 1767.

Winckelmann, Johann Joachim. *Briefe.* Ed. by Hans Diepolder and Walther Rehm. 4 vols. Berlin: De Gruyter, 1952–57.

Wilton, Andrew, and Ilaria Bignamini, eds. *Grand Tour: The Lure of Italy in the Eighteenth Century.* London: Tate Gallery Publishing, 1996.

Wittstock, Jurgen. *Geschichte der deutschen und skandinavischen Thorvaldsen-Rezeption bis zur Jahresmitte 1819.* Hamburg: University of Hamburg, 1975.

Wolohojian, Stephen, ed. *A Private Passion: 19th-Century Paintings and Drawings from the Greville L. Winthrop Collection.* Cambridge, Mass.: Harvard University Press, 2003.

Wood, Lucy, and Sarah Medlam. "Acquisition in Focus: A Pair of Egyptian Revival Chairs designed by Denon." *Apollo* 145, no. 424 (June 1997): 45–47.

Woodward, Christopher. *Soane's Magician: The Tragic Genius of Joseph Michael Gandy.* Exh. cat. London: The Soane Gallery, 2006.

Worsley, Giles. *England's Lost Houses: From the archives of Country Life.* London: Aurum Press, 2002.

Wrede, Henning. "Die Tanzenden Musikanten von Mahdia." *Mitteilungen des Deutschen Archälogogischen Instituts Römische Abteilung* 95 (1988): 100–101.

Wrede, Henning. "Zu Antinous, Hermaphrodit und Odysseus." *Boreas Münstersche Beiträge zur Archäologie* 9 (1986): 130–32.

Wright, Joanne, ed. *The Newcastles of Clumber: A Pictorial and Documentary History of an Important Nottinghamshire Family.* Exh. cat. Nottingham: Nottingham University Art Gallery, 1992.

York City Art Gallery. *Masterpieces from Yorkshire Houses: Yorkshire Families at Home and Abroad 1700–1850.* Exh. cat. York: York City Council with Sotheby's, 1994.

Zagdoun, Mary-Anne. *La sculpture archaïsante dans l'art hellénistique et dans l'art romain du Haut-Empire*, vol. 1. Athens: Ecole française d'Athènes; Paris: Diffusion de Boccard, 1989.

Zanker, Paul. "Die Villa als Vorbild des späten pompejanischen Wohngeschmacks." *Jahrbuch des Deutschen Archäologischen Instituts* 94 (1979): 496–98.

Zaphiropoulou, Photini. "Hyberboreoi." In *Lexicon iconographicum mythologiae classicae*, vol. 8. Zurich and Munich: Artemis, 1997, pp. 641–43.

Zeitler, Rudolf Walter. "Klassizismus und Utopia." *Figura* 5 (1954): 146–51.

Ziegler, Philip. *The Sixth Great Power: Barings, 1762–1929.* London: Harper Collins, 1988.

# Index

# Photography Credits

Photographs were taken or supplied by the lending institutions, organizations, or individuals credited in the picture captions and are protected by © (copyright); many names are not repeated here. Individual photographers are credited below. Permission has been sought for use of all copyrighted illustrations in this volume. In several instances, despite extensive research, it has not been possible to locate the original copyright holder. Copyright owners of these works should contact the Bard Graduate Center, 18 West 86th Street, New York, NY 10024.

A.A.W. meine Jansen: fig. 1-1.

A.C. Cooper Photographers of Mayfair: figs. 3-4 to 3-7, 4-2, 4-18.

Art & Architecture Collection, Miriam and Ira D. Wallach Division of Art, Prints and Photographs, The New York Public Library Astor, Lenox, and Tilden Foundations: 2, 2-7, 2-8, 2-13 to 2-15, 2-18 to 2-20, 3-1, 3-3, 6-1, 6-3 to 6-6, 6-8 to 6-18, 6-22, 7-2, 7-13, 7-19, 7-25, 8, 10, 11-5, cat. nos. 66-2 to 66-4, 67-1, 84-1.

Avery Architectural and Fine Arts Library, Columbia University: cat. no. 100.1.

John Blazejewski: fig. 12-7.

© The British Library Board. All rights reserved (C.180.cc.4): cat. no. 119.

Carlton Hobbs, LLC: cat. no. 78.

Richard Caspole, Yale Center for British Art: figs. 2-12, 4-3, 4-4, 4-7, 7-27, 11-10, 11-12, 11-14, 11-16, 11-17.

© Christie's Images Limited 2007: cat. nos. 48, 66-5, 90, 125.

Michael Dam: fig. 8-9.

Courtesy of Didier Aaron, Inc.: fig. 9-14.

Divisao de Documentacao Fotografica - Instituto Portugues De Museus: cat. nos. 39, 49.

Elias Eliadis: cat. nos.: 95-1, 98-1, 109.

Bettina Jacot-Descombes: fig. 8-3

Pernille Klemp: figs. 8-7, 8-11, cat. nos. 9 to 12.

Schecter Lee, Photograph © 1986 The Metropolitan Museum of Art: fig. 7-18.

© Leeds Museums and Galleries (City Art Gallery) U.K./ The Bridgeman Art Library: cat. nos. 57.

Robert Lifson, Reproduction, The Art Institute of Chicago: fig. 4-5.

Massimo Listri: fig. 15-15.

E J Mason: fig. 15-17.

© 1991 The Metropolitan Museum of Art: fig. 7-9.

Ministero per i Beni e le Attività Culturali Soprintendenza per i Beni Archeologici delle province di Napoli e Caserta: cat. no. 47-1.

© Musées de Poitiers - Christian Vignaud: cat. nos. 60, 61.

© 2006 Museum Associates / Los Angeles County Museum of Art: figs. 7-14, 7-23, 10-08.

Syd Neville: cat. no. 67.

© NTPL/Andreas von Einsiedel: fig. 8-1.

Carlos Oarvedo: cat. nos. 42, 43, 112.

R.G. Ojeda: fig. 10-6.

Edward Owen: fig. 11-7.

Phoenix Ancient Art S.A. - photography: André Longchamps, Geneva: cat. no. 47.

Powerhouse Museum, Sydney: Andrew Frolows: cat. no. 77-1.

András Rázsó 623/92: fig. 10-14.

Antonia Reeve: fig. 7-17, cat. nos. 45, 79, 83, 92.

Rijksmuseum: cat. no. 71-1.

Alan J Robertson: figs. 7-20, 12-5, 12-6, 12-8 to 12-10, 12-12 to 12-14, 12-16, 12-17, cat. nos. 106.1 to 106.21.

The Royal Collection © HM Queen Elizabeth II: cat. nos. 78-2, 78-3.

Royal Pavilion and Museums, Brighton & Hove: fig. 4-12, cat. no. 95.

Scala/Art Resource, NY: fig. 8-10.

Miki Slingsby Fine Art Photography: figs. 1-4, 2-10, 5-10 to 5-13, 6-7, 8-17, 9-15, 11-1, 15-14, cat. nos. 5, 6, 8, 35, 36, 37, 38, 41, 44, 51, 62, 69-2, 74, 91-2, 111, 112.

Roger Smith: cat. no. 112.

Speltdoorn: 11-8.

Norman Taylor: cat. no. 87.

Renaldo Viegas: fig. 7-24, cat. no. 50.

Han Vu: figs. 2-5, 2-17, 3-8, 3-9, 4-9, 4-12A, 5-4, 5-9, 7-15, 12-20, cat. nos. 65-1, 65-2, 66-1, 69-1, 70-1, 75-1, 78-1, 79-1, 80-1, 81-1, 82-1, 85-1, 86-1, 87-1, 89-1, 90-1, 91-1, 93-1, 94-1, 94-2, 95-2, 97-1, 98-2.

Elke Walford: 8-18.

Bruce White: figs. 2-1 to 2-4, 2-9, 2-11, 4, 4-14, 4-16, 5, 8-2, 12-1 to 12-4, 14, cat nos. 3, 4, 7, 14, 15, 71, 72, 73, 76, 77, 80, 81, 82, 85, 86, 88, 92, 93, 96, 97, 98, 99, 101, 104, 105, 108, 110, 114, 115, 116, 120 to 124.

Ole Woldbye: figs. 8-6, 8-12.

13